KU-544-318

FRANS HALS

National Gallery of Art, Washington DC 1 October – 31 December 1989

Royal Academy of Arts, London 13 January – 8 April 1990

Frans Halsmuseum, Haarlem 11 May – 22 July 1990

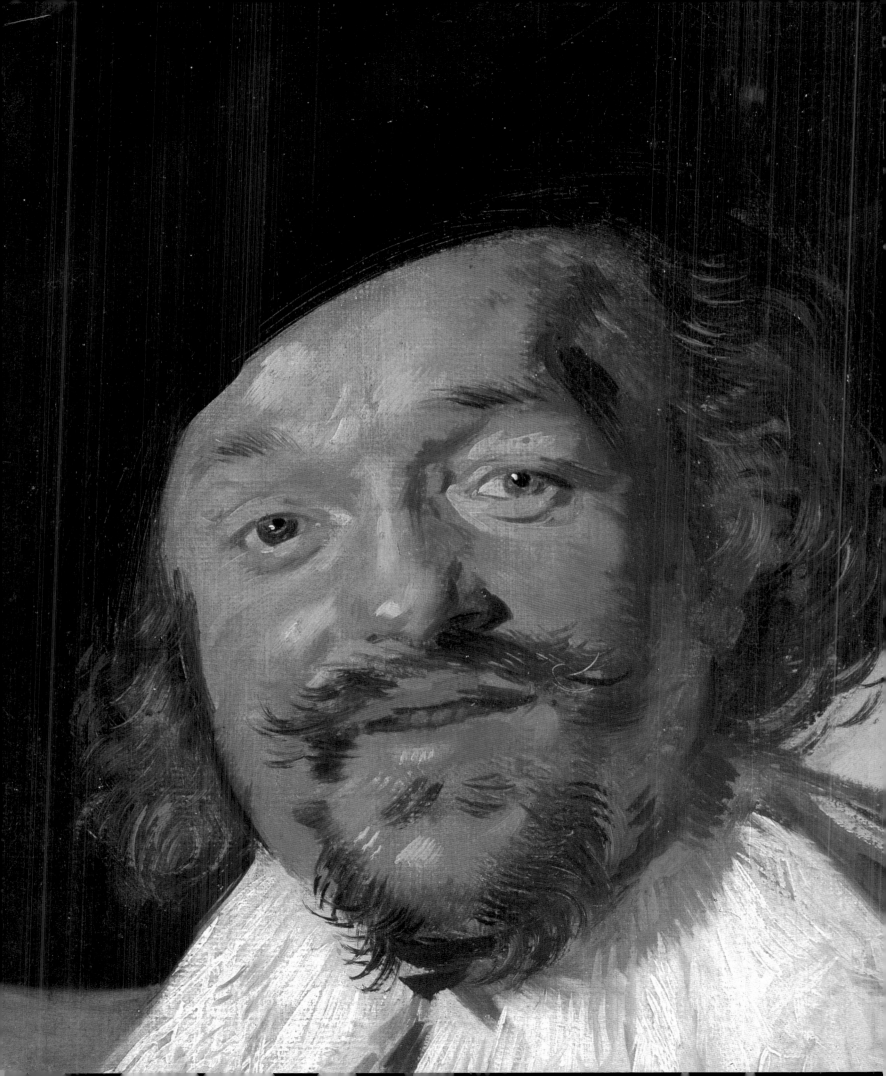

FRANS HALS

Seymour Slive

With contributions by Pieter Biesboer
Martin Bijl
Karin Groen and Ella Hendriks
Michael Hoyle
Frances S. Jowell
Koos Levy-van Halm and Liesbeth Abraham
Bianca M. du Mortier
Irene van Thiel-Stroman

EDITED BY SEYMOUR SLIVE

ROYAL ACADEMY OF ARTS, LONDON 1989

Catalogue published in association with Ludion, Brussels

Executive Committee
PIERS RODGERS, Chairman; Secretary of the Royal Academy
ROGER DE GREY, President of the Royal Academy
LAWRENCE GOWING, Chairman, Exhibitions Sub-Committee, Royal Academy of Arts
JOHN PIGOTT, Financial Comptroller, Royal Academy of Arts
NORMAN ROSENTHAL, Exhibitions Secretary, Royal Academy of Arts
MARYANNE STEVENS, Librarian and Head of Education, Royal Academy of Arts
J.D.W. TULIP, National Administration Manager, Unilever plc
ANNETTE BRADSHAW, Secretary to the Committee

Selection Committee
SEYMOUR SLIVE and CHRISTOPHER BROWN, with NORMAN ROSENTHAL, DERK SNOEP and ARTHUR J. WHEELOCK
Exhibition Coordinator: MARYANNE STEVENS
Exhibition Assistants: JULIE SUMMERS and SUSAN THOMPSON

Catalogue Coordinator: MARYANNE STEVENS
Catalogue Assistants: ALICE I. DAVIES and MICHAEL HOYLE
Catalogue Translators: MICHAEL HOYLE, YVETTE ROSENBERG and C.M.H. HARRISSON

Designed for Ludion Brussels by LOUIS VAN DEN EEDE
House Editor: PAUL VAN CALSTER

Cover illustrations:
(front) *Isabella Coymans* (cat. 69)
(back) *Malle Babbe*, detail (cat. 37)

Frontispiece: *The Merry Drinker*, detail (cat. 30)

© Royal Academy of Arts, 1989
© Max Beckmann by Cosmopress, Geneva
© of all other documents, see Photographic Acknowledgements

Typesetting and printing by Vanmelle, Ghent, Belgium
Colour separation by Scan 2000, Bilbao, Spain

Contents

Author's Acknowledgements

Katharine Baetjer
Claire Barry
Hening Bock
David Bomford
John Bradshaw
John Brearley
Harry Brooks
Ian Brunt
Carol Clark
Michael Clarke
Peter Day
John Dick
Frits Duparc
Everett Fahy

Burton Fredericksen
Dieter Gleisberg
Carlos van Hasselt
Susanne Heiland
John Jacob
David Torbet Johnson
Susanna Koenig
Katherine C. Lee
Françoise Lernout
Walter Liedtke
Christopher Lloyd
Ian McClure
Hamish Miles

Anne Morton
Charles Parkhurst
Pierre Rosenberg
Bernard Schackenburg
Zoya Slive
Timothy Stevens
Peter Sutton
Pieter van Thiel
Erik Vandamme
Michael A. Varet
Eliane de Wilde
Catherine Whistler
Christopher White

Photographic Acknowledgements

The exhibition organisers would like to thank the following for making photographs available.

ACL, Brussels; Peter Adelberg, New York; Jorg P. Anders, Berlin (cat.9, 15, 37); Annan, Glasgow; The Art Institute of Chicago; Bayerische Staatsgemäldesammlungen, Munich; British Museum, London; The Budapest Museum of Fine Arts; Photo Bulloz, Paris (cat.81, 82); Carlo Catenazzi, AGO (cat.21, 76); Centraal Museum, Utrecht; Philip A. Charles, Washington DC (cat.78); Cincinnati Art Museum; The Clowes Fund Collection, Indianapolis; Conzett & Huber, Zurich; A.C. Cooper Ltd (cat.38, 44); Courtauld Institute of Art, London; A. Dingjan, The Hague; Gebr. Douwes Fine Art; The Fitzwilliam Museum, Cambridge; The Fogg Art Museum Library, Harvard University, Cambridge, Mass.; Fotocommissie Rijksmuseum Amsterdam; The Frick Collection, New York; Docs Gleimhaus, Halberstadt; L.S. Glover, Detroit; Tom Haartsen, Ouderkerk a/d Amstel (cat.1, 41, 42, 54, 85, 86); Hälsingborgs Museum; Frans Halsmuseum, Haarlem; Hamilton Kerr Institute, Cambridge; Hermitage, Leningrad; Herzog Anton Ulrich-Museum, Brunswick; Christopher Hurst (cat.2, 3, 13); Kimbell Art Museum, Fort Worth, Texas; M. Knoedler & Co, Inc, New York; Kunsthalle, Hamburg; Kunsthistorisches Museum, Wien; Coll. F. Lugt, Paris; Mauritshuis, The Hague; Menko ten Cate, Amsterdam; The Metropolitan Museum of Art, New York; Musée des Beaux-Arts, Lille; Musée du Louvre, Paris; Musée J.P. Pescatore, Luxembourg; Museo de Bellas Artes, Bilbao; Museum of Fine Arts, Boston; The National Gallery of Ireland, Dublin; National Gallery of Scotland, Edinburgh; Nationalmuseum, Stockholm; Parke Bernet Galleries; The Parrish Art Museum, Southampton, New York; Hans Petersen, Copenhagen (cat.66, 75); Photo Pfender; Philadelphia Museum of Art; The Pierpont Morgan Library, New York; Milan Posselt, Prague (cat.62); Prentenkabinet Rijksmuseum, Amsterdam; Richmond and Rigg Photography (cat.74); Rijksmuseum Het Catharijneconvent, Utrecht; Rijksmuseum-stichting, Amsterdam; Rijksmuseum Twenthe, Enschede; The John and Mable Ringling Museum of Art, Sarasota, Florida; David Robson, Salisbury (cat.65); Christoph Sandig, Leipzig (cat.27, 28); Service photographique de la Réunion des musées nationaux, Paris (cat.6, 7, 14, 72); Seymour Slive, Cambridge, Mass.; Staatliche Gemäldegalerie, Kassel; Staatliche Graphische Sammlung, Munich; Staatliche Kunstsammlungen, Dresden; Staatliche Museen Preussischer Kulturbesitz, Berlin Dahlem; Stadhuis, Deventer; Städtische Kunstsammlungen, Augsburg; Stedelijk Archief, Haarlem; Stedelijk Museum, Amsterdam; Jim Strong Inc., New York (cat.40); Teylers Stichting, Haarlem; Martin Thorneycroft, Bridgnorth (cat.33); Victoria and Albert Museum, London; Elke Walford, Hamburg; Cor van Wanrooy, Leiden

Lenders to the Exhibition

H.M. The Queen cat. 38

BELGIUM
Antwerp, Koninklijk Museum voor Schone
 Kunsten cat. 34, 68
Brussels, Musées Royaux des Beaux-Arts de
 Belgique cat. 11, 51,60

CANADA
Ottawa, The National Gallery of Canada cat. 59
Toronto, Art Gallery of Ontario cat. 21, 76

CZECHOSLOVAKIA
Prague, National Gallery cat. 62

DENMARK
Copenhagen, Statens Museum for Kunst cat. 75
Copenhagen, Statens Museum for Kunst, on per-
 manent loan from the Ny Carlsberg Glypto-
 thek cat. 66

EIRE
Dublin, The National Gallery of Ireland cat. 36

FEDERAL REPUBLIC OF GERMANY
West Berlin, Gemäldegalerie, Staatliche Museen
 Preussischer Kulturbesitz cat. 9, 15, 37
Kassel, Staatliche Kunstsammlungen cat. 31, 83
Munich, Bayerische Staatsgemäldesammlungen,
 Alte Pinakothek cat. 17, 80

FRANCE
Amiens, Musée de Picardie cat. 81
Paris, Musée du Louvre cat. 6, 7, 14, 72
Paris, Musée Jacquemart-André cat. 82

GERMAN DEMOCRATIC REPUBLIC
Leipzig, Museum der bildenden Kunst cat. 32
Schwerin, Staatliches Museum cat. 27, 28

GREAT BRITAIN
Aurora Art Fund cat. 65
The Barber Institute of Fine Arts,
 The University of Birmingham cat. 2
The Duke of Devonshire and the Chatsworth
 House Trust cat. 3, 13

Edinburgh, National Galleries of Scotland
 cat. 24, 57, 58
Hull City Museum and Art Galleries: Ferens Art
 Gallery cat. 74
London, The Iveagh Bequest, Kenwood
 (English Heritage) cat. 44
London, The Trustees of the National
 Gallery cat. 29, 50, 53
Oxford, Senior Common Room, Christ
 Church cat. 79
Private collection, on loan to the National
 Museum of Wales, Cardiff cat. 10

NETHERLANDS
Amsterdam, Rijksmuseum cat. 12, 30, 43, 46, 47
Haarlem, Frans Halsmuseum cat. 1, 41, 42, 85, 86
Haarlem, Frans Halsmuseum, on loan from the
 Elisabeth Hospital cat. 54
The Hague, Koninklijk Kabinet van Schilderijen,
 Mauritshuis cat. 16, 18, 19

SWITZERLAND
Collection Bentinck-Thyssen, on deposit at the
 Musée d'Etat, Grand-Duché du Luxembourg
 cat. 5
Thyssen-Bornemisza Foundation, Lugano cat. 67

UNITED STATES OF AMERICA
Boston, Museum of Fine Arts cat. 84
Cincinnati, Art Museum cat. 49
Cincinnati, The Taft Museum cat. 63, 64
Forth Worth, Kimbell Art Museum cat. 8
New York, The Metropolitan Museum of Art
 cat. 20, 52, 56, 70
Pittsburgh, The Carnegie Museum cat. 4
San Diego, Museum of Art cat. 48
Saul P. Steinberg Collection cat. 55
Washington, National Gallery of Art
 cat. 39, 45, 61, 71

U.S.S.R.
Leningrad, State Hermitage Museum cat. 73
Odessa, Museum of Western and Eastern Art
 cat. 22, 23

and the following owners who wish to remain anon-
ymous: cat. 25, 26, 33, 35, 40, 69, 77, 78

Sponsor's Preface

Unilever is delighted to sponsor the largest exhibition of Frans Hals works ever to be mounted. 1990 marks Unilever's Diamond Jubilee, so this sponsorship makes a fitting opening to Unilever's Jubilee year.

Hals produced the majority of his outstanding paintings while living in Holland. As Unilever's origins are as an Anglo-Dutch business – formed when the worldwide interests of the British Lever Brothers company joined together with the Dutch Margarine Unie in 1930 – the sponsorship is particularly appropriate.

Unilever is not, of course, new to sponsorship at the Royal Academy, with whom it is always a pleasure to liaise. In 1980 we sponsored the Leverhulme Exhibition and in 1983, the Hague School Exhibition.

Exhibition sponsorship is one aspect of a wider programme of support for the Arts by Unilever over the past few years. The programme covers major events in many artistic fields, but also support for local initiatives in areas where the Company has a presence. For the London Head Office, the works of young contemporary artists are purchased for display in those parts of the building accessible to all the staff.

Support is also given in many other countries. For example, concurrently with the Frans Hals, Unilever is sponsoring a Kees van Dongen Exhibition at the Boymans-van Beuningen Museum in Rotterdam.

Our thanks go to all who have loaned paintings to make the Frans Hals exhibition so significant and to the many who have contributed to its organisation.

May this splendid exhibition bring great pleasure to all who view it.

MICHAEL R. ANGUS

FLORIS A. MALJERS

Unilever Chairmen

Unilever

President's Foreword

That the magnificent paintings of Frans Hals should be celebrated on the walls of the Royal Academy of Arts in London is a fitting tribute to a great artist by his successors in that profession. More than any of his contemporaries who contributed to the Golden Age of Dutch art, Frans Hals has been valued for his painterly skills. The bravura of his brushwork, the daring of his use of blacks and whites, the capacity to capture in a single gesture the distinctive character of his sitters, transformed urchins and comfortable burghers into lively genre pieces and monumental figures of civic grandeur and personal nobility. It was these artistic gifts which have given us the quiet beauty of the National Gallery of Scotland's *Portrait of a Woman*, in her sober black silk dress and gossamer-fine linen collars, the aloof posturing of the spendthrift dandy, *Jaspar Schade* and the brilliantly vivacious *Isabella Coymans*. They also guaranteed that the master could capture with such rare perception the grandiloquent ranks of Captain Reael's group of militiamen, complete with their swagger sashes and flags, and the haunted resignation which age has brought to the old ladies who have found themselves cast in the role of regentesses of an almshouse. When his work was rediscovered in the mid-nineteenth century, it was again this daring, this inimitable brushwork and breadth of palette which fired the enthusiasm and respect of such artists as Courbet and Manet, Liebermann and van Gogh.

The last major retrospective exhibition devoted to Frans Hals took place in Haarlem in 1962. The scholar most closely associated with that show was Seymour Slive. It is therefore wholly appropriate that this new manifestation of the artist's achievements should be undertaken in association with the Frans Halsmuseum and under the omniscient guiding hand of Professor Slive. We are profoundly indebted to him for the enormous labour he has expended on this project, not only in the selection of the works – in which he was ably assisted by Christopher Brown of the National Gallery in London, and by Derk Snoep of the Frans Halsmuseum in Haarlem and Arthur J. Wheelock of the National Gallery of Art in Washington – but also in editing and contributing so extensively to the catalogue which accompanies it. In this latter respect we also extend thanks to the scholars who have made available their recent researches in order to produce a volume which will be a lasting contribution to scholarship in the field of Frans Hals studies. Given the wealth of Hals's paintings to be found in the United States, it was only fitting that we should undertake this project in collaboration with the National Gallery of Art in Washington. We also, therefore, owe debts of gratitude to the National Gallery's director, J. Carter Brown, to Arthur J. Wheelock, and to Dodge Thompson and the staff of the exhibitions office. We also thank Derk Snoep and his staff of the Frans Halsmuseum. As always, we are most grateful to the many lenders who have so generously responded to the excitement and challenge of creating this great monographic show. Finally, without the committed support of our sponsors, the British arm of the Anglo-Dutch company Unilever, this show would not have been possible to realise in London.

It was Vincent van Gogh who noted with awe the existence of twenty-seven different blacks in the palette of Frans Hals. It was Whistler who determined to paint group portraits with a realism only previously achieved in the work of Hals. And it was John Singer Sargent, a member of this Academy, who sought to capture the skeins of brushstrokes beneath the faces and hands of two elderly regentesses. May our public too share this lasting admiration for the achievements of an artist whose appeal to painters and laymen alike would seem to be inextinguishable.

ROGER DE GREY
President of the Royal Academy

Editorial Note

Following Dutch usage, patronymics have been abbreviated in the Introduction, essays and Catalogue. Those ending in **sz** or **sdr** should be read as '-zoon' or '-dochter', i.e. the son or daughter of. Put another way, Jansz means Janszoon (the son of Jan), and Harmensdr means Harmensdochter (the daughter of Harmen). Similarly, in Dutch street names, the suffixes '-straat', '-weg', '-steeg' and '-gracht' mean 'street', 'road', 'lane' and 'canal' respectively.

All exhibited paintings are reproduced in colour. These colour plates bear their respective catalogue numbers.

The abbreviation **pl.** refers to colour plates in the Introduction and Groen & Hendriks essay. They are numbered consecutively with roman numerals.

The abbreviation **fig.** refers to figures reproduced in the Introduction, essays or Catalogue.

Figures in the Introduction and in each essay have their own set of numbers. Cross-reference to them is made by an addition of the author's name (e.g. Biesboer, fig. 5).

Comparative figures in the entries are identified by the catalogue number of the exhibited painting and a letter (e.g. fig. 12a).

Hals's paintings are identified by their catalogue raisonné numbers assigned in Seymour Slive, *Frans Hals*, vol. 3, New York & London 1974. The following abbreviations are used to refer to works listed there:

S followed by a number, e.g. s31, refers to a painting accepted as genuine.
S. followed by an **L** and a number, e.g. s.L12, refers to a lost or destroyed painting which presumably can be attributed to Hals on the basis of visual and/or documentary evidence.
S. followed by a **D** and a number, e.g. s.D34, refers to a painting that has a doubtful status or has been wrongly ascribed to the artist.

The *Bibliography Cited in Abbreviated Form*, pp. 415-26, offers full details of other catalogues of Hals's paintings which are listed in the text in abbreviated form, as well as complete bibliographical information regarding other shortened references in the texts.

Details of all exhibitions are given in *Exhibitions Cited in Abbreviated Form*, pp. 427-30.

Hals doc. and **doc.** followed by a number refer to *The Hals Documents: Written and Printed Sources, 1582-1679*, pp. 371-414.

Note on the Contributors

Seymour Slive, Gleason Professor of Fine Arts, former Director of the Fogg Art Museum, Harvard
Pieter Biesboer, Curator of the Frans Halsmuseum, Haarlem
Martin Bijl, Picture Conservator, Rijksmuseum, Amsterdam
Karin Groen, conservation scientist, Hamilton Kerr Institute, University of Cambridge
Ella Hendriks, Picture Conservator, Frans Halsmuseum, Haarlem
Michael Hoyle, translator and editor, Amsterdam

Frances S. Jowell, independent scholar, London
Koos Levy-van Halm, art historian, Restoration Department, Frans Halsmuseum, Haarlem
Liesbeth Abraham, art historian and picture conservator, Amsterdam
Bianca M. du Mortier, Keeper of Costume, Rijksmuseum, Amsterdam
Irene van Thiel-Stroman, art historian, archivist, and contributor to the forthcoming catalogue of the Frans Halsmuseum, Haarlem

Claeys Duyst van Voorhout ▷
detail (cat. 52)

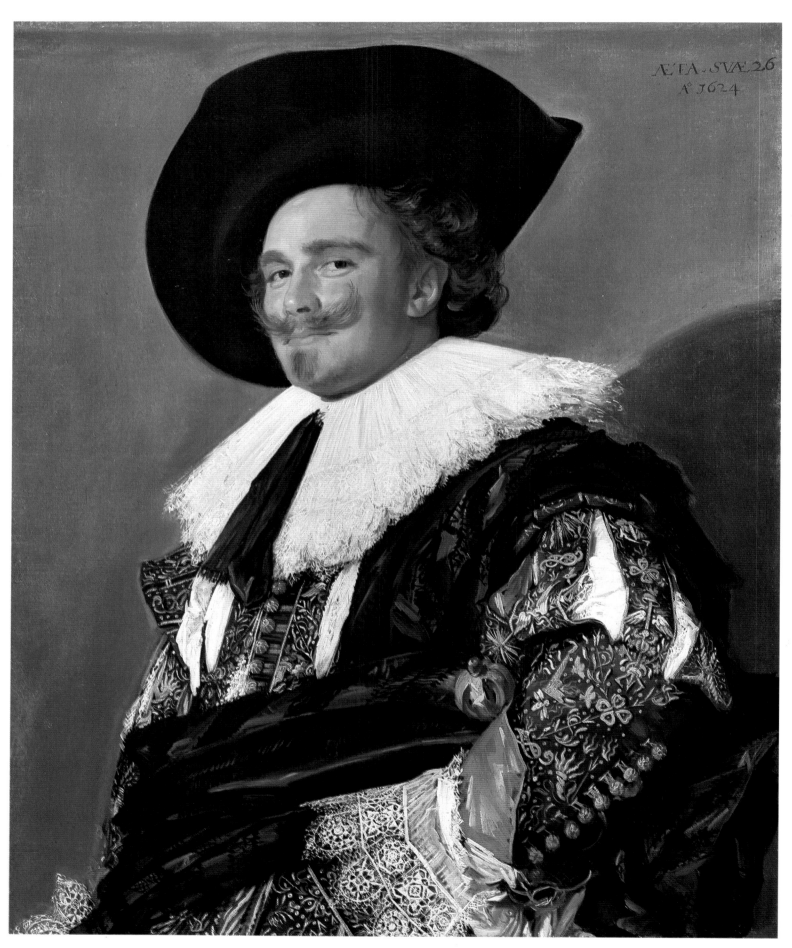

Pl. 1 Frans Hals, *Laughing Cavalier*, 1624 (s30)
London, Wallace Collection

SEYMOUR SLIVE

Introduction

The present Frans Hals retrospective is the first organised since 1962, when one was mounted to celebrate the 100th anniversary of the municipal museum in Haarlem that now bears his name. It also is the first international travelling exhibition to offer a comprehensive survey of the towering achievement of the artist who invigorated Dutch painting with a new force and naturalism from the moment he appeared on the Haarlem scene in about 1610 until his death as an octogenarian in 1666. His long career spanned virtually the entire heroic age of Dutch painting. Other artists of the new Republic who are now household names made later and briefer appearances. When nineteen-year-old Rembrandt picked up his brushes as an independent painter in 1625, Hals was a mature master in his forties. Rembrandt died three years after Hals. Young Vermeer's hand is first recognisable in the mid-1650s, when Hals was in his seventies. Vermeer outlived him by less than a decade.

Ideal art exhibitions are made only on paper. This one is no exception. Restrictions confronted by its organisers account for notable lacunae which should be mentioned straightaway. The Wallace Collection's *Laughing Cavalier* (pl. I), Hals's most famous picture, is missing. So are two key genre pieces in the Altman Collection at the Metropolitan Museum (pls. II, III) and the portrait in the Frick Collection which offers a surpassing display of his late brushwork (pl. IV). These works are immovable. Under the ironclad terms of their bequests, they can never leave the institutions now housing them. There are other gaps. The Louvre's regulations confine the celebrated *Gipsy Girl* (pl. V) to its galleries, and all five of the artist's spectacular group portraits of Haarlem's civic guard companies must remain in the city where they were painted. Additionally, some of the paintings that were lent to the exhibition were not available for showings at all its venues. So much for the unavoidable misses.

The numerous hits are cause for jubilation. Thanks to generous loans stretching from San Diego to Odessa and from Leningrad to Lugano, it has been possible to exhibit the full glory of every type of portrait the artist painted. From the beginning they give us the startling sense of the presence of a fellow being whose expression and mien seem to sum up human warmth or the will and dignity that endow ordinary men and women with unexpected grandeur. His genre pictures, unadulterated expressions of the joy of life that repeatedly depict human vitality in its most fleeting manifestations, are represented by outstanding examples which are the basis of much of his posthumous fame. Two of his little-known religious pictures are also included (cat. 22, 23). The large civic group portraits are represented by all three he did in this category: the *Regents of the St. Elizabeth Hospital* (cat. 54) and his incomparable late masterworks, the *Regents* and *Regentesses of the Old Men's Almshouse* (cat. 85, 86). Hals's accomplishment as painter of militia pieces is seen in his recently restored (1988) civic guard picture, popularly known as *The Meagre Company* (cat. 43), a work he began in 1633 but failed to complete. After three years, his exasperated clients, who found his procrastination inexcusable, had the large commission finished by Pieter Codde. It has also been possible to assemble a choice group of his small portraits, many of them used as *modelli* for engravings. Although Descartes, his only internationally known sitter, was the subject of one (cat. 66), this side of his work is not as familiar as his paintings made big as life. Frans lost none of his power of characterisation when he worked in little, and was equally at home controlling a very fine brush with his fingertips as with a broad one directed by the sweep of his arm. If he had been a surgeon, he could have performed eye operations as well as amputated limbs.

Though the number of studies dedicated to Hals since the 1962 exhibition cannot begin to match the output of the current heavy industry devoted to Rembrandt, enough has been done to help us look afresh at his œuvre. The catalogue's essays manifest the close scrutiny accorded to aspects of his paintings and the milieu in which they were produced that were hardly mentioned a generation ago.

Entirely new ground has been broken by Karin Groen and Ella Hendriks in their initial report on the results of their systematic technical examination of forty of Hals's paintings (about 18% of his existing work), a project undertaken to learn more about the artist's materials and working methods. Given the complete absence of any of his drawings, and the lack of a single word by any of his contemporaries about his studio practice, their findings are particularly valuable.

Laudably exact researchers, Groen and Hendriks rightly stress that the number of works they have studied is still too small to draw even tentative conclusions regarding some of the questions their project has raised; for example, why and when the supports and grounds of some pendant portraits are identical, and why and when others differ. And in view of the limited number of paintings they were able to examine, other

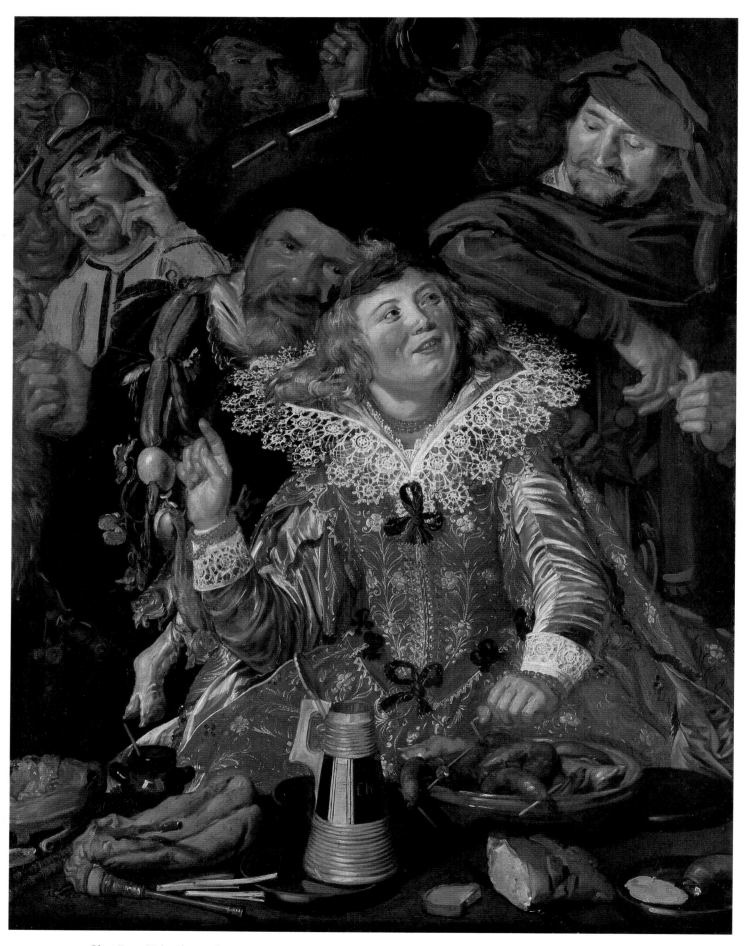

Pl. ii Frans Hals, *Shrovetide Revellers* (55)
New York, Metropolitan Museum of Art

2

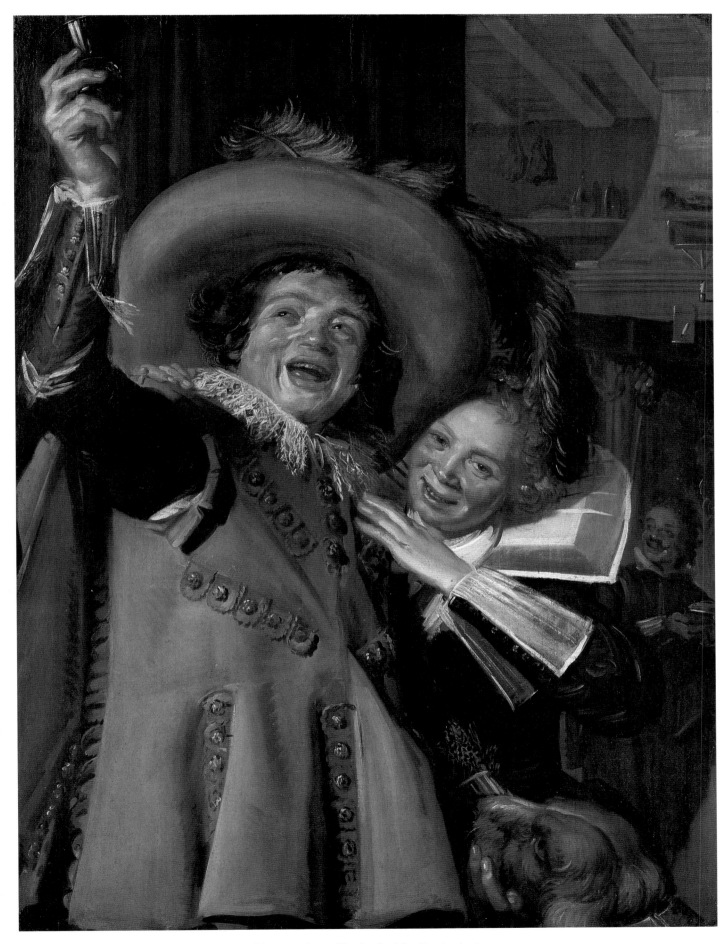

Pl. III Frans Hals, *So-called Jonker Ramp and his Sweetheart (The Prodigal Son?)*, 1623 (S20)
New York, Metropolitan Museum of Art

3

conclusions are put cautiously. However, in all like-lihood a technical study of a much larger group of his paintings will confirm three of their findings. Hals's materials do not appear to differ significantly from those given in contemporary painters' manuals, and his panel, canvas and copper supports are almost invariably pre-pared in accord with standard procedures of his day. Specialists who have made technical examinations of a proportionately larger number of Rembrandt's paintings report similar results. The spells their pictures cast are not derived from occult paints and practices. Thirdly, Hals's inimitable free brushwork is not limited to finishing touches as some critics have maintained. In works where his procedure can be followed, it is found in every stage, from the first blocking in of the forms to the fully worked-up painting.

An account of the 1988 restoration at Amsterdam's Rijksmuseum of *The Meagre Company* (cat. 43) is given by Martin Bijl. We have already mentioned that Hals began work on this collective portrait of the officers of an Amsterdam civic guard company in 1633, and that three years later it was still unfinished. Since his dissatis-fied patrons' acrimonious complaints failed to impel him to complete it, they dismissed him and called upon Pieter Codde to finish the job. Treatment of the painting gave the Rijksmuseum's conservators and curators an opportunity to study once again who painted what in the huge militia piece. Bijl discusses their findings and what the restoration revealed about Hals's materials and working methods.

Koos Levy-van Halm and Liesbeth Abraham concen-trate on the five militia pieces the artist painted for Haarlem's civic guards: three for the officers of the St. George militia and two for the St. Hadrian corps; Hals himself served as a musketeer in the St. George guard from 1612 to 1624. They also present a survey of those done by his predecessors, and show how military proto-col and changes in the function and organisation of the companies affected the way artists depicted the guards. Study of the technical data acquired during the resto-ration of Hals's five militia pieces, a campaign that began in 1984, has enabled them to show that the artist made significant changes to his group portraits while they were in progress. Their correlation of the alterations with documentary evidence reveals that most of them were not made for aesthetic reasons, but were done to keep abreast of changes in the membership of the officer corps. In some there was a considerable lag between the time the militia piece was commissioned and when it was finished, exploding the notion that Hals was a kind of inspired Cyrano de Bergerac of the brush who dashed off these monumental collective portraits in one fell swoop, and never changed a stroke after it hit the canvas. Their investigation also helps confirm what we would

expect: in seventeenth-century Dutch portrait trans-actions, artists were not given free rein. Patrons helped determine the final look of a espoke portrait.

Like most people who sat for portraitists from the early Renaissance until the late nineteenth century, when the demands some patrons placed on portrait painters began to shift, Hals's sitters looked forward to a good, perhaps even a flattering likeness and an accurate representation of the apparel they chose for the oc-casion. Costume historians, of course, have long been aware of the importance sitters placed on their garb when they had their faces commemorated; portraits are one of their primary sources. However, other historians have given scant attention to this aspect of portraiture. Bianca du Mortier's essay fills the gap for Hals.

Du Mortier offers full descriptions of the costumes worn by Hals's clients from his earliest phase, when men and women still wore sober garments that reflected sixteenth-century Spanish styles, until his very old age, when French fashions became increasingly popular. It has been possible to establish the cost or appraised value of some articles worn by his patrons, and we know that the vain fop Jaspar Schade (cat. 62) spent extravagant sums on his wardrobe, since a letter his uncle sent to his cousin, then in Paris, implored him not to spend as much money on his clothes as Jaspar had done when he was there. Shifts in taste naturally had an impact on Frans's handling, his colour harmonies and other as-pects of the final effect of his portraits. A woman portrayed in a full-length, heavy outer garment, a large millstone ruff and a long, stiff stomacher camouflaging her female form (cat. 19) cuts a different figure than one wearing a décolleté (cat. 69). Du Mortier cites specific instances that indicate how choice of costumes was affected by custom, social status, age and religion. As can be seen in Hals's family portraits, a special dis-cussion of the garments worn by children is hardly needed; their clothes were miniature replicas of those worn by adults.

A thorough study of the clothing worn by the work-ing classes in Hals's time has not yet been written. But pictures tell us they had their own garb and special accessories. Fishermen and sailors favoured shaggy wool caps often dyed blue and, to judge from Hals's portrayal of a *Fisher Girl* (fig. 1; cat. 35) and the women depicted selling fish by Adriaen van Ostade and Metsu (figs. 2, 3), young and old female fish vendors had a predilection for rather flat, black felt caps and large white flat collars worn as dickeys. Later in the century, as can be seen in Godfried Schalcken's *Woman selling Herring* (fig. 4), some artists invented fancier clothing for working women while depriving them of their earthy vigour. Schalcken's china-doll herring woman with an embroidered kerchief covering her hair,

4

embroidered collar and large pendant pearl earrings, would have been at home in Marie Antoinette's *l'Hameau*, coyly playing the part of a pampered fish vendor.

Pieter Biesboer discusses the political, social, economic and religious conditions in Haarlem, and the role its portraitists and their clientele had in the life of the city. His essay, much of it based on unpublished archival material, also serves as a concise *Who was Who in Haarlem*. Biesboer stresses that soon after 1618, when the Stadtholder, Prince Maurits of Orange, dismissed Haarlem's entire city council and stacked a new one with citizens who endorsed his militant efforts to centralise the new Republic's government and impose his strict Calvinist views, a large part of Frans Hals's patronage came from the oligarchy that controlled the new council.

Haarlem's city council was comprised of twenty-four men (in 1618 twenty-one of the newly appointed members were well-to-do brewers, representatives of the industry that was the city's main source of wealth). Councillors served for life and, since they themselves filled the council's vacancies, it was a self-perpetuating body. During the course of the century, intermarriage strengthened their powerful position, which included selecting burgomasters and aldermen from their own group, filling other civic offices, supervising the appointment of the officers of Haarlem's two militia companies, and distributing the kind of patronage available to people in high office. In brief, they virtually controlled the civic and military life of the city.

Hals served as the principal portraitist of this new élite. His work for the Olycan family helps demonstrate the point. The Olycans became members of the oligarchy in 1618 when Pieter Jacobsz Olycan was appointed to the council. In 1639, while he was serving his second term as burgomaster, and after he held the prestigious position of the city's delegate to the States-General three times, Hals painted him and his wife Maritge (née Vooght, whose brothers were also on the council). Hals made sixteen other portraits of members of the Olycan family and their relatives; for the artist's portrait of Pieter Olycan, his wife, his son Jacob and his daughter-in-law, and for references to the others, see cat. 18, 19.

Other patrician Haarlem families employed Hals as almost a portraitist-in-residence as well. Although Josephus Coymans was not a councillor, his position was mighty; he belonged to one of Holland's richest merchant and banking families. In 1644 he engaged the artist to paint companion portraits of him and his wife. Not long afterward Hals portrayed his ravishing daughter Isabella and her stout husband (cat. 68, 69). The portraits he painted for the couple are his most beautiful and original pendants (a dealer separated the pair, selling one to the Antwerp Museum in 1886 and the other to Alphonse de Rothschild; they are happily joined here for the first time in more than a century). Isabella's brother-in-law appears as an ensign in the militia piece Hals painted for the St. George guard about 1639, and the ensign's father is the ranking officer in the militia piece the artist did for the same company around 1627. Isabella was also related to Willem Coymans, the handsome swell Hals portrayed in 1644 (cat. 61). Little more than an introduction to the extended family connections and prominent positions held by Hals's upper-class patrons is needed to gain the impression that they were master-builders of power structures buttressed by familial ties.

Documents published by M. Thierry de Bye Dólleman (1973) establish that Hals himself acquired a close family connection with Haarlem's élite when he married Anneke Harmensdr, his first wife. The date of the event is unknown but it certainly occurred before September 1611, when their first son Harmen, who became a painter, was baptised. Anneke's guardian was her rich uncle Job Gijblant, a member of the city council and an officer of the St. George guard. Job was married to Teuntje Huydecoper, a member of one of Amsterdam's most prestigious and affluent families. Teuntje, later known as Antoinette, stood as Harmen's godmother at his baptism. This seemed to mark a more than auspicious start for Frans Hals, the son of a poor cloth-dresser, who was just beginning his career in Haarlem. He was enrolled as a master painter in the city's Guild of St. Luke in 1610, and his portrait of *Jacobus Zaffius* (cat. 1), his earliest existing documented work, is dated 1611. Marriage into wealthy, well-connected families could serve a portraitist very well indeed. But in the event, this apparently was not the case.

Things seem to go wrong from the very beginning. When Job Gijblant had his portrait painted in 1611, he gave the commission to Frans de Grebber (Biesboer, fig. 1), not Frans Hals, to whom the niece entrusted to his care was presumably either betrothed or already married. When Anneke died in 1615, leaving Frans with Harmen and another small child, she was buried in a pauper's grave; evidently neither her rich uncle nor her aunt were willing to contribute a guilder to help give her a decent burial. In addition, Job was one of the councillors dismissed from office in 1618, and he was not appointed again; thus, even if he wanted to help his ward's husband procure important commissions, his ability to do so had become limited. There is no evidence of any contact between Hals and the Gijblant couple during the following decades, and, when Job and Teuntje died in the late 1630s, neither of them left anything to the Halses. Teuntje's failure to bequeath part of her considerable fortune to her godson and nephew Harmen is particularly perplexing.

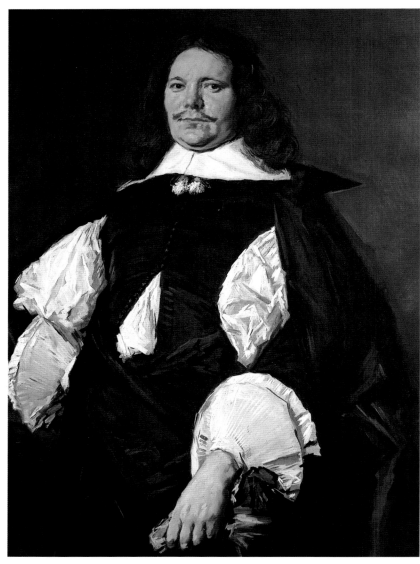

Pl. IV Frans Hals, *Portrait of a Man* (s214)
New York, Frick Collection

What went wrong? Why was Harmen and the rest of the Hals family cut off by Job and Teuntje? Perhaps the wealthy couple snubbed Frans and his offspring because they believed the painter and his family to be beneath their station, and it is not calumnious to suggest that they possibly bore a grudge against Hals because he and Anneke had a shot-gun marriage. Job, as guardian of his niece, would have been especially bitter if this were, in fact, the case. Forced marriages were not unusual at the time. Frans Hals himself was involved in one when he married Lysbeth Reyniersdr, his second wife, in February 1617. Sara, the first of their eleven children, was born nine days after their marriage. This is not the only indication of a lapse in the family's morals. A few decades later, after Sara bore one illegitimate child and was expecting her second, her parents had her committed to Haarlem's house of correction for the crime of fornication.

During the course of the artist's long career, Frans de Grebber and his son Pieter, Salomon de Bray and his son Jan, Pieter Soutman and Cornelis Verspronck were Haarlem's other leading portraitists. To be sure, Frans de Grebber portrayed Job Gijblant in 1611, but neither he nor the others customarily had clients of his status or that of the Olycan, Vooght or Coymans families. The fact that the de Grebbers, the de Brays, Soutman and, most likely, Verspronck were Catholics probably had some bearing on their patronage. Catholics were excluded from the city council (Mennonites did not serve on it or join militia companies because of their religious convictions). Biesboer shows that Haarlem's Catholics tended to favour Catholic portraitists, but he also rightly notes that the latter portrayed Protestants too. Conversely, Hals, almost certainly a Protestant from his youth, had Catholic clients, amongst them Paulus van Beresteyn and his wife Catharina van der Eem (cat. 6, 7).

The degree to which portrait commissions were affected by religion has yet to be firmly established. Consideration of the matter should take into account artists' ambitions as well as their faith: the de Grebbers, the de Brays and Soutman, unlike Hals, aspired to be history painters. They apparently did portraits, more often than not, as bread-and-butter work. If the supposition is correct, it probably had an impact on their clientele resulting in relatively small outputs as portraitists.

Hals also had many identifiable patrons whose status was a cut or two below Haarlem's élite. In station and occupation, they were similar to the burghers who sat for the city's other portraitists. These men, often accompanied by their wives and occasionally by their children, were merchants, traders (some of whom had ventured to Russia, Africa and India), clergymen, professors,

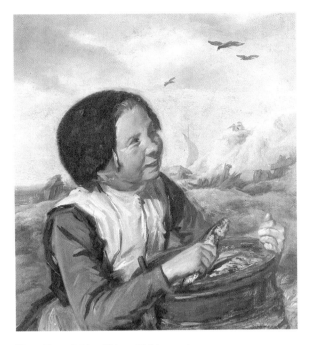

Fig. 1 Frans Hals, *Fisher Girl* (cat. 35)
Private collection

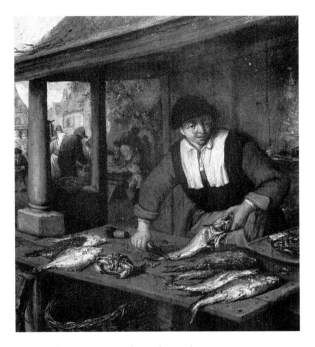

Fig. 2 Adriaen van Ostade, *Fish Vendor*
Budapest, Museum of Fine Arts (inv. 306)

Fig. 3 Gabriel Metsu, *Fish and Fruit Seller*
St. Boswells, Mertoun, The Duke of Sutherland

Fig. 4 Godfried Schalcken, *Woman selling Herring*
Amsterdam, Rijksmuseum (inv. A 2340)

Pl. v Frans Hals, *Gipsy Girl* (s62)
Paris, Musée du Louvre

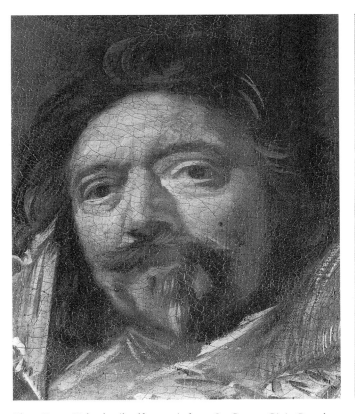

Fig. 5 Frans Hals, detail self-portrait from *St. George Civic Guard*, *c.*1639 (s124)
Haarlem, Frans Halsmuseum

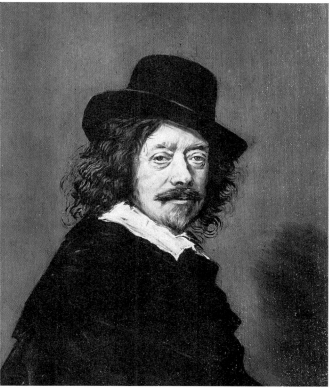

Fig. 6 Unknown artist, copy after a lost *Self-Portrait* by Hals
Indianapolis, The Clowes Fund Collection (s.l15-1)

historians, calligraphers and artists. Amongst the latter are his pupil Vincent van der Vinne (cat. 76), the landscapist Frans Post, who had painted views of sites in Brazil (cat. 77), and Adriaen van Ostade (s192). There are also references in seventeenth-century inventories to two portraits, now lost, of Judith Leyster, his gifted follower and probably his pupil, and an untraceable one of the outstanding marine painter Jan van de Cappelle. The whereabouts of Rembrandt's portrait of van de Cappelle remains unknown as well. To our knowledge, he was the only person clever enough to have himself portrayed by the two supreme Dutch portraitists of his day. His inventory also lists eight other paintings by Hals (including a *Rommel Pot Player*; see cat. 8); it is the largest recorded seventeenth-century collection of the artist's work.

Significantly, Hals the portraitist – even his genre pieces are *au fond* portraits – showed hardly any interest in his own face. Merely two self-portraits can be cited: according to an eighteenth-century tradition he appears inconspicuously in the background of his St. George

guard piece of *c.*1639 (fig. 5); the other is known only in copies after a lost original (fig. 6).

If Frans's large militia and regent pieces are excluded, more than half his sitters still remain anonymous. Though it is doubtful that additional information about his clientele will alter radically what is now known about it, every new find helps flesh out the picture. A case in point is S.A.C.Dudok van Heel's welcome discovery (1975) that the babe in Hals's beloved double portrait, long-known as 'Nurse and Child', is Catharina Hooft (cat. 9). In 1635 Catharina became the teenage bride of enormously wealthy and influential Cornelis de Graeff, who served repeatedly as an Amsterdam burgomaster and was an advisor and confidant of Johan de Witt, Grand Pensionary of Holland. When they were married, they had life-size, full-length pendants painted to mark the occasion (Staatliche Museen, Berlin [East]). Regrettably for us they gave the commission not to Hals but to a pedestrian portraitist whose hand cannot be firmly identified.

Life-size full-lengths are rare in seventeenth-century

Holland. Hals painted only one: the rich Haarlem textile merchant *Willem van Heythuysen* (cat. 17), a masterpiece that seems to sum up the vitality and confidence of the men who made the Dutch Republic the wealthiest nation in Europe during the first half of the century. He painted a second portrait of van Heythuysen, in little (cat. 51). It is equally remarkable; none of his other portraits surpass its informality.

Both paintings of van Heythuysen are most probably identifiable in an inventory made at the time of the merchant's death in 1650. What happened to them after he died, and how were they and Frans Hals's other works viewed after his own death in 1666? This is the subject of Frances Jowell's essay.

Jowell shows that for almost two centuries after the artist's death his paintings were seldom treasured as works of art. Certainly, some Haarlem citizens took parochial pride in them, and a few artists and critics acknowledged his genius as a portraitist, but nearly all of them, following the dominant taste of their time for smooth surfaces created by blended, almost invisible brushstrokes, seemed to sigh in unison: 'Too bad, he did not have more patience in finishing his pictures'.

His militia and regent pieces had safe homes in semi-public buildings, but the genealogical portraits suffered the fate of most paintings of their type. They were inherited by family members and friends. Some were displayed, occasionally it seems for unusual reasons. His portrait of *Jaspar Schade* (cat. 62) apparently found a haven for more than two hundred years in the house where it was hung soon after it was painted, because of a legend that the house would collapse if it ever were removed. Others were exiled to storerooms and then disappeared. How quickly they could be removed from living quarters is seen in the posthumous inventory made of Jan Miense Molenaer's effects in 1668, only two years after Hals died. Frans's two portraits of Molenaer's deceased wife Judith Leyster are listed in his attic, unframed. We can only guess at the number that were discarded in the following century because their sitters' jet-black costumes clashed with the tender blues and pinks of rococo interiors, or because they became only vaguely recognised as a second cousin of a maternal great-grandfather. In view of the large number that are unidentifiable today, the latter group must have been considerable.

An index of how matters stood at the end of the eighteenth century is offered by Hals's full-length of *Willem van Heythuysen* (cat. 17). Its history is a blank from about 1650 until 1789 when A. Loosjes, a minor Haarlem poet, sang its praises and noted its location in the collection of G.W. van Oosten de Bruyn in Haarlem. The collector's connection to van Heythuysen is unknown, but it is evident that he was a man of taste

and judgement; he also owned Vermeer's *Little Street*. Loosjes's poem obviously had little effect on potential buyers of the great portrait. When it appeared at van Oosten de Bruyn's sale at Haarlem in 1800, it fetched the piddling sum of 51 guilders. (Vermeer's *Little Street* did much better, particularly when we recall that Vermeer was virtually an unrecognised master in 1800; it went for 1,040 guilders.) Later when the full-length was acquired by a Prince of Liechtenstein in 1821, the name of van Heythuysen had either been forgotten or suppressed, and the portrait was wrongly attributed to Bartholomeus van der Helst.

Jowell concentrates on the way this posthumous confusion and neglect was dramatically reversed after 1850. The French art historian, critic and political activist Théophile Thoré, better known by his pseudonym W. Bürger, played the pivotal role in the quick shift. Bürger, whose passion for the art of the new Dutch Republic was inextricably linked to his own republican ideals, began to champion Frans Hals in his early publications, but most important were his pioneer articles on the artist's life and work published in 1868, two years after his studies resuscitating Vermeer's reputation appeared. They set the scene for Hals's triumphant entry into the pantheon of Western painters in the 1870s.

The City of Haarlem also helped accelerate the rediscovery of the artist's accomplishment when it opened the doors of its municipal museum in 1862 and exhibited the five militia and three regent pieces he did for the city. For the first time, artists, critics and the wider public had an easy opportunity to enjoy and study what he had achieved as a group portraitist from 1616 until about 1664. Very soon afterward his works began to have an impact on many artists who saw them, and became a touchstone in international discussions of the merits of other old masters and living artists.

Avid collecting of Hals's works began in the 1860s, and interest in acquiring them rapidly became keener. 13 May 1870 was a red letter day for the museum at Brussels when it bought the artist's little portrait of *Willem van Heythuysen* (cat. 51) and his *Johannes Hoornbeek* (cat. 60) from two different sources; they were the first works by the master to enter its collection. Not every museum was able to purchase two Hals pictures on the very same day, but a review of the acquisition dates of his works by other major museums tells a similar story: the Louvre's first two Halses were bequeathed to it in 1869; Berlin acquired a superb group of five when it purchased the Suermondt Collection in 1874; two years later the National Gallery, London, began its rich holding of his works with the purchase of a portrait. Not unexpectedly, this was the time misattributed pictures increased and some fakes began to appear on the market.

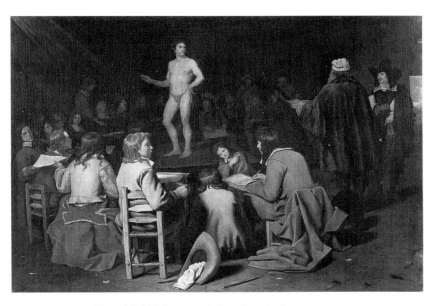

Fig. 7 Michiel Sweerts, *A Drawing Academy*
Haarlem, Frans Halsmuseum (inv. I-317)

Paintings related to him and his circle also generated interest. It is no accident that in 1875 the Society for Augmentation of the Collections of the Haarlem Municipal Museum gave the museum a painting which it and the professional staff called *Frans Hals's Studio* by Job Berckheyde (fig. 7). A label on its back identifies twelve of the score of figures in it as the artist himself greeting Philips Wouwerman, and among the young draughtsmen some of his sons, his brother Dirck and a few other artists.[1] The painting was accepted as Berckheyde's visual documentation of Hals supervising a drawing class in his crowded studio until 1893, when Hofstede de Groot noted that the traditional identification of the figures in the picture could not possibly be correct in view of what is known about their respective ages, and in 1901 he conclusively demonstrated that the painting is not by Job Berckheyde but Michiel Sweerts (Brussels 1618-1664 Goa).

With hindsight, it is difficult to understand how the identification of the aged artist in Sweerts's picture as Hals could ever have been accepted. After all, we see only the instructor's back (from the rear he looks like Rembrandt dressed in a costume that will enable him to resume work on a late self-portrait as soon as class is dismissed, but I am not suggesting Rembrandt as an alternative identification). Moreover, the idea of Hals's teaching a large drawing class with his students receiving academic training by working from a nude model had

to be accepted on faith, not fact. There is no evidence that he conducted an active, organised studio with a training programme for apprentices, or ran a school of any type, and the fact that no drawing by him has been discovered suggests that he himself did not put a high premium on the kind of training the boys are receiving.

Hals's only documented students are his son-in-law Pieter van Roestraten and Vincent van der Vinne (cat. 76). But, there is little reason to doubt that his five sons who became painters learned their craft from their father. Arnold Houbraken cites four of them in his biography of Hals, which appeared in 1718, more than a half-century after the artist's death; it is the earliest published life of the master (for a translation of it, see pp. 17-8). The other artists Houbraken calls his pupils are Dirck van Delen, Adriaen van Ostade, Philips Wouwerman and Adriaen Brouwer. If all of them were his students, he must have been the kind of teacher who encouraged his apprentices to find their own way quickly.

Houbraken does not mention Judith Leyster as a pupil. In fact, he does not refer to her at all in his still indispensable, three-volume compendium of the lives of about 650 seventeenth-century Netherlandish artists he titled *De Groote Schouburgh der nederlantsche konstschilders en schilderessen* (The Great Theatre of Netherlandish Painters and Paintresses). Although he mentions paintresses in his title, the parts assigned to them in his 'Great Theatre' are minimal: about a dozen of them are given biographies, and another dozen or so play walk-on roles. Despite Houbraken's omission of Leyster (there are other lapses – he does not say a word about Vermeer either) and the lack of documentary proof, part of her small œuvre strongly suggests she had close contact with Hals about 1630, and her husband Jan Miense Molenaer probably did too. More certain is the formal complaint Leyster laid against Hals in 1635 for illegally taking on one of her apprentices after he began studying with her.

For more than a century after Houbraken's biography of Hals appeared, it was read widely and unashamedly plagiarised. Houbraken is the source for the almost certainly apocryphal tale of the establishment of a mutual admiration society by Van Dyck and Hals

Overleaf:
Pl. VI Frans Hals, detail of head from *Boy with a Flute (Hearing)* (cat. 28)
Schwerin, Staatliches Museum

Pl. VII Frans Hals, detail of hand from *Boy holding a Glass (Taste)* (cat. 27)
Schwerin, Staatliches Museum

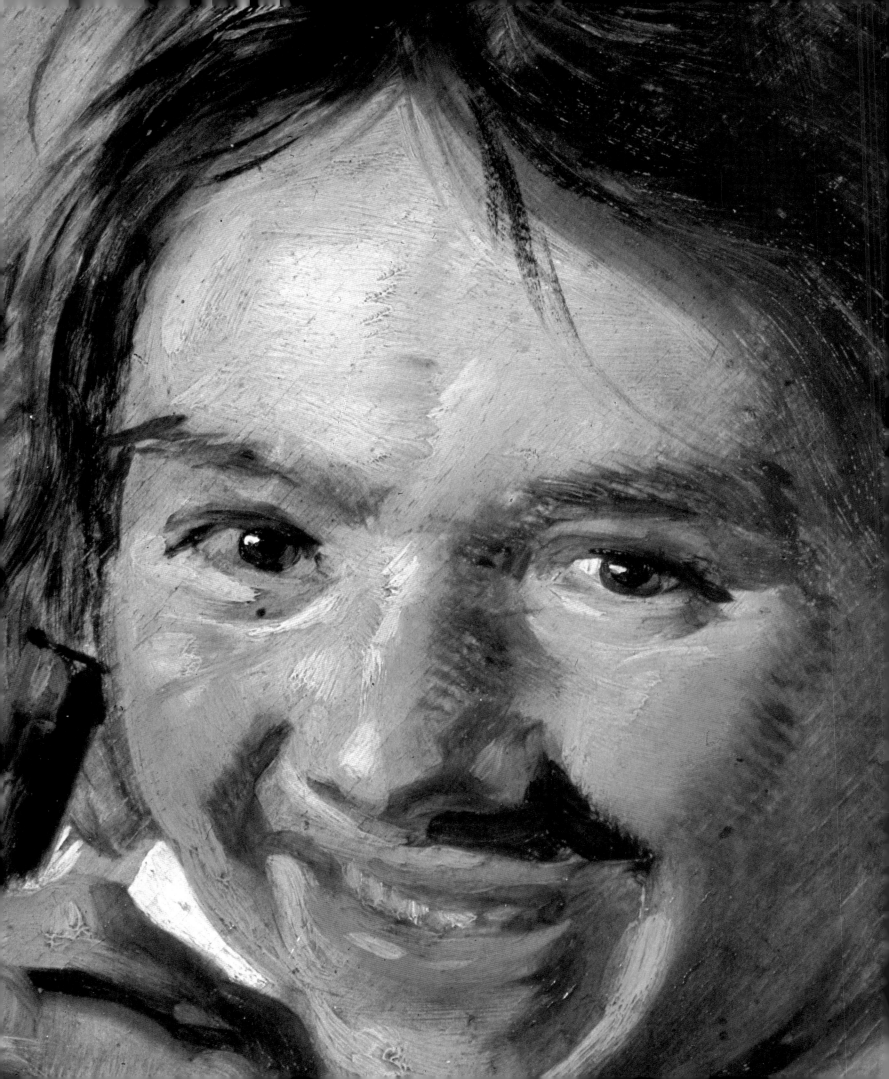

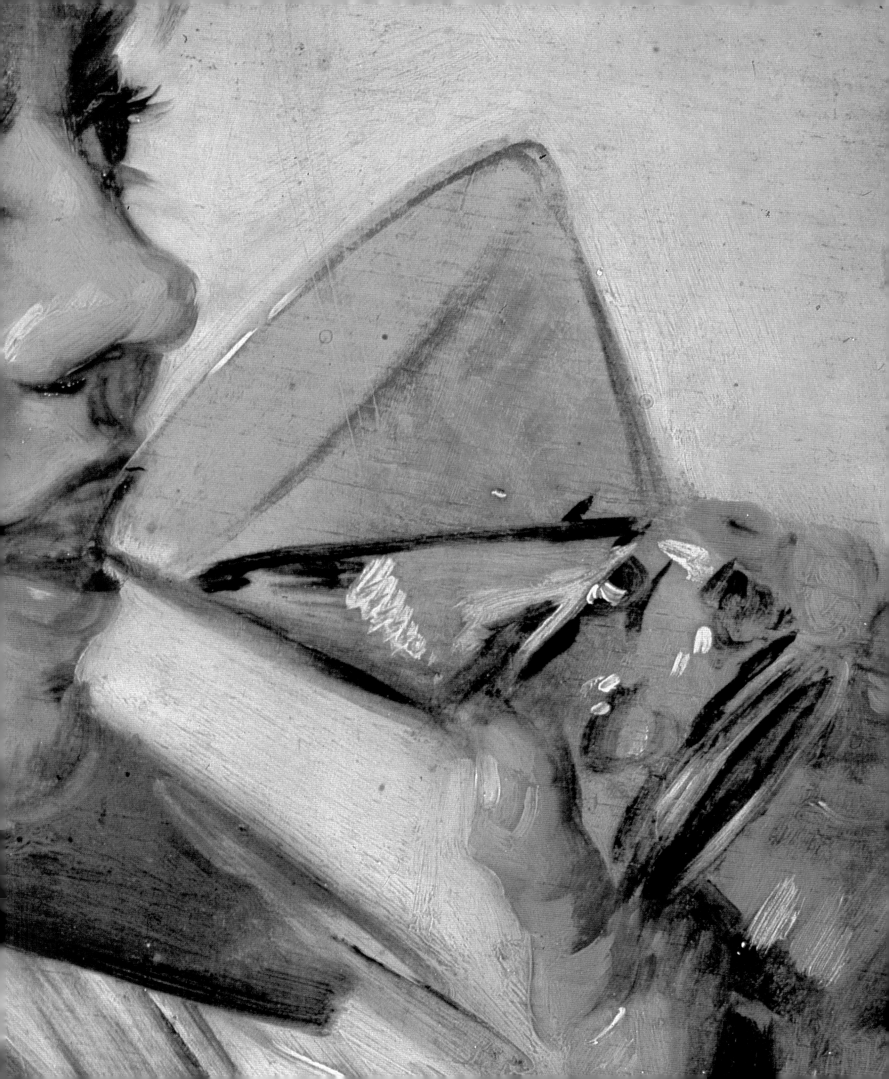

immediately after they painted each other's portraits. The story, which incorporates more than one legend regarding encounters between great artists that have been told since antiquity, was published repeatedly by later writers and taken for granted as a factual account as late as 1854 when Gustav Waagen, one of the best-informed art historians of his day, referred to it in support of his praise of Hals's *Portrait of a Man* at Buckingham Palace (cat. 38).

Houbraken was also the first to report that the artist led a less than exemplary life, and that it was his 'custom to fill himself to the gills each evening'. The only contemporary reference to his personal life that has been discovered hardly corroborates Houbraken's account. In 1679 the artist Matthias Scheitz annotated the flyleaf of his copy of Karel van Mander's *Schilder-boeck* with a thumbnail biography of Hals that includes the statement: 'He was somewhat lusty in his youth'. Nevertheless, as soon as Houbraken's account appeared, the artist's biographers popularised and embellished the notion that he led a dissipated life.

In 1866, not long after a new national pride and desire to put their nation's history on a firmer historical foundation led Dutch scholars to search their archives and libraries for documents and printed sources related to their country's seventeenth-century artists, a document was found that seemed to offer incontrovertible proof that Hals was a wife-beater as well as an alcoholic. It states that on 20 February 1616 Frans Hals was asked to appear before Haarlem's authorities because of cruelty to his wife. They reprimanded him and he, in turn, promised to abstain from drunkenness and immoderate acts. However, the document cannot refer to our Frans Hals because he did not have a wife to beat on 20 February 1616. We have already heard that his first wife was buried in May, 1615, and he did not marry again until February, 1617. Then who was the Frans Hals mentioned in the 1616 document? The answer is simple. There was another man of the same name living in Haarlem at the time. The painter has been the victim of mistaken identity.

The 1616 document refers to Frans Cornelisz Hals, a weaver who was a quick-tempered man taken into custody more than once for throwing around drinking glasses and similar acts, not to Frans Fransz Hals the painter. The identification was made in 1921, but it has not yet changed popular notions regarding the master's disreputable conduct when he was not painting. The fallacious idea that an artist who depicted merry drinkers must needs have been a tosspot himself dies hard.

Irene van Thiel-Stroman has made two contributions to the catalogue. Incorporating the latest finds, she has compiled a chronology of Hals's life that is correlated with pertinent cultural and political events of his epoch.

Of far greater magnitude is her second contribution. It is a compilation and commentary on the Hals documents which will stand as a resource of fundamental importance. For the first time it brings together all of the printed seventeenth-century texts dealing with the artist and all of the known documents related to him and his family, from one dated 1582 that enables us to deduce that he was born in Antwerp about 1582/3 to Scheitz's brief manuscript biography written thirteen years after his death. She has made a scrupulous, first-hand examination of all of the documents, apart from those published by scholars who did not provide adequate archival references. Those that have not been re-examined are signalled, as are any doubts that may exist regarding the identification of the Hals mentioned in a document. Not only references to the man known now as Frans Hals the weaver can cause confusion. It has been established that a family named Hals which had no relation to the artist's lived in Haarlem since the fifteenth century, and it had several branches by his time. Moreover, our Hals had a son named Frans who was an artist as well. References to the father and his namesake, who remains a nebulous figure as an artist, can be muddled.

Her series also includes all of Hals's paintings listed in inventories and similar sources compiled during his lifetime. Here too she has found that inadequate archival citations prevented her from verifying some that have been published. Additionally, she corrects some errors that have been made in earlier transcriptions of the documents, and rectifies the interpretation of others. And, not least important, her series includes newly published documents. Amongst them is the very first one discovered that is related to *Malle Babbe* (cat. 37). It establishes that her improbable name is not a later invention. Money was paid in 1642 to help defray the cost of Malle Babbe's confinement in Haarlem's workhouse. Until this find was made, an old inscription on the painting's stretcher was the sole basis for the identification of the frenzied woman who is the subject of Hals's peerless depiction of an instant when endlessly moving life is lived at its highest intensity.

Van Thiel-Stroman's series includes 190 documents. How does this number compare with the size of the group related to Rembrandt and Vermeer? Comparisons are difficult because specialists who gather documents on Hals's younger contemporaries use a wider net than the one van Thiel-Stroman employed here. They have published more data on their protagonists' forebears and more posthumous references as well. Though all of the existing Rembrandt documents have not yet been assembled as a set, it is fair to say their number exceeds those related to Hals by a factor of three. A more specific figure can be given to the Vermeer

documents; John Montias's exhaustive compilation of them published in 1989 numbers 454.

Like the sets related to Rembrandt and Vermeer, the Hals documents tell much less about his art than his life. A few enable us to deduce a bit about his character. From one showing him as the highest bidder for a Goltzius painting that appeared at an Amsterdam auction in 1634 but without money in his pocket to pay for it after it was knocked down to him, we can infer that upon occasion, like many people, he was overly impulsive.

Other scattered sources indicate Hals was very much his own man. This was his way from the start. After all, he virtually rejected the venerable advice that Karel van Mander, the Dutch Mannerist painter and theorist who a reliable early text (1618) tells us was his teacher, trumpeted to budding artists not to become mere face painters but to take the high road that led to fame and status by devoting themselves to history painting. Apparently, his dedication to the organisations he joined was not very strong. During the early part of his career he served as a musketeer in the St. George civic guard and was a 'friend' (not an 'active member') of a Haarlem chamber of rhetoric; he abandoned his association with both groups in 1624. He was a member of the Haarlem Guild of St. Luke from 1610 until 1666, a very long affiliation that is not astonishing. Haarlem's artists ran a closed shop; artists who did not belong to the guild were prohibited from working in the city. But it is notable that he was hardly active in the guild during the course of more than a half-century. He took no part in its significant reorganisation in 1631, only served a single term of one year as a warden of the guild, and never held the higher position of dean. Other leading Haarlem artists held these posts repeatedly. Did his colleagues find him a man unfit for official duty or did he make a successful effort to avoid administrative work and ceremonial obligations because he found them boring? When we turn to the documents that record his difficulties with the officers who commissioned *The Meagre Company*, we can be certain that in this case it was impossible to make him follow a path he himself did not set.

His paintings tell a similar story. Even in the 1620s, when he employed motifs and pictorial effects in his genre pieces that were introduced by the Dutch Caravaggisti, he did not adopt them lock, stock and barrel. The nocturnal effects they popularised did not interest him at all. He never followed their lead by depicting cheating card players, gambling soldiers or arcadian shepherds. There are no procuress scenes, and the erotic overtones found so often in their works are rare in his.

It was also in the 1620s that his own highly original, purely personal technique reached its full development in his genre pieces. He remained passionately committed to it until the very end, long after the taste for more highly polished pictures was established in Holland. A close view of the head of the *Boy with a Flute (Hearing)*, offers a beautiful example of it (pl. VI). Audacious brushstrokes keep their identity as they take the direction needed to define shapes and surfaces, while distinct hatched ones lend vibrancy to the solidity of the forms and enliven the surface life of the whole. Full consideration is given to each stroke's relation to the form represented, and to the vital part it plays in the total tonal organisation of the picture. A detail of the hand of the *Boy holding a Glass (Taste)*, shows the astounding suggestive power of his painting (pl. VII). Instead of emphasising outlines and conventional modelling to capture the roundness of the hand and glass, he used broadly brushed areas of light and dark tones to indicate the shape of both. Then, with almost miraculous control of a few swift accents and daring impasto highlights, he adds touches that build up the forms and securely define their positions in space. All has been resolved into a coherent impression suggesting the flow of intense light on a hand holding a glass.

Evidence of his original technique is found in his earliest existing works of about 1610, and there are conspicuous passages of it in his 1616 *Banquet of the Officers of the St. George Civic Guard*, his first group portrait that announces the golden age of Dutch painting like a cannon shot. The search for its sources by earlier and more recent students has been fruitless, a helpful reminder that the hunt for influences in the work of a great master can be a will-o'-the-wisp.

More vexing is the question of what Hals painted before 1610 when he was twenty-seven or twenty-eight years old. Not a work datable earlier has been found. What has happened to his juvenilia and the paintings he did in his early and mid-twenties? Was the man we know as an artist who painted as easily as he breathed a late bloomer?

Another mystery is the pay he received for his paintings. Only one fee is known. The officers who commissioned *The Meagre Company* in 1633 state that he agreed to paint the militia piece for 60 guilders per figure. Later, as part of their futile attempt to get him to complete it, they raised the price to 66 guilders. If Hals had finished the group portrait of sixteen men under this arrangement, he would have been paid 1,056 guilders for his work. Certainly not a princely sum, but, if we consider that Rembrandt received about 1,600 guilders for the *Night Watch* painted in 1642 when he was at the very height of his fame, and that about this time a master carpenter or bricklayer earned about 300 guilders annually, Hals's honorarium would have been a fair one according to the standard of his day.

Whatever he was paid for major commissions such as his Haarlem civic guard pieces, his large family portraits and portrayals of the Olycans, Vooghts, Coymanses and other patricians, it was hardly enough to support his family. Except for a windfall or two, he lived at scarcely a subsistence level from 1615-6, when he did not have the money to bury his first wife and then had trouble paying the woman who cared for his motherless young children, until his last years when he was still mired in debt. A major theme of the Hals documents is the long, pitiful record of small sums he owed his butcher, baker and shoemaker.

Though there is no foundation to the seemingly indestructible myth that he spent his last years in Haarlem's Old Men's Almshouse and that his late group portraits of its regents and regentesses are best read as his personal revenge on the society that neither adequately rewarded him for his work nor recognised his genius, it is certain that his situation worsened in his very old age.

His colleagues in the Guild of St. Luke recognised his plight in 1661 when they exempted him from payment of its annual dues of six stuivers (at that time twenty stuivers were equivalent to one guilder). In the following year, after imploring the city officials for financial assistance, he was awarded an annual pension of 200 guilders. The city fathers also gave him three cartloads of peat and paid his rent in 1664, the traditional date of his *Regents* and *Regentesses of the Old Men's Almshouse* (cat. 85, 86). Most probably the money he received for these masterworks enabled him to act as guarantor of a debt of almost 460 guilders that his son-in-law had incurred; the sum was more than twice the amount of his annual pension.

Hals was not a burden on the City of Haarlem for long. A grave that belonged to a descendant of his first wife was opened for Frans Hals in the city's St. Bavo Church on 1 September 1666. The old artist did not leave a will. What chattels and movables could he have had to bequeath to family and friends? The paintings that survived him are his precious legacy to us. The intent of the present exhibition and catalogue is to show their full range with works that helped secure his unchallenged reputation soon after the middle of the nineteenth century as one of the greatest painters in the history of Western art.

Cambridge, Mass., August 1989

Note

1. The label, transcribed in Catalogue Municipal Museum, Haarlem, 1887, p.9, no.9, identifies the figures as: '1. Ph.Wouwerman, 2. Frans Hals, 3. D. Hals, 4. F. Hals Fz., 5. H. Hals Fz., 6. J. Hals, Fz., 7. K. Hals, Fz., 8. J. Hals Fz., 9. D. Van Deelen, 10. P. Molyn, 11. G. Berckheyde et 12. Job Berckheyde'. Its anonymous author apparently derived the first nine names from Houbraken 1718-21, but erroneously gave Frans two sons called 'J. Hals Fz.'. The last three names on the list are the author's invention. Their names on it are the basis for subsequent erroneous references to Hals as their teacher.

Houbraken's Life of Frans Hals

We find a similar instance [of good-humoured artistic rivalry] in the life of Frans Hals, whose likeness is seen here opposite, with a hat on his head (fig. 1). Anthony Van Dyck, the phoenix of his day, when in the service of King Charles the First and about to sail for England, resolved to see Frans Hals before he left. He came to Haarlem and called at his house, but it took some little time to scour the taverns for him, for he never left before he had finished his tankard. Meanwhile Van Dyck stood waiting patiently, and did not make himself known, saying merely that he was a stranger and had no time but the present, yet desired to have his portrait painted, to which F. Hals agreed without further ado. He took the first canvas that came to hand and set to work. Van Dyck interrupted him little while posing, lest he be recognised or discovered. It was soon done, and Frans asked him to rise and see if it was to his liking. Van Dyck praised it, and spoke with him awhile, but in such a way that he might discover nothing. Among other things he said: 'Is this, then, how one paints? Could I not do likewise?' And taking up a bare canvas which he saw standing there, he placed it on the easel and asked him to be seated. Frans saw instantly from the way in which he took hold of the palette and brushes that this was no novice, and realised that the disguised Ulysses would reveal himself. Yet he had no inkling that it was Van Dyck, but rather some waggish painter who wished to declare himself by giving a sample of his art. It was not long before Van Dyck commanded him to rise and inspect the work. As soon as he saw it he said: 'You are Van Dyck, for none but he could do this', and he fell on his neck and kissed him.

Van Dyck took up his portrait, which was still wet, thanked him, and gave liberally to his children, who remained the bankers for but a short while, as Frans presently pressed this stroke of good fortune into lip-service.

It is said that Van Dyck went to great lengths to entice him to England, but he would not listen, being too attached to his dissolute ways. Yet he had great respect for Hals's art, and often said later that if he had blended his colours a little more delicately or thinly he would have been one of the greatest masters. For regarding control of the brush, or the ability on conceiving a portrait to so fittingly render the essential features, heights and depths, with a touch of the brush, without tempering or change, his equal was not be found.

They say that it was his custom to lay his portraits on thick and wet, only applying the brushstrokes later with the words: 'Now to give it the master's touch'.

The many portraits by Hals which are still to be seen testify to the boldness and vivacity with which his brush caught the natural likeness of human beings. In Delft, in the Old Calivermen's Hall, there is a large work in

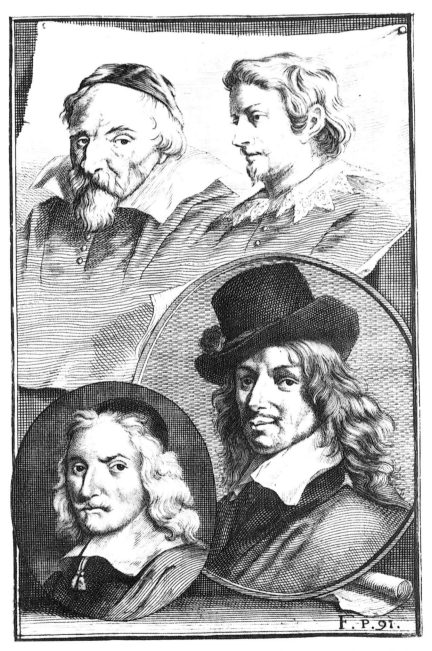

Jacobus Houbraken, Plate F in Houbraken's *Groote Schouburgh* (facing p. 90), showing Wenceslaus Coebergher (top left), Wijbrand de Geest (bottom left), Lucas van Uden (top right) and Frans Hals.

which he portrayed some of the chief men or governors of the civic guard as large as life, and so forcefully and naturally are they painted that it is as if they would address the onlooker.

He also had a brother, Dirck by name, who was a fine painter, skilled in companies and small figures. Samuel Ampzing recalls them both with the following couplet in his description of Haarlem:

How dashingly Frans paints people from life!
How neat the little figures Dirck gives us!

His excellent art and bold manner with the brush is what apprentices should take as their model and example, not his manner of living, for he was not a good driver of his life's carriage, which often veered from the centre line when he gave his passions free rein.

It was Frans's custom to fill himself to the gills each evening. His pupils, though, held him in great respect, and the eldest among them agreed that they would take it in turn to watch over him and escort him from the tavern, especially when it was dark or late, lest he fall into the water or suffer some other mishap. And bringing him duly home, they took off his stockings and shoes and helped him to bed.

One after another these pupils noticed that, no matter how sated with drink, he would always stammer out a prayer upon going to bed, which he closed with the supplication: 'Dear Lord, bear me soon to your high heaven'. And wondering among themselves whether their master was earnest in this desire, they devised a stratagem to put it to the test. Party to the plan were one Adriaen Brouwer, a pupil of his and a prankster since boyhood, and Dirck van Delen, of whom we shall speak in the year 1650. The four of them promised that they would not inform on one another. They cut four holes in the ceiling above his bedstead, through which they let down stout ropes which they fastened to its corners. The following evening, after they had assisted him to bed, 'full-brimmed and sweet' as the saying goes, and had carried the lamp from his room, they mounted the stairs in their stockinged feet without him noticing, ready to play their part. Keenly they listened to the mumbling of his evening prayer, which as usual he concluded with the entreaty: 'Dear Lord, bear me soon to your high heaven', whereupon with one accord they began raising the bed. Although deep in his cups he perceived this, and resolved that heaven had answered him, and as he felt himself ascending he changed his tone and cried out much louder than usual: 'Less haste, dear Lord, less haste, less haste', and so forth, whereupon they gently lowered him again, and he unaware that a trick had been played. Then, as he lay there snoring, they nimbly untied the ropes, and neither they nor he disclosed what had passed until many years later. But from that day on Frans abandoned the prayer, and they often laughed not to hear him pining for heaven.

I had progressed a long way with my book when a funeral notice was found among the papers of a Haarlem painter. Written on the back were the words: 'Frans died in Haarlem at the age of 85 or 86, and was buried on the 29th of the harvest month in the choir of the Great Church, his brother Dirck having gone before him in the year 1656. They were born at Mechelen.' And inscribed in the book of St. Luke's Guild in Haarlem are the names of various sons and grandsons of Frans Hals, all artists, such as Frans Hals Franszoon, Herman Hals Fransz, Jan Hals Fransz, and Klaas and Jan Hals Janszonen, of whom one is still alive in the East Indies, where he married a mestizo or half-caste. For her money, to be sure. He built a house there which he has hung with paintings in the Dutch manner, and is a great lover and skilled practitioner of music, by which he has endeared himself more to those good souls than ever he did by his painting. This seems to be an inborn quality. J. Wieland, an old amateur who knew most of them personally, attests that all the children of F. Hals were vivacious spirits and lovers of song and music.

(Translated by Michael Hoyle from Arnold Houbraken's *De Groote Schouburgh der Nederlantsche Konstschilders en Schilderessen*, vol. 1, 1718, pp. 90-5)

Chronology

□ *Painting included in the exhibition*
○ *Cultural events*
△ *Political events*

1581 △ The States (provincial assemblies) of the Northern Netherlands renounce the authority of King Philip II of Spain

1582 26 April, Franchois Hals, cloth-dresser, and his wife Adriana van Geertenryck, the future parents of Frans Hals, sell a heritable interest on Adriana's house in Antwerp (doc.1)

1582/3 Baptism of Frans Hals in Antwerp (docs.1, 10)

1583 ○ Karel van Mander, the Flemish painter, poet and biographer, settles in Haarlem

1584 △ William the Silent assassinated in Delft

1584/5 Baptism of Joost Hals in Antwerp (docs.1, 37)

1585 After August, Franchois Hals, member of the Antwerp civic guard, is registered as a Catholic (doc.2); he probably emigrated to the Northern Netherlands with his family shortly afterwards
△ August, the Spanish recapture Antwerp; many Flemings migrate to the north
△ Prince Maurits appointed Stadtholder of Holland and Zeeland

1588 △ Defeat of the Spanish Armada

1590 2 January, baptism in Haarlem of Anneke Harmensdr, Frans Hals's first wife (doc.3)

1591 19 March, baptism in Haarlem of Dirck Hals (doc.4); the earliest record of Hals's parents in Haarlem
○ Building starts on the New Militia Hall in Haarlem

1593 31 January, baptism in Haarlem of Lysbeth Reyniersdr, Frans Hals's second wife (doc.6)
13 February, betrothal in Amsterdam of Carel Hals, half-brother of Frans, Joost and Dirck Hals (doc.7)

1599 ○ Birth of the Flemish portrait painter, Anthony Van Dyck (d. 1641)

1602 △ Dutch East India Company founded

1603 End of Frans Hals's supposed apprenticeship to Karel van Mander, who now leaves Haarlem (docs.9, 25)
○ Lieven de Key (c.1560-1627) completes the Vleeshal (Meat Hall) on the market square in Haarlem
△ Death of Queen Elizabeth I of England; accession of James I

1604 ○ Publication of Karel van Mander's *Schilder-boeck*

1606 ○ Lottery to pay for the building of the Old Men's Almshouse in Haarlem, now the Frans Halsmuseum
○ Birth of Rembrandt
○ Death of Karel van Mander (b. 1548)

1609-21 △ Twelve-Years' Truce between the Dutch Republic and Spain

1610 Frans Hals enrols in the Haarlem Guild of St. Luke (doc.9); the earliest documented fact about his life

c.1610/5 Frans Hals married to Anneke Harmensdr (docs.3, 14)

1611 2 September, baptism of Harmen, son of Frans Hals and Anneke Harmensdr (doc.10)
□ Frans Hals paints the portrait of *Jacobus Zaffius*, his earliest documented work (cat.1)

1612 ○ June, Rubens (1577-1640), the Flemish history painter and portraitist, visits Haarlem

1612-7 ○ Willem Buytewech (1591/2-1624), the Rotterdam genre painter and etcher, active in Haarlem

1612-24 Frans Hals a member of the St. George civic guard (doc.11)

1613 12 May, burial of a child of Frans Hals's first marriage (doc.13)

1615 31 May, burial of Anneke Harmensdr, Frans Hals's first wife (doc.14)
10 July, Frans Hals is appointed guardian of his two minor children (doc.15)

1616 Before 6 August and between 11 and 15 November, Frans Hals in Antwerp (docs.17, 22)
4 September, burial of a child of Frans Hals's first marriage (doc.18)
15 November, Frans Hals pays arrears of an annual allowance to the nurse of his son Harmen (doc.22)
Frans Hals completes the *Banquet of the Officers of the St. George Civic Guard* (S7), his first militia piece
○ Sir Dudley Carleton, the English ambassador to the United Provinces, visit Haarlem in October; Frans Pietersz de Grebber (1572/3-1649) arranges for the shipment of art works which Sir Dudley had exchanged with Rubens

1616-24 Frans Hals a member of the Wijngaardranken Chamber of Rhetoric (doc. 16)

1617 15 January, the banns of Frans Hals and his second wife, Lysbeth Reyniersdr (doc. 23)
12 February, marriage of Frans Hals and Lysbeth Reyniersdr in nearby Spaarndam (doc. 23)
21 February, baptism of Sara Hals (doc. 24)
○ Death of Hendrick Goltzius (b. 1558), the Haarlem painter and engraver

1618 16 May, baptism of Frans Hals the Younger (doc. 26)

1620 13 December, burial of a child of Frans Hals's second marriage (doc. 27)

1621 ○ Samuel Ampzing mentions Frans and Dirck Hals in the second edition of his *Het lof der stadt Haerlem in Hollandt* (doc. 28)

1623 21 July, baptism of Adriaentje Hals (doc. 29)
19 September, Frans Hals a witness at the baptism of his niece Maria, daughter of Dirck Hals (doc. 30)

1624 12 December, baptism of Jacobus Hals (doc. 31)

1625 △ Death of Prince Maurits; his brother Frederik Hendrik succeeds him as stadtholder
△ Death of King James I of England; accession of Charles I

1626 16 October, Frans and Dirck Hals, heirs of their brother Joost, raise the distraint which Joost had placed on the estate of the artist Karel van Mander the Younger (doc. 37)
○ Adriaen Brouwer (1605/6-38), genre painter, becomes a member of the Wijngaardranken Chamber of Rhetoric in Haarlem

1627 11 February, baptism of Reynier Hals (doc. 38)
Frans Hals paints the *Banquet of the Officers of the St. Hadrian Civic Guard* (s45) and the *Banquet of the Officers of the St. George Civic Guard* (s46)

1628 25 July, baptism of Nicolaes Hals (doc. 43)
○ In the third edition of his *Beschrijvinge ende lof der stadt Haerlem in Hollandt*, Samuel Ampzing devotes several lines to Frans and Dirck Hals, and mentions the former's banquet painting of 1627 for the Calivermen's Hall (doc. 41)

1628/9 ○ Birth of the landscapist Jacob van Ruisdael in Haarlem (d. 1682)

1629 The City of Haarlem pays Frans Hals 24 pounds for restoring paintings from the Commanderie of the Knights of St. John which had been transferred to the Prinsenhof (doc. 45)
22 January, the City of Haarlem ask Frans Hals and two of his colleagues to inspect the cell in the house of correction occupied by the painter Johannes Torrentius (doc. 46)
17 May, Dirck Hals stands surety for his brother Frans's purchases at an art sale held by Frans Pietersz de Grebber (doc. 47)

1630 29 March, Frans and Dirck Hals witness a deposition made by Hendrick Willemsz den Abt, landlord of the 'Coninck van Vranckrijck', a popular haunt of artists (doc. 52)

1631 18 August, Frans Hals witnesses the will of Michiel de Decker, a merchant (doc. 54)
12 November, baptism of Maria Hals (doc. 57)
17 November, paintings by and after Frans Hals among the lots in an auction planned by Hendrick Willemsz den Abt (doc. 58)
○ Adriaen Brouwer leaves the Northern Netherlands for Antwerp
○ Reorganisation of the Haarlem Guild of St. Luke
○ Construction of the barge canal between Haarlem and Amsterdam

1632 ○ Birth of Jan Vermeer in Delft (d. 1675)

1633 Frans Hals paints the *Officers and Sergeants of the St. Hadrian Civic Guard* in Haarlem (s79)
□ Hals agrees to paint the Amsterdam *Company of Captain Reynier Reael and Lieutenant Cornelis Michielsz Blaeuw ('The Meagre Company')* at 60 guilders a head (doc. 73 and cat. 43)

1634 Frans Hals's name appears in a list of the members of the Guild of St. Luke (doc. 61)
26 January, baptism of Susanna Hals (doc. 62)
4 April, three paintings by Frans Hals are sold in a lottery organised by Dirck Hals and Cornelis van Kittensteyn (doc. 65)
14 August, Frans Hals attempts to buy a painting by Hendrick Goltzius at an Amsterdam auction (doc. 66)

1635 4 September, Judith Leyster complains to the Guild of St. Luke that Frans Hals had lured away one of her pupils (docs. 70, 71)

1635-7 △ Frenzied speculation in tulip bulbs; Haarlem struck by the plague

1636 □ 19 March, Frans Hals receives a formal summons to come to Amsterdam to finish *The Meagre Company* (doc. 73 and cat. 43)
20 March, Frans Hals, ill in bed at his home in Groot Heiligland, replies that he is willing to complete the militia piece in Haarlem (doc. 74)
29 April, Captain Reael and Lieutenant Blaeuw reject Hals's proposal, and again demand that he come to Amsterdam (doc. 75)
26 July, Frans Hals says that he is only prepared to complete the picture in Haarlem (doc. 78); it was eventually finished by Pieter Codde in 1637

1637 9 February, Frans Hals receives an annual allowance for the care of his imbecile son Pieter, who is to be housed outside the city (docs.80, 81)
○ A room in Haarlem Town Hall is placed at the disposal of the Guild of St. Luke

1638 ○ Death of Cornelis Cornelisz van Haarlem, history painter (b.1562)

1639 Frans Hals paints the *Officers and Sergeants of the St. George Civic Guard* (s124)

1640 17 January, Frans Hals owes 33 guilders in rent for a house in an alleyway off Lange Begijnenstraat (docs.87, 88)
23 December, baptism of Frans Hals's granddaughter Maria, illegitimate child of Sara Hals and Abraham Potterloo (doc.91)
○ Death of Rubens (b.1577)

1641 □ Frans Hals paints the *Regents of the St. Elizabeth Hospital* (cat.54)
○ Sir Anthony Van Dyck (b.1599) dies at Blackfriars

1642 29 March, Sara Hals, pregnant with another illegitimate child, is committed to the workhouse by her parents (doc.92)
13 June, the city authorities place Pieter, Frans Hals's imbecile son, in solitary confinement in the workhouse and undertake to pay for his support (doc.94)
5 September, Frans Hals living in Kleine Houtstraat (doc.95)
17 September, Frans Hals is ordered to pay his guild dues (doc.96)
Before 6 November, Frans Hals and several fellow-artists sign a recommendation to the burgomasters of Haarlem, arguing against a restriction on art sales in the city (doc.97)
○ Rembrandt completes *The Night Watch*

1642-9 △ The English Civil War

1644 18 January, Frans Hals is appointed a warden of the Guild of St. Luke for a year (doc.100)
27 February, Frans Hals living on Oude Gracht (doc.103)

1645 22 January, at the Court of Justice in Vianen, Frans Hals is ordered to pay 60 guilders and paint free of charge for one day to pay off the rent arrears of his son Harmen (doc.108)
13 October, Frans Hals makes a sworn statement about his son Reynier to an Amsterdam notary (doc.113)
○ Jacob van Campen (1595-1657) designs the New Church in Haarlem (completed in 1649) against the tower built by Lieven de Key in 1613

1646-7 The 18-year-old Vincent Laurensz van der Vinne (1628-1702) spends nine months as Frans Hals's pupil ('Geslagt-Register', Sliggers 1979, p.15)

1646-51 Apprenticeship of Pieter Gerritsz van Roestraten (1630-1700), the still-life painter and Frans Hals's future son-in-law (docs.138, 148)

1647 ○ Theodorus Schrevelius publishes his *Harlemum sive urbis Harlemensis incunabula* (Dutch edition, 1648), in which he praises Frans Hals's portraiture and the art of Dirck Hals (docs.116, 124)
△ Death of Prince Frederik Hendrik; his son Willem II succeeds as stadtholder

1648 27 May, Frans Hals and two others are appointed arbitrators in a dispute between a painter and an art dealer (doc.127)
△ The Peace of Münster between Spain and the Dutch Republic brings an end to the Eighty Years' War
△ Execution of King Charles I of England

1648- ○ Caesar Boëtius van Everdingen (1616/7-78),
c.57 portraitist and history painter, active in Haarlem

c.1649 □ Frans Hals paints the portrait of *René Descartes* (cat.66)

1649 4 September, as a former warden, Frans Hals attends an extraordinary meeting of the Guild of St. Luke (doc.133)
○ Death of Frans Pietersz de Grebber (b.1572/3), the Haarlem portraitist and history painter

1650 △ Death of Prince Willem II; start of the first 'Stadtholderless Period', which lasts until 1672

c.1650 ○ Jan de Bray (c.1627-97), the Haarlem portrait painter, starts on his career

1651 6 October, Pieter Gerritsz van Roestraten make a sworn statement to an Amsterdam notary about Frans Hals's son Anthonie, a sailor with the Dutch East India Company from 1646 until his death in Tonkin in 1650 (doc.138)
7 October, Frans Hals authorises his wife, Lysbeth Reyniersdr, to collect the pay due to their son Antonie from the Dutch East India Company (doc.139)

1652/3 ○ Death of Pieter Fransz de Grebber (b.c.1600), Haarlem portraitist and history painter

1652-4 △ First Anglo-Dutch War

1653 □ The Leper-House pays 65 guilders for the support of 'Malle Babbe in the workhouse' (doc.94), the only contemporary reference to this woman portrayed by Frans Hals (cat.37)

1653-8 △ Oliver Cromwell rules England as Lord Protector

1654 10 March, Frans Hals pays off a debt to Jan Ykesz, a baker, by surrendering household goods and several paintings, including works by Karel van Mander and Maerten van Heemskerck (doc. 147)

1655 8 October, Frans Hals is confirmed in the Reformed Church (doc. 151)

1656 17 May, burial of Dirck Hals, Frans's younger brother, in the Beguine Church
○ 8 January, launch of the *Weeckelyke Courante van Europa* ('Weekly Courant of Europe'), published by the Haarlem printer Abraham Casteleyn
○ Opening of the barge canal between Haarlem and Leiden

1657 ○ Death of Hendrick Pot (b. c. 1585), the Haarlem portraitist and genre painter
○ Death of the portraitist and history painter Pieter Claesz Soutman (b. 1580), who had been working in Haarlem since 1628

1660 ○ Death of the artist Judith Leyster (b. 1609), the wife of Jan Miense Molenaer
△ General Monk restores the English monarchy; Charles II ascends the throne

1661 ○ Cornelis de Bie states in his *Het Gulden Cabinet vande edel vrij Schilderconst* that Philips Wouwerman had been a pupil of Frans Hals (doc. 163)
In view of his age, Frans Hals is exempted from paying his annual dues to the Guild of St. Luke (doc. 164)
14 December, Frans Hals and two fellow-artists owe money for six paintings bought at an auction in nearby Heemstede (doc. 167)

1662 Frans Hals appraises paintings (doc. 169)
○ Death of Johannes Cornelisz Verspronck (b. before 1603 [not c. 1606/9]), the Haarlem portrait painter

1662-6 9 September-1 October, Frans Hals asks for financial assistance from the city authorities, who award him a pension of 200 guilders; in 1664 he is also given three cartloads of peat and his rent is paid for him (docs. 170-1, 174-8, 181, 185)

1663 ○ August, the Frenchman Balthasar de Monconys visits Haarlem on his journey through Holland, and admires a civic guard portrait by Frans Hals in one of the militia halls (doc. 173)

1664 □ Frans Hals paints the regents and regentesses of the Old Men's Almshouse in Haarlem, his last two group portraits (cat. 85, 86)
○ Death of Salomon de Bray (b. 1597), the Haarlem history painter and architect

1665 22 January, Frans Hals acts as guarantor for Abraham Hendricksz Hulst, his son-in law (doc. 179)

1665-7 △ Second Anglo-Dutch War, ending with the destruction of a large part of the English fleet at Chatham

1666 1 September, Frans Hals is buried in the choir of St Bavo's in Haarlem (doc. 183)
○ Isaac Newton measures the moon's orbit
○ Stradivarius labels his first violin
△ 2-9 February, the Great Fire of London

1667 8 February, burial of Pieter, Frans Hals's imbecile son (doc. 186)

1668 ○ Death of Jan Miense Molenaer (b. c.1610), the Haarlem genre painter and husband of Judith Leyster
△ Triple Alliance between England, Sweden and the Dutch Republic

1669 ○ Death of Rembrandt (b. 1606)

1672 3 May, burial of Frans Hals's son Reynier in the Leidse Churchyard in Amsterdam (doc. 38)
△ The 'Year of Calamities'; start of the Third Anglo-Dutch War and the war with France; Prince Willem III (King William III of England, 1689-1704) becomes stadtholder

1675 26 June, Frans Hals's widow, Lysbeth Reyniersdr, receives a weekly allowance from the city authorities (doc. 189)

1679 ○ 28 June, Matthias Scheitz, a German artist, jots down a brief biographical sketch of Frans Hals on the fly-leaf of his copy of Karel van Mander's *Schilder-boeck* (doc. 190)

PIETER BIESBOER

The Burghers of Haarlem and their Portrait Painters *

When the young Frans Hals and his parents left Antwerp to settle in Haarlem, the city was facing the aftermath of events which had sweeping consequences for its social and economic life. The first of these had been the successful siege by Spanish forces in 1572-3. The famine-weakened, defeated populace had to discharge an exorbitant indemnity and billet a garrison at their own expense. Haarlem was not liberated until 1577, only after the occupying forces had inflicted even more damage by starting a disastrous fire in 1576.[1] Clashes between Roman Catholics and Protestants culminated in May 1578, when the interior of the Great Church of St. Bavo was surrendered to the Protestants, who removed the altars and images and plastered the walls white. In April 1581, Catholics were prohibited from celebrating mass or administering the sacraments. Clandestine churches were soon established, and during the seventeenth century their numbers rapidly increased. Nevertheless, the Church had lost its importance as a patron of the arts.

The financial and material damage resulting from the siege and the fire was so extensive that Haarlem had to appeal for assistance to reconstruct the city. By agreement with the States (provincial assembly) of Holland, the municipality received ecclesiastical property within the city. Accommodation was urgently needed for the many refugees from the Southern Netherlands who emigrated to Haarlem after the unions of Utrecht and Arras in 1579.[2] They were fleeing not only from religious persecution, but from economic decay. The blockade of Antwerp following its fall to the Spanish in 1585 had virtually paralysed the maritime trade of the southern provinces. The south bore the brunt of the hostilities, while the north, by contrast, was relatively safe after the victory of Alkmaar and the relief of the Spanish siege of Leiden. Many of the Calvinists and Mennonites who came from Flanders were wealthy and enterprising merchants or skilled craftsmen who were to have a powerful impact on Haarlem's social and economic life. Their arrival ushered in a period of unprecedented material growth. Breweries had long been the mainstay of a thriving economy, and to these were added the linen and cloth industries, which found ideal conditions in Haarlem.[3]

By the turn of the century, the city had recovered and new buildings were being constructed. The ruling élite provided commissions both public and private for architects such as Lieven de Key and painters like Cornelis Cornelisz, Hendrick Goltzius and Frans Pietersz de Grebber.

The city government comprised twenty-four male members of the most prominent families of Haarlem. They joined the city council for life by co-option. Each year four were appointed burgomasters and seven were appointed *schepenen* (aldermen). In general they served for a two-year period each. Though not highly paid, these positions were very influential, owing to the patronage the holders controlled. Almost all posts in institutions such as the hospitals, almshouses, the law court and the local offices of the East and West India Companies, were filled by members of the city council. Thus they formed an oligarchy, and by intermarriage kept reinforcing their influential position over generations. Since the city council supervised the selection of civic guard officers, this regent élite controlled the military power of the city by appointing one another or their relatives.

The wealthiest brewers had long constituted the main body of the regent class, having in the sixteenth century replaced the impoverished landed gentry. The official change of religion in 1578-9 had tremendous social consequences. Most older, wealthy brewers' families and the few aristocrats remained Catholic, so were disbarred from government office. A new group of brewers gained access to the city council. However, the Catholic élite retained its material wealth and formed a separate social group bound together by intermarriage. National political controversies in 1618 caused yet another change in city government, and resulted in almost total control of the council by a new group, twenty-one of whom were brewers. This coterie of new regents became the core of Hals's clientele. Many successful brewers invested in real estate within and outside the city. By acquiring land and estates with titles from the impoverished aristocracy, the wealthiest developed a taste for aristocratic manners. Many of the second or third generation studied for university degrees.

The merchant class in Haarlem initially received little access to government positions or to the officer ranks of the civic guard. This was because almost all of them were from Flanders or from the Goch region, and as foreigners they were not eligible to hold office. A few commercially successful members of the second or third generation were able to marry into the regent circle.

with the homes of Hals's prominent sitters and colleagues

Pieter Wils, Map of Haarlem, engraving, 1646. Published in 1649 by J. Blaue.

1 NICOLAES OLYCAN, house and 'Scheepje' brewery (Scheepmakersdijk 17)

2 JOHAN SCHATTER, house and 'Gecroonde Ruyt' brewery (Spaarne, between Ravesteeg and Valckensteeg)

3 WILLEM CLAESZ VOOGHT, house and brewery (Spaarne, between Valckensteeg and Ravesteeg, second house from Valckensteeg)

4 PIETER JACOBSZ OLYCAN, brewery (Spaarne, sixth building to the north of Wildemansbrug; later owned by Thyman Oosdorp and Hester Olycan)

5 PIETER JACOBSZ OLYCAN, 'Hoeffeyser' brewery (Spaarne, fifth building to the north of Wildemansbrug; later owned by Jacob Pietersz Olycan)

6 PIETER JACOBSZ OLYCAN, 'Vogelstruys' brewery (Spaarne, fourth building to the north of Wildemansbrug)

7 FRANS HALS (alleyway off Lange Bagijnestraat; May 1640, see Hals doc. 88)

8 JOB CLAESZ GIJBLANT, house and brewery (Bakenessergracht, east side, four houses from Vrouwesteeg)

9 JAN DE BRAY (Bakenessergracht, west side, opposite Zakstraat; now nos. 32r and 32zw)

10 PIETER SOUTMAN (Bakenessergracht, east side, sixteenth house from the Vest; 1650-5, rented from Jacob Calantius the Elder)

11 FRANS HALS (Ridderstraat; Hals rented an unidentified house in this street from c. 1654-60, see Hals docs. 145, 150, 151, 161)

12 CORNELIS ENGELSZ and JOHANNES CORNELISZ VERSPRONCK (Jansstraat, west side, next door to St. Barbara's Hospital)

13 Burgomaster CORNELIS GULDEWAGEN (Jansstraat, west side, second house from the corner of the Grote Markt)

14 CATHARINA HOOFT (Grote Markt 13A; 1619-30)

15 BALTHASAR COYMANS (Witte Heerenstraat, with a rear entrance in Zijlstraat)

16 JOSEPHUS COYMANS (Zijlstraat, third and fourth houses from the corner of Nobelsteeg going towards Smalle Gracht)

17 PAULUS VAN BERESTEYN (Zijlstraat, second house from the corner of Nobelsteeg going towards Smalle Gracht)

18 WILLEM CROES (Zijlstraat, first house from the corner of Nobelsteeg going towards Smalle Gracht)

19 FRANS HALS (corner of Jacobijnestraat and Oude Gracht; c. 1643-50, see Hals docs. 98, 103, 113, 123, 132, 135)

20 CLAES DUYST VAN VOORHOUT (Oude Gracht, east side, ninth house from Jacobijnestraat)

21 NICOLAES VAN DER MEER (Oude Gracht, east side, fifth house from Stoofsteeg)

22 WILLEM VAN HEYTHUYSEN (Oude Gracht, east side, seventh house from Stoofsteeg)

23 JEAN DE LA CHAMBRE (Oude Gracht, west side, second house from the Ossemarkt, present-day Botermarkt)

24 JACOBUS ZAFFIUS (two houses on the corner of Gierstraat and Bredesteeg, sold in 1609; it is quite possible that Zaffius inherited these houses but never occupied them, living instead with other Roman Catholic priests at the Begijnhof)

25 STEPHANUS GERAERDTS (Koningstraat, next door to the residence of the Lords of Schagen)

26 FRANS HALS (Peuzelaarsteeg; January 1617, see Hals doc. 23)

27 WILLEM COYMANS (Klein Heiligland 64, now the Regents' House of the Vrouwe- en Anthonie Hospital)

28 FRANS HALS (Groot Heiligland, no exact location documented; March 1636, see Hals doc. 74)

29 ISAAC MASSA and MARIA VAN WASSENBERGH (Oude Gracht, north side, second house from Schagelstraat; after 1640. Massa and Beatrix van der Laen, his first wife, lived on the estate of Jonckheer Lou at Lisse, near Leiden)

30 CHRISTIAEN MASSA (Oude Gracht, south side, next door to Frans Pietersz de Grebber)

31 FRANS PIETERSZ DE GEBBER (Oude Gracht, west side, next door to the Loan Bank)

32 JACOB CLAES LOO, house and brewery (Spaarne, east side)

33 NICOLAES VAN DER MEER, house and brewery (Spaarne, east side)

34 FRANS HALS (Kleine Houtstraat, no exact location documented; September 1642, see Hals doc. 95)

35 LUCAS DE CLERCQ (Spaarne, west side, on the corner of Berkenrodesteeg)

36 PAULUS VAN BERESTEYN (Smedestraat, second house from Wijngaerdstraat; until c. 1640)

37 TIELEMAN ROOSTERMAN (Smedestraat, east side, second house from the corner of Kruisstraat)

38 WILLEM VAN HEYTHUYSEN (* his Middenhout estate on Kleine Houtweg, off the map)

HARLEMVM,
vernacule
HAERLEM.
Dimensa a Petro Wils Geometra
1646

'T SPAREN.

Amplissimis Prudentissimisq Viris
D.D. PRÆTORI CONSVLIBVS,
Scabinis et Senatui
VRBIS HARLEMENSIS;
Tabulam hanc D.D. Joan Blaeu.

Kennemer Roeden.

Rhijnlandsche Roeden.

Most of the cloth, linen and silk merchants, however, were Mennonites, so by religious conviction were unable to serve in government or the militia. They formed a strong social group dominated by an extremely rich élite during the flowering of the textile industry in Haarlem. After about 1645, only the richest were able to cope with the consequences of the decline of the textile industry, which was brought about by fierce competition from the old textile centres of Goch, Meenen, Courtrai and Cambrai after their recovery from the mass emigration of 1580-1600.[4]

A further privileged group comprised the judges, bailiffs, notaries, ministers, doctors and lawyers, all of whom required university degrees. Most were sons of the Haarlem regents or were related to them by marriage or descent. During the course of the century, such professionals came increasingly to dominate municipal government.

Frans Hals's position was strongly affected by the economic and social situation in Haarlem. Initially he had to compete with the more traditional portrait painters, Frans Pietersz de Grebber and Cornelis Engelsz. However, after the political changes of 1618, the young, rich brewers who formed the new oligarchy engaged Hals to paint four militia group portraits between 1627 and 1639 (S45, S46, S79, S124), and also commissioned portraits of themselves and their families. This second phase of Hals's career parallels the peak of Haarlem's economic prosperity between 1620 and 1645. He continued to enjoy the patronage of the wealthiest regents, the merchant class and the professional élite until the end of his career, though in later years the number of portrait commissions was affected by the city's economic decline. Haarlem's main export products, beer and textiles, had become too highly priced to compete effectively. In 1623 there had been 54 breweries, but by 1665 only 35 remained. Wealthy Haarlemmers were increasingly investing their capital in Amsterdam business ventures, which yielded a better return. Between 1650 and 1665 there was an exodus of successful merchants and enterprises for the same reason, and many artists followed in their wake, for Amsterdam was now one of the richest cities in Europe.

In 1610 Frans Hals married Anneke Harmensdr and was enrolled as a master-painter in the Guild of St. Luke (Hals docs. 3, 9). Haarlem offered excellent prospects, and his marriage brought a connection with the regent élite, his wife's guardian and maternal uncle being Job Claesz Gijblant, a member of the city council and an officer in the militia company of St. George between 1603 and 1618 (see Hals doc. 3). However, the political upheaval of that year saw Gijblant removed from office,

and he played no further part in municipal government. Furthermore, his niece, Hals's wife, had died in 1615. Gijblant lived until 1638. Although after 1618 he was no longer in a position to assist Hals in procuring official commissions, he may never have been inclined to do so, for his sister, Anneke's mother, had married beneath her social station (see Hals doc. 3). When Gijblant had his own portrait painted in 1611 (fig. 1), he engaged Frans Pietersz de Grebber, the most popular portraitist of the day, rather than his niece's husband.[5]

There is a remarkable contrast between de Grebber's portrait of Gijblant and Frans Hals's *Portrait of Jacobus Zaffius* of the same period (cat. 1). Zaffius had been archdeacon and provost of St. Bavo's, and occupied an important position among the Catholics in Haarlem. His private resources enabled him to add several rooms to the *hofje*, or court of almshouses, of Frans van Loenen.[6] Hals's portrait, though, was possibly commissioned not by Zaffius himself, but by the governors of the *hofje*. Zaffius had raised money for the building work by selling two houses to Aernout van Beresteyn in December 1609.[7]

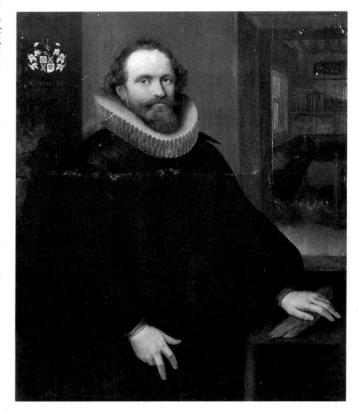

Fig. 1 Frans Pietersz de Grebber, *Portrait of Job Claesz Gijblant*, 1611
Haarlem, Frans Halsmuseum (inv. 65-95)

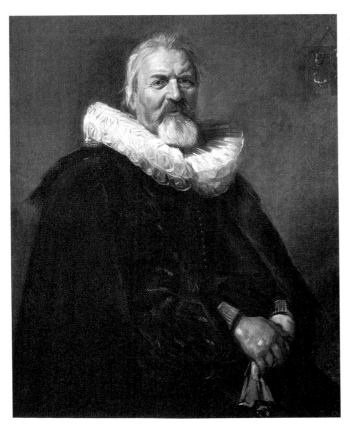

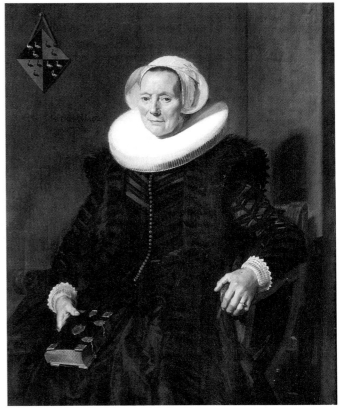

Fig. 2 Frans Hals, *Portrait of Pieter Jacobsz Olycan*, 1639 (s128)
Sarasota, John and Mable Ringling Museum

Fig. 3 Frans Hals, *Portrait of Maritge Claesdr Vooght*, 1639 (s129)
Amsterdam, Rijksmuseum

About ten years later, his son PAULUS VAN BERESTEYN**
commissioned Hals to paint portraits of himself and his
third wife, CATHARINA BOTH VAN DER EEM, whom he
married in December 1619 (cat. 6, 7). The van Bere-
steyns had been a prestigious family before the Revolt.
While remaining Catholic and thus excluded from poli-
tical power, marriages with members of Protestant re-
gent families helped them retain a high social position.
Paulus's sister, Magdalena, was the wife of burgomaster
Gerard van der Laen, and their daughter, Beatrix,
married Isaac Massa, one of Hals's patrons.[8]

Frans Hals received only one assignment for a group
militia portrait before the political upheavals of 1618:
the *Banquet of the Officers of the St. George Civic
Guard* of 1616 (s7). Nothing certain can be established
as to how he secured the commission. Although one of
the ensigns was Boudewijn van Offenberch, members of
whose family – also from Antwerp – had witnessed the
baptisms of Hals's youngest half-sister and brother,[9] his
youth makes him an unlikely intercessor on Hals's
behalf.

Like their predecessors, the new post-1618 élite com-
missioned militia portraits and, later, paintings of var-
ious groups of regents. In addition, many of them – the
Olycan family are a notable example – had portraits
painted of their families. Prince Maurits appointed
Pieter Jacobsz Olycan to the city council in 1618, and
he was elected alderman at the same time. Three of the
burgomasters appointed in 1618 were related to Olycan
by his marriage to Maritge Claesdr Vooght (figs. 2, 3).
Born on 15 September 1572 into a successful and well-
connected Amsterdam merchant family, Olycan learned
commerce in Rome and went on four trade missions to
Spain and the Baltic. In 1595 he married Maritge Claesdr
Vooght in Haarlem, and established himself there in
brewing, the trade of his wife's family.[10] One of Pieter's
six brothers, Cornelis, (b. 1581), similarly married the
daughter of a Haarlem brewing family and established
himself as a brewer in the city.[11] Pieter Jacobsz Olycan's
career was outstanding. In addition to being appointed
alderman in 1618, he was the city's delegate to the
States-General on six occasions and five times a burgo-
master.[12]

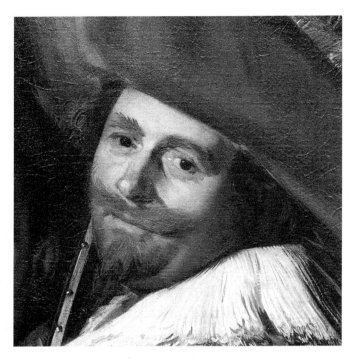

Fig. 4 Frans Hals, *Officers and Sergeants of the St. Hadrian Civic Guard*, *c.*1633, detail: Johan Schatter (s79)
Haarlem, Frans Halsmuseum

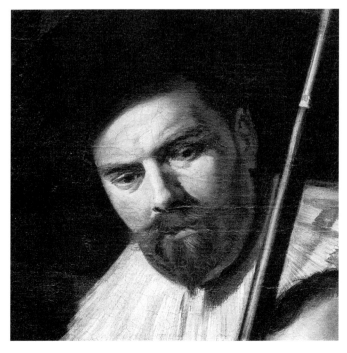

Fig. 5 Frans Hals, *Officers and Sergeants of the St. Hadrian Civic Guard*, *c.*1633, detail: Nicolaes Pietersz Olycan (s79)
Haarlem, Frans Halsmuseum

Olycan and his wife had fifteen children. Their eldest son, JACOB PIETERSZ (b. 1596), married ALETTA HANEMANS on 1 July 1625 and took over the 'Hoeffeyser' brewery. In that year, Frans Hals painted their portraits (cat. 18, 19), while Jacob also appears in the slightly later *Banquet of the Officers of the St. George Civic Guard* of *c.*1627 (s46). Their daughter, Volckera Pietersdr, (b. 1597), married Johan Herculesz Schatter (b. 1594), brewer at the 'Gecroonde Ruyt', in 1616. Schatter appears as a captain of the St. Hadrian civic guard in Hals's group portraits of 1627 and 1633 (s45 and fig. 4). Together with Pieter Jacobsz Olycan, Schatter, like his father-in-law, was appointed to the city council in 1618, and was burgomaster in 1632, 1633 and 1636.[13]

The Olycan's third child, Nicolaes Pietersz Olycan (b. 1599), married Agatha Dicx, whose father, Dirc Dircksz Dicx, was the brewer at the 'Scheepgen'. Nicolaes bought out his wife's heirs and accordingly acquired the brewery. The panelling in one of the rooms, which Nicolaes commissioned when the couple moved into the residence adjoining the brewery, has uniquely survived intact, and gives an idea of the interior appearance of the home of a prosperous Haarlem brewer.[14] Nicolaes appears as a lieutenant in Frans Hals's *Officers and Sergeants of the St. Hadrian Civic Guard* of *c.*1633 (fig. 5).

Another daughter, Maria Pietersdr (b. 1607), married Andries van Hoorn (1600-77) on 25 July 1638. Frans Hals painted their portraits in the same year (figs. 6, 7; s117, s118).[15] In 1633 Hals had portrayed van Hoorn as a captain in the St. Hadrian guard.

A daughter born to the Olycans the year after Maria, Hester Pietersdr (b. 1608), married the brewer Thyman Oosdorp (1613-68) in 1640. He held numerous public offices, and after Hester's death in 1654 he married Margaretha Schellinger. Hals's portrait of Thyman Oosdorp probably dates from the year of his second marriage, 1658 (fig. 8; s201).[16]

In 1635 Dorothea Pietersdr (1613-62) married Cornelis van Loo (1609-73), the son of Johan Claesz van Loo, who, like Pieter Jacobsz Olycan, had been appointed to the city council in 1618. Both were burgomasters in 1630 and 1639.

With the exception of Jacob, all of Pieter Jacobsz Olycan's children who survived infancy and married were allied with wealthy brewers or the sons or daughters of brewers, holding powerful positions in Haarlem's civic administration. By the end of his life, in or after 1661, Pieter Jacobsz had amassed a considerable fortune, which included 47 city properties.[17] In 1639, as the burgomaster of Haarlem, he had his own and his wife's portraits painted by Frans Hals (s128, s129), so Hals painted a total of eighteen portraits of members of the Olycan family.

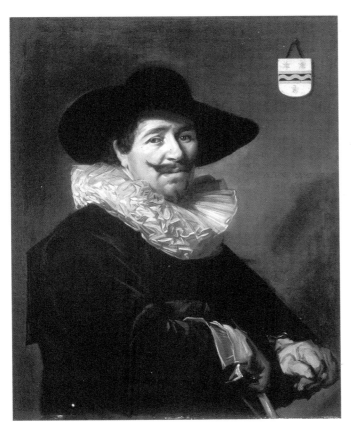

Fig. 6 Frans Hals, *Portrait of Andries van Hoorn* (s117)
São Paolo, Museum of Fine Arts

Fig. 7 Frans Hals, *Portrait of Maria Pietersdr Olycan* (s118)
São Paolo, Museum of Fine Arts

In about 1625, when Hals painted Jacob Olycan and Aletta Hanemans, he also produced the magnificent portrait of WILLEM VAN HEYTHUYSEN (cat. 17), who belonged to an entirely different social group from that of the Olycans. Van Heythuysen did not hold public office, nor was he a member of the civic guard, probably because he frequently travelled abroad. A merchant from Weert, Limburg, he was one of the many people who had emigrated to Haarlem from the textile centres in the Southern Netherlands. He remained single and made his home on Oude Gracht.[18] He died on 6 July 1650. His will and the inventory of his estate show him to have been an extremely wealthy man.[19] The proceeds from his estate were used to found one *hofje* in Weert,[20] and another near Haarlem on his estate, Middenhout.[21] Van Heythuysen's friend, Tieleman Roosterman (fig. 10), his son, Adriaen Roosterman and Johan van Heythuysen, became the first regents of the Hofje van Heythuysen.[22] Roosterman, like Willem van Heythuysen, was a merchant in cloth, linen and thread. Van Heythuysen bequeathed 1,000 guilders each to the

Dutch communities in Hanau and Frankfurt in Germany, which suggests that he had probably been a frequent visitor there.[23] Apart from his friend Tieleman Roosterman, there is no documentary reference to any other acquaintance or associate in Haarlem. In 1870, the regents of the Hofje van Heythuysen sold a portrait of Willem van Heythuysen, possibly the 'likeness of the deceased in small, in a black frame' which according to the inventory of his estate was 'in the room above the great hall' (cat. 51). The inventory also refers to an 'effigy or large portrait of Willem van Heythuysen with a swathe of black drapery hanging over it', which was said to be in the 'great hall'.[24] This is believed to be Hals's portrait of c.1625 (cat. 17).

Considerably more is known about the life of ISAAC MASSA. The son of Abraham Isaacsz Massa and Sara Jansdr Texor from Antwerp, he was baptised in Haarlem on 7 October 1586. His father was a silk textile merchant who died between 1598 and 1602. Isaac Massa is known to have lived in Russia, where he learned the

Fig. 8 Frans Hals, *Portrait of Thyman Oosdorp* (s201)
West Berlin, Staatliche Museen Preussischer Kulturbesitz (inv. 801H)

language and played an important role in helping to establish diplomatic relations with his native country.[25] He returned to Holland where he made a good match by marrying former burgomaster Gerard van der Laen's daughter Beatrix van der Laen in Lisse on 26 April 1622. He had probably been commended by his prestige as an agent of the States-General in Russia.[26] Massa was a witness at the baptism in 1623 of Hals's daughter Adriaentje,[27] but when the couple deposed a will before Massa's return to Russia in 1624,[28] it was witnessed by the painter Frans Pietersz de Grebber, the neighbour of Isaac's brother and partner, Christiaen Massa and, unlike Hals, their social peer.[29] In Russia, Massa obtained permission to purchase two cargoes of grain a year for export to Holland.[30] This valuable concession is referred to in a document drawn up after his return in 1626,[31] the year in which Frans Hals painted his portrait (cat. 21). In all Massa made five visits to Russia, on two occasions travelling via Sweden. His wife died in 1639.[32] Only one son, Abraham, was born of the marriage, probably in 1624.[33] The couple's daughter, Magdalena, died in 1637.[34]

Isaac Massa remarried on 22 April 1640.[35] His second wife, Maria van Wassenbergh, came from a less wealthy and prestigious family than Beatrix van der Laen. After his marriage, he sold a town house which had been let,[36] as well as his suburban garden containing a pavilion, fruit trees and a rose bower.[37] The couple had two sons, Jacob and Willem, born in 1641 and 1643.[38] Massa died shortly after the birth of the second child and was buried in St. Bavo's on 20 June 1643.

Unlike most of Haarlem's rich and influential brewers, the Massa brothers owned relatively little property and such houses as they had were sold after 1640. However, the property tax levied on the house on Oude Gracht was fairly high at 33 guilders, 15 stuivers and 8 penningen, compared with Willem van Heythuysen's (19 guilders).[39] Unfortunately, the inventory of Isaac Massa's estate has been lost, and no information is available about the house furnishings and works of art he presumably owned.

Verses beneath Jan van de Velde II's contemporary print of a man wielding a jawbone, after a portrait which Frans Hals painted *c.*1627, name the subject as VERDONCK (cat. 24). Van Thiel has convincingly argued that the sitter is very probably Pieter Verdonck from Ghent, who married Catharina Geleyns in Haarlem on 7 September 1597.[40] He is probably the merchant Pieter Verdonck who remarried in Rotterdam in 1630 and died there two years later.[41] Pieter was probably related to the Rotterdam cloth merchant, Balten Verdonck, a Mennonite who before 1615 married Lysbeth de Clercq, the eldest daughter of a Haarlem Mennonite family.[42] Van Thiel has established that Pieter Verdonck may have come to the fore in the dispute between the Mennonites. In 1623 he was ordered not to molest Joost Lybaert, a Flemish immigrant who had prospered as a grain merchant, and a fellow-Mennonite.[43] The poem beneath van de Velde's print possibly refers to such conflicts. The iconological meaning of the portrait of Verdonck holding the jawbone – an allusion to Samson – is that he was a man who slayed his adversaries with words. A pamphlet entitled *Het Kakebeen* ('The Jawbone'), which Laurens Willemsz published at the height of the controversy in the hope of gathering the Mennonites back to the fold, endorses this interpretation.[44] The modesty of Verdonck's costume in the portrait is presumably an allusion to his affiliation with the 'Old Flemings' emigré group, who were the most puritanical members of the Mennonite community. Verdonck must have been a prominent figure in those circles, and had probably acquired such a reputation that Hals was induced to portray him with an appropriate attribute. The print and its accompanying text could be seen as propaganda for this conservative group of Flemish Mennonites, with Verdonck represented as the champion of their cause. In 1627 Hals also painted a portrait, possibly posthumous, of the man who had kindled animosity

towards the Haarlem Mennonites, Johannes Acronius, the Protestant minister of St. Bavo's from 1619 to 1627 (s47).[45] Indeed, Hals painted a number of Catholic priests as well as members of the Mennonite community; in art, at least, they were apparently not irreconcilable.

Hals received numerous portrait commissions in the decade between 1630 and 1640, and enjoyed the patronage of some of Haarlem's wealthiest burghers. He had acquired a reputation as a portraitist, and was acclaimed by the historian Samuel Ampzing for his *Banquet of the Officers of the St. Hadrian Civic Guard* of c.1627 (s45; see Levy-van Halm & Abraham, fig. 1, and Hals doc. 41). Pendant portraits were in vogue among the established élite, those of NICOLAES VAN DER MEER and CORNELIA CLAESDR VOOGHT of 1631 being examples of the trend (cat. 41, 42). There is a remarkable discrepancy, however, between these paintings and the swift, almost sketch-like quality of the *Banquet of the Officers of the St. George Civic Guard*, c.1627 (s46, see Levy-van

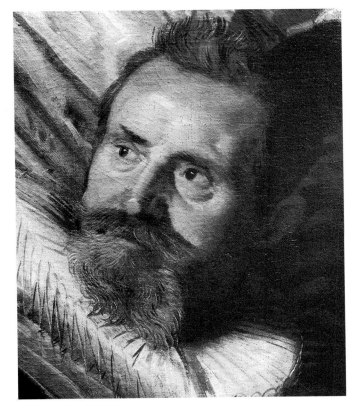

Fig. 9 Frans Hals, *Banquet of the Officers of the St. Hadrian Civic Guard*, c.1627, detail: Willem Claesz Vooght (s45)
Haarlem, Frans Halsmuseum

Halm & Abraham, fig. 13). Their archaic appearance was probably dictated by the tastes of the patrons themselves, or was perhaps intended to reflect the decorum of the office of burgomaster. Like his brother-in-law Pieter Jacobsz Olycan (whom Hals painted with a companion portrait of his wife in 1639; figs. 2, 3),[46] Nicolaes van der Meer was one of the brewer regents who rose to power in 1618. He was burgomaster in that year, as was his other brother-in-law, Willem Claesz Vooght,[47] and in 1620, 1628, 1629, 1634 and 1635. Hals portrayed him when he was at the height of this career (fig. 9).

The portraits of Tieleman Roosterman and Catherina Brugman (figs. 10, 11; s93, s94) are far more rapid and spontaneous than those of van der Meer and his wife, while the poses convey a sense of grandeur and spaciousness. Roosterman was an extremely rich merchant whose family was from Goch. His parents, Jan Roosterman and Christina Coeburcht, lived in Lange Bagijnestraat, Haarlem,[48] having probably settled in the city between 1597 and 1599.[49] Tieleman and Catharina had nine children between 1633 and 1652.[50] In 1641 they bought the house they had originally rented in Smedestraat for the princely sum of 11,025 guilders.[51] The magnitude of the debts owed to him is also evidence of his prodigious wealth. His father, too, who presented his daughter Anna with a dowry of 7,000 guilders,[52] was obviously extremely well-off. Both father and son were merchants in fine linen and silk fabrics,[53] and their business extended as far as France. Besides his large residence in Smedestraat, Tieleman owned a warehouse in Ridderstraat,[54] and a garden beyond the Kleine Houtpoort city gate.[55] He was the executor of Willem van Heythuysen's will and, as such, one of the people responsible for the construction of the Hofje van Heythuysen, becoming a regent with his son Adriaen and Johan van Heythuysen.[56]

The portraits of the conspicuously opulent Tieleman Roosterman and Catherina Brugman are in sharp contrast to those of LUCAS DE CLERCQ and his wife FEYNTJE VAN STEENKISTE, which Hals painted in 1635 (cat. 46, 47). The fact that they were Mennonites would account for the modest simplicity of their unadorned black costumes. The antenuptial contract between Feyntje and Lucas is dated 11 January 1626.[57] Feyntje's father, Pieter van Steenkiste, was a potash merchant, potash being used in linen bleaching.[58] Three of her sisters married the van Beeck brothers of Amsterdam, who were probably her brother Pieter's business associates. Lucas van Beeck went into partnership with his wife Christina's brother-in-law, Lucas de Clercq, and de Clercq's brother-in-law, Abraham Ampe.[59] These three

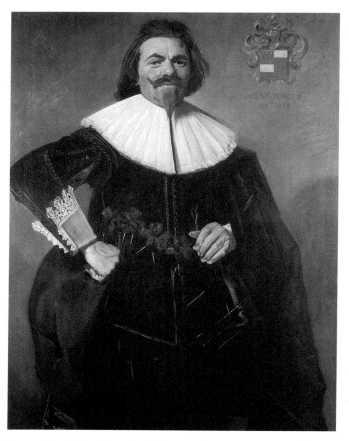

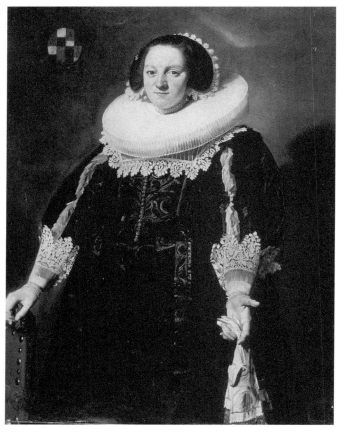

Fig. 10 Frans Hals, *Portrait of Tieleman Roosterman*, 1634 (S93)
Vienna, Kunsthistorisches Museum

Fig. 11 Frans Hals, *Portrait of Catherina Brugman*, 1634 (S94)
New York, private collection

sons-in-law of Pieter the Elder took over the van Steenkiste family business after the death of Pieter the Younger, as there were no other male heirs in the family.

In 1629, at the age of 69, Pieter van Steenkiste relinquished his power of attorney to his sons-in-law Lucas de Clercq and Lucas van Beeck.[60] Their names appear in many subsequent notarised documents.[61] Pieter died a year later. The will he and his wife left gives some idea of the wealth of property in the family.[62]

In 1638 Lucas de Clercq bought an expensive house on the River Spaarne, near the corner of Berkenrodesteeg, where he and Feyntje van Steenkiste lived.[63] Lucas de Clercq and Lucas van Beeck together bought a garden with various buildings on it in Dycklaan, outside the city gate of St. Janspoort.[64] According to the inventory of the estate drawn up after Feyntje's death, she and her husband, together with Lucas van Beeck, also owned a country estate called Clercq-en-Beeck, known today as De Beeck, in Bloemendaal, north of Haarlem.[65] This inventory contained fewer objects of

value than Willem van Heythuysen's. Only two paintings were listed with the name of the artist; a landscape by Pieter Molijn in an ebony frame, worth 24 guilders, and a landscape by Bleker worth 14 guilders. Hals's portraits of Lucas and Feyntje were not included.

During the second phase of Hals's career a new generation of portraitists emerged: Johannes Verspronck, Pieter Fransz de Grebber and Pieter Soutman. Hals's supremacy, however, remained unchallenged. He received highly prestigious commissions in the decade between 1630 and 1640, including three civic guard pieces. Johannes Cornelisz Verspronck (b. before 1603-1662) and his father Cornelis Engelsz (c.1574/5-1650) are believed to have been Catholics.[66] This does not seem to have prevented either from obtaining commissions from a wide range of clients, including a number of Calvinists. Nevertheless, Johannes Verspronck never painted a Reformed Protestant minister or theologian, whom we may suppose preferred to place their

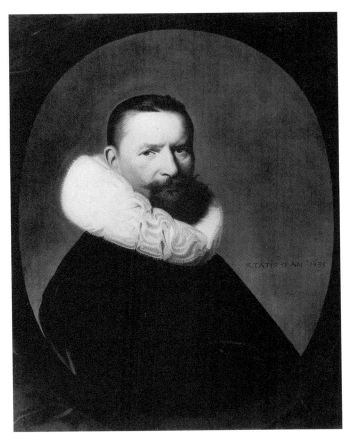

Fig. 12 Johannes Verspronck, *Portrait of Josias van Herrewijn*
Formerly Amsterdam & London, Gebr. Douwes Fine Arts

In 1637 Verspronck painted Anthonie Charles de Liedekercke and his wife Willemina van Braeckel.[74] The portrait of de Liedekercke reveals traces of Hals's influence, notably in the loose brushstrokes of his hair and the modelling of his face. The couple originally came from Flanders, and for a long time lived outside Haarlem. De Liedekercke was a naval captain. The couple were painted by Gerard ter Borch in 1654 with their young son, who died soon afterwards.[75] On her husband's death, Willemina bought a house on Oude Gracht, next door to her sister Judith and brother-in-law, Arent Meyndertsz Fabricius. To judge from the price she paid, her family must have been reasonably well-off, albeit not in the same league as van Heythuysen, or the Roostermans, Olycans and van der Meers.

It was also in 1637 that Verspronck painted a portrait of the Dicx family, in all probability the brewer and regent Cornelis Dircksz Dicx.[76] Cornelis's sister Agatha married Nicolaes Pietersz Olycan, who took over the Dicx family brewery.[77] Cornelis's daughter Margaretha, whom Verspronck painted in 1651,[78] married Gerard Colterman,[79] the son of Johannes Colterman and Anna van Schoonhoven, both of whom were painted by Verspronck in 1645.[80] The Coltermans belonged to one of Haarlem's most illustrious families of lawyers, administrators and notaries. Both Gerard Colterman's grandfather and his father had been burgomasters and bailiffs-general of Kennemerland. The family owned an imposing house in Jansstraat, close to Verspronck.[81]

Besides the Coltermans, Verspronck painted several other members of Haarlem's prominent patrician families, among them Johan van Schoterbosch,[82] Pieter Jacobsz Schoudt,[83] and Cornelis Montigny de Glarges. The de Glarges were not originally from Haarlem. Theirs was a patrician family with an estate, Eslemmes, near Maubeuge, which belonged to the Southern Netherlands until 1678. Cornelis's grandfather, Claude de Glarges, had emigrated from the south in 1550 and had settled in The Hague, where he was secretary of the Appeal Court of Holland.[84] His eldest son Gilles also had a distinguished legal career at the Court of Holland, and in 1619 was appointed Pensionary (legal adviser) of Haarlem, following the political upheaval of the previous year.[85] His eldest son Cornelis spent most of his life in France,[86] and was decorated with the Order of St. Michael, which he is wearing in Verspronck's portrait. His brother Philips was a doctor of medicine and also held a number of administrative posts in Haarlem.[87] His sister Glaudina married Johan van Clarenbeeck, who appears in Pieter Soutman's militia portrait of 1642,[88] and in Frans Hals's *Regents of St. Elizabeth's Hospital* of 1641 (cat. 54).

Verspronck's 1644 portrait of Adriana Croes[89] led to a

orders with their co-religionist, Hals (see Hals doc. 151). Compared with Hals, Verspronck has left only a modest œuvre. He probably worked with his father for some time, and presumably drew his patrons from the same circles. Cornelis Engelsz received two official commissions, both militia pieces, in 1612[67] and 1618,[68] the latter in succession to Hals's group portrait of 1616 (s7). His style and conceptualisation remained steadfastly in the tradition of Frans Pietersz de Grebber.

Verspronck lived and worked at his parents' home in Jansstraat.[69] Many of his patrons lived in the neighbourhood.[70] In 1635 he painted Josias van Herrewijn (fig. 12),[71] who lived across the road, and in 1653, after van Herrewijn's death the previous year, he painted his daughter Sara and her husband Adriaen Ingelbrechtsz.[72] The couple had probably inherited the portrait of Sara's father, prompting them to commission their own in the same format and matching *trompe-l'œil* oval frames. They also received and occupied a house in Jansstraat, which Josias van Herrewijn had bought for his own use in 1649.[73]

series of three more commissions, her daughter, Maria van Strijp, her son-in-law, Eduard Wallis, a merchant,[90] and one of his brothers sitting for their portraits in 1652 and 1653. In 1618 Adriana Croes had married Hendrick Pietersz van Strijp, a merchant in thread and linen. The couple lived on Crayenhorst Gracht. Three of van Strijp's daughters married into the Wallis family.[91] Hendrick van Strijp's will of 1639 mentions his wife's brother, Willem Croes, and her friends Josephus Coymans and Nicolaes van Damme.[92] Willem Croes was a brewer, and Josephus Coymans and Nicolaes van Damme were apparently also associates of Hendrick's.[93]

WILLEM CROES had his portrait painted by Frans Hals c.1665 (cat. 80). Johannes Verspronck having died, Croes was unable to perpetuate the family tradition. In 1650, Croes was living next door to PAULUS VAN BERESTEYN, in Zijlstraat. Josephus Coymans lived one house further away, and both had been painted by Hals (cat. 6 and s160).[94]

Although Verspronck's clientele was not on the whole as wealthy and prestigious as Hals's, there were certain exceptions. Jan van Teylingen and his wife Elisabeth Crucius were both from extremely affluent Roman Catholic families,[95] as were Adriaen van Adrichem van Dorp and Catharina de Kies van Wissen,[96] despite the fact that they were not so propertied. Verspronck also painted Frans Barendsz Cousebant,[97] a rich Catholic brewer and one of Haarlem's wealthiest landowners, who held most of the land to the south of the city between the River Spaarne and Kleine Houtweg,[98] and many houses in the centre of town. The family's breweries were on the east side of Bakenesser Gracht at numbers 59, 61 and 63, behind which was the clandestine Roman Catholic church of St. Bernardus in de Hoek. It is likely that Verspronck received commissions to paint members of the Catholic community because he himself was probably a Catholic. One of his last paintings was a portrait of the priest Augustinus Alsthenius Bloemert.[99]

The career of another contemporary of Frans Hals, Pieter Fransz de Grebber's, was affected even more profoundly by his Catholic origins than Verspronck's: nearly all his extant portraits are of clergymen. From 1634 he lived at the Begijnhof, or beguinage,[100] and was a friend of Jan Albertsz Ban (1598-1644), priest at the Begijnhof Catholic church from 1630. In 1632 Ban proposed having portraits painted of Haarlem's many priests;[101] the commissions were awarded over a period of years to Frans Hals,[102] Pieter Soutman,[103] Maria de Grebber,[104] Pieter's sister, and Pieter de Grebber himself. Some time later, Jan de Bray painted a number of Haarlem priests for St. Bernardus in de Hoek.[105] In 1631

Pieter de Grebber painted Cornelis Arents, the first priest of St. Bernardus,[106] and the vicar-apostolic, Philippus Rovenius; in 1634 he painted Boudewijn Catz (fig. 13).[107] He also produced portraits of Catholic clergymen from places other than Haarlem.[108] His close association with the Beguine church inevitably brought him a number of commissions.[109] Pieter de Grebber, though, was principally a history painter. According to Schrevelius, there was a painting by him of 'Tubalcainus, in praise of music, at the home of Burgomaster Guldewagen, himself a good musician'.[110] The reference is to Burgomaster Cornelis Guldewagen, whom Frans Hals painted around 1660-3 (fig. 79a; s212),[111] and whose wife, Agatha van Hoorn, sat to Jan de Bray in 1663 (fig. 14).[112] Her brother, Andries van Hoorn and his wife, Maria Olycan, had been painted by Hals c.1638 (figs. 6, 7; s117, s118).[113] Their son, Dammas Cornelisz Guldewagen, like his mother, had his portrait painted by Jan de Bray,[114] while his second wife, Judith Loreyn,

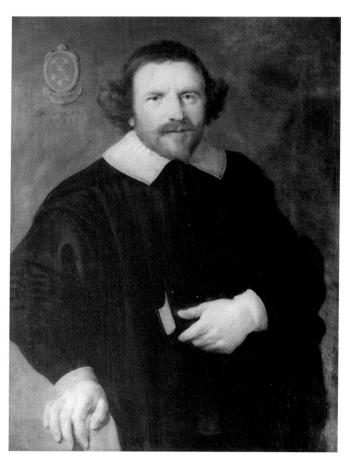

Fig. 13 Pieter Fransz de Grebber, *Portrait of Boudewijn Catz*
Utrecht, Rijksmuseum Het Catharijneconvent (inv. BMHS. 9212)

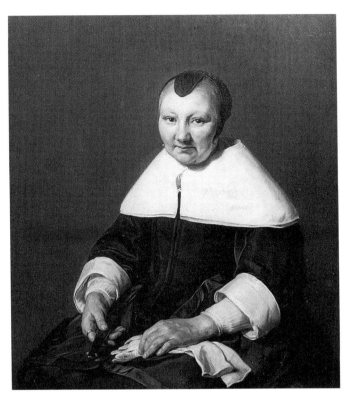

Fig. 14 Jan de Bray, *Portrait of Agatha van Hoorn*
Luxembourg, Musée Pescatore

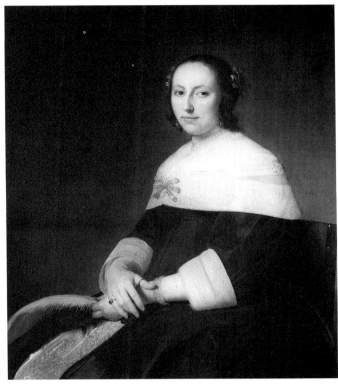

Fig. 15 Johannes Verspronck, *Portrait of Judith Loreyn*
Amsterdam & London, Gebr. Douwes Fine Arts

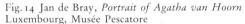

engaged Johannes Verspronck in 1649 (fig. 15).[115] Cornelis Guldewagen was a brewer at the 'Vergulde Hart'; Judith Loreyn's father, Abraham owned the 'Drie Starren' brewery on the banks of the Spaarne.[116] Her uncle, Gabriel Loreyn, a silk merchant who lived on Oude Gracht, appears in Hals's militia piece of 1639 (s124).[117] Her mother, Judith Pietersdr van der Cruysse, was also a brewer's daughter. In 1668, after the death of Cornelis Guldewagen, Judith Loreyn and her husband Dammas Guldewagen moved to the house in Jansstraat, which Cornelis had bought in 1662.[118]

Like many of Frans Hals's patrons, Verspronck's sitters were often related to one another or linked by marriage. It was common to marry into families of the same profession, the children of brewers marrying into brewers' families and those of merchants into merchant families. Within these circles there was a horizontal distinction according to power and status. The Olycans, Schatters, van Hoorns and Loos were the upper crust of the brewery world, and were Frans Hals's patrons, whereas Verspronck painted people such as Loreyn, van der Cruysse and Croes, who ranked second in the

hierarchy. Verspronck, however, painted the most important Catholic brewers and administrators, as well as a number of eminent lawyers who lived near him in Jansstraat.

Pieter Claesz Soutman was in an entirely different position. A contemporary of Frans Hals, he was born around 1585 into a distinguished Catholic family, whose position declined somewhat after 1600.[119] They were connected to the most prominent Catholic families in Haarlem – de Kies, de Kies van Wissen, Cousebant, van der Sande and van der Wiel.[120] Soutman spent many years in Antwerp, where he produced a large number of engravings after the paintings of Rubens.[121] He had returned to Haarlem by 1628, and is described in a number of documents as the painter of the King of Poland.[122] He married Gudula Fransdr van de Sande in 1630,[123] with whom he lived in a house on the corner of the Grote Markt and Grote Houtstraat belonging to Gudula's parents.[124] They later moved to Bakenesser Gracht, where Pieter Soutman died in 1657.[125]

Soutman's career developed along much the same lines as that of Pieter Fransz de Grebber. The two men were

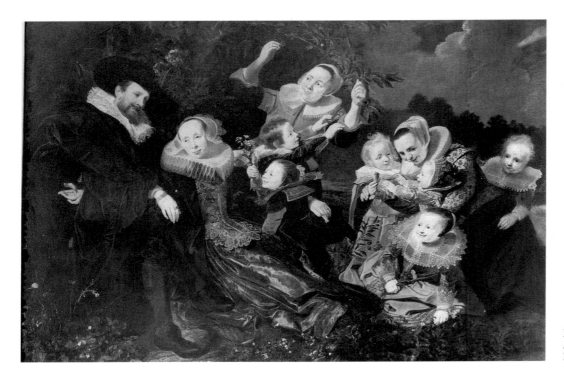

Fig. 16 Pieter Claesz Soutman, *Portrait of Paulus van Beresteyn and his Family* Paris, Musée du Louvre (inv. R.F.426)

the foremost history painters in Haarlem between 1630 and 1650,[126] but Soutman also had ambitions as a portraitist. In 1630 he sent the States-General a painting of the triumphant Prince of Orange, only to have it rejected.[127] Ten years later he offered the burgomasters of Haarlem eight sets of ten prints of members of the House of Nassau, for which he received 100 guilders.[128] That same year he presented the Prince of Orange with a bound version of the series.[129] In 1646 he requested permission to copy portraits of Counts of Holland in the Town Hall in order to produce prints after them, which he intended to publish in book form with inscriptions by Petrus Scriverius.[130] He was clearly trying to establish ties with the Prince of Orange and the burgomasters, undoubtedly in the hope of procuring commissions.

The fact that Soutman was asked to paint Jodocus Catz, the Catholic priest of St. Bernardus in de Hoek,[131] is attributable to his own Catholic affiliation. However, family ties between Soutman and Paulus van Beresteyn (both were related to the Spoorwater family) probably prompted the commission to paint van Beresteyn with his wife Catharina van der Eem and their children (fig. 16; s.D80),[132] and another of their daughter Emerentia (s.D70).[133] There is also a portrait of a woman who can be identified as Catharina's sister, Hillegont van der Eem. Frans Hals was engaged for the portraits of van

Beresteyn and van der Eem in 1619 (cat. 6, 7), presumably because Soutman was living in Antwerp at the time. Soutman also made two civic guard portraits in which the poses and gestures of the figures are reminiscent of Hals's work (fig. 17).[134] The latter's influence is also apparent in the portrait of the van Beresteyn family, although Soutman's style of painting is entirely different.

Hals was at the height of his career between 1640 and 1650, and enjoyed tremendous popularity as a portraitist. The rich style and innovative techniques which distinguish his work inspired his fellow portraitists, notably Verspronck and Soutman, to emulate his compositions and his use of apparently informal poses. It is not surprising, then, that in 1644 he was invited to paint two members of one of the city's wealthiest and most illustrious families: Josephus Coymans and his wife Dorothea Berck (figs. 68a, 68b; s160, s161).[135] The couple had married in Dordrecht on 22 November 1616, and settled in Amsterdam, where Josephus and his brothers Balthasar and Johannes had a merchants' business on Keizersgracht.[136] By 1620 the couple had moved to Haarlem,[137] and in 1628 were living in Smedestraat, in the house next-door to Paulus van Beresteyn.[138] In 1650, the Coymans family was occupying two large houses in Zijlstraat, and once again their neighbours were the van Beresteyns.[139] Josephus Coymans, unlike

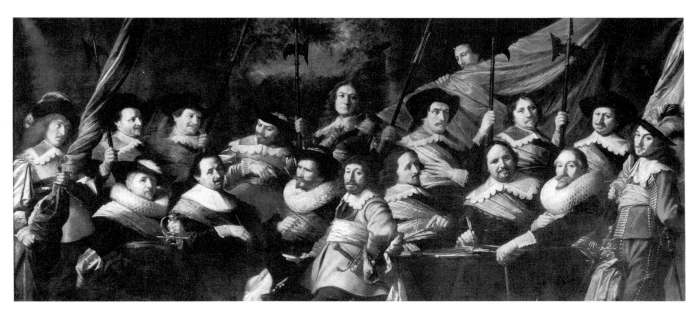

Fig. 17 Pieter Claesz Soutman, *Officers and Sergeants of the St. Hadrian Civic Guard*, with portraits of Balthasar Coymans and Jacob Druyvesteyn
Haarlem, Frans Halsmuseum (inv. I-314)

his eldest son Balthasar, did not hold public office in Haarlem,[140] yet, by their marriages, his children and grandchildren extended a network of prosperous commercial regent families based in Amsterdam and Haarlem, whose members owned estates in the vicinity of Haarlem. Hals may have received Josephus Coymans' and Dorothea Berck's portrait commissions through Aernout Druyvesteyn and his son, Jacob, both brewers. Jacob Druyvesteyn (1612-91) married Josephus Coymans's daughter, Wilhelma in 1639,[141] and was a captain in the St. Hadrian civic guard at the same time as his brother-in-law, Balthasar Coymans (fig. 17). Earlier he had been portrayed as an ensign in Frans Hals's militia piece of *c.* 1639 (S124), and his father, Aernout Druyvesteyn, is the colonel in Hals's civic guard banquet of *c.*1627 (S46).[142] It is conceivable that, since Aernout Druyvesteyn and his son Jacob had been portrayed in these two paintings, the Coymans decided to engage Hals for their portraits in 1644 (figs. 68a, 68b).

In the same year Hals painted their newly wedded daughter ISABELLA and her husband, the Amsterdam merchant STEPHANUS GERAERDTS (cat. 69, 68).[143] The marriage contract stipulated that the bridegroom would bring to the match a sum of 100,000 guilders, landed property and other effects. Isabella's parents gave her a dowry of 30,000 guilders.[144] In 1649, Geraerdts, who later held various public offices, bought an imposing house on Koningstraat for 12,800 Carolus guilders.[145]

The portrait of PAULUS VERSCHUUR, dated 1643 (cat. 56), must also have been painted in Haarlem, although Verschuur, a textile merchant, lived in Rotterdam, where he was a member of the city council and a burgomaster.[146] He was married to Maria van Berckel, the daughter of burgomaster Johan van Berckel of Rotterdam. Verschuur's elder brother Joost is known to have been a cloth merchant.[147] Their father moved to Rotterdam from Antwerp.[148] Verschuur's sister Margarieta and her husband Pieter Jacobsz Wynants (also a textile merchant) lived in Haarlem. The Wynants were Mennonites, and the family's entire circle of acquaintances appears to have been made up of textile merchants and bleachers. This is apparent from the legacy to the Mennonite Olyblock orphanage, which is mentioned in the will drawn up by Pieter Wynants and Margarieta Verschuur in 1638.[149]

Between 1655 and 1665 the Dutch economy began to decline as a result of the first two Anglo-Dutch wars and fierce competition from the textile centres of Germany and Flanders, and so too did the number of portrait commissions. Frans Hals and Johannes Verspronck, as well as Jan de Bray, who had only been painting since 1652,[150] were equally hard hit. However, the winds of fortune changed for de Bray after Verspronck's death in 1662, as Hals was by then considerably advanced in years, leaving de Bray as the only painter of any calibre

in Haarlem. He accordingly received a number of important commissions for group portraits between 1663 and 1667.[151]

In the period 1655-65, Hals painted the portraits of Cornelis Guldewagen and WILLEM CROES mentioned above (s212 and cat.80), as well as that of Thyman Oosdorp, the husband of Hester Olycan (s201).[152] According to an old inscription, the painting was executed in 1656, after Hester's death, and it may have been intended to mark the occasion of Oosdorp's forthcoming marriage to Margaretha Schellinger.[153] From 1655 until his death in 1668, Oosdorp held various important offices, including that of burgomaster.[154] In 1661 he bought a house in Grote Houtstraat, adjacent to the Mennonite church.[155]

The sudden popularity of group portraits of regents and regentesses between 1663 and 1667 came in the wake of the plague epidemic which struck Haarlem in 1664, claiming the lives of almost a third of the population and driving orphans and paupers to seek shelter at the Armekinderhuis orphanage and the Old Men's Almshouse. Jan de Bray lost his entire family, as did many other Haarlem citizens.[156] The almshouses and other charitable institutions which provided a refuge for the many elderly and destitute survivors acquired a new status in the community. Frans Hals's last important

commission was for two group portraits of the regents and regentesses of the Old Men's Almshouse, which are among the most outstanding of his later works (cat. 85, 86). Unfortunately, however, many of his sitters between 1655 and 1665 have remained unidentified. He painted two preachers,[157] a small portrait of Tegularius, which has survived (s207),[158] and portraits of fellow artists such as Jacob van Campen (S.L18), FRANS POST (cat. 77), VINCENT LAURENSZ VAN DER VINNE (cat. 76) and Adriaen van Ostade (s192).

Although Jan de Bray also received several commissions for group portraits of regents during this period, as well as a number of private assignments, he did not pose a challenge to Hals. He devoted himself principally to history painting, and most of his known portraits were of close acquaintances or members of the Catholic community. After his family had been struck down by the plague, he remained in the house his father had bought on the west side of Bakenesser Gracht. In 1668 he received the house next door in remuneration for his painting of Zaleucus for the Town Hall council chamber.[159] Interestingly, several of de Bray's portraits are small, and were probably intended for his patrons' private quarters. Those of the clergyman Josephus de Kies van Wissen,[160] and the Catholic priest, Pieter van der Wiele,[161] are more characteristic of his work, as indeed is the family portrait of Pieter Braems, Emerentia

Fig. 18 Jan de Bray, *Portrait of Pieter Braems and His Family*
Haarlem, Frans Halsmuseum (inv. 1-36)

van der Laen and their children (fig. 18), which was later donated to St. Jacob's Almshouse.[162] The family was Catholic; Pieter was a physician and the son of an Amsterdam merchant, Jan Braems, while Emerentia was the daughter of a Haarlem pharmacist, Pieter van der Laen.

De Bray's portraits after 1652 bear no resemblance to Frans Hals's work, either stylistically or iconographically. He was inspired rather by Johannes Verspronck, and to some extent elaborated on his presentation of the sitter. This is particularly evident in the group portraits, which express a closer affinity to Verspronck's *Regentesses of St. Elizabeth's Hospital* than to Hals's later regent portraits. The differences in conception are also apparent if one compares Hals's *Cornelis Guldewagen* and *Andries van Hoorn* (S212 and fig.6), and de Bray's *Agatha van Hoorn* (fig.14) and *Dammas Guldewagen*. De Bray's specialisation as a history painter led him to depict many of his patrons in the classical mode. His orientation was towards the *portrait historié*, a genre which came into vogue in the latter half of the seventeenth century.[163] His success, however, was short-lived. His financial position was precarious, and orders for both portraits and history pieces gradually dwindled, while those he did receive were poorly paid. In 1689 he was finally declared bankrupt. The economy as a whole had taken a downward turn, and the golden era of portraiture had come to an end.

Unlike de Bray, Hals and Verspronck had aspired to paint true-to-life portraits, and it was they who held sway among the portraitists of Haarlem. Pieter de Grebber and Pieter Soutman had remained within the confines of the conservative Catholic community, which favoured formalised and static representations, and although Soutman tried to adapt his style in imitation of Hals's militia portraits, his efforts were in vain.

Hals remained supreme, or at least supremely popular. Until the end of his life, he continued to receive commissions from the wealthiest and most prestigious families in Haarlem. His patrons apparently admired the lifelike quality of his work, and appreciated his genius for capturing the living moment. He had a considerable influence on Verspronck, which is apparent in a number of portraits of merchants. Following Hals's example, Verspronck tried to achieve a more relaxed quality in these paintings. His portraits of patricians, however, were dignified, formal and devoid of intimacy. Hals, by contrast, even when called upon to produce a formal and imposing portrait, never failed to capture the essential vitality of his subjects. His powerful characterisation and the lifelike quality of his work have won him a place among the greatest Western painters.

Notes

* Edited by Ivan Gaskell.
** Capitalised names refer to portraits in the exhibition.

1. Temminck 1971, p.32; Wijn 1982; Verwer 1973.
2. Briels 1978.
3. Van Loenen 1950; Hoekstra 1936; Groenman 1936; Regtdoorzee Greup-Roldanus 1936, pp.11-5.
4. See Regtdoorzee Greup-Roldanus 1936, pp.270-1.
5. Panel, 129 × 101 cm, Haarlem, Frans Halsmuseum, inv.65-95, gift of F.J.E. van Lennep, Amsterdam, 1965.
6. Kurz 1972, p.79.
7. GAH, Transportakten (Property Conveyances, further abbreviated as Tr.) 76-37, fol.206, 22 December 1609.
8. Dólleman & Schutte 1969. See below, pp.29-30, for Beatrix van der Laen and Isaac Massa.
9. See Hals docs. 1 and 4. Since the sponsorship was not reciprocated, the relationship between Hals's father and the van Offenberchs was most likely that of a socially inferior client to his patrons.
10. GAH, transcription ms. of Ysbrand Olycan's

notes on the genealogy of the Olycan family. Pieter Jacobsz Olycan's breweries were the 'Vogelstruys' and the 'Hoeffeyser' on the River Spaarne.
11. Cornelis Jacobsz Olycan, born 8 May 1581. On 8 January 1612 he married Fryn Pietersdr Aker (daughter of the brewer Pieter Quirijnsz Aker, who died in Haarlem on 30 December 1627; he had been a councillor from 1618 at the same time as Pieter Jacobsz Olycan). He was the master brewer at the 'Olycan' on Smalle Gracht in Haarlem, and had six children.
12. Naamregister 1733: States-General delegate in 1631, 1632, 1633, 1640, 1641, 1642; burgomaster in 1630, 1639, 1645, 1653.
13. Naamregister 1733.
14. Philadelphia, Philadelphia Museum of Art, See Biesboer 1986. On 3 June 1633, Agatha Dircksdr Dicx and Nicolaes Pietersz Olycan acquired from their joint heirs a brewery with an adjacent residence and a corn mill, called 'Het Scheepje', on Scheepmakersdijk on the River Spaarne. The deeds of transfer are in the GAH (see new acquisitions 1984).
15. Andries van Hoorn, the son of Dammas and Christina Suyderhoeff, was baptised on 6 March 1600 and buried on 1 September 1677. He became a councillor in 1627, was an alderman in 1631-2, 1635-6, 1639-42, 1644-5, 1648,

1651-2, and a burgomaster of Haarlem in 1655-6, 1660-1 and 1668. He was a director of the Dutch West India Company from 1658 to 1677, a captain in the St. Hadrian civic guard from 1630-3, 1636-9, 1642-5, and colonel from 1648-51. He married Maria Camerveld on 26 August 1629 and, after her death, Maria Olycan.
16. Canvas, 89 × 70 cm, Berlin-Dahlem, Staatliche Museen (S201). Thyman Oosdorp was born in Delft on 20 November 1613 and died on 20 February 1668. He was the son of Franciscus Oosdorp, headmaster of the Latin School in Amsterdam, and Maria Jansdr. He was a councillor from 1651, burgomaster from 18 February 1665 to September 1666 (GAH, ms. Pieter Velsen, *Beschrijvinge der Namen en afkomsten van de Edele Achtbare heeren Raaden in de Vroedschap der Stad Haarlem etc 1746*, fol.89r-v). His second marriage was solemnised on 14 October 1658 to Margaretha Schellinger, widow of Johan Veneman (advocate and later merchant in Amsterdam at the firm of Jan and Tymon Veneman). Her father was Hillebrand Schellinger (1580-1633), Receiver-General of the Exchange Bank on its establishment in 1609, and a councillor; Elias 1903-5, vol.1, p.300.
17. The properties were sold between 1661 and 1670 (GAH, Tr.76-72 [1661], fols.264-8; Tr.76-73 [1662], fols.19, 131-8; Tr.76-74 [1663],

fols. 114, 171; Tr.76-75 [1664], fols. 50, 51; Tr.76-79 [1669], fols. 87, 165, 166; Tr.76-80 [1669], fols. 47, 106, 107; Tr.76-81 [1670], fols. 156, 157, 165). The names of the heirs were mentioned in the will deposited with notary Nicolaes van Bosvelt on 22 February 1661 (GAH, Tr.76-72 [1661], fol. 263).

18. In 1646 Willem Heythuysen bought a house adjacent to his own residence on Oude Gracht: (GAH, Tr.76-75 [1646], fol. 85).

19. The original will has been lost. A copy was preserved in the archives of the Hofje van Heythuysen (GAH, inv. Hofje van Heythuysen, no. 1). The inventory (GAH, NA 153, fol. 328r-v) lists the contents of the 'office, entrance hall, in the chamber off the deceased's bedroom, the large hall, in the north side wing, in the south side room, in the room over the great hall, in the back room over the kitchen, in the south front room, in the room over the entrance hall, a [second] office' ('comptoir, voorhuys, inde camer vant slaepcamer van de overledene, 't groot salet, in de noord sydel huys, in de suyder sydelcamer, op de camer boven het groot salet, op de achtercamer boven de keucken, op de suyder voorcamer, op de camer boven het voorhuys, een [tweede] comptoir').

Van Heythuysen had numerous paintings and some exceptional furniture and silverware. 'Paintings in the entrance hall: Moses and Aaron, two female figures, the four evangelists painted in black and white. In the deceased's bedroom: a painting above the fireplace in a gilt frame, three more small portraits above the fireplace, a large landscape in a gilt frame, a scene of young maidens in a black frame, a kitchen piece in a gilt frame, a head in a gilt frame, a large winter scene in a gilt frame, flowers in a vase in a black frame, a kitchen piece in a black frame, a landscape in a black frame, a large landscape in a black frame, Amsterdam in a black frame, satyrs in a black frame, a breakfast piece in a black frame, a tobacco piece, Bacchus in a black frame, a head study in a black frame, a hanging hen pheasant with accoutrements, a fruit still-life, a perspective with Diana and Actaeon in a black frame, three small landscapes, eight small scenes behind glass. In the back room over the kitchen: a large scene of Tobit in a black frame, a large landscape in a gilt frame, two pieces done with the pen on panel, a large scene with nudes in an oak frame, a small landscape in a black frame, a landscape with a grotto in a gilt frame, a painting as above in a black frame' ('Schilderijen: int voorhuys: Moyses ende Aaron; nog twee vrouwe beelden. De vyer Evangeliste in wit en swart geschildert; in de slaepcamer van de overledene: een stuck voor de schoorsteen in vergulde lijst; nog drye cleyne contrefeytselen voor de schoorsteen; een groot lantschap in vergulde lijst; een tavereel van jonge mijden in swarte lijst; een keuckeschilderij in vergulde lijst; een troignie in vergulde lijst; een groote winter in vergulde lijst; een bloempotgen in swarte lijst; een keuckenschilderye in swarte lijst; een lantschap in swarte lijst; een groot lantschap in swarte lijst; Amsterdam in swarte lijst; satyrs in swarte lijst; een banketgen in swarte lijst; Taback drinckers; een bacchus in

swarte lijst; een troigne in swarte lijst; een hangend hoen cum annexis; een fruitagie; Diana en Actaeon perspettyf in swarte lijst; Drye cleyne lantschapjes; acht cleyne tavereeltgens met glas daervoor. Op de achtercamer boven de keucken: een groot tafereele van To-bit in swarte lijst; een groot landtschap in vergulde lijst; twee stuckgens metten pen ge-maeckt; een groot taferele met naeckte beelden in eycke lijst; een cleyn lantschapge mede in swarte lijst; een landtschap met een grot in vergulde lijst; een schilderytgen als boven in swarte lijst').

Furniture in the entrance hall: 'a longcase sonnerie clock in the north side wing, a four-seasons cabinet containing an uncommon painting' ('een staende uyrwerck en horlogie in de noord sydelhuys, een vyer getyden kast daerin byzondere schilderye'), and wall-cover-ings of gilt leather. There is also mention of a piece of gilt leather in van Heythuysen's bedroom. In the back room over the kitchen was a gilt East Indies cabinet ('een vergult kas-gen ... oostindisch'). In the second office was an ebony cabinet with two doors, containing twelve silver two-pronged forks, six spoons, twenty-one silver spoons, another silver gilt spoon, ten silver bowls, a wrought silver gilt goblet, a golden chain with a green stone, twelve gold and gilt buttons, a pair of rings, a diamond ring, a plain ring ('ene kastgen van ebbehout met twee deuren ... twaelff silveren gaffels ofte vorckgens; ses lepels, een en twintich silvere lepels; nog een vergult silveren lepel; tien sil-veren kommetgens; een silver vergult gedreven bekertgen, een goude kettinge met ene groene steen daeraen; twaelff knope gout ende vergult, een paer ringen; een diamant ringe; een slecht ringetgen'). There was also a collection of gold and silver coins, together with various silver objects in van Heythuysen's bedroom: 'a silver ewer, two large silver salt-cellars with dolphins and two porcelain basins belonging to the set, two small gilt saucers, two silver gilt bowls, a tall silver ewer, a smaller silver ewer, a goblet, a salt-cellar, another small silver cup, two bran-dy cups each with a silver spoon' ('een silvere schenck kan; twee groote silvere soutvaten met dolphijntgens twee porseleyne beckgens daer-toe behorende; twee cleyne vergulde schotel-tgens; twee silvere vergulde beckens; een lange silvere kan; noch een silvere kan kleynder; een kelckgen; een soutvat; noch een cleyn silvere commetgen; twee brandewyn commetgens met beyde lepels van silver').

20. Henkens 1958. The contents of his house realised 4,593 guilders, 17 stuivers and 8 pen-ningen, and a 15-*morgen* tract of land in the Schermer polder fetched a further 8,000 guilders. A *morgen* (literally, the amount of land that could be ploughed in one *morgen*, or morning) was a unit of area which could range from 8,000 to 10,000 square metres.

21. Kurz 1972.

22. This is apparent from the purchase of the messuage adjacent to the *hofje* for the sum of 900 Carolus guilders (GAH, Tr.76-77 [1670], fol. 88).

23. Copy of the will, GAH, inventory of the Hofje van Heythuysen, no. 1.

24. For the inventory of property: GAH, NA 153, fol. 328.

25. See Orchard 1982. In addition to maps pertaining to the Russian and oriental trade, Massa published a book entitled *Beschryvinghe der Samoyedenlandt in Tartarien. Nieulycks onder 't gebiedt der Moscoviten gebracht. Wt de Russche tale overgheset, Anno 1609. Met een verhael van de opsoeckingh ende ontdeckinge van de nieuwe deurgang ofte straet int Noordwesten na Rycken van China en Cathay. Ende een Memoriael, gepresenteert aen den Coningh van Spaengien, belanghende de ontde-ckinge end ghelegentheyt van 't land genoempt Australia Incognita*, Amsterdam 1612.

26. GAH, DTB, Marriage Register: betrothal, 10 April 1622, Isaac Massa, bachelor of Haarlem, residing in Wijngaerdstraat; Beatrix van der Laen, also of Haarlem (with an attestation that the marriage took place on 25 April 1622 in Lisse). Beatrix van der Laen was the daughter of Gerard van der Laen and Magdalena van Beresteyn (see above, p. 30) who owned sub-stantial properties in the Rhineland, Amstel-land, South Holland and Brabant (their immov-able property was valued on 22 November 1617; see Transportakte Beverwijk, inv. 1207, 2nd register [1591-1620], fol. 65). For Massa's chequered relations with the States-General as its occasional agent in Russia, and with Russian envoys abroad (1614-9), see Orchard 1982, pp. xiii-xx.

27. Hals doc. 29. Frans Hals's father, who was a cloth dresser, presumably did business with Isaac Massa's father, Abraham Isaacsz Massa, who gave his occupation as silk cloth merchant ('sydelaeckenvercoper'), and who came from Antwerp like Hals's parents. It was a relation-ship between subordinate and superior, as was the case with the van Offenberchs (see above, p. 27, and note 9).

28. GAH, NA 124, fol. 65, notary J. Schoudt: 'residing on the estate of Mr Lou under the jurisdiction of Hillegom' ('wonende op de hof-stede van Jonckh. Lou in de Ambachte van Hillegom'). The couple had no children at this stage, but the will mentions that Beatrix van der Laen was pregnant ('begort van kinde'), prob-ably with their son Abraham.

29. According to the deed of sale for his house on Oude Gracht, Christiaen Massa had lived next to Frans Pietersz de Grebber (d. 1649) since 1617 (GAH, Tr. 76-67 [1650], fol. 92). They are recorded as neighbours in the Property Tax Register of 1628 (R fol. 20v, for 10 guilders). The same document shows that de Grebber owned approximately the same amount of property as Christiaen and Isaac Massa (B fol. 30, Q fol. 1, D fol. 40, B fol. 1, O fol. 14, R fol. 40).

30. At the end of the Twelve-Years' Truce (1609-21), the price of grain rose to unprece-dented heights. In 1620 a *last* of rye had cost 44 Carolus guilders, but three years later it was fetching between 170 and 200 Carolus guilders (1 *last* = 2 tonnes).

31. GAH, NA 127, fol. 165, notary Jacob Schoudt, 13 October 1626. Massa shared the risk of this particular transaction with the Amsterdam merchant Gerrit Jacobsz Witsen, one of the city's wealthiest and most powerful men.

32. An eighteenth-century register of the hatchments in St. Bavo's contains the following entry: 'om de negende pilaer, Vrouwe Beatrix van der Laen, Huisvrou van d'heer Isaacq obiit 13 augustus 1639. Sonder quartieren, een Ruyt' ('on the ninth pillar [of the choir], Beatrix van der Laen, wife of Isaacq, died 13 August 1639. A lozenge, without quarterings').

33. See note 28. He accompanied Coenraad Burgh's diplomatic mission to Russia as interpreter (Scheltema 1817, p. 210).

34. She was probably born between 1627 and 1629 when Isaac Massa was again living in Holland.

35. GAH, DTB, Marriage Register: Isaac Massa, widower, residing in Jacobijnestraat, and Maria van Wassenbergh, spinster, residing in Wijngaerdstraat, Haarlem.

36. GAH, Tr. 76-61 (1641), fol. 119: 'Isaac Massa sells to Johan de Waal, present burgomaster of this city, a house in the Begijnhof, previously occupied by Breiggen Walings, for 1,025 Carolus guilders' ('Isaac Massa vercoopt aen Johan de Wael regerend burgemeester deser Stadt een huis aan het Begijnhof voormaels bewoont by Breiggen Walings voor 1025 Carolus guldens'). The house was already Massa's property in 1628, according to the Property Tax Register of that year (fol. 40), and was assessed at 6 guilders and 20 stuivers.

37. GAH, Tr. 76-62 (1642), fol. 219.

38. GAH, DTB, Baptismal Register: 10 November 1641, Jacob Massa, father Isaac Massa of Haarlem, mother Maria van Wassenbergh. GAH, DTB, Baptismal Register: 15 February 1643, Wilhelmus Massa, father Isaac Massa, mother Maria van Wassenbergh.

Jacob Massa (d. 1664) appears to have been a student in Utrecht. He was buried in St. Bavo's in October 1664. Willem Massa studied in Leiden and practised as a notary in Haarlem from 1667 to 1684. He married Aechje Abeels of Haarlem on 12 May 1665.

39. GAH, Tr. 76-64 (1645), fol. 37; Tr. 76-60 (1640), fol. 102: a one-room house in Gasthuisstraat. See also note 29.

40. Van Thiel 1980.

41. Although he is recorded as the husband of Aeltje Hendricksdr van Vollenhoven, who may have been his second wife, and of Grietje Pieters, his third, whom he married on 27 January 1630; van Thiel 1980, p. 132.

42. A notarial deed of 13 November 1615 refers to them as being married (GAH, NA 50, fol. 238r-v). According to the will of Lysbeth's parents (GAH, NA 46, 2 June 1608, fol. 188), her father Jacques de Clercq (d. 1609) came from Ghent, and her mother, Passchyntgen Gryspeere, from Rumbeke. They lived in Grote Houtstraat and bequeathed 200 Carolus guilders to the poor of the Mennonite congregation. From 1603, Jacques de Clercq had himself acted as a trustee for needy Mennonites (GAH, NA 42, 15 November 1603, fol. 78r-v). On several occasions he was referred to in this capacity in connection with bequests to the poor.

43. Van Thiel 1980, p. 132.

44. Van Thiel 1980, pp. 127ff.

45. Panel, 19.3 × 17.1 cm, Berlin-Dahlem, Staatliche Museen (S47).

46. See above, pp. 27-8.

47. Vooght is the colonel in Hals's *Banquet of the Officers of the St. Hadrian Civic Guard*, c. 1627 (S45).

48. The GAH, DTB, Marriage Registers contain the following entries: 30 November 1631, Tieleman Roosterman, bachelor, from Goch, of Bagijnestraat, and Catherina Brugman of Amsterdam. 8 August 1632, Francine Roosterman, of Lange Bagijnestraat, and Antoni Tierens. 24 December 1634, Anna Roosterman, of Lange Bagijnestraat, and François aux Brebis, merchant. 25 December 1639, Margriete Roosterman, of Lange Bagijnestraat, and Adriaen Brugmans, bachelor, residing in Amsterdam. Tieleman Roosterman had another brother, Henricus, who was buried in the church of St. Bavo on 7 June 1659. Jan Roosterman was buried there in November 1649.

49. According to the inscription on his portrait (S93), Tieleman Roosterman must have been born in 1597, probably in Goch. His sister Wendeltie was baptised in St. Bavo's on 24 November 1599.

50. GAH, DTB, Baptismal Registers: Johannes (25 July 1633), Maria (19 April 1635), Adriaen (25 April 1637), Maria (13 June 1638, died young), Christina (14 April 1641), Tilman (5 December 1642), Henricus (1645), François (19 January 1648) and Petrus (18 July 1652).

51. GAH, Tr. 76-61 (1641), fol. 158. The house, the second from the corner of Kruisstraat, on the north side, was assessed for 43 guilders and 15 stuivers in the Property Tax Register of 1650 (c fol. 52).

52. Only a copy of the marriage contract between François aux Brebis and Anna Roosterman has survived (GAH, archives of the Hofje van Heythuysen, inv. 22). The contract was drawn up by notary M. van Lievendael, whose archives have been lost (information kindly supplied by J. J. Temminck).

53. An inventory compiled on 6 November 1666 in his warehouse in Ridderstraat gives an idea of the range of their merchandise (GAH, NA 322, fol. 302).

54. GAH, Tr. 76-75 (1665), fol. 226; he sold the warehouse for 755 Carolus guilders.

55. GAH, Tr. 76-72 (1660), fol. 197; GAH, Tr. 76-74 (1663), fol. 226; GAH, Tr. 76-77 (1668), fol. 43v, for 120 Carolus guilders Jan van der Hage sells Tieleman Roosterman a garden in Wagenmakerslaan adjoining his own garden on the north side,

56. See above, p. 29.

57. GAH, NA 96, fol. 19.

58. GAH, NA 160, fol. 106, 12 October 1633: an application from the widow of Pieter van Steenkiste potash merchant ('coopman van assche').

59. Abraham Ampe was married to Levyna de Clercq, sister of Lucas de Clercq. GAH, NA 105, fol. 146: 'An agreement between Lucas van Beeck, merchant, of Amsterdam, and Lucas de Clercq, merchant of Haarlem, on the one side, and Lyvyna de Clercq, widow of Abraham Ampe, assisted by Anthonie Verbeeck and Jacob Pietersz de Wael as the guardians of the minor children born to Abraham Ampe and Lyvyna de Clercq on the other side, concerning

the trading company established by deed of 10 July 1629 between Lucas van Beeck, Lucas de Clercq and Abraham Ampe' ('Een accoord tussen Lucas van Beeck koopman te Amsterdam en Lucas de Clercq koopman te Haarlem ten eenre en Lyvyna de Clercq, weduwe van Abraham Ampe geassisteerd met Anthonie Verbeeck en Jacob Pietersz de Wael, in qualiteit als voogden over de onmondige kinderen van Abraham Ampe verwekt by Lyvyna de Clercq ter andere zijde over de compagnie van koop ende verkoop aangegaan bij acte d d 10 juli 1629 tussen Lucas van Beeck, Lucas de Clercq en Abraham Ampe'). The deed in question has not been preserved.

60. On 19 May 1629 (GAH, NA 131, fol. 120).

61. GAH, NA 135, 16 January 1639, fol. 112: 'contract of purchase and sale between Lucas van Beeck and Lucas de Clercq, merchants, and Nicolaes Anthony van Berge in Santpoort' ('contract van coop ende vercoop tusschen Lucas van Beeck en Lucas de Clercq coopluyden ten eene en Nicolaes Anthony van Berge in Santpoort ten andere syde'); GAH, NA 120, 21 April 1635: 'Lourens Cosyn, thread bleacher in the jurisdiction of Aelbertsberg, hereby acknowledges that he owes 900 Carolus guilders to Lucas de Clercq, a merchant of this city' ('Lourens Cosyn garenbleycker in de banne van Aelbertsberg erkent schuldich te syn aen Lucas de Clercq coopman alhier ene som van 900 car gulden'); GAH, NA 149, 25 February 1639, fol. 143: 'Lucas van Beeck and Lucas de Clercq, merchants, hereby give power of attorney' ('Lucas van Beeck en Lucas de Clercq coopluyden geven volmacht'); GAH, NA 156, 16 August 1631, fol. 94: 'Lucas van Beeck of Amsterdam and Lucas de Clercq of Haarlem give power of attorney to Hendrick van Beeck' ('Lucas van Beeck te Amsterdam en Lucas de Clercq te Haarlem geven volmacht aan Hendrick van Beeck'); GAH, NA 160, 16 December 1633, fol. 120: 'Davidt Vercruysse of Amsterdam acknowledges a debt to Lucas de Clercq, potash merchant' ('Davidt Vercruysse te Amsterdam erkent ene schuld aen Lucas de Clercq, aschcooper'); GAH, NA 160, 28 January 1636, fol. 286: 'Lucas de Clercq and Lucas van Beeck, potash merchants, as the representatives of Janneken Carels, widow of Pieter van Steenkiste' ('Lucas de Clercq ende Lucas van Beeck coopluyden van Assche, als laethebbers van Janneken Carels wed. Pieter van Steenkiste'); GAH, NA 164, 20 April 1635, fol. 70: 'settlement between Lucas van Beeck, representing his brother-in-law, Lucas de Clercq; and Lenaert Michielsz Casteleyn, Lieven van der Mersch and Andries de Busscher, representing their brother-in-law, David van der Cruyce' ('schikking tussen Lucas van Beeck voor Lucas de Clercq syn swager ten eenre en Lenaert Michielsz Casteleyn, Lieven van der Mersch, Andries de Busscher voor David van der Cruyce, hun swager ten andere syde'); GAH, NA 172, 4 February 1640: 'statement as requested by Lucas van Beeck and Lucas de Clercq' ('verclaring ten versoecke van Lucas van Beeck en Lucas de Clercq'); GAH, NA 173, 4 July 1644: 'Lucas van Beeck, merchant in Amsterdam, and Lucas de Clercq of Haarlem, merchants, give

power of attorney' ('Lucas van Beeck coopman te Amsterdam den Lucas de Clercq te Haarlem, cooplieden geven volmacht'); GAH, NA 174, 12 March 1646: 'Lucas de Clercq, merchant, conveys an admission of debt' ('Lucas de Clercq coopman transporteert een schuldbekentenis'); GAH, NA 179, 28 March 1647: 'marriage contract between Leendert van Beeck assisted by his uncle, Jacob van Beeck, and Anneke van Beeck, spinster, assisted by her uncles, Paulus van Maeckelenbergh and Lucas de Clercq' ('huwelijkse voorwaarden van Leendert van Beeck en syn oom Jacob van Beeck ten eenre, en Anneke van Beeck jonge dochter geassisteerd met haar ooms Paulus van Maeckelenbergh en Lucas de Clercq').

62. The will was drawn up by notary Jacob Schoudt on 30 March 1638. The conveyance for the sale of immovable property in the name of the late Pieter van Steenkiste and Janneken de Caerle lists nine city houses and a garden with a pavilion beyond the walls totalling 9,961 Carolus guilders (GAH, NA Tr. 76-58, fols. 103-4, 28 April 1638).

63. GAH, Tr. 76-58, fol. 174, 6 October 1638: for 6,100 Carolus guilders.

64. GAH, Tr. 76-59, fol. 21, 20 January 1639.

65. GAH, NA 153, fol. 48, 28 August 1640.

66. Ekkart 1979, p. 17.

67. *Officers of the St. Hadrian Civic Guard*, dated 1612, canvas, 178 × 510 cm, Strasbourg, Musée des Beaux-Arts.

68. *Banquet of the Officers of the St. Hadrian Civic Guard*, dated 1618, 171 × 247.5 cm, Haarlem, Frans Halsmuseum.

69. According to the Property Tax Register 1628, D fol. 2 (assessed at 9 guilders, 7 stuivers and 8 penningen), this was the house on the west side, adjoining St. Barbara's Hospital.

70. Johannes Colterman, Anna van Schoonhoven (Jansstraat), Johan van Schoterbosch (Jansstraat), Gerard Colterman and Margaretha Dicx (Jansstraat), Johan de Wael (Begijnhof), Adriaen van Adrichem van Dorp and Catharina de Kies van Wissen (Lange Bagijnestraat), Frans Barendtsz Cousebant (Bakenesser Gracht).

71. Signed and dated 1635, panel, 83 × 65 cm; October 1986, Delft Antique Fair, Gebr. Douwes, Amsterdam. (Ekkart 1979, p. 70, no. 5). Josias van Herrewijn (Rotterdam 1584-1652 Haarlem) spent some years as a merchant in Bremen, where he married his first wife, Sara de Haze (1577-1614).

72. *Adriaen Ingelbrechtsz*, signed and dated 1653, panel, 84 × 66 cm; *Sara van Herrewijn*, signed and dated 1653, panel, 83 × 65 cm; both on loan from the Rijksdienst Beeldende Kunst to the Frans Halsmuseum since 1985. Adriaen and Sara drew up their will in 1653 after the death of Josias van Herrewijn (GAH, NA 144, fol. 207), each naming the other as their beneficiary. The surviving partner was to inherit the house in Jansstraat.

73. GAH, Tr. 76-66 (1649), fol. 235r-v: a house belonging to burgomaster Salomon Coesaert, adjacent to his own residence. The Property Tax Register for 1650 still refers to the house as being his property. It is mentioned in the couple's will (previous note).

74. The portraits are in the Frans Halsmuseum,

Haarlem. Ekkart 1979, pp. 72-3, nos. 8-9. Willemina van Braeckel was the daughter of Pieter Aertsz van Braeckel and Arendje van Offenberch from Antwerp. Anthonie Charles de Liedekercke was born in Antwerp *c.*1587.

75. Panel, 44 × 39 cm, Haarlem, Frans Halsmuseum. See de Jongh 1986, pp. 236-8, no. 53.

76. Canvas, 76 × 63 cm, Nashville, Tennessee, Richard E. Stockwell Collection (Ekkart 1979, p. 75, no. 12). Cornelis Dircksz Dicx (Haarlem 1599-1637), of the 'Bril' brewery, was a councillor from 1625, alderman in 1629-30, 1633-4 and 1636, churchwarden in 1631-2 and 1635, lieutenant in the St. George civic guard in 1627, and captain in 1633. He married Maria Heyinckx in 1626; see Dix 1978.

77. See above, p. 28 and note 14.

78. Canvas, 95 × 75 cm, Netherlands, private collection (Ekkart 1979, p. 114, no. 84).

79. Gerard Colterman (Haarlem 1632-1670 Haarlem) was commissioner of the Court of Petty Sessions in 1655 and bailiff-general of Kennemerland in 1668-71.

80. *Johannes Colterman* (Haarlem 1591-1649 Haarlem), panel, 72 × 38.2 cm, Netherlands, private collection (Ekkart 1979, p. 100, no. 58).

81. The fifth house from the corner of Riviervismarkt on the stretch between Riviervismarkt and Lombardsteeg. It was assessed at 53 guilders and 12 stuivers in the Property Tax Register for 1628 (D fol. 1), and was still in their possession in 1650, identically assessed (Property Tax Register 1650, D fol. 52).

82. Signed and dated 1647, panel, 77 × 62.5 cm, Amsterdam, Rijksmuseum, inv. A 1253 (Ekkart 1979, p. 104, no. 66). Johan (van Overrijn) van Schoterbosch (Haarlem *c.*1564-1654 Haarlem), councillor from 1614, alderman in 1615, captain in the St. Hadrian civic guard in 1615-8, was portrayed in Cornelis Engelsz's militia piece of 1618 (see note 68 above). In 1618 he was dismissed from office by Prince Maurits.

83. Signed and dated 1641, canvas, 78 × 65 cm, Amsterdam, Rijksmuseum, inv. A 380 (Ekkart 1979, pp. 84-5, no. 30). Pieter Jacobsz Schoudt (Haarlem 1570-1645 Haarlem), councillor from 1602, alderman in 1605-6, burgomaster in 1608-9, 1613-4, 1616; dismissed by Prince Maurits in 1618.

84. I.S.M. de Haan, *Inventaris van het Archief van de familie de Glarges*, typescript 1988 (deposited at GAH). His uncles, Pieter and Gelain Zeghers van Wassenhoven van Ydeghem, were respectively a canon and a counsellor at the Supreme Court of Holland. In 1557 he married Hester van Uytwyck, the daughter of Philips van Uytwyck, squire of Uytwyck and secretary of the Supreme Court. Claude succeeded his father-in-law in this post.

85. Gilles de Glarges (The Hague *c.*1559-1641 Haarlem), Pensionary of Haarlem from 1619 to 1637, was also a governor of Leiden University. In 1600 he married Wilhelmine Cooper, who already had a son, Cornelis, whom Gilles recognised upon their marriage. Their agreement stipulated that no property was to be held in common (GAH, inventory of the de Glarges archives, inv. 26). Gilles de Glarges was portrayed by Michiel Jansz van Mierevelt in 1637 (Haarlem, Frans Halsmuseum, inv. I-258).

86. A representative of the States-General at Calais, he was born in Delft or The Hague on 12 July 1599 and buried in Haarlem on 16 April 1683. In 1633 he married Sara Paret in The Hague (The Hague 1611-1681 Haarlem). Cornelis's *album amicorum* has been preserved in the Koninklijke Bibliotheek, The Hague; see Bol 1969, pp. 16-7, fig. 12. It includes drawings by Floris van Dyck, Jacob Matham and David Bailly, and contributions by Descartes, Constantijn and Christiaen Huygens, Gerard Vossius, Caspar Barlaeus and Samuel Ampzing.

87. Born *c.*1615-1669 Haarlem; he was a councillor from 1663 and alderman in 1664-5 and 1668-9. He married Cornelia Pietersdr Verbeeck, the daughter of burgomaster Pieter Verbeeck.

88. *Officers of the St. George Civic Guard, 1639-42*; see note 134.

89. Signed and dated 1644, canvas, 93 × 75 cm (Ekkart 1979, p. 98, no. 54). Adriana Croes (Haarlem 1599-1656 Haarlem) was the daughter of Vincent Croes and Catharina Moens.

90. Signed and dated 1652, panel, 97 × 75 cm, Amsterdam, Rijksmuseum, inv. C 1414 (Ekkart 1979, p. 115, no. 86).

91. Maria van Strijp (Haarlem 1627-1707 Haarlem) married Eduard Wallis in 1647. Catharina van Strijp (1621-?) married Johannes Wallis (Haarlem 1617-1665 Haarlem) in 1641. Hester van Strijp (Haarlem 1625-1662 Haarlem) married Jacobus Wallis (Haarlem 1619-1675 Haarlem). Their will was drawn up by notary H. van Gellinckhuysen (GAH, NA 330, fol. 87).

92. GAH, NA 135, 17 May 1639, fol. 162.

93. For Josephus Coymans see note 135. Nicolaes van Damme was a merchant, and did business with Hendrick van Strijp (GAH, NA 156, 11 December 1631, fol. 149).

94. Property Tax Register 1650, B fol. 13r-v, south side of Zijlstraat heading from Nobelstraat towards Oude Gracht: first house, Willem Croes (25 guilders and 10 stuivers); second house, Paulus van Beresteyn (21 guilders and 7 stuivers); third and fourth houses, Josephus Coymans (79 guilders). For the portrait commissions, see above, p. 27 and below, p. 37.

95. Their portraits are both signed and dated 1649, canvas, 114 × 85 cm, Belgium, private collection (Ekkart 1979, p. 108, nos. 73-4). Jan van Teylingen (Haarlem *c.*1600/10-1657 Haarlem), son of Augustijn Jacobsz van Teylingen and Maria Cornelisdr, married Elisabeth Crucius (Haarlem *c.*1610/20-1692 Haarlem) in 1647. Her brother, Switbertus, was an extremely substantial landowner, as was Jan van Teylingen's father.

96. Adriaen van Adrichem van Dorp (Haarlem *c.*1600/7-1666 Haarlem), the son of Pieter van Adrichem van Dorp and Anna van Egmond van Berckenrode, member of the Roman Catholic Holy Christmas Guild, married Catharina de Kies van Wissen (Haarlem 1617-1689 Haarlem), daughter of Adriaen de Kies van Wissen and Josina van Teylingen, in 1657. *Adriaen van Adrichem van Dorp*, signed and dated 1654, panel, 78 × 63 cm; *Catharina de Kies van Wissen* signed and dated 1654, panel, 78 × 63 cm,

Netherlands, private collection (Ekkart 1979, pp. 119-20, nos. 24-5). The wills of Adriaen de Kies van Wissen and his wife Josina have survived (between 1619-63; GAH, genealogical notes on the Kies family).

97. Ekkart 1979, p. 123, no. C2. Frans Barendsz Cousebant (Haarlem c.1580-1667 Haarlem), son of Barend Wiggersz Cousebant and Magdalena Adriaensdr de Kies van Wissen, married Wijve Cornelisdr van Ryck (d. 1619) in 1613, and Adriana Gerritsdr Hulft (d. 1689) in 1623.

98. Sliggers 1984, p. 109. Zorgvliet, Buitenzorg, Spaarnelust and Buitenrust were built on land owned by Cousebant (ibid., pp. 125-8).

99. Signed and dated 1658, panel, 85 × 71 cm, Haarlem, Frans Halsmuseum, on loan from the Haarlem Broodkantoor (Ekkart 1979, p. 121, no. 98). Augustinus Alsthenius Bloemert (Haarlem 1585-1659 Haarlem), the son of Thomas Bloemert and Christina van Geest, was an assistant priest at Haarlem in 1622, a canon in 1631, parish priest for the Beguines in 1644, and for the city of Haarlem in 1645. He founded the Broodkantoor (dispensary of bread to poor Catholics) on Lange Veerstraat. Verspronck received 60 guilders for the portrait.

100. See Dirkse 1978.

101. Sterck 1932, p. 161.

102. *Nicolaes Stenius*, canvas, 100 × 75.5 cm, dated 1650, Utrecht, Rijksmuseum Het Catharijneconvent (S179).

103. Jodocus Catz, who was priest of St. Bernardus in de Hoek (1581-1641; see Dirkse 1978, pp. 112-4). Only the print after the painting survives (Hollstein, vol. 28, no. 22), and is now in the Haarlem City Archives.

104. In 1653 she painted a portrait of her brother-in-law, Father Augustinus de Wolff; Utrecht, Rijksmuseum Het Catharijneconvent.

105. *Father Johannes de Groot of St. Bernardus in de Hoek*, dated 1692, Utrecht, Rijksmuseum Het Catharijneconvent; *Pieter van der Wiele*, Roman Catholic priest in Haarlem (d. 1666), Osnabruck, Kulturhistorisches Museum; *Josephus de Kies van Wissen*, signed and dated 1672, Brussels, Musées Royaux des Beaux-Arts.

106. Signed and dated 1631, panel, 58 × 43 cm, Utrecht, Rijksmuseum Het Catharijneconvent, Dirkse 1978, p. 116, fig. 5.

107. Signed and dated 1631, panel, 84 × 71 cm, Utrecht, Rijksmuseum Het Catharijneconvent, Dirkse 1978, p. 112, fig. 2.

108. Such as *Maarten van de Velde of Zoeterwoude*, signed and dated 1639, panel, 77 × 58 cm, Utrecht, Rijksmuseum Het Catharijneconvent (Dirkse 1978, p. 121, fig. 18); *Adriaen Uyttenhage van Ruyven of Delft*, signed and dated 1638, panel, dimensions unknown, Delft, Hofje van Klaeuw (Dirkse 1978, p. 123, fig. 11).

109. Pieter de Grebber's name appears no fewer than twenty times among the witnesses in the Beguine Church Marriage Register in the period 1629-47 (Dirkse 1978, p. 123).

110. Schrevelius 1648, fol. 382. The painting has been lost.

111. Panel, 41.6 × 31.4 cm, Urbana, Illinois, Kramert Art Museum.

112. Signed and dated 1663, Luxembourg, Musée Pescatore; Slive 1970-4, vol. 1, p. 200, fig. 212.

113. See above, p. 28 and note 15.

114. 1657, last recorded in the Lestoque Collection, Denver, Colorado, in 1945. Dammas Cornelisz Guldewagen (Haarlem 1626-1685 Haarlem) was a Haarlem councillor and the city secretary.

115. Signed and dated 1649, canvas, 113 × 95 cm, dealer Douwes, Antiekbeurs Delft (1985).

116. Property Tax Register 1628, G fol. 1r-v, assessed at 49 guilders, 4 stuivers and 8 penningen.

117. Loreyn (c.1591-1660) was a sergeant in 1636-9. He married Geertruyt Jansdr van Clarenbeeck (1589-1660) on 3 February 1619. The couple drew up their will on 5 October 1621 (GAH, NA 92, fol. 192), in which he gave his occupation as silk merchant ('sydelaecken coper').

118. GAH, Tr. 76-73 (1662), fol. 37. Cornelis van Hoorn, instructed by Johan van Bemmel and Maria Anna Machgtelt van Heemskerck van Beeckensteyn, wife of Bemmel and only daughter of Johan van Heemskerck van Beeckensteyn, sells a house in Jansstraat to Cornelis Guldewagen. According to the Property Tax Register of 1650, it was the second house from the Grote Markt on the west side of Jansstraat (assessed at 42 guilders and 16 stuivers). Cornelis van Hoorn was Guldewagen's brother-in-law.

119. He was the son of Claes Steffensz Soutman and Joosje Arentsdr Calantius. His parental grandparents were Steffen Claesz Soutman (alderman from 1574-6) and Alit Pietersdr Deyman (whose brother-in-law, Arent Pietersz Deyman, was an alderman in 1579-80 and 1589). His maternal grandparents were Dr. Arent Calantius and Josina Dircksdr de Vries, the daughter of burgomaster Dirck Jacobsz de Vries (1553-4, 1556-7 and 1558). Dirck Steffensz Soutman, the half-brother of Claes Steffensz Soutman, held numerous public positions, including that of burgomaster (1612-3 and 1616). He was dismissed by Prince Maurits after the transfer of power in 1618. Claes Steffensz Soutman was the owner of the 'In de Werelt' brewery, which he sold, together with the 'Twee Starren' on 18 September 1619, his estate being insolvent (GAH, NA, 85, 8 February 1614).

120. GAH, Kies family genealogical documents.

121. He presumably left for Antwerp in 1615/6. Cornelis de Bie refers to him as a pupil and confrère of P.P. Rubens, many of whose works he reproduced in print. The Antwerp guild records refer to a person called Soutman, pupil, in 1619. In 1620 he was granted burghership of Antwerp.

122. In 1628 Soutman is mentioned by Samuel Ampzing (1628, fol. 172). His name also appears in the Resolutions of the States-General of 25 October 1628: 'at his own request, Pieter Soutman, painter of the King of Poland, residing at Haarlem, has been granted free passage and the right to take three portraits with him to enemy countries, freely and without hindrance' ('op 't versoeck van Pieter Soutman schilder van de Coninck van Polen wonende tot Haarlem is

hem geconsenteert paspoort en dat hij vry en vranck met hem mede sal moogen dragen drie contrefeitsels nae vijande landen'); The Hague, RKD, Bredius cards. King Sigismund III visited Holland in 1624. Soutman painted portraits of him, one of which is in Schleissheim and one in Stockholm; see Gerson 1942, p. 501.

123. GAH, Aldermen's Marriage Register, 21 April 1630: Pieter Soutman, bachelor, and Gudula Fransdr Chevals, spinster, both of Haarlem. They were also Roman Catholics. In later documents she is repeatedly referred to as Gudula Fransdr van de Sande. She was the daughter of Franchoys Adamsz van de Sande and Gooltgen Gerritsdr.

124. According to a notarised document (GAH, NA, notary Jacob Schoudt, 10 March 1651), the house was occupied by Pieter Soutman *cum suis*. In 1660 it was sold on the instructions of the heirs (GAH, Tr. 76-72 [1660], fol. 103).

125. The funeral notice has been preserved: '21 August 1657, a [grave] opening in the Great Church for Pieter Clasen Soutman, engraver: transept no. 302, 4 guilders; to the church for the bier, 3 guilders; two hours' bell-ringing, 24 guilders; to the deacons for the bier, 6 guilders; for late arrival, 8 guilders; for the collection 2 guilders; [total] 47 guilders' ('21 augustus 1657 een openinck in de Grote Kerck voor Mr Pieter Clasen Soutman Snyder: trans no 302 f4; voor de Roef aende kerck f3; 2 uur beluyt f24; de diakenen voor de Roeff f6; voor te laet comen f8; voor de schael f2; f47'). GAH, Burial Register, south transept no. 302, states that Soutman lived on Bakenesser Gracht.

126. See Biesboer 1983, pp. 45-8, Snoep 1969, and Brenninkmeijer-de Rooij 1982.

127. Resolutions of the States-General, 13 February 1630.

128. Treasurer's Accounts, Haarlem, 1640: 'To Pieter Soutman, painter, for presenting eight series of ten prints of the House of Nassau to be engraved by him: 100 guilders in all' ('Aen Pieter Soutman, schilder, toegevoegd wegens het vereren van achtmael tien prenten van 't huys van Nassau by hem doen snyden 100 £ eens'). The payment had been approved earlier, in the Burgomasters' Minute Book of 18 February 1640.

129. Nassau Domains, ordinance 735, 25 July 1640: 'To the painter, Soutmans, 150 Carolus guilders in remuneration for a book of eight or ten portraits in folio of Counts of Nassau and Princes of Orange' ('aenden schilder Soutmans 150 car gulden als een vereringe voor een boek van 8 of 10 contrefeytsels in folio van Graven van Nassau en Prinsen van Orangien'); The Hague, RKD, Bredius cards.

130. Burgomasters' Minute Book, 26 May 1646, fol. 92; Burgomaster's Resolutions, 11 October 1651: 'Pieter Soutman presents a book of portraits of all the Counts of Holland, drawn by him, and engraved, with inscriptions by Petrus Scriverius. The presentation to be gratefully declined by the secretary' ('Mr Pieter Soutman doende presentatie om seecker boeck met alle de afbeeldinge van alle de graven van Hollandt by hem geteeckent ende doen snyden ende het geschrifte by Petrus Scriverius gemaeckt, te vereren. Is daervan door den secre-

taris doen bedancken ende de presentatie excuseren').

131. See note 103.

132. Canvas, 167 × 241 cm Paris, Musée du Louvre, inv. RF 426. In 1885 the painting was sold by the governors of the Hofje van Beresteyn, together with Hals's two portraits of Paulus van Beresteyn and his wife, Catharina Both van der Eem (see above, p. 27).

133. Panel, 146 × 105.2 cm, Waddesdon Manor, Buckinghamshire, National Trust. Emerentia was born around 1623 and buried on 13 December 1679 (GAH, DTB, north transept no. 112). On 1 February 1663 she married Egbertus Rentinck, before the council of aldermen, and subsequently in a Catholic ceremony. Her husband was an advocate in Haarlem, who in 1684 became one of the first three governors of the Hofje van Beresteyn.

134. *Officers of the St. Hadrian Civic Guard, 1639-42*, canvas, 203 × 344.5 cm, Haarlem, Frans Halsmuseum, inv. I-313 (Riegl 1931, p. 271, fig. 82); and the *Officers of the St. George Civic Guard, 1639-42*, canvas, 182.5 × 394.5 cm, inv. I-314 (Riegl 1931, p. 271, fig. 83).

135. Josephus Coymans, born in Hamburg on 1 August 1591, buried in Haarlem on 6 November 1677, squire of Bruchem and Nieuwael. His father, Balthasar Coymans (1555-1634), lived in Antwerp until 1585 and then moved to Hamburg. He established himself in Amsterdam in 1592, where he and his sons Balthasar and Joan founded the celebrated Coymans trading company. In 1631 he was taxed on a capital of 400,000 guilders. Dorothea Berck was the daughter of Johannes Berck and Erkenraadt van Brederode. Her father was squire of Alblasserdam, burgomaster of Dordrecht, and the authorised representative of England, Denmark and Venice. The couple married in Dordrecht on 22 November 1616.

136. Elias 1903-5, vol. 2, pp. 761-2.

137. Their daughter, Erkenraadt, was baptised at St. Bavo's in Haarlem on 12 April 1620.

138. Kurz 1964.

139. Property Tax Register 1650, B fol. 13v. The third and fourth houses on the south side of Zijlstraat, going towards Smalle Gracht from Nobelstraat, belonged to Josephus Coymans (together assessed at 79 guilders). The Coymans family had been living in Zijlstraat as far back as 1640; it was the address given upon the marriage of their daughter, Erkenraadt (GAH, DTB, Marriage Register). The Zijlstraat house was sold after Josephus's death in 1677, together with a house, two houses and a room, and another house, all behind the Nobelpoort, and a coach-house in the Grote Krocht (the present-day Nieuwe Groenmarkt), for a total of 36,000 Carolus guilders (GAH Tr. 76-82 [1677],

fol. 149).

140. Balthasar appears as an ensign in Pieter Soutman's *Officers of the St. Hadrian Civic Guard, 1639-42* (see note 134); he is the figure on the far right. He subsequently became a lieutenant in the same guard (1651-4, 1657-60), and a captain in the St. George Guard (1669-72). He was a councillor from 1672 and an alderman in 1675-6.

141. On 5 July 1639 (marriage contract: GAH, NA 135 [1639], fol. 195).

142. Aernout Druyvesteyn, born in Haarlem in 1577, was a councillor, alderman and burgomaster. He was the master brewer at the 'Gecroonde Ancker' and the 'Kandelaar' on Bakenesser Gracht (Property Tax Register 1628, H fols. 1, 2). He was a lieutenant in the St. Hadrian civic guard in 1612-5, and colonel of the St. George guard in 1624-7.

143. GAH, DTB, married on 11 September 1644.

144. GAH, NA 138 (1644), fol. 221.

145. GAH. Tr. 76-66 (1649), fol. 159v.

146. Paulus Verschuur, born 1606, buried on 18 December 1667 (GAR, Verschueren Paulus, burgomaster, widower, residing at Oppert). He merged the family business with the textile manufactory of his father-in-law, Gerard van Berckel; Gudlaugsson 1954. A member of the Rotterdam council from 1642; burgomaster of Rotterdam in 1649-50, 1653-4, 1660-1 and 1667; churchwarden in 1646-8; council deputy to the States of Holland in 1646, 1648-9, 1651, 1653, 1657-9, 1663, 1667; commissioner of the exchange bank in 1651-2, 1655-6; boonlord in 1652; member of the college of peacemakers in 1657; commissioner for water rights in 1656; surveyor of manufactories in 1658-9, 1662-5; and commissioner of the East India Company in 1651.

147. GAR Conveyance Registers, XXIII (1633), fols. 635², 637; XXIV (1633), fol. 332.

148. Joost Verschueren Sr. came from Antwerp. His name appears in the Conveyance Registers (GAR XX [1625], fols. 152, 209, 234, 382, 583; XXI [1628], fols. 246, 4272, 599², 641².

149. GAH, NA 135, 23 December 1638, fol. 93: 'Pieter Jacobsz Wynants, merchant, and Margariete Verschuyre, a bequest of 100 Flemish pounds to the poor of the Olyblock community. Hendrick Jacobsz Wynants, Jan Bosschaert, Pieter Noortdyck and Paulus Verschuyre, brother, brothers-in-law and cousin respectively, are appointed executors' ('Pieter Jacobs Wynants coopman en Margariete Verschuyre legaat van 100 pond Vlaams aan de armen van de gemeente de Olyblock. Tot executeurs worden benoemd Hendrick Jacobs Wynants, Jan Bosschaert, Pieter Noortdyck, Paulus Verschuyre resp broeder, swagers en cousyn').

150. Jan de Bray's earliest known signed and dated portrait (1652) is in the National Gallery,

London, inv. 1423.

151. *Regents of the Armekinderhuis Orphanage*, 1663, inv. I-32; *Regentesses of the Armekinderhuis Orphanage*, 1664, inv. I-33; *Regents of the Lepers' Hospital*, 1667, inv. I-34; *Regentesses of the Lepers' Hospital*, 1667, inv. I-35: all at the Frans Halsmuseum, Haarlem.

152. See note 16.

153. For Margaretha Schellinger, who died in the same year as her husband, see note 16.

154. Oosdorp was a councillor from 1650, an alderman in 1650 and 1660-1, representative at the States-General 1656-8, and a burgomaster in 1665-6.

155. GAH, Tr. 76-72 (1661), fol. 380, for 32,000 Carolus guilders.

156. The plague took a total of 2,061 lives in Haarlem in the months of April and May alone. De Bray's youngest brother Jacob died in April, and his two sisters, Juliana and Margaretha, were buried in the Beguine Catholic cemetery in the same month. His brother Dirck was buried on 27 April, his father, Salomon de Bray, died on 14 May, and his brother Joseph two days later.

157. Thomas Wickenburg (S.L17), Jacob Revius (S.L16).

158. Albert Tegularius, son of Adrianus Tegularius of Amsterdam and Grietie Alberts, is recorded in the GAH Baptismal Register on 8 March 1643. The name Tegularius also appears in a conveyance: 'Anneke Tegularius, widow of Anthony Vercruyssen, hereby sells a house on the corner of Smedestraat and Crauwelsteeg, to Joost Uyttendaelen, merchant in Amsterdam, for 1,500 Carolus guilders' ('Anneke Tegularius, weduwe van Anthony Vercruyssen vercoopt een huis in de Smedestraat op de hoek van de Crauwilsteeg aen Joost Uyttendaelen, coopman tot Amsterdam voor 1500 car. gulden'); GAH, Tr. 76-69 (1667), fol. 176. Anneke was probably Adrianus's sister.

159. Burgomaster's Resolutions, 28 May 1676. The house was purchased for Jan de Bray for 1,200 Carolus guilders; Biesboer 1983, p. 60.

160. Signed and dated 1672, Brussels, Museum voor Schone Kunsten, see Sterck 1932, p. 161.

161. Van der Wiele died in 1666. His portrait is in the museum at Osnabruck.

162. *Suffer the Little Children to Come unto Me* (portrait of Pieter Braems and his family, with Christ blessing the children), canvas, 136 × 175.5 cm, Haarlem, Frans Halsmuseum, inv. I-36 (originally signed and dated 1663, later overpainted with background figures). Received from St. Jacob's Hospital in 1862. The sitters were identified by the family coats of arms on the authentic seventeenth-century frame; see Dólleman 1961.

163. Wishnevsky 1967. For the various *portraits historiés* see von Moltke 1938-9.

BIANCA M. DU MORTIER

Costume in Frans Hals

WOMEN'S FASHIONS

Women's dress in the first decades of the seventeenth century still had many of the features of sixteenth-century fashions. Fynes Moryson, an Englishman travelling in the Netherlands in 1592-3, made the following observation.

> Women, aswell [sic] married as unmarried, cover their heads with a coyfe of fine holland linnen cloth, and they weare gowns commonly of some slight stuffe, and for the most part of black colour, with little or no lace or guards, and their necke ruffes are little – or short – but of very fine linnen.[1]

This is well illustrated by the *Portrait of a Woman* (cat. 3), which was probably painted around 1610. It can be dated to the first fifteen years of the century on two counts. First, the kind of lace used for the cuffs and the undercap is very probably geometrical bobbin lace in imitation of Flemish cutwork, and is typical of the late sixteenth and early seventeenth century. Second, and most important, is the geometrical decoration cut into the fabric of the bodice.[2] The slashing of fabrics was very fashionable in the sixteenth century, and it had still not completely disappeared by 1615,[3] when embroidered and woven patterns came into vogue, usually combined with braids and trimmings.

In the first two decades of the seventeenth century, a woman would be dressed in a bodice and skirt beneath a long, sleeveless garment known as a *vlieger*. This ensemble, usually referred to as a *vlieger* costume, became fashionable in the last quarter of the sixteenth century, replacing the *tabbaard*, a long gown from which it evolved.[4] It was a style that reflected the continuing Spanish influence, which had prevailed in the Netherlands during the greater part of the sixteenth century.

Around 1570 the bodice was separated from the skirt and became very long and pointed in front. It was worn over a long, stiff whalebone corset, which prevented it from wrinkling while at the same time camouflaging the female form, as etiquette demanded. As Spanish fashion never allowed women to wear décolleté, the bodice therefore fitted around the neck and closed in front with a large number of small buttons, preferably of gold, silver or precious stones.[5]

The bodice could be worn with either matching or contrasting sleeves. Both had eyelets for lacing them together with a tagged band or ribbon, allowing the wearer to make numerous combinations of fabrics and colours. The semi-open join between bodice and sleeve would be covered with a padded coil or *bragoen*.[6] At the end of the sixteenth century, these coils took on an exaggerated form, eventually reaching the size of small wheels.

The skirt, generally of silk, cloth or serge, was amply pleated and worn over a drum-shaped petticoat.[7] Skirts were almost always decorated with a variety of braids and trimmings. A skirt of this kind was long known as a *bouwen*.[8] It was probably worn only in the seventeenth century, for the contemporary lexicographer W. Sewel, stated in 1691 that it was 'out of use now'.[9] However, there is some doubt as to whether the *bouwen* really was just a skirt,[10] for both Plantijn and Kilianus define it as a long garment similar to a *samaer*. Moreover, some archive documents mention it as having sleeves. So was a *bouwen* a combination of a skirt and bodice, or was it perhaps an altogether different, *vlieger*-like garment?[11] The latter might very well be the case.[12] In the 1619 inventory of Breda Castle, made on the death of Eleonore de Bourbon, widow of Prince Philips Willem of Orange Nassau, we find 'A cloth of gold *bouwen*, colour orange and white, value 150 guilders'.[13] This was a very large sum indeed in the first half of the seventeenth century, when a master carpenter or bricklayer would not earn more than about 250 guilders a year.[14] Could a mere skirt have been so expensive? Probably not.

The solution may perhaps be found by studying the overgarments painted in this period. A comparison of the portraits of *Catharina van der Eem* (cat. 7) and *Aletta Hanemans* (cat. 19) with those of two unidentified women (cat. 3 and S11) reveals a striking difference between the overgarments. The first two have sleeves, and might be a *bouwen*, while the latter two are sleeveless, which is characteristic of the *vlieger*.[15]

The *vlieger* was a long, open, sleeveless garment with padded coils around the armholes, and was worn over the bodice and skirt. It was generally made of a plain black fabric – velvet, satin or camlet (a textile containing camel-hair) – or of a material like silk damask embroidered or woven with a black pattern. It was always worn open, with the two front panels attached to the bodice by thin metal pins. The padded coils around the armholes were either trimmed with black velvet braid or embellished with a combination of braid and shining black jet, as in the *Portrait of a Woman* (S11). By the time this portrait was painted the *vlieger* was in wide-

spread use, having come into fashion around 1580,[16] and although rather costly,[17] it became extremely popular.

No ensemble was complete without a ruff, cuffs and a little cap. The people of the province of Holland seem to have been very particular about their linen, as Fynes Moryson relates:

> For aswell [sic] men as women for their bodies and for uses of the Family, use very fine linnen, and I think that no clownes in the World weare such fine shirts, as they in *Holland* doe.[18]

The citizens of Haarlem were fortunate in this respect, for they had a ready supply of this very fine linen, almost like silk to the touch. For over a century the city had been famous for its textile industry, which became even more important after the Spanish siege of Antwerp in 1576 and the resultant migration of many weavers from the Southern Netherlands to the cities in the north. At the beginning of the seventeenth century Haarlem owed much of its wealth and fame to the production of and trade in the various linen fabrics,[19] which were renowned at home and abroad for their whiteness and fine texture.[20]

The best quality linen to come off the Haarlem looms was cambric, which was used in ruffs, caps and cuffs.

Fig. 1 Jacob van Ruisdael, *View of Haarlem with Bleaching Grounds*, detail. The Hague, Mauritshuis (inv. 155)

These could be ordered from a linen seamstress, who sewed the items and also did the needlework.[21] Often, too, she had a variety of lace or cutwork frills with which to embellish the linen.

The lady in the *Portrait of a Woman* (cat. 3) is wearing geometrical lace cuffs with scalloped edges and a lace inner cap. In the early seventeenth century, women were still wearing caps that had come into fashion in the third quarter of the sixteenth century. They consisted of a plain outer cap of very fine, almost transparent cambric over an inner cap of lace or embroidery.[22] A thin metal wire sewn into the border of the former gave it its oval shape, while the inner cap was worn with an *oorijzer*, or cap brooch, of gold or silver. The 'wings' on either side of the face could be wide or narrow, according to taste.[23]

The ruff in this portrait is thick but small, particularly in comparison with the one worn by the woman in the *Married Couple in a Garden* of *c.*1622 (cat. 12). Ruffs steadily grew in size in the first quarter of the seventeenth century, eventually reaching the enormous proportions of the cartwheel (also known as millstone) ruff. It was of the greatest importance to keep the ruff evenly pleated and spotlessly white. The latter would not have been too difficult in Haarlem, which was surrounded by bleacheries (fig. 1).[24]

Not everyone was altogether happy about this fashion for large ruffs, which consumed an enormous amount of starch. The war with Spain was far from over, yet instead of using the expensive wheatmeal for baking bread it was turned into starch, considered 'essential' for the thousands of ruffs and cuffs that were worn daily.[25]

However well these huge cartwheel ruffs were starched, they still had to be held up by a *portefraes* or supportasse (fig. 2), which was

> ... a certain device made of wyres crested for ye purpose, whipped over either with gold thred, silver or silk. ... This is to be applyed round about their necks under the ruffe, upon the out side [sic] of the band, to beare up the whole frame and body of the ruffe, from falling or hanging down.[26]

The woman's only pieces of jewellery are two rings, one with and one without a cut gemstone.[27] The latter is probably set with a square, cut diamond which, according to Jacob Cats, was the symbol of the bond of marriage, patience, and the power of the man, and thus the best possible gift for a bride.[28] During the wedding ceremony, the bride and groom would hold each other's right hand and exchange rings.[29] This was usually a plain hoop,[30] symbolising the indissoluble bond between the two partners, and therefore deserving of a special position on the hand.[31] The careful attention which Frans Hals has given to the woman's hand in the centre of this

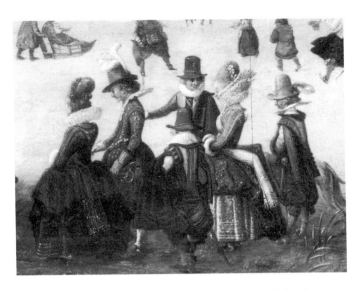

Fig. 2 Adam van Breen, *Winter Recreation*, 1611 (detail showing a supportasse)
Amsterdam, Rijksmuseum (inv. A 2510)

double portrait suggests that it was painted after her marriage.

Another striking feature of her attire is the cap, which is actually just an undercap.[32] It is partly embroidered with a floral pattern in black silk,[33] and is laced with a broad pink ribbon. The back is neatly gathered and pleated, and the edges are trimmed with a small frill of Flemish bobbin lace.

Despite the cap and the lace cuffs, the woman's dark, plain costume may convey the impression that she is dressed fairly modestly. However, her *vlieger* is most probably made of velvet, the skirt of heavy silk is decorated with silk or velvet trimmings, while the bodice is a shiny satin. In the early 1590s, Fynes Moryson had noticed that

> ... the Hollanders of old accounted the most rude of the other Provinces, at this day increased in wealth, and reputation of the States, doe by little and little admit luxury.[34]

In contrast, the portraits of *Aletta Hanemans* (cat. 19) and *Catharina van der Eem* (cat. 7), both painted in the 1620s, suggest that the rich enjoyed flaunting their wealth (fig. 3). Such conspicuous displays of luxury were frowned on by the ecclesiastical authorities, for they were in grave contravention of the Calvinist doctrine of frugality and simplicity.[35] These two portraits demonstrate that even prominent Haarlem families fell prey to this desire to parade their wealth. Aletta Hanemans's *vlieger* is trimmed with braids, and the padded coils around the armholes are decorated with little clus-

ters of jets. The cuffs are still bordered with geometrical bobbin lace. Her cap, however, has a very fashionable border of a free-flowing tape lace with a new and more fluent pattern. Catharina van der Eem is very richly clad in a *vlieger* of gleaming silk damask with a large floral pattern. The Flemish bobbin lace used for her ruff, cuffs and cap, however, is a little old-fashioned.

In some ways, the temptation to show off one's finery was harder to resist in Haarlem, given the fact that many of these choice fabrics were actually woven in the city. Its looms produced cloth, mock velvet, caffa, silk and half-silk fabrics, fustian, bombazine, camlet, ribbon and braid.[36] The ribbons and braids were used to enliven the plain fabrics of the *vlieger* and the skirt.

Both Aletta Hanemans and Catharina van der Eem are portrayed with rings on the forefinger of the right hand, indicating that they are married. They may also be wearing their bridal *borst*, or stomacher, both of which are heavily embroidered with intricate floral patterns. From around 1615 onwards, the silk or satin of the stomacher was embroidered with multicoloured silk, gold, silver and pearls. This kind of stomacher was known as a *borst*, and may have originated in the Southern Netherlands. In contemporary sources it is frequently mentioned in relation to courtship and marriage, when it would probably have been specially decorated to suit the occasion.

Aletta Hanemans's stomacher has a delicate all-over design of thin symmetrical coiling stems with tulip and

Fig. 3 '*Doch eenderley cieraed en past u niet al 't samen*
maer yeder moet hier in haar eyghen voordeel ramen
En met haer spieghel gaen voor alle dingh te raet
Om sien wat dat haer wel, en wat haer qualijck staet ...'
('Yet the selfsame jewel will not suit you all,
So each must have an eye to her own benefit
Consulting her mirror on matters great or small
To discover what flatters, and what does not befit ...')

P. Serwouters after D. Vinckboons, engraving (Hollstein 55)
Amsterdam, Rijksmuseum, Bibliotheek

Fig. 4 Fol. 61 of the *Pattern Book for Designs for Embroidery*, detail New York, Metropolitan Museum of Art, Elisha Whittelsey Collection (inv. 55.583.1)

Fig. 5 Nicoló d'Aristotile detto Zoppino, *Esemplario di lavori i dove le tenere fanciulle & altre donne nobile potranno facilmente impara il modo & ordine di lavorare, cusire, raccamare*, Vinegia 1530 (Lotz 65) Amsterdam, Rijksmuseum, Bibliotheek

violet-like flowers. The garment has obviously been boned at the bottom to make it protrude. The effect is enhanced by the large foliate tabs, which are embroidered and bordered with pearls. Catharina van der Eem's stomacher has a somewhat coarser all-over design of thick symmetrical coiling stems with large flowers. The protruding end of her stomacher is scalloped with long tongues embroidered with alternating designs of coiling stems with flowers. Both stomachers are embroidered in one piece.

This kind of complicated embroidery would have been done by a professional, male embroiderer, who would have had various patterns to choose from,[37] possibly derived from a pattern book such as the one at the Print Room of the Metropolitan Museum in New York, which was probably executed *c*.1615-35 by a Netherlandish artist. On fol. 61 is a design for the scalloped cuff of a glove with a pattern resembling that on the long tongues of Catharina van der Eem's stomacher (fig. 4).[38] Such pattern books were available to embroiderers as early as 1530 (fig. 5). They contained many designs with symbolic connotations, often relating to love and marriage.[39] Such symbols appear to have been used in the bridal stomachers, of which, unfortunately, not one has survived. They are, however, the dominant elements in the decoration of most of the extant gloves from the period.

Aletta Hanemans holds a pair of white kid gloves with embroidered, scalloped cuffs. As this painting is very probably her marriage portrait it seems likely that these are the wedding gloves she received from her husband.[40]

In the seventeenth century, the two lovers would invite family and friends to a ceremony for the signing of the marriage contract in the presence of a notary.[41] The wedding pledges were then exchanged – ring, medal, gloves, handkerchief, knife, needle and scissors – after which the betrothal could be announced. The jewels and other presents from the bridegroom, such as lace cuffs, a fan perhaps, the embroidered wedding gloves and stomacher, would be displayed in the bride's house in a basket decorated with flowers and ribbons.[42] In return the bride gave the groom a basket with lace ruffs, cuffs, a linen shirt, a nightcap and mules.[43] These baskets were ceremoniously removed to the couple's house on the wedding day.

The bride probably wore her wedding gloves to church, and only took them off shortly before the solemnisation of the marriage, when the couple gave each other their right hands – the *dextrarum iunctio*.[44] By now the gloves had lost their original legal significance, and had instead become a status symbol.[45] The glove was considered to be important in its protective capacity and thus became a symbol of Touch. The value which people attached to these gloves is attested by the

large number that have survived to the present day, as well as by the many portraits in which the woman holds a pair of gloves with heavily embroidered cuffs (fig. 6).[46]

The gradual introduction of French fashion accompanied the steady influx of migrants from the Southern Netherlands, beginning in the third quarter of the sixteenth century, when Fynes Moryson recorded that the young were clad 'to the apparrell [sic] and manners of the ... French'.[47] However, it took another quarter of a century before this 'new' fashion was generally accepted. It received a major impetus when Frederik Hendrik succeeded as stadtholder in 1625 and set up court in The Hague. His mother, Louise de Coligny, was French, and as a result he spent considerable time at the court of Henri IV, even serving as a page there until recalled to the Netherlands in 1599 for affairs of state. It is not surprising, then, that he was greatly influenced by French taste and fashions.

The development manifested itself at the end of the first quarter of the seventeenth century, when the silhouette of the costume lost its long, rigid lines, becoming rounder and softer. The changes are immediately apparent if one compares the portraits of *Catharina van*

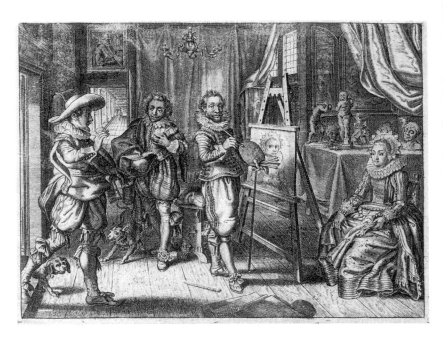

Fig. 6 '*Ten staet geen echte vrou, geen jonge dochter vry,*
In vreemde hant te zyn, oock niet in schildery.'
('It cannot be condoned in a wife or a maiden
To fall into strange hands, not even in painting.')

Anonymous after A. van de Venne, engraving from Jacob Cats, *Houwelick*, Middelburgh 1625, 'Bruyt', p. 24
Amsterdam, Rijksmuseum, Bibliotheek

der Eem (cat. 7) and *Catherina Brugman* (s94; see Biesboer, fig. 11). Although some women were still wearing the *vlieger*-like garment, this long, open overdress had by now acquired a broad shoulder-line with full, bulky sleeves, which are sometimes cut open to show the lining or the linen of the shirt. The stomacher, which has lost its low waistline and no longer protrudes, is now worn fairly short and ends in a small pointed peplum. The low, square-cut neckline was usually covered with a cambric neckerchief, often lace-edged, which was combined with either a ruff or a flat lace collar.

The head-dress, too, had changed. In the second half of the 1620s it had lost one of its layers and was worn further back from the forehead, revealing more of the hair. It was still secured to the head with a cap brooch. This style went very well with the formal, elongated Spanish look, but it proved unsuitable for the new fashion. The result was that the cap had almost completely disappeared by the mid-1630s, leaving only a lace frill around the simple coiffure. The hair was brushed away from the face and made up into a chignon which was covered by the tiny cap.[48]

This was a transitional period, with both the old and the new fashions existing side by side. 'Go she dressed in the Spanish manner, then to the Spanish give praise, but if her taste be French, why 'tis the French you admire', was the advice given to a prospective suitor in 1626.[49]

The embroidery on Catherina Brugman's stomacher and the facing on the skirt of the *vlieger* are survivals of the earlier tradition, although the embroiderer no longer used multicoloured silks but black on a black fabric. Flowers and birds are cunningly combined within the intricate pattern. On either side of the row of small buttons are carnations, symbolising love and marriage, and a bird with a pointed beak.[50]

There is a remarkable difference between the young Catherina Brugman, who wears the richest possible, free-flowing Flemish bobbin lace, and the demure Feyntje van Steenkiste (cat. 47), both of whom were painted at roughly the same time. The argument that the young are more fashion-conscious does not apply here, notwithstanding the fact that Catherina is almost ten years Feyntje's junior. The key to the latter's costume is her Mennonite persuasion. Her dress is fairly modest and rather old-fashioned, relieved only by the narrow, embroidered facing along the front panels of the *vlieger*.[51] This tendency to frugality is also reflected in the recently discovered inventory of her belongings made on her death in 1640.[52] No silk, satin or velvet, but cloth and *borat*.[53] She owned three *vlieger*s under which she could wear one of her six stomachers in combination with any of six skirts. The most expensive

items in her wardrobe were two cloaks valued at 45 guilders each. One was a *heuyck* or *huik*, which was worn outdoors to protect the head-dress and clothes from dirt and rain.[54] It came in two varieties (fig. 7), the one on the right being worn chiefly in the Northern Netherlands, while that on the left originated in Brabant and Flanders at the end of the sixteenth century, becoming fashionable in Holland in the first quarter of the next century. Unfortunately no particulars are given of Feyntje's linen caps, merely that six of them were starched. She allowed herself some luxury in her handkerchiefs, of which eight were edged with *speldewerck* or bobbin lace, and nine were made of silk. Her ruffs, however, contained no lace and were edged with wool. In the portrait she is holding a pair of plain white gloves, possibly one of the two pairs valued at 1 guilder each in her estate.

All in all, her wardrobe hardly appears to have been luxurious, either in the fabrics used or in the number of each item of apparel. Nevertheless, its total value of 475 guilders and 16 stuivers could hardly be considered paltry in comparison to the current annual wage of a master carpenter or bricklayer, which was now around 300 guilders.

On 9 October 1638 an inventory was made of the belongings of the wealthy Haarlem brewer, Job Claesz Gijblant, who had been married to Teuntje Jansdr Huydecoper. Although no values are given, theirs must have been a substantial household. Teuntje wore brocade, velvet and costly linen, and had two fur-lined *vliegers*.[55] These were ideal for winter wear, and feature in many winter landscapes of the period (fig. 8).[56] They were also favoured by older women, who clung to a tradition that originated with the fur-lined *tabbaard* of the sixteenth century, which had been the preferred dress of wealthy, elderly men and women, and gradually became a symbol of their rank and state. In 1631 Hals painted the 53-year-old Cornelia Claesdr Vooght (cat. 42), who wears a *vlieger* lined with fur. Her sister Maritge Claesdr Vooght is similarly clad in her portrait of 1639, painted when she was 62 (fig. 18e; S129). Both women are dressed in an old-fashioned manner with the large ruff, the *vlieger* with the wheel-like padded coils, the stomacher with the long boned end, and the double cambric cap. Their attire, however, is far from plain, for both seem to be clad in silk decorated with velvet braids, in stomachers that close with a long row of small golden or gilt buttons, while their finely pleated cambric cuffs are edged with bobbin lace. As ever, the older the wearer the more old-fashioned the clothes.[57]

Around 1640 the female outline filled out even further, its most distinctive feature being the sloping shoulder-line, which was accentuated by low armholes and large

MERCATORES SEU CIVES

Fig. 7 Claes Jansz Visscher, *Mercatores seu Cives* (detail from the illustrated border of *Comitatus Hollandia*, a map of the province of Holland and the North Sea), 1652 (1st edn. 1633), etching (F. Muller 1118 Am)
Amsterdam, Rijksmuseum, Prentenkabinet

Fig. 8 S. Frisius after D. Vinckboons, *Hyems* (detail of a couple skating), etching (Hollstein 233)
Amsterdam, Rijksmuseum, Rijksprentenkabinet

Fig. 9 Wenceslaus Hollar, *Fashion Accessories*, engraving, 1647
Amsterdam, Rijksmuseum, Rijksprentenkabinet

falling bands. The *vlieger*, now completely obsolete, gave way to a gown with wide sleeves, a low neckline and an open overskirt. Linen and lace were the keynotes of this new look, with the kerchief and cuffs as the main accessories.

The large square kerchief of unstarched thin cambric or fine linen, usually trimmed with lace, was worn in various ways. It could be folded diagonally, the two edges not quite meeting, and draped over the shoulders with acorn-shaped linen tassels hanging from the points, as in the *Portrait of a Standing Woman* (cat. 58). Alternatively, it could be folded to a point and held with a clasp at the front, encasing the shoulders and standing up around the neck (Jowell, fig. 2; s185). Women still wore the *neerstick*, or neckerchief, beneath the kerchief, both of which were fastened at the front with a linen cord tied in a bow. These bows, which originally had a specific function, were now purely ornamental, consisting of ribbons woven from gold and silver thread or multicoloured silk.[58]

The linen chemise revealed by the low neckline was back in vogue. Long and roomy, it was gathered at the neck and worn with a small, standing collar.

With the disappearance of the ruff, women were able to wear their hair loose, allowing the tresses to fall to

their shoulders. This coiffure was completed with the *tipmuts*, a cap which came to a point on the forehead. Pendant earrings, fashionable since the 1630s, became an indispensable accessory now that they were no longer hidden by the ruff.

Another popular item was the fan, which had been widely used in the Netherlands since the beginning of the seventeenth century, even on the ice. The commonest type was a feather fan set in a mount of metal or wood, often ebony, which had been introduced in the second quarter of the sixteenth century.[59] Another type which appeared at the same time was the folding fan, which reached Italy from China, and was introduced into the Netherlands with the spread of French fashion throughout Europe. In Hals's day it was still a fairly costly status symbol, which possibly explains why some of Haarlem's great ladies make such a point of displaying it in their portraits.[60] Both the *Standing Woman* (cat. 58) and the *Seated Woman holding a Fan* (s174) have pendants, and it is fair to assume that these were marriage portraits. Perhaps the fan had some marital symbolism.[61] Unfortunately, nothing is known about seventeenth-century 'fan etiquette', assuming there was such a thing, so it is impossible to draw any firm conclusions about the significance of fans in companion

51

portraits of this kind.[62] Broadly speaking, though, both the feather and folding fans were status symbols, which is how they are presented in Wenceslaus Hollar's engraving of 1647 (fig. 9), together with other expensive accessories like fur muffs, gloves, and neckerchiefs trimmed with wide lace borders.

The portrait of *Isabella Coymans* (cat. 69) radiates an aura of luxury and opulence. The front of her skirt is decorated with two broad frills of silver bobbin lace. Around her neck and wrists she has wide borders of free-flowing Flemish bobbin lace. This painting was formerly dated *c*.1650, but the type of lace allows us to place it a few years earlier, around 1644. That was the year of Isabella's marriage, and it is very likely that she wished to be seen in the latest fashion for the occasion.[63] Interestingly enough, she is the only woman in Hals's commissioned portraits to pose in a décolletage, modest though it is. All his other female subjects, with the exception of the *Gipsy Girl* (pl. v; s62), clung to the high-fastening neck long after the décolleté had been imported from France in the 1630s. It never caught on in Haarlem, possibly due to the fulminations of Protestant ministers of every persuasion. In July 1640, at the Synod of Gouda, the Hague classis asked:

> How – in view of the fashion at large in the land for divers baubles and worldly vanities, ... dishonourable dress, offensive baring of the body – should one treat such members who nevertheless embraced the aforesaid frivolities?

The answer was uncompromising: 'Such members are to be treated according to church ordinance, even unto suspension from Holy Communion.'[64] It was not just the bared bosom that attracted outrage. Unbound hair was considered equally reprehensible. Marcus Zuërius Boxhorn (1612-53), a professor at Leiden since 1633, decried what he saw as the general decline in his countrymen's morals:

> One sees a similar change in dress, with new fashions and imperfect styles ... making every maiden ashamed to place her head beneath her grandmother's cap.[65]

Isabella Coymans's hair, however, has a 'simple' dressing of pearls and a short, thin veil of tulle. The preachers' desperate attempts to stem the tide of fashion have here clearly fallen on deaf ears.

In the middle of the seventeenth century the armholes descended even further, and the décolletage became wider and deeper. The hair was curled and worn loose or framed around the face. Slowly but surely the fashion for hair powder and white face powder spread, and the French influence took permanent hold.

MEN'S FASHIONS

Men's dress, like women's, followed the strict and sober Spanish style in the first decades of the seventeenth century (fig. 10). In the words of Fynes Morrison:

> In the United Provinces, ... the Men use modest attire of grave colours, and little beautified with lace or other ornament. They weare short cloakes of English cloth, with one small lace to cover the seames, and a narrow facing of silke or velvet. Their doublets are made close to the body, their breeches large and fastened under the knees commonly of woollen cloth, or else of some light stuffe, or of silke or velvet.[66]

This is well illustrated by the *Man holding a Skull* (cat. 2). His doublet is fastened high around the neck and closed with a long row of small buttons down the front. It has a straight waistline and a slightly protruding peplum cut in one with the doublet. Unlike women, who wore a padded coil around the armholes, men generally favoured a flat shoulder-cap to conceal the join of detachable sleeves or to adorn doublets with set-in sleeves. The doublet itself is heavily padded to keep it in perfect shape and prevent creasing, and might even be stiffened with thin wire.

This unknown man is also wearing full breeches gathered below the knee, and long knitted stockings. Around his neck he has a starched cambric ruff, and at his wrists pleated cuffs or *ponjetten*. Over the doublet men often wore a girdle or belt, generally of expensive, decorated leather, embroidered fabric or ribbon, fastened at the front with a hook or a buckle, sometimes of precious metal. If the man had a sword it would be slung from hangers attached to the belt with hooks.[67]

This portrait, like its female counterpart, can be dated by the slashing, which is here restricted to the sleeves. Slashing, which had been so popular in the sixteenth century, made way for fabrics with a woven or embroidered pattern around 1615.[68] A good example of this is the sleeve embroidered with gold thread in the *Portrait of a Man* of 1622 (cat. 13). The pattern is abstract, highly symmetrical, and typical of the more formal embroidery of the early 1620s.

The man has a short, waisted jacket with a thigh-length peplum cut in one. The jacket is of a plain material, its sole decoration being rows of small golden buttons down the front, along the split in the side seam and on the trailing sleeves. The latter, which are attached to the armholes beneath the small, tabbed shoulder-caps, are the most striking feature of the garment. They are characteristic of the *rockgen* or *rocxken*, which originated in the sixteenth century and was worn over the doublet. Because the sleeves of the *rockgen* were too tight to fit over another garment, they were only part-

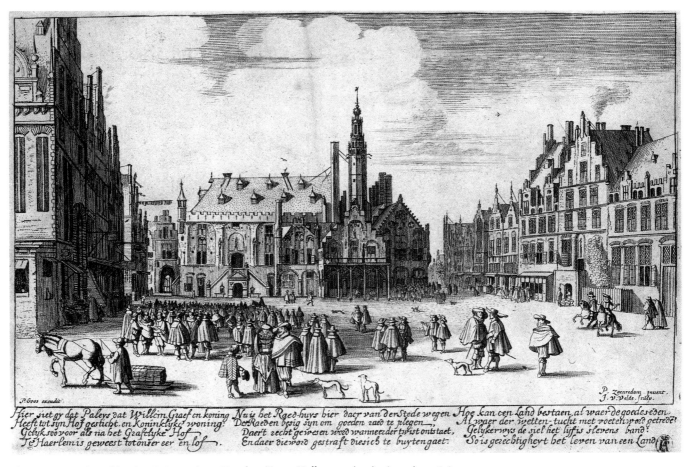

Fig. 10 Jan van de Velde after P. Saenredam, *Haarlem Town Hall*, engraving in Ampzing 1628

sewn into the armhole, allowing them to hang. Trailing sleeves became an important decorative feature of men's costume, and were all the rage in the last quarter of the sixteenth century. The *rockgen*, which was longer than the doublet and had no true sleeves, could be described as a sort of over-doublet. Fabrics of every kind and quality were used for the doublet and *rockgen*, including velvet, silk, satin, cloth and camlet, either plain or worked, and decorated with embroidery, ribbons and braid. Around the neck of his high-fastening *rockgen* the man is wearing a lightly starched, carelessly pleated ruff, also known as a *fraise à la confusion*. On the wrists, as fashion dictated, are matching *ponjetten*.

On his head he has a large hat with a wide brim tilted at an angle over his forehead.[69] Men wore two types of hat in the first quarter of the seventeenth century: the first made of a supple felt with a medium crown, and the second with a stiff, high, cylindrical crown and quite a narrow brim, as seen in Hals's *Portrait of a Man* of

1618/20 (s10). This taller variety was probably stiffened with pasteboard or a similar material. The crowns of both types were decorated with hatbands of various materials, such as silk ribbon or thin leather, and were often elaborately decorated with multicoloured and silver or gold embroidery, jewels, jet, feathers and rosettes. This custom, too, dated from the sixteenth century, and was still being widely followed throughout the first half of the seventeenth century. In 1618, for instance, Prince Philips Willem of Orange bequeathed his hatband to his wife Eleanore de Bourbon.[70] Hats became an indispensable accessory in the wardrobe of every man of fashion.

The man in the *Married Couple in a Garden* (cat. 12) is wearing a hat with a low crown and a wide brim. He is fashionably dressed in a plain black, close-fitting doublet with long, tight sleeves and small shoulder-caps around the armholes. His wide black breeches end in puffs above the knee, and are trimmed down the sides with black buttons. A black cape is draped over his left

Fig. 11 Gerrit Bleker and W.C. Duyster, *The Stag Hunt*, 1627, detail Haarlem, Frans Halsmuseum

shoulder and around his waist. His legs are clad in close-fitting black stockings which are fastened below the knee with broad garters and large, flat bows. Completing his ensemble are low, black shoes, again with large black bows. Around his neck is a falling collar of Flemish bobbin lace, and at his wrists remarkably large cambric cuffs which are turned back on the sleeve and have no lace trimming. On his right hand he is wearing a plain glove of a light-coloured material, possibly chamois. The shoulder-caps and sleeves of his doublet are decorated with black braid and buttons.

Hals painted few full-length portraits, so this is an ideal opportunity to take a closer look at men's hose and shoes. The combination of a close-fitting doublet and loose breeches was widespread in the first quarter of the seventeenth century.[71] The breeches were generously cut and sewn in flat pleats at the waistband, allowing them to fall in wide folds around the legs.[72] They were at their widest just above the knee, where they were fastened with knee-bands. They often had a row of buttons down the side seam.[73]

Below his breeches the man has a pair of long, tight, glossy black stockings, which are held up by broad, shiny black garters with a large rosette at the side. Unfortunately, it is impossible to say what material was used for the stockings, or whether they are knitted or woven. However, given the sitter's evident social position and wealth, we can assume that they are probably of knitted silk.[74]

Garters, which were generally made of the same material as the stockings in the sixteenth century, were essential features of men's dress. In the course of the seventeenth century they evolved into one of the main decorative accessories in the wardrobe of rich, fashion-conscious men.

Let a proud peacock go where many thorny bushes grow,
And lo, straightway the bramble, the foolish man entangles
By the garter as it trails, with lace so lavishly entailed.[75]

The bow or rosette was known as a *roos*, and is generally mentioned separately in contemporary sources.[76] Garters were made of silk, satin or coloured ribbon, and were trimmed with gold or silver lace according to taste. Although silk tape was certainly woven in Haarlem, it is not known whether the city produced this specific 'garter tape'.[77]

Willem van Heythuysen (cat. 17), the only person whom Hals depicted full-length and life-size, is also displaying garters trimmed with gold bobbin lace. Perhaps these are the 'pair of silk garters with bobbin lace' which were valued at 30 stuivers in his death inventory of 1650.[78] He too is elegantly clad in a close-fitting doublet with a hip-length peplum coming to a point in the front. The embroidery of the black fabric, which is very probably done in black silk, enables the portrait to be dated c.1625 or a few years later.[79] Around the waist seam, which is pointed in front and is masked by an embroidered sash or belt,[80] are a mass of *nestels* ending in metal tags.[81] In the fifteenth and sixteenth centuries these *nestels* were used to fasten the breeches to the doublet, but in the course of the seventeenth century they degenerated into pure decoration. With this doublet van Heythuysen is wearing a loose, bouffant pair of knee-breeches, and it is tempting to think that this might be the 'black, embroidered satin suit' valued at 6 guilders in the 1650 inventory.[82] Over his right arm and shoulder he has a black cloak cut rather like a cape, possibly the 'black cloth cloak lined with plush' which

was valued at 80 guilders.[83] It is strange that a man who dressed so splendidly should have such narrow strips of lace on his lightly starched ruff and his very broad cambric cuffs.[84] On his head he has a large hat, which may be the beaver one cited in his inventory.[85] The sword on which he is leaning is of a type that was introduced from Germany around 1620.[86] Van Heythuysen clearly dressed in the height of fashion, and was prepared to spend a great deal of money on his wardrobe, which was valued at 464 guilders on his death.[87]

One striking difference between the costumes of Willem van Heythuysen and *Jacob Pietersz Olycan* (cat. 18), who had his portrait painted around the same time, is that the former is wearing a fitted doublet with pointed waistline and peplum, while Olycan has a later variant of the *rockgen*. The flat shoulder-caps and the trailing sleeves continue in use in the second quarter of the seventeenth century, but now an extra buttoned seam was added down the middle of each front panel.[88] This could be left closed, or opened to give the wearer more freedom of movement.[89]

Another type of doublet, which made its appearance in the second quarter of the century, is worn by the ensign on the extreme left of the *Meagre Company* (cat. 43), which Frans Hals began in 1633. It evolved from the doublet with the pointed waistline and peplum, but the sleeves, instead of being close-fitting, are now puffed around the upper arm and tight along the forearm.

As noted above, Stadtholder Frederik Hendrik's arrival in The Hague in 1625 gave the Dutch a taste for French fashion. In France, a sumptuary edict of the same year prohibited embroidered or braided garments, with the result that the French court adopted plain fabrics decorated with slashing, a technique which had been temporarily out of fashion.[90] The speed with which it caught on in the Netherlands is illustrated by the following tailor's bill of 1631:

18 May, for Pieter [Cam], a suit of cloth in the French manner, open throughout on the arm to the back; many buttons at the nether extremities of the breeches; for the same: 5 guilders, 5 stuivers [fig. 11].[91]

The ensign in *The Meagre Company* is wearing a doublet of silver-coloured satin trimmed with a cord of gold thread and faced with long rows of small golden buttons. The slashing on the chest and upper arm reveals the white linen shirt beneath.[92] The light blue *nestels* at the waist and at the bottom of the breeches end in golden tags.

The sumptuousness of French dress at this time is typified by the *canons* – linen over-stockings with flounces edged with lace (the ensign's have a wide band of Flemish bobbin lace). *Canons* were originally intended to protect woollen or silk stockings from coming into contact with the boot-leather, but as time passed they became decorative rather than functional. Although they were usually made of white linen, inventories also mention coloured varieties.[93] Those worn in *The Meagre Company* are purely decorative. To some extent the same applies to the wide sashes trimmed with strips of costly gold or silver lace, although in the case of the civic guards this was a standard item of dress.

The central figure, with his back to the viewer (largely the work of Pieter Codde) is wearing a leather jerkin or *kolder*.[94] This garment, which usually resembles a stylish, sleeveless doublet, had been worn as a sort of cuirass by soldiers, horsemen and sailors from the sixteenth century onwards. Being a protective garment, it was made from a strong fabric or leather, generally buffalo-hide.[95] The alum used in the tanning process gave the jerkin a pungent smell which was not appreciated by ladies, as we learn from the following warning to suitors:

To an unaccustomed nose, the smell of buffalo-hide Is heavy and disagreeable. Yet, in but just a little while She shall notice it no longer, And by keeping company, forget her first disfavour.[96]

Leather garments and accessories were often perfumed in order to avoid giving offence.[97]

The jerkin in *The Meagre Company* is accompanied by a *rabat* or collar trimmed with Flemish bobbin lace.[98] Although most of the men in the painting are still wearing starched or unstarched ruffs, these were abandoned by the younger generation in the 1630s.

With the disappearance of the ruff, long hair came into fashion, and the custom of wearing it shoulder-length sparked off a heated argument between various Protestant congregations which became known as the 'Dispute of the Locks'. It began in 1640, when several church councils in the large cities, Haarlem among them, spoke out against 'men's untended hair'. In 1643, the popular Dordrecht preacher, Jacobus Borstius, delivered a 'sermon on long hair, with reference to I *Corinthians* XI:14'. Crowds turned up to listen, and such was Borstius's oratory that many men subsequently took scissors to their locks. Johan van Beverwijk, a physician, wrote a treatise on hair in which he set out to discover 'whether hair is animate and truly nourished'. In 1643, Godefridus Udemans, a preacher at Zierikzee, published a book in which he came to the conclusion that:

Fig. 12 Barent Avercamp, *Enjoying the Ice* (detail of men playing bandy). Amsterdam, Rijksmuseum (inv. A 3286)

Hair is given to us by God to warm and cover the brainpan, [and] to make a distinction between male and female. ... For men to wear their hair long, as women do, is as monstrous and unnatural as if they were to have the teeth of a lion, for both are the brand of the Antichristian locusts, Revelation 11:8.[99]

Finally, Marcus Zuërius Boxhorn, who took the opposing view, wrote a treatise in 1644 'to demonstrate that the latter [previous generations] wore their hair long and that in this respect the long-haired men of his day are neither degenerate in nature nor have they departed from the morals of their forefathers'.[100]

The argument eventually reached such a pitch that in 1645 the various parties and the church councils agreed to put an end to 'all disputes about hair'. Unperturbed by the controversy, Tieleman Roosterman (S93; see Biesboer, fig. 10), Willem Coymans (cat. 61) and Jaspar Schade (cat. 62) all had themselves portrayed with long hair in the 1630s and 1640s.

Jaspar Schade was famous both for his fashion sense

and the amount of money he spent on clothes (see cat. 62). Here he follows the latest mode by wearing his short doublet with the lower buttons undone, as does Stephanus Geraerdts (cat. 68). The latter's shirt appears to have a special *jabot* in the middle, which can be glimpsed between the front panels at the bottom.[101] Around 1640 the doublet became smaller and lost its wide peplum. Shoulder-caps were now completely out of fashion, and there was less slashing in the sleeves, which regained their old form. Smart young blades wore them with an open inside seam.[102] The ensemble is completed with quite a small, plain cambric collar fastened with tassels.

The man and the boy in the *Family Group in a Landscape* (cat. 67) are wearing a new style of breeches designed to go with the short doublet. From 1630, breeches which tied below the knee gradually narrowed as the doublet was cut closer to the body, for otherwise they would have been unable to fit beneath the peplum.[103] The French then developed the so-called 'petticoat breeches', which had cylindrical legs cut horizontally at the bottom. These two developments led to the disappearance of bouffant knee-breeches in the 1640s, and this in turn gave the *canons* a new lease of life as transitional garments between cylindrical breeches and boot (fig. 12). As can be seen in this picture, children's clothing in the seventeenth century was a miniature version of adult dress.[104] Both father and son are wearing the same type of doublet, breeches, hat and collar.

The accession of Louis XIV gave a new impetus to French fashion, and it was not long before some of the minor refinements in men's dress found their way to the Netherlands.

At the waist, between the doublet (which became even shorter) and the straight breeches there was an apron-like skirt made of loops of ribbon, or *galants*, which was known as a *tablier de galants*. One such *tablier* is worn by the unknown man whom Frans Hals probably painted around 1650 (cat. 70). He also has flounces above the narrow, gathered cuff of his puffed shirt-sleeve. This, too, was a French import. Shirts of this kind required an extravagant amount of material. As a character in a farce of 1668 says: 'Look, there are twenty-seven ells for six shirts. ... That is four-and-a-half ells for each shirt, with one ell for the sleeves. Then they have the full width, the way they are usually cut.'[105]

The majority of Hals's male sitters in Haarlem were fairly restrained in their choice of dress, apart from a few rich young men who parade the latest fashions. From contemporary inventories we also know that both young and old wore expensive fabrics of the very finest quality, however modest they may appear to our eyes.

Notes

1. Jacobsen Jensen 1918, pp. 263-4.
2. I am grateful to Mrs. P. Griffiths-Wardle for her help in identifying the various kinds of lace in the portraits discussed in this article. For a full survey of the development of lace in the period see Levey 1983, pp. 11-3, 16-8.
3. The fashion for slashing fabrics with larger or smaller incisions originated at the end of the fifteenth century, possibly after the famous Battle of Granson (1476), when the Swiss defeated the powerful armies of Charles the Bold and supposedly cut the clothing of their defeated adversaries. After the mercenaries returned home, the craze began spreading throughout Europe; see *Van Nyeuvont, Loosheit end Practike: hoe sy Vrou Lortse verheffen*, lines 325-38, dated 1497-1501, in de Jonge 1919, pp. 12-4. Although at first considered extravagant and ugly, the fashion was generally accepted by the middle of the sixteenth century, and was still being followed in the Netherlands well over fifty years later. See also Baart 1986, p. 73.
4. See der Kinderen-Besier 1933, pp. 235-8.
5. The inventory of the jewellery and clothing belonging to Maria van Voorst van Doorwerth, which was made on her death in 1610, records: 'eighteen gold buttons, each mounted with a diamond, and nine with a pearl. Twenty gold buttons, each with four pearls' ('... achtien goude cnoppen, te weten elcx met een taefel van dyamant, ende negen elcx met een paerel. Twintich goude cnoppen elcx met vier paerlen'); see van der Klooster 1981, p. 59.
6. *Bragoen* is a corruption of the Spanish word *brahon*, which literally means a piece of cloth. *Bragoenen* were decorated with a special kind of ribbon made in Leiden; see Posthumus 1910-4, vol. 3, pp. 710-4, no. 362.
7. This drum-shaped petticoat, which originated in France, came into fashion at the end of the sixteenth century, gradually replacing the Spanish bell-shaped petticoat, or farthingale. The latter was very common in the Netherlands, where it was known as a *fortigael* or *fardegalyn*, a corruption of the Spanish word *verdugo*, literally meaning green, flexible twig. These twigs, generally willow, or sometimes even cane rods, were used to make hoops, which were sewn into a linen underskirt. Contemporaries thought it made women look as if they were walking in a cage; see Pietersz 1610, p. 56b. Although fashionable women preferred the new drum shape, the farthingale did not disappear completely in the seventeenth century; see ten Brink 1885-90, vol. 1, p. 432, line 431.
8. The Dutch dictionary limits the use of this word to a specific kind of skirt worn exclusively in the seventeenth century. See *WNT*, vol. 3, part 1, col. 769.
9. Sewel 1691.
10. The two common names for a skirt, be it a petticoat or an overskirt, were *ro(c)k*, and *keurs* or *cours*. Plantijn 1573: '*Koers*, or *keurs*, woman's underskirt' ('Koers, oft keurs, vrouwen onderroc'); Sewel 1691: '*Keurs*, a Petticoat'. In Maria van Voorst van Doorwerth's inventory of 1610, however, a distinction is made between a skirt (*cours*) and an underskirt (*ondercours*);

see van der Klooster 1981, p. 61. Maria owned five *coursen*, two of velvet, two of satin and one of kersey.
11. Plantijn 1573 gives *chamarre* or *samaer* as the synonym for *bouwen*. A *samaar* is defined in *WNT*, vol. 14, col. 37, as a long garment worn by women, the cut of which changed frequently over the years. This agrees with the definition in Kilianus 1777. Van der Klooster 1981, pp. 53-4, believes that Maria van Voorst van Doorwerth's inventory of 1610 proves that the *samaer* and the *vlieger* were one and the same garment.
12. This is emphasised by van Bleyswijck 1667, p. 507, who says that the 'best garment, be it cloak, *huik*, *vlieger* or *bouwen*' of all women who died or were buried in Delft had to be given to the town's charitable institution. So here the *bouwen* is not only ranked with three other types of long, wide overgarment, but it is also referred to as a 'best garment', implying that it was costly.
13. Drossaers & Lunsingh Scheurleer 1974, p. 141: 'Eenen goudenlaecken bouwen van oraengie ende wit van couleur, geëstimeert op 150 £.' This *bouwen* is given roughly the same value as five other overgarments, which were appraised at between 100 and 150 guilders each (p. 139). The remaining seventeen, however, were valued between 20 and 90 guilders each (p. 140).
14. I am indebted to Dr. L. Noordegraaf, Professor of Social and Economic History at the University of Amsterdam, who kindly provided me with valuable information on wages in this period. He bases his calculations on a year of 275 working days.
Dr. P. Biesboer, in his researches in the Haarlem City Archives, has discovered that the City Pensionary, a high official, earned 1,600 guilders a year, and had a clothing allowance of 18 guilders. The City Secretary earned 272 guilders in the same year and received a clothing allowance of 27 guilders (Treasurer's Accounts for 1625, fol. 33).
15. *Vlieger* literally means 'flyer'. Both van Thienen 1930, pp. 45-6, and der Kinderen-Besier 1950, p. 195, suggest that the name comes from the flowing movement this kind of open garment would make when worn in the wind. However, there is no substantial evidence in contemporary sources to confirm this romantic theory.
16. The inventory of Anna of Nassau, wife of Count Willem of Nassau, which was drawn up in Delft in 1590, mentions only three *tabbaards* but eight *vliegers*, including 'A red, cloth of gold *vlieger*, ... without sleeves' ('Een roden golden laken vlieger ... sonder mouwen'); see der Kinderen-Besier 1950, pp. 261-2.
17. An inventory of 20 March 1611 for the Amsterdam Civic Orphanage lists two *vliegers* valued at 90 and 21 guilders respectively; der Kinderen-Besier 1950, p. 53, n. 17.
18. Jacobsen Jensen 1918, p. 264.
19. Ampzing 1628, p. 341. After 1577, the linen industry became Haarlem's second largest source of income after beer brewing; see Briels 1978.
20. The town was ideally situated close to the

coastal dunes at Zandvoort, where numerous bleacheries profited from the ready availability of the essential raw materials for the bleaching process. The dunes, with their natural grass vegetation, made ideal bleach-fields, as well as having an abundant supply of clean water. Dairy products like buttermilk and whey came from the local polders, soap, starch and blue from the region around the nearby River Zaan, and peat from the northern province of Friesland. Only the potash had to be imported from abroad. See Regtdoorzee Greup-Roldanus 1936, pp. 12-5, and Posthumus 1943, vol. 1, p. 458, table 208, for the price of potash from Danzig.
21. See Wardle 1983.
22. See du Mortier 1986, p. 44, figs. 70-2.
23. A contemporary source, however, advised wearers to take the shape of their face into account, recommending a wider cap for those with long, narrow faces, and the opposite for those with chubbier features; see van Heemskerck 1626, p. 104.
An *oorijzer* (literally 'ear iron') is a gold or silver head ornament which evolved from a plain silver ring which was fastened around the head to keep the hair in place. Little is known about its origins. The earliest description is in le Francq van Berkhey 1773, pp. 801-2: 'This head-dress ... is made all the more costly by a device that belongs with it, to wit a gold headpiece, which, running around the back of the head, ends at the temples and then curves back to the ears, where it protrudes in a twisted, double hook, from which they hang large beads, or often a small pearl as an ear ornament' ('Dit Kapsel ... is daar en boven zeer kostbaar door den toestel, die 'er by behoort. Te weeten, een Gouden Hoofdstel, dat, met eene bogt over 't Agterhoofd loopende, ter wederzyde aan de slaapen van 't Hoofd sluit, en verder tot aan de Ooren vervolgende, van weerskanten met een geboogen dubbelen Haak uitsteekt; waar aan ze dan Bellen, of veelal een Paerltje tot Oorsieraden hebben hangen'). The word *oorijzer* is used on ibid., p. 984. This cap brooch first appeared in the northern province of Friesland, but it was also worn in Groningen, Ost-Friesland in Germany, and in Zeeland and North and South Holland. In the latter two provinces it fell into disuse around the middle of the seventeenth century, but elsewhere it still remains an essential feature of local costume. See further Winkler 1871, pp. 139, 167.
24. Linen items were first soaked in clean water before being washed with soap in a large cauldron, into which boiling water was poured. The laundry was then checked by the washerwomen, and any remaining dirty spots treated on a washboard. After being hung for a while to remove excess water it was boiled in a kettle with lye. It was then spread out on the grass, regularly wetted with water, and left to bleach. After a rinse in clean water it was checked a final time. Ruffs, cuffs and caps could be starched in any colour to suit the latest fashion, although in Haarlem a touch of blue was generally given to anything made of cambric. The laundry was then wrung, sorted, folded and delivered to the customer; see Regtdoorzee Greup-Roldanus

1936, pp. 97-101. We know from a satirical poem by Constantijn Huygens, written on an official visit to London in 1621, that the English favoured a saffron yellow hue for their linen, whereas the Dutch preferred it with a blue blush; see Huygens 1622, lines 206-8, 343.

25. In an attempt to curb consumption, the States (provincial assembly) of Holland imposed a tax of one stuiver on each pound of starch, equivalent to roughly one-fifth of its value; see van Reyd 1626, pp. 350-1.

26. Stubbes 1583 (unpaginated); see van der Klooster 1981, pp. 60-1; also Pietersz 1610, p. 56. Unfortunately, only very few *portefraeses* have survived, but see van Thienen 1969.

27. A highly detailed contemporary source on betrothals, weddings and the customs surrounding these events is Cats 1625, which almost ranks as a manual.

28. Ibid., pp. 17-8.

29. Ibid., p. 9.

30. As in Maria van Voorst van Doorwerth's inventory; see van der Klooster 1981, p. 60, also Gans 1961, pp. 79-123, figs. 118-25.

31. Cats 1625, pp. 9-10.

32. Perhaps she felt it was too beautiful to be concealed by a thin layer of cambric.

33. The fashion for 'blackwork', as embroidery with black silk was called, originated at the beginning of the sixteenth century and remained fashionable well into the seventeenth. See Schipper-van Lottum 1980, pp. 23-8, figs. 17, 23a-i.

34. Jacobsen Jensen 1918, p. 263. Just three years later, Everhard van Reyd remarked that, for his taste, the Hollanders were dressed too 'richly in black'. In an attempt to curtail this excessive use of expensive fabrics the States of Holland imposed a tax on silk and satin which would raise around 200,000 guilders a year; see van Reyd 1626, p. 275.

35. A sermon delivered in Amsterdam in 1614 blamed this new fashion-consciousness on the Brabanders, who immigrated from the Southern Netherlands; see Rogge 1865.

36. Ampzing 1628, p. 341, proudly mentions that the black cloth woven in his city was much sought after by the Italians and Spaniards. For a short history of the textile industry in Haarlem, see Allan 1888, vol. 4, pp. 553-74. The prices of fabrics in Posthumus 1943, vol. 1, tables 138-62, pp. 317-49.

The Haarlem trader Pieter van den Broecke, whose portrait Hals painted around 1633 (cat. 44), took fabrics made in the city on his voyages to West Africa and Arabia, where he traded them profitably; see Ratelband 1950, pp. XCII, XCV. In September 1614 he had an audience with the governor of Aden, whom he presented with: '2 Haarlemmer smallen..., which present apparently pleased him...' ('welck present hem oogenschijnnelijck scheen aengenaeam te sijn'); see Coolhaas 1962, pp. 30-1. 'Haarlemmer smallen' was the name of a silk fabric woven on a narrow loom; see Allan 1888, vol. 4, pp. 571-4. See van Nierop 1930 for a detailed study of the silk industry in the province of Holland in this period (my thanks to C.A. Burgers for drawing my attention to this article).

37. For studies on the embroiderer's profession see de Bodt 1981, and de Bodt 1987, pp. 11-59.

38. For more designs from the pattern book in New York see Schipper-van Lottum 1980 figs. 36a-b; du Mortier 1984, figs. 4, 8, 13; Wardle 1986, figs. 2, 4, 12, 14, 16-7, 19, 21, 23, 26; and de Bodt 1987, figs. 39, 40-1, and p. 62.

39. For the symbolism of flowers, fruits and plants see Levi d'Ancona 1977, esp. pp. 81, 366.

40. At the beginning of our era, betrothal and marriage constituted a single legal act based on the purchase of the bride. When a split occurred in the procedure at the beginning of the Middle Ages, the betrothal became the settlement of the contract and the transfer of authority over the bride from her father to the bridegroom, and the marriage the fulfilment of the conditions there stipulated. The transfer of authority to the bridegroom was symbolised at the betrothal by the exchange of the tokens of power – staff, sword and glove. This tradition was embodied in Frankish law, while from the eleventh century the handing over of a glove was also accepted in the Netherlands as the legal seal on contracts of various kinds. It is not surprising, then, that the glove continued to play a part in marriage ceremonial in the seventeenth century, particularly at the betrothal. See further du Mortier 1984.

41. The presence of family and friends was considered essential, for 'Love, preparing the way for a good, harmonious marriage, must first be discussed with the parents or other friends, who see further than the two lovers, blinded as they are by Venus and Cupid' ('Liefde, tot een goet vreedsamigh huwelijck den weg bereyt, moet eerst wel overleyt zijn met ouders of andere vrienden, die verder sien dan de twee amoureuskens doen, die door Venus en Cupido verblindt zijn'); see Visscher 1614. 'Friend', in this context, means a relative or next of kin, see van Sterkenburg, p. 253.

42. See Schotel n.d., pp. 239-40.

43. The 1667 inventory of Amalia van Solms, wife of Stadtholder Frederik Hendrik, lists the latter's bridegroom's shirt, which his widow had treasured ever since his death in 1647; see Drossaers & Lunsingh Scheurleer 1974, p. 266, no. 841.

For pictorial evidence see du Mortier 1985, fig. on p. 342. The centre of this specially designed 'marriage tablecloth' in the Bernisches Historisches Museum, Bern, Switzerland, which is embroidered in multicoloured wool, consists of a wedding scene with the bride and groom holding each other's bare right hand while the priest blesses their union. The bride is holding the glove(s) in her left hand.

There was a superstition that it was unlucky if the glove tore while being removed during the ceremony, see Bächtold 1914, p. 136.

45. Smith 1982, p. 74.

46. The Rijksmuseum in Amsterdam possesses the actual pair of gloves (inv. 1978-48) depicted in the so-called marriage portrait of Johanna le Maire painted by Nicolaes Eliasz 'Pickenoy' around 1622. The painting and the gloves had remained together until they were sold from an English collection in 1978. This clearly illustrates how much gloves were cherished and valued by the wearers and their descendants; see du Mortier 1984.

47. Jacobsen Jensen 1918, p. 263. Courts have always played an important part in spreading new fashions. In this case it was the ladies of the court, 'de Meyskens van de Courtosye', who were the first to adapt to the new styles coming from the Southern Netherlands; see van der Laan 1918, p. 76.

48. For this development of the cap see the *Family Portrait in a Landscape* painted by Hals around 1620 (cat. 10).

49. Van Heemskerck 1626, pp. 67: 'Kleed sy haer op zijn Spaensch, de Spaensche dracht wilt prysen;/ Is 't op sijn Fransch, so houd veel vande Fransche wijsen.' A detailed study of the French influence in the Netherlands will be found in Briels 1978.

50. According to Levi d'Ancona 1977, p. 81, a Dutch bride wore a carnation on her wedding day which had to be taken from her by her husband. The complex structure of the embroidered design can be compared to that of the stomacher on fol. 75 of the pattern book in the Metropolitan Museum in New York (see note 38 above). Cf. also the embroidered stomacher in the *Portrait of a Woman*, painted by Hals in 1634 (s96).

51. The style of the embroidery closely resembles that of the pattern for a narrow band on fol. 64 of the New York pattern book (see note 38 above).

52. Haarlem City Archives, not. prot. 153, notary Jacob Schoudt, 28 August 1640, fol. 50.

53. *Borat* was a woven fabric with a warp of silk and a weft of wool. It had long been produced in Leiden and was imported into Haarlem, see Posthumus 1910-4, vol. 3 for the period 1574-1610, and vol. 4 for 1611-50.

54. See Jacobsen Jensen 1918, p. 264: 'All women in generall, when they goe out of the house, put on a hoyke or vaile which covers their heads, and hangs downe upon their backs to their legges; and this vaile in *Holland* is of a light stuffe or Kersie, and hath a kinde of horne rising over the forehead, not much unlike the old pummels of our Womans saddles, and they gather the Vaile with their hands to cover all their faces, but onely the eyes: but the Women of *Flanders* and *Brabant* weare Vailes altogether of some light fine stuffe, and fasten them about the hinder part and sides of their cap, so as they hang loosely, not close to the body, and leave their faces open to view, and these Caps are round, large, and flat to the head, and of Veluet, or at least guarded therewith, and are in forme like our potlids used to cover pots in the Kitchin.'

55. Haarlem City Archives, not. prot. 171, notary Jacob van Bosvelt, fols. 109v, 110v. See also Hals doc. 3.

56. See, for instance, the print by S. Frisius, *Hyems*, Hollstein 233, Amsterdam, Rijksprentenkabinet (our fig. 8).

57. The same argument applies to the dress in the *Portrait of a Seated Woman* (cat. 45), the sitter being 60 years old when Hals painted her in 1633. Her outer and inner cap are beautifully embellished with costly geometrical Flemish bobbin lace.

58. Bows were soon all the rage, and were made not only of fabric but also of precious metals set with jewels. See Drossaers & Lunsingh Scheurleer 1974, p. 295, nos. 9, 21. Cf. also Gans 1961, inventory 18 on pp. 403-4, p. 112, figs. 65-72, and fig. xiv, facing p. 133.

59. Even young girls were depicted with a feather fan. Examples include the *Portrait of Emerentia van Beresteyn* (s.D70), formerly attributed to Hals and now generally accepted as a work by the Haarlem artist P.C. Soutman in the Rothschild Collection at Waddesdon Manor (s.D70), and the *Portrait of a Girl dressed in Blue* of 1641 by J.C. Verspronck, another Haarlemmer (Amsterdam, Rijksmuseum, inv. A 3064. See Armstrong n.d. for a general introduction to the development of the fan in this period.

60. See, for example, the *Portrait of a Woman* of c.1633-5 (s98), and the 1638 *Portrait of Maria Pietersdr Olycan, wife of Andries van Hoorn* (fig. 18c; s118).

61. In art, according to Smith 1982, pp. 84-6, the fan is associated with married women, and can thus be read as a symbol of love and marriage. Smith also attaches importance to the gesture made with the fan, and to the way it is held.

62. Feathers occasionally had an erotic connotation in the seventeenth century, and it is possible that this was transferred to the feather fan; see Smith 1982, pp. 82-4; de Jongh 1971, p. 171, nos. 108-9; de Jongh 1976, pp. 59-61. However, in his *'t Kostelick Mal*, Constantijn Huygens speaks of the fan merely as a ridiculous extravagance and fashionable status symbol, saying that a poor man 'could live for a year on the costly folly of your ribbons and feathers' ('... over 't jaer soud' teeren/ Op 't kostelicke mall van uw Lint en uw' Veeren'), see Huygens 1622, lines 274-5.

63. See Levey 1983, fig. 149.

64. Schotel 1854, p. 11: '... hoe men – alzoo in ons vaderland grootelijks in zwang gaan verscheidene ligtvaardigheden en wereldsche ijdelheden, ... als daar zijn ... oneerbare dragt, ergerlijke ontblooting des ligchaams – met zoodanige lidmaten moest handelen, welke ... de voorgenoemde ligtvaardigheden evenwel aan de hand hielden? ... Men na kerkelijke ordening met zoodanige ledematen moest handelen, ook tot suspensie van 't Heilig Avondmaal.'

65. Schotel 1854, p. 26: 'Een gelijke verandering ziet men in de kleeding, door welker nieuwe snuffen en nooit volmaakte fatsoenen, ... elke jonkvrouw zich schaamt haar hoofd te steken onder haar bestemoêrs hulle.'

66. Jacobsen Jensen 1918, p. 263. Moryson also says (p. 285) that the Dutch 'are generally frugall, in dyett, Apparell and all expences'.

67. These hangers are worn by several of the figures in Hals's *Banquet of the Officers of the St. George Civic Guard* of 1616 (s7).

68. An intermediate form is found in the *Portrait of a Man* (s10), which Frans Hals painted between 1618 and 1620. The man is fashionably dressed in a rich fabric, which is nevertheless slashed.

69. A similar wide-brimmed hat with a low crown, dating from the first half of the seventeenth century, was found in good condition during the excavations in 1979-81 of the Dutch whaling settlement of Smeerenburg on Amsterdam Island, Spitsbergen. The settlement was occupied from 1614 to 1660; see Vons-Comis 1988, p. 99, fig. 94.

70. See van Aitzema 1669, p. 450. Just how important it was to have a good hat is illustrated by the correspondence between Maria van Reigersberch, the wife of Hugo Grotius, and her brother Nicolaes; see Rogge 1902, pp. 292-6. The Grotius family lived in Paris from 1621, and Maria was asked by various friends and relatives to send clothes and accessories in the latest French fashion. On 5 July 1625, when ordering a hat from his sister, Nicolaes described it as 'the jewel of a man's head' ('het sieraet van een mans hooft'; ibid., p. 294). In December that year Maria replied: 'Concerning the hat, ... I will see what I can do. ... Hats are rather expensive here. I have had two made for our brothers, and they will cost at least 25 guilders, without hatband' ('Wat den hoedt belangt, ... zal zien wat ick doen kan. ... De hoeien zijn al wat dier. Ick hebber twee doen maecken voor ons broeders, zullen voor het minste xxv gulden moeten kosten, zonder bandt'; ibid., pp. 122-3).

71. It was a fashion that was condemned by the stricter Protestant sects, as the poem quoted in cat. 46, 47 shows.

72. Knoester *et al.* 1970, p. 174, quote an instance of a pair of breeches taking four ells of material, or roughly 270 cm. See also van Thienen 1930, p. 24, n. 7.

73. The archaeologists working on Amsterdam Island (see note 69 above) excavated a pair of fairly well-preserved breeches. Made of a medium-fine woollen material, they are of the same design as the breeches in this painting. For a photograph and a pattern see Vons-Comis 1988, figs. 103, 101c-d, pp. 101-2. Breeches of this type were quite popular around this time.

74. In the sixteenth century, stockings were cut on the bias and sewn with a vertical seam down the back of the leg in order to give them some elasticity. Garters were insufficient to hold up the leg-length hosen which were worn with the short Spanish trunk-hose, so the two were generally sewn together or fastened with points; see de Jonge 1919, pp. 23-33. This hose cut from fabric remained in use until the beginning of the seventeenth century, but when the trunk-hose went out of fashion it was no longer necessary to manufacture the long hose. At roughly the same time came the rise of the knitting machine, which had been invented by the Englishman William Lee in 1589. This made it possible for more people to wear knee-length, knitted stockings. Until then, only the richest had been able to afford the hand-knitted silk or woollen varieties. Knitted stockings were increasingly worn with the wide breeches, which came into fashion in the first decade of the seventeenth century. The inventory of Admiral Pieter Pietersz Heyn, which was made in 1629, five years after his death, lists 'One pair of old cloth stockings' ('Een paer oude laecken kousen') alongside 'One pair of knitted woollen stockings' ('Een paer wolle gebreyde kousen'); see van Visvliet 1905, p. 194. See also Knoester *et al.*

1970, pp. 171, 173, 186, 193; Moes 1911, pp. 47-8; Vons-Comis 1988, p. 99, fig. 96; Drossaers & Lunsingh Scheurleer 1974, p. 141; Rogge 1902, pp. 76ff.

75. Cats 1726, vol. 1, p. 430: 'Laet een trotse proncker gaen, Daer veel doren-hagen staen ...,/ Siet ter stont sal hem de braem, Vatten in die malle kraem,/ Indien langen kousebant, Die soo byster is gekant.'

76. See Drossaers & Lunsingh Scheurleer 1974, p. 141, and Rogge 1902, p. 291.

77. More details are known about the role of Leiden in this branch of the textile industry; see Posthumus 1910-4, vol. 4, pp. 516-9, 522-5.

78. Haarlem City Archives, not. prot. 153, notary Jacob Schoudt, fol. 330v: '... paer zyde kousebanden met speldewerck... 30 st.' I am grateful to Dr. P. Biesboer for allowing me to examine and use this inventory.

79. Compare it to the embroidery on Catherina Brugman's stomacher (see Biesboer, fig. 11).

80. Van Heythuysen also owned 'two belts, one with silver trimmings, value 3 guilders' ('twee riemen ene met silver beslage...3£'), inventory, note 78.

81. A *nestel* was a band or tape ending in a needle or tag to allow it to be passed through an opening. One of the earliest mentions is in a collection of poems published in the second quarter of the sixteenth century. See also Cats 1726, vol. 2, p. 261; and Moes 1911, p. 41.

82. Inventory (note 78): 'swart satyne pack geborduijrt... 6£.'

83. Ibid.: 'swarte laeckene mantel met felp gevoedert... 80£.' Plush was a costly material imported from Italy, and the wealthy van Heythuysen had several items of clothing which were either made of or lined with plush. Cf. Pers 1657, vol. 2, p. 118, and de Brune 1648, vol. 1, p. 80.

84. Inventory (note 78), fols. 330v, 332r.

85. Ibid., fol. 330v.

86. See Boot 1973, p. 421.

87. Inventory (note 78).

88. A similar doublet, but made of a simple, plain material, is worn by the beater with the horn in the *Stag Hunt in a Landscape* by the Haarlem painter Gerrit Claesz Bleker (Haarlem, Frans Halsmuseum, inv.1-660; our fig. 11). See also Hals's *Portrait of Nicolaes van der Meer* (cat. 41).

89. The same principle was applied to the riding coat, which was introduced around this time. This was a roomy cloak reaching almost to the knees, with extra seams which could be fastened with long rows of small buttons. The panels could be buttoned together in various combinations, transforming the garment into anything from a cape to a coat with sleeves. A good example is the riding coat of ochre yellow mock velvet preserved in the Rijksmuseum, Amsterdam (inv. NM 1097), which was worn by Ernst Casimir, Count of Nassau-Dietz, when he was killed at the siege of Roermond in 1652.

90. At the beginning of Louis XIII's reign (1610-43), it was chiefly the *mignons*, the rather effeminate royal favourites, who decorated their tight-waisted doublets and puffed sleeves with *fenestrations* – the long, vertical incisions on the chest and upper arm which became

known as *chiquetade*. This came into general use after 1625, when de Richelieu prohibited the wearing of braid or embroidery. See Ruppert 1947. This fashion is illustrated in J. Callot's *Portrait of Claude Druet* (1630) and A. Bosse's *Philandre suivant la permission de l'édit* (1633), both in the Cabinet des Estampes, Bibliothèque Nationale, Paris. Cf. also Hals's *Laughing Cavalier* (pl.1; s30).

91. Delft City Archives, Chamber of Orphans, B.984: 'Den 18 mey voor pyeter een pack laecken kleeren op sijn frans, overall open op den erm in de rugh; onderaen de broeck overall voll knopen, daeraen verdyent... 5 gld. 5 st.'

92. Compare this with the horsemen in Bleker's *Stag Hunt* and the ensigns at far left and in the right background of Frans Hals's *Banquet of the Officers of the St. Hadrian Civic Guard* of c.1627 (s45).

93. Amsterdam City Archives, Notarial Deeds, no. 2408, cat. 4 (1652). Oddly enough, it was not until the middle of the century that the word *canon* was applied to this kind of linen stocking with a wide flounce, although a mention is found as early as 1631; see Knoester *et al.* 1970, p.183. On 24 May 1660, Samuel Pepys noted in his diary: 'Up and made myself as fine as I could, with the linning stockings on and wide canons that I bought the other day at Hague'; Pepys 1928, vol.1, p.159.

94. See Plantijn 1573; Mellema 1618 and Baart 1986. Baart refers to the garment excavated in the heart of Amsterdam in 1978 as a 'leather doublet' instead of a jerkin, which it clearly is. See also Haarlem 1988, figs. 29, 62, 68, 148, 182, 184-5, 188, 190, 191-3, 195, 197.

95. 'Buffelschen Kolder, Buf Jerkin'; Hexham 1678: 'A suitor's oath does not last as long as a buf jerkin' ('Een vrijers eed en duurt so langh niet als een buffelse kolder'); see Burghoorn 1641, vol.1, p.52. The Rijksmuseum at Amsterdam has a leather jerkin (inv.NM 1100) which is believed to have been worn by Hendrik Casimir I, Count of Nassau-Dietz (1612-40), and is depicted in his portrait by Wijbrand de Geest, which is also in the museum (inv.A 569).

96. Heemskerck 1626, p.87: 'Een ongewone neus die vind seer swaer en bangh/ De reuck van 't Buffels leer; maer door verloop eer langh/ So salse van die lucht in 't minste niet meer weten,/ En al haer ongemack door d'ommegangk vergeten.'

97. See Drossaers & Lunsingh Scheurleer 1974, p.139.

98. Hexham 1678: 'Rabat, Kraag, The Coller of a Dubble band or shut.' See also Vollenhoven & Schotel 1857, p.120.

99. Schotel 1854, pp.22-3: '... het hair ons door God gegeven is, om de hersenpan te verwarmen en te dekken, om onderscheid te maken tusschen het mannelijk en vrouwelijk geslacht. ... Dat de mannen lange hairen dragen als de vrouwen, is zoo monstreus en onnatuurlijk, alsof zij tanden hadden als leeuwen-tanden; want het een zoo wel als het ander is het brandmerk van de antichristische sprinkhanen, Apoc. IX : 8.'

100. Ibid., p.26: 'Om te bewijzen dat de laatsten lang hair hadden gedragen en dat de lang gehairde mannen van zijn tijd, te dien aanzien noch van aard verbasterd, noch van de zeden hunner voorvaderen afgeweken waren.'

101. See der Kinderen-Besier 1950, p.134.

102. The inside seam of Tieleman Roosterman's sleeve (see Biesboer, fig. 10) has numerous small buttons, allowing it to be opened to display the shirt-sleeve.

103. See *The Meagre Company* (cat. 43).

104. See Durantini 1983, Kloek 1977-8, and Schama 1987, pp.481-561.

105. Grasneb Tengnagel 1668 (unpaginated): 'Sie daer, daer is 27. ellen tot 6. hemden. ... Dat is vierendhalf ellen tot elken hemd, en ien el tot de mouwen. Dan hebbenz'er volle briette, gelyck mense gemienlyk snijt.'

FRANCES S. JOWELL

The Rediscovery of Frans Hals

Works of art grow and change as their spectators change. And the history of works of art is to a large extent the growth in the number and kinds of value which human interest finds in them.[1]

For about two hundred years after his death, Frans Hals's artistic legacy was virtually unclaimed. It was not until the 1860s that his works received the serious critical attention that held them to be masterpieces and elevated their producer to the pantheon of great artists. Until then, Hals's paintings had been largely ignored, their very survival subject to the vagaries of fortune as time and circumstance removed them from the original purposes for which they were made.

Hals was primarily a portraitist whose works were intended to commemorate his patrons, both during and after their lifetimes. While his large-scale civic group portraits remained safely (if obscurely) in municipal buildings, most of Hals's original patrons could not rely on the dynastic loyalty of subsequent generations to cherish or protect their commissioned portraits; nor were they much valued as works of art. As a result, many paintings were relegated to attics or to a listless existence on the art market, usually of uncertain attribution, occasionally altered and, it seems, often lost.

This posthumous neglect of Hals was dramatically reversed within a short period during the second half of the nineteenth century. Enhanced by their recently conferred artistic and historical status, his works became internationally popular, and Hals's name became a byword for genius. His art was now celebrated as a vital source of instruction and emulation, and occupied a prominent point of reference in contemporary art criticism. He was also given a new, pre-eminent role in art-historical accounts of the seventeenth-century Dutch School. As his rediscovered works surfaced on the art market they were avidly sought after by public museums and private collectors, and were traded up and up to meteoric prices. By the mid-1870s there was already a flourishing market in misattributions and forgeries.

This essay outlines the history of Hals's critical fortunes, from his earlier obscurity to his later celebrity, and discusses some of the various factors that converged to promote the critical and historical revival of his works, particularly in relation to aspects of contemporary painting towards the end of the nineteenth century.[2]

HALS'S EARLY REPUTATION

The near-oblivion of Hals outside Holland by the beginning of the nineteenth century can be gauged from a variety of different sources. In the many eulogies of seventeenth-century Dutch and Flemish portraiture in France during the early part of the nineteenth century, Hals's name is conspicuously absent, ousted by those of Van Dyck and Rubens, Rembrandt and van der Helst.[3] One of Hals's finest works, the full-length portrait of *Willem van Heythuysen* (cat. 17), was misattributed to van der Helst as late as 1866.[4]

The art market – an obvious barometer of taste – provides further evidence: scanty information culled from the art sales indicates generally derisory prices for works by, or attributed to, Hals.[5] The indifference of English connoisseurs at the beginning of the nineteenth century is reflected by John Smith's intentional omission of Hals from his monumental *Catalogue Raisonné of the Works of the most eminent Dutch, Flemish and French painters*.[6] Hals could not have been unknown to Smith: paintings by and attributed to him passed through London sale rooms, and he had a secure niche in most of the biographical dictionaries of painters that were then the popular form of art history.[7] However, these well-known anecdotal accounts, which in the case of Hals dwelt largely on the artist's conduct and character as well as on his construed artistic procedure, reveal some of the reasons for his low reputation.

The first published report on Hals dates from approximately sixty years after his death – the entry in Arnold Houbraken's biographical compendium of Dutch artists, *De Groote Schouburgh*.[8] It is based on Van Dyck's purported visit to Hals on the eve of his departure for England. Arriving to find the Haarlem painter, as usual, in some tavern, Van Dyck posed as a prospective client and sent for him. On his return, Hals, unaware of the identity of his visitor, picked up any old canvas that he had at hand and painted rapidly. The visitor, feigning surprise at such apparent facility of execution, insisted on painting Hals's portrait in return. Hals, recognising the master's hand in the completed work, warmly welcomed Van Dyck, but adamantly refused his invitation to accompany him to England. However, Hals did not balk at accepting money from Van Dyck for his children, which he promptly took to spend on drink. Houbraken then cites Van Dyck's supposed opinion of

Hals's art: that had he blended his colours more 'delicately' or 'thinly', Hals could have been one of the greatest masters, for he was unrivalled in his control of the brush and in his ability to bring out the essential features of a portrait with precisely aimed brushstrokes which needed no softening or modification. Van Dyck is attributed with a report of Hals's technique of initially laying in his portraits with thick and softly melting layers of paint, and later working them up with the brush, saying 'Now to give it the master's touch'.

Houbraken may have invented the encounter between Van Dyck and Hals, being reminded possibly of the classical story of the anonymous visit of Apelles to Protogenes.[9] However, in its later context, the purported meeting also alluded implicitly to two modes of painting, broadly defined as the 'smooth', or more finished, neat manner, and the 'rough', or unfinished, loose manner. This distinction had by then become an accepted way of describing two opposing styles of painting. The less finished style was justified as revealing the artist's creative imagination (rather than the manual skill of the artisan), and as demanding an active role from the spectator, who had to learn to respond to the suggestive brushwork, to stand further back when viewing the paintings, and to appreciate the bravura technique that skilfully concealed the obvious signs of labour (thus achieving the famous ideal of effortless nonchalance, *sprezzatura*, of Castiglione's perfect courtier and perfect artist).[10]

These ideas, emanating from Italy in the sixteenth century, influenced writers on art in the north, where careful finish had traditionally been the order of the day. As early as 1604, Karel van Mander, who almost certainly was Frans Hals's teacher, referred to the two possible approaches to the finish of paintings – the 'neat' and the 'rough'.[11] He recommended that apprentices start with the neat manner, and show caution in painting without preparatory drawing.

Nevertheless Hals developed his original style of portraiture in the rough manner, and his bold, unblended brushstrokes, which needed to be viewed from a distance, were appreciated in his lifetime.[12] It seems, however, that a shift in taste towards the middle of the seventeenth century favoured the smoother finish, of which Van Dyck was generally accepted as the leading proponent.[13]

Certainly Houbraken's later account has the internationally renowned Van Dyck lording it over the Haarlem painter. Despite the admiration he professedly expressed for Hals's bold and skilful brushwork, Van Dyck supposedly wanted to rescue Hals from his dissipated tavern life by whisking him off to England. He also suggested ways in which Hals could improve his style and realise his full potential.

Houbraken's story of the artists' encounter alludes both to Hals's bravura artistic procedure and to his intemperate mode of living. Houbraken then elaborates on the latter – recounting how every evening Hals, filled to the gills with drink, was escorted home by his attentive students who carefully put him to bed. Although Houbraken may not have been alone in his view of Hals's high-spirited life (an earlier comment that he 'was somewhat lusty in his youth' had been handwritten by the German painter Scheitz in his copy of an earlier work on Dutch artists, Karel van Mander's *Het Schilder-boeck*),[14] his published account of Hals was to be the start of a tenacious anecdotal tradition that dwelt emphatically on the artist's purported debauchery, and was plagiarised by writers until the mid-nineteenth century.[15]

In 1753 Descamps, for example, while explaining Hals's characteristic bold brushwork as his attempt to mask the otherwise servile and laborious exactitude demanded by portraiture, also added that when starting work on Van Dyck's portrait he not only took the first canvas at hand, but also 'arranged his palette badly'.[16] Hals's refusal to accompany Van Dyck to England is attributed explicitly to his besotted but happy existence in Haarlem.[17] In 1835 another French writer suggested, somewhat ingeniously, that because Hals spent his evenings in debauched tavern revelry he inadvertently gave rise to a school of tavern-painters, his students representing scenes from his own degenerate life.[18]

The traditional anecdotes of Hals's debauchery are found as late as the mid-nineteenth century, when biographical dictionaries had generally given way to new forms of art history: accounts of modern European art in terms of different national schools with their distinguishing traits (such as subject matter and aesthetic ideals) and the characteristic stylistic development of their artists.[19] Thus in Arsène Houssaye's *Histoire de la peinture flamande et hollandaise* of 1846, a publication which reflected the increasing popularity of seventeenth-century northern schools in France and also drew on recent art-historical interpretations of the special nature of the Dutch School, Hals was grouped with Brouwer, Craesbeeck and the Ostades in a chapter on 'Tavern and Kermis Painters'.[20] Houssaye dwells on his habitual debauchery, his unwillingness to allow Van Dyck to save him from his misery and drunkenness, and his snatching of money from his ragged, shivering children, who themselves later became 'painters, musicians and drunkards, bohemians in art as in life'.[21] Houssaye comments that even through the fumes of wine, Hals, remembering his high calling and posterity, pronounced: 'I paint for the name of Hals; the master, and I am one, ought to hide lowly manual labour with the special gifts of an artist.'[22] Houssaye emphasises that

Hals was self-taught – a natural untutored talent characterised by skill and boldness. He concludes that Hals's debauchery did not finally do him in until he was of a ripe old age.[23]

Although these accounts of Hals frequently referred to his lifelike portraiture and bold spontaneous manner, Hals's artistic procedure was also associated with his reputed wanton behaviour. His practice of finishing off with unblended brushstrokes, his *alla prima* painting technique without preparatory sketches, his apparent rapidity of execution, were all to become the focus of censorious judgements of his style and character. Thus by the late eighteenth and early nineteenth centuries, Hals's bravura virtuosity, inseparable from his feckless character, was denigrated as a slapdash procedure which resulted in an unacceptable flaw in terms of contemporary taste – negligent lack of finish.

Young artists were cautioned against Hals by Sir Joshua Reynolds in his Discourse of 1774 to students, in which he stressed the virtue of industriousness and diligent study of other masters. While admiring Hals's unequalled ability to portray a 'strong-marked character of individual nature', he regretted that he had not 'joined to this most difficult part of the art, a patience in finishing what he had so correctly planned'.[24]

In the 1790s, the prominent French dealer Lebrun gave dire warning to contemporary artists of the commercial drawbacks of Hals's alleged negligence:

> His works would sell for higher prices had he not produced so much, or painted so quickly; for a painting to fetch a high price it is not sufficient that it bear the mark of genius, it must also be properly finished; or else, I must concede that that which has been quickly executed is similarly regarded and paid for. Advice to contemporary artists who do not base their reputations firmly on finished works and precious study.[25]

Forty years later, in 1834, the English dealer Nieuwenhuys (who had possibly sold the portraits of *Stephanus Geraerdts* and *Isabella Coymans* [cat. 68, 69] the previous year) regretfully echoed similar views:

> The great facility of painting for which this artist was distinguished was, however, sometimes carried to mannerism, and we may regret that several of his works were so negligently executed with regard to the finish; for that reason it may easily be conceived that many amateurs do not esteem them, and thus they are to be obtained at very low prices.[26]

Nieuwenhuys adds that Hals was nevertheless an excellent painter, his works revealing 'the mind of a genius and the handling of a master, whose choice paintings deserve a better fate, and are worthy of a place in the finest collections'.[27]

If the later recollections of James Northcote (1746-1831), protégé and biographer of Reynolds, are to be believed, Hals did indeed have an unexpected place in a fine collection, for Northcote claimed that a portrait by Hals 'which Titian could not have surpassed' hung in Reynolds's study – presumably valued for a particular aspect of Hals's art which Northcote vividly described.

> For truth of character, indeed, he was the greatest painter that ever existed. ... Hals made no beauties; his portraits are of people such as you meet with every day in the street. He was not a successful painter – his works were not ornamental – they did not move – they did not give all [that] his sitters were whilst he saw them before him, but, what they did give, they gave with a truth that no man could surpass. I have sometimes said Titian was the greatest painter in the world; ... he gave a solemn grandeur which is very fine indeed. But still, if I had wanted *an exact likeness* I should have preferred Hals. ... Hals possessed one great advantage over many other men; his mechanical power was such that he was able to hit off a portrait on the instant; he was able to shoot the bird flying – so to speak – with all its freshness about it, which Titian does not seem to have done.[28]

Thus although Hals's ability seemingly to capture a momentary individual likeness in his portraiture was acknowledged, his free spontaneous brushwork and juxtaposed colours did not persuade these posthumous viewers of his artistic mastery: on the contrary, reminiscent of the artist's reputed intemperate character, his works were seen as lacking in finish, they were not 'ornamental', they did not 'move'; they revealed a bold but flawed talent.[29]

Such views also accorded with criteria of finish among academic theorists in France in the early nineteenth century, and until these canons of careful execution and finish were thoroughly undermined, Hals's works could not lose their stigma of negligence.[30] Favourable reception of his inferred spontaneous procedure and free, open brushwork, required not only positive criteria relating to 'rough' finish and to lively, individualised characterisation in portraiture, but also required positive appreciation of other associated qualities such as the apparent visibility of the artist's creative process and the revelation of an uninhibited and emphatically original talent.

Within the construed history of seventeenth-century Dutch art, furthermore, Hals's role needed to be established and the corpus of his works recovered, for although his major civic group portraits were accessible, they were scattered in different buildings in Haarlem and little known. Hals's reputation also needed to be rescued from the persistent allegations of debauchery. The earliest serious attempts to turn the tide in this

respect were made by local Dutch historians compiling national biographies who made determined attempts to clear Hals's name from the calumnious tradition by reference to archival sources. In 1816, van Eynden and van der Willigen rebuked Houbraken for ignoring Hals's great civic group portraits in Haarlem and Amsterdam, and emphasised the esteem in which Hals was held in his lifetime, quoting lines of praise written by Hals's contemporary, Theodorus Schrevelius, in his popular history of Haarlem:

> ... [he] excels almost everyone with the superb and uncommon manner of painting which is uniquely his. His paintings are imbued with such force and vitality that he seems to defy nature herself with his brush. This is seen in all his portraits, so numerous as to pass belief, which are coloured in such a way that they seem to live and breathe.[31]

By 1840, van der Willigen's archival research had turned up material which, he believed, showed Hals to be a more respected citizen than traditionally believed, and it is suggested that he was a man of 'cheerful disposition and generally loved'.[32] In 1843, Immerzeel insisted that Hals's masterly works were in themselves a refutation of allegations of daily drunkenness.[33] As will be seen, these local efforts to rehabilitate Hals were to be dramatically furthered some twenty years later by the establishment of the Municipal Museum at Haarlem.

Outside Holland, Hals's unjust neglect began to be registered by historians and critics during the 1850s: Gustav Waagen, Director of the Berlin Museum, commented of Hals's *Portrait of a Man* (cat. 38) that it justified Van Dyck's admiration:

> ... for the conception is unusually spirited and animated, even for Frank [sic] Hals, and agrees in every way with the broad and firm execution. In my opinion the value of this painter in the history of Dutch painting has never been sufficiently appreciated. He was the first who introduced the broad manner of Rubens into Holland, where it was adopted and followed up with the greatest success by Rembrandt, who was born twenty years later.[34]

In 1858, the French critic Paul Mantz, author of the fascicle on Hals in Blanc's mammoth collaborative series, *Histoire des peintres de toutes les écoles*,[35] predicted optimistically that Belgian and Dutch scholars would rectify the lack of reliable information on this artist who did not yet occupy his 'rightful place in art'.[36]

However, it was to be another French writer, a political journalist, art critic and art historian, the exiled Théophile Thoré, writing under the pseudonym W. Bürger, whose pioneering historical researches, connoisseurship and critical reappraisal would play this most important role in the dramatic reversal of Hals's posthumous fortunes.[37]

HALS REDISCOVERED: THE ROLE OF THORÉ-BÜRGER

Well known as one of the finest art critics during the nineteenth century, Thoré, in his later persona of Bürger (hereinafter referred to by either or both names, depending on the context), became one of the most respected connoisseurs and historians of the art of the past, particularly of the seventeenth-century Dutch School.[38] His most celebrated achievement was his spectacular rediscovery of Vermeer – an artist almost lost in oblivion. In the case of Hals, he reversed the artist's long-standing notoriety and drew unprecedented attention to his works – to their pictorial qualities, to their art-historical significance, to their essential Dutchness, and to their modern relevance.

After eight years of obscure exile, Thoré-Bürger's phoenix-like return to the art world in Paris was achieved by his review of the great Art Treasures exhibition in Manchester in 1857,[39] in which is found his first enthusiastic mention of Hals. The artist is here described as one of the freest and boldest practitioners of all schools, an eccentric and impetuous master who was 'to Rembrandt what Tintoretto was to Titian'.[40] In contrast to the laconic entries in the official catalogues,[41] Bürger pays careful attention to the two exhibited Hals portraits, and disagrees with the designation of the *Portrait of a Man* (fig. 1; S214) as a sketch, insisting it is no more of a sketch than Hals's other paintings, but is indeed extremely rapidly painted ('*très brusquement sabré à la vérité*').[42] He further refers his readers to Hals's great works in Holland, with which he was by then familiar.[43]

From his earliest eulogistic accounts, he stresses Hals's consummate mastery and the cheerfulness and spontaneity that emanate from both the subject matter and assumed artistic procedure. Thus in 1858, in the first volume of his famous catalogues of the major Dutch museums, Hals's *Married Couple in a Garden* (cat. 12), then believed to be a self-portrait with his wife, is described as representing a cheerful and affectionate pair sitting under the trees: the wife vivacious and gay, a good gossip for such an outrageous fellow, who here seems a fine gentleman, witty and elegant, whose brush seems to have frolicked over the canvas.[44] The other painting then in Amsterdam, the *Merry Drinker* (cat. 30), is dealt with more briefly, Hals's touch here characterised as brusque and accurate.[45]

In 1860, while writing on the Suermondt Collection, Bürger elaborates on Hals's presumed method of working, but instead of warning artists, as earlier writers had

done, of the dire results of emulating the Dutch master, he urges them to learn from Hals's example:

He painted so much! He painted so quickly – and so well! Even the slightest painting by him is attractive and offers a lesson to artists. All aspects of his work are instructive, his faults as well as his strengths; for his faults are always those of a great practitioner. In his exaggerated brusqueness, his risky contrasts, his informal carelessness, there is always the hand of a bountifully talented painter, and even the sign of a certain kind of genius – somewhat superficial, it is true, and inspired by the external appearances of things, by movement, style, colour and effect, by whatever moves and glitters, rather than by the secret and inner spiritual side of life, even somewhat vulgar, if one can so refer to genius – but frank and bold, as irresistible as instinct.[46]

The following is his description of the *Boy with a Flute* (cat.15) in the collection:

A young man, ... his hand beating time, imagine how rapidly this raised hand was painted. The figure is modelled against a light background, a lively study hurried over in one go. He never did otherwise. All his brushstrokes stand out, aimed exactly and wittily where intended. One could say that Frans Hals painted as if fencing, and that he flicked his brush as if it were a foil. Oh, the adroit swashbuckler, extremely amusing to observe in his beautiful passes! Sometimes a little reckless to be sure, but as skilful as he is bold.[47]

Bürger's evocations of Hals's virtuosity and bold impetuous brushwork are without the censorious warnings of lack of finish found in Hals's earlier critics; on the contrary, his procedure is advocated as exemplary for contemporary artists. This view is consistent with Thoré-Bürger's preferences in contemporary art and with his position on 'finish' – a perennial issue, which took on new urgency in the critical debates in France during the nineteenth century.[48]

In his second volume on the Dutch museums Bürger attempts to trace Hals's stylistic development by reference to Rembrandt, whose influence he detects in the broader style of such works as the 1639 *Portrait of Maritge Claesdr Vooght* (fig.18e; s129).[49] To amplify his point, Bürger compares the two St. George militia pieces of *c*.1627 and *c*.1639 then in the Town Hall of Haarlem. He describes the later work as one of the masterpieces of the Dutch School, a work of incomparable mastery ('*maestria*'), of a solid, grand and free composition. While attributing the darker colours, more intimate facial expressions, the harmonious and peaceful effects to Hals's presumed knowledge of the young Rembrandt, he notes that he retained his characteristically energetic brushwork.[50]

Fig.1 Frans Hals, *Portrait of a Man* (s214) New York, Frick Collection

Two years later, an extremely important event gave added impetus to Bürger's initial efforts to replace the conventional and superficial notion of Hals's work with a newly considered view of the full range of his art: the establishment, in 1862, of the Haarlem Municipal Museum. Hals's most brilliant works, the five life-size group portraits of the Haarlem civic guards and the three regent pieces (cat. 54, 85, 86), eighty-four figures in all, were, for the first time, all easily accessible to the public.[51] From 1862 on, it was Hals the artist who was commemorated, not just the original commissioning citizens and institutions, and the whole gamut of his major artistic achievements over fifty years, from 1616 to 1664, was spectacularly displayed. Here, in a single large room, the impressive sweep of his long career could be viewed, providing a unique and dramatic spectacle of an artist's development through maturity to old age. That Haarlem soon became a popular site for artistic pilgrimage was both a result of, and an important contributory factor to, the spread of Hals's fame and to his recently re-established art-historical status.[52]

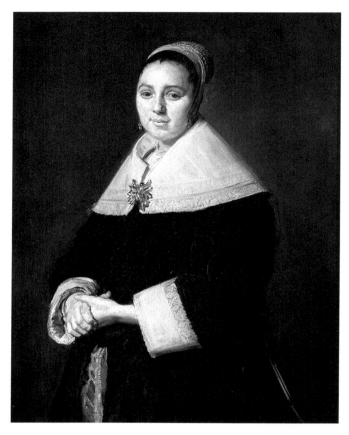

Fig. 2 Frans Hals, *Portrait of a Woman* (s185)
Vienna, Kunsthistorisches Museum

Fig. 3 View of the poster displaying Frans Hals's *Laughing Cavalier*
for the Wallace Collection (photo: Jessica Strang)

During the 1860s, Bürger's continuing championship of Hals (especially as a model for modern artists) carried special weight, for not only had Bürger become widely recognised as an erudite connoisseur of the art of the past and the leading advocate of the Dutch School, he had also once again become a prominent polemical critic of contemporary art. Furthermore, in 1868 he republished his major Salon reviews of the 1840s, together with a long introductory essay 'Les Nouvelles Tendances de l'Art'.[53] His earlier militant support of innovative artists like Delacroix and Rousseau (by the 1860s unanimously acknowledged as great masters of nineteenth-century French art), gave him the aura of a prophetic critic,[54] as well as that of a heroic rescuer of unjustly forgotten artists of the past.

In 1864 he recommended that modern artists study Hals's *Portrait of a Woman* (fig. 2 ; s185),[55] both for the general wholesomeness of the figure's demeanour, as well as for the technical excellence in the rendering of the hands.

> She is as fresh as a beautiful apple on the tree. It is health in all its exuberance. Something of the peasant, whose complexion glows in the open air. Fashionable society would not find her very elegant, but that is to her favour, for she is as open-hearted as she is ingenuous.
> The two clasped hands are marvellous. ... One can hardly detect how it is achieved by such a few bold strokes which precisely show up the form and movement.[56]

Bürger discusses the difficulties of rendering the living, agile hand, in movement or about to move, and comments that Dutch painters generally had little difficulty with the awkward problem of posing hands, placing them 'where and how they ought to be' – a pictorial ability Bürger attributes to the artists' 'naturalness' and 'sincerity'.[57] These terms, as we shall see, acquire particular meanings and values in the context of Bürger's notion of naturalism.

Bürger's promotion of Hals during the 1860s accompanied Hals's rising stardom both as a collectible old master, and as a source of inspiration for contemporary artists. He became one of the most sought-after new discoveries among collectors, who vied with each other for his works as they became increasingly available in sale rooms, especially in Paris, which became the richest centre for Hals's paintings outside Holland. In 1865, Lord Hertford and Baron Rothschild competed at auction for a certain *Portrait of a Gentleman*. The bidding reaching a spectacular 51,000 francs, which, although then considered, as a commentator later reminisced,

... to be one of Lord Hertford's crazy extravagances,

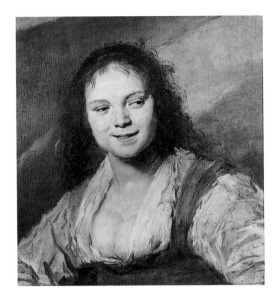

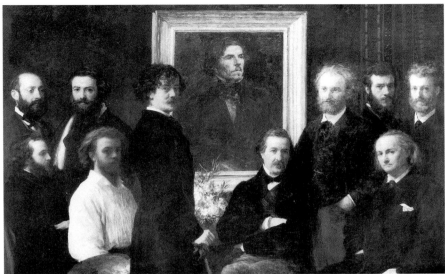

Fig. 4 Frans Hals, *Gipsy Girl* (s62)
Paris, Musée du Louvre

Fig. 5 Henri Fantin-Latour, *Homage to Delacroix*, 1864
Paris, Musée d'Orsay (photo: Réunion des Musées Nationaux)

... turned the attention of the art world to Frans Hals in a sensational way. ... People shook their heads, but artists and critics began to see that the 'mad Marquis' had been quite right, and that the picture was a fine example of a man who had been the true predecessor of the realism just beginning to come into favour.[58]

The painting in question was, of course, the so-called *Laughing Cavalier* (pl. 1; s30).[59] The following year Rothschild, determined to make up for his defeat, acquired a version of *Willem van Heythuysen*, a small informal portrait then confidently attributed to Hals, at another Paris sale (see cat. 51, fig. 51c).[60] In the same year, the Exposition Rétrospective held at the Champs-Elysées included two particularly fine paintings by Hals: the *Portrait of a Lady* (fig. 2; s185) from the Pereire Collection and the *Gipsy Girl* (fig. 4; s62), then in the La Caze Collection but shortly to enter the Louvre.[61] By 1867, Bürger observed with satisfaction that nowadays the most distinguished collectors in Paris included works by Hals among their treasures, adding 'May one of the most valiant portraitists in the world, Frans Hals, regain his legitimate position'.[62]

Bürger's role in establishing Hals's 'legitimate position' was already evident in art-historical circles.[63] His descriptions of Hals's various works in Dutch museums were even quoted in a guide-book to Holland in 1862.[64] His promotion of Hals also contributed to the latter's increasing significance to modern artists – especially, it seems, in Paris.

One of the earliest known instances of Hals as a formative source in the nineteenth century is Fantin-Latour's *Homage to Eugène Delacroix* (fig. 5), which was exhibited at the Salon of 1864. Originally planned as an allegorical composition, it was apparently transformed into a modern realist group portrait after Fantin-Latour saw a full-scale copy of one of Hals's group portraits by the Belgian artist Louis Dubois.[65] Whistler's unrealised ambition to rival Fantin's *Homage*, according to his biographer, also referred to the authority of Hals:

Whistler in London, caught the fever, planned to rival Fantin in size, ten feet by six. Like Fantin's it would be a group of portraits, like Fantin's a tribute to Realism, true to the life of their day even as the great Haarlem groups were true to life as Franz [sic] Hals knew it.[66]

That Hals's example was currently invoked in the studios of modern realist painters is borne out by the critic Zacharie Astruc. His first mention of Hals dates from 1866, in an article on the Exposition Rétrospective mentioned above:

The reputation of this master will owe much to the modern school which he has greatly impressed and which celebrates him everywhere as an inspiration. The truth is that he represents a healthy and invigorating approach, he is true to his vision and it is now or never that the sincere path must be followed if the domain of French art is to be strengthened and expanded.[67]

Astruc's later admiration for Hals as a 'duellist with the brush, ... who builds, who sculpts, who gives impasto the palpitation of flesh' (reminiscent of Bürger's earlier description),[68] presumably reflected the admiration for

Hals among his circle – which included Manet and the young Impressionists.

It is evident that by 1868, when Bürger published his two pioneering articles on Hals, there already existed a new enthusiastic audience eager for information about Hals's works.[69] Bürger gave an account of the painter's long career, and included a list of all his paintings that he had traced (or placed) in European collections. Paying tribute to the researches of Dutch archivists, Bürger challenged the 'stereotyped calumny' of the earlier biographical accounts of Hals, and dismissed the slurs on his character as insulting and probably apocryphal. He attempted instead to recast him as a gregarious, jolly, adventurous and impetuous person, introducing the artist through the supposed *Self-Portrait with Wife* (cat. 12), and quoting his own earlier description of them as a cheerful, affectionate couple.[70] The derogatory connotations of Hals's impetuous high-spiritedness were swept away in a new version of both his character and his art.

As in his earlier writings, Bürger now stresses Hals's virtuosity, commenting that he never needed preliminary studies, for he could 'express nature with the first touch of his skilful painterly brush'.[71] Bürger, with all the authority of a veteran critic and authoritative connoisseur, insists on the high quality of Hals's paintings, judging his group portrait of *The Company of Captain Reynier Reael* (cat. 43) as superior to van der Helst's celebrated group portraits.[72] The *Laughing Cavalier* (pl. 1; s30; see fig. 3) is held to show Hals's unrivalled ability to portray gaiety and good humour – surpassing both Van Dyck and Velázquez.[73]

Although Bürger initially characterised Hals's virtuosity as reflecting the superficial responses to fleeting external appearances, subsequently noting a broadening Rembrandtesque style, he now traces the development of Hals's art to an *ultima maniera* which ranks him with a galaxy of the greatest European masters.

Hals's early style is characterised by its light effects:

At the beginning, one could say that he painted in gold – doesn't one say 'to talk in golden tones'? – that a pale light sparkled everywhere like scintillating gold-dust, that he scattered the magic of colour almost too much?[74]

The *Gipsy Girl* (fig. 4) is thus described as painted in

... the golden tones with the wildness of his early style: a masterpiece improvised in a few bright hours of good humour.[75]

In the later *Malle Babbe* (cat. 37), Hals's detached, improvisatory brushwork is eulogised as the source of his expressiveness, surpassing virtuosity in its emotional intensity:

... this passion is here perhaps most abandoned to the *furia* of his genius. In this painting and in several others, Frans Hals astounds by his violence of brushstrokes and strangeness of tone – as do all impetuous colourists such as Greco, Herrera, Goya.[76]

Hals's late works are compared to Rembrandt in their sombre mysteriousness and their exaggerated but admirable violence of brushwork, impasto and execution.[77] The apogee of his achievement is found in his last works: the group portraits of the *Regents* and *Regentesses of the Old Men's Almshouse* (cat. 85, 86). Bürger marvels at Hals's *ultima maniera*:

I do not know of paintings executed with as much impetuousness – not in Hals's own work, not in the work of Rembrandt, ... Rubens, ... Greco or any other of the most enraged painters. ... The life-size figures, modelled in broad glowing strokes stand out in relief from the frames. It is superb and almost terrifying.[78]

Bürger surmises (wrongly) that the regents were like warders to the old painter:

I imagine that the old lion, defeated by poverty, was from then on, retired – imprisoned in this refuge for old men, and that it was there that he later died.[79]

The impact of Bürger's pioneering researches and of his reassessment of Hals was immediately evident in the historiography of the seventeenth-century Dutch School, in which Hals's crucial innovative and leading role was now generally acknowledged.[80] The great display of Hals's group portraits at the recently established museum at Haarlem increasingly attracted visitors – especially painters – like a magnet.[81] Most exhibitions of old masters regularly included examples of his works, and major public collections would henceforth attempt to acquire his paintings whenever possible.[82]

It must be emphasised, though, that despite Bürger's gratification at Hals's high standing among collectors, this was not his sole aim in promoting him. His art-historical researches into Hals were part of a polemical championship of Dutch art generally, and as such were inextricable from his wider concerns for contemporary art and society.[83] These interests emerge, for example, in a passage in his 1868 study of Hals, where he asks rhetorically of Hals's civic guard portraits:

Why then should these gatherings of Dutch guardsmen not be considered as great as the banquets of notables in Venetian costume?

He answers by insisting that the presence of works such as Hals's civic guard banquets next to great Veronese banqueting scenes in the Louvre would indeed challenge the hegemony of the 'supposed nobility' of Italian art.[84]

It is clear that these comments were intended as a programme for the art of his time:

> These Dutch paintings representing the contemporary life of the artists naturally make one dream of the art of our own time. ... What is to prevent one from making a masterpiece of a meeting of diplomats seated around a table ... [of] an orator at the rostrum of the Chamber of Deputies, a professor surrounded by young people; a scene from the races, a departure from the opera, a stroll down the Champs-Elysées; or just with men working at anything, or women amusing themselves with anything?[85]

Although Bürger's vision of contemporary artists painting the life of their own times in a spontaneous free technique was, of course, already becoming a reality (and was to be spectacularly realised in the next decade), this did not necessarily fulfil his terms for the art of the future. His advocacy of seventeenth-century Dutch naturalism was also associated with political ideals. The special artistic qualities were not a new theme in his (or others') writings,[86] but Bürger's emphatic explanation of the achievements of Dutch art as essentially part of the religious and political emancipation of their republic contributed greatly to the wide dissemination of this idea, and it is to this aspect of his interpretation that we must now turn.

In the first of his famous volumes on the Dutch museums, Bürger insists on a clear distinction between Flemish art – weighed down by the despotism of Catholic Spain and enslaved by pagan and religious iconography, and Dutch art – created in a Protestant, republican society, its artists free to paint their own contemporary world.[87] Dutch painters thus represented the life of their compatriots:

> ... rough sailors, bold arquebusiers, informal burgomasters, decent cheerful working men, the crowd, everyone, in a country of equality.[88]

After Bürger's disappointment with the 1848 Revolution and its short-lived Second Republic, he channelled his energies into defending an idealised Dutch Republic and its art as a model for his vision of future society and art.[89] During his exile he wrote a tract in which he envisaged an imminent universal fraternity about to sweep aside narrow parochialism and jealous territorial habits. He predicted that nations would generalise their traditions and mythologies, and proclaim an ideal, universal humanity:

> There is only one race and one nation, there is only one religion and one symbol: mankind.[90]

Bürger exhorted contemporary artists to concern themselves with humankind ('le genre humain') and to create

a universally understood language of art, which he encapsulated in his famous slogan 'art for mankind' ('l'art pour l'homme').[91] The art of the future should base itself on the principle he attributed to Dutch art: 'To create what one sees and feels' ('Faire ce qu'on voit et ce qu'on sent').[92] Bürger frequently and portentously reminds his readers that because the Dutch nation courageously threw off the yoke of religious and political domination, their art was no longer committed to the dogmas of religion and to the glorification of rulers. Unlike the Italian Renaissance artists (and their imitators), whose pagan and religious iconography was impenetrable to the uninitiated and irrelevant to the modern world, Dutch artists were freer than any other national school to create

> ... altogether the most resolute, most varied, most revolutionary, most natural and most human school, [which] thus indicates most clearly the direction of art to come.[93]

Bürger thus justifies his advocacy of an earlier school as 'the most instructive for innovators' and an augury for the future.[94] In such a context, Hals's innovative role is particularly heroic for it is now seen as having set the Dutch School on its historic path.[95]

To Bürger, naturalism did not mean verisimilitude, but the artist's enhanced representation of life around him, an original individual expression of experienced reality, which in turn would be accessible to the widest possible audience.[96] He emphasised the realisation of the subject, the artistic procedure, the method of painting as much as the actual figures represented.

Bürger always gave great significance to technical procedures themselves – the means whereby subjects are realised – for naturalism was best achieved by the mode of painting that most vividly gave the impression of the artist's response to life. Thus the communicability of naturalism resided both in its familiar subject matter and in its means.[97] Both the originality and liveliness of Hals's style, the sense of his spontaneous creative process, as well as the strongly marked individuality of Hals's subjects, are seen as symptomatic of the freedom of a society where individuality is

> ... inherent in their country of free thought, where their imaginations, as well as their souls and their consciences, had absolute independence.[98]

It was thus during the 1860s that some of the recent concerns in contemporary painting, art criticism and art history converged on Hals, vindicating his art in terms that resulted in his being claimed as an 'ever-glorious ancestor' by modern artists,[99] and a rediscovered old master by new enthusiastic audiences. By 1868 Bürger, in particular, had thoroughly overturned all the tra-

ditional accounts of Hals's art and established his pre-eminence both in the Dutch School and amongst the great masters of European art. The traditional accounts of his dissipation were treated with indignant incredulity, and his reputed wantonness was indulgently reinterpreted as jovial high spirits which could in no way cloud his innovative artistic genius – which was, furthermore, now identified with the independent and creative spirit of the Dutch republic itself.

'A NEW MAN IN A NEW WORLD' (VOSMAER)

The first popular publication on Hals after Bürger's pioneering articles dates from 1873-4: the widely reviewed, luxurious folio of etched reproductions by William Unger, which was accompanied by an extended essay by the Dutch art historian Carel Vosmaer.[100] The enthusiastic publisher, A.W. Sijthoff, attributed Hals's recent fame to three factors: the new and more profound conception of art that valued 'original spirits' above conventional talents, 'the new, perceptive researches' of W. Bürger, which had 'spread the cult of Hals's genius throughout Europe', and the establishment of the museum at Haarlem.[101] This portfolio was intended to familiarise the public further with Hals's major works – especially those in Haarlem. Vosmaer elaborated further on the special attraction of Hals to contemporary audiences:

> In modern times, a better grounded and loftier conception of Art in every domain has taught us to set a higher value on original energetic works, than on softer tamer productions of a Muse farther advanced, perhaps, in superficial cultivation, but for that very reason, less natural and less free. Ever impelled by [the] love of truth and of viewing life closer and closer to its sources, ... the nearer ... works approach the spring of inspiration, the fresher and stronger we see them issue hence, the dearer they are to us.[102]

This is indeed a long way from Lebrun and Nieuwenhuys. Furthermore, the terms such as 'natural' and 'free' in the context of the current interpretations of Dutch art had special significance, for Hals is perceived as expressing the spirited vitality of the first generation of the newly fledged republic – its optimism, exuberance, sincerity and naturalness, and his artistic originality is seen as a direct corollary to the self-innovation of the Dutch nation itself:

> The free people who had broken with Tradition, Pope and King appeared as wholly new, and only among that people was it possible for an art like the Dutch to be developed, thoroughly human, natural, independent, born directly out of the character and life of the people. That is then, the whole secret of its origin and being.

> The people had raised themselves to nationality; the individual to personality; and from this strong consciousness arose works of reality and fiction equally strong.[103]

In this context Hals is described, although of patrician descent,

> ... yet a new man in a new world ... who, with the most peculiar force, expresses and reflects the appearances of the life of the moment and only in the human figure, with all the certainty and all the thrill of nature herself.[104]

In contrast to the earlier censorious accounts of Hals's wanton tavern revelry, he is now eulogised as a portrait-ist of individuals, initially of free, popular street and tavern life, later of important images of national social life. In particular, his lively portrayal of merriment is explained as a reflection both of his own infectious good humour and of the national mood:

> Hals's sitters seem as if the painter unwittingly imparted his own joyousness to his canvasses and his panels, or that the persons sitting opposite the cheerful face of the genial humorous man, really fell into the same sunny mood.[105]

Thus by the early 1870s the reconstructed and reinterpreted Hals was imbued with several kinds of values. On one level, his paintings had become expensive commodities on the art market.[106] In art-historical terms he was now seen as the crucial innovator of the Dutch School, his works embodying republican, democratic, patriotic values – models of an exuberant pioneering naturalism, of an unstuffy response to the full range of his fellow-citizens. He was also recognised as a brilliant practitioner, whose spontaneous painterly procedure was to be increasingly invested with contemporary artistic relevance during the next few decades.

However, to what extent the individual viewers of the first generation to 'rediscover' Hals valued his works for one rather than another of these factors resists broad generalisation. Separating subject matter from technique disregards, for example, the essential inextricability of subject and procedure (the 'what' and the 'how') in Bürger's highly influential interpretations of Hals's supposed spontaneous naturalism. The aesthetic and social ideologies of Hals's audiences – especially those of the various painters who emulated or invoked his authority in their own artistic practices – need careful individual consideration.[107] A brief review of some of the responses to Hals by the artists and critics who embodied the Hals revival during the last three decades of the nineteenth century reveals the different kinds of interest and meaning that were then found in his works.[108]

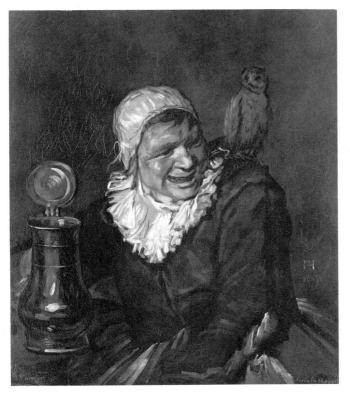

Fig. 6 Gustave Courbet, copy after Frans Hals's *Malle Babbe*, 1869 Hamburger Kunsthalle (photo: Elke Walford)

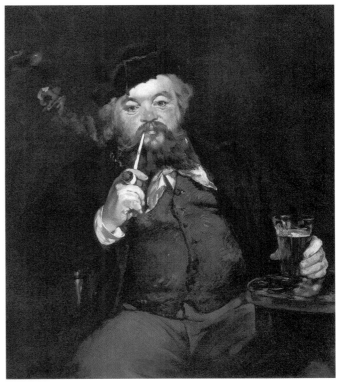

Fig. 7 Edouard Manet, *Le Bon Bock*, 1873 Philadelphia, Philadelphia Museum of Art, Mr. and Mrs. Carroll S. Tyson Collection

ARTISTIC AND CRITICAL RESPONSES IN THE LATE NINETEENTH CENTURY

The identification of Hals with realist aspirations in the 1860s has already been mentioned in relation to Fantin-Latour. Courbet took up Hals in a different way and, in a dazzling challenge to the master, copied the much-vaunted *Malle Babbe* (fig. 6) while it was on public exhibition for the first time in Munich in 1869 (cat. 37), shortly after its introduction by Bürger.[109] The latter had frequently praised Courbet as the undisputed leader of the modern French School, while always deferring to the old masters for criteria of excellence. Could Courbet, with his customary bravado, be challenging Hals and claiming a similar innovatory role in nineteenth-century art? The possibly apocryphal anecdote that Courbet removed the original *Malle Babbe* from its frame, replacing it with his copy for several days without detection, surely suggests that he had something like that in mind, and his inscription of an invented date and monogram on the canvas could have been a teasing allusion to Bürger's art-historical endeavours –

and a homage to the republican critic who had died a few months earlier.[110]

A few years later, Manet made a less strident claim on Hals (cat. 30) – albeit as seemingly obvious to some of his contemporaries – in *Le Bon Bock* (fig. 7), exhibited at the Salon of 1873. It was widely assumed to be a Halsian paraphrase: the critic Albert Wolff's comment that Manet had put 'water into his beer' provoked the painter Alfred Stevens to reply that it was 'pure Haarlem beer'.[111] The nature of Manet's relationship to Hals is no easier to define than to any of the other old masters to whom he alluded, although it was recognised as significant by his contemporaries. In a somewhat facetious vein, Degas supposedly commented that Manet 'did not paint fingernails because Frans Hals did not depict them',[112] although Antonin Proust, more seriously, partly credited Hals with inspiring Manet's determination to paint the Paris of his own time:

The boldness of Franz [sic] Hals also made a deep impression. Thus, when he returned to Paris, fortified by all these memories, Manet plunged hardily into the study of the diverse aspects of life in the great city.[113]

During the first half of the 1870s, the museum in Haarlem was visited by several artists from Paris of different generations and working in different styles, such as Claude Monet, Léon Bonnat, François Bonvin, J.B. Jongkind, Ferdinand Roybet, Charles Daubigny and Théodule Ribot, by teachers as different as Jean-Léon Gérome and Carolus-Duran, and by young American artists such as Mary Cassatt and Alden Weir.

Both Cassatt and Weir made copies after Hals's *Officers and Sergeants of the St. Hadrian Civic Guard* (s79).[114] Cassatt apparently cherished her sketch copy until the end of her life.[115] Weir was particularly inspired by Hals in his aspirations to capture 'the character and individuality' of his subject matter, and wrote home enthusiastically:

> I am now in Haarlem, the town that I revere! the birthplace of Frans Hals! How to begin to describe this wonderful man of genius is more than I know, but let me say that of all the art I have seen so far I place him by the side of Titian, if not ahead of him, in portrait painting. ... The wonders of this one great Dutchman are worth a journey around the world for an artist; he is marvellous, the individual nature and amount of nature which he has in his works is astonishing.[116]

He took visual notes of Hals's compositions, and executed lively oil sketches in emulation of his virtuoso brushwork. The lessons he learnt from Hals were to be apparent in many of his figure paintings of the late 1870s and early 1880s.[117]

The register of the visitors to the museum at Haarlem also includes signatures of painters from the major German art centres. The brilliant satirical writer and illustrator Wilhelm Busch, famous for his caricatures and poem-picture books (such as *Max und Moritz*) visited the museum in 1873, and declared Hals to be his 'chosen favourite', although his paintings which reflect their Halsian source in subject and treatment (such as *The Merry Carouser*, 1873; Frankfurt, Städelsches Kunstinstitut) are too dependent on their prototype to be considered more than pastiches.[118]

The Berlin painter Max Liebermann venerated Hals as an inspiring example. His early admiration led him to copy several works by Hals, such as, in 1873, the *Nurse and Child* (cat. 9) in Berlin and, in the winter of the same year, the *Gipsy Girl* in Paris (fig. 4).[119] In 1876 he copied several figures from the group portraits in Haarlem, such as a head from Hals's *Regentesses* (fig. 8; cat. 86).[120] According to Max Friedländer, Liebermann subsequently gained self-confidence from Hals, in whom 'he found a kindred spirit. And this master became an example, gave him a yardstick like no other painter old or new',[121] as encapsulated in Liebermann's famous comment: 'In front of Frans Hals's paintings

Fig. 8 Max Liebermann, copy after one of Hals's *Regentesses*, 1875/6
Location unknown

one longs to paint; in front of Rembrandt one wants to give up.'[122] It seems furthermore that Liebermann's sympathy for the social values with which Hals's naturalism was imbued in the early revivalist accounts, also informed his response to Hals.[123]

Liebermann's close friend, Mihaly von Munkácsy, a Hungarian painter who settled in Paris in 1872, was one of several artists from Eastern Europe who admired Hals.[124] It should be added that Munkácsy also owned a Hals, the *Portrait of a Man* of 1643 (s151).

The Munich painter Wilhelm Leibl became particularly interested in Hals after the International Exhibition in Munich in 1869 which exhibited five Hals paintings. He also met Courbet (whose copy after the *Malle Babbe* he presumably knew), upon whose invitation he visited Paris later that year. Leibl's *Gipsy Girl* (Cologne, Wallraf-Richartz Museum) seems to have been painted in homage to Frans Hals. After his return to Munich, his (and his circle's) preoccupation during

the early 1870s with the technical means of painting as a way of expressing an individual temperament, and achieving a personal transformation of subject matter by original use of colour, form, composition and touch, led them to emulate Frans Hals – the Hals who had recently been reinterpreted in similar terms. Here was an artist whose technical mastery, original, bold brushwork, virtuoso freedom in the handling of his medium, had achieved a highly individual style, and one that accorded with their cult of 'unfinish', *alla prima* painting, and realistic subject matter subsumed by the painterly performance and personal expression of 'spirit' ('*Geist*').[125] Several American painters studying in Munich attempted to emulate Hals's technical mastery in developing their styles, artists such as Frank Duveneck,[126] J. Frank Currier,[127] and in particular William Merritt Chase, who was especially effective in popularising Hals's works in the United States.[128] Chase's copy of Hals's *Regentesses* portrait (cat. 86) can be seen in the photograph of his Tenth Street studio (fig. 9).

By the middle of the 1870s Hals was a popular source of instruction and inspiration for various artists from different centres in Europe. His relevance to contemporary painters was particularly noticeable in France, where he had already been identified as a model for the young innovative painters in Paris in the 1860s. This association, however, was viewed by one painter-critic, Eugène Fromentin, with some ambivalence.

Travelling through Antwerp in 1875, on his historic visit to the Low Countries, Fromentin came across Hals's *Fisher Boy* (cat. 34), noting caustically in his diary: 'What brushstrokes! Decidedly too fashionable'. Shortly afterwards he criticised Hals's paintings in Amsterdam (cat. 12, 30) as overly witty, superficial and showy, with too much 'hand'.[129] It appears, however, from the chapter which he devoted to Hals in his famous *Maîtres d'Autrefois* that he was, despite himself, won over by his experience of the great display of 'fifty years of an artist's labour' at the Haarlem museum.[130]

'Today the name of Hals reappears in our school at the moment when the love of the natural re-enters it with some clamour and no little excess', Fromentin commented, referring to Manet and the young Impressionists towards whom he was implacably hostile, and whose emulations of Hals he deplored as a travesty of the achievements of 'one of the most clever and expert masters who ever existed anywhere', despite being 'only a workman'.[131] With a painter's eye he carefully described Hals's phenomenal technical brilliance and virtuosity as reaching an apogee in the *Officers and Sergeants of the St. Hadrian Civic Guard* of c. 1633 (Levy-van Halm & Abraham, fig. 17; s79), 'never was there better painting, never will there be any better painting',[132] but as ultimately deserting him in the last works.

Fromentin's analysis of the *Regents* and *Regentesses* (cat. 85, 86) is worth quoting in full, for he does not simply dismiss them as the products of senile old age (as is sometimes suggested), but rather as the ineffable creations of the artist's mind's eye without his former physical prowess of hand:[133]

> His hand is no longer there. He displays instead of paints; he does not execute, he daubs; the perceptions of his eye are still vivid and just, the colors entirely pure. ... It is impossible to imagine finer blacks or finer grayish whites. The regent on the right with his red stocking ... is for a painter a priceless morsel, but you

Fig. 9 Photograph of William Merritt Chase's Tenth Street studio, showing the copy of Hals's *Regentesses*
Southampton, New York, The Parrish Art Museum, William Merritt Chase Archives, Gift of Jackson Chase Storm (photo: Noel Rowe)

find no longer either consistency in design or execution. The heads are an abridgement, the hands of no importance, if the forms and articulations are sought for. The touch ... is given without method, rather by chance, and no longer says what it would say. This absence of rendering, this failing of his brush, he supplies by tone, which gives a semblance of being to what no longer exists. Everything is wanting, clearness of sight, surety in the fingers, and he is therefore all the more eager to make things live as powerful abstractions. The painter is three quarters dead; there remain to him, I cannot say thoughts, I can no longer say a tongue, but sensations that are golden.[134]

While in awe of the 'solemn hour' of Hals's receding virtuosity and the intimations of his past powers, Fromentin insists that the last sublime efforts of an expiring genius are not the best examples for his 'young comrades' to follow.[135] He is here objecting to the misappropriation of Hals by modern artists – especially by those with whom he had scant sympathy.

In 1878 the republican writer Eugène Véron, in his book *L'Esthétique*,[136] took a different view of Hals, praising him for the powerful originality of his work. Defining art as the 'direct and spontaneous manifestation of human personality',[137] he recommended Hals's style as a model for modern art (that is, art left to follow 'its own inspiration free from academic patronage').[138] The 'powerful individuality' of Hals's virtuoso brushwork and 'audacious handling' is seen as compensating for any alleged 'want of thought ... or poetic feeling':

Not only does he always put himself forward, never allowing himself to be forgotten for a moment, but we must also acknowledge that he does so with an amount of insistence and freedom which is a little brutal, and not without an appearance of excess which must scandalise over-fastidious purists. ... We prefer it greatly to that affectation of impersonal perfection which modesty extols. No other example ... shows so clearly the great importance of technical skill, especially of that part of it which is called handling. Indeed, chiefly through it, Franz [sic] Hals was a great painter; it is the principal and determinant cause of his fame.[139]

That Hals was prominently in the foreground of discussions on modern art can be further seen in an editorial article in 1883 in the influential Belgian art journal *L'Art Moderne*, entitled 'Le Modernisme de Frans Hals'.[140] Here Hals is hailed as an artist ahead of his time, whose works bear close affinities to 'the preoccupations which haunt the present generation of painters' and he is extravagantly praised as the most original, vibrant, moving, marvellous painter in the pantheon of great artists, whose aesthetic values, colour,

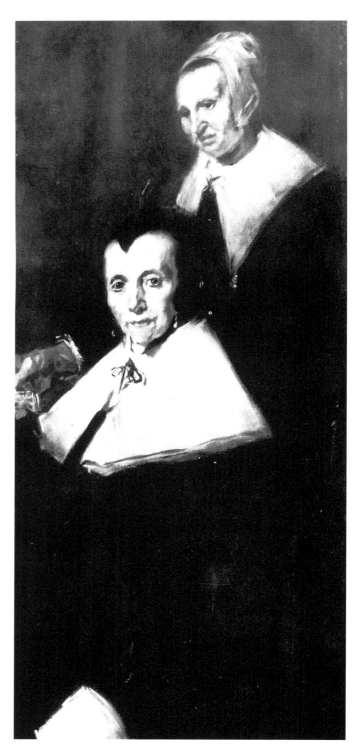

Fig. 10 John Singer Sargent, copies after figures from Hals's *Regentesses*, 1880
Birmingham, Birmingham Museum of Art, Gift of Mrs. Theodore Newhouse

Fig. 11 James Ensor, drawing after figures from Hals's *Regentesses*, 1883
Antwerp, Koninklijk Museum voor Schone Kunsten

composition and procedures belong essentially to the modern epoch.[141] In contrast to Fromentin, the lessons to be learned from Hals are located emphatically in his later works.

The exemplary modernity of the *Regents of St. Elizabeth's Hospital* of 1641 (cat. 54) is ascribed to its composition and handling, which sacrifices everything of subordinate interest to the overall impression of the 'vibrating' canvas.[142] The last group portraits of 1664 are eulogised as the full realisation of this modernity, two hundred years ahead of its time, for 'nothing in these two amazing compositions is related to the art of former times'.[143] Scornful of past opinions that viewed these late works as senile or incomplete, the writer describes the paintings in terms of harmonies of tones and colours, pictorial space, the simplified modelling of the faces and hands – the daring, bravura style embodying 'the aim and ideal of the young school' (here identified as the Franco-American School),[144] singling out, after the pre-eminent Manet, such artists as John Sargent, James Whistler and William Merritt Chase.[145]

John Singer Sargent initially turned to Hals in the formation of his own style, and later recommended Hals as a source of instruction to his students. His visit to Haarlem in 1880 was, according to his biographer Charteris,

... his first opportunity of studying Franz [sic] Hals in his native country and in the fulness of his power. The impression was never forgotten. Indeed, Hals henceforward has to be reckoned as one of the formative constituents in his art.[146]

On this first visit, Sargent 'expressed his excitement in a series of vivid copies' of early and late works by Hals, such as the copy (fig. 10) of the *Regentesses* (cat. 86).[147] Primarily interested in Hals as a stylist, Sargent attempted to emulate his virtuosity and skill in controlling tonal values.[148] In his teaching he extolled Hals's technical methods, later advising a student:

Begin with Franz [sic] Hals, copy and study Franz Hals, after that go to Madrid and copy Velasquez. Leave Velasquez until you have got all you can get out of Franz Hals.[149]

Discussing Sargent's own lessons from Hals, Ratcliff comments that

Hals came to be as important to him as Velasquez. A spearlike brushstroke that appears in his mature repertoire looks like a nineteenth-century reinvention of a similar device in Hals's painting.[150]

Artists of widely differing styles and ideologies seem to have been interested in Hals, and at different stages of their careers. Sargent's admiration was shared by other fashionable Edwardian portraitists, such as Boldini, Peploe and Yule.[151] On the other hand, the American artist Robert Henri, who adopted a dark-keyed palette and advocated spontaneous, rapid methods of painting, emulated Hals not only in his procedure, but also in the wide social range of his sitters and in the vehemence of his later style.[152] In a different vein, the response of the 23-year-old Belgian painter James Ensor, who visited Holland in 1883, may be seen in several powerful drawings (fig. 11) after the *Regentesses* (cat. 86) and *Regents* portraits.[153]

An artist who seems to have admired Hals over a long period was Whistler. Although it seems that, during the 1860s, Hals was invoked as a model,[154] the most vivid demonstration of his devotion comes from a glimpse of the dying Whistler paying his respects to the Dutch master on his last pilgrimage to Haarlem in the summer of 1902.[155]

According to his companion, the sight of Hals's works made him forget his ill-health, and he wandered down the line from the early to the late works, discussing them excitedly, envisaging Hals's relations with his sitters, how he organised the composition, how he 'divined the character'. In his enthusiasm he crept under the railing to get closer to the paintings, but was ordered back again. However, permission to view pictures from within the railing was later granted by the chief atten-

dant, who, impressed by the 'great painter' Whistler, even helped him onto a chair for a closer look.

> Now nothing could keep him away from the canvases, particularly the groups of old men and women got their full share of appreciation. ...
>
> From that moment there was no holding him back – he went absolutely into raptures over the old women – admiring everything – his exclamation of joy came out now at the top of his voice, now in the most tender, almost caressing whisper – 'Look at it – just look – look at the beautiful colour – the flesh – look at the white – that black – look how those ribbons are put in. O what a swell he was – can you see it all – and the character – how he realised it' – moving with his hand so near the picture as if he wanted to caress it in every detail – he screamed with joy, 'Oh I must touch it – just for the fun of it' – and he moved tenderly with his fingers, over the face of one of the old women.[156]

After analysing the picture, he turned with a 'fierce look in his eye' and exclaimed:

> They say he was a drunkard, a coarse fellow, don't you believe it. ... Just imagine a drunkard doing these beautiful things!
>
> Just look how tenderly this mouth is put in – you must see the portrait of himself and his wife at the Rijks Museum. He was a swagger fellow.[157]

The excitement proved too much for him and, fearing he would collapse, his companions took him back to the carriage, where he continued his reverent peroration on Hals.

Any discussion of Hals's importance to nineteenth-century painters must include his countryman, Vincent van Gogh, whose response to Hals is both documented in his letters and apparent in his works. Van Gogh consulted Hals's paintings for guidance on how to paint, on what to paint and on his own artistic identity, both as a Dutchman and as a modern painter. His belief in the relevance of Hals's works to his own was guided by the recent reconstructions of Hals, which emphasised both his authentic national character, his Dutchness, and his essential modernity. Van Gogh was familiar with, and admired, Bürger's writings on art.[158]

In October 1885 van Gogh visited Amsterdam from Nuenen – a trip made worthwhile by his first sight of Hals's *Company of Captain Reynier Reael* (cat. 43). He wrote to his brother:

> Did you ever notice that??? that alone – that one picture – is worth the trip to Amsterdam – especially for a colorist. There is a figure in it, the figure of the flag-bearer, in the extreme left corner, right against the frame – that figure is in gray, from top to toe, I shall call it pearl-gray – of a peculiar neutral tone, probably the result of orange and blue mixed in such a way that they neutralise each other – by varying the keynote,

making it somewhat lighter here, somewhat darker there, the whole figure is as if it were painted with one same gray. But the leather boots are of a different material than the leggings, which differ from the folds of the trousers which differ from the waistcoat – expressing a different material, differing in relation to colour, but all one family of gray. But just wait a moment!

> Now into that gray he brings blue and orange – and some white; the waistcoat has satin bows of a divine soft blue, sash and flag orange – a white collar. ...
>
> But that orange blanc blue fellow in the left corner ... I seldom saw a more divinely beautiful figure. It is unique.
>
> Delacroix would have raved about it, absolutely raved. I was literally rooted to the spot.[159]

Once back in Nuenen, van Gogh wrote to his brother about Hals's inspiring spontaneity:

> What struck me most on seeing the old Dutch pictures again is that most of them *were painted quickly*, that these great masters, such as a Frans Hals, a Rembrandt, a Ruysdael and so many others – dashed off a thing from the first stroke and did not retouch it so very much. ...
>
> ... and in Frans Hals, hands that lived, but were not finished in the sense they demand nowadays.
>
> And heads too – eyes, nose, mouth done with a single stroke of the brush without any retouching whatever. ...
>
> To paint in one rush, as much as possible in one rush. What joy to see such a Frans Hals, how different it is from those pictures – there are so many of them – where everything has been carefully smoothed down in the same way.[160]

Van Gogh marvels at Hals's colour effects and skilful ability to '*enlever*' with a few strokes of the brush, and determines to acquire the technique:

> I think a great lesson taught by the old Dutch masters is the following: to consider drawing and color one.[161]

Deeply involved in the critical issues of nineteenth-century art, van Gogh comments on Delacroix's affinities with these painters:

> In the museum I was thinking continually of Delacroix, why? Because standing before Hals, before Rembrandt, before Ruysdael and others, I was constantly reminded of the saying 'Lorsque Delacroix peint, c'est comme le lion qui dévore le morceau'.[162]

Van Gogh was preoccupied with Hals's colourism, and attempted to work out how he achieved his effects, such as the relation of contrast between the tone of the costume and the tone of the face. Thus he comments of the *Merry Drinker* (cat. 30) and the *Married Couple in a Garden* (cat. 12):

The *yellow* fellow, citron amorti, decidedly has dull violet in his mug. Well – the darker the costume, the lighter the face is sometimes – not accidentally – at least his portrait and that of his wife in the garden contain *two* blackish violets (blue-violet and reddish-violet) and plain black (yellow-black?). I repeat, reddish-violet and blue-violet, black and black, the three gloomiest things as it were; well, the faces are *very* fair, *extremely* fair, even for Hals.

Well, Frans Hals is a colorist *among colorists*, a colorist like Veronese, like Rubens, like Delacroix, like Velasquez.[163]

Van Gogh defends his own use of black, supporting his claim that black and white should not be considered 'forbidden fruit' by appealing to Hals's authority: 'Frans Hals has no less than twenty-seven blacks'.[164] The importance given to these technical procedures, the

Fig. 12 Vincent van Gogh, *Portrait of a Woman*, December 1885 Amsterdam, Rijksmuseum Vincent van Gogh, Vincent van Gogh Foundation

means whereby the subjects are realised and the expression of the artist's response to his subject, is reminiscent of Bürger's emphasis on communicability depending both on naturalistic subject matter and on its means of representation.

The changes in van Gogh's manner of painting after his move to Antwerp in 1885 – the more luminous palette, the short livelier brushwork which he used to convey his new urban subject matter – may be partly attributed to his careful attention to Hals's way of painting and to his example as a figure and portrait painter (fig. 12).[165] His letters from Antwerp specifically mention his admiration for Hals's *Fisher Boy* (cat. 34).[166] It has been convincingly argued that his increasing confidence in the application of lessons learnt from Hals (such as juxtaposed, fluid brushstrokes of unmixed colour, or the eschewal of preliminary drawing and tonal modelling), combined with the modern significance attributed to these procedures, partly enabled his subsequent assimilation of some of the aspects of Parisian vanguard painting.[167]

Van Gogh's guidance from Hals – the recently reconstructed Hals – is further implied in 1888 in his passionate advocacy of 'the painting of humanity, or rather of a whole republic, by the simple means of portraiture' as his overwhelming aspiration in his own art, for which the great Dutch painters – Hals and Rembrandt – provided the most inspiring examples. In a letter to Emile Bernard he invokes several paintings, many of which happen to be in the present exhibition:

Let's talk about Frans Hals. He never painted Christs, annunciations to the shepherds, angels, crucifixions or resurrections; he never painted nude, voluptuous and bestial women.

He did portraits, and nothing, nothing else.

Portraits of soldiers, gatherings of officers [cat. 43], portraits of magistrates assembled to debate the affairs of the republic, portraits of matrons with pink or yellow skins, wearing white caps and dressed in wool and black satin, discussing the budget of an orphanage or an almshouse [cat. 86]. He painted the drunken toper [cat. 30], an old fishwife in a mood of witchlike hilarity [cat. 37], the pretty gypsy whore [fig. 4], babies in their diapers, the dashing, self-indulgent nobleman with his mustache, top boots and spurs [cat. 51]. He painted himself, together with his wife, young, deeply in love, on a bench on a lawn, after the first wedding night [cat. 12]. He painted vagabonds and laughing urchins [cat. 16], he painted musicians and he painted a fat cook.

He does not know greater things than that; but it is certainly worth as much as Dante's Paradise and the Michelangelos and the Raphaels and even the Greeks. It is as beautiful as Zola, healthier as well as merrier, but as true to life, because his epoch was healthier and less dismal.[168]

Fig. 13 Vincent van Gogh, *Portrait of Postman Joseph Roulin*, August 1888
Boston, Museum of Fine Arts, Gift of Robert Treat Paine

great and universal master painter of portraits of the Dutch republic: Rembrandt, ... that broad-minded naturalistic man, as healthy as Hals himself. ... I am just trying to make you see the great simple thing: the painting of humanity, or rather of a whole republic, by the simple means of portraiture.[169]

Van Gogh aspired similarly to portray his own society for posterity, as expressed in the lines written to his sister: 'What impassions me most ... is the portrait, the modern portrait.'[170]

Van Gogh's portraits, such as his *Postman Roulin* (fig. 13), may be seen (in the context of his view of the significance of Hals's portraiture) as portrayals of modern man, and at the same time as acknowledgements of his continuing artistic debt to the great innovator of the Dutch School.[171] It is thus Hals's construed significance to contemporary art that enabled the critic Aurier, writing in 1890, paradoxically to stress van Gogh's essential modernity while at the same time claiming: 'He was well and truly Dutch, of the sublime lineage of Franz [sic] Hals'.[172]

It has been commented that each time an artist is influenced by an earlier artist he 'rewrites his art's history a little',[173] and it has also been argued that 'past work ... needs the productive work of understanding in order to be appropriated by the interpretive eye of the present'.[174] The history of Hals has, in this sense, been written countless times – but always in the light of current aesthetic and social values. Hals's revival in the nineteenth century was variously accomplished by artists, critics, historians and collectors, and reflected their own kinds of value which they found in his works. Twentieth-century interpretations of Hals (and Dutch art generally) constitute another chapter in the continuing relationship between Hals and his posthumous audiences, and question many of the assumptions of his earlier champions. They would nevertheless be gratified that Hals is still celebrated as one of the great masters of European art. This exhibition may surely be considered a tribute both to Frans Hals and to all his audiences who, in their different ways, have kept his works alive.

Comparing Hals to Rembrandt (also a 'painter of portraits') he praises these 'two brilliant Dutchmen, equal in value' who depicted 'this whole glorious republic' and continues insistently:

Hammer into your head that master Frans Hals, that painter of all kinds of portraits, of a whole gallant, live, immortal republic. Hammer into your head the no less

Notes

1. Boas 1950, p. 63. He also writes (p. 235) that 'a given work of art may in different periods have essentially different content – and therefore be admired for different, if not for contradictory, reasons. ... It would appear that works of art which "withstand the test of time" change their natures as the times change. The work of art becomes thus the locus of a new set of values determined by the preconceptions or the predominant interest of the new critic or observer.'

2. Some of the material for this essay can be found in my article on Thoré-Bürger's role in the revival of Frans Hals (Jowell 1974). Subsequent publications, such as Broos's review of Slive's monograph on Hals (Broos 1978-9), and Chu's essay on nineteenth-century visitors to the Frans Halsmuseum (Chu 1987), as well as my further researches on the subject, have also been taken into account. However, it is not possible within the confines of this essay to investigate ideological positions or hidden determinations of thought that may or may not explain the different responses of Hals's various posthumous audiences, as proposed by Hadjinicolaou in his article on methodological problems in recounting *la fortune critique* or the history of the appreciation of works of art (Hadjinicolaou 1977). I have nevertheless attempted to indicate some of the different aesthetic and social values that seem to have influenced viewers up to and including the revival of interest in Hals's works in the late nineteenth century.

3. See van der Tuin's pioneering study of attitudes towards the Dutch and Flemish old masters in French art criticism during the first half of the nineteenth century (van der Tuin 1948, esp. pp. 117-31). Occasional objections to Hals's low status simply prove the rule, such as Gault de Saint-Germain 1818, p. 281: 'This great portraitist ... seems to us to have been treated too coldly by historians. ... A good portrait by Hals does not need a name to interest us; it breathes with the suggestion of truth, *it is complete with soul and life*' ('Ce grand peintre de portraits, ... nous paraît avoir été loué trop froidement par les historiens. ... Un bon portrait de Hals n'a pas besoin de nom pour intéresser; il respire sous les nuances du vrai, *il est plein d'âme et de vie*'). On the interest in and influence of the Dutch civic guard and corporation group portraits in France, and the predominance of van der Helst and Rembrandt before the 1860s, see also Chu 1974; esp. ch. 4, pp. 49-61.

4. Attributed to van der Helst on its acquisition for the Liechtenstein Collection in 1821, it was correctly attributed by Waagen in 1866, and again by Bürger in 1868 (see cat. 17). In the pioneering nineteenth-century art-historical accounts of the Dutch School, van der Helst was given far greater prominence than Hals; see, for example, Kugler 1847, vol. 2, p. 421, where Hals is mentioned only in passing. The high esteem in which van der Helst was held was re-emphasised in the 1854 English edition of Kugler, where he is referred to as '[the] most celebrated of the Dutch portrait painters',

whose group portrait the *Company of Captain Roelof Bicker and Lieutenant Jan Michielsz Blaeuw*, was preferred even to Rembrandt's *Night Watch* (both formerly in Amsterdam Town Hall) by such authorities as Sir Joshua Reynolds; see Kugler 1854, pp. 247-8.

5. An inventory of the Louvre of 1815 included five works attributed to Hals which were assigned no monetary value at all; see van der Tuin 1948, Appendix 1, p. 188.

6. Smith 1829-37. Of the forty painters, three were French, four Flemish and thirty-three Dutch. Smith's catalogue formed the basis for all subsequent connoisseurship of Dutch paintings; see de Vries 1955, p. 162. It was superseded only by C. Hofstede de Groot's *Verzeichnis* (HdG), which is subtitled: 'Nach dem Muster von John Smith's Catalogue Raisonné'. Hals's works are listed in vol. 3.

7. The collection of lives of individual famous masters (arranged alphabetically or sometimes in schools), were the current literary form of the history of modern (i.e. post-Renaissance) art. Smith was presumably aware of, for example, the entries on Hals in Pilkington 1770, p. 282, and Bryan 1816, vol. 1, p. 521. These were taken from earlier sources: Houbraken 1718-21, Weyerman 1729-69 and Descamps 1753-63. An exception is Dezallier d'Argenville 1745-52, vol. 2, pp. 35, 190, in which Hals is referred to only in passing, as the teacher of Adriaen van Ostade and Brouwer.

8. Houbraken 1718-21, vol. 1, pp. 90-5. For the full translation of this important account see pp. 17-8 in the present catalogue.

9. See Kris & Kurz 1934, pp. 118-9. The story as recounted by Pliny in his *Natural History* describes how Apelles, wishing to acquaint himself with Protogenes' works, which he knew only by reputation, visited the artist at Rhodes. Finding Protogenes out of the studio, he left evidence of his visit by executing a drawing. On his return, Apelles, recognising the hand of Protogenes, attempted to better his performance, adding his handiwork to the panel as his signature. A subsequent rivalrous attempt by Protogenes seems to have ended the encounter – which appears to have taken place only on the panel.

10. With roots in the writings on art in classical antiquity, the justification and explanation of this stylistic distinction had become an important issue since the Renaissance. For a discussion of these ideas see Gombrich 1960, pp. 191-202.

11. See Gombrich 1960, pp. 195-6, for a translation of the passage from van Mander's didactic poem on the art of painting: 'And herewith, apprentices, I wanted to place before your eyes two perfect manners toward which you may now guide your path according to your bent, but I should still advise you to begin by applying yourselves to the neat manner, ... but whether you paint neat or rough, avoid too harsh highlights'. See also Broos 1978-9, pp. 121-3, on seventeenth-century commentaries on style that have relevance to Hals's works. Hals was first mentioned as a pupil of van Mander in 1618, see Hals doc. 25.

12. See Cornelis de Bie's comment (Hals

doc. 163), published in 1661, that Hals was 'a marvel at painting portraits or counterfeits which appear very rough and bold, nimbly touched and well composed, pleasing and ingenious, and when seen from a distance seem to lack nothing but life itself'.

13. Ultimately the two artists recognised as the leading proponents of the acceptable alternative styles were Van Dyck and Rembrandt – the latter, according to Houbraken, vol. 1, p. 259, justifying his lack of finish as the prerogative of his artistic license: 'and from this practice he would not be dissuaded, justifying himself by saying *that a work is complete if in it the master's intentions have been realized*' ('... en in zulk doen was hy niet te verzetten, nemende tot verantwoording *dat een stuk voldaan is als de meester zyn voornemen daar in bereikt heeft*'), quoted by Broos 1978-9, p. 123. For a recent interpretation of the significance of Rembrandt's use of the 'rough' manner, see Alpers 1988, pp. 14-20.

14. First published in 1871; see Hals doc. 190. On Scheitz's authority see Broos 1978-9, pp. 119-20.

15. The continuing issue of Hals's alleged profligacy and irregular morals consolidated a traditional image of the Bohemian artist; see Wittkower 1963, pp. 215-6, 228.

16. Descamps 1753-63, vol. 1, pp. 360-2: '... arrangea sa palette assez mal.' Cf. Pilkington 1770, p. 273: 'He painted in a beautiful manner, and gave his portraits a strong resemblance, a lively expression, and a true character. His colouring was extremely good, and natural; and he mixed his tints in a peculiar manner, so as to give a surprising force to his pictures, by the freedom and boldness of his pencil; it being professedly his opinion, that a master ought to conceal, as much as possible, the labour and exactness, required in portrait painting.'

17. Descamps 1753-63, p. 361: 'Abruti par le vin, il lui dit qu'il étoit heureux, et ne désiroit pas un meilleur sort que le sien.'

18. De Royer 1835, p. 433: '... la nuit, il la passait dans les orgies des tavernes les plus crapuleuses. Ce fut en imitant ses mœurs, plutôt que ses ouvrages, que les élèves de Hals devinrent des maîtres eux-mêmes.'

19. The explanation and defence of the special achievements of Dutch realism was an important part of this historiographic development. See Demetz 1963 for an interesting analysis of the different kinds of justification.

20. Houssaye 1846, vol. 2, pp. 82-7: 'Les peintres de cabaret et de kermesses.' Anon. 1847, pp. 11-2, mentions amongst Houssaye's sources such German scholars as Carl Schnaase, Heinrich Hotho and Franz Kugler. However, if Hals is mentioned at all by these authors, it is only in passing (see n. 4 above), and Houssaye relies on the traditional anecdotal accounts, to which he adds a few of his own embellishments. He was editor of the art magazine *L'Artiste* from 1844-9, during which time many articles were published on the seventeenth-century art of the Low Countries; see van der Tuin 1948, p. 22.

21. Houssaye 1846, vol. 2, p. 87: 'Peintres, musiciens et ivrognes, bohémiens dans l'art comme

dans la vie.'

22. Ibid., p. 142 : 'Cependant Hals, même dans les fumées du vin, n'oubliait pas qu'il était artiste et qu'il devait laisser un nom. "Je peins ... pour le nom de Hals. Le maître, et j'en suis un, dois cacher le travail servile du manœuvre avec les ressources de l'artiste".'

23. Unlike his pupil Brouwer, who succumbed at an early age; Houssaye 1846, p. 87.

24. Reynolds 1981, p. 109 : 'In the works of Frank Halls [sic], the portrait-painter may observe the composition of a face, the features well put together, as the painters express it; from whence proceeds that strong-marked character of individual nature, which is so remarkable in his portraits, and is not found in an equal degree in any other painter. If he had joined to this most difficult part of the art, a patience in finishing what he had so correctly planned, he might justly have claimed the place which van Dyck, all things considered, so justly holds as the first of portrait painters.'

25. Lebrun 1792-6, vol. 1, p. 71 : 'Ses productions se seraient vendues beaucoup plus cher s'il n'avait pas tant produit, ni peint si vite : car, pour qu'un tableau soit payé fort cher, il ne suffit pas qu'on aperçoive l'empreinte du génie, il faut encore qu'il soit fini; autrement, j'admets que ce qui a été fait vite se regarde et se paie de même. Avis aux artistes modernes, lorsqu'ils n'asseoient pas leurs réputations sur des ouvrages achevés et précieux d'étude.' This view accompanied the publication of an engraving after a variant of Hals's *Rommel Pot Player* (s.l.3-13 ; fig. 72). On Lebrun, see Haskell 1976, pp. 18-23.

26. Nieuwenhuys 1834, p. 131.

27. Ibid.

28. Fletcher 1901, pp. 52-3. The only other reference to a Hals painting in Reynolds's possession seems to be in the 1798 sale catalogue of his collection, which lists as no. 21, 'Franc [sic] Hals, *Portrait of a Lady*' (*A Catalogue of the Capital and genuine and valuable Collection of Pictures*, the Property of Sir Joshua Reynolds, London [H. Phillips], 8 May 1798; listed in Graves & Cronin 1901, pp. 1647-9). A *Portrait of a Lady*, once attributed to Hals in the collection of a 'Mr. Reynolds', but now attributed to Jacob Backer, is in the Museum in Kiev; see Sumowski 1983, p. 196. no. 25. An etching by Carel de Moor which represents the figure as a courtesan representing 'Touch' in a Five Senses series, is published in Slive 1970-4, vol. 1, p. 93, fig. 82. Although this seems an unlikely candidate for the painting that adorned Reynolds's study, there is at present no alternative.

29. Reynolds's view of 'the latitude which indistinctness gives to the imagination to assume almost what character or form it pleases' with regard to Gainsborough's 'unfinished manner' (see Gombrich 1960, p. 200) clearly did not apply to Hals's boldly brushed, emphatic characterisations of his individual sitters.

30. For example, Paillot de Montabert 1829 refers to bold brushwork with contempt ('*Touche*', vol. 8, ch. 525, p. 115), and to improvisation with the brush directly on the canvas as an impetuous and rough procedure ('*Procédés materiels*', vol. 9, ch. 569, p. 38).

31. See Hals doc. 116, and van Eynden & van der Willigen 1816, vol. 1, pp. 374-6.

32. Van Eynden & van der Willigen 1816, Supplement, pp. 142-3 : 'Hij was een man van een opgeruimd humeur en algemeen bemind.' An illustrious genealogy of the Hals family is optimistically cited (subsequently disproved), together with Hals's membership of the Guild of St. Luke of Haarlem in 1644.

33. Immerzeel 1842-3, vol. 2, pp. 10-1.

34. Waagen 1854, vol. 2, p. 4. Thus Rubens is here given some credit for the subsequent development of the Dutch School (cf. n. 95 below).

35. Originally published as separate instalments (for Hals, see *Bibliographie de la France* XVII [1858], no. 2801), they were subsequently republished in national schools with introductory essays. See Blanc 1862 for the volumes on Dutch art.

36. Nor did he in this project, for he was excluded from the volumes on Dutch art and, owing to his birthplace, was included in the volume on the Flemish School in 1864 as the last great Flemish portraitist. Brief attempts to establish his Dutch origins had to be abandoned in the face of later evidence that his birthplace was Antwerp, although in 1914 it was believed to be Mechelen. The continuing attempts to establish Hals's correct birthplace prompted the comment that 'race is an enormous factor in the development of every artist'; Bode & Binder 1914, p. 10.

37. Thoré (1807-69) had been a prominent republican journalist and art critic during the July Monarchy (see Grate 1959 for a thorough account of his earlier art criticism). His lifelong interest in the art of the past also dates from these years (see Jowell 1977). Initially an enthusiastic participant in the 1848 revolution, 'le citoyen Thoré' founded and edited the daily newspaper *La Vraie République*. Unsuccessful as a socialist candidate, and increasingly militant in his support of radical left-wing factions of the revolution, he was forced to flee abroad in June 1849. During his peripatetic exile (1849-59), he abandoned political journalism and returned to writing about art. In 1855 he adopted the pseudonym W. Bürger (chosen for its suggestion of supra-national citizenship) so that his proscribed writings could be published in France. After the amnesty of 1859 he returned to France, but retained his pseudonym until his death.

38. There is considerable literature on this aspect of his work; see, among others, Heppner 1937, Meltzoff 1942, Jowell 1974, Jowell 1977, Haskell 1976, pp. 85-90, and Rosen & Zerner 1974, pp. 192-202.

39. Initially published as a series of articles for the Parisian newspaper *Le Siècle*, it was republished as *Trésors d'art en Angleterre*, Paris 1857, with later editions in 1860 and 1865. References in this essay are to the second edition, Bürger 1860. *Trésors* was widely reviewed. On the exhibition, see Haskell 1976, pp. 98-9.

40. Bürger 1860, pp. 242-3 : '... est à Rembrandt ce qu'est le Tintoret au Titien.'

41. Such as Manchester 1857, p. 217 : 'scholar of Carl [sic] van Mander. Very distinguished as a portrait painter, but of dissipated habits. Van

Dyck had a high opinion of his talents.'

42. Bürger 1860, pp. 243-4 ; The other *Portrait of a Man*, of 1639 (s130), had a lively exhibition future ahead of it, appearing at the Royal Academy Winter Exhibitions in 1879 and 1888, and at the Guildhall in 1892. In 1888, in the company of the *Laughing Cavalier*, it was singled out by the reviewer in *The Times* of 7 January 1888 (p. 12a) as 'the solemn gentleman in black ... of the dignified type which Hals painted with so much mastery and style [which] many will prefer ... to the more showy effect presented by the Cavalier'. It was recently sold at auction for £680,000, London (Sotheby's), 7 December 1988, no. 96.

43. He had visited Holland in 1856 in an attempt to reforge a new career. Exploring the Dutch collections he found them to be neglected, and also noticed that there was very little written on Dutch painting in French. He wrote to a friend : 'Ah, si la Hollande voulait me faire faire les catalogues de ses musées ! ... Il n'y a point de catalogues, que notes insignifiantes, et pour tant de trésors ! Ils ne connaissent point du tout eux-mêmes leurs maîtres, ni les œuvres les plus célèbres de leurs maîtres'; letter from Thoré to Delhasse, 20 October 1856, reprinted in Cottin 1900, p. 160.

44. Bürger 1858, pp. 58-9 : 'Ils sont assis sous de grands arbres ; lui, à gauche, la tête de face, un peu renversée en arrière et souriante, encadrée dans un chapeau noir à grands bords. Il porte moustache et barbiche ; son costume de soie est tout noir, et sa main droite, gantée de blanc, est nonchalamment glissée dans le pourpoint contre la poitrine. Près de lui, sa femme en jupon noir, corsage puce, avec une grande fraise. Elle met sa main droite sur l'épaule de son mari, par un geste d'affection badine. Sa physionomie est très vivante et très gaie : bonne commère pour ce diable d'homme dont on raconte tant de brutalités ; il a pourtant l'air d'un vrai gentleman, très distingué et très spirituel et très fier. ... On sent partout le maître qui couvre une grande toile en se jouant, et dans les têtes la finesse expressive d'un portraitiste consommé.'

45. Ibid., p. 59.

46. Bürger 1860b, p. 13 : 'Il a tant peint ! il peignait si vite – et si bien ! Il n'y a pas la moindre peinture de lui qui ne soit attirante pour les artistes et qui ne leur offre des enseignements. De lui, tout est instructif, ses défauts autant que ses qualités ; car ses défauts sont toujours d'un grand praticien. Dans ses brusqueries exagérées, dans ses contrastes hasardés, dans ses négligences trop sans façon, il y a toujours la main d'un peintre généreusement doué, et même le signe d'un certain génie, assez superficiel il est vrai, et provoqué par l'aspect extérieur des choses, par le mouvement, la tournure, la couleur, l'effet, par ce qui remue et brille, plus que par les caractères secrets et intimes de la vie, – assez vulgaire même, si l'on peut parler ainsi du génie, – mais franc et brave, irrésistible comme l'instinct.'

47. Ibid., pp. 13-4 : '... un jeune homme ... sa main battant la mesure ; pensez que cette main en l'air est prestement peinte ! La figure s'enlève en lumière sur un fond clair. Vive étude, sabrée

de premier coup, – il n'en fait jamais d'autres. Tous ses coups de brosse marquent, lancés justement et spirituellement où il faut. On dirait que Frans Hals peignait comme on fait de l'escrime et qu'il faisait fouetter son pinceau comme un fleuret. Oh! l'adroit bretteur, bien amusant à voir dans ses belles passes! Parfois un peu téméraire sans doute, mais aussi savant qu'il est hardi.'

48. Some of the issues relating to finish – such as the status of the sketch and the notion of spontaneity – are discussed in Boime 1871. Boime traces the shift of emphasis from the executive refining phase to the generative spontaneous phase of painting procedure. For a further discussion see Shiff 1984, pp.70-5.

Thoré-Bürger's participation in issues relating to finish can be traced throughout his writings: for example, in 1863, discussing the *Salon des Refusés*, he denigrates the careful linear definition and detailed finish of so-called academic and official art, preferring the modern tendency among the independent naturalist painters to convey the immediate unity of '*l'effet*'. Referring to his own participation in earlier, similar critical debates, he reminds his readers that many of the greatest artists of the nineteenth century, such as Delacroix, Diaz and Corot, had been rebuked for lacking finish, and he warns that broadly painted works are often misguidedly regarded as sketches (see Bürger 1870, vol.1, p.414). A few years later, in his review of the Salon of 1868 (ibid., vol.2, p.514), Bürger specifically praises Jongkind for his 'spontaneous painting, quickly experienced, and rendered with originality', adding that he had always maintained that 'the best painters had always painted very quickly and impressionistically', citing, among others, Frans Hals ('La manière de M. Jongkind ne plait pas à tout le monde, mais elle enthousiasme les amateurs de peinture spontanée, vivement sentie et rendue avec originalité. Pour moi, j'ai adopté M. Jongkind comme un artiste de franche race et qui contraste par son excentricité avec les patients tricoteurs d'images longement ruminées').

For a further discussion of the meanings of the 'licked' or finished surface of academic or official art, and the opposing emphasis on the materiality of the paint in the work of Courbet and the Impressionists, and of Thoré's understanding of 'the relationship between realistic art and the artificiality of the means of representation' see the essay 'The Ideology of the Licked Surface: Official Art', Rosen & Zerner 1974, pp.221-9. See also Wagner 1981.

49. Bürger 1860a, p.121.

50. Ibid., p.122: 'Tenez que c'est un des chefs-d'œuvre de la haute école hollandaise. Une maestria incomparable, un dessin accusé, solide, grandiose et libre. ... Il connaît la peinture de Rembrandt alors, et cette jeune concurrence sans doute l'a poussé à une couleur plus profonde, à une expression plus intime des physionomies, à un effet plus harmonieux et plus tranquille, tout en conservant la brusquerie énergique de l'exécution.' He adds that a special study is needed to appreciate this master, who is known outside Holland only by isolated portraits.

51. The museum was first established in the Town Hall and brought together all the paintings owned by the city. The present location of the Frans Halsmuseum, in the former Old Mens' Almshouse, dates from 1913.

52. See Chu 1987. This interesting essay on 'Nineteenth-Century Visitors to the Frans Hals Museum', emphasises that the establishment of the museum in Haarlem (not yet called the Frans Halsmuseum, it should be noted), was a crucial contributory factor in the revival of Hals. Chu publishes lists of artists, critics and historians who signed the visitors' book at the museum, proving the international range of interest in Hals's works, and analyses a broadly changing pattern in the history of the reception of Hals to the end of the nineteenth century. The different stages are roughly divided into decades, and the impact of Hals on a few selected artists – both as a source of instruction or as a stylistic 'influence' in their works – is described (see n.107 below).

53. Bürger 1868.

54. Mantz 1868: '... he courageously celebrated the boldness of the growing [new] school, he believed in the insulted Delacroix, in the unknown Decamps, in the forbidden Rousseau' ('il célébrait courageusement les hardiesses de l'école grandissante, il croyait à Delacroix insulté, à Decamps méconnu, à Rousseau proscrit'). See also Sensier's reference to him as 'la vigie clairvoyante de 1830', Sensier 1873, preface.

55. Then in the Pereire Collection, which he had helped form. Bürger's entrepreneurial activities on the art market should not be overlooked; he bought, sold and 'placed' paintings, and also advised prominent collectors such as Suermondt and Double.

56. Bürger 1864, p.299: 'Elle est fraîche comme une belle pomme encore attachée à la branche. C'est la santé dans toute son exubérance. Quelque chose de la paysanne, dont le teint s'enfleurit au grand air. Les gens du monde ne doivent pas la trouver très élégante, mais ça se porte bien, et c'est franc du cœur comme du corps.

Les deux mains unies ensemble sont merveilleuses. ... On ne sait trop comment c'est fait, par quelques touches hardies qui accusent juste la forme et le mouvement.'

57. Ibid., pp.299-301: '... à cause de leur naturel et leur sincérité. ... où il faut, et comme il faut.'

58. Article in the *Times Literary Supplement*, 30 July 1914. A contemporary French account of the sale expressed astonishment at the sum reached by the rival bidders, and referred to the embarrassment of Rothschild's agent, who had been given an 'unlimited mandate' ('une commission illimitée'). The writer adds that 'Frans Hals is one of the greatest masters of all schools, and this portrait has a captivating boldness, but never has a portrait by Hals ever exceeded a few thousand francs' ('Frans Hals est un des plus grands maîtres de toutes les écoles, et ce portrait était d'une franchise entrainante; mais jamais portrait de Hals, en buste, n'avait dépassé quelques mille francs'); Dax 1865, p.188.

59. After a few opportunities for public viewing in Paris, Hertford's *Cavalier* was brought to England, where it seems to have acquired its popular title while on public view from June 1872 to April 1875 at the newly established museum at Bethnal Green, before being put on permanent display in its present location, the Wallace Collection in Manchester Square. It has apparently always been the most popular and most frequently reproduced painting in the collection, and is even on view (in the museum poster) from the pavement outside (fig.3).

Its fame has been exploited in the most unlikely places. See, for example, his invocation as the ancestor of the Scarlet Pimpernel: 'I myself had known long ago, that the Laughing Cavalier who sat to Frans Hals for his portrait in 1624 was the direct ancestor of Sir Percy Blakeney, known to history as the Scarlet Pimpernel'; Baroness Orczy, *The Laughing Cavalier*, London 1913, p.xi. Orczy's fanciful reconstructions of the relationship between Hals and the sitter, their interminable conversations, the painting in progress, and so on, extends to the history of the painting's subsequent fortunes: 'And yet countless millions must during the past three centuries have stood before his picture; we of the present generation, who are the proud possessors of that picture now, have looked on him many a time, always with sheer, pure joy in our hearts, our lips smiling, our eyes sparkling in response to his; almost forgetting the genius of the artist who portrayed him in the very realism of the personality which literally seems to breathe and palpitate and certainly to laugh at us out of the canvas.

Those twinkling eyes! how well we know them! that laugh! we can almost hear it; as for the swagger, the devil-may-care arrogance, do we not condone it, seeing that it has its mainspring behind a fine straight brow whose noble, sweeping lines betray an undercurrent of dignity and of thought' (p.x).

In 1937 a musical by Arkell and Byrne offered an elaborate explanation of his smirk (I am indebted to John Ingamells for these literary and musical references).

Commercial exploitation has resulted in the *Cavalier*'s ubiquitous appearance on chocolate boxes, board games and jigsaw puzzles.

The earliest reference I have been able to find to the 'Cavalier' part of its modern popular title is in Decamps 1873, p.175: 'A Londres, chez Sir Richard Wallace, le célèbre *Cavalier* de la galerie Pourtalès'. I have not yet been able to trace the first mention of his assumed (and exaggerated) jubilance, but I suspect it dates from the painting's first public exhibition in England.

60. Sale Baron van Brienen van de Grootelindt of Amsterdam, Paris, 8 May 1865, to Baron James de Rothschild for 35,000 frs. See cat.51, fig.51c.

61. This widely reviewed major exhibition of old masters from private collections in Paris (Paris, Palais des Champs-Elysées, *Exposition Rétrospective. Tableaux anciens empruntés aux galeries particulières*, 1866) was intended to exert a beneficial influence on contemporary painters, and at the same time improve public taste. It gave the public one of the first opportunities of seeing the latest fashions among collec-

tors and included – perhaps most significantly – several works by Vermeer.

62. Bürger 1867, p. 548: 'Qu'un des plus vaillants portraitistes du monde, que Frans Hals reprenne sa place légitime.' This comment was made à propos the Comte Mniszech, who possessed a dozen works then attributed to Hals, eight of which are presently identifiable (see S22, S38, S39, S94, S96, S149, S150 and S.L3-4). Bürger mentions others owned by collectors like La Caze (fig. 4; S62, and cat. 72; S171), Hertford (fig. 3 and pl. 1; S30), Rothschild (see n. 60 above), Oudry, who possessed several (cat. 34, 35, 36, 81; for reference to others see cat. 34) and Double (S.D51).

63. G.F. Waagen, who credited Bürger with 'laying the foundation for a history of this great [Dutch] school which may claim the meed of scientific value', now gave Hals greater prominence in his revised version of Kugler's *Handbook*, Waagen 1860, vol. 1, p. xv: 'Frans Hals was obviously the model which the great Dutch school directly or indirectly followed, and he thus assumes a significance in the history of art which has never been sufficiently acknowledged.' Waagen nevertheless expressed reservations reminiscent of earlier critics: 'His pictures also are of very unequal merit. The astonishing facility of his brush often tempted him into too broad and decorative a breadth and slightness of handling. ... [The] condition in which his mode of life invariably placed on him, could not fail to act strongly upon him' (ibid., vol. 2, p. 330). In 1863 the distinguished Dutch scholar C. Vosmaer acknowledged Bürger's pioneering researches, and agreed with his view of Hals as the most important precursor of Rembrandt in the formation of the independent seventeenth-century Dutch School: 'Heureusement il n'a pas été chercher en Italie ce qu'on ne trouve qu'en soi-même. Il est resté original et naturel, et il appartient par là à ce groupe d'artistes nationaux, qui ont imprimé à l'art Hollandais son caractère, sa physionomie spéciale.' Vosmaer praises Hals's broad, bold brushwork and his consummate mastery in terms reminiscent of Bürger; see Vosmaer 1863, pp. 84-7.

64. Guide Joanne (precursor to the Blue Guide series): du Pays 1862, pp. 215-6. Bürger's *Musées* are recommended as indispensable to the amateur (p. xix). Despite du Pays's frequent quotations of Bürger (see pp. cvii, 177, 217, 223); he inexplicably leaves Hals out of his chronological list of Dutch masters.

65. Louis Dubois' signature is found in the museum visitors' book under 1866 and 1868, but he must have been there earlier, for he made a number of full-scale copies after Hals's work, those of the *Regents* and *Regentesses* being particularly well-known in the nineteenth century (present whereabouts unknown); see Chu 1984, p. 55, and Chu 1987, pp. 115-6. It is not known which of Dubois's copies was seen by Fantin, but it has been suggested that the most likely candidate was a copy of the 1627 *Banquet of the Officers of the St. Hadrian Civic Guard* (S45; see Levy-van Halm & Abraham, fig. 1). See Chu 1974, pp. 55-6 and Fantin-Latour 1982-3, p. 198. Chu points out that Fantin con-

tinued Courbet's revival of the Dutch group portrait tradition, producing five large compositions between 1864 and 1886, although he did not travel to Holland until 1875.

66. Pennell 1930, p. 117. Pennell is presumably referring to the project for a group studio portrait that was never realised beyond two sketches; see Young *et al.* 1980, pp. 36-7, nos. 62 and 63.

67. 'La réputation de ce maître devra beaucoup à l'école moderne qu'il prise singulièrement et lui fait partout fête comme à un inspirateur. La vérité est qu'il représente un côté d'étude sain et fortifiant, qu'il ne ment point à sa vision, et que c'est le moment ou jamais de suivre les voies sincères si l'on veut que le domaine de l'art français se fortifie pour s'agrandir'; 'Trésors d'art de Paris: Exposition Rétrospective, Portraits,' *L'Etendard*, 23 July 1866, quoted in Flescher 1973, p. 299 (translated for the present essay).

68. 'Duelliste de la brosse, ... qui maçonne, qui sculpte, – qui donne à la pâte la palpitation de la chair'; 'Salon de 1868: Les Portraits', *L'Etendard*, 29 July 1868; quoted in Flescher 1973, p. 299.

69. Bürger 1868.

70. See n. 44 above.

71. Bürger 1868, p. 226: 'Frans Hals peignait si facilement qu'il n'avait pas besoin d'études pour être sûr d'exprimer la nature, au premier jet de sa brosse adroite et colorée.'

72. Second only to Rembrandt's *Night Watch*. Cf. n. 4 above.

73. Bürger frequently resorts to comparisons with other 'great masters' in his efforts to introduce his particular hero-artists to the traditionally accepted Pantheon.

74. Bürger 1868, pp. 436-7: 'Au commencement, on peut dire qu'il peignait d'or – ne dit-on parler d'or? – qu'une lumière blonde scintillait partout en paillettes éblouissantes, qu'il éparpillait même trop la magie de sa couleur.'

75. Ibid., p. 444: '... les tons d'or avec la sauvagerie de la première manière: un chef d'œuvre improvisé en quelques heures de vive lumière et de bonne humeur.' This painting, and the *Portrait of a Woman* (cat. 72) were bequeathed to the Louvre by La Caze in 1869. They were the first authentic Halses acquired by the Louvre. The critic Paul Mantz hailed the *Gipsy Girl* as a masterpiece of a great painter, adding that no one had ever painted better than Hals: '... ici il a la distinction du ton, la note exquise et rare, et une liberté de pinceau qui, dans son allure endiablée, dit toujours le mot décisif' (Mantz 1870, p. 396). Henri Rochefort's recollection of La Caze's discovery of Hals in Rochefort 1886, vol. 1, pp. 116-8, is cited in Haskell 1976, p. 77, n. 32.; for further reference to Rochefort, see cat. 34 and cat. 72.

76. Bürger 1868, p. 443. '... ce forcené s'est peut-être le plus abandonné à sa *furia* de génie. ... En effet, dans cette peinture et dans quelques autres, Frans Hals, par la violence de la touche et l'étrangeté du ton, surprend le regard, comme tous les maîtres impétueux et coloristes, Gréco, Herrera, Goya.' This painting had been first seen by Bürger at the Hoorn sale, and was acquired by his friend and patron Suermondt in

1867. Bürger discussed the painting further in an article on the Suermondt Collection (Bürger 1869) and pronounced it superior to works by celebrated masters such as Rembrandt or Velázquez in its animation.

77. Bürger 1868, p. 437.

78. Ibid., p. 438: 'Je ne connais pas de tableaux exécutés avec une pareille fougue, ni dans l'œuvre de Hals lui-même, ni dans l'œuvre de Rembrandt, ni dans l'œuvre de Rubens, ni dans l'œuvre de Greco ou n'importe quel brosseur des plus enragés. Les figures, de grandeur naturelle, modelées par des touches larges et flamboyantes, saillissent en relief hors des cadres. C'est superbe et presque effrayant.'

79. Ibid.: 'J'ai l'idée que le vieux lion vaincu par l'indigence, était dès lors retiré – emprisonné – dans ce refuge des vieillards, et que c'est là qu'il mourut plus tard.' Bürger abstains from further discussion of the regents. For the apparent, but unjustifiable amenability of these portraits to character projection, see Vinken & de Jongh 1963. Skirmishes concerning readings of Hals's relationship with his patrons from the portraits nevertheless continue; see Berger 1972 for the view that art-historical inhibitions from empathic personal response to these represented figures are evasive strategies of 'mystification'. Also Nash 1972, in response to Berger's original essay (Berger 1972a).

80. The young German scholar, Wilhelm Bode, who later wrote in *Mein Leben* that he knew Bürger's writings 'almost by heart' (quoted in Heppner 1937, p. 27), devoted his doctoral dissertation to Frans Hals and his school (Bode 1871). His work on Hals was indebted to Bürger's researches and interpretation. See also n. 63 above on Vosmaer.

81. The increasing numbers of visitors can be gauged from the visitors' register; see Chu 1987, pp. 132-41.

82. The regularity with which Hals was included in the Winter Exhibitions at the Royal Academy, London, from 1871 on is documented in Graves 1913. Works by Hals were prominent in exhibitions of old masters, as in Munich at the International Exhibition of 1869, and in Brussels at the Exposition Rétrospective in 1873.

In 1871 the Metropolitan Museum in New York was the first American museum to acquire a painting then attributed to Hals, a variant of *Malle Babbe* (fig. 37c; S.D34). Although the *Portrait of Descartes* was formerly attributed to Hals, as we have seen (n. 75), the first authentic pictures to enter the Louvre came with the La Caze Bequest in 1869 (fig. 4; S62; and cat. 72). The subsequent acquisition of the Beresteyn portraits in 1883 (cat. 6, 7) was discussed at length and with great pride by Georges Lafenestre in Lafenestre 1885.

The National Gallery in London purchased its first Hals painting in 1876, the *Portrait of a Woman* (S131).

By the time Bode and Binder published their catalogue raisonné in 1914, Hals was safely established as 'one of the two or three most fashionable among the Old Masters', both in Europe and in America. The *Times Literary Supplement*, 30 July 1914, reviewing Bode & Binder 1914, regretted the departure to America

of many of the finest examples, 'though the museums of Europe and the great houses of England still hold their own'. A few years earlier Bode had commented confidently: 'Today his name stands, together with Rembrandt's, at the head of Dutch painting, and his works command as high prices as the pictures of Rembrandt, Velázquez or Titian'; Bode 1967, p.33.

83. On one level, Bürger's scholarly connoisseurship involved the scrutiny of signatures, dates, archival material and a close study of paintings. He hoped thereby to establish a corpus of works securely attributable to each artist – material for a new 'scientific' art history – which would result in a comprehensive body of objectively verifiable information about the art of the past, a complete inventory of European art. His expertise and pioneering catalogues were most immediately consequential for the art market and for later art historians, despite his optimistic claim that his scholarship would contribute to the fraternal future of mankind of the new positivist era. However, despite his assiduous archival researches and careful examination of paintings, his catalogues were not merely descriptive inventories: they expressed his partial critical judgements, his tendentious views of history, and, most important for the purposes of this essay, his particular championship of Dutch 'naturalism' of the seventeenth century.

84. Bürger 1868, p.436, referring to such paintings as Veronese's *Noces de Cana* (Paris, Louvre): 'If only this Hals from the museum of Haarlem and the one from the Amsterdam Town Hall [cat.43] were in the Louvre, in the Salon Carré, challenging the two masterpieces of Veronese, perhaps French critics would eventually deign to attribute to Dutch masters the same eminence as to Italian artists' ('Pourquoi donc ces assemblées de franc-tireurs hollandais ne seraient-elles pas du grand art aussi bien que les banquets de personnages en costume vénitien, représentations fantaisistes des *Noces de Cana*? ... Si ce Hals du musée de Haarlem et celui de l'hôtel de ville d'Amsterdam étaient au Louvre, dans le Salon Carré, pour affronter les deux chefs d'œuvre de Paul Véronèse, peut-être que la critique française daignerait enfin admettre les maîtres hollandais à la même hauteur que les artistes italiens. ... En conscience, ces prédilections exclusives, qui reposent sur la prétendue noblesse des sujets, ne signifient rien').

85. Ibid.: 'Ces tableaux hollandais représentant la vie contemporaine des artistes font songer aussi très naturellement à l'art de notre époque. ... Qui empêche de faire un chef d'œuvre avec une assemblée de diplomates assis autour d'une table. ... Avec un orateur à la tribune des députés, un professeur au milieu de la jeunesse; avec une scène des courses, une sortie de l'opéra, une promenade aux Champs-Elysées; ou simplement avec des hommes qui travaillent à n'importe quoi, des femmes qui s'amusent à n'importe quoi?'

86. In his earlier writings of the 1840s, Thoré praised Dutch art for its exemplary independence from the Italianate tradition, its originali-

ty, its representation of all classes of society, its avoidance of esoteric iconographical traditions, its technical excellence and its poetic elevation of traditionally lower-ranking subject matter. See Jowell 1977, ch.7.

87. Bürger refers his readers to a passage in van Westrheene's recent monograph (van Westrheene 1855, pp.7-19), in which the author objects to the usual lack of distinction between Flemish and Dutch art as a historical and artistic heresy, since Dutch artists, in their individual styles, reflected their unique freedom from the domination of Church and monarchy. Bürger's description of the independence of Dutch culture extends to the physical, geographical conditions of Holland: the necessity of creating and recreating the very soil they stood on out of the low-lying marshes and polders resembling the creation of their new nationhood, the new moral and intellectual world of their recently won liberty. Bürger and van Westrheene were here alluding to an established historiographical tradition, the association of geographical, political and artistic creativity found in the writings of such authors as Schnaase, Hegel and Kugler, Bürger was probably familiar with Hegel's lectures on the philosophy of art, which, delivered at the University of Berlin during the 1820s, were translated into French in the 1840s. See Hegel 1840, esp. vol.2, p.146 (cf. Jowell 1974 p.115); also Demetz 1963, p.112, on the radical secularisation and politicisation on the part of French republican intellectuals of Hegel's and Hotho's idealist, abstract definitions of independent man.

88. Bürger 1860a, p.xiv: '... de rudes marins, de braves arquebusiers, des bourgmestres sans façon, d'honnêtes et gais travailleurs, la foule, tout le monde, en un pays d'égalité.'

89. His lifelong belief in the future fraternity of mankind – which stemmed from his early Saint-Simonian beliefs – seems to have been undaunted by political setbacks. His active political attempts to achieve change by political action was replaced from c.1855 by his return to believing in an inevitable idealist historical development – to which end he claimed to dedicate his writings on art. On Thoré's early Saint-Simonian ideas, see Jowell 1977, chs.1 and 2.

90. Thoré 1868, p.xviii: 'Il n'y a plus qu'une race et qu'un peuple, il n'y a plus qu'une religion et qu'un symbole:- l'Humanité!' He expressed these ideas in a tract 'Nouvelles tendances de l'art', which although probably written in 1857 was first published in 1862 (Bürger 1862), and again, more prominently, as the introduction to Thoré 1868. Many of the ideas were also included in the third review of his first Salon (1861) after his return from exile (Bürger 1861).

91. Bürger 1862, p.xl: 'Then the fine arts ... would become a means for the communication and exchange of ideas, a common language available to all' ('Alors les beaux-arts ... deviendraient une monnaie courante pour la transmission et l'échange des sentiments, une langue usuelle à la portée de tous'). The slogan '*l'art pour l'homme*' was first used in his Salon review of 1845, and derives its significance from the philosophy 'L'Humanité' of Pierre Leroux.

See Jowell 1977.

92. Bürger 1860a, p.xiii. To illustrate his point Bürger devised the monogram ᴙR – entitled Janus – to represent the juxtaposition of Raphael and Rembrandt, one relating to the past, viewing humanity in abstraction through pagan and Christian symbols, the other relating to the future, viewing humanity through his own eyes (ibid., p.x).

93. Bürger 1861, pp.254-5: '... et la Hollande, qui avait eu le courage de secouer tout joug religieux et politique, se sentant plus à l'aise qu'aucun autre peuple, enfanta l'école la plus délibérée, la plus originale, la plus variée, la plus révolutionnaire, la plus naturelle et la plus humaine à la fois; c'est assurément celle qui est le plus dégagée du passé, qui adhère le plus à la nature, et qui par là signale le mieux une des tendances de l'art à venir.'

94. Ibid., p.256: 'C'est pourquoi nous-mêmes, disons-le en passant, nous nous sommes consacré avec une passion exclusive à l'éclaircissement d'une de ces écoles, de celle qui nous semble la plus singulière et la plus instructive pour les novateurs.'

95. Earlier comparisons with Van Dyck or Rubens, or Hals's association with the Flemish School as a result of his possible birthplace, become irrelevant.

96. Bürger 1858, p.132: 'To reality observed conscientiously with a kind of calm passion, they add an interpretation acutely experienced from that same contact with nature. They animate outside appearances with the inspiration of their own originality' ('A la réalite consciencieusement observée avec une sorte de passion placide, ils ajoutent une interprétation vivement sentie au contact même de la nature. Ils animent la vie extérieure au feu de leur propre originalité'). Bürger and his contemporaries were, of course, unaware of allegorical meanings which have since become an issue in twentieth-century interpretations of the iconography of seventeenth-century Dutch art; nor were they alert to the limitations of perceptual 'schema' in the pictorial representation of even the most naturalistic-seeming scenes.

97. Thoré's earlier art criticism of the 1830s and 1840s attributed particular communicability to such stylistic qualities as unity of '*l'effet*' and '*l'ensemble*', particularly as achieved through colourism and chiaroscuro – terms derived from the traditional language of art criticism and theory, as in the writings of Roger de Piles (see Puttfarken 1985). Thoré, however, politicised these pictorial qualities in his writings, associating them with his general notion of progress (in art and society) and thus as means to an ideal social unity to which he aspired. His support of Delacroix, Rousseau, Decamps, Diaz (and, conversely, his opposition to Ingres and his contempt for Delaroche) was partly based on this tendentious interpretation of style and technique.

98. Bürger 1858, p.80: '... inhérente à leur pays de libre examen, où les imaginations, comme les esprits et les consciences, ont une indépendance absolue, ...'

99. Mantz 1884, reprinted as 'The Works of Manet' in Courthion & Cailler 1960, pp. 167-

76, esp. p. 170.

100. Unger & Vosmaer 1873-4. The etchings were also published with French, German and English translations of Vosmaer's text. Except for the quotation from the editor, Sijthoff, I have used the English edition.

101. See the prospectus bound into several first editions of the portfolio: 'oorspronkelijke geesten, ... nieuwe, scherpzinnige studien, ... de vereering van HALS' genie aan Europa predikte'. Sijthoff emphasises that although Hals has never been forgotten in Holland, the general public is not familiar with his works, and that in other parts of Europe he is known only through isolated portraits. A booklet bound into the Dutch edition at the British Library reprints the enthusiastic reviews of the first edition of the ten plates (1873) in newspapers and art journals from several European centres.

102. Unger & Vosmaer 1873-4, p. 34.

103. Ibid., p. 2. Changing attitudes towards Hals's portraiture could also be examined in the light of changing meanings and values attributed to individualism. Vosmaer is here alluding to the Romantic notion of uniqueness and originality as applied to individuals (the artist and his sitters) and to the nation (the Dutch Republic). For an analysis of the nineteenth-century traditions of use of the term see further Lukes 1979, esp. pp. 54-9, and Swaart 1962.

104. Ibid., p. 6.

105. Ibid., p. 8. In contrast to Rembrandt's expression of the serious side of life, Hals's art is seen as expressing the 'free naturalness' and 'humorous joyousness' of Dutch life and tradition (p. 29).

106. Decamps 1873, p. 172: 'Since Hals has at last been ranked as he always should have been, his works have been so sought after by collectors that forgers have started a new line of business; [Hals] is regularly manufactured in England. ... On the other hand, dealers regularly reattribute works by van der Vinne, Verspronck, Hals's sons, and transform them into Frans Hals' ('Depuis que Frans Hals est enfin classé comme il aurait toujours dû l'être, ses œuvres sont si recherchées des amateurs que les faussaires se sont mis de la partie; on en fabrique régulièrement en Angleterre. ... D'un autre côté, des marchands démarquent régulièrement des Van der Vinne, des Verspronck, des Hals fils, et les transforment en Frans Hals'). Similar anxieties are expressed about attributions in Ménard 1873.

107. Chu 1987, p. 112, points out that the signatures of artists associated with the 'realist and proto-impressionist trends' are found side by side with those of academic painters – all of whom are outnumbered by the naturalist painters from different parts of the world – but suggests a generally changing pattern in the reception of Hals. In the 1860s, Hals's works were 'admired primarily for their typically bourgeois subject matter and their hearty, vigorous mood. The civic guard and governors' portraits were seen as heroic monuments to the middle class. During the 1870s and 1880s, however, Hals's group portraits were admired less as celebrations of bourgeois life than for their masterful use of color and their dynamic, *alla*

prima facture. Hals's loose brushwork and verve made him a painter's painter whose craft appealed to artists of a wide range of artistic convictions.'

108. The various ways in which later artists responded to Hals, their borrowings, emulations and allusions, need ideally to be considered in the context of each artist's life and work, and in relation to the cultural determinants of their responses. See also Baxandall 1985, pp. 58-9, on the inappropriateness of the notion of artistic 'influence', because of its grammatical misrepresentation of the 'influential' earlier artist as the active agent, whereas it is in fact the later artist who makes 'an intentional selection from an array of resources in the history of his craft'.

109. Bürger 1869, see n. 76 above. This was Bürger's last publication. See also Munich 1869, no. 135.

110. Suggested in Jowell 1989. Bürger's first detailed discussion of *Malle Babbe*, then known as *Hille Bobbe*, carefully attempts to date the painting to the 1630s on stylistic grounds – in the absence of any date on the canvas; see Bürger 1869, p. 164. He also digresses to stress the importance of his documentary researches (ibid., p. 7). For an account of Courbet's copies, see the letter from P. Collin of 31 December 1877, first published in Lemonnier 1888, pp. 68-9, and reprinted in Courthion & Cailler 1950, p. 257. The different measurements of the Hals and Courbet paintings have since given rise to doubts on the reliability of the anecdote; see Hamburg 1987, pp. 305-6, no. 289. It has also been associated with Courbet's copy of the 'Rembrandt' *Self-Portrait*; see Riat 1906, pp. 271-2, and, more recently, Brooklyn 1988, p. 194. However, whether the tale is apocryphal or not, Courbet's implied challenge and particularly provocative additions to the copy of *Malle Babbe* remain open to interpretation. It is worth adding that the other two copies were also after works attributed to seventeenth-century masters who were revered and championed by Bürger (Rembrandt and Velázquez), and that Bürger's authority was repeatedly invoked in entries for the catalogue to this exhibition of old masters.

Of possible relevance to the popular reception of Hals from the 1860s, see Wagner 1981, esp. pp. 426-7, for an interpretation of Courbet's relationship to his public which suggests that the 'materiality' of his painting style, which drew attention to his abbreviated handling of brush, knife and pigment, was actually catering to current bourgeois taste rather than challenging it, his audience having learnt to appreciate not only the 'aesthetics of illusionism', but also its 'dissolution'. Were Hals's new appreciative audiences similarly responsive to the materiality of Hals's facture?

111. Hamilton 1954, pp. 166-7. See also Duret 1906, p. 136: 'among those who praised the *Bon Bock* there were also certain connoisseurs who explained that the qualities of the picture were owing to the influence of Frans Hals' ('Parmi ceux qui louaient le *Bon Bock*, il y avait aussi certains connaisseurs, qui expliquaient que les qualités du tableau étaient dues à l'influence de

Frans Hals'). Duret also comments that, on his visit to Holland, Manet saw works by Hals, an artist who had impressed him vividly in his youth, and that on his return to Paris his idea was to paint Belot with a beer mug in his hand 'en souvenir'. In 1884 the critic Paul Mantz suggested that in Manet's earlier works, such as *Le Chanteur Espagnol* and *L'Enfant à l'épée*, 'there was a hint, not of Velazquez as people freely said, but of Franz [sic] Hals, that great swashbuckler, [in] the way the paint is spread on the canvas'; Courthion & Cailler 1960, p. 170. Chu 1977, p. 118, suggests that later works, such as the *Rail Road* of 1873 (Washington, National Gallery of Art) and *Berthe Morisot with Hat, in mourning* of 1874 (Zurich, private collection) are reminiscent of Hals's late works in their open, daubing brushwork and predominantly black palette. However, it is difficult to tie down Hals's significance for Manet to 'stylistic influence'.

112. Valéry 1938, p. 147; quoted in Chu 1984, p. 60.

113. Proust 1901, p. 230. In the summer of 1872, Manet had made a special pilgrimage to Holland.

114. See Levy-van Halm & Abraham, fig. 17. Cassatt's copy dates from 1873, Weir's from 1874-5. Both are illustrated in Chu 1987, pp. 124, 126.

115. See Sweet 1966, p. 27: 'Mary Cassatt also visited Holland at this time, being chiefly interested in the works of Frans Hals. In Haarlem she copied his *Meeting of the Officers of the Cluveniers-Doelen* of 1633, and managed to achieve the spirit and freshness of the original, without slavish imitation of each brushstroke. In later years she was proud of this copy and used to show it to young art students, assuring them that such an exercise was essential for their development' (see also p. 195 for Cassatt's later advocacy of studying after Hals).

116. Young 1960, pp. xx and 62.

117. The results of Weir's enthusiasm for Hals have been thoroughly explored in Burke 1983. See pp. 76-80 for his early works in Paris and his first visit to Holland, and pp. 95-102 for his subsequent use of Hals's example in such works as *In the Park* (subsequently divided into smaller canvasses).

118. He described the impact of his first view of Hals's group portraits in letters; see Busch 1968, p. 133, cited by Chu 1987, p. 120. According to Novotny 1960, p. 175, n. 3, Busch realised that he would never be able to 'get out of his Netherlandish skin' ('aus seiner niederländischen Haut nicht heraus'; from a letter written to Paul Lindau in 1878), and kept painting a secret.

119. Liebermann's copy of the *Gipsy Girl* was included in a recent sale, London (Christie's), 21 February 1989, no. 117.

120. Hancke 1916, pp. 104-11, devotes a chapter to Liebermann's copies after Hals, from which fig. 8 is taken. See also Hancke 1916 for reproductions of Liebermann's copies after other figures from Hals's civic guard portraits (s45, s46, s124), from the almshouse *Regents* (cat. 85), as well as a later, complete copy (1884) of the *Regentesses* (cat. 86). I have been unable to

ascertain the present location of any of these copies. It is believed that at least three were in the possession of Liebermann's widow at the time of her death in 1943 (information kindly supplied by Maria White, Liebermann's granddaughter). Mrs. Liebermann committed suicide to avoid arrest and deportation by the Nazis; the paintings could have been lost, stolen or destroyed.

121. Friedländer [1924], p.46: 'In Frans Hals fand er das ihm wahlverwandte Temperament. Und dieser Meister wurde ein Vorbild, gab ihm einen Maßstab wie kein anderer Maler unter den Alten und Neuen.'

122. Ibid., pp. 48-9: '... vor den Bildern des Frans Hals bekommt man Lust zum Malen, vor denen Rembrandts verliert man die Lust daran.'

123. Friedländer, op. cit., p. 50, refers to Liebermann as the 'nervous son of the nineteenth century' threatened by the reflective, emotional aspects of Rembrandt, but inspired and made confident by Hals's wholesome, masculine, active, independent practice of art reflecting the atmosphere of public-spiritedness and freedom of the democratic citizenry. See also Eberle 1979-80, esp. pp. 31-4.

124. Chu 1987, p. 122, refers in particular to the painter Ilya Repin and the critic Vladimir Vassiljevitch Stassov.

125. See Ruhmer 1978, pp. 15-6.

126. See Duveneck 1970, p.50: 'He greatly admired Franz [sic] Hals for his rapid, free brushwork and for the realistic, almost rollicking types he delighted to paint.' Several of Duveneck's works, such as the so-called *Whistling Boy* of 1872 (Cincinnati Art Museum) or the *Smiling Boy* of 1878 (University of Nebraska), bear witness to his study of Hals, which was apparently encouraged by Wilhelm Diez, his teacher in Munich; see Booth 1970, p. 52. See also Quick 1987-8, pp. 22-3.

127. Such as his *Bavarian Girl* (private collection; illustrated in Quick 1987-8, p.29) or *Head of a Boy* (Brooklyn Museum).

128. Such as his 1875 *Woman with a Basket* (Chicago Art Institute), or his lost informal portrait of Duveneck. For the influence of Munich realism on American painters and their shared interest in Hals, see Quick 1978, pp. 28-30. Chase, who was a close friend of Whistler, exhibited with *Les Vingt*, an avant-garde group in Brussels, and subsequently became influential as spokesman for the Society of American Artists and as teacher at the Art Students League in New York for almost quarter of a century. He did much to encourage Hals's popularity in the United States. An article on his teaching in *The Art Amateur* of 1880 referred specifically to the Halsian aspirations of the students: 'Mr. Chase and Mr. Shirlaw, two enthusiasts, induct the classes in painting from the model with the enthusiasm of youth and conviction; it is expected that they will turn out many a Franz [sic] Hals from among the lively crowd of American disciples.'

As homage to Hals, the first of Chase's summer study tours in Europe was based in Haarlem in 1903. The following year one of the students recalled their responses to the paintings: 'Then there was Hals, who, with all

that Chase had said about him, claimed the right of way. Brilliancy to the nth degree – and those blacks! They have seldom been equalled and never surpassed' (Pisano 1983, pp.95, 137).

129. Quoted in Golliet 1979, pp.73-4.

130. Fromentin 1963, pp.224-34.

131. Ibid., p.226. In a similar vein (p.225): 'His method serves as a programme to certain doctrines by virtue of which the most word-for-word exactness is wrongly taken for truth, and the most perfectly indifferent execution taken for the last word of knowledge and taste. By invoking his testimony for the support of a thesis to which he never gave anything but contradictions in his fine works, a mistake is made, and in so doing, an injury is done to him. Among so many high qualities, are only his faults to be seen and extravagantly extolled.'

132. Ibid., p.230. Fromentin's detailed analyses of Hals's works are vivid and detailed, showing close observation and understanding of Hals's technical procedures.

133. Although Hals is nowhere mentioned, see Rosand 1987 for an introduction to the issue raised by the notion of an 'old age style'. In this regard it would be interesting to analyse the various responses to the *Regent* and *Regentesses* portraits. Whereas Bürger and Vosmaer considered the late works as the apogee of Hals's achievement, Fromentin doubts that the aged Hals's hand has realised what the artist envisaged. Georges Lafenestre took a similar view of these works, Hals's 'farewells to painting': 'Nothing is more touching, nothing more tragic, than to see this octogenarian whose hand is unsteady, whose eyes are downcast and troublesome, struggle with superb obstinacy against decrepitude which overcomes him while he represents other aged people like himself' ('Rien de plus touchant, rien de plus douloureux que de voir cet octogénaire dont la main vacille, dont l'œil baisse et se trouble, lutter avec un entêtement superbe contre la décrépitude qui le gagne pour représenter d'autres vieillards comme lui'); Lafenestre 1886, p.16 (see also n.143 below).

134. Fromentin 1963, pp.233-4.

135. For a perceptive analysis of Fromentin's historical and critical approach, see Meyer Schapiro's Introduction, ibid., pp.ix-xli.

136. Véron, *L'Esthétique*, Paris 1878. The quotations below are from Véron 1879. I am indebted to John House for the reference to *L'Esthétique*. Véron was a republican journalist and art critic who was best known in the 1870s as director and one-time editor (1874-6) of the magazine *L'Art*, initially published with the motto 'Tant vaut l'homme, tant vaut l'œuvre'. His ideas on art were strongly influenced by Thoré, to whom he frequently refers. See also the brief discussion of Véron in Shiff 1984, pp. 27-8.

137. Véron 1879, p.389.

138. Ibid., p.126.

139. Ibid., pp.278-9.

140. Anon. 1883. This art journal was the semi-official organ of the self-styled avant-garde Belgian group, *Les Vingt*.

141. Ibid., p.302: 'On peut étudier l'un des exemples les plus caractéristiques de ce phé-

nomène au musée de Haarlem, qui fait pénétrer dans l'intimité d'un maître mort depuis plus de deux siècles et chez lequel on trouve, à un degré d'une extrême intensité, les préoccupations qui hantent la présente génération de peintres. ... Frans Hals est un moderne. Son esthétique, son coloris, son dessin, ses procédés, appartiennent à notre époque.'

142. Ibid.: '... un impérieux besoin de rendre une impression d'ensemble en sacrifiant volontairement tout ce qui est accessoire et de peu intérêt.'

143. Ibid., pp. 302-3: 'Rien dans ces deux stupéfiantes compositions ne se rattache à · l'art d'autrefois.' Bürger was the first writer to assume that the last works – especially the *Regentesses* – were complete. Joséphin Péladan, in his provocative and fascinating book on Hals (Péladan 1912), which is outside the scope of this essay, refers to the contradictory views on these late works: '"His hand is no longer there", says Fromentin; "Marvellous sureness of hand", says Mr. Bode; "His hand trembles", says Lafenestre; "The forms are expressed with such sureness", resumes Bode; "The colours are completely summary", says Fromentin; "The coloration is obtained with such spirit", says M. Bode. Whom to believe?' ('"La main n'y est plus", dit Fromentin; "Merveilleuse sureté de main" dit Lafenestre; "Avec quelle sûreté les formes sont exprimées" reprend M. Bode; "Les couleurs sont tout à fait sommaires" dit Fromentin; "Avec quel esprit les colorations sont obtenues" dit M. Bode. A qui entendre?' [ibid., p. 20]). Péladan comments that these paintings – the impoverished artist's last contemplation of sad humanity in which there is no longer 'drawing' ('plus de *dessin*') or 'touch' ('plus de touche'), but the most marvellous colour ('le coloris le plus merveilleux') – enthrall specialists for technical reasons, and interest poets ('imaginatifs') for their macabre hideousness and haunting character ('son aspect de hideur macabre et son caractère hallucinant'); ibid., p. 32.

144. Anon. 1883, p. 302: 'l'objectif et l'idéal de la jeune école.'

145. The writer points to undeniable affinities in their technical procedures as well as in the poses of figures, the composition, lighting and general feeling: 'Il y a entre ces artistes et le maître de Harlem des affinités indéniables: même facture nerveuse, superposant les touches de couleur sans les fondre, procédant par plans, fuyant l'indécision et les tâtonnements. Mais l'exécution n'est pas le seul point de rapprochement: dans la tenue des personnages, dans la mise en scène, dans l'éclairage, dans le sentiment général, il y a entre ces modernistes et Frans Hals une parenté certaine' (ibid.).

146. Charteris 1927, p. 51. He travelled to Haarlem with Ralph Curtis and Frank Chadwick (both American students of Carolus-Duran), Paul Helleu and Beckwith. On another occasion, in July 1883, Sargent, with Paul Helleu and another young painter, took a night train to Holland, spent the day viewing Frans Hals's paintings in Haarlem, and returned directly to Paris; see Ratcliff 1983, p. 58.

147. Ormond 1970, p. 27. Ormond publishes a photograph of Sargent's studio, c.1883-4, which

shows the copy of the *Regentesses* (fig. 17, facing p. 46) presently in the Birmingham Museum of Art, Birmingham, Alabama (fig. 10). Sargent also copied the portraits of Arent Jacobsz Koets and Ensign Jacob Schout; Lieutenant Jacob Olycan and Captain Michiel de Wael from the *Banquet of the Officers of the St. George Civic Guard* of c.1627 (S46, figs. 20, 21; see also Levy-van Halm & Abraham, fig. 13).

148. He later advised: 'You must *classify* the values. If you begin with the middle-tone and work up from it towards the darks – so that you deal last with your highest lights and darkest darks – you avoid false accents. That's what Carolus taught me. And Franz [sic] Hals – it's hard to find anyone who knew more about oil-paint than Franz Hals – and that was his procedure'; Charteris 1927, p. 29. Charteris later commented that Sargent looked on Hals 'as the portrait painter with whom he had most in common' (ibid. p. 195).

149. Charteris 1927, p. 51. Charteris emphasises the extent to which Sargent referred his students to Hals, quoting further his advice to Miss Heyneman: 'Never leave "empty spaces", every stroke of pencil or brush should have significance and not merely fill in, ... copy one of the heads by Franz [sic] Hals in the National Gallery, then you will get an idea of what I mean by leaving no empty spaces in modelling a head. ... Later on he advised her to go to Haarlem, and on her return wrote: "I hope you'll have some copies of Franz Hals to show me. Jacomb Hood tells me that you have come back charged with enthusiasm and the spirit of knowledge. There is certainly no place like Haarlem to key one up"' (ibid., pp. 139-40).

150. Ratcliff 1983, p. 58. Sargent's admiration for Hals's bravura brushwork has also been detected in the style of informal portraits of the early 1880s, such as *Mrs. Charles Gifford Dyer* (1880; Chicago, Art Institute) and *Mrs. Daniel Sargent Curtis* (1882; Lawrence, Helen Foresman Spencer Museum of Art, University of Kansas); see Ayres 1986-7, p. 63.

151. McConkey 1987 refers to the interest in Hals on the part of such artists as Giovanni Boldini, who studied Hals in Holland in 1876 (p. 176); Samuel John Peploe (1871-1935), whose *Old Tom Morris* (Glasgow) is comparable to Hals in lively brushstroke and expression (p. 146); and William James Yule (1867-1900), who made a pencil sketch c.1894-5 after Hals's *Portrait of a Woman* (cat. 58) in the National Gallery of Scotland, Edinburgh; see Yule 1983, no. 24.

152. Homer 1969, p. 84, attributes the develop-

ment of Henri's spontaneous technique 'geared to the expression of vitality and immediacy' to Hals, citing a letter about a planned trip to Holland: 'I think it will be a valuable trip for health and for knowledge gained by seeing the great portraits, ... it is Frans Hals that I think of particularly.' See ibid., pp. 87-8 on Henri's response to the stimulus of Hals in his later works of 1900-12, in which Hals seems to have been the 'catalyst that thoroughly liberated Henri's brushwork'. On his special interest in the 'common people' see ibid., pp. 241, 249.

153. Schoonbaert 1968, pp. 319-20, lists two drawings after the *Regents* (inv. 2711/21-2711/22), and six drawings after the *Regentesses* (inv. 2711/23-2711/28). Although, as mentioned in Ensor 1987, p. 145, Ensor's signature does not seem to be on the Haarlem museum register, it is most likely that he did visit Haarlem – especially as he was probably familiar with the eulogy of Hals in *l'Art Moderne* the previous month (Anon. 1883). Furthermore, as pointed out by Chu 1987, p. 114, not all visitors, especially copyists, signed the registers.

154. See his reaction to Fantin's *Homage*, mentioned above, p. 67. It is interesting that Whistler possessed a photograph of Hals's portrait of *Jacob Pietersz Olycan* (cat. 18). It is presently in the Whistler Collection, Glasgow University Library (Whistler P3/15). I am grateful to Dr. Nigel Thorp for this information.

155. The following account by G. Sauter was published in Robins & Pennell 1908 – a biography undertaken with the artist's permission and assistance, and which remains the central source of biographical data on Whistler.

156. Ibid., p. 285.

157. Ibid., p. 286.

158. He frequently refers to Bürger in his letters; in the one quoted below he recommends the *Musées* (Bürger 1858) to his brother: 'read it through once more yourself, it is so beautiful'; van Gogh Letters 1958, vol. 2, letter 426, p. 418. Personal reminiscences by Anton Kerssemakers (vol. 2, letter 435c, p. 446) mention van Gogh's recommendation of Bürger's *Musées* (Bürger 1860a) and *Trésors* (Bürger 1860). It is of interest that an unattributed passage about Gainsborough, cited by van Gogh as instructive, was in fact written by the French critic (Bürger 1860, p. 394). It is of some relevance to the present argument: 'It is this brusqueness of touch that produces so much effect. The spontaneity of his impression is all there, and communicates itself to the spectator. For the rest Gainsborough had a perfect method of

ensuring the completeness of his composition. He planned his picture all at once, and carried it out harmoniously from top to bottom, without concentrating his attention on separate little fragments, without obstinately worrying over details, for he sought the general effect, and he nearly always found it, thanks to his broad vision on the canvas, which he looked at as one looks at nature, at a single glance'; vol. 2, letter 435, p. 441.

159. Van Gogh Letters 1958, vol. 2, letter 426 (October 1886), pp. 416-7.

160. Ibid., letter 427 (October 1886), p. 419.

161. Ibid., p. 420.

162. Ibid., p. 421.

163. Ibid., letter 428 (October 1886), p. 424.

164. Ibid.

165. Pollock & Orton, p. 34. See also Pollock 1980.

166. 'I was very much struck by Frans Hals's "Fisherboy"'; van Gogh Letters 1958, vol. 2, letter 436, p. 450. 'But as to the portraits – those I remember best are the "Fisherboy" by Frans Hals, "Saskia" by Rembrandt, a number of smiling or weeping faces by Rubens'; ibid., letter 439, p. 457. 'These days my thoughts are full of Rembrandt and Hals all the time, not because I see so many of their pictures, but because among the people here I see so many types that remind me of that time'; ibid., letter 442, pp. 464-5.

167. Pollock 1980, pp. 444-53.

168. Van Gogh Letters 1958, vol. 3, letter B13 (July 1888), p. 506.

169. Ibid., p. 507.

170. He continues: 'I seek it in color. ... *I should like* to paint portraits which would appear after a century to the people living then as apparitions. By which I mean that I do not endeavor to achieve this by a photographic resemblance, but by means of our impassioned expressions, ... using our knowledge of and our modern taste for color as a means of arriving at the expression and the intensification of the character'; ibid., letter W22 (June 1890), p. 470.

171. On van Gogh's debt to Hals, see also Welsh-Ocharov 1976, pp. 87-8, 150, 202, n. 29.

172. 'Il était bien et dûment Hollandais, de la sublime lignée de Franz Hals', quoted by Pollock 1980, p. 426, who further (p. 434) analyses Aurier's use of Hals as a 'paradigm through which to understand the significance of a contemporary artist, van Gogh. The latter was being cast in the image of the former.'

173. Baxandall 1985, p. 60.

174. Jauss 1982, p. 75.

KOOS LEVY-VAN HALM & LIESBETH ABRAHAM

Frans Hals, Militiaman and Painter: the Civic Guard Portrait as an Historical Document

INTRODUCTION

In the first half of the seventeenth century, Frans Hals received five commissions to paint a group of Haarlem civic guard officers, and one to depict the officers of an Amsterdam company. After completing his first militia piece, the *Banquet of the Officers of the St. George Civic Guard* of 1616, he painted two more in the 1620s and a further three in the 1630s.

These works also attracted the attention of contemporary authors. Shortly after the completion of the *Banquet of the Officers of the St. Hadrian Civic Guard* of c.1627 (fig. 1), the Haarlem chronicler, Samuel Ampzing, saw it hanging in the Calivermen's Hall. In his 1628 *Beschrijvinge ende lof der stad Haerlem in Holland* ('Description and Praise of the City of Haarlem in Holland'), he wrote that Hals had executed the picture 'most boldly from life'.[1] However, he was in no way implying that it illustrates an actual moment in time.

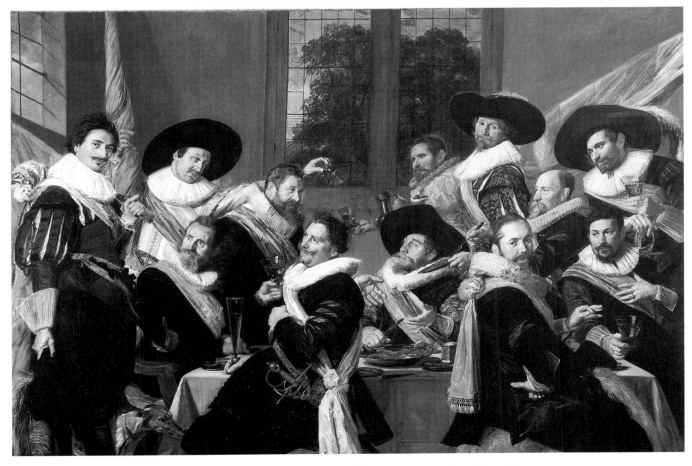

Fig. 1 Frans Hals, *Banquet of the Officers of the St. Hadrian Civic Guard*, c.1627 (s45). Haarlem, Frans Halsmuseum

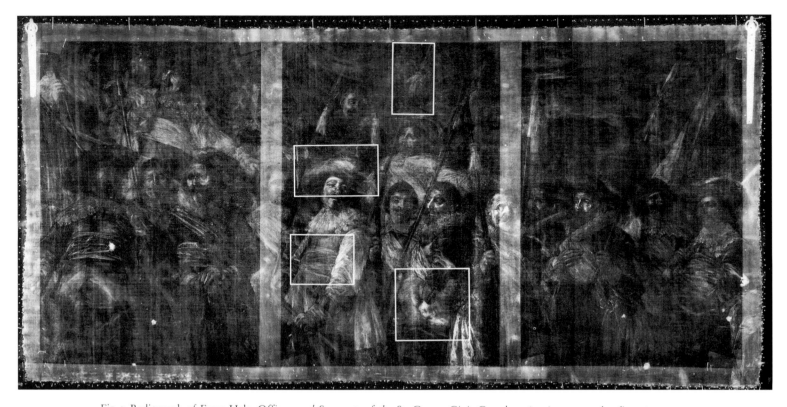

Fig. 2 Radiograph of Frans Hals, *Officers and Sergeants of the St. George Civic Guard*, c.1639 (s124; see also fig. 15)

Hals's lively figures are simply grouped around a table in accordance with an established tradition.

The misunderstanding, that what we see here represents an instant in the daily life of the civic guard, dates from a later period. Even in the course of the eighteenth century, knowledge of the traditions and conventions underlying seventeenth-century semi-official portraiture had begun to fade into the background, and the way in which people looked at a work of art completely altered.[2] The art critic Théophile Thoré, equally well known by his pseudonym, W. Bürger, who made an important contribution towards the international reappraisal of Frans Hals in the second half of the nineteenth century, praised his spontaneous brushwork and interpreted his approach to subjects taken from daily life as a direct rendering of reality.[3] In accord with his views of society, Thoré-Bürger regarded seventeenth-century Dutch painting as the expression of a nation which, as a republic, had achieved freedom both in politics and religion. Even commissions like the civic guard portraits were assigned a place within this general framework. For instance, he doubted from the start whether two drawings which are now regarded as copies of the *Officers' Banquet* of 1616 could really be preliminary studies by Frans Hals. According to Thoré-Bürger,

Hals painted so skilfully that he did not need studies to catch his models exactly.[4]

However, the possibility that the patrons' wishes might have had any importance, was something that Thoré-Bürger quite failed to appreciate. In addition, research has shown that paintings for official buildings had a specific function, and that in that respect the militia piece fitted within a tradition in which hand gestures, attributes and setting all have an allegorical and exemplary significance.[5]

Recent research on the pictures themselves, including X-ray examination (fig. 2) and investigation of other technical aspects, combined with an analysis of archive material, have added further nuances to the overall picture. Thoré-Bürger likens Hals to a fencer, saying that he 'painted as if fencing, and ... flicked his brush as if it were a foil'.[6] Hals seems to have altered many details, like a hat, a sash, a weapon or the gesture of a hand, as he painted. A number of these alterations can be related to events recorded in the civic guard archives, such as the appointment of officers in the interval between commissioning a group portrait and its completion. From this it is clear that patrons did have a say in the final result, and right up to a relatively late stage at that.

THE CIVIC GUARD PORTRAIT

The history of the militia piece in the Northern Netherlands begins with the commissions awarded by the Amsterdam calivermen.[7] On the basis of the surviving pictures, as well as written sources, at least nine of the twelve Amsterdam 'files' had their portraits painted in the period 1529-35 (a file was the smallest unit within a militia guild). The two other Amsterdam guilds, the crossbowmen and the archers, followed suit.

The calivermen owed their name to the weapon they used, the caliver, which was a light kind of musket (see fig. 3). In the first quarter of the sixteenth century, firearms guilds were established in numerous towns, or were re-formed from more ancient institutions. The existing guilds of archers and crossbowmen similarly went over to using firearms, but retained as their emblem the original weapon which had given them their names. The bow and arrow also retained a place of honour during the annual competitions of marksmanship. A body of men exercised in the use of arms could be very useful to a town in time of war. That had been demonstrated both in Flanders, with its many towns, and in the surrounding region. In 1302, at the so-called 'Battle of the Golden Spurs', Flemish urban levies beat a large French army of well-equipped knights near Courtrai.

However, an armed civilian force could also pose a threat within a city, and civic guard ordinances, the earliest of which in the Northern Netherlands date from the end of the fourteenth century, show that the city authorities were very conscious of this fact.

Those ordinances also granted the guards recognition by defining their rights, which included the entitlement to earn income by the leasing of land and fishing rights, and the levying of excise on the sales of wine and beer during the annual marksmanship contests. Furthermore, they enjoyed the privilege of free association, and were allowed to organise annual competitions for shooting at the popinjay. Set against such privileges were various obligations, such as duty during civil commotions, and military service in time of war. The religious duties of guilds organised as 'fraternities' prior to 1580 included maintaining an altar, obligatory attendance at Mass and taking part in processions.

The regulations make it apparent that the city authorities had broad discretionary powers. They decided on the size of the guilds, and had to approve the election of new guardsmen. Guild members had to be men of substance, with a predetermined level of wealth. Bad conduct or impoverishment could lead to fines or even expulsion from the guard. The official responsible for recording the fines, later known as the provost, is probably identifiable in many of the early militia pieces as the man holding a pen. Other attributes, such as a drinking bowl, a tankard or a glass, may indicate special customs within a guild, or privileges like the levy of excise on the sales of wine and beer.[8] The significance of such attributes in the paintings would not have been lost on the contemporary viewer, who would also have appreciated the more general significance of the civic guard portrait.

The concept of 'harmony' (eendracht) may well have formed the central message of many militia pieces. The word is explicitly included in the inscription on Dirck Jacobsz's Twelve Guardsmen of File E of 1563,[9] and it is also inscribed on many surviving civic guard objects, such as drinking vessels, regalia and medals.

In the early works, the guardsmen are painted in a rather static manner, next to or above one another. Only the hand gestures of these uniform guardsmen, dressed in the prescribed tabard and cap or beret, establish any contact between them. Rarely do they appear in armour, and even their weapons play a very subordinate role. In the oldest Dutch civic guard piece, A File of Amsterdam Calivermen painted by Dirck Jacobsz in 1529 (fig. 3), two guardsmen in the foreground are holding their guns by the muzzle, which identifies them as calivermen. In Cornelisz Anthonisz's so-called Copper-Coin Banquet of 1533 there are two crossbows (fig. 4), so we are clearly dealing with members of the crossbowmen's guild.[10] St. George, their traditional patron saint, is shown to the right in the stained-glass window. The archers' guild almost always adopted St. Sebastian as their patron, but the calivermen were less unanimous in their choice, their favourite saint varying from town to town.

No civic guard portraits have survived from the period when harmony had been eroded by the growing political, religious and economic dissensions which ultimately led to the revolt against Philip II. Only after the Reformation had become an accomplished fact, and the civic guards had been reorganised on military lines, was the tradition revived in Amsterdam in 1580, whence it spread to other towns in Holland and Zeeland. The city militias were now incorporated in a national military structure, and this involved them in wider actions and expeditions, most of which took place in the second quarter of the seventeenth century. Their importance then declined as the Army of the States-General grew more effective, and with the Peace of Münster of 1648 their role was reduced to maintaining civil order.

After 1580, artists began emphasising the more military nature of the new civic guards by depicting them as an armed body of men. Only in Haarlem was the civic guard banquet still the preferred subject.

The military nature of these group portraits is expressed in the dress, turn-out, arms, hierarchy of rank, and the way in which the men hold their weapons and

Fig. 3 Dirck Jacobsz, *A File of Amsterdam Calivermen*, 1529 (central panel), *Fourteen Men of a File of Amsterdam Calivermen*, c.1552 (side panels). Amsterdam, Rijksmuseum (inv. C402)

Fig. 4 Cornelisz Anthonisz, *Banquet of File H of the Amsterdam Crossbowmen* (the '*Copper-Coin Banquet*'), 1533 Amsterdam, Amsterdams Historisch Museum (inv. A7279)

other attributes. The weapons themselves now become an important element in the composition.

The second quarter of the sixteenth century saw the construction of many new militia halls (*doelen*). The guild house now developed from a modest meeting place for the guardsmen into an important public building, where assemblies and official gatherings were held. There was a further but more sporadic spate of building activity at the beginning of the seventeenth century. The need to decorate these new halls provided artists with an important source of work. Apart from commissions resulting from the building (or rebuilding) of militia halls, there were those prompted by reorganisation within the guild. Occasionally, too, there was a feat of arms to be commemorated, or an officer's promotion.

As time passed, artists gradually abandoned panel for canvasses, which became progressively larger, while the guardsmen themselves were often portrayed life-size. The genre developed through an interaction between patron and artist. Local traditions and specific events determined the choice of subject. In addition to themes such as banquets and other assemblies, variations like portraits of individual standard-bearers and the board of governors emerged. The governors constituted the administration of the guild, and were burdened with both organisational and ceremonial duties. In a number of pictures from the 1640s and 1650s by Bartholomeus van der Helst (1613-70) and Govert Flinck (1615-70; fig. 5), they are seen displaying the costly silverware of the former militia guilds. This is perhaps a reference to the

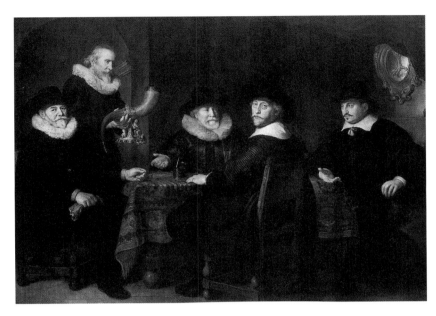

Fig. 5 Govert Flinck, *Four Governors of the Amsterdam Calivermen's Guard*, 1642
Amsterdam, Rijksmuseum (inv. C370)

rich and distant past of the civic guard, of which the seventeenth-century organisation was the ultimate and legitimate successor.

In Haarlem, though, it was impossible to proclaim ancient traditions in this way, for the militia silverware had been surrendered and melted down in 1572/3, when Spanish troops were besieging the city. The raising of a glass by a colonel or captain during the entry of the standard-bearers (as seen in the three of Hals's officers' banquets) may well point to some established tradition. For example, in the second half of the sixteenth century it became the custom for the ensigns to surrender their standards temporarily at the annual 'accounting banquets', at which important decisions were taken and differences were settled. Besides the patron, of course, the artist too brought innovations to the genre.

This is true, for example, of Dirck Barendsz (1534-92), who after a sojourn in Italy in 1562 and 1564 painted civic guard banquets in which the rigid ranks of guardsmen placed above and beside one another is broken up by depicting the foreground figures at the table from the back, but with their heads turned to the viewer (fig. 6).[11] In 1588, the internationally aware Cornelis Ketel (1548-1616), completed a group of officers standing full-length in an imposing room for the Amsterdam Crossbowmen's Hall (fig. 7).[12] His design was not to be imitated until many years later.

In Haarlem, Cornelis Cornelisz van Haarlem (1562-1638) achieved a greater illusion of depth by choosing a low vantage point for his banquet of 1583 (see fig. 9). In 1616 Frans Hals based the composition of his *Ban-*

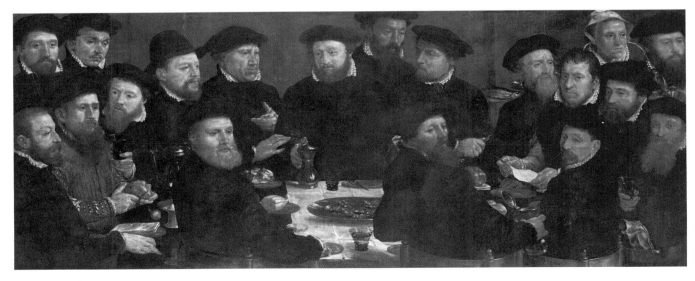

Fig. 6 Dirck Barendsz, *File L of the Amsterdam Calivermen*, (the '*Perch Eaters*'), 1566. Amsterdam, Rijksmuseum (inv. C365)

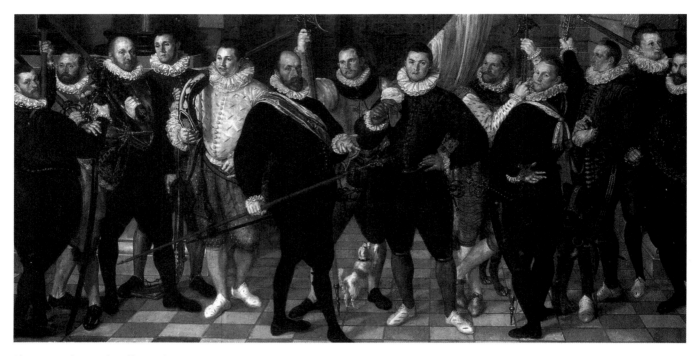

Fig. 7 Cornelis Ketel, *Officers of the Amsterdam Company of Captain Dirck Jacobsz Roosecrans*, 1588. Amsterdam, Rijksmuseum (inv. c378)

quet of the Officers of the St. George Civic Guard on Cornelisz's 1599 picture of the same subject (see fig. 10).[13] Hals, though, succeeded in depicting a truly lively gathering by making a significant modification to the arrangement of the figures and giving the poses and gestures a natural look.

Amsterdam remained the model for many other towns. The composition and detail of four large canvasses which Jan Albertsz Rotius (1624-66) made between 1649 and 1654 for the new militia hall in Hoorn are markedly similar to Govert Flinck's *Company of Captain Albert Bas* (1643) for the newly opened great assembly room of the Calivermen's Hall in Amsterdam.[14] Works to decorate this room were ordered from five other painters, among them Rembrandt (1606-69), whose canvas has now become famous as *The Night Watch*.

It is far rarer to find an Amsterdam militia piece that was influenced by one made elsewhere. In 1632 Nicolaes Eliasz (1588-1650/6) painted a civic guard banquet with twenty-three figures for the Amsterdam Crossbowmen's Hall (fig. 8),[15] and here one notices one or two points of similarity to Hals's *Banquet of the Officers of the St. George Civic Guard* of c.1627 (fig. 13). In both, the ensign to the left of centre occupies a prominent position in the foreground, and his standard is an important element in the composition. Some fifteen

years later, Bartholomeus van der Helst likewise absorbed some of Hals's idiom in a work for the Amsterdam crossbowmen. In van der Helst's *Celebration of the Peace of Münster of 1648*,[16] the banquet piece which for a long time was regarded as the apotheosis of the genre, the light tonality is particularly reminiscent of Hals.

HAARLEM

It was in Haarlem that the civic guard banquet truly flourished. In twelve of the nineteen known portraits the guardsmen are grouped round a banqueting table. In four, the entire platoon is present, in the other eight the officers alone. Of the seven civic guard portraits which do not depict a banquet, three show the guardsmen seated at table but with no meal in front of them, while in the remaining four the men are standing in formation.

Perhaps local conditions led to the tradition of these banquets. Haarlem had suffered much from strife and violence, not least during the Spanish siege of 1572/3. It was a period of terrible devastation and catastrophes from which Haarlem emerged with its motto *Vicit Vim Virtus* (Virtue conquers violence).[17]

In the earliest banquet piece, Cornelis Cornelisz van Haarlem's work of 1583 (fig. 9), virtually every military

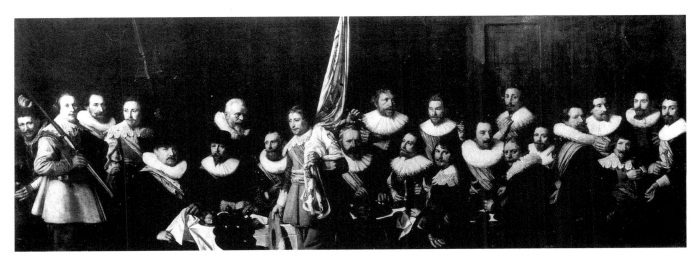

Fig. 8 Nicolaes Eliasz, alias Pickenoy, *Banquet of the Company of Captain Jacob Backer and Lieutenant Jacob Rogh*, 1632
Amsterdam, Amsterdams Historisch Museum (inv. A7313)

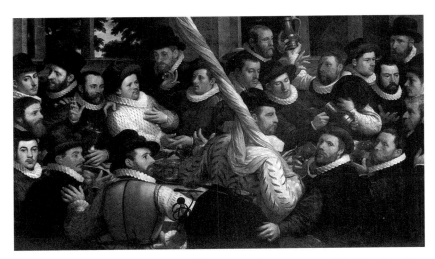

Fig. 9 Cornelis Cornelisz van Haarlem, *Banquet of the Haarlem St. George and St. Hadrian Civic Guards*, 1583
Haarlem, Frans Halsmuseum (inv. I-48)

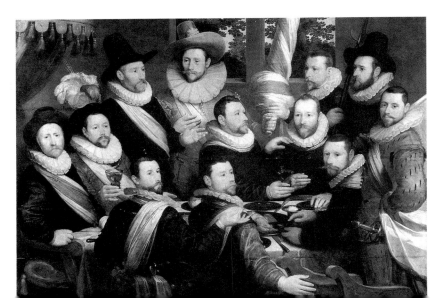

detail is conspicuously absent. Even more remarkable is the fact that according to Karel van Mander, Cornelisz's contemporary and colleague, some of the men had themselves portrayed as merchants (fig. 10).[18] And it was indeed possible to conclude a commercial transaction in the militia hall. However, sales were bound by certain rules, as evidenced not only by the guard ordinance, but also by the announcement above the chimney-breast in the great assembly room of the Calivermen's Hall which declared that: 'No commerce conducted in this hall can be held so binding that he who rues it may not revoke the agreement on the following day by paying for the wine'.[19] In this picture, the specific customs of the civic guard, like communal eating and drinking, and making deals, may symbolise a more general concept of peace and prosperity, with its message that harmony leads to a flourishing economy. Perhaps the viewer is also being reminded of the privilege on sales in the hall, where the rule of paying for the wine to seal a bargain still held sway. The way in which one man is pointedly peering into his tankard, with a colleague looking over his shoulder, may perhaps refer to the privilege of beer or wine sales, although it could also be a symbolic exhortation to temperance.

It is possible that Hals worked such an admonition into his 1627 *Banquet of the Officers of the St. George Civic Guard* (see fig. 13), where Captain Michiel de

Fig. 10 Cornelis Cornelisz van Haarlem, *Banquet of the Officers of the St George Civic Guard or Calivermen*, 1599
Haarlem, Frans Halsmuseum (inv. I-53)

Fig. 11 A. de Witt and P.H. Jonxis after Wybrand Hendriks, *Swearing-In of the Members of the 'Pro Aris et Focis' Society*, coloured engraving, 1787
Haarlem, City Archives (inv. 2243M)

The oath is being administered in the Great Assembly Room of the Calivermen's Hall. On the wall in the background are the militia pieces by Frans Hals (*c.* 1633) and Pieter Claesz Soutman (1642), with the panels identifying the sitters.

Wael is significantly turning his glass upside down. Like many other officers, Michiel de Wael was a brewer by trade. He also fulfilled many functions in both the civic guard and the city administration. In Frans Hals's *Officers and Sergeants of the St. George Civic Guard* of *c.* 1639 (see fig. 15), he is depicted as the provost, or fiscal. In Hals's banquet paintings it is only the officers who convey the message and drink to each others' health. The commissions which Hals received were thus in a certain sense easier than those of his immediate predecessors, like Frans Pietersz de Grebber and Cornelis Engelsz, who between them executed four large canvasses portraying an entire company, complete with officers. It is frequently said that Hals was the first to create sufficient space around the guardsmen to allow them to stand out as individuals. This certainly reflects his pictorial skills, but it can also be taken literally, as a glance at the crowded canvasses and small panels of his predecessors will show.

The civic guard portraits originally hung in two separate militia buildings, St. George's Hall (completed in 1593) and the Calivermen's Hall (built in 1561-3). Towards the end of the seventeenth century it was decided to economise by retaining only the Calivermen's Hall. In

the course of the eighteenth century, two of Hals's works for the St. George militia, the *Banquet of the Officers of the St. George Civic Guard* (*c.* 1627) and the *Officers and Sergeants of the St. George Civic Guard* (*c.* 1639), were transferred to the Calivermen's Hall.

Hals's officers' banquet of 1616, which was likewise painted for St. George's Hall, had already been claimed by the city authorities at the end of the seventeenth century, and was given a place of honour in the Prinsenhof (the stadtholder's occasional residence). To replace it, the guards were allowed to have their group portrait painted by Jan de Bray, but the picture never got further than an initial design, and even that now appears to be lost.[20]

The sitters in several group portraits which adorned the great assembly room of the Calivermen's Hall in the course of the eighteenth century have been identified (fig. 11). With the exception of the officers' banquet of 1616, which was hanging in the Prinsenhof, all of Hals's civic guard portraits and two by other painters had numbers added to them around 1740 which correspond to the names on a panel below the frames. Not so long ago these identifications were checked against newly discovered information and found to be reasonably reliable.[21]

In Haarlem, the two civic guards were organised into companies, the largest military unit. The number of companies was determined by the size of the city and its division into municipal wards. The St. George civic guard recruited its members in the southern half of the city, the calivermen in the north. In principle, all male citizens between the ages of eighteen and sixty were liable for civic guard service, but in practice not all were eligible. A company consisted of a hundred or more men, and was divided into four platoons. Each company was led by a captain, who was supported by a lieutenant, an ensign or standard-bearer, two sergeants and four corporals (each in charge of a platoon). In 1612 both guards were enlarged at the request of their commanding officers by the addition of a third company. Each officer corps, which was also known as the council of war, consisted at the time of a colonel, a provost (later known as the fiscal), three captains and three lieutenants. The ensigns did not belong to the officer corps. They had tenure for an indefinite period, but had to remain unmarried. The officers, apart from the provost, were appointed for three years.

Positions as officers, like the post of ensign, were reserved for a small group of wealthy people – generally brewers and merchants in Haarlem's case. It was a function that formed part of a career in government. The callings of ordinary guardsmen lay in the less exalted trades, such as carpenter, smith and baker, but also painter, shipbuilder and maltster. A few officers appear

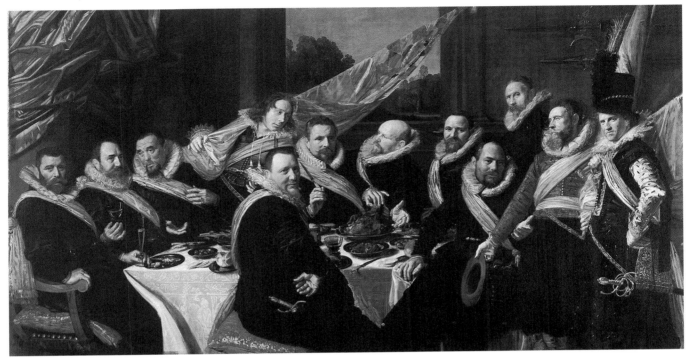

Fig. 12 Frans Hals, *Banquet of the Officers of the St. George Civic Guard*, 1616 (S7). Haarlem, Frans Halsmuseum

in several civic guard portraits, and these leading citizens also sat to Hals privately.

Occasionally, such individual portraits have helped identify a figure in a militia piece. Captain Nicolaes van der Meer, the prominent foreground figure in the 1616 *Banquet of the Officers of the St. George Civic Guard* (fig. 12), was painted again by Hals in 1631, together with his wife, Cornelia Claesdr Vooght (cat. 41, 42). It was the similarity of that male portrait to the man in the foreground of the 1616 banquet, combined with recently discovered archive data, that made it possible to identify this particular officer corps.[22] Nicolaes van der Meer was a captain in the St. George civic guard in the period 1612-5. It was probably the reorganisation of the guard in 1612 that was the occasion for the commission, for the captain of the third company occupies a place of honour on the colonel's right.

It is no coincidence that it was Frans Hals who was asked to paint this banquet. He became a member of the St. George guard in 1612, and was assigned to the newly formed third company. It was entirely customary to award the commission for a group portrait to a painter from one's own ranks. Around 1612 the calivermen had selected Frans Pietersz de Grebber to paint a platoon of the third company of which he was a member.

The assured execution of Hals's first group portrait raises the question as to whether he was already familiar with working to a large format. As noted, Cornelis Cornelisz van Haarlem's banquet piece of c.1599 (see fig. 10) formed the point of departure for Hals's composition.[23] Both pictures correspond in details like the seating at table and the room in which the group is situated. The stylised gestures of Cornelisz's stiff figures, who pointedly emphasise significant elements like an empty chair symbolising a vacant post, have given place in Hals's picture to gestures that form an integral part of the relation of one figure to another. The colonel raises his glass in the direction of the standard-bearer coming in from the right. All the officers are waiting for the captain to start carving the roast.

The places which the officers occupy at table reflect their positions within the hierarchy of the civic guard. The colonel and provost, at the head of the table on the left, are flanked by the captains, while the lieutenants are at the lower end of the table. The ensigns, who were not members of the officer corps, are depicted standing, as is the guild servant. The standard-bearer behind the table on the left is holding a partly unfurled banner, which extends diagonally up to the top edge of the picture, cutting across the window. This imparts a great

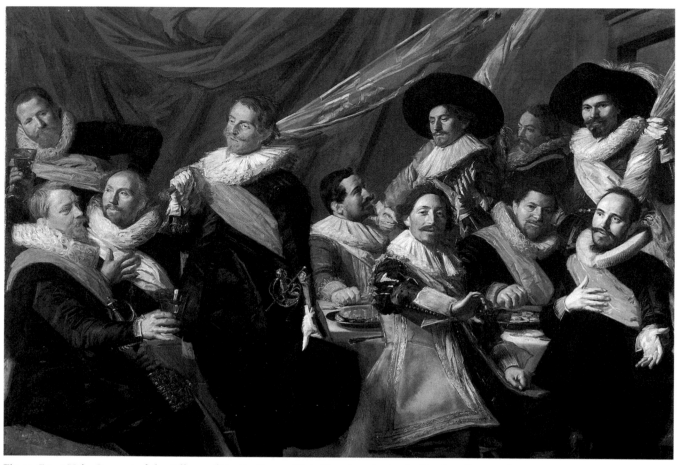

Fig. 13 Frans Hals, *Banquet of the Officers of the St. George Civic Guard*, c.1627 (s46). Haarlem, Frans Halsmuseum

sense of depth to the scene. A similar illusion of space is created by the figure in the foreground, Captain Nicolaes van der Meer, who acts as a *repoussoir*, while the drapery above and to the left of the colonel accentuates the latter's exalted rank and serves much the same purpose as a theatrical stage-flat by deflecting the eye into the picture.

That Hals did not just paint with the speed of a swordsman, is readily seen in this militia portrait. There are certainly some details which have been painted in sketchily, or done wet-in-wet, but elsewhere one finds a more traditional structure. The drapery behind the colonel, for example, is built up with several layers of paint. The top layer was originally a transparent green, of which only traces now remain at the edge of the canvas.[24]

Ten years later Hals was again asked to paint officers' banquets, by which time he had become an established portraitist. Of the two pictures of *c*.1627 (figs. 1, 13), the one for St. George's Hall best typifies his distinctive style of painting (fig. 13). In both works, which are high points in his œuvre, the clear composition is built upon diagonals. The banquet itself is of secondary importance. According to tradition, both paintings commemorate an expedition to the garrison town of Hasselt in Overijssel in 1622. It is true that Haarlem guardsmen took part in this expedition, but research has shown that none of these particular officers were involved. They served from 1624 to 1627, and were on the expedition to Heusden in 1625, and this seems a more likely explanation for the commission. Heusden was reinforced with civic guard detachments from various towns when nearby Breda was captured by Spanish troops. Even though there was no famous victory, Samuel Ampzing still deemed this martial exploit worthy of a detailed report, describing how 'the men from Haarlem and

The Hague crossed over voluntarily, fully armed and their spirits high, ... preserving the town from enemy attack'.[25]

The four men in the foreground of the *Banquet of the Officers of the St. George Civic Guard* all took part in this expedition. In later centuries the hearty officers more than once drew the quite unjustifiable comment that the only function of the civic guard was to put away enormous quantities of food and drink.[26] That, too, fits in with the supposition that the pictures are a direct representation of reality, which completely overlooks the symbolic significance of the scene.

As we have seen, one of the three commissions in the 1630s came from the Amsterdam crossbowmen. Hals began this picture of a gathering of civic guard officers in 1633, but never completed it. In 1636, impatient at his slow progress, the officers served him with a formal summons. In this and three subsequent documents, they demanded that he complete the work, while Hals, in turn, defended his position and offered a number of excuses.[27] One was that he had been required to paint the portrait in Amsterdam, but was unable to get all the guardsmen together. He only needed them to paint their heads, because he preferred to complete the picture in Haarlem. The officers refused to allow this canvas of *The Meagre Company* to leave Amsterdam; it was finished by Pieter Codde (cat. 43). Unfortunately, the documents say nothing about any agreement between the artist and his patrons concerning the purchase of materials, nor is it known whether the canvas was delivered to Hals ready primed and mounted on a stretcher. On the other hand, the documents do suggest that he painted in the basic composition before concentrating on the details. It also appears that he did not attempt to follow any strict order in painting the heads, perhaps because of the practical difficulties he complained of. They could equally well be painted in at the beginning or just prior to completion of the picture. This was confirmed by an examination of several of Hals's paintings during a recent restoration. Both with the naked eye, and under the microscope, it was evident that in all the pictures he worked first on the clothing and then on the heads and hands. However, there are also indications that he did not follow this procedure strictly, for details such as collars and cuffs were generally painted in the final phase (fig. 14).[28]

X-ray photographs of the militia pieces reveal that alterations were made during the course of painting. The fact that no preliminary drawings have survived, as they have for civic guard portraits by a few other artists, might suggest that neither the painter nor his patrons required them.[29] If the guardsmen wanted to see earlier examples of the genre, all they had to do was look

Fig. 14 Frans Hals, *Banquet of the Officers of the St. Hadrian Civic Guard*, detail (s45; see fig. 1)

The brushstrokes visible in the thumb continue beneath the darker clothing, which was applied later. The other fingers, though, are painted over the sash.

around them in the militia halls. The lack of preliminary drawings would have been due not so much to the artist's genius, as Thoré-Bürger supposed, but rather to his readiness to make alterations at any and every stage of the project. There are hardly any changes in the actual compositions, although there is always the possibility that Hals sketched in the basic design in a medium that is not readily detectable by X-rays.[30] One thing, though, seems clear: the idea that these paintings capture an actual moment in time is wholly untenable, from the technical point of view as well. The creation of these pictures was in fact a fairly lengthy process. Hals's group portraits were probably all painted towards the end of the officers' three-year period of duty. It is known that those in his only dated militia piece served from May 1612 to May 1615, and that the portrait was completed in 1616 (see fig. 12). The banquet piece which Ampzing recorded in 1628 as hanging in the Calivermen's Hall depicts officers who served from 1624 to 1627. The time taken to complete a commission probably varied from six months to several years. In the case of *The Meagre Company*, which was begun in 1633, the long period of gestation created problems. Hals, who was in Amsterdam in August 1634, had not nearly

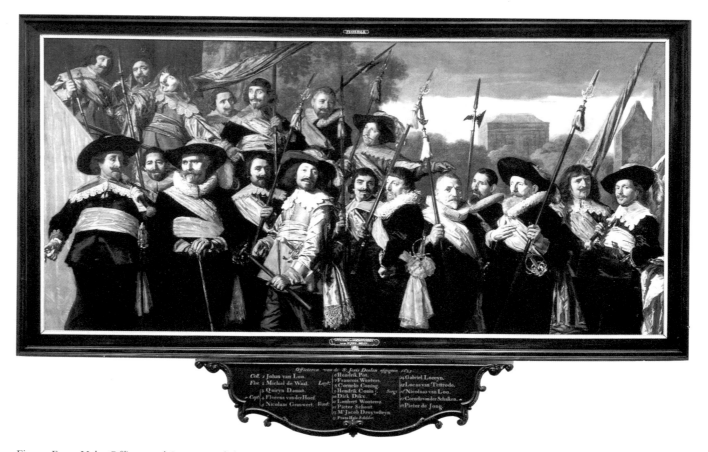

Fig. 15 Frans Hals, *Officers and Sergeants of the St. George Civic Guard*, c.1639 (s124). Haarlem, Frans Halsmuseum

1. Johan Claesz Loo, Colonel
2. Michiel de Wael, Fiscal
3. Quirijn Jansz Damast, Captain
4. Florens van der Hoeff, Captain
5. Nicolaes Grisz Grauwert, Captain
6. Hendrick Gerritsz Pot, Lieutenant
7. François Woutersz, Lieutenant
8. Cornelis Coning, Lieutenant
9. Hendrick Coning, Lieutenant
10. Dirck Dicx, Ensign
11. Lambert Woutersz, Ensign
12. Pieter Schout, Ensign
13. Jacob Druyvesteyn, Ensign
14. Gabriel Loreyn, Sergeant
15. Lucas van Tetterode, Sergeant
16. Nicolaes van Loo, Sergeant
17. Abraham Cornelisz van der Schalcken, Sergeant
18. Pieter de Jong, Sergeant
19. Frans Hals

finished the painting by 1636.[31] Actually, they were used to such dilatory progress in Amsterdam. In 1642, a bet was placed as to whether a painting by Nicolaes Eliasz, who had the reputation of being a slow worker, would be finished by a certain date.[32]

In the case of Hals's undated canvasses for the Haarlem civic guards, the changes in the composition of the officer corps and in the paintings themselves give useful information as to when they were commissioned and when they were completed.

A good example is the assembly of officers and sergeants of the St. George civic guard of the 1636-9 term of office (fig. 15).[33] Several changes which occurred during that three-year period are reflected in the painting. The numbers placed above the figures, which correspond to the list of names on the plate below the picture frame, made it possible to verify a number of details.

Thus Michiel de Wael, the fifth figure from the left in the front row, who was promoted from captain to fiscal in 1636, is depicted with the short commander's baton carried by fiscals.

In 1637, a deceased lieutenant was succeeded by Hendrick Gerritsz Pot, the artist of the group of calivermen officers of c.1630. He is the fourth figure from the left in the back row, but he does not have the partisan, a fearsome blade mounted on a stave, that would have identified him as a lieutenant. Another lieutenant, who died just a month before the corps was due to complete its term of service, is not portrayed, but he was not replaced either. Perhaps the space that had been reserved for him in the picture is the one now filled by a lieutenant of the calivermen. By this stage the two civic guards were no longer strictly separated, in fact from 1633 they formed just a single administrative unit. One of the calivermen ensigns has also been included. From 1639 to 1642 the righthand figure in the back row was a lieutenant with the calivermen. When the commission was awarded, though, he was still a sergeant with the St. George civic guard.[34] Thus in place of the partisan, which indicates his rank as a lieutenant, he should really have a halberd, the weapon carried by sergeants. And interestingly, the X-ray photograph shows that he did have one at an earlier stage of the painting (fig. 16). It was probably this officer, who is identified as Hendrick Coning, who asked Hals to alter the canvas when it was in an advanced stage, around 1639 or even later. His gesture towards the sergeant in the front row, would have made the situation clear to the contemporary viewer. The only guardsman without any badge of rank at all was identified in the eighteenth century as Frans Hals himself.[35] He is tucked away in the back row, the second figure from the left (Introduction, fig. 6).

New appointments are also reflected in the *Officers and Sergeants of the St. Hadrian Civic Guard* of c.1633

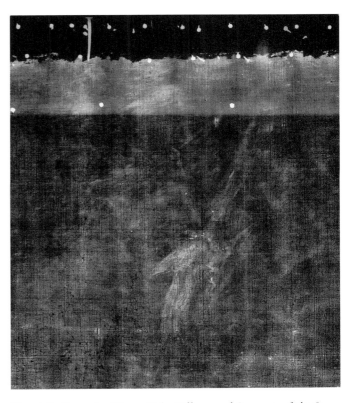

Fig. 16 Radiograph of Frans Hals, *Officers and Sergeants of the St. George Civic Guard*, c.1639, detail (s124; see fig.2)

(fig. 17).[36] Seated at the far right is the painter Hendrick Pot, who was serving with the calivermen at the time. He is wearing a blue sergeant's sash, but six months after joining the officer corps of the calivermen, he succeeded the deceased lieutenant of the orange platoon. This fact seems to have been incorporated in the picture. The lieutenant just to the right of centre (on the left is the colonel surrounded by ensigns and officers) is proffering a pen to the captain of the orange platoon. Is he about to enter the prospective lieutenant in the register, the book which Pot himself is holding? The lieutenant looking over Pot's shoulder is pointing towards the captain, Andries van Hoorn, who in turn confides in the viewer.

The changes in the officer corps of 1636-9 noted above, all of which occurred towards the end of a period of service, give the impression that Hals began late and continued to make alterations right into the next period of appointments. By contrast, the *Officers and Sergeants* of c.1633 may have been painted earlier in the service period, if the above interpretation is correct and the painting does indeed record an actual event.

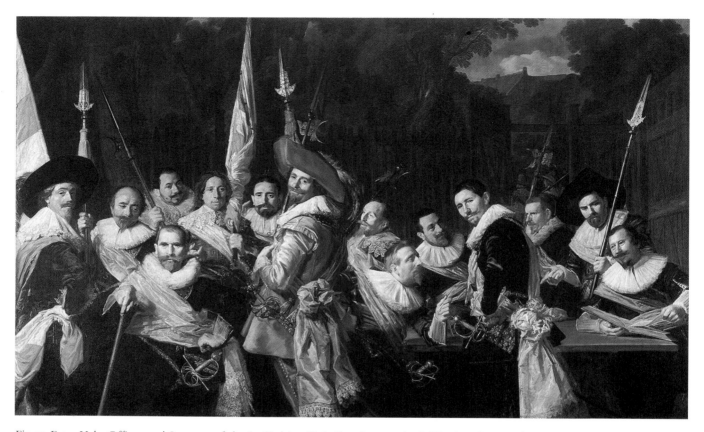

Fig. 17 Frans Hals, *Officers and Sergeants of the St. Hadrian Civic Guard*, c.1633 (s79). Haarlem, Frans Halsmuseum

The modifications to the *Banquet of the Officers of the St. George Civic Guard*,[37] whose officers served from 1624-7, seem at first sight from the X-ray photograph to have been made for compositional reasons (fig. 18). The positions of the heads of Michiel de Wael, the captain in the foreground, and of Ensign Dirck Dicx, have been altered. Originally they were turned slightly to the right, but in the final version Michiel de Wael is looking out at the viewer, while the standing ensign is looking down at the lieutenant seated behind the table. The final arrangement seems the more successful, as otherwise the composition (which avoided a central point of focus) would have fallen into two independent parts. The ensign to the left of centre has his back turned to the others. Now unity is achieved by having the captain in the foreground look directly at the viewer. Even more important, though, are the gazes of Ensign Dirck Dicx and the seated lieutenant in the centre background, which parallel the diagonal line of the flag held by the ensign on the left.

But here too, the question arises as to whether the alteration was made purely to improve the composition. Dirck Dicx only became an ensign in 1626, replacing a brother who had married.[38] The dating of the picture is partly based on this appointment.[39] It is not entirely impossible that the ensign whose pose was altered was originally the brother who married. Unfortunately, the facial features are too indistinct in the X-ray photograph to come to any firm conclusion. Caution is necessary concerning the date of the commission, partly because two of the officers were also appointed in 1625, during the term of service.

Finally, there is the *Banquet of the Officers of the St. George Civic Guard* of 1616,[40] where a number of alterations visible in the X-ray picture cannot be connected with specific events. What is remarkable is that one of those changes involved the captain of the third company, which was added to the guard in 1612. We can even take it that this reorganisation was the occasion for the commission. This particular captain, who is identified as Jacob Lourensz and is seated immediately to the right of the colonel, was originally painted with both

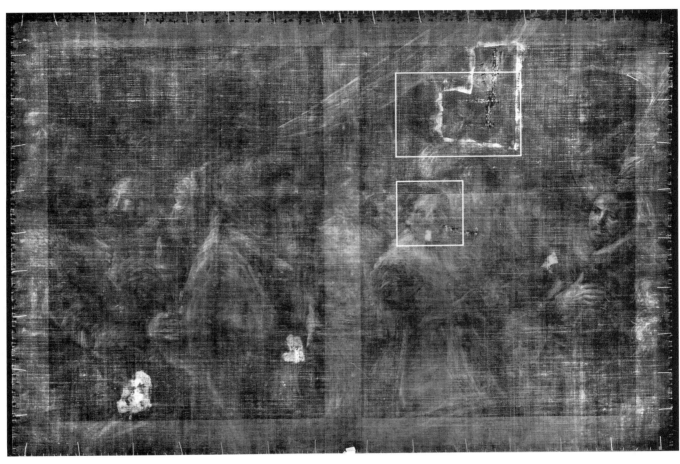

Fig. 18 Radiograph of Frans Hals, *Banquet of the Officers of the St. George Civic Guard*, c.1627 (s46; see fig. 13)

Figs. 19-20 Radiograph of Frans Hals, *Banquet of the Officers of the St. George Civic Guard*, 1616, details (s7; see fig. 12)

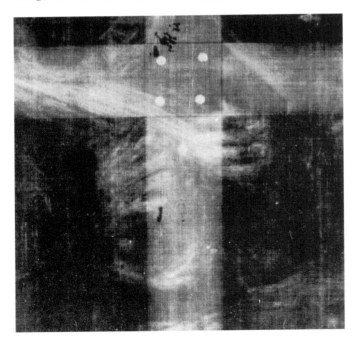

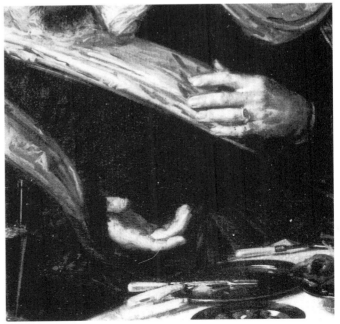

hands on his chest (fig. 19). In the final version, his right hand has been altered into a traditional speaking gesture, which both emphasises his orientation towards the colonel and at the same time creates a sense of depth. The seventh figure from the left, behind the table, has had his right hand painted out. At an earlier stage it was laid on his breast, perhaps as a sign of loyalty to the company. His head has also been altered so that he now looks out towards the viewer. Initially he was involved in the action. The subtle modulation of the gazes, with one man looking out of the picture and the next towards the action within it, is what helps make the composition so lifelike. The rapid brushwork and the spontaneous method of working which brought about such a deceptive illusion of reality do not appear to have suffered from the relatively long period of production, nor from the extensive input from Hals's patrons.

The alterations to the canvas, combined with an analysis of historical data, indicate the course of time that elapsed between the commencement of an assignment and its completion. In this way, X-ray photographs give Hals's militia pieces added value as historical documents. Now, indeed, one can speak of pictures 'true to life'.

Notes

1. Hals doc. 41.
2. For a discussion of this complex subject see Carasso 1984.
3. See Jowell, pp. 64-9.
4. Jowell 1974, p. 109.
5. Blankert 1975.
6. Jowell, p. 65.
7. Unless otherwise stated, the following discussion of the civic guard and the evolution of the militia piece is based on the introductory essays in Haarlem 1988.
8. Haverkamp-Begemann 1982, p. 66, note 4.
9. Amsterdam, Amsterdams Historisch Museum, inv. A 7342.
10. Amsterdam, Rijksmuseum, inv. C 402 (central panel); Amsterdam, Amsterdams Historisch Museum, inv. A 7279.
11. Amsterdam, Amsterdams Historisch Museum, inv. A 7287; Amsterdam, Rijksmuseum, inv. C 365.
12. Amsterdam, Rijksmuseum, inv. C 378.
13. Van Valkenburg 1958; Slive 1970-4, vol. 1, pp. 46-8; Haarlem 1988, cat. 22.
14. Hoorn, Westfries Museum, invs. A 70-3, Amsterdam, Rijksmuseum, inv. C 371.
15. Amsterdam, Amsterdams Historisch Museum, inv. A 7313.
16. Amsterdam, Rijksmuseum, inv. C 2.
17. See de Bièvre 1988.
18. Van Mander 1604, fol. 292v.
19. 'Men sal gheen coemenscap zo vast muegen duen binnen dit scutterhof Die gheen diet rout die mach tsanderen daechs met de wyncoop off'. This motto was recently discovered beneath a similar announcement dated 1605, and is published here for the first time. For the motto of 1605 see Allan 1874-88, vol. 4, p. 550.
20. Haarlem City Archives, Treasurer's Accounts for 1687, 267, fol. 85v.
21. Van Valkenburg 1958 and 1961.
22. Van Valkenburg 1958; see also Haarlem 1988, cat. 22.
23. Slive 1970-4, vol. 1, p. 46.
24. Further details will be found in the unpublished report, 'Restauratie schuttersstukken Frans Hals', archives of the Frans Halsmuseum, Haarlem. See also Middelkoop & van Grevenstein 1988, p. 22.
25. Ampzing 1628, p. 311: 'Al waer de Haerlemmers en Hagenaers tesamen vrijwillig, wel-gemoed, gewapend over-quamen. ... Bewarende die stad voor 's vijands overval.'
26. Te Lintum 1896, p. 109, and more recently Schama 1987, pp. 181-2.
27. See Hals docs. 73-5, 78.
28. See Hendriks & Groen, pp. 116ff.
29. See Haarlem 1988, p. 116, fig. 86, for a possible preliminary study for a *Civic Guard Banquet* of 1600 by Frans Pietersz de Grebber; p. 135, fig. 110, for a drawing which can be regarded as a preparatory stage for Jan Anthonisz van Ravesteyn's *Hague Magistrature receiving the Officers of the Civic Guard* of 1618, and p. 378, fig. 182, for a drawing in which the standing figures bear a striking resemblance to the comparable group in Thomas de Keyser's militia piece of 1652 for the Calivermen's Hall in Amsterdam.
30. One finds a very different procedure in a painting like Rembrandt's *Syndics* (Amsterdam, Rijksmuseum, inv. C 6), where X-ray examination has revealed numerous alterations to the composition. See van Schendel 1956 and van de Waal 1956.
31. See note 27.
32. Blankert & Ruurs 1979, no. 139, inv. A 7310, and no. 140, inv. A 7311.
33. Van Valkenburg 1961, pp. 65-76.
34. Haarlem City Archives, Old Civic Guard Archive, inv. 31-3, 1636.
35. This traditional identification is based on the number 19 painted above this figure's head, which corresponds to Hals's name on the eighteenth-century panel beneath the picture. That, in turn, was probably based on the attempted reconstruction of 1692, when a number of elderly Haarlem residents were asked to identify as many of the guardsmen as they could; see van Valkenburg 1958, p. 62. There are also two handwritten lists of names dating from the first half of the eighteenth century (Haarlem City Archives, Old Civic Guard Archive, inv. 27-1). There is no firm evidence that this is indeed Hals, for he is not listed in the membership rolls of the St. George civic guard for this period. He may have been a caliverman, like some of the other sitters, but unfortunately the calivermen's rolls for that year have not survived.
36. Van Valkenburg 1961, pp. 59-65.
37. Ibid., pp. 46-53.
38. Slive 1970-4, vol. 3, no. 46; Dix 1978, p. 90.
39. Slive 1970-4, vol. 1, p. 69.
40. Van Valkenburg 1958, p. 65; Haarlem City Archives, Old Civic Guard Archive, inv. 31-1, 1612.

The Meagre Company and Frans Hals's Working Method

The recent restoration of Frans Hals's militia pieces in Haarlem has generated a renewed and more systematic study of his way of working. This present article seeks to contribute further to this wave of new research, based as it is on another programme of restoration, namely the *Company of Captain Reynier Reael and Lieutenant Cornelis Michielsz Blaeuw*, more commonly known as *The Meagre Company*, in the Rijksmuseum, Amsterdam (fig. 1, cat. 43).[1] Begun by Frans Hals and finished by Pieter Codde, it is the only civic guard portrait on which Hals worked outside Haarlem. One question which still puzzles art historians about this unpremeditated collaboration is the distribution of responsibility between the two artists.[2] The restoration of the painting

in 1988 seemed the opportune moment to address the problem once again, working on the theory that the stage at which Hals abandoned the canvas might tell us a good deal about his working procedure.

Quite apart from the fact that Hals's broad, assured touch can easily be distinguished from Codde's meticulous hand, there is some well-known archive material relating to his part in the project.[3] Hals was already working on *The Meagre Company* in Amsterdam in 1633, but stopped when he ran into trouble with his patrons. Three years later, in 1636, he had 'only partly finished' the painting. According to Hals it had been agreed that he would 'begin the heads in Amsterdam and complete the remainder in Haarlem'. He claimed that the officers then reneged on this agreement. They, for their part, testified that this was not true, saying that they had even offered Hals an additional six guilders per sitter if he would come to Amsterdam to finish the heads and the figures, and whatever else was necessary, as he had already started doing.

For some unknown reason, though, nothing could persuade Hals to put brush to canvas in Amsterdam. In the course of this increasingly heated dispute he declared his willingness to move the unfinished painting from Amsterdam to his house in Haarlem, where he would complete the officers' dress. Having done that,

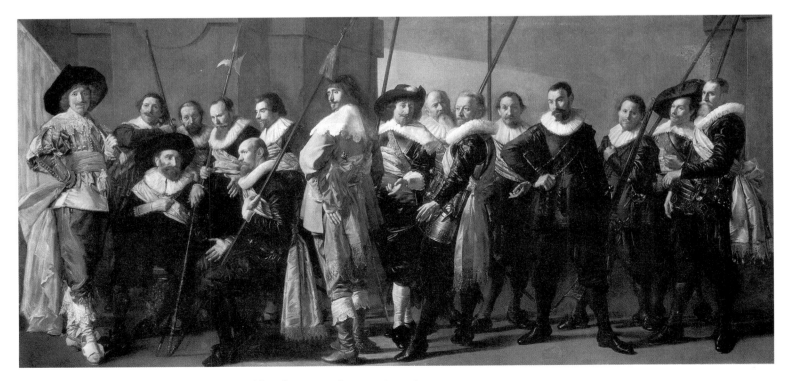

Fig. 1 Frans Hals and Pieter Codde, *The Meagre Company* (cat. 43)

Fig. 2 Nineteenth-century framing of *The Meagre Company*
1. Frame; 2. Stretcher; 3. Canvas; 4. Cord

he would paint the heads of whoever was willing to come to Haarlem. If six or seven of the officers refused to do so, he was still prepared to paint them in Amsterdam.[4]

The question remains just how far Hals had progressed with the painting, although it is clear from the above that some of the heads were largely unfinished and that there was still work to be done on the figures, which Hals proposed completing in Haarlem without the sitters. Several of the officers evidently had no objection to making the journey to his house, and although his remark that he was willing to go to Amsterdam to paint six or seven who refused was probably no more than an empty gesture, it does indicate that at least seven heads remained to be completed.

It is worth pausing at this point to analyse one or two of the words used in these documents. Several times it is said that Hals had 'begun' to paint, and one might suspect that this refers to the 'dead colouring', or monochrome underpainting. However, it is clear from the passage: 'he would paint and completely finish both the heads and figures of the men, and whatever else is necessary, here in Amsterdam, not Haarlem, as he has already begun doing' that the word 'begun' must be taken literally. Several figures had apparently been completed, for the word *opmaecken* (finish) meant applying the topmost layer of paint.[5] G. Schaep used the same term seventeen years later, when he wrote that the work had been painted by Hals and completed by Codde.[6]

Jan van Dijk, an eighteenth-century artist and historian who restored paintings belonging to the City of Amsterdam, including *The Meagre Company*, was 'convinced that it was painted all at once, without dead colour'.[7]

The technical examination for this essay involved analysis of paint samples under a laboratory microscope and study of the X-ray photographs (radiographs) of the entire canvas. A forthcoming paper on the sizes of paintings, as well as the remarkably detailed information available on past restorations of *The Meagre Company*, also proved valuable.[8]

THE CANVAS

Like all of Hals's other militia pieces, the painting consists of a seamless piece of linen which is still virtually intact, and was very probably ordered from an Amsterdam *primuurder*, or primer. Some of the unpainted edges of the canvas which are still intact, including a selvage along the top, show that the painting was mounted only once, and that it was not, as sometimes happened, placed on another stretcher after the ground had been applied. The entire canvas was presumably tensioned on the stretcher with cords (fig. 2). During a nineteenth-century restoration it was removed from what could well have been its original stretcher for relining. The present frame is old but not original, and that, together with some independent historical data, tells us the following about the history of the painting. The corner joints of the frame have not been altered, indicating that it was not made for another painting and subsequently modified. The rabbet is only one centimetre wide. From this it can be inferred with a fair degree of certainty that the painted surface measured 208 × 427.5 cm at the time of its nineteenth-century restoration, and that those may well have been its original dimensions.[9] The frame appears to date from the late seventeenth century, which coincides with the picture's transfer to Amsterdam Town Hall from the Crossbowmen's Hall. This probably entailed removing it from a fixed wooden framework and placing it in a new frame of its own. It is known that several frames were ordered for militia pieces in the late seventeenth century, and the measurements of one purchased in 1687 suggest that it could have been intended for *The Meagre Company*, or possibly for Cornelis Ketel's slightly smaller *Company of Captain Dirck Jacobsz Roosecrans and Lieutenant Pauw* of 1588 (Levy-van Halm & Abraham, fig. 7).[10]

If the size of the present frame does indeed match the original size of the painting, it can be concluded that the height of the canvas was equivalent to three ells and the length to 15 Amsterdam feet.[11]

THE GROUND

There are two ground layers,[12] the first a brownish red colour (brown ochre), and the second grey (lead white, chalk, charcoal). Since there is very little material for comparison, it is not clear whether this structure was common practice in Amsterdam at the time, or whether the grey layer was applied by the canvas primer or by Hals himself. Whatever the answer, a priming of this kind corresponds with what we know of Hals's working method.[13]

THE SKETCH

No traces of a chalk or graphite drawing were found between the ground and the paint layer. However, the X-rays did reveal a hasty sketch in grey oils with which Hals defined the position of various forms and laid in cursory guidelines.[14] This undermodelling can be seen in passages where he used radio-absorbent pigments before Pieter Codde departed from his original design. Thus the contours of a coat which Hals sketched for the fourth guardsman from the right (no. 13; fig. 3) are clearly visible, even to the naked eye, as well as the boots indicated by a single zigzag line. The outlines of a building can be seen behind this figure and his two companions on the left.

THE PAINT LAYER

The central figure (no. 8) is the key to the next stage, in which Hals painted shapes, folds and shadows with broad brushstrokes in a single operation, the colours true from the outset. This is visible to the naked eye as well as in the radiographs (fig. 4). The latter show that he originally stood with his back turned even further towards the viewer, his left hand on his breast. Instead of the sash in the finished painting, he apparently had a bandoleer with powder charges like those worn by two of his fellow officers (nos. 2 and 13). It may also have been intended to give him a sword, which would have extended from the point where his hand now is. One can also see several of the folds in his breeches painted by Hals, as well as the boots, which are executed with the same flair as those of the guardsman standing on the extreme left (no. 1). The collar and head of the

central figure must also have been in an advanced stage of completion, so it is unclear as to why Codde decided to transform him into the meagrest member of the company.

The man to his right (no. 9) must have been equally far advanced. The same applies to the background, which would have been very similar to that in Hals's *Officers and Sergeants of the St. Hadrian Civic Guard* of *c.*1633 at Haarlem (Levy-van Halm & Abraham, fig. 17; s79). The building itself was filled in with grey. There is also an underlying green layer by the head of the third man from the right (no. 14).

It is tempting to interpret the word *opmaecken* (to finish), which was the term Hals himself used, as a reference to the work still to be done on the central officer and the figure to the right of him (nos. 8 and 9), namely filling in any blank areas, adding details and placing the highlights, which he had already done for guardsman no. 1.

Although the painting has no dead colouring in the traditional sense, this is not to say that there is no underpaint at all. The third figure from the left, for instance, has a brushy, grey layer beneath the black of his clothing. Hals was evidently aiming at a richly colouristic effect, but this has been spoiled by the subsequent darkening of the black. Hals seems to have tackled all the heads, collars and ruffs in the same way. His initial touches beneath the collars are particularly apparent to the naked eye.

Two heads in the left background (nos. 2 and 4) struck Jan Six as incomplete.[15] He based this conclusion on the evidence of the documents,[16] which state that some of the men had been completely (*volcomentlijck*) finished and suggest that there were six or seven unwilling sitters, and on the fact that Codde worked mainly on the righthand side of the painting. Beneath these two heads

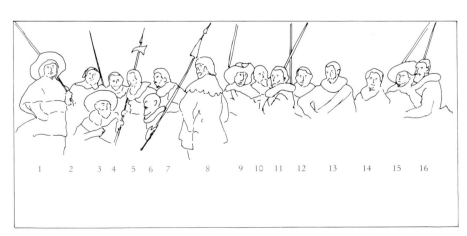

Fig. 3 Key to the sitters in
The Meagre Company

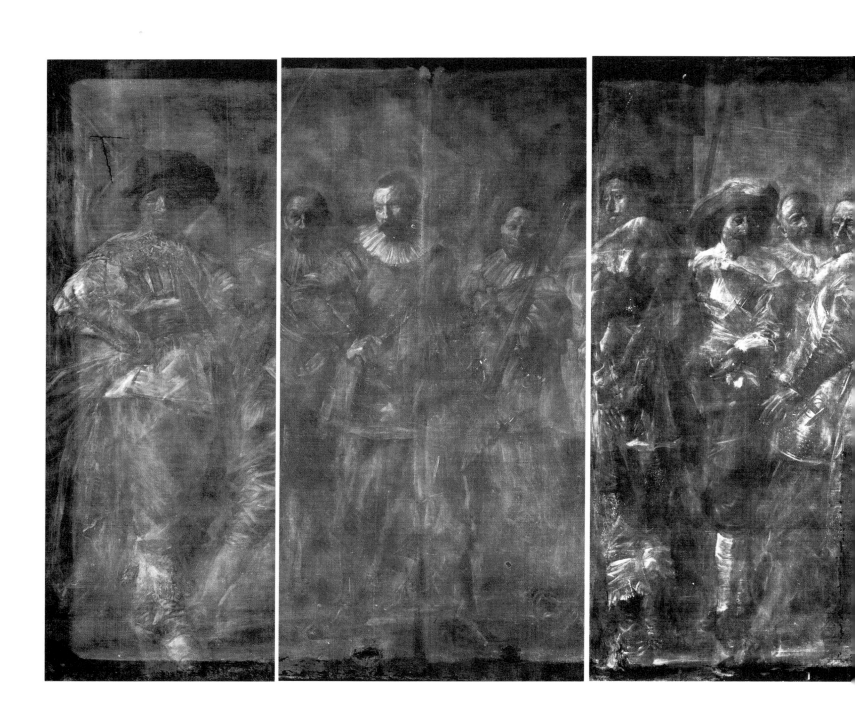

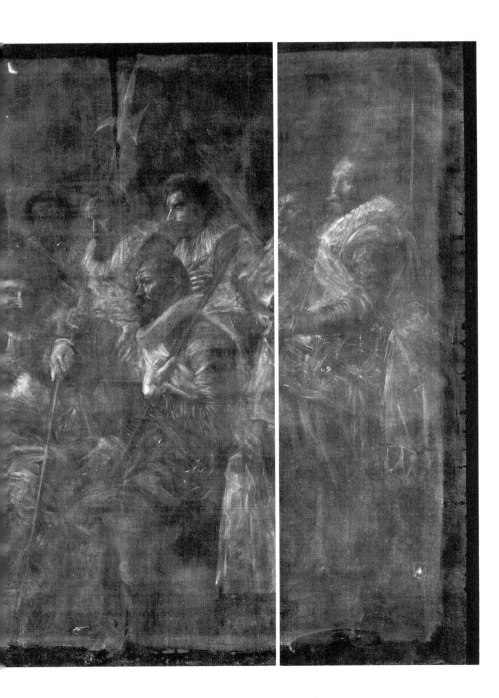

Fig. 4 X-ray mosaic of *The Meagre Company*

The radiographs were taken by G. van de Voorde of the Institut
Royal du Patrimoine Artistique in Brussels. The entire canvas was
photographed in five strips, each approximately 1 metre wide and
extending the full height of the picture (material: Structurix-D 4,
m.a.15, distance: 7.5 metres, kV 50, exposure time: 9 minutes).

one finds hard outlines of brushy, light-coloured paint by the edges of the foreheads, and eyes 'drawn' with a greenish paint.

The pigments themselves are unremarkable, apart from the lead white, which is of a finer quality in the flesh tones than in other parts of the painting, where it is mixed with chalk. This reflects the distinction made in seventeenth-century sources between lead white (*loodwit*) and flake white (*schelpwit*).[17]

The idea which we have gradually been able to form of Hals's procedure in *The Meagre Company* is that he worked fairly systematically from left to right, apparently reserving certain details for a later stage. Thus the right hand of the man (no. 6) seated to the left of the central figure was still only a sketch when Codde was permitted to test his talents on the canvas. The head and clothing of guardsman no. 9 were largely finished, whereas the central figure existed merely as a rough sketch.

Nor did Hals finish the background, which was un-usual for a seventeenth-century master. He must have had more than enough time to do so.[18] The almost total absence of reflected lights could also be due to this rather fragmentary way of working.

All in all, despite the lack of any really firm evidence, one suspects that *The Meagre Company* was painted *alla prima*. The simple building which Hals planned for the background presented no real difficulties in terms of perspective (the architectural elements in the finished picture are Codde's work). As we have seen, the purpose of the preliminary oil sketch was to define the position of the figures; it does not suggest the transfer of a drawing or small-scale sketch onto the canvas. The broadly bipartite composition would have simplified Hals's work, for it was of a type with which he had considerable experience. The similarity to the Haarlem militia piece of c.1633 (s79) is striking, especially if one tries to visualise *The Meagre Company* without Codde's additions.

Notes

1. On loan from the City of Amsterdam to the Rijksmuseum, inv. c374. It was restored in 1988 by M. Zeldenrust and the author, who is grateful to W. Th. Kloek for his critical reading of this essay.
2. Six 1893, pp. 101-4; van Dantzig 1946; Slive 1970-4, vol. 1, pp. 136-8.
3. See Hals docs. 73-5, 78.
4. Hals doc. 78.
5. Miedema 1987.
6. Hals doc. 140.
7. Van Dijk 1790, pp. 30-3: '... overtuigd dat het op eenmaal zonder dootverven geschildert is.'
8. The most valuable source for past restorations comes from the Treasurers' Daybooks published in Oldewelt 1934 and Oldewelt 1935. The technical analysis of the paint samples was carried out by M. de Keyzer, M.F.S. Karreman and J.A. Mosk of the Central Research Labora-

tory in Amsterdam. The radiographs were taken by G. van de Voorde of the Institut Royal du Patrimoine Artistique in Brussels. The entire canvas was photographed in five strips, each approximately 1 metre wide and extending the full height of the picture (material: Structurix-D 4, m.a.15, distance: 7.5 metres, kV 50, exposure time: 9 minutes).
9. Due to the various treatments, the painting had shrunk to less than 206 × 426 cm. Now, after the latest restoration, it measures 207.3 × 427.5 cm.
10. See Oldewelt 1934, pp. 141, 164-5. The painting by Ketel is Amsterdam, Rijksmuseum, inv. c378.
11. A forthcoming study of canvas sizes, chiefly of paintings in the Rijksmuseum, will give a more detailed analysis of the measuring procedure and local differences in standard measures.

An ell is equal to approximately 69 cm, and an Amsterdam foot to 28.3 cm. The observed deviations are all within an acceptable margin of error. The study also examines the reasons for minor discrepancies.
12. These findings are based on the investigation carried out by the Central Research Laboratory.
13. See Groen & Hendricks, pp. 114-6.
14. Most of the observations were made with the naked eye. For the radiograph see note 8.
15. See Six 1893, pp. 101-4, for an excellent analysis of the painting which reflects close and painstaking observation.
16. See note 3.
17. Van de Graaf 1961.
18. See note 3.

KARIN GROEN & ELLA HENDRIKS

Frans Hals: a Technical Examination

Over the period 1984 to 1988, ten paintings by Frans Hals in the collection of the Frans Halsmuseum in Haarlem, including the five militia pieces, have been restored.[1] This has provided important information about Hals's working methods and materials, and laid the foundations for a broader investigation into the artist's painting technique revealed in the works in this exhibition. Until embarking upon this most recent research programme, reports on comprehensive technical examinations of Hals paintings have been rare; in recent decades, only three have been published.[2] Taking advantage of an exhibition in 1937 which brought together a number of works by Hals, the art critic M.M. van Dantzig attempted their visual analysis.[3] In the present research programme, additional analytical and photographic techniques have been used to substantiate our observations.[4]

Our technical examination involved forty of the two hundred and twenty-two paintings attributed to Hals by Seymour Slive. During the course of it, we came to recognise a number of common characteristics. While some of these are in line with the known practice in other seventeenth-century Netherlandish workshops, others would appear to be hallmarks of Hals's own personal style. Most distinctive of these is the apparent virtuosity displayed in his handling of paint.[5] Our research not only confirmed this characteristic, but also indicated that he applied such a technique to earlier stages in the painting process, which are largely hidden from view. Bringing together these paintings on exhibition provides a rare opportunity to revise and build upon the knowledge gained from this initial look at Hals's painting technique.[6]

PAINTING SUPPORTS

Apart from three works on copper panel which survive from the first three decades of Hals's known career, including *Theodorus Schrevelius* (cat. 5) and *Samuel Ampzing* (cat. 40), roughly three-quarters of his surviving attributed works are on canvas and the rest on wood panel.[7] This preference for canvas as a painting support

conforms to the general tendency for canvas to supersede wood as the dominant support in this period.[8] Like Rembrandt, Hals consistently used wood panel for small portraits throughout his career, though the proportion of his works on wood panel to those on canvas declines progressively.[9]

A progression in picture size, associated with the material of the support, conforms to Netherlandish paintings of the period. Hals's three smallest works are on copper panel, whilst at the size of the largest of these,[10] 19.9×14.1 cm, wood panel takes over as the most common support. The dimensions of most wood panels lie between this size and around 45×35 cm, and the use of canvas predominates once the format of a picture moves above $c.60 \times 50$ cm.[11]

PANEL

Seventeenth-century sources suggest that Hals would have bought his panels ready-made from specialist craftsmen, members of the guilds of cabinet-makers and joiners. It would appear that he could have been limited to what might have been standard size frames.[12] To ascertain whether Hals's panel paintings conform to possible standard-size panels, height to width ratios of forty upright rectangular panels were plotted on a graph.[13] Although no grouping of standard-size panels emerged, a general proportional relationship of 1.25:1 was found. This agrees with the value found for other Netherlandish vertical format panel paintings of the period.[14] It is not remarkable that this standard proportion is found to be used for the uniform subject-matter of half or three-quarter-length portraits which Hals painted on panel.

Nearly all of the wood panels examined, including the larger pendants of a *Man holding a Skull* and *Portrait of a Woman* (cat. 2, 3) are made from a single plank. However, one relatively small panel, the half-length portrait of *Zaffius* (cat. 1), shows the more complex construction of two vertical planks butt-joined (the edges fastened end to end without any overlap) and glued. New technical information has revealed that the panel was not cut down at a later date, as has been previously suggested (see cat. 1). Microscopic examination and paint samples show that the ground and paint layers continue around the top, left and bottom edges of the panel and have been lightly smoothed away along the right edge (pl. VIIIa).[15] This suggests that the panel was primed and painted in its current size. Furthermore, the reverse of the panel retains its original bevelling on all four sides, which appears to have been standard practice at the time in order to facilitate framing (VIIIb). Thus a different explanation has to be found for the

Figs. 1, 2 Radiographs of *Man holding a Skull* (cat. 2) and *Portrait of a Woman* (cat. 3)
The lead white content of the ground layers clearly reveals the opposing curve of the wood grain of the two panels. They were cut from a
back-to-back position from the same bent tree-trunk, which supports their attribution as pendants.

three-quarter-length depiction of *Zaffius* in a reversed engraving of 1630 by Jan van de Velde II, traditionally thought to be a copy after this painting before it was cropped (see cat. 1).

Those wood panels examined which retain their original state show a thickness of around 1 cm, usually bevelled at the reverse along all four edges to a few mm thickness. However, the radially cut panel of *Portrait of a Woman* (cat. 79) shows bevelling on three sides only, to a thickness of 8 mm. The bevels along the top and bottom edges taper out towards the right edge which is 6-8 mm thick without bevelling. This is the thin side of a wedge-

shaped board which is produced by the radial manner of sawing a plank from the tree (at right angles to the annual rings).[16]

Another distinct variation from the norm is in the pendant portraits of *Cornelia Vooght* and *Nicolaes van der Meer* (cat. 42, 41). These are exceptionally large for works on wood panel by Hals. Uniform both in size and composition, they are made up of three vertical planks of an average width of 33 cm, which are butt-joined and glued.[17] However, the construction of the two panels differs in the cut of the planks. Most of the planks examined were sawn radially from the tree, as was the

usual practice in order to minimise the tendency to warp. This applies to the three planks which make up the panel of *Cornelia Vooght*. However, whereas the outer two planks of *Nicolaes van der Meer* are also radially cut, the middle plank was cut strictly tangentially (parallel to the annual rings) from the trunk. This unstable construction, made worse by later thinning of the panel and the addition of a heavy cradle on the back, accounts for the fact that old splits in the wood and flaking losses of the ground and paint layers occur chiefly in the weaker middle plank. Similarly, whilst *Anna van der Aar* (cat. 20) is painted on a wood panel of radial cut, its pendant *Petrus Scriverius* (s36, see cat. 20) is painted on a more unstable panel cut tangentially close to the bark, so that it has suffered more and shows a number of splits. The small panel of *Jean de la Chambre* (cat. 50) is similarly of tangential cut.

In Hals's portraits of rectangular format, the wood grain usually runs vertically. However, two portraits on panel, *Man holding a Skull* and *Portrait of a Woman* (cat. 2, 3) show opposed diagonal slants of their characteristic curving wood grain. It would appear that the two panels were cut radially from a back-to-back position in the same bent tree trunk. This is visible in raking light, and very clear from the X-ray due to the lead white content of the ground layer (figs. 1, 2). This suggests that the panels were supplied together, thus supporting their attribution as pendants.

In his genre pieces, which are occasionally on differently shaped panels, the grain sometimes runs diagonally. Furthermore, in the pendant tondos *Drinking Boy* and *Boy holding a Flute* (cat. 27, 28) or in the lozenge-shaped pendants of the *Singing Girl* and *Boy playing a Violin* (cat. 25, 26), it is noticeable that the grain slants in the opposite direction in each panel. Given these observations, one wonders whether Hals was aware of the potential visibility of the grain of these panels.

In keeping with most Netherlandish panel paintings of the period, the species of wood used for the majority of Hals's panels is oak shipped from the Baltic region.[18] Dendrochronology of the near-radially cut oak planks of *Zaffius* (cat. 1) suggests that they originated from a tree felled between c.1602 and c.1608 in that region.[19] This information provides added support for accepting the date for this work to be 1611, the date found in the inscription on the painting itself, which has been confirmed to be original. The planks used for the panel of *Cornelia Vooght* were examined by dendrochronology as well. They originated from one or more trees felled between 1621 and 1627 in the Baltic. Some of the small portraits which we examined did show that Hals used

other types of wood. The small panel of *Petrus Scriverius* (s36, see cat. 20) for example, is of a dense tropical wood, while its pendant *Anna van der Aar* (cat. 20) is of a wood from a fruit tree (pear or apple).[20] Here again, Hals's small panels appear to conform to early seventeenth-century Netherlandish patterns.[21]

CANVAS

In the Netherlands in the seventeenth century, canvas was not yet specifically woven for artists. They were thus obliged to use fabric made for other purposes, notably for sails and for bed linen. Painters would normally use canvas strips whose width was related to the Flemish 'ell', approximately 69 cm.[22] In the late *Portrait of a Man* at the Fitzwilliam Museum (fig. 85b; s218), the width of the canvas measures 69.5-70.5 cm, which corresponds to this basic unit of 1 ell.[23] We know that the entire width of the strip is present since, unusually, there are remains of the original selvedges which run parallel to the warp along the right and left sides.

Canvasses of considerable dimension were used for Hals's commissioned group portraits, for example 207.3 × 427.5 cm in the case of the *Meagre Company* (cat. 43). The possibility of rolling up these large paintings in order to transport them must have been an important consideration in the choice of canvas as a support.[24] X-rays show that the canvas of this painting, as well as the *Regents, Regentesses, Regents of the St. Elizabeth Hospital* (cat. 85, 86, 54) and all five militia pieces commissioned in Haarlem between 1616 and 1639 (s7, s45, s46, s79, s124) were woven in a single strip, its width corresponding to the vertical dimension of the paintings (fig. 3). Where the original top and bottom edges of the canvas remain, we know that the entire strip width is present. In the *Regents* and *Regentesses* the strip width measures c.172.5 cm, or 2½ ells. The last of the militia pieces (s124) measures 207.3 cm in height, which corresponds to a strip width of 3 ells. This compares with the widest single-strip canvasses observed in seventeenth-century Netherlandish paintings.[25]

The use of such wide canvasses woven in a single strip was probably more expensive than the alternative of seaming together more than one strip, where the visibility of the seams could become disturbing.[26] This study found that two canvasses made up of more than one piece resulted from alterations made at a later date. Despite differences in provenance and size, the *Portrait of a Woman* (Jowell, fig. 2; s185) has been considered a pendant to the *Portrait of a Man* at Vienna (s184). Examination of the original canvas revealed that a strip 3.5 cm wide had been cut from the bottom of the

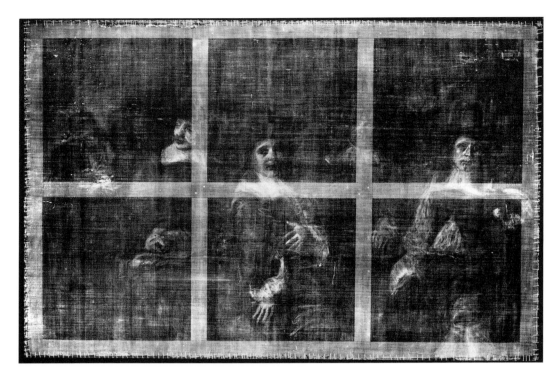

Fig. 3 Radiograph of the *Regents* (cat. 85)
The support consists of a single strip of
canvas, 2½ ells wide.

painting and placed on the top left side.[27] A length of coarser canvas had then been added below to fill out the picture's vertical dimension on the lefthand side and the whole overpainted.[28] The edges of the original canvas had also been trimmed. Once its original dimensions are reconstructed, they can be proved to more or less match those of the *Portrait of a Man*, and thus support the supposition that the two portraits are pendants. Such mutilations may have been made in order to fit the painting into an existing frame or to match another portrait.

In another male portrait (cat. 70), examination shows that a *c*.3.5 cm wide strip of unprimed canvas had been sewn onto the original canvas edge on the left side.[29] Presumably someone subsequently considered the composition more complete if the elbow were not cut at the left edge (fig. 4).

Examination suggests that all the canvasses were of a simple weave linen fabric. Investigation of the weave density of the canvasses, that is the number of warp and weft threads per square centimetre, was possible for 19 works. Since the original canvas is usually obscured by paint layers on the front side and a lining canvas on the reverse, a thread count can mostly only be taken from an X-ray of the paintings. In some cases it is not possible to distinguish warp from weft.

The weave densities measured ranged from a rather coarse 11 threads per cm along the warp (vertical) and weft directions in *Lucas de Clercq* (cat. 46), and 10 to 12 threads per cm along the warp and weft (no distinction made) in *Man in a Slouch Hat* (cat. 83),[30] to one almost double in fineness of 18-21 threads per cm along the warp and weft (no distinction made) in *Tieleman Roosterman* (Biesboer, fig. 10; S93).

There appears to be no correlation between the weave density of the canvas and its size. For example, whereas the canvasses of the *Regents* and *Regentesses* (cat. 85, 86) show a relatively fine weave of 14 threads per cm along the warp and weft directions, a coarser canvas with a thread count of 12 threads per cm along the warp and 14 threads per cm along the weft was used for the 1 ell-wide canvas of the Fitzwilliam *Man* (fig. 85b; S218) from the same period. In these group portraits the use of such a large piece of fine and hence probably more costly canvas could be explained by the importance of the commission.

The identical thread counts of the canvasses of the *Regents* and *Regentesses* (cat. 85, 86) suggests that they were acquired at the same time. One might expect to find this with other attributed companion pieces, especially where these have been found to possess identical primings (see below). However, it was found that *Feyntje van Steenkiste* (cat. 47) had been painted on a finer canvas, 16 threads per cm along the warp and weft, than that of her attributed pendant, *Lucas de Clercq*

(cat. 46) which contains 11 threads per cm along the warp and weft. Furthermore, these two canvasses had different primings (see below). However, a more comprehensive survey is needed to clarify this point.

This initial survey also revealed that Hals appears to have used a range of canvasses of different coarsenesses, even for paintings close in date, implying that he stocked or acquired different grades of canvas at any one time.[31] However, the different properties of the canvas used do not seem to have been exploited in the texture of the final paint layers. In paintings which are well preserved it can be seen that the smooth application of the priming layer conceals the canvas weave. The smooth preparation of the painting support was emphasised as of great importance in contemporary notes on painting technique.[32]

For application of size and ground layers, the canvas would be stretched by a system of lacing into an oversize wooden frame or strainer. An X-ray detail of the original canvas edges of the militia piece of c.1639 (S124), which are usually intact, shows this procedure (fig. 5). The edges of the canvas are rolled round a cord and hemmed with oblique stitches. This is to prevent the stretching cord, laced through the canvas at intervals, from pulling through. Remains of this stretching cord are visible. At the points of stretching, the canvas is drawn into a peak and the resulting scalloped deformation is termed 'primary' cusping. The ground layer is applied, forming a ridge along the seam, and this fixes the cusping deformation. Usually these original stretching edges of the canvas were cut off during later lining treatment, or are concealed by wax lining material. However, we were able to find remains of original stretching edges in a number of paintings: *Jacob Olycan* (cat. 18), *Aletta Hanemans* (cat. 19), *Feyntje van Steenkiste* (cat. 47), *Lucas de Clercq* (cat. 46), the *Regents* and *Regentesses* (cat. 85, 86), and *Portrait of a Man* (cat. 70).[33] In most cases the edges have been unrolled to form a margin of canvas without priming. The fact that the right edge of the canvas in *Feyntje van Steenkiste* (cat. 47) is a selvedge must account for the fact that it was considered sufficient to reinforce this with simple running stitches within the edge, rather than the usual stretching cord sewn into a hem.

It has been suggested that, as one moves through the seventeenth century, there is a general tendency for Netherlandish painters to use increasingly coarse canvasses.[34] This cannot be confirmed in the case of Hals, due to the small sample of canvas weaves available for measurement. More thread counts are needed to establish whether there is any chronological pattern in Hals's preference for canvasses of coarser or finer weave over a given period.

However, it has been noted that several canvasses could be cut from a single piece of primed canvas.[35] Examination of the canvasses of the proposed pendants, *Lucas de Clercq* and *Feyntje van Steenkiste* (cat. 46, 47), suggests that they were cut from the left and right sides respectively of a wider strip of primed canvas. The canvas of *Lucas de Clercq* shows a selvedge on the left side. Only the top, left and bottom edges show remains of the original stretching edges and primary cusping deformations from stretching. This suggests that it was cut from the left side of a wider strip of primed canvas. The structure of the canvas of *Feyntje van Steenkiste* is exactly reversed, suggesting that it has been cut from the opposite side of a wider strip of primed canvas. However, they were not cut from the same strip, since examination has proved that they have different weave densities. Given that they also have different primings (see below), their supports cannot be used as evidence that they were necessarily designed as pendants.

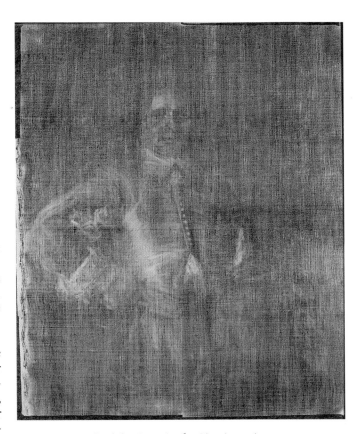

Fig. 4 Radiograph of the *Portrait of a Man* (cat. 70)
A ridge of ground layer defines the original edge of the canvas on the left. The other three edges have been cut off. An unprimed strip of canvas was later added on the left.

It appears that a canvas was sometimes restretched, possibly several times, after application of the first ground layer. When this ground layer was not yet dry, re-stretching would produce a less marked 'secondary' cusping deformation.[36] The Fitzwilliam *Man* (fig. 85b; s218) permits a reconstruction of the procedure of preparing a painting support from a piece of canvas. The support seems to have been cut from a longer length of canvas, primed with an initial layer of ground (see below). This is suggested by the presence of primary cusping only along the right and left selvedges, and the continuation of the red priming right up to the edges. This piece of red primed canvas was then restretched by lacing it onto a shorter strainer for application of the second, coarse grey priming. Three observations suggest this: secondary cusping is present around all the sides, the second grey ground covers the edges of the canvas more loosely and, being messily applied, splashes around the reverse (VIIIc), and finally, two sets of lacing holes correspond to the peaks of primary and secondary cusping resulting from two subsequent stretchings.

The primed canvas then seems to have been restretched again before painting, by folding the edges around a correctly sized stretcher and securing them with pegs, or tacks as is still common practice. This is suggested both by c.1 cm wide unpainted tacking margins, and by paint strokes which stop short of or skirt the edges of the stretcher (VIIId). Alternatively, the primed canvas could remain laced onto an oversize stretcher, in which case paint layers would extend up to the laced edges. This was the method used in painting the 1639 militia piece (s124; see fig. 5).

GROUND LAYERS OR PRIMING

Seventeenth-century sources suggest that the beauty and vivacity of a painting's colour depended upon good priming.[37] In this study, the ground layers of thirty-five paintings by Hals were analysed, and a general survey was then made to determine whether they possess the qualities of good priming and play a significant role in the appearance of the paintings.

The ground colour is usually concealed by overlying paint layers, except where these do not quite meet or cover the edges of the support. However, in the *Young Man with a Skull* (cat. 29) and the Fitzwilliam *Man* (fig. 85b; s218) sizeable areas of ground have been left visible through openings in the upper paint layers. In these paintings, the ground colour serves as the midtones of the background, draperies and even flesh. In other pictures, the ground shows through thin or translucent paint, as in the areas which depict white collars and cuffs. For example, the light brown ground shows through the ruff of the Chatsworth *Man* painted on canvas (cat. 13). In *Nicolaes van der Meer* (cat. 41), painted on panel, a brown imprimatura (a thin layer of oil paint applied to seal the absorbent ground) over the white ground shows through the collar to provide a similar effect (VIIIe).

Fig. 5 X-ray of the original stretching edge of the *Officers and Sergeants of the St. George Civic Guard* of c.1639 (s124).
At points A, a cord sewn in along the canvas edge to reinforce it is clearly visible. Also apparent is the accumulutaion of ground layer, which shows white on the X-ray, along this cord. The ground layer has been applied after stretching the canvas and fixes the 'primary' cusping deformation caused by its stretching.
At B a fragment of the original stretching cord remains. The tacks which now attach the canvas to the stretcher also show white in the X-ray.

Examination of paint samples shows that the ground is usually off-white, varying from light pinkish to ochreous. This can reach a darker cool grey or brownish tone. These slightly differing ground colours are achieved using a small number of pigments. In most cases they comprise lead white mixed with umber, sometimes with a small addition of red ochre, bone black, charcoal, fine lamp black or chalk.[38] Occasionally chalk bound in animal glue is used in the ground and a toned imprimatura laid on top. This was the traditional priming for panels favoured in the Netherlands in the fifteenth and sixteenth centuries, but can be found on some of Hals's canvasses as well as his panels. On the other hand, oil-bound grounds, which rapidly superseded chalk grounds on canvas, appear on some of Hals's panels as well as on canvasses, and in no apparent chronological sequence.[39]

Oil-bound grounds are found on Hals's earliest known panels. For *Zaffius* (cat. 1) lead white, a little red ochre and fine black were used. *Portrait of a Man* (cat. 2) and *Portrait of a Woman* (cat. 3) were both prepared with a lead white paint, mixed with a little red ochre, umber and coarsely ground charcoal black. On the small panel of the *Laughing Boy* (cat. 16) the ground consists of lead white with a little umber and very little fine black, again apparently bound in oil. The pair of small portraits of *Petrus Scriverius* (s36; see cat. 20) and *Anna van der Aar* (cat. 20) are painted on similar ground layers, containing lead white, a little red ochre and very little umber.

By contrast, in the panels by Hals of the 1630s which were examined, the traditional chalk ground was found. Small paint samples from three paintings on panel in this period were available for analysis (*Nicolaes van der Meer, Cornelia Vooght* and *Jean de la Chambre* [cat. 41, 42, 50]). All three have a priming of chalk bound by glue with an imprimatura laid on top. The imprimatura contains lead white, a little umber and yellow ochre, and very little fine black, which gives the ground a slightly yellowish appearance. Hals's chalk primings seem unusually thick when compared to those on other contemporary Netherlandish panel paintings, thus resembling the earlier manner of priming.[40]

Perhaps more surprising than the use of oil-bound grounds on some of Hals's panels is the use of chalk grounds on some of his canvasses. This is all the more peculiar, since, again, the chalk priming is thickly applied, while painters knew at the time that such grounds, when used on canvas, were prone to cracking and flaking. Van Mander, for instance, recounts how a painter who had primed a large canvas painting in this way, found the paint on his picture flaking off, since the painting had to be rolled up several times.[41] Hals applied

a chalk ground to the relatively large canvas of *Paulus Verschuur* (cat. 56), painted in 1643 (VIIIf). Another example of chalk ground on canvas is the *Portrait of a Woman* (s131) from the late 1630s, where the chalk is mixed with a little lead white, umber, red ochre and fine charcoal black, and has a greyish-brown imprimatura (lead white, chalk, umber, very little fine charcoal black). The *Portrait of a Woman holding a Fan* (cat. 53) also has a thick layer of chalk on the canvas, with the addition of very little red and black. Naturally the possibility exists that the pictures were transferred from panel to canvas, but neither the paintings themselves nor the paint samples suggest that this was done. Maria Larp (s112), which has an oil ground, does show traces of this treatment.

The main component in twenty-seven of the thirty-five paint samples of grounds which could be analysed is lead white, presumably oil-bound. Seven of these oil grounds are on panel. Umber is also nearly always present. This brown earth colour, an iron oxide which contains manganese dioxide, dries quickly due to its ability to act as a catalyst in the drying of oil.

Over a third of these grounds were 'double' grounds, that is to say, there are two paint layers covering the canvas (the oil ground on the panels consists of only one layer). Very often the difference between these two layers is not very striking. Lead white and umber are present in both layers, which often show no clear division, since one layer is applied over the other whilst it is still wet. The second layer is sometimes deeper in tone because of a greater quantity of umber present (*Officers and Sergeants of the St. Hadrian Civic Guard* [s79], c.1633), and sometimes lighter, as in the *Man* (cat. 70). Also, the first layer can be made to look more greyish by the addition of a little lamp black (*Banquet of the Officers of the St. Hadrian Civic Guard* [s45], c.1627). For the first layer in *Claes Duyst van Voorhout* (cat. 52), the cheap alternative for lead white was used, namely lead white diluted with chalk (VIIIg). In the militia piece of c.1639 (s124), the proportion of chalk in the first ground is very high.[42] Only in two instances did the two layers of ground have distinctly different hues, in the Fitzwilliam *Man* (s218) and in the *Man in a Slouch Hat* (cat. 83), both from the 1660s. On top of the first layer, which consists of a cheap, bright red earth,[43] there is a cool grey, made with lead white, charcoal black and umber (VIIIh, VIIIi). In the Fitzwilliam *Man* (fig. 85b; s218) it was apparent, after the removal of the old relining canvas, that the red ground had served the purpose of filling the interstices of the canvas weave. The reverse of the original canvas was found to be virtually untouched by later hands, and one could see

that the first ground had been pushed through the interstices, presumably with a priming knife. From some other samples of ground it is clear that to this end the canvas was first treated with glue, either as a coat or by dipping the entire canvas in a liquid glue as de Mayerne suggests, before the oil ground was applied.[44]

Although in many of the grounds lead white and umber are the main constituents, comparison of admixtures in different pictures, supposedly executed in the same period, reveal differences. For instance, the grounds of the two group portraits of militiamen painted in *c*.1627 (s45, s46) and the *Young Man with a Skull* (cat. 29) from 1626-8 all have different compositions. These often result from either simply varying the amount of coloured pigment added, or by choosing a different pigment, or by adding black.

In some of the companion, or pendant, pieces, the grounds are identical, in so far as they possess pigments with the same chemical composition, colour and particle size mixed in the same relative amounts. This is the case in the Chatsworth *Woman* and the Birmingham *Man* (cat. 3, 2), where the typical particles of coarse charcoal black are found in both pictures. In *Nicolaes van der Meer* and *Cornelia Vooght* (cat. 41, 42) the pigment compositions of the imprimatura over a chalk ground are identical. In the Vienna *Man* (s184) and *Woman* (Jowell, fig. 2; s185), one layer of priming was applied over another which was still wet, with chalk added to the first layer and a little finely ground red ochre to the second. The concentration of umber, present in both layers, is the same in both pictures. Given the limited number of pigments present in Hals's paintings, it is all too easy to conclude that his grounds, even when examined under a microscope, appear to be similar. It is only when viewed under a very powerful microscope that it is possible to assert an absolute affinity between any two grounds.

It has been shown above that some pendant portraits painted both on canvas and panel can possess identical grounds, indicating that they have been primed together. Additionally, the panel supports themselves can be made from planks cut from the same tree. One might also expect pendants painted on canvas to show identical prepared supports. However, we cannot know until a broader survey of thread counts has been made. In the case of the two supposed companions, *Lucas de Clercq* and *Feyntje van Steenkiste* (cat. 46, 47), not only is the canvas support different, but their primings are also at odds. Lucas de Clercq's consists of two layers and contains more umber than *Feyntje van Steenkiste*. Feyntje's has three ground layers with red ochre added

in the top layer, which makes the painting ground slightly more pinkish. It has been suggested earlier that supports could be cut from a single strip of canvas, which was pre-stretched and primed. If these canvasses also have identical grounds, the supposition is reinforced. Apart from pendants, nearly all the grounds examined differ slightly in composition, even when the pictures are close in date. This, together with the fact that many different grades of canvas were used, would suggest that Hals did not keep a large roll of canvas in his studio, but rather that he acquired his canvasses and panels with the ground applied from a supplier in small batches. It is even possible that the patron supplied his own primed support for his portrait. It has been pointed out earlier that preparing canvasses and panels was a separate profession. In 1631, the St. Luke Guild in Haarlem, which Hals joined in 1610 (Hals doc. 9), clarified the profession of the *primuurder* as an identifiable craft within the guild.[45]

So can any significance be attached to the type of ground used? The effects of the two types of ground, chalk with a tinted imprimatura and the oil ground made chiefly with lead white and umber, are only slightly different. The first one appears slightly more yellowish with a granular texture, while the second seems in general very light and smooth. There is no consistent correlation between ground and support. One is lead to conclude that Hals views his ground primarily as a smooth painting surface. However, he does appear to have exploited slight variation in the colour of the grounds, usually light pink to ochre, to provide warm mid-tones showing through white collars and cuffs in portraits on both panel and canvas. With the exception of the Fitzwilliam *Man* (fig. 85b; s218) and the *Man in a Slouch Hat* (cat. 83), this use of a flesh-coloured ground can be associated with the traditional use of a flesh-coloured imprimatura found in Netherlandish paintings on panel.[46] The Haarlem *primuurders* seem to have continued this application of a flesh-coloured priming when canvas supports became the vogue. The introduction of painting on canvas does not seem to have coincided with the import from Italy of recipes for priming them, at least not in Haarlem.[47] A possible explanation for the two notably different grounds of the Fitzwilliam *Man* (fig. 85b; s218) and the *Man in a Slouch Hat* (cat. 83) is that the primed supports were acquired from somewhere else.

PAINT LAYERS

Hals seems to have first sketched his forms using blackish or brownish lines applied thinly with a brush, directly onto the primed painting support. Where areas of

light paint have become more translucent, these underpainted lines are sometimes left visible where they draw the folds of ruffs or indicate the end of a sleeve or cuff. In the lower left corner of the *Married Couple in a Garden* (cat. 12) for example, where an early stage in the painting process seems to be revealed,[48] these lines can be clearly seen just beyond the left side of the man. Lines of drawing are also visible around the right side of the head of the Oxford *Woman* (cat. 79) where the placement of her whole figure has been changed, and they seem to relate to the fixing of an earlier position for the head (VIIIj). The fluent appearance of these underdrawing lines suggests a swift sketch of the composition, which was often modified in the finished painting. Recent examination of Hals's large group portraits in Haarlem and Amsterdam has revealed frequent revision occurring at various stages in the process of their painting (Levy-van Halm & Abraham, p. 97ff).[49] These observations suggest a flexible working process, and may explain the apparent absence of any preparatory studies for Hals's group portraits. However, we cannot discount his possible use of even a most rudimentary compositional sketch which was subsequently discarded.

Following the stage in which forms are set down using painted lines, the next stage appears to involve the laying in of the main areas of colour. Examination of the paintings suggests the use of a variety of coloured underpaints. Black clothing often appears to have been underpainted in thin washes of brownish to greyish paint. Like the underdrawing, this paint is visible in only a few places through upper paint layers, for example, where the white layers of the left glove and cuff against the black drapery do not quite meet in the Edinburgh *Woman* (VIIIk, from cat. 58). Thin brownish paint, for example, shows through the thinly painted black costumes of all five guard pieces (S7, S45, S46, S79, S124), and locally through the black cap of *Zaffius* (cat. 1). Unusually, in the dresses of the *Regentesses* (cat. 86) large areas have been left open in upper paint layers to provide warm mid-tones. The dark underpaint can be recognised in paint cross-sections as a thin (*c*. 5-10 μm) layer with a mixture of pigments differing slightly from those used in overlying paint. In the *Portrait of a Man* (cat. 70) at the Metropolitan Museum of Art, lead white, a carbon black and a little yellow ochre and umber were used. In the *Regents* (cat. 85), where the layer is thicker (*c*. 22 μm) bone black was used in addition to the pigments used for the top layers,[50] which include smalt (a glass coloured blue by cobalt oxide) and green verditer (an artificial copper pigment manufactured in the seventeenth century). Due to the catalytic action of the umber, smalt or green verditer pigments added, these

thin paint layers would dry quickly, allowing the following stage in the painting process to be resumed quickly.

Sometimes strokes of light paint also underlie black clothing. For example, in *Feyntje van Steenkiste* (cat. 47), evidence of whitish strokes sketching the axis and form of her left sleeve is revealed by abrasion of the overlying black paint layer. In the black costumes of the *Portrait of a Man* and of the *Regents* and the *Regentesses* (cat. 70, 85, 86), thick underlying impasto strokes, which only sometimes relate to the highlights and forms finally painted, are visible as ridges in raking light.

Paint samples show that these are grey in colour, containing lamp black mixed with lead white. Due to their thickness and lead white content, they provide a clear, positive image in the X-ray. Perhaps it was necessary to apply these light strokes to regain clarity where the dark underpainting had covered too much of the light priming. Light collars and cuffs are often first sketched using strokes of whitish paint which suggest the limits and main forms of the folds. This lead white containing underpaint can be clearly seen on the X-ray when the final collar or cuff departs in size or shape, as in the *Regents* (see fig. 3).

Flesh paint is underpainted using colours which vary from white to pinkish to reddish. Paint samples show that whilst the hand of the *Bearded Man with a Ruff* (S34) is underpainted using a light red (containing vermilion mixed with lead white and a little umber), the right hand of *Paulus Verschuur* (cat. 56) is underpainted with white (lead white mixed with chalk). A pinkish underpainting appears to be most common, as locally visible around the edges of the hands of the *Regentesses* (cat. 86).

A number of paint samples taken from the sashes of the five militia pieces in the Frans Halsmuseum, Haarlem (S7, S45, S46, S79, S124) show their variously coloured underpaints, which are more subdued than the final colour. Grey paint (white mixed with fine lamp black) underlies the blue and sometimes the red sashes. Red and yellow sashes are underpainted with yellow mixtures (containing yellow ochre or an organic yellow). Blue sashes are also underpainted using pale blue mixtures containing indigo (also used for the final paint layer).

This preliminary laying in of areas using various colours could be associated with the stage of painting termed 'dead colouring' in sixteenth and seventeenth-century documents and treatises. An article in the 's-Hertogenbosch charter of 1546, issued by the Guild of St. Luke

in Haarlem, stipulates that on panel each colour must first be 'dead coloured' and in this way come to lay on a double ground.[51] According to Miedema, this prescription was made as a method of achieving quality control, and, though differing in concept, Hals's practice of dead colouring stems from this requirement. Writers have defined dead colouring in different ways, so the term remains rather elusive.[52] However, van Mander must have had a painter such as Hals in mind when he wrote:

> These fellow-artists go to it, without taking great pains, working direct with brush and paint with a free approach and thus set down their paintings deftly in the dead colour; they 're-dead colour' too sometimes, soon after, so as to achieve a better composition. Thus those who are abundantly inventive go audaciously to work, thereafter making an improvement here and there.[53]

This statement suggests that a dead colour stage could be used as a way of producing a more or less final design. Paint samples did sometimes show several thin superimposed layers of underpaint which indicate that, in their dead-coloured state, the paintings did not just consist of flat patches of colour. Often it is hard to distinguish where these dead colour layers end and the following stage of paint application begins, especially when the composition of paint layers applied in both stages is similar. A break in the work process is sometimes suggested by the presence of a thin layer of medium in between paint layers. This medium seems to have been used for oiling out, i.e. wetting the surface in order to saturate the colours for better visibility when painting was resumed. The documents relating to the *Meagre Company* (cat. 43; Hals docs. 73-5, 78) also suggest that the partially dead-coloured state in which Hals left it was considered as a provisionally completed stage of the painting, which could be taken further by another painter. A revision in the head of the regentess seated to the left behind the table in the *Regentesses* (cat. 86), provides another piece of evidence that dead colouring could possess rather refined modelling (fig. 6). Microscopic examination of the earlier underlying head (to the right of that now visible) which seems to have been left in its dead-coloured state,[54] through the craquelure of the overlying background paint, suggests that it has been modelled, varying in local colour from white to light pink and grey.

From these observations we can gain an idea of the general appearance and use of the dead colour stage in paintings by Hals. The dead-coloured stage of painting seems to have been used for the first lay-in of coloured areas. This differs from the monochrome dead colouring found in early works by Rembrandt, which establishes

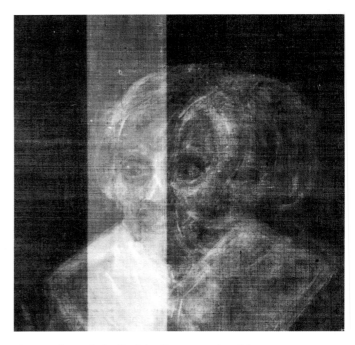

Fig. 6 Radiograph detail of the *Regentesses* (cat. 86) Hals repositioned the head in the finished painting.

the basic tones of the composition on the light priming.[55] Hals's dead colours are usually more subdued than the colour of final paint layers, and often show a different combination of the same pigments. The painting can be taken far in a dead-coloured stage. Dead colouring is sometimes absent from areas or even whole paintings which are painted using a direct and open manner (*Young Man with a Skull* [cat. 29] and *Man* [fig. 85b; s218]), proving that it was not a rigid procedure.

The *opmaecken* or working-up of the painting would follow. In Hals's portraits this seems to involve achieving nuances of colour, detailing the elements and fixing the final contours. Sometimes the period between dead colouring and working-up must have been short, since paint samples show that the dead colour was still wet when painting continued, causing the underlying paint layer to be pulled up and mixed.

For the execution of his portraits, Hals's procedure must have depended on his sitter's time and commitment as illustrated in the documents on *The Meagre Company* (cat. 43). Here Hals first suggests working up the clothing and then executing the heads of the incomplete figures (Hals doc. 78). Constantijn Huygens recounts how the painter Jan Lievens first painted Huygens's clothing and bare hands and postponed the

painting of his face until spring, since the days were short.[56] In early paintings by Rembrandt, figures appear to have been painted in after the background had been laid down.[57] On the other hand, an unfinished picture by Van Dyck shows that some painters would start with the head.[58]

A study of the areas of overlapping paint, on the surface of the picture itself and in sample cross-sections, make it possible to reconstruct Hals's normal sequence of working up the various parts. The figures appear to have been worked up against the painted background, though overlap of the figure on the background is by no means as great as in the early paintings of Rembrandt. The close junction at the point of contact between the paint areas of the background and of the figure is often obscured by final contours and touches added to draw them together. In rapidly executed portraits, such as *Tieleman Roosterman* (Biesboer, fig. 10; s93), the background and figure have been worked up more or less simultaneously. A paint sample taken near the edge of the black drapery shows that the latter overlaps the thinly painted greenish-grey background, whereas the background paint is clearly swept over the top of the hair (VIIIl).

Draperies are usually painted first, the hands being left in reserve to be filled in later. Sometimes the hands are painted entirely over the finished drapery (VIIIm, from cat. 42). Most likely the hands were usually painted together with the face. In painting the face, the lips are added last, either into an area blocked out in the ground layer or over the flesh or moustache. The hair is detailed, often bringing strands of hair or flesh-coloured strokes across the sudden transition where hair meets flesh (VIIIn). The hair is also worked into background paint which is still wet (VIIIo, from cat. 24). Collars and cuffs are completed, overlapping the paint of flesh and draperies around their edges (fig. 3, from cat. 85). Cuffs are sometimes painted entirely over a finished sleeve (see cat. 42) or blocked out (VIIIp). Ends of hair locks, which can appear dissociated from the rest of the hair (VIIIl, VIIIn), are sometimes added over the collar to integrate it (VIIIq, from cat. 58). Jewellery is added over the flesh. Final contours and touches are then applied, sometimes into wet paint.

These observations accord with van Dantzig's conclusion that the sequence of the build-up progresses from the background to foreground features.[59] However, as with other aspects of Hals's technical procedures, exceptions to this general observation should be noted. The peripheral hand of the Fitzwilliam *Man* (s218), for example, overlapping the cuff, was the last

element to be added, as if almost forgotten. Such idiosyncrasies occur most frequently in Hals's group portraits, where his procedure must have depended especially on the availability of his sitters.

From the 1630s onwards, Hals was largely confined to painting the sombre regent fashion of black garments. Examination in raking light of these black draperies in a number of paintings reveals relieved brushstrokes which enliven the surface. Where they underly the black paint layer, they often bear no connection with the forms and modelling of the garments at the surface, and have to do with an earlier painting stage. In other cases, distinct relieved strokes lie at the paint surface (*Jean de la Chambre*, *Feyntje van Steenkiste*, [cat. 50, 47]). Typically they appear fluid with rounded edges which have been pushed up. This property has to do with the consistency of the paint applied, and can also be found in white and coloured strokes. Such a white stroke, on the left cuff of *Lucas de Clercq* (cat. 46) has been used as one of the few accents which enliven his sombre costume.

Paint samples show that the typical build-up of the black draperies is first a layer containing lamp black, either pure or mixed with lead white or bone black. Bone black, sometimes with umber added, was then used for the deepest tones, and lamp black mixed with lead white for the cool greyish highlights. Sometimes small quantities of ochres and umber were used. Copper was found in many of these blacks, although only in a few cases could green pigment particles be distinguished under the microscope, indicating that a soluble copper compound had been added to speed up the drying process. This corresponds closely to de Mayerne's described method for painting black draperies, that is first to use lamp black mixed with lead white and umber, and then to deepen the colour using ivory black mixed with verdigris.[60]

Green verditer was identified in a few places in draperies which did not appear green (*Laughing Boy*, *Regents*, *Regentesses*, cat. 16, 85, 86). In the front panel of the dress of the *Woman* (Jowell, fig. 2; s185), the green was not used as a drier, but was combined with red glazes for its colour to suggest the shot-silk material (VIIIr). The grey, watered satin costume of *Claes Duyst van Voorhout* (cat. 52) was rendered by adding azurite, an organic red pigment, and black to the lead white in the top layer, which overlies the lead white/lamp black mixture. Highlights were blended in with different proportions of these mixtures, for instance in the arched stroke circumscribing his left elbow, or thinly scumbled over the grey.

In some of Hals's most direct paintings the draperies seem to have been chiefly laid down in one layer, straight onto the ground (*Young Man with a Skull*, [cat. 29], Fitzwilliam *Man* [fig. 85b; s218], *Man in his thirties*, [s81]). In the *Young Man with a Skull* (cat. 29), large areas of light reddish ground have been left visible through openings in the paint layer to provide warm mid-tones. Adjacent areas have been swept into each other whilst still wet, using hatched strokes (viiis). A swift technique is also apparent in the painting of the red sash, from which a sample shows application of the red over brown whilst still wet. In the Fitzwilliam *Man* (fig. 85b; s218), the swiftness of painting the draperies is almost sloppy. Arbitrary splashes of vermilion appear scattered around the yellow impasto on his right cuff and on the grey drapery below. About a century ago, observation of such displaced drops of paint on another late portrait were attributed by Bode and Moes to a trembling hand and short-sightedness, which Slive called patent nonsense.[61] In these draperies, splashes of solvent have even been allowed to run down the painting and dissolve paint layers (viiit). This can also be seen in the draperies of the *Merry Drinker* (cat. 30) and (less obviously) in the Edinburgh *Man* (cat. 57). In the Fitzwilliam *Man* (s218) and the *Merry Drinker* (cat. 30), Hals's rapid technique is also evident from the way he draws a few hairs by scratching through the wet paint. Similarly the contour of the nose of *Young Man with a Skull* (cat. 29) is scratched in. This short-cut device can be associated with Hals's more swiftly executed paintings, though he never uses it to the same extent as Rembrandt.[62]

In Hals's rendering of cuffs, as with collars, we can trace a development in his technique which corresponds to their changed material and structure in keeping with fashion. In the *Man holding a Skull* (cat. 2) the stiff ruffles are sculpted by pushing through turning strokes of white impasto, which more or less reveal the underlying black sleeve (viiiu). The different densities of white in the strokes suggest various transparencies of the linen, whilst the relieved edges to strokes draw the edges of the ruffles. The pattern of the open lace edging to the cuffs of *Cornelia Vooght* (cat. 42) has been rendered using thinly applied white lines over the black sleeve (viiiv). Only a few black accents have been added on top, where they are too small to leave in reserve in the underlying black. The lace edging to the cuffs of *Maria Larp* (s112) shows a different approach. The reserves in the lacework have taken on an independent identity, being painted with separate black touches, either under or over the white (viiiw). In the lace edging of the cuffs of *Tieleman Roosterman* (Biesboer, fig. 10; s93) this change in technique goes a step further. The more closed structure of the white lace has been painted as a homogeneous layer. The openings in the lace which reveal the underlying black sleeve have become the figurative element, and are suggested by touches of black and grey on top. Comparison with *Cornelia Vooght* (cat. 42) reveals how the procedure of rendering patterned lace has been reversed, reflecting its changed structure.[63]

Hals's portraits are consistently lit from the left, causing a shadow to be cast on the right.[64] At its simplest, the background was painted using a single, thin paint layer, as in *Tieleman Roosterman* (s93; viiix). In places, the greenish grey paint has been brushed on very thinly using bold zigzag strokes, which reveal the underlying pinkish ground. Paint samples show that this paint contains lead white, lamp black and ochres. Different coloured ochres and the addition of bone black model the background layer. Painted two decades later, the greenish grey background of the Vienna *Man* (s184) is also a single paint layer containing these same pigments, modelled and applied in the same streaky way. The olive green background of *Lucas de Clercq* (cat. 46) is also one paint layer, simplified even further by the use of only one black pigment for modelling, possibly bone black. Only in the greyish green backgrounds of two small paintings on panel, *Petrus Scriverius* (s36; see cat. 20) and *Anna van der Aar* (cat. 20), was a finely-ground charcoal black pigment found. In addition to the pigments mentioned so far, umber is often encountered in background paint mixtures. Despite the simple character and build-up of the backgrounds in Hals's single portraits, and the limited range of pigments used, they do show a wide variety of colouring. An exceptionally elaborate modelling is apparent in the olive green background of *Feyntje van Steenkiste* (cat. 47). The colour has been adjusted toward a lighter colour in a build-up of three paint layers, perhaps to coordinate with the lighter background of her husband's portrait (cat. 46). The first paint layer was dry before it was adjusted by subsequent layers, which overlap the black drapery in places and have been applied as touches over the left side of her cap, suggesting that the adjustments were made at a late stage of painting. The thicker build-up of the background paint layer compared to that of her husband, which is abraded, can be seen clearly on the painting.

From the examination, it is clear that the landscape backgrounds of the 1639 and especially the 1633 militia pieces, as well as the backgrounds in the *Regents* and *Regentesses* (cat. 85, 86) have changed considerably in the course of time, due to the effects of natural ageing. The curtains, tablecloths and cushions in the *Regents* and *Regentesses* would have been a crimson colour,

more vivid than they are now, and with more modelling.[65] The paint mixtures used in these areas are responsible for the broad drying cracks. Darkening of the paint medium in the landscapes in the two guard pieces has changed the balance of light and dark in these paintings. We can only recover some idea of the depth and detail which the background in the *Regents* would originally have possessed from a watercolour copy executed by Wybrand Hendricks, probably in the nineteenth century (fig. 85a). There is also a Wybrand Hendricks watercolour copy of the 1633 militia piece which possibly indicates the earlier appearance of the background landscape.[66]

Many of the portraits display a coat of arms. It has been suggested that those on *Nicolaes van der Meer* and its pendant *Cornelia Vooght* (cat. 41, 42) are both inaccurately rendered.[67] Paint samples have shown that they are later additions over the varnished background paint. Analysis identified the blue pigment in the emblems as Prussian blue, which only became available to artists around 1720. The coat of arms must have been added after this date, most likely in the nineteenth century, when attempts were first made to identify and reunite companion portraits. Prussian blue was also found in the coats of arms in *Tieleman Roosterman* (s93 ; VIIIy), *Jacob Olycan* (cat. 18) and *Aletta Hanemans* (cat. 19), confirming that these too must be later additions.

Though there can be no talk of discovering any standard procedure in the creation of Hals's portraits, this essay attempts to describe characteristics which recur in the rendering of their various elements. When drawing conclusions from the results obtained in this investigation, one has to bear in mind that the forty paintings examined represent a small proportion of the two hundred and twenty-two attributed to Hals. Also, it was possible to investigate some pictures more thoroughly than others, largely because they were undergoing restoration and hence available for examination over a much longer period. Despite these reservations, certain conclusions can be drawn from this first attempt to analyse the materials and techniques used by Hals.

First, although his handling of paint sets him apart from his contemporaries, the supports for his paintings are in keeping with seventeenth-century practice in the Netherlands. There is some chronological pattern in Hals's increased use of canvas in place of panel, which agrees with seventeenth-century practice. Second, a specific chronological pattern is nearly absent in his primings, the later ones being only slightly darker. Hals's pictures are inconsistent in the materials used for their primings. In this respect, his procedures differ from Rembrandt's. For Hals, the main objective of his primings seems to have been to obtain a flesh-coloured painting ground through whatever materials seemed appropriate. This flesh-coloured priming in both his canvas and panel paintings stems from a tradition in Netherlandish painting on panel. Third, where he used rich glazes in the early Chatsworth *Woman* (cat. 3), he was still employing this technique in the late *Regents* and *Regentesses* (cat. 85, 86), although this is not so obvious now to the naked eye due to ageing of the paint film. Hals's use of particular pigments for rendering draperies, and his use of siccatives for the slow-drying blacks, agrees fully with recipes of the period. Lastly, one can say that as one moves through Hals's career there is an increase in the looseness of paint application in his portraits, which already appears in his genre paintings, of which the 1626-8 *Young Man with a Skull* (cat. 29) is an example. Hals works spontaneously with the brush, from the first sketching-in of the composition up to the final touches, hereby contradicting what, according to Houbraken, he himself said about only the finishing touches being the hallmark of the master.[68]

Notes

1. For an account of their restoration see Middelkoop & van Grevenstein 1988.
2. Butler 1972, Butler 1970, Grimm 1974, Käppler 1985.
3. Van Dantzig 1937.
4. Most of the paintings were examined and photographed in situ. The paint surface was examined with an operation microscope, using magnifications up to ×40, and selected areas photographed. After obtaining permission from the owners of the paintings, paint samples (generally 0.25 mm² in area) could sometimes be removed for cross-sectioning and micro-chemical tests. The cross-sections were made by embedding each sample in a block of polyester resin. The block was ground down and polished until the side of the sample was exposed to the surface of the block. The cross-sections were then examined under a Leitz Ortholux microscope in normal and long wavelength uv incident light. Remains of the sample material were used for microscopic examination in polarised light, and for micro-chemical tests. Further identification of the elements present was done with the electron microprobe in the Department of Earth Sciences, University of Cambridge. This technique enables chemical analysis on very small selected areas, and therefore on individual paint layers in the cross-section. The presence of umber, for instance, was confirmed by the occurrence of peaks for both manganese and iron in the X-ray spectrum collected by this technique.

The samples were too small for analysis of the paint medium by gas chromatography. From observation during micro-chemical testing, the medium seemed to be mostly a drying oil.

Radiographs of the Chatsworth and Birmingham pictures were made in situ by Chris Hurst, using a Gilardoni portable X-ray machine. Radiographs of the five militia pieces and three regent group portraits in the Frans Halsmuseum were made by G. Van de Voorde, of the Koninklijk Instituut voor het Kunstpatrimonium in Brussels, using special large format

cronaflex film. Radiographs were also kindly provided for examination by the Rijksmuseum in Amsterdam, the National Gallery, London, the Iveagh Bequest in Kenwood House, the Metropolitan Museum in New York, and the National Gallery of Art in Washington.

5. Jowell 1974.

6. We are very grateful to the following institutions which have kindly allowed us to examine their paintings by Hals: Amsterdam, Rijksmuseum and Jan Six Collection; Birmingham, Barber Institute of Fine Arts; Cambridge, Fitzwilliam Museum; Chatsworth, Duke of Devonshire's Settlement; Edinburgh, National Gallery of Scotland; The Hague, Mauritshuis; London, National Gallery, Iveagh Bequest in Kenwood House and the Royal Collection in the Queen's Gallery, Buckingham Palace; New York, Metropolitan Museum of Art; Oxford University, Christ Church College; Vienna, Kunsthistorisches Museum. For providing photographs and other technical information we are grateful to: Kassel, Staatliche Kunstsammlungen; Cincinnati, Taft Museum; Washington, National Gallery; Berlin, Gemäldegalerie. Lastly, we should like to thank Christie's of London for sponsoring a continuation of this research.

7. Proportion based on 222 paintings attributed as autograph in Slive 1970-4, vol. 3.

8. Bruyn et al. 1986, p. 15; van de Graaf 1958, p. 13.

9. Hals's production of paintings on wood panel, following the chronology given by Slive 1970-4, expressed as a percentage of his total known production. 1611-9, 50%; 1620-9, 36%; 1630-9, 27%; 1640-9, 14%; 1650-9, 14%, 1660-4, 27%.

10. Portrait of a Man (s48), Berlin-Dahlem, Staatliche Museen.

11. Miedema 1981.

12. Bruyn et al. 1982-6, vol. 1, p. 17

13. The sizes of panels attributed as autograph in Slive 1970-4, vol. 3, were plotted.

14. No general agreement has yet been reached as to the standard sizes of panel available, aside from this general proportion; see Bruyn 1979. Miedema 1981, Bruyn et al. 1982—, vol. 1, pp. 14, 16.

Hals occasionally used circular, octagonal and oval formats for portraits: s50, s51; s98, s99; s115, s116. Sometimes, too, he used similar formats for his genre pictures on wood panel.

15. Unpublished report by Michaela Burek, 1986, Frans Halsmuseum.

16. Bruyn et al. 1982—, vol. 1, pp. 13-4.

17. Van Dantzig 1937 incorrectly states that the panel of Cornelia Voogt comprises five vertical planks.

18. Klein et al. 1987.

19. Dendrochronology of panel paintings by Hals in the Frans Halsmuseum was carried out by Dr. P. Klein, University of Hamburg, Department of Wood Biology. Microscopic examination of the painting and paint samples have confirmed that the coat of arms and inscription are original and were not added later, as previously suggested.

20. Wood species identified by Ton Wilmerink, Furniture Conservator, New York, Metropoli-

tan Museum of Art.

21. Bauch & Ekstein 1981, van de Graaf 1958, p. 12.

22. Bruyn et al. 1982—, vol. 2, pp. 18-9.

23. Technical information on this painting came to light during its restoration by Ian McClure, Director of the Hamilton Kerr Institute, University of Cambridge, who is preparing a separate report for publication.

24. Hoogstraten 1678, p. 339, points out an advantage of canvas, that it is 'most suited for large paintings and, when well primed, easiest to transport' ('bequaemst voor groote stukken, en wel geprimuurt zijnde lichtst om te vervoeren'). Vasari, in Brown 1960, p. 236, mentions that canvas is of little weight and is easily transported when rolled up.

25. Two other paintings in the Frans Halsmuseum, Pieter de Grebber's militia piece of 1619 (slightly reduced in size) and Pieter Soutman's militia piece of 1642, are both painted on a canvas 3 ells wide.

26. For discussion of this point see Bruyn et al. 1982—, vol. 2, pp. 41-2.

27. Paint samples confirm that the build-up and composition of paint layers on the transferred strip matched that of the original paint. Before intervention, the size of the canvas, which now measures c. 100.2 × 80.8 cm, can be reconstructed to have been c. 103.7 × 77.3 cm.

28. Due to inconsistent records of the painting's earlier size, it is not possible to say when this mutilation took place.

29. A ridge of priming along the original rolled stretching edge, which has been opened out, is visible in the X-ray.

30. We are grateful to Mr. H. Brammer and his colleagues of the Staatliche Kunstsammlungen Kassel, for providing information about their painting.

31. Houbraken 1718-21, pp. 90-2, relates how when Van Dyck visited Hals's studio unrecognised, Hals 'took up the first canvas that came to hand' to paint his portrait ('zoo goed en zoo kwaad, als hy toen maar aan de hand had'). Although the visit was most probably apocryphal, it is worth noting. See Houbraken's Life of Hals in this catalogue, pp. 17-8.

32. Van de Graaf 1958, pp. 138-42, nos. 6-20. De Mayerne gives several recipes which suggest smoothing the priming layer using a curved priming knife or pumice stone. Exceptionally, the texture of the Regentesses canvas does seem to have been exploited. In places of thinner paint application some strokes catch on the high points of canvas weave, reflecting its characteristic structure. Though exaggerated by past lining treatment this effect does seem intentional.

33. In the last-named painting the evidence was obtained from the X-ray.

34. Bruyn et al. 1982—, vol. 2, pp. 19-20.

35. Ibid., pp. 31-7.

36. Ibid., pp. 32-3.

37. Van de Graaf 1958, p. 141, no. 18: '... de l'Imprimerye de laquelle selon comme elle est bonne ou mauuaise depend la beauté et Viuacité des Couleurs.'

38. All the pigments identified in the paintings by Hals are mentioned in the text, with the

exception of lead-tin yellow, which occurs for instance in the jewellery of the Chatsworth Woman (cat. 3), and red lead, which could be present in two of the grounds. Results of analyses and technical information on the individual paintings is at the Hamilton Kerr Institute in Cambridge and the Frans Halsmuseum in Haarlem. For information on pigments see Roy 1988-9.

39. Van de Graaf 1958, p. 138, no. 4. De Mayerne mentions the use of an oil ground on panel. Such a priming would fill the pores in the wood.

40. Miedema 1973, ch. 12, 16: 'Ons moderne Voorders voor henen plochten Hun penneelen dicker als wy te witten.'

41. Speaking of Pieter Pourbus I (c. 1534-98), in van de Graaf 1958, p. 21: 'en maeckte ... eenen grooten Oly-verwe doeck ... doch also hy hem te dick ghewit hadde met lijm-verwe/ en dickwijls op en afgerolt wiert/ sprongh oft schilferde hy te veel plaetsen af.'

42. Roy 1988-9, pp. 21-2.

43. Bruyn et al. 1982—, vol. 2, pp. 42-3, note 90, list inventory valuations which show that ochre pigments were much cheaper than lead white.

44. Van de Graaf 1958, p. 141, no. 18. De Mayerne suggests that the purpose of dipping the canvas in glue was 'pour boucher les petitz trous de la toille seche que l'Imprimeure ne passe a trauers'.

45. Miedema 1980, p. 94.

46. Van Mander 1936, p. 160, states that it was the practice of Hieronymus Bosch, as of other old masters, to lay a translucent, flesh-toned primuersel over the white ground of panels.

47. Bruyn et al. 1982—, vol. 2, p. 42, suggest that Amsterdam imported new recipes for priming, developed chiefly in Italy, along with the use of canvas as a painting support. Most (if not all) grounds on canvas, analysed from the first ten years of Rembrandt's activity in Amsterdam, show a double ground which resembles that found on these two paintings by Hals, namely a grey over a red ochre oil ground.

48. P.J.J. van Thiel kindly informed us that this was discovered by the removal of overpaint during the picture's last conservation treatment.

49. In addition, A. van Dorssen, unpublished study, 'The separation of hands in the painting "The Corporalship of Captain Reael"', August 1988, lists some changes made in the painting.

50. We are grateful to Dr. J. Kelch of the Gemäldegalerie, Berlin, for providing us with the as yet unpublished autoradiographs of the Portrait of a Woman (s89) of c. 1630-3 (for an explanation of the technique of autoradiography, or neutron activation analysis, see for instance Sayre & Lechtman 1968, and Ainsworth et al. 1982). Dr. Kelch writes: '... especially the fifth autoradiograph provides splendid insight into Hals's working method and personal handwriting. The blackening of this film, exposed from the 10th to the 32nd day after activation, is caused mainly by phosphorus, an ingredient of bone black.' The autoradiograph shows broad, discontinuous lines around the top and bottom of the collar and below the cuffs and hands. These lines do not correspond to shadows on the black drapery and therefore seem to belong

to an earlier stage in the painting process and were applied in order to indicate the position of collar, cuffs and hands. A similar procedure was observed on examining the *Portrait of a Woman* (s131) under the operation microscope.

51. Miedema 1987, p. 141 : '... op goed droege eyckenboert oft wageschot, zijnde elcke verwe ierst gedootverwet ende alsoe op eenen dobbelen grondt.'

52. The 's-Hertogenbosch charter of 1546 refers to the dead-colouring technique of the early Flemish masters, whereby thin and transparent glazes are built up over the pure dead colour. An alternative description of dead colour is given in a Dutch text cited in the English manuscript of Thomas Marshall's 'Commonplace-book' of *c.*1640-50, which describes areas of even colour which approximate the final colours in their flat tints. See Vey 1960. Neither of these conceptions of dead colour conform to what we have observed in paintings by Hals.

53. Miedema 1973, ch. 12, 5 : 'En vallender aen stracx, sonder veel quellen/ Met pinceel en verw', in sinnen vrymoedich/ En dus schilderende dees werck-ghesellen/ Hun dinghen veerdigh in doot-verwen stellen/ Herdootverwen oock te somtijden spoedich/ Om stellen beter : dus die overvloedich/ In 't inventeren zijn, doen als de stoute/ En verbeteren hier en daer een foute.'

54. This is suggested by the thinness of the paint layer (apparent in raking light) and its low-density image on the X-ray, which indicates little modelling using lead white pigment: unpublished report by Michaela Burek, 1986, Frans Halsmuseum.

55. Bruyn *et al.* 1982—, vol. 1, pp. 20-4. In paintings by Hals, van Dantzig 1937, p. 24, identifies a stage of setting down a monochrome sketch using a dark golden ochre over the lighter, golden ochre imprimatura.

56. Huygens 1987, p. 88. Constantijn Huygens (1596-1687) wrote about his meeting with Lievens in an autobiographical sketch of his youth around 1629. The full, original Latin text is in Worp 1897.

57. Bruyn *et al.* 1982—, vol. 1, pp. 25-30.

58. Talley 1981, pls. 29, 30.

59. Van Dantzig 1937, p. 33, no. 4.

60. Van de Graaf 1958, p. 153, no. 34b : 'Drapperie noire. Noir de Lampe, peu d'Vmbre, vn peu de blanc. Enfoncés auec Noir d'yuoire, mesle auec Verdet. Rehaussés auec noir de Lampe allie de blanc & d'vn peu d'ombre.'

61. Slive 1970-4, vol. 1, pp. 198-9.

62. Bruyn *et al.* 1982—, vol. 1, p. 31.

63. This corresponds to a change observed in Rembrandt's rendering of lace on collars and cuffs. See Bruyn *et al.* 1982—, vol. 2, p. 63.

64. During microscopic examination of the paint surface we sometimes observed a blue pigment (probably azurite) used to colour the white or iris of the eye on the lit side of the face. The similar blue appearance of the eye on the unlit side of the face is achieved by the optical effect of a fine black mixed with white (*Claes Duyst van Voorhout, Seated Woman* [cat. 52, 79]).

65. The *Regents* was last cleaned in 1910, by C.F. de Wild. Since then, the heightened contrast between the large areas of darkened background and clothing, and light areas, has been the main reason for delaying another cleaning of the paintings. The yellowed varnish layers now present, mellow this unintended effect to some extent.

66. Slive 1970-4, vol. 1, p. 135, fig. 137.

67. Dólleman 1975, p. 57 ; de Jongh 1986, p. 136.

68. See Houbraken's Life of Hals in this catalogue, pp. 17-8.

TABLE I: GROUNDS

S no.	picture	date	p(anel) c(anvas)	colour (1)	(2)	composition (3)
1	ZAFFIUS	1611	p	white		lead white, a little red ochre and fine black, yellowish medium
2	MAN WITH SKULL	c. 1610	p	whitish	grey	lead white, a little red ochre, umber and coarse charcoal black
3	WOMAN	c. 1610	p	whitish	whitish	lead white, a little red ochre, umber and coarse charcoal black
7	MILITIAMEN	1616	c	flesh	pinkish	lead white, umber, a little bright red ochre and black (2 layers, maybe a little chalk in the top one)
18	MAN	1622	c	light brown	light brown	lead white, a little chalk, umber, finely ground bone black
29	LAUGHING BOY	c. 1620-5	p	light yellowish	yellowish	lead white, a little umber, very little finelackpicture
32	J. OLYCAN	1625	c	grey	dark	sample incomplete
33	A. HANEMANS	1625	c		light bluish	lead white, chalk, a little red lead?
34	BEARDED MAN WITH RUFF	1625	c	light yellowish	light pinkish ochreous	lead white, very little red ochre and fine black (a little red lead?)
36	SCRIVERIUS	1626	l	light greyish-ochreous	light brownish	lead white, a little red ochre
37	ANNA VAN DER AAR	1626	p	yellowish	translucent whitish	lead white, a little red ochre, very little umber and black
45	MILITIAMEN	c. 1627	c	light pinkish	whitish	lead white, very little red ochre, very little fine black (2 layers, the bottom one more greyish)
46	MILITIAMEN	c. 1627	c	flesh	light ochre/pink	lead white, a little chalk, a little umber, a dark red pigment, very little black (2 layers?)
57	VERDONCK	c. 1627	p	ochre	whitish	lead white, a little umber (?)
61	YOUNG MAN WITH SKULL	c. 1626-8	c	cold pink	light colour	two layers wet-in-wet: 1st lead white, umber, a little fine black; 2nd lead white, umber, a little red ochre and very little organic red and black
77	N. VAN DER MEER	1631	p	white	white	chalk/glue with imprimatura: lead white, chalk, ochre, umber, very little fine black
78	C. VOOGHT	1631	p	white	white	chalk/glue with imprimatura: lead white, chalk, ochre, umber, fine black
79	MILITIAMEN	c. 1633	c	light flesh colour	light brown	lead white, umber (2 layers, 2nd ground darker)
81	MAN IN HIS 30's	1633	c	light yellowish	whitish	lead white, a little umber
84	P. VAN DEN BROECKE	c. 1633	c	light ochreous	no samples	
93	T. ROOSTERMAN	1634	c	light pinkish	light pinkish	lead white, umber
104	L. DE CLERCQ	c. 1635	c	pink-ochre	grey-brown	lead white, umber, very little red ochre, very little fine charcoal black (two layers)
105	F. VAN STEENKISTE	1635	c	light pinkish	light brown	three layers wet-in-wet: lead white, umber, very little red ochre added in 3rd ground. Only little umber in the 3rd ground. 2nd ground darkest (umber)

S no.	picture	date	p(anel) c(anvas)	colour (1)	(2)	composition (3)
112	M. LARP	c. 1635-8	c	?	light	lead white, little umber
119	C. DUYST VAN VOORHOUT	c. 1638	c	brownish	pink	1st lead white, chalk, umber a little bone black; 2nd lead white, very little umber, red and brown ochre (whole layer stained pinkish, no fine pigment visible)
122	J. DE LA CHAMBRE	1638	p	light	whitish	chalk/glu with imprimatura: lead white, very little brown ochre and very, very little fine black
124	MILITIAMEN	c. 1639	c	light brown	light brown	1st chalk, a little lead white (lumps), umber, a little yellow ochre; 2nd lead white, a little chalk, umber, very little red ochre
131	WOMAN	c. 1638-40	c	brownish?	brown	chalk, a little lead white, umber, a little fine charcoal black and red ochre. Medium-rich at the top. Imprimatura: lead white, chalk, umber, very little fine charcoal black
141	WOMAN WITH FAN	c. 1640	c	ochreous	ochreous	chalk, very little red and black, yellowish-brown medium
144	PAULUS VERSCHUUR	1643	c	yellow	light colour	chalk (prob. bound in glue), a layer of yellowish medium on top; Imprimatura: lead white, a little umber or ochre, very little fine black
156	MAN	c. 1643-5	c	light ochre		no samples
157	WOMAN	c. 1643-45	c	light ochre		no samples
184	MAN	c. 1650-2	c	yellowish	light reddish	lead white, chalk, umber, very little red ochre
185	WOMAN	c. 1650-2	c	light yellowish	light yellow	lead white, chalk, umber, very little red ochre
190	MAN	1650-2	c	greyish-brown	light ochreous	lead white, umber, ochre (lighter towards the top, 2 layers wet-in-wet?)
211	SEATED WOMAN	c. 1660	p	yellowish		no samples
217	MAN	1660-6	c	cool grey		double ground: 1st bright red ochre; 2nd coarse lumps of lead white, charcoal clack and umber
218	MAN	1660-6	c	cool grey		double ground: 1st bright red ochre; 2nd coarse lumps of lead white, charcoal black and umber
221	REGENTS	c. 1664	c	greyish brown	whitish	lead white, chalk, umber
222	REGENTESSES	c. 1664	c	greyish brown	whitish	lead white, chalk?, umber

(1) Colour as observed with the naked eye.
(2) Colour as observed through the stereo-microscope.
(3) Pigments identified using microscopy, micro-chemical tests and electron microprobe analysis.

Pl. VIII

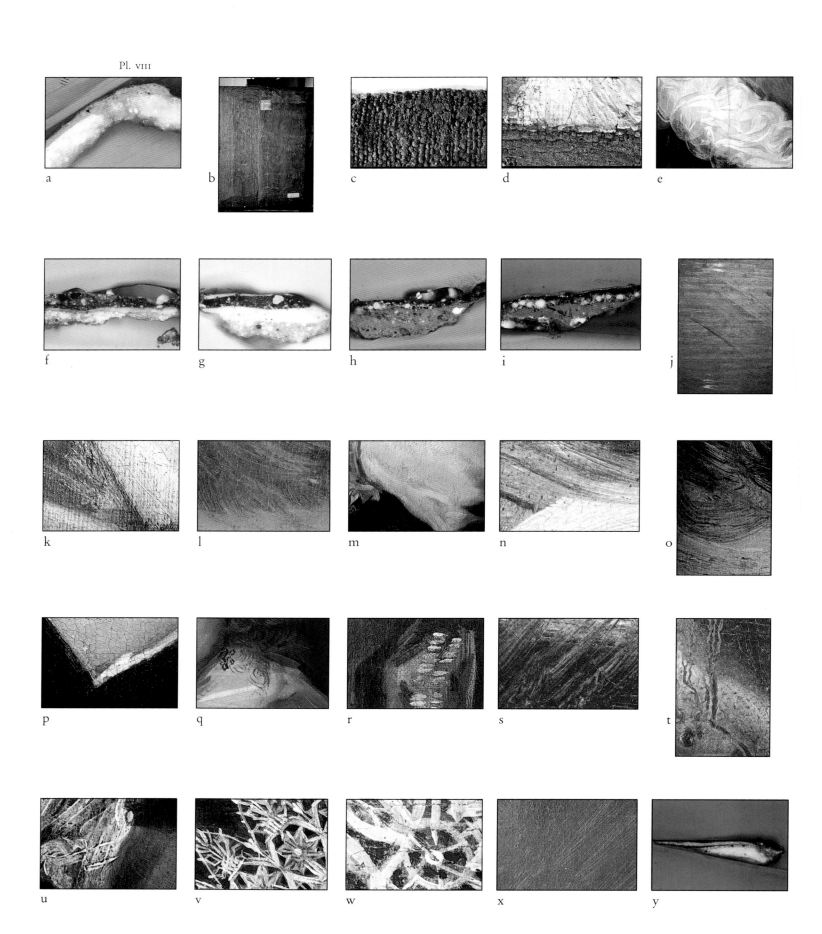

a

b

c

d

e

f

g

h

i

j

k

l

m

n

o

p

q

r

s

t

u

v

w

x

y

a) Paint cross-section of a sample taken along the edge of the *Zaffius* panel (cat. 1), showing ground and paint layers extending over the edge of the panel (magn. x200).

b) The reverse of the *Zaffius* panel (cat. 1), which retains its original bevelling on all four sides.

c) Detail along a reverse edge of the Fitzwilliam *Man* (s218). The messily applied, second, grey ground, has splashed around onto the back of the painting. The first, red ground is seen to have been pushed through the interstices in the canvas.

d) Detail along the bottom edge of the Fitzwilliam *Man* (s218). The light-coloured, impasto paint stops short of the edge, which, after priming, was folded around a stretcher.

e) Detail of the collar of *Nicolaes van der Meer* (cat. 41). The brown imprimatura over the white ground shows through the thin, translucent paint of the collar.

f) Paint cross-section of a grey highlight in the black drapery of *Paulus Verschuur* (cat. 56). This painting on canvas has a chalk ground with a yellowish imprimatura on top (the even grey oval right of centre is an air bubble caught in the embedding material) (magn. x200).

g) Cross-section through the scumbled white paint in the drapery in *Claes Duyst van Voorhout* (cat. 52). The cheap alternative for lead white, namely lead white diluted with chalk, was used for the bottom ground layer (magn. x200).

h) Cross-section through the deepest black in the drapery of the Fitzwilliam *Man* (s218), showing the double ground. On top of a bright red earth there is a cool grey composed of lead white, charcoal black and umber (magn. x200).

i) Cross-section of the *Man in a Slouch Hat* (cat. 83), showing a double ground similar in colour and composition to the Fitzwilliam *Man* (s218) (magn. x200).

j) Macro-photograph of the *Portrait of a Seated Woman* (cat. 79), to the right of her head, with a black line of underdrawing showing through the thin background paint.

k) Macro-photograph of the *Portrait of a Standing Woman* (cat. 58), bottom of her left cuff. Very thin, grey-brown underlayer and fine black line along the edge of the sleeve directly on the ground. It can be seen that they disappear under the white paint layer.

l) *Tieleman Roosterman* (s93), macro-photograph showing the greenish-grey background paint swept over the hair.

m) Detail of *Cornelia Vooght* (cat. 42). The hand is painted entirely over the finished drapery.

n) *Portait of a Man in his Thirties* (s81), macro-photograph of the junction of forehead and hair, showing the abrupt transition with strands of hair brought across.

o) Macro-photograph of the hair of *Verdonck* (cat. 24). The curls are swept into the wet paint of the background.

p) *Portrait of a Man* (s184), macro-photograph of his collar, which is blocked out in the painting of the drapery. A final white contour of the collar overlaps the black drapery. This procedure contrasts with that in a painting like *Cornelia Vooght* (cat. 42), where the cuff is not blocked out, but painted entirely over the finished sleeve.

q) Detail of the *Portrait of a Standing Woman* (cat. 58), locks of hair added over the collar to integrate it.

r) Macro-photograph of the Vienna *Portrait of a Woman* (s185), front panel of her dress. Green verditer was identified in the dark areas of the shot-silk material (the same green pigment was identified in the strip added along the lefthand side ; see the section on 'Canvas').

s) Macro-photograph of the drapery of the *Young Man with a Skull* (cat. 29). Rough, wet-in-wet sweetening or hatching of dark into light areas of the drapery. The light, pink-ochre ground is still visible through the hatching.

t) Macro-photograph of the drapery of the Fitzwilliam *Man* (s218), showing Hals's sloppiness in some of his paintings. Splashes of solvent have been allowed to run down the painting, dissolving paint layers.

u) Macro-photograph of the *Man holding a Skull* (cat. 2). The stiff ruffles of the cuff are sculpted by pushing through turning strokes of white impasto, locally revealing the underlying black sleeve.

v) Macro-photograph of *Cornelia Vooght* (cat. 42), showing that the cuff is rendered with thinly applied white lines over the black sleeve.

w) For *Maria Larp* (s112, macro-photograph), the reserves in the lacework take on an independent identity, being painted with separate black touches either under or over the white.

x) Macro-photograph of the background in *Tieleman Roosterman* (s93), painted on thinly with zigzag strokes which reveal the underlying pinkish ground.

y) Cross-section of the blue in the coat of arms of *Tieleman Roosterman* (s93), where Prussian blue was again identified (magn. x200).

A Note on the Presentation of the Catalogue

The paintings are catalogued in an order that approximates their date of execution.

Where external evidence permits, a firm date is cited without qualification.

Approximate dates are based on stylistic and/or other probative external evidence. They exceed by far the number of firmly dated works for good reason. During the first four decades of his long career, Hals did not often inscribe dates on his portraits, and none assigned to the last fifteen years of his activity bear one. His genre pictures tell a similar story; only one is dated (so-called *Jonker Ramp and his Sweetheart*, 1623; pl. III).

Signatures on the catalogued works are noted. When Hals signed his pictures, he most often used the joined monogram FH. It too is employed sparsely and erratically. This is the case with even his prime commissions: not one of his three regent group portraits is monogrammed, signed or dated (cat. 54, 85, 86). Amongst the five monumental militia pieces he painted for Haarlem's civic guards, only one is monogrammed (*Banquet of the St. George Civic Guard*, datable c.1627; s45) and just one is dated (*Banquet of the St. George Civic Guard*, 1616; s7). Major bespoke portraits (such as his life-size, full-length of *Willem van Heythuysen*; cat. 17) are often not signed or dated, and neither are some of his most celebrated genre pieces such as *Malle Babbe* (cat. 37); *The Gipsy Girl* (s62).

The dates on Hals's portraits are almost invariably part of an inscription that records his sitter's age, indicating that they primarly served its genealogical function, not the artist's desire to record for posterity the year he completed it. As for his haphazard use of his monogram and exceedingly rare signature, he possibly felt they were redundant in the light of his inimitable brushwork, which provided an unmistakable signature to his paintings.

All paintings are in oil. The support of each work is identified in the entries. Dimensions are given in centimetres (cm), height preceding width.

Paintings are shown in all three venues unless otherwise indicated.

For a note on abbreviations and shortened bibliographical and exhibition references used in the entries, see *Editorial Note*.

Very special gratitude is due to Alice I. Davies, catalogue assistant in Cambridge, Massachusetts, for all her research and her work on other aspects of the project from its inception to completion. I am also indebted for multifaceted help from Michael Hoyle, catalogue assistant in Amsterdam, which included most of the translations of the Dutch inscriptions on the prints after Hals's paintings cited in the entries. He is also responsible for sharpening the accuracy and felicitousness of other translations of seventeenth-century Dutch texts.

All of the translations of Latin inscriptions on the prints of Hals's works cited in the entries were made by D. L. Stockton in collaboration with the Revd. L. M. Styles, Fellows of Brasenose College, Oxford. I am beholden to them for their contribution.

More personal is my enormous debt to the private owners of Hals's paintings and members of the staffs of the museums that house the master's works which are catalogued here. They facilitated my study of their paintings in every possible way. I extend my profound thanks to all of them.

S.S.

Jacobus Zaffius

1611
Panel, 54.5 × 41.5 cm
Inscribed and dated below the coat of arms on the left: AETATIS
SVAE/ 77 AN° 1611
S1
Frans Halsmuseum, Haarlem (inv.I-511)

Identification of this bust portrait dated 1611 of the Catholic clergyman Jacobus Zaffius (1534-1618) is based upon the reversed engraving made almost two decades later by Jan van de Velde II (1593-1641) which depicts Zaffius three-quarter length seated in an armchair at a table with his hand resting on a skull, the most obvious vanitas symbol (fig. 1a). Van de Velde's print is inscribed: '*AETA 84* [Zaffius's age at his death] ... *F. Hals/ pinxcit* ... *J.V. Velde/ sculpsit anno/ 1630*' (Franken & van der Kellen 44).

Since the portrait's discovery in 1919 there has been a consensus that it is a precious, if imperfectly preserved, fragment of Hals's earliest existing documented work and that van de Velde's engraving shows it before it was mutilated. It also has been noted that if van de Velde's print is an accurate copy – and, to judge by his close copies after five other paintings by Hals, there was little reason to doubt it – the coat of arms and inscription originally on the portrait were cut away when it was reduced in size, and the present arms and inscription were added after it was cut (for van de Velde's faithful engravings after three pictures discussed here, see cat. 5, 20, 24; for his other prints after Hals and one that reproduces a lost work, see s38, s47, s.L8).

The status of the portrait seemed quite straightforward until conservators at the Frans Halsmuseum, made a technical study of it during the course of its recent restoration (see Groen & Hendriks, p. 109). Microscopic examination of the painting and study of cross-sections of paint samples taken from the edges of its support constructed of two vertical planks revealed that the ground and paint layers continue around the top, left and bottom edges and have been lightly smoothed away along the right edge (pl. VIIIa). These findings establish that the panel was primed and painted in its present size, apart from a small strip that may have been cut along the right edge, a conclusion supported by the bevelling of the back of the panel on its top, left and bottom edges (pl. VIIIb). Thus, the portrait is not a fragment.

This revelation indicates that there never was a need to replace the portrait's armorial bearings and inscription; technical examination confirmed they are in fact original. Dendrochronology of the picture established that, like most Netherlandish panels of the period, its support is oak imported from the Baltic or Poland (Klein *et al.* 1988). Its panel originated from an oak tree felled between about 1602 to 1608, a date consistent with the year 1611 inscribed on the painting.

Knowledge that the portrait is not a fragment raises new questions. Is the painting a partial copy by another hand after the three-quarter length known from van de Velde's print? Hardly. The sitter's intense expression, the surety of the detached brushwork and the convincing suggestion of cast daylight on the solid form of the head speak for the attribution to Hals, not an anonymous copyist capable of simulating the qualities of his early portraits. Is the bust portrait Hals's preliminary or preparatory study for the large portrait? Possibly. But if so, it is unique in the artist's œuvre and in the history of seventeenth-century Dutch portraiture. Not a single life-size painted study for a portrait of the period is known. More probable is the hypothesis that it is Hals's own

partial copy of his three-quarter length, although it should be stressed that, if this assumption is correct, it too makes the portrait a *unicum*. To our knowledge Hals made no other copies of his work.

Zaffius was made abbot of the Augustine monastery at Heilo, near Alkmaar, in 1568. Three years later he was invested in St. Bavo's Cathedral at Haarlem as provost and archdeacon of the episcopal chapter. He struggled in vain to preserve Catholicism in the diocese of Haarlem. On 29 May 1578 he witnessed the terrible destruction wrought by the iconoclasts to St. Bavo, and three years later his refusal to give what remained of the chapter's possessions to the city of Haarlem resulted in a prison sentence. William the Silent, Prince of Orange, secured his release. We only can conjecture whether Hals's bust portrait of him or the one known from van de

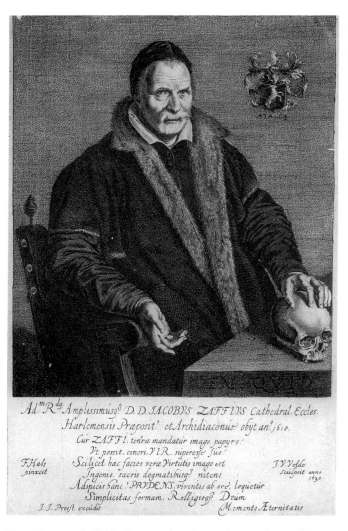

Fig. 1a Jan van de Velde II, engraving after Hals's *Jacobus Zaffius*, 1630

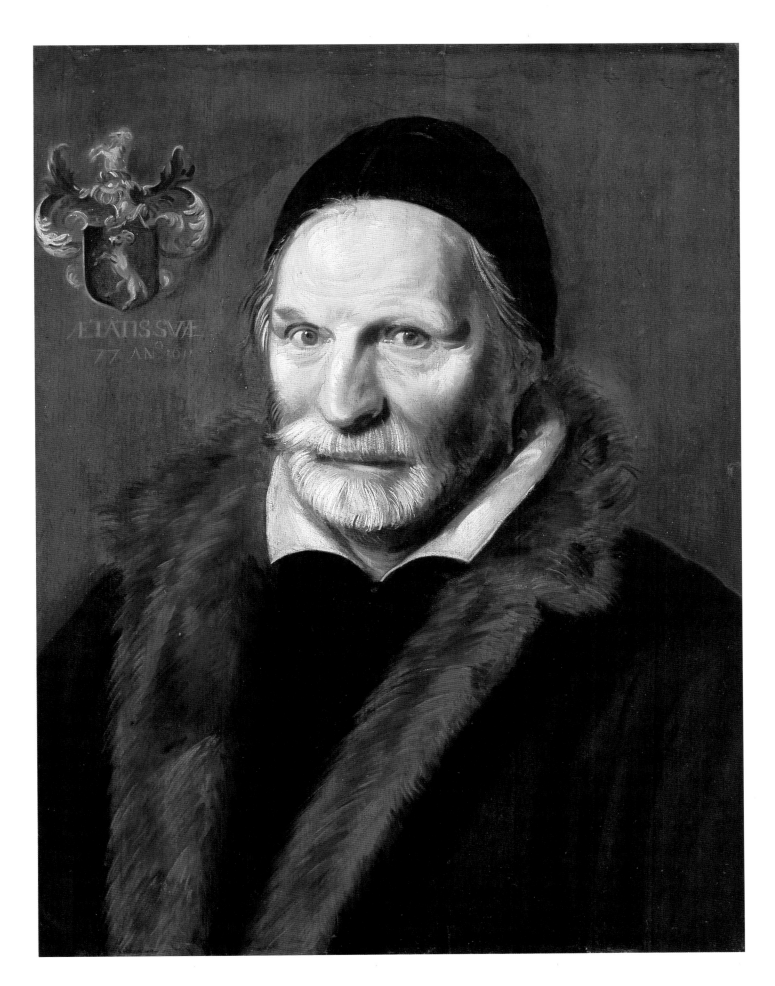

Velde's engraving was made to hang in the Vijf Kameren Hofje (today the Frans Loonen Hofje), a charitable institution for old people that received a very generous benefaction from Zaffius in 1609.

The circumstances that led Jan van de Velde to engrave Hals's portrait of Zaffius long after it was painted and the sitter had died have not been discovered. However, the anonymous Latin inscription on van de Velde's engraving spells out the principal function of the portrait, and, indeed, of most formal portraits from the time they began to be painted in the early Renaissance until our own day. It was made as a memorial to posterity:

> Why is the likeness of Zaffius entrusted to fragile paper?
> So that the Man may outlive his ashes.
> In truth, this face is the image of true Virtue,
> Shining with intelligence and holy doctrine.
> 'Simplicity', wise Zaffius will say from his living lips,
> 'Where thou seest here a form, true Faith sees God'.

Variations on the theme of effigies made 'so that man may outlive his ashes', accompanied by unqualified words of praise for the sitter's virtues, are common in inscriptions on Dutch portrait prints. So is the fact that nothing is said in them about the portraitist who created the image put on 'fragile paper' by the engraver. During Hals's long career about thirty prints were made after his portraits. Apart from a credit line that tells us that Frans Hals painted the work, not one of their inscriptions adds a word about him or his art, and references to the printmakers who copied him are very rare (see cat. 5). There can be no doubt about it. Our preoccupation with who created a work of art and in what manner it was done was not shared publicly by many of Hals's contemporaries.

PROVENANCE According to KdK 3 the painting was discovered in 1919 by the London art dealer H.M. Clark. Acquired by the Frans Halsmuseum in 1920 as a gift from Mr. and Mrs. Philips-de Jongh, Eindhoven.

EXHIBITIONS Haarlem 1937, no. 1; Haarlem 1962, no. 3; Osaka 1988, no. 7.

LITERATURE *Icon. Bat.* no. 9378; Moes 86; HdG 245; Bode-Binder 298; S. Kalff, 'Eene vroege schilderij van Frans Hals', *Oude Kunst* V (1919-20), pp. 265ff.; G.D. Gratama, 'Le portrait de Jacobus Zaffius par Frans Hals', *La Revue d'Art* XXIII (1922), pp. 60-5 and in *Onze Kunst* XXXIX (1922), pp. 36-40; KdK 3; Slive 1961, pp. 173f.; Baard 1967, p. 39; Slive 1970-4, vol. 1, pp. 23-4; Grimm 1; Montagni 2; van Thiel 1980, p. 118; Baard 1981, p. 70.

2 Portrait of a Man holding a Skull

*c.*1611
Panel, 94 × 72.5 cm
Unidentified coat of arms, upper right, flanked by the inscription: ...
ITA MORI/AETAT SVAE 60
S2
The Barber Institute of Fine Arts, The University of Birmingham
Exhibited in London

The Birmingham *Man* and Chatsworth *Woman* (cat. 3), Hals's earliest known pendants, announce the type of commission he received most frequently during the course of his long career. At least thirty pairs of portraits of husbands and wives are known or, to put it another way, more than one quarter of his existing œuvre belongs to this category. And thanks to his or his patrons' lasting penchant for including coats of arms in portraits after this age-old tradition was broken by other eminent Dutch portraitists – Miereveld and Ravesteyn began to minimise them and not a single one of Rembrandt's portraits includes armorial bearings – it has been possible to pinpoint the identity of some of his clients (for an informative essay on the use of arms in Hals's time, see Kretschmar 1977). Of course coats of arms, like inscriptions, can be later additions (see cat. 18, 19, 41, 42) and sometimes they are wrongly identified, as happened with the one on the present portrait. When it was revealed after the painting was cleaned about 1938, it was suggested that the heraldic arms belonged to Bartout van Assendelft (*c.*1558-1622). Soon afterwards it was demonstrated that this proposed identification was based on a mistaken description of the arms, and that neither the coat of arms nor the age of the woman in the pendant correspond with those of Assendelft's wife, Margriet van der Laen (Sewter 1942). The couple remains unidentified.

Probably many of Hals's single portraits known today originally had mates; we can only guess at the number that have been lost. Since the revival of interest in Frans's work in the nineteenth century, many attempts have been made to reunite his separated couples. As we shall see, some of the reunions have been less successful than others. Nevertheless it is eminently sensible to try to arrange such matches. Husband and wife always complement each other in some way in his companion pieces. When separated, we see only half of this intention.

Ample evidence indicates that the place women held in seventeenth-century Dutch society was more important than it had been in earlier times. But in portraiture the male still took precedence over the female. This was acknowledged by Hals and other artists when they painted pendants, double or family portraits according to the laws of heraldry. As in the Birmingham-Chatsworth pair, the pictures were composed so the husband assumed his traditional place of precedence on the dexter side and the wife was on the sinister side (the sides dexter and sinister refer respectively to the right and left of the person wearing the escutcheon). The tradition was a hoary one. It was used by late medieval artists when they painted donors in altarpieces, and later portraitists continued to give husbands this kind of priority over their wives.

The dexter-sinister rule was not iron-clad; however, it was hardly ever broken by Hals. His pendants painted about 1633-5 now at Stuttgart (S95, S96) are his only known breach of the arrangement. In this exceptional instance the male portrait may have been painted while the sitter was still a bachelor and the pendant a bit later. This was not uncommon. Pendants bearing different dates were done in earlier times, and Rubens, Van Dyck and Rembrandt also painted some. In almost all cases the man sat for his portrait before his female companion.

It has been suggested that this occurred with the Birmingham-Chatsworth pair too (see Literature below and Literature cited under cat. 3; the proposal that they never were intended as pendants is unconvincing). Whether there was a time-lag between the two portraits is discussible, but thanks to an investigation made of their supports in 1988 we now can be certain that the unusually large single oak planks upon which they were painted could hardly be more closely related (Groen & Hendriks, p. 111). The two homogenous panels show the same striking feature: a pronounced curving grain which runs diagonally in one direction in the portrait of the *Man* and in the other direction in the portrait of the *Woman*. The distinctive pattern of the grain in each, clearly visible in raking light and radiographs (Groen & Hendriks figs. 1, 2), indicates that the panels have a common origin. They were positioned 'back to back' in the same bent tree trunk. Thus Hals either ordered the pair of matched panels for the commission or had them in stock. It also is notable that the pigment composition used for the grounds of panel is identical (ibid., p. 115). However, when he finished the portraits he painted upon them can be determined only on the basis of their style.

Based on what can be deduced from the similarity of the Birmingham *Man* to *Zaffius* of 1611 (cat. 1), it is datable about the same time. The bold brushwork on the ruff already suggests Hals's characteristic touch. Other passages, where the attack is more timid, and the rigid pose, may justify placing the work a bit earlier, but until more is known about Hals's early efforts it would be foolish to try to assign precise years to the undated works of his first phase.

Slight differences in style suggest that the woman's portrait may have been painted a few years later. Her luminous flesh tints recall those found in portraits by Rubens not long after his return to Antwerp from Italy in December 1608; they are not evident in the Birmingham pendant. Perhaps the woman's portrait was painted after Hals had an opportunity to study works by the Flemish master. However, there is no reason to insist it was done after Frans visited Antwerp in 1616 (he was reported there before 6 August and returned to Haarlem between 11-15 November; Hals doc. 22). Similar gleaming flesh tones are found in Hals's *St. George* banquet piece of 1616 (Levy-van Halm & Abraham, fig. 12), known to have been painted before his Antwerp trip. To judge from it, Hals knew something about what Flanders's leading artist was painting before he made his only documented journey to his native city. Leaving aside the possibility that Hals travelled to the Southern Netherlands before 1616, the supposition that he already had seen the Flemish master's works gains strength when it is recalled that Rubens's paintings were known in the Northern Netherlands soon after the Truce of 1609 was signed.[1]

The conspicuous skull held by the man, like the one seen in Jan van de Velde II's engraving of Hals's three-quarter length of *Zaffius* (fig. 1a), makes the portrait a *momento mori*

133

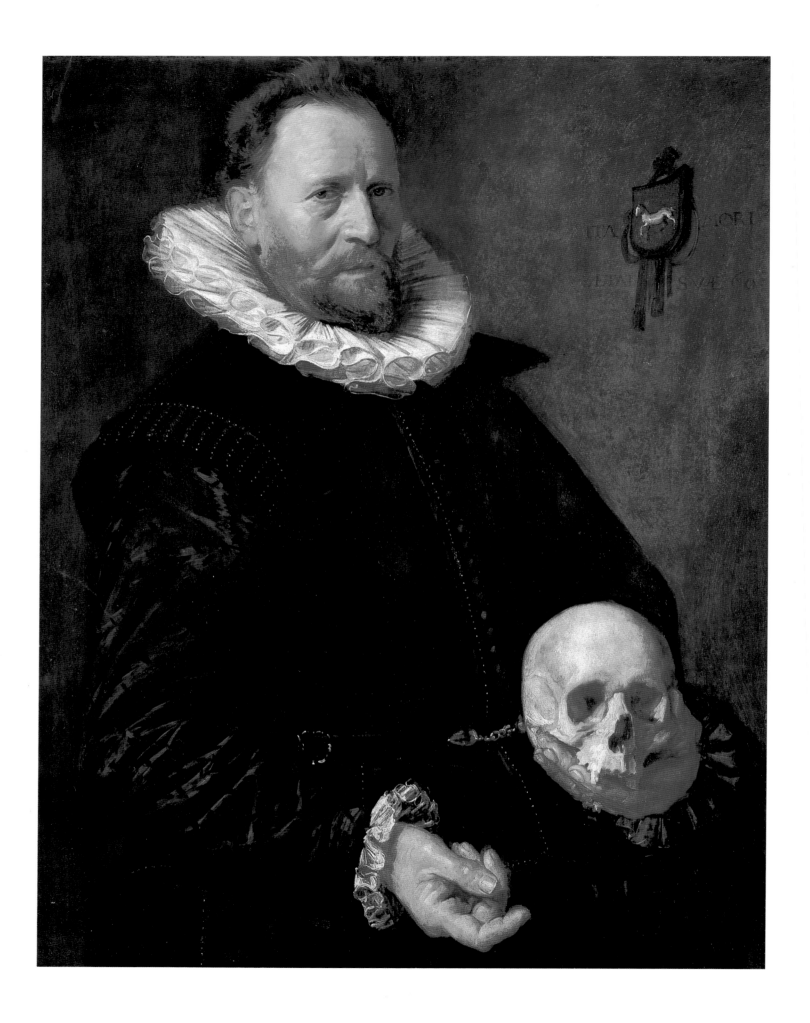

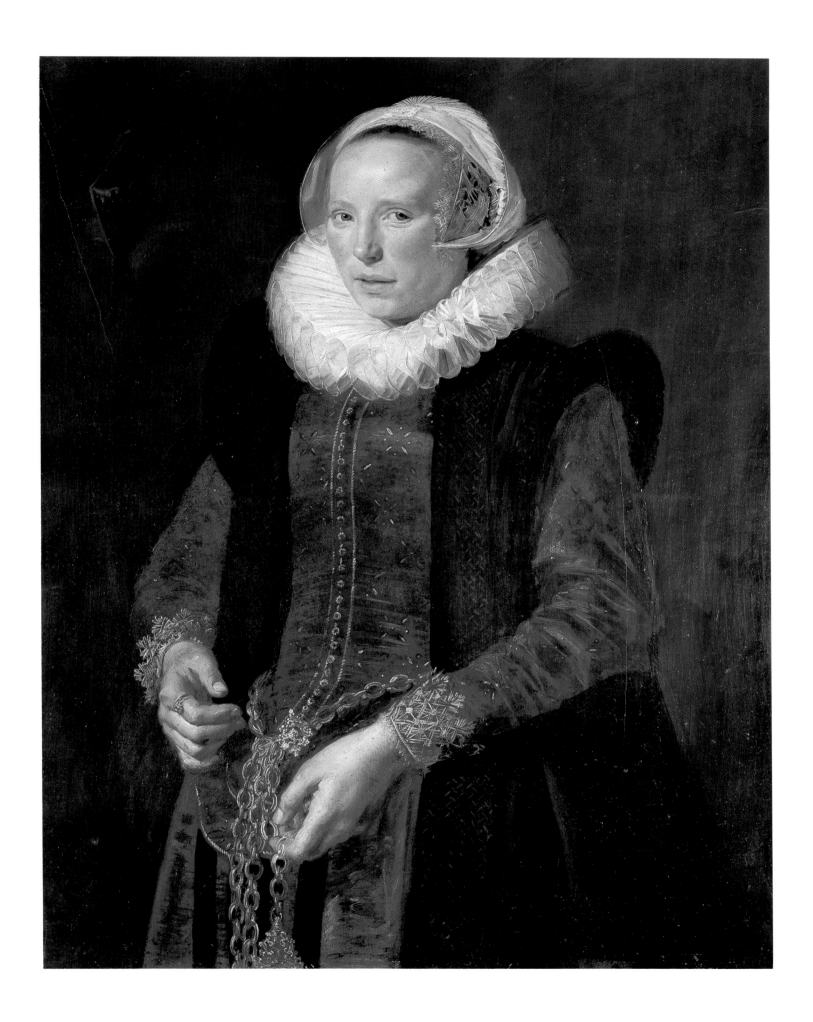

as well as a likeness. After these two works were painted, skulls disappear from Hals's commissioned portraits. The moralising prop occurs only once again in his œuvre; one is held by the young man in his *Vanitas* at the National Gallery, London (cat. 29). Skulls also became rare in portraits by other Dutch artists. During the course of the century their clients preferred to be seen with a book, hat or gloves in hand rather than a death's head. However, allusions to the vanitas theme did not disappear completely. Flowers, timepieces and other less grim reminders of the transience of all things, the certainty of death and the necessity of leading a life that offers hope for eternal salvation, occasionally occur (see cat. 17, 49).

Dutch women were hardly ever portrayed displaying skulls. Since the early Renaissance, when this overt symbol of death began to appear in portraits, it most often rested in male hands. The handsome lady of this pair holds the end of the heavy gold chain that circles her waist. Although jewellery is frequently part of the paraphernalia found in moralising vanitas still-life paintings, the chain in her portrait is an indication of her status and wealth. Following a fashion of the time, the elaborate locket at the end of her chain may have served as a container for a scent ball, a bezoar or some other talisman or even a miniature carved skull. The fact that only half the locket is visible suggests the portrait may have been cut a bit at its bottom edge. The woman's gold chain ornament is also a notable early example of Hals's use of glazes (organic red glazes over a yellow impasto comprised of lead-tin yellow and red ochre); traditional glazing is found as well in the crimson parts of her dress (crimson lake glazes over a strongly modelled underpaint that is principally thick lead white; the composition of these glazes was kindly provided by Groen and Hendriks).

The woman's stiff bodice, probably boned to make it protrude at its bottom, serves as a good platform for the display of her chain. The slashes cut into the fabric of her bodice and into the sleeves of her companion's costume, which had been very popular in sixteenth-century Netherlandish apparel, soon gave way to fabrics with woven or embroidered patterns; for further details regarding the couple's costumes, see du Mortier, pp. 46, 52.

PROVENANCE Before 1914 in the collection of Mrs. Yves of Moynes Park, Halstead. She gave the following account of its earlier history in a letter cited in the Barber Institute Catalogue (1952, p. 58): 'The picture came to me through my mother's father Mr. Patrick Murray who inherited from Patrick [Murray], 5th Lord Elibank, who died in 1778. I have always heard that it came into Lord Elibank's possession by his marriage with Maria Margaretta, daughter of Cornelius de Young, Lord of Elmeat (of the house of La Marck) and Receiver General of the United Provinces. She was the widow of Lord North and Grey and died in 1762.' About 1914 the picture was sold by the dealers Messrs. Sulley, London, to Ayerst H. Buttery, and it passed to his son Horace A. Buttery. It appeared in a sale at London (Christie's), 14 May 1926, no. 75, but presumably was bought in, as it still was owned by Buttery in 1929 and 1937. Purchased by the Barber Institute of Fine Arts from H. A. Buttery in 1938.

EXHIBITIONS London 1929, no. 116; Haarlem 1937, no. 7 (1620-6); London 1952-3, no. 68; Haarlem 1962, no. 1.

LITERATURE Bode-Binder 88; KdK 4 (c.1610-2); Trivas 2 ('... obviously connected with the period of the first group portrait of 1616 ... whether it was executed a few years earlier or later remains a matter of conjecture'); Catalogue Barber Institute of Fine Arts, University of Birmingham, 1952, p. 58; Gudlauggson 1963, p. 8 (doubtful if it is a pendant of cat. 3); Slive 1970-4, vol. 1, p. 24 (c.1611; pendant of cat. 3); Grimm 5 (c.1616), p. 41 (uncertain if it is a pendant of cat. 3); Gerson 1973, p. 172 (c.1616; pendant of cat. 3); Montagni 5 (c.1615; presumed pendant of cat. 3); Baard 1981, pp. 66-8 (1610-1).

1. Van Gelder 1950-1 remains basic for a study of the topic. Rubens's *Supper at Emmaus* (St.-Eustache Church, Paris) probably was in Holland by 1611. The engraving of it made in that year by the Leiden printmaker Willem Swanenburg bears a Latin verse written by the Haarlem poet and historian Petrus Scriverius (who commissioned portraits from Hals in 1626 [see cat. 5]) which indicate that the painting belonged to de Man, a collector who lived in Delft. In the following year Swanenburg engraved Rubens's lost *Lot and his Daughters*; the location of the painting in 1612 is unknown but, since Swanenburg died at Leiden on 15 August 1612, the probability that it too was engraved in Holland is great.

Moreover, Rubens himself went to Haarlem in 1612, probably to search for a printmaker who could produce the quality of engraved reproduction he wanted made after his own paintings (de Smet 1977). Apparently the Haarlem engraver Jacob Matham (who made a print after a Hals portrait in 1618 [see cat. 5]) filled the bill. Around 1613 he made an engraving after *Samson and Delilah* which

Rubens painted for his friend and patron Nicolaes Rockox (acquired by the National Gallery, London, in 1980; inv. 6461). Matham dedicated the print to Rockox, and his inscription states the painting can be seen in his home at Antwerp. Did Matham make his engraving in Antwerp or in Holland? Until the recent reappearance of a *modello* for the painting (acquired by the Cincinnati Art Museum in 1972; inv. 1972.459), it seemed reasonable to assume that Matham engraved it in Antwerp and may even have accompanied Rubens on his return trip to the city. However, close similarities between the *modello* and the print indicate that Matham based his engraving on it rather than on the finished work. The small *modello* (panel, 53.3 × 59 cm) most probably was sent north and engraved in Haarlem.

It also is possible that Buytewech's etching of *Cain slaying Abel* of c.1612-3 was done in Haarlem after Rubens's painting now in The Princes Gate Collection, Courtauld Institute Galleries, London (inv. 298; for the etching see Rotterdam & Paris 1974-5, no. 110).

3 Portrait of a Woman

c.1611
Panel, 94.2 × 71.1 cm (measurements at left edge and bottom respectively)
Unidentified coat of arms, upper left corner, flanked by the inscription: AETA SVAE 32 (?); the last digit has been read as a 7 by some students
S3
The Duke of Devonshire and the Chatsworth House Trust (inv. 267)

See commentary to its pendant, cat. 2.

PROVENANCE There are two portraits by Hals at Chatsworth, this one and a *Portrait of a Man*, 1622 (cat. 13). According to Dodsley's *London and its Environs*, 1761 (vol. 2, pp. 120, 230), a Hals was in the collection of the 3rd Earl of Burlington, at Chiswick Villa, in 1761, while another was in the possession of the Duke of Devonshire, at Devonshire House, Piccadilly, in the same year; but there is no indication which portrait is referred to in each case.

EXHIBITIONS London 1904, no. 284; London 1929, no. 53; Nottingham 1945, repr. p. iii; London 1948, no. 1; London 1952-3, no. 69; Sheffield 1955, no. 13; Haarlem 1962, no. 2.

LITERATURE Bode 1883, 145 (*c*.1628); S.A. Strong, *The Masterpieces in the Duke of Devonshire's Collection of Pictures*, London 1901, no. 27; Moes 197; HdG 382 (*c*.1630-5); Bode-Binder 91; KdK 1921, 14 (*c*.1619); KdK 48 (*c*.1626-8); Trivas 3 (' ... little doubt of its being executed in the period 1615-18'); A. Scharf, 'The Devonshire Collection', *B.M.* xc (1948), p. 357; Gudlaugsson 1963, p. 8 ('questionable if it is a companion picture to the Birmingham portrait [cat. 2] and perhaps painted after Hals' 1616 trip to Antwerp'. In a letter dated 18 April 1963, Gudlaugsson subsequently informed me that he found these conclusions a bit rash. He wrote the coats of arms indicate the portraits belong together and that he is no longer certain the woman's portrait is as late as 1616. He found the evidence of Rubens reminiscent, and asked if it is possible to presume that Hals made a trip to Antwerp before 1616); Slive 1970-4, vol. 1, p. 24 (*c*.1611; pendant of cat. 2); Grimm 6 (*c*.1617; uncertain if it is a pendant of cat. 2); Gerson 1973, p. 172 (*c*.1616; pendant of cat. 2); Montagni 6 (presumed pendant of cat. 2).

4 Pieter Cornelisz van der Morsch

1616
Panel transferred to canvas, 88.1 × 69.5 cm
Inscribed on the wall to the left: WIE BEGEERT; at the upper right a
coat of arms, a unicorn argent rising from the sea (?) pierced by a
shaft and flanked by the inscription: AETAT SVAE 73, and below by
the date: 1616
s6
The Carnegie Museum of Art, Pittsburgh; acquired through the
generosity of Mrs. Alan M. Scaife, 1961 (inv. 61.42.2)

The model is identified as 'PIERO, STADS BODE te LEYDEN' ('Piero, Municipal Beadle of Leiden') on a watercolour copy of the painting by the Haarlem artist Vincent Jansz van der Vinne (1736-1811). The copy (fig. 4a) shows the inscriptions and coats of arms presently on the painting. It also includes Hals's customary connected monogram to the left of the model's shoulder. Since the monogram is not visible on the original, it may have been van der Vinne's invention or lost in a harsh cleaning that postdates the watercolour.[1]

On the basis of van der Vinne's copy and the reference to the painting in the van Tol sale in 1779, which describes the man as 'Piro', beadle and rhetorician of Leiden, the model was securely identified by Hofstede de Groot in 1910 (HdG 205) as Pieter Cornelisz van der Morsch (1543 [not 1546]-1629), a man well known in Leiden. He played the part of the buffoon in performances arranged by the Leiden chamber of rhetoricians 'De Witte Accoleijen' (The White Columbines), and his name appears also on the Leiden lists of court messengers (gerechtsboden).

Some earlier specialists have concluded that van der Morsch also must have been a fisherman or fishmonger (Bode 1883, 143; Moes 259; Dülberg 1930, p. 60; Valentiner 1936, no. 2). If not, why does he hold a smoked herring (bokking) in one hand and a straw-filled basket with fish in the other? The motto on the painting 'WIE BEGEERT' ('Who Desires') also seemed to bolster the argument that van der Morsch is depicted hawking his fish.

P. J. J. van Thiel (1961) showed that this seemingly convincing reading of the picture is wrong in his iconographic analysis of the painting, a pioneer study which helped demonstrate that later-day interpretations of Dutch paintings that do not take into account seventeenth-century visual traditions and literary sources can be wide of the mark.

Granted: no special knowledge is needed to take delight in Hals's depiction of the aged van der Morsch's knowing expression or in his daring brushstrokes that define the straw in his basket and the summary treatment of the hand holding it (although the hand could distress a pedantic drawing instructor). But there is another level of meaning to the portrait that was missed by modern viewers until van Thiel found the key in a book of verses written by van der Morsch between 1599 and 1618 (Gedichten van Piero ..., now in the Leiden City Archives, Guild Archives, no. 1496), which includes his epitaph. In it he characterised himself as a man who distributed smoked herrings ('die deelde Bucken'; Bucken = bokkingen), and as a beadle (Bo = Bode):

Graf Dichtgen
Hier Leyt Pier//o
die deelde Bucken
En was Hier//Bo
Van In te Rucken
overleden den ...
A° 16[29].

His reference to his work as a beadle needs no explanation but his characterisation of himself as a man who distributes herrings does. Van Thiel presents ample evidence to show that in Hals's time 'iemand een bokking geven' meant to shame someone with a sharp remark. The inscription 'WIE BEGEERT' is not a reference to the sale of smoked herring or to van der Morsch's own motto (which was 'LX.N tyt' = elk zijn tijd = 'every man comes to his appointed hour'). It refers to his readiness to rebuke or to ridicule. The fish and the inscription have been used to portray van der Morsch in his role as Piero, the fool of 'De Witte Accoleijen'.

Rhetoricians and other seventeenth-century Dutch viewers who shared the period's rage for emblems may have been challenged to find an epigram that would tie 'Who Desires' (the motto) and the fish (the icon) together and thereby complete an emblematic reading of the portrait. Van Thiel offers an epigram from Lucretius's De Rerum Natura (book 4) as quoted in Ripa's Iconologia, a best-selling emblem book of the day. Under Cupidity, Ripa appropriately cites Lucretius's word that people blinded by desire do foolish things and mistake the false for the true. The epigram, in combination with the other two elements, completes the emblem and gives the portrait another meaning. It tells us that van der Morsch

Fig. 4a Vincent Jansz van der Vinne, watercolour after Hals's Pieter Cornelisz van der Morsch
Paris, Institut Néerlandais, Fondation Custodia (Coll. F. Lugt; inv. 1505)

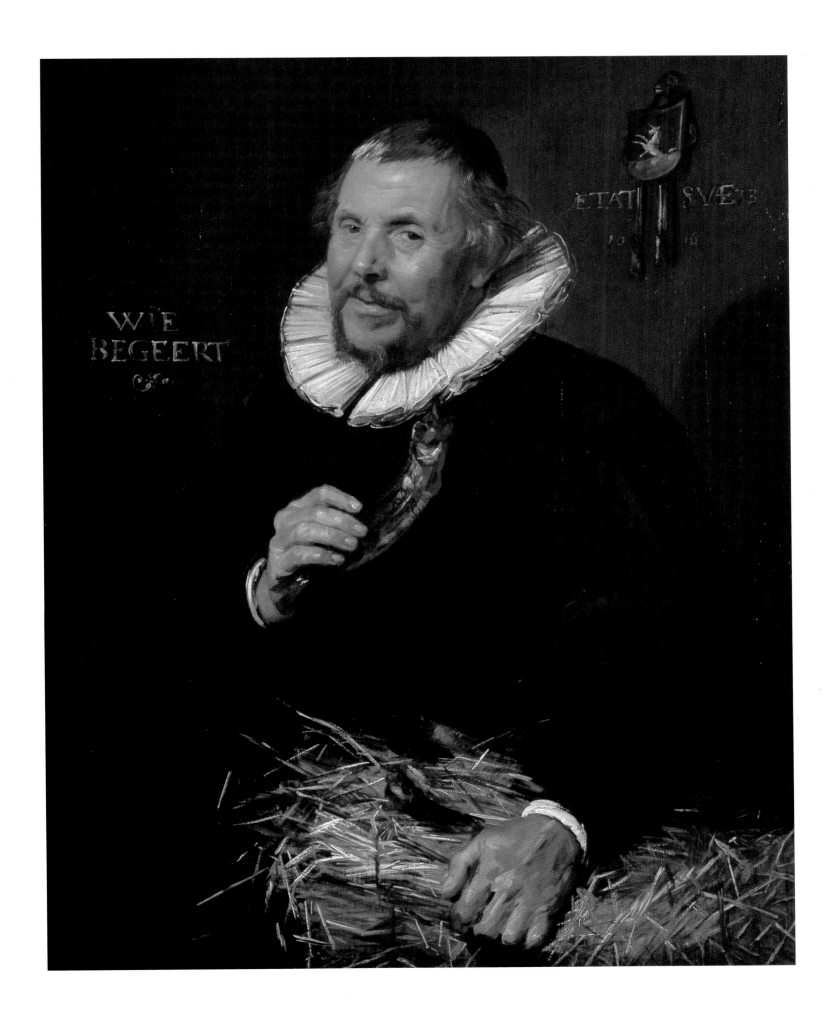

was not a scoffing buffoon, but a moralising one who used his sharp tongue to confront humankind with its shortcomings.

Van Thiel also suggests that the pseudo-coat of arms (van der Morsch had no armorial bearings) hanging from a monkey's head in the upper right of the painting possibly should be read as a rebus. It displays the sea and a unicorn, which can be interpreted as a sea unicorn or *narwhal*. In Dutch, *nar* is a word for fool.

Was the iconographic programme of the portrait contrived by Hals or by the rhetorician from Leiden? Or was it the result of their joint effort? We have no answers to these questions but we do know that Hals had more than a passing interest in rhetoricians and their readings, dramatic performances and fellowship. In 1616, the year he painted van der Morsch's portrait, he became a *beminnaer* (friend) of 'De Wijngaardranken' (The Vine Tendrils), a Haarlem chamber of rhetoricians, and he remained associated with it until 1624 (Hals doc. 16).

1. A technical examination made during the course of the original picture's restoration in 1974 revealed that the background is extensively abraded and there are paint losses throughout due to flaking. The painting has had edges added all around that slightly enlarge it (4.5 cm at the sides). Microscopic examination of the inscriptions shows some repaint, but they are almost intact, apart from the number '3' of the age '73', which falls within the added 4.5 cm strip; it is a later addition. The second '16' of the date '1616' also is new. If the new numerals in the '73' and '1616' inscribed on the painting are accepted as accurate transcriptions of numerals that have disappeared, van der Morsch's age (he was born in 1543) agrees with the one reported on Hals's portrait.

PROVENANCE Sale M. van Tol, Zoeterwoude (near Leiden), 15 June 1779, no. 8; sale Amsterdam, 16 June 1802, no. 75 (B. Kooy, Dfl. 55); sale Barend Kooy, Amsterdam, 30 April 1820, no. 38; sale C.H. Hodges *et al.*, Amsterdam, 27 February 1838, no. 294; sale J.A. Töpfer, Amsterdam, 16 November 1841, no. 28; Martin Colnaghi, London, 1866; Earl of Northbrook, Stratton, Micheldevers, Hants, Catalogue 1889, no. 61; Duveen Bros., Inc., N.Y.; sale the late Mr. and Mrs. Alfred W. Erickson, New York (Parke-Bernet), 15 November 1961, no. 13; presented through the generosity of Mrs. Alan M. Scaife to The Carnegie Museum of Art, Pittsburgh, Pennsylvania, 1961.

EXHIBITIONS Detroit 1935, no. 1; Haarlem 1962, no. 6; Baltimore 1968, pp. 24-5; New York 1973b; Tokyo & Kyoto 1976; New Brunswick 1983, no. 66.

LITERATURE Van der Willigen 1870, pp. 348-9; Bode 1883, 143 ('Ein Häringshändler'); Moes 259; HdG 205; Bode-Binder 89; KdK 11; Valentiner 1936, 2; P.J.J. van Thiel, 'Frans Hals' portret van de Leidse rederijkersnar Pieter Cornelisz. van der Morsch, alias Piero (1543-1629). Een bijdrage tot de ikonologie van de bokking', *O.H.* LXXVI (1961), pp. 153-72; Gordon Bailey Washburn, 'Two Notable Pictures for Pittsburgh', *Carnegie Magazine*, February 1962, pp. 41-7; Slive 1970-4, vol. 1, p. 25; Grimm 3; Catalogue Museum of Art, Carnegie Institute, Pittsburgh, 1973, pp. 72-3; Montagni 9; Handbook Museum of Art, Carnegie Institute, Pittsburgh, 1985, pp. 46-7.

5 Theodorus Schrevelius

1617
Copper oval, 15.5 × 12 cm; set into a wooden panel at a later date
Inscribed on the book: AET. 44/1617 and in the upper right: AETAT/
SVAE ...
s8
Collection Bentinck-Thyssen, Ascona (on loan to Musée d'Etat,
Grand Duchy of Luxembourg)

Although Hals made small portraits from the beginning until
the very end of his career, this aspect of his activity is not
nearly as well known in our time as his work done large as
life. Today more than thirty-five of his existing paintings can
be categorised as portraits in little. None of them, however,
are true miniatures. They could not have been worn as pen-
dants or used to decorate the lids of tiny boxes. Not one is
even as small as the portrait medallion held by the sitter for
his early life-size portrait now at the Brooklyn Museum
(fig. 20b). Hals was not one of those artists who, according to
the seventeenth-century miniaturist Edward Norgate (1919,
p. 19), made portraits 'about the bignes of a penny, wherein
the lives and likenes must be a worke of Faith rather than
Sence'.

This oval portrait of Theodorus Schrevelius (1572-1649),
who began his career as a schoolmaster in Haarlem and then
was rector of Leiden's Latin School from 1625 to 1642, is his
earliest and smallest existing one of this type. It is painted on
copper, a support favoured at the time by miniaturists and
other artists who wanted to give their paintings a smooth,
enamel-like finish. Hals seldom painted on copper; only two
others are known and they too are very small: *Samuel Amp-
zing* of 1630 (cat. 40), and the *Portrait of a Man* of 1627 at Ber-
lin (19.9 × 14.1 cm; s48). But even when Hals painted on a
support that readily lends itself to a high finish, he did not
attempt to fuse his brushstrokes. On the contrary. The lively
accents that he used to help animate his works from the time
we recognise his hand are seen here on a small scale in the
well-preserved passages of the precious little portrait (there is
evidence of repaint in the dark areas, at the top of the head,
and in the beard). Hals's technique was the same whether he
controlled the movement of his brush with his fingertips and
wrist or made large sweeping strokes with his arm.[1]

The identity of the sitter is established by two contempo-
rary prints. In 1618, a year after the little portrait was painted,
Jacob Matham (1571-1631) engraved it in reverse, adding an
elaborate frame embellished with classical gods and other
figures as well as a Latin verse by Petrus Scriverius of whom
we shall hear more later (fig. 5a; 26.1 × 15.9 cm; Hollstein,
vol. 11, p. 244, no. 398). The poem extols the sitter's work as
a schoolmaster, and is one of the rare ones that has a word
of praise for the engraver, but, not unexpectedly, says nothing
about the painter (see cat. 1):

> Because he bridled so many hard mouths of wayward youths,
> With the force of his eloquence and his palladian discipline,
> Schrevelius was worthy, Mathanius, of your copper,
> Worthy too to win this reward for his conscientious care,
> So that if perchance envious time should blot out his name
> And hide the man, his likeness may speak for him.

A few decades later, Schrevelius's portrait was engraved by
Jonas Suyderhoef (c. 1613-86); his print also reverses the
painting (21.6 × 14.2 cm; Hollstein, vol. 28, p. 250, no. 114,
repr.). The Latin verse on Suyderhoef's engraving by C.
Barlaeus (Casper van Baerle, a professor who taught in Lei-
den, then Amsterdam) follows the custom of eulogising the
sitter and ignoring both the engraver and the painter:

Theodore Schrevelius, Headmaster of the Gymnasium
at Haarlem
 'Gifts from our Enemies are no Gifts'
It were easy to portray this man when the stronger vigour of
His age and looks would themselves portray my Schrevelius.
Now it is harder to praise in his old age the man under
 whose championship
Frail savagery bowed its stiff head to Phoebus [=Raw
 schoolboys were instructed in the arts of learning].
He who taught all how to live now lives for himself, and that
Tongue so elegant for Latinity is now silent.
Worn by his work as a schoolmaster, worn by so many
 labours,
His weary old age now beseeches Heaven for repose.

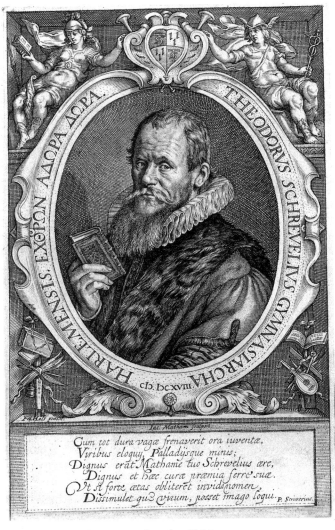

Fig. 5a Jacob Matham, engraving after Hals's
Theodorus Schrevelius, 1618

141

However, Schrevelius himself did not ignore Hals's art. He can be credited with writing one of the rare seventeenth-century appreciations of his work. The schoolmaster gave him highest marks and a special commendation for his original technique in a passage in his *Harlemum ...*, first in Latin in 1647 and in the following year in Dutch (Hals doc. 116), a popular history of Haarlem published in his native city. He wrote that Frans Hals:

> ... excels almost everyone with the superb and uncommon manner of painting which is uniquely his. His paintings are imbued with such force and vitality that he seems to defy nature herself with his brush. This is seen in all his portraits, so numerous as to pass belief, which are coloured in such a way that they seem to live and breathe.

While Schrevelius was rector of the Latin School at Leiden, his friend Arnoldus Buchelius (Arnold van Buchell), the Utrecht jurist and art-lover, visited him at his home there during his visit to the city in 1628. Buchelius wrote in his journal that his host showed him his own portrait by Hals (Hals doc. 42). Most likely the portrait, which Buchelius noted he admired, was the present small oval.[2] Arnoldus also recorded in his journal that his host gave him an engraving after Hals's portrait of their mutual friend Petrus Scriverius, the historian and poet who composed the verse that accompanies Matham's print of the present portrait. Hals's small painting of Petrus Scriverius and the print that reproduces it are discussed in cat. 20.

On the page of his journal that includes his reference to Hals, Buchelius wrote a note (1928, p. 67) about another artist: 'The son of the Leiden miller is highly esteemed, but prematurely.' Buchelius's short sentence is the earliest known reference to Rembrandt's art. His reservation about young Rembrandt's achievement underlines a point often overlooked when the accomplishments of Rembrandt and Hals are compared: they belong to different generations. In 1628 Rembrandt was a 22-year-old artist just beginning to fulfil his brilliant promise, while Hals was a mature master of about forty-five who already had created a large body of work which amply demonstrated his genius. Moreover, the range of possibilities open to each of them when they picked up their brushes as independent artists was radically different.

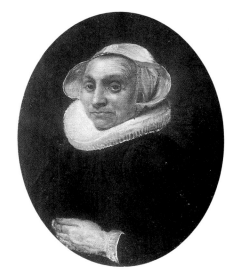

Fig. 5b Unknown artist, *Theodorus Schreve-
lius*, copy after Hals
Dublin, private collection

Fig. 5c Unknown artist, *Portrait of a Woman*,
possibly copy after Hals's lost *Maria van
Teylingen* (S.L19)
Dublin, private collection

A painted oval copy by an unidentified hand of the portrait
(fig. 5b) and its oval pendant, a *Portrait of a Woman* (fig. 5c),
are in a private Irish collection; both are on panel and both
measure 14.5 × 10.8 cm. The existence of the copies suggests
that Hals's 1617 portrait of Schrevelius originally had a com-
panion piece. The woman's portrait may very well be a replica
of the artist's lost portrait of Maria van Teylingen (1570-1652)
whom Schrevelius married at Alkmaar on 25 July 1599. Hals's
small *Portrait of a Woman*, dated 1628, now in an English
private collection (s51) has been identified as Maria van
Teylingen by Valentiner (KdK 73), but not on very firm
grounds. In any event, the two pictures do not appear to
portray the same woman. No known print can be used to help
establish the identification of the woman, hardly astonishing
after we recall that, whenever contemporary prints were made
of the artist's pendant portraits of married couples, only
husbands were engraved. The men who patronised Hals and
other Dutch portraitists whose clientele was similar to his may
have appreciated the achievements of their wives, but they
found no reason to celebrate them by having multiple images
made of their faces accompanied by captions extolling their
accomplishments.

PROVENANCE Aspects of the nineteenth-century history and refer-
ences to the date inscribed on the painting, as well as the identity of
the sitter, have been confused. They are best discussed together. Ac-
cording to the 1926 Warneck sale catalogue, the portrait was bought
by Warneck in 1864 from a minister in Holland. There also is reason
to believe the painting was with Count Bloudoff, Brussels, 1873
(*Icon. Bat.* no. 7130-1; Moes 71). Bode states (1883, p. 85, no. 79) that
in 1878 Warneck of Paris owned a small portrait of Scriverius inscrib-
ed 'AEtat 44' and dated 1613. He also wrote it was the earliest dated
painting by the artist (Bode 1883, pp. 43-4). This work is now un-
traceable; possibly it never existed. Bode may have made a double
error; Warneck's 1613 painting of Scriverius may in fact have been
Hals's 1617 portrait of Schrevelius. The plot thickened in 1905 when
Moes listed a portrait of Theodorus Schrevelius by Hals in the col-
lection of E. Warneck, Paris (*Icon. Bat.* 7038-1), and also listed a
portrait by Hals dated 1613 of Petrus Scriverius in the Warneck Col-
lection, probably from the collection Blondoff (sic), Brussels, 1873
(*Icon. Bat.* 7130-1). *Icon. Bat.* 7038-1 may be identical with 7130-1.
Moes 69 lists the Warneck painting as Schrevelius again and states it
is dated 1617; it may be identical with Moes 71: Scriverius, dated
1613, Count Bloudoff, Brussels, 1873. After Moes published his cata-
logue of 1909, references to Hals's mysterious portrait of Scriverius
dated 1613 disappear from the literature. Sale Warneck, Paris, 27-8
May 1926, no. 46; Heinrich Baron Thyssen-Bornemisza, Schloss Ro-
honcz, Lugano-Castagnola; by descent to the present owner.

EXHIBITIONS The Hague 1903, no. 35; Paris 1911, no. 60; Munich
1930, no. 145; Birmingham 1950, no. 23; Amsterdam 1952, no. 42;
Haarlem 1962, no. 7; Paris 1970, no. 24; Düsseldorf 1970-1, no. 21;
Tokyo *et al.* 1986, no. 23; Lausanne, Paris & Brussels 1986-7, no. 23;
Luxembourg 1988, no. 23. In recent years the painting has been on
extended loan at the Kunstmuseum, Düsseldorf (1970-84) and at the
Musée de l'Etat, Luxembourg.

LITERATURE Possibly Bode 1883, 79; *Icon. Bat.* no. 7038-1 and possi-
bly no. 7130-1; Moes 69, possibly identical with 71; HdG 222; Bode-
Binder 93; KdK 13; *Arnoldus Buchelius, 'Res Pictoriae'*, ed.
G. J. Hoogewerff & I. Q. van Regteren Altena, The Hague 1928, p. 66;
Sammlung Schloss Rohoncz (catalogue by Rudolf Heinemann), Lu-
gano-Castagnola 1937, vol. 1, no. 181; Slive 1970-4, vol. 1, pp. 8, 28-9,
59; Grimm A 26 (small, inaccurate copy); Montagni 11; Broos 1978-
9, p. 118 (not by Hals).

1. For the argument, which I find
unconvincing, that this little portrait
and twenty-four other works done on
a small scale, which have been accept-
ed as authentic pictures by Hals, are
not by his hand but are anonymous
copies after lost originals, or painted
by his sons Frans II and Jan, see
Grimm 1971 (*passim*) and Grimm
1972 (*passim*). Twelve other Hals
small paintings excluded by Grimm

are included in the present catalogue:
cat. 20, 25, 26, 40, 48-51, 59, 65, 66,
77.

2. For sensible reasons to reject the
supposition that Buchelius was shown
one of two other small Hals portraits
dated 1628 (s49, s50) which have been
called portraits of Schrevelius on the
basis of flimsy evidence, see Hals
doc. 42.

Paulus van Beresteyn

Catharina Both van der Eem

*c.*1620
Canvas, 137.1 × 104 cm (original support)
Inscribed to the right below the coat of arms: AETAT SVAE [?4]o/162[?0 or ?9]
S12
Musée du Louvre, Paris (inv. R.F.424)

*c.*1620
Canvas, 137.2 × 99.8 cm (original support)
Inscribed to the left below the coat of arms: AETA ... SVAE .../ ... [?20 or ?29]
S13
Musée du Louvre, Paris (inv. R.F.425)

The poses Hals used for these grand three-quarter lengths of Paulus van Beresteyn (1588-1636) and his third wife Catharina van der Eem (1589-1666) were part of the stock-in-trade of Netherlandish portraitists. He himself used very similar ones for companion pieces datable only a few years earlier (Kassel; S10, S11), and he rang changes on them later. Here both husband and wife are seen standing rather rigidly against neutral backgrounds relieved only by escutcheons. Of atmospheric life there is not a trace. The colour scheme still shows the dark tonality of his early commissioned portraits, but enriched by the minute precision of the treatment of the great display of lace and embroidery, particularly in Catharina's elaborate scalloped stomacher. The two are virtually mirror images. Both have been placed a bit off centre, and the husband, with his arm akimbo, asserts himself more than his wife. Catharina could not have been an easy subject for an artist. What was a portraitist to do with the pale glory of her moon-shaped face? We sense that she has not been flattered. Her eyes are beady, her nose is long and sharp, her chin is weak and her forehead is abnormally large. The shape of her coat of arms appears as a commentary on the configuration of her extraordinary head, while her husband's exuberant escutcheon reflects some of his flamboyance.

As always in Hals's works, the light in both portraits comes from the left and, as always, the woman's face is lighter in tonality than her husband's. In the world of seventeenth-century Dutch portraitists the sun consistently shines more brightly on women than on men, a consequence of the dexter-sinister rule – if the light comes from the left, the right side of a husband's head must needs be partially in shadow and the wife's in full light. The artist took full advantage of the pictorial effect that the iconographical programme for pendant portraits dictated. De Jongh rightly has emphasised (1975, p. 585) that long before Hals's time portraitists accentuated the difference between the facial colouring of men and women, and that at least one later Dutch theorist discussed the matter. In 1707 Gerard de Lairesse wrote in his *Groot Schilderboek* (vol. 2, pp. 6-7) of the distinction in the fall of light on man and woman:

> ... as for the lighting – it is a matter of moment whether this falls on the man or the woman: because the female sex generally possesses greater tenderness and loveliness, it requires, more so than the man, the most beautiful and pleasing light. (*Noopende de daaging, hier aan is veel gelegen, om die op man of vrouw toe te eigenen: want vermits het vrouwelyk geslacht gewoonlyk meerder tederheid en bevalligheid bezit, zo heeft het zelve, boven den man, ook het schoonste en aangenaamste licht noodig.*)

The sitter for the male portrait was identified in 1900 by M.G. Wildeman as Paulus van Beresteyn, a member of an old Haarlem family, who was active as a lawyer in his native city. As a Catholic he did not qualify for many public offices; however, he served as a judge (commissioner of Petty Sessions) from 1615 to 1617 and also worked as an attorney for the Haarlem St. Luke Guild. On 12 December 1619 he

married Catharina van der Eem, who also was a Catholic. The pendants probably were painted as marriage portraits.

It is apparent to the naked eye that the inscription on Paulus's portrait has been corrupted by a later hand: the '4' of the '40' and the '9' of the '1629' have been repainted, an observation confirmed by ultraviolet and infra-red examination (see note 1 below). Hofstede de Groot (154) observed as early as 1910 that the inscription had been changed; he suggested that it originally gave Paulus's age as thirty and was dated 1620. On the basis of style, technique and costume a date of about 1620 for it is convincing. For characteristic male three-quarter lengths done about a decade later, see the *Portrait of a Man*, dated 1630, at Buckingham Palace, and Haarlem's *Nicolaes van der Meer* of 1631 (cat. 38, 41).

However, it should be noted that in 1620 Paulus was thirty-one or thirty-two years of age, not thirty. Why the discrepancy? A few possible reasons can be offered. Not only were ages often given as approximate in documents of the period, but some people counted the second year as the age of two when we say one year old. Alternatively, the inscription may have been added to the portrait at a later date when members of the Beresteyn family were a bit vague about Paulus's year of birth or even the identity of the model, and the confusion possibly was compounded by subsequent changes made to it. The partially legible dates inscribed on the portrait of *Catharina* also are untrustworthy (see note 1 below).

Since Jacques Foucart (Paris 1970-1, no. 96) first suggested that Pieter Claesz Soutman (c.1585-1657) possibly participated in the execution of *Catharina*, Soutman's authorship or that of another follower has been proposed for it with varying degrees of certainty; it also has been suggested that the picture was not intended as a pendant to *Paulus* but is a copy after a lost Hals made to serve as a companion piece (see Literature below). Gerson (1976, p. 423), who firmly maintained that Hals painted *Paulus* about 1620 and that a different artist – perhaps Soutman – was responsible for Catharina's portrait, offered two reasonable hypotheses for this unusual (but not unique) case: the female portrait was commissioned from another artist to replace an older portrait by Hals, or to match a male portrait whose pendant Hals for unknown reasons never executed. In support of the second hypothesis he notes that Paulus was married for the second time on 9 January 1618 to Anna van Steyn; it may be that Paulus was painted on this occasion, and that the artist never had the opportunity to portray Anna because of her early death in the same year.

Did another artist paint part or all of *Catharina*? To help answer this question and the relationship of the woman's portrait to *Paulus*, Pierre Rosenberg, Chief Curator of the Department of Paintings at the Louvre, kindly arranged to have a technical examination made of both paintings in the museum's laboratories in 1988. The examination establishes that the two portraits have very similar canvas supports, have identical grounds and employ identical paint media.[1] According to the report, these findings virtually confirm the supposition that *Catharina* was painted about the same time as

Paulus, either in Hals's studio or in the atelier of a follower who was intimately acquainted with Frans's preparation of grounds and materials or who procured pre-primed canvas from the same source.[2]

Additionally, the report states that infra-red photography of the two portraits shows significant differences in the manner of working. How can the differences in handling be explained? Was *Catharina* partially or entirely the work of a close follower? Is it a contemporary copy after a lost Hals? (The successful manner in which the pendants complement each other seems to indicate that Hals himself was responsible for the compositions of both.) Or is *Catharina* possibly a Monday morning effort by Hals? Though I still am strongly inclined to support the attribution of both portraits to Hals, in light of the Louvre's findings derived from infra-red photography, it seems prudent to leave these queries open until the original paint layer of the paintings, which normally tells us more about an artist's handling than infra-red photos, can be studied afresh in the exhibition alongside unquestioned works by the master datable to the same phase of his activity.

One of the children of Paulus's third marriage was Nicolaes van Beresteyn (1629-84), an amateur artist and the founder of the Hofje van Beresteyn at Haarlem, a charitable institution for Catholic men and women established in 1684 (see Gerson 1941). Perhaps Nicolaes inherited the portraits of his parents and left them to the Hofje he founded. In any event they formerly belonged to the Hofje along with the portrait of his sister *Emerentia van Beresteyn*, now at Waddesdon Manor, and the large *Family Portrait* at the Louvre of his father and mother, six of their children and two servants (Biesboer, fig. 16). During the nineteenth century all four pictures were attributed to Hals. Today the Waddesdon Manor *Emerentia* and Louvre *Family Portrait* are ascribed to Soutman and dated *c*.1630 (Slive 1970-4, vol. 3, nos. D70, D80).

When the Hofje decided to sell the four Beresteyn portraits in 1876, a unsuccessful attempt was made to raise money to purchase them for Holland. In 1882 the portrait of Emerentia was sold by the Hofje to Baroness Wilhelm von Rothschild for 210,000 francs and in 1885 the Louvre acquired the other three for 104,950 francs (100,000 guilders). The sale of these pictures caused a scandal. Dutchmen deplored the loss of national treasures, while some Frenchmen considered the high price the Louvre paid for three of the paintings unjustifiable (for extensive bibliography of the sales, with special emphasis on the Dutch side of the story, see van Hall 1936, nos. 10314-25).

Paulus, the '4' and '9'; *Catharina*, the age '38' and '2' in the year (I find the '38' totally illegible, and the last digit of the year can be read as a 'o' or '9'). According to the report, infra-red photography also reveals differences in handling: in *Paulus* the flesh tones are juxtaposed and superimposed skilfully and the brushwork is energetic, while the touch is rigid in *Catharina*. The report adds that these differences are also evident in infra-red photos of the hands, embroidery and lace. Although the manner of painting differs, the report concludes that the identical grounds of the portraits and the similarity of their supports confirms that *Catharina* could be the work of a Hals disciple close to his studio.

2. If *Catharina* was indeed painted *c*.1620, an attribution of it to Soutman cannot be documented, since none of his works datable to the years before he left Haarlem for Antwerp *c*.1619 have been identified. Soutman returned to Haarlem only *c*.1628 and, as mentioned at the conclusion of this entry, a few years later he almost certainly painted portraits for the Beresteyn family which formerly were wrongly ascribed to Hals. Now, there is no reason to assume that Soutman could not have painted yet another Hals-like portrait after 1628. However, I find it unlikely that its ground would be identical with a ground Hals employed for a portrait painted about a decade earlier. Admittedly, this is a guess, but, until much more research is done on the materials used by Hals and his followers, it is not possible to offer more.

PROVENANCE The pair was acquired for the Louvre from the Hofje van Beresteyn in March 1885, along with the *Family Portrait of Paulus van Beresteyn and his Wife Catharina Both van der Eem with their Six Children and Two Servants* (R.F.426; Dfl. 100,000 was paid for the lot). At the time of its purchase the *Family Portrait* was attributed to Hals; it is now ascribed to Soutman (S.D80).

EXHIBITIONS Amsterdam 1952, nos. 45,46 (despite the inscriptions both painted in or *c*.1620); Paris 1960, nos. 417 (*Paulus*: dated 1629), 418 (*Catharina*: dated 1639); Paris 1970-1, no. 96 (*Paulus*: *c*.1620; perhaps Soutman had a hand in the pendant).

LITERATURE Bode 1883, nos. 9, 10 (both dated 1629); *Icon. Bat.* no. 519-2 (as Nicolaes van Beresteyn); M.G. Wildeman, 'De portretten der Beresteijn's in het Hofje van Beresteijn te Haarlem', *O.H.* XVIII (1900), pp. 129-36; Moes 15, 16 (both dated 1629); HdG 154, 155 (despite the inscription probably 1620); Bode-Binder 121, 122; Catalogue (by L. Demonts) Louvre, Paris, 1922, pp. 21-2, nos. 2386, 2387 (both dated 1629); KdK 15, 16 (both probably 1620); Dülberg 1930, pp. 61, 64 (neither portrait by Hals); Trivas 7, 8 (both probably 1620); E.A. van Beresteyn, *Genealogie van het geslacht van Beresteyn*, vol. 2, The Hague 1941, p. 58ff., no. 117 (argues for a date of 1629 for *Paulus*) and p. 60, no. 122 (accepts date of 1629 for *Catharina*); E.A. van Beresteyn & W.F. del Campo Hartman, ibid., vol. 1, The Hague 1954, pp. 219ff. (this two-volume work is a bibliographical curiosity; vol. 1 was published thirteen years after vol. 2); Slive 1970-4, vol. 1, p. 50 (both 1620); Grimm 15 (*Paulus*: 1620; *Catharina*: p. 42, by Soutman, *c*.1629); Gerson 1973, pp. 172-3 (*Catharina* by Soutman); Montagni 18, 19 (both questionably dated 1620; another hand, perhaps Soutman's, participated in *Catharina*); Gerson 1976, p. 423 (*Catharina* by Soutman); Catalogue Louvre, Paris, 1. *Ecoles flamande et hollandaise*, 1979, p. 66, R.F.424: *Paulus* (4 and 9 of inscription repainted; perhaps originally dated 1628; questionable if it is a pendant to *Catharina*); R.F.425: *Catharina*, entourage de Hals (inscribed: AETA SUAE 38, 1629; 38 and 2 repainted, but doubtlessly after the original numerals; perhaps a copy after a lost Hals which was made to serve as a pendant).

1. The report of the Louvre's findings, dated 10 November 1988, and a set of technical photos made during the examination were helpfully provided by Lola Faillant-Dumas, Coordinator of Study and Research on Paintings at the laboratory of the Musées de France. A summary of the report follows.
SUPPORT Both paintings are relined. Their original canvas supports are of the same irregularity and fine texture, *Paulus*'s a bit more tightly woven (14 warp threads and 16 weft threads per square cm) than *Catharina*'s (13 warp threads and 14 weft threads per square cm).
GROUND Analysis of samples taken from the dark backgrounds of both paintings establishes that their grounds are identical. They are greyish white, constituted principally of lead white, with coarse grains of orangish-red (in which red lead has been detected) and fine grains of black, probably ground charcoal. (The question of whether the portraits were painted on pre-stretched, grounded canvasses, which were supplied by craftsmen who specialised in this kind of work and which were used occasionally by Hals and his contemporaries has not yet been investigated).
MEDIUM It is an emulsion of protein in a fatty body, most probably animal glue in oil (based on colour tests using black amide and heat).
RADIOGRAPHS *Paulus*; opaque, only the collar shows some white accents. *Catharina*; also opaque, but the modelling of the face and some details of the costume (cap, collar, stomacher, cuffs) show some white highlights.
INFRA-RED PHOTOGRAPHY Some of the dates near the coats of arms have not only been repainted but modified:

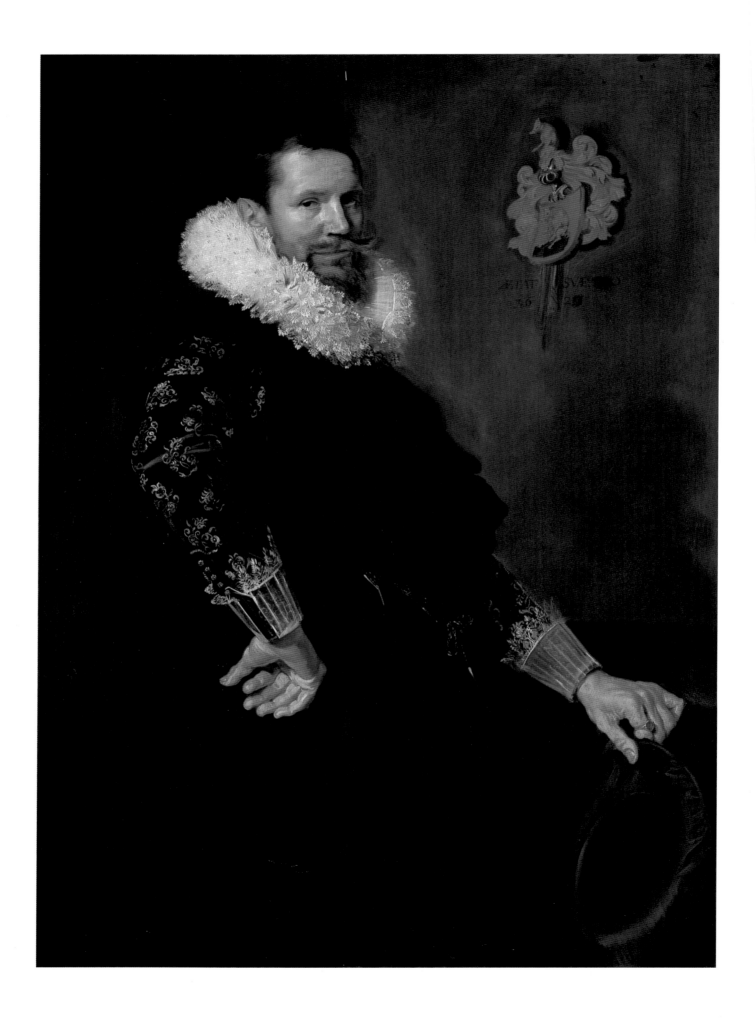

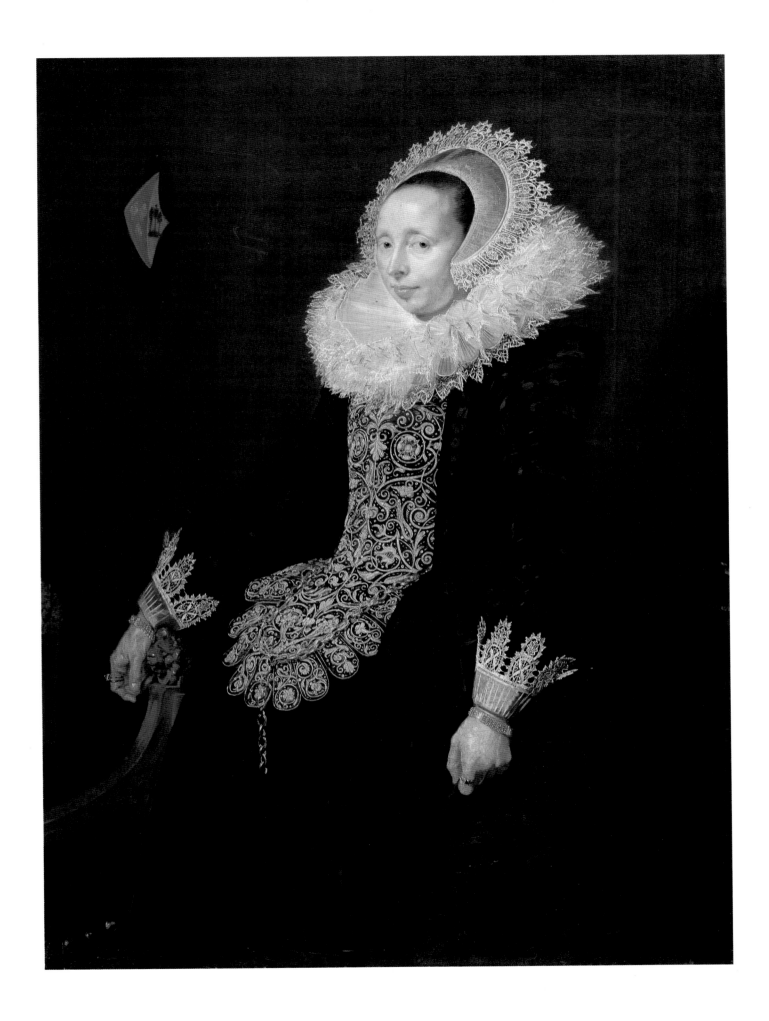

The Rommel Pot Player

c.1618-22
Canvas, 106 × 80.3 cm
S.L3-1
Kimbell Art Museum, Fort Worth, Texas (inv. ACF 1951.01)

Most likely Hals created two versions of this appealing subject: this one, which shows the merry rommel pot player surrounded by five smiling children of various ages, some of them offering the old man coins, and another depicting the same rommel pot player with six children and other changes (fig. 8a; S.L3-2). The numerous contemporary and later replicas of each composition, and the frequency with which they were used as a point of departure for works by gifted and less gifted copyists and pasticheurs ranks them with Hals's most beloved paintings. When they were catalogued in 1974, seven other versions of the Kimbell painting and a half-dozen of the expanded composition were listed (Slive 1970-4, vol. 3, under L3). Earlier cataloguers ascribed various versions of the two compositions to Hals himself, but for more than a generation there has been a consensus that all are based on one or, more probably, two lost originals (ibid.). However, restoration of the Kimbell painting in 1988, which included removal of a coat of discoloured varnish that veiled many of its qualities, offers reason to attribute it to the artist's own hand. Examination of the original relined canvas established that its original tacking edges have been removed, and radiographs indicate that the four sides of the support have been trimmed.[1] A replica of the painting that was in a private Dutch collection in 1982 most probably shows its appearance before it was cut (fig. 8b).[2]

Despite some awkward passages (the outstretched hand of the grimacing boy on the right; the modelling of the rommel pot player's sleeve), the fresh, direct brushwork and the vitality of the figures speak for the ascription to Frans; the surety of touch that characterises the old man and children is worthy of the master. Particularly convincing is the little girl

who smiles at the beholder. She holds her own when juxtaposed to Hals's celebrated, much more highly finished portrait of the two-year-old Catharina Hooft (cat. 9); it is difficult to put a portrayal of a child to a more severe test.

Hals's treatment of the theme was novel. No earlier painting relies so heavily on the delight of a group of children for its principal effect. To be sure, earlier Netherlandish artists had depicted street musicians with young listeners. Around the turn of the century, David Vinckboons (1576-c.1632) painted little village scenes that include crowds of gnome-like children listening to a hurdy-gurdy player. The settings for Vinckboons's pictures ultimately were derived from Pieter Bruegel's panoramic views of towns, as were the pathetic blind beggars who are the protagonists in his paintings of this type. Hals's treatment of a begging street musician is different. Not only is the mood one of unadulterated joy, but he gives a close-up as big as life of the old rommel pot player and his young audience. Though the composition is crowded, the figures are not as tightly knit as those in his life-size, multifigured *Shrovetide Revellers*, datable about 1615, now at the Metropolitan Museum (pl. 11; s5), suggesting that the composition was invented a few years later. However, unlike the overcrowded Metropolitan painting, here the artist has provided some breathing room above the group. But the two figures in the doorway of the Kimbell painting are summarily sketched as those above the heads of the principal Shrovetide revellers[3] – not an uncommon feature in the backgrounds of Hals's rare multifigured subject pictures.

The *Rommel Pot Player* also can be related to Shrovetide; it could illustrate the Dutch inscription on a print datable to

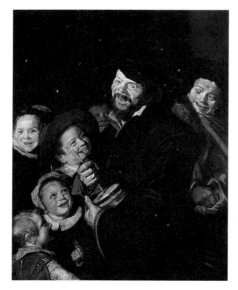

Fig. 8a Unknown artist, *The Rommel Pot Player*, copy after Hals (S.L3-2)
Wilton House, The Earl of Pembroke

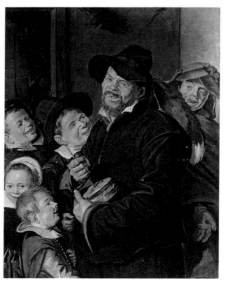

Fig. 8b Unknown artist, *The Rommel Pot Player*, copy after Hals (S.L3-5)
The Netherlands, private collection

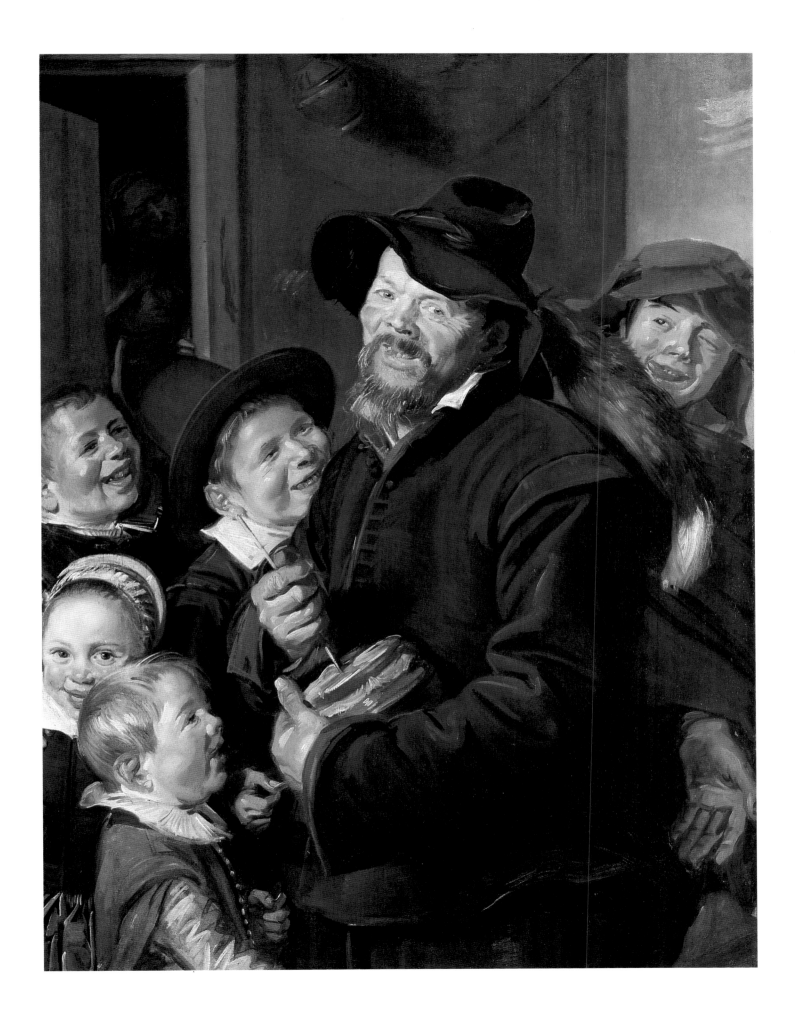

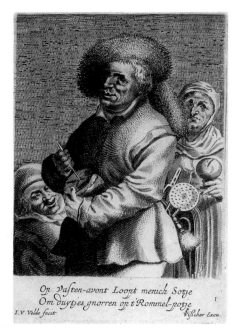

Fig. 8c Jan van de Velde II, engraving

Fig. 8d Attributed to David Bailly, *Vanitas Still-Life*
St. Gilgen, F.C. Butôt

Fig. 8e Detail from *Vanitas Still-Life*, attributed to David Bailly

the 1620s by Jan van de Velde (1593-1641) of a similar subject derived from Hals's original idea (fig. 8c; Franken & van der Kellen, p.61, no.90):

Many fools run around at Shrovetide
To make a half-penny grunt on a rommel pot
(*Op Vasten-avont Loopt menich Sotje*
Om duytjes gnorren op 't Rommel-potje)

The huge, floppy red beret worn by the winking young fool sticking out his tongue in the Kimbell painting suggests the scene takes place at carnival time, but of course fantastic berets and rommel pots could be used on other occasions.

There can be no doubt that Hals's rommel pot player is closely associated with seventeenth-century ideas about folly. Dangling from the old man's hat is a large foxtail, a traditional attribute of a fool. Also telling is the drawing of him without his young audience that appears in a sketchbook included in a *Vanitas Still-Life* (figs. 8d, 8e) as part of the paraphernalia that alludes to folly in the painting and which is contrasted with other objects that are references to the Neo-Stoical wisdom of preparing for death. His appearance in the still-life, which is datable to the mid or late 1620s, indicates how quickly he became well-known. The *Vanitas Still-Life* has been ascribed to the Leiden painter David Bailly (1584-1657), who made more than one copy of another fool by Hals, his *Buffoon Playing a Lute*, now at the Louvre and likewise datable to the twenties (see cat. 14).[4] It has been noted, too, that a drawing dated 1624 by Bailly passed through a 1792 sale at Utrecht described as '... Boontje ... in those days a well-known fool of Haarlem, playing a rommel pot ...' ('... *Boontje ... in dien tijd een bekend gekje te Haarlem, speelende op de rommelpot ...*'), which most probably was a copy after Hals's musician (Bruyn 1951, p.233, note 1). If it was, it establishes 1624 as the *terminus ante quem* for Hals's portrayal of the sympathetic fool.

The very act of listening to a rommel pot is itself a folly best endured by the young, who apparently have a higher tolerance than adults for the ghastly sound produced by the home-made instrument, which consists of a pig's bladder stretched across an earthenware jug half-filled with water. When a long, wet reed is stuck through the middle of the bladder and moved between the thumb and fingers or slipped up and down, the instrument produces sounds not unlike those emitted by a stuck pig.

The most attractive contemporary variant of the Kimbell painting is the small one now at Chicago, which can be attributed safely to Hals's follower and probable pupil Judith Leyster; it is datable to the thirties (fig. 8f; panel, 39.1 × 30.5 cm; S.L3-3). As for those cited in old inventories that have not yet been pinned down, the most tantalising is the reference to '*een rommelpot van Frans Hals*' (S.L3-14) found in the inventory made of the marine painter Jan van de Cappelle's spectacular collection of about 175 paintings and 7,000 drawings that was compiled after his death in 1679. Van de Cappelle had more than a passing interest in Hals. He owned nine of his paintings, the largest recorded seventeenth-century collection of his works. In addition to possessing a *Rommel Pot Player*, van de Cappelle commissioned Hals to paint his own portrait, which has not been identified, and amongst his other untraceable paintings by the artist was a portrait of Hals's wife. Rembrandt, Rubens and Van Dyck were not as well represented; van de Cappelle possessed six, four and six paintings respectively attributed to them. One cannot but wonder if van de Cappelle owned some of Hals's lost drawings. Were they in the portfolio described in his inventory as containing '382 drawings by various masters' or in the one with '76 drawings by various masters'?

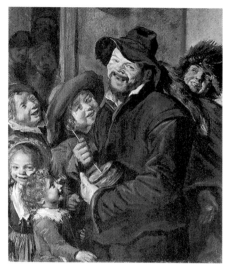

Fig. 8f Judith Leyster, *The Rommel Pot Player*, copy after Hals (S.L3-3) Chicago, The Art Institute of Chicago, Charles H. and Mary F.S.Worcester Collection

1. During the course of the restoration of the painting I profited from discussions with Claire Barry, conservator at the Kimbell Art Museum. Apart from the observations given above regarding the support, her report (museum files) states that the ground of the painting is white. Its paint surface is generally abraded in both the thinly sketched and more heavily painted areas. In the darks, numerous pinpoints of abrasion reveal the white ground; they were repainted during restoration. Some glazes also have been abraded (boy's face, upper left; forehead of the boy in the brown hat; partially in the face of the rommel pot player). Abrasion and age also reveal *pentimenti* throughout.

2. Identical with s.L3-5. In addition to the data given for the version in that entry, it should be noted that it appeared in the sale London (Christie's), 13 March 1936, no.36.

3. A former owner apparently found these heads too coarse and had them painted out; they were revealed when the painting was cleaned at the Metropolitan Museum in 1951. For a discussion of other changes made to the picture and reproductions of it before its 1951 restoration, see S5.

4. For the attribution of the still-life to Bailly and a discussion of its iconography, consult de Jongh in Auckland 1982, no.38. A less convincing ascription of it to the Haarlem artist Hendrick Pot (c.1585-1657) is offered by Wurfbain 1988, p.51.

PROVENANCE Sir Frederick Cook, Doughty House, Richmond, Surrey, by 1903; by descent to Sir Francis Cook, and in his collection until after 1946; dealer Newhouse, New York, who sold it to Kay Kimbell, Fort Worth, Texas.

EXHIBITIONS London 1903, no.173; Fort Worth 1953, no.8.

LITERATURE HdG 137-5 (replica); Bode-Binder 10 (copy); KdK 24 (replica; c.1623); Catalogue (by Maurice W.Brockwell) Cook Collection, Richmond, 1932, vol.2, p.44, no.265; Trivas App. 3 (variant); Slive 1970-4, vol.1, pp.36-9 (one of the best copies of a lost original of c.1618-20); Catalogue Kimbell Art Museum, Fort Worth, 1972, pp.52-4 (after a Hals of c.1615-8); Grimm A6 (copy of a lost original of c.1624-6); Montagni 28a (copy of a lost original painted after 1623); Handbook Kimbell Art Museum, Fort Worth, 1981, p.59.

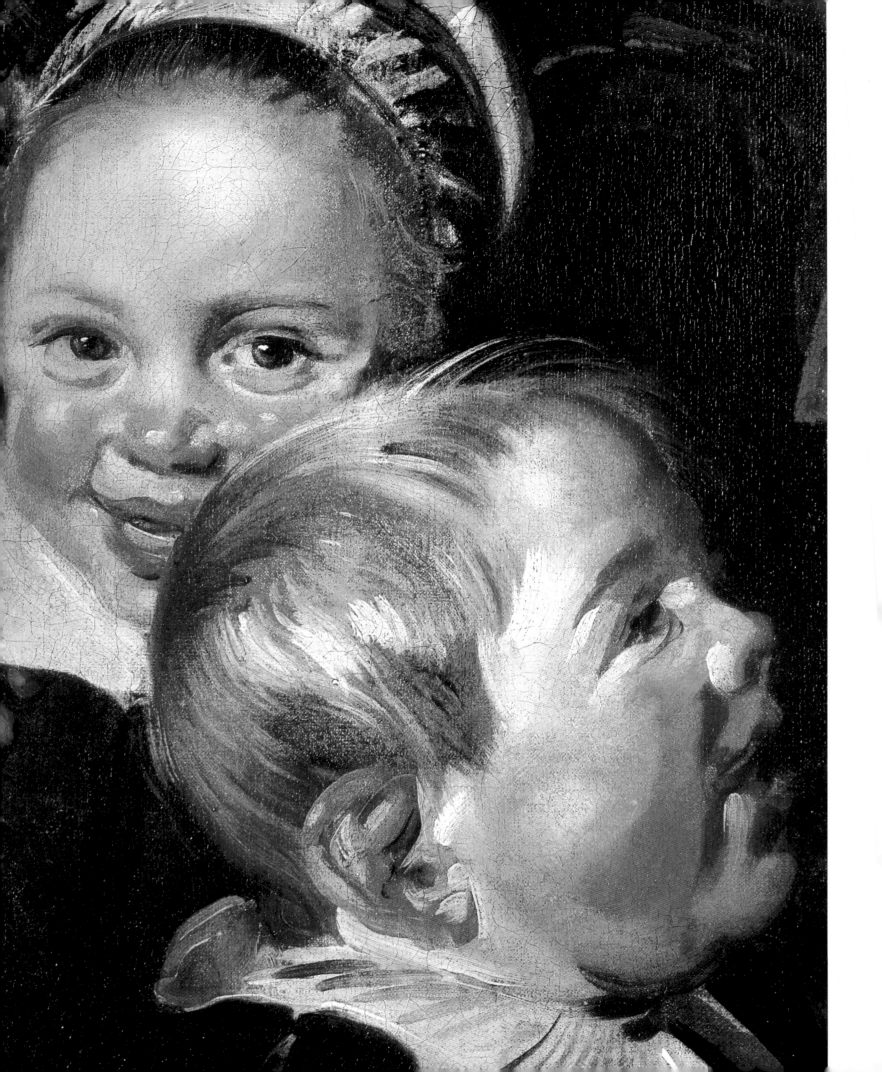

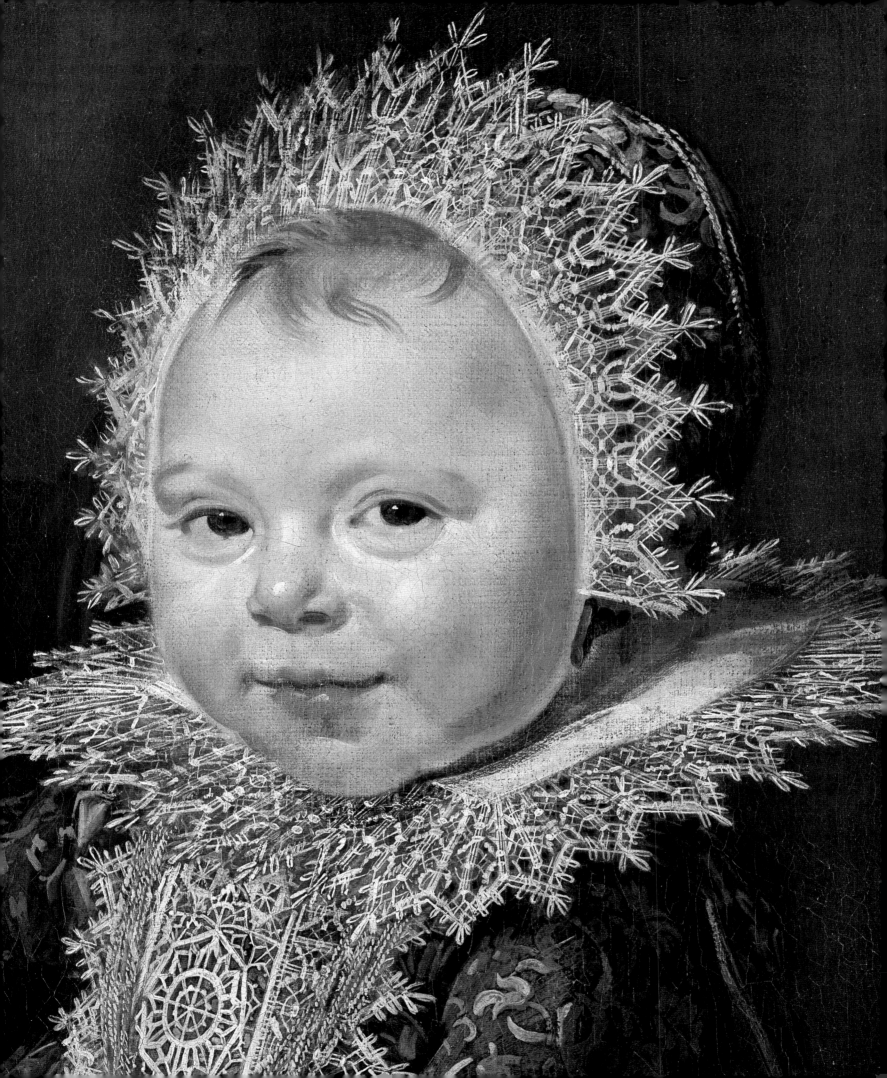

9　Catharina Hooft with her Nurse

c. 1619-20
Canvas, 86 × 65 cm
S14
Staatliche Museen Preussischer Kulturbesitz, West Berlin (inv. 801 G)
Exhibited in Washington

The double portrait is a supreme example of Hals's sympathetic characterisation of women and children as well as his ability to satisfy his patrons's demand during these years for meticulous treatments of sumptuous displays of rich brocade, lace, jewellery and, in this painting, a gold rattle decorated with bells. Here it seems the woman was about to offer an apple to the young child when their attention was diverted by the spectator, to whom they appear to turn spontaneously. The women could have posed in the attitude Hals gave her, but certainly not the child. This obvious point is worth making because of the seemingly uncorrectable popular notion that Hals and many of his contemporaries merely painted what they saw before their eyes. How long could the youngster have posed? Young children are notoriously bad models, and not all artists are willing to paint them. Vermeer, the father of fifteen, never portrayed one. Children wiggle, squirm and squeal – but never in Hals's world. The conviction that we are sharing a passing moment in the life of the woman and child is the result of the conscious intellectual effort Hals made to relate the figures to each other and to the onlooker. Their fleeting expressions of warmth and smiling contentment had to be observed and then fixed.

Despite a nineteenth-century tradition that the double portrait represents a nurse and child, recent students have entertained the possibility that the woman modestly dressed in black, whose position clearly is a subordinate one, may have been the young child's mother who was willing to see her richly dressed child the centre of attention. They also have wondered about the child's sex, since both young boys and girls wore dresses in seventeenth-century Holland.

Thanks to Dudok van Heel's research (1975) these questions have been resolved. He has established that in this instance tradition is correct. The woman is indeed a nurse and furthermore the child is a girl. The latter is Catharina Hooft who was born in Amsterdam on 28 December 1618. At the time the portrait was painted in about 1620, her parents lived in Haarlem. In 1635 she became the young bride of extremely wealthy Cornelis de Graeff, squire of Zuid Polsbroek, who later served repeatedly as burgomaster of Amsterdam and became the city's guiding political force as well as adviser and confidant of Johan de Witt, Holland's leading statesman (for Cornelis de Graeff's connection to Hals's patron Petrus Scriverius, see cat. 20).

When Catharina died in 1691 at Ilpenstein Manor, the double portrait was in her possession. The inventory of her estate made after her death lists in the manor's salon (called the 'Johan de Witts zaal') '1 painting of a babe in arms in the direct family line'. The painting was listed again in the inventory made in 1709 of the estate of her son Pieter de Graeff as 'a nurse with a young child by Frans Hals'. His inventory also lists a gold bell appraised at 57 guilders and 18 stuivers. The bell could very well have been the fine gold rattle Catharina held in her fist when she was portrayed by Hals at the age of about two years. The bell is now untraceable, but the subsequent history of the double portrait is clear. It remained in the possession of the de Graeff family until it was sold in 1870.

The costumes the sitters wear are in accord with their sex and status. Although young Dutch boys and girls did indeed wear dresses, Catharina's high pointed lace cap and her stiff semi-circular lace collar distinguish her as a girl. Boys wore rounder, flatter caps and falling collars. The woman's old-fashioned plain black costume, without a bit of lace and ornamented only by wheel-like padded coils around its armholes, is consonant with her position as a nurse. As for Catharina, the three Japanese kimonos listed in a posthumous inventory compiled of some of her effects indicate that she had a taste for clothes that were le dernier cri in her old age (see cat. 84).

Why was Catharina shown with her nurse, not her mother? Dudok van Heel's research establishes that Catharina's mother was forty-four when the double portrait was painted, and he speculates that at her age she was too old to be portrayed as the mother of an infant. Here I disagree. It is just as reasonable to assume that a woman would be very proud to be portrayed with the child she bore when she was in her forties. Another explanation is that Catharina's parents simply wanted a visual record of their beautiful daughter with the sympathetic woman who tended their young one's needs. What, in fact, prompted the commission remains open, but there can be no doubt that Hals provided his patrons with a paradigm of the unusual subject of a life-size portrait of a young child with her nurse.

PROVENANCE　Listed in the inventory compiled in 1691 at Ilpenstein Manor of the estate of Catharina de Graeff (née Hooft) as '1 schilderij zijnde een kind op de arm 't geslagt Raackende' ('1 painting of a babe in arms in the direct family line'), and then in the 1709 inventory of the effects of her son Pieter de Graeff (1638-1707) in his Amsterdam house on the Heerengracht as 'minne met een kindje van Frans Hals' ('a nurse with a young child by Frans Hals'). At the division of Pieter's estate in 1709, the painting went to his oldest son Jan de Graeff (1673-1714); then by descent, via oldest sons, to Gerrit de Graeff (1797-1870). The provenance above established by Dudok van Heel (1975, pp. 153-6). Sale Ilpenstein Castle (part of the estate of Gerrit de Graeff), Amsterdam 1872, no. 16 (as 'servante et petite fille'; Dfl. 4,500; Roos for Suermondt); acquired with the Barthold Suermondt Collection, Aachen, for the Königliches Museum, Berlin, 1874.

EXHIBITIONS　Brussels 1873a, no. 18 (c.1635); Brussels 1873b, no. 78; Amsterdam 1950, no. 50; Haarlem 1962, no. 8.

LITERATURE　Bode 1883, 87 (c.1630); Moes 92; HdG 429 (1630-5); Bode-Binder 131; KdK 15 (c.1620); Trivas 1 (1615-7); Slive 1970-4, vol. 1, pp. 60-1 (c.1620); Grimm 11 (c.1619); Montagni 17 (c.1620); S.A.C. Dudok van Heel, 'Een minne met een kindje door Frans Hals', Jaarboek Centraal Bureau voor Genealogie XXIX (1975), pp. 146-59 (establishes identity of sitters and early provenance); Catalogue Gemäldegalerie, Berlin, 1978, p. 208, no. 801 G; Baard 1981, pp. 78-80; Catalogue Gemäldegalerie, Berlin, 1986, p. 38, no. 801 G.

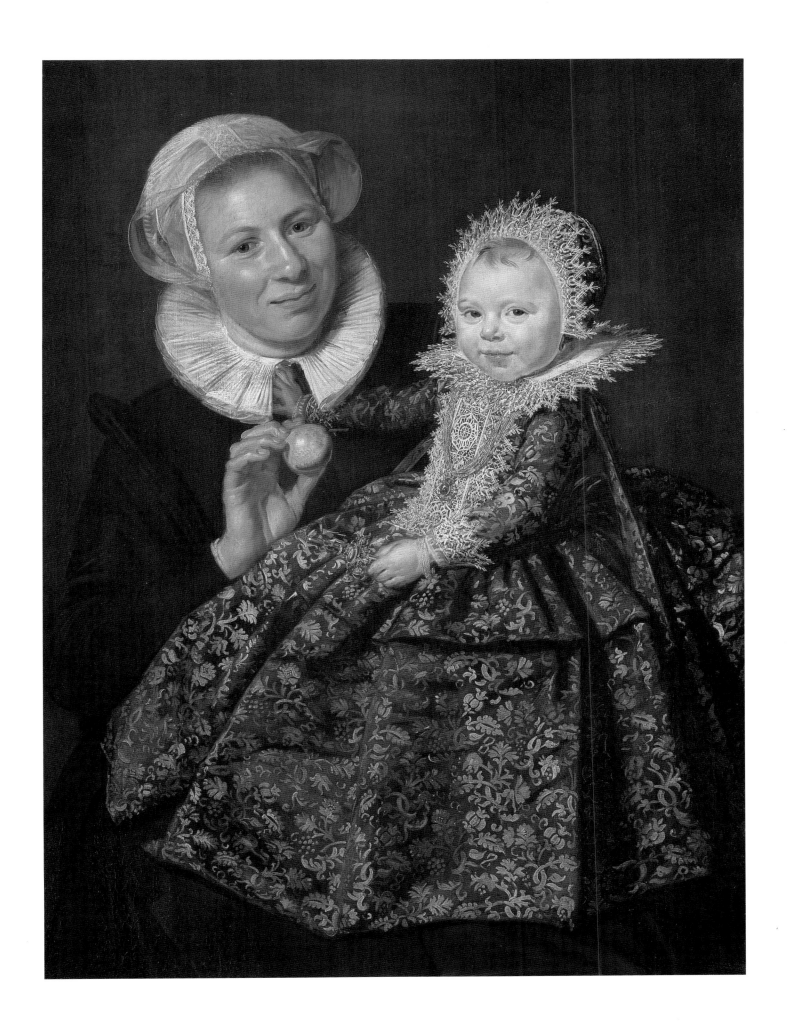

Family Portrait in a Landscape

c.1620
Canvas, 151 × 163.6 cm (original support)
Signed on the rock with the connected monogram: FH and on the left
sole of the shoe of the child seated on the left: S. de Bray/16[2]8
S15
Viscount Boyne, Bridgnorth, Shropshire
Exhibited in London and Haarlem

The popularity of family portraits in Hals's time can be related to the Protestant exaltation of marriage and its natural consequences, as well as to the pride some Dutchmen took in showing their progeny. Abolition of monasticism and clerical celibacy in the new Republic led to an increased emphasis upon the importance of marriage and family life. The family, not the monastery or nunnery, became the ideal place for Bible instruction and character development. It would be rash, however, to make a causal connection between the new stress Protestants placed on the family and the large number of family portraits painted in seventeenth-century Holland until the religious faiths of a fair sample have been established. This is difficult because so many of the families portrayed remain anonymous. The four families depicted by Hals during the course of his career are not an exception. None have been identified.

Datable about 1620, the life-size Boyne *Family Portrait* is the earliest (for the others, see cat. 49, 67 and fig. 67a). The father and mother are seen seated on the ground surrounded by seven children. Although the group is out-of-doors, the space remains shallow. The parents and three children at the right are in one plane, while the three figures behind establish another close to them. Variety of movement, gesture and expression create an unusual diversity of interest, and it appears that when one member of this family glanced or gesticulated toward another he or she seldom received a response. Some members of the family are on almost the same horizon-

tal level while others form a vertical row, an arrangement that does not establish the dominent accents that unify Hals's group portraits from the beginning. Clearly something is amiss here. The smiling baby girl in the lower left corner, whose cheeks have a higher polish than the apples nearby, is partially responsible for this (fig. 10a). She was not part of Hals's original composition but a later addition by another artist who made no attempt to emulate Frans's fluent touch and lively accents. The convincing visual evidence that Hals did not paint the child is confirmed by the signature on the sole of her left shoe: '*S. de Bray/16[2]8*'. Thus, the only family portrait Hals signed also bears the signature of Salomon de Bray (1597-1664), a leading Haarlem artist and architect.

The fact that Hals painted eight figures and the landscape in the large family group and de Bray only one indicates that this was not the kind of planned collaboration that took place once between Hals and Claes van Heussen, and upon occasion with a couple of other artists (see cat. 33). But it is not difficult to surmise what happened. The baby girl painted by de Bray most probably was born after Hals completed the group, and for some reason de Bray, not Hals, was commissioned to add the baby's portrait, a type of addition not unusual in Dutch family portraiture.

A reconstruction of the *Family Portrait* with de Bray's child removed is seen in fig. 10b. It was made by transplanting the thistle from the lower left corner of Hals's *Married Couple* (cat. 12), which is datable a few years later. In both paintings

Fig. 10a Salomon de Bray, detail from *Family Portrait in a Landscape*

Fig. 10b Reconstruction of Hals's *Family Portrait in a Landscape* before de Bray's addition

Hals used a plant to fill the triangular area formed by a lounging figure and the edges of the painting. The gardening done in the reconstruction produces an unlikely hybrid. The plant in the corner of the Boyne painting is not a thistle, but ivy, a plant frequently used in family portraits to allude to marital fidelity (Bedaux 1987). Nevertheless, some idea of Hals's original composition can be gathered from the reconstruction.

Substitution of the plant for the child does not markedly improve the design. To be sure, removal of the young child creates the kind of diagonal accent Hals used during the first decades of his activity to help unify group portraits, but here it ends too abruptly. In his *Married Couple* (cat. 12) a similar compositional device has been balanced well by an open view into a garden and distant landscape. The Boyne group reveals other anomalies. The almost square format for a large group portrait is exceptional at this time; oblong ones are the rule. And if we recall Hals's success at subordinating lively figures and groups to the overall design of his large banquet piece of 1616 (Levy-van Halm & Abraham, fig. 12) and consider that his ability to control even more animated ones in his civic guard pieces of 1627, the Boyne group is curiously uncoordinated. Only the two small children who smile at each other on the right form a small unified group. The girl who stands behind the mother looks at her serious sister. The father looks directly at us. His wife looks at him. Three children glance toward the right. What are they looking at? The mother is

Fig. 10c Reconstruction of *Family Portrait in a Landscape* before de Bray's addition and *Three Children with a Goat Cart* (cat. 11)

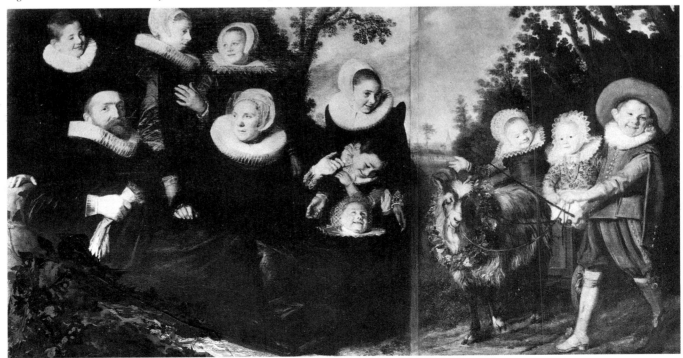

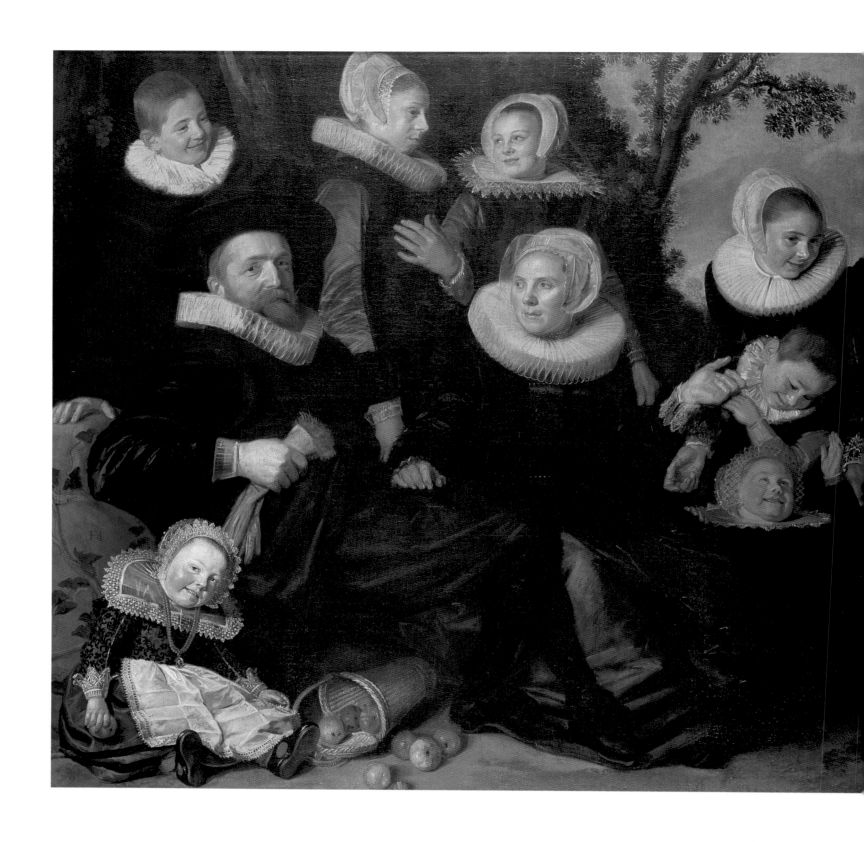

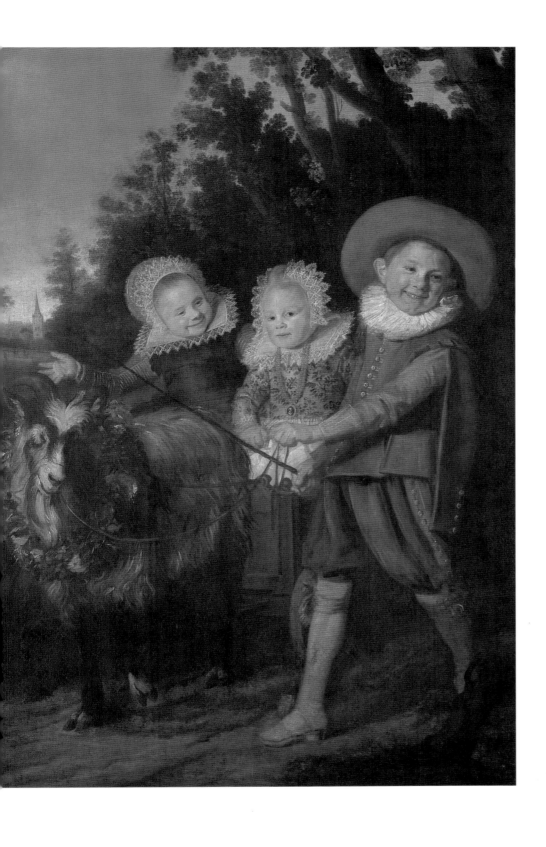

calling attention to something on the right. What is she pointing to? It has been proposed (Slive 1969) that originally she pointed to *Three Children with a Goat Cart*, now in Brussels (cat. 11), and that it is a fragment of the Boyne *Family Portrait*. A reconstruction of the joined pictures that shows its state before the addition of the de Bray child, and which includes an imaginary strip about 5 cm wide is reproduced in fig. 10c.

A considerable amount of evidence supports the proposal that the Brussels and Boyne pictures originally were joined. Although the former is less well preserved than the latter, it is evident that their handling and spirit are identical. Additionally, their heights are virtually the same. The costumes of both are datable to the early twenties. When joined, their foregrounds and backgrounds align, the diagonal accent in the Boyne group is no longer over-emphatic, and the lively gestures and glances make better sense. The pronounced horizontal format is also the normal one for the time, as can be seen in Jacob Gerritsz Cuyp's *Family Group with a Goat Cart* of 1631 at Lille (fig. 10d). And finally, both pictures were in the same Leiden sale in 1829 as consecutive lots. Their appearance establishes that the large family group was cut by this date, but why it was mutilated remains a mystery.

Exhibition of the two paintings next to each other in Brussels in 1971 indicated that the reconstruction is plausible and that both pictures may have been cut a bit at the top. At that time Broos (1971) noted a nice detail which gives further support to the reconstruction: de Bray's child wears a double band of corals with a pendant; the very same necklace is worn by the very young girl in the goat cart (corals were worn by Dutch infants and toddlers as talismans). He reasonably concluded that the necklace was a family piece which always was worn by the youngest child. Before the appearance of the baby girl de Bray painted, the child in the goat cart was the family's youngest.

Far-fetched is the suggestion that the bridled goat whose reins are held by the young boy alludes to good up-bringing. Goats frequently have been associated with lust and desire; therefore, it is argued, the reined goat indicates that the boy has learned to keep his passions under control (Middelkoop & van Grevenstein 1988, p. 23). Of course bridled goats can refer to bridled lust. But even if we take into account the Christian teaching that coitus is sinful when not practised for

Fig. 10e Attributed to Frans Hals, *Portrait of a Boy* (fragment)
Ex-Kimbell Art Museum, Fort Worth, Texas

procreation, or that it should be practised in moderation, and even if we discount the idea that a family portrait is a record and celebration of the parents' fertility, a reference to controlled sexual desire is hardly an appropriate public allusion to the care and training of young children.

Valentiner (KdK 21) correctly observed that the half-length portrait of a boy seen against a background of tree trunks, foliage and a bit of sky is probably the fragment of a larger picture (fig. 10e).[1] Its flattened paint layer and extensive inpainting of losses and heavily abraded areas make it difficult to judge its authenticity, but enough can be seen of its design and the fragment of a girl's collar at the left edge, uncovered during a cleaning at the Kimbell Art Museum in 1973, to suggest that it is datable about the time of the Boyne-Brussels portraits and was part of a group in a landscape. Grimm's attempt to make a reconstruction of the Boyne-Brussels painting that includes the Kimbell fragment and also broadens the composition by one-third to incorporate four invented life-size figures is unconvincing (Grimm 1972, p. 19; fig. 18).

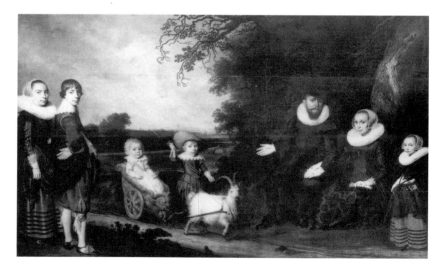

Fig. 10d Jacob Gerritsz Cuyp, *Family Portrait with a Goat Cart*, 1631
Lille, Musée des Beaux-Arts (inv. P. 211)

1. Sale Kimbell Art Foundation, New York (Sotheby's), 4 June 1987, no. 50 (as follower of Frans Hals; $11,000). Listed in Grimm 14; Slive 1970-4, vol. 3, under 15; and Montagni 22.

PROVENANCE Sale J. A. Bennet, Leiden, 10 April 1829, no. 57 (Dfl. 45, bought in).

EXHIBITIONS London 1929, no. 369 (1635-40); Brussels 1971, no. 43A; on extended loan to the National Museum of Wales, Cardiff.

LITERATURE HdG 444; C. Hofstede de Groot, 'Twee teruggevonden schilderijen door Frans Hals', *O.H.* XXXIX (1921), p. 65ff. (c. 1635-40); KdK 159-61 (c. 1630-40); K. Bauch, review of London 1929 exhibition in *Zeitschrift für bildende Kunst* LXIII (1929-30), p. 12 (datable to the artist's early phase, c. the time of his *Married Couple* [cat. 12]); Seymour Slive, 'A Proposed Reconstruction of a Family Portrait by Frans Hals', *Miscellanea I.Q. van Regteren Altena*, Amsterdam 1969, pp. 114ff.; Slive 1970-4, vol. 1, pp. 61-6; Broos 1971; Grimm 12; Ekkart 1973, p. 253; Montagni 20; Middelkoop & van Grevenstein 1988, pp. 7, 23.

11 Three Children with a Goat Cart

c.1620
Canvas, 152 × 107.5 cm (original support)
s16
Musées Royaux des Beaux-Arts de Belgique, Brussels (inv. 4732)
Exhibited in London and Haarlem

Originally part of the *Family Portrait in a Landscape*, (Cat. 10).

PROVENANCE Sale J.A.Bennet, Leiden, 10 April 1829, no.58 (Dfl.25); sale Charles John Palmer, Great Yarmouth, 27 February 1867, no.93 (£31:10s). Moore (1988, p.69) notes that Druery (1826, p.80) lists a number of Dutch and Flemish paintings in the Palmer residence at Yarmouth, 'some of the best ... were bought of Mr. Isaacs, who has imported from Holland and Flanders, some of the finest specimens of *Hobbima, Ruysdael, &c.*, in the kingdom.' The residence was owned since 1809 by John Danby Palmer (1769-1841) who served twice as Mayor of Yarmouth (Moore 1988, p.69). When and how the Hals fragment entered the Palmer Collection is unknown. Collection Hughes (probably J.Newington Hughes in Winchester); dealer E.Warneck, Paris; dealer Arthur Stevens, Brussels; Mrs. Ernest Brugmann de Waha, Brussels, who gave it to the museum in 1928 in memory of her husband.

EXHIBITIONS Delft 1953, no.18; Amsterdam 1955-6, no.6; Brussels 1961, no.50; Brussels 1962-3, no.35; Brussels 1967-8, no.5; Brussels 1971, no.43B.

LITERATURE Bode 1883, 36; Moes 91; HdG 430 (c.1625-30); Bode-Binder 111; C. H[ofstede]. d[e]. G[root]., 'Een nog nooit afgebeeld meesterwerk van Frans Hals', *O.H.* XXXVII (1919), p.128; KdK 22 (c.1620-2); Leo van Puyvelde, 'Les enfants à la chèvre par Frans Hals', *Bulletin des Musées Royaux des Beaux-Arts de Belgique* II (1929), pp.62-5 (c.1630), van Puyvelde also published the painting in '"Children with a Goat" by Frans Hals', *B.M.* LIV (1929), pp.80-5, repr. p.83; W.R.Valentiner, 'Rediscovered Paintings by Frans Hals', *Art in America* XVI (1928), pp.236-7; Catalogue Musées Royaux des Beaux-Arts, Brussels, 1949, p.56, no.985; Seymour Slive, 'A Proposed Reconstruction of a Family Portrait by Frans Hals', *Miscellanea I.Q. van Regteren Altena*, Amsterdam 1969, pp.114ff.; Slive 1970-4, vol.1, pp.63-6; Broos 1971; Grimm 13; Ekkart 1973, p.253; Montagni 21; Catalogue Musées Royaux des Beaux-Arts, Brussels, 1977, no.95; Inventariscatalogus van de oude schilderkunst, Koninklijke Musea voor Schone Kunsten van België, 1984, p.133, inv.4732; Middelkoop & van Grevenstein 1988, pp.7,23; Moore 1988, pp.68-9, fig.49.

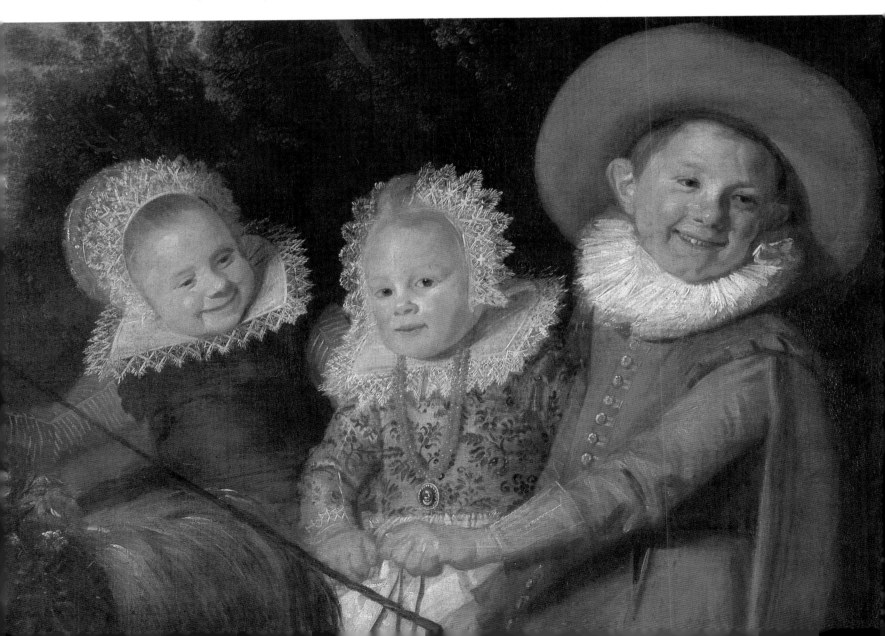

12 Married Couple in a Garden
(Isaac Massa and Beatrix van der Laen?)

c.1622
Canvas, 140 × 166.5 cm
S17
Amsterdam, Rijksmuseum (inv. A133)
Exhibited in Haarlem

This life-size portrait of a married couple, Hals's only double portrait of a husband and wife, is brimful of what seems to be unalterable mutual affection. Yet everything about the pair appears transitory. Their attitudes and expressions are momentary. The husband looks as if he were about to speak, while his wife's smile is at the point where it must either broaden or relax, and her hand resting on his shoulder must shift as soon as he changes his precarious position. Light plays over their faces and glistens here and there on their costumes. Even the winding ivy seems to rustle as it throws shadows on the sturdy trunk to which it clings. The rest of the landscape follows the conventional three-colour scheme: warm browns in the foreground, cooler greens in the middle ground and shades of blue in the background. The imaginary garden in the middle distance recalls the setting for lovers seen in the lost *Banquet in a Park* (S.L1), one of the earliest pictures attributable to Hals; a similar vista of a garden appears a few years after the couple was painted in the great life-size full length of *Willem van Heythuysen* (cat. 17).

The arrangement of the couple is as original as it is bold. Instead of placing the pair in the centre, Hals shifted them to the side. To be sure, the man has been given his traditional place on the dexter side and his pose also is traditional – one arm akimbo, the other resting on his heart – but these conventions have been transformed by the pronounced inclination of his seated figure. Though he is larger than his wife, and his size is increased by the enormous brim of his hat, and he is set slightly forward, he does not dominate the scene. Husband and wife have equal importance here. She occupies the centre, and her intensely lit face and hands as well as her huge heavily starched millstone ruff and the violet and plum-coloured accents of her costume focus attention on her. Particularly lovely is her white cap partly embroidered in black silk, laced with a sweet pink ribbon and edged with bobbin lace. It is an undercap (*ondermuts*), usually covered by a more elaborate outercap held in place by a 'head iron' (*hooftijsertgen*); undercaps are seldom seen in portraits of the period (for other aspects of her and her husband's apparel, see du Mortier, pp. 46, 53-4). Equally vigourous and fluid brushstrokes model the costumes, and the subtle correspondences in the couple's attitudes help establish a concordance between the beautifully matched pair. In the lower left corner, close to the man's right side, a very rare glimpse of Hals's brush underdrawing is visible. Most often traces of such preliminary sketches are hidden by overlying paint layers.

Various attempts to identify the famous couple show the difficulty of establishing the identity of Hals's sitters when the principle evidence for identification is visual. During the nineteenth century the couple was published repeatedly as a self-portrait of Hals with his second wife Lysbeth Reyniersdr. Valentiner continued to champion this identification (KdK 20; *Art in America* XIII [1925], pp. 148ff.; ibid. XXIII [1935], pp. 90-5), but he found few supporters. Students rightly followed Hofstede de Groot (427), who stated in 1910 that the traditional identification was incorrect. Binder (Bode-Binder, p. 19) called it a portrait of Dirck Hals and his wife Agneta

Jansdr. Since Dirck and his wife baptised their first child on 17 October 1621 (the date of their marriage is unknown) and the portrait is datable to around 1622, Binder's suggestion is not an impossible one. But until an undisputed portrait of Dirck is discovered, his hypothesis will remain untested.

The husband also has been called a portrait of Isaac Massa whose physiognomy is subject to closer scrutiny than Dirck's. There is a consensus that Massa was painted twice by Hals, once in 1626 (cat. 21) and again in about 1635 (cat. 48). He was tentatively suggested as the husband first in the Rijksmuseum catalogue of 1934 and then again in the 1960 catalogue. A year later, on the basis of the evidence offered by Hals's two other portraits of Massa, de Jongh and Vinken proposed, in their seminal article on the double portrait, that the man in the painting is indeed Massa and, more specifically, they argued that the painting is a marriage portrait of him and his first wife Beatrix van der Laen. They strengthened their case with documentary evidence: Massa's first marriage took place in Haarlem on 25 April 1622, a date that could hardly be more compatible with one assigned to the work on the basis of its style. Yet, as the references in the Literature cited below indicate, since de Jongh and Vinken published this identification in 1961, it has not been accepted unanimously. And the proposal that the remarkable *Portrait of a Man* at Chatsworth (cat. 13) is yet another portrayal of Massa has found even fewer adherents. Inclusion in the exhibition of Hals's one documented and another generally accepted portrait of Massa (cat. 48, 21) and both other candidates offers the rare opportunity of making a first-hand study of all four of them. A fresh examination may alter some earlier conclusions.

The identification of the couple may be debatable, but there can be no doubt that the painting is a marriage portrait. Hals's contemporaries would have noticed that one of the two rings which the lovely woman proudly displays on her forefinger is her wedding band, a new fashion that became popular despite criticism by Dutchmen bound to the more traditional convention. De Jongh and Vinken (1961; also see de Jongh in Haarlem 1986, no. 20) have shown that many of Hals's contemporaries would have noticed much more. Their analysis of the marriage portrait, one of the pioneer studies that alerted people of our time to symbolic allusions in seventeenth-century Dutch painting that we might miss (it was published in the same year as van Thiel published his findings that offered the key to the meaning of Hals's portrait of *Pieter van der Morsch* [cat. 4]), showed that Hals continued to employ well-established iconographic traditions in the Amsterdam painting that allude to love and marital fidelity.

The couple has been appropriately portrayed in a garden, one of Venus's traditional abodes. Lovers have been represented seated in gardens since the fifteenth century, and numerous later emblems made to illustrate marital fidelity and happiness popularised the scheme (fig. 67c). Rubens followed the tradition when he painted his *Self-Portrait with Isabella Brandt in a Honeysuckle Bower* about 1609-10 (fig. 12a). If Hals saw Rubens's double portrait when he visited Antwerp in 1616, and recalled aspects of its iconographical programme

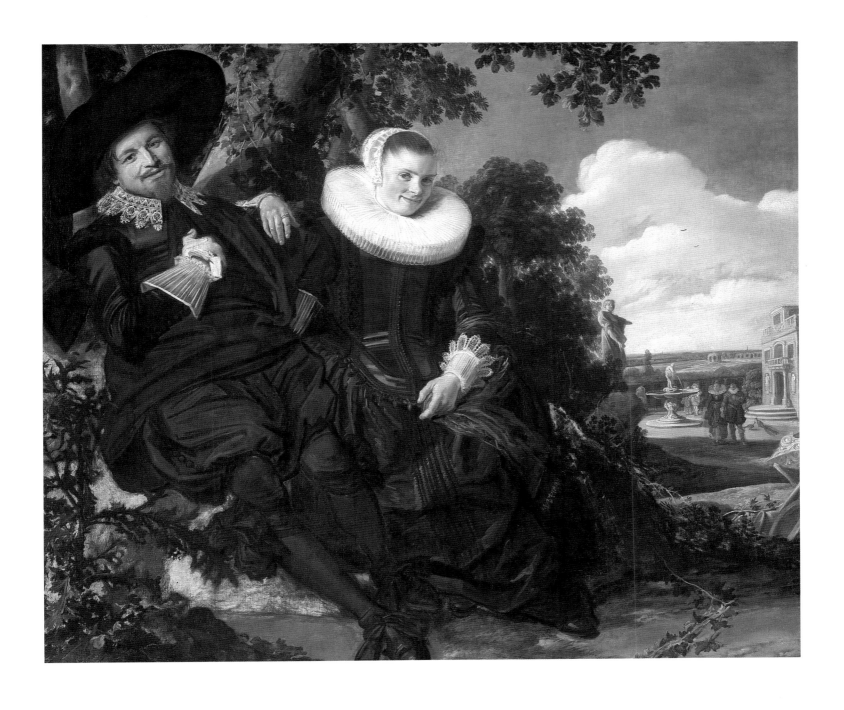

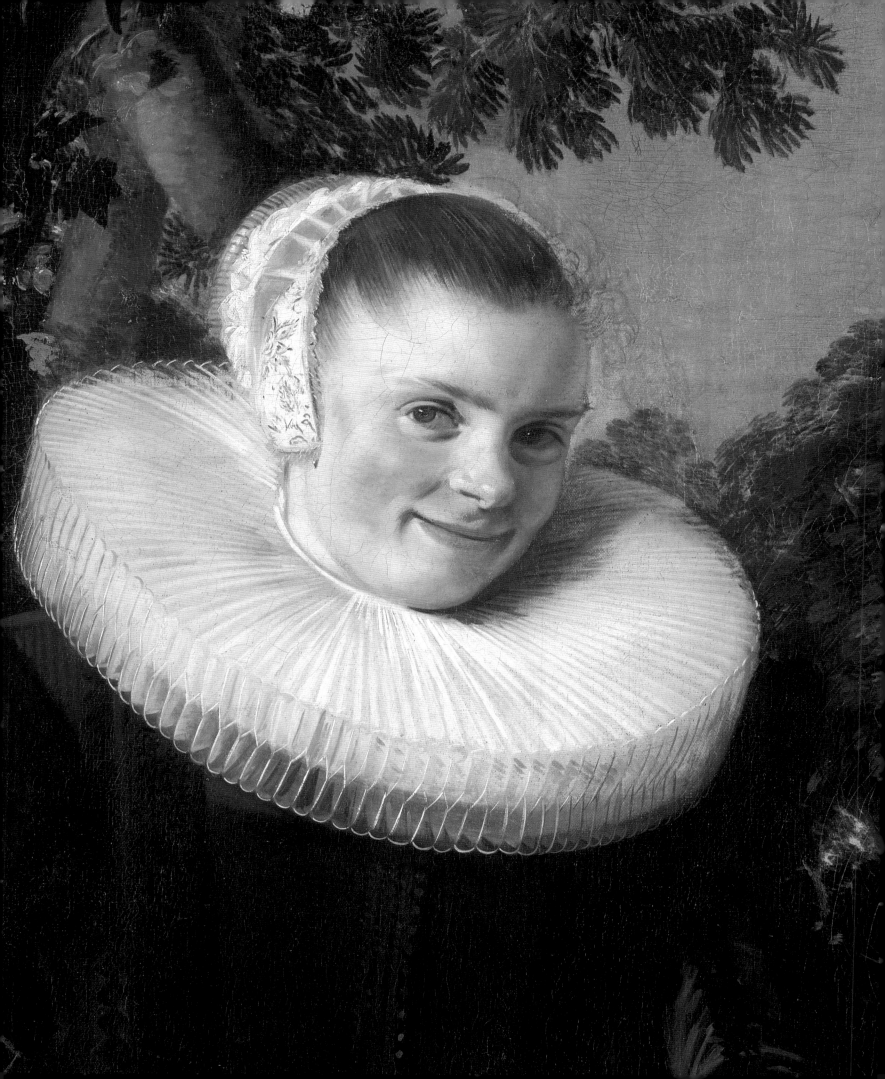

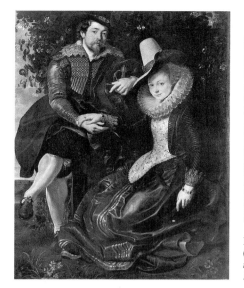

Fig. 12a Peter Paul Rubens, *Self-Portrait with Isabella Brandt in a Honeysuckle Bower* Munich, Bayerische Staatsgemäldesammlungen (inv. 334)

Fig. 12b *Amicitia etiam post mortem durans* (with the additional manuscript motto *Amicita vera*) in Andrea Alciati, *Viri clarissimi ... Emblematum Liber*, Augsburg 1531

when he painted the *Married Couple*, he must have firmly resolved that no one would ever accuse him of plagiarising the pictorial organisation of the Flemish master's first marriage portrait.

Numerous literary and emblematic references cited by de Jongh and Vinken support a symbolic interpretation of other motifs in the painting. Ivy, a familiar symbol of steadfast love, faithfulness and fertility, plays a more conspicuous role here than it does in the Boyne *Family Portrait* (cat. 10). It lies on the ground at the feet of the woman and winds behind her. The sparkling vine clinging to the tree behind the couple is a reference to marital love and dependence. Vines even cling to a dead tree, hence the mottoes which accompany pictures of them wound around one in emblematic literature (fig. 12b): 'True friendship or love continues after death'; 'Lasting friendship or love'; 'His decline cannot tear him away from me'; 'This is a friend after death'; 'As in life so in death'. The prominent thistle in the lower left corner is not an allusion to the husband's prickly character as Schmidt-Degener, sometime director of the Rijksmuseum, wrote before the extensive use of symbolism in seventeenth-century Dutch painting was signalled (de Jongh in Haarlem 1986, p. 9), but it is another reference to fidelity (a thistle is called *Männertrau* in German). The frequency with which Juno and her attributes appear on Dutch marriage medals indicates that it is not far-fetched to suggest that the peacocks in the imaginary love garden are allusions to the goddess and protectress of marriage, while the urns and architectural fragments on the extreme right would not be out of place as references to transience and vanity in a marriage portrait of the period.

Smith (1986) offers a different iconographical interpretation of the double portrait, which accepts the Massa-van der Laen identification without reservation. He rejects the notion that the painting has, in effect, a straightforward unified programme celebrating love and marriage. He argues instead that the dress and mien of its figures and symbolic allusions in the portrait make a moral distinction between the virtues of married life on the one hand and sensual love, lust and pride, principally exemplified by the couples in the garden behind them, on the other hand. He also finds that the painting offers Massa's own sharp critique of aristocratic and courtly notions of romance. His study contributes important material – not least, ivy clinging to a tree can allude to strangulation as well as steadfastness in the period's emblematic literature. However, even if we agree for the sake of the argument that the

sitter is Massa, the middle-class morality Smith assigns to Massa that led him to endorse or design the dual meaning he reads into the painting is unprovable. Although more is known about Massa's activities than those of most of Hals's sitters (see cat. 21, 48), not a shred of evidence offers a hint about his own personal attitude toward the way love and romance was practised by either the middle class or aristocrats of Dutch society.

Restoration of the painting at the Rijksmuseum in 1984 revealed scattered little paint losses, mostly in the lower half of the picture. The light greyish tones of the mound upon which the man is seated appear to be the painting's ground, a supposition supported by small remains of brown pigment in the area, particularly surrounding the large thistle. Thus, the mound originally probably was painted brown, and its colour disappeared in an earlier cleaning. If this is the case, the large thistle formerly was less conspicuous (kind communication from C. J. de Bruyn Kops, former curator at the Rijksmuseum).

PROVENANCE Sale Jan Six, Amsterdam, 6 April 1702 (bought in); sale H. Six van Hillegom, Amsterdam, 25 November 1851, no. 15 (Dfl. 530); acquired by the Rijksmuseum in 1852.

EXHIBITIONS London 1929, no. 64; Haarlem 1937, no. 10; Amsterdam 1945, no. 31; Brussels 1946, no. 38; New York, Toledo & Toronto 1954-5, no. 28; Haarlem 1962, no. 10; Haarlem 1986, no. 20.

LITERATURE Unger-Vosmaer 1873, no. XII (c. 1617; Frans Hals and his second wife); Bode 1883, 15 (c. 1624; Frans Hals with his second wife); Moes 90 (portrait of a couple); HdG 427 (a married couple; not Frans Hals and his wife); Bode-Binder 96 and p. 19 (very probably Dirck Hals and his wife); KdK 20 (perhaps Frans Hals and his wife); Catalogue Rijksmuseum, Amsterdam, 1934, p. 118 (a married couple; perhaps Isaac Massa [the earliest published reference to the Massa identification]); Trivas 13 (an unidentified married couple; without doubt the man represented in the Chatsworth portrait [see cat. 13]); H. van de Waal, 'Frans Hals, Het echtpaar', *Openbaar Kunstbezit* v (1961), 25 (identity of couple uncertain); de Jongh & Vinken 1961, pp. 117-52; Gudlaugsson 1963, p. 9 (not Massa and van der Laen); Slive 1970-4, vol. 1, pp. 66-8 (c. 1622; identification as Massa and van der Laen arguable); Grimm 34 (c. 1627; as *Double Portrait of a Married Couple*); Hinz 1974, p. 202 (an unidentified married couple); van Thiel *et al.* 1976, p. 256, no. A133 (*Marriage Portrait of Massa and van der Laen*, married in Haarlem 25 April 1622); Montagni 34 (c. 1625; as *Portrait of a Couple*); Baard 1981, pp. 86-8 (c. 1622; Massa and van der Laen?); Smith 1986, pp. 2-34 (c. 1622; Massa and van der Laen).

13 Portrait of a Man

1622
Canvas mounted on panel, 107 × 85 cm
Inscribed in the corners, upper left: AETAT SVAE 36, and upper right:
ANº 1622
s18
The Duke of Devonshire and the Chatsworth House Trust (inv. 266)
Exhibited in Washington and London

Du Mortier (pp. 52-3) offers a full commentary on the costume of this patron whose head is almost buried in his casually pleated ruff (known as a *fraise à la confusion*). The pose Hals gave the standing man seen behind a painted frame also is noteworthy. In no other portrait does Hals present his sitter with crossed arms, a posture emphasised by the light playing across his sleeves, fashionably embroidered with gold thread (about a decade earlier slashes cut into the fabric of sleeves were still in vogue). To my knowledge the pose is Hals's invention, and no other Dutch portraitist of the period adopted it. The pose began to find favour only during the following century and then was used with increasing frequency, so by the time Manet painted his portrait of Clémenceau about 1879-80 now at the Kimbell Art Museum (fig. 13a; another version is in the Musée d'Orsay), the pose was a commonplace one for artists' and photographers' sitters (in fact, Manet most probably used an identifiable photograph of Clémenceau with crossed arms for his portraits of him; see Hanson 1983, pp. 27-8, fig. 15).

The gesture of crossed arms can have a variety of meanings and, like most gestures, its significance is related to facial expression and posture as well as to the situation of the subject. Festive genre pictures by Buytewech and Dirck Hals occasionally show little fashion-plate dandies with crossed arms, but their moods have nothing in common with the Chatsworth sitter's, and Hals's *Fisher Boy* at Antwerp (cat. 34) has even less. Crossed arms can signify defiance, insolent arrogance, impatience, sloth or incredulity – the list can be

extended. To some of Hals's contemporaries, who were accustomed to regarding arm and even foot placement as part of fully articulated speech, folded arms must have been seen as inexpressiveness. No contemporary Dutch comment on the gesture has been discovered, but other Europeans provide hints to its earlier meanings. To the Italian theorist Giovanni Paolo Lomazzo 'crossing arms' was a base action. Shakespeare mentions 'wreathed arms' in connection with discontent and melancholy: Titus implores Marcus, in *Titus Andronicus* (III, 2), to 'unknit that sorrow-wreathen knot, Thy niece and I, poor creatures, want our hands, And cannot passionate our tenfold grief With folded arms'. In *The Two Gentleman of Verona* (II, 1) Speed tells Valentine that he knows Valentine is in love because he has learned to wreathe his arms like a malcontent.

The inscription and date of 1622 were revealed by cleaning, confirming the date Bode (137) assigned to it on the basis of style in 1883. He suggested it is a self-portrait, an identification repeated in *Icon. Bat.* (no. 3139-4), Davies (1902, pp. 94f.) and Valentiner (*Art in America* XIII [1925], pp. 148f.; ibid. XXIII [1935], pp. 90-5). Valentiner also proposed that the figure who plays the role of Hanswurst in Hals's early *Shrovetide* picture (pl. II; 55; he is the man making an obscene gesture on the right side of the painting) can be identified as a self-portrait on the basis of its similarity to the Chatsworth sitter (ibid.). But Moes, as early as 1909 (p. 27), rightly dismissed the idea that the Chatsworth painting is a self-portrait.

Attempts have been made to identify the man with Hals's other sitters. Trivas (13) wrote that he is without doubt the husband in Amsterdam's *Married Couple* (cat. 12). De Jongh and Vinken (1961, p. 147) reject his categorical assertion. Since then various attempts have been made to identify him as Isaac Massa on the basis of his similarity to Hals's 1626 portrait of Massa (cat. 21). Although the inscription on the Chatsworth portrait offers support for the claim (Massa was 36 in 1622), the proposal has not satisfied all students (see Literature below), and I find no reason to accept it. The presence of Hals's documented portrait of Massa in the exhibition (cat. 48), as well as the others that have been identified as him (cat. 12, 21), provides an opportunity to study the question afresh.

The irregularity of the areas that extend beyond the painted oval frame Hals provided for the portrait suggests the painting has been cut on four sides. For additional word on the artist's use of simulated frames, see cat. 20.

Fig. 13a Edouard Manet, *Georges Clémenceau*, 1879-80
Fort Worth, Texas, Kimbell Art Museum,
(inv. AP 81.1)

PROVENANCE There are two portraits by Hals at Chatsworth, this one and a *Portrait of a Woman* (cat. 3). According to Dodsley's *London and its Environs*, 1761 (vol. 2, pp. 120, 230), a Hals was in the collection of the 3rd Earl of Burlington, at Chiswick Villa, in 1761, while another was in the possession of the Duke of Devonshire, at Devonshire House, Piccadilly, in the same year; there is no indication which portrait is referred to in each case.

EXHIBITIONS London 1904, no. 280; London 1929, no. 48; Nottingham 1945, repr. p. ii; London 1948, no. 17; London 1952-3, no. 52; Sheffield 1955, no. 12; Leeds 1955, no. 52; Manchester 1957, no. 107; Haarlem 1962, no. 9; San Francisco, Toledo & Boston 1966-7, no. 16; London 1976, no. 48; Washington 1985-6, no. 247.

LITERATURE Waagen 1854, vol. 2, pp. 94-5; Bode 1883, 137 (c.1622; self-portrait); *Icon. Bat.* no. 3139-4 (self-portrait); S.A. Strong, *The Masterpieces in the Duke of Devonshire's Collection of Pictures*, London 1901, no. 26; Moes 156, identical with Moes 157; HdG 287 (c.1630-5); Bode-Binder 152; KdK 41 (c.1625); Trivas 9; de Jongh & Vinken 1961, p. 147 (not Massa); Gudlaugsson 1963, pp. 8-9 (Massa); Slive 1970-4, vol. I, p. 52 (not Massa); Grimm 16 (Massa); Ekkart 1973, p. 253 (reservations regarding Massa identification); Montagni 23 (probably Massa); Smith 1986, pp. 26-7 (Massa).

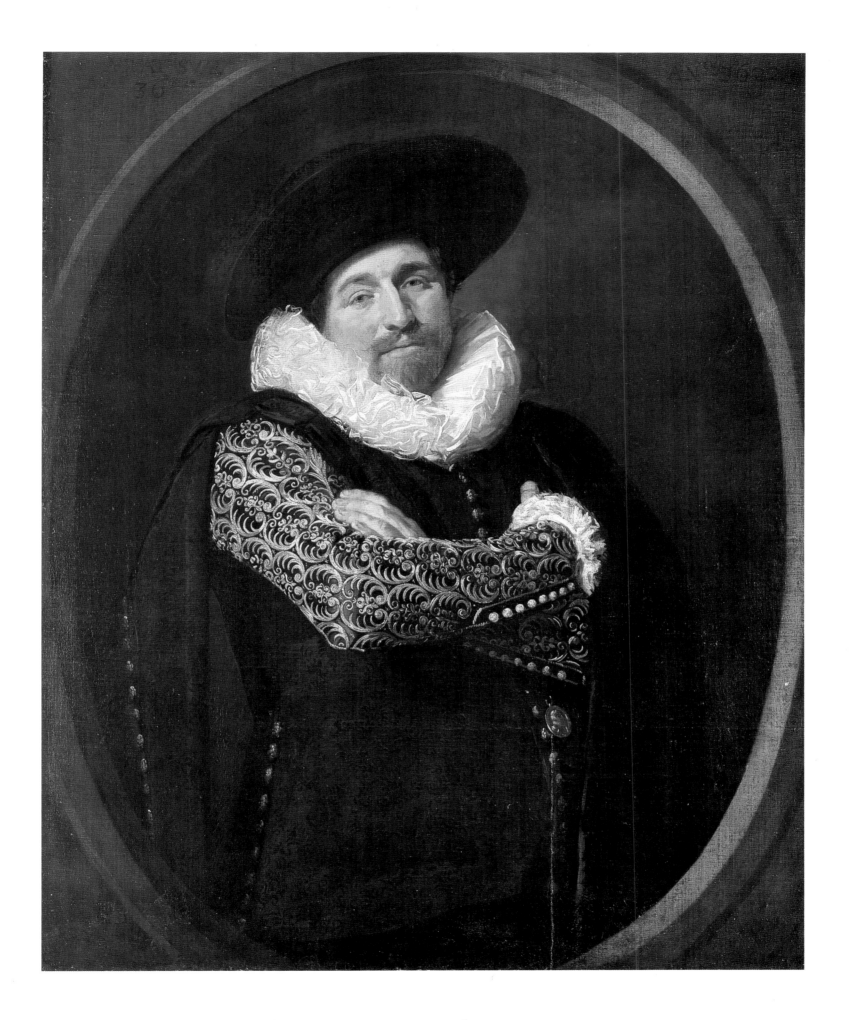

14 Buffoon playing a Lute

c.1623
Canvas, 70 × 62 cm
Signed, upper right, with the connected monogram: FHF (the final F
is not linked to the H)
S19
Musée du Louvre, Paris (inv. R.F. 1984-32)
Exhibited in London

After painting multifigure genre pieces in the 1610s, Hals began to concentrate upon life-size half-lengths that depict only a single person seen close-up. This splendid painting is one of the earliest of the new type.

The smiling lute player wears a buffoon's costume, perhaps the kind worn by theatrical performers or members of Dutch rhetorician societies (Hals was a member of a chamber of rhetoric in Haarlem from 1616 to 1624; Hals doc. 16). During the eighteenth and nineteenth centuries there were misguided attempts to identify the buffoon as Adriaen Brouwer (see Bruyn 1951, p. 222, note 1), and Moes (1909, pp. 37-8) erroneously called him the Leiden rhetorician Pieter van der Morsch; for the latter's unquestioned portrait, see cat. 4.

The handsome man remains unidentifiable, but Hals's source for the half-length is clear. The vogue for genre pieces like it was popularised by Caravaggio's Dutch followers, particularly Hendrick ter Brugghen, Honthorst and Baburen,

who had been to Rome, where they assimilated aspects of the Italian master's uncompromising realism and the expressive power of his chiaroscuro effects. By the early 1620s they had settled in Utrecht, where they produced works that incorporated their own personal interpretation of Caravaggio's motifs and pictorial innovations (fig. 14a). They were principally responsible for introducing aspects of Caravaggio's spectacular achievement to the Netherlands. But closer knowledge of his accomplishment could have been obtained via another route. Dutch artists who had never visited Italy had an opportunity to get a first-hand look at one of Caravaggio's paintings in Amsterdam even earlier. In 1617 a posthumous inventory made there of the effects of Louis Finson (also Finsonius), a Flemish Caravaggesque painter who moved to Amsterdam after working in Italy and France, lists three paintings by Caravaggio which the deceased owned jointly with another artist; one of them can be securely identified as Caravaggio's

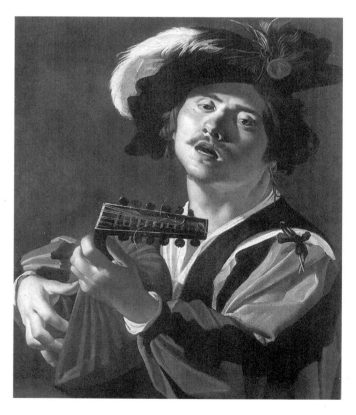

Fig. 14a Dirck van Baburen, *Lute Player*, 1622
Utrecht, Centraal Museum (inv. 11481)

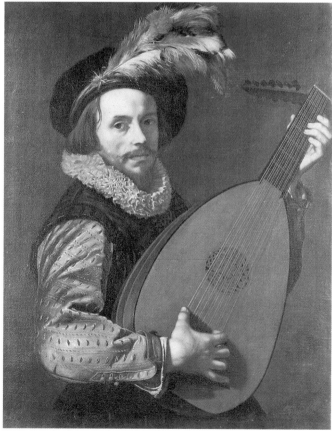

Fig. 14b Louis Finson, *Lute Player*
Dresden, Staatliche Kunstsammlungen (inv. 1841)

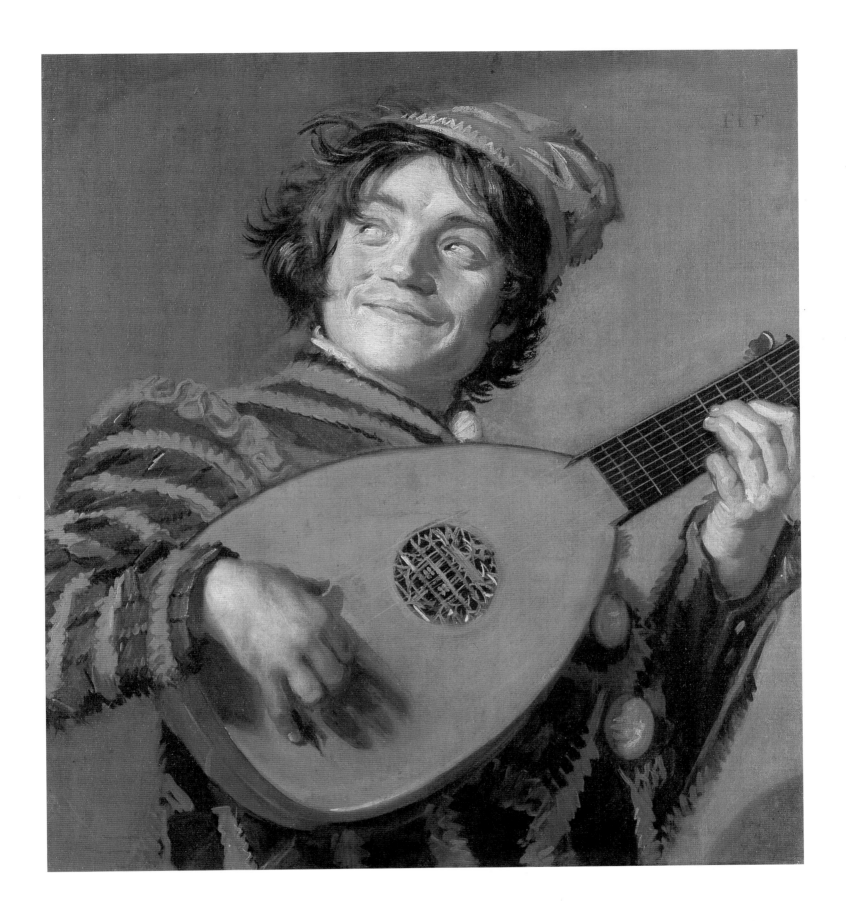

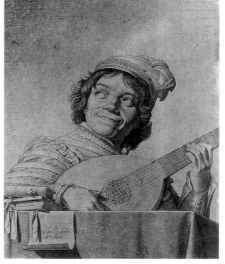

Fig. 14c Unknown artist, *Buffoon playing a Lute*, copy after Hals
Amsterdam, Rijksmuseum (inv. A 134)

Fig. 14d David Bailly, pen and wash drawing after Hals's *Buffoon Playing a Lute*, 1626
Amsterdam, Rijksmuseum, Prentenkabinet

Fig. 14e Detail from David Bailly, *Vanitas Still-Life with a Painter*, 1651
Leiden, Lakenhal (inv. 1351)

Madonna of the Rosary, a large altarpiece which Finson acquired in Naples, which is now in Vienna (inv. 147; Bodart 1970, pp. 12, 30). Moreover, the half-length genre pieces that Finson himself painted, which show the unmistakable impact of Caravaggio's style, perhaps helped popularise the motif in Holland (fig. 14b; Bodart 1970, pp. 163-4, no. 42; another Caravaggesque half-length of a lute player attributable to Finson is in the Bayerische Staatsgemäldesammlungen, inv. 4868).

The vivid colour contrasts of the buffoon's costume and the strongly focused daylight, which still models form more than it suggests bright, airy atmosphere, places the painting rather early in the 1620s. Before the Louvre acquired the picture in 1984, a seventeenth-century copy at the Rijksmuseum (fig. 14c) was much better known than the original. When first viewed, it appears to be an excellent replica, but a juxtaposition of the two works shows that the fine gradations of Hals's modelling were far beyond the copyist.[1]

Since the Rijksmuseum's copy was most likely used as the basis for a carefully finished drawing of the buffoon by David Bailly which he signed and dated 1626 (fig. 14d), it probably was painted in or before that year. In any event, the 1626 date establishes a firm *terminus ante quem* for Hals's original. Bailly also used a copy of a drawing of the painting, this time in an oval format, as one of the host of referential objects that allude to the foolishness of man's activities in his huge *Vanitas Still-Life with a Painter*, signed and dated 1651, at Leiden (fig. 14e). For a copy of Hals's *Rommel Pot Player* included in an earlier *Vanitas* by Bailly or one of his followers, see cat. 8.

Hals created the impression that his lute player is seen from below, a view Bailly rationalised in his copies by placing the figure behind a table set well above the beholder's eye level. Perhaps the painting originally was intended to hang high, the way two of Hals's paintings are mounted in a painting by Jan Steen (fig. 31c). Hals, of course, did not invent the idea of showing a model from this point of view. Italian painters of illusionistic wall and ceiling decorations had been placing figures on balconies since the Renaissance. Their *trompe-l'oeil*

tricks appealed to the Utrecht Caravaggisti, particularly to Honthorst and Baburen who can be credited with introducing *di sotto in su* compositions to Holland. Honthorst painted ambitious ones in 1622 and 1623, and Baburen made a few about the same time, usually with painted balustrades or window casements to heighten the illusionism. Hals never employed these props in his genre pieces. However, he recognised early that a figure seen from below – even ever so slightly – appears to tower over the beholder. Good use was made of this knowledge in his commissioned portrait of the so-called *Laughing Cavalier* of 1624 (pl. 1), and in his later portraits of *Claes Duyst van Voorhout* (cat. 52) and of haughty *Jaspar Schade* (cat. 62). He also quickly realised that the darting glance he gave the lute player could be used to enhance the instantaneous effect of a portrait as well as a genre piece. As early as 1626 he employed it for his unorthodox portrayal of *Isaac Massa* (cat. 21).

How did Utrecht Caravaggism find its way to Haarlem? Slatkes brightly suggests (1981-2, pp. 173-5) that Jacob van Campen may have been a conduit. He reminds us that van Campen, best known for his architectural accomplishments, particularly his masterpiece, Amsterdam's new Town Hall, also must have had a long, exceptional career as a painter. He entered the Haarlem artists' guild as a master painter (*meesterschilder*) as early as 1614; his work in this sphere was highly praised by his contemporaries. Van Campen's close connection to Amersfoort, a town only twenty kilometres from Utrecht, would have enabled him to keep abreast of the innovative paintings done there by the Dutch Caravaggisti. As he commuted between Amersfoort and Haarlem, he could have kept his colleagues in Haarlem informed of the latest news from Utrecht. A few rare Caravaggesque paintings by van Campen support Slatkes's hypothesis.

Less speculative is Slatkes's important publication of a monogrammed and dated 1623 *Musical Trio* by Pieter de Grebber (fig. 14f; canvas, 93 × 77.5 cm; Slatkes 1981-2, pp. 173-4), a Haarlem artist who, like van Campen, was a pupil of his father Frans de Grebber. The debt of de Grebber's

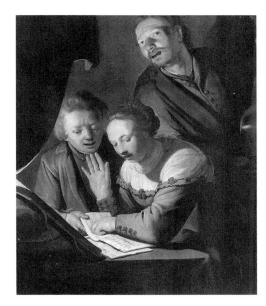

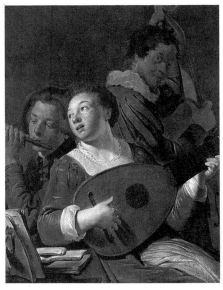

Fig. 14f Pieter de Grebber, *Musical Trio*, 1623
Private collection

Fig. 14g Pieter de Grebber, *Musical Trio*
Bilbao, Museo de Bellas Artes (inv. 69/114)

Musical Trio to Utrecht Caravaggism is unmistakable in the types, the gestures and the hidden artificial light source he used for his painting. It firmly establishes that the Caravaggesque innovations made by the Utrecht painters found their way to Haarlem by 1623. Slatkes also rightly notes that another *Musical Trio* at Bilbao (fig. 14g; canvas, 91 × 94 cm), which has had various attributions, is certainly by de Grebber and even may be the pendant to the signed and dated work.

Although Hals employed motifs and pictorial effects the Utrecht Caravaggisti introduced, he did not adopt them *en bloc*, and he never tried to make his personal, detached brushwork conform to their more highly finished paintings. The nocturnal effects they popularized, which were used by de Grebber in his 1623 *Musical Trio*, did not interest him. A possible exception is the *Denial of Peter* ascribed to Hals, which appeared in a sale at The Hague in 1779 (HdG 3). The subject traditionally is shown as a night scene but the painting remains untraceable and there is no way of determining the validity of the attribution. Though none of Hals's existing works show figures at night illuminated by artificial light, his pupils and followers were not as committed to *plein air* effects. Dirck Hals, Brouwer, Leyster and Jan Miense Molenaer, and Adriaen van Ostade all painted nocturnal scenes.

Hals's range of themes and *dramatis personae* also were much more limited than those used by the Caravaggisti. Unlike them he apparently never painted historical and mythological scenes. Religious paintings, one of their strong suits, hardly interested him. Apart from his unusual Evangelist series, only one or two *Prodigal Son* pictures may be identifiable; these works and merely two additional references to biblical themes that have been spotted in old inventories and a sale catalogue can be added to the untraceable *Denial of Peter* cited above (see cat. 22, 23).

And unlike the Utrecht painters, Frans never depicted cheating card players, gambling soldiers or arcadian shepherds. The erotic overtones found so frequently in their works are rare in his œuvre as well. There are no lechers with seducible young companions, no procuress scenes, no licentious couples. Even a woman wearing a décolletage is a rarity. The only women he depicted with them are his *Gipsy Girl* at the Louvre (pl. v, s62), the handsome young woman in his lost *Merry Trio* (s. l 2), and his latish portrait of *Isabella Coymans* (cat. 69).

1. The copy has been wrongly attributed to Hals himself (Bode 1883, 16), then to his brother Dirck (Davies 1902, p. 102), to one of Frans's sons (Moes 1909, p. 102) and to Hals's gifted follower and probable pupil Judith Leyster (Catalogue Rijksmuseum, 1960, p. 176, no. 1455, A2; Rosenberg *et al.* 1966, p. 107). Today it is safely listed as an 'old copy' (van Thiel *et al.* 1976, p. 257, no. A124), sensible recognition that there is no firm name for its artist. Another copy, formerly in a private collection, Milan, appeared in the sale anon., London (Sotheby's), 3 June 1981, no. 60 (panel, 79 × 69 cm).

PROVENANCE A *Lute Player* by Hals ('Een luytslaeger van Frans Hals') is listed in the 18 January 1669 inventory of Laurens Mauritsz Douci, Amsterdam (no. 12, appraised at Dfl. 15 [HdG 88a]), but it is impossible to establish if it is identical with the Louvre's picture. According to a wax seal and an inscription on the verso, with the *marchand-expert* Etienne Leroy, Brussels before 1873; acquired by Baron Gustave de Rothschild, Paris, 14 February 1873 with other unspecified objects for 47,982.60 francs (see Paris 1987, p. 78). Baron Robert de Rothschild; Baron Alain de Rothschild; acquired as a donation in lieu of taxes, 1984.

EXHIBITIONS Paris 1921, no. 19; Haarlem 1937, no. 20; Haarlem 1962, no. 12; Paris 1985-6, no. 47; Utrecht & Brunswick 1986-7, no. 58 (before 1626; entry by R. Klessmann); Paris 1987, pp. 78-81 (c. 1625-6; entry by J. Foucart).

LITERATURE Bode 1883, 45; Moes 216; HdG 98; Bode-Binder 71; KdK 29 (c. 1623-5); Trivas Appendix 4 (variant); Bruyn 1951, pp. 217-8, 222; Slive 1970-4, vol. 1, pp. 85-7 (early 1620s); Grimm 23 (dated 1626); Popper-Voskuil 1973, pp. 67-8; Montagni 33; Wurfbain 1988, p. 52; Grimm 1988, p. 407 (c. 1625-6).

15 Singing Boy with a Flute

c. 1623-5
Canvas, 62 × 54.5 cm
Signed, lower right, with the connected monogram: FH
S25
Staatliche Museen Preussischer Kulturbesitz, West Berlin (inv. 801 A)
Exhibited in Haarlem

In this half-length it is difficult to decide what to admire most: the natural gaiety and spontaneous movement of the young musician or the effect of full daylight playing over him. The bright light does not enter as a beam, but floods the figure and the light grey background, producing a kind of overall, open-air atmosphere. Ter Brugghen led the way for such *plein air* effects in his exquisite pendant half-lengths of flute players at Kassel dated 1621; one is reproduced here (fig. 15a). Hals must have been familiar with such works by the most gifted of the Dutch Caravaggisti. By 1624 he used this type of bright daylight in his *Laughing Cavalier* (pl. 1), and it is seen again in his *Merry Lute Player* (fig. 15b; bequeathed by Harold Samuel in 1987 to the Corporation of the City of London), datable to about the same time. Hals's young musicians, however, belong to a different race than ter Brugghen's. His young people live at a higher pitch, their pulse beats faster. The restrained mood and tender poetry of the Utrecht artist's best paintings remained foreign to him, and he never responded to the slow, ample classical rhythms ter Brugghen assimilated after spending about a decade in Italy.[1]

Other links with the Dutch Caravaggesque painters are seen in the boy's rudimentary theatrical costume and his prominent upraised hand seemingly beating time to his music. His plumed beret and cloak – certainly not customary apparel for Haarlem boys in the 1620s – and his gesture were employed frequently by the Utrecht Caravaggisti. Baburen used the conspicuous gesture as early as 1622 (fig. 15c) and de Grebber's *Musical Trio* (fig. 14f) of 1623 shows how rapidly it found its way to Haarlem. Ter Brugghen's *Singing Boy* dated 1627 (fig. 15d) serves as an exemplar of Utrecht usage of both the costume and the gesture.[2]

Very appealing is Valentiner's assertion (KdK 55) that the models for the Berlin painting and the artist's other pictures of young musicians that can be grouped with it (S23, S24, S26) surely were Hals's own children. The only support for his statement is Houbraken's report published in 1718 that he was told by J. Wieland, an old amateur who claimed he knew most of Hals's children personally, that all of them 'were vivacious spirits and lovers of song and music' (Houbraken, p. 18). Until more substantial evidence turns up, Valentiner's claim remains an attractive idea, not a firm identification.

Less hypothetical is the presumption that the *Singing Young Boy with a Flute* was intended as a personification of Hearing, a subject taken from the theme of the Five Senses. This interpretation is bolstered by Hals's other paintings that can be connected with Five Senses series, notably his ravishing paintings of young boys who represent Taste and Hearing now at Schwerin (cat. 27, 28), and by references of 1661 and 1663 to three small paintings belonging to a set, two of which may be identical with little pictures now in a private collection, Montreal (cat. 25, 26). Hofstede de Groot's citation of a complete set of five by Hals listed in a 1654 Amsterdam inventory has not been verified (Hals doc. 146).

Numerous series of the Five Senses by Netherlandish artists indicate that the subject, whose origin can be traced back to antiquity, was a favourite one in Hals's time. A few artists continued the earlier tradition of presenting each of the senses as an idealised figure, usually a half-draped female accompanied by traditional attributes, but most of them presented the theme by showing scenes of daily life. A series engraved about 1595 by Jan Saenredam after drawings by Goltzius announced the way the subject was soon to be treated (fig. 15f; Hollstein,

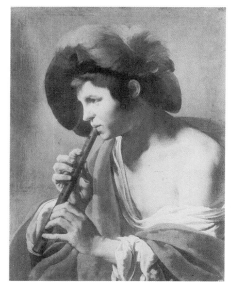

Fig. 15a Hendrick ter Brugghen, *Flute Player*, 1621
Kassel, Staatliche Gemäldegalerie (inv. 179)

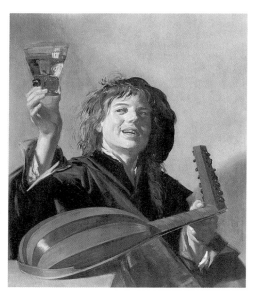

Fig. 15b *Merry Lute Player* (S26)
Corporation of the City of London

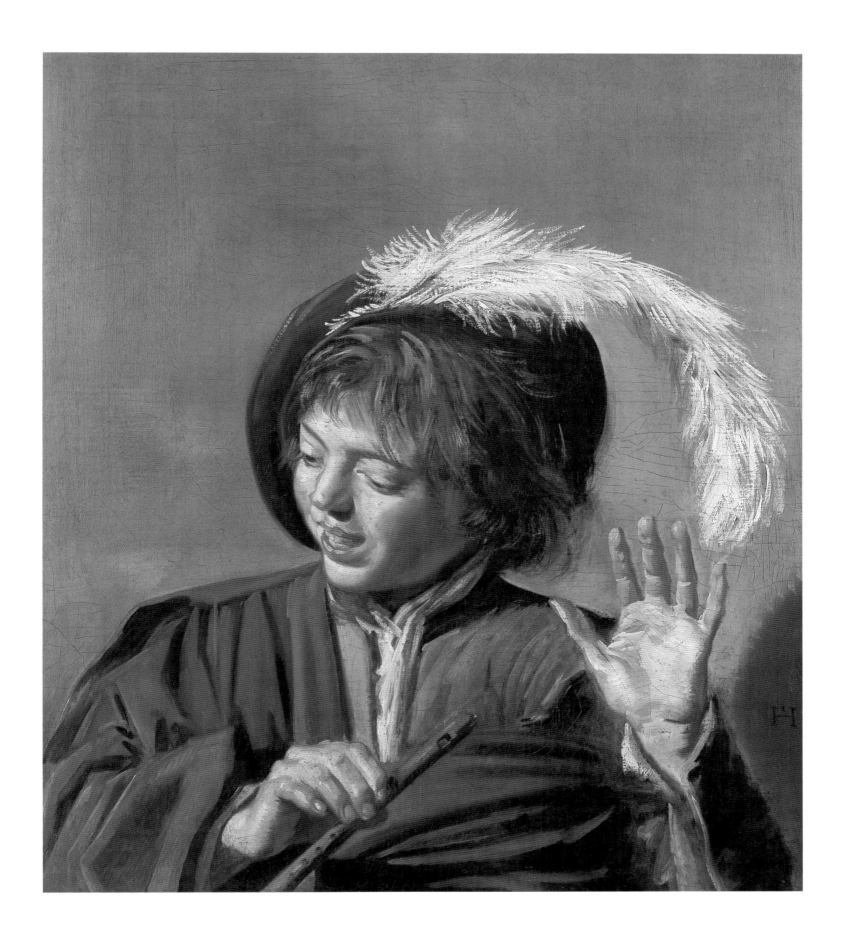

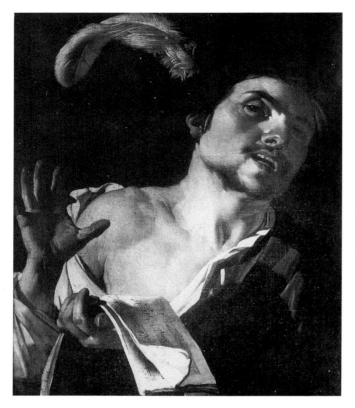

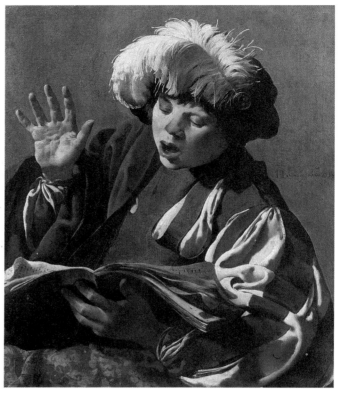

Fig. 15c Dirck van Baburen, *Singing Man*, 1622
Halberstadt, Das Gleimhaus

Fig. 15d Hendrick ter Brugghen, *Singing Boy*, 1627
Boston, Museum of Fine Arts (inv. 58.975)

Fig. 15e Dirck Hals, *The Five Senses*, 1636 The Hague, Mauritshuis, (inv. 57/1-5)

 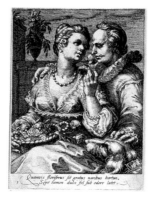 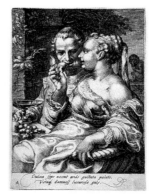 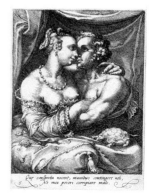

Fig. 15f Jan Saenredam, *The Five Senses*, engravings after series of drawings by Goltzius

174

vol. 23, pp. 76-7, nos. 101-5). Goltzius represented each sense by the appropriate activities of five fashionably dressed couples. During the following decades many variations were made on the secularisation of the motif. Five tiny tondi by Frans Hals's brother Dirck, dated 1636, indicate how the action of a child, or simply a picture of a child with fitting familiar objects, was used to allude to one of the senses (fig. 15e).[3]

The Latin inscription on the engravings made after Goltzius's Five Senses drawings demonstrate that the subject could be used to help teach a moral lesson. Their captions admonish onlookers not to abandon themselves to the pleasures of the senses, an idea in accord with the notion that all earthly delights are transitory and jeopardise the hope for eternal salvation: 'vanity of vanities, all is vanity' (*Ecclesiastes* 1:2). Doubtlessly some Dutchmen must have nodded their heads in approval of these warnings. But were there not others who gave greater attention to Goltzius's partially clothed, deep-bosomed women than to the admonitions inscribed on the engravings? Similarly, Five Senses pictures of young people by Frans Hals, Dirck Hals and others could detonate more than one set of thoughts. Some contemporaries probably read them as visual sermons on transience. If one is so inclined, what in the world cannot serve as a sermon on transience? However, the sight of radiant youth at play need not invariably lead to moralising thoughts on the vanity of life's delights and the inevitability of death. The fact that so many straightforward Dutch vanitas pictures were painted (for Hals's, see cat. 29) and so many sermons and pamphlets were published on the dangers of life's transitory pleasures suggests that far too few were paying attention to *momento mori* admonitions. The need for reminders of the message seems to have been urgent.

Even before the Berlin painting was restored at the museum in 1959-60, it was apparent that a strip about 6 cm wide had been added to the bottom. Examination of its paint layer established that the strip had not been painted by Hals and that the book and end of the flute as well as the drapery on it, which are visible on reproductions of the picture made before it was treated (see KdK 55; Trivas 38), had been added by another hand. The later addition has not been removed but is now covered by the frame. The 1959-60 restoration also freed the work of some repaint.

hand to which a singing teacher could point in teaching solmisation (the practice of using a set of syllables to denote the tones of a musical scale).

Although the evidence is not weighty, there is enough to assume that educated Dutchmen of the time recognised a Guidonian hand when they saw one. I would stress that they did not see many in these pictures. Apart from the one in the Berlin painting, all of Hals's singers raise their right, not their left, hands and they do not display outstretched fingers. The pictures Stevens cites (p.96) by ter Brugghen and Baburen, as well as other paintings that can be added to her list by Honthorst, Jan van Bylert and Pieter de Grebber, likewise present singers with their right hands raised.

Stevens rightly observes that in some pictorial contexts a raised hand seemingly keeping time to music can allude to the virtue of temperance (also see van Thiel 1967-8, pp.90ff.), and that the significance of musical activity in paintings can range from references to heavenly harmony to sinful dissipation. In view of these associations is there any particular significance to the raised hand in paintings of singers by Hals and the Utrecht Caravaggisti? Was it employed merely to indicate the beating to time, or was it used purposefully to bring extra significance to the painting? Stevens concludes (p.101) it most probably had a special meaning: '... it seems to be associated with some kind of elevated, intellectualised music that is associated with rational understanding rather than simply with sensuous enjoyment.'

In support of her hypothesis she observes (ibid.) that in the group by Hals and the Utrecht painters in which the upraised hand is so prominent it 'always belongs to a singer who reads music – one who is thus not a low-class street singer or drunken carouser – and signs of bordellos, wild parties, etc., are absent', while in Dutch pictures that associate music with the sensual world the performers 'do not read from notated music, an activity that would presume both prior education and a kind of intellectualisation opposed to the sensuality of the scene'.

Stevens's conclusions regarding the absence of references to sensuality in Utrecht paintings of performers with one hand beating time and the other holding notated music needs modification. These allusions are conspic-

uously present in the dishevelled dress of Baburen's 1622 red-nosed singer holding a music book (fig. 15c) and in the costumes – particularly the low-cut necklines – of ter Brugghen's and Honthorst's female singers with music. These figures belong to the demimonde. For the convincing argument that the female singer with an upraised hand and a music book in ter Brugghen's *Duet* of 1628 at the Louvre is a prostitute, see de Jongh in Amsterdam 1976, pp.58-61, no.8. Stevens refers (p.122, note 75) to de Jongh's analysis as another interpretation, but neither summarises it nor attempts to refute it.

Stevens classifies (p.101, note 71) Hals's Berlin singer with the intellectual type that reads music. The young boy has not qualified for this distinction since c.1960 when his music book was covered by the painting's frame because it was established then that it is a later addition. She also erroneously includes in her list of Hals's paintings of singers his lost portrait of the Deventer minister *Caspar Sibelius*, known from two engravings by Jonas Suyderhoef (s.l.112). Surely, Sibelius is presented in the portrait in clothes worn by Dutch ministers in the 1630s, and he is holding a Bible or prayer book while making a rhetorical gesture; he is not beating time from a song book.

To the possible meanings of the gesture of a raised hand with palm out and fingers outstretched another can be proposed: Stop. Then proceed with extreme caution.

3. The fundamental study of the theme remains Kauffmann 1943, pp.133-57; also see Slive 1970-4, vol. 1, pp.77-80. The attribution of an etched set, personifying each sense as an idealized female figure and with a mythological scene, to the Amsterdam artist Jacob Backer (1608-51), first made by Bauch (1926, pp.111-2, nos. 1-5, fig. 10) and accepted by Slive (1970-4, vol. 1, p.79, fig. 54), is wrong; Czobor (1972) has convincingly attributed it to the Antwerp artist Jacob (Jacques) de Backer (c.1560-c.1590). Two years before Dirck Hals painted the small set now at the Mauritshuis (fig.15f; each tondo is only 12 cm in diameter), another series by him, framed in ebony, was appraised at the substantial price of 104 guilders in a list prepared on 4 April 1634 for a Haarlem lottery (Miedema 1980, vol.1, p.170, A70).

PROVENANCE Sale B. Ocke, Leiden, 21 April 1817, no.45 (Dfl. 78, Lelie); sale Amsterdam, 16 December 1856, no.19 (panel, 68 × 56 cm); Collection Barthold Suermondt, Aachen, by 1860; acquired with Suermondt's collection for the Königliches Museum, Berlin, 1874.

EXHIBITIONS Brussels 1873a, no.16; Brussels 1873b, no.76; Washington *et al.* 1948-9, no.57; Amsterdam 1950, no.51; Philadelphia, Berlin & London 1984, no.47.

LITERATURE Bürger 1860b, pp.13-4, 148-9, no.45; Bode 1883, 90 (c.1625); Moes 218; HdG 81; Bode-Binder 56; KdK 55 (c.1627); Trivas 25 (c.1625-7); Slive 1970-4, vol. 1, p.88; Grimm 30 (c.1627); Montagni 32 (c.1625); Catalogue Gemäldegalerie, Berlin, 1978, p.201, no.801 A; Stevens 1984, pp.96, 101 note 71; Catalogue Gemäldegalerie, Berlin, 1986, p.38, no.801 A.

1. Marten Jan Bok, 'On the Origins of the Flute Player in Utrecht Caravaggesque Painting', in *Hendrick ter Brugghen und die Nachfolger Caravaggios in Holland*, ed. Rüdiger Klessmann, Brunswick [1988], pp.135-41, publishes a document establishing that an early sixteenth-century Venetian half-length of a flute player was in Utrecht by March 1623, and its subject, and others similar to it, quite possibly had an impact on artists active in the city.

2. The significance of the upraised hands in this group of paintings has been discussed by Mary L. Stevens (1984). She notes that when the left hand is shown raised, with the palm out and the fingers extended, as it is in the Berlin painting, it recalls an image intimately associated with singing: the hand of Guido. The Guidonian hand, named for the Benedictine monk Guido of Arezzo (c.1050), is a figure representing the tones of the great scale on the joints of the left

16 Laughing Boy

c.1620-5
Circular panel, diameter 29.5 cm
Signed, lower left, with the connected monogram: FH [?F]
There are traces of another connected monogram at the upper left
S29
Mauritshuis, The Hague (inv. 1032)
Exhibited in Haarlem

After carefully painting heaps of colossal ruffs and yards of intricate lace and embroidered brocade for his bespoke portraits, it must have been a pleasure for Frans Hals to relax by painting informal pictures such as the Mauritshuis's *Laughing Boy*. The magnificent tondo most probably was painted for the artist's own delight. Its lack of conventional finish indicates it was not intended as a commissioned portrait and, since the boy is neither engaged in a specific activity nor accompanied by an attribute, it cannot be categorised as a genre or allegorical piece. The subject is more original: it is a record of a child's sheer joy in living.

Perhaps a few other similarly vivacious studies of young children were painted for the artist's pure pleasure and had their props added as afterthoughts to make them conform to popular iconographic themes. An oil sketch of a laughing boy could have been easily transformed into an allegory of Hearing by providing the youngster with a flute (fig. 16a), while another could have been made into an acceptable vanitas merely by the addition of a soap bubble (fig. 16b).

Hofstede de Groot (29) and Valentiner (KdK 31 right) called the Mauritshuis painting a pendant to the *Child holding a Flute* now at Cincinnati Art Museum (inv. 1973.450; Slive 1970-4, vol. 3, no. D5-1, fig. 108). Since the Cincinnati picture is not by Hals, their proposal is untenable. Moreover, it is doubtful if the attribute-less boy at the Mauritshuis was intended as the pendant of a *Child holding a Flute*, a picture that qualifies as a representation of the sense of Hearing.

To judge from the numerous contemporary copies of Hals's fresh oil sketches of children, they must have been very popular in his own day, and after the nineteenth-century revival of interest in the artist's work modern copyists, pasticheurs and forgers helped satisfy a new demand for them.

A half-dozen versions of the Cincinnati *Boy* are known (see Slive 1970-4, vol.3, nos.D5-2 through D5-7, figs. 109-13). Three copies by anonymous artists of the Mauritshuis picture have been published (figs. 16c, 16d, 16e; Slive 1970-4, vol.3, no. 29) and an unpublished fourth has recently turned up (fig. 16f).[1] Even in reproductions it is easy to see how Hals's suggestive touch and sparkling accents disintegrate in the hands of his followers.

1. Dr. Gode Krämer kindly called my attention (19 August 1976) to the unpublished Augsburg painting: oval panel, 29.7 × 28.5 cm, set into a rectangular panel, 35.2 × 34.5 cm; falsely monogrammed. The copy that was formerly in the Collection Albert Lehman (fig. 16d) appeared in the sale Amsterdam (Paul Brandt), 20 November 1973, no. 13 (wrongly catalogued as a genuine Hals; Dfl. 250,000).

PROVENANCE Baron Albert von Oppenheim, Cologne; sale Baron Albert von Oppenheim, Berlin (Lepke), 19 March 1918, no. 16; Mrs. Friedländer-Fuld, Berlin (files RKD); Mrs. M. von Kühlmann, Berlin (later Mrs. Goldschmidt-Rothschild, Paris); acquired by the Mauritshuis in 1968.

EXHIBITIONS Cologne 1876, no.46; Düsseldorf 1886, no. 132; Haarlem 1937, no. 22; Haarlem 1962, no. 11; Washington *et al.* 1982-3, no. 18; Paris 1986, no. 28.

LITERATURE Bode 1883, 113; Bode 1887, p.40; Levin 1887, p.458; Moes 235; HdG 28 (wrongly described as a boy holding a flute); Bode-Binder 29; KdK 31 right (c.1623-5); Slive 1970-4, vol. 1, pp.75-6; Catalogue Mauritshuis, The Hague, *Vijfentwintig jaar aanwinsten*, 1970, no. 15; Grimm 18 (c.1624-6); Montagni 29 (c.1625); Catalogue Mauritshuis, The Hague, 1977, p. 104, no. 1032 (c.1620-5); Baard 1981, p.184 (c.1620-5); Hoetink *et al.* 1985, pp.192-3, no.7, pp.371-2, no. 1032; Broos 1987, pp. 175-9, no. 30 (c.1625).

Fig. 16a *Laughing Boy holding a Flute (Hearing?)* (S27)
England, private collection

Fig. 16b *Laughing Boy with a Soap Bubble (Vanitas?)* (S28)
U.S.A., private collection

Fig. 16c Unknown artist, *Laughing Boy*, copy after Hals
Dijon, Museum (inv. 7116)

Fig. 16d Unknown artist, *Laughing Boy*, copy after Hals
Ex-Albert Lehmann, Paris

Fig. 16e Unknown artist, *Laughing Boy*, copy after Hals
Location unknown

Fig. 16f Unknown artist, *Laughing Boy*, copy after Hals
Augsburg, Städtische Kunstsammlungen (inv. L815)

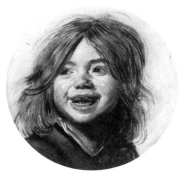

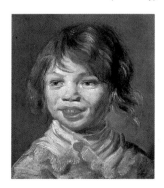

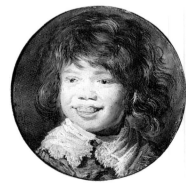

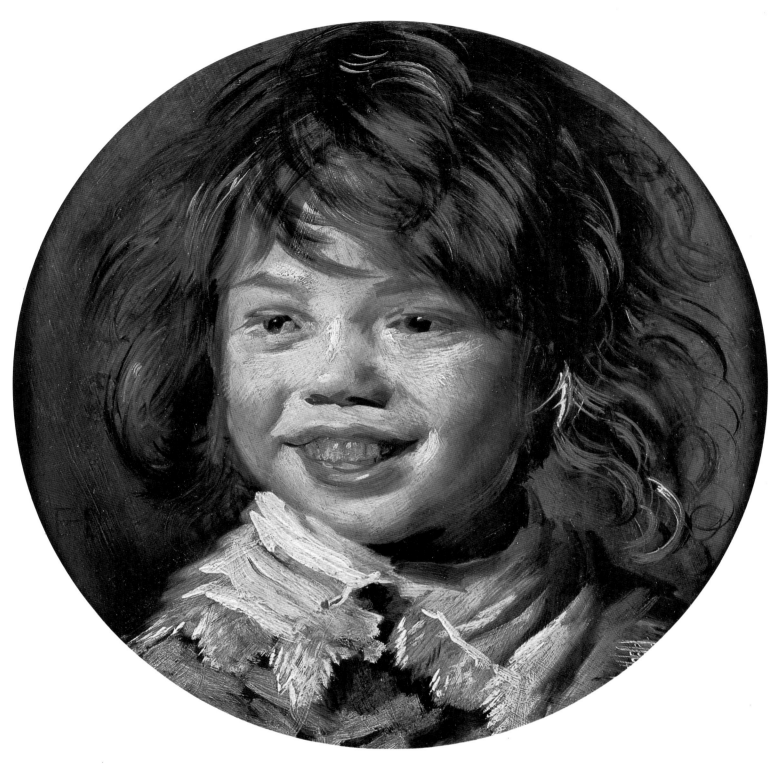

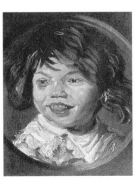

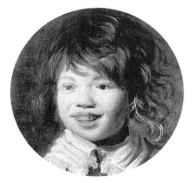

17 Willem van Heythuysen

c.1625
Canvas, 204.5 × 134.5 cm
S31
Bayerische Staatsgemäldesammlungen, Munich (inv. 14101)

This portrait of Willem van Heythuysen, which was dated c.1635 by earlier cataloguers but upon the basis of style and costume should be dated about a decade earlier, is the artist's only known life-size full length. Portraits of its type were not popular in seventeenth-century Holland. Most Dutch homes simply were not large enough for them. Moreover, it was a type still used primarily for state portraits and the nobility. In the Northern Netherlands it was only the most powerful, the wealthiest or the most pretentious who commissioned them. The Van Dyckian trappings behind Heythuysen also are unusual in Hals's work. So is the sword. Heythuysen was not a military man. The name of this Haarlem citizen does not appear on the rosters of the city's civic guard. Heythuysen was a very rich merchant who made his great fortune in Haarlem's famous textile industry, the principal source of the city's prosperity after beer brewing. However, even if we knew nothing of Heythuysen's life, there's no disputing it: Hals's portrait of him standing as big as life captures the confidence and vitality of the burghers who made Holland the most powerful and richest nation in Europe during the first half of the seventeenth century. It is one of those rare pictures that seems to sum up an entire epoch.

A sense of energy is conveyed by the tautness Hals gave Heythuysen's bolt-upright figure. His extended leg does not dangle but carries its full share of weight. One arm juts out, stiff as the large sword he holds. The other makes a sharp angle from shoulder to elbow to hip. As in most of Hals's portraits of the twenties, the light falls with equal intensity on the head and hands, but a new awareness of its animating powers is evident in the reflections on the black-on-black acanthus pattern of his satin jacket and some other shiny highlights that contrast with sharp shadows heightening Heythuysen's palpable presence. Although the props in the background clearly are subordinate to his proud figure, they are worked beautifully into the design. The vertical accent of the pilaster on the right reinforces his erect carriage, and the burgundy drapery is incorporated into the pattern formed by his elephantine pair of bouffant knee-breeches and cloak cut like a cape.

The prominent roses in this portrait of a man who remained a bachelor could allude, as they do so often, to the pleasures and pain of love, but references in van Mander's *Schilderboeck* and in Jacob Cats's popular emblems, as well as works by other Haarlem artists, indicate that they and the lovers in the garden in its background (similar lovers in a garden are seen in the background of the Rijksmuseum's *Married Couple* [cat. 12]) very probably were intended as reminders of life's transience (sources for the latter interpretation are discussed by Boot 1973, pp. 422-4). Roses were as familiar vanitas symbols in Heythuysen's time as the skull, hour-glass and inverted torches that appear on his tomb at St. Bavo's Church in Haarlem. An inscription on it could serve as a motto for Hals's portrait (fig. 17a):

I wrought, I stood,	(*Ick wrocht, Ick stond,*
I sought, I found.	*Ick Soght, Ick vond.*
I suffered, My peace	*Ick leed, Ick deed*
I have achieved.	*nu vreed In steed.*)

For Hals's small portrait of van Heythuysen painted about a

decade or so later, that is as informal as this one is formal, see cat. 51. There is excellent reason to believe that both were listed in the inventory made of Heythuysen's effects in his large house on the Oude Gracht in Haarlem after his death on 6 July 1650.[1] The inventory refers to 'The effigy or large portrait of Willem van Heythuysen with a swathe of black drapery hanging over it' in the Great Hall, and in the room above it to a 'likeness of the deceased in small, in a black frame'. The former most probably is a reference to the present portrait; the black cloth draped over it may have been a mourning cloth. The inventory also lists the deceased man's

Fig. 17a Pieter van Looy, *Willem van Heythuysen's tomb at St. Bavo, Haarlem*, pen and wash drawing
Haarlem, City Archives (inv. 53-1826M)

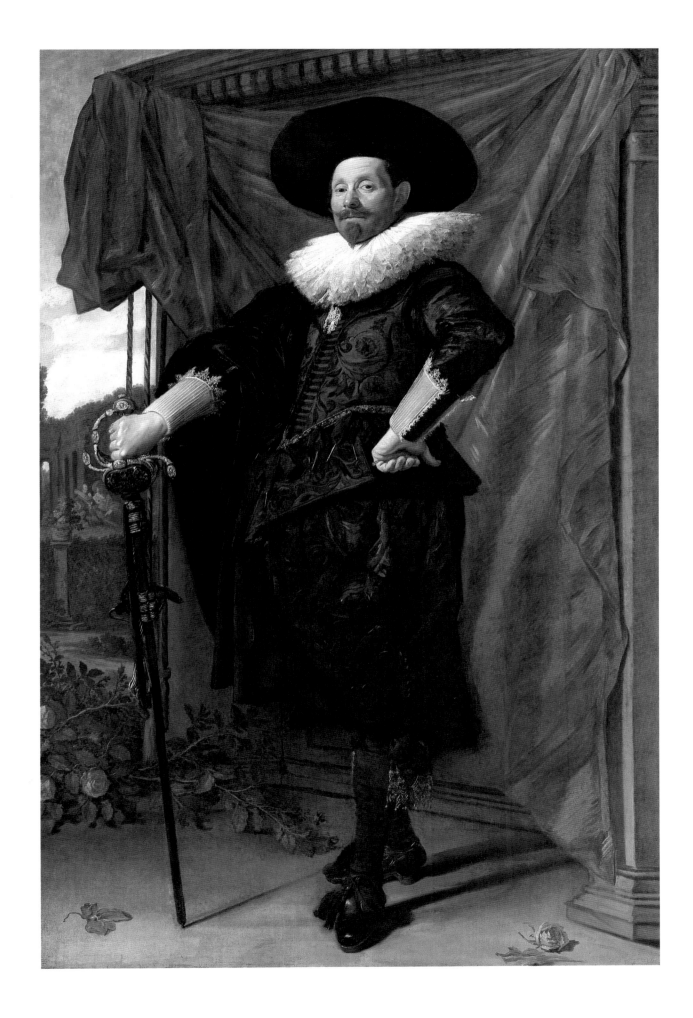

extensive holdings: a vast number of paintings, expensive furniture and silver, a large library, jewellery, maps of Europe, a coin collection, weapons – amongst them a *Degen ofte rapier* ('a sword or rapier'; perhaps the one in the Munich portrait) – and an expensive wardrobe, including red satin underwear.

Heythuysen was born in Weert, Limburg. Neither the date of his birth nor when he settled in Haarlem is known. Amongst his generous bequests were endowments for two *hofjes* or almshouses, one in his native city Weert and the other, the Hofje van Heythuysen, near Haarlem on his country estate called 'Middelhout', which still serves the needs of eleven old women. His frequent trips abroad for his textile business are well documented; they probably help explain why he never joined Haarlem's civic guard or held office in the city. His circle of friends included Tieleman Roosterman, another wealthy Haarlem textile merchant, who was named the executor of his will. In that capacity Roosterman became one of the first regents of the Hofje van Heythuysen (Biesboer, p. 29). Hals's portrait of Roosterman in a cocksure mood is now at the Kunsthistorisches Museum, Vienna; the artist's portrait of his over-dressed wife, Catherina Brugman, is in a private collection (Biesboer, figs. 10, 11; S93, S94).

The history of the Munich portrait is obscure until 1789, when A. Loosjes singled it out for special mention in a poem written in praise of Hals. Loosjes noted that it belonged to G.W. van Oosten de Bruyn, a Haarlem historian and collector who owned Vermeer's *Little Street*. But not everyone was equally impressed. When it appeared in de Bruyn's sale in Haarlem in 1800, it fetched the trifling sum of 51 guilders. Later, when it was purchased at auction in 1821 for the Liechtenstein collection, the name of the model was either suppressed or forgotten, and the picture was wrongly attributed to Bartholomeus van der Helst, an error that is a tribute to the picture's quality since at that time van der Helst was held in far greater esteem than Hals.

The wrong attribution also provides an index of the state of knowledge of Dutch painting during the first decades of the nineteenth century. Waagen was the first to recognise the hand of the artist who painted the great portrait in his volume on Vienna's art treasures published in 1866. In 1868 Thoré-Bürger wrote: '*En Allemagne, quoique les Hals ne soient pas rares, il paraît qu'on ne les connaît pas très bien, du moins à Vienne; car, dans la splendide galerie Lichtenstein, un de ses plus beaux portraits et des plus importants est attribué à van der Helst!*' The Liechtenstein catalogue of 1873 corrected the attribution and identified the sitter. Then things changed rapidly. When Bode published his Hals monograph in 1883, he called it 'the masterwork of Hals's single portraits'. Bode's judgement has stood the test of time as well as the market place. In 1969 the portrait was purchased for the Alte Pinakothek from the Liechtenstein Collection for 12 million German marks, at that time the highest price ever paid for a painting.

For oil sketches and drawings that wrongly have been called preparatory studies for the painting, see Slive 1970-4, vol. 3, no. 31.

PROVENANCE Almost certainly the portrait in the 'Groot Salet' (Great Hall) cited in the inventory compiled of van Heythuysen's effects in his large house on the Oude Gracht, Haarlem, after his death in 1650 (the inventory does not provide artists' names): 'Het Effigum ofte Conterfeijtsel van Willem van Heythuysen met een lap swaert laecken daervoor' ('The effigy or portrait of Willem van Heythuysen with a swathe of black cloth hanging over it'), cited in Boot 1973, p. 422; see cat. 51 for another portrait of him that probably is identical with a small portrait listed in the posthumous inventory. G.W. van Oosten de Bruyn, Haarlem, by 1789; his sale Haarlem, 8 April 1800, no. 13 (Dfl. 51); acquired in 1821 by Johann I. Josef (1760-1836), Prince of Liechtenstein (as a work by Bartholomeus van der Helst); purchased by the Bayerische Staatsgemäldesammlungen from the Liechtenstein Collection, Vaduz, in 1969 for DM 12,000,000.

EXHIBITION Lucerne 1948, no. 157.

LITERATURE A. Loosjes, *Frans Hals: Lierzang vorgeleezen bij gelegenheid der uitdeeling van de prijzen in de Tekenakademie te Haarlem, 1789*, Haarlem [1789], pp. 12-3; G.F. Waagen, *Die vornehmsten Kunstdenkmäler in Wien*, Vienna 1866, vol. 1, p. 271 (Hals, not B. van der Helst); Bürger 1868, p. 441 (Hals, not B. van der Helst); *Katalog der Fürstlich Liechtensteinschen Bildergalerie*, Vienna 1873, p. 19, no. 150 (identified as Heythuysen); Unger-Vosmaer 1873, no. XVI (c. 1635-40); Bode 1883, 123 (c. 1630); *Icon. Bat.* no. 3507-1 (wrong provenance); Th. Frimmel, 'Wann ist das Heythuysen-Bildnis in die Liechtenstein Sammlung gekommen?', *Blätter für Gemäldekunde*, Beilage, Leif. 11 (May 1907), p. 30; Moes 44; HdG 191 (c. 1635; wrong provenance); Bode-Binder 220; KdK 153 (c. 1636); A. Stix and E. von Strohmer, *Die Fürstlich Liechtensteinsche Gemäldegalerie in Wien*, Vienna 1938, pp. xi, 99, no. 54; Trivas 64 (c. 1633-6); J. Henkens, 'Het Hofje van Willem van Heythuysen te Weert en zijn Stichter', *De Maasgouw* LXXVII (1958), pp. 73-80; Slive 1970-4, vol. 1, pp. 52-4 (c. 1625); Steingräber 1970, pp. 300-8 (c. 1625-31/2); Grimm 21 (1625-6); Boot 1973, pp. 420-4; Montagni 39 (c. 1625); Catalogue Alte Pinakothek, Munich, 1983, pp. 238-9, no. 14101 (1625-30).

1. References to the posthumous inventory were first published by Boot in 1973. For a transcription see Biesboer, note 19. For its references to Heythuysen's wardrobe and a description of the clothes he wore for the Munich portrait, see du Mortier, pp. 54-5.

Jacob Pietersz Olycan Aletta Hanemans

1625
Canvas, 124.6 × 97.3 cm
Inscribed, upper right: AETAT SVAE 29/A°. 1625. His coat of arms
hangs on the left
S32
Mauritshuis, The Hague (inv. 459)
Exhibited in Washington

1625
Canvas, 124.8 × 98.2 cm
Inscribed, upper left: AETAT SVAE 19/AN° 1625. Her coat of arms
hangs on the right
S33
Mauritshuis, The Hague (inv. 460)
Exhibited in Washington

Since Jacob Pietersz Olycan (Haarlem 1596-1638 Haarlem) and Aletta Hanemans (Zwolle 1606-1653 Haarlem) were married in 1625, these three-quarter lengths most probably were painted to memorialise the occasion. As in the earlier Beresteyn pendants (cat. 6, 7), a close harmony has been established between the pair by making them mirror images, but nice variations have been made on the familiar poses. Jacob Olycan almost confronts us squarely, not at an angle with his head rather sharply turned, and his akimbo arm and draped cloak accent his massiveness. The modifications in young Aletta's pose are less marked, but one small alteration makes her cut a more symmetrical figure than Beresteyn's wife: her hand rests on her richly embroidered stomacher instead of extending down to a chair – a minor change that regularises her silhouette and helps establish a correspondence between the pair. Both portraits are enlivened by the vivacity of the brushwork, particularly in the wide expanse of Aletta's rose-violet silk skirt. Every item of Aletta's apparel, from her cap trimmed with a very fashionable border of tape lace to her white kid gloves with embroidered scalloped cuffs, qualifies her as one of the best-dressed women in Haarlem in 1625 (du Mortier, pp. 47-8). Her husband followed the latest fashions as well (ibid, p. 55).

Recent tests made on very tiny paint samples taken from the coats of arms on the portraits confirm Hofstede de Groot's observation (208, 209) that the armorial bearings are later additions. The samples revealed traces of Prussian blue, a pigment not generally available until after 1720 (Groen & Hendriks, p. 121).

The Olycan coat of arms are canting arms (or *armes parlant*) which Broos has shown (1987) can be read as a thumbnail history of Jacob's family. The jar with two handles is a reference to Jacob's family name (Olycan = *oliekan* = oil can or jar), and recalls that his grandfather was a merchant who sold oil, grain and other provisions in his Amsterdam shop 'in de Olycan' on Kalverstraat. Jacob's father, Pieter Jacobsz Olycan (1572- in or after 1658), owned two breweries in Haarlem, De Vogelstruys (The Ostrich) and 't Hoeffeyser (The Horseshoe); hence the ostriches with horseshoes in their beaks on the coat of arms. After his marriage Jacob became the owner of 't Hoeffeyser.

Identification of Jacob does not depend only upon the coat of arms and inscription on the portrait. Hals portrayed him again as a lieutenant in his *Banquet of the Officers of the St. George Civic Guard* of c.1627 (fig. 18a). There can be no doubt that the sitters are identical.

During the course of the following decades the Olycan family and their relatives virtually employed the artist as their family portraitist. In 1631 Frans portrayed Jacob's uncle and maternal aunt: *Nicolaes van der Meer* and *Cornelia Claesdr Vooght* (cat. 41, 42). When his sister Maria Pietersdr Olycan married Andries van Hoorn, one of the pillars of Haarlem's

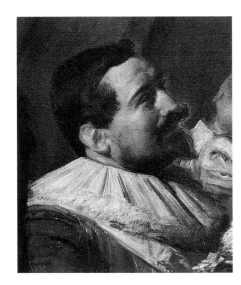

Fig. 18a Detail of Jacob Olycan from *Banquet of the Officers of the St. George Civic Guard*, c. 1627 (S46)
Haarlem, Frans Halsmuseum

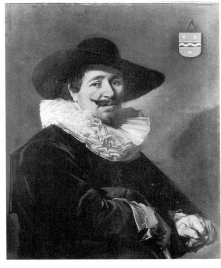

Fig. 18b *Andries van Hoorn*, 1638 (S117)
São Paulo, Museum of Art

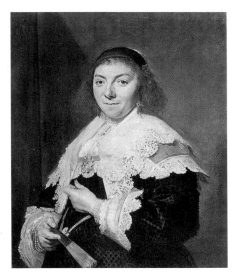

Fig. 18c *Maria Pietersdr Olycan, wife of Andries van Hoorn* (S118)
São Paulo, Museum of Art

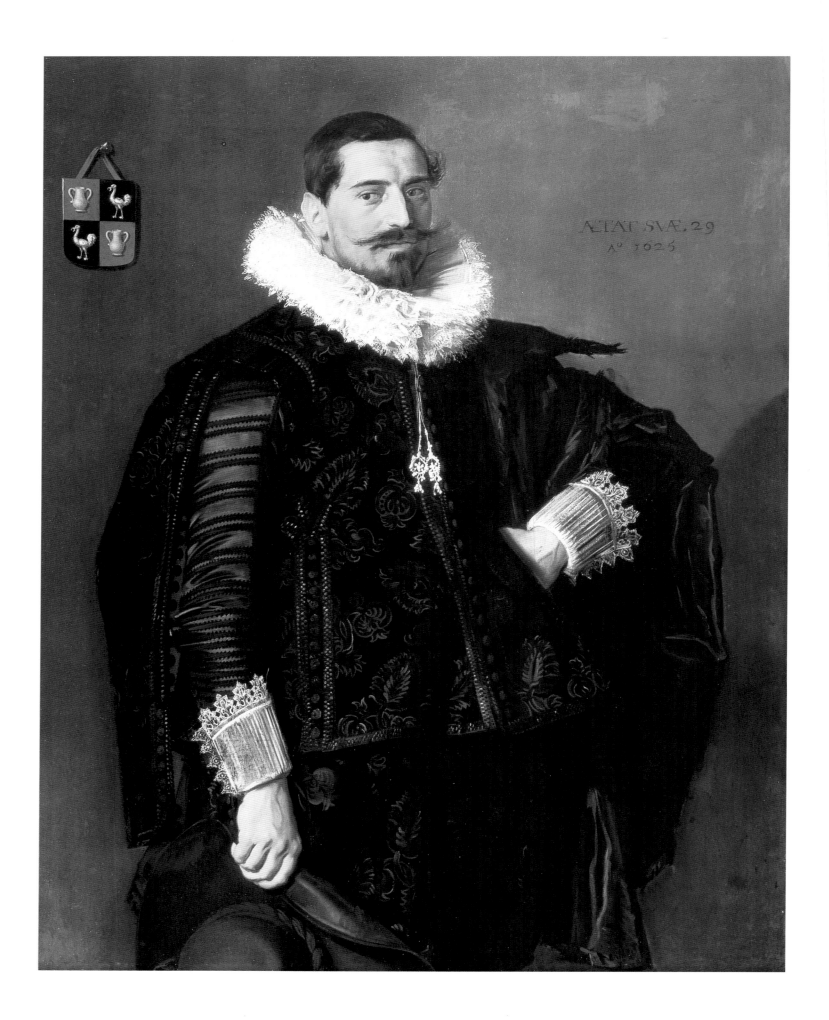

ÆTAT SVÆ. 29
Aº 1625

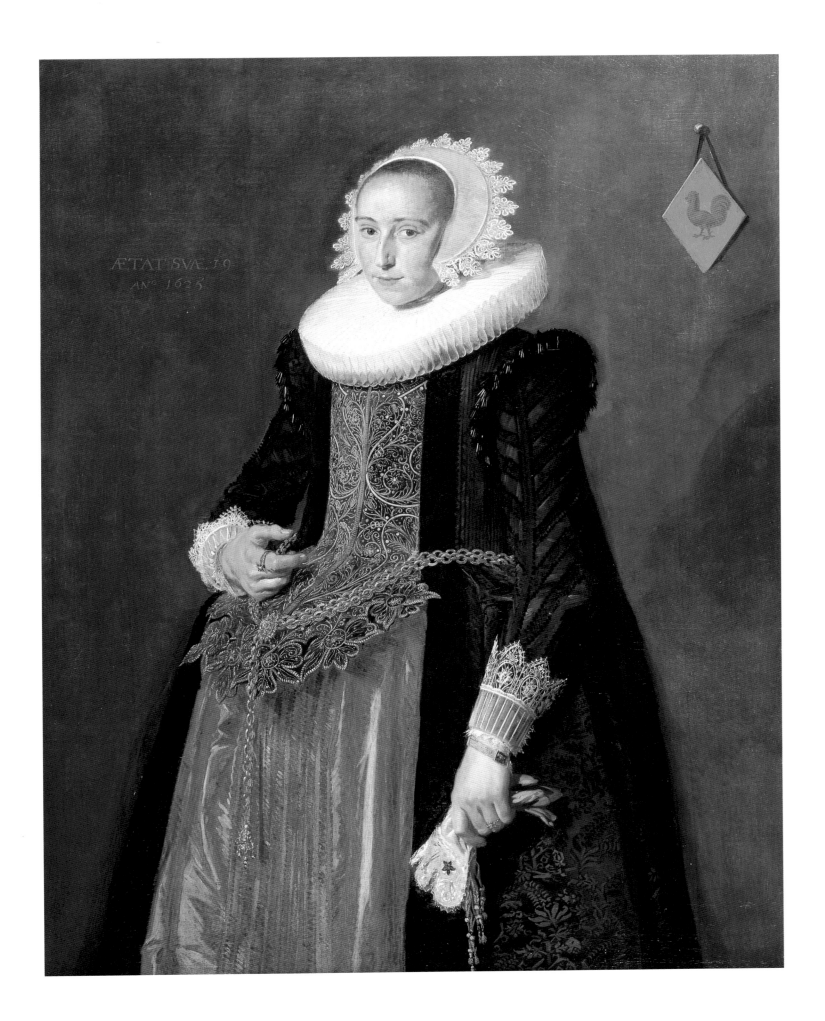

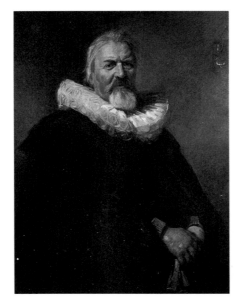

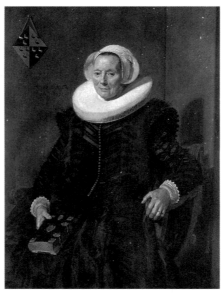

Fig. 18d *Pieter Jacobsz Olycan* (S128)
Sarasota, Florida, The John and Mable Ringling Museum of Art

Fig. 18e *Maritge Claesdr Vooght, wife of Pieter Jacobsz Olycan*, 1639 (S129)
Amsterdam, Rijksmuseum

society, in 1638, Hals painted their portraits to commemorate the event (fig. 18b, 18c). In the following year he painted Jacob's father and mother, Pieter Jacobsz Olycan and Maritge Claesdr Vooght (fig. 18d, 18e). And it seemed difficult for Hals to produce a group portrait of the officers of Haarlem's civic guards without portraying a member or future member of the family – a good indication of how tightly knit Haarlem's city council, whose members were elected by the council itself, and which supervised the appointment of the militia officers, kept the corps. Amongst the seven that can be identified are Nicolaes Jansz van Loo and Johan Claesz van Loo who appear as colonel and sergeant respectively in Hals's group portrait of *Officers and Sergeants of the St. George Civic Guard* of c.1639 (S124).[1] After Jacob Olycan's death in 1638, Johan van Loo became Aletta Hanemans's second husband and Nicolaes van Loo her father-in-law. Thyman Oosdorp (fig. 75b; S201), who commissioned a portrait from Hals datable 1656, and Cornelis Guldewagen (fig. 79a; S212), who sat for the artist in the early 1660s, were also part of the extended family.[2] In all, if the duplications in the guard pieces are counted, Hals painted eighteen portraits of the prominent Olycan family and their relatives by marriage.

PROVENANCE The pendants passed to Jacob Olycan's sister Maria Olycan-van Hoorn; after her marriage in 1662 to Cornelis Ascanius van Sypesteyn, they remained in the possession of the van Sypesteyn family (Broos 1987, pp. 181, 184, note 11). Sale anon., Amsterdam, 16 May 1877, no. 10 (the pair; both bought in by the van Sypesteyn family for Dfl. 19,580); the pendants were purchased by the Dutch government from the van Sypestein family for Dfl. 10,000 in 1880.

EXHIBITIONS Amsterdam 1945, nos. 34, 35; Paris 1986, no. 29 (fig. 1a, offered as yet another portrait of Olycan by Hals, is in fact a portrait of Michiel de Wael) and no. 30.

LITERATURE V. de Steurs, 'Twee portretten van Frans Hals', *Nederlandsche Kunstbode* III (1881), pp. 44-6; Bode 1883, 24, 25; *Icon. Bat.* nos. 5537-1, 3134, respectively; Moes 58, 59; HdG 208, 209; Bode-Binder 102, 103; KdK 42, 43; Trivas 18, 19; Slive 1970-4, vol. 1, pp. 50, 123-4; Grimm 19, 20; Montagni 35, 36; Catalogue Mauritshuis, The Hague, 1977, p. 103, nos. 459, 460; Smith 1982, pp. 96-101; Hoetink *et al.* 1985, pp. 194-5, no. 38, p. 371, nos. 459, 460; Broos 1987, pp. 181-3, no. 31.

1. The other five are: Jacob's brother Nicolaes, as a lieutenant in the St. Hadrian piece of c.1633 (Biesboer, fig. 5), which also includes his brother-in-law Johan Schatter as a captain (Biesboer, fig. 4) and his future brother-in-law Andries van Hoorn who held the same rank. Schatter appears as a captain, in the St. Hadrian banquet of c.1627 as well. Jacob's maternal uncle, Willem Claesz Vooght, is the colonel who has the place of honour at that feast (Biesboer, fig. 9).

2. Thyman Oosdorp married Jacob Olycan's sister, Hester Pietersdr (1608-54), in 1640. The identification of Hals's portrait at Berlin as Oosdorp is based on old inscriptions on the back of the painting, one of which states that it was painted in 1656, two years after Hester's death (see S201, and Biesboer, p. 28); its style is consistent with the date. Cornelis Guldewagen's sister-in-law was Maria Pietersdr. For more on the Olycan family, most of whom were brewers or married to the sons and daughters of brewers, see Biesboer, pp. 27-9.

Anna van der Aar

1626
Panel, 22.2 × 16.5 cm
Signed at the bottom of the moulding of the simulated oval frame
with the connected monogram FHF and dated 1626
Inscribed to the left of the model's head: A° AETAT/50
S37
The Metropolitan Museum of Art, New York, The H.O. Havemeyer
Collection (inv. 29.100.9)
Exhibited in Washington

The pendant of this exquisite small painting is Hals's portrait of *Petrus Scriverius* (fig. 20a), the sitter's husband. The two panels are identical in size, monogrammed and dated 1626, and have the same provenance. Their paint surfaces are generally well-preserved. However, there is a deep continuous vertical crack, flanked by other long cracks, near the center of the panel support of *Petrus*, which makes it potentially unstable; hence, his portrait could not be lent to the exhibition.

Investigation of the panel supports of both portraits indicates that differences in the cuts of the planks from which they were made helps explain the differences in their present state of preservation. Anna's panel was made from a plank that was sawn radially (at right angles to the annual rings), a cut that minimizes warping, whilst Petrus's was cut tangentially (parallel to the annual rings) and very close to the bark, a cut that is inherently less stable than a radial one. The panels also differ in species of wood. Anna's panel can be identified as fruit tree (pear or apple); Petrus's is of a dense tropical wood (Groen & Hendriks, p. 111).

The little that is known about Anna van der Aar links her to Leiden. She was born there (1576/7), it is where she married Petrus Scriverius (1599), and her friends presented her with an album of poetry when she celebrated her eightieth birthday in the city in 1656 (Wolleswinkel 1977, p. 109). Her husband, also known by his Dutch name Pieter Schrijver, was born in Haarlem (1576), studied at Leiden University and then settled in the city where he spent his long life (d. 1660) as an historian and poet.

Significantly, the fifty-year-old couple did not select a Leiden artist as their portraitist, but turned to Frans Hals of Haarlem. Schwartz (1985, p. 25) notes they had opportunities to sit for him in 1626, since in that year Scriverius had occasion to visit his nearby native city, first at the death of his parents who died there within eight days of each other in July, and again while helping prepare publication of Samuel Ampzing's *Beschryvinge ende lof der stad Haerlem in Holland*, which appeared in 1628. For Hals's little portrait of Ampzing and the references he made to the artist in his *Lof der stad Haerlem*, see cat. 40.[1]

In the small portraits Hals placed Anna and her husband behind simulated oval openings and, to heighten the illusionistic effect, he portrayed Scriverius with his hand extended beyond his painted frame. Porthole portraits of this type were used by classical Roman sculptors, revived by Renaissance artists, and were particularly popular during the late sixteenth century when Mannerist portraitists used simulated frames for inscriptions and as supports for rich emblematic displays. Shortly after the turn of the century, life-size, porthole portraits appeared in Holland and Hals soon followed the new vogue. His earliest existing one, painted about 1615, shows his sitter holding a miniature portrait in his hand extending beyond the painted frame (fig. 20b). We have seen that Hals again used the device for his 1622 life-size *Portrait of a Man* at Chatsworth (cat. 13). Frans continued to employ the scheme for large and small portraits until about 1640, when he – or his patrons – lost interest in such *trompe-l'oeil* effects (strictly speaking, of course, a tiny porthole portrait cannot be classified as a *trompe-l'oeil* – an effective one must be life-size). Rembrandt used simulated frames for some of his portrait etchings and continued to use the device after it had been abandoned by Hals. His 1646 etching of the minister Jan Cornelisz Sylvius (fig. 20c; Bartsch 280) shows the preacher with his hand poked beyond the frame in a manner that recalls portraits Hals did three decades earlier.

Hals's portrait of Scriverius was engraved by Jan van de Velde II (fig. 20d; inscribed: '... *A° 1626 ... Harlemi, Fr. Hals pinxit. I.v. Velde sculpsit.*' [Franken & van Kellen 33]). Typically, a print of the portrait of his wife is unknown. And typically, the anonymous Latin verse inscribed on the tablet below the engraved portrait praises the sitter's qualities but does not mention either the artist who painted it or the one who engraved it:

> You see here the face of one who, shunning public office,
> Makes the Muses his own at his own expense.
> He loves the privacy of his home, sells himself to none,
> Devoting all his hours of leisure to his fellow-citizens.
> While he castigates the faults and bland dreams of men of old,
> He is also afire to win the esteem of you, his fellow Batavians.
> Let gangs of workmen hired at great expense make a great din,
> A free right-hand will produce sincere work.

A glimpse of a way van de Velde's print of Scriverius was passed from hand to hand is found in the journal of the Utrecht jurist Arnoldus Buchelius (Arnout van Buchell). In an entry made in 1628 during a trip to Leiden, he wrote that his friend Theodorus Schrevelius, rector of the city's Latin school, gave him an impression of the engraving (Hals doc. 42). During the same visit he saw and admired Hals's own painted portrait of Schrevelius (ibid. and cat. 5).

Buchelius's citation of the print whets our appetite to know more. Did Schrevelius give him his only impression of it or did he have a stock on hand which he distributed to friends? Was the print made for private use or the open market? How many impressions were pulled from the plate? These questions and similar ones that can be posed about engravings done after Hals's portraits remain unanswered, although it is reasonable to assume that when a publisher's name is inscribed on a print (none are on impressions of van de Velde's engraving of Scriverius) it was intended for public distribution.

Additionally, nothing is known about the commissions Hals received for his works that were engraved. Again, it is reasonable to assume that contemporary engravings done after his life-size works were done as straightforward reproductive prints. But were any of his small painted portraits done expressly as *modelli* for engravers? Probably some were. To be sure, seventeenth-century engravers often worked from grisailles or *bruintjes* (monochromes in brown) rather than

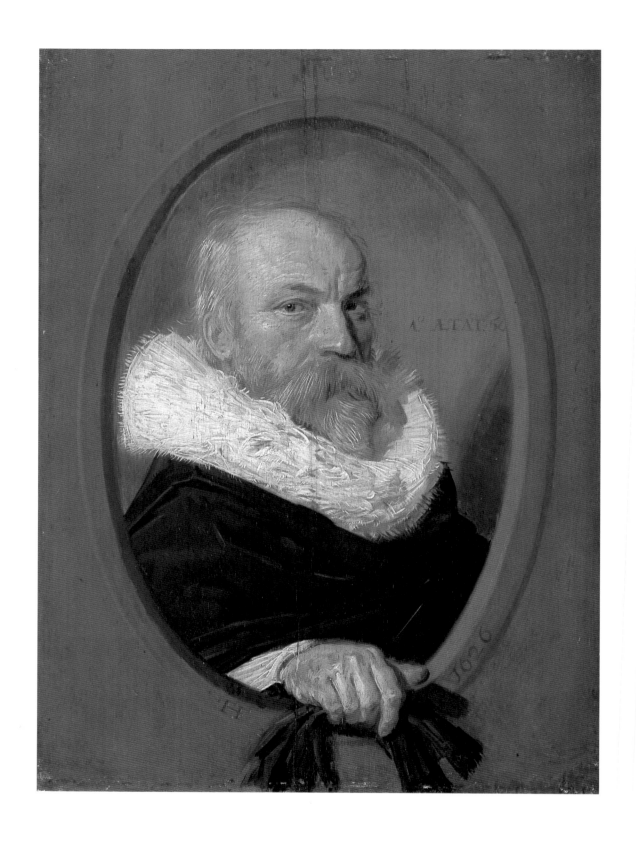

Fig. 20a *Petrus Scriverius*, 1626 (s36)
New York, The Metropolitan Museum of
Art, The H.O. Havemeyer Collection

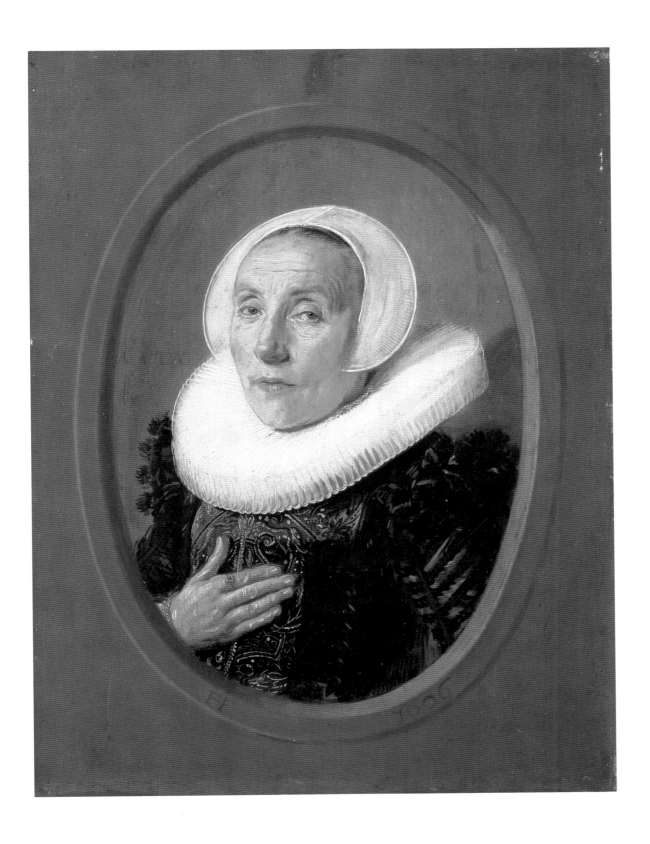

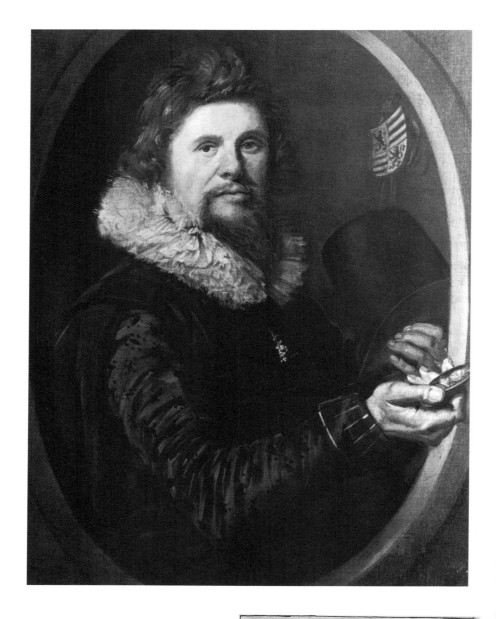

Fig. 20b *Portrait of a Man holding a Medallion* (s4)
Brooklyn, The Brooklyn Museum

Fig. 20c Rembrandt, *Jan Cornelisz Sylvius*, etching, 1646

Fig. 20d Jan van de Velde II, engraving after Hals's *Petrus Scriverius*

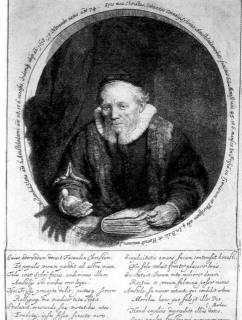

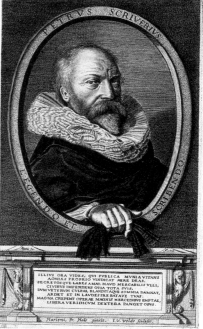

188

paintings done in colour; however, abundant evidence indicates that printmakers of the time had no difficulty translating colours into the black lines of their prints. Moreover, a *modello* in colour gave a patron a more lifelike small portrait for his cabinet than one done in greys or browns. In Hals's time the highest praise went to portraits that seem alive. The hoary trope was expressed repeatedly. Schrevelius, whose portrait, as we have seen, was painted by Hals, employed it, with specific reference to Hals's colours, when he extolled the artist's qualities in his *Harlemum ...*, 1647 (Dutch edition 1648; see cat. 5 and Hals doc. 116). Hals's portraits, he wrote, 'are coloured in such a way that they seem to live and breathe'.

When Petrus Scriverius's celebrated library and twenty-four paintings were auctioned at Amsterdam in 1663, amongst the pictures were three separate little paintings of musicians by Hals. They are identical with three little pictures from a Five Senses series by Hals that appeared in a 1661 inventory of the effects of Anna and Petrus's son Willem Schrijver (1608-61). Two of them are possibly identical with paintings now in a private Canadian collection (cat. 25, 26). Willem Schrijver was well-connected. He was the brother-in-law of the enormously wealthy and powerful Cornelis de Graeff, whose second wife was Catharina Hooft who was portrayed by Hals as a baby with her nurse about 1620 (cat. 9). Willem's collection also included three family portraits by Hals; they have not been identified but their subjects are known.[2] Thus Anna and Petrus's son had six Frans Hals paintings in his possession. Not a spectacular number. Yet it is the largest recorded contemporary collection of his works, apart from the nine listed in Jan van de Cappelle's posthumous inventory compiled in 1680 (see cat. 8).

By 1873 the little portraits of Anna and her husband were in the collection of the well-to-do textile manufacturer and *marchand-amateur* John W. Wilson (Brussels 1815-1883 Neuilly sur Seine) whose family settled in Haarlem after the Belgian revolt of 1830. He too managed to put together a noteworthy collection of Hals's works. In addition to the Scriverius pendants, Wilson owned three others. All are in the exhibition: Dublin's *Fisher Boy* (cat. 73), the portrait of *Pieter van den Broecke* from Kenwood House (cat. 44) and Prague's portrait of *Jaspar Schade* (cat. 62).

The existence of another portrait of Scriverius dated 1613 which is cited by Moes (*Icon. Bat.* no. 7130-31) is doubtful (see Slive 1970-4, vol. 3, no. 36).

PROVENANCE The pendants appeared together in the following collections: M.J. Caen van Maurik, Oudewater; dealer Etienne Le Roy, Brussels; John W. Wilson by 1873; his sale Paris, 14 March 1881, nos. 56, 57 (the pair: fr. 80,000, Petit; the catalogue notes Petrus Scriverius was engraved by J. van de Velde and reproduces his print); sale E. Secrétan, Paris, 1 July 1889, nos. 124, 125 (the pair: fr. 91,000, Petit); dealer Durand-Ruel, Paris; H.O. Havemeyer (until 1907); Mrs. H.O. Havemeyer, New York (1907-29), who bequeathed them to the museum, 1929.

EXHIBITIONS The paintings were exhibited together in the following exhibitions: Brussels 1873, pp. 81-2 (with etchings of both portraits by Adrien Didier [1838-after 1885]); Paris 1874, nos. 231, 232; Detroit 1935, nos. 6, 7; New York 1973a, no. 4 (the pair).

LITERATURE The pair is cited together in the following references: Tardieu 1873, p. 219; Paul Eudel, *L'Hôtel Drouot en 1881*, Paris 1882, p. 72; Bode 1883, 65, 66; *Icon. Bat.* nos. 7 (Anna), 7130-2 (Petrus); Moes 72, 73; HdG 224, 225; Bode-Binder 106, 107; KdK 50 left and right; Valentiner 1936, 17, 18 (erroneously described as oval panels); Slive 1970-4, vol. 1, pp. 58-9, 77; Grimm, pp. 29, 63, A9, A10 (copies); Montagni 45, 46 (probably copies); Wolleswinkel 1977, pp. 109-10, 114-5 (both by Hals); Strauss & van der Meulen 1979, p. 61, no. 1628/1; Baetjer 1980, vol. 1, p. 83, vol. 3, p. 399 (both by Hals); van Thiel 1980, p. 118 (Scriverius cited as the type of *modello* Hals prepared for Jan van de Velde's engraved portraits after his works).

1. The poems inscribed below two engravings after Hals's portrait of Ampzing most probably were written by Scriverius (see cat. 40). He also composed the verse on an engraving Jacob Matham made in 1618 of Hals's small portrait of Theodorus Schrevelius (cat. 5, fig. 5a), and is the author of one of the poems inscribed below Rembrandt's etching of Sylvius (fig. 20c). The other poem on Rembrandt's etched portrait is by Casper van Baerle, the author of the verse that accompanies Jonas Suyderhoef's engraving of Hals's little portrait of Schrevelius mentioned in cat. 5. Clearly some of Hals's and Rembrandt's patrons and their friends were in close contact. But we only can speculate if Hals and Rembrandt ever met, and what they would have discussed if they had an opportunity to compare notes.

2. See Hals doc. 166 for a discussion of the untraceable Hals paintings in Willem Schrijver's 1661 inventory and references to the auction in 1663 of the three little Five Senses pictures he owned. Three of Willem's family portraits by Hals can be traced back to an inventory made in 1657 of the effects of Floris Soop, the nephew of Anna and Petrus. When they were with Floris, they were in good company. His inventory includes a reference to a portrait of him which has been identified as Rembrandt's *Portrait of a Standard Bearer* of 1654 (Bredius-Gerson 275), now at the Metropolitan Museum (see Hals doc. 166).

21 Isaac Abrahamsz Massa

1626
Canvas, 79.5 × 65 cm
Inscribed and dated on an upright of the chair: AETA/41/1626
S42
Art Gallery of Ontario, Toronto, Bequest of Frank P. Wood, 1955
(inv. 54/31)

Although Isaac Abrahamsz Massa's name suggests a Jewish origin, it will be recalled that Dutch Protestants, as other Protestants, often gave and still give their children Old Testament names. Isaac was baptised at St. Bavo's Church in Haarlem in 1586 and was buried there in 1643 (not 1635); the vital statistics of other members of the family indicate they too were Calvinists. His family, like Hals's, emigrated from Antwerp, most probably after the city fell to the Spanish in 1585.

Hals painted Massa at least twice, once in this portrait of 1626 and again in about 1635 (cat. 48). Some students maintain that Amsterdam's *Married Couple* (cat. 12), datable about 1622, is a portrait of him and his first wife Beatrix van der Laen, daughter of a former Haarlem burgomaster, and was made to celebrate their marriage in Haarlem on 25 April 1622.[1] Much less convincing is the proposal that Hals's unusual portrait of a man with folded arms at Chatsworth of 1622 (cat. 13) is a portrayal of him.

In any event, Frans and Isaac must have been friends since Massa stood as a witness to the baptism of Hals's daughter Adriaentje in 1623 (Hals doc. 29). Other members of their families had close contact too, not all of it pleasant. In 1640 Hals's daughter Sara gave birth to an illegitimate daughter (Hals doc. 91). The midwives who attended her testified they heard her say in her deepest distress that Abraham Potterloo, the son of Susanna Massa, was the father of the child, and no one else. The father was Isaac Massa's nephew.[2]

As a boy, Isaac was apprenticed to Amsterdam merchants who traded with Russia. In 1600, at the age of thirteen, he travelled there, living with his employer for eight years. He became fluent in Russian, a skill that served him well on five later trade and diplomatic missions to the country, and in his own country as a diplomatic agent and translator. During his first long stay he witnessed Russia's 'Times of Troubles' when the country was plagued by war, famine and intrigue. He took copious notes on the harrowing events he saw, and managed to obtain a unique map of seventeenth-century Moscow, which, he wrote, was procured with great difficulty, because in 1605 it was considered an act of treason for a Moscovite to give one to a foreigner.

Upon his return to Holland Massa wrote his *Short History of the Beginnings and Origins of These Present Wars in Moscow under the Reigns of Various Sovereigns down to the Year 1610*, which he presented in manuscript to Maurits of Nassau, Prince of Orange. His history includes a rare account of the life and murder of the False Dimitri, the pretender who became Tzar after Boris Godunov's death. Since its first publication in 1866, it has been an important source for historians of the period. Massa also made contributions as a geographer and cartographer. He translated from the Russian accounts of Siberian topography, and his valuable maps of Siberia were the first to appear in the West. Although he was awarded a gold medal by the States-General in 1616 in recognition of his services after a mission to Moscow, his relations with the assembly at The Hague were not untroubled. His contacts in Sweden were more amicable. In 1625 King Gustavus Adolphus granted him a patent of nobility. The verse below Adriaen Matham's engraved copy after Hals's small

portrait of Massa done about 1635 refers to this honour, as well as to his difficulties at home (see cat. 48).

The Toronto portrait was first recognised as Massa in 1937, when van Rijckevorsel observed that the sitter bears an unmistakable resemblance to Hals's securely identified little portrait of him (cat. 48). The identification proved that Valentiner's repeated attempts to establish that the Toronto painting is a self-portrait were futile (Valentiner 1925; 1935; 1936). The wiry lettering and numerals of the date 1626 inscribed on the chair have nothing in common with Hals's other inscriptions of the twenties. However, to judge from the portrait's style, there is no reason to doubt the date the inscription provides; it may have been copied from the back of the canvas during an old relining.

The portrait, an outstanding example of Hals's vivid characterisations and power to paint a momentary pose and instantaneous expression, is the earliest known single portrait of an informally seated model turned in a chair with his arm resting on its back. Mannerist artists made some attempts in this direction, but in their work movement is never as lively, nor is life so convincingly grasped as something moving in space and time.

After Hals invented the casual pose, he used it for portraits done during the course of the following four decades. Five that employ it are in the exhibition (cat. 59, 61, 77, 82, 83); three others are known (s86, s167, s186). A review of them indicates that he cannot be charged with copying himself.

Fig. 21a Max Beckmann, *Self-Portrait*, 1944 Munich, Bayerische Staatsgemäldesammlungen, (inv. 10974)

190

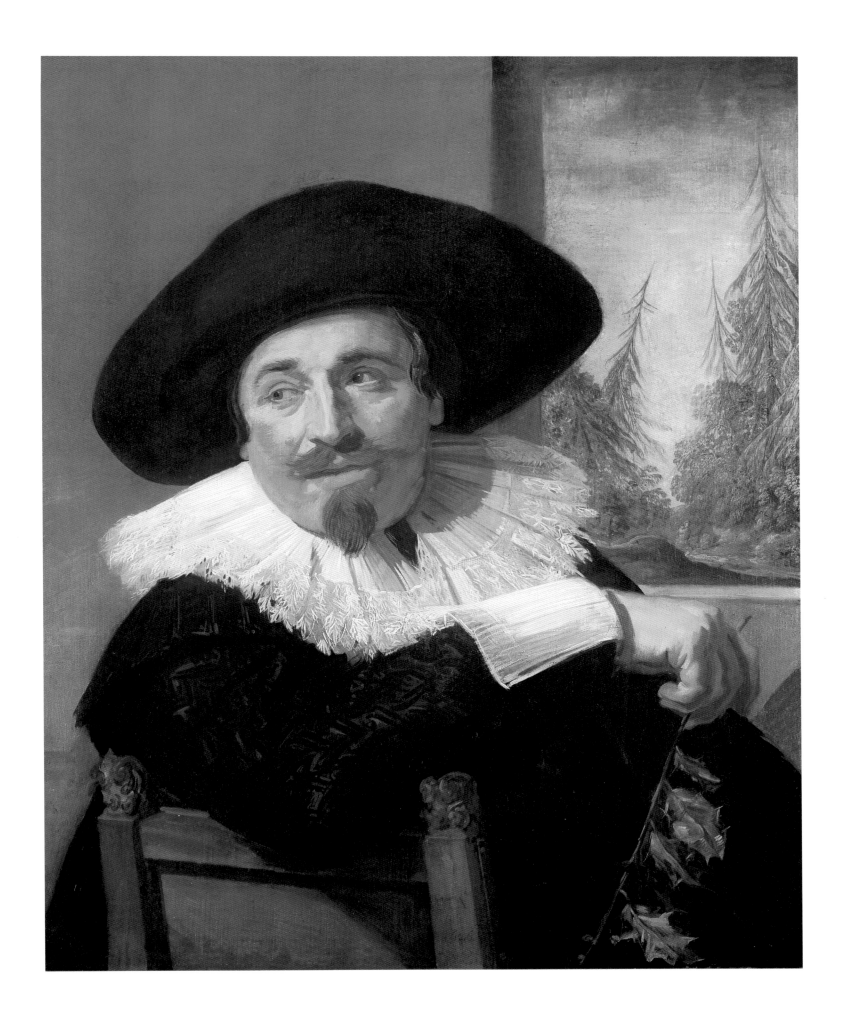

Fig. 21b Detail from *Isaac Abrahamsz Massa*

Fig. 21c Pieter Molijn, *Landscape with Pines*, drawing
Munich, Staatliche Graphische Sammlungen (inv. 21130)

They are variations on the theme he invented. The pose was quickly adopted by other Dutch artists, as well as an international group of portraitists, and it remained popular during the following centuries. Max Beckmann's *Self-Portrait* of 1944 (fig. 21a) ultimately is derived from the scheme Hals introduced in 1626.

The sprig of holly Massa holds can be read as a traditional allusion to friendship or, perhaps, constancy. More unusual is the view of a northern landscape in the background (fig. 21b). Hals almost invariably employed neutral backgrounds for his single portraits. The landscape probably is a reference to Massa's activities in Russia – by the time the portrait was painted he had completed his fifth journey to the country. The possibility that it alludes to Sweden, where he was promoted to the nobility a year before the portrait was painted, is less likely.

Not a passage in the exceptional landscape reveals the hatched brushwork that is characteristic during this phase and so evident on Massa's collar and his sprig of holly. The hypothesis that Frans may have used one mode of painting for his sitters and another for landscapes during these years is weakened when we see that his personal touch is as evident in the landscape backgrounds of the *Married Couple* of about 1622 (cat. 12) and in his portrait of *Willem van Heythuysen* done only a few years later (cat. 17) as it is in the figures in these paintings. In my view, the landscape is by the Haarlem landscape specialist Pieter Molijn (1595-1661) whose drawings and paintings of the mid-twenties are strikingly similar to it. Molijn's drawing at Munich (fig. 21c), for example, shows the same type of wind-whipped firs. Other landscapes done at this time display the long, liquid strokes of the pinaceous trees and the tiny dabs and touches of the heavy foliage seen in the landscape. For additional examples of collaboration between the two artists, see cat. 49, 57.

1. Beatrix van der Laen's mother was the sister of Paulus van Beresteyn, whose portrait was painted by Hals *c.*1620 (cat. 6), another case that shows the close family relationships between Hals's clients. For the van der Laens, see Dólleman & Schutte 1969, and Biesboer, p. 30.

2. Upon further questioning if she had relations with other men, Sara replied 'Yes, I have been with more.' (Hals doc. 93). Sara's morals remained lax. In 1642 she was pregnant again with an illegitimate child. Upon this occasion, at the request of her mother, she was confined to Haarlem's workhouse because of fornication (Hals doc. 92). Sara was married in 1645, but not to Abraham Potterloo (see Hals docs. 109, 110). Abraham's mother, Susanna Massa, must have been close to the Hals family; she was a witness at the baptism of one of Dirck Hals's children in 1624 (under Hals doc. 4).

PROVENANCE Earl Spencer, Althorp Park, Northampton; Duveen Brothers, New York; Frank P. Wood, Toronto, who bequeathed it to the gallery in 1955; stolen in September 1959, and returned to the gallery in the same year.

EXHIBITIONS London, Royal Academy, Winter Exhibition, 1907, no. 41; Toronto 1926, no. 149; London 1929, no. 376; Haarlem 1937, no. 25; Chicago 1942, no. 10; Montreal 1944, no. 25; New York, Toledo & Toronto 1954-5, no. 30; Indianapolis & San Diego 1958, no. 47; Raleigh 1959, no. 56; Haarlem 1962, no. 13; Montreal 1967, no. 23; New Brunswick 1983, no. 67.

LITERATURE *Catalogue of the Pictures at Althorp House, in the County of Northampton, with Occasional Notices, Biographical or Historical*, 1851, p. 63, no. 262 ('Frank Hals. Himself.'); A. van der Linde, *Isaac Massa van Haarlem*, Amsterdam 1864; *Histoire des guerres de la Moscovie (1601-1610) par Isaac Massa de Haarlem*, ed. Michael Obolensky & A. van der Linde, Brussels 1866; Moes 122; HdG 246; Bode-Binder 108; KdK 45; Valentiner 1925, pp. 148ff. (self-portrait); Valentiner 1935, pp. 90-5 (self-portrait); Valentiner 1936, 14 (self-portrait); van Rijckevorsel 1937, pp. 173-5 (identification of the sitter as Massa); Trivas 20; J. A. Leerink, 'Een Nederlandsche cartograaph in Rusland: Amsterdam-Moskou in de zeventiende eeuw', *Phoenix* 1 (1946), pp. 1-17; Johannes Keuning, 'Isaac Massa, 1586-1643', *Imago Mundi, A Review of Early Cartography* x (1953), pp. 65ff.; Hubbard 1956, pp. 78, 151, repr. pl. XXXVII; de Jongh & Vinken 1961, pp. 146-7; Seymour Slive, 'Master Works in Canada, No. 7, Frans Hals, Isaac Abrahamsz. Massa', *Canadian Art* XXIII (1966), pp. 42-3; Slive 1970-4, vol. 1, pp. 54-8 (landscape by Molijn); Grimm 22; Montagni 48; Handbook Art Gallery of Ontario, Toronto, 1974, p. 41 (landscape possibly by Pieter Molijn); Baard 1981, p. 94; Isaac Massa, *A Short History of the Beginnings and Origins of These Present Wars in Moscow under the Reigns of Various Sovereigns down to the Year 1610*, trans. with intro. by G. Edward Orchard, Toronto 1982; Smith 1986, pp. 17-8.

*c.*1625
Canvas, 70 × 55 cm
Above the head of the ox there appear to be indistinct traces of the connected monogram: FH. Inscribed at a later date with an inventory number in the lower right corner: '1895', and another by a different hand in the lower left corner: '1914'
S43
Museum of Western European and Oriental Art, Odessa (inv. 181)

*c.*1625
Canvas, 70 × 55 cm
Inscribed at a later date with an inventory number in the lower right corner: '1896', and another by a different hand in the lower left corner: '1908'
S44
Museum of Western European and Oriental Art, Odessa (inv. 180)

These remarkable paintings belong to a series of the Four Evangelists. References to the set in old auction catalogues were known to nineteenth-century historians (Kramm 1858; Bode 1883), and Hofstede de Groot scrupulously recorded them in his 1911 catalogue. However, few students took these ascriptions seriously. Knowing that old attributions, like more recent ones, can be dead wrong, most specialists believed the chance of finding Evangelists portrayed by the artist who painted *The Laughing Cavalier* and *Malle Babbe* were about as great as discovering still-lifes by Michelangelo. But the discovery was made when Irene Linnik recognised two paintings she found gathering dust in a storeroom of the Odessa museum, where they were attributed to an unknown nineteenth-century Russian artist, as Hals's lost *St. Luke* and *St. Matthew*. She published her important find in 1959.

It has been possible to reconstruct much of the history of Hals's four Evangelists from the time they made their first recorded appearance in a 1760 auction at The Hague where they were purchased by Jan Yver, a Dutch art expert and auctioneer. They appeared again in a sale at The Hague in April, 1771. A few weeks later they were sold at Amsterdam where Jan Yver once again purchased them. In 1771, the same year Yver acquired the set, he was commissioned to buy paintings for the wonderous collection Catherine II was a-massing for the Imperial Hermitage at St. Petersburg. Documentary evidence that *St. Luke* and *St. Matthew* were amongst the paintings Yver sent to Russia is provided by the numbers inscribed in their lower right corners: 1895 (*Luke*), 1896 (*Matthew*). These are the inventory numbers assigned to the two pictures in the 1773 catalogue of the Hermitage's

paintings. Compiled by Ernst Minich, it was the first catalogue made of the collection (*St. Mark* and *St. John* were numbered 1894 and 1897, respectively). Furthermore, the descriptions and measurements of the four Evangelists given in the 1773 catalogue coincide with those sold in Holland in 1760 and 1771.

Minich wrote that Hals's Evangelists were very expressive and painted with the mastery of a quick brush. Another generation evidently thought less highly of them. In 1812 Tsar Alexander I ordered F. Labensky, then head of the painting collection at the Hermitage, to select a group of pictures for the decoration of churches in Tauride Province in the Crimea. Thirty paintings were chosen, amongst them the four Evangelists. They left St. Petersburg for their trip south on 20 March 1812. It has not been determined when the set was broken, when the pictures lost their correct attributions, or how two of them found their way to Odessa.

After Linnik made her discovery, another part of the history of the Evangelists was literally revealed in 1973 when Grimm studied a *Portrait of a Bearded Man holding a Bible* (fig. 22a), which was purchased in 1955 as a Luca Giordano by Silvio Severi of Milan. Severi recognised Hals's connected monogram on the work (to the right of the model's head) and realised that the sitter's head is similar to Hals's *St. Luke*.[1] Grimm astutely assumed that the portrait must have been considerably reworked by another hand. A technical examination proved he was correct. Paint samples of the collar and clumsy cuffs showed small traces of chromium oxide green (veridian), a pigment not available before the nineteenth century, and other samples revealed two different grounds, paint

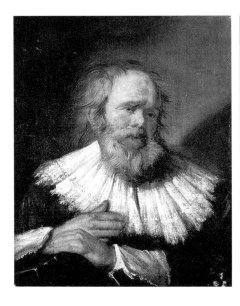
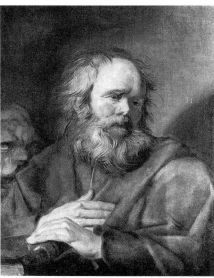

◁
Fig. 22a *St. Mark*, before removal of overpaint
Private collection

Fig. 22b *St. Mark*, after restoration
Private collection

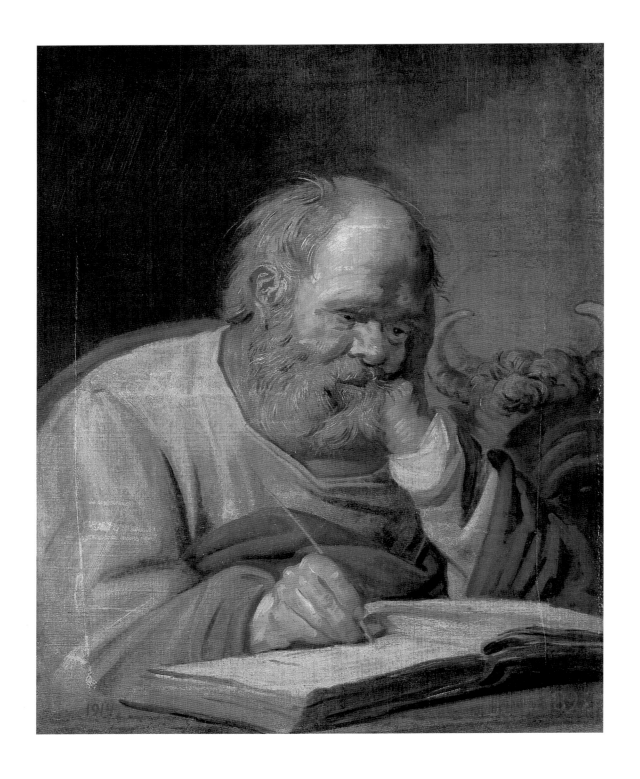

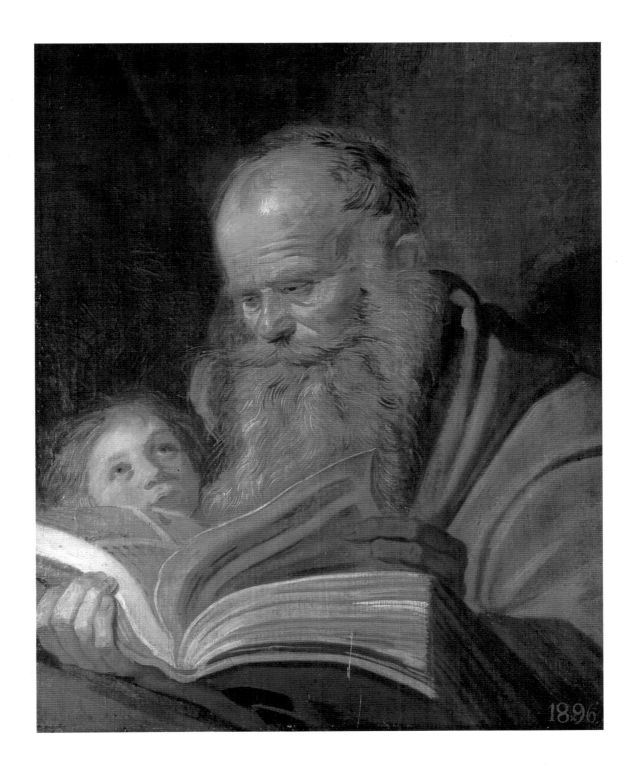

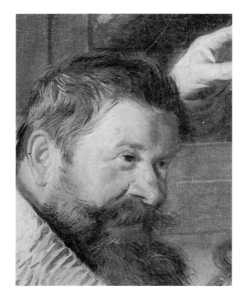

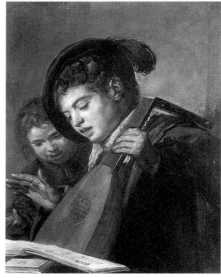

◁

Fig. 22c Detail of Johan Damius from *Banquet of the Officers of the St. Hadrian Civic Guard*, c.1627 (s45)
Haarlem, Frans Halsmuseum

Fig. 22d *Two Singing Boys* (s23)
Kassel, Staatliche Kunstsammlungen

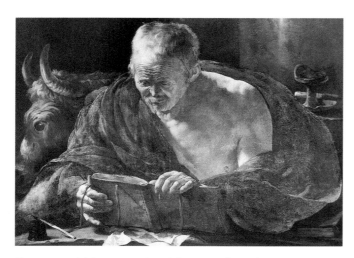

Fig. 22e Hendrick ter Brugghen, *The Evangelist Luke*, 1621
Deventer, Stadhuis

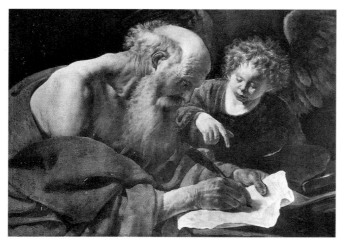

Fig. 22f Hendrick ter Brugghen, *The Evangelist Matthew*, 1621
Deventer, Stadhuis

layers and surface coatings. Removal of extensive repaint revealed *St. Mark* (fig. 22b; canvas, 69.2 × 52.2 cm), the third Evangelist of the series. Repaint had covered the lion, Mark's attribute, and had transformed the saint's robes into a Dutch costume of the 1630s (Grimm 1974). The original paint surface of the areas that had been blotted out is now generally abraded.

Was *St. John*, Hals's fourth Evangelist, subjected to the kind of treatment *St. Mark* received? A search has revealed nothing. Since an untraced drawing of *St. Luke* after Frans Hals by the Haarlem artist Frans Decker (or Dekker; 1684-1751) that appeared in a 1775 sale (C. van den Berg, Haarlem, 29 August 1775, no. 247: *St. Lucas naar F. Hals, door F. Dekker*), was possibly a copy after the painting now in Odessa, there is a slim chance that a copy of *St. John* may turn up. If it does, it will be a precious document.

The style of the Evangelists is entirely consistent with the artist's works datable to the 1620s. Passages in them are enlivened by the swift, fluid brushstrokes that make their appearance in genre works datable before the middle of the twenties and which are found in commissioned portraits painted later in the decade. The handling of the head of St. Luke and Hals's portrayal of Johan Damius (fig. 22c), an officer seen in his St. Hadrian banquet piece of c.1627, could hardly be more alike. The pentimenti in Luke's ox, now evident because of abrasion in the background, clearly indicate that Frans had a second thought about the place of the saint's attribute. The composition as well as the touch in *St. Matthew* is closely related to the artist's *Two Singing Boys*, datable c.1623-5, at Kassel (fig. 22d) and to his *Two Laughing Boys* at Leerdam painted a few years later (fig. 25a; s60). The little boy who serves as an angel, Matthew's attribute, is a first cousin of the lads in the Kassel and Leerdam pictures. It is notable that Hals did not find it necessary to provide Matthew's angel with wings. In both paintings the drapery is broadly mapped and some passages are mechanical and even awkward (Luke's left sleeve and the angular neckline of his garment; Matthew's hands and huge book). Hals, *au fond* a portraitist, with characteristically free and impulsive brushwork, concentrated on the heads: Luke convincingly lost in

thought, Matthew studying a text under the admiring gaze of his little angel.

Hals followed a well-established Netherlandish pictorial tradition when he painted his half-lengths of the Evangelists with their attributes. Most celebrated today are those by Hendrick ter Brugghen, dated 1621 (two are reproduced here: figs. 22e, 22f), and other Utrecht Caravaggisti whose works he conceivably could have known. A host of other Dutch painters and printmakers produced them as well. Nevertheless, no specific model can be cited as a source for his series. At this stage in his career, he did not need one. His set, like others, possibly was painted for a private chapel or a clandestine Catholic church (schuilkerk). In Haarlem Catholic services were forbidden in April 1581, but soon afterwards hidden churches were consecrated, usually in homes, and were tolerated, as they were elsewhere in Holland, by the city's officials.

There also is evidence that in Hals's time at least one set of paintings of the Four Evangelists hung in a private Protestant house in Haarlem. The inventory made of the pictures and other effects in Willem van Heythuysen's large house on the Oude Gracht after his death in 1650 lists a set in the entry hall (voorhuys). Although none of the paintings cited in that inventory are given attributions, it is almost certain that Hals's two remarkable portraits of Heythuysen are listed in it (see cat. 17, 51). It is nice to think that this wealthy patron owned Hals's Four Evangelists as well. Regrettably the thought must be dismissed. The inventory specifically describes his set as painted in 'white and black' ('De vyer Evangeliste in wit en swart geschildert' [Haarlem City Archives, Not. Prot. 153, fol. 328; Biesboer, note 19]). Obviously Hals's Evangelists are not grisailles, and to our knowledge it is a technique he never employed.

The Evangelists remain exceedingly exceptional works in Hals's œuvre. Apart from them, and one or perhaps two others which may be identical with his Prodigal Son paintings cited in 1646 and 1647 Amsterdam inventories (Hals docs. 115, 119), no other biblical subjects by Hals have been identified. His Prodigal Son pictures may be identical with his so-called Jonker Ramp and his Sweetheart, 1623, now at the Metropolitan Museum (pl. III; S20) or a lost Banquet in a Park attributable to him, that was formerly in Berlin (S.L1). Both paintings can be classified with a group of Netherlandish depictions of the Prodigal Son in a contemporary setting, wasting his substance with loose women. There are only four other references to religious pictures attributed to him in old sale catalogues; they remain unverifiable and untraceable.[2]

Not enough is known about Hals's religious faith to attempt a correlation between it and the rarity of his religious pictures. It has been established that his father was listed as a Catholic in Antwerp in 1585 (Hals doc. 2), but there is no evidence that he remained one after he emigrated north. As many Netherlanders of his day mature Franchois Hals may have challenged and changed his faith. As for his son, the material found in Haarlem's archives links Frans to the Dutch Reformed Church; his first and second wives were members of it and he became a confirmed member in 1655 (Hals doc. 151).

We have no idea if Hals was a devout, church-going man, but, when we consider that he depicted only a handful of biblical pictures during a career that spans more than five decades, it is evident that he neither had a strong inner urge to paint Old or New Testament subjects nor made much of an effort to find patrons who would commission them. After painting his Evangelists, he apparently was quite content not to compete with Frans de Grebber and his son Pieter, Salomon de Bray and his son Jan, and Pieter Soutman, the artists who were Haarlem's leading history painters. The de Grebbers, the de Brays and Soutman all were Catholics, a fact that certainly helps account for commissions they received for religious pictures. However, it will be recalled that many Dutch Protestant artists also depicted them. The most notable one of course was Rembrandt.

1. The painting was offered in the sale anon., London (Christie's), 20 October 1972, no. 83, as 'Portrait of a Bearded Man' by F. Hals; Provenance: Mattioli family, Salerno (bought in).

2. Still missing are: The Denial of Peter (HdG 3; canvas, 121.5 × 225.4 cm; sale P. Bout, The Hague, 20 April 1779, no. 5 (Dfl. 17,10); The Magdalene (HdG 8; panel, 48 × 38.4 cm; sale F.H. de Groof, Antwerp, 20 March 1854, no. 64); St. Francis praying in a Landscape, ascribed to Hals, and a Virgin and Child with St. Anthony in a Desert, with the unlikely attribution to him and Gaspar de Crayer, which appeared in a sale at Ghent in 1838 (sale, A.M. Vissers, widow of P.B. Emmanuel, Ghent, 21 November 1838, nos. 23, 24). In connection with these old unverifiable attributions, it should be noted that a David with the Head of Goliath at Copenhagen was acquired in 1755 as a Frans Hals and bore his name for about a century, but no one in our time with a nodding acquaintance with his work would ascribe it to him. The painting subsequently was attributed to Jan de Bray, Jacob Backer and Pieter de Grebber (see Catalogue Royal Museum of Fine Arts, Copenhagen, 1951, no. 14, repr.). One other religious picture related to Hals is worth mentioning. A St. Peter catalogued as in the style of Hals appeared in a sale at Amsterdam (26 September 1763, no. 118: 'St. Petrus, in de manier van F. Hals'; Dfl. 12). Possibly it was identical with a Head of St. Peter by Jan Hals, alias the Golden Ass, which was sold at the sale Joshua van Belle, 6 September 1730, no. 42 ('Een trony van St. Peter, door Jan Hals alias den Gulden Ezel, h. 1 v. 6 d., br. 11½ d.; fl. 16'). Since Bredius first published this reference (1888a, p. 304), it has been assumed that Jan the Golden Ass is identical with Frans Hals's son Jan Hals (c. 1620 – before 11 November 1654), and it also has been assumed that Jan visited Rome where he acquired his nickname when he joined the Bentveughels. However, van Thiel-Stroman (under Hals doc. 123) rightly stresses that the identification is not supported by contemporary documents nor by the style or subject of works that can be securely attributed to Frans's son Jan.

For a reference made in 1654 to an untraceable Preaching of St. John the Baptist by Hals's oldest son Harmen (1611-69), see Hals doc. 147; only Harmen's genre pieces have been identified.

PROVENANCE Sale Gerard Hoet, The Hague, 25 August 1760, no. 134: 'De vier Evangelisten, zynde vier Borst-Stukken met Handen, door F. Hals; hoog 26½, breet 21 duimen' (Dfl. 120, Jan Yver); sale The Hague, 13 April 1771, no. 35 (the four Evangelists as a lot); sale F.W. Baron van Borck, Amsterdam, 1 May 1771, no. 34 (the four as a lot; Dfl. 33, Jan Yver); the set of four acquired by Catherine II for the Imperial Hermitage by 1773; the set of four removed from the Hermitage 20 March 1812 and sent to Tauride Province in Crimea; Picture Gallery of Russian Art, Odessa; delivered to the Odessa Museum of Western Art in 1920.

EXHIBITION Haarlem 1962, nos. 77, 78; on loan to the Hermitage, Leningrad 1960 and September 1962, and to Pushkin State Museum of Art, Moscow, 1965.

LITERATURE Terwesten 1770, vol. 3, p. 231, no. 124; Minich 1774, nos. 1895, 1896; Kramm 1858, vol. 2, p. 362; Lacroix, 1862, p. 114, nos. 1895, 1896 (reprint of Minich 1774); Bode 1883, p. 70, note 1; HdG 4-7; I. Linnik, 'Newly Discovered Paintings by Frans Hals', Iskusstvo, 1959, no. 10, pp. 70-6 (Russian text); I. Linnik, 'Rediscovered Paintings by Frans Hals', Soobcheniia Gosudarstvennogo Ermitazha, XVII (1960), pp. 40-6 (Russian text); Slive 1961, pp. 174-6; Slive 1970-4, vol. 1, pp. 100-3; Grimm 40, 41 (c. 1627), Catalogue Museum of Western European and Oriental Art, Odessa, 1973, p. 27; Claus Grimm, 'St. Markus von Frans Hals', Maltechnik/Restauro 1 (1974), pp. 21-31; Montagni 41, 42 (c. 1625); Kuznetsov & Linnik 1982, nos. 125, 126.

*c.*1627
Panel, 46.7 × 35.6 cm
Signed on the right above the collar: FHF (the last two letters in monogram)
S57
National Galleries of Scotland, Edinburgh (inv. 1200)
Exhibited in London and Haarlem

Verdonck is one of Hals's paintings that was subjected to a radical transformation by another hand (for others that suffered from significant later alterations, see under cat. 22 and cat. 73). When it was given to the National Gallery of Scotland in 1916, it justifiably was called 'The Toper' since it showed the shaggy man holding a short stemmed goblet, not a jawbone; and he was not bareheaded but wore a large, claret-coloured, velvet beret (fig. 24a). Hofstede de Groot (77) catalogued the painting in this form. In 1927 the Dutch restorer A.M. de Wild suggested the beret and glass were later additions. His observations were sound. The beret was crudely painted and the shape and decoration of the goblet were almost as preposterous as the manner in which the glass was held. Additionally, de Wild recognised that the original picture is identical with a contemporary engraving of it (in reverse) by Jan van de Velde II (fig. 24b; Franken & van der Kellen 42) which includes a quatrain that identifies the subject:

This is Verdonck, the brazen fellow,
Whose jawbone assails one and all.
He cares for none, neither great or small,
And thus to the workhouse was sent.
(*Dit is Verdonck, die stoute gast,*
Wiens kaekebeen elck een aen tast.
Op niemant, groot, noch kleijn, hij past,
Dies raeckte hij in't werckhuis vast.)

Radiographs and cleaning tests proved that de Wild's observations regarding the later additions were correct. After he removed the glass, beret and other repaint, the original painting of Verdonck's huge jawbone and unruly hair were found intact.

De Wild published his findings and the procedure he used for cleaning the picture in *Technische Mitteilungen für Malerei* in 1930. The appearance of de Wild's article prompted H. Birzeniek, then secretary of Riga's Art Museum, to send a letter to the editor of the journal which purported to tell why and how *Verdonck* was repainted. To preserve the anonymity of the people who played the leading roles in his report, he used initials instead of names.

During the 1890s, Birzeniek wrote, the Chamberlain S.N.N. collected old Dutch pictures in St. Petersburg. His wife, who ruled their household, did not share his passion for collecting, and under no circumstances would allow a painting she did not find pretty to enter the house. When S.N.N. arrived home one day with the picture we now know as Hals's *Verdonck*, she found it horrid. An unkempt fellow holding a jawbone was not permitted to cross their threshold, she maintained. What was to be done?

S.N.N. took his treasure to the St. Petersburg picture restorer J.L.N. and asked him to beautify it. The sensitive restorer refused. It would be sacrilegious to alter a single stroke painted by the great Dutch master. S.N.N. then played his trump card. If J.L.N. would not make the necessary changes, he would go elsewhere to have them done. The virtuous restorer was caught – a man who did not know his

business might ruin the picture. Therefore he agreed to do the work. He first coated the painting with mastic varnish and allowed it to dry. Then, using paint from which as much oil as possible had been removed, and which was heavily diluted with mastic varnish, he transformed the jawbone into a goblet. The repaint was so thin, Birzeniek noted, that the original paint layer could be seen through it and could easily be removed with turpentine or even by rubbing the passage with one's finger tips. This alteration was not enough for Madame S.N.N. She insisted that Verdonck was still badly in need of a haircut. For this reason the beret was added. After this additional change had been made, *Verdonck* found a place in the collection of Chamberlain S.N.N.

Birzeniek wrote that he had heard the story from the lips of the restorer who had made the alterations. He added that his informant was delighted to learn that his repainting had been removed and that, in effect, he had saved a work by Frans Hals. De Wild responded that he welcomed this chapter of the picture's history but did not fail to add that the repaint was

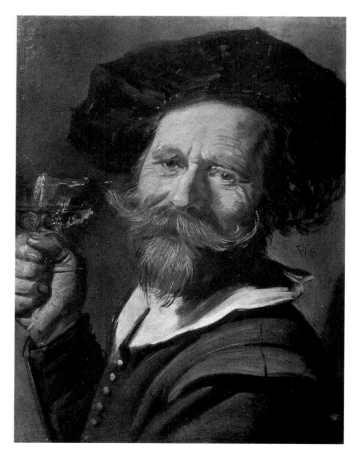

Fig. 24a *Verdonck*, before removal of overpaint

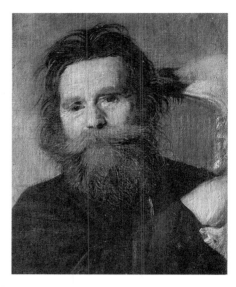

Fig. 24b Jan van de Velde II, engraving after Hals's *Verdonck*

Fig. 24c Unknown artist, *Verdonck*, 1627, copy after Hals (under S57) Cincinnati, Cincinnati Art Museum (inv. 1978.432)

Fig. 24d Unknown artist, *Verdonck*, copy after Hals (under S57) Paris, Coll. Comte R. de Pomereu, 1962

neither solvent in turpentine nor could it be removed with his finger tips. The repainted passages were, in fact, very difficult to take away.

Though we know that works of art have been tampered with to make them conform to a caprice, we seldom learn the precise circumstances that bring about the changes. Thus we too welcome this Chekovian story. It sounds credible. But is it? As can be seen from the Provenance of the picture given below, there is no reason whatsoever to believe that the painting de Wild restored left Great Britain from the time it was in the possession of the Vaile family in the 1820s until it was presented to the National Gallery of Scotland in 1916. In view of its history it is improbable that it was in St. Petersburg in the 1890s. If Birzeniek's tale is not a hoax, or if the restorer J.L.N. did not have a fantasy, another version of *Verdonck* wearing a beret and holding a goblet may still be in some collection in the Soviet Union.

Borenius (1928) and the compiler of the 1929 Edinburgh catalogue (p. 131) erroneously attributed Jan van de Velde II's print of the painting (fig. 24b) to his father Jan I, who died in 1623, a year, they concluded, that offered a *terminus ante quem* for the picture. However, the attribution of the print to Jan II (1593-1641), who made six other prints after Frans's work, is firm, and the style of the painting fits well with Hals's works done about 1627. Jan II was close to the Hals family about this time. In 1627 he was a witness at the baptism of Frans's son Reynier and three years earlier he was a witness at the baptism of Dirck Hals's daughter (Hals doc. 38 and under Hals doc. 4, respectively).

It rightly has been emphasised that Jan's print is a reproduction of the painting, and should not be classified with the engravings he and other printmakers made of Hals's small commissioned portraits that served as *modelli* for their engravings (van Thiel 1980, pp. 117-8); for another by Jan in the latter category, see fig. 20d; Jan's print probably was sold as a broadside. A mirror image of it engraved by an unknown artist published by Claes Jansz Visscher (1587-1652), and later in the century by Johannes Ram (1648-93), testifies to its popularity (ibid., pp. 118-9, fig. 4). There also is a reduced anonymous painted copy at Cincinnati, monogrammed and dated 1627, which depicts Verdonck wearing an incongruous

lace-trimmed collar and seen behind a simulated frame (fig. 24c). Another portrait of Verdonck holding a jawbone by an unidentified artist, probably active in Haarlem, indicates that its author was familiar with Hals's image (fig. 24d). After the Edinburgh painting was cleaned, the jawbone disrespectful Verdonck holds was identified as one that belonged to an ass (Borenius 1928). O. Charnock Bradley, Principal of the Royal Dick Veterinary College, Edinburgh, was quick to point out that it is the jawbone of a cow (letter dated 12 August 1928 in the files of the gallery). We only can guess whether Hals would have used the jawbone of an ass as a prop if he had been able to beg or borrow one, but there can be no doubt that in a country where stock and dairy farming was one of the mainstays of the economy it was easier to procure the jawbone of a cow than of an ass.

Until van Thiel published his study of *Verdonck* in 1980, it was assumed that the jawbone Hals's subject holds is merely a quasi-emblem alluding to Verdonck's sharp tongue that attacks everybody; a colloquial usage of 'to jaw' in Dutch (as well as in English) is talking imprudently, offensively or excessively. Van Thiel's study of the iconography of the jawbone indicates that there is reason to believe Hals's contemporaries would have readily associated it with the biblical hero Samson as well.

Van Thiel shows that the story of Samson's conquest of the Philistines (*Judges* xv : 15-9), upon which the iconography of the jawbone is based, is rare in Northern Netherlandish art; significantly, it is found only in works by the Haarlem Mannerists, including one by Hals's teacher Karel van Mander. The jawbone also was employed by seventeenth-century emblemists, and at least one of them used it in relation to the story of Samson's conquest to allude to 'Patience' and 'Prayer' (van Thiel 1980, p. 121). Salomon de Bray (1597-1664) probably had the latter meaning in mind in his painting of *Samson with a Jawbone*, dated 1636, that is a pendant to his *David with a Sword*, which symbolises 'Humility' (ibid., pp. 123-4; both paintings are in the J. Paul Getty Museum, Malibu; nos. A69.P-23, A69.P-22, respectively). De Bray's preliminary drawing for his *Samson* is at the Haarlem City Archives (fig. 24e; dated 1636 $\frac{3}{22}$). The drawing was mounted at a later date on a larger sheet of paper, and its owner, most likely

familiar with Jan van de Velde II's print of Hals's painting, wrongly assumed it was another portrait of Verdonck and inscribed part of the engraving's quatrain on the mount.[1]

Van Thiel's consideration of a book uniquely titled *Kakebeen* ('Jawbone') by Laurens Willemsz van Alkmaar, a Mennonite, throws light on the milieu in which the Edinburgh picture was produced. *Kakebeen* (Rotterdam, 1636) is a polemical tract that fiercely attacks the doctrinal views of the leader of another Mennonite sect. Its author's explanation of the tract's title refers to *Judges* XV : 16, suggesting that he saw himself as a new Samson who attacks his enemies with his words. This supposition is virtually clinched by the volume's engraved frontispiece by Crispin van de Passe II of Samson, jawbone in hand, victorious over the thousand Philistines (van Thiel 1980, p. 131, fig. 19).

In Laurens Willemsz's *Kakebeen* there is a reference to a Verdon[c]k, whom van Thiel has identified as Balten Verdonk, the deacon of a Mennonite congregation in Rotterdam whose religious beliefs were in accord with those of the author of the tract. Now, it is improbable that Hals's painting is a portrait of the Rotterdam deacon, but Balten Verdonk did have relatives in Haarlem and the subject of Hals's picture possibly was one of them.

The best candidate for this distinction is Pieter Verdonck who was admonished by the burgomasters of Haarlem in 1623 – a few years before Hals painted the Edinburgh picture – to cease molesting a certain Joost Lybaert upon pain of imprisonment. In view of this reprimand and other circumstantial evidence (most telling is Joost Lybaert's known affiliation with the Mennonite sect violently opposed by the author of *Kakebeen*), Hals's *Verdonck* may be a portrait of Pieter Verdonck, as another new Samson who vanquished his enemies with his words as the biblical hero did with his jawbone and like him, may have ended up in prison.

Fig. 24e Salomon de Bray, *Samson*, 1638, drawing
Haarlem, City Archives (inv. P.V. X 37)

1. Unaware of the existence of Salomon de Bray's 1636 painting of *Samson* now at the Getty Museum, I came to the same erroneous conclusion; I also misread the date inscribed by de Bray on his drawing and did not note that the inscription of its mount is by a later hand (Slive 1970-4, vol. 1, p. 83 and vol. 3, no. 57).

PROVENANCE According to a letter from Caroline S. Vaile, the daughter of Lawrence W. Vaile, DL and JP for Kent, who lived in Ramsay, her grandfather was given the picture by his stepmother about the 1820s and then it passed by descent to her father (files, National Gallery of Scotland). Sale [Lawrence W. Vaile] London (Christie's), 13 July 1895, no. 85 ('Man with Glass of Wine'; £430, Lesser); sold by Messrs. Agnew to John J. Moubray of Naemoor before 1914, who presented it to the gallery in 1916.

EXHIBITIONS Haarlem 1937, no. 6; Haarlem 1962, no. 16.

LITERATURE *Icon. Bat.* no. 8369; Moes 80; HdG 235, identical with HdG 77; Bode-Binder 297; A.M. de Wild, 'Frans Hals: Het portret van Verdonck', *Historia* III (1927), pp. 18-21; T. Borenius, 'The Discovery of a Lost Painting by Frans Hals', *Apollo* VIII (1928), pp. 191-2; and in *Pantheon* II (1928), pp. 518, 521; A.M. de Wild, 'Gemälde-Röntgenographie', *Technische Mitteilungen für Malerei*, no. 20 (15 October 1930), pp. 230-4 (for a letter pertaining to this article by H. Birzeniek and de Wild's response, see ibid., no. 24, pp. 283-4); Valentiner 1935, p. 101, no. 4 (about 1626); Trivas 10 (c.1624-7); Catalogue National Gallery of Scotland, Edinburgh, 1957, pp. 119-20, no. 1200; Slive 1970-4, vol. 1, pp. 80-3; Grimm 37 (wrongly states it is dated 1627); Montagni 56; Baard 1981, p. 96 (c.1627); P.J.J. van Thiel, 'De betekenis van het portret van Verdonck door Frans Hals: de ikonografie van het kakebeen', *O.H.* XCIV (1980), pp. 112-40.

25 • 26 Singing Girl Boy playing a Violin

*c.*1626-30
Panel (lozenge), 18.2 × 18.4 cm
Signed at the right with the connected monogram: FH
S54
Private collection, Montreal

*c.*1625-30
Panel (lozenge), 18.4 × 18.8 cm
Signed at the left with the connected monogram: FH
S53
Private collection, Montreal

These paintings, Hals's smallest genre pictures, have the sparkling technique and blond tonality seen in the artist's little portraits of Anna van der Aar (cat. 20) and her husband Petrus Scriverius, and in his other commissioned portraits datable to the second half of the 1620s that are done on the same scale. There are also close analogies with the life-size painting of *Two Laughing Boys* at the Hofje van Aerden, Leerdam (fig. 25a); particularly in the swiftness of touch and use of a loaded brush. The fur hat worn by the boy looking into a jug in the Leerdam picture is one of Hals's most dazzling performances. The young violinist's fur hat is a miniature version of it. Judith Leyster's attempt to emulate this aspect of Hals's handling is seen in a figure in her variant after Hals's *Rommel Pot Player* (fig. 25b; for the total painting, see fig. 8g); juxtaposition of her effort with Hals's points up the difference between the master and a very talented follower.

The pair possibly belonged to a Five Senses series. The young boy playing a violin could easily represent Hearing and his companion singing from her music book could conceivably personify Sight. If this hypothesis is correct, the small pictures may be identical with two of the three little paintings from a Five Senses series by Hals that were listed in a 1661 inventory of the effects of Willem Schrijver, the son of Petrus Scriverius. When these works were auctioned in 1663 along with other possessions of the latter, they were described as three little paintings of musicians (see Provenance below). For Hals's portrait of Petrus Scriverius and other paintings by the artist owned by his son Willem, consult cat. 20.

The lozenge format of the panels is not unusual in Dutch painting of the time but it is rare in Hals's work. Perhaps the tiny pictures were intended as inserts for a cabinet or a musical instrument, a use not incompatible with the suggestion that they may have belonged to a Five Senses series.

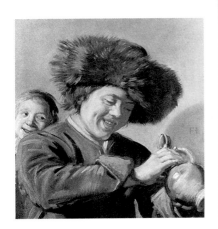

Fig. 26a *Two Laughing Boys*
Leerdam, Hofje van Aerden (s60)

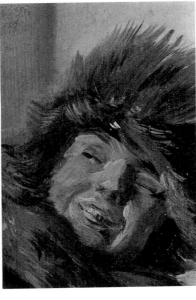

Fig. 26b Detail from Judith Leyster, *The Rommel Pot Player*, copy after Hals (S.L3-3) Chicago, The Art Institute of Chicago, Charles H. and Mary F.S. Worcester Collection

PROVENANCE Possibly two of the three little paintings from a Five Senses series by Hals ('Drie schildereijties van de vijff sinnen door Hals gedaen') that appeared in the 10 October 1661 inventory made in Amsterdam of the effects of Willem Schrijver (1608-61). The paintings appeared in the posthumous auction held at Amsterdam on 3 August 1663 of holdings that belonged to Willem's father Petrus Scriverius (Pieter Schrijver; 1576-1660); in this sale they were listed as 'Three individual [little paintings of] musicians' by Hals ('Dry be-zondere speelmannetjes'); see Hals doc. 166. Dealer Lawrie and Co., London had them as a pair by or before 1904, and they have re-mained together to the present day : C.T. Yerkes, New York; John W. Gates, New York; R.F. Angell, Chicago; Angell Norris, Chicago; sale anon. New York (Christie's), 13 January 1987, no. 141.

EXHIBITIONS On extended loan as a pair to the Art Institute of Chicago, 1923-86; also exhibited Chicago 1933, nos. 61a, 61b; Chicago 1934, nos. 90a, 90b; Detroit 1935, nos. 11, 12.

LITERATURE Catalogue C.T. Yerkes, New York, 1904, nos. 37, 38; Moes 237, 238; HdG 87, 118; Bode-Binder 45, 46; KdK 68, lower and upper (c.1627-30); W.A.P., 'The Angell Collection', *Bulletin, Art Institute of Chicago* XVII (1923), p. 51; Valentiner 1936, 23, 24 (c.1627-30); Grimm, p. 214 (both 'circle of Frans Hals'); Montagni 312, 313 (doubtful).

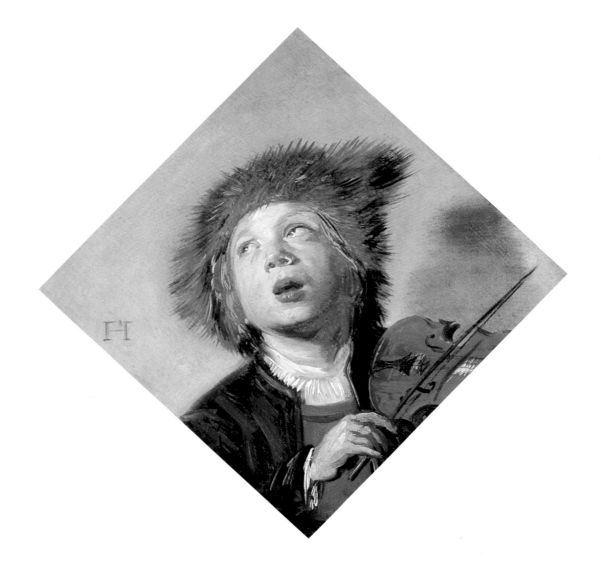

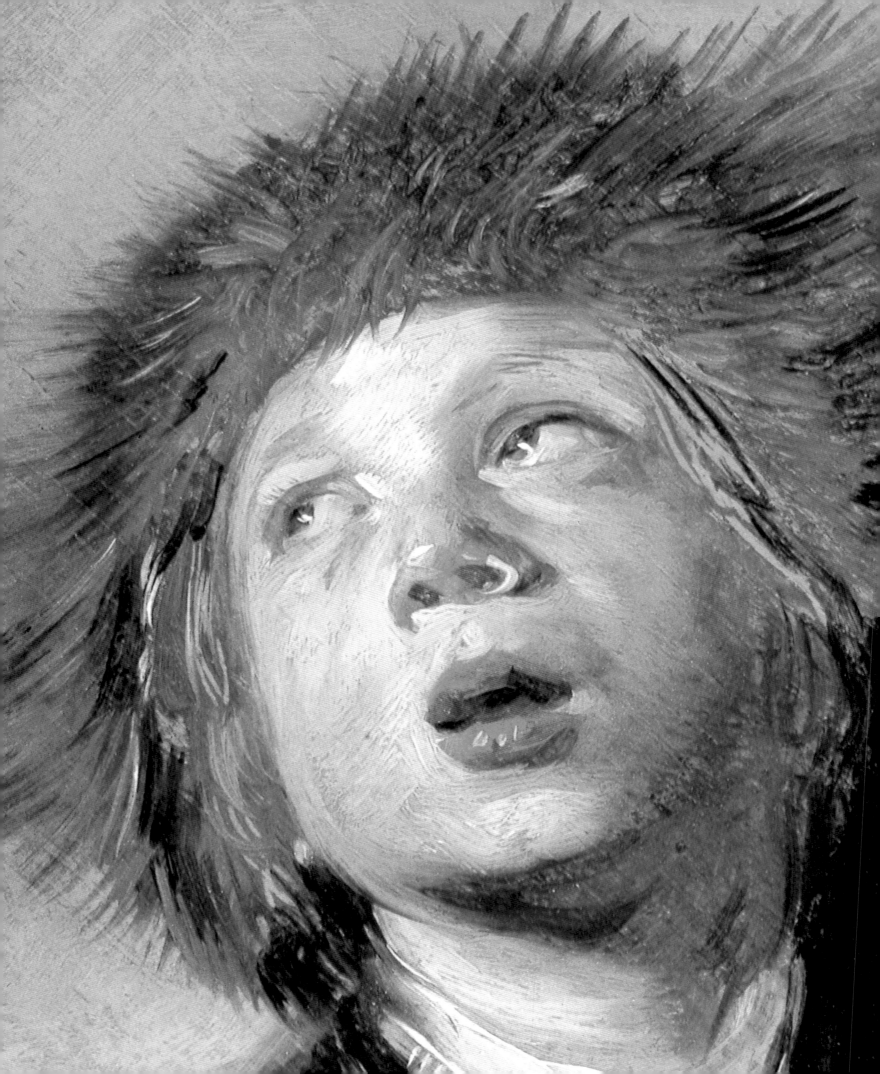

27 • 28 Drinking Boy (Taste) Boy holding a Flute (Hearing)

c.1626-8
Circular panel, diameter 38 cm
On the right, there are very indistinct traces of the connected monogram: FHF
S58
Staatliches Museum, Schwerin (inv. G 2476)

c.1626-8
Circular panel, diameter 37.5 cm
S59
Staatliches Museum, Schwerin (inv. G 2475)

These tondi can be safely related to traditional representations of Taste and Hearing in pictures of the Five Senses by Hals and his contemporaries (for a discussion of others, see cat. 15, 16, 25, 26). There is, however, nothing traditional about their highly individual brushwork and silver tonality which anticipate the most brilliant manifestations of nineteenth-century *plein air* painting. They are high points of Hals's depiction of bright shimmering daylight animating elusive moments of joyful life. The close relation of their high key and brushwork to the bright light and the boldest passages of the militia banquet pieces of *c.*1627 (Levy-van Halm & Abraham, figs. 1, 13; S45, S46) suggest a date of about 1626-8 for the matchless pair.

Many copies and variants exist of both paintings; most of them are poor caricatures of the originals. They come in sundry sizes and shapes, and some copyists have coupled the two boys in one picture, while others have made pastiches by combining one of the boys with other laughing children by Hals.

The *Boy holding a Flute* has been copied more frequently than its pendant, perhaps because few artists were willing to accept the challenge of copying the hand with a glass in its companion piece. Worthy of mention is a mezzotint of it (in reverse) by Jan Verkolje II (probably died before 1763; Wurzbach, no. 1), and painted copies at Lille and Gothenburg

which have been accepted erroneously in the literature as autograph (for additional references to these works and other copies, see S58, S59).

PROVENANCE The two paintings entered the collection between 1725 and 1792; they are listed in Johann Gottfried Groth, *Verzeichnis der Gemälde in der Herzoglichen Galerie*, Schwerin, 1792 (S54.7, S54.8; both as 'Unbekannt') and again in F.C.G. Lenthe's 1836 collection catalogue (279, 283; both as 'Unbekannt'). They were identified as paintings by Hals in Eduard Prosch's ms. catalogue of 1863 (vol. 4, 53, 54) and appear as such in subsequent Schwerin catalogues. Unidentified labels on the backs of the panels are inscribed: No. 188/1808, No. 189/1809, respectively.

EXHIBITION Celle 1954, nos. 421, 420.

LITERATURE Catalogue (by Friedrich Schlie) Grossherzogliche Gemälde-Galerie, Schwerin, 1882, nos. 445, 444; Catalogue (by Wilhelm Bode) Grossherzogliche Gemälde-Galerie, Schwerin, 1891, p.25 (both *c.*1625); Bode 1883, 117, 118; Moes 229, 230; HdG 11, 32; Bode-Binder 8, 9; KdK 52, 53 (1626-7); Trivas 29, 30 (1626-7); Catalogue Staatliches Museum, Schwerin, *Holländische Maler des XVII. Jahrhunderts*, 1962, nos. 111, 110; Slive 1970-4, vol. 1, pp.79, 106-7; Grimm 38, 39 (1627-8); Montagni 57, 58 (1626-8); Catalogue Staatliches Museum, Schwerin, *Holländische und flamische Malerei des 17. Jahrhunderts*, 1982, nos. 112, 111 (both unsigned).

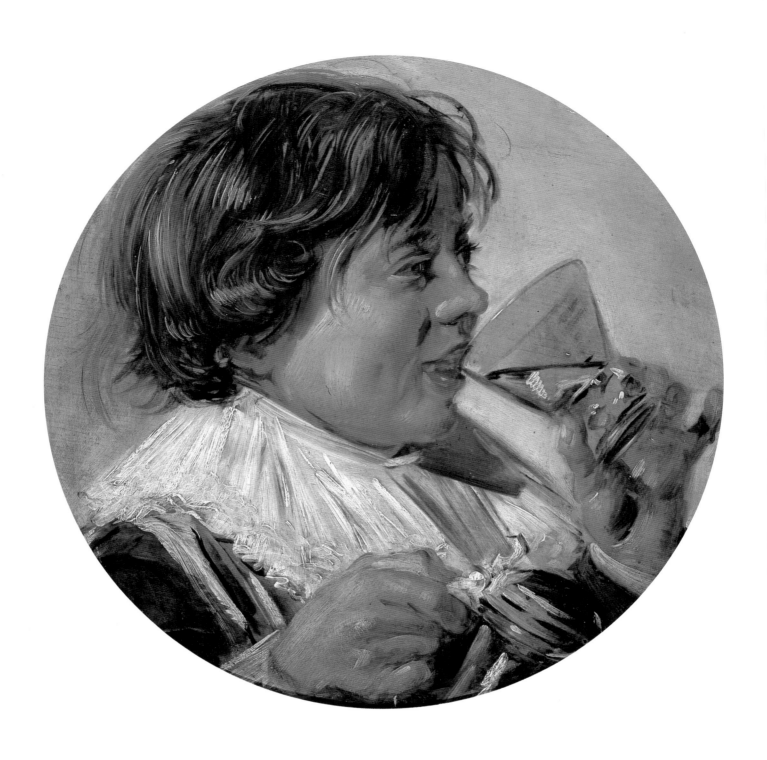

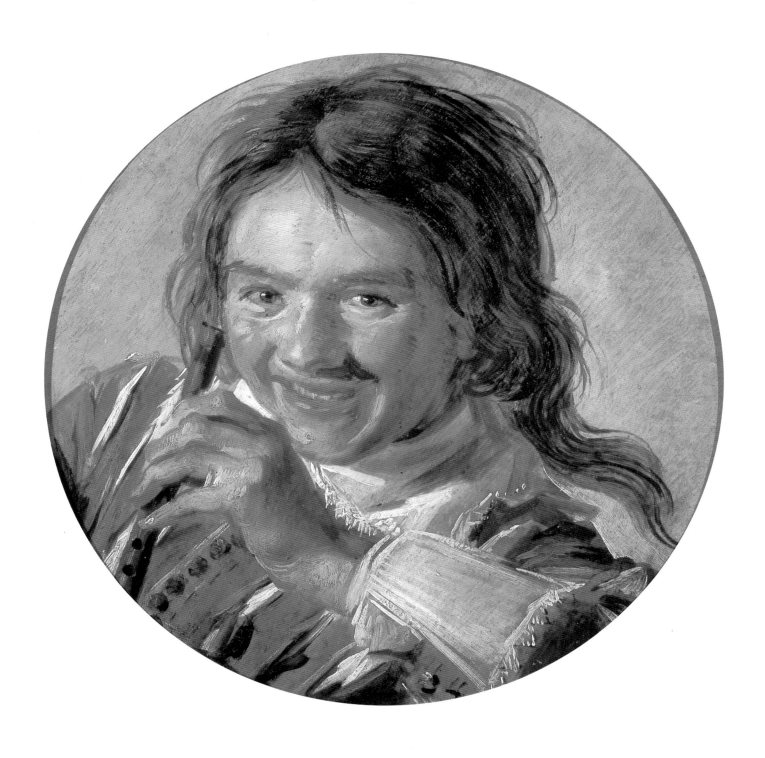

29 Young Man with a Skull (Vanitas)

*c.*1626-8
Canvas, 92.2 × 80.8 cm
s61
The Trustees of the National Gallery, London (inv. 6458)

The intensification of light, the largeness of forms, the greater fluidity of the brushwork and the more pronounced use of vibrant hatched strokes, which soften edges without diminishing their weight or solidity, distinguish this magnificent life-size half-length from those datable a few years earlier. Here Hals's attack was swift and direct, an impression confirmed by technical examination (Groen & Hendriks, pp. 118, 120). The picture shows no trace of underpainting. The ample drapery was laid down in only one layer on a light reddish ground which remains visible in large areas where it provides mid-tones. Wet-in-wet application of paint is found in the areas that are melded by distinctive hatched strokes (see pl. VIII s) and in the huge red feather that decorates the young man's beret.

Plietzsch (1953) is the only specialist who has doubted the painting's authenticity. According to him it was done about 1630-5 by Judith Leyster who, with feminine adaptability, came deceptively close here to the artist who was probably her teacher. There is, however, nothing in Leyster's documented œuvre that approximates the vigorous power of the work. Plietzsch's implication that women artists are more adaptable than their male colleagues also is wrongheaded.

Traditionally, the young man Hals portrayed has been identified as Hamlet, when, in the grave-digger's scene, he discourses upon a skull that had a tongue and once could sing, and upon the pates of other mortals, and finally with skull in hand, upon poor Yorick's. Bode-Binder (64) and Valentiner (KdK 227) correctly expressed laconic reservations regarding this title. Possibly they knew that there is no evidence that a work by Shakespeare was ever performed in Holland or translated into Dutch in Hals's time. Borenius and Hodgson (1924) were sceptical of the title as well: 'The description of the subject as Hamlet is perhaps more attractive than accurate

... the introduction of a skull as an emblem into portraits, more especially of youthful sitters, was a frequent device ever since the sixteenth century.' They erred, however, when they bracketed the painting with conventional portraits. The boy's costume has nothing in common with the fashions of the day. It is the kind the Dutch Caravaggisti used for their stagey genre and allegorical pieces, and which Hals himself employed during the 1620s for paintings of the same type. However, they were on the mark when they emphasised the emblematic character of the skull the young man holds.

The painting certainly was intended as a vanitas, as Valentiner first recognised (1936, under no. 86) when he related it to a Northern Netherlandish tradition that begins with Lucas van Leyden's engraving done about 1519 of a *Young Man holding a Skull* (fig. 29a; Bartsch 174). Goltzius and Jan Muller (1571-1628) continued it in Holland (van Thiel 1967-8, p. 94, note 1). In Goltzius's splendid pen drawing dated 1614, a fancifully dressed young man holds a skull and a tulip, and behind him is an hourglass — all reminders of the transcience of life and certainty of death (fig. 29b). For those who failed to get the point, Goltzius helpfully inscribed his drawing '*Quis Evadet/ Nemo*' ('Who Escapes? No Man'). A drawing by Muller of the same theme is at the Teyler Foundation, Haarlem (fig. 29c) and another was in the art market; the latter is inscribed '*Cognita mori*' (Reznicek 1956, p. 116, no. 26, fig. 25). And not long after Hals painted his vanitas, Brouwer's pupil Joos van Craesbeeck placed a skull in the hands of his smoker (fig. 29d), most probably as an allusion to the familiar biblical warning: 'My days are consumed like smoke' (*Psalms* CII : 3).

An intriguing reference to a vanitas by Hals is found in a proposal dated 4 April 1634 for a lottery of thirty-three paintings at an inn in Haarlem: '*no. 13. Een vanitas van F.*

Fig. 29a Lucas van Leyden, *A Young Man holding a Skull (Vanitas)*, engraving

Fig. 29b Hendrick Goltzius, *Young Man holding a Skull and a Tulip (Vanitas)*, 1614, drawing
New York, The Pierpont Morgan Library (inv. III, 145)

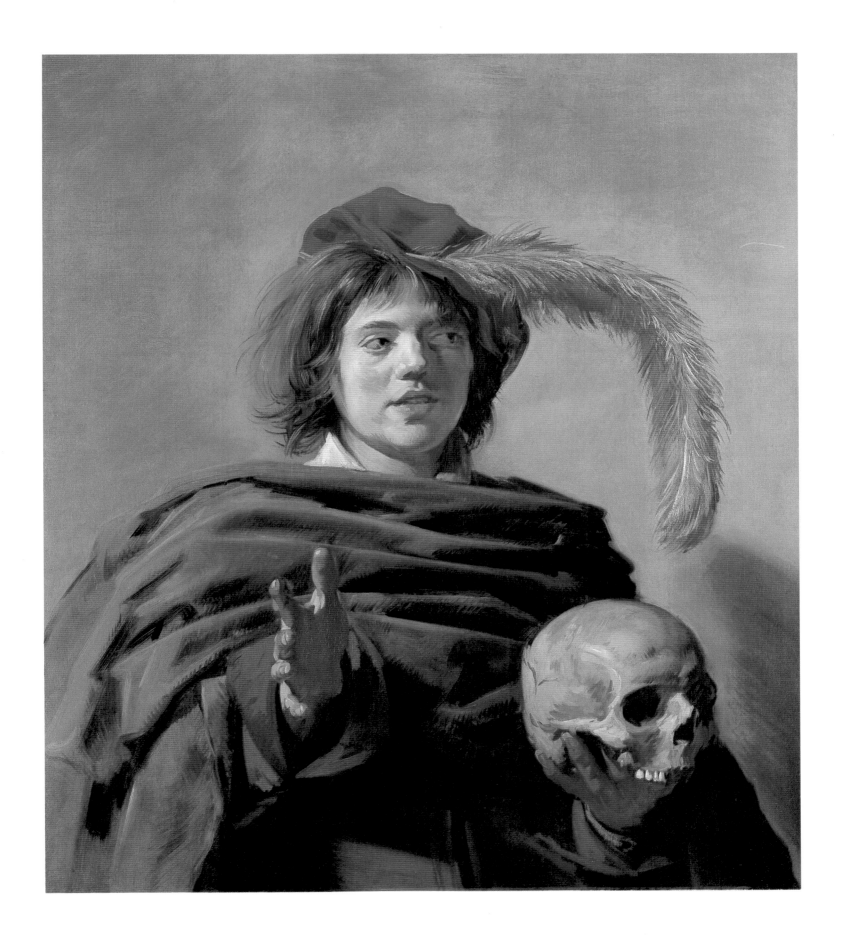

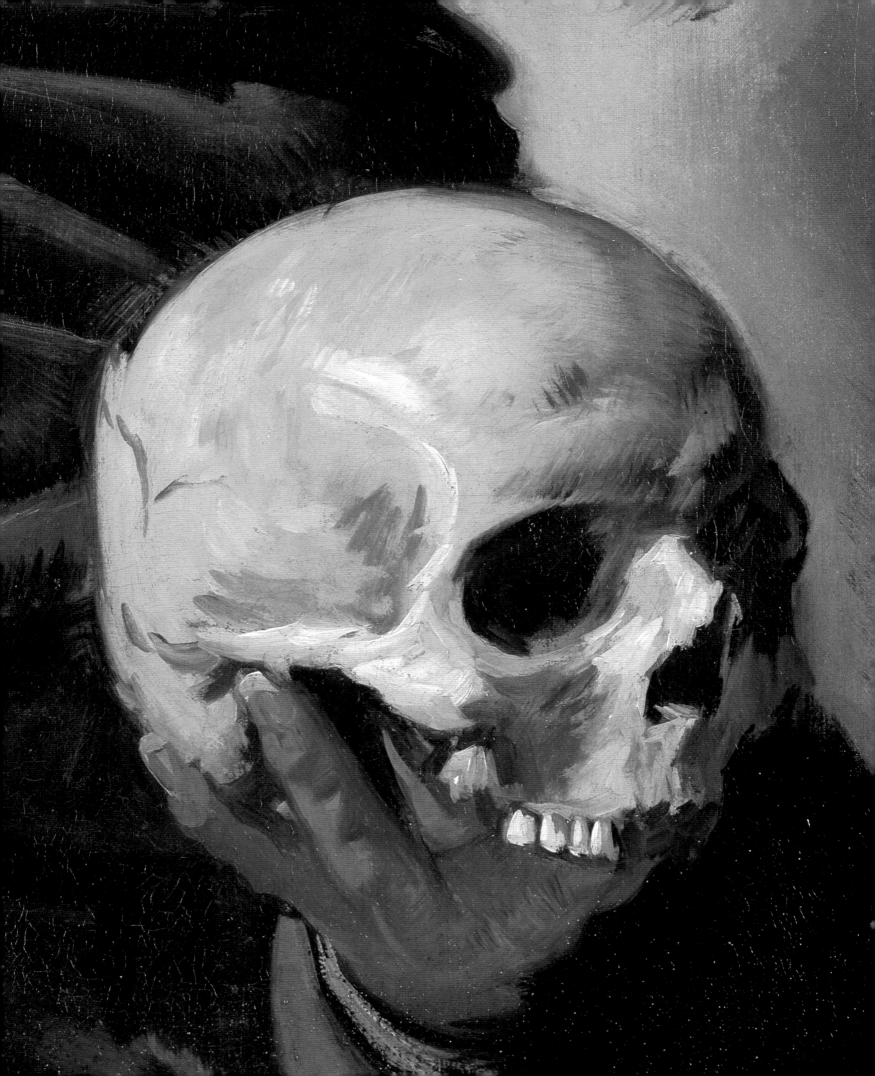

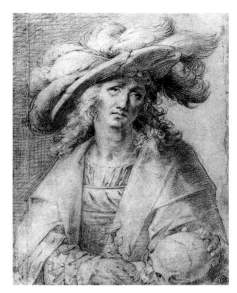

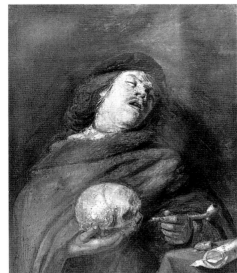

Fig. 29c Jan Muller, *Youth with a Skull*, drawing
Haarlem, Teyler Museum (inv. N 81a)

Fig. 29d Joos van Craesbeeck,
Man holding a Skull and a Pipe (Vanitas)
Location unknown

Hals' appraised at 34 guilders (Hals doc. 65). There is no way of determining if it was identical with the National Gallery's picture, but we can be certain it is not identical with 'a little vanitas by Frans Hals in an ebony frame' cited in an inventory made of Pieter Codde's effects at Amsterdam on 5 February 1636 upon the occasion of his separation from his wife (Hals doc. 72). The London painting cannot·be described as 'a little vanitas' (*'een vanitasken'*). Codde's vanitas must refer to another one of Frans's paintings of the theme, perhaps one of his small pictures of a laughing child making bubbles (see fig. 16b, s28 and s.D27). Bubbles were almost as ubiquitous as skulls as symbols of transience in Dutch pictures of the subject. But no matter what the subject of Codde's vanitas was, we know that in his household it failed to serve as an effective reminder of the transitory nature of all life and the necessity of concentrating on spiritual matters in the hope of eternal salvation. A cause of Codde's separation from his wife was his adulterous affair with his maid (see cat. 43), and from what is known of his wife's activities, she was not a model of virtue either.

In the sale K. van Winkel and others, Rotterdam, 20 October 1791, lot 175 is described a painting by Frans Hals of 'A young man with a skull in his hand [21.6 × 15.4 cm], on panel' (*'Een Jong Manspersoon met een Doodshoofd in zijn hand, hoog 8, breed 6 duim, op panel'*). This untraced tiny panel may have been a copy of the National Gallery's painting, and possibly is identical with a 'little copy of the so-called Hamlet' which Hofstede de Groot saw at the Gallery Locarno, Paris, in December 1928. He described the boy in the copy as looking 'horridly skew-eyed' (unpublished note, RKD).

PROVENANCE Possibly in the collection of Count Truchsess (Reichs-erbtruchsessen Joseph Franz Anton, Graf von Waldburg-Zeil-Wurz-bach [1784-1813]) by 1803, and in his London sale by private contract in a building called the Truchsessian Gallery on New Road, Marylebone, opposite Portland Place, beginning 14 May 1804, no. 397 ('Don Juan with a Skull') and again in his sale Truchsessian Gallery, London (Skinner and Dyke), 24-6 April 1806, no. 13 ('Hamlet with Yorick's Scull'); I have not yet examined the sale catalogue, Truchsessian Gallery, London (Coxe), 2 June 1810. Possibly the same painting passed through the following auctions: sale Houghton, London (Christie's), 2 April 1813, no. 54 (F. Halls [sic]; 'Portrait of a Youth' with a handwritten note 'Moralising on a Skull'; bought in at £8); sale London (Stanley), 13 May 1815, no. 103 (Frank Hals; 'A Young Man Moralising on a Skull'; £6.6); sale Peter Coxe, London (Stanley), 14 June 1815, no. 20 (Frank Hals; 'Hamlet Prince of Denmark, moralising on the scull of Yorick'; bought in). For information regarding the complicated history of the Truchsess Collection and references to the 1813 and 1815 sales cited here, I am indebted to Burton B. Fredericksen, Director, Getty Provenance Index; a discussion of some aspects of the Truchsess Collection's history is offered in Gerda Franziska Kircher, *Die Truchsessen-Galerie*, Frankfurt, Bern & Las Vegas 1979. According to the Elton Hall Catalogue (1924, no. 24), the painting was purchased for Sir James Stuart, Bart., by Andrew Geddes (1783-1844), the painter; inherited by his daughter, Mrs. Woodcock, 1849; inherited by her son, the Rev. E. Woodcock, 1875; inherited by his sister, Mrs. Stuart Johnson, 1893; purchased from her by the 5th Earl of Carysfort, Glenart Castle, Ireland in 1895 through Messrs. Lawrie and Co., London (£3,800). By descent to Col. D. J. Proby; Granville Proby, London; Major Sir Richard Proby, Bt., M.C., Peterborough; purchased by the National Gallery from the Trustees of the Elton Hierloom Settlement in 1980, with Christie's acting on behalf of the Settlement.

EXHIBITIONS Dublin 1896; Haarlem 1937, no. 93; London 1938, no. 132; London 1952-3, no. 102; Haarlem 1962, no. 18; San Francisco, Toledo & Boston 1966-7, no. 17; London 1976, no. 48; Leningrad & Moscow 1988, no. 12.

LITERATURE *Catalogue of the Truchsessian Picture Gallery, now exhibiting in the New Road, opposite Portland Place to which are added biographical Notices respecting the German, Dutch and Flemish Masters*, London 1803, p. 52 ('Franz Hals, Don Juan with a skull; canvas, 2'10" × 2'5"'); HdG 102 (as Hamlet); Bode-Binder 64 (*'Der sogenannte Hamlet'*); KdK 227 ('Der sogenannte Hamlet'; *c.*1645; Valentiner, who did not know the original in 1923, added that perhaps it was painted earlier); Tancred Borenius & J. V. Hodgson, *A Catalogue of the Pictures at Elton Hall*, London 1924, p. 29, no. 24; Valentiner 1936, under 86 (obviously a work of the twenties; most likely a vanitas); Trivas 26 (1625-7); E. Plietzsch, 'Ausstellung holländischer Gemälde in der Londoner Akademie', *Kunstchronik* VI (1953), p. 123 (Judith Leyster); Slive 1970-4, vol. I, pp. 88-9 (most likely a straightforward vanitas); Grimm 26 (*c.*1626-7; so-called Hamlet); Montagni 50 (*c.*1626-7; Hamlet? Vanitas?); *The National Gallery Report*, January 1980-December 1981, p. 24-5; Burton B. Fredericksen (ed.), *The Index of Paintings Sold in the British Isles during the Nineteenth Century: 1801-1805*, vol. I, Santa Barbara & Oxford 1988, p. 342.

The Merry Drinker

c.1628-30
Canvas, 81 × 66.5 cm
Signed at the right with the connected monogram: FH
S63
Rijksmuseum, Amsterdam (inv. A 135)

Before nineteenth-century Dutch interest in Hals's paintings had been rekindled, this masterpiece was acquired by the Rijksmuseum for merely 325 guilders at a Leiden sale in 1816, a year after the museum was established in Amsterdam by King Willem I. The acquisition was made thanks to the personal predeliction of Cornelis Apostool, the Rijksmuseum's first director. A good index of the taste at the time for seventeenth-century Dutch paintings is offered by the price of 5,610 guilders paid at the same sale for an Italianate landscape by Jan Both; it was acquired by Willem I for the royal collection at The Hague and is now at the Mauritshuis (inv. 20). This aspect of the story of Hals's early nineteenth-century reputation is told in van Thiel's history of the Rijksmuseum's painting collection (van Thiel *et al.* 1976, p. 19). He also notes that it was at Apostool's behest that the Dutch State purchased Vermeer's *View of Delft* for 2,900 guilders in 1822, a work the King decided to keep at the Mauritshuis, where it is now its prize holding.

The Merry Drinker attracted the attention of George Agar Ellis (later Lord Dover), an early English visitor to the new Rijksmuseum. An entry in the catalogue Ellis compiled during his visit to Flanders and Holland in 1822 singles out in what he called Amsterdam's 'Musée, or Academy': 'An unfinished, but very spirited Man's head, with a large hat on, by Frans Hals' (Ellis 1826, p. 57). Ellis's brief sentence in his catalogue which he wished 'albeit unworthy of the honour [to] be considered a sort of supplement' to Sir Joshua Reynolds's tour over the same ground, is the earliest published comment on

the painting. For Ellis's reference to Hals's *Meagre Company* which he saw in Amsterdam's Town Hall (where Reynolds must have seen it as well, but failed to mention in his *Journal*), see cat. 43, under Literature.

The status of *The Merry Drinker* changed rather quickly. Not long after Thoré-Bürger resuscitated Hals's reputation in 1868, and when the artist's paintings that show conspicuous passages of his detached brushstrokes no longer were called unfinished, the picture was ranked by critics and the wider public with the *Night Watch* and the *Windmill at Wijk* as one of the Rijksmuseum's icons of the golden age of Dutch painting, and it remains one of the museum's most popular works.

Its 1971 restoration, which included removal of a coat of discoloured varnish, revealed qualities that formerly were obscured. The contrast between the man's warm flesh tones, his golden-ochre leather jerkin,[1] and the cool, silvery-grey background now shows more of Hals's original intention. The painting's spontaneous brushwork, thin paint and restriction of vibrant impasto touches to the highlights relate it to the small tondi at Schwerin (cat. 27, 28) and the half-lengths of *Peeckelhaering* and the so-called *Mulatto* (cat. 31, 32). Its distinctive hatching is found also in the London *Vanitas* (cat. 29), but here it is used with greater economy, and in this painting, as he did in the London picture, he defined a few forms by scratching into wet paint with the butt end of his brush.

The Merry Drinker can be connected to works done by the

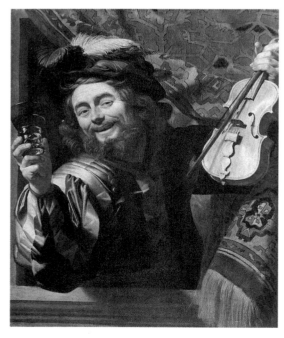

Fig. 30a Gerard van Honthorst, *The Merry Violinist*, 1623
Amsterdam, Rijksmuseum (inv. A 180)

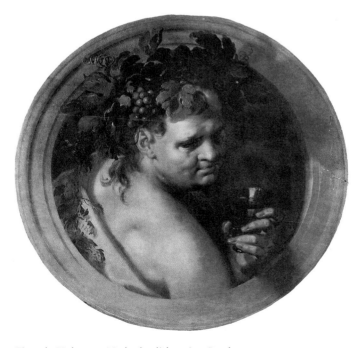

Fig. 30b Unknown Netherlandish artist, *Bacchus*
Buscot Park, Berks., Coll. Lord Faringdon, 1965

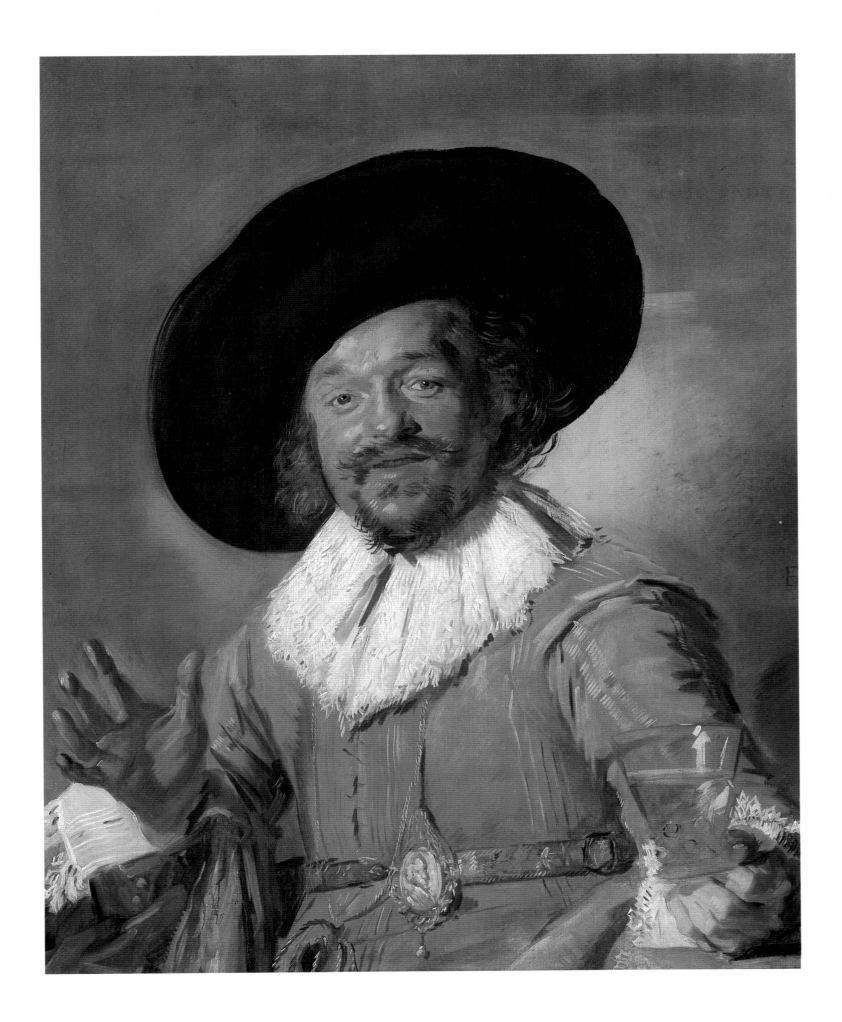

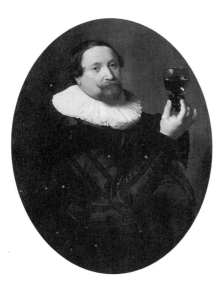

Fig. 30c Jacob Matham, engraving after Cornelis Ketel's lost *Portrait of Vincent Jacobsen*,

Fig. 30d Detail from Jacques de Gheyn II, *Bailiff Halling seated at a Table and a Woman nursing a Child*, drawing, 1599 Amsterdam, Rijksmuseum, Prentenkabinet (inv. 57:257)

Fig. 30e Nicolaes Eliasz, called Pickenoy, *Maerten Rey*, 1627 Amsterdam, Rijksmuseum (inv. A 698)

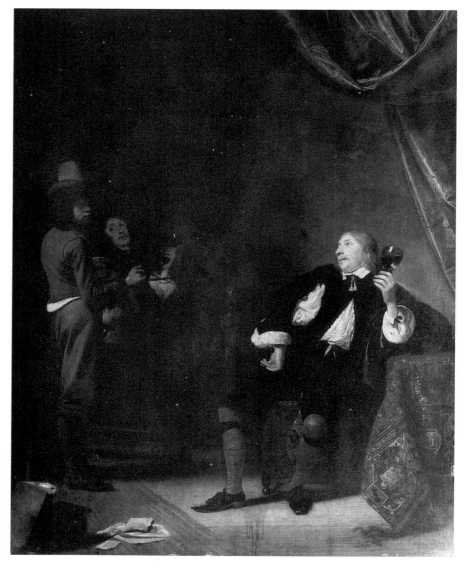

Fig. 30g Detail of Captain Michiel de Wael from *Banquet of the Officers of the St. George Civic Guard*, c. 1627 (s46) Haarlem, Frans Halsmuseum,

Fig. 30f Simon Kick, *An Artist painting a Portrait* Dublin, The National Gallery of Ireland (inv. 834)

Utrecht Caravaggisti when part of their stock-in-trade were lively characters holding glasses while appealing to the beholder with their gestures and expressions (fig. 30a). But drinkers made appearances in Dutch painting much earlier. About 1530 Maerten van Heemskerck presented the father in his *Family Portrait*, now at Kassel (inv. 33), with a glass in hand and, after Cornelis Anthonisz introduced a civic guardsman holding a glass in his ur-militia banquet piece of 1533 (Levy-van Halm & Abraham, fig. 4; Amsterdams Historisch Museum, inv. A7279), they seldom were absent from Dutch group portraits of guards gathered around a festive board. Drinkers play also prominent roles in early Prodigal Son scenes and moralising genre pictures, and Bacchus himself frequently appears with glass in hand in works done by late Netherlandish Mannerists (fig. 30b).

Portraits of men holding glasses also were done about 1600. Van Mander singled out for special mention (1618, fol. 191v) Cornelis Ketel's portrait of Vincent Jacobsen holding a fine *roemer* filled with Rhine wine. Ketel's lost portrait is known from an engraving made in 1602 by Jacob Matham (fig. 30c; Hollstein, vol. 11, no. 383). If we disregard the print's Mannerist frame and overlook the sitter's rather melancholic expression, Ketel's portrait appears as a precursor of the many pictures of merry drinkers painted in Holland in the following decades. Ketel's intention, however, was not to show the joy of drinking or to paint an allegory of the sense of taste. The glass held by Vincent Jacobsen is an attribute of his profession; he was a wine-gauger. His *roemer* is another reminder that the meaning of everyday objects found in seventeenth-century Dutch painting depends upon their context. About the time Ketel portrayed Jacobsen, Jacques de Gheyn II made a portrait drawing of a man holding a glass (fig. 30d; only the left side of the sheet is reproduced here; the right side shows a buxom woman suckling a baby). De Gheyn inscribed the drawing, which anticipates the naturalism and immediacy but not the animation of some of Hals's drinkers: 'The worshipful Halling, drawn from life when still a bailiff to the Court of Holland. Anno 1599 IDG Fe' ('*den Erntfesten halling geteykent naer tleuen, als hy noch was doorwaerder van Hooue van Hollant, anno 1599. IDG Fe*'; van Regteren Altena 1983, vol. 2, no. 679). In 1627, about the time Hals painted *The Merry Drinker*, Nicolaes Eliasz, called Pickenoy, depicted the wine merchant and steward of one of Amsterdam's civic guard companies holding a *roemer* (fig. 30e), again as an attribute of a patron's trade.

Portraits of sitters holding glasses continued to be painted later in the century, as can be seen in Simon Kick's *Artist painting a Portrait*, datable about 1650 (fig. 30f). The occupation of the painter's unidentified model is unknown and we have no way of determining if Kick is giving us a view of general studio practice by suggesting that some portraitists' clients held frightfully uncomfortable poses while the artist transcribed what was before his eyes into paint. However, we have evidence that there was one seventeenth-century English portraitist who did so. Samuel Pepys records in his diary on 17 March 1666, the day John Hayles began his portrait, that: 'I ... do almost break my neck looking over my shoulders to make the posture for him to work by'.

To turn to Hals's *Merry Drinker*, after considering the way the variations on the motif were depicted by his gifted predecessors and contemporaries, is to see how one of his best-known works follows established Dutch pictorial and iconographic traditions. Yet it is difficult to categorise the painting. It has been called a genre piece. It also has been interpreted as a representation of the sense of taste, and related more specifically to the pleasure of drinking as opposed to its bitter aspects (Kauffmann 1943). The possibility that it is a portrait

cannot be ruled out either, despite the fact that its mood and momentary quality radically break with established portrait conventions of the day. After all, some of the portrayals of drinkers in his two group banquet pieces of Haarlem's civic guards of 1627 are equally unconventional (fig. 30g). Could the *Merry Drinker* be a portrait of Hendrick den Abt, the Haarlem innkeeper who planned to auction a *Peeckelhaering* by Hals and three other of his paintings in 1631 (see cat. 31 and Hals doc. 58)? Perhaps the medal the drinker wears offers a clue to his identity. It has been seen as a portrait medal of Prince Maurits of Orange (HdG 63; KdK 61; Trivas 32; Catalogue Rijksmuseum, 1960, no. 1091) but Hals's summary treatment of it makes the identification tenuous indeed.

Is the painting a genre piece, an allegorical subject or a portrait? In Hals's hands these categories are not mutually exclusive. He worked along the borderlines where they merge and, as is so often the case when we consider one of his paintings, the question of how to classify it seems pertinent until we are confronted by the picture. Then pigeon-holes are forgotten. *The Merry Drinker* speaks to us as a startling expression of life charged with all its vital energy. For this unique subject there is no traditional label.[2]

1. For a discussion of leather jerkins worn about this time, the tanning process that could give them an offensive odour, and the possible consequence a man faced if he courted a woman while wearing one, see du Mortier, p. 55.

2. A half-dozen copies are known (Slive 1970-4, vol. 3, no. 62). For a discussion of a modern forgery based on the original, which was wrongly published as authentic by Hofstede de Groot (*B.M.* XLVI [1925], p. 193), and subsequently the subject of an acrimonious lawsuit in the Dutch courts, see S.D21.

PROVENANCE Sale dowager of C.P. Baron van Leyden van Warmond, née H.J. de Thomas, Leiden, 31 July 1816, no. 13 (Dfl. 320).

EXHIBITIONS Paris 1921, no. 21; London 1929, no. 61; Haarlem 1937, no. 32; Amsterdam 1945, no. 33; Brussels 1946, no. 39; Cape Town 1952, no. 47; Zurich 1953, no. 42; Rome 1954, no. 44; Milan 1954, no. 51; New York, Toledo & Toronto 1954-5, no. 1; Haarlem 1962, no. 22; Brussels 1971, no. 45.

LITERATURE Ellis 1826, p. 57; Unger-Vosmaer 1873, no. XIX (c. 1627); Bode 1883, 17 (c. 1625-30); Moes 264; HdG 63; Bode-Binder 53; KdK 1921, 59 (c. 1627-30); KdK 61 (c. 1627); Trivas 32 (c. 1627); Kauffmann 1943, p. 141 (related to the sense of taste); Slive 1970-4, vol. 1, pp. 110-1; Grimm 43 (1627-8; 'Taste'); Montagni 64 (1627-8; 'Taste').

31 Peeckelhaering

c.1628-30
Canvas, 75 × 61.5 cm
Inscribed to the right of the man's shoulder: *f. hals f.*
s64
Staatliche Kunstsammlungen, Kassel (inv. GK 216)
Exhibited in Haarlem

The lower-case signature is unique in Hals's œuvre; although it has been partially strengthened, there is no reason to doubt its authenticity. Trivas (35) noted that the dates of about 1640 given to the painting by Bode (1883, 97) and of around 1635-40 by Valentiner (KdK 140) were too late. He justly pointed out that the painting is closely related in style to the so-called *Mulatto* at Leipzig (cat. 32), which is based on the same model, and to Amsterdam's *Merry Drinker* (cat. 30), and placed the group in the late twenties. However, his claim that a print by Jacques de Gheyn II, who died in 1629, provides a *terminus ante quem* for these three paintings is an error (see cat. 32).

The title 'Peeckelhaering' is derived from an anonymous verse on a reduced engraved reproduction (in reverse) of the painting by Jonas Suyderhoef (*c.*1613-86), which is inscribed 'F. Hals Pinxit' (fig. 31a; Hollstein, vol. 28, p. 209, no. 16; 26.9 × 21.5 cm):

> Look at Monsieur Peeckelhaering,
> He praises a cooling, brimful mug
> And is constantly occupied with the wet vessel,
> For his throat is always dry.
> (*Siet Monsieur Peeckelhaering an*
> *Hy pryst een frisse volle kan*
> *En hout het met de vogte back*
> *Dat doet syn keel is altyt brack.*)

Peeckelhaering was the name of a popular theatrical character, and like the names given to other stock players of the period (Jean Potage, Hans Wurst, Hans Supp), his refers to his gluttony (Gudlauggson 1945, p. 55ff.; Weber 1987, pp. 134-5). Voracious consumption of herring of course generates an almost unquenchable thirst. 'The fish must swim' could have served as an appropriate motto for Hals's Peeckelhaering.

During the seventeenth century, when comic figures of Dutch farces did not have the fixed traditions of Italian players, Peeckelhaering sometimes assumed a different character and costume. Hals represented him as a Falstaffian type in his early *Shrovetide Revellers* at the Metropolitan Museum (pl. II; s5). In the Kassel picture and the one Hals painted of him, now in Leipzig (cat. 32), the buffoon has some resemblance to Brighella, who figures in the repertoire of *commedia dell'arte* players.

The Kassel painting may have belonged to Jan Steen. It makes an appearance as a picture within a picture in his *The Doctor's Visit* (fig. 31b; Catalogue Wellington Museum, 1982, no. 1525). It also hangs on the back wall of Steen's *Baptismal Party* at Berlin (figs. 31c, 31d) as a pendant to a picture that is most probably a lost *Malle Babbe smoking* by Hals (fig. 37b). Perhaps the Kassel painting had a companion picture. Valentiner (KdK 140, note) suggested that it was the Metropolitan Museum version of *Malle Babbe* (fig. 37c); the New York picture, however, is not an original but is by an unidentified follower (s.D34).

Hals's *Peeckelhaering* was used appropriately as the engraved frontispiece of a small anthology of jokes and jests published in 1648 (fig. 31e): *Nugae Venales sive Thesaurus ridendi & Jocandi ...* (n.p.). The engraving, which reverses the picture, is inscribed '*nugae venales*' ('Jests for Sale'). It is one of the rare seventeenth-century book illustrations based on a work by Hals (for another, see cat. 50). The engraver of the print and the compiler of the 1648 joke book remain anonymous; the volume's place of publication is not known either. Since the book went through more than one edition, it must have enjoyed some success, but it could not have done much to spread Hals's fame; his name is not inscribed on the frontispiece. Although editions dated 1642, 1648, 1663, 1689 and 1720 are recorded, copies of the volume are scarce; the engraving is lacking in the 1624, 1689 and 1720 editions that have been examined.

There is a reference to a *Peeckelhaering* by Hals as early as 1631 in a list of paintings that Hendrick Willemsz den Abt, keeper of a Haarlem inn called the 'King of France' planned to auction (Hals doc. 58). It is not known if the *Peeckelhaering* was the picture now in Kassel, the Leipzig painting, or a lost variant, but the reference provides a *terminus ante quem* for Hals's depiction of the subject.

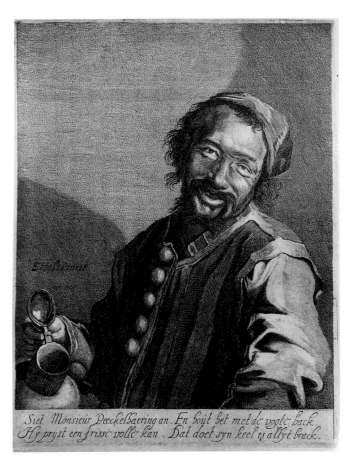

Fig. 31a Jonas Suyderhoef, engraving after Hals's *Peeckelhaering*

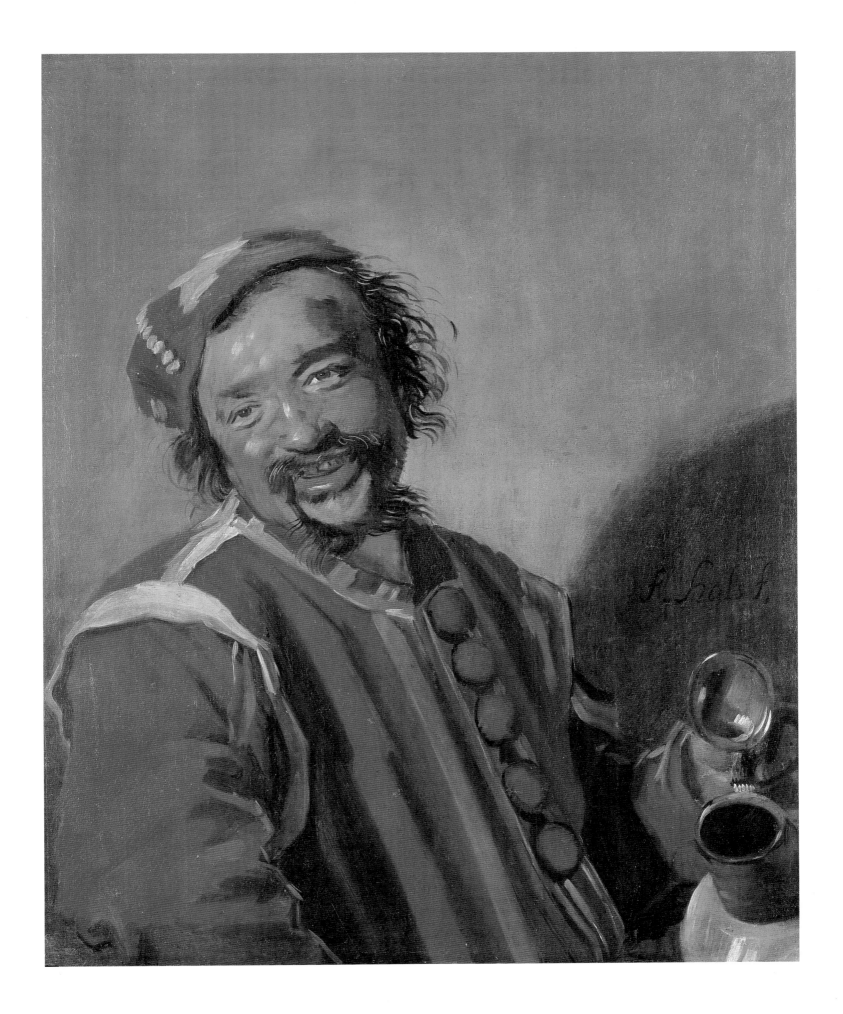

217

Fig. 31b Detail of Hals's *Peeckelhaering*
from Jan Steen, *The Doctor's Visit*
London, Apsley House,
Wellington Museum (inv. 1525)

Twelve drawings and more than seventy paintings are included in Abt's auction list. Amongst the pictures were four by Frans Hals (*Peeckelhaering*, a painting of a head and two tondi), six by Dirck Hals and five by 'Young Hals' (probably Frans's twenty-year-old son Harmen). Additionally there were 'various copies after Frans Hals', 'various copies after Dirck Hals', and no fewer than 'twelve copies after Porcellis'. References to copies of works by Frans and Dirck as well as a dozen after Porcellis made as early as 1631 are a salutary reminder to art historians with expansionist tendencies.

Peeckelhaering continued to be a popular and recognisable figure in seventeenth-century Holland. Dirck Hals shows him pouring wine in a *Merry Company* scene dated 1639 (fig. 31f); Dirck's Peeckelhaering is obviously derived from his older brother's painting of him at Leipzig, or from Suyderhoef's print after the Kassel picture.

Hofstede de Groot (95) notes that paintings called 'Peeckelhaering', but without reference to the artists who painted them, are cited in the inventories of Hendric Brugge, Leiden 1666; Hendrick Huyck, Nymwegen, 10 January 1669; and Jan Zeeuw and Marie Bergervis, who died in Amsterdam in 1690. Another is listed in a codicil made by Dirck Pietersz Brugman at Haarlem on 29 November 1658: 'The painting of Peeckelhaering with a *roemer* of wine, in an ebony frame'. Dirck Pietersz was a relative of Catherina Brugman who married Tieleman Roosterman; Hals painted three-quarter length pendants of the couple outfitted in ostentatious costumes in 1634 (s93, s94; see Biesboer, figs. 10, 11).[1]

A copy of the Kassel picture, whose provenance begins in 1891 and which appeared last in a 1979 auction (anon., London [Sotheby's], 12 December 1979, no. 101 [£7,000]), has been confounded with the original. It is erroneously reproduced by Valentiner (KdK 1921, 129; KdK 140) and Gudlauggson (1945, p.61, fig.65) as the Kassel painting. Trivas (35a; 35b) divided its provenance; the two copies he lists are, in fact, one. For its full provenance and bibliographical refer-

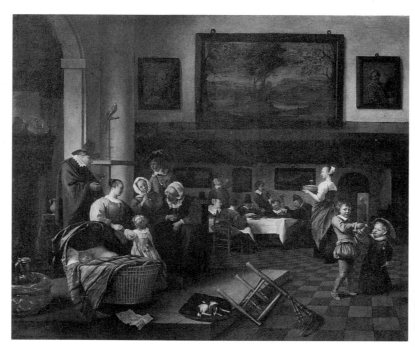

Fig. 31c Jan Steen, *Baptismal Party*
West Berlin, Staatliche Museen Preussischer Kulturbesitz (inv. 795 D)

Fig. 31d Detail of Hals's *Peeckelhaering*
from Jan Steen, *Baptismal Party*

ences, see s64. To help avoid confusing it with other copies and forgeries, part of its history is offered here.

The copy was confiscated from a private Dutch collector by the Nazis after they occupied the Netherlands during World War II. It then appeared in the sale, The Hague (van Marle and Bignell), 1 July 1941, no. 12, where it was purchased by the infamous forger Han van Meegeren. Was the master counterfeiter deceived? Did he believe he had acquired a Hals original? I, for one, like to think so. What appears to be the copy can be seen in a photo of van Meegeren's living room that was published in 1945 (*The London Illustrated News*, 207, p. 561). Soon afterward it was reproduced as a 'genuine fake Hals' by the notorious forger (ibid., p. 696). Now, van Meegeren is known to have made at least one unsuccessful attempt to work in Hals's style (see fig. 37i), but he certainly did not paint the copy of the Kassel painting discussed here, whose provenance, as we have seen, goes back to 1891. This part of the copy's story ends with its confiscation from van Meegeren by the Dutch government, which returned it to its lawful owner.

1. J. van Venetien kindly provided the passage from the codicil (GAH, NA 342, fol. 15: 'de schilderij van Peeckel-haering en een roemer van wijn daarbij, met een ebbenhouten lijst'). Dirck Pietersz set aside his *Peeckel-* *haering* for Marija Harmans who was living with him at the time. I am beholden to van Venetien also for word of the connection between Catherina Brugman and Dirck Pietersz Brugman.

Fig. 31e Unknown artist, engraving after Hals's *Peeckelhaering*, the frontispiece of a 1648 edition of *Nugae Venales*

PROVENANCE Listed in *Haupt-Catalogus von Sr Hochfürstl. Durch^lt Herren Land Grafens Wilhelm zu Hessen, sämtlichen Schildereyen, und Portraits. Mit ihren besonderen Registern. Verfertiget in Anno 1749*. No. 363: 'Hals, Francois. Ein lachender Bauer mit einem Krug in der linken Hand, auf Leinen in schwarzem Rahmen mit vergulder Leiste (Höhe: 2 Schuh 5 Zoll; Breite: 1 Schuh 11 Zoll)'.

EXHIBITIONS Schaffhausen 1949, no. 45; Amsterdam 1952, no. 44; Haarlem 1962, no. 25.

LITERATURE Bode 1883, 97 (c.1640); Moes 267; HdG 95; Bode-Binder 66; KdK 1921, 129 (c.1635-40); KdK 140 (as noted in the text above, in this catalogue and in the 1921 edition of it, Valentiner erroneously reproduced a copy of the Kassel painting instead of the original); Trivas 35 (c.1627); Catalogue Hessisches Landesmuseum, Kassel, 1968, no. 216 (c.1628); Slive 1970-4, vol. 1, pp. 80, 94, 96 (end of the twenties); Grimm 44 (1628-9); Montagni 62 (1627); Herzog 1977, (n.p.), fig. 2 (c.1628-30); Weber 1987, pp. 134-5.

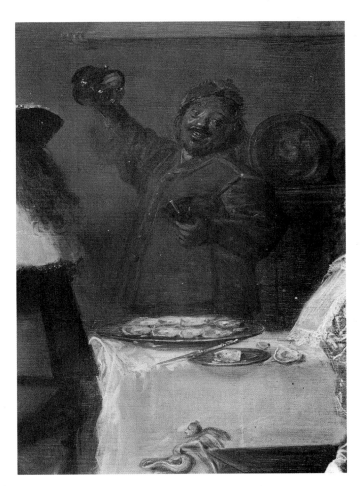

Fig. 31f Detail of Peeckelhaering from Dirck Hals, *Merry Company*, 1639 Stockholm, National Gallery (inv. 1549)

32 So-called Mulatto

c.1628-30
Canvas, 72 × 57.5 cm (original support)
Signed, lower right, with the connected monogram: FH
s65
Museum der bildenden Künste, Leipzig (inv. 1017)
Exhibited in London and Haarlem

This painting is popularly but wrongly known as the 'Mulatto'. It probably is hopeless to try to change its title now, if we consider that specialists have signalled that the picture's common name is erroneous since 1914, when Bode and Binder pointedly catalogued it as the 'so-called Mulatto'.

Heiland (1985) established that the painting's popular title is not very old. It made its debut as the *'Joyeux Mulâtre'* when it appeared in David P. Sellar's sale held in Paris in 1889. Merely two years earlier, when it was lent by Sellar to a Royal Academy exhibition in London, it was catalogued (with the not unusual anglicisation of Frans's name) as Frank Hals's 'Portrait of a Man ... in a red coat and cap ... his laughing face turned towards the spectator'. The invented title the picture acquired at the 1889 auction did not take hold immediately. In 1892, when the painting was lent by Alfred Thieme, its new owner, to a Munich exhibition, it was shown as a 'Portrait of a Laughing Man'. It only became the 'Mulatto' again in the catalogue of Thieme's collection published in 1900. Bode's powerful historical imagination got a bit out of hand when he wrote in his introduction to Thieme's catalogue that the 'Mulatto' was one of those characters from Holland's overseas provinces, probably Java, who immigrated as sailors and who entertained in taverns. Although Bode silently eliminated these details when he listed the picture as the 'so-called Mulatto' in 1914, the fantastic title became fixed.

The painting is, in fact, a depiction of Peeckelhaering, the stock theatrical character whom Hals also portrayed laughing and wearing the same costume in his picture now at Kassel (cat. 31). The same man must have served as the model for both works, and they are datable about the same time. In the Leipzig painting, Peeckelhaering's complexion is more ruddy, obviously the inspiration for the sobriquet he acquired late in the nineteenth century.

Leipzig's Peeckelhaering is less well-preserved than Kassel's. It has scattered losses, especially at the bottom, and passages of its paint surface have been moderately to severely abraded and flattened. Nevertheless, the vivacity of the artist's brushwork, particularly in the head, can still be fully appreciated. X-ray examination of the painting made during the course of its recent restoration revealed that during an old relining its original canvas support was enlarged, after the removal of the tacking edges, by the addition of canvas strips that measure about 3.3 cm at the top and about 4.8-5.5 cm on the right side. These later additions presently are covered by the frame. The painting has been cut at the bottom; its left side is virtually intact. The ground of the original canvas support is lead white, which was then covered with an imprimatura of light greyish umber (for a full discussion of the results of the technical investigation of the painting and its treatment, see Käppler 1985). The traces of a date near the monogram that are mentioned in the earlier literature (catalogues Leipzig, 1924 [1627?] and 1979 [16..?]) are not visible today.

Peeckelhaering's hand is only summarily suggested, not an uncommon feature in Hals's genre pictures and in some of his commissioned portraits, particularly the later ones. It is the kind of passage that has disturbed critics who become upset by less than academic perfection in all parts of a painting. Perhaps Hals allowed the hand to remain a bit out of focus to help concentrate the beholder's attention upon his model's magnificent head, but it simply may be a part that was not fully worked up.

Not long before the picture was restored, it was argued that the model is shown holding a coin between his thumb and middle finger which has been partially obscured by old repaint. The presence of the coin led to the conclusion that Hals intended this Peeckelhaering to represent the sense of Touch, since there is a pictorial tradition for alluding to Touch in this manner (Grimm 1972, pp.75-6). However, recent removal of the repaint revealed not a trace of a coin; thus, this allegorical interpretation must be abandoned (Käppler 1985, p.2). Even before the picture was cleaned, Senenko offered cogent reasons for rejecting this reading (1980, pp.144-5 and note 49).

Leipzig's Peeckelhaering is attribute-less, but his gesture as well as his costume help characterise him as a buffoon. Blankert has noted (1967) that his pointing finger is a gesture traditionally given to fools, and generally implies scorn or derision ('not worth sticking your finger out'). He has established that it is used in a score of seventeenth-century Dutch representations of Democritus. In these works the laughing philosopher is shown disparaging his weeping fellow philosopher, Heraclitus. According to the catalogue of a London sale held in 1773, Hals himself tried his hand at a *Democritus* and *Heraclitus*. Its compiler wrote: 'tho' this master was not used to treat such subjects, he has shewen great expression of grief in one, and drollness in the other'.[1] No seventeenth-century painter was better qualified than Hals to paint Democritus, who laughed at the world's folly. More difficult to imagine is how he would have depicted Heraclitus, the sage who wept at its foolishness.

Perhaps Leipzig's Peeckelhaering once had a companion picture. There is, however, no convincing reason to accept Valentiner's suggestion (KdK under 142) that its pendant is Hals's celebrated *Malle Babbe* at Berlin (cat. 37).

Valentiner had a predilection for mating Hals's genre pieces and portraits. There is an astonishingly early precedent for his practice. About 1670, the English printmaker Edward Le Davis (1640?-84?) coupled two of Hals's works (in reverse) on a single plate (fig. 32a). Leipzig's Peeckelhaering is shown as a Merry-Andrew and Hals's straightforward *Portrait of a Man* (fig. 32b), datable to the early 1640s, which is now in the Hermitage, is presented as a mountebank doctor. Joining this pair must have been the engraver's idea. Hals made some unusual pendants, but it is highly improbable that he intended his conventional portrait of a young man as a companion to his personification of folly painted about a decade earlier.

The first state of Le Davis's print is inscribed: *'The Mountebanck Doctor/ and His Merry Andrew/ Printed and Sold by Henry Overton/ at the White Horse without Newgate/ London Franc Haultz Pinxt. Edwardus Le Dauis Londini, Sculp.'* In the second state Le Davis changed the spelling of the artist's surname to 'Hault' and added a verse in which his Merry-Andrew honestly reveals:

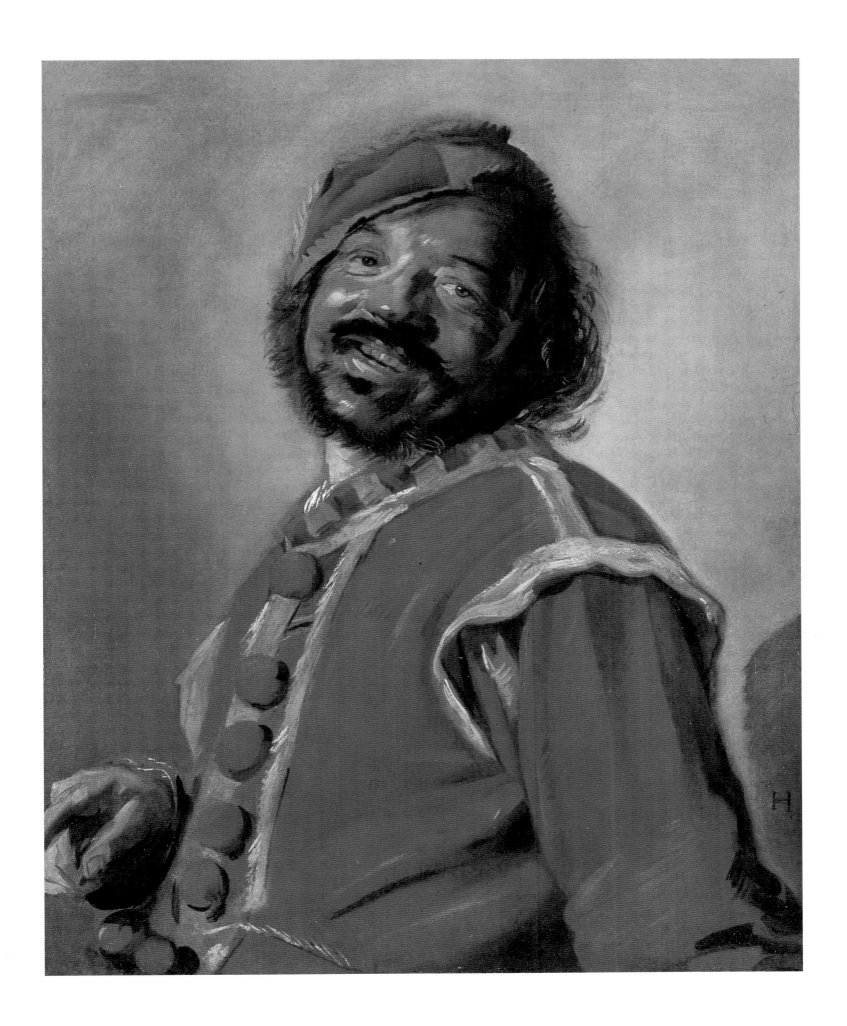

I am a Fool but not for want of wit
I play the fool that wee by Fools may get
For whosoever does the Packets buy
In troth I think they're greater fools then I
In parting with their Gold and Silver Coin
To Cure your poor Consumptive Purse and mine.

The Mountebank Doctor is equally straightforward:

My Antick fool in thy fantastick Dress
With Grinning Looks thy wonted words Express
And let thy Humours all be Acted well
That so I may my worthy Packets Sell
For tho I in Velvet Coat Appear
I am not worth one single Groat a Year.

Le Davis's transformation of Hals's Peeckelhaering into a Merry-Andrew, the name given to a mountebank's assistant in England about this time, was not a radical one. A Merry-Andrew and Peeckelhaering had similar occupations: they entertained with their buffoonery.[2]

We already have heard that the Leipzig picture has been cut at the bottom. Le Davis's engraving may show how much of the lower part of the painting is missing. To judge from the print, Peeckelhaering's bright red and yellow cap and costume originally were decorated with feathers (or stiff hairs?). If they were not the engraver's invention, they must have been lost before the painting's last restoration, since not a trace of them was detected when the painting was examined during its treatment. Juxtaposition of the print with the painting also indicates that the flying outer locks of Peeckelhaering's hair probably have been lost by abrasion; similar locks of hair are still wonderfully intact in the Kassel picture and in Kenwood House's portrait of *Pieter van den Broecke* (cat. 44), datable a few years later. Finally, it is noteworthy that Le Davis eliminated Peeckelhaering's hand. Did he find it too awkward to engrave or was he cramped for space? The latter supposition was probably the case.

Le Davis can be credited with making the earliest known references in England to the artist, as well as finding highly original ways to spell Frans Hals's name. Few Englishmen adopted his orthography (Franc Haultz or Hault), but permu-

Fig. 32a Edward Le Davis, engraving after Hals's *So-called Mulatto* and his *Portrait of a Man* (S134)

tations on the spelling of the artist's name are frequent in England during the eighteenth and early nineteenth centuries. George Vertue wrote of a painting of a 'Doctor by France Hals' (see note 2 below), and, when Horace Walpole presented a list of prints by Edward Le Davis in his *Anecdotes of Painting*, he included: 'A Merry Andrew, after Francis Halls, graved in an odd manner' (*Anecdotes of Painting in England*, ed. Ralph N. Wornum, vol. 3, London 1849, p. 942). 'Frank Halls' is another common variant used in England until about 1850.

The portion of Le Davis's print that depicts Peeckelhaering was known to Trivas (34). He incorrectly attributed it to Jacques de Gheyn II, who died 29 March 1629, and concluded that the painting must have been painted before that date. Although the documentary evidence Trivas offered to support a date late in the twenties for the picture must be rejected, the date he assigned to it on the basis of style is acceptable.

Le Davis's intriguing print indicates that two of Hals's paintings made their way to England by about 1670. As noted in the provenance listed below, nothing firm is known about the history of the painting Le Davis called a Merry-Andrew

until it was recorded in a London collection in 1887. If it is identical with the 'Merry Andrew' attributed to Hals that was sold in London in 1765 for 10 shillings and 10 pence, it is a serious contender for the record low price paid for a work by the master. Not much more is known about the history of the Hermitage's *Portrait of a Man*, which Le Davis dubbed a Mountebanck Doctor.[3]

For references to five copies of the Leipzig picture, see Slive 1970-4, vol. 3, no. 65.

Fig. 32b *Portrait of a Man* (s134), Leningrad, Hermitage

1. Sale anon. [James Ansell], London (Christie's), 6-7 April 1773, no. 59 (101.5 × 116.8 cm; £3.18s).

2. *The Oxford English Dictionary ... on Historical Principals* (Oxford 1933, vol. 6, p. 364) defines a Merry-Andrew as one who entertains by antics and buffoonery; a clown; and 'properly (in early use), a mountebank's assistant'. The earliest literary reference to the name cited in this source is dated 1673, about the date that can be assigned to Le Davis's print. The 2nd edn. of the *Dictionary* (Oxford 1989, vol. 9, p. 641) provides the same definition and does not offer an earlier literary reference.

3. Catherine II acquired the portrait for the Imperial Hermitage from the Johann Ernst Gotzkovsky collection, Berlin, in 1764. If we assume that af-

ter Le Davis gave the sitter the title of doctor he kept it while he was in England, we may have a few clues to the picture's history after about 1670. R.E. Hutchinson, Keeper, Scottish Portrait Gallery, kindly informed me that in the catalogue of the sale held about 1732 of works belonging to Colonel Charteris, no. 99 is described as 'an exceeding fine portrait of a physician by Francis Halls' (purchased by Mr. Stewart). Perhaps this painting is identical with the Leningrad portrait. Conceivably the monogrammed portrait George Vertue listed in his notebooks *c.*1750 as 'a picture 3/4 painted of a Doctor by France Hals' also is identical with the Hermitage painting (*The Twenty-Sixth Volume of the Walpole Society, 1937-38*, Vertue Note Books, vol. 5, Oxford 1938, p. 61).

PROVENANCE Probably in England about 1670; possibly sale anon. [Greenwood], London (Hobbs), 2-3 May 1765, no. 3 (F. Hals, A Merry Andrew; £0.10.10); David P. Sellar, London, by 1886; his sale Paris (Petit), 6 June 1889, no. 38 (as 'Joyeux Mulâtre'); purchased in 1889 from dealer C. Sedelmeyer, Paris, by Alfred Thieme, Leipzig, who bequeathed it to the museum in 1916.

EXHIBITIONS London, Royal Academy, Winter Exhibition, 1887, no. 80 (lent by David P. Sellars as 'Portrait of a Man' by Frank Hals); Munich 1892, no. 34 (as 'Bildnis eines lachenden Mannes'); Haarlem 1962, no. 24; Yokohama, Saporo & Hiroshima 1985-6, no. 45; *Merkur und die Musen: Schätze der Weltkultur aus Leipzig*, Künstlerhaus, Vienna, 22 September 1989-18 February 1990, no. V/2/16.

LITERATURE *Galerie Alfred Thieme in Leipzig* (intro. by Wilhelm Bode), Leipzig 1900, no. 31 (as 'Der Mulatte'); Moes 268; HdG 96; Bode-Binder 65; KdK 143 (c.1635-40); Trivas 34 (before 29 or 31 March 1629); A. Blankert, 'Heraclitus en Democritus', *N.K.J.* XVIII (1967), p. 57, note 57; Slive 1970-4, vol. 1, pp. 94, 96-7 (1628-30); Grimm 45 (1628-9); Montagni 62 (1627); Catalogue Museum der bildenden Künste, Leipzig, 1979, no. 1017 (dated 16..?); Käppler 1985, pp. 2-6; Heiland 1985, p. 6.

Fruit and Vegetable Seller

1630
Canvas, 157 × 200 cm
Signed and dated on the stone wall on the right: *CVHeussen fecit A 1630* (the first four letters and the *se* are joined)
S70
Private collection

This colossal still-life is signed and dated 1630 by Claes (Nicolaes) van Heussen, a Haarlem specialist of the genre. Details regarding his life (Haarlem 1599-after 1631 Haarlem) are sparse and only a handful of his works have been identified. They are variously signed (C.v. Heussen and C.V. Heus) and are dated between 1626 and 1631. He won enough local fame in his own day for Samuel Ampzing to make a passing reference to him in his history of Haarlem, published in 1628;[1] for Hals's portrait of Ampzing and the latter's comments about him, see cat. 40.

To judge from his surviving works van Heussen was inspired by the huge, abundant displays of fruits and vegetables favoured by Flemish artists and by their followers in the Northern Netherlands. Apparently he did not attempt the unpretentious, monochromatic still-lifes that Pieter Claesz and Willem Claesz Heda were painting at this very time in Haarlem, today prized as Holland's unique contribution to the subject. Like so many exuberant Flemish still-life specialists, he felt compelled to animate his still-lifes with some live action and, as they often did, he called upon a figure painter to do the job. Van Heussen could not have found a better collaborator. Hals painted the coquettish young woman who has turned momentarily to look at the viewer as she reaches into a basket. Frans's firm modelling and economical touches are unmistakable in a close view of the girl's head (fig. 33a). His characteristic hatched strokes are apparent also in the

young woman's apparel, and a comparison of the fluid touch of the fluttering ivy clinging to the fluted column behind her with the meticulously painted branches and leaves in the still-life indicates that he worked up this passage as well.

Nothing about the way Hals's young woman is integrated into the huge still-life makes one doubt that she was painted in 1630, the year van Heussen inscribed on the painting. This date is of more than antiquarian interest. It provides the only firm date on a Hals subject or genre piece, apart from his painting of a prodigal couple dated 1623 at the Metropolitan Museum of Art (pl. III).

The absence of Hals's signature on the still-life tells us that his contemporaries did not put a premium on his participation, and that van Heussen received the lion's share of credit for the work. However, we do know that collaborative works by seventeenth-century Dutch painters most often bear only one signature. Salomon de Bray's signature on Hals's monogrammed, early *Family Portrait* (cat. 10), is an exception to the rule. As we have seen, de Bray's little girl was a later addition, not part of a planned collaboration. When Molijn painted landscape backgrounds for Hals's family portraits, he did not add his signature to them (see cat. 21, 49, 67). Hals did not sign them either. It is also noteworthy that Pieter Codde did not put his signature on the huge militia piece he completed for an Amsterdam company after Hals refused to finish what he had begun (cat. 43).

One other case of a joint effort between Hals and another painter is known from a deed written in 1656. In describing portraits a Haarlem painter received of his grandparents, it states that the 'portraits were made and painted by Mr. Franchoys Hals the elder and the *comparquement* by Buytewech, also called Geestige Willem' (Hals doc. 153). The meaning of *comparquement* is obscure but it is reasonable to assume that it refers to the kind of elaborate cartouche-like painted frame supplied by Willem Buytewech for one of his own copies after Hals (Slive 1970-4, vol. 3, p. 4, no. 5 and fig. 4). Neither portrait listed in the 1656 document has been identified, but we can be certain that the pendants must have been painted during the early years of Hals's activity, since Buytewech joined the Haarlem guild in 1612, and in 1617 returned to his native Rotterdam, where he died in 1624.

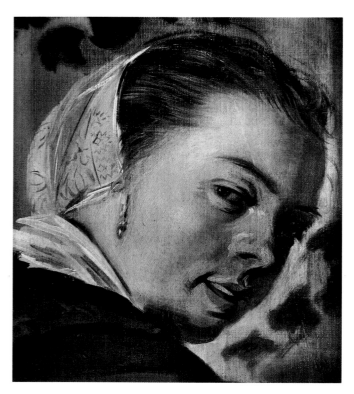

Fig. 33a Detail from *Fruit and Vegetable Seller*

1. Ampzing briefly writes (1628, p. 372), between equally brief references to the Haarlem still-life specialists Willem Claesz Heda and Hans Bollongier: 'Van Heuszen komt dan ook met uwe fruyten hier' ('Van Heuszen come forth too with your fruit').

PROVENANCE Probably sale Amsterdam, 6 August 1810, no. 41 (Dfl. 50, Roos); probably sale E.M. Engelberts, Amsterdam, 25 August 1817, no. 33 (Dfl. 47, Woodburn); Viscount Boyne, Bridgnorth, Shropshire.

EXHIBITIONS London 1929, no. 122; London 1952-3, no. 97.

LITERATURE HdG 121c; C. Hofstede de Groot, 'Twee teruggevonden schilderijen door Frans Hals', *O.H.* XXXIX (1921), pp. 67-8; Slive 1970-4, vol. 1, pp. 58, 140-3; Grimm 52; Montagni 76.

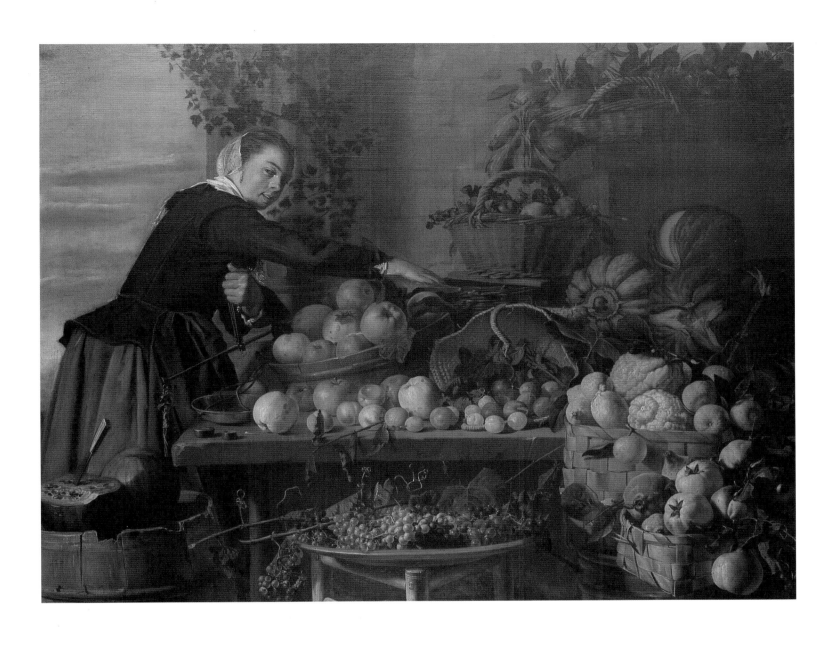

34 Fisher Boy

*c.*1630-2
Canvas, 74 × 61 cm
Signed, lower right, with the connected monogram : FH
S71
Koninklijk Museum voor Schone Kunsten, Antwerp (inv. 188)
Exhibited in Washington

In the country where fishing was the basis of the economy, pictures of fisherfolk were not uncommon. Most often they were depicted in coastal scenes, where they appear as little figures working on the shore, but they also were represented individually to personify Water and Phlegm in allegorical representations of the Four Elements and the Four Temperaments, and Goltzius even made a series of drawings of the apostles showing several in the guise of contemporary Dutch fishermen (Reznicek 1961, vol. I, nos. 50-62). Hals can be credited with adding a new theme to this part of the Dutch artist's repertoire. He was the first to paint half-length, life-size pictures of fisher boys and girls, an innovation that distinguishes him as the first artist to make a working child the subject of a painting. His earliest known one is datable to the late 1620s (fig. 34a).

In common with virtually all of Hals's genre pictures, there are no contemporary written or printed references to these unusual paintings. The earliest one cited is found on the caption of a mezzotint of the artist's lost *Laughing Fisher Boy* by Johannes de Groot (1688/9, still active 1722), which is inscribed : '*F Hals [the F and H ligated] Pinxit J. de Groot Fe*' (fig. 34b). However, to judge from the number of old copies and variants of them, they were as popular in his time as his other attractive pictures of youngsters.

Those done by his followers have produced some distorted notions of Hals's own achievement. Bode, Hofstede de Groot and Valentiner included dubious ones amongst the works they catalogued as originals (reasons for rejecting ten they wrongly accepted, and a number of depressing versions of them, are discussed in Slive 1970-4, vol. 3, nos. D9 to D16 and D33, D34). On the other hand, Trivas went too far when he eliminated every single picture of this category from Hals's œuvre. Grimm also rejects all of them and assigns them to an anonymous painter he calls the 'Master of the Fisherchildren'. In my opinion he includes some authentic works in this group, and the style of others he has assembled is too heterogeneous to assign to a single artist.

An impressive original of the type is the Antwerp *Fisher Boy*, which ranks with the great Baroque portraits of children, though strictly speaking of course it is not a portrait – the parents of this boy did not belong to a class that commissioned genealogical portraits. (It is of interest to note that when Vincent van Gogh, who fervently wanted to succeed as a portraitist of the working class, cited the old master portraits he remembered best at Antwerp's museum, the first one he recalled was the *Fisher Boy*; *van Gogh Letters* 1958, vol. 2, letter 436, p. 457). When seen closeup, the boy's smiling face speaks to us with disarming childish frankness and unaffected simplicity. Only after we recognise what appears to be a deformity in one of his eyes does a faint shade seem to pass across his joyful expression.

The fine tonal harmony and similarity of the technique of the *Fisher Boy* to Hals's *Fruit and Vegetable Seller* of 1630 (cat. 33) suggest a date for it about the same time, or perhaps a few years later. Analogies in the treatment of the heads are particularly striking. Though the brushwork is freer and bolder, and angular strokes have been used more extensively to blur outlines, the sharp contrasts of light and shadow that

Fig. 34a *Laughing Fisher Boy* (S55) Burgsteinfurt, Westphalia, Prince zu Bentheim und Steinfurt

Fig. 34b Johannes de Groot, mezzotint after Hals's lost *Laughing Fisher Boy* (S.L5)

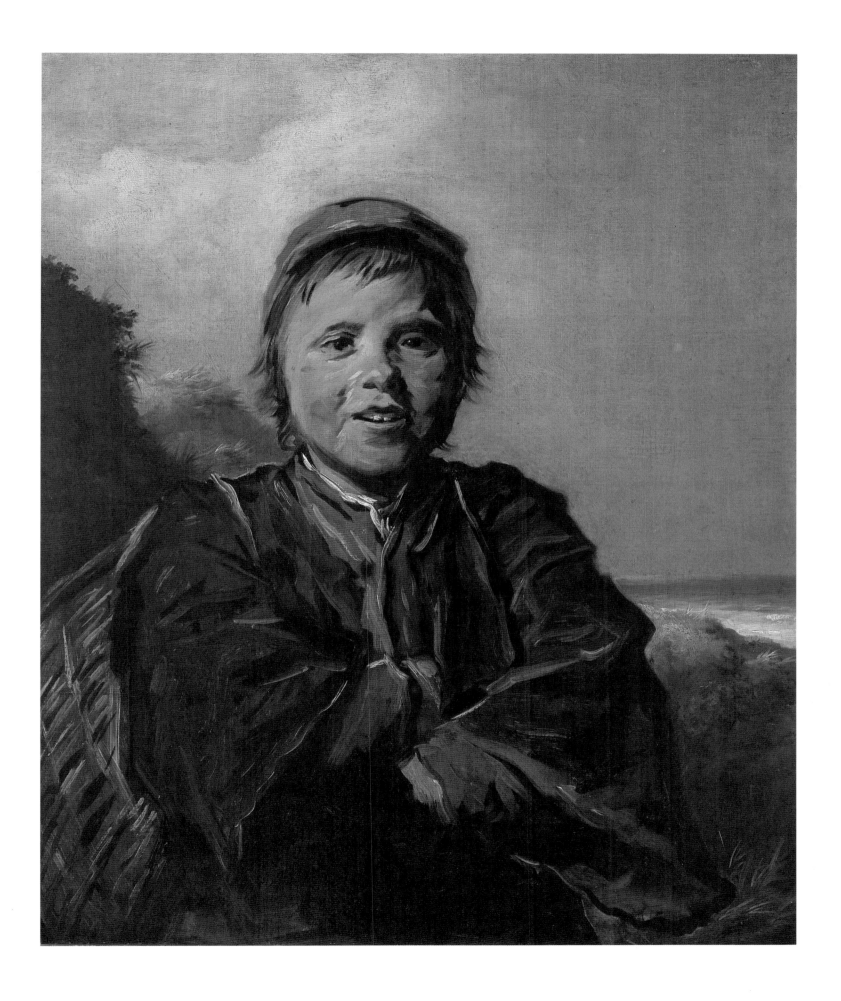

Fig. 34d Jan Miense Molenaer, *A Beach Scene with Fishermen* Sale London (Sotheby's), 24 October 1973, no. 129

Fig. 34c Johannes Reekers, *Fisher Boy*, etching

model forms and the few detached strokes that give definition to the salient features are very close. The range of the viscosity of the paint, from the thinly brushed-in passages to the heavy impasto highlights, which provide such lively accents, also is similar. The same bold attack coupled with exquisite pictorial refinement is found in the *Fisher Girl* (cat. 35), now in a private collection, and in the Dublin *Fisher Boy* (cat. 36), suggesting that they too were painted in the early thirties. As in the Antwerp painting, the red sleeves worn by these fisher children provide vivid colour accents, but the general effect has become more monochromatic than in the earlier genre pieces.

Koslow maintains (1975) that the wreathed arms of the Antwerp *Fisher Boy* and the one at Burgsteinfurt (fig. 34a) have the moralising intention of showing the sin of sloth. Granted, in other contexts this gesture can express the vice of idleness, but that is not its meaning in Hals's paintings. Numerous depictions of Dutch fisherfolk of all ages – some done as late as the nineteenth century (fig. 34c) – show that they assumed the posture to help them bear the weight of the heavy baskets they carry on their backs. Their habitual use of the gesture makes the wreathed arms of Hals's 1622 *Portrait of a Man* at Chatsworth (cat. 13) appear even more unorthodox.

Jan Miense Molenaer (c. 1610-68), the Haarlem painter whose early works show similarities to Hals's (but are never

as close to Frans's as a group done by his wife Judith Leyster), included the Antwerp *Fisher Boy* as a miniature full-length in an unpublished signed painting of fisherfolk on a dune near the sea (fig. 34d; panel, 37.5 × 33 cm). He appears again as a full-length in another *Beach Scene* by Molenaer (fig. 36a), where he is the boy with his arms crossed with a basket on his back approaching the principal group that includes full-lengths plagiarised from Hals's *Fisher Girl* (cat. 35), his Dublin *Fisher Boy* (cat. 36), and yet another *Fisher Girl* with a barrel on her head, that is based on a lost original (fig. 35d). Two of the figures in the background of this painting repeat fishermen found in Molenaer's dunescape mentioned above (fig. 34d). A third beach scene by Molenaer also is populated with recognisable fisher children derived from Hals (fig. 35b).

Molenaer's patent predilection for Frans's young fisherfolk suggests that he may have been responsible for some of the nameless ones done in Hals's manner; for example, the copy of the Antwerp *Fisher Boy* at the Rijksmuseum, Amsterdam (inv. A 950). However, neither it nor any of the others by the master's followers are attributable to him.

Valentiner (KdK 117, right) suggested that the Antwerp *Fisher Boy* and the *Fisher Girl* (cat. 35) were possibly pendants. Although the two paintings have similar dimensions, and both were possibly in the same Brussels sale in 1746, and they certainly were in Alphonse Oudry's sale held in Paris in 1869

(see Provenance below), their compositions do not support the view that they were designed as a pair. Neither does Koslow's attempt (1975, pp. 429-31) to use an iconographical interpretation to bolster the notion that the two pictures were companions. She argues their pairing is based on the principle of opposition reminiscent of the medieval juxtaposition of vice and virtue, the boy with his crossed arms exemplifying idleness, the girl with her barrel of fish exemplifying labour. Her case rests on her interpretation of the boy's wreathed arms; she argues they make him an exemplar of sloth. We have already heard that this interpretation is unconvincing.

It is noteworthy that when the Antwerp *Fisher Boy* and its putative companion appeared in the 1869 sale of Albert Oudry, they were not listed as pendants. Oudry, a very wealthy French engineer, had more than a passing interest in Frans Hals. Amongst the eighty-nine Dutch and Flemish paintings offered in his sale, seven were catalogued as works by Hals. In addition to the two fisher children already cited, he owned the Dublin *Fisher Boy* (cat. 36) and the artist's powerful late portrait of *Herman Langelius* (cat. 81). Thoré-Bürger was on the mark when he wrote in his pioneer study on Hals (1868, p. 466), published a year before the Oudry sale, that some of the engineer's paintings by the artist were of '*haute qualité*'.

How did Oudry manage to acquire Hals's portrait of Langelius and three paintings of fisher children?[1] A possible clue is offered in the memoirs of Henri Rochefort, the art lover and pamphleteer who began his career as an ardent republican and ended it as a vitriolic nationalist and anti-Semite. Rochefort writes (1896-8, vol. 1, pp. 117-8) that upon occasion he advised Oudry. According to his account, when the great collector Louis La Caze (whom Rochefort admired for buying Hals's *Gipsy Girl* dirt cheap; see cat. 72) refused to purchase Rembrandt's late *Saul and David* now at the Mauritshuis (Bredius-Gerson 526), he successfully persuaded Oudry to buy it. Perhaps Rochefort recommended paintings by Hals to Oudry as well.

1. Another *Fisher Boy* in Oudry's 1869 sale (no. 36) is possibly identical with the dubious painting of the subject in the Assheton Bennett collection (S.D13). His *Portrait of a Man* and a *Woman* (nos. 30, 31 respectively) remain unidentified. It has not been noted that his *Dutch Interior* with *Three Children near a Fireplace* attributed in his sale catalogue to Frans Hals II (no. 37) can be safely identified as the picture, now in the Frans Halsmuseum (inv. I-121), signed and dated 1635 by Frans's son Jan (Johannes).

PROVENANCE Possibly identical with *A Boy with a Basket on his Back* which was sold with *A Woman selling Anchovies* in the sale Gerard Vervoort, Brussels, 19 September 1746, no. 49 (Dfl. 49; 'een Jonge met een Mande op zyn Rugge' and 'een Vrouw die Ansjovis verkoopt', by Frans Hals; HdG 55, 112 respectively). Sale Alphonse Oudry, Paris, 16 April 1869, no. 35 (not no. 33; fr. 1250). *A Fisher Girl holding a Herring in her Hand* appeared in the same sale (no. 32; fr. 1550), a painting possibly identical with the anchovy seller cited above, which is now in a private collection (cat. 35); however, it is uncertain if the artist intended the pictures as pendants. The present painting was purchased by the museum from J.C. Mertz, Paris, in 1871. According to C. Sedelmeyer's 1898 *Catalogue of 300 Paintings* (no. 46), it was also in his possession.

EXHIBITIONS Haarlem 1937, no. 53; Haarlem 1962, no. 27; Brussels 1971, no. 46.

LITERATURE Bode 1883, 37 (c. 1640); Moes 254; HdG 49 and possibly HdG 55; Bode-Binder 76; KdK 117 right (c. 1633-5); Slive 1970-4, vol. 1, pp. 141-3; Grimm 1971, p. 175 and Grimm 1972, p. 214 (Master of the Fisherchildren); Ekkart 1973, p. 254 (not by Frans Hals); Montagni 319; Koslow 1975, pp. 418, 429-32 (Frans Hals).

35 Fisher Girl

*c.*1630-2
Canvas, 80.6 × 66.7 cm
Signed on the barrel with the connected monogram: FH
S72
Private collection, New York

This *Fisher Girl* disappeared after it was sold in Paris in the 1881 Beurnonville sale. Bode-Binder (288) and Valentiner (KdK 1921, 110) recorded it as untraceable; in their catalogues they reproduced the etching Eugène Gaujean (1850-1900) made of it for the 1881 sale catalogue. Then Valentiner recognised the painting in the Brooklyn Museum and published it in 1923 (KdK 117 left) as a possible pendant to the Antwerp *Fisher Boy* (cat. 34). Although both pictures are datable to about the same time, it is doubtful they were intended as a pair; for a discussion of the unsuccessful attempt to link them on the basis of an iconographic interpretation, see cat. 34.

The painting is in very good condition, with abrasion limited to its lower edge and the right side of the barrel. The girl's unfinished left arm gives us a glimpse of the way the artist began to brush in forms. On the other hand, the dune-scape, opening to a new overall airiness and spaciousness by the subdued contrast of pale yellows and silvery greys, and the brightening of the sky at the horizon, is fully realised. It indicates that Hals was familiar with the innovative tonal landscapes his younger colleagues Jan van Goyen, Pieter Molijn and Salomon van Ruysdael began to paint in Haarlem in the late twenties, and also makes us regret that he did not try his hand as a landscapist more often. Gregory Martin

(1971, p. 243) has rightly observed that the debt of Hals's pupil Philips Wouwerman (1619-68) can be seen in his teacher's ravishing landscapes of this type.

A technical detail about the painting recorded in a conservator's report in the files of the Brooklyn Museum (7 April 1937) is worth noting. Examination revealed that it was executed on a canvas that was not tacked to a stretcher but was tensioned in the centre of an oversize one by cords. The original size of the support is preserved and the holes where the cords pierced the fabric are visible at the edges. For a discussion of other canvasses Hals employed that were laced to their stretchers in the same fashion, see Groen & Hendriks, pp. 113-4, and Bijl, p. 104.

Seventeenth-century Dutch paintings that show a canvas suspended in an oversize stretcher are not uncommon. About the time Hals painted the *Fisher Girl*, one was depicted by Jan Miense Molenaer: *The Artist's Studio* dated 1631 (fig. 35a). Molenaer had contact with Hals during these years. Indeed he must have known the artist's *Fisher Girl*; she appears as a full-length along with other fisher children derived from Hals's work in two of his shore scenes (figs. 35b, 36a). For another Molenaer painting of the type, see fig. 34d.

What thoughts did Hals's fisher children conjure up in the

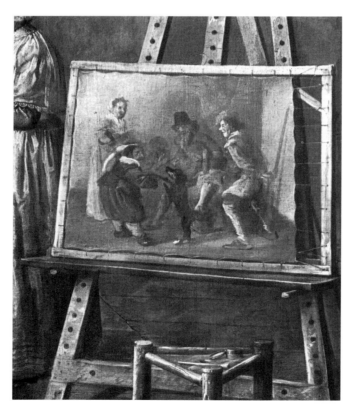

Fig. 35a Detail from Jan Miense Molenaer, *The Artist's Studio*, 1631 East Berlin, Staatliche Museen (inv. 873)

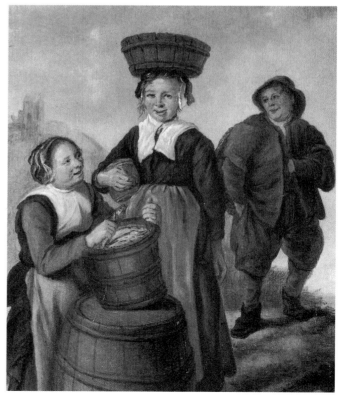

Fig. 35b Detail from Jan Miense Molenaer, *Beach Scene with Fisher Children*. Formerly The Hague, S. Nijstad

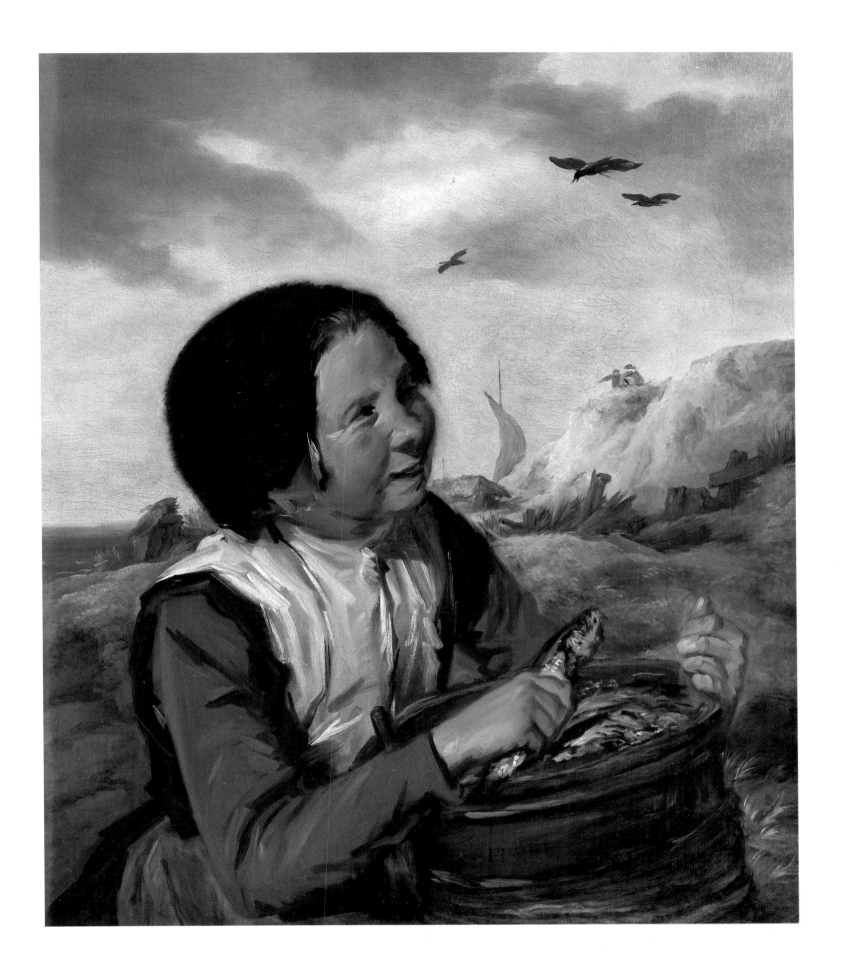

Fig. 35c Engraving designed by Adriaen van de Venne to illustrate a poem in Jacob Cats, *Doot-kiste voor de levendige, of Sinne-beelden uyt Godes woordt ...*, Amsterdam 1655

Fig. 35d Unknown artist, *Fisher Girl*, copy after a lost Hals (S.D33) Cincinnati, Cincinnati Art Museum

contemporary viewers? These pictures of young people who seem to burst with pleasure and appear braced by the fresh sea air, not oppressed by their work at the shore, could hardly have been looked upon as commentaries on the abuses of child labour and the need for social change. A more fitting interpretation – and one that is not anachronistic – has been offered by Julius Held, who suggested (private communication) that some contemporary Dutchmen may have looked upon Hals's working children as reminders of the virtues of 'natural life' over 'town life'. He noted that Jacob Cats, seventeenth-century Holland's most popular moralising poet, interpreted the subject that way in a poem published in 1655: 'Apropos of a young woman of Scheveningen who carries a basket of fish on her head' ('*Op de gelegenheyt van een Scheveninghes vroutje dat een benne met visch op haer hooft draeght*'). Cats's poem proclaims that life and work at the seashore, where one can be happy and free, is preferable to the pomp of town life, a variation on a theme familiar in Dutch art and arcadian poetry since the turn of the century.

Cats's poem is illustrated by an engraving designed by Adriaen van de Venne (1589-1662) of a young fisherwoman at the Scheveningen shore (fig. 35c), who recalls a lost *Fisher Girl* by Hals known today in two copies; the best one is at the Cincinnati Art Museum (fig. 35d). This precursor of Hogarth's more famous *Shrimp Girl* makes a prominent appearance as a full-length in two of Molenaer's beach scenes that give Hals's fisher children leading roles (figs. 35b, 36a). An engraving after her or one of Hals's others of this type could have served equally well as an illustration for Cats's poem.

Royalton-Kisch has observed (1988, p. 116, no. 88) that the young woman used to illustrate Cats's poem resembles closely, in reverse, a fishwife who appears in van de Venne's watercolour of *Three Fisherwives* in his album dated 1626 of 102 miniatures at the British Museum. Given the context of the watercolour, and noting that fishing sometimes was employed in Dutch art to convey amorous meanings, and that fish also was used as a sexual euphemism, Royalton-Kisch finds (ibid., pp. 106-7) sexual allusions in the watercolour and others of fishermen and fishwives in van de Venne's album.

He has not proposed, and I see no reason to suggest, that there are sexual allusions in Hals's half-lengths of fisher children. As for Molenaer, no exegesis is needed to explain the intent of the old fisherman fondling Hals's *Fisher Girl* (fig. 36a).

Hofstede de Groot (114) mentioned that an old copy of the *Fisher Girl* was in the London art market in 1908. It may be identical with one that was in Coll. J.H. Garkin, London, 1905; Coll. S.J. Graaf van Limburg-Stirum, The Hague; sold for £1,800 by Sabin (31.8 × 26 cm; photo FARL). A photo of another copy from the dealer Duits is in the photo archive of the National Gallery, London; it is succinctly annotated 'canvas, life size.' Yet another copy is in the collection of Mrs. Inga-Lill Sundin, Stockholm (58 × 51 cm).

PROVENANCE Possibly identical with a *Woman selling Anchovies* sold as a lot with *A Boy with a Basket on his Back* in the sale Gerard Vervoort, Brussels, 19 September 1746, no. 49 (Dfl. 49; 'een Vrouw die Ansjovis Verkoopt' and 'een Jonge met een Mande op zyn Rugge' by Frans Hals; HdG 112, 55 respectively); possibly sale Rotterdam, 20 July 1768, no. 2 (Dfl. 140; Verhaag); sale Alphonse Oudry, Paris, 16 April 1869, no. 32; sale Baron de Beurnonville, Paris, 9-16 May 1881, no. 302; sale, Ernest May, Paris (Petit), 4 June 1890, no. 105; Augustus A. Healy, who bequeathed it to the Brooklyn Museum in 1921 (inv. 21.143); sold by the museum to Wildenstein, New York, 1967; private collection, Switzerland.

EXHIBITIONS Detroit 1935, no. 28; Haarlem 1937, no. 54; Bloomington 1939, no. 13; New York 1945, no. 3; Los Angeles 1947, no. 11; Raleigh 1959, no. 59; Haarlem 1962, no. 28.

LITERATURE Bode 1883, 51; HdG 114, possibly identical with HdG 112 and 112a; Bode-Binder 288; KdK 117 left (c.1633-5); Valentiner 1936, 52 (1635); Slive 1970-4, vol. 1, p. 143; Grimm 1971, pp. 175-7 and Grimm 1972, p. 214 ('Master of the Fisherchildren'); Ekkart 1973, p. 254 (not by Frans Hals); Gerson 1973, p. 173 ('I will fight ... to the last breath in order to protect that Girl from being attributed ... to a "Master of the Fisher-children"'); Koslow 1975, pp. 429-31 (Frans Hals); Montagni 320.

▷
Detail from cat. 36

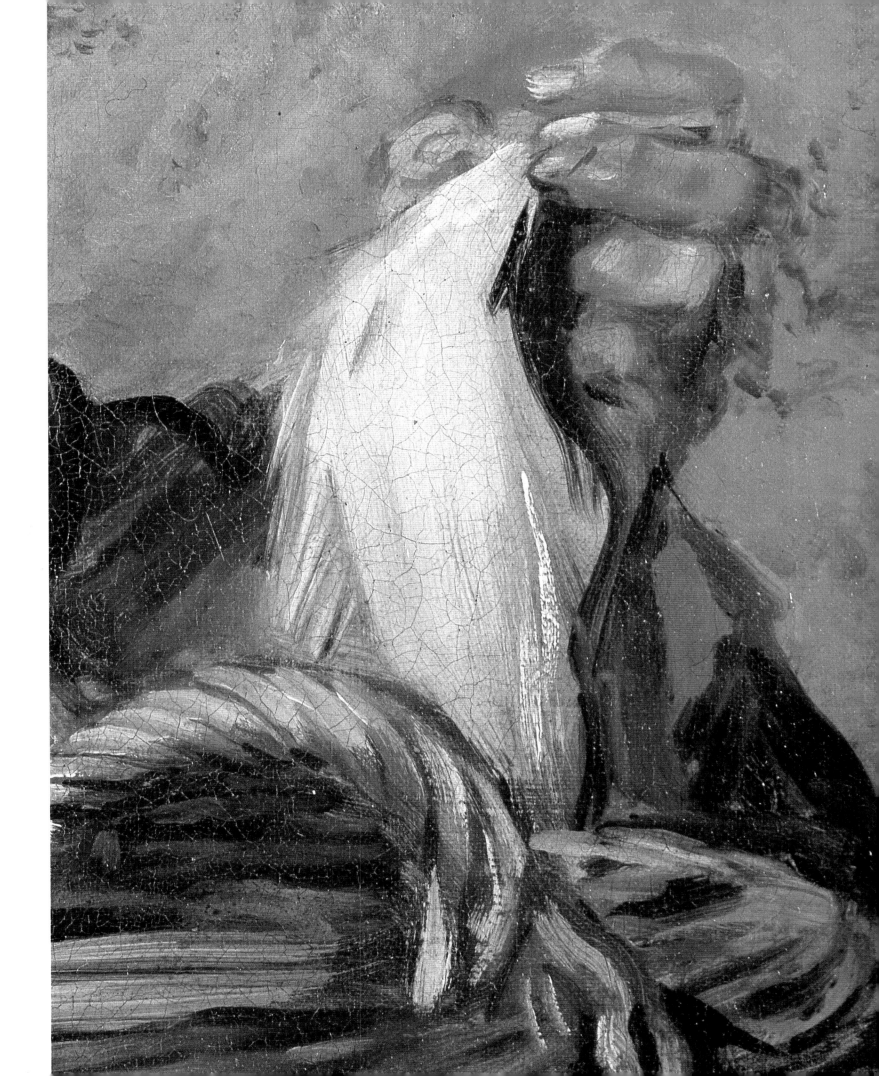

36 Fisher Boy

c.1630-2
Canvas, 72 × 58 cm
Signed, lower left, with the connected monogram: FH
S73
The National Gallery of Ireland, Dublin (inv.193)

When the author of the 1958 Antwerp catalogue (p.102, no.188) called this *Fisher Boy* a '*répétition avec variantes*' of the Antwerp *Fisher Boy* (cat.34), he stretched the term '*répétition*' beyond recognition. The painting is an independent composition. It does, however, have close stylistic affinities with the Antwerp picture as well as with Hals's *Fisher Girl* (cat.35), and with the figure Hals painted in Claes van Heussen's huge fruit and vegetable still-life, dated 1630 (cat.33).

Jan Miense Molenaer incorporated the Dublin *Fisher Boy* seen full-length in his untraceable *Beach Scene with Fisherfolk* (fig.36a). Also recognisable in Molenaer's painting are figures derived from Hals's *Fisher Boy* in Antwerp (cat.34) and his *Fisher Girl* (cat.35). The standing girl carrying a wooden tub on her head likewise is based on a Hals invention. The best version of the last named is at the Cincinnati Art Museum (fig.35d; S.D33). For further discussion of the Hals paintings upon which they are based and other coastal scenes by Molenaer that include them, see cat.34, 35.

The painting was in the collection of Alphonse Oudry by 1869 and with John W. Wilson four years later (see Provenance below). Additional word regarding six other paintings attributed to Hals that Oudry owned and four in the collection of Wilson is offered under cat.34, 20, respectively.

PROVENANCE Sale Alphonse Oudry, Paris, 16 April 1869, no.33 (fr.1,130); John W. Wilson, by 1873; his sale Paris, 14 March 1881, no.60, purchased by the gallery at the sale (fr.7,100, Hecht).

EXHIBITIONS Brussels 1873, p.85 (with etching by Paul le Rat [1849-92]; the 3rd edn. of the cat. gives a facsimile of the monogram; earlier editions erroneously reproduced a Diaz signature); Haarlem 1937, no.49; London 1952-3, no.86.

LITERATURE Tardieu 1873, pp.218-9; Bode 1883, 68 (*c*.1620); Moes 255; HdG 51; Bode-Binder 77; KdK 118 (*c*.1633-5); Slive 1970-4, vol.1, pp.143-4; Grimm 1971, p.175 and Grimm 1972, p.214 (Master of the Fisherchildren); Montagni 321; Koslow 1975, p.432, note 87 (Frans Hals); Gerson 1976, pp.423-4 (not by Frans Hals); Potterton 1986, pp.54-5, no.193 (ascribed to Frans Hals).

Fig. 36a Jan Miense Molenaer, *Beach Scene with Fisherfolk*
Location unknown

37 Malle Babbe

c.1633-5
Canvas, 75 × 64 cm
S75
Staatliche Museen Preussischer Kulturbesitz, West Berlin (inv. 801 C)
Exhibited in Washington and London

The frenzied vitality of Hals's *Malle Babbe* has been admired from the time Thoré-Bürger first published the painting in 1869, and the mature Courbet paid homage to the great Dutch realist by copying it in the same year at Munich's international exposition (fig. 37a). Since then it has been universally recognised as a supreme example of Hals's power of characterisation, his mastery of expressing spontaneous movement and emotion, and the fury of his suggestive brushwork.

The identification of his subject is based on a seventeenth or possibly eighteenth-century inscription on a piece of the painting's old stretcher which has been let into a new one. It reads: '*Malle Babbe van Haerlem ... Fr[a]ns Hals*'. Thoré-Bürger, in his thorough way, published a facsimile of the inscription, but following a reading of it published in an 1867 sale catalogue he erroneously read 'Hille Bobbe' for 'Malle Babbe'; this accounts for the incorrect title found in the older literature.

A hitherto unpublished document establishes that the improbable name Malle Babbe is not an invention. It states that in 1653 the authorities of Haarlem's Leper-House contributed 65 guilders toward Malle Babbe's support when she was confined to the city's house of correction (Hals doc. 94). Although it is the only thing known about her, it is easy to understand why she is popularly known as the 'Witch of Haarlem'. It is not necessary to believe in sorcery to be convinced that her wild, animal-like movement and demonic laugh are not the result of the amount of beverage she has consumed from her gigantic tankard, but are controlled by more potent, mysterious forces which could challenge man's faith as well as his rational powers. Only Goya, in his late phase, conjured up similar aspects of the savage side of humankind's nature.

The date of c.1633-5 given to the painting is based on its unprecedented breadth and economy of handling; both anticipate Hals's late style. I cannot name a single one of his genre pieces that postdates it. In view of the paucity of dates on his genre pictures the date – like so many others – remains tentative and may be modified by other evidence. At first blush Courbet's copy appears to offer some. Courbet boldly scratched into the wet paint of his replica the year 1645 and the artist's interconnected monogram to the right of Malle Babbe's arm. However, this troublesome inscription can be dismissed as Courbet's invention. The well-preserved original does not show a trace of either date or monogram. Thoré-Bürger did not cite them when he published the painting in 1869. He dated the work between 1630 and 1640. In 1869, Lützow, who knew the original and Courbet's copy, did not mention them either; he wrote he disagreed with his French colleague's date, and placed the painting in the 1640s. Lützow was also justifiably critical of Courbet's copy, which he said misses the painting's light tone, severely dampens the glimmer of its colours, and makes the facial expression less lively. The disappointing quality of Courbet's copy suggests the story that the French realist managed to substitute his copy for the original when it was exhibited in Munich in 1869, and that for several days his trick fooled the public is apocryphal. The anecdote is a late variation on the old *topos* that artists display their virtuosity by their ability to imitate exactly the work of others (Kris & Kurz 1979, pp. 97-8). As for the mysterious date on the copy, Frances Jowell offers the best explanation

Fig. 37a Gustave Courbet, *Malle Babbe*, 1869, copy after Hals Hamburger Kunsthalle (inv. 316)

Fig. 37b Detail probably showing Hals's lost *Malle Babbe Smoking* (S.L7) from Jan Steen, *Baptismal Party* West Berlin, Staatliche Museen Preussischer Kulturbesitz (inv. 795 D)

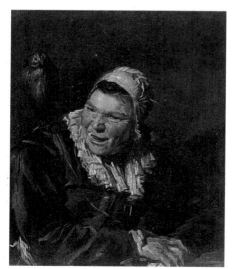

Fig. 37c Unknown artist, *Malle Babbe*, variant after Hals (S.D34) New York, The Metropolitan Museum

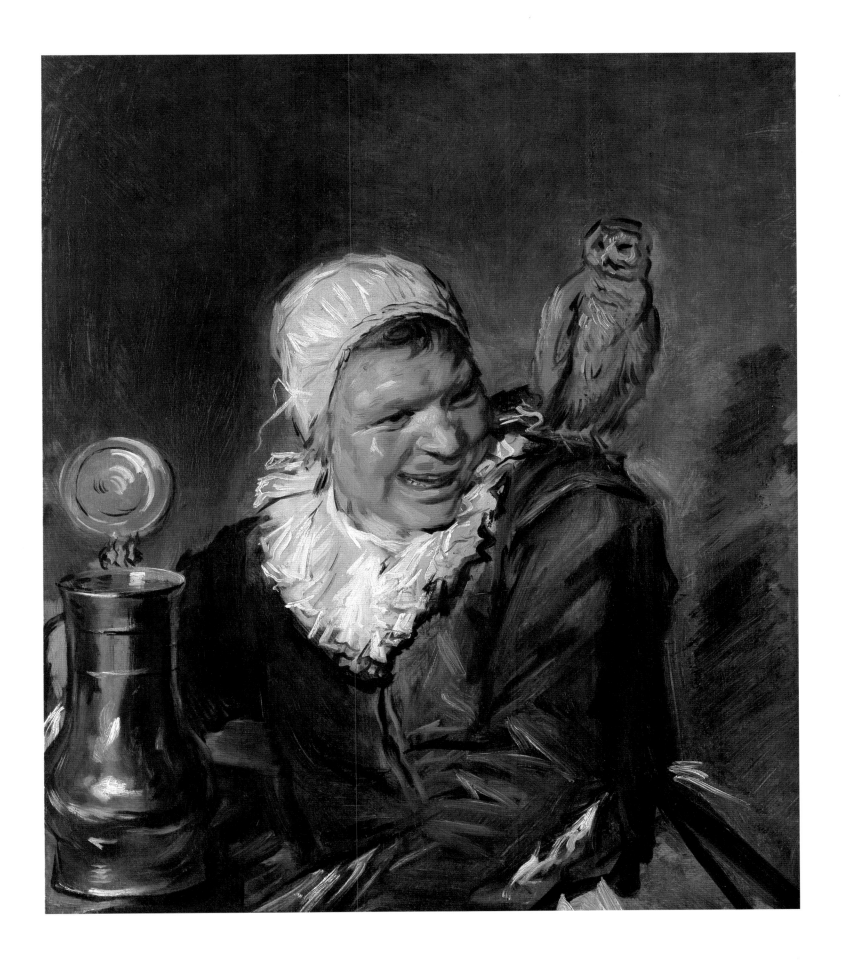

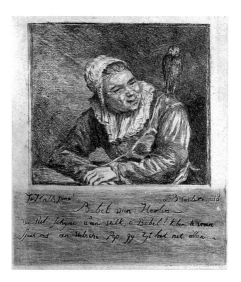

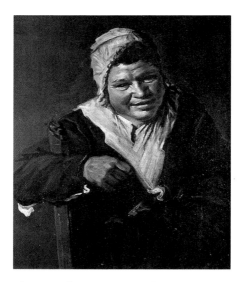

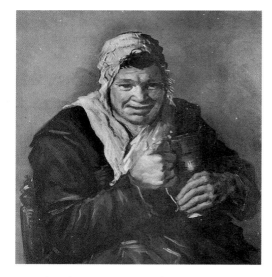

Fig. 37d Louis Bernhard Coclers, etching after a variant of Hals's *Malle Babbe*

Fig. 37e Unknown artist, *Malle Babbe* (S.D35) Lille, Musée des Beaux-Arts

Fig. 37f Unknown artist, *Seated Woman holding a Jug* (S.D36) Formerly New York, Jack Linsky

for it. She suggests that perhaps Courbet added it as both a teasing allusion and a homage to his friend Thoré-Bürger who, like art historians of his day and ours, generate seemingly endless debates regarding the year or decade in which a picture was painted (Jowell, p. 71).

Valentiner's supposition (KdK 142) that the so-called *Mulatto* at Leipzig (cat. 32) is a pendant to the Berlin picture is doubtful on stylistic grounds. However, companion pieces of this very type appear mounted in the background of Jan Steen's *Baptismal Party* at Berlin (fig. 31c) where Steen painted a beautiful miniature copy of Frans's *Peekelhaering* now at Kassel (fig. 31d) paired with what is very likely a *Malle Babbe smoking* by Hals, now lost (fig. 37b).

Other portraits of Malle Babbe are known. Amongst the existing variants, the one at the Metropolitan Museum (fig. 37c) comes closest to the standard set by the Berlin picture, but when seen next to the latter, it betrays another hand. With all its spontaneity, the pictorial organisation of the Berlin painting remains clearly thought out. Malle Babbe's sharply turned head makes a strong counter-movement to the emphatic diagonal thrust of the design, which is subtly reinforced by the direction of the energetic brushwork on her collar, cap, sleeve and apron. In the New York painting the tautness has slackened considerably, the detached strokes are hardly part of the dominant rhythm established by the movement of the figure, and we miss the decisive accents which give a convincing roundness to the forms even when they are suggested with a single touch of light or dark paint. The possibility that it is a copy of a lost original cannot be ruled out.

Louis Berhard Coclers (1740-1817) etched the New York variant (or another version of it?) in reverse (fig. 37d; Siccama 1895, no. 23). The couplet on his print reads:

Babel of Harlem,
To you, your owl is a falcon. O Babel! I am glad of it.
Play with an illusion. You are not alone.

(*Babel van Harlem*
uw uil schijne u een valk, o Babel! 'k ben te vreen
Speel met een valsche pop, gij zijt het nit alleen.)

As we shall see, Cocler's lines cast light on the meaning some of Hals's contemporaries most likely found in the Berlin original.

More remote from Hals is a painting at Lille called *Malle Babbe* (fig. 37e), which has been erroneously accepted by some cataloguers as authentic. A technical examination of it established that it employs pigments that were not available to Hals (*Cent Chefs-d'Oeuvre de Lille*, Lille 1970, p. 110). Yet another putative Malle Babbe, formerly in a New York private collection, has been ascribed to him (fig. 37f); the feeble painting is neither a portrait of the famous model nor by Hals.

Malle Babbe predictably found favour with pasticheurs. The unidentified one who put together the coarse painting of *Malle Babbe and a Smoker* at Dresden (fig. 37g) made a melange of the New York *Malle Babbe*, a well-known *Smoker* at the Louvre, variously attributed to Adriaen Brouwer and Joos van Craesbeeck, and a fish still-life very similar to those by Abraham van Beyeren. The attribution of this pot-pourri to Frans Hals II (*Icon. Bat.* no. 748-4; Catalogue Dresden, 1930, no. 1406) is without foundation. Yet another unidentified pasticheur transformed Malle Babbe into a fishwife and gave her a slovenly and very merry drinking companion (fig. 37h). The artist who painted it based part of his work on the Berlin picture. Perhaps the drinker was taken from a picture by Pieter van Roestraten (1630-1700), who was Hals's apprentice for five years and became his son-in-law in 1654 (Hals docs. 138, 148), or by Petrus Staverenus, a genre painter active in Haarlem about 1635; in any case he scarcely reflects a lost work by the master.

A more recent effort to rival Hals's peerless original was made by the Dutch forger Han van Meegeren (1889-1947), best known for his Vermeer fakes. His *Malle Babbe*, falsely signed on the right with Hals's connected monogram, was seized in his studio in 1945; it was deposited by the Amsterdam District Court in the Rijksmuseum, Amsterdam, in 1947 (fig. 37i). Paint samples tested by Bernard Keisch (1968) conclusively confirm that the painting, as well as four others that van Meegeren painted in Vermeer's manner are modern. To our knowledge, van Meegeren never attempted to sell his *Malle Babbe*. Perhaps the counterfeiter himself recognised that his deception has only a superficial resemblance to Hals's

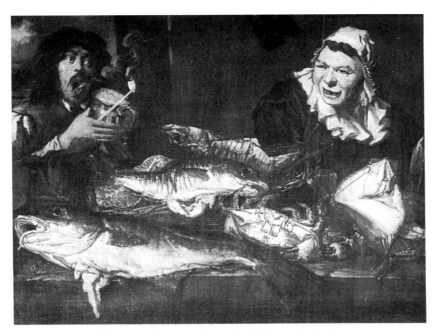

Fig. 37g Unknown artist, *Malle Babbe and a Smoker*,
pastiche after Hals
Dresden, Gemäldegalerie (inv. 1364)

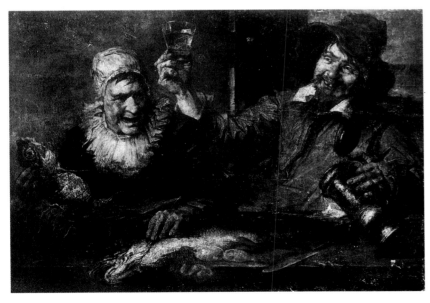

Fig. 37h Unknown artist, *Malle Babbe and a Drinking Man*,
pastiche after Hals
Formerly The Hague, S. Holdan

originals and that it would not pass muster. And, as always, when we turn to works by the master's followers, copyists and forgers, something else is missing; there is not a trace of the psychological penetration found in Hals's works. Admittedly, judging this aspect of his legacy will always remain partially subjective, but who would argue that van Meegeren's gross drinker touches depths of the human spirit?

After learning that close ties can be established between some of Hals's pictures and the popular moralising and allegorical traditions of his time, it is reasonable to ask whether the artist intended his incomparable *Malle Babbe* to be nothing but a study of a fleeting moment in the life of the shrieking old crone, or whether the subject may have some additional significance. Her pet owl offers a clue.[1]

Nowadays the owl is most frequently thought of as a symbol of wisdom. As a venerable attribute of both Athena and Minerva, its connection with sagacity and learning is ancient. However, an owl can personify many different ideas, and it figures in numerous proverbs to illustrate a wide range of truisms. References to owl symbolism are frequent in medieval, Renaissance and Baroque texts, and the subject has not been neglected in the modern literature.

In his drawing of *Owls in a Tree* (Boymans-van Beuningen Museum), Hieronymus Bosch makes good use of an old tradition and depicts the bird that prefers darkness to light as a personification of sin, and moralises about the power of evil over man. Bosch would have found Malle Babbe's owl a most appropriate symbol of the demonic forces which appear to possess the 'Witch of Haarlem'. Though there is no proof that Haarlem's citizens thought she was in league with evil spirits, there is ample evidence that the nocturnal bird perched upon her shoulder has been associated with the powers of darkness since the idea was expounded in medieval encyclopedias and bestiaries. Traditionally the owl also personifies foolishness, stupidity and ignobility. It appears as a symbol of gross folly in Bosch's work, and is used in analogous ways by Lucas van Leyden, Peter Huys, Karel van Mander and Jacob Jordaens. Valeriano lists foolishness among the ideas that the owl can signify in his *Hieroglyphia*, a voluminous treatise published in 1556 and frequently reprinted to satisfy the demand of a public devoted to emblems. Ripa, citing Valeriano as an authority in his *Iconologia*, uses the owl as one of the attributes of vulgar and common people ('*Vulgo, overo ignobilita*') because it is the bird the Egyptians had employed to represent ignobility. Erudite and less erudite seventeenth-century collectors probably had little difficulty recognising the appropriateness of the owl perched on the shoulder of the lascivious shepherd leering at the raised skirts of the seated young woman in Rembrandt's bucolic etching of the *Flute-Player* (1642; Bartsch 188).

Owls also have been associated with drunkeness, and in Holland inebriated men have been and still are called as 'drunk as an owl' ('*zoo beschonken als een uil*') or 'as tight as an owl' ('*zoo zat als een uil*'). Another common Dutch adage about the bird is included in the caption of Cocler's etching after a variant of Hals's *Malle Babbe* that is mentioned above (fig. 37c): 'To you, your owl is a falcon'. The proverb 'Everyone thinks his owls are falcons' ('*Elk meent zijn uil een valk te zijn*') is an old one. It is included in a verse inscribed on a drawing by van Mander, most probably Hals's teacher, of *A Fool with an Owl* (Albertina, Vienna), and Jacob Cats, who repeatedly found inspiration in folk sayings, quotes it – good testimony that it was popular in Hals's day. English equivalents of the saying are 'Every mother thinks her sprats are herrings' and 'Everyone thinks his geese are swans'.

That seventeenth-century Dutchmen did not forget that owls could allude to wisdom is apparent in the painting of a

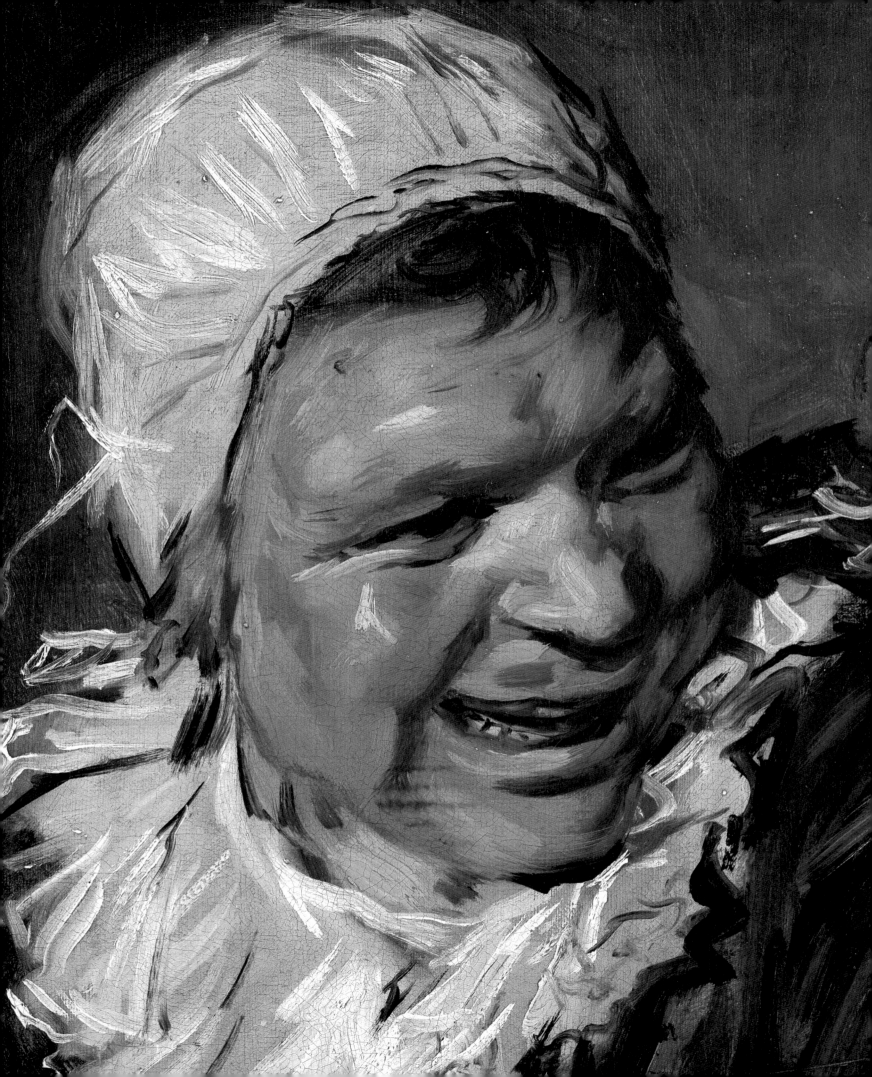

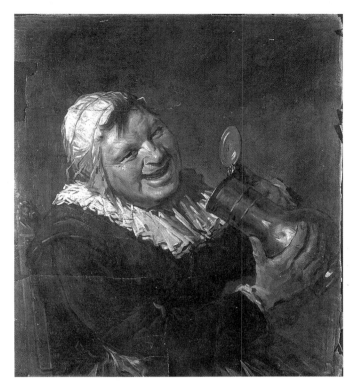

Fig. 37i Han van Meegeren, *Malle Babbe*, in the manner of Hals
Amsterdam, Rijksmuseum (inv. A 4242)

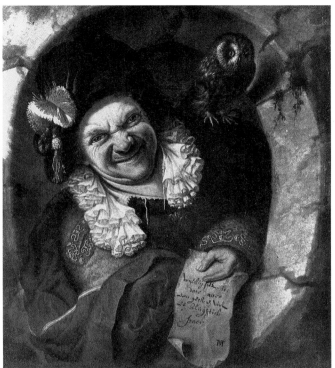

Fig. 37j Bartolomaeus Maton, *A Fool with an Owl*
Stuttgart, private collection

fool in fancy dishabille with an owl perched on his shoulder
(fig. 37j) by Bartolomaeus Maton (*c*.1643-after 1682), a Lei-
den pupil and follower of Gerard Dou. Maton's message that
a fool's search for wisdom is preposterous is spelled out by
the verse inscribed on a piece of paper held by this latter-day
Till Uilenspiegel:

Wise people, look, this is rare
A fool, an owl, a ridiculous pair.
(*Wijse lui siet tot/ dats raer
Een geck, een uyl een klughtich paer.*)

The pictorial organisation of Maton's picture – particularly its
strong oblique axis – is unusual in Leiden painting about 1675,
the date that can be assigned to his portrayal of a fool. It
suggests that he possibly had a chance meeting with Hals's
Malle Babbe. But little else in his highly finished and con-
trived picture recalls Hals's explosive masterwork. Maton also
found it imperative to add an inscription to explain the signifi-
cance of his model's owl. Frans Hals, of course, did not. He
never found reason to send owls to Athens.

PROVENANCE Possibly sale Amsterdam, 1 October 1778, no. 58
(Dfl. 9.5, Altrogge); possibly sale Nijmegen, 10 June 1812, no. 88;
sale F. J. Signault & J. J. van Limbeek, Amsterdam, 12 May 1834,
no. 92 (Dfl. 9, Roos; listed as on panel); sale L. Stokbroo van
Hoogwoud en Aartswoud, Hoorn, 3 September 1867, no. 69
(Dfl. 1,660). A letter dated 22 January 1868, Aachen, from Barthold
Suermondt to the Haarlem doctor and amateur archivist A. van der
Willigen establishes, that Suermondt purchased the painting at the
Stokbroo sale in 1867 (information kindly provided by J. W. Niemeij-
er; the letter is now at the RKD). The painting was acquired with the
Suermondt Collection for the Königliches Museum, Berlin, 1874.

EXHIBITIONS Munich 1869, no. 135; Brussels 1873a, no. 17; Brussels
1873b, no. 78; Amsterdam 1950, no. 52; Haarlem 1962, no. 31.

LITERATURE Bürger 1869, pp. 162-4; C. von Lützow, 'Hille Bobbe
van Haarlem. Oelgemälde von Franz Hals in der Galerie Suermondt
zu Aachen', *Zeitschrift für bildende Künste* v (1870), pp. 78-80; Un-
ger-Vosmaer 1873, no. XX (*c*.1650); Bode 1883, 92 (*c*.1650); *Icon. Bat.*
no. 748-1; Moes 260; HdG 108; Bode-Binder 68; KdK 142 (*c*.1635-
40); Trivas 33 (*c*.1628); Seymour Slive, 'On the meaning of Frans
Hals' "Malle Babbe"', *B.M.* CV (1963), pp. 432-6; Slive 1970-4, vol. 1,
pp. 145-52; Grimm 47 (1629-30); Montagni 71 (1629-30); Catalogue
Gemäldegalerie, Berlin, 1978, p. 202, no. 801 C; Baard 1981, p. 118
(*c*.1635 or later); Catalogue Gemäldegalerie, Berlin, 1986, p. 38,
no. 801 C.

1. For a fuller discussion of Malle
Babbe's owl which includes refer-
ences to the sources cited below, see Slive
1963. Additional references to owl

symbolism in Dutch art of the period
are offered by de Jongh in Amster-
dam 1976, no. 65.

38 Portrait of a Man

1630
Canvas, 116.1 × 90.1 cm
Inscribed, upper right: AETAT SVAE 36/AN. 1630
s68
Her Majesty Queen Elizabeth II
Exhibited in London and Haarlem

This imposing knee-length of an unidentified man in his prime shows a shift that begins to take place in Hals's style during the thirties, when his paintings acquired a greater unity and simplicity, silhouettes of figures became more regular, and bright colours were replaced by more monochromatic effects. Areas of attraction are reduced and there is a new restraint in the use of pictorial accents.

Waagen recognised the portrait's qualities in 1854 when he wrote:

> Van Dyck's admiration for Hals is well justified by this specimen; for the conception is unusually spirited and animated even for Frank [sic] Hals, and agrees in every way with the firm and broad execution. In my opinion the real value of this painter in the history of Dutch painting has never been sufficiently appreciated.

Waagen's reference to Van Dyck's admiration for Hals is based on the tale Houbraken told in his biography of the artist, published in 1718 told about the meeting the artists had in Haarlem (for a translation of the biography, see pp. 17-8). The story of their encounter, which is almost certainly fictitious, was retold and embroidered repeatedly by later biographers and, as Waagen's remark indicates, it still had canonical status around the middle of the nineteenth century.

At the time Waagen was justified in saying that Hals's real value has never been sufficiently appreciated. But things changed quickly. Not long after Waagen's death in 1868, thanks to his critical reappraisal of the artist's achievement but even more to the dedicated efforts of Thoré-Bürger, Hals acquired a secure place in the pantheon of Western painters (see Jowell).

The results of a cleaning done in 1970-1 (reported in the Buckingham Palace exhibition catalogue, 1971-2, no. 5) revealed that the picture 'had been overpainted, particularly heavily in the costume. The fall of drapery below the sitter's elbow and an area of draping below the waist on the right hand had been painted out. The inscription had been strenghtened'.

Valentiner's suggestion (KdK 85) that the portrait is probably a pendant to a *Portrait of a Woman*, now in an English private collection (s.D65, fig. 186) is unacceptable; the attribution of the latter to Hals is dubious.

PROVENANCE The little that is known about the painting's early history is published by Oliver Millar (London 1971-2, pp. 17, 72-3). He notes that the portrait is first referred to at Buckingham House during the reign of George III; it may have been acquired by him, or conceivably by his father, Frederick, Prince of Wales. The latter's accounts include, under 30 September 1753, 2s. to a man 'for Measureing the Dutch pickters, in the Wardrope' (Accounts of the Prince and Princess preserved in the Duchy of Cornwall Office, vol. 25 [1], fol. 54). The portrait was removed to St. James's Palace in 1828; in the Picture Gallery at Buckingham Palace by 1841.

EXHIBITIONS London, Royal Academy, Winter Exhibition, 1875, no. 102; London, Royal Academy, Winter Exhibition, 1892, no. 124; London 1946-7, no. 358; Edinburgh, 1947, no. 8; Haarlem 1962, no. 26; London 1971-2, no. 5.

LITERATURE Jameson 1844, no. 45; Waagen 1854, vol. 2, p. 4; Bode 1883, 134; Moes 125; HdG 286; Bode-Binder 126; KdK 84; Trivas 37; Grimm 49; Montagni 77; White 1982, pp. 43-4, no. 56.

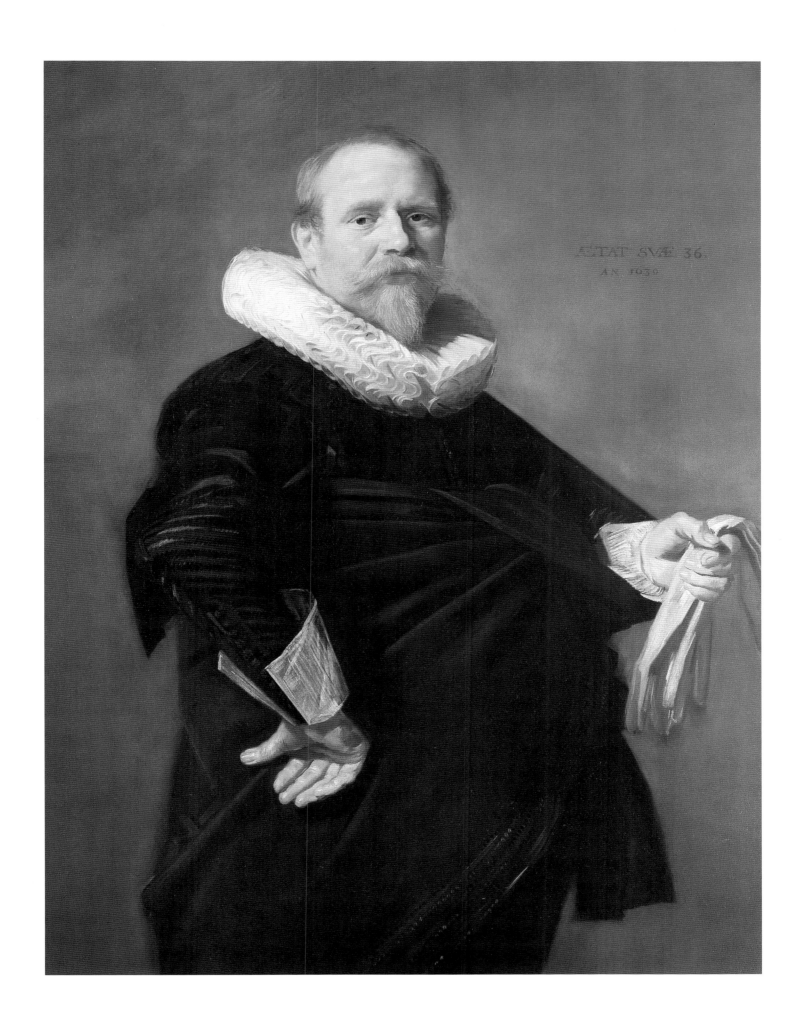

39 A Young Man in a Large Hat

c.1628-30
Panel, 29.2 × 23.2 cm
s66
National Gallery of Art, Washington, D.C., Andrew W. Mellon
Collection (inv. 1940.1.12)

According to Schneider (1918-9), who first published the
small painting, it was acquired by C.J.G. Bredius of Woerden
as a work by Jan Miense Molenaer. The error is understand-
able. About 1630 Molenaer and Judith Leyster, the artist he
married in 1636, painted works inspired by Hals's little infor-
mal oil sketches of this type. But they never matched the
fluidity of touch or airiness of this engaging portrait of a boy
seated in a complicated pose and, to judge from their existing
paintings, neither of them used illusionistic painted frames for
their pictures. The subdued colour contrasts relieved by only
a few vivid accents place the work about 1628-30.

PROVENANCE Collection van der Hoop; collection E.J. (or other ini-
tials depending on the date) Thomasson à Theussink van der Hoop
van Slochteren (reference from H. Gerson); C.J.G. Bredius, Woerden;
dealers Knoedler and Co., New York & Paris; A.W. Mellon, Wash-
ington, D.C.; gift of the A.W. Mellon Educational and Charitable
Trust to the gallery in 1940.

EXHIBITION On loan to The Hague, Mauritshuis, 1919.

LITERATURE H. Schneider, 'Ein neues Bild von Frans Hals', *Kunst-
chronik und Kunstmarkt*, N.F., XXX (1918-9), pp. 368-9; KdK 51
(c.1626-7; wrong size); Trivas 23 (c.1627); Grimm 42 (c.1628); Sum-
mary Catalogue National Gallery of Art, Washington, 1975, no. 498;
Montagni 67; Catalogue National Gallery of Art, Washington,
European Paintings, 1985, p. 197, no. 1940.1.12.

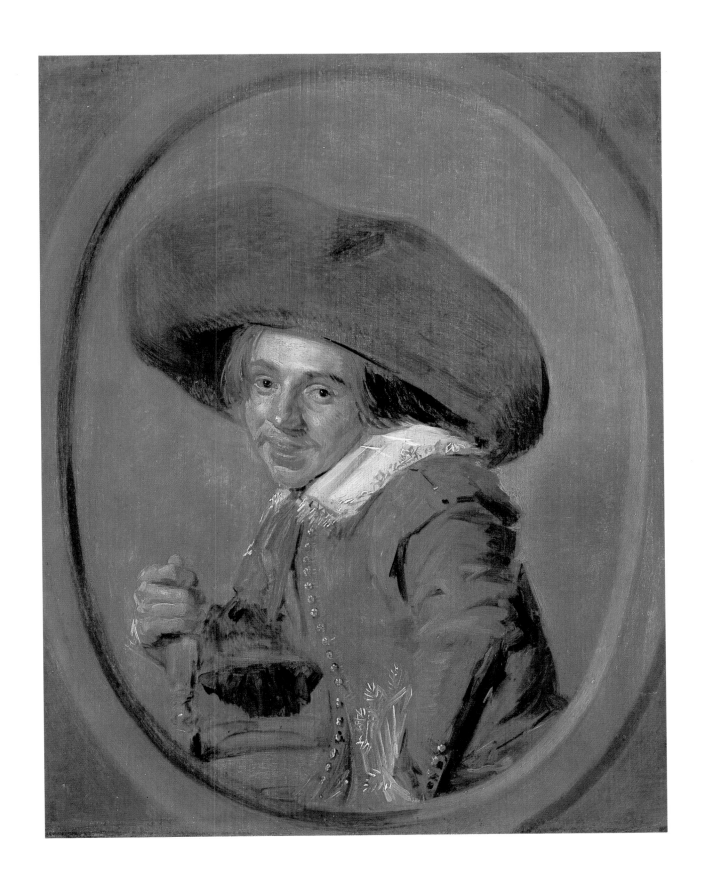

40 Samuel Ampzing

*c.*1630
Copper, 16.2 × 12.3 cm
Inscribed at the right: AETAT. 40/A[N ?]° 163...
s76
Private collection

The sitter, Samuel Ampzing (1590 [not 1591]-1632), was a Haarlem clergyman, poet and historian.[1] He did not mention Hals in his *Den lof van Haerlem*, which he published anonymously in 1616, but in this poem in praise of his city he did refer to leading Haarlem masters of the time: Goltzius, Cornelis van Haarlem and Hendrick Vroom. In 1621 a revised and expanded edition of the poem appeared (*Het lof der stadt Haerlem in Hollandt*). Once again he cited the trio of artists mentioned above. In addition he included a dry list of more than fifteen of the city's active artists, including Frans and his brother Dirck, without attempting to distinguish their individual qualities (Hals doc. 28). In his much more extensive history of Haarlem published in 1628 (*Beschryvinge ende lof der stad Haerlem in Holland*; Hals doc. 41) he offers more:

Forth Halses, come forth!
Take here a seat, yours it is by right.
How dashingly Frans paints people from life!
How neat the little figures Dirck gives us!
Brothers in art, brothers in blood.
Nurtured by the same love of art, by the same mother.

Ampzing also mentions Hals's great *Banquet of the Officers of the St. Hadrian Civic Guard* of *c.*1627 (Levy-van Halm & Abraham, fig. 1; s45), then in the Calivermen's Hall, the company's headquarters. He called it a work 'done most boldly from life' ('*seer stout naer 'tleven gehandeld*'). Although the phrase is a commonplace one of the time, it is treasured as the earliest published reference to one of Hals's specific works. Not many more explicit references were made about his paintings during his lifetime or, indeed, during the course of the following century.

As for Ampzing, he did more than pay lip service to Hals's ability to paint '*naer het leven*'. A few years after he published his lines on Frans he commissioned the present little portrait. It is painted on copper, a support the artist favoured for his very small portraits. The last digit of the year inscribed on it is illegible. All earlier cataloguers have read it as '0', a reading that tallies with Ampzing's age inscribed on the painting.

Ampzing is seen with his face dramatically lit, his fiery eyes on the beholder. He holds a book, the ubiquitous quasi-symbol of theologians and scholars since the early Renaissance. Hals equipped earlier sitters with books. In his even smaller portrait (also on copper) of the historian and teacher Theodorus Schrevelius, painted in 1617, the sitter displays his as an attribute (cat. 5). Not Ampzing. He has his forefinger inserted in the volume, suggesting that he has just interrupted his reading to look at us, his finger inserted in his volume to mark his page. The minor change is another example of Hals's gift for enlivening a portrait with a convincing momentary action.

Jonas Suyderhoef (1613-86) engraved the portrait in reverse (fig. 40a; Hollstein, vol. 28, p. 227, no. 59). His engraving, almost twice the size of the small painting, is inscribed: '*AETAT.40/F. Hals pinxit/I. Suijderhoef Sculp.*' and bears a Dutch poem[2] signed 'P.S.', almost certainly Petrus Scriverius's initials (see cat. 20). The same initials appear under the Latin poem[3] inscribed on the print Jan van de Velde (1593-1641) engraved in reverse of the portrait after Ampzing's death; his print, a trifle smaller than the painting, is inscribed: '*aetats 41/a° 1632 ... F.H. pinx ...*' and bears van de Velde's monogram (Franken & van der Kellen 3).

1. For a discussion of the character of Ampzing's work as a poet and historian and its close connection to Haarlem's political and cultural climate during his activity in the city, consult de Bièvre 1988, pp. 308ff.

2. 'O Haarlem, look upon Ampzing's likeness,
He who gives us his city to read.
A shepherd, true to the church of God,
And zealous in the work of the Lord.
Whose sacred verses and poetry
Uplift the pious with inspiring gravity.
Rightly is he beloved of all Haarlem's childern,
And of the Lord's people.'

3. 'No need is there for sculptor's chisel or painted canvasses.
Ampsingius's fame, known to all, cannot die.
It lives on in the stricken face of the Ausonian Bishop [?Bishop of Rome]
Ah! how many scars will you read on the Spaniard's brow!
Why, devoted congregation, do you seek to have your Herald pictured on copper?
The wounded faces of so many men will bear witness to him.
The blow is fresh; the open scar has not yet healed;
And, if the wounds do close, the toothmark will remain.'

PROVENANCE Said to have been bought in Holland by an ancestor of Lord Clancarty; sale Lord Clancarty, London, 12 March 1892, no. 32 (£735; Lesser, who sold it to Wallis; the catalogue states that the painting appeared in the 1820 van Eyck sale at The Hague, but this seems to be an error. Lugt lists three van Eyck sales around this time: Amsterdam, 21 October 1821; Loosduinen, 7 June 1822; The Hague, 18-24 December 1822. The painting does not appear in any of them); Sir William C. van Horne, Montreal; Miss L. Adaline van Horne, Montreal; dealer Edward Speelman, London, 1966, who sold it to Lord Harold Samuel, Wych Cross, England; in 1975 it was again with Speelman who sold it in that year to the present owner.

EXHIBITIONS Montreal 1906, no. 5; New York 1909, no. 25; Atlanta 1985, no. 29; New York 1988, no. 24.

LITERATURE *Icon. Bat.* no. 149-1; Moes 12 (1630); Sir Martin Conway, 'Sir William van Horne's Collection at Montreal', *The Connoisseur* XII (1905), p. 140, repr. p. 137; HdG 151 (1630); Bode-Binder 128 (1630); KdK 82 (1630); Valentiner 1936, 34 (1630); Hubbard 1956, p. 151; Slive 1970-4, vol. 1, pp. 5-7, 125; Grimm A18b (copy; dated 1630); Montagni 73 (perhaps done in Hals's studio with final touches by the artist; 1630); van Thiel 1980, p. 118 (by Hals; cited as the type of *modello* used by Jan van de Velde II for engravings after the artist's small paintings); *Small Paintings* 1980, vol. 2, no. 114 (with wrong citation of year on van de Velde's print).

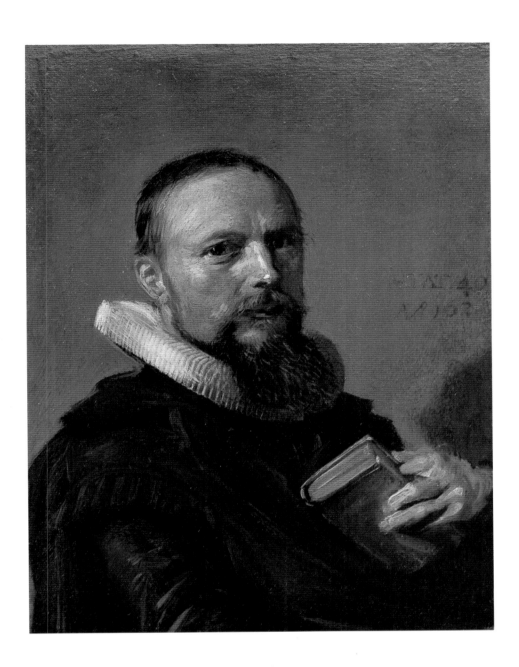

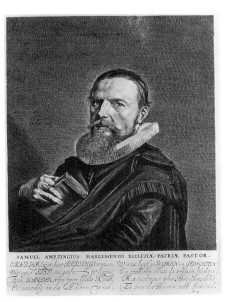

Fig. 40a Jonas Suyderhoef, engraving after Hals's *Samuel Ampzing*

247

Nicolaes Woutersz van der Meer Cornelia Claesdr Vooght

1631
Panel, 128 × 100.5 cm
Inscribed and dated under the coat of arms on the right: AETAT SVAE 56/AN° 1631
S77
Frans Halsmuseum, Haarlem (inv. I-117)

1631
Panel, 126.5 × 101 cm
Inscribed and dated on the left: AETAT SVAE 53/A° 1631
Her coat of arms is in the upper left
S78
Frans Halsmuseum, Haarlem (inv. I-118)

Like the 1630 *Portrait of a Man* at Buckingham Palace (cat. 38), these impressive three-quarter-length pendants of the wealthy Haarlem brewer, alderman and burgomaster Nicolaes Woutersz van der Meer (c.1574-1637), and his wife Cornelia Claesdr Vooght, with their simplified silhouettes and the contrast between the figures and their backgrounds reduced, are indicative of the change that occurs in Hals's style in the early thirties. Both large portraits are painted on panel supports (for a discussion of their construction and how differences in the cut of the planks that comprise them have affected their present state of preservation, see Groen & Hendriks, p. 111; the planks used for the panel of Cornelia's portrait originated from one or more trees felled in the Baltic between 1621 and 1627, ibid.). In accord with the tendency of the time, Hals used wooden panels less often in his later works. None of his existing life-size, three-quarter lengths done after 1631 are painted on wood. However, until the very end a grounded wood panel remained Hals's favourite surface for small portraits.

Hals had portrayed Nicolaes van der Meer once before. He appears as a lively captain with his arm akimbo in Hals's 1616 *Banquet of the Officers of the St. George Civic Guard* (fig. 41a).[1] At that date it seemed safe to predict that the brewer would gain weight as he grew older. Hals made no effort to minimise his girth fifteen years later, when he portrayed him during his fourth term as burgomaster.

Nicolaes's marriage to Cornelia in Haarlem 9 August 1589

(Dólleman 1975, p. 59) related him to the powerful Olycan clan; Cornelia's sister Maritge Claesdr Vooght was the wife of Pieter Jacobsz Olycan, the most prestigious member of the family. For Hals's portraits of this couple and almost a score of other members of their extended family, see cat. 18, 19.

In the Haarlem pendants the artist established a connection between his two patrons by suggesting that both are in the same room. The wall behind standing van der Meer appears to be continued in the pendant to the corner where his wife is seated. The device had been used by earlier portraitists, as had the scheme of showing a wife seated while her husband stands.

There also are precedents for the poses Hals set for the couple. A few years earlier Hals himself used the pose of a man standing with one hand resting on the back of a chair in a portrait datable to the late twenties at the Frick Collection (fig. 45a; S67), and in the very same year Hals painted van der Meer, Rembrandt made a life-size portrayal of the Amsterdam fur merchant *Nicolaes Ruts*, one of the young artist's first commissioned portraits, in a similar pose (fig. 41b; Bredius-Gerson 145).

Other artists used the scheme too. Van Dyck had employed it in some of the precocious portraits he painted at Antwerp c.1618, such as the one now at Brunswick (fig. 41c) where the thick application of the heavy paint and glowing glazes shows his unmistakable debt to Rubens. Within a few years Van Dyck abandoned this type of robust portraiture for an ideal

Fig. 41a Detail of Nicolaes van der Meer from *Banquet of the Officers of the St. George Civic Guard*, 1616 (S7) Haarlem, Frans Halsmuseum

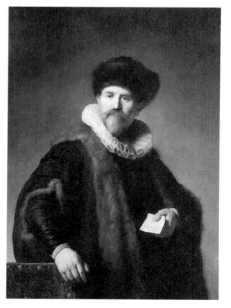

Fig. 41b Rembrandt, *Nicolaes Ruts*, 1631 New York, The Frick Collection (inv. 43.1.150)

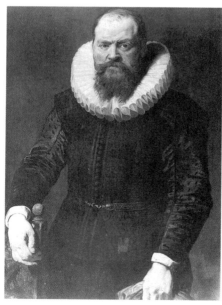

Fig. 41c Anthony Van Dyck, *Portrait of a Man* Brunswick, Herzog Anton Ulrich-Museum (inv. 86)

of elegance which gave his patrons an unsurpassed air of choice breeding and refinement. This aspect of Van Dyck's world remained outside of Hals's ken.

The seated pose Hals used for his portrayal of Cornelia Claesdr Vooght was even more familiar than the scheme he employed for her husband. Titian and Antonio Moro had created paradigms of this type which soon became part of the standard repertory of European artists. Hals used it more than once for female sitters during the thirties (see cat. 45) and again during the following decades. The portrait he painted in 1639 of Maritge Claesdr Vooght now at the Rijksmuseum (fig. 18e; S129), Cornelia's older sister, uses the same scheme with only some small changes. The two sisters also are wearing similar, rather old-fashioned, but not inexpensive, clothes: double cambric caps, large ruffs, stomachers with long boned ends, and fur-lined *vliegers* (a long, sleeveless garment worn open).

A grey wash drawing after Cornelia's portrait by Jan van der Sprang, dated 1762, is at the Haarlem Archives (fig. 41d). When the drawing was first published (Slive 1970-4, vol. 3, no. 78), it was noted that since neither the coat of arms nor the inscription on the painting appear on the copy, which has all the hallmarks of a faithful one, both may have been added after van der Sprang made his drawing. Subsequent analysis of paint samples showed that the escutcheons in Cornelia's portrait as well as those in her husband's are in fact later additions. They were done over the varnished background paint and the blue pigment in them is Prussian blue which

became generally available only after about 1720 (Groen & Hendriks, p. 121). These additions probably postdate van der Sprang's 1762 drawing.

There is evidence of other changes made to the paintings. Paint samples taken from the faces of both portraits show a very thin intermediate layer of varnish between paint layers suggesting that the changes evident in the faces are later overpaint rather than *pentimenti*. The easy mechanical separation and the different character of the later paint layer seems to confirm this hypothesis. Radiographs of Cornelia's head allow a reconstruction of the face (smaller and more delicate), collar (much smaller), cap (slightly larger). Since van der Sprang's drawing of 1762 shows much closer resemblance to the face now visible, Cornelia's head probably was changed before the date of the drawing. When these overpainted areas were applied still remains problematic. Further pigments analyses and other means of investigation will be employed in an effort to determine their status.[2]

1. The identity of the sitters was first recognized by J. van den Bosch, who published his find in an unorthodox place. It is listed as one of the theses he was prepared to defend along with his dissertation on *Hereditaire Ataxie*, which he presented to Amsterdam University in 1953 in partial fulfilment of the requirements for his medical degree.

2. The changes made to the pendants noted above were observed first by Anne van Grevenstein, former restorer at the Frans Halsmuseum, during the course of her treatment of the paintings. Ella Hendriks, current restorer at the museum, kindly communicated them to me and also provided the results of her own examination of the paintings.

PROVENANCE The pair bequeathed by Jonkheer J.C.W. Fabricius van Leyenburg to the museum in 1883.

EXHIBITIONS Haarlem 1937, nos. 40, 41; San Francisco 1939, nos. 77, 78; Chicago 1942, nos. 12, 13; Haarlem 1962, nos. 29, 30; Haarlem 1986, no. 22 (the pair); Osaka 1988, nos. 8, 9.

LITERATURE *Icon. Bat.* no. 4927 (reference to van der Meer); Moes 53, 54; HdG 200, 201; Bode-Binder 134, 135; KdK 94, 95; Trivas 38, 39; Slive 1970-4, vol. 1, pp. 112-3; Grimm 53, 54; Montagni 78, 79; Dólleman 1975, pp. 46-60.

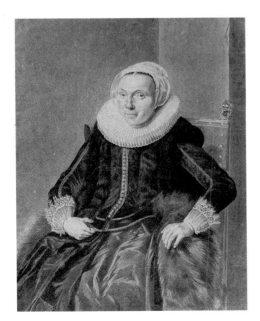

Fig. 41d Jan van der Sprang, wash drawing after Hals's *Cornelia Claesdr Vooght*, 1762 Haarlem, City Archives

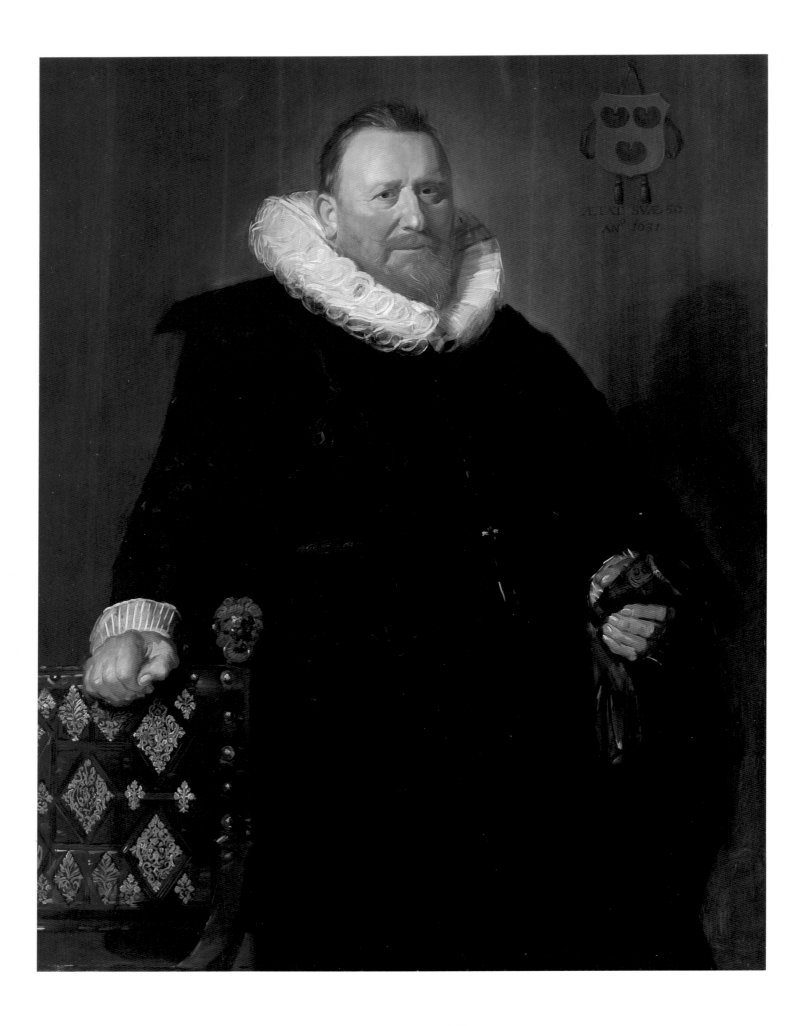

ÆTAT SVÆ 50
AN° 1631

250

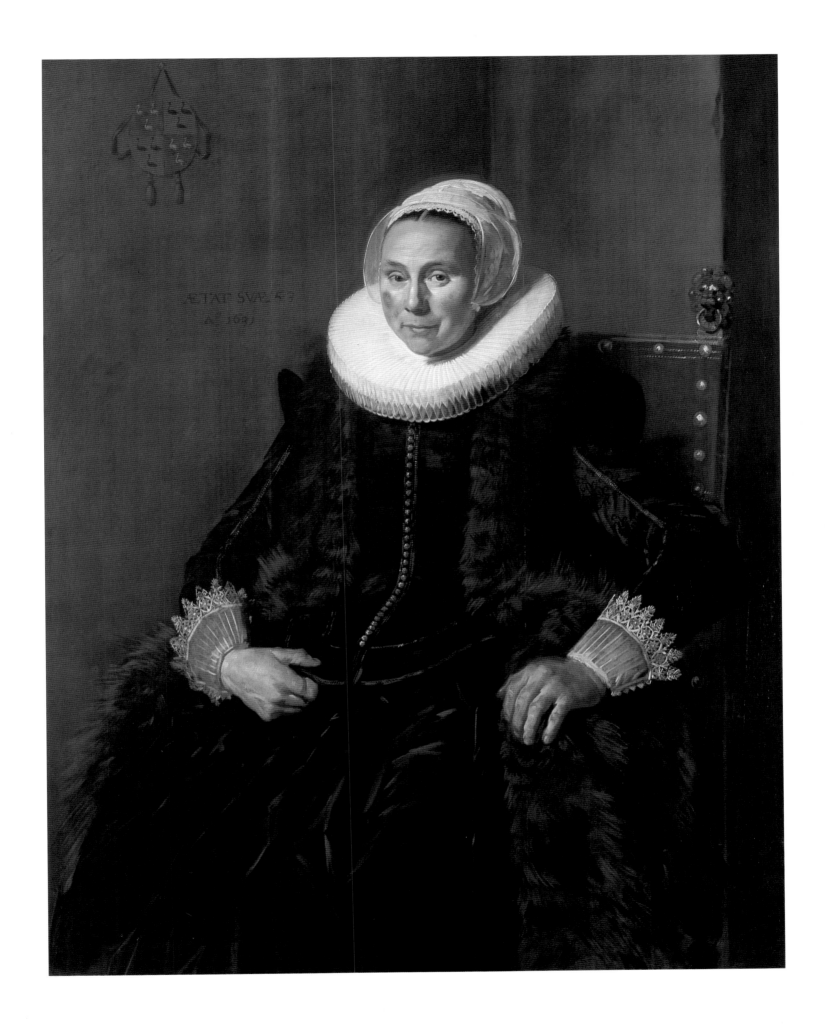

43 Officers of a Company of the Amsterdam Crossbow Civic Guard under Captain Reynier Reael and Lieutenant Cornelis Michielsz Blaeuw, known as 'The Meagre Company'

Commissioned from Frans Hals in 1633, but in 1636, when he had not yet finished it, given to Pieter Codde for completion. Dated at the right edge near the centre: A° 1637
Canvas, 207.3 × 427.5 cm
S80
The City of Amsterdam; on loan to the Rijksmuseum, Amsterdam (inv. C 374)
Exhibited in Washington and London

In 1879 Scheltema wrote that the large civic guard portrait bears Hals's monogram. Subsequent publications have not mentioned it and no trace of it was found during the course of its 1988 restoration at the Rijksmuseum. For an account of what its recent treatment revealed about Hals's materials and working method, see Bijl, pp. 103-8.

Captain Reael is the officer seated to the left, and the animated seated man next to him is Lieutenant Blaeuw; the names of their subordinate officers are unknown. Like Rembrandt's most famous painting, which even the most pedantic specialists are willing to call the *Night Watch* (as almost everyone knows, his civic guard piece is not a night – or a day – watch), Hals's group portrait is best known by its popular title: *The Meagre Company*. Jan van Dijk can be credited with coining the nickname when he described it in his list of pictures in Amsterdam's Town Hall, published in 1758, and noted that all the members of the militia group are so withered and slender that one justifiably can call them the meagre company ('*dat ze alle zo dor en rank zyn, dat men ze met recht de magere Compagnie zoude kunnen noemen*').

Little more than a cursory examination is needed to reveal that Hals was mainly responsible for the officers portrayed on the left side and that another hand was principally responsible for those on the right. What name would have been given to the second hand if a contemporary document had not provided it? It is safe to bet that one of Hals's sons would have been proposed as a likely candidate, and Judith Leyster would have had her advocates too. Would any expert have pronounced that the Amsterdam painter Pieter Codde (1599-1678) was the second artist? Virtually nothing in Codde's known œuvre hints that it is he. Yet a list compiled by Gerard Schaep of the pictures hanging in the headquarters of the three militia companies at Amsterdam in 1653 informs us that Codde is our man. Schaep lists it in the Crossbowmen's Hall as no. 23: '*A°. 1637. Ibidem tegenover de schoorsteen Capn. Reynier Reael, Lut. Corn. Michielsz. Blau, a°. 1637 bij Francois Hals geschildert ende bij Codde voorts opgemaeckt*' (Hals doc. 140).

Schaep's reference to a 1637 militia piece opposite a fireplace in the *Voetboogsdoelen* of Captain Reynier Reael and Lieutenant Cornelis Michielsz Blaeuw painted by Hals and finished by Codde was published by Scheltema in 1879 and again in 1885. News that Hals and Codde had worked on the painting travelled fast. Van Gogh was aware of it when he wrote passionately and at great length to Theo in 1885 about 'a picture (unknown to me till now) by Frans Hals and P. Codde, about twenty officers full-length', which he saw at the Rijksmuseum's newly opened building. Vincent said he 'was literally rooted to the spot' by Hals's ensign on the extreme left: 'I seldom saw a more divinely beautiful figure *... Delacroix would have raved about it – endlessly raved' (see Jowell, p. 76).

Today it is common knowledge that Codde executed part of the group portrait. No student has expressed astonishment about the fact. And rightly so. There is no reason why one of Hals's gifted contemporaries, who ordinarily painted small, rather carefully finished pictures, would not have been willing and able to shift style and scale in order to comply with the demands of a special commission. Codde's performance serves as a reminder that not all existing anonymous seventeenth-century pictures done in Hals's manner had to have been painted by members of his immediate circle.

Thanks to four archival documents published by Bredius in 1913, quite a bit is known about Hals's transactions with his Amsterdam clients (Hals docs. 73-5, 78). They also shed a glimmer of light on his personality and allow us to make some deductions about his working procedures. When we recall that not a single scrap provides a word regarding his relations with any of his other patrons, and how little contemporary sources tell us about him, they gain in importance.

The documents establish that Hals accepted the commission in 1633 and that all work on it was done in Amsterdam. There is no record that a specific scheme was stipulated for the painting, but it is evident that Frans followed the well-established Amsterdam tradition of portraying civic guards full-length. Nearby Haarlem's tradition was different. Its civic guards showed a distinct preference for three-quarter length collective portraits, as seen in all five Hals painted for them between 1616 and 1639. By the time he received the commission for the Amsterdam group, he had painted three for Haarlem, each of them showing guards celebrating at a banquet table, and he very well may have been putting finishing touches to his fourth, *The Officers and Sergeants of the St. Hadrian Civic Guard*, datable 1633 (fig. 43a). In the St. Hadrian piece the guards have abandoned their festive board. They are portrayed outdoors in the yard of their Haarlem headquarters with a landscape behind them, once more airy and spacious but now darkened by the natural aging of the medium and some pigments. The similarity of its composition to the one Hals devised for the Amsterdam guards is notable. They too are shown in the open air, and recent investigation indicates that originally there was a building in the background which was subsequently painted out; Hals may have planned to add some landscape details as well. In both group portraits, the complicated play of diagonals that interlaces the artists's earlier banquet pieces has given way to a horizontal arrangement that ingeniously links the group of officers standing around the seated ones with their companions on the right. The momentary quality of the earlier groups still is apparent in both, but there is less agitation and instantaneous action.

The close congruencies between the disposition of the figures in *The Meagre Company* with those in the *St. Hadrian* group supports the view that the composition of the former was Hals's invention, a supposition strengthened by radiographs, which show traces of Hals's rapid underdrawing in oil that fixes the position of forms throughout the large group

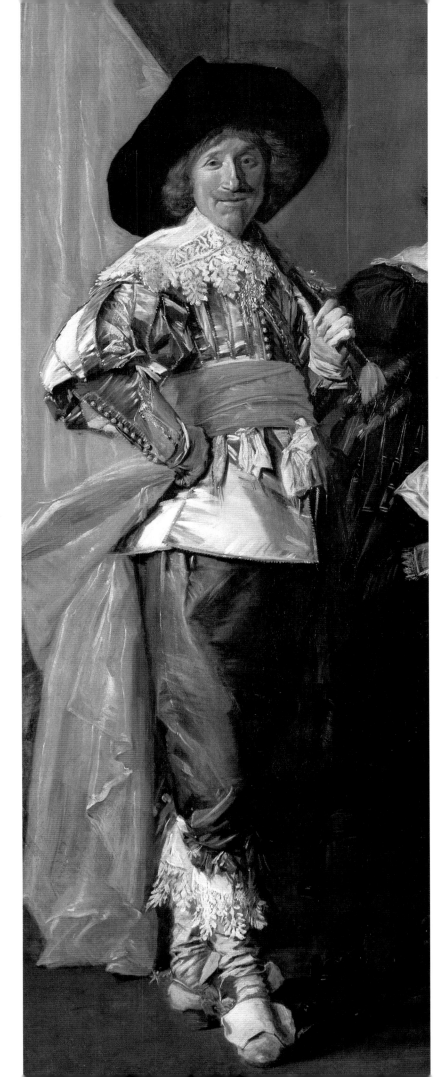

portrait. There are no traces of a preliminary drawing in chalk or graphite between the ground and paint layer. Hals himself worked from left to right, evidently merely blocking in or reserving some areas to be finished later. The documents tell us that when he stopped working on the commission, six or seven heads were only partly finished and some figures needed finishing as well. This is the job Codde took in hand, and he probably touched some passages that Hals had completed on both the left and right sides to help unify the completed group portrait. The architectural elements in the finished picture also are his work. Codde apparently made a concerted effort to simulate Hals's technique but, when the inimitable brushwork of Hals's ensign wearing a silver-coloured satin doublet on the extreme left is compared with the touch he used for the standing officer in the middle, the difference between their handling is obvious. Codde made changes in the stance of this figure which are visible to the naked eye and in radiographs. After he completed the painting in 1637, to our knowledge, Codde never again tried to paint life-size or small portraits in Hals's manner.

The fact that the Amsterdam officers turned to Hals for their portraits in 1633 is an indication of the high esteem he enjoyed at the time. They could have given the commission straightaway to Codde who, as we shall see, may have been a member of Captain Reael's company at this time, or to Thomas de Keyser, the leading Amsterdam portraitist of the day, or to young Rembrandt, who only recently had settled in the city but already had secured a reputation as a group portraitist with his *Anatomy Lesson of Dr. Tulp* of 1632.

According to the documents, there is little reason to believe Hals travelled often to Amsterdam to work on the choice commission, but we can be certain he was in the city at least once in 1634, because in August of that year he attended an Amsterdam auction where an unidentified painting by Goltzius was knocked down to him for 86 guilders (Hals doc. 66). He did not have all the cash needed to pay for it, an indication that, like many mortals, upon occasion he was overly impulsive. He managed to borrow the necessary money and returned with it in hand, but the auctioneer refused to give him the work. Then, at Hals's request a notary went with the money to fetch the painting for him. How the affair ended is unknown, but a Goltzius painting was not amongst his very modest collection of four paintings – if it can be called a collection – when his household goods were put up as collateral in 1654 for a debt he owed his baker (Hals doc. 147).

From a document dated 19 March 1636 we learn that Captain Reael and his officers had lost patience with their portraitist and had no faith in his word. They realised more than a year earlier that Hals was not making any progress on the commission. In June 1635 they managed to extract a promise from him that he would finish it. Subsequent written and verbal appeals were made, but to no avail. Hence they

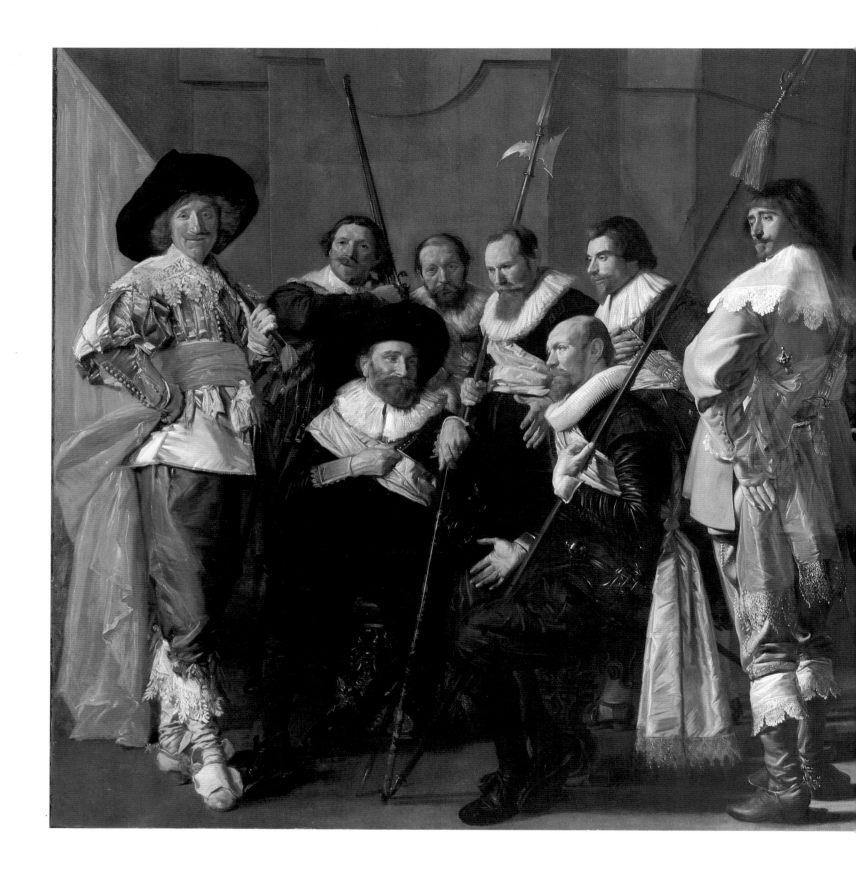

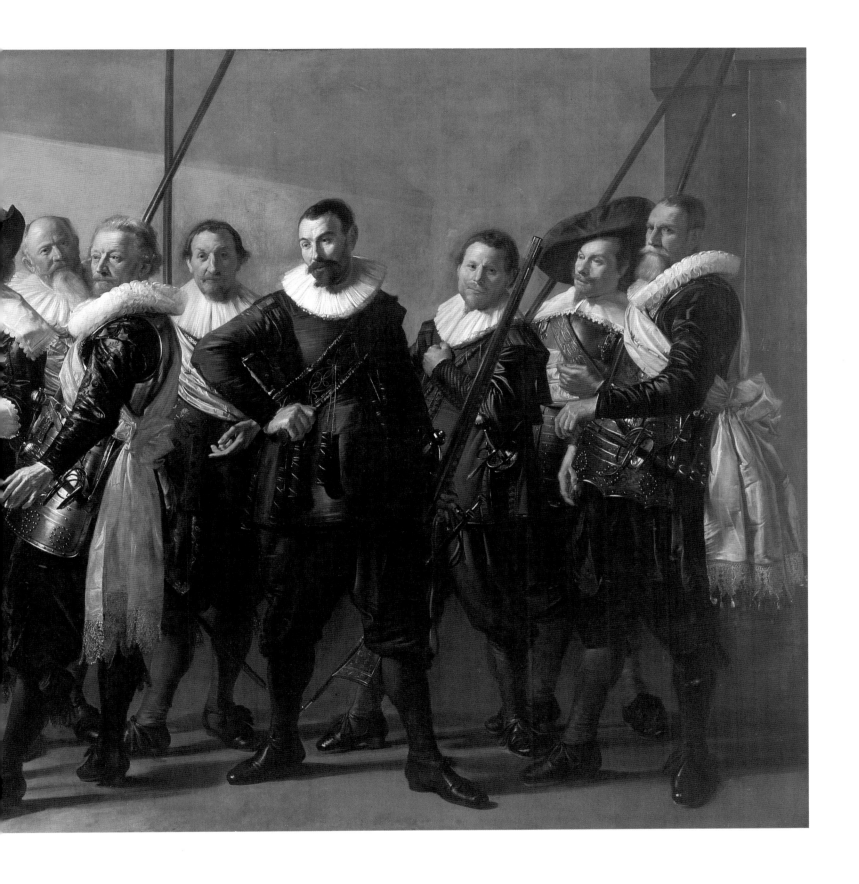

now were summoning him by legal writ to come to Amsterdam within a fortnight to finish the work commissioned three years earlier. He was warned that, if he did not respond to the summons, his patrons would no longer consider themselves bound to their agreement with him. Moreover, if he failed to begin work again within fourteen days, his patrons reserved the right to have the painting finished by another good master, and legal proceedings would be instigated against him to recover the money he had already been paid, plus damages for non-performance.

The complaint was read to him by a notary on 20 March 1636 in Haarlem, where he was confined at home in bed with a bad leg. Hals maintained that he had agreed to make the group portrait in Haarlem, not Amsterdam, and only later had consented to make the initial sketches of the heads in Amsterdam and then to finish them in Haarlem. He already had started the work but was unable to proceed, because it had been impossible to get all his patrons together. Despite the inconvenience and heavy expenses he incurred using this procedure, for which he had been promised payment that he had not yet received, he stated that he was ready to finish the commission if the officers would come to Haarlem to pose.

On 29 April 1636 the officers acknowledged receipt of his 'frivolous and untruthful response' ('*frivole ende onwaerachtige andtwoorde*'). They stated that they wanted him to come to Amsterdam within ten days and complete the work in a satisfactory manner. He was asked point blank to answer their demand 'yes' or 'no'. This document also states that originally it was agreed that Hals was to receive 60 guilders for each head, but later the guards agreed to pay him 66 guilders if he would paint and finish both the heads and figures of the men, and whatever else was necessary, in Amsterdam, as he had already begun doing. Had he fulfilled his contract under this arrangement, he would have been paid 1,056 guilders for the group portrait. If we recall that Rembrandt was paid about 1,600 guilders for the *Night Watch* in 1642, when he was at the very peak of his popularity, Hals's honorarium was sizeable according to the standards of his day. An idea of the value their patrons assigned to their work and what they, in turn, were prepared to accept as payment for exceptionally large group portraits is gained when we consider that around this time the annual wage of a master carpenter or bricklayer was about 300 guilders.[1]

In his reply to the above document, dated 26 July 1636, Hals told a notary that he stood by his original response. However, he offered a concession. He stated he was prepared to transport the painting from Amsterdam to Haarlem, where he would finish any of the officers's clothing which had not yet been painted. He would then do the heads and assumed no one would object to travelling to Haarlem to pose while their unfinished portraits were worked up to completion, since this would not take up much of their time (even without full knowledge of the facts of the case, this part of his testimony is believable). Furthermore, if six or seven officers could not travel to Haarlem, he would transport the painting back to Amsterdam where he would work up the heads. His statement indicates that for this commission he most probably did not have preliminary or preparatory studies of heads on hand for the individual portraits. If he relied on such *aide-mémoires* for other commissions, none have survived.

Here the story, as recorded in the documents, ends. But it is not difficult to guess what happened. The Amsterdam militiamen found it impossible to make Hals comply with their demand, and they employed Codde to finish the picture.

A key question remains open: why was Pieter Codde, of all artists, selected to complete the group portrait? I.H. van

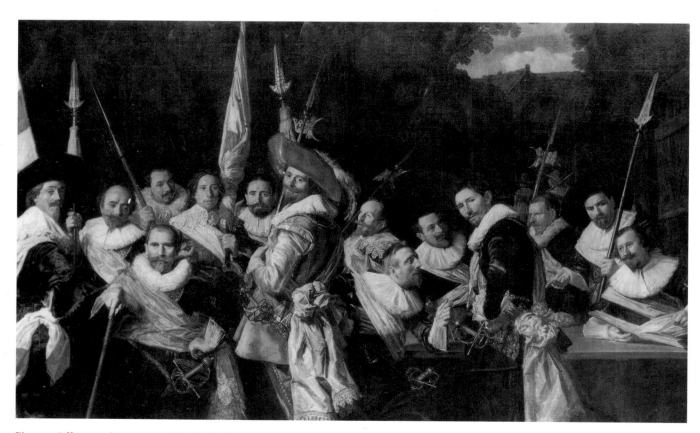

Fig. 43a *Officers and Sergeants of the St. Hadrian Civic Guard*, c.1633 (S79) Haarlem, Frans Halsmuseum

Eeghen (1974, pp. 138-46) offers the best hypothetical answer. She notes that Codde lived in Precinct (*wijk*) XI of Amsterdam, which was where Reael's men resided (this was normal practice; the men in the *Night Watch* lived in Precinct II, etc.). Possibly Codde was a member of Reael's company, and he even may have been one of its officers. Furthermore, according to van Eeghen's research, he was the only artist living in Precinct XI at the time. There is ample precedence for giving guard portrait commissions to artists who were members of the companies they portrayed. Hals belonged to the ranks of Haarlem's St. George guard when he was called upon to paint his 1616 banquet piece of its officers, and Frans Pietersz de Grebber was a member of the city's caliver company when he was commissioned about 1612 to do a collective portrait of them. Self-portraits also were worked into these paintings; according to a reliable tradition Hals's is in his *St. George* piece of 1639 (Introduction, fig. 6; S124). Thus, Codde's portrait – or self-portrait – may be in *The Meagre Company*.

Codde's scandalous affair with his maid in 1636 offers another clue. Codde's conduct with her led to imprisonment in the Town Hall, where both spent a night in shackles, and subsequently to the break-up of his marriage. When Codde and his wife separated, an inventory was made of his effects (included was a vanitas painting by Hals cited in cat. 29). Frans Bruyningh, the notary who certified Codde's inventory on 5 February 1636, was the same notary who prepared the two complaints that exasperated Reael and Blaeuw lodged against Hals only a few months later. Of course this may have been coincidental but the possibility that it is an indication of a personal connection that helped lead to Codde's commission to finish the group portrait cannot be discounted.

1. Information on wages during this period was kindly provided to Bianca du Mortier by Dr. L. Noordegraaf, Professor of Social and Economic History, University of Amsterdam; see her essay, pp. 45, 50 and note 14.

PROVENANCE From the Amsterdam *Voetboogdoelen* (headquarters of the crossbowmen's civic guard). Transferred to the Major Court Martial Chamber in the Town Hall (now the Royal Palace) and afterwards to the Burgomaster's Room in the same building. Lent to the Rijksmuseum by the City of Amsterdam since 1885.

EXHIBITIONS Amsterdam 1867; on loan to the Frans Halsmuseum from 20 May until 9 October 1946; Haarlem 1962, no. 37; Haarlem 1988, no. 194.

LITERATURE J. van Dijk, *Kunst en historiekundige beschryving en aanmerkingen over alle de schilderijen op het Stadhuis te Amsterdam*, Amsterdam 1760, pp. 30ff.; Ellis 1826, p. 67 ('in The Stadhouse ... A good Frank Hals, of a great size, representing a Company of the armed Burghers of Amsterdam; a very well painted picture, and of an admirable effect'); Unger-Vosmaer 1873, no. XVII; [P. Scheltema], *Historische beschrijving der schilderijen van het Stadhuis te Amsterdam*, Amsterdam 1879, pp. 14-5, no. 35 ('Het stuk is geteekend: FH 1637'); Bode 1883, 119; P. Scheltema, 'De schilderijen in de drie doelens te Amsterdam, beschreven door G. Schaep, 1653', in *Aemstel's Oudheid*, vol. 7, Amsterdam 1885, pp. 121ff.; D.C. Meijer Jr., 'De Amsterdamsche schutters-stukken in en buiten het nieuwe Rijksmuseum', *O.H.* III (1885), p. 122; J. Six, 'Opmerkingen omtrent eenige meesterwerken in 's Rijks Museum', *O.H.* XI (1893), pp. 102ff.; *Icon. Bat.* no. 6214; Moes 5; HdG 428; A. Bredius, 'De geschiedenis van een schuttersstuk', *O.H.* XXXI (1913), pp. 81ff.; Bode-Binder 159; KdK 119; M.M. van Dantzig, 'Het Corporaalschap van kaptein Reiner Reael', *Phoenix* I (1946), no. 10, pp. 5-9; Brandt 1947, pp. 31-2; H.P. Baard, *Frans Hals, The Civic Guard Portrait Groups*, Amsterdam & Brussels 1949, pp. 23-4, plates E and 33-40; Slive 1970-4, vol. 1, pp. 136-8; Grimm 77; van Eeghen 1974, pp. 138-40; Montagni 98; van Thiel *et al.* 1976, p. 257, no. C374.

*c.*1633
Canvas, 71.2 × 61 cm
S84
The Iveagh Bequest, Kenwood (English Heritage), London (inv. 51)

Antwerp-born Pieter van den Broecke (1585-1640 [not 1641]) first was a trader in West Africa and then served the Dutch East India Company in Java, Arabia, Persia and India[1]. When he returned from India in 1630 as the admiral of the home-ward-bound fleet which brought the widow of Jan Pietersz Coen, a principal founder of the Dutch empire in the east, back to the Netherlands, he was rewarded by the Dutch East India Company for his seventeen years of service with a golden chain worth 1,200 guilders. This is the chain he wears in his portrait.

In 1634 van den Broecke published an account of some of his far-flung commercial activities (*Korte Historiael Ende Journaelsche Aenteyckeninghe Van al 't gheen merck-waer-dich voorgevallen is, in de langhduerighe Reysen ... als inson-derheydt van Oost-Indien*, Haarlem). It and other reports[2] give the impression of a vigourous, straightforward man who possessed the aggressiveness and cunning needed to meet the cut-throat competition for trade in Africa and the Orient during the first decades of the century.

The frontispiece of his 1634 volume is a reduced engraved reproduction of Hals's painting (in the same direction) by Adriaen Jacobsz Matham (*c.*1600-60) inscribed: '*AETATIS SVAE 48, ANNO CIC ICC XXXIII ... F. HALS PINX. A. MATHAM SC.*' (fig.44a; Hollstein, vol.11, p.213, no.55; 16.5 × 12.2 cm). Matham's 1633 print sets the portrait in an oval frame decorated with weapons, dolphins and a cartouche providing a ground for a quatrain:

Here the van den Broecke, the astounder of the Persians,
When the Batavian first came roaring across the Red Sea,
Who, on the continents of Arabia and Indus,
First fostered trade for the Dutch nation.

Matham also added a small parapet in front of van den Broecke upon which his motto is inscribed: *een uur betaelt het al* (An hour repays it all) and a swag of drapery behind the sitter, as he did in his 1635 engraving after Hals's small portrait of Massa (fig.48a), an embellishment Frans himself very seldom employed.

Fig.44a Adriaen Matham, engraving after Hals's *Pieter van den Broecke*, 1633

Fig.44b Isack Ledeboer, engraving after Hals's *Pieter van den Broecke*

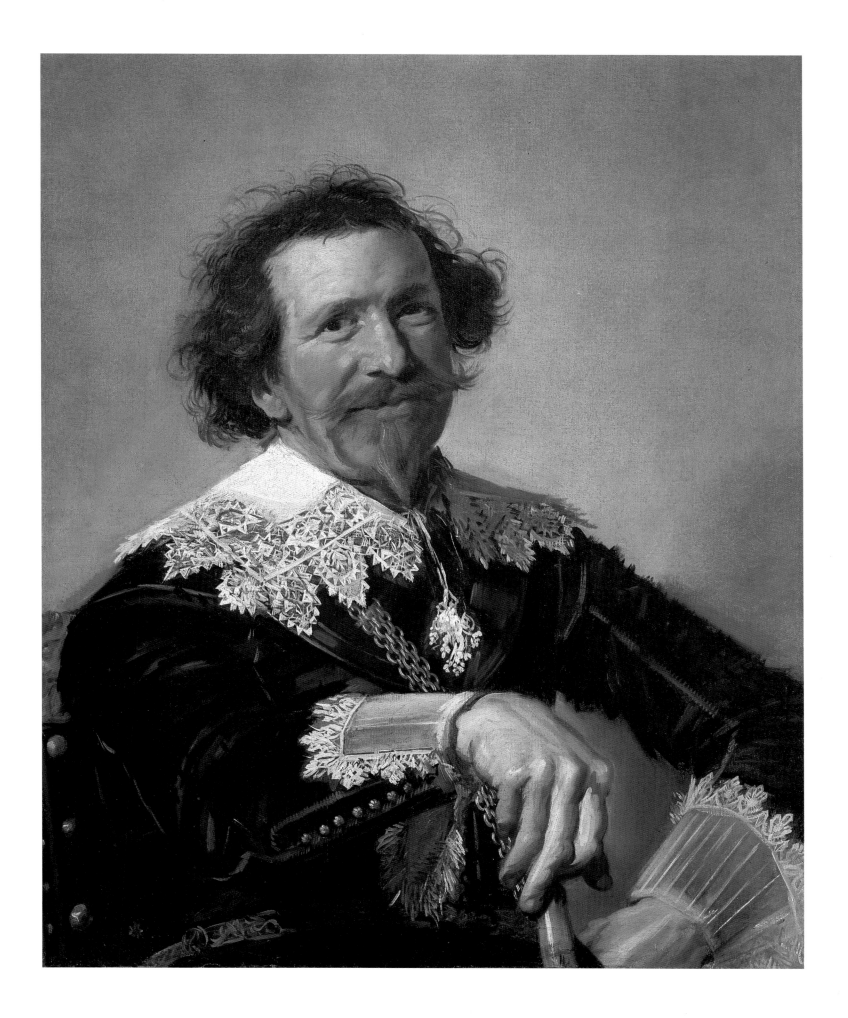

A radiograph of the painting established that its original canvas support has been cut at its bottom edge (Conran & Rees Jones 1958, p.259), a fact that earns the rather coarse print Isack Ledeboer (1692-1749) made after the portrait (in the same direction) more than a passing glance (fig.44b). His print shows van den Broecke almost three-quarter length. Does it present the original form of the portrait? Not when we notice that Ledeboer's print hardly qualifies as a faithful reproduction of Hals's picture. In it van den Broecke is shown standing, not seated. Indeed, the sitter's chair has disappeared completely. The print's deviations from the original are best attributed to Ledeboer; its swag of drapery suggests Matham's print was his point of departure. The amount of canvas that has been removed from the lower edge of the original canvas has not yet been determined; judging from Matham's engraving not much was cropped.

Hals and van den Broecke must have been good friends and most probably Matham can be called one as well. When Hals's daughter Susanna was baptised in 1634, about a year after the artist painted the Kenwood portrait, van den Broecke is listed as the first witness of the event. The second witness who is cited only as Adriaen Jacobsz was almost certainly Matham (Hals doc.62).

A full-size reproduction of Matham's print was included in John W. Wilson's 1881 sale catalogue (see Provenance below); on the basis of it the model for the painting was first identified and the portrait assigned the date of 1633 (for the four other Hals paintings in Wilson's sale, see cat.20). Bode (1883, 67) and Moes (*Icon. Bat.* no. 1130; Moes 21) knew of the existence of Matham's print when they dated the portrait 1633. Valentiner also knew of the engraving (KdK 163), but he overlooked the 1633 date on it when he placed the portrait about 1637. J.G. van Gelder (1938) called attention to the appearance of Matham's print in van den Broecke's publication of 1634, and rightly emphasised that the style of the painting as well as the year inscribed on the engraved copy support a date of 1633 for it.

The portrait was etched by Léopold Flameng (1831-1911). For a weak painted copy of the picture which passed through more than one London sale since 1925, see Slive 1970-4, vol. 3, no. 84.

1. For reference to the Haarlem textiles he traded and gave as gifts on his ventures abroad, see du Mortier, note 36.

2. *Reizen naar West-Afrika van Pieter van den Broecke: 1605-1614*, ed. K.Ratelband, The Hague 1950; *Pieter van den Broecke in Azië*, ed. W.Ph.Coolhaas, 2 vols., The Hague 1962-3; C.G.Brouwer, 'Le voyage au Yémen de Pieter van den Broecke (serviteur de la v.o.c.) en 1620, d'après son livre de résolutions', in I.A.El-Sheikh *et al.*, *The Challenge of the Middle East*, Amsterdam 1982, pp.1-11; C.G.Brouwer, 'Under the Watchful Eye of Mimī Bin ʿAbd Al-lāh: The Voyage of the Dutch Merchant Pieter van den Broecke to the Court of Djaʿfar Bāshā in SanaʾA, 1616', in *All of One Company: Essays in Honour of Prof. M.A.P.Meilink-Roelofsz*, Utrecht 1986, pp.42-72.

PROVENANCE John W.Wilson by 1873; his sale Paris, 16 March 1881, no.59 (fr.78,100, Petit; correctly identified as Pieter van den Broecke; the sale catalogue includes a reproduction of Adriaen Matham's print of the portrait); sale E.Secrétan, Paris, 1 July 1889, no.123, purchased by Agnew for Earl of Iveagh (fr.110,500).

EXHIBITIONS Brussels 1873, p.84 (as 'L'Homme à la Canne'; etched by Léopold Flameng); Paris 1883, no.1; London, Royal Academy, Winter Exhibition, 1891, no.121; London 1928, no.212; Manchester 1928, no.4; Haarlem 1962, no.33.

LITERATURE F.Muller, *Beschrijvende catalogus van 7000 portretten*, Amsterdam 1853, no.731; Tardieu 1873, p.219; *Icon. Bat.* no.1130 (1633); Bode 1883, 67 (1633); Moes 21 (1633); HdG 161; Bode-Binder 181; KdK 163 (c.1637); J.G. van Gelder, 'Dateering van Frans Hals' portret van P.v.d.Broecke', *O.H.* LV (1938), p.154; Trivas 42; G.L.Conran & S.Rees Jones, 'X-rays at Kenwood', *The Museums Journal* LVII (1958), pp.237-9; Catalogue The Iveagh Bequest Kenwood, London 1960, p.16, no.51; Slive 1970-4, vol.1, p.117 (c.1633); Grimm 58 (1633); Montagni 85 (c.1633); Baard 1981, pp.114-6 (c.1633).

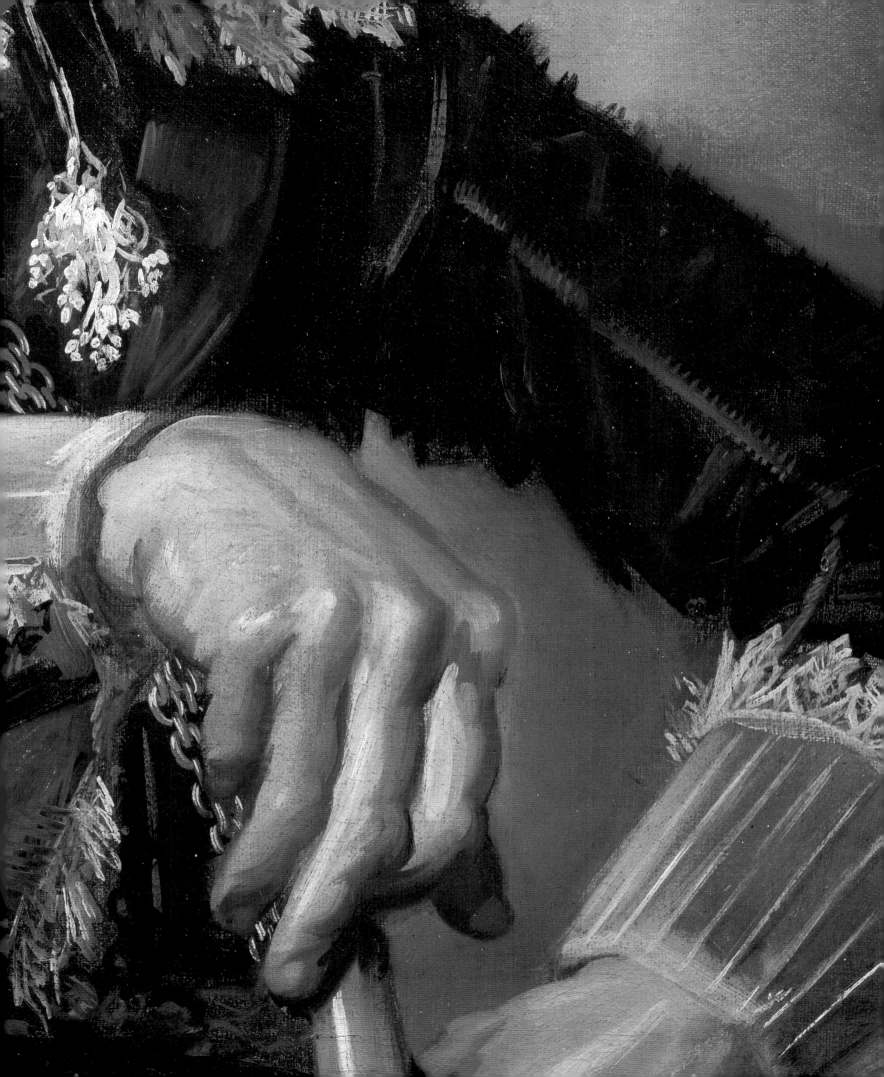

45 Portrait of a Seated Woman

1633
Canvas, 102.5 × 86.9 cm
Inscribed at the right: AETAT SVAE 60/ANº 1633
s82
National Gallery of Art, Washington, D.C., Andrew W. Mellon
Collection (inv. 1937.1.67)

The portrait, one of Hals's most powerful of a woman, employs a pose similar to the one he used for *Cornelia Claesdr Vooght* (cat. 42). Although painted within a few years of each other, the difference in their impact is considerable. Of course the obvious differences in the physical appearances of the ladies is partially responsible for this. Compared to the massive woman in this portrait, Cornelia is a wisp of a thing. And no one will fail to notice that the considerable size of the Washington woman appears amplified by the very tiny Bible or prayer book she holds in one hand, and that the grip of her other on the end of her chair, unlike Cornelia's, is an iron one. The difference in the character of the light in each painting also helps account for the diversity. Cornelia's portrait misses the bright light that filters through the Washington picture, giving it greater animation.

No doubt this sixty-year-old woman's husband was portrayed in a companion picture. Valentiner (KdK 108; 1936, no. 41) and Trivas (41) identified him as the model who posed for the *Portrait of a Man* now at the Frick Collection (fig. 45a) and Arthur K. Wheelock, Curator of Northern Baroque Art at Washington, has informed me that in his opinion they probably are correct.

Previously I had argued (Slive 1970-4, vol. 3, nos. 67, 82) that their disparate provenances, sizes and styles do not support the proposed marriage. In reviewing the proposal, I readily grant that the paintings' separate provenances, which cannot be traced back beyond the nineteenth century, do not make a *prima facie* case against it. The difference in their present sizes also is not very significant (the Frick canvas measures 115.6 × 91.4 cm; the Washington one 102.5 × 86.9 cm). Moreover, a technical examination indicates that both

have been cut; originally they may have been closer in size.[1] However, the similarity of their dimensions may be the result of a more or less standard size Hals regularly used for his three-quarter lengths. A survey of the dimensions of his portraits of this type suggests that he did,[2] but no firm conclusions can be made on this matter until a technical examination is made of them to determine how many have intact supports and the number on canvas that have been trimmed when they were relined or cut for other reasons (for a pair of portraits that pose similar questions, see cat. 71, 72).

What remains to be discussed is the way the Frick and Washington portraits complement each other and their styles. When the pair is coupled they show the scheme Hals employed for his pendants of van der Meer and Cornelia Vooght (cat. 41, 42). No problem here. However, I find the style of the Frick portrait incompatible with the date of 1633 inscribed on his putative companion. Its distinctive blond tonality and the very thin paint used for it find their closest parallels in portraits Hals painted in the second half of the twenties, for example, the officers in his *Banquet of the St. George Civic Guard* (Levy-van Halm & Abraham, fig. 13; s46), datable to about 1627. In my view the Frick portrait was painted in the late twenties, not 1633. Regrettably, it was impossible to arrange a test of this conclusion in the exhibition. The terms of The Frick Collection bequest prohibit any of its works from travelling.

Naturally, the man's portrait at the Frick could have been painted before his putative wife's likeness at Washington. One such possible case is in the exhibition (cat. 2, 3) and there is another in Hals's œuvre (the pendants at Stuttgart [s98, s99]). The circumstances that conceivably could have made the strong woman delay four or five years before Hals managed to paint her portrait, which could be the subject of a short story, will not be offered here.

Fig. 45a *Portrait of a Man* (s67)
New York, The Frick Collection

1. The Frick painting has been cut irregularly at the bottom edge (see Slive 1970-4, vol. 3, no. 87). Examination of the Washington portrait during its restoration in 1985 revealed that it has been cut on all four sides. Its present tacking margins are covered with paint; if they were flattened, the picture's dimensions would be 105.6 × 89.4 cm. Since virtually no cusping is visible along its edges in radiographs, the original image probably was larger. Additionally, if the woman's portrait is identical with the one that appeared in the 1817 Jurriaans sale (see Provenance below), according to the sale catalogue, at that

time it measured 48 × 36 duimen (= 125.4 × 92.5 cm), close to the present dimensions of the Frick picture (115.6 × 91.4 cm, and which, as we have noted, has been cut at the bottom). A comparative study of the canvasses and pigments employed for the grounds has not yet been made.

2. Exceptions to these approximate dimensions are Hals's earliest pendants at Birmingham and Chatsworth (cat. 2, 3), which are his smallest (each on panel, c. 94 × 72 cm), and the Beresteyn pair at the Louvre (cat. 6, 7), which is the largest (each on canvas, c. 137 × 102 cm).

PROVENANCE Probably sale, anon. [Jurriaans], Amsterdam, 28 August 1817, no. 20 (Dfl. 200, Roos); Comte de la Rupelle, from whom it was bought by dealer C. Sedelmeyer, Paris (Cat. 1905, no. 13); James Simon, Berlin, by 1910; dealer Duveen, New York; Andrew W. Mellon, Washington, D.C., 1920, who presented it to the gallery in 1937.

EXHIBITIONS Berlin 1906, no. 49; New York 1939, no. 179.

LITERATURE Moes 186; HdG 371; Bode-Binder 138; KdK 109; Valentiner 1936, 41; Trivas 41; Slive 1970-4, vol. 1, p. 115; Grimm 60; Summary Catalogue National Gallery of Art, Washington, 1975, p. 168, no. 67; Montagni 83; Catalogue National Gallery of Art, Washington, *European Paintings*, 1985, p. 196, no. 1937.1.67.

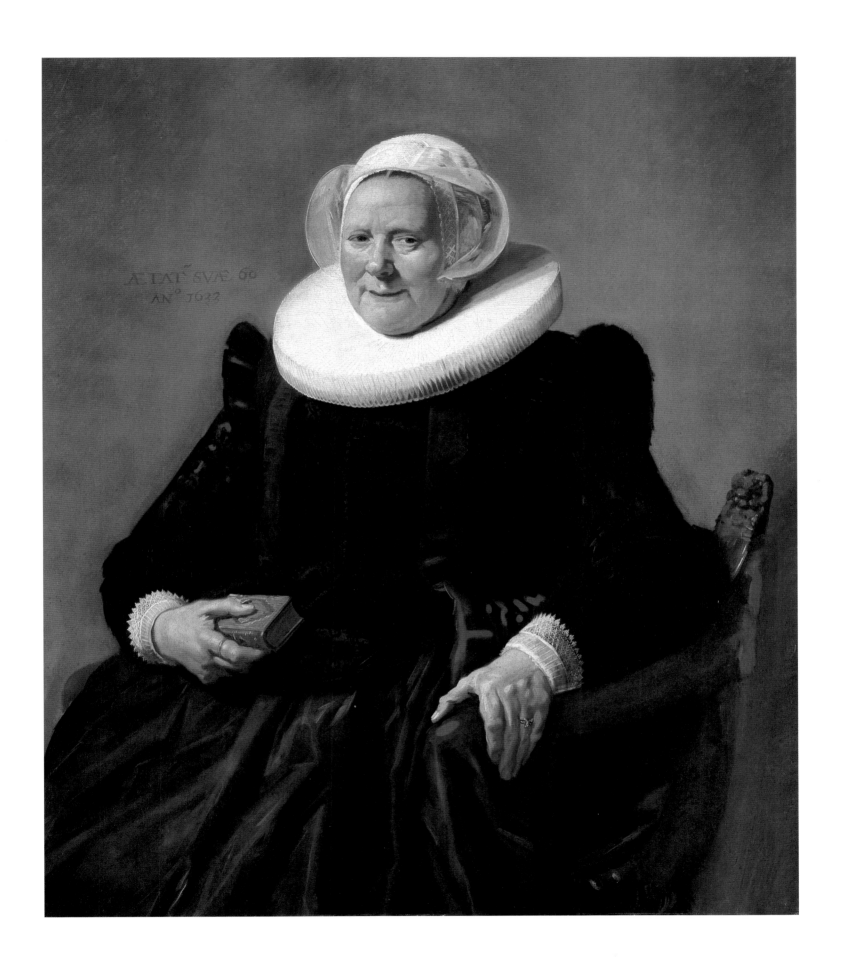

263

c.1635
Canvas, 126.5 × 93 cm
s104
The City of Amsterdam; on loan to the Rijksmuseum, Amsterdam
(inv. C 556)
Exhibited in Haarlem

1635
Canvas, 123 × 93 cm
Inscribed, upper left: AETAT SVAE 31/ANº 1635
s105
The City of Amsterdam; on loan to the Rijksmuseum, Amsterdam
(inv. C 557)
Exhibited in Haarlem

Lucas de Clercq (*c.*1593-1652) and Feyntje (Feyna, Feryntgen) van Steenkiste (1603/4-40), both Mennonites, signed their marriage contract in Haarlem on 11 January 1626. Their portraits are not listed in an inventory made of their estate in 1640; according to a family tradition they have been in the possession of descendants of the sitters since they were painted (see Provenance below). Consult Biesboer (p.37-8) for Lucas's business connections and references to the couple's Haarlem properties.

Although the supports for these two beautiful portraits appear to have been cut from wider strips of pre-primed canvas (remains of their original stretching edges still exist), differences in the density of their weaves indicate that they were cut from different strips. The canvas used for *Lucas* is rather coarse, while the one used for his wife is much finer. The grounds applied to their respective canvas supports also differ (Groen & Hendriks, pp. 112, 116).

Now, it is reasonable to expect that Hals's companion pictures would be painted on matching supports and have identical grounds, and indeed, thanks to recent technical investigations, we know that this is the case with some of Hals's pendants (cat. 2, 3 and 85, 86). However, a much broader survey of supports and grounds is needed before we can get an idea of the artist's general practice. At present we know that he employed many different grades of canvas and that the grounds applied to them differ. This suggests that he did not keep a big bolt of canvas in his studio, but purchased canvasses as he needed them from a primer (*primuurder*) who specialised in preparing panels and pre-primed canvasses for artists (ibid., p. 113).

Alternatively, it is arguable that the differences in the materials used for the two portraits indicate that they were not painted at the same time or that they even may have been painted by different artists. In fact, the dates and attributions of these two pictures have been challenged. It has been proposed that the portrait of Lucas predates Feyntje's by almost a decade, and attempts have been made to attribute one or both paintings to Judith Leyster or to an anonymous follower (for the authors of these various opinions, see Literature below).

Since I do not find the style of Lucas's portrait or the costume he wears incompatible with the date of 1635 inscribed on the painting of his wife, and I know nothing in Judith Leyster's œuvre – not to mention analogous works by nameless artists – that matches the grand design and fluency of touch of these companion pieces, I find the doubts expressed about their chronology and authorship unconvincing.[1]

The companion pieces can be defended as beautiful examples of the modest grandeur Hals achieved in the midthirties when he depicted patrons in deceptively simple, black costumes. That he could equally well satisfy the demands of clients with more ostentatious tastes during this phase, as is seen in his portraits of the Roosterman couple (see Biesboer figs. 10, 11), is not surprising. To be sure, Hals's earlier inclination to create movement with emphatic diagonals has not been completely supressed in the portrait of Lucas, but the jagged contours of his figure have been subdued by the deep shadows behind him which are close in value to his huge cape and breeches. Feyntje's portrait shows more of the artist's new tendency to simplify forms. She stands before us with the nobility of the tower of the great church at Utrecht.

Sober black clothes of course were worn in Holland long before the pendants of Lucas and Feyntje were painted, but until the thirties gaily coloured accessories were frequent, and young people often wore bright colours. The decision to wear black or something gayer was affected by age, by temperament and sometimes by religion. The choice of accessories was influenced by the same factors. It is no accident that we see only an edge of Feyntje's white cuffs, which are trimmed with very modest borders of lace. As a Mennonite, she would have found it unthinkable to have herself portrayed displaying the gigantic, too patently expensive lace cuffs worn by many of her contemporaries.

In his poem *Mennonite Courtship* (*Menniste Vryagie*), written between 1621 and 1626, Jan Jansz Starter tells of a swain who courted a Mennonite maiden whose disapproval of his fashionable dress – including his far too large cuffs – made him change his choice of attire:

> Once I went a-courting a fair Mennonite maid. ...
> She had but look at me to show she was dismayed.
> My hair too long, my ruffs unruly,
> My poignets too broad, all starched too bluely,
> My breeches too wide, the doublet too tight,
> The garters too long, and on my shoes I had roses.
> In brief, it were a sin such a worldly man to kiss. ...
> It was not long before I came to her once more,
> Quite changed in my manners, my speech and my dress.
> My coat plain and black, my hair cut short,
> My ruff, whitely starched, as flat as a board,
> And not a tassel to be seen on my whole attire.[2]

1. Though its documentary value is marginal, it is worth noting that a late eighteenth or early nineteenth-century drawing after Lucas's portrait by an unidentified artist that is inscribed on the verso: '... Hals 1635 N 242' was in the possession of the dealer Yvonne Tan Bunzl, London, 1972 (26.5 × 22 cm).

2. 'Ick vrijden op een tijd een soet Mennisten-susje/ ... Sij sagh niet aan mij, of het scheen haer te mishaegen,/ Dan was myn hayr te langh, dan al te wild myn kragen,/ Pouvretten al te weyts, het stijtsel al te blaeuw,/ Dan was myn broeck te wijd, dan 't wambas al te naeuw,/ Elck kousse-band te langh, 'k had roosen op myn schoenen,/ In 't kort, sy maeckten sond, so werltschen man te soenen .../ 't En was niet langh daer na, ick quam weèr by haer treden,/ Verandert beyd in spraeck, in wesen en in kleden:/ Myn mantel was gantsch slecht en swart, myn hayr gekort,/ Myn wit-gesteven kraegh soo plat gelijck een bort,/ Op al myn kleeren sat niet een uytwendigh koordje...' (Starter 1634, pp.22-3; in line 4, *pouvretten* = *ponjetten* or *punietten* [French: *poignets*]; see Starter 1864, p.487, note 1; see du Mortier, pp.52, 53). Feyntje's own tendency toward simplicity is amply seen in the recently discovered inventory made of her wardrobe after her death in 1640 (ibid., p.49).

PROVENANCE According to a kind communication from Miss I.H. van Eeghen, a descendant of the sitters and former archivist of Amsterdam's City Archives, after Lucas de Clercq died in 1652 the pendants passed by descent to members of the de Clercq family, who first lived in Haarlem and then always resided in Amsterdam after Pieter de Clercq (1661-1730) settled there in 1685. They were lent by Mr. and Mrs. P. de Clercq and Mr. and Mrs. P. van Eeghen to the City of Amsterdam, 1891; on loan from the City of Amsterdam to the Rijksmuseum since 1891.

EXHIBITIONS Amsterdam 1867; Rome 1956-7, nos. 126, 127.

LITERATURE E.W. Moes, 'Feynte van Steenkiste van Frans Hals', *Oud en Nieuw op het gebied van kunst ... in Holland en Belgie*, 1889-92, pp. 127-30 (erroneously dated 1636); *Icon. Bat.* nos. 1563, 7550 (1636); Moes 24, 25 (1636); HdG 165 (*Lucas* very characteristic of the mid-thirties), HdG 166 (*Feyntje* dated 1635); Bode-Binder 160, 161; J. Six, 'De Frans Hals-Tentoonstellung in 's Rijksmuseum', *Onze Kunst* XXIX (1916), pp. 92-3 (doubts authenticity of *Lucas*; attributes *Feyntje* to Judith Leyster); KdK 138, 139 (1635; the authenticity of the pendants has been doubted without any justification whatsoever); Trivas 22 (*Lucas* a pendant to the 1635 portrait of *Feyntje*, but the costume as well as the technique of the portrait points to an earlier date, c.1627); Trivas 58 (1635); Slive 1970-4, vol. 1, p. 116 (1635; both by Hals); Grimm 1971, p. 148 (*Feyntje* by Judith Leyster); Grimm 31 (*Lucas*, c.1627), p. 215 (*Feyntje* by Judith Leyster); Montagni 63 (*Lucas*, c.1627), 253 (*Feyntje*, 1635; probably not Hals); van Thiel *et al.* 1976, p. 256 (both by Hals).

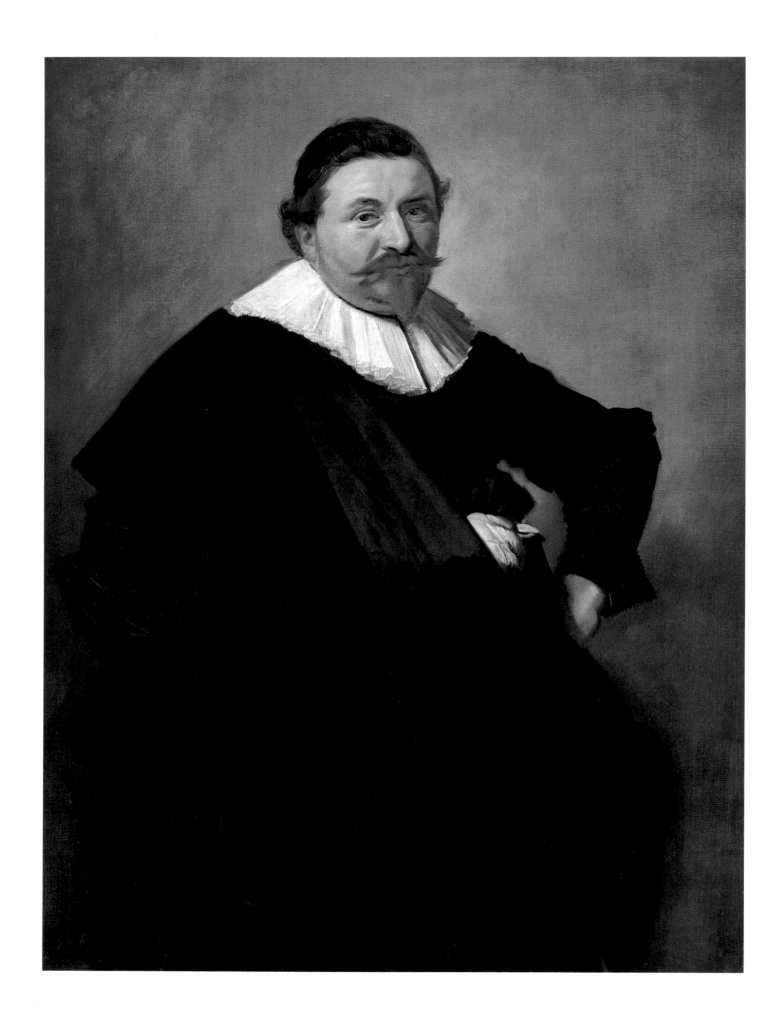

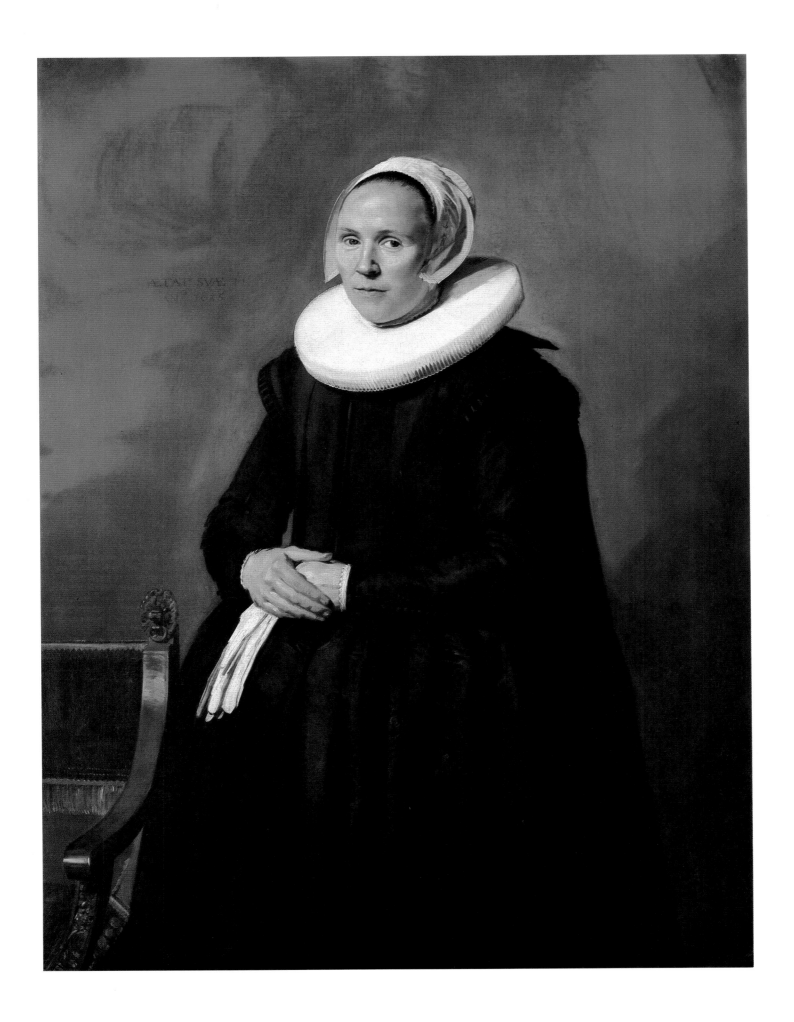

48 Isaac Abrahamsz Massa

c.1635
Panel, 20.3 × 18.6 cm
Signed, middle right, with the connected monogram: FH
S103
Lent by the San Diego Museum of Art; gift of Misses Anne R. and
Amy Putnam (inv. 46:74)

This small portrait of Isaac Massa, the versatile Haarlem merchant engaged in the Russia trade whom Hals portrayed in 1626 (cat.21), is datable to about 1635 on the basis of Adriaen Matham's reversed engraving inscribed: '*Anno 1635 ... AEtatis Suae 48 ... F. Hals, pinxit. A. Matham Schulpsit.*' (fig.48a; Hollstein, vol.11, p.214, no.62). In the little portrait, the intense colour and value contrasts of the earlier work are replaced by a more monochromatic effect. Massa's suit is now a fine silvery grey enriched by the light blue of his sash and white accessories, while the warm, dark brown neutral background creates a delicate airy effect. In his engraving Matham replaced Hals's plain background with swathes of drapery; he made a similar change to his engraving after Hals's portrait of Pieter van den Broecke (cat.44, fig.44a). The engraver's garnish dissipates some of the informality of Hals's portrayal of Massa, who appears before us, stouter than he was in 1626, with his head slightly cocked, his lips parted and his hand outstretched as if speaking.[1]

The appearance of Massa's curious motto '*In coelis Massa*' ('Massa in heaven'), inscribed at the top of Matham's print, led his earlier biographers to conclude that he died in 1635; he actually died in 1643. Below the engraved portrait is a verse

signed C.M. (the initials of his brother Christiaan Massa?):

Pursued by hatred and envy, he obtained honour from the Tsar and the Swedish king
And sought their favour, while fulfilling the commissions entrusted to him by the States.
When envy brought accusations upon him, he continued on his way, relying on God,
And obtained greater honours from the commander of the Goths, while laughing at envy.
Promoted now to the nobility, and having become rich, he now calmly awaits his eternal bliss.[2]

The reference in the poem to hatred and envy that produced accusations are not signs of a paranoiac streak in Massa. On more than one occasion rival merchants sent letters to the States-General that slandered him, alleging that he was a traitor working in the Netherlands as a political correspondent of the Tsar (Massa 1982, p.xix). The 'greater honours from the commander of the Goths' apparently refers to the patent of nobility he received from King Gustavus Adolphus in 1625. For additional details about Massa's life and other portraits by Hals that have been called portrayals of him, see cat.21.

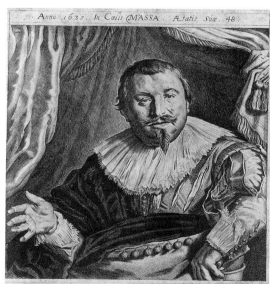

Fig.48a Adriaen Matham,
engraving after Hals's *Isaac Abrahamsz Massa*, 1635

1. S.Nijstad (private communication) has observed that Massa's extended fingers appear to have fingernails on the wrong side of the hand; a technical examination probably will show that discoloured varnish and perhaps old repaint in this area accounts for the apparent anomaly. The distinctive highlights seen on the ends of the sitter's fingers in Matham's engraving now appear as fingernails.

2. Translation by G.Edward Orchard, cited from Massa 1982, p.xx.

The Dutch text reads:
'Vervolcht van Haet en nijt, vooruluchte hij tot d'eer bij Keyser, Koning, Heer/ Er won er gonst met dienst, Slants Staaten hem betrouden, wiens liefd' eens weer verkoude,/ Als hem die nijt belaagd, omstutten sijnen loop gesterct van Godt in hoop./ Erlangd hij meerder gonst, bij 't grootste Hooft der Gotten, dies hij de nijt bespotten,/ Gadelt en verrijct, vernoucht nu sijn gemoet en wacht na d'eeuwich goet.'

PROVENANCE A mutilated printed label on the back of the panel reads: '... the Will of the Right Honorable Henr[y]/ [M]ontagu Templetown [Earl Templeton], deceased, is given in .../ ... of an Heirloom, with Castle Upton, in Ireland./ June, 1863.' The number 1493 is inscribed in ink on the label. According to Bode-Binder (148) the painting was with the dealer J.Böhler, Munich, and then with the dealer Henry Reinhardt, New York; dealer Goudstikker, Amsterdam, Catalogue, July 1915, no.20; collection Marcus Kappel, Berlin; F.B.Gutmann, Heemstede; gift of Anne R. and Amy Putnam to the museum in 1947.

EXHIBITIONS Haarlem 1937, no.52; Los Angeles 1947, no.7; Indianapolis & San Diego 1958, no.48; Raleigh 1959, no.57.

LITERATURE *Icon. Bat.* no.4865, Moes 52, and HdG 199 describe the painting from Adriaen Matham's engraving of 1635. Bode-Binder 148; KdK 129 (1635); van Rijckevorsel 1937, pp.173-5; Catalogue The Fine Arts Gallery, San Diego, 1960, p.25; de Jongh & Vinken 1961, pp.146-7; Slive 1970-4, vol.1, p.127; Grimm A21b (an inexact and highly probable reduced copy); Montagni 102b (copy); Massa 1982, pp.xx-xxi.

268

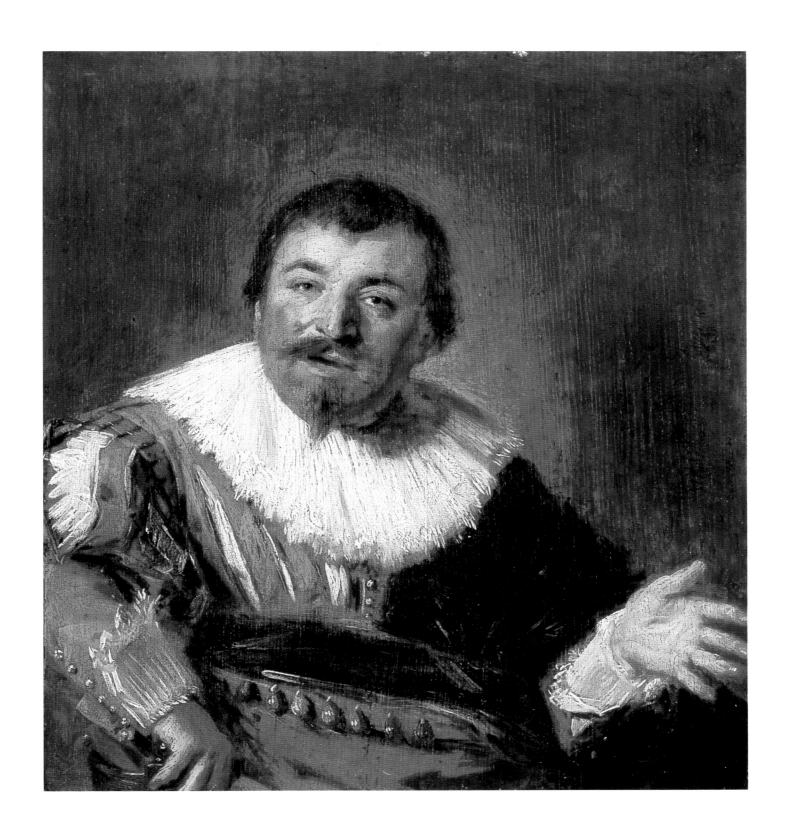

269

49 Family Portrait

c.1635
Canvas, 113 × 93.4 cm
S102
Cincinnati Art Museum, Cincinnati (inv. 1927.399)

During the twenties and thirties, the Amsterdam portraitist Thomas de Keyser popularised the vogue for collective portraits in little of groups seen in domestic settings which often look as if they record actual interiors but as often as not are imaginary (Adams 1985). Pieter Codde and Jan Miense Molenaer soon followed his lead, and during the ensuing decades Gerard ter Borch, Adriaen van Ostade, Emmanuel de Witte and other artists occasionally painted them too. These small group portraits anticipate the 'conversation pieces' which became a popular branch of portraiture during the eighteenth century, particularly in Holland and England. Rembrandt once tried his hand at this type when he painted a *Married Couple* in 1632/3, soon after he settled in Amsterdam (Isabella Stewart Gardner Museum; Bredius-Gerson 405; I find its ascription by Bruyn *et al.* 1986, vol. 2, no. C67, pp. 728-39 to one of Rembrandt's workshop assistants unconvincing). The Cincinnati *Family Portrait*, which can be dated a few years later, is Hals's only known group portrait on this scale. Moes (1909, pp. 28-9) rightly states that early attempts to identify the standing father as Willem van Heythuysen (cat. 17, 51) or as the artist's self-portrait are groundless. Not only do the physiognomies speak against these identifications, but van Heythuysen is disqualified because he was a bachelor

and Hals because he had more than a half-dozen children at this time.

The unidentified family is unified principally by the sharp diagonal organisation of the group which has been placed well in the foreground and by the dominant black of their clothing, relieved only by the warm brown dress worn by the youngest child. Their costumes are characteristic of the mid-thirties, one of the reasons Ekkart (1973) offers for his convincing rejection of Grimm's attribution (1971) of the portrait to Hals's nebulous son Frans II with a date of about 1648-50.

The family's contagious smiles also establish an inner bond between them. E. de Jongh notes (in Haarlem 1986, p. 54) that the gestures of the mother's hand on her bosom and the father's outstretched hand are cited in Cesare Ripa's recipes for personifications of fidelity and friendship (or love) in the Dutch edition of his *Iconologia* published in 1644. However, there is no need to consult a handbook on iconology to grasp the meaning of the clasped hands of the two little girls, which help express their joyous relationship (fig. 49a).

Behind the family there is a curious mixture of an interior and a vista of a garden and stately house. If the setting is meant to represent a terrace, it is an odd one. The straightback chair is a familiar prop in Hals's work, and enough can be seen of

Fig. 49a Detail from *Family Portrait*

Fig. 49b Chair, Dutch, first half of the seventeenth century
Amsterdam, Rijksmuseum

it to show its close similarity to one now in the Rijksmuseum (fig. 49b), but the *roemer* and lemon on the table covered with a Near-Eastern carpet are unusual in his œuvre; it is one of his rare still-lifes. By Hals's standards, the two chairs and miniature still-life were a lengthy description of things people live with. He also painted the large swatch of drapery; here, however, he may have stopped. The large structure in the middle ground and the view beyond it seem to have been done by another hand. The short, thinly brushed strokes of the foliage recall the landscapes Pieter Molijn painted about this time. If he painted these parts of the picture (I am inclined to think he did), it was neither the first nor the last time he collaborated with Hals (see cat. 21, 67).

A few of the symbolic allusions that are found in some of the artist's other works appear in the portrait. The vines clinging to the cracked edifice can allude to steadfast love (see cat. 12) or to fidelity (Bedaux 1987, pp. 158-61); both are appropriate references in a family portrait. And abundant references in seventeenth-century Dutch literature and art confirm that the roses strewn on the floor of the little group portrait are allusions to the joys of love or to humankind's quick passage on this earth (see cat. 17).

Two drawings on parchment by Jan Gerard Waldrop (1740-1808) after figures in the family portrait have been identified: a three-quarter length of the mother, inscribed '*F. Hals pinxit/ J.G. Waldorp delin. 1782*' at the E.B. Crocker Art Gallery, Sacramento, California; the two young girls seen three-quarter length, inscribed '*F. Hals pxt/ J.G. Waldorp del/ 1782*' at the Kupferstichkabinett, Staatliche Museen, West Berlin. A chalk drawing after the painting by Abraham Delfos (1731-1820) appeared in the sale P. van Zante, Leiden, 19 October 1792, no. A.4.

PROVENANCE Sale J. van Leeuwarden, widow of P. Merkman, Haarlem, 21 September 1773, no. 4; sale J.D. Nijman, Amsterdam, 16 August 1797, no. 117 (Dfl. 32.50); probably sale O.W.J. Berg van Dussen Muilkerk, Amsterdam, 7 July 1825, no. 44 (Dfl. 151); in the possession of dealer Nieuwenhuys, 1862; sale Vicomte du Bus de Gisignies, Brussels, 7 May 1882, no. 33; sale E. Secrétan, Paris, 1 July 1889, no. 126; Rudolphe Kann, Paris; dealer Lawrie and Co., London; dealer C. Sedelmeyer, Paris, *Cat. of 300 Paintings*, 1898, no. 55; R.B. Angus, Montreal; Scott and Fowles sold it in 1910 to Mrs. Thomas J. Emery, Cincinnati, Ohio; bequeathed to the museum in 1927 by Mary M. Emery.

EXHIBITIONS Detroit 1935, no. 34; Cleveland 1936, no. 221; Haarlem 1937, no. 69; New York 1937, no. 18; Montreal 1944, no. 23; Haarlem 1962, no. 35.

LITERATURE Bode 1883, 35 (c.1638); Moes 87 (attribution questioned); HdG 440; Bode-Binder 192; KdK 148 (c.1636); Valentiner 1936, 58 (c.1636); Slive 1970-4, vol. 1, pp. 132-4; Grimm 1971, p. 163, no. 22 (Frans Hals II; 1648-50); Ekkart 1973, p. 254 (by Frans Hals; costumes indicate the date of c.1635 is correct); Montagni 277 (attributed to Frans Hals); Millard F. Rogers Jr., *Favorite Paintings from the Cincinnati Art Museum*, New York 1980, p. 22; *Masterpieces from the Cincinnati Art Museum*, Cincinnati 1984, p. 109; Haarlem 1986, p. 54 (by Frans Hals).

1638
Panel, 20.6 × 16.8 cm
Inscribed, upper left: 1638./... 33.
S122
The Trustees of the National Gallery, London (inv. 6411)

Jean de la Chambre 'de Oude' (1605/6-68) was a calligrapher, a skill highly valued in seventeenth-century Holland and, like many Dutch calligraphers of his day, he also was the master of a French school. His was in the Ursulasteeg at Haarlem. Hals's little portrait of him served as a *modello* for Jonas Suyderhoef's engraving of it in the same direction (fig. 50a; Hollstein, vol. 28, p. 242, no. 96; 25.5 × 17.5 cm). The print was used as a frontispiece for a book de la Chambre published with six engraved specimens after his own fine hand. The one reproduced here (fig. 50b) offers a biblical quotation that includes wise counsel for schoolmasters: 'Understanding is a wellspring of life unto him that hath it: but the instruction of fools is folly' (*Proverbs* XVI:22).

Like the painting, Suyderhoef's print bears the date 1638, and is inscribed at the lower right: *'F. Hals pinxit/ J.S. Hoef sculpsit'*. The inscription below the portrait gives the title and date of the book: *Verscheyden geschriften, geschreven ende int Koper gesneden,/ door Jean de la Chambre, liefhebber ende beminder der/ pennen, tot Haarlem. Anno 1638* (Various writings, written and engraved on copper, by Jean de la Chambre, lover and devotee of the pen, at Haarlem. 1638).

The print is one of a few done by Hals's contemporary engravers that does not reverse the painting it copies. In this case it is not difficult to say why: de la Chambre, proud of his calligraphy, wanted to be depicted in his frontispiece with his pen in his right hand as he is seen in the painting. If Hals's lost portraits of the calligraphers Arnold Möller, datable about 1629, and Theodore Blevet, dated 1640, both known from contemporary engravings (figs. 50c, 50d) are ever discovered,

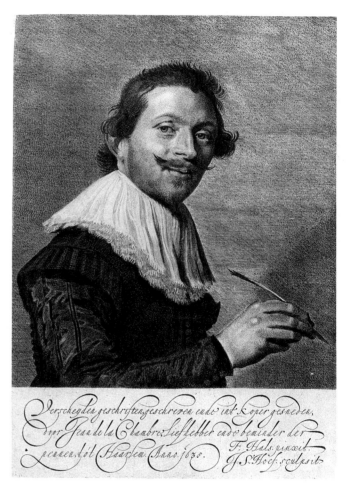

Fig. 50a Jonas Suyderhoef, engraving after Hals's *Jean de la Chambre*, 1638

Fig. 50b *Klockheyd is een levendige ton ...*, engraving in Jean de la Chambre, *Verscheyden geschriften ...* Haarlem 1638

the probability is high that they will reveal that the prints are not mirror images of the originals.

Christopher Brown's investigation has established that de la Chambre was succeeded by his son, also Jean, as master of the French school. After his death in 1685 his widow advertised the sale of the schoolhouse in the *Haarlemer Courant* where it was described as new, solidly built with a schoolroom and a dining room big enough to hold sixty to seventy, and several rooms for boarders (London 1976, no. 51).

Theodore Blevet (1598-1661), the calligrapher whose lost portrait is mentioned above, was also a French schoolmaster. In 1626 he settled in Beverwijk, a village near Haarlem in the midst of the city's famous bleaching fields, where he established a French boarding school. The inventory (Rijksarchief Noord-Holland, NA, no. 248, fols. 62f.) made at Beverwijk in 1664 of his widow's effects lists in *'de beste camer: een*

273

schilderije van Sara Blevet, een dito van Mr. Blevet, een dito van zijn huisvrouw' ('in the best room: a painting of Sara Blevet, a ditto of Mr. Blevet, a ditto of his wife'). Sara most probably was the couple's daughter who died at an early age.[1] The name of the artist who painted the little portraits is not cited, and of course it is possible that they were not by Hals. But the possibility that two of the paintings refer to Hals's lost portrait of Blevet and to an untraceable one of his wife cannot be excluded; following the practice of the time, the wife's portrait was not engraved (see cat. 5).

1. Information regarding the family and its inventory was kindly provided by J. van Venetien.

PROVENANCE Sale Amsterdam, 1 April 1883, no. 74 (Dfl. 90, Roos); dealer C. Wertheimer, London; dealers P. and D. Colnaghi, London, from whom it was purchased by W.C. Alexander, London, 16 March 1892 (£650); by descent to the Misses Rachel F. and Jean I. Alexander, who presented it to the gallery in 1959; entered the gallery in 1972.

EXHIBITIONS London 1900, no. 45; London 1952-3, no. 108; London 1972, no. 6411; London 1976, no. 51 (Grimm incorrectly calls the painting a copy).

LITERATURE *Icon. Bat.* no. 1523; Moes 50; HdG 164; Bode-Binder 166; KdK 169; Slive 1970-4, vol. 1, p. 127; Alistair Smith, 'Presented by the Misses Rachel F. and Jean I. Alexander: Seventeen Paintings for the National Gallery', *B.M.* CXIV (1972), pp. 630-4; Grimm A25b (copy); Ekkart 1973, p. 254 (not Hals); Catalogue The National Gallery, London, 1973, p. 305, no. 6411; Montagni 128 (copy).

Fig. 50c Lucas Kilian, engraving after Hals's lost *Arnold Möller* (S.L9)

Fig. 50d Theodor Matham, engraving after Hals's lost *Theodore Blevet*, 1640 (S.L13)

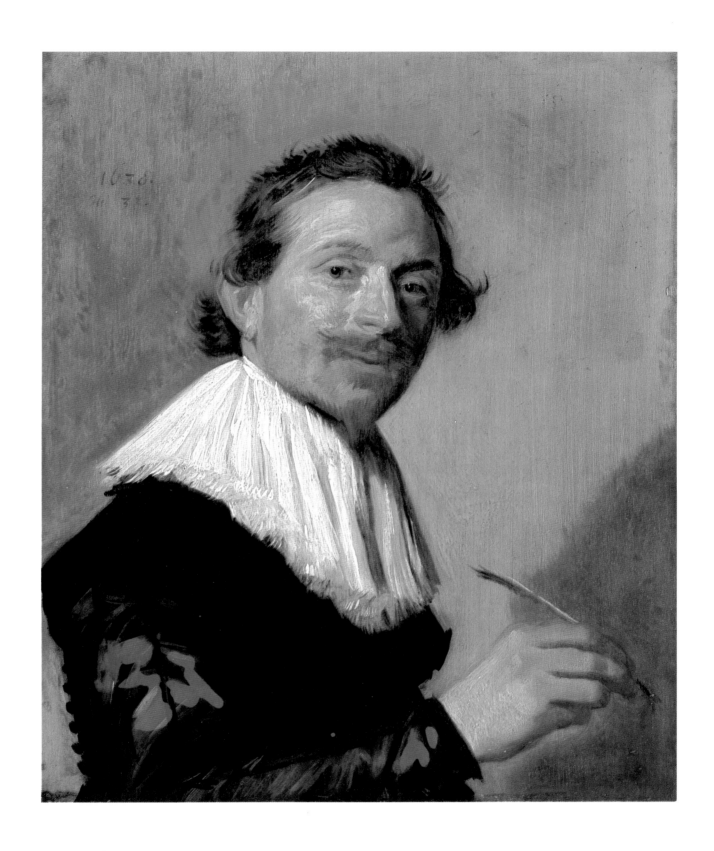

51 Willem van Heythuysen

c.1638
Panel, 46.9 × 37.5 cm
Signed with the connected monogram at the lower right: FH
S123
Musées Royaux des Beaux-Arts de Belgique, Brussels (inv. 2247)
Exhibited in London

Hals's love for representing the momentary is brilliantly combined with his sitter's nonchalant attitude in this small portrait of Willem van Heythuysen, the wealthy textile merchant and philanthropist whom the artist portrayed standing large as life more than a decade earlier (cat. 17). Movement is expressed by the swift brushwork, the flickering light, and, above all, by van Heythuysen's unusual pose with whip in hand, leaning back in his precariously tipped-back chair.

No earlier Dutch portraitist portrayed a sitter the way van Heythuysen is seen here, with one leg resting on his knee. According to Giovanni Paolo Lomazzo, a late sixteenth-century Italian theorist, depicting a patron with one knee on the other was a serious breach of decorum that was as bad as portraying him standing picking his ear. To judge from the rarity of the leg position in Dutch portraiture, Lomazzo's notion, which would have been endorsed by other Renaissance or Baroque theorists, found its way to the Northern Netherlands.

One can believe that only close friends saw van Heythuysen in this unbuttoned mood, and they probably were the people who had the best opportunity to enjoy Frans's intimate little portrait of him, a supposition that finds support in the posthumous inventory made of the effects in his large Haarlem house. The inventory lists a 'likeness of the deceased in small, in a black frame' in the room above the Great Hall. It also lists an effigy of van Heythuysen in the Great Hall. Although the inventory does not give attributions to any of the pictures it cites, it is highly probable that the 'portrait in small' hanging in the more private part of his house refers to this little, informal portrait of van Heythuysen, while the one mounted in the Great Hall, which would have served as a salon for more formal affairs, is a reference to Hals's grand, life-size full-length now in Munich (cat. 17).

Unique for Hals is the inclusion of a domestic interior in the portrait. His only other existing work that suggests one is the *Family Portrait* at the Cincinnati Art Museum (cat. 49), but in it the furnished interior is part of a terrace; instead of a definable back wall of a room, we are given a view of an architectural pile and a vista of a garden and house.

Though there is no precedent for the remarkable pose and fresh direct touch Hals used for his small portrayal of van Heythuysen, little portraits of seated or full-length figures made their appearance in Holland before it was painted. The Amsterdam artist Thomas de Keyser (1596/7-1667) led the way with a few done after the mid-twenties, and other artists soon followed suit. These novel portraits were not merely reduced versions of traditional life-size commissioned works. They took on a new genre-like character, probably derived from the small gallant company scenes then in vogue. As portrayed in little by de Keyser in about 1627 (fig. 51a), the Leiden artist David Bailly would be perfectly at home in one of Dirck Hals's little merry company pictures of gallants with fashionable women, and so would van Heythuysen as seen in Hals's small portrait of him.

A version of the Brussels painting, whose whereabouts has been unknown to students since it appeared in an 1870 Paris sale, surfaced recently; the work, which has never been repro-

duced, is now in a private French collection (fig. 51b; canvas, 52 × 62 cm).[1] The painting was severely damaged during the 1940s and subsequently heavily restored. To judge from what can be seen of its original paint surface, it is a copy by another hand. Its canvas support also raises a question about its authenticity. To our knowledge Hals never used canvas for his small pictures. Except for one that is painted on paper and mounted on canvas, whose status remains undetermined (see Slive 1970-4, vol. 3, no. L17), all of his existing ones are painted on copper or wood panel.

Two other versions of the Brussels painting have been cited in the literature. Named after their former owners, they are the Rothschild and Mildmay pictures, respectively (fig. 51c: panel, 46 × 36 cm; fig. 51d: panel, 46.5 × 36 cm). They have been recorded variously as originals and, more often, as copies. Yet another opinion has been offered: neither the Brussels painting nor the other versions can be attributed to Hals. All are copies after a lost original. For the authors of these various ascriptions, see the Literature cited below.

The Rothschild picture has been untraceable since it was listed in a Brazilian collection in 1963.[2] To judge from photos, it is far tighter in execution than the Brussels painting and overly emphatic in depicting details and accessories – indications that it is a copy by another hand. Again, judging from photos, the technique of the Mildmay version also appears alien to Hals, and is attributable to a copyist.[3] Its author could very well have been active in the seventeenth century, since

Fig. 51a Thomas de Keyser, *David Bailly*
(still-life probably by Bailly)
Formerly Paris, Madame E. Stern

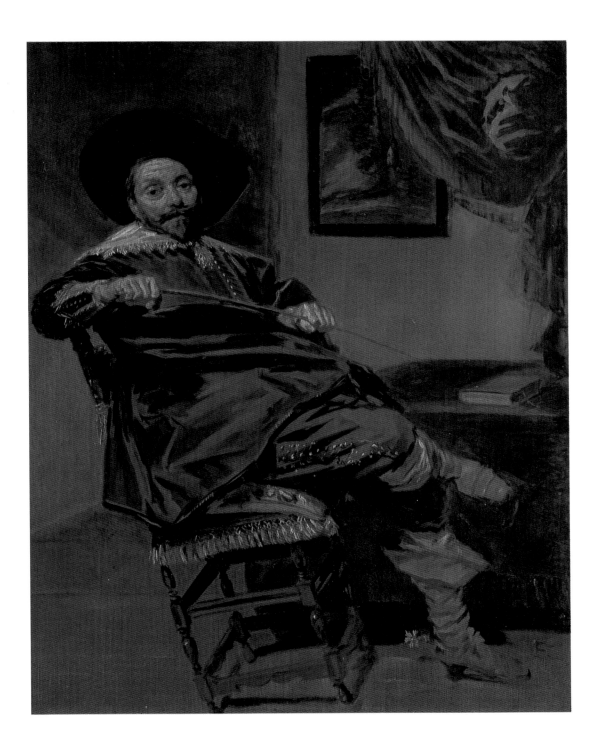

a technical examination has established that its panel was cut from the plank of a tree felled *c.*1599, and that all its pigments were available to Dutch artists of the period (Middelkoop & van Grevenstein 1988, p.96).

Some technical data also is available on materials used for the Brussels picture (curatorial files of the museum). A dendrochronological analysis made in 1971 of its panel determined that it was cut from a plank of an oak tree probably felled about 1642. In view of the usual plus or minus five years of error of such dates, this finding is compatible with the date in the late thirties assigned to the portrait here. However, it has not yet been determined if the dendrochronological date must be shifted by about six years towards the present in light

of the very recent finding that most Netherlandish panels are of Baltic and Polish origin, which changes the reference chronology that was used to establish their dates in earlier studies (Klein *et al.* 1987, pp.51ff.).

A thorough analysis of the pigments used in the Brussels painting has not been made. The analysis of only one has been recorded (1971). It is of considerable significance. A sample taken from the blue pigment used for the fringe on van Heythuysen's chair determined that it is Prussian blue. Since Prussian blue was not synthesised until *c.*1703-6, and was not generally available until about 1720, does its presence indicate that the Brussels portrait must needs be a copy painted in the eighteenth century or later? To judge from its pictorial qual-

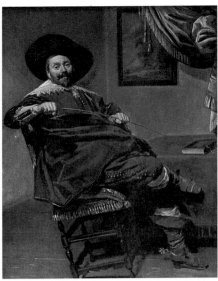

Fig. 51b Unknown artist, *Willem van Heythuysen*, copy after Hals France, private collection

Fig. 51c Unknown artist, *Willem van Heythuysen*, copy after Hals Formerly Paris, Robert de Rothschild Collection

Fig. 51d Unknown artist, *Willem van Heythuysen*, copy after Hals Private collection

ities, it is not and, until it has been established that the trace of Prussian blue is not later repaint and additional analyses confirm that its ground layer and other pigments are not in accord with Hals's usage, I am not prepared to demote the painting to the status of a copy.

A watercolour copy of the portrait by Hendrick Tavenier (1734-1807), finished by Cornelis van Noorde (1713-95), is in the Haarlem City Archives (inscribed on the verso: '*Willem van Heithuysen ... door H. Tavenier Na[ar] Schilderij Getekent & d[oor] C v Noorde Na[ar] dito v[an] Frans Hals op Gemaakt*'). Possibly one of these Haarlem artists or one of their colleagues was responsible for the existing painted copies of van Heythuysen. It also should be noted that P.E.H. Praetorius (1791-1876), the amateur artist and supporter of the arts in Amsterdam and Haarlem, who probably made a painted copy of Hals's *Jaspar Schade* (cat. 62; fig. 62b), records in his memoirs that amongst the copies he made in 1865 and in 1866 he did one of Hals's *Willem van Heythuysen*. Almost certainly it was a copy of the Brussels picture, since at that time it still belonged to the Hofje van Heythuysen (Damsté 1985, p. 39).

history of this version from the time it made its first appearance in the sale H. Bingham Mildmay, London (Christie's), 24 June 1893, no. 21, until it was published as in a private collection by Middelkoop (in Middelkoop & van Grevenstein 1988, pp. 96-7); in his opinion it is a seventeenth-century copy. An English in-

scription painted on the verso of the panel states: 'William van Heythuysen a Protestant left Flanders on account of his religion & brought over with him 28 Families into Holland some of which afterwards settled in England.' The Literature cited below for the Brussels painting lists published references to the painting.

PROVENANCE Possibly the painting described in the inventory made of the effects in van Heythuysen's large house on Oude Gracht, Haarlem after his death in 1650: 'Conterfeijtsel vanden overleden int klijn in swarte lijst' ('likeness of the deceased in small, in a black frame'), cited in Boot 1973, p. 422. Hofje van Heythuysen, Haarlem; a label on the verso of the panel in an old (seventeenth-century?) hand reads: 'Willem van Heijthuysen/ Stichter van dit Hofje/ Overleden den 6' July 1650' ('Willem van Heythuysen. Founder of this hofje. Died 6 July 1650'). Sold by the Hofje to the dealer Henri Le Roy, who in turn sold it to the Brussels museum, 13 May 1870 (fr. 17,000).

EXHIBITIONS Amsterdam 1867; London 1929, no. 49; Haarlem 1937, no. 71; Zurich 1953, no. 46; Rome 1954, no. 50; Milan 1954, no. 55; Haarlem 1962, no. 40; Brussels 1961, no. 48; Brussels 1962-3, no. 34; Brussels 1971, no. 47.

LITERATURE *Nederlandsche Spectator* 1865, p. 127; Bode 1883, 31 (c.1635); *Icon. Bat.* no. 3507-2; Moes 46 (repetition of the Rothschild version); HdG 188 (original; Rothschild version a copy); Bode-Binder 222; KdK 165 (c.1637; to judge from a photo of the Rothschild version, the Brussels painting is higher in quality); Trivas, App. 5 (one of three variants after Hals; 'I have not been able to see the other two variants'); Catalogue Musées Royaux des Beaux-Arts, Brussels, 1949, p. 56, no. 203; Slive 1970-4, vol. 1, pp. 130-1; Steingräber 1970, pp. 307-8 (original; Rothschild version a copy); Grimm A26b (copy; Rothschild version [A26a] also a copy); Ekkart 1973, p. 254 (copy); Boot 1973, p. 422; Montagni 121a (copy; Rothschild version [121b] a copy); Catalogue Musées Royaux des Beaux-Arts, Brussels, 1977, no. 96; *Inventariscatalogus van de oude schilderkunst*, Koninklijke Musea voor Schone Kunsten van België, 1984, p. 132, inv. 2247; Middelkoop & van Grevenstein 1988, pp. 96-7 (Middelkoop suggests the Brussels picture is a copy by Hals himself done c.1655 after the Rothschild painting which he argues was the first version that Hals painted; he dates the latter in the late 1630s and assigns the Mildmay version to a seventeenth-century copyist).

1. Sale Martial Pelletier, Paris, 28 April 1870, no. 12 (as a 'Portrait d'un seigneur en costume de l'époque de Louis XIII'; 4,650 francs); acquired in 1870 by Mrs. Henriette Vogel de Schreiber (born Henriette Bollinger in 1840). Reappearance of the Pelletier version and knowledge that it was purchased by a private collector in 1870 help clarify the provenance of the Brussels painting which was acquired by Le Roy directly from the Hofje van Heythuysen. Le Roy sold it to the museum on 13 May 1870. Hofstede de Groot (188) and Slive (1970-4, vol. 3, no. 123) discuss the possibility that the Brussels picture may have been placed by Le Roy in the Pelletier sale held about three weeks earlier (with the wrong description of its support and dimensions) and then bought back. It now is certain that the Brussels picture never appeared in the Pelletier sale. I

am beholden to the present owner of the picture for information about its history and permission to publish it.

2. PROVENANCE: Sale B. de Bosch, Amsterdam, 10 March 1817, no. 9; sale Amsterdam, 14 May 1832, no. 30 (Dfl. 850, van Brienen); G.Th.A.M. Baron van Brienen van de Grootelindt of Amsterdam, Paris, 8 May 1865 (35,000 francs, Baron James de Rothschild); Baron Gustave de Rothschild, Paris; Robert de Rothschild, Paris; dealer F. Mont, New York, 1950; Otto Schuller, São Paulo, Brazil, in 1963. LITERATURE: Bode 1883, 44; *Icon. Bat.* no. 3507-3; Moes 45; HdG 190 (replica); Bode-Binder 221, pl. 141a. For subsequent references to it, see the Literature cited for the Brussels picture below.

3. I have been unable to trace the

278

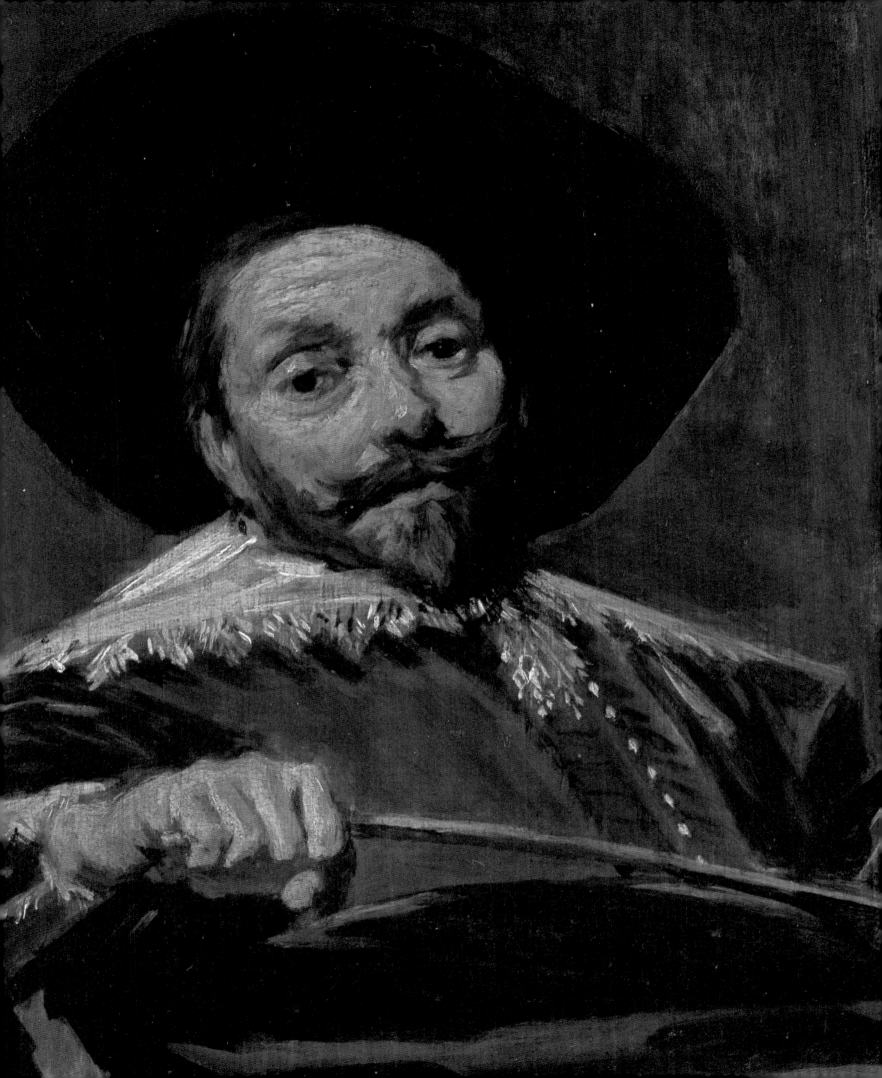

52 Claes Duyst van Voorhout

*c.*1638
Canvas, 80.7 × 66 cm
S119
The Metropolitan Museum of Art, New York, The Jules Bache
Collection (inv. 49.7.33)
Exhibited in Washington

In 1854, when few people had a clear idea of Hals's work, Waagen wrote that he was inclined to attribute this broadly painted, spirited portrait of a man with 'his eyes and cheeks telling of many a sacrifice to Bacchus' to Hals. Waagen's estimate of pictures as well as people was sound. His attribution of the unsigned portrait is beyond dispute, and his opinion of the sitter's drinking habits was virtually substantiated when it was discovered that the man portrayed is Claes Pietersz Duyst van Voorhout, brewer in the Swan's Neck ('Swaenshals') brewery at Haarlem. According to Collins Baker (1920), the back of the painting was inscribed: '*Claes Duyst van Voorhout brouwer in des Brouwerij het Zwaanschel?*' Today the inscription is known only from a rather garbled transcription of it published in the 1856 Petworth catalogue, and from Baker; it was lost when the painting's canvas support, which had been mounted on a panel, was transferred to a stretcher in 1925 (museum files). However, if '*Swaenshals*' is read for '*Zwaanschel?*', there is no reason to doubt Baker's reading. In Haarlem's City Archives, there are references to Nicolaes (Claes) Pietersz Duyst van Voorhout, brewer in the '*Swaenshals*'; in 1629 he testified that he was 29, an age consistent with the man portrayed in the Metropolitan's portrait, which is datable about a decade later.[1]

The arm-akimbo pose that Hals used here for his brilliant characterisation of stout Voorhout was one he employed for half-lengths from the twenties (*The Laughing Cavalier*, 1624; pl. 1) to his outstanding *Portrait of a Man* at the Hermitage (cat. 73), datable to the early fifties. Here the regularised silhouette and monochromatic effect are charcteristic of the mid and late thirties. The embroidery and contrasting colours so popular a few years earlier have disappeared; variety and patterns are achieved by the sheen and reflection of light on grey watered satin.

There are two large patches of paint loss in the hat-brim, some scattered small losses, and the hair and background are moderately abraded. The face and clothing are well preserved.

1. Biographical data on Voorhout was provided to the museum by Josine E. de Bruyn Kops, sometime curator at the Frans Halsmuseum, in a letter dated 30 May 1975.

PROVENANCE The Earls of Egremont; Colonel Egremont Wyndham, Petworth, by 1854; the Lords of Leconfield, Petworth; Duveen Bros., New York, by 1927; Jules S. Bache by 1929, given by him to the museum in 1949.

EXHIBITIONS London 1929, no. 367; Detroit 1935, no. 33; Haarlem 1937, no. 66; New York 1939, no. 174; Los Angeles 1947, no. 12.

LITERATURE Waagen 1854, vol. 3, p. 36; *Catalogue of Pictures in Petworth House, Sussex*, London 1856, p. 41, no. 383: F. Hals, 'Portrait of "Van Voorhout"'. (Claas Dugalt Van Voorhout brouwer in dos Brouwery Swaan, A.R.P.S., *written on the back*.)'. In the older literature there are references to Colonel Egremont Wyndham's *Catalogue of Paintings at Petworth*, 1850; I have not been able to locate a copy of it. Bode 1883, 153 (*c.*1630); Moes 33; HdG 176; Bode-Binder 114; C.H. Collins Baker, *Catalogue of the Pictures in Possession of Lord Leconfield* (Petworth House), 1920, no. 383; KdK 154; *Catalogue of Paintings in the Bache Collection*, New York 1929, unpaginated; Valentiner 1936, 59; *Catalogue of Paintings in the Bache Collection*, Metropolitan Museum, 1938, no. 34; ibid., 1944, no. 33; Trivas 62 (*c.*1635); Slive 1970-4, vol. 1, pp. 122-3; Grimm 73 (*c.*1635); Montagni 110 (*c.*1635); Baetjer 1980, vol. 1, p. 83 (possibly Claes Duyst van Voorhout), vol. 3, p. 399; Baard 1981, p. 122 (*c.*1638).

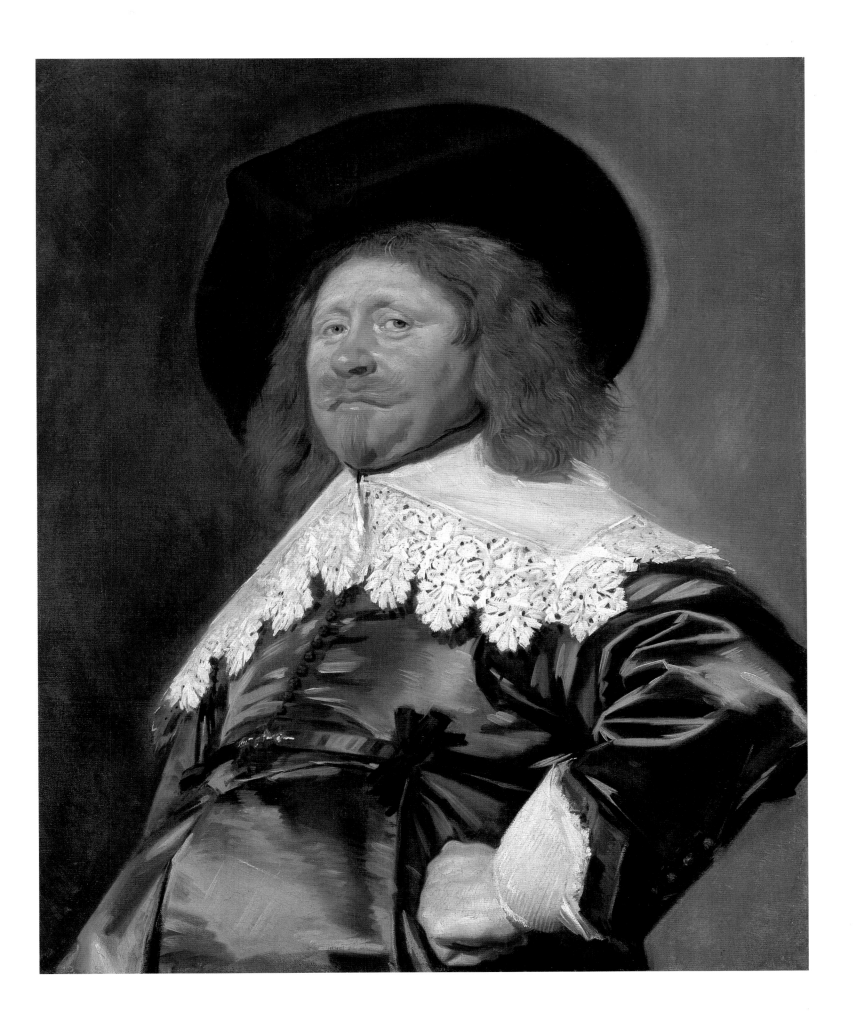

53 Portrait of a Woman holding a Fan

c.1640
Canvas, 79.8 × 59 cm
S141
The Trustees of The National Gallery, London (inv. 2529)

The style and costume of this beautiful portrait date it about 1640. MacLaren (1960) noted that a similar costume is worn by the woman in Pieter Codde's *Family Portrait* at the National Gallery, London (inv. 2576), dated 1640. There is an even closer similarity to the costume seen in the *Portrait of a Woman* of 1640 by Johannes Cornelisz Verspronck (Haarlem before 1603-1662 Haarlem) at the Rijksmuseum Twenthe, Enschede (fig. 53a). Verspronck's sitter does not wear a diadem cap (*diadeemmuts*) but her large, flat three-tiered lace collar, silver bow and ample lace-trimmed cuffs virtually replicate those worn by Hals's patron. The elaborate collars worn by these women began to replace older types in about 1640; however, the latter continued to be worn by people who felt no complusion to adopt a new fashion.

Fans began to appear in the hands of modish women who sat for portraits in the 1630s, but they were in vogue in the Netherlands much earlier. The most popular type was the kind held by Hals's and Verspronck's sitters, a fan of feathers set in a mount. Another type was the folding fan (see cat. 58, 64, 65). Both kinds were expensive; hence they most probably were status symbols. There is no evidence that they had any other significance or if there was such a thing as a 'fan language' in seventeenth-century Holland (du Mortier, p. 51).

Hals's style and repertoire of poses had a pronounced impact on Verspronck, particularly in those he painted early in his career. Verspronck, however, hardly ever tried to emulate Hals's freedom of touch, and his highly finished portraits are seldom as animated as Frans's. It is characteristic of him to portray the hands of the woman in his Enschede portrait at rest; those in Hals's portrait are in positions that could change momentarily.

The way the woman's right hand and fan are cropped in the London portrait, and the way the sitter crowds the frame, suggests that the picture has been cut at its bottom edge and sides. This supposition seemed to be confirmed by radiographs made of it during its restoration at the National Gallery in 1988-9, which show distinct cusping along the top edge of the canvas but not on its three other sides. A conclusion that can be derived from this evidence is that only the canvas at the top of the painting still is close to its original tacking edge and that the other three sides have been cut. However, David Bomford, the gallery's conservator who treated the picture, noted that another plausible explanation can be offered for the absence of cusping on three sides of the original canvas support: if the canvas used for the portrait was cut from a larger one that had been prestretched and primed, the same effect would be seen in the radiographs. He suggests that Hals may very well have used such a support for the painting and, in the event, it was a bit too small for the portrait. Hence, the crowding and the sitter's rather awkward right arm. But Hals made the best of it when he turned the woman's right forefinger to give it a resting place on the bottom edge of the frame.

Which of the two explanations of what the radiographs reveal is correct? I am inclined to accept Bomford's. Others may disagree. Here we have another reminder that data obtained by technical examination does not always provide an open-and-shut case. Like data obtained by other methods, more often than not it must be interpreted.

An additional aspect of the materials used for the painting is notable. Its priming is a thick layer of chalk mixed with only a little lead white, umber, red ochre and fine charcoal black added. Chalk grounds are often found on panels but are seldom used on canvasses, since they tend to flake and crack after application to fabric (Groen & Hendriks, p. 115). Hals's three-quarter length of *Paulus Verschuur* (cat. 56) also has a chalk ground.

Spanton's report (1927) that the present painting and the *Portrait of a Man*, also at The National Gallery (inv. 2528; S163), were in the hands of the same London dealer about 1865 may be correct, but it would be erroneous to conclude they were intended as pendants. Valentiner's two different attempts to identify a companion picture to the painting have been rightly rejected by MacLaren.[1]

1. MacLaren (1960, under 2529) understandably found no good reason to accept Valentiner's suggestion (KdK 201) that the present picture is probably the pendant to the *Portrait of a Man*, formerly Count Xavier Branicki Coll. (sale L. and G. Guterman, New York [Sotheby's], 14 January 1988, no. 18 [bought in]. When I catalogued the Branicki *Man* in 1974 [S.D56], I stated that it may be a copy after a lost original; subsequent cleaning revealed it is a flattened, abraded original). MacLaren also correctly rejected Valentiner's later proposal (1928, p. 248) that the *Woman* is the pendant of the *Man fingering his Collar Tassel*, Barker Welfare Foundation, New York (S.D60).

PROVENANCE MacLaren notes (1960, under 2528) that the present portrait and the *Portrait of a Man* at the National Gallery (no. 2528; S163) are said to have been in the possession of the London dealer Joseph Flack about 1865 (see W. S. Spanton, *An Art Student and his Teachers in the Sixties, with other Rigmaroles*, London 1927, p. 33); sale Rev. Robert Gwilt, London, 13 July 1889, no. 78 (£1,680, Agnew); sold by Agnew to George Salting, July 1889; George Salting Bequest, 1910.

EXHIBITION London, Royal Academy, Winter Exhibition, 1891, no. 127.

LITERATURE Moes 192; HdG 385; Bode-Binder 257; KdK 201 (c.1643); Valentiner 1928, p. 248; MacLaren 1960, p. 148, no. 2529 (c.1640) and under no. 2528; Grimm 1971, p. 162, no. 10 (c.1643; Frans Hals II); Catalogue The National Gallery, London, 1973, p. 305, no. 2529; Montagni 256.

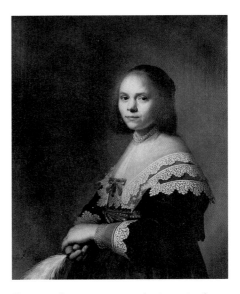

Fig. 53a Johannes Verspronck, *Portrait of a Woman*, 1640
Enschede, Rijksmuseum Twenthe (inv. 514)

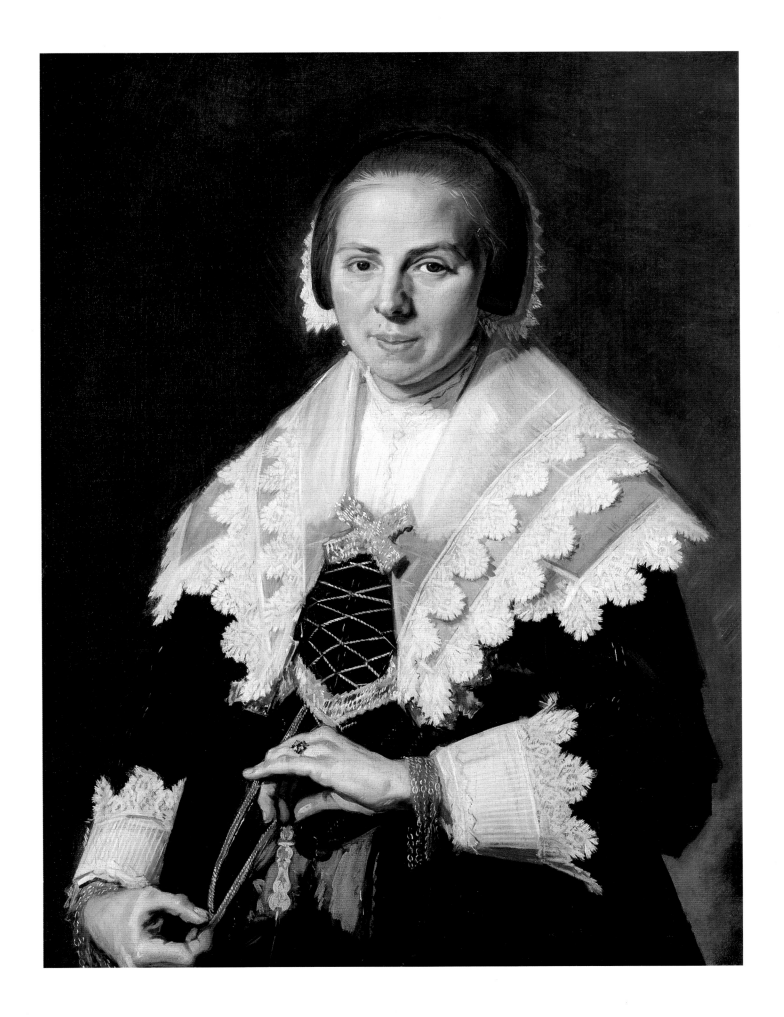

1641
Canvas, 153 × 252 cm
S140
Frans Halsmuseum, Haarlem (inv. 1-114); loan from the Elisabeth
Hospital

Traditionally dated 1641, this collective portrait of the *Regents of the St. Elizabeth Hospital*, an institution dedicated to the care of the sick and needy, marks the direction Hals's art was to take during the following decades. The gaiety of his early group portraits of officers gathered around a banquet table has been replaced appropriately by a new dignity and sobriety. An unspecified business matter, not a spectacular performance of eating and drinking, is the order of the day. An inkpot has replaced the *roemer*, and a ledger, instead of a dish of oysters, is found on the table. A few coins lying before the regent seated on the right may identify him as the treasurer of the group.

More than one treasurer of the hospital, and probably other colleagues as well, was familiar with a painful family problem Hals and his second wife faced. Pieter, one of their sons, was an imbecile. In 1637 the burgomasters of Haarlem instructed St. Elizabeth Hospital to contribute 50 guilders (the sum was soon raised to 60) for his support. It was the hospital's share of the 125 guilder annual allowance the city's authorities provided for Pieter with the stipulation that he be housed outside the city; the balance was made up of contributions from Haarlem's Leper-House and poor relief fund (Hals docs. 80, 81). In June 1642, probably less than a year after the group portrait was painted, the burgomasters decided that Pieter was to spend the rest of his life in solitary confinement in Haarlem's workhouse, a combined house of correction and charitable institution. The workhouse was to receive 100 guilders for his annual support, 50 guilders paid by St. Elizabeth Hospital, and again the balance was to come from the Leper-House and poor relief fund (Hals doc. 94). Pieter was buried in a pauper's grave in February 1667 in a churchyard near St. Elizabeth's; the regents made their final contribution toward his maintenance three weeks earlier (Hals doc. 196). In 1642, the very same year Pieter was confined to the workhouse, his sister Sara was incarcerated there, at her mother's request, for the crime of fornication. She was expecting her second illegitimate child (Hals doc. 92). Her first was baptised in December 1640 (Hals docs. 91, 93).

Not a trace of these dark clouds casts a shadow over the group portrait. On the contrary. Unusual for Hals is the prominent stream of mild light that enters the room and, although the dominant colour harmony has become almost monochromatic, there still is a brightness that recalls earlier paintings. The well-illuminated map behind the regents, which appears to represent Flanders, also is unusual; it is the only one known in his œuvre.[1]

New in the work is Hals's abandonment of the device he had used in all his earlier group portraits of making some of his sitters appeal directly to the beholder. Here not one of the five regents has been related to the spectator. In addition, Hals did not create an inner unity between them by focusing their collective attention on a common action. Some of the regents glance at the man in the front plane, but the latter appears quite unaware of their attention. Yet a bond has been established between the men by the subdued accentuation of their finely characterised heads and their lively hands. The position of the head of the handsome regent seen in profile appears as casual as the subtly observed position of his little finger resting

on the edge of the table. We sense that as soon as he turns toward his colleagues the group will concentrate as one man on their agenda.

The style of the portrait supports the old tradition that it was painted in 1641. Additional evidence is found in a manuscript register at the Haarlem City Archives, *Namen der Personen die gedient hebben als Regenten van St. Elizabets Gast-Huys Binnen Haerlem zedert 't Jaer, 1509*. The five men registered as regents in the year 1641 are: François Wouters, Dirk Dirks Del, Johan van Clarenbeek, Salomon Cousaert, and Sivert Sem Warmond (ibid., p. 440). Wouters, the regent on the extreme right, can be securely identified. He had posed as a lieutenant in Hals's 1639 group portrait of the St. George civic guard (fig. 54a). The likeness is unmistakable.[2] Since regents of the hospital changed annually, and Wouters did not serve again around this time, it is reasonable to conclude that the group represents the regents of 1641 and that the painting was done in that year.[3]

In 1641 Johannes Cornelisz Verspronck (before 1603-1662) painted a companion piece to the group portrait, the *Regentesses of the St. Elizabeth Hospital* (fig. 54b; canvas, 152 × 210 cm; signed and dated 1641; Haarlem 1979, no. 29). Like Hals's picture it was painted for the hospital and still belongs to the institution; it has been on loan to the Frans Halsmuseum since 1929 (catalogue 1929, no. 541). Its date and subject, rather than its careful finish, make it a pendant to Hals's regent piece. Whether its smaller horizontal dimension was dictated by its orginal site or by Verspronck's commission to depict four sitters (the hospital was directed by four regentesses and five regents) has not been determined.

Hals's and Verspronck's 1641 group portraits vie for the distinction of being the first regent pieces painted in Haarlem; none earlier are known. However, the genre was not new to Holland. The governing officials of guilds and charitable institutions (sometimes accompanied by an employee and occasionally with individuals representative of their mandate) had been painted in the Netherlands since the late sixteenth century. They were particularly popular in Amsterdam, where the earliest known was done in 1599. By 1617-8 the Amsterdam painter Cornelis van der Voort (1576-1624) introduced the simple but novel idea of showing figures seated or standing around a cloth-covered table. His scheme became popular quickly and has had a very long life (Haak 1972, pp. 15-9). It was used by both Hals and Verspronck and is still employed today by portraitists and photographers.

A more specific source from nearby Amsterdam can be cited for Hals's portrait. The striking similarities in mood and composition between it and the little oil sketch Thomas de Keyser (Amsterdam 1596/7-1667 Amsterdam) painted in 1638 of *Cornelis van Davelaer announcing the Arrival of Marie de Medici to the Four Burgomasters of Amsterdam*, which was engraved in reverse by Jonas Suyderhoef (fig. 54c; Hollstein, vol. 9, p. 242, no. 11), indicates that Hals took more than a passing glance at the print. Hals had close contact with Suyderhoef, to whom he was related (Suyderhoef's brother married his niece, the daughter of Dirck Hals [van der Willigen 1870, p. 273]). Suyderhoef made sixteen engravings after Hals's work; no other seventeenth-century printmaker made

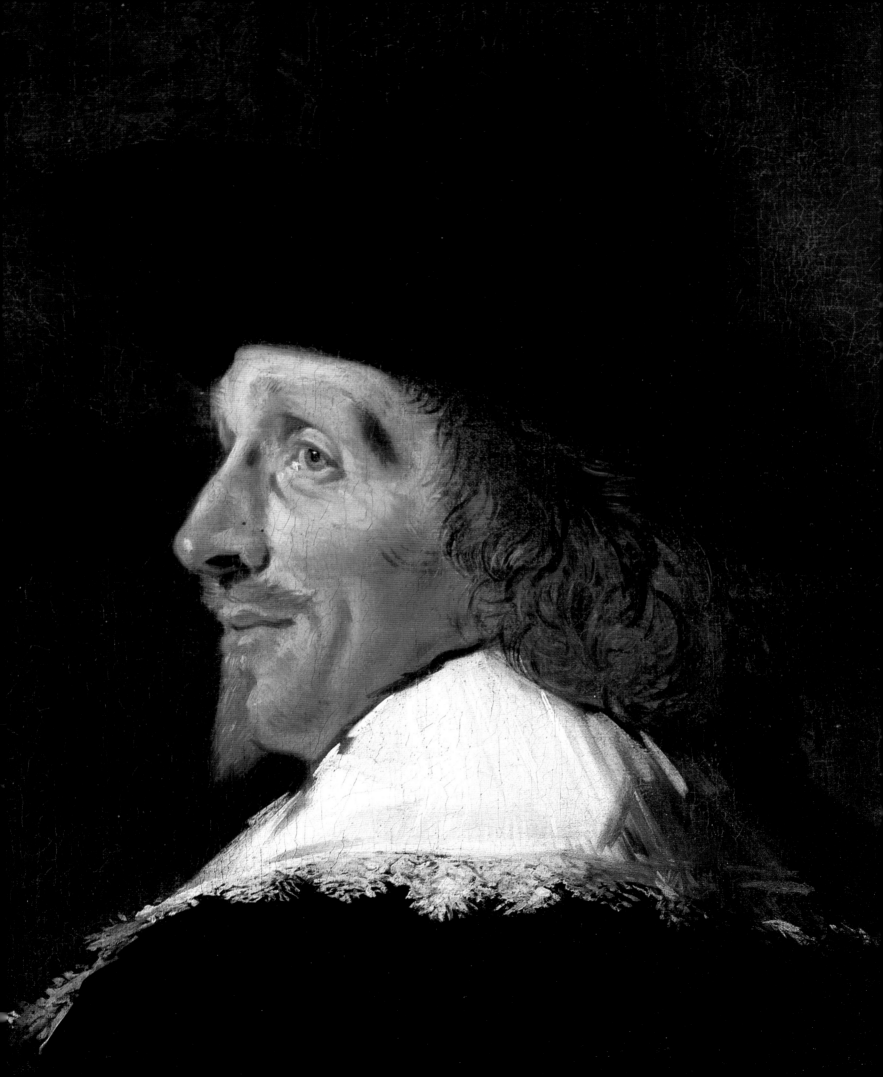

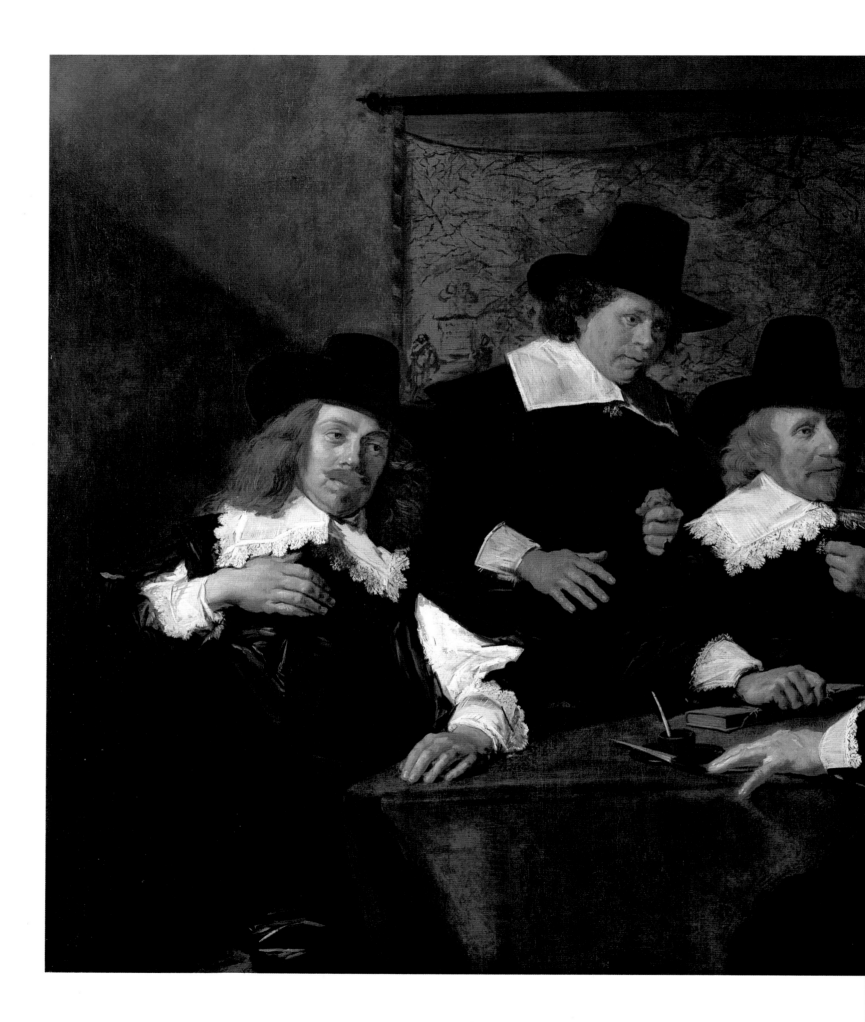

286

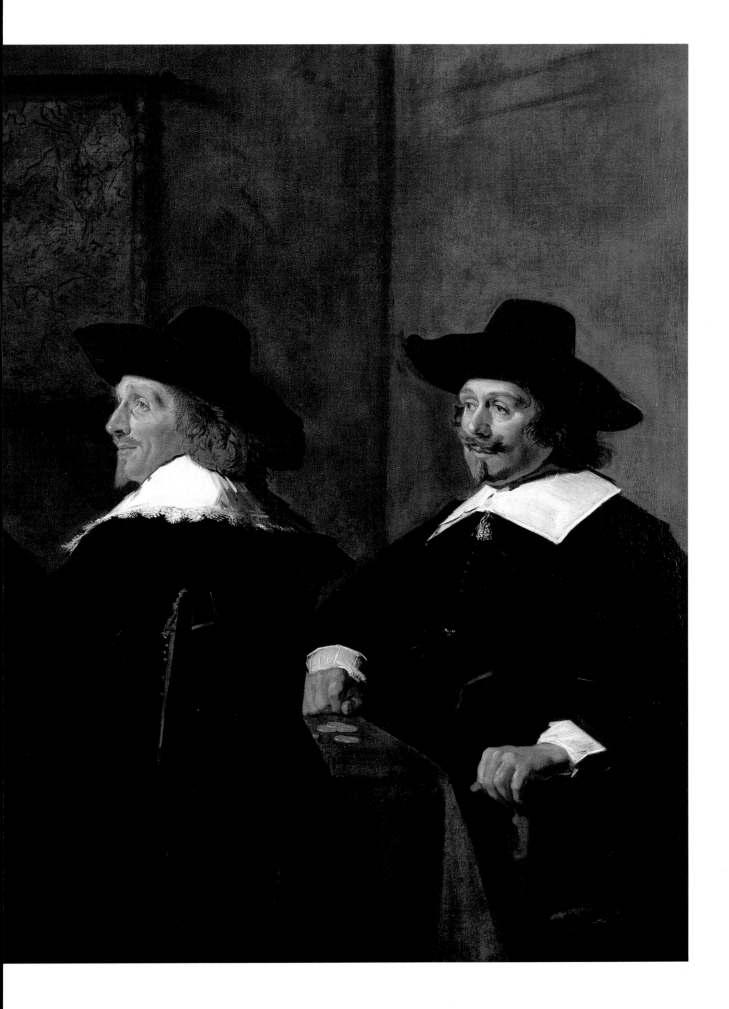

Fig. 54a Detail of François Wouters from *Officers and Sergeants of the St. George Civic Guard c.* 1639 (S124) Haarlem, Frans Halsmuseum

ly rare in Hals's work. In none of his paintings is one given such a prominent place as the regent in the foreground of his 1641 group portrait.

Commissioned profile portraits are exceptional also in the work of other seventeenth-century Netherlandish artists. Those painted by Rembrandt can be counted on the fingers of one hand, and even Rubens, who had intimate knowledge of classical gems and coins as well as of the static Renaissance portraits they inspired, seldom selected a side view. The profiles in de Keyser's group are as unusual as van Davelaer's dramatic action that he introduced into his small collective portrait, which anticipates the kind of confrontations but not the subdued tensions found in Gerard ter Borch's exquisite genre pieces. In his portraits, ter Borch avoided profiles too; to be sure, they appear in his famous painting of *The Swearing of the Oath of Ratification of the Peace of Münster* (National Gallery, London, inv. 896), but he could scarcely have done without them in a group portrait that represents more than fifty of the dignitaries present at that ceremony.

The Dutch bias against the profile view was shared by other Baroque artists. They and their patrons must have felt there was something archaic about stressing the topographic contours of half a face. The profile view could hardly appeal to artists devoted to making the full roundness of a head palpable. Moreover, it sharply limits the range of a sitter's glance, a serious restriction to portraitists who want their subjects to appear to make direct contact with the beholder.

1. Welu 1977, p. 33, note 72. The specific source for the map and any special significance it may have had remains undetermined. There is a chance that the map may appear. We-lu has identified the one seen in Johannes Cornelisz Verspronck's group portrait of the *Regentesses of the House of the Holy Ghost at Haarlem*, signed and dated 1642 (Frans Hals-museum; Catalogue 1929, no. 288) as a map of the Seventeen Provinces that is known in a unique, sumptuous 1671 edition published by Huyck Al-lart (active c. 1650-75) and which is found again, with some variations, in paintings by Pieter de Hooch and Vermeer datable about 1658 and 1662 respectively. On the basis of these works, Welu assumed (1975, pp. 534-5; 1977, p. 46) there must have been earlier editions of Allart's map. He was right. He has kindly informed me that an earlier edition of the map by Hendricus Hondius, published at The Hague in 1630, has recently been found. Hopefully, the map in Hals's group portrait will turn up as well. *N.B.* Welu (1975, p. 535, note 35; 1977, p. 46) and Hedinger (1986, p. 148, note 205, fig. 35a) wrongly refer to Verspronck's group portrait cited above as his *Regentesses of the*

St. Elizabeth Hospital; no map hangs on the wall depicted in this work (see text below and fig. 54a).

2. Valentiner (KdK 1921, 179) pub-lished a bust portrait of François Wouters which he called a preparato-ry study for the regent piece (panel, 46.2 × 36.2 cm; dealer E. Bottenwei-ser, London; dealer Goudstikker, Amsterdam, Catalogue no. 28, Nov-ember 1924, no. 51; sale, Goudstikker, Amsterdam [Mak van Waay], 4-10 October 1949, no. 29). Valentiner rightly eliminated the work from his 1923 catalogue; it is a feeble imi-tation.

3. Johan van Clarenbeek also can be identified as the third regent from the left; he appears as an officer in Pieter Soutman's group portrait of the *St. Hadrian Civic Guard*, 1642, at the Frans Halsmuseum (Biesboer, fig. 17).

4. For support of the supposition that de Keyser's little group portrait was commissioned privately by Cor-nelis van Davelaer expressly for a print which depicted a glorious mo-ment in his life, consult Adams 1985, pp. 379-80.

as many. Six are reproduced in the present catalogue.

If Thomas de Keyser sent his little panel to Haarlem to be engraved, it is not difficult to imagine Suyderhoef and Hals discussing the merits of the Amsterdam painter's composition in the printmaker's studio. It is hardly far-fetched to suggest that the oil sketch was transported to Haarlem for Suyderhoef's convenience. The architectural painter Dirck van Delen shipped his panels over a much greater distance when he sent them from Zeeland, the southernmost province of the Netherlands, to Haarlem where Dirck Hals painted small figures into his fanciful interiors (see Philadelphia, Ber-lin & London 1984, no. 45 and Potterton 1986, no. 119).

In his little painting of 1638 de Keyser followed the Amster-dam predilection for full-length group portraits. Van Dave-laer, who has just entered the room with news of Marie de Medici's arrival, was the commander of the guard of honour that escorted the Queen Mother into the city.[4] Two of the burgomasters seated at the table appear to concentrate on his message; the other two seem to be struck dumb by the news or are too phlegmatic to respond. When Hals painted his regent piece three years later, he made no attempt to show his figures reacting to a single, specific event, and unlike de Keyser he chose – or was commissioned – to make a three-quarter-length group portrait, not a full-length one. But he did seem to be impressed by the way de Keyser grouped four seated figures around a table. As we would expect, Hals made variations on the Amsterdam artist's invention, but the corre-spondences in the general arrangement of the seated men, particularly the position of the man seen in profile from the back, can hardly be accidental. Profile portraits are exceeding-

PROVENANCE Painted for the St. Elizabeth Hospital, which still owns the picture; on loan to the Frans Halsmuseum since 1862.

EXHIBITIONS Haarlem 1937, no. 84; Maastricht, Heerlen & 's-Herto-genbosch 1945; Haarlem 1962, no. 47; Osaka 1988, no. 11.

LITERATURE Unger-Vosmaer 1873, no. VIII; Bode 1883, 6; Moes 7; HdG 436; Bode-Binder 196; KdK 194; Catalogue Frans Halsmu-seum, Haarlem, 1929, p. 67, no. 128; L.C. Kersbergen, *Geschiedenis van het St. Elizabeths of Groote Gasthuis te Haarlem*, Haarlem 1931; Trivas 81; Slive 1970-4, vol. I, pp. 155-8 (1641); Grimm 108 (1640-1); Montagni 147 (1641); Baard 1981, pp. 128-30 (1641).

Fig. 54b Johannes Verspronck, *Regentesses of the St. Elizabeth Hospital*, 1641
Haarlem, Frans Halsmuseum

EFFIGIES NOBILISSIMORUM ET AMPLISSIMORUM DD. CONSULUM QUI REIP. AMSTELODAMENSI PRÆFUERE TUNC, CUM EORUM MANDATO ADVOCATUS CORNELIUS A DAVELAER, D. IN PETTEN, EQUITATUS PATRITII PRÆFECTUS, CHRISTIANISSIMAM REGINAM MARIAM DE MEDICIS, EANDEM URBEM INGRÆDIENTEM, DEDUXIT.

D. ANTONIUS OETGENS *van Wateren* D. ALBERTUS CONRADI BURGH, *nuper ad* D. PETRUS HASSELAER, D. ABRAHAMUS BOOM, *in*

Fig. 54c Jonas Suyderhoef, engraving after Thomas de Keyser's *Cornelis van Davelaer announcing the Arrival of Marie de Medici to the Four Burgomasters of Amsterdam*

289

55 Portrait of a Man holding a Book

*c.*1640-3
Canvas, 66 × 48.5 cm
Signed, lower right, with the connected monogram: FH
S143
From the collection of Saul P. Steinberg
Exhibited in Washington and London

To judge from Hals's existing commissioned works he painted many more life-size three-quarter and half-lengths than bust portraits. This exceptionally well-preserved bust makes us regret that he did not use the format more often, for it affords the special pleasure of taking a close look at parts of his portraits without losing sight of the whole. While studying the robust face of this unidentified model, the beholder hardly can fail to see the book he holds and admire Hals's bright decision to show not the book's ivory coloured parchment back but its red sides and front which complement his sitter's pronounced ruddy complexion. If the portrait were not monogrammed, the brushstrokes that define the daring highlight on one of his patron's large, shaggy eyebrows almost could serve as the artist's signature.

A clumsy copy at the Walters Art Gallery, Baltimore (inv. 37.345; canvas, 65 × 49.5 cm) was catalogued erroneously by Valentiner (1936, 81) as the original with the provenance and a reproduction of the present painting. In a letter dated 25 March 1938 (files of the gallery) Valentiner states that he had confused the copy with the original.

A miserable modern pastiche based on the original was exhibited as 'Dutch School, Seventeenth Century' at the exhibition of the Society *'La Peau de l'Ours'* in 1937 at Brussels (see B.J.A.Renckens, 'De fantasie der copiisten', *Kunsthistorische Mededeelingen van het Rijksbureau voor Kunsthistorische Documentatie* 1 [1946], pp.63-4). It was catalogued erroneously as a work by Frans Hals in the sale Wegg, Brussels (Giroux), 11 May 1925, no.19.

PROVENANCE J.Simon, Berlin by 1910; dealer F.Kleinberger, Paris; dealer Sulley and Co., London; dealer A.Preyer, The Hague; dealer Kleykamp, The Hague, Catalogue, 1926, no.16; Mrs. J.Goekoop-de Jongh, Breda; C.Goekoop, Aerdenhout; dealer S.Nystad, The Hague, 1970; acquired by the present owner in 1983.

EXHIBITIONS On loan to Haarlem, Frans Halsmuseum, 1919; Haarlem 1937, no.92; Rotterdam 1938, no.82; Rotterdam 1955, no.71; Amsterdam 1970, no.29 (dealer S.Nystad, The Hague).

LITERATURE HdG 290 (muddled provenance); KdK 224 (*c.*1645); Trivas 84 (*c.*1641-5); Grimm 102 (*c.*1639-40; with the unlikely suggestion that it is a pendant to Hals's *Portrait of a Woman* at the National Gallery, London [no.1021; S131]); Montagni 137 (*c.*1639).

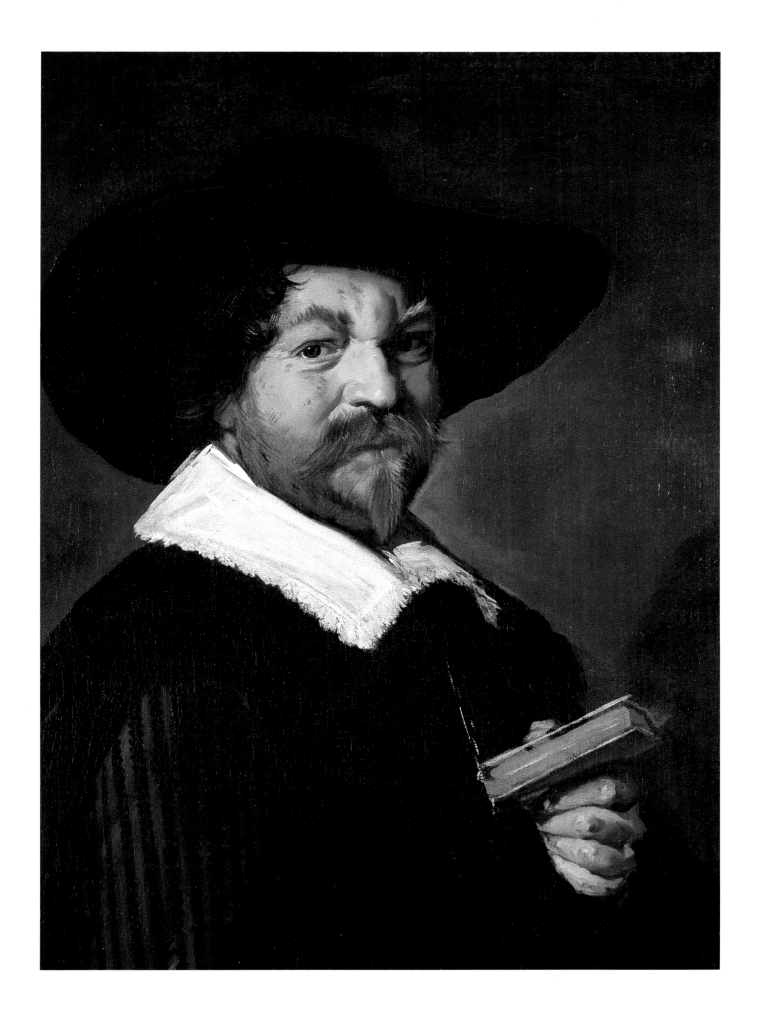

1643
Canvas, 118.7 × 94.6 cm
Inscribed to the right of the head: AETAT SVAE 37/AN° 1643, and
signed below the inscription with the connected monogram: FH
S144
The Metropolitan Museum of Art, New York (inv. 26.101.11)
Exhibited in Haarlem

Gudlaugsson (1954) identified the sitter for this three-quarter length as the wealthy Rotterdam merchant Paulus Verschuur (1606-67), who owned the city's largest textile mill. Verschuur also was often a member of Rotterdam's city council, serving as its burgomaster seven times, and in 1651 he was elected a director of the Rotterdam chamber of the Dutch East India Company, a position always held for life.

The latter appointment enabled Gudlauggson's sharp eye to identify this patron. He recognised that Pieter van der Werff (1655-1722) painted a free, oval copy of the bust of the portrait (fig. 56a; canvas, 82 × 68 cm; Rijksmuseum, Amsterdam; on loan to the Historisch Museum, Rotterdam). Van der Werff's copy, datable about 1700, belongs to a series that consisted originally of at least forty-seven portraits which he and other artists made of the directors of the Rotterdam chamber of the Dutch East India Company (1602-1742). The series was painted for the New East India House which was built as the headquarters of the Rotterdam chamber in 1698 (destroyed 1940). Like the thirty-seven other surviving portraits in the series, the copy is still in its original frame, which bears the sitter's name and the year (1651) he was elected a director (for

additional data regarding the series, see van Thiel *et al.* 1976, pp. 706-11).

It is noteworthy that the rich Rotterdam merchant and important civic leader turned to Frans Hals for his portrait, not to an artist from his own city, nearby Delft or The Hague. However, making contact with Hals in Haarlem could not have been difficult for Verschuur. He had family ties in the city, and most likely business contacts as well. His sister, who lived in Haarlem, was married to a textile merchant whose entire circle of acquaintances appears to have been made up of people associated with cloth merchants and bleachers (Biesboer, p. 37). The Rotterdam textile manufacturer could also have made contact with Hals through commercial connections with the Coymans family (Gudlaugsson 1954, p. 236). The latter's powerful firm included textile dyeing among its activities. For Hals's seven portraits of the Coymans and their extended family, see cat. 61, 68, 69.

The ground applied to the large canvas support of the portrait is chalk, not an uncommon one for panels but unusual for canvas since chalk on textile tends to flake and crack (Groen & Hendriks, p. 115; for another portrait with a chalk priming, see cat. 53). Hals's own teacher Karel van Mander tells of the experience of Pieter Pourbus I (c.1534-98) who found that paint flaked off on a large picture on canvas he had primed with chalk because it had to be rolled up several times (ibid.). If Verschuur ordered his portrait shipped from Haarlem to Rotterdam, it is nice to think that Hals cautioned his client not to roll it, but transport it flat on its stretcher.

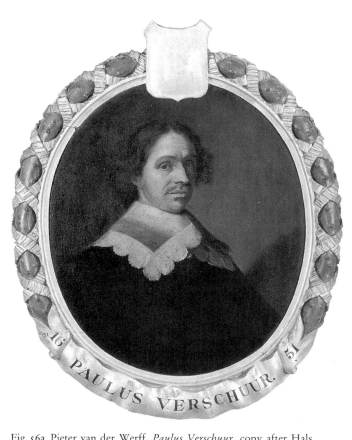

Fig. 56a Pieter van der Werff, *Paulus Verschuur*, copy after Hals
Amsterdam, Rijksmuseum (inv. A 4501)

PROVENANCE Sale A.J. Bösch, Vienna, 28 April 1885, no. 20 (Dfl. 14,000); dealer C. Sedelmeyer, Paris; Mrs. Collis P. Huntington, New York; gift of Archer M. Huntington, in memory of his father Collis Potter Huntington, to the museum, 1926.

EXHIBITIONS New York 1909, no. 35; Detroit 1935, no. 38; Los Angeles 1947, no. 15; Raleigh 1959, no. 63.

LITERATURE Moes 136; HdG 360; Bode-Binder 273; KdK 208; Valentiner 1936, 74; Trivas 85; S.J. Gudlaugsson, 'Een portret van Frans Hals geïdentificeerd', *O.H.* LXIX (1954), pp. 235-6; Slive 1970-4, vol. 1, pp. 153, 174; Grimm 120; Montagni 159; Baetjer 1980, vol. 1, p. 83, vol. 3, p. 400.

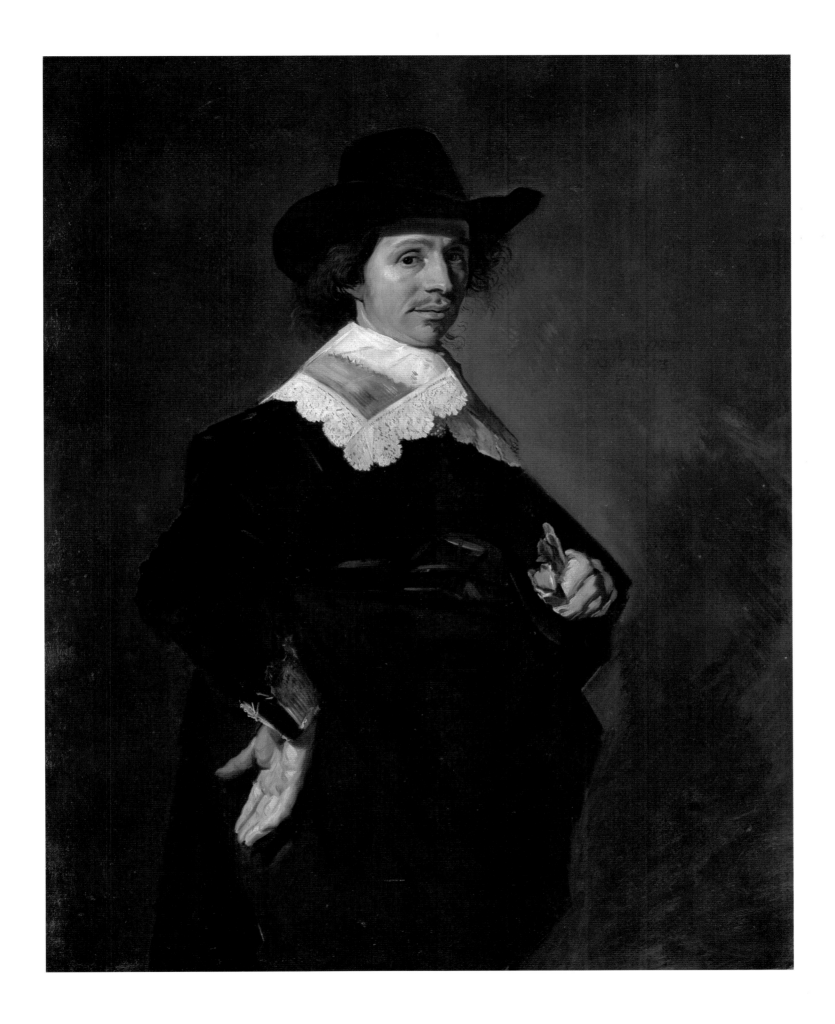

57 • 58 Portrait of a Standing Man Portrait of a Standing Woman

*c.*1643-5
Canvas, 115 × 86.1 cm
S156
National Galleries of Scotland, Edinburgh (inv. 691)

*c.*1643-5
Canvas, 115 × 85.8 cm
S157
National Galleries of Scotland, Edinburgh (inv. 692)

These masterful pendants of the 1640s are especially welcome loans. They have not been seen as a pair outside of Edinburgh since they were presented to the National Gallery of Scotland in 1885.

The man's portrait impresses by its pictorial restraint and monochromatic effect. Particularly fine is the way Hals focused attention upon the head by reducing the tonality of his patron's bare and gloved hand and cuffs. Variety of subdued accents could hardly be under better control. His familiar pose recalls the one used for the three-quarter-length of *Paulus Verschuur* painted in 1643 (cat. 56), but here the man stands more frontally and his face is seen in fuller light. His gently smiling, more outgoing wife tells another story. Her portrait includes a dazzling display of Hals's wizardry with white.

She is wearing an ensemble that was the height of fashion about 1645 (du Mortier, p. 51). As we have seen, by this time millstone ruffs were *passé*. Now fashionable women wore very large kerchiefs that were folded in different ways. This woman's white one, made of thin cambric or very fine linen, follows and emphasises her shoulder line. Under it is a neckerchief, made of the same white material (in 1644 Hals depicted *Dorothea Berck* [fig. 68b] wearing a similar kerchief and neckerchief).

Vincent van Gogh, who ranked Hals as 'a colourist amongst colourists' maintained that he 'had no less than twenty-seven blacks' (van Gogh Letters 1958, vol. 2, letter 428, p. 424).

Hals's handling of the different values and viscosities of white that he used for the transparent layers of fabric draped over the Edinburgh woman's shoulders, not to mention the other conspicuous white and silver accessories of her costume, make one certain that he also had no less than twenty-seven whites.

Other aspects of her apparel indicate that this lovely sitter knew and wore what was the *dernier cri* in the forties. She is wearing a 'tip cap' (*tipmuts*) which covers merely the very top of her forehead, and her hair is worn long, a style introduced about 1640 that closes the silhouette made by flat collars or kerchiefs and large, bulky sleeves. Only a few years earlier, fashionable women wore their hair up and covered it with diadem caps that followed their coiffure. And by the time her portrait was painted, some women must have felt only partially clothed if they appeared in public without pendant earrings and a fan.

One thing is missing in both portraits: the familiar chair that Hals and other Dutch portraitists so often placed alongside a client portrayed standing. This prop disappeared from Frans's pendants in the early forties and was never introduced again. Stripped of it, the beholder, like the artist, gives full attention to his patrons.

It would be as boring as it would be pointless to list the countless copies made after Hals's paintings. However, people familiar with the work of Frits Lugt (1884-1970), author of the indispensable, multi-volume *Marques de Collections* and *Répertoire des Catalogues de Ventes: 1600-1925*, will be interested to learn that in 1901 he made a faithful copy of the bust of the *Man* (fig. 57a), proof that as a teenager he was a skilful draughtsman.[1] In choosing the Edinburgh portrait as his model, he also showed signs, while still a youth, of the taste and judgement that helped make him one of the foremost connoisseurs and collectors of his day.

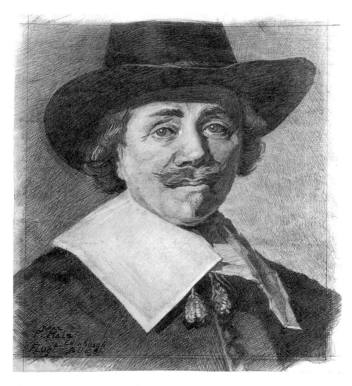

Fig. 57a Frits Lugt, pencil drawing after Hals's *Portrait of a Standing Man*, 1901
Paris, Institut Néerlandais, Fondation Custodia (Coll. F. Lugt)

1. Pencil, 39.4 × 34.5 cm. Inscribed lower left: 'naar/ F. Hals/ Edinburgh/ F Lugt/ Juli 1901'; lower right, diagonally: *Naar*. I am beholden to Carlos van Hasselt for providing a photo of the drawing and for the transcription of its inscription. He has informed me that precocious Lugt was certainly in Edinburgh in 1901 as an employee of the auction house Frederik Muller. Whether he made his drawing in the gallery or after a reproduction would be a difficult matter to establish, but to judge from its elaborate technique it probably was made from a first-rate heliograph.

PROVENANCE The pair was bought by the Rt. Hon. William McEwan from Major Jackson, St. Andrews in 1885; presented by the former to the gallery in 1885.

EXHIBITIONS Both lent to the gallery by Major Jackson, St. Andrews, 1884-5; the *Man* was exhibited London 1929, no. 114.

LITERATURE Moes 109, 110; HdG 274, 377 (*c.*1635-40); Bode-Binder 169, 170; KdK 206, 207 (*c.*1643); Grimm 138, 139 (*c.*1648); Montagni 169, 170 (*c.*1645); Catalogue National Gallery of Scotland, Edinburgh, 1976, p. 47, nos. 691, 692 (*c.*1643-5).

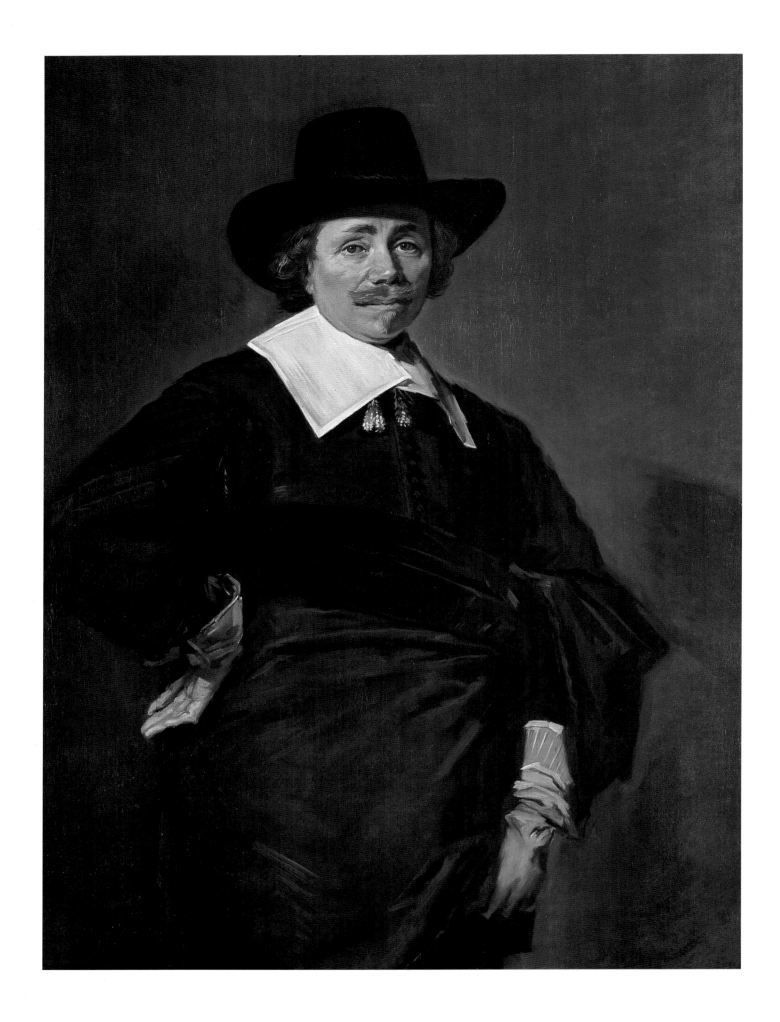

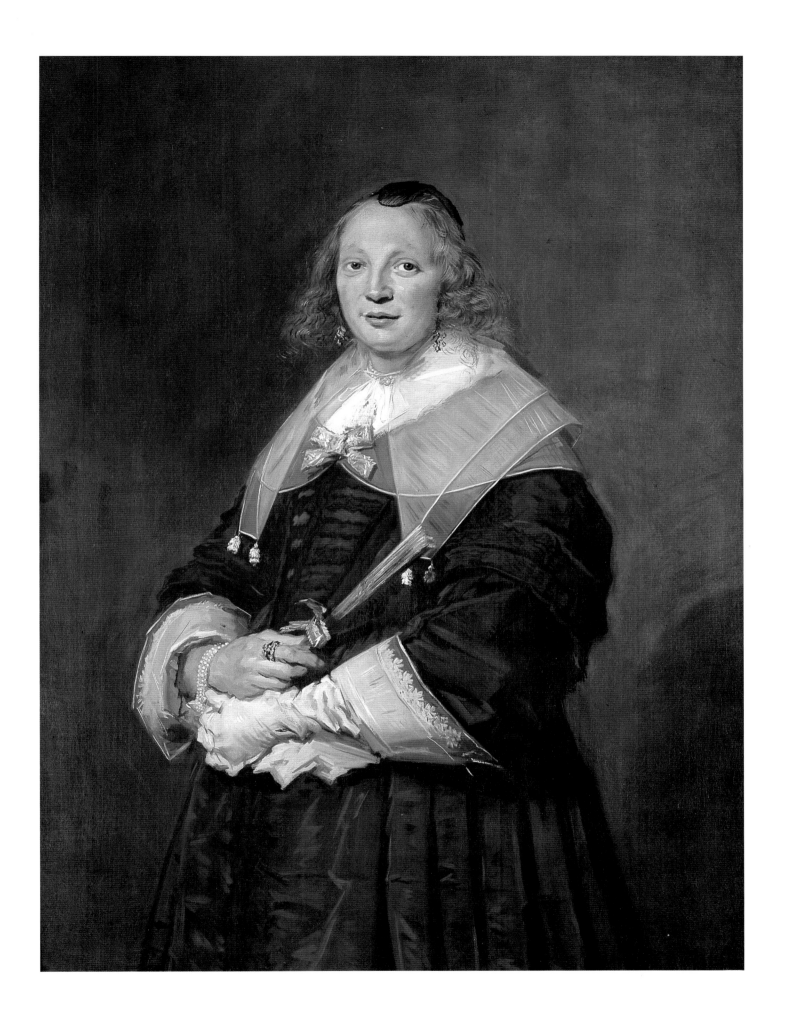

Seated Man holding a Branch

c.1645
Panel, 42.4 × 33 cm
Signed, lower right, with the connected monogram: FH
S155
National Gallery of Canada, Ottawa (inv. 15901)
Exhibited in Washington

Since no print after this small painting exists, it probably belongs to the group of Hals's little portraits designed for private enjoyment, not as *modelli* for engravers. Despite the use of a familiar relaxed pose, the little portrait strikes a new note; its very free touch and rather dark tonality anticipate the artist's later works. The branch the man holds may have a symbolic meaning, but until it has been identified its significance remains problematic. Botanists consulted have neither accepted Hofstede de Groot's opinion that it is holly (HdG 258), nor have they been able to establish its identity.

Likewise obscure is the sitter's identity. He has been erroneously called the Haarlem landscapist Frans Post more than once. Now, Hals did indeed paint a small portrait of Frans Post which has been securely identified on the basis of Jonas Suyderhoef's engraving of it (see cat.77). Though the two works employ similar compositional schemes, no more than a glance is needed to confirm that the sitters are not identical.

Grimm has proposed (1970; 1971) that the sitter is Adriaen van Ostade on the basis of his resemblance to Hals's portrait of the popular Haarlem genre painter now at the National Gallery, Washington (S192). The similarity, however, is not compelling enough to secure the identification. Grimm's additional claim (1970) that the Ottawa picture is not by Hals but a reduced variant after Washington's *Ostade* by an anonymous artist working in the master's studio, whom he subsequently (1971) identified as the artist's son Frans Hals II, is unacceptable. Frans II (1618-before November 1677; Hals doc.26) remains a shadowy figure. Not a single one of the disparate works that have been attributed to him is securely documented and none of them – or those done by any other of the master's followers – approximate the quality of the Ottawa portrait (for additional word regarding other works wrongly attributed to Hals's nebulous namesake, see Slive 1970-4, vol.3, no.155).

Jan Gerard Waldrop (c.1740-1808) made two careful black chalk drawings on parchment after the portrait (perhaps Waldrop owned it). One, in the Frans Halsmuseum, is inscribed with the connected monogram to the right of the head: '*FH pinx/ J.G. Waldorp del/ 1778*'. Hals's monogram does not appear in the lower right corner. It does, however, make an appearance in his second drawing, made twelve years later; this sheet is now at the Teyler Museum, Haarlem (inv. PP990; repr. in Jellema 1987, p.43). Perhaps a late eighteenth-century restoration revealed the monogram on the painting. Alternatively, the uncommonly large monogram may have been added by another hand. The Teyler copy is inscribed at the upper right: '*F. Hals pinx/ J.G. Waldorp del 1790*', and on the verso: '*de Digter Post*' ('the poet Post'). Why Waldorp called him 'the poet Post' is a mystery; a seventeenth-century Dutch poet named Post is unknown today.

Waldorp's drawing after a lost Hals *Portrait of a Woman*, inscribed with the connected monogram: '*FH pinx/ 1664/ J.G. Waldorp del/ 1779*' (Frans Halsmuseum; S.L20), has been catalogued as a copy after the lost companion piece to the Ottawa portrait (Bode-Binder 243; KdK 213). There is no reason to accept this conclusion; neither the size of her figure nor her position in the space allotted to her is compatible with the arrangement of her alleged companion.

In 1895, while the Ottawa portrait was still in the Bonomi-Cereda Collection, Milan, Bernard Berenson informed Isabella Stewart Gardner that it was available for purchase. She declined it (Samuels 1979, p.219). If she had acquired the picture, it would have been the only Hals at Fenway Court and one of the first by the artist to cross the Atlantic. Berenson, who died a decade before the painting was acquired by Ottawa, would have been pleased to learn that the outstanding little portrait that caught his attention at the beginning of his very long career finally found a permanent home on the North American continent.

PROVENANCE Probably the painting wrongly identified as a portrait of Frans Post in the sale Johan van der Marck, Amsterdam, 25 August 1773, no.441: 'Frans Post Westindisch landschapschilder ... Men zeit hem verbeeld met een hoed op 't hoofd en een lauwertek in de hand, zittende en rustende met zyn arm op de leuning van een stoel. Door Frans Hals fix en kragtig geschilderd, op paneel, h. 17 1/2 br. 12 3/4 duim.' (Dfl. 42, Fouquet); Bonomi-Cereda Coll., Milan by 17 January 1856 (see O. Mündler manuscript diary, The National Gallery, London); sale Bonomi-Cereda, Milan (Genolini), 14-6 December 1896; dealers P. & D. Colnaghi, London, 1896, no.21; Oscar Huldschinsky, Berlin; sale Huldschinsky, Berlin (Cassirer), 10 May 1928, no.11 (as a portrait of Frans Post); Gerald Oliven, Beverly Hills, California; sale Gerald Oliven, London (Sotheby's), 24 June 1959, no.66 (as a portrait of Frans Post; £48,000, Leonard Koester); Major A.E. Allnatt, London; acquired by the gallery from the estate of A.E. Allnatt through L. Koester in 1969.

EXHIBITIONS Berlin 1906, no.48; Berlin 1909, no.47; London 1962, no.19; Haarlem 1962, no.54.

LITERATURE *Icon. Bat.* no.6034 (as Frans Post); Moes 166; HdG 258; Bode-Binder 242; KdK 212 (c.1644); Slive 1970-4, vol.1, p.162; Grimm 1970, p.172 (workshop variant after Frans Hals's *Portrait of Adriaen van Ostade* in the National Gallery, Washington, D.C. [inv. 1937.1.70; S192]); Grimm 1971, p.162, no.15 (portrait of Adriaen van Ostade by Frans Hals II which is based on the Washington picture; not before 1645); Ekkart 1973, p.253 (hardly a portrait of Ostade); Montagni 234; Baard 1981, p.138 (by Frans Hals; not a portrait of Ostade); Catalogue National Gallery of Canada, Ottawa, *European Painting*, vol.1, 1987, pp.130-2, no.15901 (by Frans Hals; not a portrait of Ostade).

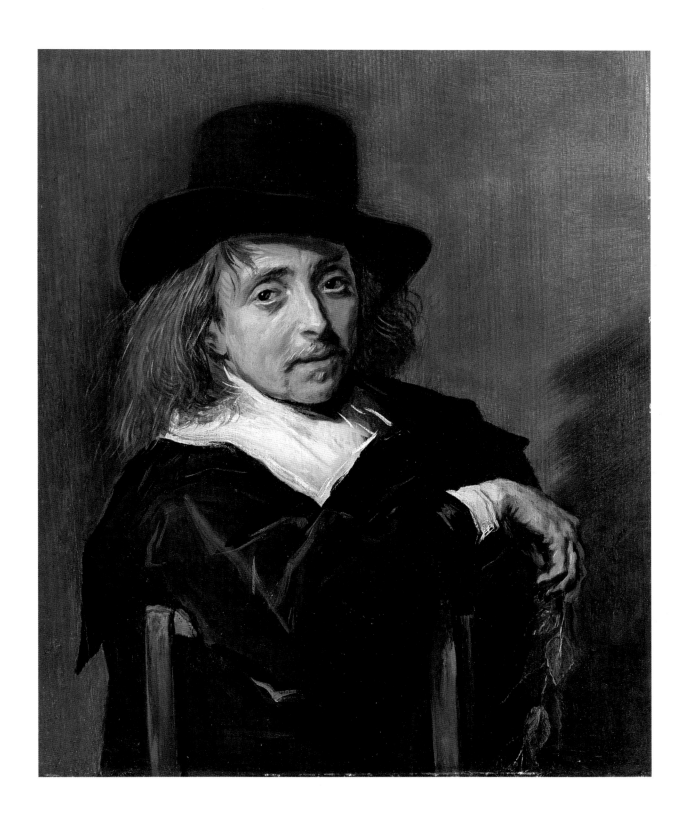

60 Johannes Hoornbeek

1645
Canvas, 79.5 × 68 cm
Inscribed at the lower right: AET.SVAE/27./1645
S165
Musées Royaux des Beaux-Arts de Belgique, Brussels (inv. 2245)
Exhibited in Haarlem

Johannes Hoornbeek (Haarlem 1617-1666 Utrecht) was a minister at Mülheim (near Cologne) from 1639 to 1643. In 1644 he was appointed professor of theology at Utrecht University, where he became a minister in the following year. Perhaps he selected Hals to portray him, with a partially open book in hand – his invisible thumb marks his place – and wearing his academic robes, to commemorate the event. He left Utrecht for Leiden University, where he gave his inaugural lecture in 1654. A modern biographer emphasises that Hoornbeek was not a run-of-the-mill cleric *cum* professor. He had command of thirteen languages, and his publications indicate that he took a lively part in the religious controversies of his day (de Bie & Loosjes 1931, vol. 4, pp. 277-86).

Jonas Suyderhoef (*c.*1613-86) made a beautiful, reduced engraved reproduction (in reverse) of the portrait (fig. 60a; Hollstein, vol. 28, p. 239, no. 88; 33.2 × 25.8 cm). Captions on early states of the engraving describe Hoornbeek as a professor at Utrecht; in later states the original caption is burnished out and replaced with one that states he is a Leiden professor. Suyderhoef's plate was cut down and considerably reworked by a later hand (fig. 60b). The reduced, reworked print was published by Pierre van der Aa in his *Fundatoris, Curatorum et Professorum ... Academia Lugduno-Batava ... Effigies* [?1720], which includes portraits printed from other reworked plates by Suyderhoef, C. van Dalens II, C. Visscher and others acquired by van der Aa. The illusionistic frame around the portrait was printed from a separate plate and was used again to embellish additional portraits in the volume. Hals's portrayal of Hoornbeek also was engraved (in reverse) by Jan Brouwer (*c.*1626-still active 1662; Hollstein, vol. 3, p. 250, no. 12).

The drawing of 'A Gentleman', wrongly catalogued as 'Frans Hals' in the sale Francis Wellesley, London (Sotheby's), 28 June-2 July 1920, no. 411, repr. (pencil, 14.3 × 16.5 cm), is a copy after one of the engravings of Hals's portrait of Hoornbeek. Another drawing after one of the prints, first wrongly attributed to Frans Hals himself and then without sufficient reason given to Salomon de Bray, is at the Kupferstichkabinett, Staatliche Museen, West Berlin.[1]

A reduced painted copy of the Brussels painting by an anonymous hand has been erroneously ascribed to Hals by earlier cataloguers (fig. 60c); Valentiner maintained it was the artist's preliminary study for the original.[2] Would that Valentiner's claim were correct. Not a single preliminary or preparatory sketch by Hals has been identified. Other painted copies of the portrait are known, and some unidentified ones have been cited in the literature.[3] The portrait also served as the basis for a miserable pastiche which presents the distinguished minister and professor of theology in a costume never worn in the seventeenth or any other century (fig. 60d; canvas, 74 × 58.5 cm).

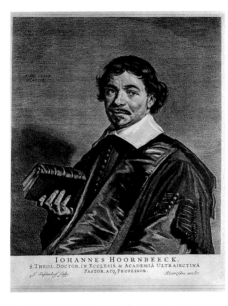

Fig. 60a Jonas Suyderhoef, engraving after Hals's *Johannes Hoornbeek*

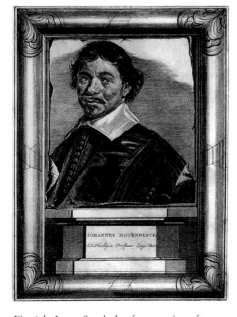

Fig. 60b Jonas Suyderhoef, engraving after Hals's *Johannes Hoornbeek*. Impression from the cut and reworked plate published by Pierre van der Aa in *Fundatoris, Curatorum et Professorum ... Academia Lugduno*, Leiden [?1720]

1. No. 597; metal point on paper prepared with a grey ground, 20.5 × 17 cm; ex-Coll. Suermondt, acquired by the Berlin museum in 1874. Alfred von Wurzbach's con-

clusion (*Repertorium für Kunstwissenschaft* 11 [1879], pp. 409-10) that it is a preliminary study by Frans Hals himself for the Brussels painting is certainly wrong. F. Lippmann (*Zeich-*

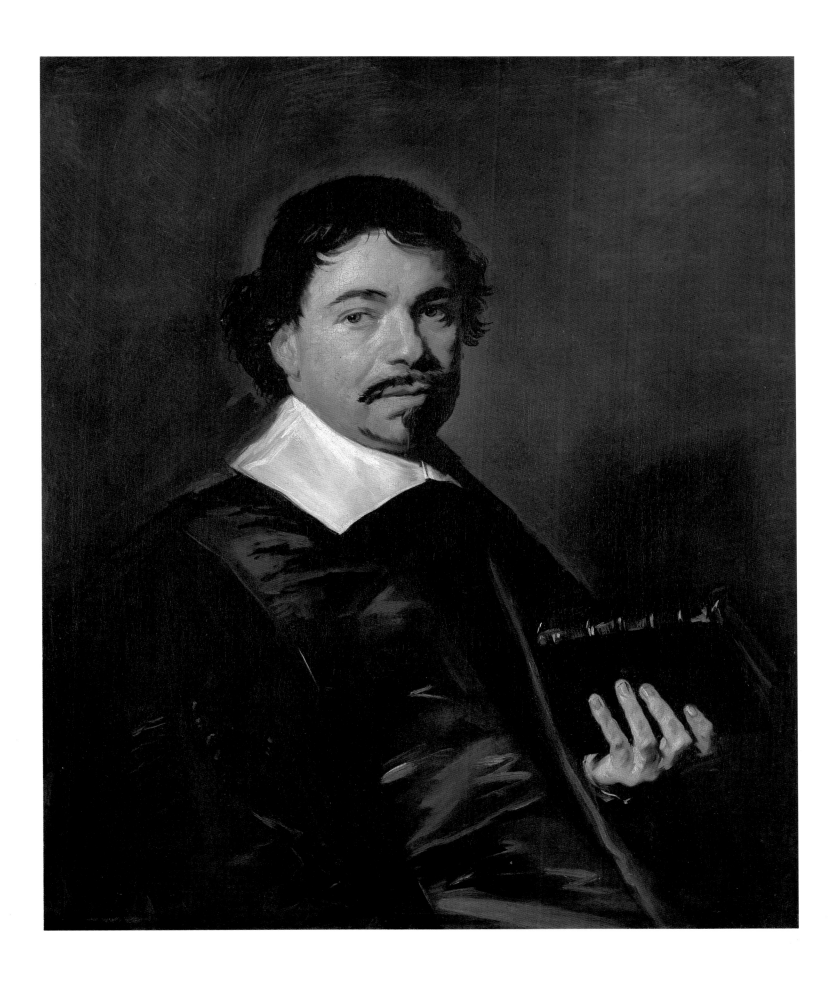

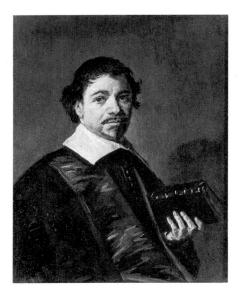
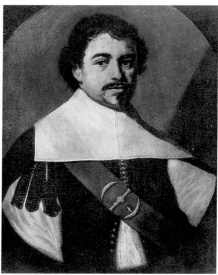

Fig. 60c Unknown artist, *Johannes Hoornbeek*, copy after Hals (s165-1) Detroit, Mrs. Emory L. Ford

Fig. 60d Unknown artist, *Johannes Hoornbeek*, pastiche after Hals Location unknown

nungen Alter Meister im Kupferstich-kabinett..., Berlin 1910, p. xiii, no. 303, repr.) notes that the drawing is in the same direction and has the same measurements as Suyderhoef's engraving, and probably is based on it. He adds that the signature and date on the drawing (S. de Bray 1650) probably are false, and the attribution to de Bray is very doubtful. Bock-Rosenberg (Catalogue Staatliche Museen, Berlin, 1930, p. 96, no. 597) question the attribution to S. de Bray. J.W. von Moltke ('Salomon de Bray', *Marburger Jahrbuch für Kunstwissenschaft* XI-XII [1938-9], p. 411, Z153) accepts the attribution to Salomon de Bray but adds that the signature is doubtful. He calls it a drawing after the Brussels painting and fails to note that it reverses it; the attribution of the weak drawing to de Bray is dubious.

2. Panel, 31 × 24.5 cm. PROVENANCE: Sale Miss James, London, 20 June 1891, no. 31 (£241.10); Mrs. Joseph, London; dealer Knoedler, New York; dealer Reinhardt, New York; Mrs. Emory L. Ford, Detroit. EXHIBITIONS: London, Royal Academy, 1871, no. 250 (Miss James); Detroit 1935, no. 42. LITERATURE: Moes 49; HdG 194 (replica, 75 × 60 cm); Bode-Binder 225, plate 143a (the reproduction is confused with the original in Brussels; 75 × 60 cm); KdK 222 (study for the Brussels painting;

75 × 60 cm); Valentiner 1936, 78 (study for the Brussels painting; 30.7 × 24 cm); s165-1.

3. Copies are at: Utrecht University (*Icon. Bat.* no. 3728-2; Leiden University (canvas, 76.5 × 60.5 cm; presented to the university by Hoornbeek's descendants in 1737; *Icon. Bat.* no. 3728-3; Ekkart 1973a, no. 93); Coll. Eugenio C. Bayo, Bilbao (42 × 35 cm; cited in Valdivieso 1973, p. 267). A poor modern copy of the bust was in the Steiner Gallery, New York (photo: FARL). I have been unable to check the support and dimensions of a portrait of Hoornbeek listed by Hofstede de Groot (under 193) that appeared in the sale anon., Amsterdam, 21 August 1799, no. 51 (Dfl. 51, Coclers). Since the Brussels painting probably appeared in Coclers's sale held in Amsterdam in 1811 (see Provenance below), the picture that was purchased by Coclers in 1799 may qualify as the earliest traceable reference to the original. If the reference to a panel support is an error for canvas in the description of a portrait of Hoornbeek that appeared in the supplementary sale anon., Amsterdam (J. de Vries), 6-7 May 1845, no. 270 (80 × 76 d.), it too may be identical with the Brussels painting since there is reason to believe that it probably passed through de Vries's Amsterdam salesrooms in 1842 and again in 1849 (see Provenance below).

PROVENANCE Hofstede de Groot (under 193) published references to a portrait of Hoornbeek on canvas that appeared in early seventeenth-century sales which he concluded referred to a copy since he erroneously cited the support of the Brussels painting as panel; a review of the descriptions cited in the following catalogues suggests the painting, in fact, may be identical with the Brussels portrait. The dimensions of all of them fit the present painting and all are described as having canvas supports: sale L.B. Coclers, Amsterdam (Schley), 7 August 1811, no. 26 (Dfl. 51, Josi); sale anon. [Jurriaans], Amsterdam (Schley), 28 August 1817, no. 19 (Dfl. 120, Brak); sale anon., Amsterdam (J. de Vries), 15 March 1842, no. 9 (Dfl. 29, de Vries); sale anon., Amsterdam (de Vries), 1 May 1849, no. 63. The portrait may be identical also with HdG 194a: sale Daniel Mansfield, Amsterdam, 13 May 1806, no. 70 (canvas, 77.5 × 66.5 cm; Dfl. 61). Sale D. Vis Blokhuyzen of Rotterdam, Paris, 1 April 1870, no. 22 (fr. 11,600, Gauchez); purchased by the museum from Léon Gauchez, Paris, 13 May 1870 (fr. 20,000).

EXHIBITIONS London 1929, no. 353 (panel); Haarlem 1937, no. 90; Brussels 1961, no. 49; Haarlem 1962, no. 55; Brussels 1962-3, no. 33; Brussels 1971, no. 48.

LITERATURE Bode 1883, 32; *Icon. Bat.* no. 3728-1; Moes 48 (incorrectly dated 1651); HdG 193 (panel), possibly identical with HdG 194a; Bode-Binder 224 (panel), plate 143b (the reproduction is confounded with the reduced copy now in the collection Emory Ford, Detroit [see fig. 60c]); KdK 223 (panel); Trivas 91; Catalogue Musées Royaux des Beaux-Arts, Brussels, 1949, p. 56, no. 202; Slive 1970-4, vol. I, p. 160; Grimm 131; Montagni 168; Catalogue Musées Royaux des Beaux-Arts, Brussels, 1977, no. 97; *Inventariscatalogus van de oude schilderkunst*, Koninklijke Musea voor Schone Kunsten van België, 1984, p. 182, inv. 2245; Baard 1981, p. 140.

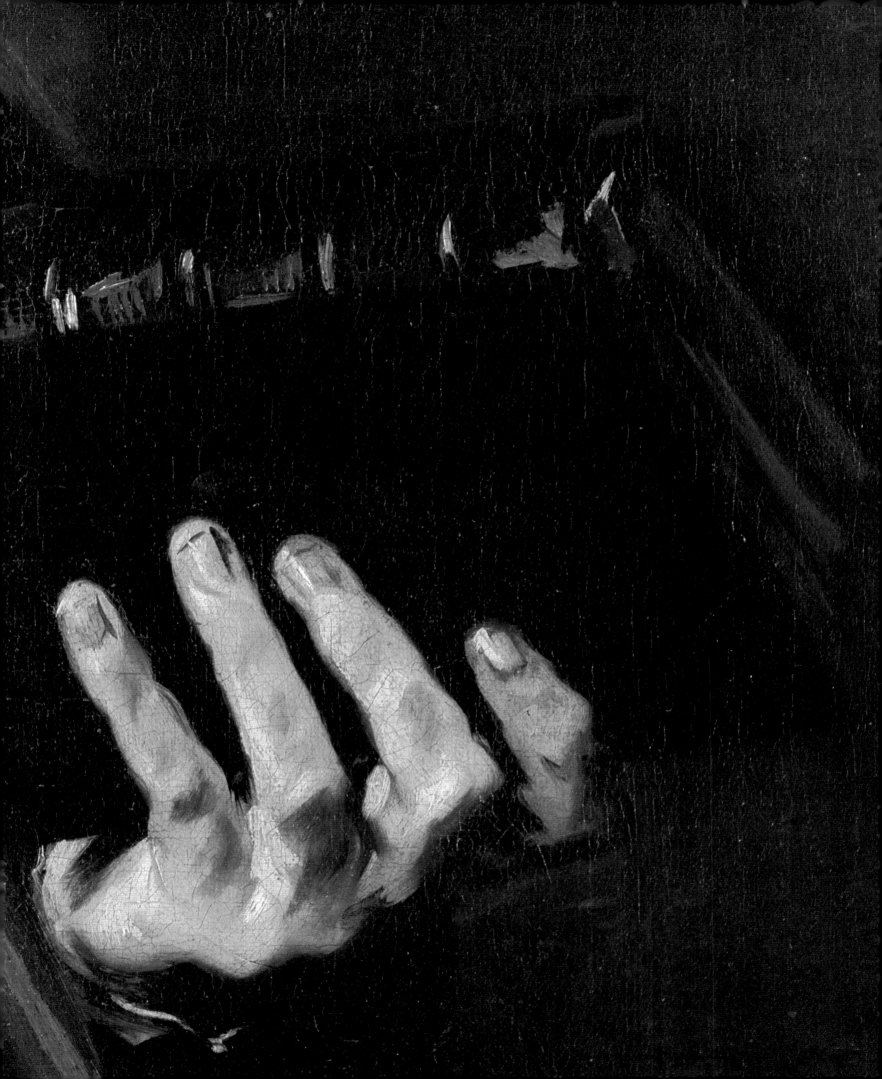

61 Willem Coenraetsz Coymans

1645
Canvas, 76.8 × 63.5 cm
Inscribed to the right of the model's head: AETA SVAE 26/1645; the last numeral of the sitter's age has been altered from 2 to 6. Above the inscription, the sitter's coat of arms: three black oxen's heads and necks on a gold field
S166
National Gallery of Art, Washington, D.C., Andrew W. Mellon Collection (inv. 1937.1.69)

The pleasure Hals took in painting this dandy's hat decorated with a pompom, the acres of white of his huge flat collar, and particularly the dancing light on the gold embroidery on his jacket with its slashed sleeves, that expose a fancy shirt with pleated sleeves seems to have been as great as the delight his young patron took in wearing his fashionable outfit and displaying his shoulder-length hair. During Hals's time long hair was never completely outmoded for men. Sitters wearing long locks can be spotted in his portraits from the time two ensigns appear wearing them in his *Banquet of the St. George Civic Guard* of 1616 (Levy-van Halm & Abraham, fig. 12). However, when flat collars began to replace ruffs in the 1630s long hair became more common for men as well as women. The vogue amongst men generated a heated controversy in church councils that became known as the 'Dispute of the Locks'. Discussion became so overheated that in 1645, the year Hals portrayed the sitter for Washington's portrait, the parties involved in the argument agreed to end 'all disputes about hair' (du Mortier, p. 56).

The coat of arms hanging from a nail on the wall identifies this handsome model, seated in a pose Hals favoured, as a member of the Coymans family whose arms were *armes parlante*, like those adopted by the Olycan and Hanemans families discussed in cat. 18, 19. Here the black oxen's heads and necks are a play on the family name Coymans = Koeymans; *koey* or *koei*, now written *koe*, is Dutch for cow.

Various attempts have been made to pinpoint the sitter's identity (see Literature below). The name that gained widest currency is Balthasar Coymans (1618-90), squire of Streefkerck and Nieuw-Lekkerland and holder of many high offices. Knowledge that Hals made portraits in 1644 of Josephus Coymans and his wife Dorothea Berck, the parents of Balthasar and his sister Isabella, the subject of a masterpiece Frans painted in the early fifties, lent support to the identification (for Hals's portrait of Isabella and her husband, and further word on those of her parents and relatives, see cat. 68, 69). The age of 26 inscribed on the painting, which is dated 1645, appeared to clinch it; Balthasar was born 15 March 1618 (Elias 1905, p. 763).

However, this identification is based solely on tampered evidence: it is obvious that the age inscribed on the painting has been altered from *22* to *26*, a change evidently made between 1898 and 1900 (Slive 1958). The age of 22 in 1645 rules out Balthasar as the model; it also excludes Josephus Coymans's other two sons. Subsequent research by Katrina V.H. Taylor (1970) established that the sitter is Willem (Guilliam) Coymans who belonged to another branch of the family.

Willem was baptised in Amsterdam on 20 August 1623 and buried at St. Bavo's Church in Haarlem 28 April 1678. He was the son of Coenraet Coymans (a distant cousin of Josephus Coymans) and Maria Schuyl, who were married in Amsterdam in 1614. Coenraet's name is cited in notarial deeds in Amsterdam until 1640. The appearance of his name on documents in the Haarlem City Archives dated in the forties indicates that he moved to Haarlem about this time; he was

buried at St. Bavo's in Haarlem on 29 November 1659. In April 1660 an inventory was made of Coenraet's effects; Hals and his sometime collaborator Pieter Molijn (1595-1661) were called upon to appraise twenty-nine pictures in his estate (Hals doc. 160), establishing that the two artists had contact until their last years. The inventory also indicates that Hals had contact with Willem Coymans fifteen years after he painted his portrait. His name and that of his brother-in-law Johan Fabry appear at the beginning of the inventory, as they do on several other notarised business records in Haarlem and Amsterdam.

PROVENANCE Mrs. Frederick Wollaston, London; dealer C. Sedelmeyer, Paris, Catalogues 1896, no. 2, and 1898, no. 54; Rudolphe Kann, Paris; purchased by Duveen, Paris, with the entire Kann collection in 1907; Mrs. Collis P. Huntington (died 1924); bequeathed to Archer E. Huntington; sold by Duveen in 1929 to Andrew W. Mellon, who gave it to the gallery in 1937.

EXHIBITIONS New York 1909, no. 37 (Balthasar Coymans; the identification is uncertain); San Francisco 1939, no. 80a (Balthasar Coymans).

LITERATURE *The Illustrated Catalogue of 300 Paintings ... of the Sedelmeyer Gallery*, Paris 1896, p. 66, no. 2 (Koeymans Loon van Alblasserdam); *Icon. Bat.* no. 1779 (Balthasar Coymans); W. Bode, *Gemälde-Sammlung des Herrn Rudolph Kann*, Vienna 1900, plate 49 (Koeymanszoon van Alblasserdam); W. Bode, *Catalogue de la collection Rodolphe Kann*, vol. 1, Paris 1907, no. 40 (Koeijmanszoon van Alblasserdam); C.J. Holmes, 'Recent Acquisitions by Mrs. C.P. Huntington from the Kann Collection: 1. Pictures of the Dutch and Flemish Schools', *B.M.* XII (1908), pp. 201-2 (Koeijmanszoon of Alblasserdam); John C. van Lennep, 'Portraits in the Kann Collection', *B.M.* XIII (1908), pp. 293-4 (most likely Johan Koeymans); Moes 27, HdG 168, Bode-Binder 245, KdK 225, and Valentiner 1936, 82, all identify the model as Balthasar Coymans; Seymour Slive, 'Frans Hals' Portrait of Joseph Coymans', *Wadsworth Atheneum Bulletin*, Winter 1958, pp. 20-1, note 7 and Slive 1970-4, vol. 1, p. 160 (inscription partially altered by a later hand; a member of the Coymans family but not Balthasar); Katrina V.H. Taylor, 'A Note on the Identity of a Member of the Coymans Family by Frans Hals', *National Gallery of Art, Report and Studies in the History of Art 1969*, Washington 1970, pp. 106-8 (Willem Coymans); Grimm 148 (Willem Coymans); Summary Catalogue National Gallery of Art, Washington, 1975, p. 170, no. 69 (Balthasar Coymans); Montagni 167 (Willem Coymans?); Catalogue National Gallery of Art, Washington, *European Paintings*, 1985, p. 196, no. 1937.1.69 (Willem Coymans).

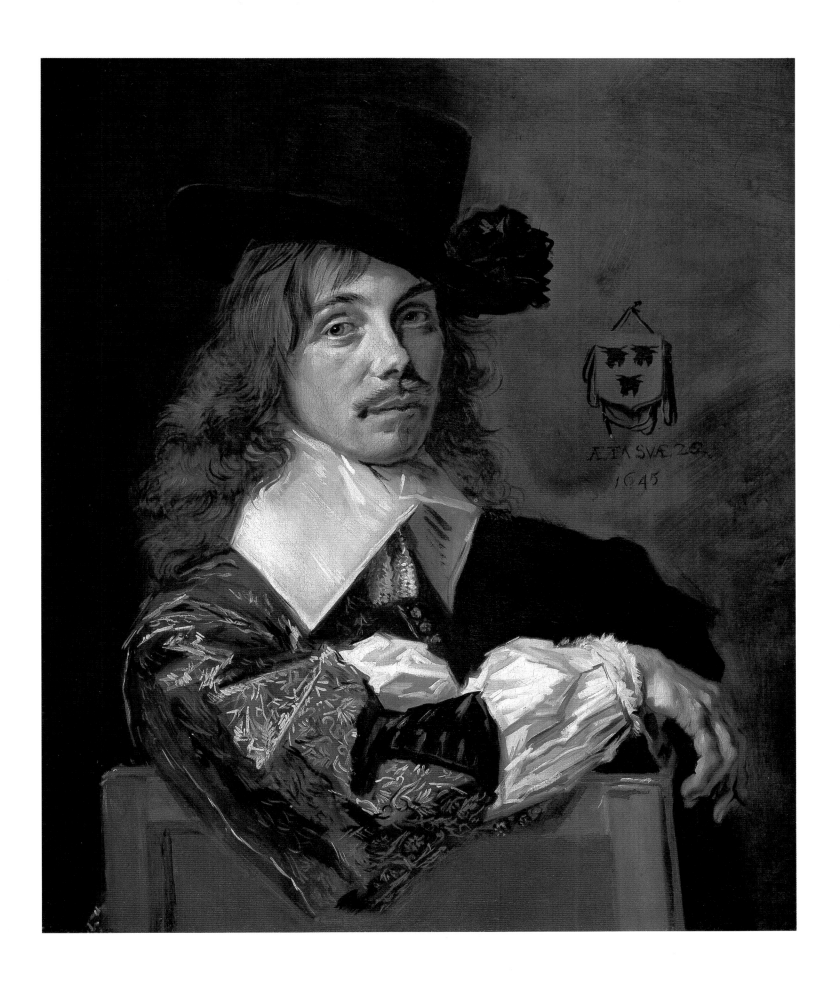

62 Jaspar Schade

c. 1645
Canvas, 80 × 67.5 cm
s168
National Gallery, Prague (inv. 0638)

Since this masterwork made its first public appearance at Brussels in 1873 as one of five Hals paintings in John W. Wilson's collection (for a list of the others, four of which are in the exhibition, see cat. 20), the sitter has been called a member of the Schade van Westrum family, a patrician family of Utrecht. From the beginning it was suggested he is Jaspar (or Jasper; 12 August 1623 - 25 October 1692) but the identification was not firmly established until much later (van de Ven 1932). Subsequently, Damsté, who did extensive research on the painting's early history, learned that Jaspar himself, his father, his sons and official documents use only the name Schade, never Schade van Westrum. In fact, it is not certain if Jaspar had the right to call himself Schade van Westrum (Damsté 1985, p. 41, note 1). Hence, his less pretentious name is adopted here.

Jaspar Schade, however, was not titleless. He was squire of Tull and 't Wael, and later served as deacon of the chapter of Oudmunster at Utrecht, representative of his province to the States-General, and president of the Court at Utrecht. Hals's portrait of him almost certainly hung in the country house he built in the vicinity of Utrecht, and it passed with the house to his descendants and then to its later owners. Even owners of the house who were insensitive to the portrait's extraordi-

nary qualities had reason to keep it; according to legend, the house would collapse if the painting were removed (see Provenance below).

Hals's characterisation of Jaspar, and his firm control over the pictorial organization of the portrait, convince us that as a young man his sitter was a vain, proud peacock, an impression confirmed by a contemporary report that he spent extravagant sums on his wardrobe. In a letter dated 7 August 1645 (almost certainly in the year the present portrait was painted), Louis van Kinschot admonished his son Kaspar, then in Paris, not to run up tremendous bills with his tailors the way his cousin Jaspar Schade had done.[1]

A subtle emphasis on verticality in the portrait contributes to Jaspar's haughty air – not that an emphasis on vertical forms must needs express arrogance, but here it certainly does. His hat's upturned brim and the straight arrangement of his long hair accentuate the length of the face of a man looking down at people below his station. And, while thin, frail bodies may contain most noble spirits, this one hardly inspires confidence in its inner strength. As dazzling as Hals's appraisal of his sitter are the zigzag and angular strokes that suggest the nervous dance of bright light on his grey taffeta jacket while creating an electrifying movement on the picture surface.

Jaspar was portrayed again in 1654 by Cornelis Jonson van Ceulen (London 1593 - 1661 Utrecht) in a three-quarter length now at the Rijksmuseum Twenthe, Enschede (fig. 62a). In it Jaspar's dress is still elegant, and he has struck a similar pose but he now has an unmistakable Van Dyckian air, a quality Cornelis learned how to give his sitters in London and which he helped popularise in Holland after settling there in 1643. His portrait's smooth finish and careful simulation of the texture of various stuffs – not to mention the nonchalance of Jaspar's limp hand – expresses an ideal of portraiture radically different from Hals's highly personal style and, as Frans's later portraits show, it was one that he did not attempt to follow.

Cornelis Jonson's portrait is still in its original frame done in the pendulous style variously called lobate or auricular (in Dutch: *kwabwerk*, or 'dewlap work'); its pendant, a portrait of Jaspar's wife Cornelia Strick van Linschoten, also at Enschede, still has its as well (inv. 698b; for a discussion of both frames, see Amsterdam 1984, no. 34). Lobate frames became almost as fashionable in Holland after the middle of the century as portraits that emulate Van Dyck's manner.

The present elaborately carved frame on Hals's portrait of Jaspar, although not original, also is of interest. Van de Ven noted (1932) that it bears Schade's eight quarterings, but in a muddled order (he provides a discussion of all its arms and diagrams of their present and proper order). Van de Ven was informed by the Director at Prague that the frame was a nineteenth-century one, and confusion arose over when it was made. However, a description of the quarterings on the frame included in Wilson's 1873 exhibition catalogue and another published two years later (Matthes 1875, p. 239) indicate they were in the right order then. New light was thrown on the matter when Damsté (1985) discovered an unpublished framed copy of the Prague portrait in a private Dutch collection (fig. 62b), which he established was painted as a replacement for the original as a condition of its sale soon after

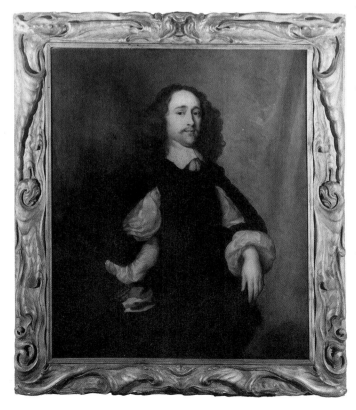

Fig. 62a Cornelis Jonson van Ceulen, *Jaspar Schade*, 1654
Enschede, Rijksmuseum Twenthe (inv. 698a)

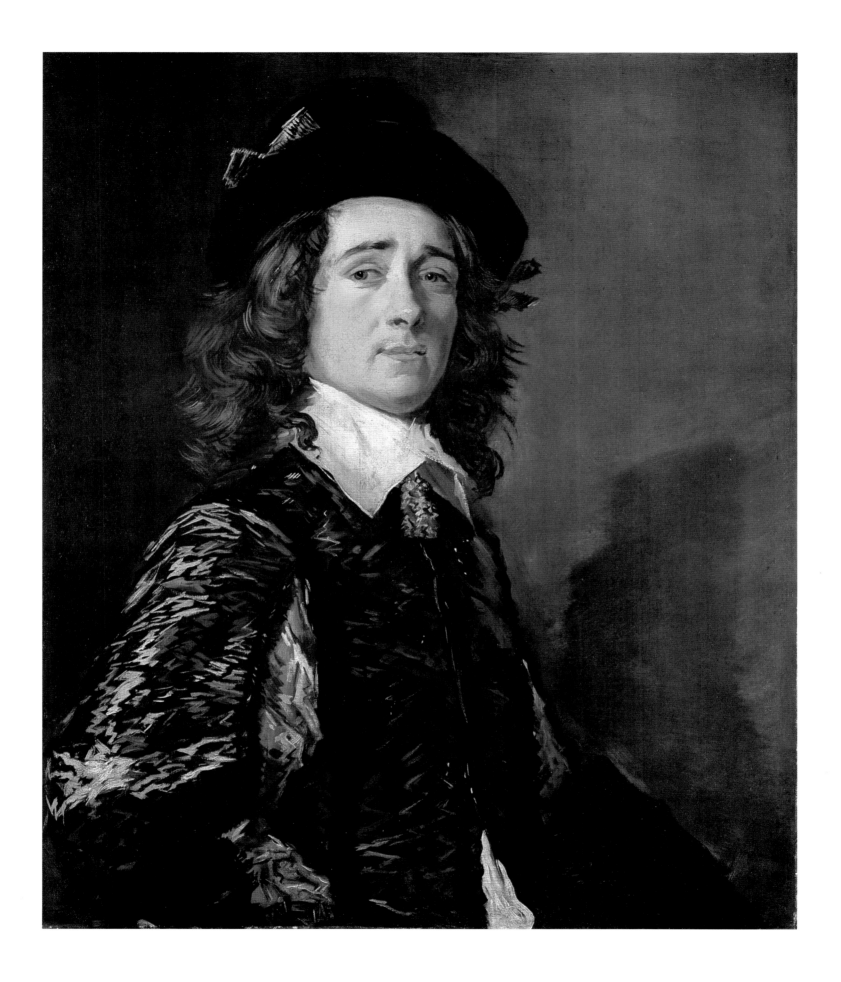

Fig. 62b Unknown artist [?P.E.H. Praetorius], *Jaspar Schade*,
copy after Hals
Private collection

1. 'Une chose vous prie-ie de vivre modestement sachant comment ie suis ennemi, de toute pompe extérieure. Je vous diraij franchement que vostre tante Schadé lisant celles de son puisné se mit en une altération bien grande aijant la proposition d'un habit de 300 francs et autres frais.',
C.P.L. Kinschot, *Genealogie van het Geslacht van Schooten...*, vol. 1, Tiel 1910, p. 324.

PROVENANCE Until recently the published history of the painting began in 1873, when the portrait was exhibited with John W. Wilson collection in Brussels. Now, thanks to Damsté's research (1985), it is almost certain that it was mounted in the country house (later known as *Zandbergen*) which Jaspar Schade built in the vicinity of Utrecht not long after the middle of the seventeenth century and that it passed with the house by descent to his eldest son Gaspar Cornelis (d. 1701) who bequeathed the property to his brother-in-law Jacob Noirot. Between the time Noirot sold the house in 1740 and its purchase by the Beuker family in 1865, it had nine owners. Although the painting is not mentioned in any deeds of sale, apparently it was always sold with the house – according to a legend the house would collapse if the picture were removed. Beuker descendants state that the member of their family who purchased the house in 1865 acquired the portrait with it. He sold the painting to P.E.H. Praetorius (1791-1876) on the condition that the latter had a copy painted as a replacement (see the commentary above for a note on this copy and its frame). Perhaps Praetorius sold the portrait to Wilson. In any event, it was in Wilson's possession by 1873. The portrait's brief, subsequent history is much easier to follow: Sale John W. Wilson of Brussels, Paris, 14 March 1883, no. 58 (fr. 43,100, Sedelmeyer); Johann II, Prince of Liechtenstein, Vienna, who gave it to the Picture Gallery of the Society of Patriotic Friends of Art in Bohemia at Prague in 1890; Rudolphinum, Prague.

EXHIBITIONS Brussels 1873, p. 83 (as a 'Portrait of a Member of the Schade van Westrum Family', with a note that the frame bears the date 1645 and the family's eight coats of arms; suggests the sitter is possibly Jaspar Schade; with an etching of the portrait by Charles Walmer [1846-1925]); Brussels 1935, no. 730; Haarlem 1937, no. 91; Haarlem 1962, no. 56.

LITERATURE Tardieu 1873, pp. 217ff.; E.P. Matthes *et al.*, 'Schilderij van Frans Hals', *Navorscher* XXV (1875), pp. 13-5, 239-40; XXVI (1876), pp. 511-2; XXVII (1877), p. 28; *Icon. Bat.* no. 6803; Bode 1883, 124 (1644); Moes 68; HdG 221; Bode-Binder 244; KdK 226; A.J. van de Ven, 'Een Nederlandsch schilderij te Praag', *Maandblad van het Genealogisch-Heraldisch Genootschap: 'De Nederlandsche Leeuw'*, L (1932), pp. 243-6, reprinted in *Historia* III (1937), pp. 201-3; Slive 1970-4, vol. I, pp. 161-2 (c. 1645); Grimm 132 (c. 1645); Montagni 166 (c. 1645); Baard 1981, p. 136 (c. 1645); Catalogue National Gallery, Prague, 1984, pp. 156-7 (with further references to Czech literature); P.H. Damsté, 'De geschiedenis van het portret van Jaspar Schade door Frans Hals', *O.H.* XCIX (1985), pp. 30-43.

1865 to P.E.H. Praetorius. The copy's frame has the arms in the correct order, except those on the upper right and left sides are transposed. Thus, the present Prague frame must have been made after 1875. The copy most probably was painted and framed about the time the original was sold to Praetorius. The fate of the original frame remains unknown. Its copies, even with their confused quarterings, testify – if testimony is needed – to the premium some of Hals's patrons placed on the genealogical function of portraiture.

The Prague frame and the copy both bear the date 1645. Most probably they were derived from the painting's original frame. The date is supported by Jaspar's modish costume and the style of the portrait, particularly the similarity of the crackling brushwork on his jacket to the treatment of the costume in Hals's portrait of young Willem Coymans that is securely dated 1645 (cat. 61).

Bode (1883, 124), who saw the portrait when it was in the Liechtenstein Gallery at Vienna, stated that it was dated 1644. Later cataloguers wrote that it was dated 1645. Today, the picture bears no trace of a date or of a signature. Neither does the copy (fig. 62b). Damsté reasonably suggests that Praetorius, who was sold the original soon after 1865 on the condition that he provide a copy of it, possibly painted the duplicate. Praetorius, best known as an active supporter of the arts in Haarlem and Amsterdam, was also an amateur artist. There is excellent reason to believe he made a copy of Hals's little portrait of Willem van Heythuysen in about 1865-6, a few years before it left Haarlem and acquired its new permanent home in Brussels's Musées Royaux des Beaux-Arts in 1870 (see cat. 51).

63 • 64 Portrait of a Seated Man holding a Hat

Portrait of a Seated Woman holding a Fan

*c.*1648-50
Canvas, 109.8 × 82.5 cm
S173
Bequest of Mr. and Mrs. Charles P.Taft; The Taft Museum, Cincinnati, Ohio (inv. 1931.451)

*c.*1648-50
Canvas, 109.5 × 82.5 cm
S174
Bequest of Mr. and Mrs. Charles P.Taft; The Taft Museum, Cincinnati, Ohio (inv. 1931.455)

Though these vivacious companion pieces of an unidentified young couple have abraded passages, and some old retouches done by a restorer with a less than profound grasp of Hals's mature technique are evident, the pendants still rank with Hals's most sympathetic portraits of a husband and wife. The woman's large kerchief draped over her shoulders and standing up around her neck, her broad sleeves and cuffs, her gold embroidery and silver bow, and her greenish-gold watered satin skirt were the height of fashion in Holland about 1645-50. More unusual is her informal pose. Only two other portraits by Hals present women seated sideways with their arms hooked over the back of a chair, and both were made during this phase of his activity: the small portrait of the woman who may be *Maria Vernatti* (cat.65) and the Metropolitan Museum's *Portrait of a Woman* which is the pendant to a *Painter holding a Brush* at the Frick Collection (s187, s186 respectively). This casual attitude once was reserved exclusively for the lively women who appear in the little genre pieces done a generation earlier by Buytewech, Dirck Hals and other specialists of paintings of spirited parties that look as if they are about to get out of hand. By mid-century, some of Hals's patrons obviously did not think the informal pose was a breach of decorum when employed for a life-size family portrait.

Brockwell (1920) saw a resemblance between the Taft *Woman* and the regentess in the right foreground of Hals's late group portrait of the *Regentesses* (cat. 86), whom he identified as Adriana Bredenhoff. There is no foundation for his identification of the latter, and the similarity he found between the two sitters is far-fetched.

A late, spuriously monogrammed and illegibly dated copy of the woman's portrait has passed through several American private collections (San Francisco, 1964; San Antonio, Texas,

1980; panel, *c.*28 × 23 cm). A handwritten label on the verso states that it belonged to 'E.J.Poynton', perhaps a reference to Sir Edward John Poynter (1836-1919), sometime Director of the National Gallery, London, and President of the Royal Academy of Arts (1896-1918).

PROVENANCE The provenance of the pair is identical: Lord Talbot of Malahide, Malahide Castle near Dublin; dealer Sulley and Co., London, 1908; dealer Scott and Fowles, New York, 1909; Taft Collection, 1909.

EXHIBITIONS Haarlem 1937, nos.95, 96; New York 1937, nos.22, 23; New York 1939, no.187 (*Man* only); San Francisco 1940, no.190 (*Man* only); Cincinnati 1941, no.30 (*Man* only); Los Angeles 1947, nos.16, 17; St. Louis 1947, no.20 (*Woman* only); New York, Toledo & Toronto 1954-5, nos.32, 33 (not exhibited in Toronto); Haarlem 1962, nos.59, 60.

LITERATURE W.Walton, 'Art in America', *B.M.* XVI (1910), p.368; Bode-Binder 253, 254; Maurice W.Brockwell, *A Catalogue of ... the Collection of Mr. and Mrs. Charles P.Taft*, New York 1920, nos.27, 28; KdK 238, 239 (*c.*1648-50); Valentiner 1936, 89, 90 (*c.*1645-8); M.M. van Dantzig, 'Twee portretten van Frans Hals of ... moderne vervalschingen?', *Maandblad voor Beeldende Kunsten* XVII (1940), pp.149-52 (both paintings are modern forgeries). Dantzig's unconvincing arguments were successfully demolished by A.J.Moes-Veth ('Nog eens: twee portretten van Frans Hals', *Maandblad voor Beeldende Kunsten* XVII [1940], pp.202-4) and J.J.H. der Kinderen-Besier ('Het kostuum der vrouw op het aan Frans Hals toegeschreven portret te Cincinnati', ibid., pp.205-6). Catalogue Taft Museum, Cincinnati, 1954, pp.161-2, nos.477, 479; Slive 1970-4, vol.I, pp.158-9 (authentic works by Hals); Grimm 1971, p.163, nos.23, 24 (both by Frans Hals II; *c.*1650); Montagni 270, 271.

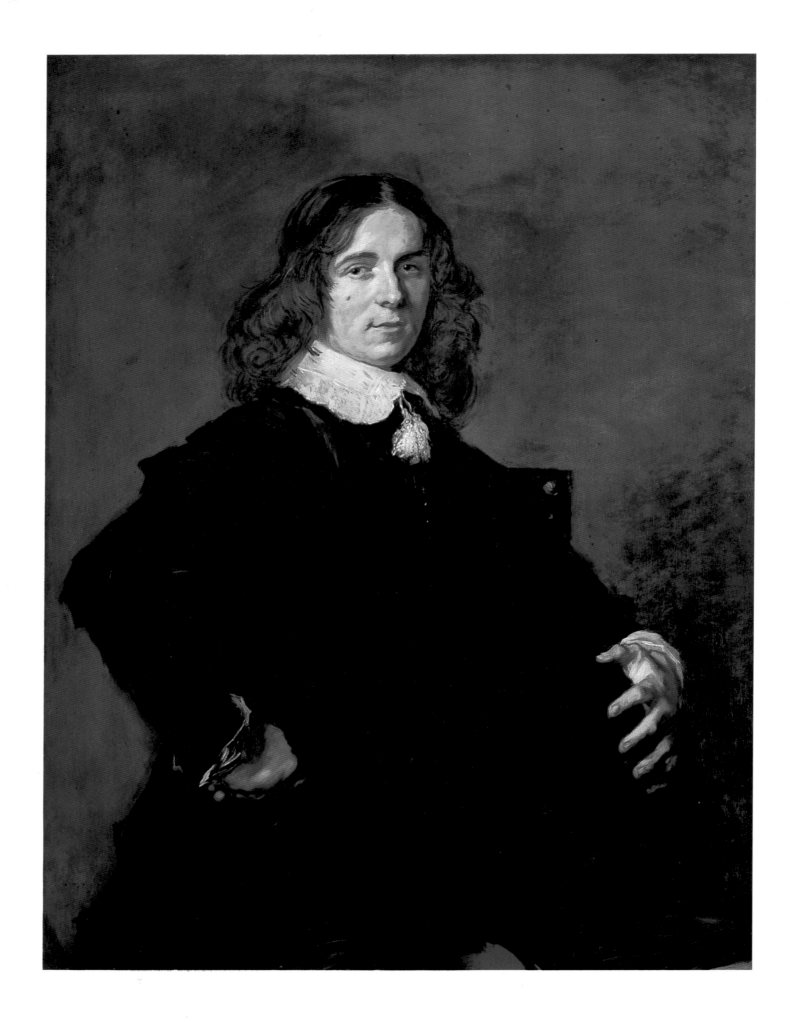

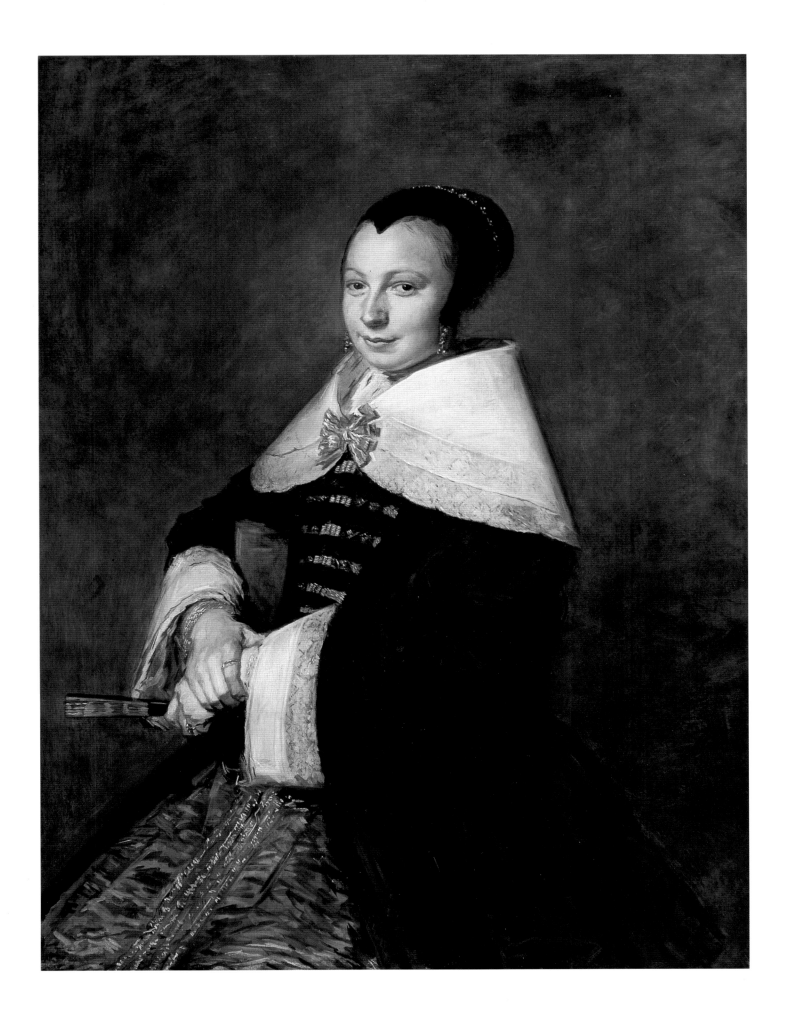

65 Portrait of a Seated Woman, presumably Maria Vernatti

c.1648-50
Panel, 35 × 29 cm
S172
Aurora Art Fund

The sitter for this little portrait has been given the unusual informal pose that Hals used for his lovely life-size *Portrait of a Woman* at the Taft Art Museum (cat. 64). Both are datable to the late 1640s.

When the painting first was published by Bode and Friedländer in 1912, they noted that the model probably is Maria Vernatti, who belonged to a Dutch family which settled in England in the seventeenth century, and added that the Earl of Gainsborough, who owned the picture, was said to be a descendant of the Vernatti family. A handwritten label on the back of the panel by an unidentified hand offers more information:

> F. Hals, Portrait of Mary Vernatti. This picture has never been sold until the other day, since Hals painted it. It has remained in the possession of English descendants of this Dutch family, until I bought it. It has never been exhibited. The Vernattis were a Dutch family who came to England in the 17th century. Sir Philibert Vernatti introduced the Dutch method of drainage and land reclamation into Lincolnshire.

Scraps of historical evidence support the traditional provenance and identification. Genoveva Maria Vernatti (born in Rotterdam c.1622-3, married Frederick Backer at Delft in 1648) was the daughter of Sir Philibert Vernatti (1590-c.1646), a Dutch hydraulic and sanitary engineer who settled in England in 1628 and was knighted by Charles I. Vernatti drained lands in Norfolk, Northamptonshire, Lincolnshire, Cambridgeshire and Yorkshire. In the middle of the fen district of Lincolnshire near Spaulding there is a drainage canal called the Vernatti Drain; it is named after him. He was naturalised in 1631 (Molhuysen, vol. 9, cols. 1200-3).

Genoveva Maria's brother, Louis Philibert Vernatti, worked for the Dutch East India Company in India, where he also served as a corresponding-member of the Royal Society of London. 'It must be admitted that he did not supply the *virtuosi* of London with any information of great interest before he was sent home in disgrace for indulging in the contraband trade which it was his official duty [as Advocate-Fiscal] to suppress.' (Boxer 1979, p. 38; also see Molhuysen, vol. 9, col. 1200).

PROVENANCE According to Bode & Friedländer (1912), from the collection of the Earl of Gainsborough, England; Carl von Hollitscher, Berlin; Mrs. Catalina von Pannwitz, Heemstede.

EXHIBITIONS Berlin 1914, no. 60; Haarlem 1937, no. 87; Rotterdam 1939-40, no. 29.

LITERATURE W. Bode & Max J. Friedländer, *Die Gemälde-Sammlung des Herrn Carl von Hollitscher in Berlin*, Berlin 1912, no. 41; Bode-Binder 236; KdK 215 (c.1644); Max J. Friedländer, *Die Kunstsammlung von Pannwitz*, vol. 1, Munich 1926, no. 31 (c.1645); Trivas 90 (c.1644-50); Slive 1970-4, vol. 1, p. 159 (1648-50); Grimm 1971, no. 16 (Frans Hals II); Montagni 261 (despite its high quality, not by Hals).

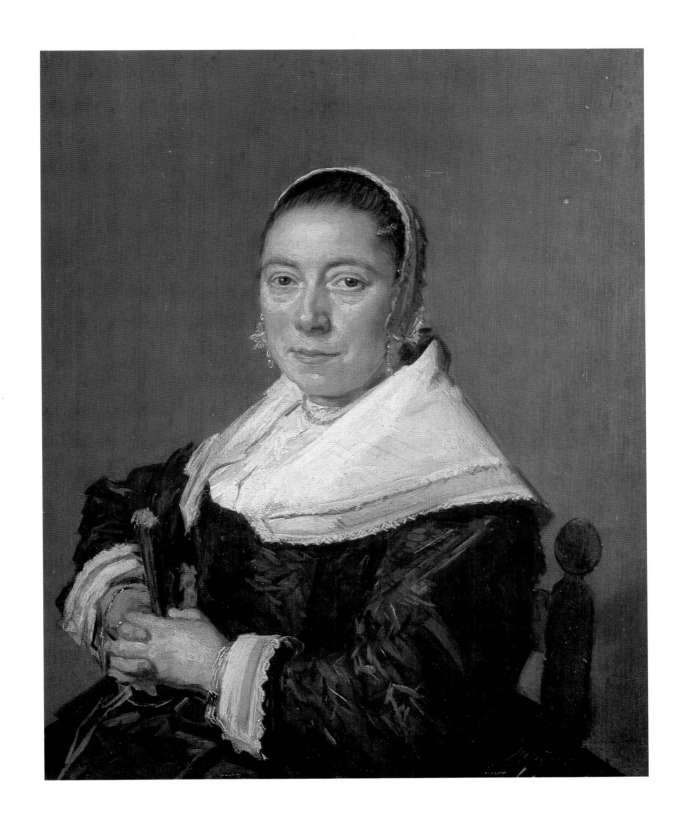

66 René Descartes

*c.*1649
Panel, 19 × 14 cm
S175
Statens Museum for Kunst (The Royal Museum of Fine Arts),
Copenhagen, on permanent loan from the Ny Carlsberg Glyptotek
(NCG inv.998)
Exhibited in Haarlem

Among the many Dutch artists who made portraits of René Descartes were Jan Lievens, Jan Baptist Weenix and, if an attribution in an eighteenth-century Dutch inventory is correct, Rembrandt.[1] However, the image of the French philosopher fixed most firmly in the public's mind is Frans Hals's. His portrait of his most famous sitter exists in numerous versions, the best of which by far, is the small oil sketch at Copenhagen. In my opinion it is the only existing original.

The little portrait is moderately abraded and badly scratched; repaint covers the losses. Its unusual elongated, upright format, the cramped space allotted the figure and cropped hand suggest the portrait was cut down at a later date; if the panel were originally its present size, it is hard to imagine that Hals, even in a quickly done sketch, would have painted merely the tips of the three fingers. Maybe these feeble fingers are the effort of the restorer who painted in the losses and strengthened some of the portrait's contours.

The possibility that an original life-size portrait of Descartes based on the small Copenhagen sketch may turn up cannot be excluded, but until it does the little portrait can be accepted as the *modello* Jonas Suyderhoef used for his fine (reversed) engraving of Hals's portrait, and we can assume it shows its state before the panel was cut (fig.66a; Hollstein, vol.28, p.233, no.74).

Suyderhoef's engraving is inscribed at the top: '*NATVS HAGAE TVRONVM PRIDIE CAL. APR. 1596. DENATVS HOLMIAE CAL. FEB. 1650*', and below: '*RENATUS DESCARTES, NOBILIS GALLUS, PERRONI DOMINUS, SUMMUS MATHEMATICUS & PHILOSOPHUS.*', followed by an anonymous Latin verse that tells us:

> Here is the likeness of the *Child of Nature*: the one son
> Who opened a way for the mind to the womb of that Mother.
> While assigning all miracles to their own proper causes,
> He alone remained the only miracle in the world.

The print is inscribed at the bottom: '*F. Hals pinxit J. Suyderhoeff sculpsit.*'

The *terminus ante quem* for the portrait is September 1649, when Descartes boarded a ship for Sweden and entered the service of Queen Christina after spending two decades in Holland. His decision to leave was much regretted by his Dutch friends. Among them was the philosopher Augustijn Bloemaert, a Catholic priest of Haarlem. Since one of Descartes's earliest biographers tells us that Bloemaert asked for a portrait of Descartes so that he could find '*quelque légère consolation dans la copie d'un original dont il risquoit la perte*', the Haarlem priest may have commissioned the portrait from Hals (Baillet 1691, vol.2, pp.386-7).

There also is a tantalising, tenuous link between Hals and the bookseller Jan Maire, who published Descartes's *Discours de la Méthode* in 1637. According to Hofstede de Groot, a Leiden inventory compiled of Maire's effects after his death in 1666 cites a *Smoker* and a *Merry Company* by Hals (HdG 80c and 145f). Hofstede de Groot fails to give his source in Leiden's notarial archives for these listings; it has not yet been possible to verify them (Hals doc.184).

Descartes's stay in Sweden was brief and tragic. After his arrival he must have thought of the reservations he himself had expressed about going 'to live in the land of bears among rocks and ice'. Queen Christina insisted upon an hour of instruction in philosophy every morning at five, an uncongenial time for most people and an unconscionable one for Descartes, who as a boy had acquired the life-long habit of spending his mornings in bed. Late in January 1650, the scholar caught a bad chill; he died on 11 February of the same year. Descartes was internationally mourned, a fact that helps explain the number of portraits made of the 'supreme mathematician and philosopher' soon after his death. Judging from the number that were produced during the following decades, the demand for them increased rather than diminished.

The most frequently reproduced versions of Hals's portrait are the life-size copies now at the Louvre (fig.66b; cat. 1979,

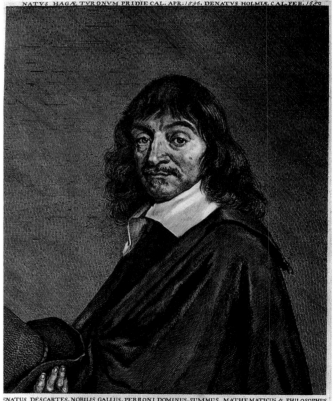

Fig.66a Jonas Suyderhoef,
engraving after Hals's *René Descartes*, 1650

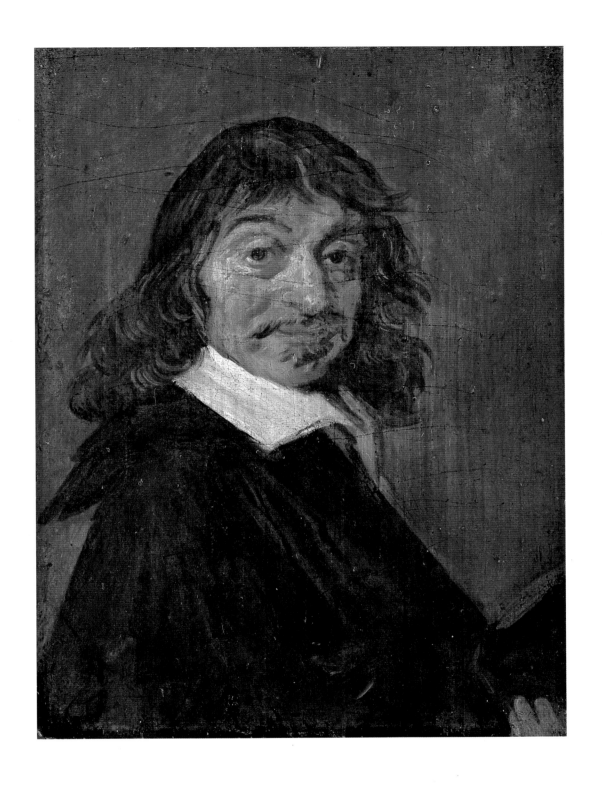

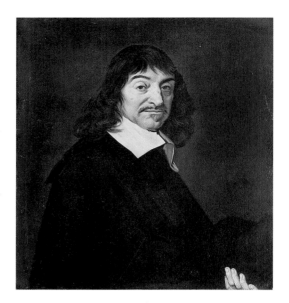

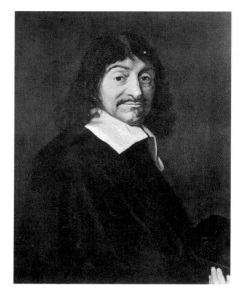

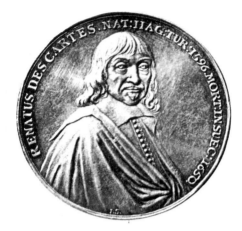

Fig.66b Unknown artist, *René Descartes*, copy after Hals (s175-1) Paris, Musée du Louvre

Fig.66c Unknown artist, *René Descartes*, copy after Hals (s175-2) Hälsingborg, Museum

Fig.66d Jan Smeltzing, medal after Hals's *René Descartes* The Hague, Koninklijk Penningkabinet (inv. 1951-276)

p.66, INV.1317 [after Hals]) and at the Hälsingborgs Museum (fig.66c). Both miss the vigourous touch and decisive modelling of the Copenhagen sketch. Though the artist who made the Louvre painting was timid, he seems to have had a better understanding of Hals's technique than the copyist who painted the Hälsingborg portrait. But the latter had a more sensitive grasp of Descartes's personality – or, to be more precise, of Descartes's personality as seen by Frans Hals. He captured more of the lively expression Hals gave the philosopher, and something of the intense, penetrating look which, Alain wrote (1936, p.253), seems to say *'encore un qui va se tromper'*.

For a discussion of six additional painted copies, see Slive 1970-4, vol.3, nos.175-3 to 175-8. Yet another is in the Amsterdams Historisch Museum (inv.A22659; Blankert & Ruurs 1975-9, pp.129-30, no.169 ['old copy']). None of the artists responsible for any of the existing copies have been identified. The difficulty of ascribing names to them is underlined by a reference to an unfinished one by the Haarlem genre painter Cornelis Dusart (1660-1704) in a posthumous inventory compiled of his effects in 1704: *'no.134. Descartes van Corn. Dusart gedoodverwt'* (Bredius, vol.1, p.34). Dusart's portrait of Descartes of course had to be a copy; he was born a decade after the philosopher had died. We cannot tell whether his copy subsequently was finished by another hand and is one of the existing versions after Hals's original. However, if we did not have the 1704 inventory reference, even on their wildest flights of fancy not many specialists would suggest that Dusart, best known as a follower of Adriaen van Ostade, made a portrait of the founder of modern rationalism.

A list of eight printmakers who made engravings derived from versions of Hals's painting or Suyderhoef's engraving of it is cited in Slive 1970-4, vol.3, no.175. Also see ibid., for references to various specimens of the medal that Jan Smeltzing (1656-93) made *c.*1685 after Hals's portrayal (fig.66d).

For the argument that Descartes never sat for Hals, and that

his celebrated and frequently copied likeness of the philosopher is a posthumous one based on his imagination and an engraved portrait done in 1644 by Frans van Schooten the Younger, an amateur artist, mathematician and physicist, see Nordström 1957-8. Reasons for rejecting Nordström's hypothesis are offered in Slive 1970-4, vol.1, pp.166-8.

1. Lievens's drawing of Descartes is in Groningen (Museum voor Stad en Lande, inv.1913-173) and Weenix's painting is in Utrecht (Centraal Museum, cat. 1952, no.337); reproduced in Slive 1970-4, vol.1, figs.169, 170 respectively. An untraceable brush drawing by Rembrandt of Descartes is mentioned in the manuscript catalogue of the collection of Valerius Röver (d.1739) in the library of the Municipal University, Amsterdam (H.S.14461IA18).

PROVENANCE According to the 1951 Royal Museum catalogue (p.120, no.290), the painting was purchased from a Copenhagen second-hand dealer by Herman Gram, who sold it in 1896 to Carl Jacobsen, founder of the Ny Carlsberg Glyptotek.

EXHIBITIONS Paris 1937, no.355; Amsterdam 1952, no.49.

LITERATURE Adriaen Baillet, *La Vie de Monsieur Des-Cartes*, vol.2, Paris 1691, pp.386-7; Karl Madsen, 'Frans Hals-Descartes', *Tilskueren* 1896, pp.133-46; HdG 172; KdK 242 (*c.*1649; preparatory study for Louvre version); G.Falck, 'Museets Tilvaekst af Aeldre Malerkunst', *Kunstmuseets Aarsskrift* XI-XII (1924-5), p.42 (authentic); G.Falck, 'Frans Hals Mansportraet ...', *Kunstmuseets Aarsskrift* XVI-XVIII (1929-31), p.133; Alain [Emile Chartier], *Histoire de mes pensées*, Paris 1936, p.253; Catalogue Royal Museum of Fine Arts, Copenhagen, 1951, p.120, no.290; Johan Nordström, 'Till Cartesius Ikonographie', *Lychnos* 1957-8, pp.194-250 (with an English summary); Gregor Sebba, *Bibliographia Cartesiana: A Critical Guide to the Descartes Literature, 1800-1960*, The Hague 1964; Slive 1970-4, vol.1, pp.164-8; Grimm A31b (copy); Ekkart 1973, p.254 (copy); Montagni 173b (copy).

67 Family Group in a Landscape

c.1648
Canvas, 202 × 285 cm
S177
Thyssen-Bornemisza Collection, Castagnola-Lugano
Exhibited in Washington

This life-size, full-length family portrait, and the one that includes twice as many figures at The National Gallery, London (fig. 67a), are the most important commissions Hals received during the late forties. They are the only works that show his accomplishment as a group portraitist between the time he painted the *Regents of the St. Elizabeth Hospital* in 1641 (cat. 54) and his late *Regents* and *Regentesses of the Old Men's Almshouse* (cat. 85, 86).

Like Hals's other family portraits (fig. 67a; cat. 10, 49) the identity of the family remains unknown. When the painting was exhibited at the Royal Academy in 1906, it was catalogued incorrectly as 'Portraits of the Painter with his Family', an identification accepted by Roger Fry, whose faith in it lead to another error. Fry wrote to Sir Purdon Clarke, then Director of the Metropolitan Museum on 7 January 1906 (a few weeks before he accepted the position of Curator of Paintings at the Metropolitan) that Hals's *Portrait of the Painter* with Knoedler's 'has a considerable likeness to the man in the *Family Group* belonging to Colonel Warde now on view in Burlington House and as this is supposed to be the artist it confirms the supposition' (*Fry* 1972, pp. 246-7). The portrait of a painter that Fry called to the attention of his future employer, which is now in the Frick Collection (S186) is not Hals's self-portrait, nor is it his portrait of Rembrandt as was proposed later.[1] The artist who sat for the Frick portrait has not been identified.

Stretcher damage runs vertically the entire length of the middle of the canvas and there are scattered tears and losses. The painting was restored by William Suhr in 1965-6; photos that record his work are at the Getty Center for the History of Art and the Humanities, Santa Monica.

Notable in the family portrait is the sensitive portrayal of its five figures, not least the black boy (a servant or slave?) near the centre. As portrayed by Hals, his dignity and reserve have nothing in common with the stereotypical blacks depicted by so many of the artist's contemporaries. His characteri-

sation of the smiling boy in fashionable knee-breeches and the older girl are equally sympathetic, while the subtle value painting and vivacious brushwork show qualities that helped the artist win his posthumous fame.

The group is yet another work that establishes Hals's close ties with the pictorial and iconographic traditions of his time. The attitude of the seated father and mother with their right hands joined (*dextrarum iunctio*), is an allusion to marital fidelity that would have been recognised readily by many people of the time. A picture of a couple seated in a landscape, with the woman always on the man's left and with their hands joined, has been employed to symbolise marital fidelity at least since it was used to accompany the motto and poem that make up the emblem '*In fidem uxoriam*' in Andrea Alciati's *Emblematum Liber* of 1531, the frequently reprinted emblem book mentioned in connection with the *Married Couple* at Amsterdam (cat. 12). One reproduced from the 1608 edition of Alciati's work published in Antwerp is seen in fig. 67b.

Today we know that Hals's contemporaries were much more accustomed to looking for symbolic allusions in paintings than we are, which helps explain why the one in this family portrait was not signalled until a couple of decades ago (Slive 1970-4, vol. 1, pp. 179-81). It also raises the familiar but difficult question: when does an event or object in a seventeenth-century picture signify nothing but itself and when does it have symbolic meaning? The dog to the right of the lovely girl in this portrait is a case in point. Is the shaggy dog part of the symbolic story? Dogs were and are often used to signify fidelity. One plays a role in Alciati's emblem '*In fidem uxoriam*'. However, a dog which alludes to marital fidelity always is shown near the couple and usually rests upon the woman's skirt. Did Hals modify the tradition or paint a straightforward portrait of a family pet?

There can, however, be no doubt that the clasped hands of the couple had symbolic meaning for seventeenth-century beholders, even if they did not know Alciati's emblem book.

Fig. 67a *Family Group in a Landscape* (S176)
London, National Gallery

Fig. 67b 'In fidem uxoriam', woodcut in An-
drea Alciati, Emblemata, Antwerp 1608

Fig. 67c Marriage Medal
Dutch, seventeenth century
The Hague, Koninklijk Penningkabinet
(inv. 1054)

Fig. 67d Marriage Medal
Frisian, seventeenth century
Private collection

Joined hands have been a popular symbol of faithfulness from ancient times to this day. In the Western world a handshake still seals a pledge. The device was commonplace in Renaissance and Baroque imagery to affirm the virtues and pleasures of friendship, love and marriage. The most frequent motif on seventeenth-century Dutch betrothal and marriage medals is a picture of a couple with joined hands (fig. 67c). When a couple went to the new Town Hall of Amsterdam to register their intentions of marriage in the Chamber of Matrimonial Affairs, they saw a pair of clasped right hands carved in the centre of the mantelpiece. When they were married, they heard the officiating magistrate say: 'Take off your gloves and give each other the right hand', and holding hands they took their vows (Fremantle 1959, p. 74). Clasped hands also were found appropriate for medals commemorating engagements, marriages and wedding anniversaries. The marriage medal reproduced here (fig. 67d) includes a heart, skull and bone, and is inscribed 'Getrouw tot in den doot' ('Faithful until death').

The grove of large trees and the panoramic view in the background of the family group are attributable to Pieter Molijn (1595-1661). Despite significant differences in scale, close analogies can be found between the landscape in Molijn's Wayfarers on a Road, 1647, Frans Halsmuseum (inv. 60-65; repr. in Slive 1970-4, vol. 1, p. 177, fig. 189) in the treatment of the branches and heavy foliage behind the group as well as the feathery trees and flat landscape to the right of the girl. Molijn, however, was not responsible for all the flora in the painting. Hals's fluid and economic touch is recognisable in the plant in the lower left corner of the painting. We already have seen that Molijn's hand also is found in Hals's 1626 portrait of Isaac Massa (cat. 21) and probably in his small Family Portrait of the thirties (cat. 49). The landscape background of Hals's Family Portrait at the National Gallery can be attributed to him as well (fig. 67a). The two artists continued to have contact until the last years of their long lives. In April 1660, Hals and Molijn were called upon to appraise the pictures in the estate of the recently deceased

Coenraet Coymans, the father of Willem Coymans, whom Hals portrayed in 1645 as a smartly dressed young man (cat. 61).

1. Dirk Vis (*Rembrandt en Geertje Dircx*, Haarlem 1965, pp. 185-6) maintains that the Frick portrait and its companion piece, *Portrait of a Woman holding a Fan*, at the Metropolitan Museum (s187), are Hals's portraits of Rembrandt and his mistress Geertje Dircx. For arguments against his case, which is no more credible than Houbraken's tale that Hals painted Van Dyck (Houbraken, p. 17), see W.R. Scheller's review of his book (*O.H.* LXXXI [1966], pp. 117-8) and Slive 1970-4, vol. 3, nos. 186, 187. Not a shred of evidence suggests that Rembrandt ever was portrayed by Hals or that Hals sat for Rembrandt.

PROVENANCE Probably William Bristow (d. 1758); reportedly bought by his nephew, John Warde of Squerryes Court (Westerham, Kent), at the posthumous sale of Bristow's estate, London, 1759; inherited by his son John (d. 1775) and thence by descent to Lt.-Col. Charles A.M. Warde who reportedly sold it privately to dealer Joseph Duveen in 1909 (c.£55,000); from whom it was bought in 1910 by Otto H. Kahn, New York (£100,000); Mogmar Art Foundation, New York, by 1935; acquired that year through dealer Rudolph Heineman by Baron Heinrich Thyssen-Bornemisza (Ivan Gaskell kindly provided the history of the painting summarised here which corrects and amplifies those published earlier).

EXHIBITIONS London 1906, no. 102 (as 'Portraits of the Painter and His Family'); Paris 1921, no. 17; Detroit 1935, no. 44; Brussels 1935, no. 728; Lugano 1949, no. 106; New York, Toledo & Toronto 1954-5, no. 29 (not shown in Toronto); Rotterdam 1955, no. 69; Rotterdam & Essen 1959-60, no. 82; London 1961, no. 61.

LITERATURE *The Arundel Club*, vol. 1, London 1904, no. 12; Moes 89; HdG 441 (c.1640); Bode-Binder 272; KdK 229 (c.1645); Valentiner 1936, no. 85; *Sammlung Schloss Rohoncz*, Lugano 1937, no. 183; Catalogue Thyssen-Bornemisza Collection, Castagnola-Ticino, 1969, no. 124; Slive 1970-4, vol. 1, pp. 178-81; Grimm 1971, p. 163, no. 30 (Frans Hals II; c.1652); *Letters of Roger Fry*, ed. with an intro. by Denys Sutton, vol. 1, London 1972, pp. 246-7; Ekkart 1973, pp. 254-5 (by Frans Hals); Montagni 279; Baard 1981, p. 142; Catalogue Thyssen-Bornemisza Collection, Castagnola, 1981, no. 124.

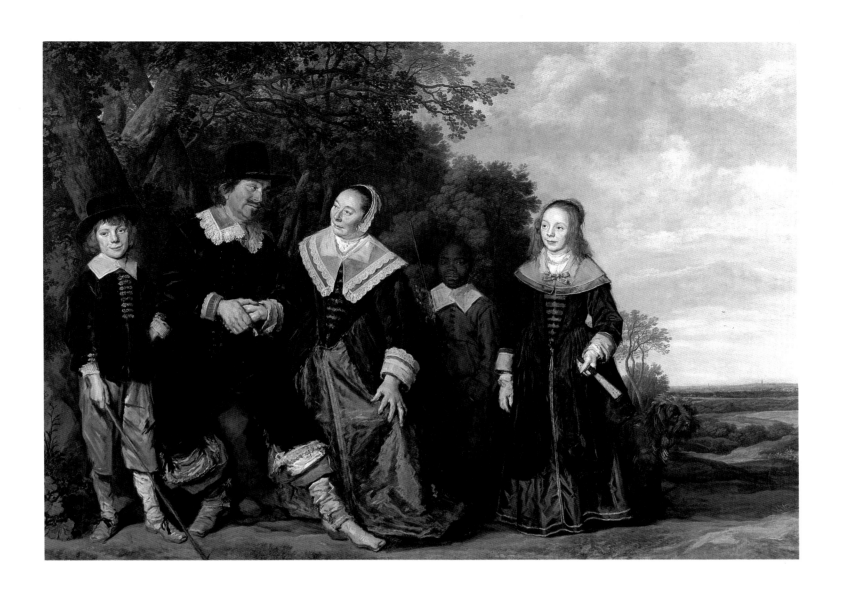

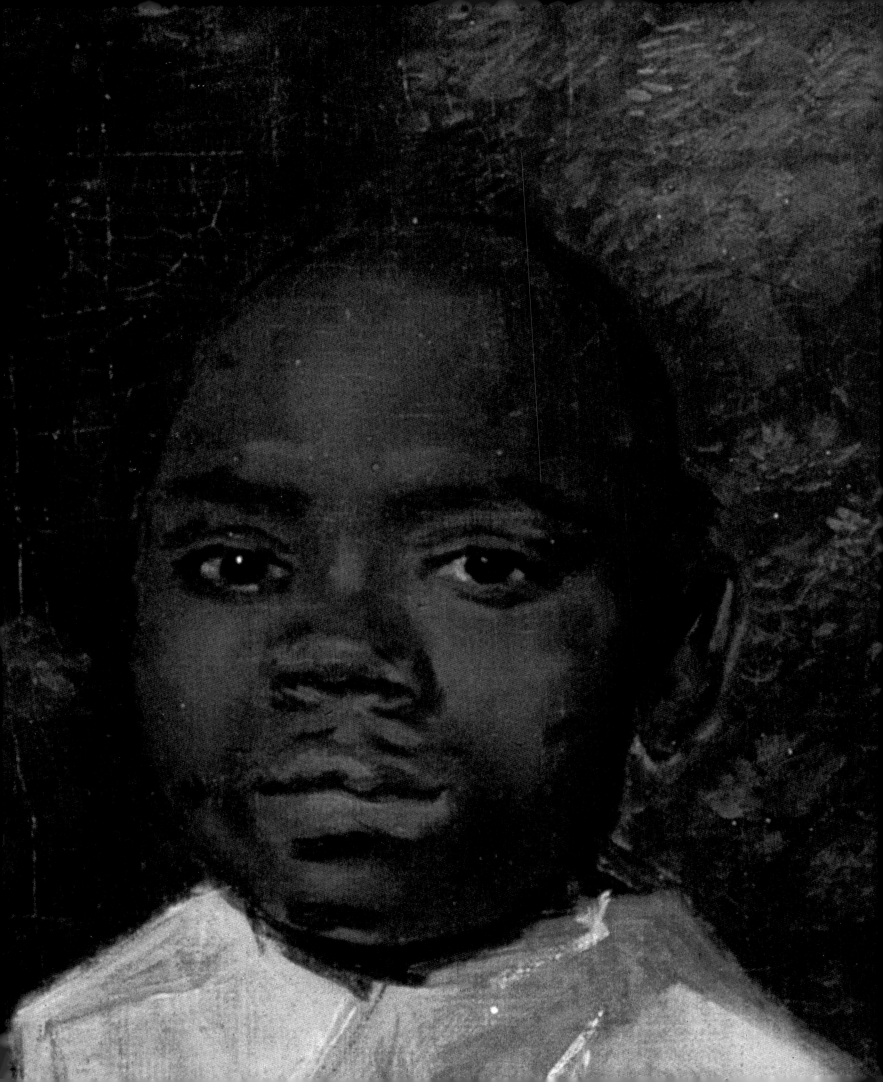

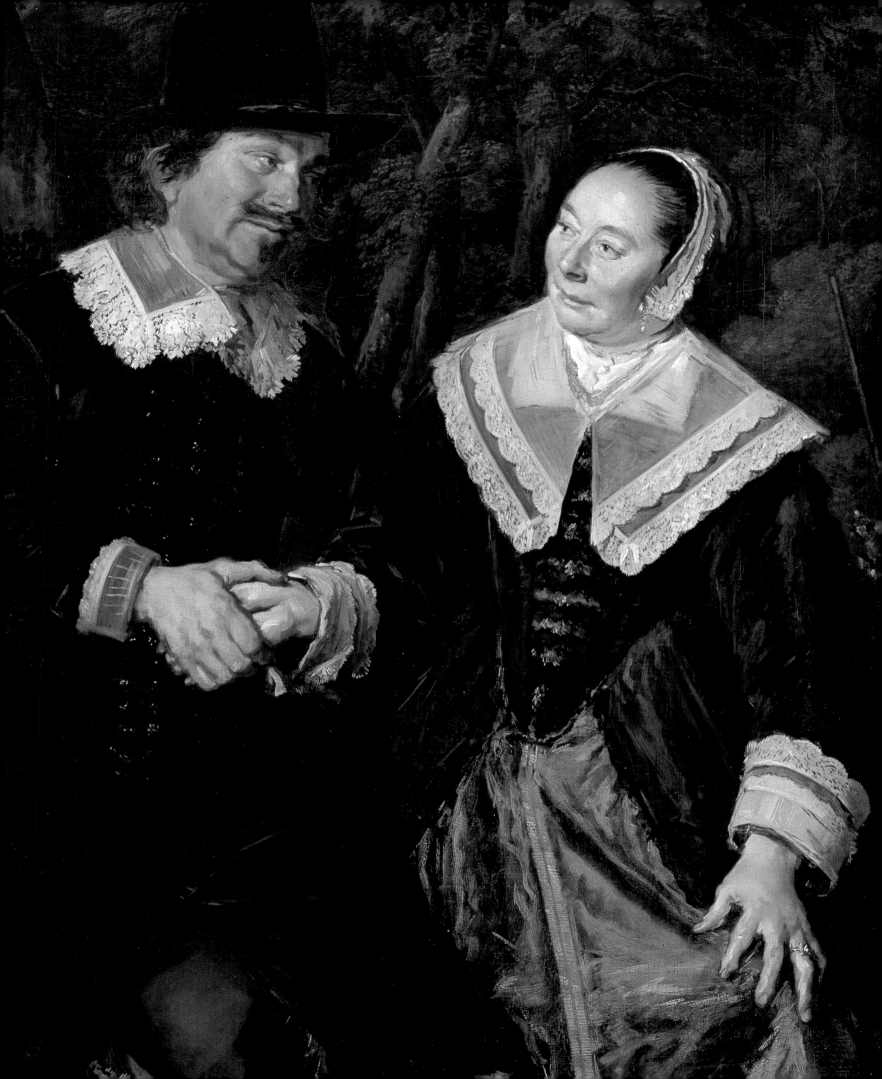

*c.*1650-2
Canvas, 115 × 87 cm
The Geraerdts coat of arms is painted to the right of the head
s188
Koninklijk Museum voor Schone Kunsten, Antwerp (inv. 674)
Exhibited in London and Haarlem

The opulent pendants of Stephanus Geraerdts and Isabella Coymans (cat. 69) have a unique place in Hals's work. None of his other companion pieces radiate such warmth, and there is nothing comparable in his œuvre – or in the history of earlier marriage portraits – for the action he arranged between the couple. Isabella was designed, as was customary, to hang as the sinister pendant. She stands turned toward her husband offering him a rose. Portly Stephanus is portrayed seated with his arm outstretched to receive it. When juxtaposed, the glances they exchange, their smiles and their gestures create a tension that psychologically and rhythmically binds them together. Disunited, these links are broken. Sadly, the portraits are no longer joined. Of all cases of separation of Hals's companion pieces this is the cruelest. Since 1888 Stephanus has been seated in Antwerp companionless with his arm outstretched, while Isabella has been alone, offering her rose in various private collections. The happy reunion of the pair in London and Haarlem is the first time they have been seen together since they appeared at the Royal Academy in 1877.

Though husband and wife turn toward each other, their figures are frontal, emphasising the bulk of their bodies, one massive, the other slender and elegant, and both invigorated by the artist's vibrant touch. Like some other fashionable young women about mid-century, Isabella wears a costume with a lowered neckline which reveals a bit of her bosom and her shoulders. Her modest décolletage earns her the distinction of being Hals's only portrait of a patrician wearing one.[1] The gossamer veil pinned to her hair that sparkles with tiny pearls and silver and red ribbons, her huge silver bow, and the extravagant display of lace on her collar, cuffs and on the white satin panel of her skirt, reflect a taste for showy frills not shared by any other woman portrayed by Hals. In his hands these decorative accents as well as the intense whites and glittering gold embroidery on Stephanus's jacket become dynamic elements enlivening the couple.

It has been proposed that the rose irresistible Isabella offers her husband should be read as a vanitas symbol, and as a warning of earthly love's fickleness and the dangers of voluptuousness (Boot 1973). Granted, in some contexts roses could have these meanings for Hals's contemporaries. But these allusions and others that can be compiled (then as now 'no rose without a thorn' was a popular adage) are so distant from the sympathetic relationship Hals established between his sitters it seems almost perverse to search for them. One must lead a dull life indeed not to recognise that Isabella's rose is a token of love, the flower's most popular meaning since the late Middle Ages, and in no more need of an exegesis than a Valentine card. In the context of these portraits it also is reasonable to interpret the watch that dangles below the large bow fixed at Isabella's waist as an accessory she wore as proudly as her jewellery, not as a symbol of transience.

The coats of arms on the paintings, the last to appear on Hals's portraits, identify the sitters. Stephanus Geraerdts (Steven Gérard) was born at Amsterdam and died at Haarlem on 27 January 1671. At the time of his marriage to Isabella Coymans on 4 October 1644 at Haarlem, he lived on Keizers-gracht at Amsterdam. The appealing notion that Hals painted the pendants about 1644 to celebrate their marriage is not supported by the style of the paintings. Stephanus subsequently held municipal office in Haarlem as an alderman and councillor. Isabella was born in Haarlem and died there on 7 October 1689. Two years after Stephanus's death she married Samuel Gruterus (Elias 1905, vol. 2, p. 764).

In 1644 Hals painted portraits of Isabella's parents *Josephus Coymans* and *Dorothea Berck*, pendants that also are now in different collections, the former in Hartford and the latter in Baltimore (figs. 68a, 68b).[2] Perhaps they were made to hang in the bride's new home.

Isabella's family belonged to the top stratum of Dutch society. Her maternal grandfather served Holland as ambassador to England, Denmark and the Venetian Republic. Her father, squire of Bruchen and Nieuwwaal, and other members of the family were very rich merchants and bankers. Josephus's brothers Balthasar and Johannes commissioned Jacob van Campen to build them a stately double house in Amsterdam in 1625 (Keizersgracht 177). It was van Campen's first architectural commission (Swillens 1961, p. 20), the beginning of a series that triumphantly culminated with his designs for Amsterdam's new Town Hall (for copies after Hals's lost portrait of van Campen, see Slive 1970-4, vol. 3, no. L15). In 1645, a year after Hals painted the pendants of Isabella's parents, Balthasar Coymans and Brothers Bank in Amsterdam had transactions that amounted to about 4,140,000 guilders, more than any other bank in the city during that year (Elias 1905, vol. 2, p. 767). One cannot help wondering how much Hals was paid for his four portraits of this enormously wealthy family. For Hals's swagger portrayal of Willem Coenraetsz Coymans, dated 1645, who belonged to another branch of the family, see cat. 61.

The small oil sketch on paper mounted on panel (20 × 18.5 cm), published by Valentiner (KdK 1921, 246; KdK 261) as a preliminary study by Hals for the bust of Stephanus Geraerdts, is a copy by another hand (Provenance: H. E. ten Cate, Almelo; dealer D. Katz, Dieren; dealer H. Schaeffer, New York). Other copies of the peerless pendants also are known.[3]

1. Low necklines appear in only two other works by Hals: a not very daring one is worn by the pretty young flirt in his lost *Merry Trio* (s.L2; *c.*1616), and the *Gipsy Girl* (pl. v; s62) displays a décolletage that is more conspicuous. For support of the suggestion that the *Gipsy Girl* is a portrait of a courtesan probably designed to hang in a brothel, see Slive 1970-4, vol. 1, pp. 92-4.

2. Biesboer (p. 37) suggests that the impetus for this commission conceivably came from Josephus Coymans's satisfaction with Hals's portrayal of his son-in-law Jacob Druyvesteyn as an ensign in the artist's St. George guard piece of *c.*1639 (Levy-van Halm & Abraham, fig. 15; s124). Jacob be-came his son-in-law in 1640 when he married his daughter Wilhelma. Jacob's father, Aernout Druyvesteyn, is portrayed as the colonel in Hals's St. George militia piece of *c.*1627 (Levy-van Halm & Abraham, fig. 13; s46).

3. A reduced copy (91.5 × 71.1 cm) of *Geraerdts* wearing a dark green suit instead of a black one, and bearing armorials in the corner, appeared in the sale J. C. O'Connor and others, London (Robinson and Fisher), 5 July 1928, no. 203 (files of the RKD). It is noteworthy that the painting that appeared in the sale C. J. Nieuwenhuys, London, 10 May 1833, no. 26 (116.8 × 88.8 cm), which may be identical with the Antwerp portrait (115.4 × 87.5 cm), is described by

Isabella Coymans

*c.*1650-2
Canvas, 116 × 86 cm
The Coymans coat of arms is painted to the left of the head
s189
Private collection
Exhibited in London and Haarlem

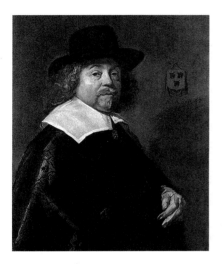

Fig. 68a *Josephus Coymans*, 1644 (s160)
Hartford, Wadsworth Atheneum

Fig. 68b *Dorothea Berck, Wife of Josephus Coymans*, 1644 (s161)
Baltimore, The Baltimore Museum of Art

See commentary to cat. 68, the portrait's companion piece.

PROVENANCE Perhaps sale C. J. Nieuwenhuys, London (Christie's), 10 May 1833, no. 45 (£22, Pennel); Newman Smith, London; dealer E. Warneck, Paris, acquired it and its pendant *Stephanus Geraerdts* (cat. 68) in England; dealer Stephen Bourgeois, Cologne and Paris, sold the pair to Prince Demidoff, San Donato, Italy; Prince Demidoff returned them to Bourgeois who separated the couple, selling *Isabella Coymans* to Alphonse de Rothschild, Paris, and *Geraerdts* to the Antwerp Museum in 1886; Edmond de Rothschild, Ferrières (stolen by the Nazis during World War II; according to exhib. cat. Paris 1946, no. 77 'Destiné à la collection de Hitler'); Baronne Edouard de Rothschild, Paris.

EXHIBITIONS London, Royal Academy, Winter Exhibition, 1877, no. 38; Paris 1921, no. 20 (lent by Robert de Rothschild); Paris 1946, no. 77; Haarlem 1962, no. 63 (in the catalogue but not exhibited).

LITERATURE C. J. Nieuwenhuys, *A Review of the Lives and Works of Some of the Most Eminent Painters*, London 1834, p. 129, no. 25. The dimensions and description Nieuwenhuys gives of the portrait and its pendant (no. 26) fit the painting and the Antwerp picture (cat. 68); however, he notes the arms of both portraits are painted at the bottom (ibid., p. 130); Bode-Binder 259; KdK 263 (*c.* 1650-2); Trivas 100 (1650-2); Slive 1958, p. 21; Slive 1970-4, vol. 1, pp. 184-5; Grimm 136 (*c.*1648); Boot 1973, pp. 422-3; Montagni 176 (*c.*1648-50); Baard 1981, p. 146 (*c.*1650-2).

Nieuwenhuys himself (1834, p. 130) as bearing its coat of arms at the bottom; as noted in the Literature below, he also described the pendant in 1834 with its coat of arms at the bottom. It has not been possible to determine if these were removed after 1834 and subsequent cleaning revealed the arms now visible on the pendants. Therefore, the possibility that the Nieuwenhuys pictures are not identical with the Antwerp portrait and its pendant cannot be excluded. For references to possible subsequent appearances in the art market of the reduced copy of *Geraerdts* dressed in green, and to what may be yet another version of the painting, see Slive 1970-4, vol. 3, no. 188.

A weak copy of Isabella Coymans's portrait (canvas, 114 × 86 cm) was confused with the original late in the nineteenth century. It made its first appearance in the Rudolph Kann collection, Paris. Moes rightly questioned its attribution to Hals in 1897 (*Icon. Bat.* no. 1785). Around 1906 it was sold by Durand-Ruel, Paris, to P. A. B. Widener of Philadelphia (see

F. J. M., 'Notes on the Widener Collection, 1. Frans Hals: The Lady with a Rose', *B.M.* XI [1907], pp. 129-30, repr. p. 125). It was exhibited erroneously as the original in the Hudson-Fulton Exhibition, New York in 1909 (no. 38, repr.). The copy was catalogued again as a work by Frans Hals in *Pictures of P.A.B. Widener at Lynnewood Hall, Elkins Park, Pennsylvania, Early German, Dutch and Flemish Schools* ... (notes by Hofstede de Groot & Wilhelm R. Valentiner, Philadelphia 1913, unpaginated). In 1909 Moes (35) listed the copy without question, and Hofstede de Groot (181) listed it with a provenance confused with the original's in his 1910 catalogue. By the time Bode and Binder published their Hals study in 1914, the error must have been discovered; they cite only the original (259). The Widener copy has been untraceable since it made a modest appearance at an anonymous sale Amsterdam (Muller), 14 October 1918, no. 32 ('Haarlem School, Smiling Lady'; Dfl. 750).

PROVENANCE Perhaps sale C. J. Nieuwenhuys, London (Christie's), 10 May 1833, no. 46 (Yates); Newman Smith, London; dealer E. Warneck, Paris, acquired it and its pendant (cat. 69) in England; dealer Stephen Bourgeois, Cologne and Paris, sold the pair to Prince Demidoff, San Donato, Italy, who subsequently returned them to Bourgeois; Bourgeois separated the pendants, selling *Geraerdts* to the Antwerp Museum in 1886 (fr. 85,000) and *Isabella Coymans* to Alphonse de Rothschild.

EXHIBITIONS London, Royal Academy, Winter Exhibition, 1877, no. 29; Haarlem 1937, no. 102; Haarlem 1962, no. 62.

LITERATURE C. J. Nieuwenhuys, *A Review of the Lives and Works of Some of the Most Eminent Painters*, London 1834, pp. 129-30, no. 26. The dimensions and description Nieuwenhuys gives of the work and its pendant (no. 25) fit the Antwerp portrait and its companion now in a private collection (cat. 69); however, he notes: 'The arms of the family in these portraits are painted on the bottom of the picture' (ibid., p. 130). *Icon. Bat.* no. 2688 (Frans Hals?); Moes 34; HdG 180 (probably 1645); Bode-Binder 258; KdK 262 (*c.*1650-2); Trivas 99 (*c.*1650-2); Slive 1958, p. 21; Catalogue Koninklijk Museum, Antwerp, 1970, p. 102, no. 674; Slive 1970-4, vol. 1, pp. 184-5; Grimm 135 (*c.*1648); Boot 1973, pp. 422-3; Montagni 175 (*c.*1648-50); Baard 1981, p. 144 (*c.*1650-2).

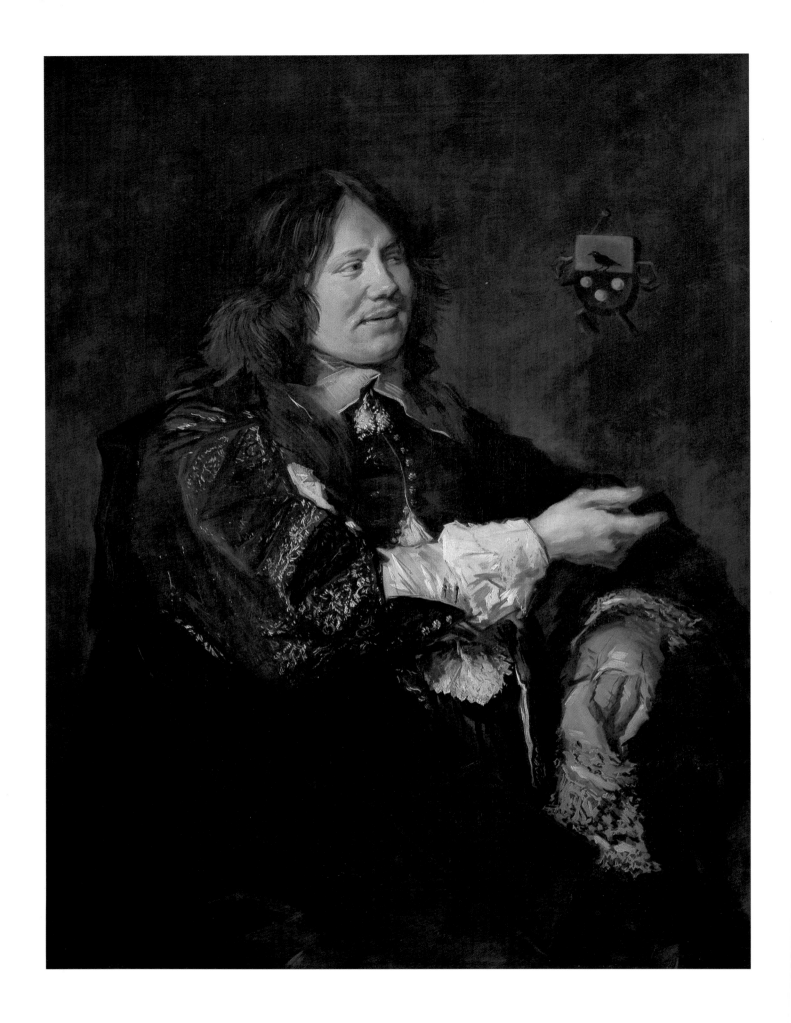

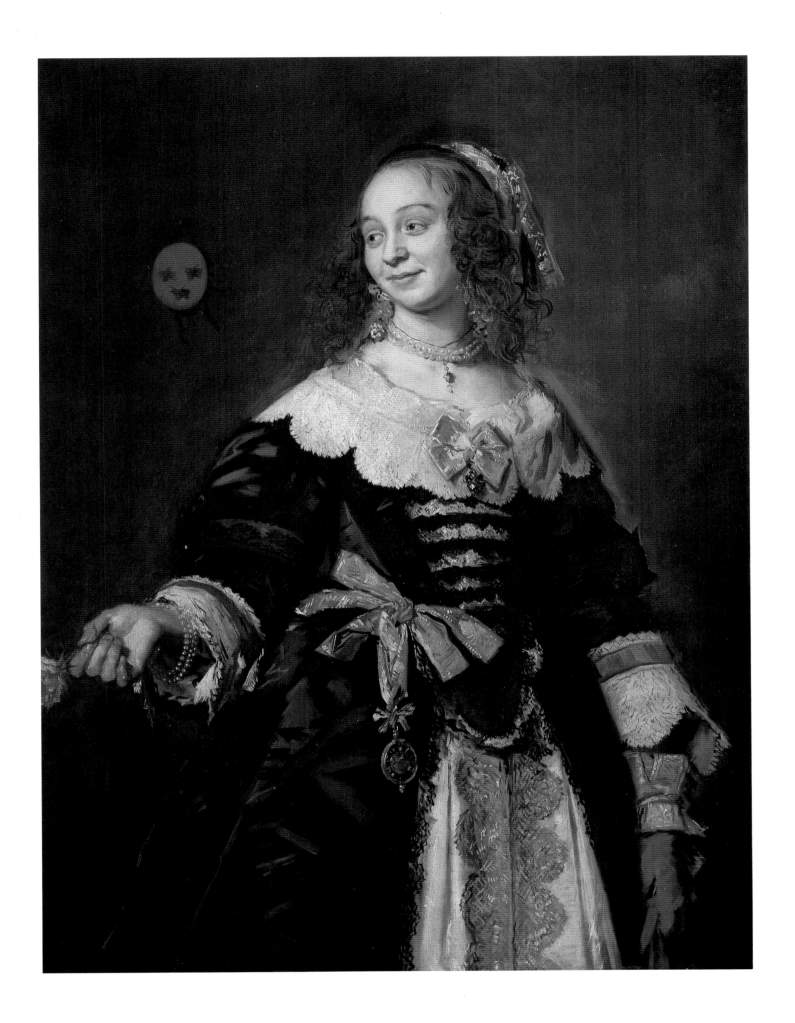

70 Portrait of a Man

c.1650-2
Canvas, 110.5 × 86.3 cm
S190
The Metropolitan Museum of Art, New York, Marquand Collection
(inv. 91.26.9)
Exhibited in London

Frontal poses become more frequent in Hals's late phase, indicating that he too was affected by the classicising trend that led Dutch artists to seek quieter and more stately effects after mid-century. This three-quarter length is one of the finest of the type. The seemingly spontaneous treatment of the blacks of the sitter's suit, mantle and foreshortened hat show the artist's unfaltering control over fine distinctions of this hue and, as in so many of his late works, his flickering brushwork is most evident in the light passages. Unusual are the lilac, grey-green and rose loops of ribbon dangling at the man's waist which provide daring accents against his black costume while establishing a delicate accord with the warm and cool colours of his face.

His ribbon loops, or gallants, were worn as an apron-like skirt at his waist; it was a French creation known as a *tablier de galants*. The generous flounces on his shirt sleeve above his cuff also reflect a French import (du Mortier, p. 56). Reflections of French taste were hardly new in Holland when the portrait was commissioned. They appeared in the Northern Netherlands even before the turn of the seventeenth century. However, they were given a new impetus at the court in The Hague when Frederik Hendrik succeeded as stadtholder in 1625. He had acquired the taste naturally; his mother was French and he had spent considerable time at the court of Henri IV (ibid., p. 55). During the course of the following decades, French fashions and taste gained in popularity in other circles, and not long after Hals's death they became dominant.

At an undetermined later date the canvas of the painting was extended by a strip of unprimed canvas about 3.5 cm wide at the left, now covered by the frame's rabbet, and restretched so that some of its original support and paint surface on the right side extend over the present stretcher. The background is generally abraded; abrasion is evident also in the hair on the right side of the sitter's face. *Pentimenti* (and later repaint?) are evident in his right hand.[1]

1. A reduced copy wrongly attributed to Harmen Hals appeared in the sale New York (Parke-Bernet), 14 March 1951, no. 9 (panel, 38 × 29 cm), and again in the sale New York (Parke-Bernet), 5 March 1952, no. 31.

PROVENANCE Sale Earl of Buckinghamshire, London, 17 March 1890, no. 131; Henry G. Marquand, New York, who gave it to the museum in 1890.

EXHIBITIONS New York 1909, no. 40; Haarlem 1937, no. 105; Haarlem 1962, no. 61; New Brunswick 1983, no. 68.

LITERATURE Moes 184; HdG 297; Bode-Binder 260; KdK 266 (c.1652-4); Valentiner 1936, 102 (c.1652-4); Slive 1970-4, vol. 1, p. 194; Grimm 143 (1649-50); Montagni 181; Baetjer 1980, vol. 1, p. 83, vol. 3, p. 400; Baard 1981, commentary with frontispiece.

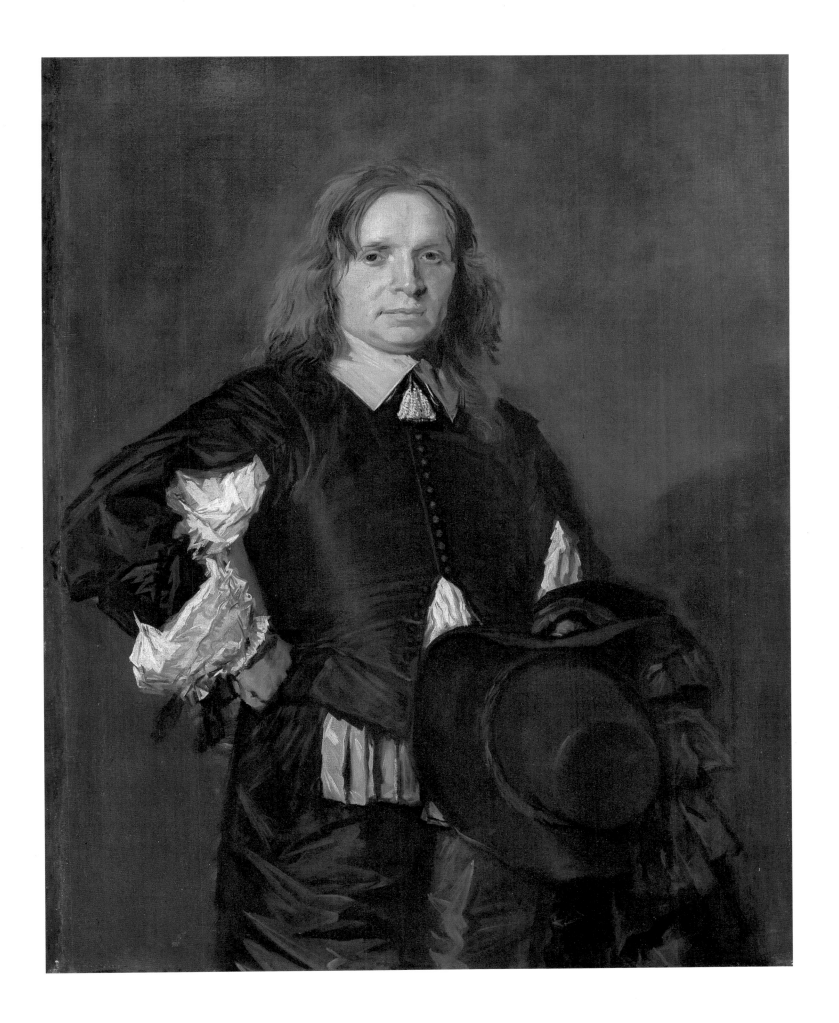

327

71 • 72 Portrait of a Man

c.1650-2
Canvas, 115 × 84.5 cm
S191
National Gallery of Art, Washington, D.C., Widener Collection
(inv. 1942.9.29)

For this three-quarter length Hals used a pose he first employed in 1625 for his portrait of *Jacob Pietersz Olycan* (cat.18), and then varied in works done in the thirties and forties. After he had been using the scheme for a quarter of a century, one might imagine that Hals, the almost unrivalled virtuoso of the brush, would turn out yet another without a hint of a struggle. Not so. Evidence of the probes and adjustments he made before he created his final image are seen in the numerous *pentimenti* that became visible after the portrait was freed of its markedly discoloured surface coating and extensive old repaints during its restoration at the National Gallery in 1984-5. His alterations are particularly visible in the hat, which shows several changes, and in the contours of the cloak.

Treatment of the portrait revealed scattered losses and that the paint layer is generally abraded, except for the sitter's splendid head, hands and the whites of his costume, which are excellently preserved. Technical examination established that at one time in its history the painting was almost certainly on a stretcher that measured c.108 × 80 cm; its present dimensions are 115 × 84.5 cm and there is no question that it originally was somewhat larger. What is known about the history of its various dimensions is best discussed in a note.[1]

The questions that so often arise when we see a seventeenth-century Dutch portrait of a man or a woman without a spouse come to mind when we confront the Washington *Man*. Are we viewing only half of the commission this patron gave to Hals? Was he designed to be seen alongside a three-quarter length of his wife who would have been given the customary position at her husband's left side?

Valentiner answered these questions 'Yes' when he categorically asserted (KdK 256) that the Washington *Man* is without a doubt ('ohne Zweifel') a companion to Hals's *Portrait of a Woman* at the Louvre (cat.72); he repeated his claim in 1936 (no.47).

Before the recent restoration of the Washington *Man*, I argued (S191) that Valentiner's conclusion was unacceptable because the dimensions of the Louvre's *Portrait of a Woman* (108 × 80 cm) are smaller than her presumed mate's and, if it were enlarged to match the size of its putative pendant, the space around her figure would make an even more incongruous contrast with her presumed companion. But, as noted above, at one time the Washington *Man* most probably was on a stretcher whose dimensions were c.108 × 80 cm, virtually identical to the present dimensions of the Louvre portrait. Despite the Washington portrait's larger actual size, this discovery gives new force to Valentiner's marriage of the pair.

However, another objection to Valentiner's mating of the portraits was founded on the date assigned to each of them on the basis of their style. Since the 1920s there has been a consensus that both are datable about 1650, but in an attempt to give the pictures a more precise date I proposed (S191) that the broader and more economic touch of the Washington *Man* suggests that it postdates the Louvre *Woman* by a few years, a proposal I still put forward, though I readily agree that documentary evidence for establishing a firm chronology for the works Hals produced during the final decades of his

activity is slim indeed. Moreover, mature Hals conceivably could have used freer brushwork in a portrait of a man than a woman.

If it has been shown that at one time the dimensions of the Washington *Man* matched the present size of the Louvre *Woman*, and it is conceded that both portraits were painted at the same time, is there enough evidence in hand to conclude that the paintings were intended as companion pieces? I think not.

Until a technical examination is made of the four edges of the Louvre picture, the relation of its present dimensions to those of the Washington painting cannot be determined. Furthermore, until a technical survey is made of the sizes of Hals's three-quarter-length pendants, it will not be known if the similarity between the dimensions of the two pictures is possibly the result of a standard size the artist employed for portraits of this type. Additionally, comparative studies of the canvas supports, grounds and pigments used for each portrait, which have not yet been made, may tell us something new. But even after all this data is available, it still will be necessary to decide how well the configuration and mood of these outstanding portraits complement each other.

There is no reason not to address the last point now. I find the pair ill-matched, not as a consequence of Hals's depiction of the character of his sitters but because the pictorial congruencies that relate his other companion pictures to each other are scarcely evident here. On the basis of this visual evidence, I continue to endorse the view that the portraits were not designed as pendants. Granted, a first-hand look at them joined in the exhibition (to judge from their provenances, if they were intended as companions, no one has seen them together since at least 1820) may lead to another conclusion. Visitors to the exhibition, if so inclined, also will have an opportunity to decide if they want to serve as marriage broker or divorce lawyer in the case of the Washington *Man* and the *Woman* from the Louvre.

1. Technical examination has established that the original canvas support has been lined with another canvas support which is tacked to its present stretcher. It has been lengthened by the addition of a strip c.2.5 cm wide along its upper edge. Radiographs reveal the presence of this strip as well as large, regularly spaced, overpaint losses in the paint and ground layers extending c.2.5 cm from the edges of the original support, including the upper edge below the added strip. Because of their size and spacing, these losses can be assumed to be empty tack holes. Apparently, at one point in its history the painting was reduced in size (c.108 × 80 cm) and tacked to a smaller stretcher, with the edges of the front of the painting bent around to serve as tacking edges. There is no inherent evidence which might indicate its original size. Radio-

graphs show the least amount of cusping in the original support along the vertical edges, with almost none along the right edge. At the time of the above-mentioned reduction in size, a wide strip may have been cut off the top edge and the original tacking edges may have been removed. In a later restoration treatment the painting was brought to its present, larger size (115 × 84.5 cm), the tacking margins flattened, the upper strip added, and all the losses filled and inpainted. The ground on the original support is a thin, evenly applied white layer containing some white lead. The above data is cited from reports, prepared by Sarah L. Fisher, Ross M. Merill and David Bull of the National Gallery's Painting Conservation Department, in the gallery's curatorial files.

Portrait of a Woman

c.1648-50
Canvas, 108 × 80 cm
S171
Musée du Louvre, Paris (inv. M.1.927)

PROVENANCE Probably bequeathed by Lord Frederick Campbell to an ancestor of the Earl Amherst, Montreal, Sevenoaks, Kent c.1820; in the possession of the Earl Amherst until 1910; dealer C. Sedelmeyer, Paris, Catalogue, 1911, no.11, who sold it on 13 January 1911 to P.A.B. Widener, Elkins Park, Pennsylvania; entered the gallery in 1942 through inheritance from his estate by gift through power of appointment of Joseph E. Widener, Elkins Park.

EXHIBITIONS London, Royal Academy, Winter Exhibition, 1894, no.81 (lent by the Earl Amherst); London, Royal Academy, Winter Exhibition, 1910, no.89 (lent by the Earl Amherst).

LITERATURE *The Arundel Club. Sixth Year's Publications*, London 1909, no.9; Moes 162; HdG 294 (c.1645); *Pictures of P.A.B. Widener at Lynnewood Hall, Elkins Park, Pennsylvania, Early German, Dutch and Flemish Schools ...*, notes by C. Hofstede de Groot & Wilhelm R. Valentiner, Philadelphia 1913, vol.1, no.16; Bode-Binder 247; KdK 256 (c.1650-2); *Paintings in the Collection of Joseph Widener at Lynnewood Hall*, Elkins Park, 1923 [unpaginated]; ibid., 1931, pp.84-5; Valentiner 1936, 97 (c.1650-2); Catalogue National Gallery of Art, Washington, *Works from the Widener Collection*, 1942, no.625; Grimm 145 (c.1650); Summary Catalogue National Gallery of Art, Washington, 1975, p.170, no.625 (c.1650-2); Montagni 183 (1650); Catalogue National Gallery of Art, Washington, *European Paintings*, 1985, p.197, no.1942.9.29.

Nothing is known about the history of this three-quarter-length *Portrait of a Woman* before it was acquired by Louis La Caze (1798-1869), one of the Louvre's most generous benefactors. It came to the museum in 1869 with his munificent bequest, which included Hals's famous *Gipsy Girl* (pl.v; s62; the two pictures were the first authentic works by the artist to enter the Louvre), Rembrandt's late *Bathsheba* (Bredius-Gerson 521) and 579 other paintings. Henri Rochefort tells us in his autobiography that La Caze purchased the *Gipsy Girl* for the trifling price of 300 francs and that it was the very first painting he acquired. He adds (Rochefort 1896-8, vol.1, p.116) that La Caze should be credited with discovering Hals's qualities before Thoré-Bürger. Rochefort's assertion is dubious, but there can be no doubt that La Caze's acquisition of the *Portrait of a Woman* establishes that he was as discriminating in his choice of a mature portrait by the master as he was in his selection of one of his earlier genre pieces. Hals's unflattering yet sensitive characterisation of the middle-age woman, and the surety of his touch in the painting – particularly noticeable in the depiction of her hands, gloves and cuffs – rank it with Frans's best female portraits of the last decades of his activity.

The woman's stance toward the right, and the format of the picture indicate that she almost certainly had a pendant. See cat.71 for Washington's *Portrait of a Man*, the painting which has been proposed as her companion piece.

PROVENANCE Dr. Louis La Caze (1798-1869), Paris, who bequeathed it to the Louvre in 1869.

EXHIBITIONS Rome 1928, no.44; Tokyo 1966, no.40; Paris 1969 (unnumbered); Paris 1970-1, no.98; Birmingham 1989-80, no.58.

LITERATURE Paul Mantz, 'La Collection La Caze au Musée du Louvre', *G.B.A.*, 2e série, III (1870), p.396; Bode 1883, 42 (c.1650); Catalogue Louvre, Paris, 1890, no.2385; Moes 193; HdG 389; Bode-Binder 269; Catalogue (by L. Demonts) Louvre, Paris, 1922, p.26, no.2385; KdK 257 (c.1650-2); Trivas 94 (1647-50); Grimm 142 (1648-50); Montagni 174 (1648-50); Catalogue Louvre, Paris, 1979, p.66, no.M.1.927.

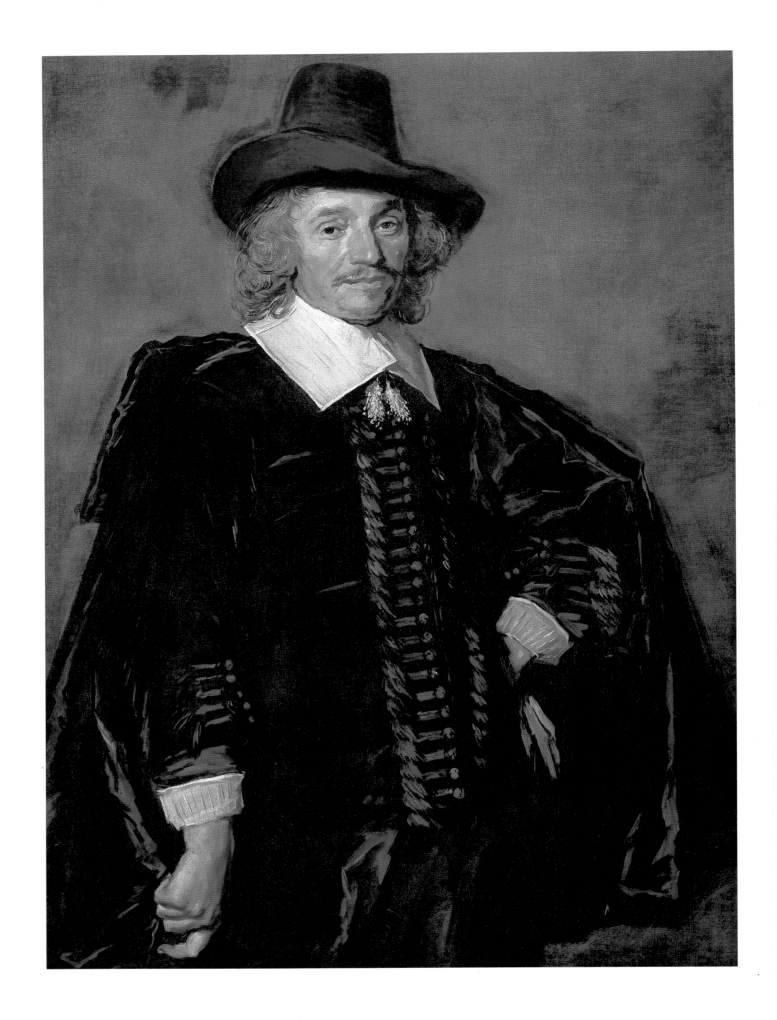

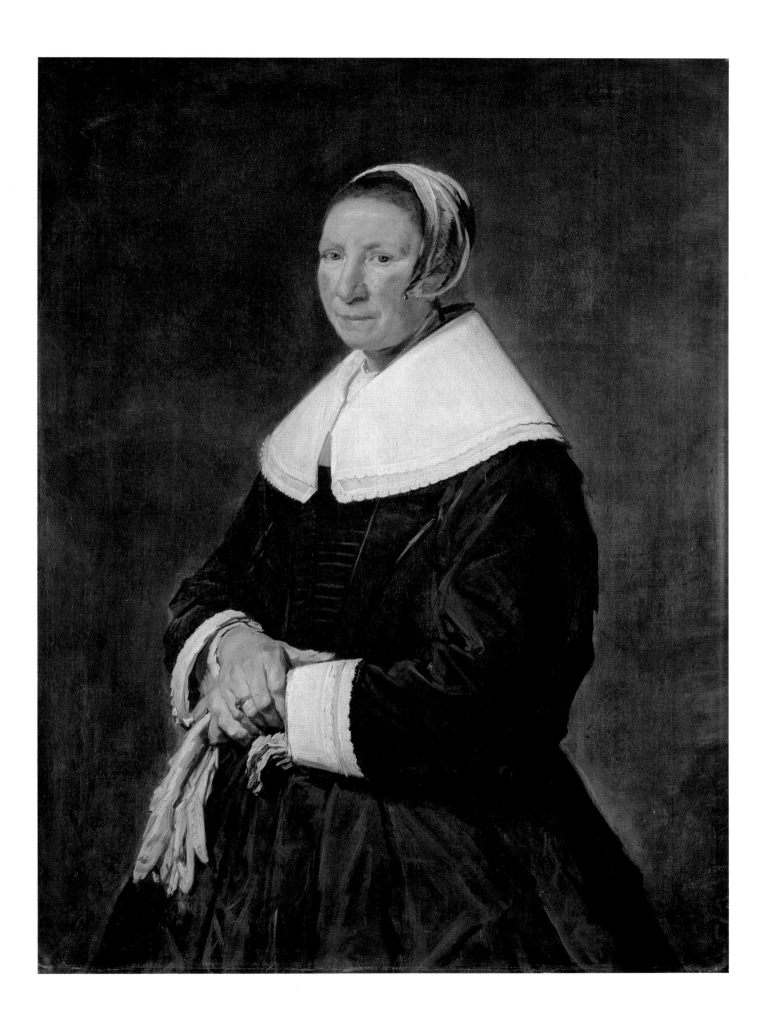

73 Portrait of a Man

c.1650-3
Canvas, 84.7 × 67 cm
Signed on the right with the connected monogram: FH
s193
State Hermitage Museum, Leningrad (inv. 816)

The Hermitage *Man* belongs to the magnificent series of the artist's portraits datable to the early fifties. The broad, vigourously brushed washes of the sitter's ponderous figure, which suggest its weight so convincingly and with such economy, and the bold treatment of his cuff may speak for a somewhat later date, but the fusion of the flesh tones and the relative restraint of the accents in the head and hair account for the phase to which the work is assigned here.

I.Q. van Regteren Altena (1929; 1948), H. Fechner (1960) and Lewinson-Lessing *et al.* (1962) argue that a black and white chalk drawing on blue-grey paper at the British Museum (fig. 73a) served as Hals's preliminary study for the portrait. If they are correct, the sheet would qualify as Hals's sole surviving drawing that can be related to one of his paintings, and, since not one of the handful of others that have been attributed to him is acceptable as autograph, it also would have the special honour of being his only surviving sheet.

Unargued doubts regarding the drawing's authenticity have been expressed by earlier students.[1] The case against the attribution to Hals is persuasive. The one-to-one correspon-

dence between many of the nervous black chalk strokes in the drawing with passages in the painting are indicative of the hand of a careful copyist working after the finished portrait, not a literal translation into paint by the master of what he had done in chalk. Additionally, the lines that define contours and establish values are neither as decisive nor as suggestive as Hals's characteristic touch. Even with the aid of white chalk highlights, they do not convincingly model the head or the bulk of the monumental figure. The highlights are decorative and have been scattered too generously without due consideration of the light source; they flatten rather than round forms. Like so many of Hals's followers, the draughtsman achieved an animated surface at the expense of solidity and clarity of spatial relationships.

The drawing, however, remains a valuable document because it shows the original state of the Hermitage portrait. It indicates that the sitter once wore a rakishly tilted hat decorated with a pompom. The hat has been overpainted. The unmistakable traces of it that are visible to the naked eye today have been confirmed by X-rays; they even can be seen in reproductions. It has been claimed that Hals himself painted

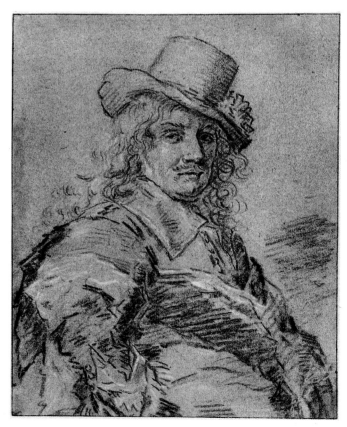

Fig. 73a Unknown artist, black and white chalk drawing after Hals's *Portrait of a Man*
London, British Museum (inv. 1895.12.14.98)

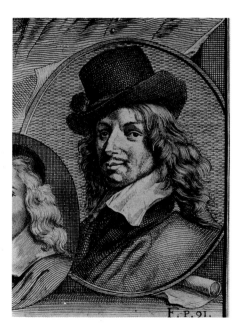

Fig. 73b Jacobus Houbraken, *Portrait of Frans Hals*, engraving in Arnold Houbraken, *De Groote Schouburgh*, Amsterdam 1718

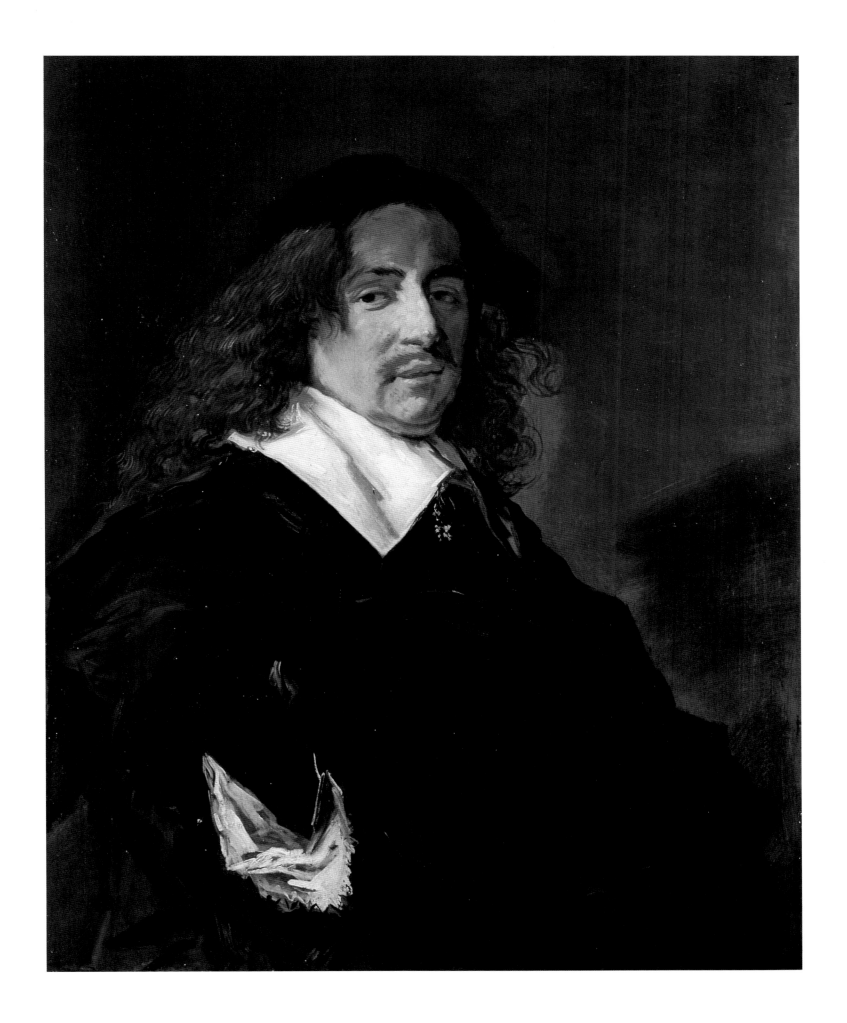

333

Fig. 73c Unknown wood-engraver, *Portrait of Frans Hals* in J. Immerzeel Jr., *De Levens en Werken* ..., vol. 2, Amsterdam 1843

tendency to give his subjects a kind of elegance is seen in the long silken locks he gave his putative portrait of Hals. It is noteworthy that the elongated face of Jacobus's portrait bears a closer resemblance to the British Museum drawing than to the rather broad one in the Hermitage painting. One would like to propose that he used the drawing as the point of departure for his engraving, and even go further and suggest that he drew it. Although the possibility that the British Museum sheet is an eighteenth-century copy cannot be ruled out, the similarities between it and the print do not provide a firm enough basis to claim that it served as a model for the engraving, and not enough is known about his gift as a draughtsman to propose that it was his effort.

If some people erroneously believed about 1718 that the Hermitage's *Portrait of a Man* was Hals's self-portrait, the notion was rejected later in the eighteenth century. The earliest documented reference to it is found in the catalogue compiled in 1774 of Catherine the Great's collection. There the painting is not listed as a 'Self-Portrait' but as a 'Portrait of a Man'.

The location of the small version of the Hermitage painting formerly in the collection H.E. ten Cate (panel, 20.5 × 18.3 cm) is unknown. Hofstede de Groot states it is an original study by Hals (RKD notes); to judge from a photograph it is an indifferent copy.

the hat out (van Regteren Altena 1929 and 1948; Fechner 1960; Lewinson-Lessing *et al.* 1962) but the dead passages of repaint in the area cannot be attributed to him. They indicate that the sitter was deprived of his hat by another hand, probably to satisfy the whim of a later collector or dealer. The alteration is not unique. The tremendous hat worn by the sitter for Hals's *Portrait of a Man* at the Fitzwilliam Museum, Cambridge, also was painted out because it did not suit the taste of a later generation, and reappeared only when the painting was cleaned in 1949 (fig. 85b; S218). Tests of the repaint on the Hermitage portrait and determination of the condition of the original paint layer below it may indicate that it can be safely removed, and the sitter could once again appear wearing his stylish hat.

The model for the Hermitage portrait bears a close resemblance to the engraved portrait of Hals that Arnold Houbraken used to illustrate the artist's biography in his *Groote Schouburgh* published in 1718 (fig. 73b; vol. 1, facing p. 91). The engraving, like most of the portraits in the *Groote Schouburgh*, can be securely attributed to Arnold's son Jacobus (1698-1780). Since Houbraken's biography was the main supplier of information about the artist until nineteenth-century historians began their archival work, his son's print became the principal source for the popular image of Hals. As late as 1843 the wood-engraver who provided illustrations for Immerzeel's lexicon on Netherlandish artists based his portrait of the artist on it (fig. 73c; Immerzeel 1843, vol. 2, p. 10).

The likeness of Hals that Jacobus Houbraken bequeathed to posterity bears little resemblance to the heads that have better reason to be called Frans's self-portraits (Introduction, figs. 6, 7). But its similarity to the works at Leningrad and London is close enough to suggest that Arnold Houbraken probably knew the image, considered it a self-portrait, and instructed his son to base his engraving on it. Jacobus's

1. Hind, who did not note the drawing's connection with the Leningrad portrait, wrote that its attribution is very uncertain, and added that the name of Cornelis Saftleven has been suggested (Arthur M. Hind, *Catalogue of Dutch Drawings of the XVII Century*, vol. 3, London 1926, p. 110, no. 3).

Trivas (90 and App. 8) called it doubtful. W. Martin introduced the drawing to the literature as a genuine Hals in a review that savaged Davies's 1902 monograph devoted to the artist (W. M[artin]., *B.M.* II [1903], p. 108); in this instance his criticism of Davies was unjustified.

PROVENANCE Acquired by Catherine II between 1763 and 1774.

EXHIBITIONS Haarlem 1962, no. 79; Washington *et al.* 1975-6, no. 21; Madrid 1981, p. 38; Rotterdam 1985, no. 9; Sydney & Melbourne 1988, no. 15.

LITERATURE Catalogues Hermitage, Leningrad, 1863 to 1916, no. 772; Waagen 1864, p. 172, no. 772; Bode 1883, 130 (c. 1660, or later); Moes 182; HdG 309 (c. 1645, or later); Bode-Binder 266; KdK 258 (c. 1650-2); I.Q. van Regteren Altena, 'Frans Hals teekenaar', *O.H.* XLVI (1929), pp. 149-52; Trivas 96 (c. 1650); I.Q. van Regteren Altena, *Holländische Meisterzeichnungen des siebzehten Jahrhunderts*, Basel 1948, p. XVIII, no. 16; Catalogue Hermitage, Leningrad, 1958, vol. 2, p. 170, no. 816 (c. 1660); H. Fechner, '"Muzhskoi Portret" roboty Fransa Galsa', *Soobshcheniia Gosudarstvennogo Ermitazha* XIX (1960), pp. 14-6; W.F. Lewinson-Lessing *et al.*, *Meisterwerke aus der Hermitage: Holländische und Flämische Schule*, Leningrad 1962, no. 28; Slive 1970-4, vol. 1, pp. 191-3; Grimm 148 (c. 1652-3); Montagni 186 (c. 1652); Baard 1981, p. 148; Catalogue Hermitage, Leningrad, 1981, p. 176; Kuznetsov & Linnik 1982, no. 37.

▷
Detail from cat. 74

74 Portrait of a Woman

c.1655-60
Canvas, 60 × 55.6 cm
S196
Ferens Art Gallery: Hull City Museums and Art Galleries (inv. 526)
Exhibited in London and Haarlem

Until the portrait was published by W. Martin in 1952, it was attributed to Aelbert Cuyp (Dordrecht 1620-1691 Dordrecht). Martin rightly recognised it as an authentic work by Hals, but placed it about a decade too early when he dated it around 1645. The frontal pose and the handling relate to paintings datable to the second half of the fifties. Here the rigidity of a bust portrait seen *en face* is broken by Hals's observation that his patroness posed with her head tilted ever so slightly, and by his making her huge kerchief a bit asymmetrical. There is moderate abrasion on the forehead, dress and background but these minor losses are not detractions in this affecting portrait which shows that old Hals lost none of his ability to characterise the poignantly tender side of a young woman's nature.

PROVENANCE According to W. Martin (1952, p. 360), it possibly was acquired 'by the 4th and last Earl of Egremont to replace the pictures removed by his predecessor from Orchard Wyndham House to Petworth, which was left away from him when he inherited the earldom in 1836. On the death of his widow, the last Countess of Egremont, in 1876, Orchard Wyndham and all its contents passed to the grandfather of the present owner [George Wyndham], who has come into the property from his uncle, the late Mr. William Wyndham.' George Wyndham, Orchard Wyndham, Wilton, near Taunton, Somersetshire; sale George Wyndham, London (Christie's), 24 November 1961, no. 70; purchased by the gallery in 1963.

EXHIBITIONS London 1952-3, no. 137; Manchester 1957, no. 118; Liverpool 1968, no. 40; Leeds 1982-3, no. 4; Birmingham 1989-90, no. 55.

LITERATURE W. Martin, 'An Unknown Portrait by Frans Hals', *B.M.* XCIV (1952), pp. 359-60 (c.1645); Ferens Art Gallery *Bulletin*, April-June 1963, unpaginated (1655-60); Slive 1970-4, vol. 1, p. 194; Grimm 1971, p. 163, no. 52 (Frans Hals II; 1656-60); Montagni 264 (attributed to Hals); Baard 1981, p. 152 (c.1660; Hals).

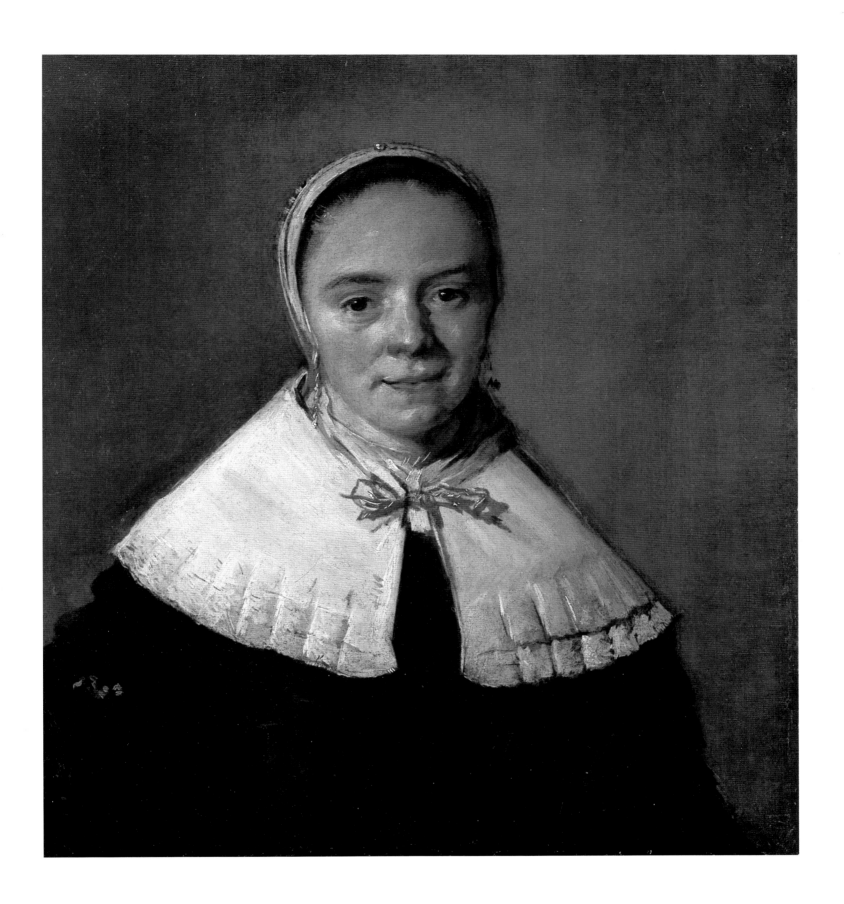

337

75 Portrait of a Man

c.1655-60
Canvas, 104 × 84.5 cm
Signed, lower right, with the connected monogram: FH
S202
Statens Museum for Kunst (The Royal Museum of Fine Arts),
Copenhagen (inv. 3847)

The imposing portrait shows how Hals's execution became more flexible and daring in works datable after the mid-fifties. As in other portraits assigned to this phase, the head of the man is modelled with incredibly fine gradations of thin paint in the light areas that contrast with a few shadows. But a distinctly different technique is used for the model's large hands, gloves and cuffs, where Hals relies on a minimum of bold, disembodied touches to suggest forms. He appears to have deliberately allowed this area to go out of focus to force concentration on his patron's head. These variations in finish are not new. He used them in genre pictures painted more than two decades earlier.

Valentiner (KdK 280) suggested that the portrait probably was the companion piece of the *Portrait of a Woman* formerly in the collection of Joseph Samson Stevens, New York. In my opinion there is no foundation to his proposal; moreover, the attribution of the Stevens painting to Hals is questionable (see Slive 1970-4, vol. 3, no.D78 and fig. 201).

Copenhagen's portrait belonged to the Suermondt Collection, which was acquired by the Berlin museum in 1874. The rich collection brought four other masterworks by Hals to Berlin; three of them are in the exhibition: *Catharina Hooft with her Nurse, Boy with a Flute, Malle Babbe* (cat. 9, 15, 37; the fourth is a little *Portrait of a Man* [inv. 801F; S35]). In about 1927, Wilhelm von Bode, then director of the Kaiser-Friedrich-Museum, de-accessioned the present portrait. Friedrich Winkler (1931, p. 489), at the time one of the museum's curators, tells us why. As German museum acquisition funds were pitifully low after World War I, exchange or sale of works of art frequently was the only way a museum could acquire a new treasure. During the 1920s Bode occasionally did both for his museum. In this case Bode

... exchanged [the] very beautiful male portrait by Frans Hals for the first large landscape by Rubens worthy of his museum which he found on the art market; for fifty years he had searched for and failed to discover such a work. Hals was over-abundantly represented in the museum, and from the latest period of the artist during which the exchanged picture originated, the Kaiser-Friedrich-Museum possessed still another, and a better one.

The Rubens acquired by Bode for Berlin is the artist's *Landscape with Cows and Duck Hunters* (fig. 75a). The number of Hals paintings considered overabundant at the time was eleven, and the late Hals judged superior to the present painting is his *Thyman Oosdorp* (Biesboer, fig. 8).

Did the great Bode de-accession the wrong late Hals? No matter how the question is answered, in the end, the transaction benefited both Berlin and Copenhagen.

PROVENANCE Collection B. Suermondt, Aachen, from which it was acquired by the Berlin museums in 1874; sold by the Kaiser-Friedrich-Museum *c*.1927; purchased at Amsterdam in 1929 by the Copenhagen museum.

EXHIBITION Brussels 1873b, no. 80.

LITERATURE *Verzeichnis der ... Sammlungen des B. Suermondt*, Berlin 1875, no. 17; Bode 1883, 88 (*c*.1660); Moes 164; HdG 254 (*c*.1660); Catalogue Kaiser-Friedrich-Museum, Berlin, 1912, no. 801E; Bode-Binder 263; KdK 280 (*c*.1657-60); G. Falck, 'Frans Hals' Mandsportraet og Philips Konincks Landskab', *Kunstmuseets Aarsskrift* XVI-XVIII (1929-31), pp. 127ff., F. Winkler, 'Der Tauschhandel der Museen und der Braunschweiger Vermeer', *Pantheon* VIII (1931), pp. 488-9; Catalogue The Royal Museum of Fine Arts, Copenhagen, 1951, p. 120, no. 289; Slive 1970-4, vol. 1, p. 195; Grimm 1971, p. 163, no. 31 (Frans Hals II; 1654-6); Montagni 243.

Fig. 75a Peter Paul Rubens, *Landscape with Cows and Duck Hunters*
West Berlin, Staatliche Museen Preussischer Kulturbesitz (inv. 2013)

338

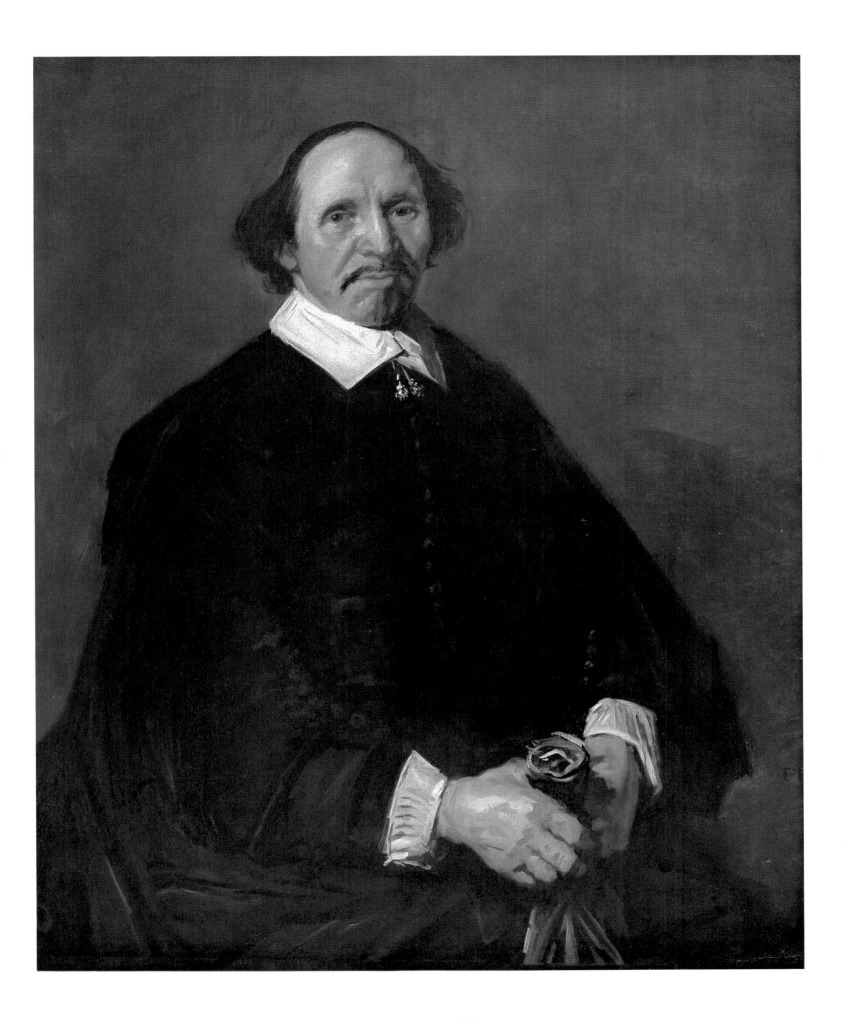

Vincent Laurensz van der Vinne

*c.*1655-60
Canvas, 64.8 × 48.9 cm
An indecipherable monogram, lower right, that bears no relation to
Hals's known monograms
S203
Art Gallery of Ontario, Toronto, Bequest of Frank B. Wood, 1955
(inv. 54/32)

The identification of the sitter is based on Vincent Laurensz van der Vinne's own mezzotint after it, which bears the title 'Vincent Laur: Vand': Vinne' and is inscribed: '*F. Hals Pinxit VvVinne Fec.*' (fig. 76a). The print and other old copies of the portrait (fig. 76b; references to additional copies are cited below) suggest the painting has been cut on both sides. The paint surface is moderately abraded and there are scattered losses on the right side of the head, parts of the background and along the four outer edges.

Van der Vinne (1628-1702) was a Haarlem painter who founded a minor dynasty of easily confused artists because of the penchant of successive generations of his family to give their sons the same Christian names (for the family's genealogy, see van der Willigen 1870, Supplement F). The Vincent that Hals portrayed was his pupil for nine months in 1646-7 (Geslagt-Register van der Vinne, Sliggers 1979, p. 15). He left his native city on 21 August 1652 for a journey that took him through Germany, Switzerland and France; he returned home on 1 September 1655. The illustrated journal he kept during

his travels offers a rare record of a Dutch artist's *Wanderjahre* (Sliggers 1979). Since the style of Hals's portrait precludes a date prior to Vincent's departure for his three-year trip, his return to Haarlem in 1655 provides a *terminus post quem* for the portrait. Its brevity of touch and exceptionally fluid brushwork suggest a date closer to 1660 than 1655. As noted in the Provenance below, an inventory made of van der Vinne's effects in 1668 cites a painting by Frans Hals, and another compiled after his death in 1702 lists a 'portrait of the deceased'. These laconic references possibly refer to the Toronto portrait.

In the portrait, Hals is even more laconic about his pupil's profession. He did not include an attribute to indicate that his sitter was an artist. Similarly, when Hals portrayed Frans Post (cat. 77), he offered no hint that his model was a landscapist, and support for the identification of his portrait of *Adriaen van Ostade* (National Gallery, Washington; S192) is not bolstered by a single reference to his craft. Hals gave clues that his sitters were artists in only two of his portraits: one shows

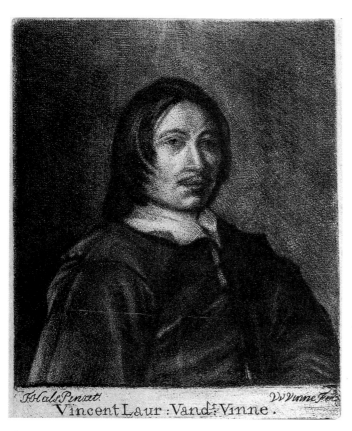

Fig. 76a Vincent Laurensz van der Vinne, mezzotint after Hals's *Vincent Laurensz van der Vinne*

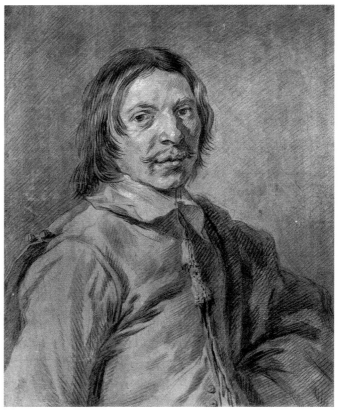

Fig. 76b Lodewyck de Moni, drawing after Hals's *Vincent Laurensz van der Vinne*
London, British Museum (inv. 1865.1.14.829)

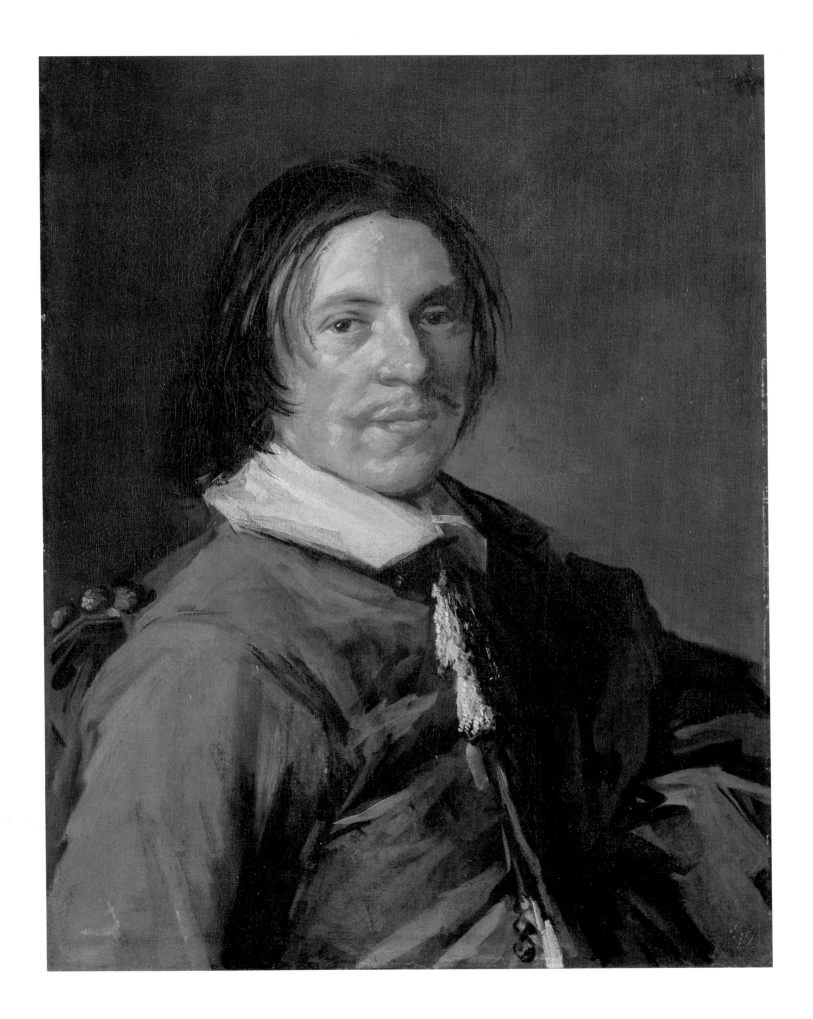

a patron holding a brush (Frick Collection; s186); the other presents a man near a conspicuous palette hanging on a wall (Art Institute of Chicago; s164). Despite these unmistakable signs that both portraits depict painters, all efforts to pinpoint their identities have failed.

Houbraken tells us that van der Vinne became the kind of artist who painted anything that came his way – kitchens and attics as well as cabinet pictures and signboards. According to Houbraken he specialised as a sign-painter because he usually applied himself to what was most profitable; the quality of his output in this kind of painting made his contemporary Job Berckheyde dub him 'The Raphael of the Signboard Painters'.

Houbraken also notes that van der Vinne was good at making portraits, and that they were done with a bold brush in the manner of his teacher Hals, who, he adds, used to tell his students: 'You must smear boldly; when you are settled in art, neatness will surely come by itself' ('*Gy moet maar stout toesmeeren: als gy vast in de Konst wert zal netheit van zelf wel kommen*'; Houbraken 1718-21, vol.2, p.211). His biographer's word that he could work skilfully in his master's style makes van der Vinne a contender for the authorship of some of the unattributable pictures done in Hals's manner. However, none have been identified,[1] and the still-lifes and landscapes that are securely attributed to him show no trace of his teacher's original technique.

The idea that the indecipherable monogram on the Toronto portrait may be van der Vinne's own can be dismissed out of hand. Not only does his mezzotint explicitly state that Hals painted it, but nothing in the pupil's own paintings indicates that he ever approached Hals's summary brushwork while maintaining fine adjustments in the transitional tones suggesting the shimmer of silvery light filtering over surfaces without sacrificing solidity of form. Only Velázquez could match this performance. The attempt to pass the portrait off as a signed and dated Velázquez by 1873 (see Exhibitions below) was an intelligent bit of skullduggery.

More copies of the Toronto portrait are known than of most of Hals's mature works. In addition to van der Vinne's mezzotint and the drawing after it by Lodewyck de Moni (1698-1771) at the British Museum (fig.76b), watercolour copies by Cornelis van Noorde (1731-95) are at the Haarlem City Archives (dated 1754) and at the Rijksprentenkabinet, Leiden (dated 1758), and there is an anonymous watercolour copy of it at the Teyler Museum, Haarlem. Parochial interest in the sitter, whose own family included artists who, in turn, fathered two more generations of artists, helps account for the portrait's popularity. But the eighteenth-century copyists'

fascination with the intensity and economy of the late portrait should not be sold short. In their own way each of the copyists attempted to replicate it.

A poor copy of the painting is in the Gemäldegalerie, Dresden.[2]

1. The intriguing painting described as a portrait of V. van der Vinne with a drawing in his hand, painted in the manner of Frans Hals, which appeared in the sale van der Marck, Amsterdam, 25 August 1773, no.472 (canvas, 31 × 25 d.), is untraceable. Possibly it was a self-portrait done in Hals's style.

2. Catalogue 1908, no.1362; panel, 63 × 47.5 cm. PROVENANCE: Sale L. van Oukerke, 19 May 1818, no.14 (said to be on canvas; Dfl.20, Lebe); Coll. van der Vinne, Haarlem, from which it was acquired by A. van der Willigen in 1859; sale A. and A.P. van der Willigen, Haarlem, 20 April 1874, no.36 (Dfl.21, Vegtel). LITERA-TURE: *Icon. Bat.* no.8517-3 (I have been unable to locate the print by C. van Noorde which is mentioned in this reference); Moes 82; HdG 236a ('probably derives from a genuine lost painting'; Hofstede de Groot did not recognise that his no.324 was the original); Valentiner 1936, 103, note (copy, possibly late eighteenth century or even later).

A miserable portrait called Vincent Laurensz van der Vinne (panel, 25 × 20 cm), which is listed and reproduced in Bode-Binder 284 and KdK 272, is neither a portrait of van der Vinne nor by Hals. In 1914 it was with the London dealer E.H.Gorett, and in 1923 in the Lucerne art market.

PROVENANCE Two inventories are known of van der Vinne's effects: one was compiled in 1668 after the death of his first wife; the second after his own death on 28 July 1702. The former lists a painting by Frans Hals in his possession (Bredius, vol.4, p.1259, no.22); the latter cites 'het portret van den overledene' (ibid., p.1261, no.3); both inventories are published in full in Sliggers 1979, pp.168-72. These references to a painting by van der Vinne's teacher and a portrait of the deceased possibly refer to the present painting. Count Kaunitz, Imperial Chancellor of Austria (d.1794), Vienna; Grünauer, Vienna; Baroness Auguste Stummer von Tavarnok, Vienna; F.Kleinberger, Paris; Frank P.Wood, Toronto, who bequeathed it to the gallery in 1955; stolen in September 1959, and returned to the gallery in the same year.

EXHIBITIONS Vienna 1873, no.138 (the catalogue states that it had formerly borne the false signature and date 'Diego Velasquez, 1642'); Toronto 1926, no.150; Toronto 1955, no.31; Haarlem 1962, no.64; San Francisco, Toledo & Boston 1966-7, no.21; Baltimore 1968, pp.24-5.

LITERATURE T. von Frimmel, *Verzeichnis der Gemälde im Besitze der Frau Baronin Auguste Stummer von Tavarnok*, Vienna 1895, p.30, no.73; *Icon. Bat.* no.8517-2; Moes 178; HdG 324; Bode-Binder 238; KdK 253 (c.1650); Valentiner 1936, 103 (c.1655); Hubbard 1956, p.151; Slive 1970-4, vol.1, pp.187-8; Grimm 156 (c.1658); Montagni 200 (1655-60); Handbook, Art Gallery of Ontario, Toronto, 1974, p.42; Sliggers 1979, p.18.

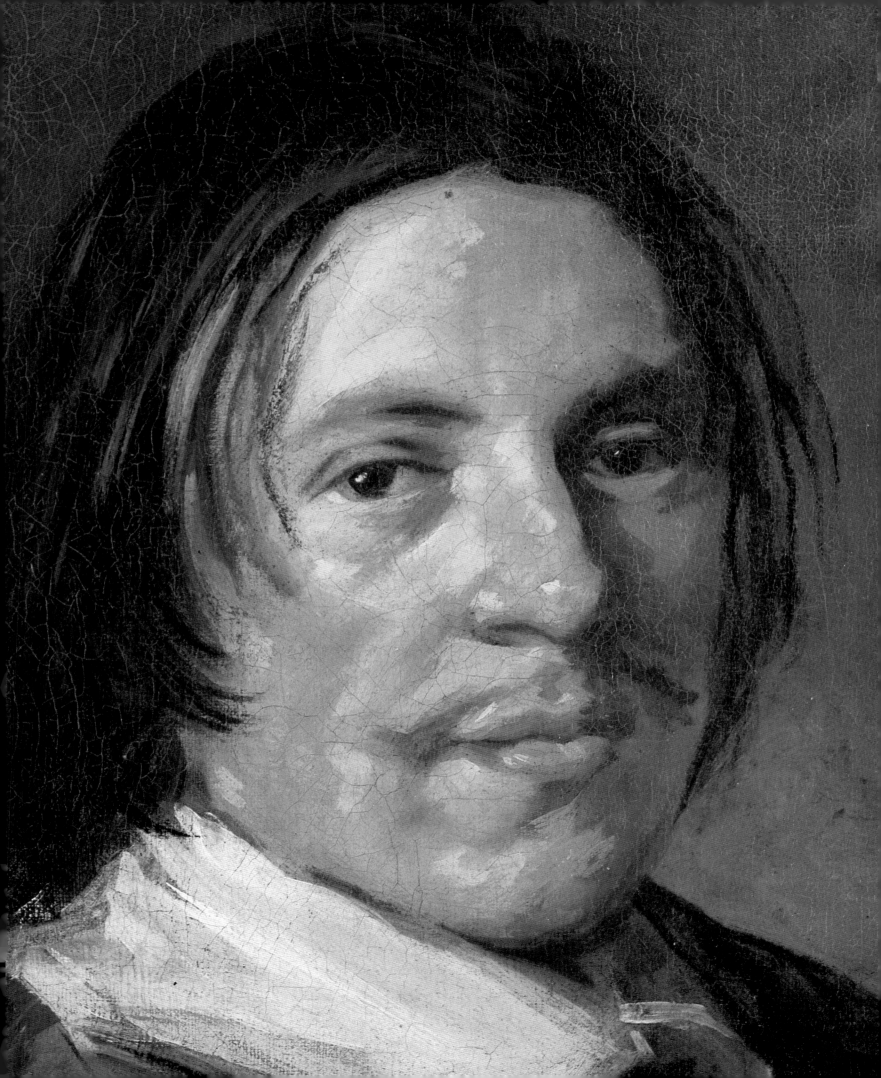

77 Frans Post

*c.*1655
Panel, 27.5 × 23 cm
s206
Private collection

The identification of the friendly sitter for this small informal portrait as the Haarlem landscapist Frans Post (*c.*1612-80) is based on an inscription written on the lower margin of an impression of the first state (*avant la lettre*) of Jonas Suyderhoef's reversed engraving (Wussin 1863, 68) of it at the Albertina (fig.77a; inv. H.I.61, p.60): '*Francois Post, Peinctre de prince Mauriti Gouveneur des Indes Occidentales*'. Suyderhoef's print (27.8 × 22.9 cm) and the little painting are almost identical in size, which suggests that the painting was painted as a *modello* for the engraving. Wussin also lists a second state of the print *avec la lettre*; I have been unable to locate an impression of it. Hollstein (vol.28, p.247, no.106) catalogues Suyderhoef's print as Frans Post after Hals, but makes no reference to the Albertina impression or to the various states of the engraving.

Frans Post earned a special place in the history of landscape painting when he joined the retinue of Count Johan Maurits of Nassau Siegen on his expedition to secure a firm footing for the Dutch West India Company in the north-eastern part of Brazil. The landscapes Post made there from 1637 to 1644 were the first ones of the New World done by a trained European artist. They are precious records of a seventeenth-century Dutchman's response to a strange continent inhabited by exotic natives, plants and beasts; an outstanding one is at the Louvre (fig.77b). Upon his return to Holland in 1644 Post settled in Haarlem, where he continued to paint Brazilian landscapes with the help of his early studies.

Frans's brother Pieter Post (*c.*1608-69) was also a painter, but is better known as an architect who worked in the classical style that began to dominate Dutch building after the middle of the century. Hals's portrait of Frans Post had been identified erroneously as a portrait of his brother until Moes (1905) established that it represents the member of the family whose

speciality was depicting views of Brazil. As in his portrait of the Haarlem artist Vincent Laurensz van der Vinne (cat.76), Hals provides no brush, palette or other accessory to indicate that Frans Post was a professional painter.

Hals's portrayal of Frans Post is datable about 1655, and probably is one of the earliest of the existing small portraits he painted during his last phase. Apart from the one of Post, eight others are known; three are catalogued here (cat.78, 79, 80); the others are: s199, s207, s208, fig.78a; s210, fig.78b; s212, fig.79a. The approximate dates assigned to this group are based solely on their style; none of these little portraits are dated. All show that, until the very end, Hals remained at home working on a small as well as a life-size scale.

A portrait by Hals called 'Frans Post, West Indian landscape painter' appeared in a 1773 Amsterdam sale. However, to judge from its description and dimensions,[1] this picture probably is identical with the artist's little painting of a *Seated Man holding a Branch* now at Ottawa (cat.59). If it is, the claim that entered the early literature that the Ottawa picture also portrays Post is untenable. The sitters for these portraits surely are different men.

1. Sale J. van der Marck, Amsterdam, 25 August 1773, no.441: 'Frans Post Westindisch landschapschilder ... Men ziet hem verbeeld met een hoed op 't hoofd en een lauwertek in de hand, zittende en rustende met zyn arm op de leuning van de stoel. Door Frans Hals fix en kragtig geschilderd, op paneel, h. 17 1/2 br. 12 3/4 duim.' (Dfl.42, Fouquet). M.G.Wildeman (1905) and E.Larsen (*Frans Post*, Amsterdam & Rio de Janeiro 1962, p.222, note 209) incorrectly state that a wash drawing by the Haarlem artist Cornelis van den Berg (1699-1774) after the painting described in the 1773 Amsterdam sale is at the City Archives at Haarlem (XIII, 42). Van den Berg's drawing is, in fact, a copy after Hals's portrait of Frans Post, and, since it reverses the little painting, was probably done after Suyderhoef's engraving.

PROVENANCE Possibly sale Amsterdam, 10 May 1830, no.142 (Dfl.1, Gruyter); possibly sale J.Smies, J.H.Knoop and others, Amsterdam, 24 February 1834, no.45; sale Albert Levy, London (Christie's), 6 April 1876, no.338 (£157.10); J.Walter, Bearwood; dealer C.Sedelmeyer, Paris, Catalogue, 1902, no.19; H.Teixeira de Mattos, Vogelenzang; dealer F.Muller & Co., Amsterdam; P.A.B.Widener, Elkins Park, Pennsylvania; sale P.A.B.Widener, Amsterdam (Muller), 10 July 1923, no.110; dealer Knoedler, New York; George Lindsay, St. Paul, Minnesota, who bequeathed it to his nephew Edwin B.Lindsay, Davenport, Iowa; Mrs. David Corbett (d.1988), Evanston, Illinois; sale Estate of Elizabeth Lindsay Corbett, New York (Christie's), 31 May 1989, no.112 (bought in).

EXHIBITIONS London, Royal Academy, 1873, no.97; London, Royal Academy, 1882, no.123; The Hague 1903, no.39; Amsterdam 1906, no.57; on loan to Municipal Art Gallery, Davenport, Iowa, 1953-54; The Hague 1979-80, no.47.

LITERATURE Bode 1883, 144 (*c.*1650; 'Portrait of a Man'); van Someren, vol.3, 1891, p.503, no.4290 (incorrectly identified as Pieter Post); *Icon. Bat.* no.6034; G.W.Moes, 'Frans Post geschilderd door Frans Hals', *Bulletin Nederlandschen Oudheidkundigen Bond* VI (1905), pp.57-9, 93 (also see a note by M.G.Wildeman, ibid., p.92); Moes 64; HdG 215; *Pictures in the Collection of P.A.B.Widener at Lynnewood Hall, Elkins Park, Pennsylvania, Early German, Dutch and Flemish Schools ...*, notes by C.Hofstede de Groot & Wilhelm R.Valentiner, 1913, unpaginated; Bode-Binder 228; KdK 271 (*c.*1655); Slive 1970-4, vol.1, pp.186, 197 (*c.*1655); Grimm A35b (1652-4; small copy); Montagni 190 (copy).

Fig.77b Frans Post, *The São Francisco River with Fort Maurits, Brazil*, 1638
Paris, Musée du Louvre (INV.1727)

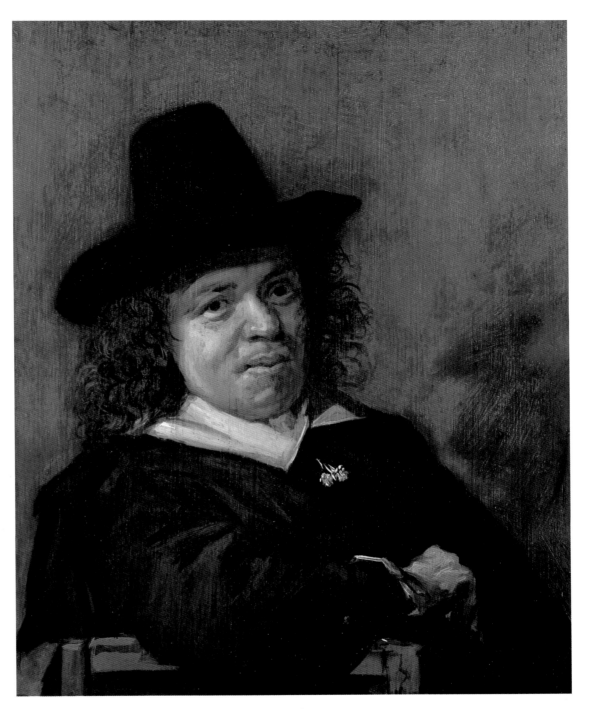

Fig. 77a Jonas Suyderhoef, engraving after Hals's *Frans Post*

78　Portrait of a Preacher

c.1658-60
Panel, 35.5 × 29.5 cm
Signed, lower right, with the connected monogram: FH
S209
Private collection

This outstanding portrait sums up in miniature the freedom of handling and the sombre undertone common to Hals's life-size late works. The unidentified man's skullcap accounts for his traditional identification as a preacher. However, we know that divines were not the only seventeenth-century Dutchmen who wore skullcaps.

In 1910 Hofstede de Groot (273) suggested that the sitter may be Jan Ruyll, the Haarlem minister whose portrait by Hals was celebrated in a poem Arnold Moonen wrote in 1680, which was published in his *Poëzij* (Amsterdam 1700, pp.679-80). Later Hofstede de Groot (1915-6, pp.321-3) proposed that Hals's little, late *Portrait of a Man* at the Rijksmuseum may be his portrait of Jan Ruyll (fig.78a). Moes (1909, pp. 66-7, 103, no.67) offered yet another small late portrait, now at the Mauritshuis (fig.78b) as his candidate for Ruyll. There is no evidence to support any of these identifications. Hals's portrait of Ruyll remains unidentified or is lost. Moonen's poem, straightforwardly called 'Joannes Ruil, painted by Frans Hals' ('*Joannes Ruil, door Frans Hals geschildert*'), does not offer a clue that would help trace it. He writes only that he found some satisfaction in Hals's portrait of the deceased Haarlem preacher, adds a couple of complimentary words about the artist's brushwork and gently, but conventionally, urges us to use it as a reminder of the admonitions Hals's sitter preached:

> Here is the portrait of your devout Ruyll
> O Haarlem, your hero, your support, and pillar
> Of temple peace, as naturally as if he lived,
> Thanks to Hals, whose brush spiritedly glides

With height and depth. But if the spirit of the man had ever charmed you.
Retain the lesson heard from his golden mouth.
1680
(Dit is de beeltenis van uw' getrouwen Ruil,
O Haerlem, uwen helt, uw kerkpilaer, en zuil.
Der tempelvrede, zoo natuurlyk of hy leefde.
Men dank' dit Hals, wiens kunstpenseel dus geestigh zweefde
Met hoog en diep. Doch heeft 's Mans geest usj ooit bekoort.
Bewaer de lessen, uit zijn'gulden mont gehoort.
1680)

PROVENANCE　Baron von Liphart, Rathshof near Dorpat, later of Dresden; Edward W.Bok, Philadelphia; Mrs. Edward W.Bok, later Mrs. Efrem Zimbalist, Philadelphia; Cary William Bok, Philadelphia; sale estate of C.W.Bok, London (Christie's), 25 June 1971, no.18 (£54,000, Brod); Brod Gallery, London, *Twelve Portraits*, 1971, no.1; private collection, England; dealer Brod, London, 1974. Valentiner (KdK 1921, 267; KdK 283) unaccountably states that the painting was in the Heilbuth Collection, a reference he understandably deleted when he published the picture again in 1936 (no.104). Perhaps he originally confounded the present painting with another small late portrait, now at the Mauritshuis (fig.78b), which was in the Heilbuth Collection.

EXHIBITIONS　New York 1937, no.25; Haarlem 1962, no.76.

LITERATURE　Moes 179; HdG 273 (c.1650; possibly a portrait of Jan Ruyll); Bode-Binder 274; KdK 283 (c.1658); Valentiner 1936, 104 (c.1658); Slive 1970-4, vol.1, p.198; Grimm 155 (1658); Montagni 201 (c.1658).

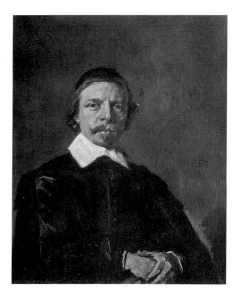

Fig.78a *Portrait of a Man* (S208)
Amsterdam, Rijksmuseum

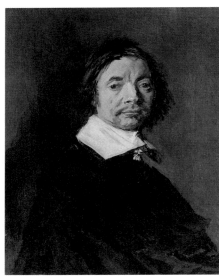

Fig.78b *Portrait of a Man* (S210)
The Hague, Mauritshuis

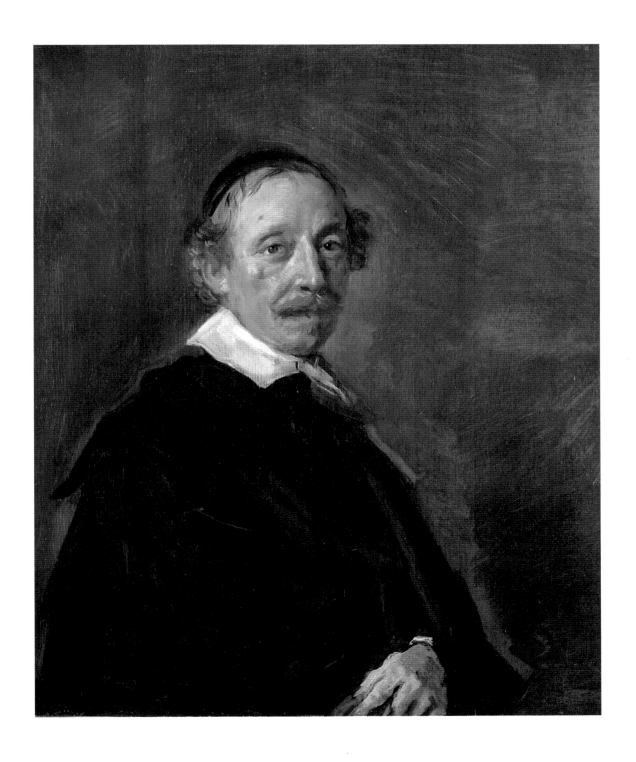

Portrait of a Seated Woman

*c.*1660-6
Panel, 44.5 × 34.3 cm
Signed, lower right, with the connected monogram: FH
S211
Senior Common Room, Christ Church, Oxford (inv. PO589)
Exhibited in London

The pose of this stout woman suggests she had a pendant. Close to the right side of her head a rare glimpse of the artist's underdrawing can be seen beneath the thin layer of background paint; it is related to an earlier position he adopted for his sitter (pl. VIII j).

The superb painting is Hals's only existing small female portrait datable to his last period. Evidently the candour and open brushwork which we value so highly in the artist's late works were not qualities that many Dutch women looked for during these years when they hired an artist to make a miniature-like portrait. Indeed, there is excellent reason to believe that the wife of at least one of Hals's clients chose not to sit for hers. Jan de Bray, not Hals, made the pendant (fig.79b) to the freely painted little portrait Hals did of *Cornelis Guldewagen* about 1660-3, now at Urbana (fig.79a). De Bray's portrait of Guldewagen's wife is dated 1663. If she decided not to pose for Hals about this time, she could not have made a better choice than de Bray. He was able to provide her with a degree of finish that was alien to old Hals, and was flexible enough to adjust his palette and tonalities to make a harmonious companion piece to her husband's little portrait.

The reverse of the Oxford portrait's radially cut wooden support is bevelled on three sides, not four, which was the practice to facilitate framing. Its thin right side (*c.*8-10 mm) is the thin side of a radially cut plank; hence it did not need bevelling (Groen & Hendriks, p.110).

PROVENANCE Perhaps identical with 'A Small Portrait of a Woman, showing both hands', which appeared in the sale Amsterdam, 15 April 1739, no.99 (Dfl.21; see Hoet, vol.1, 581); bequeathed to the Senior Common Room of Christ Church by William Scoltock, M.A., in 1886.

EXHIBITIONS Haarlem 1937, no.111; London 1938, no.271; London 1945, no.8; Amsterdam 1952, no.52; London 1952-3, no.115; Haarlem 1962, no.68; Oxford 1975, no.35; London 1976, no.52.

LITERATURE Perhaps identical with HdG 399f; Slive 1970-4, vol.1, p.199; Slive 1970-4, vol.3, no.211 (erroneously cited as identical with Trivas 90); Grimm 160 (1658-60); Montagni 204 (*c.*1660).

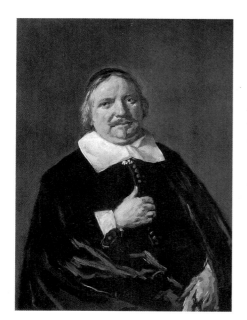

Fig.79a *Cornelis Guldewagen* (s212)
Urbana, University of Illinois, Krannert Art Museum

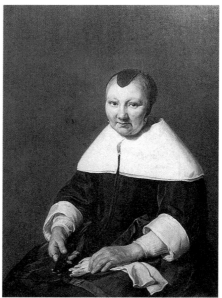

Fig.79b Jan de Bray, *Agatha van Hoorn*, 1663
Luxembourg, Musée J.P. Pescatore

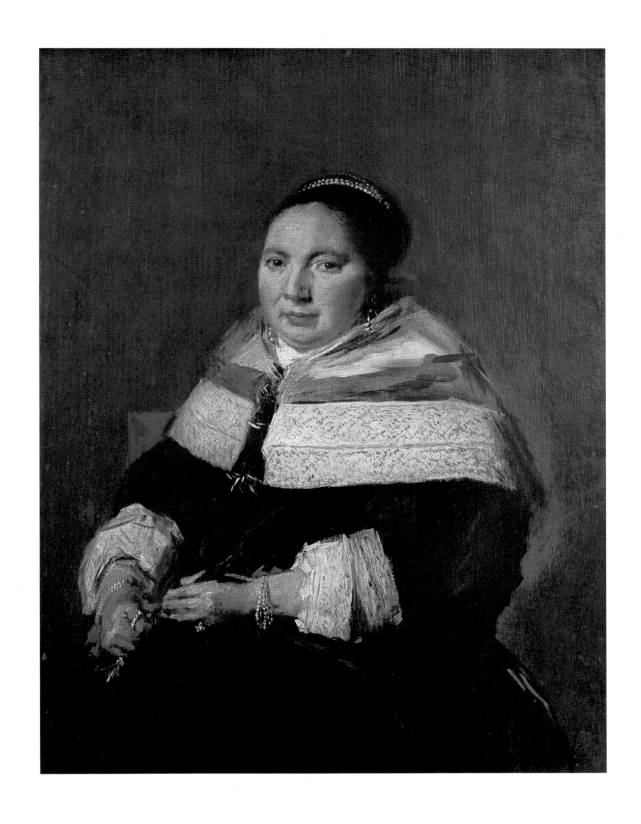

80 Willem Croes

c.1662-6
Panel, 47.1 × 34 cm
Signed, lower left, with the connected monogram: FH
S213
Bayerische Staatsgemäldesammlungen, Munich (inv. 8402)

Bode (1883, 26) and Moes (*Icon. Bat.* no. 1808; 1909, 30) state that this brilliant little portrait of Willem Croes, a Haarlem brewer, is dated 1658. However, as early as 1906 Voll noted that the picture does not bear a date, and no trace of one can be seen today. To judge from the painting's exceptionally fluid handling, it was done later than the fifties, and it may very well be one of the artist's latest existing little portraits. Croes was buried in Haarlem on 11 August 1666; Hals died there less than three weeks later.

As in his other little portraits, Frans adjusted the size of each stroke to the small scale of the panel. Here virtually every trace of conventional finish has been eliminated. The sacrifice could hardly have been more worthwhile. Smooth surfaces and clear outlines were a small price to pay for the enormous gain in spirit.

Willem Croes's choice of Frans Hals as his portraitist raises a question regarding his patronage of Hals, when we learn that not he but Johannes Verspronck was the favourite artist of the Croes family of Haarlem. Verspronck painted characteristically neat portraits of Croes's sister, her daughter and son-in-law (Ekkart in Haarlem 1979, nos. 54, 86, 87) and almost certainly one of her son-in-law's brother (ibid., no. 93). Then why did Croes turn to Hals instead of Verspronck for his portrait? The late date proposed here for the little portrait may provide the answer. If Willem Croes decided to have his portrait done after June 1662, he could not have followed the family tradition of commissioning Verspronck to paint it; Verspronck was buried in Haarlem on 30 June 1662.[1]

Hals's work must have been familiar to Croes, who was a friend of Josephus Coymans, whose portrait as well as those of his wife, daughter and son-in-law were painted by Frans Hals during the artist's maturity (see cat. 68). In 1650 Croes and Josephus Coymans were almost next-door neighbours

and, furthermore, the house adjacent to Croes's was occupied by Paulus van Beresteyn who commissioned Hals to paint his and his wife's portraits about 1620 (cat. 6, 7).

A brush drawing signed 'frago' has been published by Alexandre Ananoff (*L'œuvre dessinée de Jean-Honoré Fragonard*, Paris 1970, vol. 4, no. 2544, fig. 634) as a copy by Fragonard after the Munich portrait. It is also cited in Slive 1970-4 (vol. 3, no. 213, fig. 52). According to Eunice Williams (private communication), the drawing is a modern (twentieth-century?) forgery that can be grouped with others by the same hand that appear in Ananoff's corpus.

1. Pieter Biesboer endorses a late date (c. 1665) for the portrait as well; the supposition that Croes turned to Hals because of Verspronck's death was proposed first by him (Biesboer, p. 34). His research also turned up the information regarding Croes's close Haarlem neighbours mentioned below (ibid.).

PROVENANCE Steengracht van Oosterland, The Hague; Baron C.C.A. van Pallandt, The Hague; Countess van der Linden (née van Pallandt), Lisse; Mr. van Stolk, Haarlem, from whom it was acquired by the museum for 85,000 marks in 1906.

EXHIBITIONS Amsterdam 1872, no. 88 ('Mansportret'); The Hague 1881, no. 150; Rome 1928, no. 42; Amsterdam 1948, no. 70; Paris 1949, no. 105.

LITERATURE Bode 1883, 26 (dated 1658); *Icon. Bat.* no. 1808 (dated 1658); K. Voll, 'Frans Hals in der Alten Pinakothek in München', *Kunst und Künstler* IV (1906), pp. 319-21 (c. 1650); K. Voll, 'Frans Hals in der Alten Pinakothek', *Münchner Jahrbuch der bildenden Kunst* I (1906), pp. 33-5 (c. 1658); Moes 30 (dated 1658); HdG 171 (c. 1658); Bode-Binder 276; KdK 267 (c. 1653-5); Trivas 104 (not earlier than 1655); Slive 1970-4, vol. 1, p. 200 (later than 1658); Grimm 159 (c. 1658-60); Montagni 206 (c. 1660); Catalogue Alte Pinakothek, Munich, 1983, p. 239, no. 8502 (c. 1660).

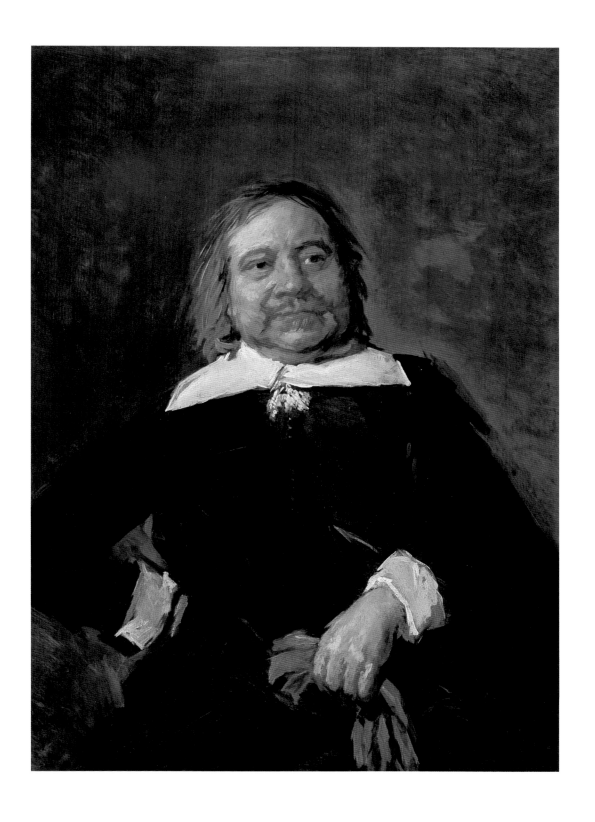

Herman Langelius

*c.*1660
Canvas, 76 × 63.5 cm
Signed, right at shoulder level, with the connected monogram: FH
S215
Musée de Picardie, Amiens
Exhibited in Washington

Moes (1909, pp.68, 102, no.51) identified the sitter as the leading Amsterdam minister Herman Langelius (1614-66). He was characterised by the contemporary poet Jeremias de Decker as a man who 'fought with the help of God's word, as with an iron sword, against atheism', a description not contradicted by Hals's powerful portrait. Langelius played an important role in banning Vondel's drama *Lucifer* from the Amsterdam stage after two performances and in the confiscation of printed copies of it, actions that predictably made the tragedy a best-seller which appeared in numerous editions to satisfy the public's hunger for a proscribed play.

After the death of Hals and Langelius – they died within a fortnight of each other – the portrait was engraved in the same direction by Abraham Blooteling (1640-90); his print is inscribed: '*M. HERMANNUS LANGELIUS ... OBIIT X SEPT. A°MDCLXVI ... F. HALS PINXIT ... A. BLOTELINGH SCULPSIT.*' (fig.81a; 38.7 × 25.5 cm; Hollstein, vol.2, p.176, no.25).

Neither the anonymous Latin[1] nor Dutch[2] poem on Blooteling's print mention Hals's portrait but there is little reason to doubt that it served as the subject of a poem by Herman Frederik Waterloos which was included in *De Hollantsche Parnas*, an anthology of verse published at Amsterdam in 1660 (Hals doc.158):

> Why, old Hals, do you try and paint Langelius?
> Your eyes are too dim for his learned lustre,
> And your stiffened hand too crude and artless
> To express the superhuman, peerless
> Mind of this man and teacher.
> Haarlem may boast of your art and early masterpieces,
> Our Amsterdam will now bear witness with me that you
> Have perceived not half the essence of his light.

If Waterloos's poem refers to the portrait – and it is hard to imagine it does not – it establishes 1660 as the *terminus ante quem* for the painting. The poem is one of the rare contemporary appraisals of a specific work by Hals, and is also the earliest published claim that the old artist's eyes had failed him and his hand had become benumbed, a charge repeated in Eugène Fromentin's popular *Les Maîtres d'autrefois*, published more than two centuries later (also see cat.85, 86).

Waterloos is critical of Hals's late, broad technique, and we, in turn, cannot but wonder about his use of 'stiffened' (*stramme*) to describe the flowing strokes that build the portrait's forms. However, the import of the Amsterdam poet's criticism of the Haarlem painter is distorted if it is not recognised that it includes an element of parochial civic pride. The boast that we do things better in Amsterdam – or in Haarlem, as the case may be – was as common in seventeenth-century Holland as it is today.

Waterloos's verse also is in accord with the well-established literary convention of praising a sitter at the expense of his portrait (Emmens 1956). He used the *topos* again in his poem, also published in *De Hollantsche Parnas* (1660, vol.1, p.406), on an untraceable portrait by Rembrandt of the poet Jeremias de Decker, the man who summed up Langelius's character in a nutshell. Waterloos, however, was more charitable with the Amsterdam painter than with the one from Haarlem: '... if

you [Rembrandt] attempt to surpass his [de Decker's] pen with your brush/ Then you must elevate your mind far higher, Than when you portray common folk ...' ('*... En zo ghy door't pinseel zyn pen zoekt t' overtreffen/ Zo moest ghy uwen geest al vry wat hoogher heffen/ Als oft ghy slechte slagh van menschen maalen zouwt ...*').

The Amiens portrait made its first modern appearance when it was offered in the sale of Alphonse Oudry's collection in Paris, 1869; for reference to the six other works attributed to Frans Hals that appeared in the same sale, see cat.30.

1. 'To all, heretics, the world, waverers and sinners,/ He was everything, shipwreck or sea, guiding-star or earthquake./ In his heart, a devotee of God; in his soul, a ray of light; in his voice/ A Paul in his eloquence, a rare glory to the apostolic flock./ A bachelor, he was married to his books, and a man to whom/ His life was a labour devoted to propagating children for Heaven,/ Such – O, how sad to say! – was his likeness here on earth in Amsterdam.'

2. 'Lauded by his admirers, but never in full due,/ Whose gracefulness gives praise to the Godhead./ The mere mention of his name is to honour him/ For his matchless gifts and wisdom supreme./ To whose golden tongue thousands are beholden/ Who now, upon his death, fearful sighs must heave./ Langelius, the gifts he brought to Sion,/ From them do God, and he, and it, pluck summer fruits.'

PROVENANCE Sale Alphonse Oudry, Paris, 15-20 April 1869, no.34 (as 'Un Professeur de l'Université de Leyde'; fr.1045); Olympe and Ernest Lavalard, Paris; bequeathed by the Lavalard brothers to the museum in 1890, and accessioned in 1894.

EXHIBITIONS Haarlem 1937, no.108; Amsterdam 1952, no.51; London 1952-3, no.48; Haarlem 1962, no.70; Paris 1970-1, no.99; Amsterdam 1971, no.39.

LITERATURE Bode 1883, no.46; Catalogue Musée de Picardie, Amiens, 1899, p.199, no.96 ('Un professeur de l'Université de Leyde'); A.Bredius, 'Nederlandsche kunst in provinciale musea van Frankrijk', *O.H.* XIX (1901), pp.11-2; *Icon. Bat.* no.4362; Moes 51; HdG 197; Bode-Binder 281; KdK 284 (*c.*1659); Slive 1970-4, vol.1, pp.200-1; Grimm 161 (1659-60); Montagni (*c.*1660); Baard 1981, p.150 (*c.*1660).

Fig.81a Abraham Blooteling, engraving after Hals's *Herman Langelius*

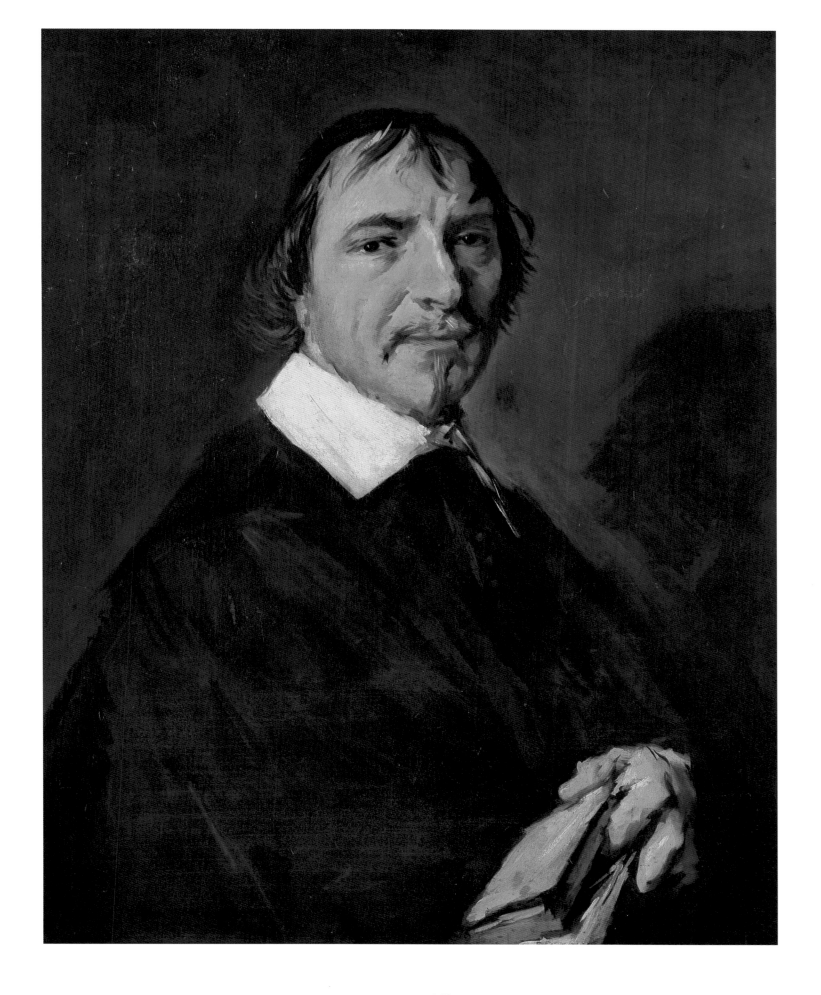

353

82 Portrait of a Seated Man

*c.*1660-6
Canvas, 69 × 60.5 cm
S216
Musée Jacquemart-André, Paris

The approximate dates assigned to Hals's very late paintings on the basis of their style must be even more tentative than those offered for his earlier undated works. There is not a single documented picture for the 1660s. We only know that 1660 is the highly probable *terminus ante quem* for his portrait of Herman Langelius (cat. 81), and that his group portraits of the *Regents* and *Regentesses* of Haarlem's Old Men's Alms-house have been traditionally dated 1664 (cat. 85, 86). Since the regents served from 1662 to 1665, the traditional date given to them may be correct, but it also is arguable that they were painted at another time during their term, or after it ended.

In view of this flimsy evidence and the very small size of our sample (hardly a dozen works are candidates for the 1660s), it seems sensible only to assume that paintings which are even bolder, more concentrated and summary than *Langelius* probably postdate our *Langelius*. Hence, the date of about 1660-6 is offered here for the present portrait and others assigned to the final years of his activity. The absence of a relative chronology for these paintings may disturb people who like to hear the grass grow. Others may take comfort in the thought that there cannot be much difference between what Hals painted when he was in his late seventies or early eighties.

In the Jacquemart-André portrait and the one at Kassel (cat. 83), Hals once again used the informal pose of a sitter turned in a chair, a scheme he introduced in his 1626 *Portrait of Isaac Massa* (cat. 21) and upon which he rang changes in the following decades. Here the man's erect attitude and the horizontal position of his arm give firmness and stability, while bold, hardly modulated accents free the portrait from any trace of rigidity. New is the painting's light tonality. The sitter wears a light grey jacket enlivened by touches of golden yellow on the sash across his breast. The background is dark grey rather than the deep olive green found so often in the late

works when his sitters wear black. The portrait's colour harmony is rare but not unique during these years. The *Portrait of a Man* at the Fitzwilliam (fig. 85b; S218), likewise datable to this phase, has an even lighter, dominantly grey tonality. A change in men's fashions rather than a shift in the artist's late palette accounts for these unexpected colour harmonies. After wearing predominantly black apparel for about a generation, more and more Dutchmen began to don lighter and brighter colours.

A reduced copy of the portrait by an unknown hand was in a French private collection in 1984 (panel, *c.*45 × 50 cm); it is reported to have been acquired by the present owner's father and uncle in Turin, 1908. An even smaller variant (modern?) appeared in the sale Valkenburg, Geneva (Moos), 23 May 1936, no. 72, repr. (panel, 19.5 × 15.5 cm).

PROVENANCE Purchased from the dealer Rupprecht, Munich, in 1884 by Madame Edouard Jacquemart-André, Paris, who bequeathed it to the Institut de France in 1912.

EXHIBITIONS Paris 1911, no. 52; Haarlem 1937, no. 110; New York 1956, no. 17; Haarlem 1962, no. 73; Paris 1970-1, no. 100.

LITERATURE Bode 1883, no. 69 (*c.*1655); Moes 145; HdG 300 (erroneously described as wearing a hat, 'Nach Bredius um 1650-55 gemalt'); W. Martin, 'Ausstellungen altholländischer Bilder in Pariser Privatbesitz', *Monatshefte für Kunstwissenschaft* IV (1911), p. 438 (late 1640s); G. Lafenestre, 'La peinture au Musée Jacquemart-André', *G.B.A.* XI (1914), pp. 36-7; Bode-Binder 265; KdK 288 (*c.*1661-3); Trivas 105 (*c.*1660-3); Catalogue Musée Jacquemart-André, Paris, 1948, p. 37, no. 427; Slive 1970-4, vol. I, pp. 202, 204; Grimm 163 (1660-4); Montagni 208 (1660-6).

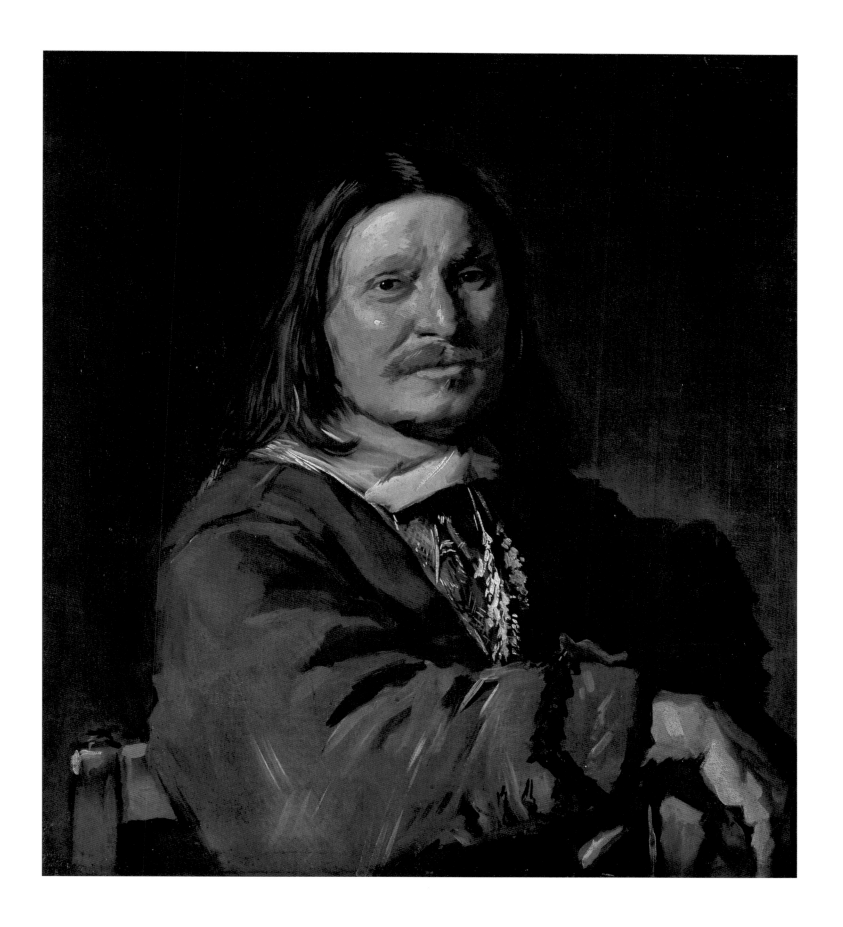

355

83 Portrait of a Man in a Slouch Hat

*c.*1660-6
Canvas, 79.5 × 66.5 cm
Signed, left near the shoulder, with the connected monogram: FH
S217
Staatliche Kunstsammlungen, Kassel (inv. GK219)
Exhibited in Haarlem

In this celebrated portrait Hals presents a sitter once again in the casual pose he invented and popularised. The way the great curved sweep of the brim of the man's enormous hat and the bold diagonals of his figure organise the dynamic design as well as the impression of vivid animation, and a hint of a landscape through an open window, recall Frans's 1626 portrayal of *Isaac Massa* (cat. 21), the work which introduces the scheme. Although the portrait's consistently bold, broad treatment is unprecedented, a close view of the man's smiling face indicates there has not been a fundamental change in his technique. As in his earlier portraits, forms are built up with light and dark touches on a middle tone, but here the fluid strokes have become swifter and the economic juxtaposition of hues more courageous.

It is fair to ask if the painting's widely admired abbreviated touch is, in fact, the brushwork of a portrait never carried beyond an intermediate stage. The answer partially depends upon one's notion of a finished painting. According to Houbraken, Rembrandt offered his: a picture is completed when the master has achieved his intention.[1]

The vast production of face painters working in Holland about the time Hals painted the Kassel portrait leaves no doubt that most Dutch patrons expected their portraits to be highly finished, with the transitions between colours blended and softened. To put the matter in the language of their day, they preferred a smooth (*net* or *fijn*) manner of painting to the rough (*rouw*). But what about Hals's clients? Was the sitter for the Kassel portrait satisfied with his hardly defined hand, or the way his hair was suggested with merely a few sweeping brushstrokes of yellow ochre? Evidently he was. And so were other patrons who commissioned portraits from him in his last years. They surely must have known that old Hals would present them with a portrait done in his highly personal, late *rouw* manner, not one with a licked finish. These clients surely knew his frosty age as well. With this knowledge their choice of Hals to commemorate their faces sets them apart. Not everyone opts for a portraitist in his late seventies or early eighties.

About this time Hals's unique technique won more than the approbation of his late patrons. Cornelis de Bie recorded his approval of the artist's rough, bold manner in his *Het Gulden Cabinet*, a handbook which includes notes on art theory and artists' biographies that was published at Antwerp in 1661. In his biographical sketch on Philips Wouwerman (Hals doc. 163) de Bie writes:

> He [Wouwerman] studied with Frans Hals, who is still alive and living in Haarlem, a marvel at painting portraits or counterfeits which appear very rough and bold, nimbly touched and well composed, pleasing and ingenious, and when seen from a distance seem to lack nothing but life itself ...

De Bie's lines indicate that the criticism the Amsterdammer Herman Waterloos made of the old master's highly personal style was not universally endorsed by his contemporaries (see cat. 81). They also show that knowledge and appreciation of Hals's daring, detached brushwork had percolated south to his native city of Antwerp before his death.

The dark strokes that appear to be traces of a narrow hat brim underneath the present large one in the portrait are not *pentimenti* but part of the original design, indicating that from the very beginning Hals had the intention of painting the colossal hat that has become one of the most famous in the history of Western art.

The canvas Hals used for the painting is rather coarse (10 to 12 threads per cm along the warp and weft [no distinction made]). It has been noted that Netherlandish painters had a tendency to use ever coarser canvas during the seventeenth century. However, a chronological pattern of Hals's preference for various grades of canvas cannot be proposed until a much larger sample is made of thread counts than the one currently available (Groen & Hendriks, p. 113).

An unusual double ground of distinctly different hues covers the canvas support (pl. VIII i). Its first layer is bright red earth; upon it there is a layer of cool grey paint, an admixture of lead white, charcoal black and umber. Of the more than forty Hals paintings that have been studied recently, the only other work that revealed the same double ground of red and grey is the late *Portrait of a Man* at the Fitzwilliam (fig. 85b; s218), which is datable about the same time. Groen and Hendriks suggest (ibid., pp. 115, 116) that both of these notably different primed supports may have been imported into Haarlem from somewhere else.

1. Houbraken 1718-21, vol. 1, p. 259: '... een stuk voldaan is als de meester zyn voornemenen daar in bereikt heeft ...'; also see Slive 1953, p. 182.

PROVENANCE Listed in the *Haupt-Catalogus von Sr Hochfürstl. Durch[lt] Herren Land Grafens Wilhelm zu Hessen, sämtlichen Schildereyen, und Portraits ... Verfertiget in Anno 1749*: 'No. 833 Hals (Franz) Ein Portrait mit ein Grossen Huth in Schwartzer Kleidung lehnent auf einen Armstuhl, auf Leinen in Verguldeten Rahmen vom M: Tarno (Höhe: 2 Schuh 6½ Zoll; Breite: 2 Schuh 1 Zoll)'. Taken to Paris by Denon in 1806 and returned in 1816.

EXHIBITIONS Haarlem 1937, no. 113; Schaffhausen 1949, no. 48; Haarlem 1962, no. 74.

LITERATURE Bode 1883, 101 (c.1660); Moes 174; HdG 268 (of the last period); Bode-Binder 280; KdK 289 (c.1661-3); Trivas 107 (1661-4); Catalogue Hessisches Landesmuseum, Kassel, 1968, no. 219 (c.1661-3); Slive 1970-4, vol. 1, p. 202-3; Grimm 165 (1660-66); Montagni 212 (1665); Herzog 1977 [n.p.], figs. 3-5; Baard 1981, pp. 158-60 (c.1660-6).

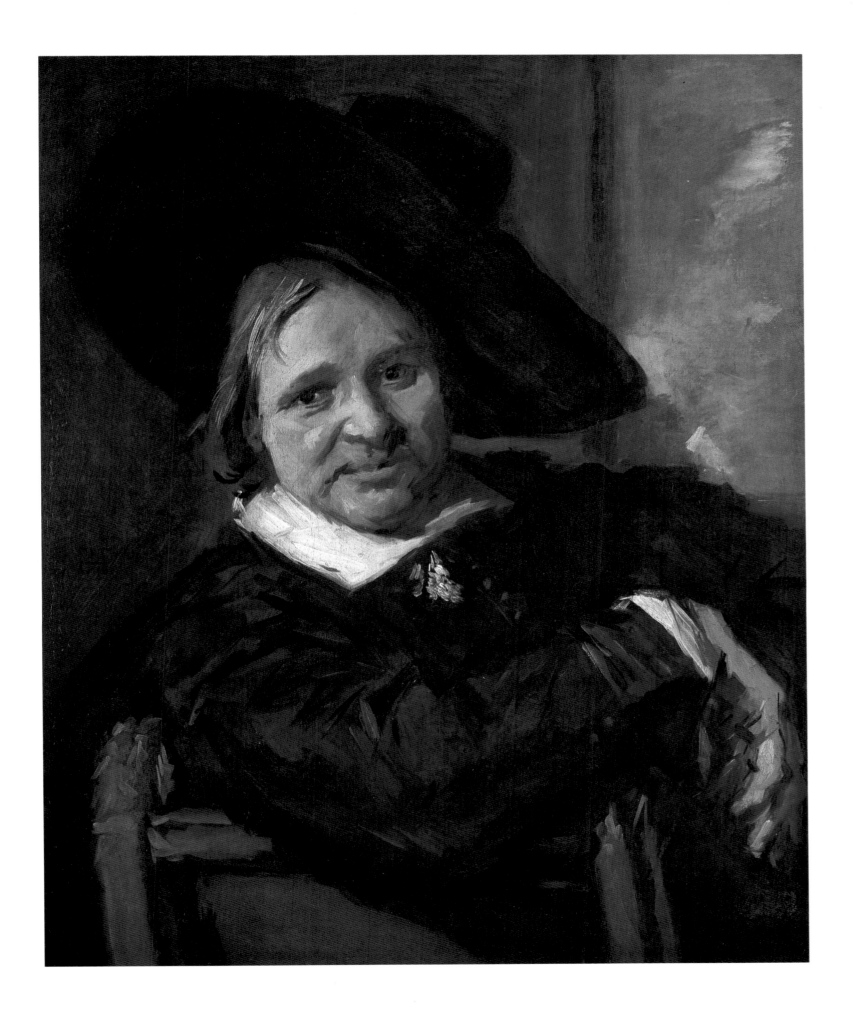

84 Portrait of a Man

*c.*1660-6
Canvas, 85.8 × 66.9 cm
Signed, lower right, with the connected monogram: FH
S220
Museum of Fine Arts, Boston; gift of Mrs. Antonie Lilienfeld in
Memory of Dr. Leon Lilienfeld (inv. 66.1054)

The portrait strikes an unexpected note in Hals's œuvre because the sitter is wearing a fashionable deep reddish-plum coloured silk kimono, not the expected black suit and white collar, and, unless he allowed his own hair to grow until it reached his chest, he is wearing an expensive, full-bottom wig in emulation of French fashion that increasingly permeated Dutch art and culture after the middle of the century. Despite the protests of preachers, the French fad of cutting off one's own hair to wear someone else's gained popularity in some upper-class circles.

The shoguns of Japan were responsible for starting the Dutch kimono craze which became popular during the last quarter of the century, and even more so during the following one. It was their custom to give thirty kimonos to officers of the Dutch East India Company when the annual commercial treaty was signed at an elaborate ceremony in Edo. When these rare and exotic *schenckagie-rocken* (gift-gowns) were brought back to Holland, they created a small sensation and fetched enormous prices. The vogue quickly spread to other countries. Since demand was far greater than supply, the East India Company found it profitable to commission oriental tailors to make others for export. Kimonos became a kind of status symbol. Statesmen, merchants and scholars who could afford them were proud to have themselves portrayed in this outfit. Women also wore them. Three are listed in the posthumous inventory (1695) of the effects of wealthy Catharina Hooft whom Hals portrayed with her nurse when she was a baby (cat. 9). However, no portrait of a woman wearing one is known. At this time women probably found them too *négligé* for portraits designed for posterity.[1]

In England, men who were unable or unwilling to purchase the garments could hire them. Samuel Pepys records in his diary on 30 March 1666 (conceivably in the very year the Boston portrait was painted) that he sat for John Hayls till almost quite darke upon working my gowne, which I hired to be drawn in; an Indian gowne, and I do see all the reason to expect a most excellent picture of it'. What Pepys called an 'Indian gowne' in 1666, a Dutchman would have called a *Japonsche rock*. The portrait by John Hayls (1600?-79) of Pepys wearing the yellow-brown gown he hired is now in the National Portrait Gallery, London (fig. 84a). Thanks to Pepys's compulsion to record the details of his daily life, we know when he began to sit for Hayls (17 March 1666 '... and I do almost break my neck looking over my shoulders to make

Fig. 84a John Hayls, *Samuel Pepys*, 1666
London, National Portrait Gallery (inv. 211)

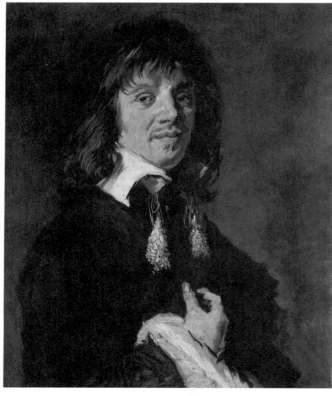

Fig. 84b *Portrait of a Man* (S219)
Zurich, Bührle Foundation

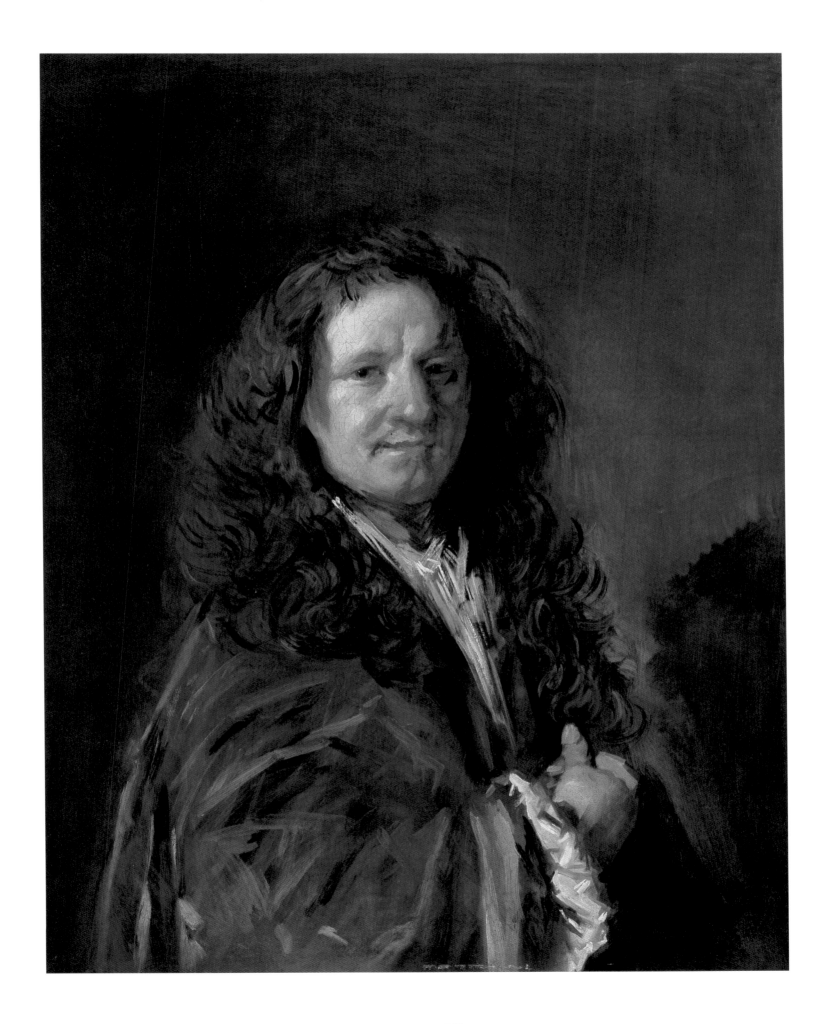

the posture for him ...', the alterations he demanded [changes in the sheet of music; deletion of the landscape his portraitist had painted in the background], when he fetched the finished work [16 May 1666] and what he paid [the portrait: £14; the frame: 25 shillings]).

Would that one of Hals's patrons left such a detailed record of a portrait transaction. We even would be grateful for a scrap that tells less. There is not a single existing record of the price Hals received for a painting during the course of his more than half-century career. We know only that he agreed in 1633 to paint full-lengths in his Amsterdam civic guard piece for 60 guilders per head, a fee that was later raised to 66 guilders if he would fulfill certain conditions – and this is a work he never completed (cat.43).

It can be deduced from the Boston portrait that Hals had stylish clients until the very end, for the consistently broad technique of the painting as well as the sitter's attire place it with his very latest works. The pose, the brevity and freedom of handling – even the claw-like hand – relate it to his late male portrait in the Bührle Foundation Collection (fig.84b) and the streaming brushstrokes of opaque and lightly washed paint that depict the highlights and shadows on the shot-silk kimono find a close parallel in the treatment of the great cape worn by the model for the Fitzwilliam portrait (fig.85b; s218), another work datable to his very last years. Close stylistic analogies also can be found in the *Regents* and *Regentesses* portrait traditionally dated 1664 (cat.85, 86). The large amount of space above the sitter's head suggests that the bottom edge of the painting may have been cut.

1. For the garment's history and vogue, see A.M.Lubberhuizen-van Gelder, 'Japonsche Rocken', *O.H.* LXVII (1947), pp.137-52; inventory references to Catharina Hooft's kimonos are cited ibid., p.151. Eighteenth-century tourists offer reports on the fashion. A visitor to Leiden University noted in a travel book published in 1735: 'Les Etudians ne s'y piquent point, comme en Allemagne, de magnificence en habits; plusieurs ne quittent presque jamais leur robe de chambre; & c'est l'habillement favori des Bourgeois. Cela me fit croire, la prémière fois que je passai par cette Ville, qu'il y regnoit quelque Maladie épidémique. En effet toue ces désha-

billés dans les rues parroissent autant de convalescens.' (Charles-Louis, Baron de Pöllnitz, *Memoires. Contenant les observations qu'il a faites dans ses voyages, et le caractère des personnes qui composent les principales cours de l'Europe*, Amsterdam, 2nd edn., 1735, vol.4, pp.154-5). In 1762 a German tourist wrote about a Professor Schroeder who lectured 'wie alle Holländische Theologen im Schlafrock, so wie auch viele von seinen Zuhörern in diesem Putze erschienen' (from Johann Beckmann's *Dagboek van Zijne reis door Nederland in 1762*, cited in Lubberhuizen-van Gelder 1947, p.150).

PROVENANCE Max Strauss, Vienna; Dr. Leon Lilienfeld, Vienna, and later of Winchester, Massaschusetts; Mrs. Antonie Lilienfeld, Winchester, Massaschusetts, who presented it to the museum in 1966 in memory of Dr. Leon Lilienfeld.

EXHIBITIONS Vienna 1873, no.41; Tokyo & Kyoto 1968-9, no.25; Boston 1970, no.50; Tokyo, Fukuoka & Kyoto 1983-4, no.14.

LITERATURE HdG 323; Bode-Binder 279; G.Glück, *Niederländische Gemälde aus der Sammlung des Herrn Dr. Leon Lilienfeld in Wien*, Vienna, 1917, pp.54-6, 63, no.25; KdK 293 (c.1664-6); Slive 1970-4, vol.1, p.208; Grimm 1971, p.163, no.34 (Frans Hals II); Montagni 213 (Frans Hals); Murphy 1985, p.128.

85 • 86 Regents of the Old Men's Almshouse

Regentesses of the Old Men's Almshouse

Traditionally dated 1664
Canvas, 172.5 × 256 cm
S221
Frans Halsmuseum, Haarlem (inv. I-115)

Traditionally dated 1664
Canvas, 172.5 × 256 cm
S222
Frans Halsmuseum, Haarlem (inv. I-116)

We have noted already that regent pieces were painted in Holland, particularly in Amsterdam, since the late sixteenth century, but Haarlem did not follow suit until 1641, when the regents and regentesses of the St. Elizabeth Hospital commissioned Hals and Johannes Verspronck, respectively, to paint their collective portraits (cat. 54). More than two decades later the regents and regentesses of Haarlem's Old Men's Almshouse turned to the aged Hals for their group portraits.

In the regents's portrait the artist's old tendency of creating an impression of casual informality and instantaneousness recurs and, at first blush, its pictorial unity may appear less successful than in his earlier groups. A watercolour copy of the painting by Wybrand Hendricks (1744-1831) explains why (fig. 85a). The portrait group has darkened considerably during the course of more than three centuries. When Hendricks copied it about 1800, rich effects of light filtering over the figures still were apparent, and the surfaces of the deep burgundy-coloured table cloth, cushions and large swag of drapery were more clearly defined. Today the clarity of the spatial relationships is lost, and delicate adjustments in the modelling of the black clothing which formerly softened the great diversity of attraction have virtually disappeared.[1] But these losses are forgotten as soon as one examines Hals's grasp of the personalities of his sitters and the light areas that have not been obscured by darkening of the paint medium – the fresh, spontaneous brushwork of the flesh tones, the streaming passages of intense white of the linen and the incredibly daring red stocking of the regent on the right.

The better-preserved regentesses's portrait excells as much by the power and order of its design as by the characterisation of the women. The four lady governors are seen gathered around a table, while a subordinate woman appears to enter the room bearing some message without disturbing the tranquility of her superiors. All attempts to give a firm attribution to the large Hercules Segers-like mountainous landscape on the wall in the background have been unsuccessful. However, a plausible proposal recently has been made for its subject. Pieter Biesboer has noted that it is most probably a lost painting of the *Good Samaritan* listed in an inventory compiled of the contents of the regentesses's chambers of the Old Men's Almshouse in 1786.[2] A picture of the parable certainly would have been an appropriate allusion to the charitable work done by the regentesses Hals commemorated in his group portrait. Its subject would not have been unusual either. There is a venerable Netherlandish tradition of decorating boardrooms of almshouses, hospitals and orphanages with pictures of acts of Christian charity. Regrettably, the proposed identification of the subject of the darkened, imperfectly preserved landscape within the portrait cannot be clinched. Today, it does not show a trace of the Samaritan and the half-dead man he succoured. In fact, no figures are visible in it.

The group of women appear to exist in a well-ordered world, which gains strength from their strong individuality. The outstretched hand of the regentess at the head of the table is a conventional gesture frequently found in Dutch group portraits, while the glove laced between the fingers of the standing regentess shows that Hals's penchant for recording closely observed details has not left him. As moving as the haunting expression of the seated woman on the right is her long, thin hand, which tells us more about the fragility of life than a warehouse of vanitas still-life paintings. Each woman

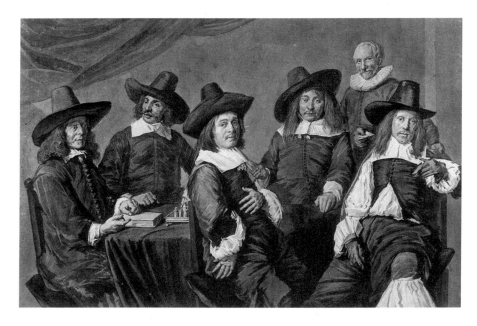

Fig. 85a Wybrand Hendricks, watercolour after Hals's *Regents of the Old Men's Almshouse*
Haarlem, Teyler Museum (inv. W 45)

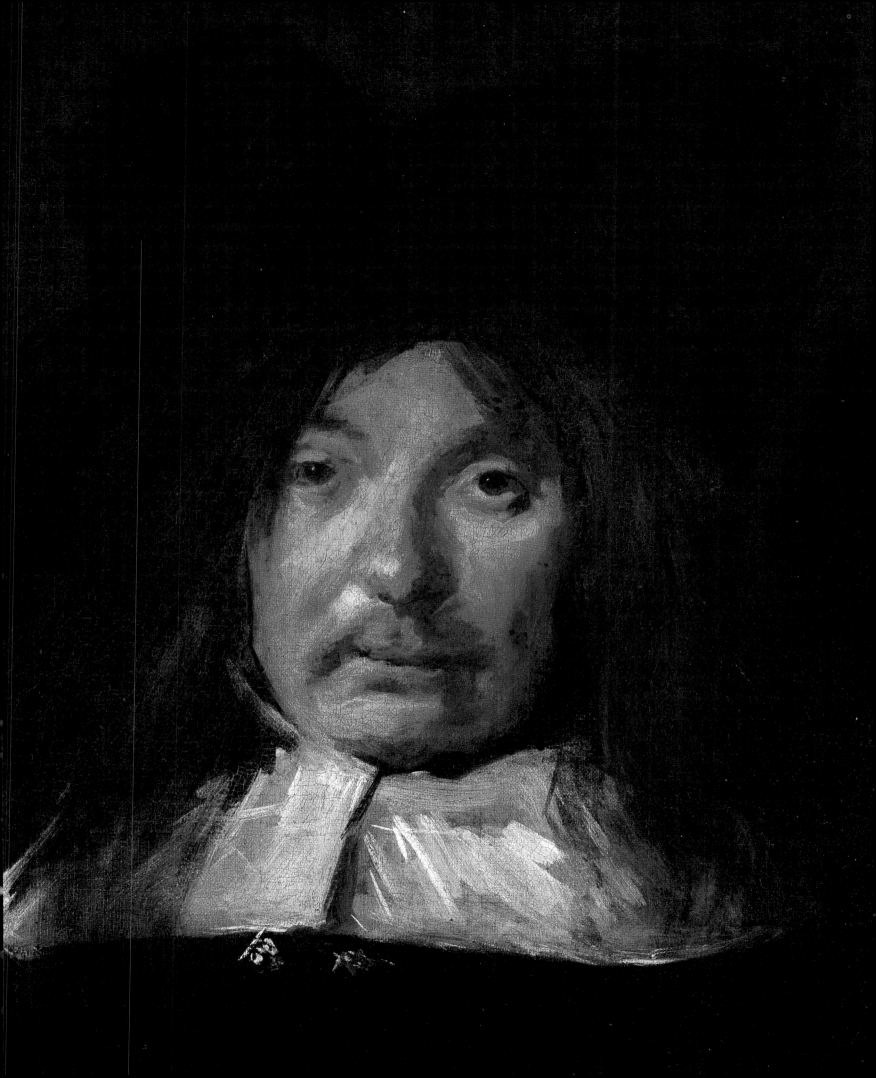

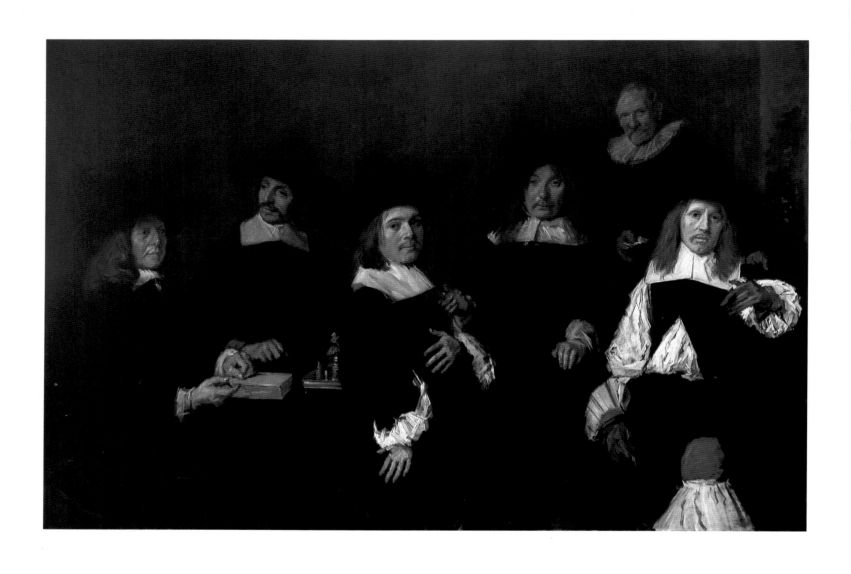

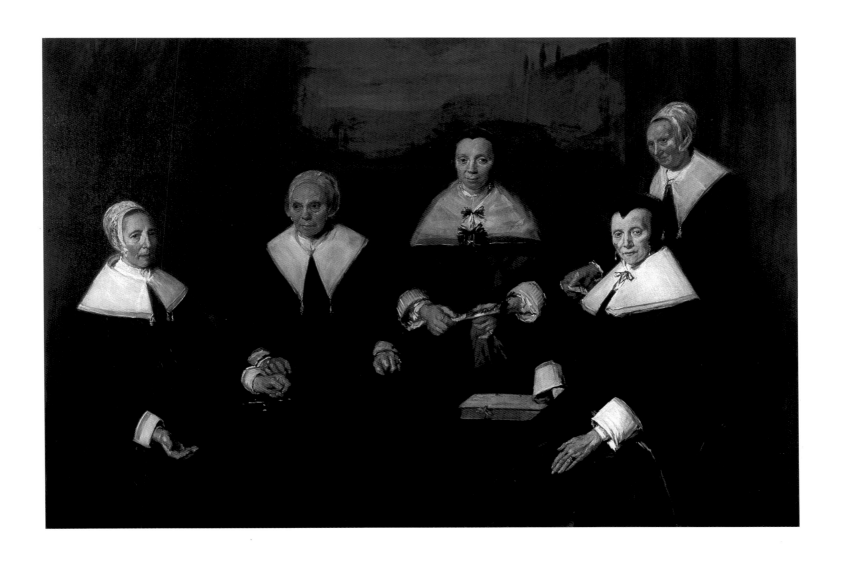

speaks to us of the human condition with equal importance. Each one stands out with equal clarity against the enormous dark surface, yet they are linked by the firm rhythmical pattern formed by their heads and hands. Subtle modulations of the deep, glowing blacks still contribute to the harmonious fusion of the whole and form an unforgettable contrast with the powerful whites and vivid flesh tones, where the detached strokes reach a peak of breadth and strength.

There is no firm documentary evidence for the traditional date of 1664 assigned to the portraits. We only know that the five regents Hals portrayed held their offices from 1662 to 1665. They are Jonas de Jong, Mattheus Everswijn, Dr. Cornelis Westerloo, Daniel Deinoot and Johannes Walles.[3] It has not been possible to correlate these names with the individual portraits. The bare-headed man behind them has not been identified. The names of the regentesses are Adriaentje Schouten, Marijtje Willems, Anna van Damme, Adriana Bredenhof. Here again no source tells us who is who, and the name of the woman who appears to bear a message remains unknown.

Since the myth that old Hals was the charge of the regents and regentesses of Haarlem's Old Men's Almshouse, and that he seized the opportunity to take shattering revenge on his heartless caretakers when he painted their portraits, dies as hard as the apocryphal story that Rembrandt's *Night Watch* was refused by the militiamen who commissioned it because they did not want to be portrayed as dim bits of animated shade, it should be stressed again that Hals was never an inmate of the almshouse. That he was dirt poor in his last years there can be no doubt. In response to his own request to

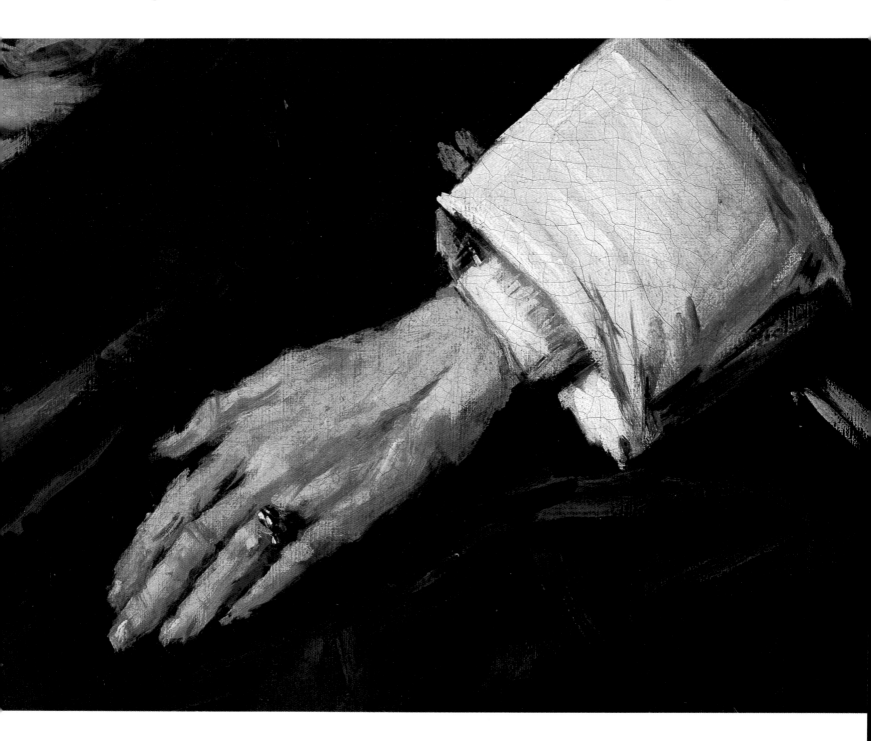

366

Haarlem's municipal authorities for financial assistance, in 1662 he received a grant of 50 guilders (Hals doc. 171) and a subsidy of 150 guilders to be paid in quarterly installments (Hals doc. 170). In 1663 the subsidy was replaced by an annual pension of 200 guilders which was pledged to him for the rest of his life (Hals doc. 174). During the following year the authorities paid him a rent subsidy and on two occasions gave him three cartloads of peat for fuel (Hals docs. 175, 177). Yet, on 22 January 1665 he was able to stand security for a debt of 458 guilders, 11 stuivers that his son-in-law had incurred (Hals doc. 179). Probably the fees he received for these two group portraits explain how he managed to serve as guarantor for a sum more than twice his annual pension.

The idea of helping needy Hals may have crossed the minds of his patrons when they awarded him these commissions, but it could hardly have been the determining factor. Vanity plays a greater role than charity when a portrait is designed for public display. If his clients had not been convinced that Hals was up to the commissions, they easily could have assigned them to another Haarlem portraitist or to one from nearby Amsterdam. Jan de Bray would have been a front runner in Haarlem. After Johannes Verspronck died in 1662, his star rose rapidly and he already had proved his gift as a group portraitist in 1663 with his suave *Regents of the Haarlem Orphanage* (Frans Halsmuseum, inv. 1-32) and was called upon to paint the regentesses of the same institution in 1664. But the governors of the almshouse decided upon Hals. Their artist did not fail them.

What did Hals's patrons think of these masterworks? Neither they nor their contemporaries left us a word about their reactions to them. However, it is safe to assume that his clients were satisfied with the first group portrait he painted for them. If not, ample evidence indicates that the exceedingly exacting and litigious patrons of the period would have had no difficulty finding a way to employ another artist to do the second.

The earliest known reference to the works was published by Vinken and de Jongh (1963) in their thorough history of critical reaction to the two portraits. It is found in Pieter Langedijk's manuscript for his projected history of Haarlem begun about 1750 and left unfinished at the time of his death in 1756 (ibid., p. 10, note 19). In his description of the almshouse, Langedijk briefly notes that the paintings were mounted in different rooms. How they were hung in Hals's time is unknown. Langedijk adds that he has been unable to discover the names of the sitters. Regarding their quality he merely offers two words: 'artfully done' ('*konstig gedaan*'), and not a single word about Hals's characterisation of his sitters.

Vinken and de Jongh have shown that late eighteenth and early nineteenth-century critics did not have much more to say about them. Things changed in 1877, when the obscure Dutch critic Jo. de Vries claimed ('Een bezoek aan Haarlems Museüm van Oude Kunst', *Eigen Haard*, 1877, p. 254) that Hals represented one of the men who sat for him in a drunken state; namely, the regent wearing a large tipped slouch hat, which hardly covers any of his long, lank hair, and with curiously set eyes which do not focus. The conclusion that he is inebriated, which subsequently achieved almost canonical status, is patent nonsense. Even a trace of the high spirits Hals showed in his early group portraits of militiamen celebrating around a banquet table would have been out of place in a regent portrait. If the man in question or his four colleagues found he had been shown drunk, the portrait would have been rejected. It was not.

A medical explanation has been offered by Vinken and de Jongh to account for the unusual expression on this regent's face. They propose (1963, p. 4) that the sitter's partial facial paralysis has been erroneously interpreted as the look of a man in a drunken stupor. Their hypothesis is reasonable; however, neurologists are best qualified to judge if this diagnosis can be made solely on the basis of Hals's portrait. If the regent had a facial deformity, it is noteworthy that neither he nor the artist felt it had to be hidden. Such candour is unusual even in seventeenth-century Holland, where few portraitists gained reputations for endowing sitters with more natural beauty than their creator gave them. A portraitist who endorsed humanist ideas of decorum would have depicted him in profile or adopted a three-quarter view that tactfully displayed his best side.

As for the sharp angle of the regent's large hat, it is a reflection of contemporary fashion, not an index of his sobriety. The taste for wearing enormous hats askew was not uncommon earlier in the century, and during the 1660s it seems to have become a mania, as can be seen in Hals's *Portrait of a Man in a Slouch Hat* at Kassel (cat. 83) and his *Portrait of a Man* at the Fitzwilliam (fig. 85b), as well as in works done by Vermeer and other artists during these years (fig. 85c; fig. 85d). The hat worn by the Fitzwilliam *Man* was found so disturbing by a former owner that he had it painted out; cleaning of the picture in 1949 revealed it.

The groundless charge first made in 1877 that Hals painted the regent drunk became the keystone of later erroneous interpretations of the group portraits as the artist's devastating critique of the society that allowed him to die impoverished and misunderstood, a reading that is as unsupportable as it is anachronistic, despite the cruel fact that he did indeed die poor and without the slightest hint that later generations would give him a secure place in the pantheon of Western painters.

Equally misguided is the notion that the portraits are the

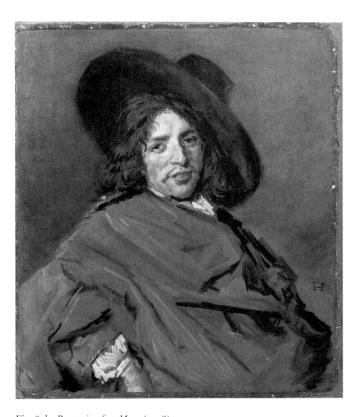

Fig. 85b *Portrait of a Man* (s218)
Cambridge, Fitzwilliam Museum

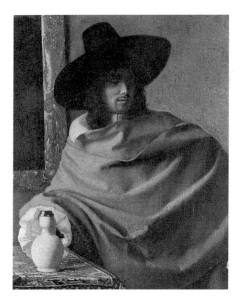

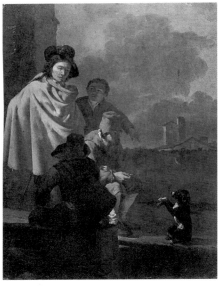

Fig. 85c Detail from Jan Vermeer, *Young Woman drinking with a Man* West Berlin, Staatliche Museen Preussischer Kulturbesitz (inv. 912 C)

Fig. 85d Karel du Jardin, *Men with a Dog* Cambridge, Fitzwilliam Museum (inv. 362)

feeble efforts of an octogenarian who has spent his genius. A hint of this idea is found as early as 1660 in Herman Waterloos's poem, almost certainly on Hals's late portrait of *Herman Langelius* (cat. 81), but it did not gain currency until the painter *cum* critic and novelist, Eugène Fromentin, alluded to it in his influential *Les Maîtres d'autrefois*, a work frequently reprinted and translated after it appeared in 1876. Although Fromentin had a profound appreciation of aspects of old Hals's achievement (Jowell, pp. 73-4), for him, the artist's clearness of vision and certainty of touch had failed him by the time he painted the large group portrait: 'The painter is three-quarters dead.' Granted the virtuoso who painted intricate lace and brocades with stunning ease during the first decades of his long career is not at work here. But Hals's brush has neither fumbled nor has he lost his nearly miraculous surety of touch. He is using the personal shorthand some of the greatest masters discover in their old age. Like the old Titian, Rembrandt and Goya, the late Hals eliminated all details which interfered with his profound vision of the men and women who confronted him and, with abbreviated touches of colour, created two of the most searching portraits ever painted.

Simeon ('oude Simeon') and a *Diana*; none of these paintings are identifiable. For reference to a lost Nicolaes Berchem painting of the *Good Samaritan* that belonged to the St. Elizabeth Hospital at Haarlem, and which appears mounted in the background of a group portrait of four regentesses of that institution painted by the Haarlem artist Frans Decker (1684-1751), see P[ieter]. B[iesboer]., 'Nieuw Bruikleen', *Kijken in Haarlem*, September/October 1983, no. 16, pp. 126-7. Its presence in Decker's group portrait lends support to Biesboer's identification of the subject of the picture within Hals's picture. Did Berchem also paint the landscape that Hals included in his regentesses piece? If he did, it would be unique in his very large œuvre. None of his known historiated or *pur* landscapes are comparable to it in format or style.

3. If Johannes Walles is identical

with Jacobus Wallis, who was born in Haarlem in 1619 and buried there on 17 March 1665, his death provides a very probable *terminus ante quem* for the group portrait of the regents (to our knowledge posthumous portraits were not included in regent pieces). Michael Hoyle kindly signalled the possible connection between Johannes Walles and Jacobus Wallis; the latter belonged to a Scottish family (Wallace) that had settled in the staple port of Veere. For more on the Wallis family and their connections with Hals's patrons Josephus Coymans (fig. 68a) and Willem Croes (cat. 80), see Biesboer p. 34. As noted in the text below, Hals had more than 450 guilders in hand on 22 January 1665. This sum, an astronomical one for old Hals is almost certainly related to his work on the two group portraits – perhaps an advance, but more likely payment in full for them; it supports the traditional date assigned to the portraits as well.

1. For a discussion of the composition of the paint layers in both group portraits, and how their state of preservation affects their present appearance, see Groen & Hendriks, pp. 111ff. The large portraits are painted on identical single strips of relatively finely woven canvas; remains of their stretching edges still exist (ibid.). The much larger group portrait of Captain Reael and his officers at Amsterdam (cat. 43), and all five of Hals's militia pieces at Haarlem as well as his regent portrait of 1644 (cat. 54), likewise are painted on single strips of canvas.

2. I am beholden to Pieter Biesboer for informing me of the unpublished reference to the lost *Samaritan* (*Samaritaan*) in *De Inventaris van alle de goederen so gevonden sijn in den Jaaren 1786. In het Oude Mannenhuis der Stad Haarlem. Regentesse Comptoir* (Haarlem City Archives). The inventory also lists Hals's own late portrait of the *Regentesses* and Pieter de Grebber's large *Works of Charity* of 1628, now in the Frans Halsmuseum (catalogue 1929, no. 115). In addition to the untraceable, unattributed *Samaritan*, the inventory cites a *Nativity* ('bethelems stal'), an *Old*

PROVENANCE Old Men's Almshouse ('Oude-Mannenhuis'), Haarlem; on exhibit at the Frans Halsmuseum since 1862.

EXHIBITIONS Haarlem 1937, nos. 114, 115; Amsterdam 1945, nos. 38, 39; Brussels 1946, nos. 43, 44; Haarlem 1962, nos. 71, 72.

LITERATURE Unger-Vosmaer 1873, nos. IX, X; Bode 1883, 7, 8; Moes 8, 9; HdG 437, 438; Bode-Binder 286, 287; KdK 290, 291; Trivas 108, 109; G. D. Gratama, *Frans Hals, les régents et les régentes de l'Hospice de Vieillards, Les grandes œuvres d'art* (Études et documents photographiques), Brussels, Paris & The Hague 1937; P. J. Vinken & E. de Jongh, 'De boosaardigheid van Hals' regenten en regentessen', *O.H.* LXXVIII (1963), pp. 1-26; Slive 1970-4, vol. 1, pp. 210-5; Grimm 166, 167 (the pair: *c*.1664); Montagni 209, 210 (the pair: *c*.1664).

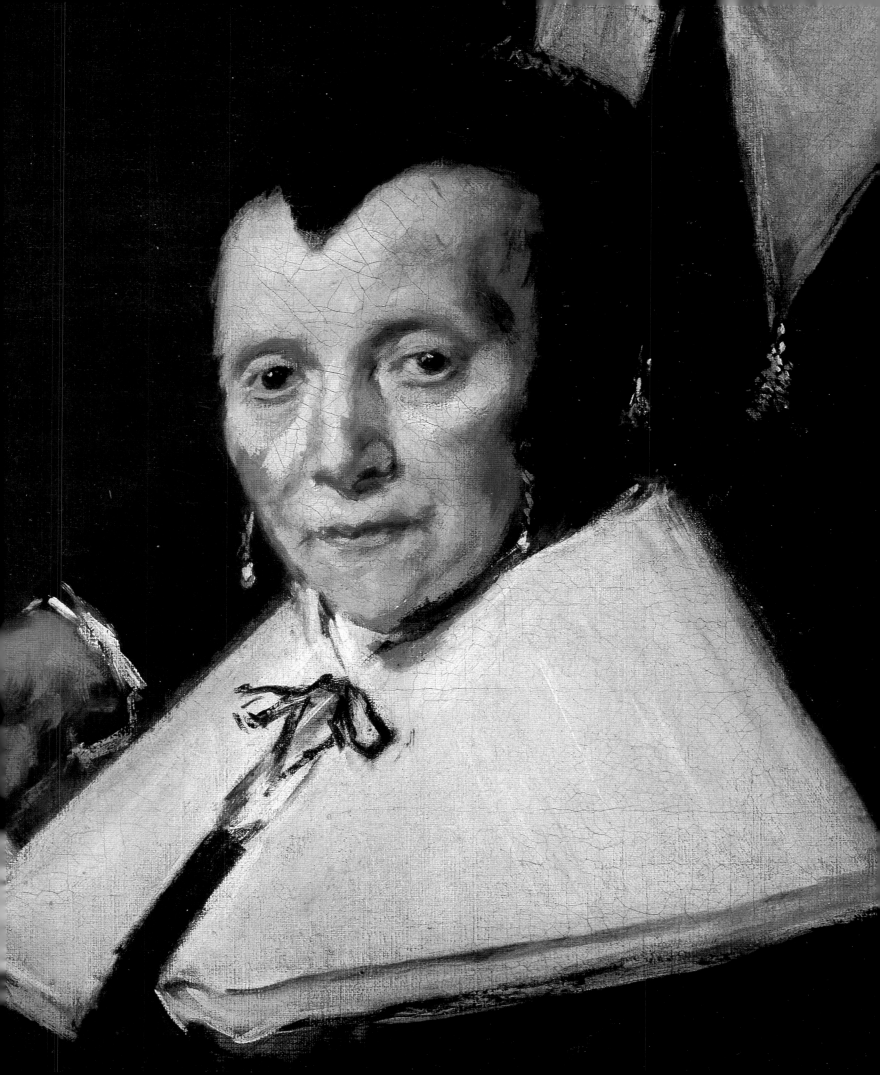

IRENE VAN THIEL-STROMAN

The Frans Hals Documents:
Written and Printed Sources,
1582-1679

The series opens with documents on Hals's parents and ends with Scheitz's brief biographical sketch of 1679.

The sources fall into three categories:
1. Documents relating to the life of Frans Hals and his family.
2. Texts dealing with Frans Hals as an artist.
3. Listings of paintings by Frans Hals in inventories and similar sources. This group is limited to documents dating from Hals's lifetime, i.e. up to and including 1666.

All the material has been checked in the original, with the exception of some data published by A. van der Willigen, C. Hofstede de Groot and A. Bredius, for which there is inadequate archival reference.

Frans Hals was not the only person of that name living in Haarlem. There were several branches of another Hals family, which had settled there in the fifteenth century (Dólleman 1974). As a result, some of the following documents may not actually apply to Frans Hals the artist. They are those in which the name is not preceded by the title Mr. or *Meester* (Master) or followed by the words *schilder* or *Mr. schilder* (painter, or master painter), and in which it is not clear from the context that they do indeed refer to the artist. Any such doubts are noted in the relevant commentary. There are no known documents on the painters Willem Hals and Hendrick Hals mentioned in A. Wurzbach's *Künstler-Lexikon* (1906-11). The Frans Hals who beat his wife has been unmasked as a Haarlem weaver called Frans Cornelisz Hals (Bredius 1921, p. 64; Bredius 1923/24, p. 19; Dólleman 1974, pp. 192-3).

Many of the documents mention sums of money involving pounds, guilders, Carolus guilders, stuivers and penningen (pennies). In Hals's day there was no difference between a pound and the two types of guilder, which consisted of roughly 20 to 22 stuivers and 80 or more penningen. Another unit of currency in use at this time was the Flemish pound, which was worth 6 guilders. It is virtually impossible to express the value of these sums in modern terms.

Patronymics ending in 'sz' or 'sdr' should be read as '-zoon' or '-dochter', i.e. the son or daughter of. Jansz means Janszoon (the son of Jan), and Reyniersdr the daughter of Reynier.

I am grateful to Dr. Florence W.J. Koorn and her colleagues at the Haarlem City Archives and to S.A.C. Dudok van Heel of the Amsterdam City Archives for their assistance in deciphering difficult handwriting and their advice on the meaning of obsolete terms.

ABBREVIATIONS

ARA	Algemeen Rijksarchief, 's-Gravenhage (General State Archives, The Hague)
ARAH	Algemeen Rijksarchief, Haarlem (General State Archives, Haarlem)
DTB	Doop-, trouw- en begraafboeken (Baptismal, Marriage and Burial Registers)
GA	Gildearchief (Guild Archives)
GAA	Gemeentearchief, Amsterdam (Amsterdam City Archives)
GAD	Gemeentearchief, Delft (Delft City Archives)
GAG	Gemeentearchief, 's-Gravenhage (The Hague City Archives)
GAH	Gemeentearchief, Haarlem (Haarlem City Archives)
GAL	Gemeentearchief, Leiden (Leiden City Archives)
GAR	Gemeentearchief, Rotterdam (Rotterdam City Archives)
NA	Notarieel archief (Notarial Archives)
NHG	Nederlands Hervormde Gemeente (Dutch Reformed Congregation)
OA	Oud archief (Old Archives)
RA	Rechterlijk archief (Judicial Archives)
RKD	Rijksbureau voor Kunsthistorische Documentatie (Netherlands Institute for Art History, The Hague)
SAA	Stadsarchief, Antwerp (Antwerp City Archives)

FRANS HALS'S RESIDENCES IN HAARLEM

The following are the dates or periods when Frans Hals is documented as living at the relevant address.

1617, January	Peuzelaarsteeg (doc. 23)
1636, March	Groot Heiligland (doc. 74)
1640, May	Lange Bagijnestraat (doc. 88)
1642, September	Kleine Houtstraat (doc. 95)
1643, November- 1650, November	Oude Gracht (docs. 98, 103, 113, 123, 132, 135)
1654, January - 1660, May	Ridderstraat (docs. 145, 150, 151, 161)

| 1 | 1582, 26 April — FRANS HALS'S PARENTS, FRANCHOIS HALS AND ADRIANA VAN GEERTENRYCK, SELL AN INTEREST ON ADRIANA'S HOUSE IN ANTWERP

Adriana van Geestenryck, eertyts getrouwt gehadt hebbende Henricke Thielmans, met Franchoys Hals, droochscheerder, nu ter tydt eius marito et tutore, vercochten omme eene somme gelts Jan de la Flie, suyckerbackere, tsjaers erfflyck vier carolusgulden goet prout communiter, jaerlycker ende erfflyckere renten, op de helft ende alle haer paert, actie ende deel, van eenen huyse cum fundo et pertinentiis omnibus, gestaen ende gelegen in de Nyeuwstrate ...

SAA, Collectanea 16, fols. 448v-9r.
Literature: van Roey 1972, pp. 147 note 3 and 165 (Appendix 1; full transcription).

Preamble to a deed of sale of a redemption interest of four Carolus guilders on half a house and plot of land in Nieuwstraat (also called Rozenstraat) in Antwerp. This heritable interest was sold by Adriana van Geestenryck (usually spelled Geertenryck in later documents), the widow of Henrick Thielmans, and her second husband, Franchois Hals, cloth-dresser, to the pastry-baker Jan de la Flie.

This document is evidence that by April 1582 Franchois Hals was married to Adriana van Geertenryck, widow of the tailor Henrick Thielmans, who had bought the Rozenstraat house in 1577 (in other documents it is referred to as 'St. Jacob'; SAA, Aldermen's Letters, no. 350, 1577, fol. 68r-v). No record has been found of the marriage, which must have taken place shortly before. If the couple were Catholic (and Franchois was certainly registered as such in 1585; doc. 2), then it is quite possible that their wedding was never officially recorded, for Catholic services were banned in Antwerp between July 1581 and August 1585. There are no surviving Protestant marriage registers covering this period.

Franchois was the son of a Mechelen couple, Frans Hals, a dyer, and Barbara de Witte (Coninckx 1914/15, p. 160), and in 1562 he came to Antwerp with his brother Carel, where he found work as a cloth-dresser. On 22 September of that year he married Elisabeth Baten, who died in 1581. Five days later Carel (who also died in 1581) married Cornelia Wils, who only survived her husband by a year. Both wives were born in Antwerp, and the marriages took place in the Church of St. Jacob, (SAA, Parish Register, no. 215). Carel and Cornelia had no children.

Franchois had several other brothers and sisters, one of whom, Cathelijne, appears in Haarlem in 1589 as a witness in a case involving her neighbour, when she gave her age as 50 (GAH, NA 8 [notary Michiel van Woerden], fol. 104r).

The dates of baptism of four of Franchois' children from his first marriage are recorded in the earliest known baptismal register of St. Jacob's, which was begun in 1567 (SAA, Parish Register, no. 46). They were Carel (8 September 1567; see doc. 7), Clara (27 September 1569), Johannes (4 January 1572) and Maria (7 July 1574). Maria's godmother was Maria van Offenberch, probably a sister of Dirck van Offenberch, the later godfather of Franchois' youngest son Dirck, who was born in Haarlem (doc. 4).

Between 1580 and 1585 Franchois is listed in the tax assessment registers as living in Rozenstraat in Antwerp (SAA, Audit Office, nos. 2198, 2296, 2230, 2321, 2247, 11th district, fifth

penny). In 1580/81 he paid tax on a small house which he had rented from Jan de la Flie, the man to whom Adriana van Geertenryck sold the interest on her house in 1582. According to these tax registers, in 1581 Adriana was the owner of the house called 'St. Jacob' in Rozenstraat, which had been listed the previous year under the name of her husband, Henrick Thielemans. Her house was two doors away from the one rented by Franchois Hals, whom she soon married.

Franchois Hals's first wife, Elisabeth Baten, died after the summer of 1581 and before Christmas that year. This emerges from the records of a lawsuit brought against the Wils family by Franchois and his immediate relatives after the death of his sister-in-law Cornelia Wils (d. before 1 November 1582), claiming a portion of the estate of Franchois' brother Carel, who had died around Christmas 1581. The court records show Carel to have been an alcoholic and a wastrel who had no money at all when he married. His wife even had to buy his clothes. She, on the other hand, emerges as a very hard-working spouse, who provided for both of them as a washerwoman and cleaner. The suit lasted from 1 November 1582 to 8 October 1583 (SAA, Court of Justice, no. 1258, Verdict Roll 1583-4, fols. 151v-3r) and proved utterly fruitless, for the simple reason that there was nothing to be had from such a meagre estate. Even before Carel was buried, Franchois had asked his sister-in-law for a keepsake in the form of the six new shirts which his wife Elisabeth had sewn for his brother, as well as his rapier, buff jerkin and long stockings, which Cornelia reluctantly handed over (van Roey 1972, pp. 166-7, Appendices 2 and 3: full transcriptions). Clothing of this kind was worn by members of the civic guard.

It is clear from this deed of sale that Franchois, who was left with at least four young children when his first wife died in the autumn of 1581, had married his neighbour Adriana van Geertenryck before April 1582. She also had one or more children from her own first marriage. Two sons, Frans and Joost, were born to Franchois and Adriana before they left Antwerp for the Northern Netherlands some time after late 1585 and before early 1591 (their youngest son Dirck was baptised in Haarlem on 19 March 1591; doc. 4). It is not known when Frans and Joost were baptised, but it is believed that Frans was born first, in 1582 or 1583, because he was named after his Mechelen grandfather on his father's side, which seems to have been the custom for the eldest son, and that his brother Joost was born in 1584 or 1585.

The house in Rozenstraat in which Frans and Joost were born was occupied on 18 July 1586 by the new tenant, Thomas van Oudendijck (SAA, Audit Office 2190, 1584 Register of Tax Arrears, fol. 46v; van Roey 1957, p. 3), so the Hals family must have left Antwerp before that date.

All that is known of the half-brothers and sisters of Frans and Joost Hals from their parents' first marriages (Franchois Hals and Elisabeth Baten; Adriana van Geertenryck and Henrick Thielmans) is that Carel Hals settled in Amsterdam around 1593 (doc. 7), and that his youngest sister, Maria Hals, married a tailor called Geeraert Immermans in Antwerp in 1596 (cf. van Roey 1972, pp. 158-62).

| 2 | 1585, after 15 August — FRANCHOIS HALS LISTED AS A CATHOLIC
+ *Franchois Hals*

SAA, Guilds and Trades, no.4830/1, fol.383v (civic guard).
Literature: van Roey 1957, p.3.

When the Spanish took Antwerp in August 1585 they decided to purge the civic guard of non-Catholics, who were not trusted to bear arms. They accordingly drew up 'exclusion lists' recording the religion of the officers and men of the guard, service in which was compulsory for all male citizens aged between 18 and 60. The cross preceding Franchois Hals's name signifies that he was a Catholic. He and fifteen others formed one of the civic guard companies, which tells us that he was not one of the wealthier citizens of Antwerp, for then he would have served in one of the six armed guilds (information kindly provided by Mrs. G. Degueldre, Antwerp City Archives).

Since Franchois is recorded as a Catholic in Antwerp it seems unlikely that he migrated to the Northern Netherlands for religious reasons. However, one wonders whether he was telling the truth when questioned about his religion, for his youngest son Dirck was baptised a Protestant in Haarlem (doc.4). Economic considerations, though, undoubtedly played a part in his decision to start a new life in the Dutch Republic.

| 3 | 1590, 2 January — BAPTISM OF ANNEKE HARMENSDR, FRANS HALS'S FIRST WIFE
Den 2 january een kint gedoopt Anna, de vader Herman Dirrix, de moeder Pieterkin Claes, getuugen Claes Joppen, Lysbet Hermans

GAH, DTB 2 (NHG Baptismal Register), fol. 1.
Literature: Dólleman 1973, p.251.

The baptismal record of Anna, eldest daughter of the bleacher Harmen Dircksz of Den Bosch (buried 27 September 1607) and Pietertje Claesdr Gijblant of Haarlem (buried 23 May 1599), who registered their banns in Haarlem on 6 December 1588. The baptism was witnessed by the child's grandparents, Claes (Nicolaes) Joppen and Lysbeth Harmensdr.

Six children from the marriage of Anna's parents were baptised (cf. doc.15), the youngest of which was buried with its mother, according to the burials register.

Anna's paternal grandparents were Dirck Anthonisz, a bleacher (buried at Haarlem on 9 May 1599), and Lysbeth Harmensdr de Bitter (Anna's godmother), a fairly well-to-do couple (see doc.15) who probably came from Antwerp and had lived in Goch and Den Bosch before receiving their Haarlem citizenship around 1580. Harmen, Anna's father, was the eldest of their seven sons.

Anna's maternal grandparents were the Haarlem brewer Nicolaes Joppen Gijblant (her godfather) and Marietje Heerendr. In 1596 their son, alderman Job Claesz Gijblant (buried 16 October 1638), was to marry Teuntje Jansdr Huydecoper, the daughter of an Amsterdam patrician family and the future godmother of Frans Hals's eldest son, Harmen. Job Gijblant was the guardian of the five children of his sister Pietertje Claesdr, Anna's mother (see doc.15), but when he

died without issue he left everything to the children of his sister Aefje Claesdr, the wife of the Haarlem alderman Gilles Claesz de Wildt (Dólleman 1973, p.256; see also Biesboer).

The church registers make no mention of Anna's marriage to Frans Hals, which must have taken place in Haarlem before the baptism of their son Harmen on 2 September 1611. The aldermen's register for this period, which recorded non-Reformed or mixed marriages, has not survived.

Three children were born of Hals's short-lived first marriage: Harmen, and two unnamed children who died at a very early age (docs.13, 18).

Anna was buried on 31 May 1615 (doc.14).

| 4 | 1591, 19 March — BAPTISM OF FRANS HALS'S BROTHER DIRCK
Aldoe een kint gedoopt Dirric genaemt, de vader Franchois Hals, de moeder Adriana Hals, de getuugen Dirric van Offenberch, Nicolaus Snaephaen, Maria van Loo

GAH, DTB 2 (NHG Baptismal Register), fol. 52.
Literature: Moes 1909, p.7; Bredius 1914, p.216; van Roey 1957, p.3.

The baptismal record of Dirck Hals, the youngest son of the cloth-dresser Franchois Hals of Mechelen and his second wife, Adriana van Geertenryck of Antwerp, here registered as Adriana Hals (cf. doc.1). The witnesses were Dirck van Offenberch, son of the Antwerp merchant Peter van Offenberch and his wife Anna Ridders, Nicolaas Snaephaen, former innkeeper on the Meir in Antwerp, who became a member of the Reformed Church in Haarlem on 2 April 1586 after producing evidence of his membership of the Antwerp congregation (GAH, OA Church Council 24/1, fol.54), and Maria Boudewijnsdr van Loo, the wife of Dirck van Offenberch's brother Pieter (cf. doc.1). Their son Boudewijn appears as an ensign in Hals's militia pieces of 1616 and 1627 (1970-4, vol.1, S7, S46).

Dirck's entry in the baptismal register is the earliest record of Hals's parents in Haarlem, to which they emigrated after the fall of Antwerp in August 1585.

Dirck, too, became a painter like his elder brothers Frans and Joost (doc.37), who were born in Antwerp. He specialised in genre scenes, and although dated works are known from 1619 onwards he did not become a member of the Haarlem Guild of St. Luke until 1627 (Miedema 1980, pp.420, 933, 1034). From 1618 to 1624 he served as a musketeer in the second company of the third corporalship of the St. George civic guard, in which his brother Frans served from 1615 to 1624 (doc.11). In the same period he was a member of the rhetoricians' society known as 'De Wijngaardranken' (The Vine Tendrils; doc.16). In 1620 or 1621 he married Agneta Jansdr, who bore him seven children between 1621 and 1635. His eldest son Anthonie (Haarlem 1621-1691 Amsterdam) also became an artist (not to be confused with Frans Hals's son of the same name, who was a sailor; cf. doc.138). In 1623 Frans Hals was a witness at the baptism of his daughter Maria (doc.30), and in 1624 the engraver Jan van de Velde II (doc.38) and Susanna Massa, sister of Isaac Massa (docs.29, 91), were the witnesses for his daughter Hester (van der Willigen 1866, pp.123-4; van der Willigen 1870, p.149). Dirck was living in Leiden in 1641/2 and 1648/9, and possibly in the intervening

period as well (Bredius 1923/24a, p.61). On 17 May 1656 he was buried in the Beguine Church in Haarlem (GAH, OA churchwardens 42/1 [grave register 1655-61], unpaginated). Cf. docs. 28, 41, 47, 52, 58, 65, 68, 116, 121.

| 5 | 1592, 6 June — FRANS HALS'S FATHER FRANCHOIS TES-TIFIES IN HAARLEM ON BEHALF OF HUYBRECHT DE WIT
Op huyden den VIen dach junij in den jaere ons heeren XVc twee ende 't negentich compareerden voor mij Adriaen Willemsz, openbaer notaris bij den hove van Hollandt toegelaten, ende voor den getuigen hiernaer genoempt mr. Dirck Janssz schoolmeester, oudt omtrent XXXIX jaeren, ende Franchois Hals lakenbereyder van Mechelen oudt omtrent XLII jaeren, beyde inwoonderen der stadt Haerlem, ende hebben ter instantie van Huybrecht de Wit mede lakenbereyder van Tuernault bij heure mannen waerheyt ende zyelen salicheyt in plaetse van gestaefden eede geseydt, getuycht ende voor de oprechte waerheyt verclaert, dat omtrent een jaer geleden zijluiden getuigen zoo beyde als oock elcx int bysonder daer by ende present sijn geweest ten huyse ofte woonstee van Jan Matheeussz in de Camp ende mede ten respective huyssen ofte woonplaetse van hen getuigen, ende aldaer tot verscheyde reysen gesien ende gehoort hebben, dat Tanna Sweenen den voors. requirant van de trouwe, dien hij haer vuyt lichtvaerdicheyt ende beschonken zijnde bij eenge forme gegeven ende zij geaccepteert mocht hebben, wederomme vrijgestelt, ontslagen ende gequeyten heeft, sulcx dat hij ende zij soo vrij souden wesen ende blijven, als zij van tevooren waeren geweest ...
GAH, NA 35 (notary Adriaan Willemsz), fol. 168r-v.
Literature: van Roey 1957, p.3.

Franchois Hals, cloth-dresser of Mechelen, approximately 42 years of age, and master Dirck Jansz, schoolmaster, approximately 39 years of age, make a sworn statement at the request of Huybrecht de Wit, cloth-dresser of Turnhout. They testify that on several occasions, in the house of Jan Matheusz in de Camp and in their own homes, they have heard that Tanna Sweenen had released Huybrecht de Wit from his promise of marriage, which she had accepted despite the fact that it had been given lightly, while her suitor was in an inebriated condition. Franchois Hals did not sign this document.

His age is wrongly given as 42, for that would mean that he had been born in 1550 and had married for the first time when he was only 12 (22 September 1562). He must have been at least 10 years older.

Huybrecht de Wit of Turnhout is recorded in Antwerp in 1580 as the purchaser of a plot of land and a house in Berchem (van Roey 1957, p.3). He was probably another of the Flemish immigrants who came to Haarlem after Antwerp fell to the Spanish in August 1585.

| 6 | 1593, 31 January — BAPTISM OF LYSBETH REYNIERSDR, FRANS HALS'S SECOND WIFE
Lysbeth dochter van Reynier Jans ende Anna Thonis
De getuygen Janneken Thonis ende Maryken Jacobs
GAH, DTB 2 (NHG Baptismal Register), fol. 140v.

The baptismal record of Lysbeth, daughter of Reynier Jansz

and Anna Thonisdr, witnessed by Janneke Thonisdr, probably a sister of Anna Thonisdr, and one Maryken Jacobsdr.

Lysbeth Reyniersdr, who never learned to write (she signed documents with a cross), became Frans Hals's second wife in February 1617 (doc. 23). She died some time after 26 June 1675 (doc. 189).

Her sister Hillegond, who was almost two years younger, was baptised on 4 September 1594. She too appears several times in the following documents.

| 7 | 1593, 13 February — BANNS OF FRANS HALS'S HALF-BROTHER, CAREL HALS, AND MARYTJE JANSDR
Ten dage, jare [13 February 1593] *ende voer commissarissen voorscreven, compareerden Caerl Hals, Franszone van Antwerpen, passementwercker, oudt omtrent XXIIII jaeren, wonende by Jan Rooypoorte in de Nieustadt, vertoonende acte onder de handt van Johannes Damius, inhoudende des vaders consent, ter eenre, ende Marytgen Jansdochter, weduwe van Jan Gerritsz., mandemaecker, verclaerende een half jaer weduwe geweest te hebben, wonende als voren ter andre sijden ende naerdien sy op alles naer behooren geantwoort hadden syn hun haere geboden verwilliget.*
[signed] [a mark for Carel Hals] *Marij Jans*
 [in the margin] *Caerl Hals Franssz.*
GAA, DTB 406 (NHG Banns Register), fol. 295.
Literature: de Vries 1885, p.147; van Roey 1972, pp. 152-3.

The betrothal in Amsterdam of Frans Hals's half-brother Carel, born in Antwerp, some 24 years old (he was actually baptised on 8 September 1567), a braider, the eldest son of the cloth-dresser Franchois Hals of Mechelen and his first wife Elisabeth Baten of Antwerp (doc. 1), and Marijtje Jansdr, the widow of Jan Gerritsz, a basket-maker, both residing near the Jan Rooden Gate (part of the first new city district of 1585). The bridegroom produces the document giving his father's consent to the marriage, which was drawn up by the Haarlem clergyman Johannes Damius, and the bride declares that she was widowed six months previously.

A week earlier, on 6 February, the couple had appeared before the Commissioners of Marital Affairs to register their banns, but unfortunately the bridegroom had failed to produce his father's consent, while the bride, who was only widowed five months previously, was refused permission to marry until she had reached the statutory term of six months' widowhood (GAA, DTB 406, fol. 287). They married in March 1593 (precise date unknown; (GAA, DTB 969, fol. 165), and on 5 March 1598 their twins Franchois and Lysbeth were baptised in Amsterdam's Old Church (GAA, DTB 3, fol. 118).

This half-brother of Frans, Joost and Dirck Hals probably emigrated to Haarlem with his father and his stepmother, Adriana van Geertenryck (doc. 1), and only later moved to Amsterdam.

| 8 | 1599, 18 February — DEBT OWED BY FRANS HALS'S FATHER FRANCHOIS TO JAN PIETERSZ
Acte van opdrachte van Franchois Hals.
Op huyden soe compareerden voor mij notario ende getuygen ondergeschreven Franchois Hals droochscheerder ende Adri-

aentgen van Geestenrick [in the margin: *geechte luyden*] *wonende alhyer binnen Haerlem. Ende bekenden wel ende eenichdoenlyck schuldich te wesen Jan Pietersz osseweyer den somme van seven ende dertich guldens ende twee stuivers als reste van coop van een halven osse, dien hij henluyden voorleden Lucasmarct vercoft danckelicken gelevert ende tot desen dage toe gewacht heeft daer van zij hem bedancken. Ende omme hem van zijn deuchdelyck achterwesen te verseeckeren soe hebben zijluyden metterdaet den voorn. Jan Pietersz als willich pant metter minne in handen gestelt ende opgedraegen gelijck zij hem opdraegen ende in handen stellen bij desen allen heuren gerede ende moeble goederen, die zij jegenwoordelicken hebben ende besitten egeene vuytgesondert omme datelicken offe t'zijnen believen aengetast ende vercoft te werden als zijn vrij eygen goet tot zijn voors. achterwesen soe mette costen daeromme te doen ende te lijden, hen comparanten houdende dienaengaende met allen rechten ende vormen te wesen, sonder eenige oppositie daertegens te doen in 't minste ofte 't meeste.*
Consenterende hyervan acte gemaect te werden in forma.
Actum den XVIIIen february anno XVc negen ende negentich, present den getuygen ondergeschreven
[signed] *Jan Bout, Willem Verstrien*
Quod attestor M. v. Woerden '99

GAH, NA 14 (notary Michiel van Woerden), fol. 36r.
Literature: Bredius 1914, p. 216.

Franchois Hals, cloth-dresser, and his wife Adriana van Geertenryck, residents of Haarlem, acknowledge that they owe Jan Pietersz, grazier, 37 guilders and 2 stuivers, being the balance due on half an ox which they had bought from him at the last St. Luke's Fair. They thank him for not pressing his claim until now, and cede him all their household goods as surety, which he is free to dispose of as he sees fit.

It is not known whether Frans Hals's parents ever had to surrender their meagre belongings to this creditor.

| 9 | 1610 — MEMBERSHIP OF THE GUILD OF ST. LUKE
1610 Frans Hals

GAH, GA 193 (cover: *Schilders bij 't Sint Lucas Gild ingeschreven* ['Painters registered with the Guild of St. Luke']).
Literature: Bredius 1915-22, p. 2216; Miedema 1980, vol. 2, C7 (membership rolls after 1796, pp. 1030-41), pp. 1030 note 376, 1034.

Frans Hals's enrolment as a master-painter in the Haarlem Guild of St. Luke. It is preserved in a membership roll reconstructed in the eighteenth century by the painter Vincent Jansz van der Vinne (Haarlem 1736-1811 Haarlem), who took his information from membership registers which are now lost, and from the extant *Goede bekende schildersnaamen geschreven door V.L. v.d. Vinne en na zijn dood nagezien en bijgeschreeven door L. v.d. Vinne* ['The names of well-known painters noted down by V.L. v.d. Vinne and revised and enlarged after his death by L. v.d. Vinne'] (GAH, Guild Archive 193). The latter compilation was begun by Vincent Laurensz van der Vinne (Haarlem 1628-1702 Haarlem), the great-grandfather of Vincent Jansz and a pupil of Hals, whose portrait of him is now in Toronto, Art Gallery (cat. 76). The list was continued by his son Laurens Vincentsz van der Vinne

(Haarlem 1658-1729 Haarlem). This document, in which Vincent Laurensz van der Vinne added a 'd' after the names of painters who had died, contains the entry *Frans Hals d.* (Miedema 1980, vol. 2, C1 [membership rolls 1702], pp. 931-5, esp. p. 932).

Hals's registration in the Haarlem guild is the earliest documented fact about his life, albeit from a secondary source. Karel van Mander's anonymous biographer says that Hals was a pupil of van Mander's (doc. 25). If that is so, his apprenticeship must have ended in 1603, when van Mander moved to Zevenbergen House, between Alkmaar and Amsterdam, before settling in Amsterdam in 1604, where he lived until his death in 1606. It is not known why Hals, who was about 21 years old in 1603, only joined the guild in 1610.

| 10 | 1611, 2 September — BAPTISM OF HARMEN, FRANS HALS'S SON BY HIS FIRST MARRIAGE
Harman
Sone Frans Hals van Antwerpen ende Anneken Hermans
De getuygen Isaac Dirickx ende Thuenken Jans

GAH, DTB 5 (NHG Baptismal Register), fol. 226.
Literature: van der Willigen 1866, p. 116; van der Willigen 1870, p. 140; Dólleman 1973, p. 255.

The baptism of Harmen Hals, son of Frans Hals and his first wife Anneke Harmensdr (doc. 3). The witnesses, Isaack Dircksz (see doc. 15) and Teuntje Jansdr Huydecoper, wife of the brewer and alderman Job Claesz Gijblant; see doc. 3), were Anneke's uncle and aunt.

Harmen Hals also became a painter, and was a member of the Guild of St. Luke, although it is not known when he enrolled (Miedema 1980, pp. 933, 1035). Between 1642 and 1669 he lived in Vianen (doc. 108), Gorchem and Noordeloos, with occasional periods in Amsterdam (Bredius 1923/24b, p. 62; Bredius 1923/24e, p. 260; Wiersum 1935, p. 40). Three children were born of his marriage to Claesje Jansdr, the date of which is unknown: Anna (1638/9), Lysbeth (baptised in Amsterdam's New Church on 7 December 1645) and Bartel (date of birth unknown). He was left nothing in the wills of his rich uncle and aunt Gijblant, but did receive a legacy of 638 guilders from Maria Harmensdr, his mother's sister (GAH, NA 169, fol. 218v, dated 3 July 1642; Bredius 1909a, p. 196). Harmen was buried on 15 February 1669 in St. Anne's Churchyard in Haarlem (GAH, DTB 77, fol. 71r).

It is interesting to note that this document expressly states that Frans Hals came from Antwerp.

| 11 | 1612 — MEMBERSHIP OF THE CIVIC GUARD
M[usquetier] Frans Hals schilder

GAH, OA of the militia (*Registers van de loffelijcke Schutterij der stadt Haerlem* ['Members of the honourable civic guard of the city of Haarlem'] 1612-8 and 1618-30), inv. 31/1, fols. 24r and 42v, of 1612 and 1615; inv. 31/2 (unpaginated) of 1618 and 1621.
Literature: Haarlem 1988, p. 112.

From 1612 to 1615 Frans Hals served as a musketeer in the newly formed third company of the third corporalship of the St. George civic guard (see Levy-van Halm & Abraham, n. 35).

He then transferred to the second company of the third corporalship until 1624, in which his brother Dirck also served as a musketeer from 1618 to 1624.

| 12 | 1612, 6 October — FRANCHOIS HALS'S WIDOW, ADRIANA VAN GEERTENRYCK, TESTIFIES ON BEHALF OF HER FORMER LANDLORD, OLIVIER CORNELISZ

Op huyden compareerde voor mij openbaere notaris ende nabeschreven getuugen Adriaentgen van Geertenryck, de na-gelaten weduwe van wijlen Frans Hals out over de LX jaren, poorterse deser stadt. Ende heeft bij haer vrouwen waerheyt in plaetse van eede ten versoecke van Olivyer Cornelisz packer verclaert ende geaffermeert waerachtich te wesen, dat zij deposante den tijt van een geheel jaer in huyre bewoont heeft de huysinge mette erve van den requirant voornoemt, gestaen ende gelegen alhier binnen Haerlem in de Rampsteege als van den eersten meye XVIc ende thien totten eersten meye XVIc ende elff, als sij daer vuyt vertrocken es ende ten welcken tijde daerinne gecomen is een Pieter Fonte. Ende dat bij tijde zij deposante 't voors. huys bewoonde noyt eenige leckagie aen de voors. huys bevonden heeft, daerover sij eenige redenen van clachte soude hebben connen doen, int alreminste anders dan alleen, dat bij groot slachreegen zij deposante wel eenige leckagie heeft vernomen int cleyne koockentge ter seyde den schoorsteen, daeraen sij evenwel geen schade en heeft geleden, off int minste gepretendeert, maer gaerne int voors. huys soude hebben willen blijven indien zij metten voornoemde requirant in de huyre hadde connen accorderen.

...

GAH, NA 83 (notary Willem van Trier), fol. 148r-v.
Literature: Bredius 1914, p. 216.

Adriana van Geertenryck, the widow of Frans Hals's father Franchois, over 60 years old and a citizen of Haarlem, testifies on behalf of the packer Olivier Cornelisz, whose house in Rampsteeg she had rented for a year from 1 May 1610. After she moved out the house was rented to Pieter Fonte. She now states that she never had any cause to complain about the house leaking, except in a downpour, when water came in beside the chimney in the small kitchen, although it had never caused any damage. She would happily have remained there, but was unable to agree with her landlord on the rent. This is followed by the statement of another witness, the bricklayer Pieter Claesz, who had investigated complaints of leakage with Pieters, the city messenger. Olivier Cornelisz evidently hoped that these depositions would silence his troublesome tenant.

Adriana signed this document, which was drawn up in the house of notary Willem van Trier in Jansstraat, as Adriaentgen van Geertenryck.

The fact that she had rented the house in Rampsteeg from 1 May 1610 suggests that her second husband, Franchois Hals, died in the spring of that year.

| 13 | 1613, 12 May — BURIAL OF A CHILD OF FRANS HALS'S FIRST MARRIAGE

Een opening voor een kint van Frans Hals schilder -10-

GAH, DTB 69 (Burials Register, gravediggers' fees), fol. 252r.
Literature: Dólleman 1973, p. 254.

Gravediggers' fee for preparing a grave, location unspecified, for an unnamed child of Hals's first marriage. The child's date of baptism is not known. Cf. docs. 3, 18.

| 14 | 1615, 31 May — BURIAL OF ANNEKE HARMENSDR, FRANS HALS'S FIRST WIFE

Een openin[g] in de Heyligeng[ees]tkerk voor Annetgen Harmans – niet

GAH, DTB 70 (Burials Register, gravediggers' fees), fol. 4.
Literature: Dólleman 1973, p. 254.

Item for preparing a grave at no charge in the chapel of the Heilige Geesthuis (Holy Spirit Almshouse), here referred to as the Church of the Holy Spirit, for Hals's first wife, Anneke Harmensdr.

The Masters of the Holy Spirit, who cared for the poor, the aged, foundlings and orphans, had founded their home in 1394, to which they later added a chapel. This burial in a pauper's grave indicates that Frans Hals did not have the money to bury his wife anywhere else. Cf. doc. 3.

| 15 | 1615, 5 August — FRANS HALS'S PORTION FROM THE SALE OF HOUSES BELONGING TO THE LATE DIRCK ANTHONISZ, HIS FIRST WIFE'S GRANDFATHER

Isack Dircxsz ende Jacob Dircxs, gebroeders, voor henzelven elc voor een vijffde paert ende Hugo Steyn, secretaris deser stadt, als procuratie hebbende van Elisabet Floris, weduwe van saliger Abraham Dirxsz, ten overstaen van de heeren weesmeesteren gepasseert, voor burgemeesteren ende regeerders der stadt Amstelredamum den XIIIIen july XVIc vijfthien, ons schepenen verthoont, oock voor een vijffde paert, Frans Hals, getrout gehadt hebbende Anna Harmansdr, voor hemzelven ende voorts bij den edele heeren weesmeesteren deser stadt geauthoriseert, als blijct bij de acte van den Xen july XVIc vijfthien, mede ons schepenen verthoont omme vanwegen zijne twee kinderen bij de voors. Anna Harmans geprocreëert, d'opdrachte van de navolgende huysen t'mogen doen, mitsgaders noch den edele Job Claesz Gyblant, schepen deser stadt, als oom ende voocht van Maria, Nicolaes, Elisabeth ende Pieter, onmondige kinderen van wijlen Harman Dircxs, als bij den voors. heeren weesmeesteren deser stadt totte navolgende opdracht geauthoriseert volgens de voors. acte van authorisatie, oock t'samen voor een vijffde paert, ende seigneur Rogier van der Hulst, coopman binnen deser stadt, als eerst bij 't leeven van zaliger Johan Dircxsz van Goch, bij procuratie gepasseert voor notaris ende seeckere getuigen binnen St. Lucas in de coninckrijcke van Hispanien, volmachtich van den zelven ende daernaer de zelve bij naerder scrijvens van de executeurs van desselfs overledens boel geconfirmeert, dienvolgende daervooren vaststaende ende de rato in zijn prive naem belovende te caveren voor 't leste ende vijfde vijfde paert [mark referring to the marginal annotation], alle kinderen ende kindts kinderen ende erffgenaemen van wijlen Dirck Anthonisz, in sijnen leven poorter deser stadt Haerlem, vercoopen in die voors. qualiteyt Gillis de Clercq een huys

376

mette erve staende ende leggende in den Aneganck getekent mette letter A. [followed by a description of the house] – [for the sum of] *IIIm IIIIc carolus guldens vrij suyver gelt ende te betaelen, te weten vyer ende 't negentich halven stucken camericx doeck gereet nevens d'opdracht ter somme van vijfthienhondert guldens ende de reste op drye meyen anno XVIc sesthien, d'eerste telcken een derde paert. Actum den vijffden augusti anno 1615.*
[signed] *Jacob Laurensz, N. Woutersz, 1615*

> [in the margin] *Met renunciatie van de beneficie ordinis et excussionis der crachten van dien hem bekent sijn ende verbintenisse van sijn persoon ende alle sijne goederen present staende, roerende ende onroerende, gene uytgesondert.*

GAH, Property conveyances 76/42, fols.95r-7r.
Literature: Dólleman 1973, pp.249-50.

Conveyance of the sale to Gillis de Clercq of the first of four houses (fols.95r-6r) which had belonged to the Haarlem bleacher Dirck Anthonisz (buried 9 May 1599; cf. doc.3), the grandfather of Hals's first wife, Anneke Harmensdr. These four adjoining properties in Anegang and Grote Houtstraat (identified by the letters A to D in the deed) were all sold at the same time by the heirs – Dirck Anthonisz's children and grandchildren.

Frans Hals, who had lost his wife Anneke Harmensdr a few months before, acted as joint heir and guardian (appointed 10 July 1615) of his two children, who were minors.

Three of the heirs, each with a one-fifth interest in the estate, were Dirck Anthonisz's sons Isaack and Jacob Dircksz, and Elisabeth Floris, the widow of his son Abraham Dircksz, who was represented by Hugo Steyn, the Haarlem city secretary. Another fifth was to be divided between the surviving minor children of the testator's son Harmen Dircksz (represented by their uncle and guardian, Job Claesz Gijblant) – Maria, Nicolaes, Elisabeth and Pieter (brothers and sisters of Hals's wife, Anneke Harmensdr) – and Frans Hals himself. The remaining one-fifth share was to go to Rogier van der Hulst, a Haarlem merchant and the authorised representative of the unnamed executors of the testator's deceased son Johan Dircksz van Goch, who had lived at St. Lucas in Spain.

The houses designated Anegang A and B were sold for 3,400 guilders each, which was to be paid *in natura* with 94 half-lengths of cambric to a value of 1,500 guilders, with the balance to be paid over three years. House C, on the corner of Anegang and Grote Houtstraat, fetched 5,720 guilders. All three were bought by Gillis de Clercq. The fourth house, Grote Houtstraat D, was sold for 1,625 guilders to the tailor Claes Dircksz.

The total proceeds of the sale came to 14,145 guilders, of which Frans Hals received a fifth of a one-fifth share, or roughly 565 guilders.

| 16 | 1616 — MEMBERSHIP OF THE CHAMBER OF RHETORIC
Frans Hals [under the headings *Beminnaers* and *Tweede lid*]

GAH, inv. LL5 (Lists of the members of the Wijngaardrankrhetoricians' society from 1603 to 1810, begun in 1727 by Jan Abraham Casteleyn from the old membership rolls and maintained until 1810), unpaginated.

Literature: van der Willigen 1866, p.121; van der Willigen 1870, p.145; Heppner 1939/40, p.23.

From 1616 to 1624 Frans Hals was a 'friend' or 'second member' (an active member was known as a *camerist*, or first member) of the Haarlem chamber of rhetoric called 'De Wijngaardranken' (The Vine Tendrils), whose motto was 'Love above all'. His brother Dirck was a friend of the society from 1618 to 1623.

| 17 | 1616, 6 August — DEBT OWED TO JAN FRANSZ VAN BACKUM
Pieter Ruychaver als geordonneerde curateur over den boel en de goederen van Jan Fransz van Backum in dier qualiteit eyscher contra Frans Hals, gedaechde. T'eyschen vier gulden vijftien stuyvers uyt zaecke van gecochte schilderije uyttenboel van de voorsz Jan Fransz, welcke vier gulden 15 stuyvers den eyscher bij de secretaris Bartelmies Jacobsz van de ontfanck gecort zijn, maeckende mede eysch van costen oft concludeert etc.

> [in the margin] *In state overmits de boode Heermansz relateert, dat de gedaechde tot Antwerpen is wonachtich.*

GAH, RA 116/3 (Court of Petty Sessions), fol.183v.
Literature: Bredius 1923/24, p.20 (excerpt).

Frans Hals owes 4 guilders and 15 stuivers for a painting which he had bought from the estate of Jan Fransz van Backum, who is represented in court by Pieter Ruychaver, his curator in bankruptcy. The expenses of the secretary, Bartelmies Jacobsz, were deducted from this sum. The case was adjourned when the messenger reported that Frans Hals was away in Antwerp.

Hals spent several months in Antwerp (see doc.22), but the reason for his visit is not known.

| 18 | 1616, 4 September — BURIAL OF A CHILD OF FRANS HALS'S FIRST MARRIAGE
Een opening voor 't kint van Frans Hals -10-

GAH, DTB 70 (Burials Register, gravediggers' fees), fol.20r.
Literature: Dólleman 1973, p.254.

Gravediggers' fee for preparing a grave, location unspecified, for an unnamed child of Hals's first marriage to Anneke Harmensdr. The child was alive on 5 August 1615, but there is no record of when it was baptised (see docs.3, 15).

| 19 | 1616, 14 October — DEBT OWED TO NEELTJE LEENDERS
Neeltgen Leenders, huysvrouwe van Guilliaem de Buys, eyscheresse contra Frans Hals schilder, gedaechde. T'eyschen vijff gulden ter cause van bereeckent gel[t] mette costen.

> [in the margin] *Partijen ende compareeren niet*

GAH, RA 116/3 (Court of Petty Sessions), fol.239r (in reality fol.240r).
Literature: Bredius 1923/24, p.20 (excerpt; dated 6 September instead of 14 October 1616).

Frans Hals owes 5 guilders for expenses incurred by Neeltje Leenders, the wife of Guilliaem de Buys. After the death of his first wife, Hals had taken Neeltje on as a nurse for his two small children, one of which had since died (doc. 18). Neither party was in court.

The outcome of this lawsuit is not known. Cf. docs. 20-22.

| 20 | 1616, 8 November — DEBT OWED TO NEELTJE LEENDERS

Neeltgen Leendertsdr, huysvrouwe van Guilliame de Buys, eyscheresse contra Frans Hals schilder, gedaechde. T'eyschen seven ende daertich gulden vier stuyvers als reste van een jaer alementatie vant houden van zijn kint, mette costen.

> [in the margin] *D'eyseresse present, de gedaechde en compareert niet. Commissarissen verleenen 1e deffaut, 2e citatie.*

GAH, RA 116/4 (Court of Petty Sessions), fol. 5r.
Literature: Bredius 1923/24, p. 20 (excerpt).

See commentary to doc. 22.

| 21 | 1616, 11 November — DEBT OWED TO NEELTJE LEENDERS

Neeltgen Leenders, huysvrouw van Guilliame de Bruyn [sic], eyscheresse contra Frans Hals schilder, gedaechde. Omme als noch t'antwoorden op te geeyschte sevenendertich gulden vier stuyvers over verteerde costen van des gedaechdes kint mette costen, staende fol. 5 voors. oft datter zal gaen twede deffaut ende recht.

> [in the margin] *D'teffaute is gepurgeert. D'eyscheresse ende gedaechdes moeder present. De moeder bekent de schult ter somme toe van dertich gulden ende seyt binnen een dach oft twee te zullen betaelen. Commissarissen dien volgende condemneeren de gedaechde in de bekende dertich gulden mette costen, ende nopende de reste, ordonneeren d'eyscheresse naeder bewijs, committeeren wijders A. [Heeremans], bode omme naer 't scheyden van de rolle in de Nieuwe Doelen alhier te verschijnen ende te versoecken, dat in hande van de secretaris van commissarissen de somme van 37 gulden 4 stuyvers uytte penningen, de gedaechde competerende, mochten werden geconcigneert, omme dezelve uytgedeelt ende daervan gedisponeert te werden naer behooren.*

GAH, RA 116/4 (Court of Petty Sessions), fol. 6r.
Literature: Bredius 1923/24, pp. 20-1 (excerpt).

See commentary to doc. 22.

| 22 | 1616, 15 November — DEBT OWED TO NEELTJE LEENDERS

Neeltgen Leenders eyscheresse contra Frans Hals schilder, gedaechde. Dat mijn edele heeren gelieven ten principale te disponeeren opte verder geeyschte seven gulden vier stuyvers ter lester rolle fol. 5.

> [in the margin] *D'eyscheresse en de gedaechde present, partijen hebben door tusschenspreecken van den heeren commissarissen hun differentien zelve gesubmitteert; de welcke, op alles gelet hebbende, verclaren voor uytspraecke, dat de gedaechde aen eyscheresse eens voor alle pretentien sal betaelen drie gulden twaelff stuyvers ende compenseerende costen, mits dat de penningen sullen werden geconstitueert in handen van de secretaris als int voorgaende vonnis is geordonneert, alwaer d'eyscheresse die ontfangen zal. Frans Hals gedaechde autoriseert A. Heermansz bode,*

omme van Jan Napels te ontfangen de somme van XVI gulden ende heeft dit voorsz. vonnis datelijck voldaen ende d'eyscheresse aengetelt ter somme van drie gulden xii stuyvers.

GAH, RA 116/4 (Court of Petty Sessions), fol. 9r.
Literature: Bredius 1923/24, p. 21 (excerpt).

Neeltje Leenders, who had been taking care of Hals's children (see doc. 20), had claimed 37 guilders and 4 stuivers as the outstanding arrears on an annual allowance for looking after Hals's son Harmen. Hals, who had been unable to appear because he was visiting Antwerp (see doc. 17) was represented at the second hearing (doc. 21) by his mother, Adriana van Geertenryck. She acknowledged that there was a debt of 30 guilders, which she would pay within two days. The commissioners ruled that Hals was to pay this sum, and that Neeltje Leenders was to substantiate her claim for the remaining 7 guilders and 4 stuivers. The court messenger was sent to the Nieuwe Doelen (New Militia Hall) to attach the full amount of 37 guilders and 4 stuivers from a fee owed to Hals (possibly in payment for his civic guard portrait of 1616; S7). The money was then handed over to the clerk of the court, who made the payment.

This particular document deals with the fresh summons to decide the matter of the remaining 7 guilders and 4 stuivers. Hals now appeared in person and reached a settlement with Neeltje Leenders. The sum was halved, and Hals was ordered to pay 3 guilders and 12 stuivers to the clerk. He now authorises the court messenger to receive 16 guilders from Jan Napels, treasurer of the Nieuwe Doelen, whereupon 3 guilders and 12 stuivers are paid to Neeltje Leenders. It is not clear why Hals allowed the court to collect so much money on his behalf, but it may have been to pay the costs of the lawsuit.

It is clear from these court records of 6 August and 11 and 15 November that Frans Hals went to Antwerp before 6 August 1616 and returned between 11 and 15 November of that year.

| 23 | 1617, 15 January — BANNS OF FRANS HALS AND LYSBETH REYNIERSDR

Frans Hals weduwnaer van Antwerpen, woonende in de Peuselaersteege met Lysbeth Reyniers van Haerlem, woonende in de Smeestraet

> [in the margin] *Getrouwt op de attestatie van Haerlem tot Sparendam den 12 february 1617*

GAH, DTB 49 (NHG Banns Register), fol. 79.
Literature: van der Willigen 1866, p. 116; van der Willigen 1870, p. 140 (the wedding date wrongly given as 12 September).

Banns announcing the marriage between Frans Hals, then living in Peuzelaarsteeg, and his second wife, Lysbeth Reyniersdr of Haarlem, living in Smedestraat. The marginal annotation states that they were married on 12 February 1617 in the nearby village of Spaarndam. Cf. doc. 6.

We know the names of eleven of Hals's children by this second marriage, and the baptismal dates of eight of them, all in the period 1617-34. They were Sara (1617; doc. 24), Frans (1618; doc. 26), Adriaentje (1623; doc. 29), Jacobus (1624; doc. 31), Reynier (1627; doc. 38), Nicolaes (1628; doc. 43),

Maria (1631; doc. 57) and Susanna (1634; doc. 62). The names alone are known of Jan (doc. 123), Pieter (doc. 80) and Anthonie (doc. 138).

| 24 | 1617, 21 February — BAPTISM OF SARA, DAUGHTER OF FRANS HALS'S SECOND MARRIAGE
Zara
De vader Frans Hals van Andwerpen
De moeder Lysbeth Reyniersdr
De getuygen Dirrick Hals
 Reinier Jansz
 Hillegond Reiniersen
GAH, DTB 6 (NHG Baptismal Register), fol. 154.
Literature: van der Willigen 1870, p. 140.

Frans Hals's eldest daughter Sara was baptised nine days after his marriage to Lysbeth Reyniersdr, his second wife. The witnesses were his brother Dirck, and Reynier Jansz and Hillegond Reyniersdr, Lysbeth's father and sister.
 On 11 March 1645 the banns were announced in Amsterdam between Sara and a seaman called Sieuwert (Sjoerd) Eles (Eebes) of Molkwerum in Friesland, where they married on 20 March (cf. docs. 109, 110, also docs. 91-3).

| 25 | 1618 — FRANS HALS MENTIONED AS A PUPIL OF KAREL VAN MANDER
Hij [Karel van Mander] *heeft verscheyden discipulen ghehadt, waer van dat eenighe goede Meesters gheworden zijn, namelijck dese, Iaques de Moschero, Jacob Martensz, Cornelis Enghelsen, Frans Hals, conterfeyter van Haerlem, Evert Krijnsz yut den Haghe, Hendrick Gerritsz Oost-Indien en Francois Venant en veel ander hier te langh om te verhaelen, als oock zijn outste soon Karel van Mander, ghebooren te Haerlem, woonende tot Delft ...*
('He had several pupils, some of whom became good masters: Jacques de Moscher, Jacob Martensz, Cornelis Engelsz, Frans Hals, portrait painter of Haarlem, Evert Krijnsz van der Maes of The Hague, Hendrick Gerritsz Pot ['East Indies'], François Venant, and many more too numerous to mention here, as well as his eldest son Karel van Mander, who was born in Haarlem and lives in Delft.')
(Karel van Mander's anonymous biographer in van Mander 1618, unpaginated)

Karel van Mander himself makes no mention of Frans Hals in the first edition of his *Schilder-boeck* (1604). Van Mander's own biography first appeared in the second edition of 1618 (cf. doc. 9).

| 26 | 1618, 16 May — BAPTISM OF FRANS, SON OF FRANS HALS'S SECOND MARRIAGE
Frans
Vader Frans Hales van Antwerpen
Moeder Lysbeth Reyniers
Getuygen Gerrit Reyniers
 Hillegond Reyniers
GAH, DTB 6 (NHG Baptismal Register), fol. 242.

The baptismal record of Frans Hals the Younger, the eldest son of Hals's second marriage. The witnesses were a brother and a sister of Hals's wife Lysbeth.
 Frans Hals the Younger also became an artist, and was a member of the Guild of St. Luke (date of enrolment unknown; Miedema 1980, pp. 137, 932, 1035), but there are no documented works from his hand. He continued living in Haarlem, marrying there in November 1643 (doc. 98). He is known to have died before November 1677, because the will which his son Johannes, a seaman, made before embarking on a voyage was drawn up at the house of Nicolaes Hals, who is referred to as Johannes's uncle and guardian (GAH, NA 423 [notary J. de Ram], fol. 170).
 Hals's son is explicitly referred to as Frans Hals the Younger in documents of 1645 and 1649 (Bredius 1923/24c, p. 215), but he may sometimes be confused with his father when that designation is lacking.

| 27 | 1620, 13 December — BURIAL OF A CHILD OF FRANS HALS'S SECOND MARRIAGE
Frans Halses kint een openingh -10-
GAH, DTB 70 (Burials Register, gravediggers' fees), fol. 75r.

Gravediggers' fee for preparing a grave, location unspecified, for an unnamed child, presumably born to Frans Hals and his second wife Lysbeth. There is no baptismal record for this child, who evidently died in infancy.

| 28 | 1621 — AMPZING ON FRANS AND DIRCK HALS
Wat wil ick oock van Dijck, van Wieringen hier melden,
De Grebbers, Matham, Pot, Ian Jacobs, Vroom en Velden,
De Halsen, Campen, Smit, Brey, Bouchorst en Molijn,
En and'ren die hier meer, jae sonder eijnde, sijn?
 [in the margin] *Frans en Dirck Hals Fr.*
('What shall I say here of van Dyck and van Wieringen,
The Grebbers, Matham, Pot, Jan Jacobs [Guldewagen],
Vroom and Velden,
The Halses, Campen, Smit, Bray, Bouchorst and Molijn,
And others, a list unending, who all can here be found?')
(Ampzing 1621, unpaginated)

See commentary to doc. 41.

| 29 | 1623, 21 July — BAPTISM OF ADRIAENTJE, DAUGHTER OF FRANS HALS'S SECOND MARRIAGE
Adriaentgien
Vader Frans Hals van Haerlem
Moeder Elisabeth Reyniers
Getuygen Isaac Massa
 Hillegond Reyniers
GAH, DTB 7 (NHG Baptismal Register), fol. 293.
Literature: van der Willigen 1866, p. 116; van der Willigen 1870, p. 140.

Record of the baptism of Adriaentje Hals, daughter of Frans Hals and Lysbeth Reyniersdr. Hals's place of origin is mistakenly given as Haarlem instead of Antwerp. The witnesses were

Hillegond, Lysbeth's sister, and Isaac Massa (Haarlem 1586-1643 Haarlem), merchant, historian and cartographer. Hals's 1635 portrait of Massa (cat. 48) is documented by Adriaen Matham's engraving. On the basis of this there is general agreement that the 1626 portrait in Toronto (cat. 21) is also of Massa. It has also been argued that the *Married Couple in a Garden* are Massa and his first wife, Beatrix van der Laen (cat. 12). The identification of Massa as the man in the Chatsworth painting is much less convincing (cat. 13).

In 1654 Adriaentje married the still-life painter Pieter van Roestraten (see docs. 138, 148, 157).

| 30 | 1623, 19 September — FRANS HALS WITNESSES THE BAPTISM OF MARIA, DAUGHTER OF HIS BROTHER DIRCK
Maria
Dirrick Hals van Haerlem, pater
Agnijetken Jans, mater
Frans Hals
Margrita Jans, getuygen
GAH, DTB 7 (NHG Baptismal Register), fol. 309.

Frans Hals witnesses the baptism of his niece Maria, the daughter of his brother Dirck and his wife Agnietje Jansdr (see doc. 4).

On 25 June 1651 Maria married Adriaen Pietersz Suyderhoef (Haarlem 1619-1667 Haarlem), brother of the engraver Jonas Suyderhoef (Haarlem c. 1613 - 1686 Haarlem). Cf. doc. 114.

| 31 | 1624, 12 December — BAPTISM OF JACOBUS, SON OF FRANS HALS'S SECOND MARRIAGE
Jacobus
Vader Frans Hals van Antwerpen
Moeder Lysbeth Reyniers
Getuigen Jan Pietersz Berendrecht
 Hillegondt Reyniers
GAH, DTB 7 (NHG Baptismal Register), fol. 436.
Literature: van der Willigen 1866, p. 116; van der Willigen 1870, p. 140.

The baptismal record of Jacobus Hals, son of Frans Hals and Lysbeth Reyniersdr. The witnesses were Jan Pietersz Berendrecht, probably the father of the Haarlem publisher and artist Pieter Jansz van Berendrecht, and Lysbeth's sister Hillegond.

Jacobus probably died young, and may have been the 'child of Frans Hals' who was buried in the Beguine Churchyard on 30 May 1648 (see doc. 128).

| 32 | 1624, 20 December — DEBT OWED TO JAN JANSZ
Jan Jansz eyscher contra Frans Hals gedaechde. T'eyschen betalinge ende bij provisie namptissement van 3-6-0 over coop van een bont jack mette costen.

[in the margin] *D'eyschers vrou present, de gedaechde compareert niet. D'eyschers vrou leyt over haer boeck ende presenteert 't zelve met eede te stercken. Commissarissen gesien 't boeck ende gelet op de non comparitie vande gedaechde decerneeren deffault, ende met oncoste vandien houden de schult voor bekent, condemneeren de*

gedaechde de geeyschte somme van 3 gulden 6 stuyvers bij provisie te innen onder cautie; surcerende d'executie 3 wecken.

GAH, RA 116/9 (Court of Petty Sessions), fol. 66v.
Literature: Bredius 1923/24, p. 21 (excerpt).

Jan Jansz, apparently a draper or furrier, demands payment of 3 guilders and 6 stuivers for a *bont jack* (either a jacket of many colours or a fur jacket, probably the latter). His wife is present in court and produces her account book. The commissioners, noting the defendant's absence, declare default and order him to pay the money within three weeks, as well as the court costs.

The relevance of this court record is doubtful, for there is no evidence that it relates to Frans Hals the painter.

| 33 | 1626, 14 May — ADRIAEN WATH, HILLEGOND REYNIERSDR AND ROELANT LAURENSZ TESTIFY AGAINST HENDRICKJE WETSELAERS, A FEMALE QUACK WHO PRACTISED ON FRANS HALS'S SECOND WIFE, LYSBETH REYNIERSDR
Ter instantie ende versoecke van Lysbet Reyniers, huysvrouwe van Mr. Frans Hals, schilder.
Compareerde voor mijn Jacob Schoudt, notaris publycq bij den Hove van Hollandt geadmitteert, binnen de stadt Haerlem residerende, ten bijwesen van de naerbeschreven getuygen, Mr. Adriaen Wath, chirurgijn, oudt omtrent XXVII jaeren, ende Hillegont Reyniersdr, weduwe van Jacob Willemss., oudt omtrent XXXII jaeren, beyde binnen Haerlem wonende, ende hebben bij heurluyder manne ende vrouwe waerheyt, in plaetse van gestaeffde eede, ten versoucke verclaert, getuycht ende geaffirmeert waerachtich te wesen elcx 't geene hiernaer volcht, te weten eerst de voors. Mr. Adriaen Wath, dat sijnen broeder Mr. Dirck Wath, gaende als chirurgijn over de voors. requirante omme te cureren seeckere wonde ofte accident 't welck sij aen de rechter sijde van haer aengesicht hadde, op hem getuyge begeert ende versocht heeft, dat hij eens met hem wilde gaen ten huyse van de voors. Frans Hals ende 't voors. accident besichtigen, omme te besien hoe seecker vrouspersoon, genaempt Henrickgen Wetselaers, die te vooren als meesterse daerover gegaen hadde, de voornoemde requirante hadde bedorven. Gelijck hij getuyge dienvolgende, mette voorn. sijnen broeder ten huyse vande voors. Frans Hals gegaen sijnde ende het accident vande voorn. Lysbet Reyniers gevisiteert hebbende, gesien ende bevonden heeft, datte mortificatie daer volcomelijck inne was ende datter voor de voorn. Lysbet Reyniers noch meerder pijne, smerte ende swaericheyt uuyt te verwachten stondt, bij aldien sij mette voors. Henrickgen Wetselaers voort gemeestert ende onder geen goet chirurgijns handen gecomen hadde.
De voors. Hillegont Reyniers verclaert, dat sij, terwijle de voorn. requirante het voors. accident aen haer aensicht gehadt ende de voorn. Henrickgen Wetselaers daerover te meesteren gegaen heeft, ten huyse vande voors. Frans Hals is geweest mette voorn. Henrickgen Wetselaers. Ende de voorn. requirante tegens deselve Henrickgen haer beclach doende van de ellendige ende extreme pijne ende smerte die sij nacht ende dach was lijdende, daervan sij nyet en conde rusten, ende dat sij nyet en genas noch en beterde, heeft sij getuyge gehoort, datte voors. Henrickgen Wetselaers daerop antwoorde ende seyde, datte cleyne kinderen in de wiech terstont wel conden

slapen als sij haer medicamenten, die sij tot curatie van diergelijcke accidenten daer op leyde. Datt sij nyet en wiste wat de voors. Lysbet Reyniers schorte, datter yemant in de weer was, ofte datter de duyvel mede spelen moste. 'T welck sij getuygen presenteren tot allen tijden, elcxs in sijn regardt, met solemnelen eede te bevestigen, ende consenteerden etc. Aldus gedaen ende gepasseert binnen de voors. stadt Haerlem, ten huyse mijns notarii, staende in de Nobelstraet, den 14e mey 1626, in presentie van Passchier Caluwaert ende Guilliame Cool, packer, als getuijgen hiertoe versocht.
[signed] Mr. Adriaen Jansen Wat, (teijcken eyghen hant Hillegont Reyniers), Passchier Caelewaert, Guiliaem Cool. Quod attestor J. Schoudt, notarius publicus.
[rider]

Compareerde mede voor mijn notario ende getuygen boven genoempt, Roelant Laurens, smalwerker, oudt omtrent 24 jaeren ende heeft mede bij sijne mannewaerheyt in plaetse van gestaeffde eede ten versoecke als boven verclaert ende geaffirmeert, waerachtich te wesen, dat hij getuyge seer wel gekent de persoon van Henrickgen Wetselaers in de bovenstaende attestatie vermelt, dewelcke bij sijnen getuygens moeder geleert heeft, toe te maecken ende te prepareren eenige salve, dienende omme te cureren wonden, die gebrant sijn. Ende dat hij getuyge wel ende seeckerlijcken weet, datte voorn. Henricken Wetselaers totter cureren vant gebrande accident, 't welck de voors. Lysbet Reyniers nu onlangs aen de rechte sijde van haer aensicht heeft gehadt, nooit dieselffde salve nyet gebruyckt en heeft, maer dat sij daer meerder bij gedaen alst behoorde, waerdoor de voorn. Lysbet Reyniers oock nootsaeckelijck seer groote ende extreme pijne ofte smerte heeft moeten lijden, overmits 't voors. accident bij de voors. Henricken Wetselaers met meesters oock gantsch en geheel bedurven es geweest. Oock voor redenen van wetenschappe gevende, dat hij getuyge 't voorz. accident selffs mede heeft besichtiget, verclaert mede bij hij getuyge, dat hij op een seeckeren tijt beyde de voors. Lysbet Reyniers aent voors. accident was sittende, ten huyse van de voors. Frans Hals geweest es, alwaer doen ter tijt mede innequam de voors. Henricken Wetselaers, dewelcke soo haest sij vernomen hadde, dat hij getuyge daer in huys was, nyet es deurve binnen comen, maer terstonts wederom 't huyse uuytginck. [reference to marginal annotation]
Overbodich stavende hij getuyge 't selve mede ten allen tijden met solemnelen eede te bevestigen. Ende consenteerende.
Actum ut supra, coram iisdem testibus [signed] merck eygen hant Roelant Laurens, Guiliaem Cool, Passchier Caelewaert Quod attestor J. Schoudt, notarius publicus

 [in the margin] ende dat soodanige accident in acht ofte uyterlick tien daghen 't langst soude ende behoorde gecureert te wesen.

GAH, NA 127 (notary Jacob Schoudt), fols.73v-4r.
Literature: van Hees 1959, pp. 41-2 (with transcription).

Adriaen Wath, surgeon of Haarlem, and Hillegond Reyniersdr, widow of Jacob Willemsz, file a complaint against Hendrickje Wetselaers for practising quackery on Frans Hals's wife, Lysbeth Reyniersdr. Hendrickje had been treating a burn on Lysbeth's face with the wrong salve for such a long time that the flesh had mortified. When Lysbeth complained that she could not sleep for the pain and that the wound was not healing, the woman replied that she had used

the salve on newborn infants without any ill effects, so this must be the work of the devil.

On the same day a 24-year-old narrow-cloth weaver called Roelant Laurensz testified that his mother had given Hendrickje Wetselaers the recipe for the salve, but that she had tampered with the proportions. On one occasion, when he had been visiting Lysbeth Reyniersdr, the quack had called, but had immediately turned tail and fled on seeing him there.

| 34 | 1626, 26 May — DEBT OWED BY A WOMAN, POSSIBLY FRANS HALS'S SECOND WIFE, TO THE WIDOW OF CLAES HUYGENSZ
De weduwe van Claes Huygensz contra de huysvrou van Frans Hals gedaechde. T'eyschen betalinge ende bij provisie namptissement van 20-0-0 over verdient meesterloon ende gedaen costen, mette costen.

 [in the margin] D'eyscheresse present, de gedaechde compareert niet; 1e deffault, 2e citatie

GAH, RA 116/10 (Court of Petty Sessions), fol. 210r.
Literature: Bredius 1923/24, p. 21 (excerpt).

See commentary to doc. 36.

| 35 | 1626, 29 May — DEBT OWED BY A WOMAN, POSSIBLY FRANS HALS'S SECOND WIFE, TO THE WIDOW OF CLAES HUYGENSZ
De weduwe van Claes Huygensz contra de huysvrou van Frans Hals gedaechde. Om te andtwoorden op de geeyste 20-0-0 ofte het 2e defaut te begeren, fol. 210.

 [in the margin] In state, eyscheresse compareert niet

GAH, RA 116/10 (Court of Petty Sessions), fol. 211v.

See commentary to doc. 36.

| 36 | 1626, 9 June — DEBT OWED BY A WOMAN, POSSIBLY FRANS HALS'S SECOND WIFE, TO THE WIDOW OF CLAES HUYGENSZ
De weduwe van Claes Huygensz contra de huysvrou van Frans Hals gedaechde. Om t'andtwoorden op de geeyste 20-0-0 ofte het 2e defaut te begeren, folio 210.

 [in the margin] D'eyscheresse en de gedaechde present. Commissarissen partijen gehoort, condemneren de gedaechde in plaetse van de geeyste somme van 20 gulden aen den eyscheresse te betaelen ses gulden compencerende costen.

GAH, RA 116/10 (Court of Petty Sessions), fol. 214r.

A woman, possibly Lysbeth Reyniersdr (the document identifies her merely as 'the wife of Frans Hals', so it might be another couple altogether) owed 20 guilders to the widow of Claes Huygensz for wages and expenses (doc. 34). The nature of the work is not specified. The 'wife of Frans Hals' had failed to put in an appearance at the first hearing, and the claimant at the second (doc. 35), but both now attended the third session. Having heard the arguments the commissioners decide that the defendant should pay the claimant 6 guilders instead of 20.

| 37 | 1626, 16 October — FRANS HALS WITHDRAWS THE ATTACHMENT IMPOSED BY HIS LATE BROTHER JOOST ON THE POSSESSIONS OF THE LATE KAREL VAN MANDER THE YOUNGER
Op huyden compareerde voor mijn Jacob Schoudt, notaris publicus bij den hove van Hollandt geadmitteert, binnen der stadt Haerlem residerende, Frans Hals Mr. schilder ende poorter deser stede, voor hem selven ende vervangende Dirck Hals, sijnen broeder, t'samen erffgenamen van Joost Hals, heuren overleden broeder, verclaerende hij comparant inder voorsz. qualiteyt gerenunchieert ende ontslagen te hebben, gelijck hij renunchieert ende ontslaet mits desen, alsulcken arreste ende becommenisse, als den voorn. Joost Hals sijnen broeder all in den jaere 1623 heeft laeten doen op den boel ende goederen van saliger Caerl Vermander, binnen der stadt Delft overleden, stellende mitsdien de selve goederen wederom in sijne eerste ende voorige staete, sulcxs die voor date vant voors. gedaen arrest geweest zijn. Actum den XVIen octobris anno 1626. T'oirconden deses bij de voors. Frans Hals geonderteyckent, [signed] Frans Hals Mij present J. Schoudt, notarius publicus subscripsit

GAH, NA 127 (notary J. Schoudt), fol. 170v.
Literature: Bredius 1923/24, pp. 19-20 (excerpt); van Roey 1972, p. 151.

Frans Hals, as the heir of his brother Joost (date of death unknown), acting for himself and his brother Dirck, withdraws the attachment which Joost had levied in 1623 on the estate and possessions of the late Karel van Mander the Younger (buried in Delft on 26 February 1623). The reasons for the attachment are not known.

Joost Hals, who was born at Antwerp in 1584 or 1585, was almost certainly the second son of Franchois Hals of Mechelen and his second wife, Adriana van Geertenryck of Antwerp, who had settled in Haarlem between late 1585 and March 1591 (see doc. 1). Joost was reputedly a painter, but not one of his works has been identified. Documents published by Bredius show that on 27 June 1608 he was fined for throwing a stone which injured a guard on the Kleine Houtbrug (Burgomasters' Resolutions), and on 21 and 26 November 1619 his name appears on the case list of the Court of Petty Sessions as owing 5 guilders, 14 stuivers and 8 penningen for food and drink.

| 38 | 1627, 11 February — BAPTISM OF REYNIER, SON OF FRANS HALS'S SECOND MARRIAGE
Reinier
Vader Frans Hals van Antwerpen
Moeder Lysebeth Reyniers
Getuygen Jan van Velde
Francoys Elout
Marijtge Huberts

GAH, DTB 8 (NHG Baptismal Register), fol. 60.
Literature: van der Willigen 1866, pp. 116-7; van der Willigen 1870, p. 140.

The baptismal record of Reynier, son of Frans Hals and Lysbeth Reyniersdr. The witnesses were the painter, draughtsman and engraver Jan van de Velde II (Rotterdam 1593-1641 Enkhuizen), who made prints after seven of Hals's paintings between 1626 and 1632, the still-life artist Franchois

Elout (Haarlem 1589-1636 Haarlem), and Marijtje Hubertsdr.

Reynier went to sea (see doc. 113) before taking up painting. He married twice (docs. 144-5, 155), and settled in Amsterdam in 1654. He was buried in the city's Leidse Churchyard on 3 May 1672 (GAA, DTB 1227, fol. 189). See also doc. 159.

| 39 | 1627, 11 May — DEBT OWED TO CORNELIS DIRCKSZ
Cornelis Dirricxsz eyscher contra Frans Hals gedaechde. T'eysche betalinge ende bij provisie namptissement van 7-0-0 over geleeverde boter ende kaas mette costen.
[in the margin] *In state*

GAH, RA 116/11 (Court of Petty Sessions), fol. 143v.
Literature: Bredius 1923/24, p. 21 (excerpt).

See commentary to doc. 40.

| 40 | 1627, 6 July — DEBT OWED TO CORNELIS DIRCKSZ
Cornelis Dirricxsz eysscher contra Frans Hals gedaechde. T'eysche betalinge ende bij provisie namptissement van 3 gulde over koste van meerder somme mette costen.
[in the margin] *In state*

GAH, RA 116/11 (Court of Petty Sessions), fol. 182v.

Cornelis Dircksz, who had demanded 7 guilders from Frans Hals in May 1627 for supplying him with butter and cheese (cf. doc. 39), now sues him for a further 3 guilders in costs. The case is adjourned for a second time.

The relevance of this court record is doubtful, for there is no evidence that it relates to Frans Hals the painter.

| 41 | 1628 — AMPZING ON FRANS AND DIRCK HALS
Komt Halsen, komt dan voord,
Beslaet hier mee een plaetz, die u met recht behoord.
Hoe wacker schilderd Frans de luyden naer het leven!
Wat suyv're beeldekens weet Dirck ons niet te geven!
Gebroeders in de konst, gebroeders in het bloed,
Van eener konsten-min en moeder opgevoed.
Daer is van Franz Hals een groot stuck schilderije van enige Bevelhebbers der schutterije in den Ouden Doelen ofte Kluveniers, seer stout naer 'tleven gehandeld.
('Forth, Halses, come forth!
Take here a seat, yours it is by right.
How dashingly Frans paints people from life!
How neat the little figures Dirck gives us!
Brothers in art, brothers in blood,
Nurtured by the same love of art, by the same mother.
There is a large painting by Frans Hals of some of the officers of the civic guard in the Old Doelen or Calivermen's Hall, done most boldly from life.')
(Ampzing 1628, p. 371)

Samuel Ampzing (Haarlem 1590-1632 Haarlem), made a fleeting mention of Frans and his younger brother Dirck as 'the Halses' in the second, 1621 edition of his *Beschrijvinge ende lof der stad Haerlem in Holland* (Description and Praise of the City of Haarlem in Holland; doc. 28), the first edition

of which appeared in 1616. Here he devotes several lines to them. The 'large painting' he refers to is the militia piece of 1627 (s45).

Hals painted Ampzing's portrait around 1630 (cat. 40).

| 42 | 1628, 10 January — BUCHELIUS ADMIRES FRANS HALS'S PORTRAIT OF SCHREVELIUS AND IS GIVEN A PRINT OF HALS'S PORTRAIT OF SCRIVERIUS

Rector Screvelius monstrabat et suam effigiem ab Halsio, pictore Harlemensi, in tabella pictam admodum vivide, a quo et pictus Scriverius, ad quam picturam eundem in aere expressit Veldius, cujus mihi geminam effigiem dedit.

Utrecht, University Library, ms. 1781 (*Aantekeningen betreffende meest Nederlandse schilders en kunstwerken* ['Notes on most Dutch painters and works of art']), fol. 17v.
Literature: van Rijn 1887, p. 151; Hoogewerff & van Regteren Altena 1928, p. 66; Strauss & van der Meulen 1979, p. 61.

The Utrecht jurist Arnout van Buchell (Utrecht 1565-1641 Utrecht), who left copious notes on art, visited Leiden in 1628, where he saw Hals's small oval portrait (cat. 5) of Theodorus Schrevelius (Haarlem 1572-1649 Leiden), formerly a Haarlem schoolmaster and since 1625 rector of the Latin School in Leiden. Buchelius is probably not referring here to one of the two male portraits dated 1628 (s49, s50), for quite apart from doubts about the sitter's identity it is unlikely that either work had been completed by 10 January of that year. During the visit, Schrevelius presented Buchelius with a print by Jan van de Velde after Hals's 1626 portrait of the Haarlem historian and poet, Petrus Scriverius (Haarlem 1576-1660 Oudewater), which is now in the Metropolitan Museum, New York (s36; see cat. 5 and cat. 20 for a discussion of Scriverius).

Schrevelius himself wrote about Hals in 1647 (doc. 116).

| 43 | 1628, 25 July — BAPTISM OF NICOLAES, SON OF FRANS HALS'S SECOND MARRIAGE

Nicolaes
Vader Frans Hals van Antwerpen
Moeder Lysbeth Reyniers
Getuygen Nicolaes de Camp
 Geesken Jans

GAH, DTB 8 (NHG Baptismal Register), fol. 205.
Literature: van der Willigen 1866, p. 117; van der Willigen 1870, p. 140.

The baptismal record of Nicolaes, son of Frans Hals and Lysbeth Reyniersdr. The witnesses were the painter Nicolaes de Camp (de Kemp) the Younger (Haarlem 1609-1672 Haarlem; cf. docs. 82, 153), and someone called Geesje Jansdr.

Nicolaes, who became a painter like his father, married in Haarlem in February 1655 (doc. 150). On 2 November of that year he became a member of the Guild of St. Luke, of which he was warden in 1682 and 1685 (Miedema 1980, pp. 1034 [member], 695-9, 709, 1034, 1065-6 [warden]). He was buried on 7 June 1686 in the Great Church of St Bavo (GAH, DTB 83, fol. 75: nave 111).

He painted genre pieces in the manner of Jan Miense Molenaer and landscapes in the style of Jacob van Ruisdael.

He also produced a number of topographically accurate views of Haarlem.

See also docs. 141-3 and 188.

| 44 | 1628, 1 September — DEBT OWED TO ABRAM DE NIJSSE

Abram de Nijsse eyscher contra Frans Hals gedaechde. T'eysche betalinge ende bij provisie namptissement van 4-0-0 over reste van geleeverde waer volgens des eyscher register mette costen.

[in the margin] *Partijen compareren niet*

GAH, RA 116/12 (Court of Petty Sessions), fol. 205v.
Literature: Bredius 1923/24, p. 21 (excerpt).

Abram de Nijsse sues Frans Hals for 4 guilders for provisions, as recorded in his account book. Neither party is in court.

The relevance of this court record is doubtful, for there is no evidence that it relates to Frans Hals the painter.

| 45 | 1629 — THE CITY OF HAARLEM PAYS FRANS HALS FOR RESTORING PAINTINGS

Frans Hals Mr. schilder uuyt saecke vant verlichten ende veranderen van eenige stucken schilderije gecomen uyten convent van Sinte Jehans alhier vermogens sijne declaratie, ordonnantie ende quictantie ... XXIIII L.

GAH, Treasurer's Accounts 1629 (19/209), fols. 92v-3r.
Literature: van der Willigen 1866, p. 121; van der Willigen 1870, p. 145; Gonnet 1915, p. 139; Bredius 1923/24, p. 21 (full transcription).

The city of Haarlem pays Frans Hals 24 pounds for cleaning and retouching some paintings from the Commanderie of the Knights of St. John, which had passed to the city after the secularisation of 1581. In 1625 the pictures were moved to the Prinsenhof (the stadtholder's occasional residence).

| 46 | 1629, 22 January — THE CITY OF HAARLEM ASKS FRANS HALS AND TWO OTHER PAINTERS TO REPORT ON WHETHER TORRENTIUS'S CELL IN THE HOUSE OF CORRECTION IS SUITABLE AS A STUDIO

Den Mrs. schilders Pieter Molijn, Franchoys Hals ende Johan van de Velde gelast ende geordonneert te neme inspectie van de gelegentheyt van de camere Johannes Torrentius in den werckhuyse deser stadt omme te schilderen ende de heeren te dienen van rapport ende schriftelijck advies.

[in the margin] *Inspectie te nemen van Torrentius camere*

GAH, Burgomasters' Resolutions 1629 (inv. 10/6), fol. 61r-v.
Literature: van der Willigen 1866, pp. 209-13; van der Willigen 1870, pp. 296-301; Bredius 1909, p. 56; Rehorst 1939, pp. 57-8.

On 30 August 1627 the painter Johannes Symonsz Torrentius (Amsterdam 1589-1644 Amsterdam), was sent to the house of correction for being a member of the banned Society of Rosicrucians. The burgomasters now direct the painters Pieter Molijn (London 1595-1661 Haarlem), Frans Hals and Jan van de Velde II (Rotterdam 1593-1641 Enkhuizen) to submit a written report on the suitability of Torrentius's cell as a studio.

The report itself has not survived.

| 47 | 1629, 17 May — DIRCK HALS STANDS SURETY FOR HIS BROTHER FRANS'S PURCHASES AT AN AUCTION

Ick ondergescreven stelle mijselve mits desen als borg onder renuntiatie vant beneficie ordinis seu excussionis voor Mr. Frans Hals mijnen broeder voor alle 't gundt hij in de vendue gehouden tot Mr. Frans Pietersz Grebber ofte seigneur Snelling gecoft heeft omme d'selve somme sonder vertreck promptelijck sonder figure van proces te voldoen. Onder verbant van mijn persoon ende goet. Actum 17 mey 1629. [signed] Dirck Hals

GAH, RA 75a (register of auction recognisances), fol. 16.
Literature: Bredius 1923/24, p. 21 (full transcription; the date incorrectly given as 1627).

Dirck Hals provides an unconditional bond for all the works which his brother Frans bought at a public art auction held by Frans Pietersz de Grebber (Haarlem 1572/3-1649 Haarlem) or by Snelling.
It is not known what paintings Frans Hals bought at this sale.
Frans Pietersz de Grebber and Andries Snelling (Miedema 1980, pp. 420, 423) were painters who also dealt in art.

| 48 | 1629, 10 July — DEBT OWED TO JACOB SEIJMENSZ

De selve eyscher [the baker Jacob Seijmensz] contra Frans Hals gedaechde. T'eysche betalinge ende bij provisie namptissement van 5-17-0 over geleevert broot mette costen.

[in the margin] *Ut supra namptissement,* [deleted: *rest 4 stuyvers.*]

GAH, RA 116/13 (Court of Petty Sessions), fol. 225r.
Literature: Bredius 1923/24, p. 21 (excerpt).

Jacob Seijmonsz, a baker, sues Frans Hals for 5 guilders and 17 stuivers for bread purchases. The debt is to be paid under suretyship.
The relevance of this court record is doubtful, for there is no evidence that it relates to Frans Hals the painter.

| 49 | 1629, 21 August — DEBT OWED TO BARTHOLOMEUS VAN EECKHOUT

Bartelmeeus van Eekhout eyscher contra Frans Hals gedaechde. T'eysche betalinge ende bij provisie namptissement van 11-17-0 over verdient arbeydloon mette costen.

[in the margin] *1ste deffault, 2 de citatie*

GAH, RA 116/13 (Court of Petty Sessions), fol. 273r.
Literature: Bredius 1923/24, pp. 21-2 (excerpt).

See commentary to doc. 50.

| 50 | 1629, 24 August — DEBT OWED TO BARTHOLOMEUS VAN EECKHOUT

Bartelmies van Eeckhout contra Frans Hals gedaechde. Om t'antwoorden op te geeyste 11-17-0 ofte gedaechdes diffaut te begeeren folio 273.

[in the margin] *D'eyscher present, de gedaechde compareert niet. Eyscher leyt over zijn reeckening ende presenteert dezelve met eede te stercken. Commissarissen dienvolgende ende gehoort 't relaes van de boode, die relateert, dat de gedaechde seyt niet te zullen*

coomen, oock gelet op de non comparitie van de gedaechde decerneren twede deffault voors. uyt crachte vandien. Houden de schult voor bekent, condemneren de gedaechde de geeyschte somme van elff gulden seventien stuyvers bij provisie te namptisseren onder cautie.

GAH, RA 116/13 (Court of Petty Sessions), fol. 278r.

Bartholomeus van Eeckhout had demanded a provisional settlement from Frans Hals of 11 guilders and 17 stuivers for arrears of wages and court costs (see doc. 49). Hals, who had not attended the first session, was summoned for a second time and again failed to appear. The claimant now produces his bill for the commissioners' inspection. After the messenger had informed them that Hals refused to attend, the commissioners declare a second default. They rule that he has acknowledged the debt, and order him to pay the full sum.
It is not known what kind of work van Eeckhout had done for Hals.
The relevance of this court record is doubtful, for there is no evidence that it relates to Frans Hals the painter.

| 51 | 1629, 14 December — DEBT OWED TO AN UNKNOWN PERSON

... over reste van eetbaere waer, mette costen.
Literature: Bredius 1923/24, p. 22 (excerpt).

No trace has been found of this document, which is mentioned by Bredius.

| 52 | 1630, 29 March — FRANS HALS AND HIS BROTHER DIRCK SIGN A DEPOSITION MADE BY HENDRICK WILLEMSZ DEN ABT

... compareerde Hendrick Willemsz den Abt, waert in de Coninck van Vranckrijck, out omtrent 35 jaeren. Dewelcke, ten versoecke van Dirck van 't Heem, poorter inde Beverwijck, heeft getuicht waerachtich te wesen, dat in augusto lestleden te zijne deposants huyse gegijsselt geweest [es] door Jan van Daele, deurwaerder van de gemeene middelen onder 't quartier van Haerlem, eenen Jan Pieckeyen, waert aent Wijckerheck ...
Testibus Frans ende Dirck Hals als getuygen. [signed] *Frans Hals, Dirck Hals, Heynderick Willemsz den Abt, W. Crousen de Jonge*

[in the margin] *den 29en martii 1630*

GAH, NA prot. 155 (notary Willem Crousen de Jonge), fol. 208r.
Literature: Bredius 1923/24, p. 22 (mentioned).

Frans Hals and his brother Dirck sign a deposition drafted by notary Willem Crousen the Younger for Hendrick Willemsz den Abt, aged 35, landlord of the 'Coninck van Vranckrijck' (cf. doc. 58), an inn in Smedestraat which was very popular with artists. At the request of Dirck van 't Heem of Beverwijk, den Abt declares that Jan Pieckeyen, landlord of the 'Wijkerhek' had been arrested in his house the previous August by the bailiff of the Common Purse.

1630, 5 November — DEBT OWED TO THE WIDOW OF OCTAEF JANSZ

De weduwe van Octaeff Jans eyscheresse contra Frans Hals gedaechde. Omme te hebben betalinge ende bij provisie namptissement van vijff gulden vijff stuyvers over geleverde schoenen volgens 't register waervan copi wert gepresenteert mette costen.

> [in the margin] *Commissarissen verleenen tegen de gedaechde, vermits sijn non comparitie, 't eerste deffault ende voort proffijt vandien, gesien reeckeninge uyt d' eyscheres boeck getoogt ende gehoort de verclaringe van Abraham de Vos als procuratie hebbende van de eyscheresse, houden de schult voor bekent. Condemneeren den gedaechde de geeyschte somme bij provisie te namptiseren onder cautie, den gedaechde verstreckende van d'exceptie declinatoir.*

GAH, RA 116/14 (Court of Petty Sessions), fol. 16r (renumbered 19).
Literature: Bredius 1923/24, p. 22 (excerpt).

The widow of Octaef Jansz, represented by Abraham de Vos, sues Frans Hals for 5 guilders and 5 stuivers for a consignment of shoes. The defendant fails to put in an appearance, so the commissioners declare a first default. After questioning de Vos and inspecting his account book, the commissioners admit the debt and order the defendant to lodge a provisional surety equal to the sum demanded, declaring that the case is outside their jurisdiction.

The relevance of this court record is doubtful, for there is no evidence that it relates to Frans Hals the painter.

| 54 | 1631, 18 August — FRANS HALS WITNESSES THE LAST WILL OF MICHIEL DE DECKER

... daer als getuygen van goede geloven mede present jegenwoordich waeren d'eersame Frans Hals, meester schilder ende Jacob van Wijndes, garentwijnder, poorteren off inwoonderen der voorz. stadt, tot kennisse van dese neffens mij notario voornoemd [Willem van Trier] specialicken versocht werden. Ende mette testateur dit bewerpe hebben getekent.

GAH, NA prot. 102 (notary Willem van Trier), fols. 111r-2r.
Literature: Bredius 1923/24, p. 22 (mentioned).

A document drafted by notary Willem van Trier noting the attendance of Frans Hals, master painter, and Jacob van Wijndes, thread-twiner, as witnesses to the last will of Michiel de Decker, a merchant of Middelburg, in the latter's house in Crayenhorstergracht in Haarlem. The draft was signed by van Trier but not by the witnesses.

| 55 | 1631, 26 August — DEBT OWED TO HENDRICK PIETERSZ GANS

Henricq Pieterss. Gans eyscher contra Mr. Frans Hals schilder gedaechde. Omme te hebben betalinge ende bij provisie namptissement van XLII gulden als reste, over coop van een os, volgens des eyschers schultboeck, daer van copie wert gepresenteert, mette costen.

> [in the margin] *In state*

GAH, RA 116/14 (Court of Petty Sessions), fol. 260r (renumbered 265r).
Literature: Bredius 1923/24, p. 22 (excerpt).

See commentary to doc. 56.

| 56 | 1631, 5 September — DEBT OWED TO HENDRICK PIETERSZ GANS

Heijndrick Pietersz Gans eyscher contra Mr. Frans Hals gedaechde. Omme t'antwoorden op de geeyste XLII gulden staende ter rolle van de 2e september lestleden folio 267 ofte het IIe diffault ende 't proffijt vandien te begeeren.

> [in the margin] *Den bode, relaterende XXIX gulden ontfangen t' hebben, ende wegens de resterende somme versocht de gedaechde tijt om te voldoen. Commissarissen vermits des gedaechde non comparitie verlenen IIde deffault ende voort proffijt vandien, gehoort de relatie van de voors. bode, dat den gedaechde de schult bekende ende oock XXIX gulden hadde betaelt, versochte van de resterende tijt van 6 wecken, dienvolgende condemneren de gedaechde in de geyschte somme mette costen, te betaelen de voors. XXIX gulden nu datelijck gereet ende de resterende somme binnen de tijt van een maent.*

GAH, RA 116/14 (Court of Petty Sessions), fol. 267v (renumbered 272v).
Literature: Bredius 1923/24, p. 22 (excerpt).

Hendrick Pietersz Gans had produced a copy of his accounts receivable ledger, demanding payment from Frans Hals of the outstanding balance of 42 guilders for the purchase of an ox (see doc. 55). The case had been adjourned. Frans Hals again fails to answer the summons, and the commissioners now declare a second default. On being told by the court messenger that Hals had already paid 29 guilders of the debt and had asked for six weeks' grace to make up the balance, they order him to pay the remainder within one month. Cf. doc. 59.

| 57 | 1631, 12 November — BAPTISM OF MARIA, DAUGHTER OF FRANS HALS'S SECOND MARRIAGE

Maria
Vader Frans Hals van Antwerpen
Moeder Lysbeth Reyniers
Getuygen Barent van Somere
 Judith Jans

GAH, DTB 8 (NHG Baptismal Register), fol. 538.
Literature: van der Willigen 1866, p. 117; van der Willigen 1870, p. 140.

The baptismal record of Maria, daughter of Frans Hals and Lysbeth Reyniersdr. The witness Barent van Someren (Antwerp 1572/3 - 1632 Amsterdam) was a history painter and art dealer in Amsterdam. His wife was Leonora Mijtens, the daughter of Aert Mijtens (Brussels 1541 - 1601 Rome). The second witness, Judith Jans, was probably the artist Judith Jansdr Leyster (Haarlem 1609-1660 Heemstede; see docs. 70, 71), although there was also a Haarlem midwife called Judith Jansdr.

Van der Willigen confused this Maria with the daughter of Dirck Hals, who was born in 1623 and later married Adriaen Suyderhoef (see doc. 30).

On 22 February 1684 a Maria Hals was buried in the Great Church in Haarlem (north transept, no. 233). It is unclear whether this was the daughter of Frans or Dirck Hals.

| 58 | 1631, 17 November — PAINTINGS BY AND AFTER FRANS HALS IN A LIST OF WORKS TO BE AUCTIONED BY HEN-

DRICK WILLEMSZ DEN ABT
1 stuck van Frans Hals een troonge
noch een peekelharing van Frans Hals
2 ronden van Frans Hals
verscheijde copijen naer Frans Hals

(From the *Lijste van verscheijden schilderijen toebehoorende Heijnde-rick Willemsz den Abt, die hij meent te verkoopen* ['List of divers paintings belonging to Hendrick Willemsz den Abt which he intends to sell']).

GAH, GA 196e.
Literature: van der Willigen 1866, p.120; van der Willigen 1870, p.144; van Hees 1959, p.38; Miedema 1980, vol.1, A 45 (documents 1631), pp.136-7.

On 17 November 1631 Hendrick Willemsz den Abt, landlord of the 'Coninck van Vranckrijck' in Haarlem's Smedestraat (see doc. 52), submitted for the burgomasters' approval a list of paintings by various masters which he wanted to auction. In addition to a *troonge*, a *peekelharing* (the name of a popular character in comedies of the period; see cat. 31) and two circular paintings by and several copies after Frans Hals, the list contains six 'pieces' by and various copies after his brother Dirck, and a further five by 'the young Hals', which would be the 20-year-old Harmen. The word *troonge* or *tronie* most often refers to an imaginary head or bust, not a true portrait, which was known as a *conterfeytsel*. On occasion, though, *tronie* could also apply to a portrait (as in doc.74).

| 59 | 1632, 10 September — FRANS HALS DEMANDS PAYMENT FROM HENDRICK PIETERSZ GANS
Frans Hals eyscher contra Hendrick Pietersz Gans gedaechde. T'eyschen betalinge ende bij provisie namptissement van 3 gulden over offcueren van een os, volgens de acte van de cuermeesters mette costen.

[in the margin] *Compareerde alhier in iudicio Lambert Tuenisz ende Jan Gerritsz ende verclaerden ten versoecke van Hendrick Pietersz, dat het een gebruycx ende usantie is, dat datten soo wanneer een beest aengewassen is, dat d'coopers selve aen vercoper moeten laten weten, hoeveel datter moet affgetrocken werden. Commissarissen hebben, naer alingh verblijff van partijen aent collegie gedaen, voor uytspraeck verclaert ende verclaren bij desen, datten gedaechde in plaetse van 3 gulden aen eyscher sall betaelen twe gulden eens openlick daerinne condemneert met cumpensate van costen.*

GAH, RA 116/16 (Court of Petty Sessions), fol.40v.
Literature: Bredius 1923/24, p.22 (the date given as 17 instead of 10 September; the names of the plaintiff and defendant transposed).

Frans Hals sues Hendrick Pietersz Gans, a butcher, for 3 guilders, because an ox had been condemned as unfit to eat. The butcher calls two witnesses, who declare that the usual practice is for the buyer to tell the seller how much should be deducted from the price if a beast has gained weight by putting on fat rather than lean. Hals's compensation is reduced from 3 to 2 guilders. Cf. docs. 55, 56.

| 60 | 1633, 7 January — FRANS HALS DEMANDS PAYMENT FROM HIS SISTER-IN-LAW, HILLEGOND REYNIERSDR
Mr. Frans Hals eyscher contra Hillegondt Reyniers gedaechde.

T'eyschen betalinge ende bij provisie namptissement van 15 gulden als reste van meerder somme ende daerenboven, dat de gedaechde sall werden gecondemneert te doen behoorlijcke reeckening, bewijs ende reliqua vant 'tgene den gedaechde van eysscher noch onder haer heeft. Maken mede eysch van costen 4 gulden 8 stuyvers.

[in the margin] *Commissarissen partijen gehoort voor ende alleer in desen te disponeren, remvoyeren partijen ende haeren differenten aen Edele Nicolaes Suycker oudt commissaris ende Jacob Pietersz Buttinga omme 't selve te hooren liquideeren ende accordeeren, is doendelijck; op pene van 3 gulden bij den voors. comparanten te verbueren ende in cas van geen accort sullen commissarissen, mannen gehoort hebbende, recht doen naer behooren.*

GAH, RA 116/16 (Court of Petty Sessions), fol.86r.
Literature: Bredius 1923/24, p.22 (excerpt).

Frans Hals sues his sister-in-law, Hillegond Reyniersdr, for 15 guilders, being the balance of a larger sum, and demands that she give an accounting of all his property that she has in her possession. The commissioners order the parties to submit the matter to the adjudication of the painter, art dealer and former commissioner of the Court of Petty Sessions, Nicolaes Suycker the Younger (Haarlem 1577-1636 Haarlem), and to Jacob Pietersz Buttinga (Amsterdam c.1600-1646 Haarlem), regent of the Holy Spirit Almshouse, the Old Men's Almshouse, and lieutenant of the Calivermen's Guard. If they fail to do so they will be fined 3 guilders and the commissioners will deliver judgement after hearing evidence from the two mediators.
The reasons for this action are not known.

| 61 | 1634 — MEMBERSHIP OF THE GUILD OF ST. LUKE
Meesters Schilders: Frans Hals [and others]

GAH, GA. List excerpted by G.W. van Oosten de Bruyn from the lost membership roll of the Guild of St. Luke, 1634-8, cols.199-204, esp. col.199.
Literature: Miedema 1980, vol.2, B7 (books 1634-8), pp.419-24, esp. p.420.

Frans Hals's name appears in the 1634 membership roll of the Guild of St. Luke.

| 62 | 1634, 26 January — BAPTISM OF SUSANNA, DAUGHTER OF FRANS HALS'S SECOND MARRIAGE
Susanna
Vader Frans Hals van Antwerpen
Moeder Lysbeth Reiniers
Getuygen Pieter vande Broucke, Adriaen Jacobs, Neeltje Jans

GAH, DTB 9 (NHG Baptismal Register), fol. 218.

The baptismal record of Susanna, daughter of Frans Hals and Lysbeth Reyniersdr. The first witness, Pieter van den Broecke (Antwerp 1585-1640 Malacca), traded with West Africa between 1605 and 1614. His travel journal was published in Haarlem in 1634, the year of Susanna's birth. His portrait on the title page was engraved by Adriaen Jacobsz Matham (Haarlem c.1600-1660 The Hague) after Frans Hals (cat.44). The second witness, who is listed merely as Adriaen Jacobsz, was very probably Matham.

Susanna married Abraham Hendricksz Hulst on 23 May 1660 (see docs. 161, 179).

| 63 | 1634, 10 March — DEBT OWED TO BOUWEN FRANSZ
Bouwen Fransz eyscher contra Mr. Frans Hals. T'eysche beta-linge ende bij provisie namptissement van 23-17-2 penninghen over gelevert broot volgens het register ende dan staet den eyscher overboodich wederom te restitueeren soodanige schil-derije als hij in bewaerder hant heeft, mette costen.

[in the margin] *Commissarissen verlenen 1e default 2e citatie*

GAH, RA 116/17 (Court of Petty Sessions), fol. 75v.
Literature: Bredius 1923/24, p. 22 (excerpt).

See commentary to doc. 64.

| 64 | 1634, 14 March — DEBT OWED TO BOUWEN FRANSZ
Bouwe Fransz eyscher contra Mr. Frans Hals gedaechde. Omme t'antwoorden op d'geeyste dryeentwintich gulden 17 stuyvers 2 penninghen, staende ter rolle van den 10 meert lestleden folio 75vso off het IIe default met proffijt vandien t' begeeren.

[in the margin] *Commissarissen partijen ten weder sijde gehoort hebbende, doende recht. Condemneeren den gedaechde in geeyste somme, mits datten eyscher sall moeten restitueeren d'schilderije, die den gedaechde in onderpant gestelt heeft; tot taxatie van Nico-laes Suycker ende Mr. Frans Pietersz Grebber 'tgene daeraen soude mogen verergert wesen ende bij den gedaechde sal gecort werden, compenserende costen in reeden.*

GAH, RA 116/17 (Court of Petty Sessions), fol. 79r.
Literature: Bredius 1923/24, p. 22 (excerpt).

Bouwen Fransz had produced his account book to back his claim against Frans Hals for 23 guilders, 17 stuivers and 2 penningen for bread supplies, and had declared that he was willing to return the painting which he had received as collat-eral (doc. 63). Hals, who had failed to answer the first sum-mons, was again called before the court. The commissioners order him to pay the sum demanded, and rule that the baker must return the painting which Hals had given him to cover the debt, after it has been appraised by the artists Nicolaes Suycker the Younger (Haarlem 1577-1636 Haarlem) and Frans Pietersz de Grebber (Haarlem 1572/3-1649 Haarlem). Any decrease in its value will, within reason, be deducted from the debt.

| 65 | 1634, 4 April — PAINTINGS BY FRANS HALS IN A LOTTERY LIST DRAWN UP BY HIS BROTHER DIRCK AND ANOTHER ARTIST
No. 13. Een vanitas van F. Hals ... 34 gulden
No. 28. Een ruyter tronij van F. Hals ... 16 gulden
No. 29. Een tronij, als vooren ... 16 gulden

Literature: van der Willigen 1866, pp. 13-4 (Appendix II); van der Willigen 1870, ibid.; van Hees 1959, p. 39; Miedema 1980, vol. I, A 70 (documents 1634), 4 April 1634 (pp. 157-9): announcement of a painting lottery.

Three paintings by Frans Hals, a vanitas valued at 34 guilders (probably not a vanitas still-life, as assumed by C.A. van Hees

[van Hees 1959, p. 39], but a vanitas figure, such as the *Young Man holding a Skull* [cat. 29]), and two *tronies* (paintings of heads), each valued at 16 guilders, are to be sold by lottery in the 'Basterdpijp' inn in Smedestraat on 4 April 1635 in the presence of two wardens (both named) of the Guild of St. Luke. The lottery had been organised by Cornelis van Kit-tensteyn (Delft 1598-after 8 October 1652), an engraver who was also the landlord of the 'Basterdpijp', and Hals's brother Dirck. A *ruyter* was a scoundrel or rogue, so one of these *tronies* was the head of a low-life type.

No trace of this document has been found. It is mentioned by A. van der Willigen without any indication of the source.

| 66 | 1634, 14 August — NOTIFICATION SERVED ON THE AMSTERDAM AUCTIONEER DANIEL JANSZ VAN BEUNINGEN ON BEHALF OF FRANS HALS, DEMANDING DELIVERY OF A PAINTING BY HENDRICK GOLTZIUS
Op huyden den veerthienden augustii sesthien hondert vyerendertich hebbe ick etc. ter presentie etc. mij ten versoecke vanwegen Frans Hals, schilder tot Haerlem, getransporteert ten woonplaetse van Daniel Jansz van Beuningen ende, sijn huysvrou verclaeringhe doende dat haer man niet thuys en was, deede daeromme aen haer mijn exploict ende, vanwegen als boven aldaer geinsinueert ende haer voorgelesen 't gunt volght:
Alsoo ghij gerequireerde [e]en openbaere vendue, van dewel-cken alvooren billietten waeren geaffigeert, aen de meest biedende niet alleen opgeveylt maar oock naer verscheyden affvraginghe off niemant meerder wilde bieden, aen den re-quirant als meest biedende op donderdach lestleeden ten huysse van Emanuel Colijn op den Dam in coop toegeslaegen hebt een stuck schilderij van Goltius ten prijse van sessentach-tich guldens; ende hij insinuant ten tijde hij sulcx hadde gemijnt soo veele gelts niet bij hem hebbende, is gelt gaen haelen, laetende de voors. schilderije in u bewaeringhe; ende weder met gelt kerende, hebt ghij geweygert de voors. schilde-rije te leveren, waerover den requirant van u gere-quireerde, die als opveylder hem het stuck schilderij moet leveren, door mij notaris versoeckt bij deesen datelijcke leve-ringe van de voors. schilderij, presenterende u de sessentachtich guldens terstont te voldoen ten welcke fijne ick die bij mij hebbe ende bij faute off weygeringhe van 't geene voors is, protesteert mits desen van genochsaeme presentatie ende voorts van alle costen, schaeden ende interesten, daerdoor alreede gehadt, gedaen ende geleeden, ende noch te hebben te doen ende te lijden tottet uuteynde der saecke toe. Omme sulcx alles met den aencleven te vervolgen ende verhaelen daer ende soo behooren sal. Waerop de huysvrou van de voors. Daniel Jansz van Beuningen seyde: ick salt mijn man seggen ende ick en ontfangh dit gelt niet.
Gedaen binnen Amsterdamme ter presentie van Jan Baptista Stoepart ende Cosimo de Moucheron als getuygen. Daernae hebbe ick notaris voors. versoeck ende protest gedaen ende gerevereert aen voors. Daniel Jansz van Beuningen selffs, die seyde: den Dokter heeft de schilderije, die moet hij spreecken.

GAA, NA 669, no. 31 (notary Jan Warnaerts), fols. 109v-10r.
Literature: van Eeghen 1974, pp. 137-40.

Legal notification of a claim against the Amsterdam

auctioneer, Daniel Jansz van Beuningen, by Jan Warnaerts, an Amsterdam notary acting for Frans Hals. The document is witnessed by Jan Baptista Stoepaert and Cosimo de Moucheron. Shortly before 14 August 1634, van Beuningen had knocked down a painting by Hendrick Goltzius (Mühlbracht 1558-1617 Haarlem) to Frans Hals for 86 guilders at a public auction in Emanuel Colijn's bookshop on Dam Square. Hals did not have the full amount on him, and left the painting in the auctioneer's care while he went to borrow some money. When he returned, van Beuningen refused to surrender the painting. Notary Warnaerts, who only managed to speak to the auctioneer's wife, asked her to hand over the painting immediately in return for cash payment. She said that she would tell her husband that he had called, but refused to accept the money. Eventually van Beuningen himself announced that 'the doctor has the painting, so he [Hals] should speak to him'.

This doctor was probably the man who had sent the painting for sale in the first place. It is not known what the subject of the painting was, or whether Hals ever managed to get hold of it. At the time he was in Amsterdam working on *The Meagre Company* (cat. 43; see docs. 73-5, 78).

C.J. Gonnet (Gonnet 1915, p. 141) maintains that Hals bought Goltzius's *Tityus* for 89 guilders at an Amsterdam auction in 1630, and that he then sold it to the painter and art dealer Nicolaes Suycker the Younger, who found the City of Haarlem willing to buy it for 200 guilders. The payment to Suycker for this painting (now Haarlem, Frans Halsmuseum) is certainly recorded in the Treasurer's Accounts for 1630, but it has been impossible to locate the documentary evidence for Gonnet's assertion that Hals bought the picture in Amsterdam.

| 67 | 1634, October — A FRANS HALS PAINTING IN THE INVENTORY OF ISAACK SCHOL
...

GAH, inventory of Isaack Schol.
Literature: HdG 447a.

This listing has not been verified. C. Hofstede de Groot records it in his *Verzeichnis* as '*Ein Gemälde*', but fails to give the source in the Haarlem notarial archives.

| 68 | 1635, 16 March — DEBT OWED BY FRANS AND DIRCK HALS TO THE HEIRS OF ARENT JACOBSZ COETS
Frans Hals ende Dirck Hals sijn schuldich mede van coop van een os de somme van 't negentich gulden ... 90 gulden

GAH, NA 152 (notary Jacob Schoudt), fols. 515-25, esp. fol. 516.
Literature: Bredius 1923/24, p. 22 (excerpt; the date incorrectly given as 1 March).

This entry in the death inventory of Arent Jacobsz Coets, steward of the Nieuwe Doelen (New Militia Hall), who died on 1 March 1635, states that Frans Hals and his brother Dirck owed the estate 90 guilders as their share in the purchase of an ox. Similar amounts were owed by some two dozen of the late steward's customers.

Coets appears in Hals's *Banquet of the Officers of the St. George Civic Guard* (s46).

| 69 | 1635, 1 May — FRANS HALS PAYS HIS GUILD FEE
Mr. Frans Hals. is betaelt [the last two words added later]
[added in the top margin] *Omgegaan den boode met den kist den 7en may 1635 om de jaarige 4 stuyvers restanten voor de 2e male.*

GAH, GA 196-f (list of the members of the St. Luke Guild who had failed to pay their dues).
Literature: Miedema 1980, vol. 1, A 76 (documents 1635), p. 165; A 118 (documents 1642), p. 238.

On 1 May 1635 Frans Hals was in arrears with his annual contribution of 4 stuivers to the Guild of St. Luke. On 7 May, however, he paid it to the messenger who had been sent around to collect from the defaulters, as indicated by the words '*is betaald*' ('paid') added in another hand. Cf. docs. 61, 96, 164.

| 70 | 1635, 4 September — COMPLAINT LAID BY JUDITH LEYSTER AGAINST FRANS HALS CONCERNING A PUPIL
Vorder van den deecken Pot int collegie openingh gedaen wegens klachte aen hem gedaen van jouffrou Judith Jansen Leijster schilderesse, hoe dat haer is ontgaen een leerjonghen dewelcke bij Frans Hals is aengenoomen, belasten den knecht aen Hals voors. te doen waerschouwen den jonghen van hem te wijsen ende langer niet te houden op de boeten 3 gulden.

[annotated in the margin] *Saecken te verrichten op den ordinaere sitdach te houden den 2en october anno 1635.*
Aen Klaes vraghen sijn rappoort gedaen tot Frans Hals weegens Mr. Judith Leystar haer jonghen etcetera.

GAH, GA 197h (draft minutes 1635).
Literature: Miedema 1980, vol. 2, B 8 (books 1635), p. 430 (sub 5 and marginal text sub 4).

See commentary to doc. 71.

| 71 | 1635, 2 October — COMPLAINT LAID BY JUDITH LEYSTER AGAINST FRANS HALS CONCERNING A PUPIL
Mede bij vinderen beslooten Mr. Frans Hals teegens de naesten te ontbieden, over het aenhouden van sijn discipul Willem Woutersen teegens 't verbodt van vinderen mede sonder de selve aen te geeven volgens de keur.
[the following passage deleted]
Teegens verboth heeft Mr. Frans Hals te betalen vande inkomen ende verbeurtte de jonghen van joffrou Laystaer by hem gehouden, derhalven hem teegens de naeste te ontbieden voor vinderen.

GAH, GA 197 (draft minutes 1635: minutes of the meeting of 2 October 1635).
Literature: Bredius 1917, pp. 71-3; Miedema 1980, vol. 2, B 8 (books 1635), pp. 433 (sub 8), 434 (sub 10).

Judith Leyster (Haarlem 1609-1660 Heemstede), a member of the Haarlem Guild of St. Luke since 1633, had laid a formal complaint against Frans Hals for taking on Willem Woutersz as his pupil after the latter had begun studying with her (he left after a few days). The guild officials ordered Hals to cease instructing Woutersen on pain of a fine of 3 guilders (doc. 70). Hals refused to do so, and he is now recalled before the board to explain his behaviour, and to answer a second charge of

failing to register his pupil with the guild or pay the apprenticeship fee.

The wardens award Judith Leyster half the tuition fee she believes she is entitled to, and like Hals she is ordered to pay arrears of the apprenticeship fee.

Judith Leyster, who was heavily influenced by Hals and may even have been his pupil, was probably one of the witnesses at the baptism of Hals's daughter Maria in 1631 (doc. 57). In 1636 she married the painter Jan Miense Molenaer (Haarlem c.1610-1668 Haarlem). Listed in the inventory of his estate are '*Een rontje van Hals*' ('A roundel by Hals'), '*Een stuckje van Hals*' ('A small piece by Hals'), and '*2 Conterfeytsels van Jan Molenaer sijn huijsvrou van Frans Hals sonder lijst*' ('Two portraits of the wife of Jan Molenaer by Frans Hals, unframed'; GAH, NA 313 [notary Willem van Kittensteyn], unpaginated, dated 8 September 1668; Bredius 1915-22, pp.2-9). In his transcription of this last entry, Bredius incorrectly inserted the conjunction '*en*' ('and') between the words '*Jan Molenaer*' and '*sijn huijsvrou*', concluding that Hals had painted the portraits of both Molenaer and Leyster. No such portraits have been identified, although the painting in the National Gallery of Art in Washington, which is now regarded as a Judith Leyster self-portrait (s.D69), used to be taken as a portrait of her by Frans Hals.

| 72 | 1636, 5 February — A VANITAS BY FRANS HALS IN THE INVENTORY OF PIETER CODDE
een vanitasken van Frans Hals met een ebbenhouten binnenlijst

GAA, NA 837 (notary Frans Bruyningh): inventory of Pieter Codde.
Literature: Bredius 1888, p.188. HdG 9; van Eeghen 1974, p.140.

An entry in the inventory of the household effects of the Amsterdam artist Pieter Codde (Amsterdam 1599-1678 Amsterdam) and his wife Maritje Arensdr, which was taken by the Amsterdam notary Frans Bruyningh on 5 February 1636 after the couple had decided on a legal separation. Among their possessions was a small vanitas scene by Frans Hals with an ebony inner frame (cf. doc.65). This is a flat frame to which a moulded frame can be attached as a separate slip.

| 73 | 1636, 19 March — FORMAL COMPLAINT AND SUMMONS BY REYNIER REAEL, DEMANDING THAT FRANS HALS COMPLETE THE MILITIA PIECE NOW KNOWN AS 'THE MEAGRE COMPANY'
Op huyden den 19en martii anno 1636 compareerden voor mij Frans Bruijningh etc. ter presentie etc., d'edele Reynier Reael, out schepen ende capiteyn van een vaendel burgers binnen deeser stede, ende Cornelis Michielsen Blaeuw, sijn luytenant, voor henselven ende vervangende d'andere officiren van 't voorsz. vaendel. Ende verclaerden hoe dat sij comparanten al drye jaeren geleden Frans Halsch, schilder tot Haerlem woonachtich, hadden aenbesteet seecker stuck schilderije, te weeten de conterfeytsels van alle de officiren van 't voorsz. vaendel. Ende hoewel de voors. Frans Halsch behoort hadde 't voors. stuck schilderije al over langh volcoomentlijck affgeschildert ende affgedaen te hebben, gelijck hij sulcx op Sint Jan lestleeden aennam ende belooffde te doen ende te presteren,

*soo is hij van sulcx te doen tot noch toe wel onbehoorlijck in gebreecke gebleeven, nietteegenstaende verscheyden interpellatien, soo mondelingh als schriftelijck daeromme aen hem gedaen, hebbende 't voors. stuck schilderije maer voor een gedeelte gedaen, streckende 't selve tot schaede, intresse ende naedeel van de comparanten, die daeromme alsnoch mits deesen versoecken, dat de voors. Frans Halsch hem binnen veerthien daegen nae de insinuatie deses sal hebben te vervoegen binnen deeser stede omme 't voors. stuck ende 't gene daeraen noch ontbreect ende resteert voorts aff te schilderijen, in behoorlijcke forme, off bij faute van dien, dat de comparanten verstaen sullen alsdan niet langer in den voors. Frans Halsch gehouden te sijn, maer 't selve stuck alhier door een ander goet meester sullen laeten voltrecken, gereserveert de comparanten actie nopende de penningen die op 't voors. stuck alreede betaelt sijn, daervan expresselijck protesterende mits deesen, alsmede van allen costen, schaeden ende intressen geleeden ende te lijden tottet uyteynde van de saecke toe. Authoriserende voorts alle notarissen ende publycque persoonen, ende bijsonder dengeenen hiertoe versocht sijnde, omme 't gunt voors. is den voors. Frans Halsch te insinueren, ende hen comparanten daervan te leeveren acten, een oft meer, in debita forma. Gedaen binnen der voors. stede van Amsterdamme ter presentie van Jacob Bruijningh, mede notaris publycq, ende Anthony Meerhout, getuygen hiertoe versocht.
Quod attestor ego
F. Bruijningh, Notarius publicus 1636*

GAA, NA 833 (notary Frans Bruijningh), fols. 110v-11.
Literature: see doc.78.

See commentary to doc.78.

| 74 | 1636, 20 March — FRANS HALS'S REPLY TO THE COMPLAINT BY REYNIER REAEL CONCERNING PROGRESS ON THE MILITIA PIECE NOW KNOWN AS 'THE MEAGRE COMPANY'
*Op huyden den 20en martii 1600 zes ende dertich, soo hebbe ick Egbert van Bosvelt, secretaris van de weescamer der stadt Haerlem ende Notaris publycq bij den Hove van Hollant geadmitteert, mij metten ondergeschreven getuygen ten versoucke van den edele Dirck Willemsz Abbas van wegen den edele heeren comparanten in de aengehechte acte genoemt, gevonden aen den persoon van Mr. Frans Hals, schilder (die sieckelyck aen een quaet been te bedde lach) ende hebbe hem de voors. acte van de 19en deser voorgelesen, ende aen hem antwoort versocht. Die mij notaris ten antwoorde gaff: dat hij 't stuck wel aengenomen hadde te maecken, nyet dan tot Amstelredamme maer tot Haerlem; dan naederhant, alhoewel nochtans ongehouden, bewillicht dat hij de troinges tot Aemstelredamme soude beginnen ende tot Haerlem voorts opmaecken, gelijck hij oock al hadde begonnen te doen ende oock volbracht soude hebben, indyen hij de persoonen bijeen hadde connen crijgen, ende daertoe nyet connen geraecken, soodat hij daeromme in zijn huys veel versuymt ende tot Amstelredamme in de herberge veel verteert heeft in plaetse dat geseyt was dat men hem soude defroyeren.
Nyettemin, omme te presteren dat hij aengenomen ende belooft heeft, es als noch tevreden, indyen de persoonen tot Haerlem believen te comen, dat hij 't werk datelyck bij der hant nemen ende sonder vertouven affmaecken sal ende zijn*

eere daerin betrachten, ende dat het met meerder lust tot
Haerlem als tot Amsterdam sal gedaen werden, overmits hij
dan binnenshuys ende bij zijn volck zijnde 't oge oock daer op
mach hebben. Aldus gedaen t'zijnen huyse op 't Groote Heyli-
gelant in presentie van Adriaen van Bosvelt, deurwaerder van
den voors. Hove ende Jacob Maertensz, beyde wonende bin-
nen Haerlem als getuygen van gelove tot kennisse van desen
gerequireert.

[signed] d'oirconde A. van Bosvelt
Jacob Maertens
E. van Bosvelt nots. pub.

GAH, NA 63 (notary Egbert van Bosvelt), fol. 80r.
Literature: see doc. 78.

See commentary to doc. 78.

| 75 | 1636, 29 April — REYNIER REAEL'S REBUTTAL OF
FRANS HALS'S REASONS FOR THE DELAY IN COMPLETING THE
MILITIA PIECE NOW KNOWN AS 'THE MEAGRE COMPANY'
Op huyden den XXIX aprilis anno 1636 compareeden voor mij
Frans Bruijningh etc., ter presentie etc. d'edele Reynier Reael,
out schepen ende capiteyn van een vaendel burgers binnen
deeser stede, ende Cornelis Michielsen Blaeuw, sijn luytenant,
voor henselven ende vervangende d'andere officiren van 't
voors. vaendel, ende verclaerden, dat sij gesien hebbende de
frivole ende onwaerachtige andtwoorde bij mr. Frans Halsch,
schilder tot Haerlem, gedaen, op haerluyder verclaeringe,
insinuatie ende proteste, seggen bij replycq, dat sij eerst metten
voorn. Frans Halsch geaccordeert ende verdraegen sijn, dat hij
de troniges alhier ter stede soude beginnen ende tot Haerlem
voorts opmaecken, daervooren hij soude hebben ende genieten
tsestich guldens van yeder personagie, dan daernae metten
voorn. Frans Halsch naeder accorderende soude van yeder
personagie oft conterfeytsel hebben ses guldens meerder, te
weeten sesentsestich guldens, mits dat hij daertegens weeder
alhier ter stede, ende niet tot Haerlem, de personagien, soowel
van lichaemen als troniges, ende sulcx als behoort soude schil-
deren ende volcoomentlijck opmaecken, gelijck hij oock
alreede eenige personagien hier ter stede also heeft beginnen
te doen; soo ist, dat sij comparanten alsnoch versoecken dat
den voorn. Frans Halsch hem binnen den tijdt van thien
daegen nae de insinuatie deeses sal hebben te vervoegen bin-
nen deeser stede, omme 't voors. stuck schilderije voorts te
vervolgen ende naer behooren op te maecken ende voltrecken.
Op welck versoeck den voornoemde Frans Halsch sijn ronde
verclaeringe van jae oft neen, sal hebben te doen, opdat men
mach weeten, waernae men sich sal hebben te reguleren, ende
dit alles onvermindert haerluyder voirige gedaene verclaeringe
ende proteste, daerbij de comparanten alsnoch sijn persiste-
rende. Authoriserende voorts alle notarissen ende publycque
persoonen, ende bijsonder dengeenen hiertoe versocht sijnde,
omme 't gunt voors. is den voorn. Frans Halsch te insinueeren,
ende hen comparanten daervan te leeveren acten, een oft meer,
in debita forma. Gedaen binnen der voors. stede van Amster-
damme ter presentie van Jacob Bruijningh, mede notaris pu-
blycq, ende Anthony Meerhout, getuygen hiertoe versocht.
Quod attestor ego F. Bruijningh, Notarius publicus 1636

GAA, NA 833 (notary Frans Bruijningh), fols. 143v-4v.
Literature: see doc. 78.

See commentary to doc. 78.

| 76 | 1636, 9 May — SYMON DE BRAY ACTS AS GUARANTOR
FOR FRANS HALS
Compareert Symon de Bray, procureur ende heeft hem selffs
in zijn prive naem ghestelt cautionaris voor 't namptissement
ter somme van 80 gulden uit huyshuur geobtineert bij Jacob
Pieterss van de Mee[r] ter saecke van Frans Hals schilder, den
3 april 1636, omme de voors. somme wederomme te restituee-
ren soo naermaels ten principaele sulcx bevonden mochte
werden te behoren, onder verbant van alle sijne goederen ...
actum IXen maie 1636.

[in the margin] Cautie

GAH, RA 47/7 (register of authorisations, recognisances, etc.), fol. 11r.
Literature: Bredius 1923/24, pp. 22-3 (excerpt).

Lawyer Symon de Bray, brother of the artist Salomon de Bray
(Amsterdam 1597-1644 Haarlem) acts as a guarantor for Frans
Hals, who owed 80 guilders in back rent to Jacob Pietersz van
der Meer on 3 April 1636.

According to a notarial document of 20 March 1636
(doc. 74) Hals was then living in Groot Heiligland in Haarlem.

Symon de Bray was a 'friend' of the 'Wijngaardranken'
(Vine Tendrils) chamber of rhetoric from 1618 to 1622, as was
Frans Hals from 1616 to 1624.

| 77 | 1636, 23 May — DEBT OWED TO HERCULES JANSZ
D'selffde eyscher [Hercules Jansz] contra Frans Hals ge-
daechde. T'eyschen betalinge ende bij provisie namptissement
van 53 stuyvers 10 penninghen over eetwaren mette costen.

[in the margin] In state

GAH, RA 116/18 (Court of Petty Sessions), fol. 124r.
Literature: Bredius 1923/24, p. 23 (excerpt).

Hercules Jansz demands payment of 53 stuivers and 10 pen-
ningen from Frans Hals for provisions. The case is adjourned.

The relevance of this court record is doubtful, for there is
no evidence that it relates to Frans Hals the painter.

| 78 | 1636, 26 July — FRANS HALS'S SECOND REPLY TO THE
COMPLAINT BY REYNIER REAEL CONCERNING PROGRESS ON
THE MILITIA PIECE NOW KNOWN AS 'THE MEAGRE COMPANY'
Op huyden den 26 julii 1636 soo hebbe ick Jacob van Bosvelt
openbaer notaris bij den Hove van Hollant geadmitteert
binnen de stadt Haerlem residerende mij metten onderge-
schreven getuygen ten versoucke van den edele Pieter Pietersz
provoost van de burgerije tot Amsterdam, van wegen de edele
heeren comparanten in de geannexeerde acte genomineert
gevonden ten huyse en aen den persoon van Mr. Frans Hals
schilder alhier ter stede, ende hebbe hem d'voorsz. acte we-
sende gedateert den 29 aprilis 1636 lestleden voorgelesen ende
aen hem sijne ronde verclaringe van jae ofte neen daerop
versocht. Die mij notaris ten antwoorde gaff dat hij persisteer-
den bij de antwoorde dien hij Egbert van Bosvelt notaris
binnen Haerlem den 20 martii voorleden achtervolgende sijne
insinuatie aen hem geinsinueerde vanwegen de comparanten
geexpresseert in den aengehechte acte gedaen gegeven heeft.

Voegende dien onvermindert daerbij dat hij tevreden es het stuck schilderije in denselve acte verhaelt datelijck van Amsterdam te haelen ende tot sijnen huyse te brengen, omme bij hem de ongeschilderde clederen aldaer eerst opgemaeckt te werden. Ende d'selve gedaen sijnde, d'troinges van de goetwillige personen, van hier tot Haerlem te comen tot sijnen huyse door dien niemant daerbij om den corten tijt en es geinteresseert ofte oock niet vertrout dat daer ymant tegens es, te schilderen; ende oock soo het mochte gebeuren dat daer onder ses ofte seven onwillige, ofte die het haer niet gelegen en soude mogen comen mochten sijn dat hij om alle voldoens wille d'selve ses ofte seven personen, het voors. stuck soo nae voltoyt hebbende, tot Amsterdam schilderen ende 't selve stuck werxs dan naer behooren voltrecken sall, waervan de voorsz. Pieter Pietersz vanwegen als boven versocht heeft dese acte die gepasseert es binnen der voorsz. stadt Haerlem in presentie van Barent Deteringh ende Vechter Hasewindius inwoonders deser stadt als getuygen hiertoe versocht.

[signed] *V. Hasewindius, B. Deteringh, 23/1636*

d'oirconde Jacob van Bosvelt nots. publ. 1636

GAH, NA 165, (notary Jacob van Bosvelt), fol. 265r.
Literature: Bredius 1913, pp. 81-4; Haarlem 1988, no. 194 and pp. 383-4 (full transcriptions by J. Levy-van Halm).

Four documents drawn up between 19 March and 26 July 1636 (docs. 73-5, 78) detail the dispute between Frans Hals and the Amsterdam militia captain, Reynier Reael and his lieutenant, Cornelis Michielsz Blaeuw, who were also acting on behalf of their fellow officers of the St. George civic guard company. Reael and Blaeuw accused Frans Hals of defaulting on his commission to paint a militia piece for the Crossbowmen's Hall, which was still unfinished three years after Hals had started working on it. They demanded that Hals honour his side of the bargain, but to no avail. The painting, which is now on loan to the Rijksmuseum from the City of Amsterdam (cat. 43), was eventually finished by the Amsterdam artist Pieter Codde (Amsterdam 1599-1678 Amsterdam). See doc. 140.

According to the first document (73), Hals had accepted the commission from the Amsterdam militiamen in 1633. When they realized that he was not making any progress they had extracted a promise from him on the previous John the Baptist's Day (24 June 1635) that he would indeed complete it. However, even their subsequent appeals, both verbal and written, had not the slightest effect, so they demanded that he come to Amsterdam within a fortnight to finish the painting. If he refused, his patrons considered themselves free to have the work completed by a good Amsterdam master, in which case they would start legal proceedings to recover the money he had already been paid, plus damages for non-performance.

The second document (74) contains Frans Hals's reply to this formal complaint, which had been read to him the following day by a Haarlem notary. Hals, who was in bed with a bad leg at his home in Groot Heiligland, admitted that he had accepted the assignment, but only on condition that he could paint the group portrait in Haarlem, not Amsterdam. Although he had not been obliged to do so, he had subsequently agreed to go to Amsterdam to make the initial sketches of the officers' heads, which he would then finish in Haarlem. He had already started on this but was unable to

finish, because it had been impossible to get all the officers together. This had taken him away from home on many occasions, and he had incurred heavy lodging expenses in Amsterdam which had not been repaid, despite a promise that he would be recompensed. Nevertheless, he declared that he was now prepared to finish the painting quickly, provided the officers came to Haarlem. He could work more enthusiastically at home, where he would be able to keep an eye on his apprentices.

The third document (75) is Reael and Blaeuw's response to Hals's rebuttal, which they described as ridiculous and untrue. According to them, it had originally been agreed that Hals would do the portrait heads in Amsterdam and fill in the detail in Haarlem for a fee of 60 guilders a head. This was later raised to 66 guilders, provided he did the work in Amsterdam instead of Haarlem, and that he completed both the heads and the full figures there, as he had already started doing in some cases. This time the captain and his lieutenant demanded that Hals come to Amsterdam within ten days to finish the painting. They required a clear answer, one way or the other, so that they knew where they stood.

The fourth and last document in this saga (78) gives Hals's second reply. The third document had only been read to him three months after it had been drawn up. He says that he stands by his original reply, but is prepared to move the painting from Amsterdam to his house in Haarlem, where he will first finish any of the officers' dress which has not yet been painted. He will then do the heads, and assumes that no one will object to coming to Haarlem for the purpose. However, if six or seven of the officers are not prepared to make the journey he will bring the painting to Amsterdam, where he will fill in the remaining heads.

It seems that his offer was not taken up and that negotiations were broken off immediately after this reply was received.

These documents show that Hals could not have worked on the large canvas in Haarlem, as he had wanted to do, and that it never left Amsterdam. It can be assumed that he was still working on it there in August 1634, when he bought a painting by Goltzius at an auction (doc. 66). It was not until later that he began having trouble with his patrons.

| 79 | 1636, 28 August — DEBT OWED TO GERRIT GOVERTSZ

Gerrit Govertsz eyscher contra Frans Hals gedaechde. T'eyschen betalinge ende bij provisie namptissement van 16 gulden, 19 stuyvers, 8 penninghen over gehaelt broot mette costen.

[in the margin] *Conparuit*

GAH, RA 116/18 (Court of Petty Sessions), fol. 206v.
Literature: Bredius 1923/24, p. 23 (excerpt).

Gerrit Govertsz, a baker, demands 16 guilders, 19 stuivers and 8 penningen from Frans Hals for supplying him with bread. Hals is present in court.

The relevance of this court record is doubtful, for there is no evidence that it relates to Frans Hals the painter.

| 80 | 1637, 9 February — RELIEF FOR THE CARE OF FRANS HALS'S IMBECILE SON PIETER

Pieter Franssen Hals, innocente soone van Frans Hals, wert toegestaen om te ontfangen alle jaeren vant Elisabeths Gasthuys 50 gulden, vant Leprooshuys 25 gulden ende van de schael 25 gulden, mits dat de vrunden deselve buyten de stadt sullen moeten besteden, ende oock van alle vordere onderhout van cledinge ende anders versorgen.

[in the margin] *Pieter Franssen Hals innocente soone te alimenteren*

GAH, Burgomasters' Resolutions 1637 (10/10), fol. 148r.
Literature: Bredius 1923/24, p. 23 (full transcription).

See commentary to doc. 81.

| 81 | 1637, 25 February — RELIEF FOR THE CARE OF FRANS HALS'S IMBECILE SON PIETER

Burgermeesteren en de regeerders deser stad Haerlem ordonneren mits desen den regenten vant Elysabeths gasthuys ende vant Leprooshuys respectievelijck tot onderhout van Pieter Franssen te betalen jaerlix, te weten de regenten vant gasthuys sestich ende vant leprooshuys dertich gulden, ende dat de verdere costen sullen gedragen werden bij de regenten van de schalen.

[in the margin] *Onderhout van Pieter Fransz.*

GAH, Burgomasters' Resolutions 1637 (10/10), fol. 151v.
Literature: Bredius 1923/24, p. 23 (excerpt).

Frans Hals had an imbecile son called Pieter (date of baptism unknown). On 9 February 1637 the burgomasters decided to pay an annual allowance of 125 guilders for his support. This sum was to be provided by three charitable institutions: 50 guilders from St. Elizabeth's Hospital, 25 guilders from the Leper-House, and 25 guilders from the poor relief fund. His parents were to house him outside the city and provide his clothes (doc. 80). Now, two weeks later, the parties' contribution to the allowance was altered to 60 guilders from St. Elizabeth's, 30 guilders from the Leper-House and the remainder from the poor relief. See also docs. 94, 186.

| 82 | 1638, 1 February — THE GUILD OF ST. LUKE SUPPORTS AN APPEAL FOR GUILLIAM POLYDANUS AT THE REQUEST OF FRANS HALS AND TWO OTHER ARTISTS

Ingestaen Mr. Nicolaes de Kemp schilder, Mr. Frans Hals schilder ende Mr. Pieter Holsteijn glasescrijver, versouckende weegens eenen Guilljame Polydanus, alsoo hij oudt ende seer onmachtich was niet meer en konde doen om hemselven te geneeren, derhalve hadden sij lieden door mededooghentheydt alreede soo veele te weeghen gebracht, ende de moytten aengenoomen datse hem Polydanus een schilder weesende, de toesegginghe hadde doen hebben om int ouden mannenhuys te koomen; ende alsoo daer toe eenyghe behoefticheeden van nooden waren, eer men int selve mocht komen te wonen, soo van bed als andersints, ende de voors. Polydanus niet met allen en hadde, was bij haer lieden goet gevonden een collecte te doen hebben alreede eenyghe gildebroeders verwillicht omme daer een stuck gelts toe te geven, versochten dierhalven meede yets van den gilde daertoe te moghen genieten: 'twelck deecken ende vinderen oock wel gesindt waren te doen naer vermooghen, maer naer overlegh van de saecke bevonden hem

Polydanus in sijn tijdt wel met schilderen geneert te hebben, maer noijt voor gildebroeder in vinderenbouck bekent te sijn, ofte in den gilde te weesen, dierhalven verstonden niet gehouden te weesen, hem van den gilde weeghen onderstandt te doen, maer yder voor sijn perticulier soo veel als hem goet dochte waren dies bereydt ende gewillich, ordonneerden ende versochten neffens dien als dat sij lieden [Frans Hals and others] hetselve gelt 'twelck alreede was, ofte mochte werden vercreeghen tot behulp der voors. Polydanus datse met hetselve bij den vinder Molijn wilden komen, ende hem brengen, want alsoo Molijn voors. op dien tijdt de Schael bediende, nam aen van alles wat daer vorders tekort mocht komen, hem Polydanus daeraen te helpen tot contentement van het Oudemannenhuys; waermeede sijn sijlieden wel vergenoeght vertrocken.

GAH, GA, 189/1 (wardens' book B [fragment], 1637-8), minutes of the meeting of the dean and wardens of 1 February 1638 (sub 6).
Literature: van der Willigen 1866, pp. 177-8; van der Willigen 1870, pp. 244-5; Wurzbach 1906-11, p. 339; Miedema 1980, vol. 2, B 9 (books 1637-8), p. 468.

Frans Hals, the artist Nicolaes de Kemp (Camp) II (Haarlem 1609-1672 Haarlem; cf. docs. 43, 153), and the glass painter Pieter Holsteyn (Schleswig-Holstein c. 1580-1662 Haarlem), had petitioned the Guild of St. Luke for a contribution from its funds for the collection being held with the guild's approval for the old and indigent artist, Guilliam Polydanus (now completely unknown). The money was to be used to buy a bed and the very basic necessities, for otherwise Polydanus could not be admitted to the Old Men's Almshouse. The guild refused to make an official contribution, because Polydanus had never been a member, but decided that if necessary the collection would be supplemented with money from the poor relief fund. which was administered by the painter Pieter Molijn (London 1595-1661 Haarlem).

| 83 | 1639, April — A FRANS HALS PAINTING IN THE INVENTORY OF AERT CONINCX

...

GAA, inventory of Aert Conincx.
Literature: HdG 145e.

This listing has not been verified. C. Hofstede de Groot records it in his *Verzeichnis* as '*Ein Gesellschaft junger Leute*', but fails to give the source in the Amsterdam notarial archives.

| 84 | 1639, 12 May — LUCAS LUCE AND HENDRICK UYLENBURCH VALUE A FRANS HALS PAINTING BELONGING TO THE WIDOW OF CORNELIS RUTGERS

...

GAA, NA.
Literature: HdG 447b.

This listing has not been verified. C. Hofstede de Groot records it in his *Verzeichnis* as '*Ein kleines Gemälde*', but fails to give the source in the Amsterdam notarial archives. His entry shows that, on 12 May 1639, the painter Lucas Luce and the art dealer Hendrick Uylenborch had examined a small

painting by Frans Hals belonging to the widow of Cornelis Rutgers in Amsterdam, and had valued it at 12 guilders.

| 85 | 1639, 4 August — SETTLEMENT OF A QUARREL BETWEEN A WOMAN, POSSIBLY HALS'S SECOND WIFE, AND WOUTER BARENTSZ
Tusschen de huysvrouwe van Frans Hals ende Wouter Barentsz geleyt vreede ende geinterdiceert alle wegen van feyten.

[in the margin] *Vreede*

GAH, Burgomasters' Resolutions 1639 (10/11), fol. 47r.
Literature: Bredius 1923/24, p. 23 (full transcription).

Record of the official reconciliation between Wouter Barentsz and 'the wife of Frans Hals', either Lysbeth Reyniersdr or someone married to a namesake of Hals.

| 86 | 1640, 13 January — DEBT OWED TO COMMERTJE JACOBSDR, WIDOW OF WILLEM TAS
Jan Baltensz als voocht van Commertge Jacobs eyscher contra Frans Hals gedaechde. T'eyschen om 33 gulden van huyshuyr mette costen.

[in the margin] *In state. Commissarissen verlenen 1[ste] default 2[de] citatie*

GAH, RA 116/22 (Court of Petty Sessions), unpaginated.
Literature: Bredius 1923/24, pp. 23-4 (excerpt; the name incorrectly given as Annetge Tassen).

See commentary to doc. 88.

| 87 | 1640, 17 January — DEBT OWED TO COMMERTJE JACOBSDR, WIDOW OF WILLEM TAS
Jan Baltensz als voocht van Commertgen Jacobs eyscher contra Frans Hals gedaechde. T'antwoorde op d'geyschte 33 gulden oft het 1[ste] default met provisie vandien te begeren.

[in the margin] *Commissarissen decerneren defaute ende eerste proffijt vandien. Gehoort d'relacy van boode, datte gedaechde d'schult bekent, doende recht, cederende den gedaechde in bekende somme mette costen te betaelen binnen 2 maenten mits cautie.*

GAH, RA 116/22 (Court of Petty Sessions), unpaginated.

See commentary to doc. 88.

| 88 | 1640, 3 February — DEBT RECORDED IN THE INVENTORY OF COMMERTJE JACOBSDR, WIDOW OF WILLEM TAS
... ende noch een huys metten erven bewoont bij Mr. Frans Hals, Schilder, staende in een poort uytcomende in de Lange Bagynestraet. Vrij.
Schulden:
Frans Hals sal te Meye schuldich sijn van huyshuyr 66 guldens.

GAH, NA 64 (notary Egbert van Bosvelt), unpaginated.
Literature: Bredius 1923/24, p. 24 (excerpt).

Jan Baltensz, the guardian of Commertje Jacobsdr, had demanded 33 guilders in rent from Frans Hals (doc. 86).

After failing to attend the first session, Hals ignored the second summons as well. The commissioners declared him in default and, on learning from the court messenger that he admitted the debt, ordered him to pay the money within two months and to lodge a surety (doc. 87).

According to the inventory of Commertje Jacobsdr, whose husband Captain Willem Jansz Tas had died on 5 March 1638, Hals was living in a house in an alleyway off Lange Bagijnestraat, for which a further 66 guilders' rent was due in May.

Commertje Jacobsdr had her estate inventoried for her forthcoming marriage, on 12 February, to Lowijs van Vliet. Two houses which she had inherited from Tas, one on Oude Gracht and the other in Lange Bagijnestraat, both unencumbered, were sold on 4 May 1640 for 3,200 and 920 guilders respectively to former burgomaster Ouwel Akersloot and Mattheus Gerritsz van Driel (GAH, 76/60, fols. 137v-8v). The location and price of the house occupied by Frans Hals show that it was a modest dwelling. His next known address was Kleine Houtstraat (see doc. 95).

The inventory also lists one painting by Hendrick Vroom and several unattributed works.

| 89 | 1640, 25 April — A HALS PAINTING OWNED BY JOHANNES DE RENIALME
Een toebackdrinker met een kan van Hals -12-

GAA, NA 421 (notary Jacob Jacobsz), fol. 356.
Literature: HdG 9; Bredius 1915-22, p. 13, no. 7.

Mention of a painting of a pipe-smoker with a tankard by Hals. No forename is given, but it could well have been by Frans Hals (see S.L6). The entry appears in the inventory of paintings and furniture belonging to the Amsterdam art dealer Johannes de Renialme, which were stored in the attic of Lambert Massa's house. The inventory was taken at the request of Lucretia Coymans, widow of Pieter Cruijpenning. This particular painting was valued at 12 guilders.

The same work is valued at 18 guilders in Renialme's death inventory of 27 June 1657 (GAA, NA 1915 [notary Frans Uyttenbogaert], fol. 663. HdG 80b; Bredius 1915-22, pp. 230-9, no. 115).

| 90 | 1640, 25 August — SETTLEMENT OF A QUARREL BETWEEN GERRIT PHILIPSZ AND FRANS HALS'S WIFE, LYSBETH REYNIERSDR
Gerrit Philipsz es tersaecke hij eenigh gewelt tegens de vrou van mr. Frans Hals heeft gepleecht in ses guldens ten behoeve van de armen [gecondemneert].

[in the margin] *Gerrit Philipsen condemnatie*

Tusschen Gerrit Philipsz ende de vrou van mr. Frans Hals is geleyt vreede op correctie.

[in the margin] *Vreede*

GAH, Burgomasters' Resolutions 1640 (10/11), fol. 241v.
Literature: Bredius 1923/24, p. 24 (excerpt).

One Gerrit Philipsz is ordered to pay 6 guilders into the poor relief fund for assaulting Lysbeth Reyniersdr, the wife of Frans Hals. The case was later settled amicably.

1640, 23 December — BAPTISM OF MARIA, THE ILLE-
GITIMATE CHILD OF FRANS HALS'S DAUGHTER SARA
Maria
Vader Abraham Potterlo van Haerlem
Moeder Sara Frans
Getuygen Maritje Willems
GAH, DTB 11 (NHG Baptismal Register), fol. 153.

The baptismal record of Maria, the illegitimate daughter of
Abraham Potterloo (also called Potter de Loo) and Frans
Hals's daughter Sara (see doc. 24). The witness was Maritje
Willems, widow of Assueris Stevensz. On 7 May 1642 she and
two other women were to make a deposition on the paternity
of Sara's daughter (doc. 93).

Abraham was the son of the Haarlem twiner Jan Willemsz
Potter de Loo and Susanna Massa, the sister of Isaac Massa
(see doc. 29), who was a family friend of the Halses. On 17
November 1624 Susanna Massa had witnessed the baptism of
Hester Dircksdr Hals, the daughter of Frans's brother Dirck
(see doc. 4).

Sara, who was sent to the workhouse two years later for
fornication (doc. 92), married a seaman called Sjoerd Eebes in
Molkwerum in the northern province of Friesland in March
1645 (see docs. 109, 110).

| 92 | 1642, 29 March — FRANS HALS'S DAUGHTER SARA IS
SENT TO THE HOUSE OF CORRECTION AT HER MOTHER'S RE-
QUEST BECAUSE OF FORNICATION
*De huysvrouwe van Frans Hals versochte uuyt den naeme van
haere man, dat hare outste dochter, omme redenen bij monde
verhaelt, mochte werden gebracht op hope van beternisse in
verseeckeringe int werckhuys deser stadt, daerop bij bur-
germeesteren es geordonneert (naer voorgaende consent voor
sooveele in hen es), dat deselve Hals eerst ende alvooren met
de regenten vant voors. werckhuys sal spreecken ende daer-
mede geaccordeert sijnde, dat den heeren burgermeesteren
ordre sullen stellen, dat deselve door den capiteyn van de
nachtwaecke in verseeckeringe sal werden gebracht.*

[in the margin] *Outste dochter van Frans Hals te logeren int
werckhuys*

GAH, Burgomasters' Resolutions 1642 (10/12), fol. 187v.
Literature: Bredius 1923/24, p. 24 (full transcription; the date incor-
rectly given as 31 March).

Lysbeth Reyniersdr, acting for her husband Frans Hals, pe-
titions the burgomasters to have her eldest daughter Sara (see
doc. 24) committed to the workhouse for correction. The
reason, which was given verbally, is not recorded in the
document, but Sara was now expecting her second illegitimate
child. The burgomasters decide that Frans Hals should first
come to an agreement with the regents of the workhouse.
Only then will they order the captain of the night watch to
arrest Sara. According to the marginal annotation she was
indeed sent to the workhouse.

In December 1640 Sara had borne an illegitimate daughter,
Maria, fathered on her by Abraham Potterloo or Potter de
Loo (doc. 91). Some five weeks after Sara had been committed
to the workhouse Frans Hals had the women who had attend-
ed the birth swear a deposition on the paternity of his grand-
child (doc. 93).

| 93 | 1642, 7 May — DEPOSITION OF THREE WOMEN TO THE
EFFECT THAT ABRAHAM POTTERLOO IS THE FATHER OF SARA
HALS'S DAUGHTER MARIA
*Op huyden den sevenden meye 1642 compareerden voor mij
notaris ende den getuygen ondergenoemt Maritge Willems,
weduwe van Assueris Stevensz., oudt LXXI jaren, Maritge
Cornelis, huysvrouwe van mr. Pieter Holsteyn, oudt XLIX
jaren ende Barbara Heyndrixs, oudt XL jaren, huysvrouwe
van Corstiaen Pietersz ebbenlijstwerker. Ende hebben bij
heurluyder vrouwen waerheyt in plaetse van eede ten
versoucke van mr. Frans Hals mr. schilder, voor de oprechte
waerheyt verclaert, dat zij getuygen mede binnen Haerlem ten
huyse van Lysbeth, moer in de Achterstraet, present zijn
geweest ende gesyen hebben dat Sara, de dochter van de voors.
mr. Frans Hals, van een jongedochter es verlost. Ende gehoort,
dat zij in haeren meesten noot van baren zijnde, voort verlos-
sen, opt affvraghen van 't voors. vroetwijff verclaert heeft, dat
Abraham Potterloo, de soon van Susanna Masse, de vader van
haer kint was ende nyemant anders, ende 't selve tot verschey-
den reysen repeteerden. Verder bij 't voors. vroetwijff ge-
vraeght zijnde oft zij bij nyemant meer geweest en hadde,
antwoorde: 'jae, ick hebbe bij meer geweest'. Presenterende
en getuygen 't selve met eere te bevestigen. Aldus gepasseert
binnen Haerlem ten huyse mijns notaris present ende getuygen
ondergeschreven*
[signed] *merck* [mark of] *Maritgen Willems, merck* [mark of]
Maritgen Cornelis, merck [mark of] *Barbara Heyndericxs, Jan
Tuenissen Verbraken, Marynus Jansen Verbraken
T'oirconden E. Bosvelt, notarius publicus*

GAH, NA 66 (notary Egbert van Bosvelt), unpaginated.
Literature: Bredius 1923/24, p. 24 (fairly full transcription).

At Frans Hals's request, Maritge Willemsdr (aged 71), widow
of Assueris Stevensz, Maritge Cornelisdr (49), wife of the glass
painter Pieter Holsteyn, and Barbara Heyndricksdr (40), wife
of the ebony frame-maker Corstiaan Pietersz, declare that
they were present in the house of the midwife Lysbeth in
Achterstraat when Hals's eldest daughter Sara was delivered
of a child. Just before the baby was born, the midwife asked
Sara who the father was, and the witnesses heard her say that
it was Abraham Potterloo, the son of Susanna Massa. Under
questioning, Sara admitted having had relations with other
men as well.

Midwives attending the birth of an illegitimate child were
obliged to ask the mother to name the father in the presence
of witnesses. The depositions of these three women were not
taken until nearly eighteen months after the birth in December
1640. When the infant girl was baptised (doc. 91) the father's
name was given as Abraham Potterloo. Some weeks before
this document was drawn up, Sara's parents had had her
committed her to the workhouse, because she was pregnant
for a second time (doc. 92). A few months later, on 5 Novem-
ber 1642, Sara denied to notary Egbert van Bosvelt that there
was any truth in the rumour that Pieter Woutersz, a baker,
was the father of another child she was expecting. (GAH, NA
66, unpaginated. Bredius 1923/24, p. 25).

| 94 | 1642, 13 June — RELIEF FOR THE CARE OF FRANS
HALS'S IMBECILE SON PIETER, WHO IS NOW TAKEN INTO THE
WORKHOUSE

De regenten vant Werckhuys sijn geordonneert Pieter Fransz Hals, innecente zoon van Frans Hals int voorszeyde werckhuys te logeren in een bysondere plaetse buyten de gemeenschap van mensen ende te doen arbeyden indien hij daertoe bequaem is, ende deselve voorts doen onderhout in cost ende clederen, ende dit alles bij provisie voor alle welcke de voorszeyde regenten jaerlicxs sullen genieten de vijftich guldens van Ste Elisabets Gasthuys, vijffentwintich gulden vant Leprooshuys ende vijffentwintich gulden van de regenten van de Schael, als hiervooren is gementioneert.

[in the margin] *Pieter Franssen Hals te alimenteren*

GAH, Burgomasters' Resolutions 1642 (10/12), fol. 210v.
Literature: Bredius 1923/24, p. 23 (full transcription).

On 13 June 1642 the Haarlem burgomasters decided that Frans Hals's imbecile son Pieter (see docs. 80, 81) was to spend the rest of his life in solitary confinement in the workhouse, which was a combined house of correction and charitable institution. He was to be allowed to do any work that suited him. The workhouse was to receive an annual allowance of 100 guilders, made up of 50 guilders from St. Elizabeth's Hospital and 25 guilders each from the Leper-House and the poor relief fund.

In 1653 the Leper-House paid 35 guilders for Pieter Fransz Hals and 65 guilders for 'Malle Babbe in the workhouse' (information kindly provided by Dr. Florence Koorn, Haarlem City Archives). That document (GAH, cabinet 7-2-1-10), is the only one that has so far come to light on this Haarlem woman who was immortalised by Frans Hals (cat. 37). It also happens to be the only surviving financial record from this institution.

The identification of the subject as Malle Babbe is based on a seventeenth or possibly eighteenth-century inscription on a piece of the painting's old stretcher which has been let into the new one. It reads: '*Malle Babbe van Haerlem ... Fr[a]ns Hals*' (S75, fig. 65).

Pieter Hals was buried in the Southern Churchyard on 8 February 1667 at the expense of St. Elizabeth's Hospital (doc. 186).

| 95 | 1642, 5 September — DEBT OWED TO HENDRICK HENDRICKSZ
Heynderick Heydericxsz eyscher contra Frans Hals in de Cleynne Houtstraet gedaechde. Om te hebben betalinghe ende bij provisie namptissement van de somme van 5-0-0 van een gecochte slaepbanck mette costen.

[in the margin] *In state*

GAH, RA 116/23 (Court of Petty Sessions), fol. 42r.
Literature: Bredius 1923/24, p. 25 (excerpt).

Hendrick Hendricksz sues Frans Hals of Kleine Houtstraat for 5 guilders for the delivery of a bed. The case is held over.

In 1651 Hals's wife, Lysbeth Reyniersdr, owed money to the same cabinet-maker for a small chest which she had bought (doc. 137), so it seems fairly certain that this document of 1642 does indeed relate to Frans Hals the painter. In May 1640 he had had to move out of his rented accommodation in Lange Bagijnestraat (see doc. 88), and according to this court record he was now living in Kleine Houtstraat.

| 96 | 1642, 17 September — FRANS HALS IN ARREARS WITH HIS GUILD DUES
Mr. Frans Hals. schilder ... 4

GAH, GA 196/36 (list of the members of the St. Luke Guild who had failed to pay their annual contribution of 4 stuivers, with excerpts from the burgomasters' adjudication [authentic copies]).
Literature: van der Willigen 1866, p. 121; van der Willigen 1870, p. 145. Miedema 1980, vol. 1, A 118 (documents 1642), pp. 238-9.

On 17 September 1642 Frans Hals's name was placed on the list of members who had not yet paid their annual guild dues of 4 stuivers. The burgomasters order him to pay his contribution, on pain of attachment by the captain of the night watch. Cf. doc. 69.

| 97 | 1642, before 6 November — FRANS HALS AND OTHER ARTISTS SIGN A RECOMMENDATION TO THE BURGOMASTERS OF HAARLEM DISSENTING FROM THE PETITION OF THE GUILD OF ST. LUKE BOARD TO RESTRICT SALES OF PAINTINGS
... ende was onderteijckent u Edele onderdanige dienaers Frans Pietersz de Grebber aut deken, Pieter de Molijn aut deken, C. van Kittensteyn out vinder, Salemon van Ruijsdael, Frans Hals. Onder stont Cornelis Vroom is uijt den voornoemden gilde gescheijden ende heeft hem al over langen tijt laten uijtdoen vermits hem al de rasernij van 't gilt niet aen en stont, heeft hem derhalven geexcuseert, ...

GAH, GA 196/28 (authentic copy of a response by a group of guild members to a petition of 22 July 1642, in which the dean and wardens of the guild had asked the burgomasters to ban art sales; with a marginal note of 6 November 1642).
Literature: Miedema 1980, vol. 1, A 120 (documents 1642), pp. 246-52 (sub 29).

Frans Hals is a co-signatory to this document, together with Frans Pietersz de Grebber (Haarlem 1572/3-1649 Haarlem) and Pieter Molijn (London 1595-1661 Haarlem), past deans of the guild, Cornelis van Kittensteyn (Delft 1598-after 8 October 1652), former warden Salomon van Ruysdael (Naarden 1600/3-1670 Haarlem) and, initially, Cornelis Vroom (Haarlem 1590/1-1661 Haarlem), who had subsequently left the guild in protest at its policy. The document contains a detailed recommendation to the burgomasters, criticising what the signatories regard as an 'absurd and baseless' petition from the guild board to restrict auction sales of paintings.

The market had been flooded with pictures, which had depressed prices. The proposed ban on unrestricted auctions would benefit the more successful painters and art sellers, but would not be in the interests of their less prosperous colleagues, who relied on a large turnover. The signatories support the latter group, and advise the burgomasters not to restrict the sale of works by guild members, but instead to put a curb on out-of-town artists.

At their board meeting of 8 November 1642 the guild officials under the chairmanship of Pieter Saenredam (Haarlem 1597-1665 Haarlem) complained about the time it had taken to draw up this recommendation. The board disagreed with its findings, and sent a separate report to the burgomasters putting its own side of the case (Miedema 1980, vol. 2, B 11 [books 1642-4], pp. 567-9). Cf. doc. 133.

| 98 | 1643, 15 November — BANNS OF FRANS HALS'S SON, FRANS, AND HESTER JANSDR VAN GROENVELT

Frans Franss Hals jongeman van Haerlem, woonende op de Oude Gracht, met Hester Jans van Groenvelt jongedochter mede van Haerlem, woonende in de Jacobijnestraet
Testes sponsi: mater Lysbet Reiniers
sponsae: Jacob van Teylingen
[in the margin] *Attestatie gegeven op Blommendael den 29 november anno 1643*

GAH, DTB 51 (NHG Banns Register), fol. 255.
Literature: Bredius 1923/24-c, p. 215.

The banns of Hals's son, Frans Hals the Younger (Haarlem 1618-before November 1670; cf. doc. 26), of Oude Gracht (his parents' home), and Hester Jansdr van Groenvelt (buried 7 April 1669) of Jacobijnestraat in Haarlem. The witnesses were Lysbeth Reyniersdr, the bridegroom's mother, and Jacob van Teylingen, who was probably the bride's guardian. A note in the margin states that the marriage took place on 29 November 1643 in the neighbouring village of Bloemendaal.

Frans Hals and his wife, Lysbeth Reyniersdr, were later to be witnesses at the baptism of the first two of the eleven children born of this marriage (see docs. 105, 112).

On 12 May 1669, more than a month after his wife's death, Frans Hals the Younger rented a house in Klerksteeg for a year. It is not known where he had been living prior to that date.

| 99 | 1644, 16 January — FRANS HALS NOMINATED FOR A SEAT ON THE BOARD OF THE ST. LUKE GUILD

Alsoo deken en vindren bevonden den tijt van haere dienst ontrent verstreecken te weesen hebben samen goet gevonden een nieuwe nominatie te stellen en deselve op maendag toecommende wesende den 18 deses voor de edele heere burgermeesteren te brengen en daertoe te compareren des middags voor de klockslag van elve op het stadthuys op de boeten van 6 stuijvers en hebben de nominatie bij de meeste stemme in geschrifte gestelt en gekoosen tot deecken mr. Willem Claesen Heda en tot out ofte voorvinder Jacob Jansen Begijn, ende voorts geordineert een dubbelt getal om bij de edele heere burgermeesteren drie nieuwe vindren uutgekosen te worden als volgt
uut de konst
Mr Frans Hals schilder
Mr Jacobus de Wet schilder
Mr Aelbert Sijmons de Valck schilder
Mr Jan Cornelisse Versprong schilder
uut de ambachten
Mr Frans Symons blickwercker
Mr Hendrick Eijmberts glaesemaker

GAH, GA 189/2 (minutes of the meeting of the dean and wardens), fol. 107r (sub 4).
Literature: Miedema 1980, vol. 2, B 11 (books 1642-4), p. 606.

See commentary to doc. 101.

| 100 | 1644, 18 January — APPOINTMENT OF THE NEW BOARD OF THE ST. LUKE GUILD

Burgermeesters ende regeerders der stadt Haerlem hebben tot deecken ende vinders vant St. Lucasgilde deser stadt omme voor 't aenstaenden jaere te dienen gestelt ende geordonneert, stellen ende ordonneren bij desen tot deecken: Willem Claesz Heda, tot outvinder: Jacob Jansz Bagijn, tot vinders: Frans Hals, Aelbert Symonsz van Valck, Frans Symonsz bleekslager ... Actum ter camere den 18 januarii anno 1644.

GAH, GA 195 (appointments of deans and wardens, 1626-59), fol. 11.
Literature: Miedema 1980, vol. 2, Dekens en Vinders, p. 1059.

See commentary to doc. 101.

| 101 | 1644, 26 January — INSTALLATION OF THE NEW BOARD OF THE ST. LUKE GUILD

Vorders bij deken en vindren op dato ingestaen de gedagvaerde drie nieuwe vindren als mr. Frans Hals, mr. Aelbert Sijmons de Valck ende Frans Sijmons ende naer alle behoorlijcke overleeveringe soo van de St. Lucaskist met alle daer in behoorde, volges de lijst in de kist en den dekens keur staende. Meede den nieuwe deken en vindren elck sijn sleutel en keur overgelevert ende van alle omtfang ende uutgift in vindren jarigen dienst voorgevallen rekening gedaen ende bevonden bij den gilde overig te weesen tot de betaeling van haer gehouden maeltijt op gisteren gedaen de somme van 44 gulden 1 stuiver.

GAH, GA 189/2 (minutes of the installation of the new dean and wardens), fol. 107v (sub 3).
Literature: van der Willigen 1866, p. 121; van der Willigen 1870, p. 145. Miedema 1980, vol. 2, B 11 (books 1642-4), p. 607.

As required, the retiring board of the Guild of St. Luke had submitted their recommendations for a new board to the burgomasters. Willem Claesz Heda was nominated to succeed as dean, and Jacob Jansz Begijn as senior warden. The five candidates for the office of warden (from whom the burgomasters had to choose three) were the painters Frans Hals, Jacobus de Wet and Albert Symonsz de Valck, and the craftsmen Frans Symonsz, tinsmith, and Hendrick Eymbertsz, glass-maker (doc. 99).

On 18 January the burgomasters duly announced the new board for 1644, on which Frans Hals was to serve as a warden (doc. 100).

The new board was installed on 26 January, and received the guild coffer, keys, copies of the guild statutes, and the accounts for the previous year. A sum of 44 guilders and 1 stuiver still remained to be paid for a banquet held the previous day.

Frans Hals was a guild official for only one year. Most of his colleagues, like Salomon de Bray, Hendrick Pot, Pieter Molijn and Pieter Saenredam, served many terms as dean or warden.

| 102 | 1644, 2 February — FRANS HALS PRESENT AT THE FIRST MEETING OF THE NEW BOARD OF THE ST. LUKE GUILD

Ordinaere sijdtdach en vergaerderinge gehouden ter kamer van St. Lucasgildt binnen Haerlem den 2 februarij 1644

tegenwoordich de heer deken Heda, Bagin, Hals, Valck, Frans Sijmens ...

GAH, GA 197 (draft minutes of a meeting of the dean and wardens).
Literature: Miedema 1980, vol. 2, B 12 (books 1643-4), p. 612.

The record of Frans Hals's attendance at the first meeting of the new guild board (cf. docs. 99-101).

| 103 | 1644, 27 February — DEBT OWED TO JAN MERSJANT
D'selve eyscher [Jan Mersjant] *contra Frans Hals woonende op de Ouwe Graft gedaechde. Om te hebben betalinge ende provisie namptissement van somme van 5-2-0 over coop ende leverantie van grof lij[n]waet aen den selven gedaechde zijn vrouw vercocht mette costen.*

[in the margin] *In state*

GAH, RA 116/24 (Court of Petty Sessions), fol. 134r.
Literature: Bredius 1923/24, p. 25 (excerpt).

Jan Mersjant sues Frans Hals of Oude Gracht for 5 guilders and 2 stuivers for strong linen bought by Hals's wife. The case is held over. Cf. docs. 130-1.

| 104 | 1644, 10 May — DEBT OWED TO CLAES OUWELE
Claes Ouwele eyscher contra Frans Hals woonende op de Ouwe Gracht [this address deleted] *hoeck van de Nobelstraet gedaechde. Om te [hebben] betalinge ende bij provisie namptissement van de somme van 1-9-0 van verteert gelach mette costen.*

[in the margin] *De gedaechdens vrouw bekent de schult, versoeckt graesselijck atterminatie. Commissarissen dienvolgende doende recht, condemneeren de gedaechde geyschte somme mette costen te betaelen binnen de tijt van een maent mits cautie.*

GAH, RA 116/24 (Court of Petty Sessions), fol. 179r.
Literature: Bredius 1923/24, p. 25 (excerpt).

Innkeeper Claes Ouwele sues Frans Hals, residing ('on Oude Gracht' deleted) at the corner of Nobelstraat, for 1 guilder and 9 stuivers for food and drink. His wife admits the debt, but asks for time to pay. The commissioners order the defendant to settle the debt within one month.

The deletion of Oude Gracht, where Frans Hals was living at the time, indicates that this debt was incurred by his son or someone else of the same name (cf. docs. 106-7).

| 105 | 1644, 14 July — FRANS HALS WITNESSES THE BAPTISM
OF HIS GRANDDAUGHTER LYSBETH
Lysbeth
Vader Frans Hals van Haerlem
Moeder Hester Jans
Getuygen Frans Hals
 Elisabeth de grootmoeder

GAH, DTB 12 (NHG Baptismal Register), fol. 112.

The baptismal record of Lysbeth, eldest daughter of Frans Hals the Younger and Hester Jansdr (see doc. 98). The baptism was witnessed by the grandparents, Frans Hals and Lysbeth Reyniersdr.

| 106 | 1644, 23 August — DEBT OWED TO JAN JOOSTEN
D'selve eyscher [Jan Joosten] *contra Frans Hals woonende op de hoeck van de Nobelstraet gedaechde. Om te hebben betalinge ende bij provisie namptissement van de somme van 3-10-0 van verteert gelach mette costen.*

[in the margin] *Commissarissen verleenen het 1e deffault, ordonneeren de 2e citatie.*

GAH, RA 116/25 (Court of Petty Sessions), unpaginated.
Literature: Bredius 1923/24, p. 25 (excerpt).

See commentary to doc. 107.

| 107 | 1644, 25 august — DEBT OWED TO JAN JOOSTEN
D'selve [Jan Joosten] *contra Frans Hals woonende in de Nobelstraet gedaechde. T'antwoorden op den eysch van 3-10-0 staende ter lester rolle ofte het tweede deffault met het proffijt vandien te begeeren.*

[in the margin] *Commissarissen fiat, comparuit ende absolutie.*

GAH, RA 116/25 (Court of Petty Sessions), unpaginated.

Innkeeper Jan Joosten had sued Frans Hals, living on the corner of Nobelstraat, for 3 guilders and 10 penningen for food and drink (doc. 106). Hals did not appear in court and a new writ was issued. This time he answered the summons and the debt was remitted.

This debt was not incurred by Hals himself, but by his son or someone else of the same name. Cf. doc. 104.

| 108 | 1645, 22 January — FRANS HALS ACTS AS GUARANTOR
FOR HIS SON HARMEN
Heijndrick Heijndricksz. van Roy, hovenier int Bosch, impetrant contra mr. Franchois Hals gedaechde, eysch doen.

[in the margin] *Bosch* [the lawyer] *versochte default met een ander citatie.* [added in a different ink:] *de postulant Bosch concludeert tot betaelen van sestich carolus gulden boven een dach schilderen ter cause van een jaer huyshuyr, verschenen mey 1644, offslaende solutum cum expensis.*

Idem requirant contra eundem gerequireerde versoeck doen.

[in the margin] *Bosch versochte dat de hant staende onder de huercedule alhier overgelevert gehouden sall worden voor bekent ende dienvolgende namptissement op de somme in de requeste verhaelt, offslaende solutum.*

ARA, Vianen Court of Justice 30303, no. 21, unpaginated.
Literature: Wiersum 1953, p. 40.

In the Court of Justice at Vianen, Hendrick Hendricksz van Roy, forester, represented by his lawyer, Bosch, demands payment of 60 Carolus guilders and one day's painting from Master Franchois Hals in return for a year's rent, the rental period having expired in May 1644. Bosch also asks for the signature on the rent agreement to be recognised, so that a surety can be lodged against the debt.

In fact it was not Frans Hals who owed rent, but his eldest son Harmen (see doc. 10). He had been living in Vianen, near Utrecht, since 1642, and he was inundated with writs for months after this first summons, none of which had the slightest effect. It is possible that he had already moved to Amsterdam, where his daughter Lysbeth was baptised in the

New Church on 7 December 1645 (GAA, DTB 421, fol. 474). This court record, one of the many relating to the case in which Frans Hals's name appears, suggests that he stood bond for his son.

| 109 | 1645, 11 March — BANNS OF FRANS HALS'S DAUGHTER, SARA, AND SJOERD ELES (EEBES) IN AMSTERDAM
Compareerde als vooren op de acte van Mellius Aegidius [written above this name: *Salomon Echinus pastor tot Haerlem*] *oprecht in Molqueren opgeteekent Sjeord* [sic] *Eles van Molqueren varent gesel, woonende tot Molqueren ende Sara Hals van Haerlem, woonende buyte de Anthonispoort.*
[in the margin] *De gebooden sijn te Haerlem sonder verhinderinge gegaen, geteekent Henricus Swalmius pastor aldaer.*
GAA, DTB 461 (NHG Banns Register), fol. 380.

See commentary to doc. 110.

| 110 | 1645, 12 March — BANNS OF FRANS HALS'S DAUGHTER, SARA, AND SJOERD ELES (EEBES) IN HAARLEM
Sieuwert Eebes, jongeman van Molqueren, woonende aldaer met Sara Hals, jongedochter van Haerlem, woonende tot Amsterdam.
[added in a different hand] *Mellius Egidius, pastor tot Molqueren getuygt met attestatie van den 20 martii 1645 desen bovengenoemde persoonen aldaer getrouwt te sijn.*
[in the margin] *attestatie gegeven den 26 martii 1645 op Molqueren*
GAH, DTB 51 (NHG Banns Register), fol. 310.

Hals's daughter Sara, living beyond St. Anthony's Gate in Amsterdam, was betrothed in Amsterdam on 11 March 1645 to Sjoerd Eles (Eebes), a seaman from Molkwerum in Friesland (doc. 109). Here, on the following day, they register their banns in Haarlem. The marriage took place at Molkwerum on 20 March, and is attested to in these two documents by the ministers Henricus Swalmius and Salomon Echinus of Haarlem, and Mellius Aegidius of Molkwerum.

Sara, who had borne two illegitimate children between 1640 and 1642 (docs. 91-3), had finally found herself a husband.

| 111 | 1645, 23 March — DEPOSITION OF FRANS HALS'S WIFE AND SEVERAL OTHER WOMEN CONCERNING DIRCK JANSZ VAN STELLINGWERFF
Ter instantie ende versoecke van de vrinden ende bloetverwanten van Dirck Jansz van Stellingwerff, cleermaecker van sijnen hantwerck, tegenwoordich gevangen.
Compareerde voor mijn Jacob Schoudt ... ten bijwesen van de naebeschreven getuygen: Aeltgen Gerritsdr, out LXXV jaeren, ende Maycke Nuyts, huysvrouwe van Anthony Wiggers, cleermaecker, ende omtrent LI jaeren, Anthony Casteleyn, wolkammer, oudt omtrent LXVII jaeren, Maritge Willemsdochter, weduwe van Assuverus Stevenszoon, oudt omtrent LXXIIII jaeren, Hillegont Pietersdr, weduwe van Huyck Franssen, oudt omtrent LXI jaeren, Elysabet Reyniers, huysvrouwe van meester Frans Hals, oudt omtrent LI jaeren ende Adriaentgen Marinussen, huysvrouwe van Jan Teunissen, tafellaeckenwercker, oudt omtrent LXVII jaeren,

alle binnen deser stadt woonachtich ...
De voors. Elysabet Reyniers verclaert, dat zij getuyge, soo den voors. Dirck Jansz als mede Cathelijn Jans, alle beide wel heeft gekent, aleere sijluyden met malcanderen waeren getrout
...

GAH, NA 150 (notary Jacob Schoudt), fols. 119r-20v.
Literature: Bredius 1923/24, p. 25 (excerpt).

At the request of the friends and family of Dirck Jansz van Stellingwerff, a tailor who has been sent to prison, Lysbeth Reyniersdr and several other Haarlem citizens testify that they know him well. Lysbeth adds that she knew both van Stellingwerff and his wife Cathelijne Jansdr before they married.

Appended to this deposition is a similar statement by the artist Hendrick Gerritsz Pot (Amsterdam c.1585-1657 Amsterdam), also of Haarlem.

| 112 | 1645, 19 September — FRANS HALS AND LYSBETH REYNIERSDR WITNESS THE BAPTISM OF THEIR GRANDSON JOHANNES
Johannes
Vader Frans Hals van Haerlem
Moeder Hester Jans
Getuygen Frans Hals
 Lysbet Reyniers
GAH, DTB 12 (NHG Baptismal Register), fol. 357.

The baptismal record of Johannes, the eldest son of Frans Hals the Younger and Hester Jansdr (see doc. 98). The baptism was witnessed by the grandparents, Frans Hals and Lysbeth Reyniersdr.

| 113 | 1645, 13 October — FRANS HALS ACKNOWLEDGES RECEIPT OF MONEY DUE TO HIS SON REYNIER FROM THE WIDOW OF HENDRICK DIRCKSZ VAN DE GRAEFF
Op huyden den 13e october 1645 compareerde voor mij Henrick Schaeff notaris etc. ende den ondergeschreven getuygen Frans Hals, schilder tot Haerlem op de Oude Graft, althans sijnde binnen deser stede, als vader van sijn onmondige soon Reyniers Hals mettet schip Delf jongst uut Oost-Indien gearriveert. Ende bekende voor hem ende sijnen erven ontvangen te hebben uyt handen van Lijntgen Pietersdr, nagelaten weduwe van saliger Henrick Dircxsz van de Graeff, op 't selve schip Delff in 't herwaert komen overleden, sodanige somme van een hondert carolus guldens als den voors. Reynier Hals door den voors Henrick Dircxsz van de Graeff bij sijnen testament, binnen 't scheepsboort gemaeckt, sijn gelegateert ende versproocken [deleted: *in vergoedinge ende voldoeninge van seeckere twee en twintich rijcxdaalders die de selve van de voors. Reynier Hals onder hem ende zijn administratie hadde*]. *Bedanckende haer derhalve voor goede voldoeninge ende betalinge der voors. somme ende belovende haer noch den haren noch over 't voors. legaet, off noch vordre pretentien, die sij noch mochten hebben off vermenen te hebben, niet meer noch verder te eysschen, manen, moeyn, noch molesteren, door hemselffs, noch door andre in rechte noch daer buyten in geender manieren, maer haer van alles ende volcomen te ende ten vollen quiteren end bij desen, belovende haer*

Lijntgen Pieters oock te indemneren, bevrijden, ontlasten, costeloos ende schadeloos te houden van alle moeyenisse ende nasprake, soo haer Lijntgen dienaengaende door yemant anders selffs oock door sijn persoon mocht opkomen off aengedaen worden. Onder verbandt als naer recht [mark for the passage to be inserted at this point] alles oprecht. Consenterende etc. Gedaen t' Amsterdam ter presentie van Wouter Oosthoorn ende Jan Fransz Coman, mijn clercqen, als getuygen hiertoe versocht.*
** ontslaende hierbij ende mits desen het arrest soo hij comparant op de voors. gagien van de voors. Henrick Dircxsz heeft gedaen, doen willen ende dat 't [illegible word] selven hierbij sal sijn affgedaen ende ontslagen ende geen verder effect sorteren.*
[signed] *H. Schaeff notarius publicus, Frans Hals, W. Oosthoorn, J. F. Coman*

> [in the margin] *den 25 july 1646 copie voor de huysvrou van Frans Hals*

GAA, NA 1339 (notary Hendrik Schaaff), fol. 88v-9r.
Literature: Bredius 1923/24, p. 26 (excerpt).

Frans Hals of Oude Gracht in Haarlem makes a sworn statement in Amsterdam to notary Hendrik Schaaff. He is acting in his capacity as the father of his son Reynier, a minor (see doc. 38), who had recently returned from the East Indies aboard the *Delff*. Hals acknowledges receipt of 100 Carolus guilders from Lijntje Pietersdr, widow of Hendrick Dircksz van de Graeff, who had died aboard the ship on its return voyage. Van de Graeff had left the money to Reynier in his last will, which was made on the *Delff*. Hals withdraws the attachment he had levied on Hendrick Dircksz's wages, and declares the matter closed.

The fact that Hals had sequestered Dircksz's pay shows that there had been a dispute with his widow about payment of the money to which Reynier was entitled. It appears from the deleted passage that initially it was considered not to be a legacy at all, but repayment of the 22 rijksdaalders (a rijksdaalder was equivalent to 2½ guilders) which Hals had given to Dircksz for safekeeping.

| 114 | 1645, 23 November — DEPOSITION OF FRANS HALS'S WIFE, LYSBETH REYNIERSDR, REGARDING MATHIJS POLEN
Op huyden den 23 november 1645 compareerden voor mij notaris en de getuygen hier naergenoemt, Adriaen Suyderhoeff jonghman, out omtrent 27 jaeren, ende Lysbeth Reyniers huysvrouw van Frans Hals. Ende hebben bij haerluyder manne ende vrouwe waerheyt in plaetse van eede, die zijluyden overbodich stonden te doen, ten versoecke van Willemijntie van Santen, huysvrouw van Dirck Verhart, geseyt, getuycht ende verclaert waerachtich te wesen, dat omtrent een vierendeel jaers geleden, sonder in den perfecten dach ende tijt achterhaelt te willen zijn, sij deposanten eenen Mathijs Polen tot verscheyde maellen hebben hooren seggen, als dat hij aen Geertruyt Jaspers, weduwe van Willem Jansz, verlooft was ende dat hij bij haer te bedt geweest was ende dat hij met haer niet en kost doen 't gunt hij wel gaeren mit haer hadt willen doen. Eyndende hiermede haerluyder depositie. Aldus gedaen, verleden ende gepasseert binnen der stadt Haerlem ten comptoire mijns notaris, ten presentie van Joost Gerritss ende

Heynderick van Gellinckhuysen als getuygen hiertoe versocht. [signed] *Adryaen Suid[e]r[h]oef, 't merck van Lysbeth Reyniers, 't merck van Joost Gerrits, H. van Gellinckhuysen Quod attestor S. Coesaert, notarius publicus, 1645*

GAH, NA 177 (notary Salomon Coesaert), fol. 456r.
Literature: Bredius 1923/24, p. 26 (excerpt).

Adriaen Suyderhoef, a bachelor aged about 27, and Lysbeth Reyniersdr, the wife of Frans Hals, testify on behalf of Willemijntje van Santen, the wife of the Haarlem landscapist Dirck Verhaert (active 1631-64 in The Hague, Haarlem and Leiden), that some three months previously they had heard one Mathijs Polen repeatedly complain that he had shared the bed of his bride-to-be, Geertruit Jaspersdr, the widow of Willem Jansz, but that she had refused to have intercourse with him.

Adriaen Andriesz Suyderhoef (Haarlem 1619-1667 Haarlem) was a brother of the engraver Jonas Suyderhoef (Haarlem c. 1613-1686 Haarlem), and he later married Maria Dircksdr Hals, one of Frans Hals's nieces (see doc. 30).

| 115 | 1646, 24 March — A FRANS HALS PAINTING IN THE INVENTORY OF CORNELIA LEMENS
...
GAA, NA.
Literature: HdG 1; Slive 1974, no. 20.

This listing has not been verified. C. Hofstede de Groot records it in his *Verzeichnis* as 'Der verlorene Sohn', but fails to give the source in the Amsterdam notarial archives. From his information it appears that Cornelia Lemens, the wife of Abraham Macarée, had paid her rent on 24 March 1646 with this painting, which was valued at 48 guilders. This *Prodigal Son* may also have been the one that featured in a commercial transaction in 1647 (doc. 119).

| 116 | 1647 — SCHREVELIUS ON FRANS AND DIRCK HALS
Nec silentio involvendi fratres Halsii, Franciscus et Theodorus Hals, quorum alter inusitato pingendi modo, quem peculiarem habet, omnes superat, tanta enim in ejus pictura acrimonia et vivacitas, vigor etiam, ut Naturam penicillo provocare nonnumquam videatur, loquuntur id infinita ejus prosoopa [printed in Greek], ita colorata ut spirare videantur. Exstant tabulae in aula antiqua civium militarium, in quibus ad vivum depinxit, Tribunos, Duces, Fiscales, signiferos, satellites in armis suis: in Tabula altera accumbentes in mensa, et se mutuo provocantes salutis haustis. Alter nimirum Theodorus Hals; vir bonus, et artis graphicae minime rudis, imagines solitus pingere in minori forma graciles et elegantes, in quibus etiam excellit.
(Schrevelius 1647, p. 289)

This passage was translated as follows in the 1648 Dutch edition of Schrevelius's book (p. 383):
Hier kan ick oock met stille swijghen niet verby gaen, Frans ende Dirck Hals Ghebroeders, van de welcke d'eene, die deur een onghemeyne manier van schilderen, die hem eyghen is, by nae alle overtreft, want daer is in sijn schildery sulcke forse ende leven, dat hy te met de natuyr selfs schijnt te braveren met sijn Penceel, dat spreecken alle sijne Conterfeytsels, die hy ghemaeckt heeft, onghelooflijcke veel,

die soo ghecolereert zijn, dat se schijnen asem van haer te gheven, ende te leven. Daer zijn noch veel stucken schildery in de oude Schutsdoelen, in de welcke hy nae 't leven gheschildert heeft Collonels, Cappiteyns, Fiscaels, Vendrichs, Sergeant, in haer volle wapenen. Ende wederom in een ander Tafereel Schutbroeders, sittende aen tafel, malkanders ghesontheydt toe-drinckende. 'd'Andere Hals is oock een goedt hals, die in kleyne stucken ende Beelden te maken seer aerdigh ende suyver is, heeft oock in dese een luyster.

('Nor can I let this pass in mute silence, Frans and Dirck Hals, brothers, of whom the one excels almost everyone with the superb and uncommon manner of painting which is uniquely his. His paintings are imbued with such force and vitality that he seems to defy nature herself with his brush. This is seen in all his portraits, so numerous as to pass belief, which are coloured in such a way that they seem to live and breathe. The old militia hall still has many of his works, in which he has painted colonels, captains, fiscals, ensigns and sergeants from life, all fully armed. Another scene shows the militia brothers seated at table, drinking each other's health. The other Hals is also a good fellow, very fine and pure in small pieces and figures, and in this he too shines.')

In 1617 Frans Hals painted the portrait of Theodorus Schrevelius (Haarlem 1572-1649 Leiden) on copper (cat. 5), a picture greatly admired by Buchelius (doc. 42).

| 117 | 1647, 17 January — DEPOSITION OF DIRCK VERHOEVEN RELATING TO ONE OF FRANS HALS'S SONS
Op huyden den 17en januarii 1647 compareerde voor mij notaris ende getuygen naergenoemt Dirck Verhoeven silversmith, ende heeft bij sijnne manne waerheyt in plaetse van eede die hij overbodich stondt te doen ten versoecke van Heyltie Lodewijcxs, huysvrouw van Willem Heyndericxsz geseyt, getuycht, ende verclaert waerachtich te wesen, dat op sondachavont omtrent 7 uuren ten huyse van requirante gecomen is de huysvrouw van mr. Frans Hals, alwaer hij deposant is huysvrint. Ende dat hij deposant gehoort heeft, dat de huysvrouw van mr. Frans Hals tegens de requirante ende tegens haer man seyde: 'ghij meucht het huysie wel weer verhueren, het is mijn soons gelegentheyt niet hier te comen', daerop ende haer man beyden antwoorden: 't is wel, wij sullen dan het huysie weer verhueren.' Eyndigende hiermeede zijn depositie, aldus gedaen, verleden ende gepasseert binnen der stadt Haerlem ten comptoire mijns notaris in presentie van de ondergeschreven getuygen: Dirck Verhoeven, H. van Gellinckhuysen, P. van Oosterhooren. Quod attestor S. Coesaert, notarius publicus 1647.

GAH, NA 174 (notary Salomon Coesaert), fol. 168r.
Literature: Bredius 1923/24, p. 26 (excerpt).

The silversmith Dirck Verhoeven (Amsterdam 1620-1694 Amsterdam) appears as a friend of Heyltje Lodewijcksdr and her husband Willem Heynericksz to declare that Lysbeth Reyniersdr, the wife of Frans Hals, visited Heyltje at 7 o'clock on Sunday evening to say that she and her husband could rent out the small house to another tenant, for her son was not planning to return. The couple replied that they would do so.

Willem Heynericksz owned a house in Bredesteeg and another in Drossestraat. It is not clear which of Frans Hals's sons had rented the house and had now decided not to return.

| 118 | 1647, 31 January — A FRANS HALS PAINTING IN THE

...

GAD, NA, inventory of Johan Hogenhouck.
Literature: HdG 125a.

This listing has not been verified. C. Hofstede de Groot records it in his *Verzeichnis* as 'Ein Gemälde mit zwei Jungen', but fails to give the source in the Delft notarial archives.

| 119 | 1647, 28 March — MARTIN VAN DE BROECKE EXCHANGES PAINTINGS AND JEWELLERY FOR MERCHANDISE WITH ANDRIES ACKERSLOOT
Een verloren soon van Frans Hals

GAA, NA 1081 (notary Joost van de Ven), fol. 66r-v.
Literature: HdG 2; Bredius 1915-22, p. 641; Slive 1974, no. 20; Strauss & van der Meulen 1979, p. 254.

The Amsterdam merchant Martin van de Broecke exchanges jewellery set with pearls and diamonds, and thirty-four paintings, including a Lucas van Leyden, a Goltzius, five Rembrandts and a *Prodigal Son* by Frans Hals, to a total value of 8,000 guilders. In return he was to receive merchandise belonging to another Amsterdam merchant, Andries Ackersloot, including masts, rope and Swedish iron.

The painting, which was an unusual subject for Hals, may well be the same piece that was used as payment for rent in 1646 (doc. 115). It may be identical with the *Banquet in a Park*, which Slive accepts as an early work by Hals. Formerly in the Kaiser-Friedrich-Museum in Berlin, that picture was lost during the Second World War (S.L1). Another possible contender is his so-called *Jonker Ramp and His Sweetheart* (pl. III; S20).

| 120 | 1647, 12 July — BAPTISM OF ADRIAENTJE, DAUGHTER OF FRANS HALS THE YOUNGER
Ariaentje
Vader Frans Hals van Haerlem
Moeder Hester Jans
Getuygen Elisabeth Reyniers
 Annetje Jans

GAH, DTB 13 (NHG Baptismal Register), fol. 189.

The baptismal record of Adriaentje, daughter of Frans Hals the Younger and his wife, Hester Jansdr. The witnesses were Lysbeth Reyniersdr, Hals's wife, and Annetje Jansdr, who was probably the baby's aunt.

| 121 | 1647, 4 August — DEBTS OWED BY FRANS AND DIRCK HALS TO THE HEIRS OF OTTO GERRITSZ
Frans Hals ... 59-8-
Dirck Hals ... 42-3-

GAH, NA 216 (notary Nicolaas Bosvelt), fols. 81r-3v (esp. fol. 81v).
Literature: Bredius 1923/24, p. 26 (excerpt).

Frans and Dirck Hals owe 59 guilders, 8 stuivers, and 42 guilders, 3 stuivers respectively to the heirs of shoemaker Otto Gerritsz, whose death inventory was taken by notary Nicolaas Bosvelt in Haarlem on 4 August 1647.

| 122 | 1647, 22 September — TWO FRANS HALS PAINTINGS IN THE INVENTORY OF CORNELIS VAN DER TIN

...

GAH, NA, inventory of Cornelis van der Tin.
Literature: HdG 447c-d.

This listing has not been verified. C. Hofstede de Groot records it in his *Verzeichnis* as '*Zwei Gemälde (Rundbilder)*', but fails to give the source in the Haarlem notarial archives.

| 123 | 1647, 29 December — BANNS OF FRANS HALS'S SON, JOHANNES, AND MARIA DE WIT
Joannes Hals jongeman van Harlem, woonende op d'Oude Graft, met Maria de Wit jongedochter, mede van Harlem, woonende in de Spaerwouderstraet

> [in the margin] *Attestatie gegeven op Blommendael den 12 januarius anno 1648 ende dito aldaer getrouwt*

GAH, DTB 52 (NHG Banns Register), fol. 91.
Literature: van der Willigen 1870, p. 150.

The banns of Johannes Hals (Haarlem *c.* 1620 - before 11 November 1654 Haarlem; baptismal date unknown), the son of Frans Hals and his second wife Lysbeth Reyniersdr, living on Oude Gracht (his parents' home), and Maria de Wit of Spaarnwouderstraat in Haarlem. The marginal note states that they were married on 12 January 1648 in the nearby village of Bloemendaal.

Only a few months later, on 24 July 1648, Johannes (Jan) Hals was listed as a widower of St. Jansstraat in Haarlem. On 4 August of that year he was again living on Oude Gracht (opposite 'De Blaeuwe Arent'; Bredius 1923/24f, pp. 263-4). He remarried two years later (doc. 132).

Jan Hals, who was also an artist, produced portraits in his father's style and genre scenes. His name appears in the membership list of the Guild of St. Luke compiled by Vincent Laurensz and Vincent Jansz van der Vinne (see doc. 9), but with no record of his date of admission (Miedema 1980, pp. 933, 1037).

Lot number 42 at an auction held in Rotterdam on 6 November 1730 was '*een trony van St. Pieter, door Jan Hals alias Den Gulden Ezel*' ('a head of St. Peter, by Jan Hals, alias the Golden Ass'; Bredius 1888a, p. 304). That Jan Hals has been identified ever since as a son of Frans Hals. It was also assumed that he had visited Rome in his youth, where he acquired his nickname on joining the society of Netherlandish artists known as the *Bentveughels*. Other references which have been cited to support this theory include a poem by Joost van den Vondel (Cologne 1587-1679 Amsterdam) entitled: '*Op de doorluchtige afbeeldinge van Homerus, door schilder Joan den Ezel*' ('On the celebrated depiction of Homer by the painter Jan the Ass'), a picture belonging to a Delft collector. The identification proposed on the basis of this eighteenth-century source is not supported by contemporary documents, nor is it borne out by the style of Jan Hals's genre scenes, which are of a distinctively Haarlem cast and do not suggest any contact with the Dutch Italianate painters. Houbraken (vol. 2, p. 357), writing shortly before the Rotterdam auction, associated the nickname with a German artist.

One interesting piece of information is contained in the inventory of the Haarlem ribbon-maker Nicolaas van der Gon and his wife Cornelia van Schaep (GAH, NA 372 [notary Lourens Baert], fol. 373r, dated 9 December 1665), which lists five portraits by Frans and Jan Hals. The lifesize pictures of van der Gon and his wife, who married on 11 April 1651, were painted by Frans Hals, and those of van der Gon's brother (name unknown) and his wife and son by Jan Hals. None of these five portraits has been identified.

| 124 | 1648 — SCHREVELIUS ON FRANS AND DIRCK HALS

See doc. 116.

| 125 | 1648, 12 March — A FRANS HALS PAINTING IN THE INVENTORY OF THE WIDOW OF CRIJN HENDRICKSZ VOLMARIJN
Een stuck van Frans Hals

GAR, Chamber of Orphans register YYY, p. 174.
Literature: Haverkorn van Rijsewijk 1894, p. 146; HdG 447e; Bredius 1915-22, p. 1637.

A painting of an unspecified subject by Frans Hals listed in the death inventory of Trijntje Pietersdr, widow of Crijn Hendricksz Volmarijn (d. 1645), a Rotterdam painter and art dealer.

| 126 | 1648, May — A FRANS HALS PAINTING IN THE INVENTORY OF LAMBERT HERMANSZ BLAEUW
Een gek van Frans Hals -10-

GAA, NA.
Literature: Bredius 1927, p. 21.

Listed in the inventory of the Amsterdam hat-trimmer Lambert Hermansz Blaeuw is a painting of 'a fool' by Frans Hals, which Johannes Collaert valued at 10 guilders.

This listing has not been verified. Bredius reports it without identifying the source in the notarial archives.

| 127 | 1648, 27 May — FRANS HALS AND TWO OTHER ARTISTS APPOINTED TO ARBITRATE IN A DISPUTE BETWEEN JAN WIJNANTS AND WOUTER KNIJFF
Jan Wijnants eyscher contra Wouter Knijff meester schilder gedaechde. T'antwoorden op eysch van 50-0-0 staende ter rolle van den 2e mey 1648 ofte het tweede deffault met het proffijt vandien te begeeren.

> [in the margin] *Commissarissen voor in desen te disponeeren, remvoyeeren partijen ende haerluyden different aen de eersame Frans Pietersz Grebber, Frans Hals en Cornelis Symonsz van der Schalcken omme henluyden te hooren ende te vereenigen, is doennelyck etc.*

GAH, RA 116/28 (Court of Petty Sessions), unpaginated.
Literature: Bredius 1925, pp. 275-6.

Wouter Knijff (Wesel 1605/6 - 1694 Bergen op Zoom), who was active in Haarlem as a painter and art dealer from 1640 to 1693, sold a fake Adriaen Brouwer to Jan Wijnants (active 1626-53 in Haarlem; father of the landscapist of the same

name). Wijnants demanded his money back, with damages, and sued for a total of 50 guilders (Court of Petty Sessions, 8 April and 2 May 1648). Knijff, however, insisted that he had sold him a genuine Brouwer. Artists Frans Hals, Frans Pietersz de Grebber (Haarlem 1572/3-1649 Haarlem) and Cornelis Symonsz van der Schalcken (Haarlem 1611-1671 Haarlem) are now appointed to arbitrate in the dispute.

| 128 | 1648, 30 May — BURIAL OF A CHILD OF FRANS HALS OR OF HIS SON FRANS
Een kint van Frans Hals opt Bagijnhoff -20 -

GAH, DTB 71 (Burials Register, gravediggers' fees), fol. 172.

Gravediggers' fee for burying a child of Frans Hals in the Beguine Churchyard.

This might be a reference to the burial of Jacobus Hals, a son of Frans Hals's second marriage, who was baptised in Haarlem on 12 December 1624 (doc. 31) and died young. Circumstantial evidence for this is provided by the fact that his brothers, Frans Hals the Younger and Jan Hals, each had a son in 1650 whom they named Jacobus. It could, however, be a child of Frans Hals the Younger and Hester Jansdr van Groenvelt, who married in 1643 (doc. 98).

| 129 | 1648, June — STATEMENTS ABOUT A LOTTERY OF PAINTINGS VALUED BY FRANS HALS
...

GAH, NA (notary Johannes Colterman).
Literature: Bredius 1923/24, p. 26.

Statements about a large lottery of paintings held in 1641 for which Frans Hals had acted as appraiser.

No trace has been found of this document, which is mentioned by Bredius.

| 130 | 1648, 21 November — DEBT OWED TO JAN MARCHANT (MERSJANT)
De selve eyscher [Jan Marchant] *contra Frans Hals gedaechde. Om te hebben betalinge en bij provisie namptissement van de somme van 5-2-0 van gelevert lij[n]waet mette costen.*
> [in the margin] *Commissarissen verleenen het eerste deffault, ordonneeren de 2e citatie*

GAH, RA 116/29 (Court of Petty Sessions), unpaginated.
Literature: Bredius 1923/24, p. 26 (excerpt).

See commentary to docs. 103, 131.

| 131 | 1648, 24 November — DEBT OWED TO JAN MARCHANT (MERSJANT)
De selve eyscher [Jan Marchant] *contra Frans Hals gedaechde. T'antwoorden op den eysch van 5-2-0 staende ter lester rolle ofte het tweede deffault met het proffijt vandien te begeren.*
> [in the margin] *Commissarissen partijen gehoort ende op alles geleth, dienvolgende doende recht, condemneeren de gedaechde de geeyschte somme mette costen te betaelen binnen een maent mits cautie.*

GAH, RA 116/29 (Court of Petty Sessions), unpaginated.
Literature: Bredius 1923/24, p. 26 (excerpt).

Jan Marchant had sued Frans Hals for 5 guilders and 2 stuivers owed for linen. Hals did not appear in court, and the commissioners awarded a first default (doc. 130). A second summons was served, and after hearing both sides the commissioners order him to pay the sum within one month.

In 1644 Frans Hals had owed money to the same creditor (doc. 103). Since no address is given on this occasion, the defendant may have been Frans Hals the Younger.

| 132 | 1649, 16 May — BANNS OF FRANS HALS'S SON, JOHANNES, AND SARA GERRITSDR
Johannes Hals, weduwnaer van Haerlem, woonende op de Oude Gracht met Saertie Gerrits, jongedochter, mede van Haerlem, woonende in de Spaerwouwerstraet
> [in the margin] *attestatie gegeven op Spaerendam den 4 junii 1649 ende aldaer getrout*

GAH, DTB 52 (NHG Banns Register), fol. 161.
Literature: van der Willigen 1870, p. 150; Bredius 1923/24f, pp. 263-4.

The banns of Johannes Hals (Haarlem c.1620-before 11 November 1654 Haarlem), son of Frans Hals and his second wife Lysbeth Reyniersdr, widower since July 1648 of Maria de Wit, residing on Oude Gracht (cf. doc. 123), and Sara Gerritsdr, spinster, of Spaarnwouderstraat. The marginal note states that the marriage took place in the nearby village of Spaarndam on 4 June 1649.

After his marriage Jan Hals moved to the Vest near the Plague-House, from which it can be inferred that he married from his parents' home.

On 11 November 1654 two of Jan Hals's children were taken into the orphanage (GAH, Burgomasters' Resolutions 10/17, fol. 188v). They were Jacobus, baptised on 26 January 1650, and a child who is not known from any document. Johannes and his wife Sara clearly died before this date, but it is not known when, because the burial registers for the period 29 January 1650 to 3 June 1656 are missing.

| 133 | 1649, 4 September — FRANS HALS ATTENDS AN EXTRAORDINARY MEETING OF FORMER WARDENS OF THE GUILD OF ST. LUKE ON A PROPOSAL TO RESTRICT ART AUCTIONS
Namen der oude vinderen gekompareert Salemon de Breij, Pieter Serdam, Floris van Schoten, Frans Hals, Frans de Hulst, Molijn vertrocken. Deze sitdach is gehouden om te beandwoorden aen de heren burgemeesteren van wegen de weringe van de venduwen buiten de stat, soo is den besten middel voorgestelt voor het gemeene best, dat men van de keur bij het gerechte gemaeckt niet soude afwijcken, en die in sijn kracht te laten, maer dat alle gildebroers, die int gildt syn en daervan behoorlijck blijck tonen, sullen mogen een ofte meerder met malcander haer eijgen gemaecte stucken op manier van vendu verkopen en een behoorlijke lijst met nombers geteijckent aen vinders te geven, waerdoor het buiten soude geweert kunnen werden.

GAH, GA (excerpts by G.W. van Oosten de Bruyn from the lost wardens' book D), cols. 212-8, esp. col. 216.

Literature: Miedema 1980, vol. 2, B13 (books 1645-51), p. 616.

Extraordinary meeting of the former wardens of St. Luke's Guild, Salomon de Bray, Pieter Saenredam, Floris van Schoten, Frans Hals and Frans de Hulst (the absentee was Pieter Molijn, who had evidently been expected to attend), to advise the burgomasters on curtailing art auctions outside the city. They recommend that the existing statute be enforced, but that guild members should be allowed to sell work at auction several times a year, provided a numbered list is first lodged with the wardens. Cf. doc. 97.

| 134 | 1650 — A FRANS HALS PAINTING IN A LEIDEN INVENTORY

...

GAL, NA.
Literature: HdG 447f.

This listing has not been verified. C. Hofstede de Groot records it in his *Verzeichnis* as '*Ein Gemälde*', valued at 15 guilders, but fails to give the source in the Leiden notarial archives.

| 135 | 1650, 26 November — DEBT OWED TO THE HEIRS OF HENDRICK DEN ABT
D'selve eyscher [Adriaen Wijnants als procuratie hebbende van mr. Jan Claerhout, als testamentare voocht van Willem den Abdt ende Josyntge van Nast, weduwe van Heynderick den Abt, zoo in dier qualite eyscher] contra Frans Hals schilder op d'Ouwe Gracht gedaechde. Omme te hebben betalinge ende bij provisie namptissement van den somme van 31-10-4, reste van verteert gelach mette costen.

[in the margin] *De gedaechde ontkent iets aen eyscher schuldich t'sijn. Commissaris ordonneert als vooren [den eyscher met Seyntge van Nast tegens dinghsdach boven te comen].*

GAH, RA 116/31 (Court of Petty Sessions), unpaginated.
Literature: Bredius 1923/24, pp. 26-7 (excerpt).

See commentary to doc. 136.

| 136 | 1650, 29 November — DEBT OWED TO THE HEIRS OF HENDRICK DEN ABT
D'selve eyscher [Adriaen Wijnants] contra Frans Hals schilder gedaechde. Om bij mijn edele heere te disponneeren op den eysch van 31-10-4 staende ter lester rolle.

[in the margin] *Commissarissen houden deze saeck in state*

GAH, RA 116/31 (Court of Petty Sessions), unpaginated.

Jan Claerhout (represented by Adriaen Wijnants), the guardian of Willem den Abt and Josijntje van Nast, the son and widow of Hendrick den Abt, former landlord of the 'Koning van Vrankrijck' in Smedestraat, had sued Frans Hals of Oude Gracht for 31 guilders, 10 stuivers and 4 penningen owed for food and drink. Hals refused to acknowledge the debt, and the commissioners had ordered him and the widow den Abt to reappear before them (doc. 135). They now decide to hold the case over while the claim is reinvestigated.

| 137 | 1651, 28 January — DEBT OWED BY FRANS HALS'S SECOND WIFE TO HENDRICK HENDRICKSZ
Heynderick Heyndericxsz eyscher contra Lisbeth ... , huysvrouw van mr. Frans Hals gedaechde. Om te hebben betalinge ende bij provisie namptissement van de somme van 4-0-0 van een kasgen mette costen.

[in the margin] *Commissarissen, vermits de absentie van de gedaechde, verleenen tegens haer het eerste deffault en voort proffijt vandien, gehoort de verclaringe van de deuchdelijckheyt van de schult, dienvolgende doende recht condemneeren de gedaechde de geeyschte somme bij provisie te namptisseren onder cautie, de restituendo.*

GAH, RA 116/31 (Court of Petty Sessions), unpaginated.
Literature: Bredius 1923/24, p. 26 (excerpt).

Hendrick Hendricksz demands payment of 4 guilders for a small chest bought by Frans Hals's wife Lysbeth Reyniersdr (surname omitted). Lysbeth does not attend the hearing, and the commissioners declare a first default. Convinced that the claim is fair, they also order her to lodge a provisional surety. Cf. doc. 95.

| 138 | 1651, 6 October — DEPOSITION OF PIETER GERRITSZ VAN ROESTRATEN AND CLAES FRANSZ CONCERNING FRANS HALS'S SECOND WIFE
Op huyden den sesten october 1651 compareerden voor mij Pieter van Velsen, notarius publicus tot Amsterdam, Pieter Gerritsz van Roestraten, out omtrent 22 jaren, ende Claes Franssen, out omtrent 21 jaren, beyde tot Haerlem woonachtich, ende hebben ter requisitie ende instantie van Lysbet Reyniers, huysvrou van Frans Hals, schilder, tot Haerlem mede woonachtich, bij ware woorden in plaetse ende onder presentatie van eede mits desen gedeposeert, verclaert ende geattesteert, dat sij deposanten de requirante in desen ende haren man voornoemt seer wel kennende sijn, gelijck mede wel gekent hebben haren soon, met malcanderen echtelicken geprocreëert, genaemt Antonis Hals, voor jongen naar Oost-Indyen gevaren met 't schip de Walrus [in] 1646. Ende, soo [zij] bericht sijn, op Tonquijn overleden [in] 1650. Gevende voor redenen huerder wetenschap dat de deposant Pieter Gerritsz van Roestraten vijff jaren bij de requirante ende haren man gewerct heeft ende de deposant Claes Franssen ettelicke jaren in desselfs gebuijrte gewoont heeft, mette ouders als den overleden haren soon voornoemt ommegegaen ende verkeert hebben.
Gedaen in Amsterdam, ter presentie van Heijndrick Rosa als getuyge.
[signed] *Pieter Gerritsen van Roestraten, K F (bij Claes Franssen gestelt), H. Roosa, 1651, P. van Velsen notarius*

GAA, NA 1788 (notary Pieter van Velsen), fols. 554-5.
Literature: Unpublished note of A. Bredius, RKD, The Hague; van Hees 1959, p. 40 (full transcription).

Pieter Gerritsz van Roestraten (Haarlem 1630-1700 London), aged about 22, and Claes Fransz, aged about 21, both of Haarlem, declare in Amsterdam at the request of Lysbeth Reyniersdr, the wife of Frans Hals, that they know her and her husband well, and had been friends of their son Anthonie Hals, who had sailed to the East Indies as a boy in the *Walrus*. Anthonie, so they had heard, had died in 1650 in Tonkin

(modern Vietnam). Van Roestraten explains that he had been a member of the Hals household for five years, and Claes Fransz (not Hals's son Claes) states that he had been a neighbour for several years and had associated with the parents and with Anthonie.

Lysbeth Reyniersdr, who was acting on her husband's authority (see doc. 139), needed this deposition in order to claim the pay due to her dead son Anthonie (date of baptism unknown) from the chambers of the Dutch East India Company in Amsterdam.

Pieter van Roestraten, the still-life painter, was later to marry a daughter of his former master (doc. 148).

| 139 | 1651, 7 October — FRANS HALS AUTHORISES HIS SECOND WIFE TO COLLECT THE PAY DUE TO THEIR LATE SON ANTHONIE
Op huyden den 7 october 1651 compareerde voor mij notarius ende getuygen ondergenoempt den edele mr. Frans Hals schilder wonende binnen deser stadt ende heeft in der bester ende sterckster forme, style ende maniere eenichsints doenlick zijnde geconstitueert ende volmachtich gemaect als hij constitueerde ende maeckte volmachtich bij desen d'eerbaere Lysbeth Reyniers zijns comparants huysvrouwe spetialicken omme van den edele heeren bewinthebberen der geoctroyeerde Oostindische Compagnie ter camere tot Amsterdam ofte elders daert behoort, in te vorderen ende t'ontfangen soodanige somme van penningen, als Antony Hals, zijn comparants soon, aen de voors. Compagnie te goet soudt mogen hebben, quitantie van haeren ontfanck te passeren ende de voors. heeren bewinthebberen van alle naermaninge te bevrijden, 't welck hij comparant belooft van waerde te houden onder 't verbant als naer recht. Aldus gepasseert binnen der stadt Haerlem ter presentie van de getuygen ondergeschreven.
[signed] *Frans Hals, J. Vlaming, Joost Klaes. T'oirconden: N. van Bosvelt, notarius.*

GAH, NA 198 (notary Nicolaas van Bosvelt), fol. 74r (renumbered 66r).
Literature: van Hees 1959, p. 41.

Frans Hals authorises his wife Lysbeth Reyniersdr to collect from the chambers of the Dutch East India Company, in Amsterdam or elsewhere, the pay due to their son Anthonie (date of baptism unknown), who had sailed to the East Indies in the *Walrus* as a boy in 1646, and had died in Tonkin in 1650 (see doc. 138).

| 140 | 1653, February — SCHAEP'S LIST OF PAINTINGS IN THE HALLS OF THE THREE MILITIA COMPANIES AT AMSTERDAM
A°. 1637. Ibidem [in the Crossbowmen's Hall] *tegenover de schoorsteen Cap". Reynier Reael, Lut. Corn. Michielsz. Blau, a°. 1637 bij Francois Hals geschildert ende bij Codde voorts opgemaeckt.*

GAA, ms. 5059 (*Memorie ende lijste van de publycke schilderijen op de Voetboogsdoelen, sooals die waren in Februarij A°. 1653* [Memorandum and list of the official paintings housed in the Crossbowmen's Hall in February 1653]).
Literature: Scheltema 1885, p. 134.

This entry by Gerard Pietersz Schaep (1599-1655) states that

the group portrait of the corporalship of Captain Reynier Reael (*The Meagre Company*) for the Crossbowmen's Hall in Amsterdam, which Hals had started painting in 1633 and had abandoned in 1636 (see docs. 73-5, 78 and cat. 43), was completed in 1637 by the Amsterdam artist Pieter Codde (Amsterdam 1599-1678 Amsterdam).

| 141 | 1653, 16 August — FRANS HALS'S SON, CLAES FRANSZ, AND SIJTJE GERRITSDR ATTEMPT TO MARRY UNDER FALSE PRETENCES
Compareerden als vooren Claes [deleted: *Gerrits*] *Fransen van Antwerpen varentgesel, out 23 jaer, woonende op de Binnen Emster, geen ouders hebbende, ende Sijtie* [deleted: *Claes*] *Gerrits van Groningen, out 23 jaer, geen ouders hebbende, woonende als vooren.*
[in the margin] *Uytrecht, X, S: Gerrits*
Dese persoonen kunnen niet trouwen dewijl Claes Fransen Hals van Haerlem vandaen is, sij daer noch een vader en moeder heeft, ende hij een schilder [deleted: *ende geen varent gesel is*], *en Sijtje Gerrits mede van Haerlem is, ende daerbij een moeder met twee kinderen, en sijlieden met voordacht beijden haer stadt ende hij sijn qualiteyt ende vader en moeder heeft missaeckt, volgens het seggen van Lysbeth Reyniers moeder van de voors. Claes Fransen.*

GAA, DTB 471 (NHG Banns Register), fol. 337.

See commentary to doc. 143.

| 142 | 1653, 26 November — ORDER COMMITTING SIJTJE GERRITSDR TO THE HOUSE OF CORRECTION
Sijtgen Gerrits is ter oorsaecke sij met eenen Claes Franssen Hals naer Amsterdam heeft begeven, ende aldaer voor commissarissen van de Huwelijcxe Saecken de geboden laten aenteijkenen, te weten elckx op een quade naem, als Claes Franssen van Antwerpen, varent gesel, ende de voors. Sijtge Gerrits van Groeningen, beyde te wonen op de binnen Eemster, ende geen ouders te hebben, ende daerover sijnde bij den heere officier in apprehentie genoomen, bij provisie geordonneert, gebracht te werden int werckhuys deser stadt, om aldaer de cost met der handenarbeyt te gewinnen, 't sij met heeckelen als andersints, doch alles tot discretie van de regenten, ende niet te ontslaen dan tot naerder ordre, lasten de regenten voors. 't selve naer te comen, des dat de voorschreve Frans Hals ende sijn vrouw haer soon Claes Hals sullen sien hier te gecrijgen, off anders dat de voorschreve vrouw sal werden ontslagen.
[in the margin] *Sijtgen Gerrit int werckhuys*

GAH, Burgomasters' Resolutions 1653 (10/17), fol. 110r-v (unpublished note of A. Bredius, RKD, The Hague).

See commentary to doc. 143.

| 143 | 1653, 13 December — ORDER TO RELEASE SIJTJE GERRITSDR FROM THE HOUSE OF CORRECTION
Vermits Frans Hals ende sijn huysvrouwe niet naer en comen 't geene hen was gelast van haer soon Claes Hals hier ter stede te gecrijgen ende oock niet gesint te doen, is geordonneert, dat

de voorschreve Sijtgen Gerrits uyt het werckhuys sal werden gelaten, des haer kinderen onderhoudende ende haer dragende buyten claghten op verdere straffe.

[in the margin] *Sijtgen Gerrits ontslagen*

GAH, Burgomasters' Resolutions 1653 (10/17), fol. 114r (unpublished note of A. Bredius, RKD, The Hague).

On 16 August 1653 the 23-year-old Claes Fransz Hals (see doc. 43) and Sijtje Gerritsdr, of the same age, had made a false declaration in Amsterdam. Claes Fransz had concealed the fact that his surname was Hals, said that he came from Antwerp rather than Haarlem, and gave his profession as seaman instead of painter. Sijtje Gerritsdr had failed to mention that she had two children, and said that she came from Groningen, not Haarlem. Moreover, both of them had falsely asserted that they were orphans, but had spoken the truth when they said they were living on Binnen Eemster. Their deception was unmasked, for in the margin there is a note stating that the two parties cannot marry, because Claes Fransz Hals comes from Haarlem and is a painter (the words 'and not a seafarer' are deleted), and because Sijtje Gerritsdr also comes from Haarlem and has two children. In addition, neither is an orphan. Claes's mother, Lysbeth Reyniersdr, had come to Amsterdam to put matters straight (doc. 141).

On 26 November 1653 the burgomasters of Haarlem decided to send Sijtje Gerritsdr to prison for going to Amsterdam with Claes Fransz Hals and registering under false pretences. She was sentenced to earn her keep in the workhouse by combing flax or some such work. Claes had not returned to Haarlem, and the burgomasters advised Frans Hals and his wife to bring him home. If he did not return Sijtje would be discharged from the workhouse (doc. 142).

Now, since Frans Hals and his wife refuse to bring their son back, Sijtje is released after a little more than a fortnight in the workhouse so that she can look after her children. Her sentence is set aside.

Just over a year later Claes, who had eventually returned to his parents' home, married the wealthy Janneke Hendricksdr van Haexbergen, widow of Willem Jansz (doc. 150).

| 144 | 1653, 27 December — BANNS OF FRANS HALS'S SON, REYNIER, AND MARGRIETJE LODEWIJCKSDR, IN AMSTERDAM

Opgehouden
Compareerden als vooren Reynier Hals van Haerlem, schilder out 22 jaer, woonende tot Haerlem ende Margrietje Lode-wijckx van Amsterdam, out 19 jaer, geassisteert met haer moeder Annetje Pi[e]ters, woonende op de Noordermarckt.
[signed] *Reynier Hals, Gryette Loodewick*

[in the margin] *Hij zijn vaders consent in te brengen. Zijn vaders consent is goet ingebracht ende gaet het derde gebot den 12 april 1654, de geboden sijn tot Haerlem sonder verhinderingh gegaen.*

[below the signatures] *Deze persoonen den 12 April 1654 getrout tot Slooterdijck. Teste M. Meursius, predikant aldaer.*

GAA, DTB 472 (NHG Banns Register), fol. 260.
Literature: Bredius 1923/24-e, p. 258 (excerpt).

See commentary to doc. 145.

| 145 | 1654, 11 January — BANNS OF FRANS HALS'S SON, REYNIER, AND MARGRIETJE LODEWIJCKSDR, IN HAARLEM
Reynier Hals, jongeman van Haerlem, woonende in de Ridderstraet, met Margrietie Lodewijcx, jongedochter van Amsterdam ende aldaer woonende.

[in the margin] *Attestatie gegeven op Amsterdam den 25 januarii anno 1654*

GAH, DTB 52 (NHG Banns Register), fol. 399.
Literature: Bredius 1923/24e, p. 258.

On 27 December 1653, Frans Hals's son Reynier (Haarlem 1627-1672 Amsterdam) by his second marriage to Lysbeth Reyniersdr was betrothed in Amsterdam to Margrietje Lode-wijcksdr, 19 years old, who lived on the Noordermarkt. The bride-to-be was attended by her mother, Annetje Pietersdr. Reynier had given his age as 22 instead of 26, and stated that he was living in Ridderstraat in Haarlem (his parents' home). The wedding had to be delayed until Reynier produced his father's consent (doc. 144). Reynier now registers in his home town, and an attestation was sent to Amsterdam, arriving there on 25 January.

The note entered beneath the signatures on the banns of December 1653 (doc. 144) states that the marriage, which was to be short-lived (see doc. 155) and childless, was celebrated on 12 April 1654 by M. Meursius, minister at Sloterdijk near Amsterdam.

Margrietje was the daughter of Lodewijck Wierius and Anna Pietersdr (Piering). She had been baptised in the Old Church in Amsterdam on 26 March 1634, the witnesses being Grietje Caels and Catlijn Verstraeten (GAA, DTB 6, fol. 401). A search has failed to reveal her date of death.

| 146 | 1654, 13 January — FRANS HALS PAINTINGS IN THE INVENTORY OF DIRCK THOMASZ MOLENGRAEFT

...

GAA, NA.
Literature: HdG 10, 447g-i.

These listings have not been verified. C. Hofstede de Groot records them in his *Verzeichnis* as '*Die fünf Sinne*' and '*Drei kleine Bilder*', but fails to give the source in the Amsterdam notarial archives.

| 147 | 1654, 10 March — DEBT OWED TO JAN YKESZ
Op huyden den Xen martii XVIc vier en vijftich compareerde voor mij Hendrick van Gellinchuysen, notaris publycq, bij den Hove van Hollant geadmitteert, ende bij den heere Bailljuw van Kennemerlandt tot exercitie vandien in sijn jurisdictie toegelaten, binnen der stadt Haerlem residerende, ende de naergenoemde getuygen, den eersamen Franchois Hals mr. schilder wonende binnen der voors. stede Haerlem (mij notario bekent) ende bekende deuchdelijcken schuldich te wesen aen den eersamen Jan Ykessz backer, mede wonende binnen de voors. stede Haerlem, de somme van twee hondert carolus gulden, spruytende ter saecke van gelevert ende gehaelt broot, alsmede van deuchdelijcke geleende ende verstreckte penningen, bij hem comparant van de voornoemde Jan Ykessz ten dancke genooten ende ontfangen, ende derhalven soo ver-

*claerde hij comparant bij desen in titule van betalinge aen
deselve Jan Ykessz te transporteren, cederen ende tot een
volcomen ende absoluyt eygen over te dragen alle de naervol-
gende goederen: als te weten drie bedden ende peuluwen met
sijn toebehooren, een eycke kas met een eycke tafel ende vijff
stucken schilderij, als namentlijck een stuck van Vermander,
wesende de predicatie van Johannes de Dooper, een stuck
schilderij van Heemskerck, alwaer de kinderen van Israel het
manna rapen, noch twee stucken, één van hem comparant ende
één van sijn soon, ende ten laetsten noch een stuck van sijn
comparants outste soon, wesende een predicatie. Stellende hij
comparant de voorn. Jan Ykessz in de actuele possessie ende
besith van alle de voors. goederen ende van den eygendom van
dien afftredende, bekennende mede van de waerde ende
cooppenningen van dien al wel voldaen, ende betaelt te wesen,
soo dat hij comparant bekendt geen recht ofte actie te reserve-
ren. Compareerde mede voor ons notaris en de getuygen, de
voors. Jan Ykessz ende verclaerde de voors. transporte aen te
nemen ende te accepteren, sulcxs hij doet bij desen in voldoe-
ninge van de voors. twee hondert carolus gulden, die de voorn.
Franchois Hals aen hem schuldich is. Wijders heeft de voors.
Jan Ykessz vrijwillichlijck geconsenteert ende geaccordeert,
dat de voors. Frans Hals de boven genomineerde goederen
ende schilderijen precario ende bij vergunninge eenen tijt lanck
noch sal mogen gebruycken ende possideren, sonder de selve
alst hem eygenaer sal believen op te houden maer danckelijck
te laten volgen, alles oprecht ende ondert verbant van
heurluyder persoonen ende goederen. Aldus gedaen ende ge-
passeert in de jurisdictie van de heerlickheyt van Heemstede
ten huyse van Zacharias Geraerts, herbergier in Rustenburgh.
In presentie van voorn. Zacharias Geraerts ende Laurents van
Hecken, damastwercker, wonende in meester Lottenlaen, als
getuygen ten desen gerequireert. Ende was onderteyckent
Frans Hals, Jan Icken, dit is 't selff gestelde merck van Sacha-
rias Geraerts, Loures van Hecke.
Ten oirconde ende was onderteeckent H. v. Gellinchuysen,
notarius publicus. Accordeert met d'originele minute onder mij
notaris berustende.
Bij mij ende was geteeckent H. v. Gellinchuysen, notarius
publicus. Actum den IXen december anno 1656.*

[in the margin] *Frans Hals*

GAH, no.13/488 (Register of deeds of transfer executed in the pres-
ence of a notary), fol. 22v.
Literature: van der Willigen 1870, pp. 145-7.

Frans Hals acknowledges a non-itemised debt of 200 guilders
to the Haarlem baker Jan Ykesz for bread supplies and a loan,
which he pays off with household goods and paintings. The
baker is to receive three beds with bolsters and appurtenances,
an oak chest, an oak table and five paintings: a *Preaching of
John the Baptist* by Karel van Mander, a *Gathering of the
Manna* by Maerten van Heemskerck, an unspecified painting
by Hals himself, and two pictures by his sons, one of which
is a *Preaching of John the Baptist* by the eldest (Harmen, in
other words). Jan Ykesz states that he will accept these goods,
but allows Frans Hals the use of them for the time being.
Notary H. van Gellinchuysen of Haarlem drew up the deed
of transfer in the Rustenburg inn in Haarlemmerhout, which
fell under the jurisdiction of Kennemerland, in the presence
of the witnesses Zacharias Geraertsz, the innkeeper, and

Laurents van Hecken, a damask-worker of Meester Lotten-
laan in Haarlemmerhout.

All of the paintings mentioned in this deed have disappeared
without trace.

| 148 | 1654, 6 June — BANNS OF PIETER GERRITSZ VAN
ROESTRATEN AND FRANS HALS'S DAUGHTER, ADRIAENTJE
*Compareerden als vooren Pieter Gerritsen van Roestraette
van Haerlem, schilder, out 24 jaer, ouders doot, geassisteert
met Claes Hals, de bruyts broeder, woonende op de Anthonis-
breestraet ende Ariaentje Hals van Haerlem, out 27 jaer,
getoont acte van ouders consent, woonende als vooren.*
[signed] *Pieter Gerritsen van Roestra,* [a cross for Adriaentje
Hals]

GAA, DTB 473 (NHG Banns Register), fol. 247.
Literature: de Vries 1885, p. 310.

The betrothal in Amsterdam of the 24-year-old painter, Pieter
Gerritsz van Roestraten (Haarlem 1630-1700 London), an
orphan, and the 27-year-old Adriaentje Hals of Haarlem (she
was actually 30; see doc. 29), Frans Hals's daughter by his
second wife, Lysbeth Reyniersdr. The bridegroom was at-
tended by his future brother-in-law, Claes Hals (see doc. 43).
The bride produces her parents' consent. Both are living in
Anthonie Breestraat in Amsterdam.

No children were born of this marriage while the couple
were living in Amsterdam. They made their will on 3 October
1659 (doc. 157), and moved to England some time after 1 May
1663 (the date on which Adriaentje witnessed the baptism of
a child of her brother Reynier). Van Roestraten remarried
shortly before his death.

| 149 | 1654, 19 December — DEBT OWED TO CORNELIS
GERRITSZ SLUYS
*Den selven eyscher [Cornelis Gerritsz Sluys] contra Frans
Hals gedaechde. Om te hebben betaelinge ende bij provisie
namptissement van de somme van F 70-10 penningen, reste
van meerder somme over de coop van een os mette costen.*

[in the margin] *In staete tot vermaninge van den eyscher*

GAH, RA 116/34 (Court of Petty Sessions), fol. 50v.
Literature: Bredius 1923/24, p. 27 (excerpt; the sum of money given
as 7 instead of 70 guilders).

Cornelis Gerritsz Sluys sues Frans Hals for 70 guilders and
10 stuivers, being the balance of a larger sum for the purchase
of an ox. The commissioners hold the case over at the
plaintiff's request.

The relevance of this court record is doubtful, for it might
well apply to Hals's son or some other Frans Hals.

| 150 | 1655, 21 February — BANNS OF FRANS HALS'S SON,
CLAES, AND JANNEKE HENDRICKSDR VAN HAEXBERGEN
*Claes Fransen Hals, jongeman van Harlem, wonende in de
Ridderstraet, met Janneken Hendrix van Haexbergen, we-
duwe van Willem Jansen, wonende in de Turfsteege.*

[in the margin] *deze alhier getrout den 29 meert 1655*

GAH, DTB 53 (NHG Banns Register), fol. 7.

The betrothal of Frans Hals's son Claes (Haarlem 1628-1686 Haarlem; doc. 43) by his second wife, Lysbeth Reyniersdr, living in Ridderstraat (his parents' house), and Janneke Hendricksdr van Haexbergen, widow of Willem Jansz (Jenckens), former servant of the Bailiff of Kennemerland. The marginal note states that the marriage took place in Haarlem on 29 March.

The marriage was childless. Claes made two wills, in 1656 and 1667, and in each he left his parents their legal portions (cf. doc. 152). On 21 May 1664 he bought a mead brewhouse in Turfsteeg. See also docs. 141-3, 188.

| 151 | 1655, 8 October — FRANS HALS'S CONFIRMATION IN THE REFORMED CHURCH
Frans Hals woonende in de Ridderstraat, testis uxor

GAH, inv. 24/5 (OA Church Council NHG), fol. 141r.
Literature: van der Willigen 1870, p. 151.

Frans Hals of Ridderstraat is confirmed as a member of the Reformed Church. His wife acts as witness.

Van der Willigen believed that this new church member was Hals's son Frans, but in fact it was probably Frans Hals himself. Around this time three of his children married from Ridderstraat, seemingly from their parental home: Reynier in 1654, Claes in 1655 and Susanna in 1660. It is unlikely that Frans the Younger, who had a large family, was living at the same address, although of course he may have had another house in the same street. Frans Hals was most probably born a Catholic (see doc. 2), but both his wives had been baptised in the Reformed Church. A further reason for believing that this document refers to him is that his second wife, Lysbeth Reyniersdr, witnessed her son Claes's confirmation in 1672 (doc. 188). Like her sister Hillegond, she was very probably a member of this Reformed congregation.

| 152 | 1656, 31 March — LAST WILL OF FRANS HALS'S SON CLAES
... in eygene persone verschenen ende gecompareet es Niclaes Hals, schilder, wonende alhier tot Haerlem, sieckelijck te bedde ... indien ten overlijden van hem testateur sijne vader ende moeder ofte één van beyde noch int leven was, in sulcken gevalle sal de voors. Jannetie Hendrix, sijne huysvrouwe, aen deselve sijne ouders moeten uytkeren ende geven haerluyder naecte legitime portie, sulcx deselve naer scherpicheyt van rechte op sijn comparants naer te laten goederen ... : sijn testateurs graewwe mantel ofte sijn slechtste pack kleederen sullen een pont groot aen gelt, welck van drien sijluyden sullen gelieven te verkiesen, versoeckende, dat sijne ouders henluyden daermede sullen vergenoegen, alsoo de gemelte sijne ouders seer wel is bekent, dat hij gene ofte seer weynige goederen tot sijnen huwelijcke aengebracht heeft ...

GAH, NA 278 (notary Willem van Kittensteyn), fol. 149r-v (esp. fol. 149r).

Excerpt from the will of Claes Hals (Haarlem 1628-1686 Haarlem; see doc. 43), made on his sickbed, in which he names his wife as his sole heir. On his death, his parents Frans Hals and Lysbeth Reyniersdr are to receive their legal portions.

They may choose between his grey cloak, his everyday suit of clothes, or 1 Flemish pound (6 guilders). He asks them to be satisfied with this, for he had few possessions on his marriage.

On 22 September 1667, a year after his father's death, he again fell ill, and asked notary Joan Geraerts to draw up a new will (GAH, NA 353 [notary Joan Geraerts], fols. 69r-70r). On his death his mother was to receive her legal portion, but if she died before him his brother Frans Hals the Younger was to inherit his suit and cloak. As it happened, Claes outlived both his mother and his brother, being buried in Haarlem on 7 June 1686.

| 153 | 1656, 6 November — NICOLAES DE KEMP RECEIVES PORTRAITS OF HIS GRANDPARENTS BY FRANS HALS
Op huyden den VIe november 1656 compareerden voor mij Zeger van der Pullen, openbaere notaris bij den Hoven van Hollandt geadmitteert, binnen der stadt Haerlem residerende ende voir den naergenoemde getuygen Jan de Kemp, Maddaleentje ende Antenette de Croon, beyde jonge dochteren, de welcke altsame bekende volcomentlijcke door handen van haeren broeder ende oom Niclaes de Kemp te sijn voldaen, ende haerlieden te houden voor gecontenteert wegens twee conterfeytsels, wesende hem Jan Kemp sijn grootvader ende grootmoeder, ende haer Maddaleentje ende Antenette de Croon haer overgrootvader ende -grootmoeder, welcke voors. conterfeytsels sijn gemaeckt en geschildert bij mr. Franchoys Hals den oude ende het comparquement bij Buytewegh, ofte anders genaemt Geestige Willem. Beloovende mitsdien haerlieder comparanten voornoemde broeder ende oom Niclaes de Kemp ter saecke van de twee voorschreven conterfeytsels nu nochte nimmermeer meer te sullen moeyen ofte molesteren in rechte, nochte daer buyten, noch te gedoogen door jemanden gedaen te sullen werden. Maer deselve hem bij desen overgevende voor sijnne vrij eijgen ende sulcx omme daer mede gedaen te mogen werden als met sijnne vrij eygen goederen. ...

GAH, NA 240 (notary Zeger van der Pullen), fol. 65v (renumbered 53).
Literature: van Hees 1959, pp. 36-7 (full transcription).

Nicolaes de Kemp (Haarlem 1609-1672 Haarlem; see docs. 43, 82) receives from his brother Jan and his nieces Magdaleentje and Antoinette de Croon two portraits of his grandparents by Frans Hals the Elder, with painted borders ('comparquement'; see s5, p. 4) by Willem Buytewech (Rotterdam 1591/2-1624 Rotterdam). Since Buytewech became a member of the Haarlem Guild of St. Luke in 1612 and returned to his native Rotterdam in 1617, these two portraits must date from that early period.

| 154 | 1656, 7 December — FRANS HALS PAINTINGS IN THE INVENTORY OF JEAN FRANÇOIS TARTAROLIS
Een conterfeytsel van Hals
Een conterfeytsel van Hals
Een bordeeltje van Codde, idem van Hals
Twee copien na Hals

GAL, NA 611 (notary Sylvester van Swanenburch), deed 124.
Literature: HdG 142a, 426a; Bijleveld 1927, pp. 185-7.

The inventory of the estate of Jean François Tartarolis of Leiden, who died on 26 May 1653, lists two portraits and a brothel scene by Hals (no forename given), and two copies after Hals. The brothel piece is mentioned on the same line as a similar work by Pieter Codde. Cf. doc. 162.

The artist is very probably Frans Hals the Elder, for the name of his brother Dirck is given in full against two other paintings, an octagonal piece and a 'Merry Company'. The theoretical possibility that 'Hals' is a son of Frans Hals can be disregarded, partly because of the mention of copies 'after Hals'.

Jean François Tartarolis emigrated to Leiden from his birth-place in Lombardy around 1622, and received his citizenship in 1627. He married Barbara Mathijsdr van Creenburch, who came from a patrician family, and owned the loan banks of Leiden, Breda and Leeuwarden.

| 155 | 1657, 16 September — BANNS OF FRANS HALS'S SON, REYNIER, AND ELISABETH GROEN
Reynier Hals jongman van Haerlem met Elisabeth Groen jongedochter van Middelburgh, beyde wonende alhier.

GAG, RA 746 (Banns Register), fol. 96r.
Literature: Bredius 1882, p. 667.

Reynier (Haarlem 1627-1672 Amsterdam; see doc. 38), son of Frans Hals and Lysbeth Reyniersdr, was betrothed in The Hague to Elisabeth Groen of Middelburg on 16 September 1657. This was Reynier's second marriage (see docs. 144-5).

The banns do not say where the actual marriage took place, but it was probably in Middelburg, whose archives were destroyed in the Second World War. Reynier is described as a bachelor of Haarlem, whereas he was really a widower of Amsterdam. This is the only document that has so far come to light on his Hague period. Lysbeth (Middelburg 1635-1689 Amsterdam) was the daughter of Pieter Groen and Maycken Dammas (Bredius 1923/24e, p. 262: GAA, NA J. Paerslaken, dated 7 April 1672). The couple are documented in Amsterdam from November 1657. Only two of their six baptised children survived their father: Jan and Jacob. Reynier and his wife made their will on 23 April 1652 (doc. 168). Lysbeth Groen was buried in Amsterdam's West Churchyard on 10 April 1689 (GAA, DTB 1105, fol. 223), when her occupation was given as second-hand dealer. See Bredius 1923/24e, pp. 258-62: documents 1653-75.

| 156 | 1657, 2 November — A FRANS HALS PAINTING OWNED BY CORNELIS VAN DER LUCHT
...

GAL, NA.
Literature: HdG 447j.

This listing has not been verified. C. Hofstede de Groot records it in his *Verzeichnis* as '*Ein Gemälde*', but fails to give the source. It seems that Cornelis van der Lucht of Leiden sold a painting by Frans Hals for 5 guilders in order to pay off a debt.

| 157 | 1659, 3 October — LAST WILL OF PIETER GERRITSZ VAN ROESTRATEN AND ADRIAENTJE HALS
Uutgesondert in cas Frans Hals ende Lysbeth Reyniers, haer testatrices ouders, beyde tegelijck ofte een vandien ten tijde van des testatrices overlijden mochten in levende lijve zijn, alsoo zij testatrice in soodanighe gelegentheit deselfde nu voor als dan tot haere mede-erffgenaemen stelt, doch niet anders als in de bloote legitime portie naar scherpheyt van rechten gereekent ende anders niet ...

GAA, NA 2423 (notary Pieter van Toll), fols. 21v-2r.
Literature: de Vries 1885, p. 310.

Excerpt from the joint will of the painter Pieter Gerritsz van Roestraten (Haarlem 1630-1700 London) and his wife Adriaentje Hals (Haarlem 1623-before 1700 London [?]; see docs. 29, 148), residing on the corner of Beulingstraat in Amsterdam. If Adriaentje dies before her husband her parents will receive their legal portion.

| 158 | 1660 — WATERLOOS'S EPIGRAM ON FRANS HALS'S PORTRAIT OF HERMAN LANGELIUS
Wat pooght ghy ouden Hals, Langhelius te maalen?
Uw ooghen zyn te zwak voor zyn gheleerde stralle[n];
En Uwe stramme handt te ruuw, en kunsteloos,
Om 't bovenmenschelyk, en onweêrgaadeloos
Verstant van deeze man, en Leraar, uit te drukken.
Stoft Haarlem op uw kunst, en jonghe meesterstukken,
Ons Amsterdam zal nu met my ghetuighen, dat
Ghy 't weezen van dit licht, niet hallef hebt ghevat.
('Why, old Hals, do you try and paint Langelius?
Your eyes are too dim for his learned lustre,
And your stiffened hand too crude and artless
To express the superhuman, peerless
Mind of this man and teacher.
Haarlem may boast of your art and early masterpieces,
Our Amsterdam will now bear witness with me that you
Have perceived not half the essence of his light.')

(H.F. Waterloos, in: van Domselaar 1660, vol. 1, p. 408)

A poem by Herman Frederik Waterloos on Hals's portrait of c.1660 of the divine, Herman Langelius (1614-66), which is now in the Musée de Picardie (cat. 81). The poet follows the established convention by praising the model at the painter's expense, and playing Amsterdam off against Haarlem (Emmens 1956).

| 159 | 1660, 22 March — REYNIER HALS EXCHANGES PAINTINGS BY HIS FATHER OR HIS BROTHER FRANS
... twee schilderijen van Frans Hals geruylt ...

GAA, NA 2487 (notary Jacob Hellerus), fol. 2.
Literature: Bredius 1923/24, p. 27 (excerpt).

A notarial deed recording Reynier Hals's exchange of two unspecified paintings by his father or his brother with a dealer called Lambert Gerritsz for two drawings by unnamed artists. It turned out that the drawings had been stolen from one Jan Hendricksz Admiraal, but Reynier was prepared to return them to their rightful owner for 3 rijksdaalders (7½ guilders).

| 160 | 1660, 24 April — FRANS HALS AND PIETER MOLIJN VALUE PAINTINGS OWNED BY COENRAET COYMANS
... ende de schilderijen [valued] *door mrs. Frans Hals ende Pieter Molijn schilders alhier ter stede ...*
[signed] *Pieter de Molijn schilder, Frans Hals*

GAH, NA 344 (notary Maximiliaan Bardoel), fols. 166r-71v (esp. fol. 171r-v).
Literature: Bredius 1923-24, p. 27 (excerpt).

Excerpt from the death inventory of the Haarlem merchant Coenraet Coymans, drawn up by notary Bardoel at the request of the testator's son Willem and son-in-law Johan Fabry. The twenty-nine paintings in the estate were valued by Frans Hals and his colleague Pieter Molijn (London 1595-1661 Haarlem).
 Coenraet Coymans married Maria Schuyl in Amsterdam in 1614. He moved to Haarlem in the 1640s, and was buried there in the Church of St. Bavo on 29 November 1659.
 Hals's 1645 portrait of a member of the Coymans family (cat. 61) is of Coenraet's son Willem.

| 161 | 1660, 23 May — BANNS OF ABRAHAM HENDRICKSZ HULST AND FRANS HALS'S DAUGHTER SUSANNA
Abraham Hendricks Hulst, jongeman van Haerlem, wonende in de Berckerosteech, met Susanna Hals, jongedochter van Haerlem wonende in de Ridderstraet.
 [in the margin] *getrout den 6 juny anno 1660*

GAH, DTB 53 (NHG Banns Register), fol. 264.

The banns of Abraham Hendricksz Hulst of Berkenrodesteeg in Haarlem, and Susanna (Haarlem 1634-1684 Haarlem; doc. 62), the daughter of Frans Hals and Lysbeth Reyniersdr, living in Ridderstraat (her parents' home). The marginal note states that the marriage took place in Haarlem on 6 June 1660. The couple later had two daughters. See also doc. 179.

| 162 | 1660, 2 October — A FRANS HALS PAINTING IN THE INVENTORY OF PAULUS DE WITTE
Een schilderije wesende een geseltschap van cortisaenen ende juffre van Frans Hals

GAA, Bankruptcy Chamber 367, fol. 94v (unpublished note of C. Hofstede de Groot, RKD, The Hague).

A painting of a group of courtesans and young women by Frans Hals listed in the bankruptcy inventory of the Amsterdam cloth merchant Paulus de Witte. The painting has not been identified. Cf. doc. 154.

| 163 | 1661 — CORNELIS DE BIE ON FRANS HALS
Hy [Philips Wouwerman] *heeft gheleert by Franchois Hals oock noch in't leven ende tot Haerlem woonachtich is die wonder uytsteckt in't schilderen van Pourtretten oft Conterfeyten, staet seer rou en cloeck, vlijtigh ghetoetst en wel ghestelt, plaisant en gheestich om van veer aen te sien daer niet als het leven en schijnt in te ontbreken, ...*
('He [Philips Wouwerman] studied with Frans Hals, who is still alive and living in Haarlem, a marvel at painting portraits or counterfeits which appear very rough and bold, nimbly touched and well composed, pleasing and ingenious, and when seen from a distance seem to lack nothing but life itself.')

De Bie 1661, pp. 281-2.

Cornelis de Bie (Lier 1627-after 1711 Antwerp) gives a vivid description of Hals's forceful brushwork in his *Gulden cabinet*, a collection of biographical sketches of seventeenth-century artists. Cf. doc. 190.

| 164 | 1661 — FRANS HALS EXCUSED PAYMENT OF HIS GUILD DUES
F: Hals (verschoond door ouderdom)

GAH, GA 193 (contribution roll for 1661).
Literature: Miedema 1980, vol. 2, C 7 (membership rolls after 1796), pp. 1032, 1041.

Frans Hals is exempted from paying his annual dues of 6 stuivers to the Guild of St. Luke on account of his age.

| 165 | 1661, 10 October — A FRANS HALS PAINTING IN THE INVENTORY OF WILLEM VAN CAMPEN
Een tronye van Frans Hals

GAA, NA 1716 (notary Pieter de Bary), fols. 312-13.
Literature: Bredius 1915-22, p. 1120; Dudok van Heel 1969, p. 220; Strauss & van der Meulen 1979, p. 491, no. 1661.11.

A painting of a head by Frans Hals listed in the inventory of Willem van Campen (1611-61), who had died on 19 September. Campen, who was a regent of the Amsterdam Civic Orphanage, was the son of Nicolaas Willemsz van Campen, architect of the Amsterdam Playhouse, and a cousin of Jacob van Campen (Haarlem 1595-1657 Amersfoort), who built Amsterdam's new Town Hall (now the Royal Palace on Dam Square), and had his portrait painted by Frans Hals (now lost; see S.L18).

| 166 | 1661, 26 October — FRANS HALS PAINTINGS IN THE INVENTORY OF WILLEM SCHRIJVER
Drie schildereijties van de vijff sinnen door Hals gedaen
Een conterfeytsel van den ouden Capitein Soop door Hals gedaen
Een dito van den Jonge Jan Soop, door Hals gedaen
Een dito van Floris Soop
Een dito van Pieter Soop door Hals gedaen
Een cleyn dito van de Jonge Jan Soop

GAA, NA 2804-B (notary Hendrick Westfrisius), fols. 971-94.
Literature: Bredius 1915-22, p. 216; Dudok van Heel 1969a, p. 249; Slive 1970-4, vol. 3, no. 36.

Five family portraits listed in the estate of Willem Schrijver (1608-61), son of the historian Petrus Scriverius (Pieter Hendricksz Schrijver, Haarlem 1576-1660 Oudewater) and Anna van der Aar, the couple whom Frans Hals painted in 1626 (see cat. 20). Three were by Hals (no forename is given, but it was undoubtedly Frans Hals, because at least one of them dates from before 1638, the year of the sitter's death). There were

also three small pictures of the *Five Senses* by 'Hals', once again very probably Frans Hals.

The three Hals portraits are of the Amsterdam glass-blower Jan Hendricksz Schrijver (1578-1638), alias Soop (he was named after his maternal grandfather, Jan Soop, and adopted his surname), the brother of Petrus Scriverius and one-time captain of the Fencibles ('old Captain Soop'), and of his sons Jan (1602-55; known as 'the young Jan Soop') and Pieter (1609-46; 'Pieter Soop').

The two portraits in this inventory not by Hals were a small picture of Soop's son Jan, and one of his third son, Floris (1604-57).

Four of these five family portraits are also listed, without the artist's name, in the inventory of Floris Soop, which had been taken four years before (GAA, NA 1915 [notary Frans Uyttenbogaert], dated 3 May 1657). The one painting missing in that inventory is the small portrait of Jan Soop. Against that, it mentions three more family portraits which do not appear in this 1661 inventory. They were a second painting of Jan Hendricksz Soop with a dog ('*een conterfeytsel van capiteyn Soop met een hondt*'), and two more portraits of his son Floris, one hanging in the music room, the other painted 'as large as life' ('*een conterfeytsel van Floris Soop*' and '*idem noch van Floris Soop soo groot als het leven*'). I.H. van Eeghen has identified this large painting of Floris Soop as Rembrandt's *Portrait of a Standard-Bearer* of 1654 in the Metropolitan Museum, New York (van Eeghen 1971, pp. 173-80).

These family portraits were therefore left by Floris Soop, the last surviving member of the Schrijver family to call himself Soop, to his uncle Petrus Scriverius in 1657, who in turn passed them on to his son Willem Schrijver, whose marriage to Wendela de Graeff made him the brother-in-law of the prominent Amsterdam burgomaster, Andries de Graeff.

The three small paintings of the *Five Senses* were auctioned in Amsterdam at the Keizerskroon on 3 August 1663 as 'three individual musicians' (lot 21 : '*Dry byzondere speelmannetjes, van Hals*'), along with twenty-one other pictures and Petrus Scriverius's famous library, the Bibliotheca Scriveriana (Frederiks 1894, p. 63 ; HdG 136a ; Dudok van Heel 1969a, p. 252).

| 167 | 1661, 14 December — DEBT OWED TO PIETER SPIJCKERMAN AND LAMBERT HEYNDRICKSZ
Johannes van Hove, secretaris deser gerechtsrolle, als invorderende de penningen vande vercochte schilderijen van Pieter Spijckerman ende Lambert Heyndricxsz, mrs. schilders, vercocht in de Heerlicheyt van Heemstede op den 9en ende 24en augustii 1661 verleden, requirant, contra Frans Hals, woonende tot Haerlem als principael, Hendrick Aelberts Princeman in de Nieuwe Raemstraet ende Adriaen Oudendijck op Couwenhoorn, als borgen ende mede principalen, gerequireerden. Omme willige condemnatie te hebben gedecerneert op de voorwaerden waerop de voors. schilderijen sijn vercocht, ende de aenteeckening van vercochte schilderijen daer instaende voor soo veel de gerequireerdens aengaet.

[in the margin] *Schepenen dienvolgende gesien hebbende de voors. voorwaerde ende de posten daer achter staende, houden deselve voor bekent, condemneren de gerequireerden aen den requirant te betalen de somme van 18 gulden 19 stuyvers tot 22 stuyvers de*

gulden ter saecke van 6 schilderijen bij den voornoemde Frans Hals, volgens de voors. aenteeckeninge achter de voors. voorwaerde staende gekocht ende noch [van] ider der voors. guldens één stuyver tot rantsoen, alles conform de voors. voorwaerde, maeckende tesamen [ff] 21-16 mette costen mits d'een betaelende d'ander sal sijn bevrijdt.
Gellinchuysen, volgens sijn speciale procuratie in de voorwaerde (bij presentatie vermelt) geinsereert, consenteert in de versochte condemnatie.

ARAH, RA Heemstede 548 (Aldermen's Rolls), fols. 15v-6r.
Literature: Bredius 1923/24, pp. 27-8 (excerpt).

Johannes van Hove, clerk of the court at Heemstede near Haarlem, demands that Frans Hals of Haarlem and his bondsmen, the artists Hendrick Aelberts Princeman and Adriaen Oudendijck, living in Nieuwe Raamstraat and on Koudenhorn in Haarlem, be ordered to comply with the conditions under which Frans Hals, acting for all three, had bought six (unspecified) paintings at the sales held by the artists Pieter Spijckerman and Lambert Heyndricksz in the manor of Heemstede on 9 and 24 August 1661. The marginal annotation states that the aldermen had studied the conditions of sale and the posted prices of the paintings in question, and that they now order the three defendants to pay 18 guilders and 19 stuivers (at 22 stuivers to the guilder), plus a stuiver per guilder tax, making a total of 21 guilders and 16 stuivers. Hals's lawyer accepted the judgement.

| 168 | 1662, 23 April — LAST WILL OF FRANS HALS'S SON REYNIER
Ten waere hij testateur in cas voors. [Reynier Hals] d' eerst afflijvigh waere ende op sijn overlijden Frans Hals ende Lysbeth Reyniers tot Haerlem, oft een van haer beyden noch leeffden, in welcke geval hij testateur begeert bij sijn ouders oft bij de langstlevende den selven alleenlijck sal werden genoten de legitime portie deselve nae scherpicheyt van rechten uyt sijn testateur naerlatenschap competerende. Waeromme hij testateur sijn ouders daerinne tot mede-erffgenaemen institueerde mits desen ...

GAA, NA 2461 (notary Reinier Duée), fol. 200r.
Literature: Bredius 1923/24e, pp. 258-9 (excerpt).

Excerpt from the will of Frans Hals's son Reynier (Haarlem 1627-1672 Amsterdam) and his second wife, Lysbeth Groen, whom he married in 1657 (doc. 155). They are living on Singel, near the Heiligeweg Sluice, and Reynier is ill in bed. They name each other as sole heir. If Reynier is survived by one or both of his parents, the due legal portion is to be paid.

The will was witnessed by the artists Egbert van Heemskerck (Haarlem c.1634-1704 London) and Roelof de Vries (Haarlem c.1631-after 1681 Amsterdam).

| 169 | 1662, 16 August — FRANS HALS VALUES PAINTINGS
Compareerde voor mij Lourens Baert, openbare notaris [...] den edele Emanuel Demetrius, coopman, altans woonende binnen deser stadt, mij notario bekent, dewelcke van den edele Abraham Engelsz, coopman binnen deser stadt, bekende ontfangen te hebben aen contante penningen de somme van hondert seven en vijftich guldens en tien penningen ende

daerenboven noch aen schilderijen bij hem comparant van de voornoemde Abram Engelsz tot taxatie van Gijsbert van Leeuwen, als goede man van de meergenoemde Abram Engelsz, ende Frans Hals, als goede man van hem comparant (bij henlieden respectieve daertoe vercoren) aengenomen, bedragende ter somme van drie en 'tsestich guldens en drie stuyvers, maeckende met malcanderen tesamen uyt een somme van twee hondert en twintich gulden dartien stuyvers, welcke voors. schilderijen bestaende in vijf stucx hij comparant oock mede bekent op heden dato deser van de meergenoemde Abram Engelsz ontfangen te hebben ...*

GAH, NA 366 (notary Lourens Baert), fols. 104r-5r.
Literature : Bredius 1923/24, p. 28 (excerpt; the date imprecisely given as August 1662).

The Haarlem merchant, Emanuel Demetrius, states that he has received five paintings and 157 guilders and 10 penningen in coin from his colleague and fellow townsman, Abraham Engelsz. The pictures had been appraised at 63 guilders and 3 stuivers by two experts : Frans Hals acting for Demetrius, and the art dealer Gijsbert van Leeuwen for Engelsz (Miedema 1980, p. 614).

| 170 | 1662, 9 September — FRANS HALS RECEIVES FINANCIAL ASSISTANCE FROM THE CITY OF HAARLEM
Frans Hals, mr. schilder, burger ende outburgers soon deser stadt es op sijn schriftelijck vertooch, bij requeste gedaen, ten insichte van de redenen ende middelen daer bij verhaelt, tot een subsidie toegestaen ende geaccordeert eerst een somme van 50 carolus guldens datelijck te ontfangen bij ordonnantie op de heeren thesauriers deser stadt, ende dan noch bij provisie voor den tijt van één jaer een somme van hondert en vijftich carolus guldens, alle vierendeelen jaers een gerecht vierde paert, inne te gaen metten eersten octobre deses jaers 1662, toecomende te ontfangen van de heeren thesauriers deser stadt voornoemt, die 'tselve in uytgeve haerdre reeckeninge, geleden ende gepasseert sal werden nae behooren, mits desen alleenelijcken beneffens quitantie overbrengende.

GAH, Burgomasters' Resolutions 1662 (10/20), fol. 184r.
Literature : van der Willigen 1866, p. 122 ; van der Willigen 1870, p. 147 ; Bredius 1923/24, p. 28 (full transcription).

See commentary to doc. 185.

| 171 | 1662, after 9 September — FRANS HALS RECEIVES FINANCIAL ASSISTANCE FROM THE CITY OF HAARLEM
Frans Hals tot een subsidie in zijn hoochdringende noot toegeleyt vermogens d'ordonnantie ende quitantie betaelt d'somme van L pond.

GAH, Treasurer's Accounts 1662 (19/242), fol. 68r, undated.

See commentary to doc. 185.

| 172 | 1663, 28 July — A FRANS HALS PAINTING OWNED BY JOHAN DE BAEN
Den 28 Julij 1663 heeft Johan de Baen een tronike van Frans Hals gesonden en dat geset op [value left blank]

[in the margin] *Int Jaer 1669 aen d'Heer Bernouts verhandelt bij d'Hr Johan de Baen als eigenaer en hier geroyeert.*

Literature : Bredius 1881-2, pp. 134-5 ; HdG 446a.

At the beginning of 1657 the Hague burgomasters had placed a room at the disposal of the Confrérie, the fraternity founded by a group of Hague artists who had broken away from the Guild of St. Luke in 1656. The fraternity members either lent or donated paintings to decorate their meeting-room. The portraitist Jan de Baen (Haarlem 1633-1703 The Hague) had contributed a small imaginary head by Frans Hals, but in 1669 he sold it to a man called Bernouts, and it was now removed from the chamber.

| 173 | 1663, August — FRANS HALS MENTIONED IN THE JOURNAL OF BALTHASAR DE MONCONYS
Il y a [in Haarlem] *une maison nommé le Doul ..., et il y a force grands portraits de ces Messieurs* [officers] *assemblez, et un entre autres d'Als, qui est avec raison admiré des plus grands peintres.*

(De Monconys 1665-6, p. 159)

In August 1663, while travelling through Holland, the Frenchman Balthasar de Monconys called at Haarlem, where he visited one of the militia halls.

| 174 | 1663 (31 December) — FRANS HALS RECEIVES FINANCIAL ASSISTANCE FROM THE CITY OF HAARLEM
Frans Hals mr. schilder, betaelt de somme van 162 guldens 10 stuyvers, te weten drye vierendeel jaers tegens 150 guldens 'sjaers ende 'tlaetste vierendeel jaers tegen 200 gulden 'sjaers volgens d'acte van de edele heeren burgermeesteren in dato den 1en februarii 1664. Verschenen den laetsten december 1663 by vier quitantien ... 162 guldens 10 stuyvers.

GAH, Treasurer's Accounts 1663 (19/243), fol. 51v, undated.
Literature : Bredius 1923/24, p. 28 (full transcription).

See commentary to doc. 185.

| 175 | 1664, 17 January — FRANS HALS RECEIVES FUEL AND A RENT SUBSIDY FROM THE CITY OF HAARLEM
Op het request, gepresenteert bij Frans Hals schilder nopende het genieten van eenige brant als huyshuyr, is verstaen, dat hem bij provisie toegevoeght sal werden drie wagens turff ende dat de luyden, die huyshuyr van hem mosten hebben, dat deselve souden boven comen.

[in the margin] *Schilder Frans Hals*

GAH, Burgomasters' Resolutions 1664 (10/21), fol. 7r.
Literature : van der Willigen 1866, p. 122 ; van der Willigen 1870, p. 147 ; Bredius 1923/24, p. 28 (full transcription).

See commentary to doc. 185.

| 176 | 1664, 1 February — FRANS HALS RECEIVES FINANCIAL ASSISTANCE FROM THE CITY OF HAARLEM
De twee hondert carolus guldens Frans Hals jaerlijcx toegeleyt

voor desen, is verstaen, dat hem daer een acte van sal werden gegeven, omme hetzelve alle vierendeel jaers uyt handen van de thesauriers telckens met 50 guldens te mogen ontfangen, soo lange hij leeft, innegegaen sijnde den eersten october 1663 laestleden.

[in the margin] *Frans Hals*

GAH, Burgomasters' Resolutions 1664 (10/21), fol. 19v.
Literature: van der Willigen 1866, p. 122; van der Willigen 1870, p. 147; Bredius 1923/24, p. 29 (full transcription).

See commentary to doc. 185.

| 177 | 1664, 21 August — FRANS HALS RECEIVES FUEL FROM THE CITY OF HAARLEM
Op het versoeck ende te kennen geven van de huysvrouw van Frans Hals omme voor dit jaer wederomme te hebben ende genieten drie wagens turff, is hetselve omme redenen toegestaen.

[in the margin] *Huysvrouwe van Frans Hals drie wagens turff*

GAH, Burgomasters' Resolutions 1664 (10/21), fol. 97v.
Literature: Bredius 1923/24, p. 29 (full transcription).

See commentary to doc. 185.

| 178 | 1664 (31 December) — FRANS HALS RECEIVES FINANCIAL ASSISTANCE FROM THE CITY OF HAARLEM
Frans Hals mr. schilder toegevoucht zijnde volgens d'acte van den heeren burgermeesters in dato den eersten february 1664 een somme van IIc pond jaerlichs, verschenen den lesten december 1664 bij vyer quitantien ... IIc pond.

GAH, Treasurer's Accounts 1664 (19/244), fol. 51r, undated.
Literature: Bredius 1923/24, p. 29 (full transcription).

See commentary to doc. 185.

| 179 | 1665, 22 January — FRANS HALS ACTS AS GUARANTOR FOR HIS SON-IN-LAW ABRAHAM HENDRICKSZ HULST
Op huyden den 22 january 1665 compareerde voor mij onderschreven openbaer notaris ende getuygen naergenoemt mr. Frans Hals meester schilder binnen deser stadt, mij notaris wel bekent, ende verclaerde, alsoo Abraham Hendrixe Hulst, sijn comparants schoonzoon, aen Pieter Jansz van der Steen, buttercooper, schuldich ende ten achteren is de som[m]e van vier hondert acht en vijftich gulden elff stuyvers over geleverde butter ende zeep en voorts geleverde waren, die gemelte Abraham Hendrixe van de voors. Pieter van der Steen heeft genoten ende ontfangen, ende waervoor Adriaen Volckertsz sijn selven borge als principaele heeft geconstitueert, ende dewijle d'voors. Abraham Henderixe is gecondemneert geworden d'selve penningen te moeten betalen, ende daertoe gene gelegentheyt hebbende 'tselve als nu te comen doen, en dienvolgende de voors. so[m]me van penninge voor hem sal furneren ende betaelen, onder belofte dat gemelte Abraham Hendrixe die t'allen tijde tot contentemente van de voors. Adriaen Volckertsz, wederom sal restitueren gelijck hij ten desen comparerende als vooren als noch aenneemt ende belo[o]ft bij desen, dat hij comparant tot meerder verseeckertheyt van de voors. Adriaen Volckertsz sijn selven gestelt ende

geconstitueert heeft, sulcx hij doet bij desen tot borge ende als principaele schuldenaer, onder renunciatie van de benefitie ordinaris et excusionis, de effecte vandien hem wel bekent sijnde, omme alle gebreecke van betalinge, die t'eeniger tijt aen de voors. penningen souden mogen comen te vallen, t'allen tijde als sijn eygen schult voor de voors. Abraham Hendrixe, sijn schoonsoon, te sullen oprechten ende voldoen. Alles ter goeder trouwen ende onder verbant van sijn comparants persoon ende goederen, gen[e] uytgesondert, stellende deselve bedwangh van alle rechten en de rechteren ende specialyck de Hove van Hollant. Aldus gedaen ende gepasseert binnen der stadt Haerlem, in presentie van Johannes Casteleyn ende Pieter Rijcke als getuygen hiertoe versocht die desen mede neffens d'comparante ende mij notaris hebben getekent.
[signed] *Frans Hals, Abram Hindericks Hulst, Johannes Castelijn, W. Kittensteyn notarius publicus*

GAH, NA 296 (notary Willem van Kittensteyn), fol. 38r-v.
Literature: Bredius 1923/24, p. 29 (fairly full transcription).

Frans Hals stands surety for his son-in-law, Abraham Hendricksz Hulst, husband of Susanna Hals (doc. 161), who had been ordered to pay off a debt of 458 guilders and 11 stuivers to the dairy trader Pieter Jansz van der Steen for purchases of butter, soap and provisions. Adriaen Volckertsz, who had originally stood bond for the sum, agrees to settle the debt because of Hulst's inability to pay. Hulst, though, must promise to repay him in due course. Frans Hals underwrites this promise by acting as the new guarantor for his son-in-law.

Although Hals had himself been living on an annual pension from the Haarlem authorities of 150 guilders since 1662 (raised to 200 guilders in October 1663; see commentary to doc. 185), he was evidently in a position to guarantee payment of this large sum of nearly 460 guilders, possibly because he had been paid for the two regent pieces which he had painted for the Haarlem Old Men's Almshouse in 1664 (cat. 85, 86).

| 180 | 1665, 4 June — FRANS HALS PAINTINGS IN THE INVENTORY OF ANTONIE VAN HALEWIJN
Op het geremonstreerde bij monde van Cornelis van Halewijn, geadsisteert met de advocaet Le Saige ende Cornelis van Campen als curateur over de boedel van Antony van Halewijn, is naer genomen kennisse van saecken, verstaen ende geresolveert, dat de conterfeytsels van de voornoemde Anthony van Halewijn ende sijn huysvrouw, beyde gemaeckt door meester Hals, mitsgaders noch eenige schilderijen van deselves voorouders, alle berustende onder de gemelten Cornelis van Campen, bij de voornoemde Halewijn sullen mogen aengenomen werden bij taxatie, tot welcken eynde de edele Sijbrant Camey ende Willem Romeyn versocht en gecommitteert werden de voors. schilderijen in alle redelickheyt te taxeren en haer dienthalven te verclaren, omme deselve schilderijen tegens de getaxeerde somme bij de voornoemde van Campen gewisselt en in sijne reeckeninge verantwoort te werden.

[in the margin] *schilderijen bij taxatie an te nemen*

GAH, RA 26/1 (Aldermen's Daybook), fol. 100r.
Literature: Bredius 1923/24, pp. 29-30 (full transcription).

At the request of Cornelis van Halewijn, his lawyer le Saige, and Cornelis van Campen, trustee in bankruptcy of Antonie van Halewijn, the petitioner is granted permission to have an appraisal made of Hals's portraits of Antonie van Halewijn and his wife, and of various paintings which had belonged to Antonie's ancestors. The valuation is to be done by the art dealer Sijbrant Camey (Miedema 1980, p.691) and the painter Willem Romeyn (Haarlem c.1624-1694 Haarlem). The object was to allow van Halewijn to buy the paintings from the trustee for their appraisal value.

Cornelis van Halewijn rescued the painting collection from the bankrupt estate of his brother Antonie (buried 14 June 1684), brewer in the 'Twee ruyten met het cruys' on Bakenessergracht, who had married Catharina Visschers some time before 1 December 1659 (baptism of a daughter in the Catholic parish of St. Joseph).

According to this document the portraits of Antonie van Halewijn and his wife were painted by 'Master Hals', so it is not absolutely certain that they were by Frans Hals. They may have been by his son Jan.

| 181 | 1665 (1 December) — FRANS HALS RECEIVES FINANCIAL ASSISTANCE FROM THE CITY OF HAARLEM
Frans Hals mr. schilder toegevoucht zijnde volgens d'acte van den heeren Burgermeesters in dato den eersten february 1664 jaerlichs een somme van IIc pond verschenen den eersten december 1665 bij vier quitantien ... IIc pond.

GAH, Treasurer's Accounts 1665 (19/245), fol.53v, undated.

See commentary to doc.185.

| 182 | 1666, 30 March — FRANS HALS'S SECOND WIFE, LYSBETH REYNIERSDR, WITNESSES THE BAPTISM OF HER GRANDDAUGHTER HESTER
Hester
Vader Frans Hals de jonge van Haerlem
Moeder Hester Jans
Getuyge Lysbeth Reyniers

GAH, DTB 19 (NHG Baptismal Register), fol.36.

The baptism of Hester Hals, youngest daughter of Frans Hals the Younger and Hester Jansdr (see doc.98). The witness was Hals's second wife, Lysbeth Reyniersdr.

| 183 | 1666, 1 September — BURIAL OF FRANS HALS
Dito [den eersten septembris] een openinck in de Groote Kerck voor mr. Frans Hals opt Coor no 56 ... F 4 [sub: Reeckeninck van de graefmaeckers]
Frans Hals ... F 1-10 [sub: Reeckeninck van de baerdragers]

GAH, DTB 76 (NHG Burials Register), fols.102, 104.
Literature: van der Willigen 1866, p.123; van der Willigen 1870, pp.148-9; Dólleman 1973, pp.255-6; Delleman 1985, pp.165-6.

Gravediggers' fee for opening grave number 56 in the choir of the Great Church of St. Bavo in Haarlem for Master Frans Hals, and the pallbearers' fee of 1 guilder and 10 stuivers.

Frans Hals, who probably died about three days before his funeral, at the age of 84, was buried on 1 September in the grave of alderman Nicolaas Joppen Gijblant (d. before 1600), the grandfather of his first wife, Anneke Harmensdr (see doc.3). Hals's name was not added to the tombstone until 1918, when the Haarlem Historical Society had his name and date of burial carved into the original slab. In 1962, at the time of the Frans Hals exhibition held to mark the centenary of the Frans Halsmuseum in Haarlem, a new tombstone for Hals alone was placed on the grave. His name was then removed from Gijblant's slab, which was moved three places to the right.

In 1973, in his attempt to establish the ownership of the grave, Dólleman rightly assumed that Pietertje Gijblant (d. 1599), the mother of Hals's first wife, Anneke Harmensdr (see doc.3), had inherited the grave of her parents, Nicolaas Joppen Gijblant and Marietje Heerendr. However, he was wrong in believing that the grave then passed to Pietertje's eldest daughter Anneke. In fact it went to Anneke's sister, Lysbeth Harmensdr, who was buried there on 21 November 1678 (GAH, DTB 81 [Burials Register], fol.143). Lysbeth died at the age of 85 in the Frans Loenen Almshouse, to which the grave was transferred on 31 March 1691 (GAH, OA Churchwardens, no.55/1, unpaginated). In 1699 the almshouse sold it to Salomon van Echten, a former burgomaster of Haarlem.

| 184 | 1666, after 14 September — TWO FRANS HALS PAINTINGS IN THE INVENTORY OF JAN MAIRE
...

GAL, NA.
Literature: HdG 80c, 145f.

These listings have not been verified. C. Hofstede de Groot records them in his *Verzeichnis* as 'Ein Raucher' and 'Eine Gesellschaft', but fails to give the source in the Leiden notarial archives. The inventory must have been drawn up shortly after Maire's death. The paintings have not been identified.

The bookseller Jan Maire, who published Descartes' *Discours de la méthode* in 1637, died at Leiden on 14 September 1666. For Hals's portrait of Descartes see cat.66.

| 185 | 1666 (1 October) — FINAL PAYMENT OF FRANS HALS'S FINANCIAL ASSISTANCE FROM THE CITY OF HAARLEM
Frans Hals mr. schilder toegevoecht sijnde volgens d'acte van de heeren burgermeesteren in dato den eersten february anno 1664 een somme van 200 pond s'jaers, over negen maenden subsidie verschenen tijde deser reeckeninge bij die quitantien betaelt ... CL pond.

GAH, Treasurer's Accounts 1666 (19/246), fol.57v, undated.
Literature: Bredius 1923/24, p.30 (excerpt).

From 9 September 1662 to 1 October 1666 the Haarlem authorities paid Frans Hals a pension totalling 762 Carolus guilders and 10 stuivers (docs.170-1, 174, 176, 178, 181). On two occasions in 1664 he also received three cartloads of peat, and his rent was paid for him (docs.175, 177).

He was granted the annuity as a citizen and the son of a former citizen of the town in response to his own written request (doc.170), together with his reasons for applying for

financial assistance (not listed in the document). In 1662 he received a lump sum of 50 guilders (doc. 171) and a subsidy of 150 guilders for one year (doc. 170), to be paid in quarterly instalments from 1 October against signature of a receipt. From 1 October 1663 the subsidy was replaced by a life pension, and the sum was increased to 200 guilders. In 1663 he received a total of 112 guilders and 10 stuivers for the period 1 October 1662 to 1 July 1663 (three-quarters of 150 guilders plus 50 guilders, being one-quarter of 200 guilders; doc. 174). In both 1664 and 1665 he received 200 guilders (docs. 178, 181), and in 1666 he was paid the three quarterly instalments until his death, amounting to 150 guilders.

| 186 | 1667, 8 February — BURIAL OF FRANS HALS'S IMBE-CILE SON PIETER
Dito [8 February] *Pieter Hals bestelt vant Gasthuis, suyderhoff* -o-

GAH, DTB 76 (Burials Register, gravediggers' fees), fol. 193.

Registration of the free burial of Pieter Hals, the imbecile son of Frans Hals (see docs. 80, 81, 94), in the Southern Churchyard in Haarlem.

St. Elizabeth's Hospital paid its final contribution of 52 guilders and 10 stuivers towards Pieter's maintenance on 14 January 1667 (GAH, archive of St. Elizabeth's Hospital 20/3, fol. 9).

| 187 | 1667, 22 November — BURIAL OF A CHILD OF FRANS HALS
22 dito [November] *de soon van Frans Hals, gasthuis* -1-
[sub: *Reeckeninck van de graefmaekers*]
22 dito [November] *de dochter van Frans Hals* -10-
[sub: *Reeckeninck van de baerdragers*]

GAH. DTB 76 (Burials Register, gravediggers' fees), fols. 300-1.

Gravediggers' fee for preparing a grave in the Hospital Graveyard for a son of Frans Hals, and a pallbearers' fee of 10 stuivers for a daughter of Frans Hals. It is not clear whether the deceased was male or female, for one of the entries speaks of a son, and the other of a daughter. Moreover, it is not even certain that it was a child of Frans Hals himself, who was already dead. The father may have been Frans Hals the Younger.

| 188 | 1672, 15 April — FRANS HALS'S WIDOW, LYSBETH REYNIERSDR, WITNESSES HER SON CLAES'S ADMISSION TO THE REFORMED CHURCH
Claes Hals van Haerlem woonende in de Turfsteeg, getuyge Lysbet Hals de moeder

GAH, inv. 24/7 (OA Church Council NHG), fol. 12v.

Frans Hals's widow Lysbeth Reyniersdr acts as a witness for her son Claes (see doc. 43), living in Turfsteeg, on his acceptance as a member of the Reformed Church in Haarlem. In 1655 she had also witnessed her husband's admission to the church (doc. 151).

| 189 | 1675, 26 June — FRANS HALS'S WIDOW, LYSBETH REYNIERSDR, RECEIVES FINANCIAL ASSISTANCE FROM THE CITY OF HAARLEM
Op de iterative instantien van d'weduwe van Frans Hals, als dat sij nu tot hoge jaren gecomen ende tot armoede vervallen sijnde, wat subsidie versochte, is haer in plaetse van het requeste tot dier eynde gepresenteert in de vroetschap voor te dragen, toegestaen, bij provisie alle weecken uyt het rapsodium oft uyt de condemnatien ten behoeve van de armen, te ontfangen veertien [deleted: *twaelf*] *stuyvers.*

[in the margin] *De weduwe van zaliger Frans Hals veertien stuyvers ter we[e]ck toegeleyt*

GAH, Burgomasters' Resolutions 1675 (10/22), fol. 239r.
Literature: van der Willigen 1866, p. 122; van der Willigen 1870, p. 148; Bredius 1923/24, p. 30 (full transcription).

Lysbeth Reyniersdr, the 82-year-old widow of Frans Hals, had repeatedly asked the city authorities for financial assistance, pleading her great age and need. The burgomasters of Haarlem now agree that she should receive 14 stuivers weekly from the poor relief fund.

The dates of Lysbeth Reyniersdr's death and burial are not known.

| 190 | 1679, 28 June — MATTHIAS SCHEITZ ON FRANS HALS
Den treffelicken Conterfeiter Frans Hals van Harlem heeft geleert bij Carel Vermander van Molebeke, hei is in sein Jeugt wat lustich van leven geweest, doen hey out wass ende mit sein schilderen (hetwelck nu nit meer wass als weleer) nit meer de kost verdinen kon, heefft hey eenige Jaren, tot dat hei starff, van de Ed. Ovricheit van Haerlem, seker gelt tot sein onderhouding gehat, om de deigt seinder Konst. Hei iss omtrent A°. 65, off 1666 gesturven, ende na mijn gissen wel 90 Jaren, off niet veel minder out geworden.
('The most excellent portrait painter, Frans Hals of Haarlem, was a pupil of Karel van Mander of Meulebeeke. He was somewhat lusty in his youth, and when he was old and no longer able to earn a livelihood from his painting (which was not as fine as formerly) the noble government of Haarlem paid him money for his upkeep for some years until his death, because of the merits of his art. He died around 1665 or 1666, a good 90 years old I would hazard, or not much less.')

Literature: Vosmaer 1871, p. 62; Bode 1871, p. 64.

The German artist Matthias Scheitz (Hamburg c. 1630 - c. 1700 Hamburg), had been a pupil of Philips Wouwerman's (Haarlem 1619 - 1668 Haarlem) in the 1640s. On 28 June 1679, under the heading 'Memorial', he annotated the fly-leaf of his copy of Karel van Mander's *Schilder-boeck* with brief biographies of Rubens, Jordaens, Rembrandt, Frans Hals and Philip Wouwerman, all of whom he had known personally. Cf. doc. 163.

Bibliography cited in Abbreviated Form

van der Aa
A.J. van der Aa *et al.*, *Biographisch Woordenboek der Nederlanden ...*, 21 vols., Haarlem 1852-78

Adams 1985
Ann Jensen Adams, *The Paintings of Thomas de Keyser (1596/7-1667): A Study of Portraiture in Seventeenth-Century Amsterdam*, diss., Harvard University, 1985, 4 vols., University Microfilms International, Ann Arbor (Mich.) 1986

Ainsworth et al. 1982
M.W. Ainsworth *et al.*, *Art and Autoradiography*, New York, Metropolitan Museum of Art, 1982

van Aitzema 1669
L. van Aitzema, *Saken van Staet en Oorlogh*, vol. 1, Amsterdam 1669

Allan 1874-88
F. Allan, *Geschiedenis en beschrijving van Haarlem, van de vroegste tijden tot op onze dagen*, 4 vols., Haarlem 1874-88

Alpers 1988
Svetlana Alpers, *Rembrandt's Enterprise*, London 1988

Ampzing 1621
[Samuel Ampzing], *Het lof der stadt Haerlem in Hollandt*, Haarlem 1621

Ampzing 1628
Samuel Ampzing, *Beschryvinge ende lof der stad Haerlem in Holland*, Haarlem 1628

Anon. 1847
Anon., 'Histoire de la peinture flamande et hollandaise', *L'Artiste*, 4ᵉ série, IX (1847), pp. 11-2

Anon. 1883
Anon., 'Le Modernisme de Frans Hals', *L'Art Moderne* III, 38 (23 September 1883), pp. 301-3

Armstrong n.d.
N. Armstrong, *The Book of Fans*, New York n.d.

Ayres 1986-7
Linda Ayres, 'Sargent in Venice', in exhib. cat. *John Singer Sargent*, New York, Whitney Museum of American Art, 1986-7, pp. 49-73

Baard 1967
Hendricus Petrus Baard, *Frans Halsmuseum*, Munich, Ahrbeck & Hannover 1967

Baard 1981
H.P. Baard, *Frans Hals*, trans. by George Stuyck, New York 1981

Baart 1986
J.M. Baart, 'Een 16de-eeuws leren wambuis naar landsknechten-mode', in exhib. cat. *De smaak van de elite*, Amsterdam, Amsterdams Historisch Museum, 1986, pp. 68-77

Bächtold 1914
H. Bächtold, *Die Gebräuche bei Verlobung und Hochzeit*, Basel, Schweizerischen Gesellschaft für Volkskunde, 1914

Baetjer 1980
Katharine Baetjer, *European Paintings in The Metropolitan Museum of Art ... A Summary Catalogue*, 3 vols., New York 1980

Bartsch
Adam Bartsch, *Le Peintre Graveur*, 21 vols., Leipzig 1854-70

Bauch 1926
Kurt Bauch, *Jakob Adriaensz. Backer: Ein Rembrandtschüler aus Friesland*, Berlin 1926

Bauch & Ekstein 1981
J. Bauch & D. Ekstein, 'Woodbiological Investigations on panels of Rembrandt Paintings', *Wood Science and Technology* XV (1981), pp. 251-63

Baxandall 1985
Michael Baxandall, *Patterns of Intention*, London 1985

Bedaux 1987
Jan Baptist Bedaux, 'Fruit and Fertility: Fruit Symbolism in Netherlandish Portraiture of the Sixteenth and Seventeenth Centuries', *Simiolus* XVII (1987), pp. 150-68

van Beresteyn 1941
E.A. van Beresteyn, *Genealogie van het geslacht van Beresteyn*, vol. 2, The Hague 1941

van Beresteyn & del Campo Hartman 1954
E.A. van Beresteyn & W.F. del Campo Hartman, *Genealogie van het geslacht van Beresteyn*, vol. 1, The Hague 1954

Berger 1972
John Berger, *Ways of Seeing*, London 1972

Berger 1972a
John Berger, 'On Frans Hals', *The Listener*, 13 January 1972

de Bie 1661
Cornelis de Bie, *Het Gulden Cabinet van de Edel Vry Schilder-const*, Antwerp 1661

de Bie & Loosjes
J.P. de Bie & J. Loosjes, *Biographisch woordenboek van Protestantsche godgeleerden in Nederland*, 6 vols., The Hague 1919-49

Biesboer 1983
P. Biesboer, *Schilderijen voor het Stadhuis Haarlem, 16e en 17e eeuw. Kunstopdrachten ter verfraaing*, Haarlem 1983

Biesboer 1986
P. Biesboer, 'Een Haarlems interieur in Philadelphia', *Haerlem Jaarboek* 1986, pp. 97-104

de Bièvre 1988
E. de Bièvre, 'Violence and Virtue: History and Art in the City of Haarlem', *Art History: Journal of the Association of Art Historians* II, 3 (September 1988), pp. 303-34

Bijleveld 1927
W.J.J.C. Bijleveld, 'De boedel van Jean François Tartarolis te Leiden', *O.H.* XXXXIV (1927), pp. 183-8

Blanc 1862
Charles Blanc, *Histoire des Peintres de toutes les écoles, Ecole Hollandaise*, 2 vols., Paris 1862

Blankert 1975
A. Blankert, *Kunst als regeringszaak in Amsterdam in de 17e eeuw: rondom schilderijen van Ferdinand Bol*, Amsterdam 1975

Blankert & Ruurs 1975-9
A. Blankert & R. Ruurs, *Schilderijen daterend van vóór 1800, voorlopige catalogus*, Amsterdam, Amsterdams Historisch Museum, 1975-9

van Bleyswijck 1667
D. van Bleyswijck, *De Beschryvinge der Stadt Delft*, Delft 1667

B.M.
The Burlington Magazine

Boas 1950
George Boas, *Wingless Pegasus*, Baltimore 1950

Bodart 1970
Didier Bodart, *Louis Finson (Bruges, avant 1580-Amsterdam 1617), Académie royale de Belgique, Classe des Beaux-Arts, Mémoires, 2ᵉ série*, XII (1970), 4

Bode 1871
W. Bode, 'Frans Hals und seine Schule', *Jahrbuch für Kunstwissenschaft* IV (Leipzig 1871) pp. 1-66

Bode 1883
W. Bode, *Studien zur Geschichte der holländischen Malerei*, Brunswick 1883

Bode 1887
W. Bode, 'Die Ausstellungen alter Gemälde aus Privatbesitz in Düsseldorf und Brussel in Herbst 1886', *Repertorium für Kunstwissenschaft* X (1887), pp. 30-50

Bode 1967
Wilhelm Bode, *Great Masters of Dutch and Flemish Painting*, trans. M.L. Clarke, New York 1967 (from *Rembrandt und seine Zeitgenossen*, 1st German edn. 1906)

Bode & Binder
Wilhelm von Bode & M.J. Binder, *Frans Hals, sein Leben und seine Werke*, 2 vols., Berlin 1914

Bode & Binder 1914
Wilhelm von Bode & M.J. Binder, *Frans Hals. His Life and Work*, 2 vols., trans. by M.W. Brockwell, Berlin 1914

de Bodt 1981
S. de Bodt, 'Dan isser de Borduerwercker', *N.K.J.* XXXI (1981), pp. 65-71

de Bodt 1987
S. de Bodt, exhib. cat. '... op de Raempte off mette Brodse ...'. *Nederlands Borduurwerk uit de zeventiende eeuw*, Amsterdam, Amsterdams Historisch Museum, 1987

Boime 1971
Albert Boime, *The Academy and French Painting in the Nineteenth Century*, London 1971

Bol 1969
L.J. Bol, *Holländische Maler des 17. Jahrhunderts nahe den grossen Meistern, Landschaften und Stilleben*, Brunswick 1969

Boot 1973
Marjan Boot, 'Über Willem van Heythuysen, seinen Nachlaß und die symbolische Bedeutung des Porträts von Frans Hals in München', *Pantheon* XXXI (1973), 4, pp. 420-4

Booth 1970
Billy Ray Booth, *A Survey of Portraits and Figure Paintings by Frank Duveneck, 1848-1919*, University of Georgia, Ph.D. diss., 1970, University Microfilms, Ann Arbor (Mich.)

Boxer 1979
C.R. Boxer, *Jan Compagnie in War and Peace: 1602-1799*, Hong Kong, Singapore & Kuala Lumpur 1979

Brandt 1947
P. Brandt Jr., 'Notities over het leven en werk van den Amsterdamschen Schilder Pieter Codde', *Historia* XII (1947), pp. 27ff

Bredius 1881-2
A. Bredius, 'De boeken der Haagsche "Schilders-Confrerye"', in vol. 4 of Fr. D.O. Obreen (ed.), *Archief voor Nederlandsche kunstgeschiedenis*, The Hague 1881-2, pp. 45-121

Bredius 1888
A. Bredius, 'Iets over Pieter Codde en Willem Duyster', *O.H.* VI (1888), pp. 187-94

Bredius 1888a
A. Bredius, 'Een schilderij van Jan Hals door Vondel bezongen', *O.H.* VI (1888), p. 304

Bredius 1909
G.B. Bredius, *Johannes Torrentius*, The Hague 1909

Bredius 1909a
A. Bredius, 'Herman Hals te Vianen', *O.H.* XXVII (1909), p. 196

Bredius 1914
A. Bredius, 'De ouders van Frans Hals', *O.H.* XXXII (1914), p. 216

Bredius 1915-22
A. Bredius, *Künstler-Inventare: Urkunden zur Geschichte der Holländischen Kunst des XVIten, XVIIten und XVIIIten Jahrhunderts*, 7 vols., The Hague 1915-22

Bredius 1917
A. Bredius, 'Een conflict tusschen Frans Hals en Judith Leyster', *O.H.* XXXV (1917), pp. 71-3

Bredius 1921
A. Bredius, 'Heeft Frans Hals zijn vrouw geslagen?', *O.H.* XXXIX (1921), p. 64

Bredius 1923/24
A. Bredius, 'Archiefsprokkels betreffende Frans Hals', *O.H.*, XLI (1923-4), pp. 19-31

Bredius 1923/24a
A. Bredius, 'Archiefsprokkels betreffende Dirck Hals', *O.H.* XLI (1923-4), pp. 60-1

Bredius 1923/24b
A. Bredius, 'Archiefsprokkels betreffende Herman Hals', *O.H.* XLI (1923-4), p. 62

Bredius 1923/24c
A. Bredius, 'Eenige gegevens over Frans Hals den Jonge', *O.H.* XLI (1923-4), p. 215

Bredius 1923/24d
A. Bredius, 'Aanteekeningen bij Harmen Hals', *O.H.* XLI (1923-4), p. 249

Bredius 1923/24e
A. Bredius, 'Oorkonden over Reynier Hals', *O.H.* XLI (1923-4), pp. 258-62

Bredius 1923/24f
A. Bredius, 'Oorkonden over Jan Hals', *O.H.* XLI (1923-4), pp. 263-4

Bredius 1925
A. Bredius, 'Archiefsprokkels v: hoe een landschapschilder omstreeks 1650 het werk zijner kunstbroeders waardeerde', *O.H.* XLII (1925), pp. 275-6

Bredius 1927
A. Bredius, 'Hoe een varendgezel schilder werd: Hans Juriaensz van Baden', *O.H.* XLIV (1927), pp. 17-22

Bredius & Gerson
Abraham Bredius, *Rembrandt: The Complete Edition of the Paintings*, 3rd edn., revised by H. Gerson, London & New York 1969

Brenninkmeijer-de Rooij 1982
B. Brenninkmeijer-de Rooij, 'Notities betreffende de decoratie van de Oranjezaal in Huis ten Bosch, uitgaande van H. Peter-Raupp, Die Ikonographie des Oranjezaal, Hildesheim/New York, 1980', *O.H.* XCVI (1982), pp. 133-91

Briels 1978
J.C. Briels, *De Zuidnederlandse emigratie 1572-1630*, Haarlem 1978

ten Brink 1885-90
J. ten Brink, *G.A. Bredero. Volledige Werken*, 3 vols., Amsterdam 1885-90

Brooklyn 1988
Sarah Faunce & Linda Nochlin, exhib. cat. *Courbet Reconsidered*, New York, Brooklyn Museum, 1988

Broos 1971
B.P.J. Broos, [review of Brussels 1971 exhibition], *Vrij Nederland*, 11 December 1971

Broos 1978-9
B.P.J. Broos, 'A Monument to Hals [review of Slive 1970-4]', *Simiolus* X (1978-9), pp. 115-23

Broos 1987
Ben Broos, *Meesterwerken in het Mauritshuis*, The Hague 1987

Browne 1960
G.B. Brown (ed.), *Vasari on Technique*, New York 1960

de Brune 1648
J. de Brune, *Wetsteen der Vernuften*, 2 vols., Amsterdam 1648

Bruyn 1951
J. Bruyn, 'David Bailly, "fort bon peintre et pourtraicts et en vie coye"', *O.H.* LXVI (1951), pp. 148-64, 212-27

Bruyn 1979
J. Bruyn, 'Een onderzoek naar 17de-eeuwse schilderijformaten, voornamelijk in Noord-Nederland', *O.H.* XCIII (1979), pp. 96-115

Bruyn et al. 1982—
J. Bruyn, B. Haak, S.H. Levie, P.J.J. van Thiel and E. van der Wetering, *A Corpus of Rembrandt Paintings*, The Hague, Boston & London 1982—

Bryan 1816
Michael Bryan, *A Biographical and Critical Dictionary of Painters and Engravers, from the Revival of the Art Under Cimabue ... to the Present Time*, 2 vols., London 1816

Bürger 1858
W. Bürger, *Musées de la Hollande, Amsterdam et La Haye*, Paris & Brussels 1858

Bürger 1860
W. Bürger, *Trésors d'art en angleterre*, Brussels & Ostend 1860 (1st edn. Paris 1857)

Bürger 1860a
Musées de la Hollande. Musée van der Hoop à Amsterdam et musée de Rotterdam, Paris 1860

Bürger 1860b
W. Bürger, *Galerie Suermondt à Aix-la-Chapelle, avec le catalogue de la collection par le Dr. Waagen*, Brussels & Ostend 1860

Bürger 1861
W. Bürger, 'Salon de 1861. De l'Avenir de l'Art', *La Revue Germanique* XV (1861), pp. 248-60

Bürger 1862
W. Bürger, 'Nouvelles Tendances de l'Art', *La Revue Germanique* XIX (1862), pp. 60-80

Bürger 1864
W. Bürger, 'Galerie de MM. Pereire', *G.B.A.* XVI (1864), pp. 193-213; 297-317

Bürger 1867
W. Bürger, 'Les Collections Particulières', *Paris Guide*, vol. 1, Paris 1867, pp. 536-55

Bürger 1868
W. Bürger, 'Frans Hals', *G.B.A.* XXIV (1868), pp. 219-30, 431-48

Bürger 1869
W. Bürger, 'Nouvelles Etudes sur la Galerie Suermondt a Aix-la-Chapelle', *G.B.A.*, 2ᵉ pér., I (1869), pp. 5-37, 162-87

Bürger 1870
W. Bürger, *Salons de Bürger, 1861 à 1868*, 2 vols., Paris 1870

Burghoorn 1641
J. Burghoorn, *Nieuwe Werelt vol Gecken ...*, 2 vols., The Hague 1641

Burke 1983
Doreen Bolger Burke, *J. Alden Weir: An American Impressionist*, Newark 1983

Busch 1968
Wilhelm Busch, *Sämtliche Briefe. Kommentierte Ausgabe in zwei Banden*, ed. Friedrich Bohne, Hanover 1968

Butler 1970
Marigene Butler, 'Portrait of a Lady by Frans Hals', *Museum Studies* V (1970)

Butler 1972
Marigene Butler, 'Porträt einer Dame von Frans Hals. Eine erfolgreiche Anwendung mikroskopischer Untersuchungsmethoden an Farbschichten', *Maltechnik* II (1972), pp. 76-91

Carasso 1984
D. G. Carasso, 'De schilderkunst en de natie: beschouwingen over de beeldvorming ten aanzien van de zeventiende-eeuwse Noordnederlandse schilderkunst, circa 1675-1875', *Theoretische Geschiedenis* XI (1984), pp. 381-407

Cats 1625
Jacob Cats, *Hovwelick, Dat is Het gansch Beleyt des Echten-Staets ...*, Middelburg 1625

Cats 1726
J. Cats, *Alle de Wercken*, 2 vols., Amsterdam & The Hague 1726

Charteris 1927
Evan Charteris, *The Life of John Singer Sargent*, New York 1927

Chu 1974
Petra ten Doesschate Chu, *French Realism and the Dutch Masters*, Utrecht 1974

Chu 1987
Petra ten Doesschate Chu, 'Nineteenth-Century Visitors to the Frans Hals Museum', in *The Documented Image. Visions in Art History*, ed. Gabriel Weisberg & Laurinda Dixon, Syracuse 1987, pp. 111-44

Coninckx 1914/15
H. Coninckx, 'Les Hals à Malines', *Annales de l'Académie Royale d'Archéologie de Belgique* LXVI (1914/15), pp. 145-84

Constable 1953
W. G. Constable, *The Painter's Workshop*, Oxford 1953

Coolhaas 1962
W. Ph. Coolhaas, *Pieter van den Broecke in Azie*, The Hague 1962, vol. I

Cottin 1900
P. Cottin (ed.), *Thoré-Bürger peint par lui-même, lettres et notes intimes*, Paris 1900

Courthion & Cailler 1950
Pierre Courthion & Pierre Cailler (eds.), *Courbet raconté par lui-même et par ses amis*, vol. 2, Geneva 1950, pp. 245-66

Courthion & Cailler 1960
Pierre Courthion & Pierre Cailler (eds.), *Portrait of Manet by Himself and his Contemporaries*, trans. M. Ross, London 1960

Czobor 1972
Ágnes Czobor, '"The Five Senses" by the Antwerp Artist Jacob de Backer', *N.K.J.* 1972, pp. 317-27

Damsté 1985
P. H. Damsté, 'De geschiedenis van het portret van Jaspar Schade door Frans Hals', *O.H.* XCIX (1985), pp. 30-43

van Dantzig 1937
M. M. van Dantzig, *Frans Hals: echt of onecht*, Amsterdam & Paris 1937

van Dantzig 1946
M. M. van Dantzig, 'Het "Corporaalschap van kapitein Reinier Reael"', *Phoenix* I (1946), 10, pp. 5-9

Davies 1902
G. S. Davies, *Frans Hals*, London 1902

Dax 1865
Pierre Dax, 'Chronique', *L'Artiste*, 7ᵉ série, I (1865), pp. 187-92

Decamps 1873
Louis Decamps, 'Le Frans Hals de MM. C. Vosmaer et W. Unger', *G.B.A.*, 2ᵉ pér., VIII (1873), pp. 163-76

Delleman 1985
T. A. Delleman, '"In het eerst bouwde men de kerken op de graven, naderhand stichtte men de graven in de kerken"', in N. J. de Boer et al., (eds.), *De Bavo te boek: bij het gereedkomen van de restauratie van de Grote of St. Bavokerk te Haarlem*, Haarlem 1985, pp. 165-6

Demetz 1963
Peter Demetz, 'Defenses of Dutch Painting and the Theory of Realism', *Comparative Literature* XV (1963), pp. 97-115

Descamps 1753-63
J. D. Descamps, *La vie des peintres flamands, allemands et hollandais*, 4 vols., Paris 1753-63

Dezallier d'Argenville 1745-52
A. J. Dezallier d'Argenville, *Abrégé de la vie des plus fameux peintres*, 3 vols., Paris 1745-52

van Dijk 1790
J. van Dijk, *Kunst- en historie-kundige beschryving over alle de schilderyen op het Stadhuis te Amsterdam*, Amsterdam 1790

Dirkse 1978
P. Dirkse, 'Pieter de Grebber; Haarlems schilder tussen begijnen, kloppen en pastoors', *Haerlem Jaarboek* 1978, pp. 109-27

Dix 1978
R. A. J. Dix, 'Haarlems Regentengeslacht in de steigers', *Gens Nostra – Ons Geslacht: Maandblad der Nederlandse Genealogische Vereniging* XXXIII, 3/4 (March/April 1978), pp. 85-95

Dólleman 1961
M. Thierry de Bye Dólleman, 'Laat de Kinderkens tot my komen', *Haarlem Jaerboek* 1961, pp. 77-87

Dólleman 1973
M. Thierry de Bye Dólleman, 'Nieuwe gegevens betreffende Anneke Hermansdr., de eerste echtgenote van Frans Hals', *Haerlem Jaarboek* 1973, pp. 249-57

Dólleman 1974
M. Thierry de Bye Dólleman, 'Vier verschillende families "Hals" te Haarlem', *Jaarboek Centraal Bureau voor Genealogie* XXVIII (1974), pp. 182-211

Dólleman 1975
M.Thierry de Bye Dólleman, 'De Haarlemse Burgemeester Nicolaas Wouterszoon van der Meer (ca.1574-1637)', *Jaarboek Centraal Bureau voor Genealogie* XXIX (1975), pp.46-60

Dólleman & Schutte 1969
M.Thierry de Bye Dólleman & O.Schutte, 'Het Haarlemse geslacht van der Laen', *De Nederlandse Leeuw* LXXXVI (1969), pp.311-45

van Domselaar 1660
Tobias van Domselaar, *Hollantsche Parnas*, Amsterdam 1660

Drossaers & Lunsingh Scheurleer 1974
S.W.A.Drossaers & Th.H.Lunsingh Scheurleer, *Inventarissen van de inboedels in de verblijven van de Oranjes ..., 1567-1795*, vol.1, The Hague 1974

Dudok van Heel 1969
S.[A.C.Dudok van] H[eel], 'Twee Rembrandts bij Willem van Campen', *Amstelodamum* LVI (1969), p.220

Dudok van Heel 1969a
S.A.C.Dudok van Heel, 'Het maecenaat De Graeff en Rembrandt, II', *Amstelodamum* LVI (1969), pp.249-53

Dudok van Heel 1975
S.A.C.Dudok van Heel, 'Een minne met een kindje door Frans Hals', *Jaarboek van het Centraal Bureau voor Genealogie en het Iconographisch Bureau* XXIX (1975), pp.146-59

Dülberg 1930
Frans Dülberg, *Frans Hals: ein Leben und ein Werk*, Stuttgart 1930

Durantini 1983
M.F.Durantini, *The Child in Seventeenth-Century Dutch Painting*, Ann Arbor (Mich.) 1983

Duret 1906
Théodore Duret, *Histoire de Edouard Manet et son Oeuvre*, Paris 1906

Duveneck 1970
Josephine W.Duveneck, *Frank Duveneck, Painter-Teacher*, San Francisco 1970

Eberle 1979-80
Matthias Eberle, 'Max Liebermann zwischen Tradition und Opposition', in exhib. cat. *Max Liebermann in seiner Zeit*, Berlin, Nationalgalerie, 1979-80, pp.11-41

van Eeghen 1971
I.H. van Eeghen, 'De Vaandeldrager van Rembrandt', *Amstelodamum* LVIII (1971), pp.173-81

van Eeghen 1974
I.H. van Eeghen, 'Pieter Codde en Frans Hals', *Amstelodamum* LXI (1974), pp.137-41

Ekkart 1973
Rudolf E.O.Ekkart, [review of Claus Grimm, *Frans Hals: Entwicklung, Werkanalyse, Gesamtkatalog*, Berlin 1972], in *O.H.* LXXXVIII (1973), pp.252-5

Ekkart 1973a
R.E.O.Ekkart, *Icones Leidensis*, Leiden 1973

Ekkart 1979
R.E.O.Ekkart, exhib. cat. *Johannes Cornelisz. Verspronck*, Haarlem, Frans Halsmuseum 1979

Elias 1905
Johan E.Elias, *De vroedschap van Amsterdam, 1578-1795 ...*, 2 vols., Haarlem 1903-5

Emmens 1956
J.A.Emmens, '"Ay Rembrandt, maal Cornelis stem"', *N.K.J.* VII (1956), pp.133ff

Ensor 1987
R.Hoozee, S.Bown-Taevernier & J.F.Heijbroek, exhib. cat. *Ik James Ensor: tekeningen en prenten*, Ghent, Museum voor Schone Kunsten; Amsterdam, Rijksprentenkabinet, 1987

van Eynden & van der Willigen 1816
R. van Eynden & A. van der Willigen, *Geschiedenis der Vaderlandse Schilderkunst*, 3 vols., Haarlem 1816; Supplement 1840

Fantin-Latour 1982-3
Exhib. cat. *Fantin-Latour* Paris, Ottawa & San Francisco 1982-3

FARL
Frick Art Reference Library, New York

Flescher 1973
Sharon Flescher, *Zacharie Astruc: Critic, Artist and Japoniste*, New York & London 1973

Fletcher 1901
Ernest Fletcher, *Conversations of James Northcote R.A. with James Ward on Art and Artists*, London 1901

le Francq van Berkhey 1773
J. le Francq van Berkhey, *Natuurlyke Historie van Holland*, vol.3, part 2, Amsterdam 1773

Franken & van der Kellen
Daniel Franken & J.Ph. van der Kellen, *L'œuvre de Jan van de Velde*, Amsterdam & Paris 1883; 2nd edn., with additions and corrections by Simon Laschitzer, Amsterdam 1968

Frederiks 1894
J.G.Frederiks, 'Het kabinet schilderijen van Petrus Scriverius', *O.H.* XII (1894), pp.62-3

Fremantle 1959
Katharine Fremantle, *The Baroque Town Hall of Amsterdam*, Utrecht 1959

Friedländer [1924]
Max Friedländer, *Max Liebermann*, Berlin n.d. [1924]

Fromentin 1963
Eugene Fromentin, *The Old Masters of Belgium and Holland*, trans. by M.Robbins, New York 1963, with introduction by Meyer Schapiro (1st edn. *Les Maitres d'Autrefois. Belgique, Hollande*, Paris 1876)

G.B.A.
Gazette des Beaux-Arts

Gans 1961
M.H.Gans, *Juwelen en mensen, De geschiedenis van het bijou van 1400 tot 1900, voornamelijk naar Nederlandse bronnen*, Amsterdam 1961

Gault de Saint-Germain 1818
Gault de Saint-Germain, *Guide des amateurs de tableaux pour les écoles allemande, flamande et hollandaise*, Paris 1818

van Gelder 1950-1
J.G. van Gelder, 'Rubens in Holland in de zeventiende eeuw', *N.K.J.* 1950-1, pp.102-50

Gerson 1942
H.Gerson, *Ausbreitung und Nachwirkung der holländischen Malerei des 17. Jahrhunderts*, Haarlem 1942

Gerson 1973
H.Gerson, 'A Monograph on Hals [review of Slive 1970-4, vols.1 and 2]', *B.M.* CXV (1973), pp.171-3

Gerson 1976
H.Gerson, 'The Frans Hals Catalogue [review of Slive 1970-4, vol.3]', *B.M.* CXVIII (1976), pp.422-4

van Gogh Letters 1958
The Complete Letters of Vincent van Gogh, 3 vols., London 1958

Golliet 1979
Pierre Golliet, 'La Redécouverte de Frans Hals: Thoré-Bürger, Edouard Manet, Eugene Fromentin', *Colloque Eugène Fromentin* (Travaux et Mémoires de la Maison Descartes, Amsterdam, No.1), *Publications de l'Université de Lille* III (1979), pp.53-87

Gombrich 1960
E.H.Gombrich, *Art and Illusion. A Study in the Psychology of Pictorial Representation*, New York 1960

Gonnet 1915
C.J.Gonnet, 'Oude schilderijen in en van de stad Haarlem', *O.H.* XXXIII (1915), pp.132-44

Gorter 1867
S.Gorter, 'Eene tentoonstelling van oude kunst', *De Gids*, December 1867, pp.453-93

van de Graaf 1958
J.A. van de Graaf, *Het De Mayerne Manuscript als bron voor de schildertechniek van de barok*, Mijdrecht 1958

van de Graaf 1961
J.A. van de Graaf, 'Betekenis en toepassing van "loodwit" en "schelpwit" in de 17de eeuwse nederlandse schilderkunst', *Bulletin de l'Institut Royal du Patrimoine Artistique* IV (1961), pp. 198-201

Granberg 1911
Olof Granberg, *Inventaire général des trésors d'art ... en Suède*, vol. 1, Stockholm 1911

Grasneb Tengnagel 1668
M. Grasneb Tengnagel, *Klucht van Frick in 't Veurhuys*, Leiden 1668

Grate 1959
Pontus Grate, *Deux Critiques d'Art de l'Epoque Romantique: Gustave Planche et Théophile Thoré*, Stockholm 1959

Graves 1913
Algernon Graves, *A Century of Loan Exhibitions, 1813-1912*, vol. 2, London 1913

Graves & Cronin 1901
Algernon Graves & William Vine Cronin, *A History of the Works of Sir Joshua Reynolds*, vol. 4, London 1901

Grimm 1970
Claus Grimm, 'Ein meisterliches Künstlerporträt: Frans Hals' Ostade-Bildnis', *O.H.* LXXXV (1970), pp. 170-6

Grimm 1971
Claus Grimm, 'Frans Hals und seine "Schule"', *Münchner Jahrbuch der bildenden Kunst* XXII (1971), pp. 146-78

Grimm [cat.no.]; Grimm 1972
Claus Grimm, *Frans Hals: Entwicklung, Werkanalyse, Gesamtkatalog*, Berlin 1972

Grimm 1974
Claus Grimm, 'St. Markus von Frans Hals', *Maltechnik/Restauro* I (1974), pp. 21-31

Grimm 1988
Claus Grimm, 'Le "Joueur de Luth" de Frans Hals au Louvre', *La Revue du Louvre* XXXVIII (1988), pp. 399-408

Groenman 1936
S. Groenman, *De Haarlemse industrie der zware lakenen*, Haarlem 1936 (typescript in the GAH)

Gudlaugsson 1945
S.J. Gudlaugsson, *De komedianten bij Jan Steen en zijn tijdgenooten*, The Hague 1945

Gudlaugsson 1954
S.J. Gudlaugsson, 'Een Portret van Frans Hals geidentificeerd', *O.H.* LXIX (1954) pp. 235-6

Gudlaugsson 1963
Sturla J. Gudlaugsson, 'Zur Frans-Hals-Ausstellung in Haarlem: Juni-September 1962', *Kunstchronik* XVI (1963), pp. 3-9

Haak 1972
B. Haak, *Regenten en regentessen, overlieden en chirurgijns. Amsterdamse groepsportretten van 1660 tot 1885*, Amsterdam 1972 [jointly published by the Amsterdams Historisch Museum and *Antiek*]

Hadjinicolaou 1977
Nicos Hadjinicolaou, 'La "Fortune Critique" et son sort: sur le problème de l'histoire de l'appréciation des œuvres d'art', *Histoire et Critique des Arts*, 3 (November 1977), pp. 7-15

van Hall 1936
H. van Hall, *Repertorium voor de Geschiedenis der Nederlandsche Schilder- en Graveerkunst*, vol. 1, The Hague 1936

Hamilton 1954
G.H. Hamilton, *Manet and His Critics*, New Haven 1954

Hancke 1914
Erich Hancke, *Max Liebermann*, Berlin 1914

Hancke 1916
Erich Hancke, 'Liebermanns Kopien nach Frans Hals', *Kunst und Künstler* XIV (1916), pp. 525-34

Hanson 1983
Anne Coffin Hanson, 'Manet's Pictorial Language', in exhib. cat. *Manet: 1832-1883*, Paris, Grand Palais, 22 April-8 August 1983; New York, The Metropolitan Museum, 10 September-27 November 1983, pp. 20-8

Haskell 1976
Francis Haskell, *Rediscoveries in Art. Some Aspects of Taste, Fashion and Collecting in England and France*, London 1976

Haverkamp Begemann 1982
E. Haverkamp Begemann, *Rembrandt: the Nightwatch*, Princeton (NJ) 1982

Haverkorn van Rijsewijk 1894
P. Haverkorn van Rijsewijk, 'Rotterdamsche schilders: de schilders Volmarijn', *O.H.* XII (1894), pp. 136-59

HdG
C. Hofstede de Groot, *Beschreibendes und kritisches Verzeichnis der Werke der hervorragendsten holländischen Maler des XVII. Jahrhunderts*, vol. 3, *Frans Hals ...*, Esslingen a.N. & Paris 1910. English translation of vol. 3 by E.G. Hawke, London 1910

Hedinger 1986
Bärbel Hedinger, *Karten in Bildern: Zur Ikonographie der Wandkarte in holländischen Interieurgemälden des siebzehnten Jahrhunderts*, Hildesheim, Zurich & New York 1986

van Heemskerck 1626
J. van Heemskerck, *Minne-kvnst, Minne-baet, Minne-dichten, Mengel-dichten*, Amsterdam 1626

van Hees 1959
C.A. van Hees, 'Archivalia betreffende Frans Hals en de zijnen', *O.H.* LXXIV (1959), pp. 36-42

Hegel 1840
G.F. Hegel, *Cours d'Esthétique*, ed. and trans. by C. Bénard, 2 vols., Paris 1840

Heiland 1985
Susanne Heiland, 'Nachbemerking' to 'Untersuchungen und Restaurierungen des Gemäldes "Der Mulatte" von Frans Hals', *Mitteilungen: Museum der bildenden Künste, Leipzig*, 2/3 (1985), p. 6

Henkens 1958
J.H. Henkens, 'Het Hofje van Willem van Heythuysen te Weert en zijn Stichter', *De Maasgouw* LXXIII (1958) pp. 74-9

Heppner 1937
A. Heppner, 'Thoré-Burger en Holland. De ontdekker van Vermeer en zijn liefde voor Neerland's Kunst', *O.H.*, LV (1937), pp. 17-34, 67-82, 129-44

Heppner 1939/40
Albert Heppner, 'The popular theatre of the Rederijkers in the work of Jan Steen and his contemporaries', *Journal of the Warburg and Courtauld Institutes* III (1939/40), pp. 22-49

Herzog 1977
Erich Herzog, *Holländische Meister des 17ten Jahrhunderts*, Fridingen 1977

Hexham 1678
H. Hexham, *Dictionarium, ofte Woordenboek ...*, Rotterdam 1678 (1st edn. 1658)

Hinz 1974
Berthold Hinz, 'Studien zur Geschichte des Ehepaarbildnisses', *Marburger Jahrbuch für Kunstwissenschaft*, n.s., XIX (1974), pp. 139-218

Hoekstra 1936
P. Hoekstra, *Het Haarlemse brouwersbedrijf in de 17e eeuw*, Haarlem 1936

Hoet
Gerard Hoet, *Catalogus of naamlyst van schilderyen, met derzelver pryzen zedert een lange reeks van jaaren ...*, 2 vols., The Hague 1752

Hoetink et al. 1985
H.R. Hoetink et al., *The Royal Picture Gallery: Mauritshuis*, Amsterdam & New York 1985

Hofstede de Groot 1907-28
C. Hofstede de Groot, *Beschreibendes und kritisches Verzeichnis der Werke der hervorragendsten holländischen Maler des XVII. Jahrhunderts*, 10 vols., Esslingen a.N. 1907-1928

Hofstede de Groot 1915-6
C. Hofstede de Groot, 'Frans Hals. Mansportret. Rijksmuseum te Amsterdam', *Oude Kunst* I (1915-6), pp. 321-3

Hollstein
F.W.H. Hollstein, *Dutch and Flemish Etchings, Engravings and Woodcuts*, Amsterdam 1949—

Homer 1969
William Innes Homer, *Robert Henri and His Circle*, Ithaca (NY) 1969

Hoogewerff & van Regteren Altena 1928
G.J. Hoogewerff and J.Q. van Regteren Altena, *Arnoldus Buchelius 'Res Pictoriae': aantekeningen over kunstenaars en kunstwerken voorkomende in zijn Diarium, Res Pictoriae, Notae Quotidianae en Descriptio Urbis Ultrajectinae (1583-1639)*, The Hague 1928

van Hoogstraten 1678
S. van Hoogstraten, *Inleyding tot de Hooge Schoole der Schilderkonst*, Rotterdam 1678

Houbraken
Arnold Houbraken, *De Groote Schouburgh der Nederlantsche Konstschilders en Schilderessen*, 3 vols., Amsterdam 1718-21

Houssaye 1846
Arsène Houssaye, *Histoire de la peinture flamande et hollandaise*, Paris 1846

Hubbard 1956
R.H. Hubbard, *European Paintings in Canadian Collections: Earlier Schools*, Toronto 1956

Huygens 1622
Constantijn Huygens, *Kerkuraia Mastix, 't Kostelick Mal*, Middelburg 1622

Huygens 1987
Constantijn Huygens, *Mijn Jeugd*, translation and commentary by C.L. Heesakkers, Amsterdam 1987

Icon. Bat.
E. Moes, *Iconographia Batava*, 2 vols., Amsterdam 1897-1905

Immerzeel
J. Immerzeel Jr., *De levens en werken der Hollandsche en Vlaamsche kunstschilders, beeldhouwers, graveurs en bouwmeesters*, 3 vols., Amsterdam 1842-3

Jacobsen Jensen 1918
J.N. Jacobsen Jensen, 'Moryson's reis door en zijn karakteristiek van de Nederlanden', *Bijdragen en Mededeelingen van het Historisch Genootschap te Utrecht*, XXXIX (1918), pp. 214-305 (1st edn. *An Itinerary Written by Fynes Moryson Gent*, London 1617)

Jameson 1844
Mrs. Jameson, *Companion to the Most Celebrated Private Galleries of Art in London*, London 1844

Jauss 1982
Hans Robert Jauss, *Toward an Aesthetic of Reception*, trans. by Timothy Bahti, Brighton 1982

Jellema 1987
Renske E. Jellema, *Herhaling of Vertaling? Natekening uit de achttiende en negentiende eeuw*, Haarlem 1987

de Jonge 1919
C.H. de Jonge, 'Bijdrage tot de kennis van de kleederdracht in de Nederlanden in de XVI eeuw', part 2, *O.H.* XXXVII (1919), pp. 1-70

de Jongh 1971
E. de Jongh, 'Realisme en schijnrealisme in de schilderkunst van de zeventiende eeuw', in exhib. cat. *Rembrandt en zijn tijd*, Brussels, Paleis voor Schone Kunsten, 1971, pp. 143-95

de Jongh 1975
E. de Jongh, [review of Grimm 1972 and Slive 1970-4], *The Art Bulletin* LVII (1975), pp. 583-7

de Jongh 1976
E. de Jongh, exhib. cat. *Tot Lering en Vermaak*, Amsterdam, Rijksmuseum, 1976

de Jongh 1986
E. de Jongh, exhib. cat. *Portretten van echt en trouw*, Zwolle & Haarlem, Frans Halsmuseum, 1986

de Jongh & Vinken 1961
E. de Jongh & P.J. Vinken, 'Frans Hals als voortzetter van een emblematische traditie. Bij het Huwelijksportret van Isaac Massa en Beatrix van der Laen', *O.H.* LXXVI (1961), pp. 117-52

Jowell 1974
Frances Suzman Jowell, 'Thoré-Bürger and the Revival of Frans Hals', *The Art Bulletin* LVI (March 1974), pp. 101-17

Jowell 1977
Frances Suzman Jowell, *Thoré-Bürger and the Art of the Past*, New York & London 1977

Jowell 1989
Frances S. Jowell, 'Politique et esthétique: du citoyen Thoré à William Bürger', *La Critique d'Art en France, 1850-1900* (Actes du colloque de Clermont-Ferrand, 25, 26 et 27 mai, 1987, reunis et présentés par Jean-Paul Bouillon), Saint-Etienne 1989, pp. 25-41

Judson 1959
J. Richard Judson, *Gerrit van Honthorst: A Discussion of his Position in Dutch Art*, The Hague 1959

Käppler 1985
Ingrid Käppler, 'Untersuchungen und Restaurierung des Gemäldes "Der Mulatte" von Frans Hals', *Mitteilungen Museum der bildenden Künste, Leipzig*, 2/3 (1985), pp. 2-6

Kauffmann 1943
Hans Kauffmann, 'Die Fünfsinne in der niederländischen Malerei des 17. Jahrhunderts', *Kunstgeschichtliche Studien: Festschrift für Dagobert Frey zum 23. April 1943*, ed. H. Tintelnot, Breslau 1943, pp. 133-57

KdK
W.R. Valentiner, *Frans Hals ... in 322 Abbildungen mit einer Vorrede von Karl Voll* (Klassiker der Kunst, vol. 28), 2nd rev. edn., Stuttgart, Berlin & Leipzig 1923

KdK 1921
W.R. Valentiner, *Frans Hals ... in 318 Abbildungen mit einer Vorrede von Karl Voll* (Klassiker der Kunst, vol. 28), Stuttgart & Berlin 1921

Keisch 1968
Bernard Keisch, 'Dating Works of Art Through Their Natural Radioactivity: Improvements and Applications', *Science* CLX (1968), pp. 413-5

Kilianus 1777
C. Kilianus, *Etymologicvm Tevtonicae lingvae, sive Dictionarivm Tevtonico-Latinvm*, 2 vols., Utrecht 1777 (reprint of the 1st edn. of 1599)

der Kinderen-Besier 1933
J.H. der Kinderen-Besier, *Mode-methamorphosen. De kleedij onzer voorouders in de 16e eeuw*, Amsterdam 1933

der Kinderen-Besier 1950
J.H. der Kinderen-Besier, *Spelevaart der Mode. De Kleedij onzer Voorouders in de zeventiende Eeuw*, Amsterdam 1950

Klein et al. 1987
P. Klein, D. Eckstein, T. Wazny, J. Bauch, 'New Findings for the Dendrochronological Dating of Panel Paintings of the 15th to 17th century', *ICOM Committee for Conservation* 1 (1987), pp. 51-4

Kloek 1977-8
W. Kloek, *Alleen kijken naar meisjes of jongetjes*, Amsterdam, Rijksmuseum, 1977-8

van der Klooster 1981
L.J. van der Klooster, 'De juwelen en kleding van Maria van Voorst van Doorwerth', *N.K.J.* XXXI (1981), pp. 50-64

Knoester et al. 1970
H. Knoester, A. Graafhuis, A.G. Bosch & H.A.E. de Vos tot Nederveen Cappel, 'Het kasboek van mr. Carel Martens, 1602-1649', *Jaarboek Oud Utrecht*, Utrecht 1970, pp. 154-223

Koslow 1975
Susan Koslow, 'Frans Hals *Fisherboys*: Exemplars of Idleness', *The Art Bulletin* LVII (1975), pp. 418-32

Kramm
Christiaan Kramm, *De Levens en Werken der Hollandsche en Vlaamsche Kunstschilders ...*, 7 vols., Amsterdam 1857-64 (an edited and enlarged edition of Immerzeel 1842-3)

Kretschmar 1977
F.G.L.O. Kretschmar, 'Zijn wapens op Nederlandse portretten een Betrouwbaar Middel tot Identificatie?', *Jaarboek van het Centraal Bureau voor Genealogie en het Iconographisch Bureau* XXXI (1977), pp. 38-60

Kris & Kurz 1934
Ernst Kris & Otto Kurz, *Die Legende vom Künstler*, Vienna 1934

Kris & Kurz 1979
Ernest Kris & Otto Kurz, *Legend, Myth and Magic in the Image of the Artist: A Historical Experiment*, trans. by Alastair Laing & Lottie M. Newman with additions by Otto Kurz, New Haven & London 1979 .

Kugler 1847
D. Franz Kugler, *Handbuch der Geschichte der Malerei*, 2 vols., Berlin 1847

Kugler 1854
D. Franz Kugler, *Handbook of Painting, the German, Flemish Dutch, Spanish and French Schools*, 2 vols., ed. with notes Sir Edmund Head, trans. 'by a lady', London 1854

Kurz 1964
G.H. Kurz, 'Waar thans het Politiebureau in de Smedestraat staat', *Haerlem Jaarboek*, 1964, pp. 37-8

Kurz 1972
G. Kurz, *De Haarlemse Hofjes*, Haarlem 1972,

Kuznetsov & Linnik 1982
Yury Kuznetsov & Irene Linnik, *Dutch Paintings in Soviet Museums*, New York & Leningrad 1982

van der Laan 1918
N. van der Laan, *Uit Roemer Visscher's Brabbeling* I, Utrecht 1918 (originally published as Brabelingh by Roemer Pietersz. Visscher in 1614)

Lacroix
Paul Lacroix, 'Musée du palais de l'Ermitage sous le règne de Catherine II', *Revue Universelle des Arts* XIII (1861), pp. 164-79, 244-58; XIV (1861), pp. 212-25; XV (1862), pp. 47-53, 106-23 (includes a reprint of Minich 1774)

Lafenestre 1885
Georges Lafenestre, 'Le musée de Haarlem et les tableaux achetés par le Louvre', *G.B.A.*, 2ᵉ pér., XXXI, XXXII (1885), pp. 340-456, 202-17

Lafenestre 1886
Georges Lafenestre, *Le Musée Municipal de Haarlem*, Dornach & Paris 1886

Lebrun 1792-6
J.-B.-P. Lebrun, *Galeries des Peintres Flamands, Hollandais et Allemands*, 3 vols., Paris 1792-6

Lemonnier 1888
Camille Lemonnier, 'Courbet et son Oeuvre', *Les Peintres de la vie*, Paris 1888, pp. 3-75

Levey 1983
S.M. Levey, *Lace, a History*, London, Victoria & Albert Museum, 1983

Levi d'Ancona 1977
M. Levi d'Ancona, *The Garden of the Renaissance*, Florence 1977

Levin 1887
Th. Levin, 'Die Ausstellung von Bildern älterer Meister zu Düsseldorf', *Kunstchronik* XXII (1887), pp. 433-8, 452-8, 488-91, 516-9

te Lintum 1896
C. te Lintum, *Das Haarlemer Schützenwesen (De Haarlemsche schutterij) in seiner militärischen und politischen Stellung von alten Zeiten bis heute*, Enschede 1896

van Loenen 1950
J.C. van Loenen, *De Haarlemsche brouwerindustrie voor 1600*, Amsterdam 1950

Lugt
Frits Lugt, *Répertoire des catalogues de ventes publiques*, 4 vols., The Hague & Paris 1938-87

Lukes 1979
Steven Lukes, 'The Meanings of "Individualism"', *Journal of the History of Ideas* XXXII (1971), pp. 45-66

McConkey 1987
Kenneth McConkey, *Edwardian Portraits. Images of an Age of Opulence*, Woodbridge (Suffolk) 1987

Manchester 1857
Catalogue of the Art Treasures of the United Kingdom Collected at Manchester in 1857, London 1857

van Mander 1604
Karel van Mander, *Het Schilder-boeck*, Amsterdam 1604

van Mander 1618
Karel van Mander, *Het Schilder-boeck*, Haarlem 1618, 2nd edn.

van Mander 1936
Karel van Mander, *Het Schilder-boeck*, Amsterdam 1936 (1st edn. Haarlem 1604)

Mantz 1868
Paul Mantz, [review of Thoré 1868], *G.B.A.* 1868, pp. 400-1

Mantz 1870
Paul Mantz, 'La collection La Caze au musée du Louvre', *G.B.A.*, 2ᵉ pér., 1870, p. 396

Mantz 1884
Paul Mantz, 'Les Oeuvres de Manet', *Le Temps*, 6 January 1884; reprinted as 'The Works of Manet' in Courthion & Cailler 1960, pp. 167-76

Martin 1971
Gregory Martin, 'The Inventive Genius of Frans Hals [review of Slive 1970-4, vols. 1 and 2]', *Apollo* XCIV (1971), pp. 242-3

Massa 1982
Isaac Massa, *A Short History of the Beginnings and Origins of These Present Wars in Moscow under the Reign of Various Sovereigns Down to the Year 1610*, trans. with intro. by G. Edward Orchard, Toronto, Buffalo & London 1982

Mellema 1618
E.L. Mellema, *Le grand Dictionaire François-Flameng ...*, Rotterdam 1618 (older edn. Antwerp 1598, but not ed. princ.)

Meltzoff 1942
S. Meltzoff, 'The Rediscovery of Vermeer', *Marsyas* II (1942), pp. 145-66

Ménard 1873
René Ménard, 'Exposition Rétrospective de Bruxelles', *G.B.A.*, 2ᵉ pér., VII (1873), pp. 531-45

Middelkoop & van Grevenstein 1988
N. Middelkoop & A. van Grevenstein, *Frans Hals: leven, werk restauratie*, Amsterdam 1988

Miedema 1973
H. Miedema, *Karel van Mander, Den Grondt der edel vry Schilderconst*, translation and commentary by H. Miedema, 2 vols., Utrecht 1973

Miedema 1980
Hessel Miedema, *De archiefbescheiden van het St. Lukasgilde te Haarlem: 1497-1798*, 2 vols., Alphen aan den Rijn 1980

Miedema 1981
H. Miedema, 'Verder onderzoek naar zeventiende-eeuwse schilderijformaten in Noord-Nederland', *O.H.* XCV (1981), pp. 31-49

Miedema 1987
H. Miedema, 'Over kwaliteitsvoorschriften in het St. Lucasgilde; over "doodverf"', *O.H.* CI (1987), pp. 141-7

Minich 1774
Ernst Minich, *Catalogue des tableaux que se trouvent dans les galeries, salons et cabinets du Palais Impérial de S. Petersbourg*, St. Petersburg 1774

Moes [cat.no.]; Moes 1909
E.W. Moes, *Frans Hals, sa vie et son œuvre*, trans. by J. de Bosschere, Brussels 1909

Moes 1911
E.W. Moes, 'De inventaris van de inboedel nagelaten door Dirck Alewijn in 1637', *Amstelodamum* IX, Amsterdam 1911, pp. 31-55

Molhuysen
P.C. Molhuysen, Fr. K.H. Kossmann, *et al.*, *Nieuw Nederlandsch Biografisch Woordenboek*, 10 vols., Leiden 1911-37

von Moltke 1938-9
J.W. von Moltke, 'Jan de Bray', *Marburger Jahrbuch für Kunstwissenschaft* XI-XII (1938-9), pp. 421-52

de Monconys 1665-6
Balthasar de Monconys, *Journal des voyages de Monsieur de Monconys*, 3 vols., Lyons 1665-6

Montagni
E.C. Montagni, *Tout l'œuvre peint de Frans Hals*, intro. by Albert Chatelet, Paris 1976 (trans. [by Simone Darses] of the Italian edn., Milan 1974)

Montias 1989
John Michael Montias, *Vermeer and his Milieu: a Web of Social History*, Princeton (NJ) 1989

Moore 1988
Andrew W. Moore, *Dutch and Flemish Painting in Norfolk*, London 1988 (pub. in conjunction with the commemorative William and Mary Tercentenary exhibition at Norwich Castle Museum, 10 September - 20 November 1988)

du Mortier 1984
B.M. du Mortier, 'De handschoen in de huwelijkssymboliek van de zeventiende eeuw', *Bulletin van het Rijksmuseum* XXXII (1984), 4, pp. 189-201

du Mortier 1985
B.M. du Mortier, 'Zur Symbolik und Bedeutung von Hochzeitshandschuhen', in exhib. cat. *Die Braut ..., Zur Rolle der Frau im Kulturvergleich*, Cologne, Rautenstrauch-Joest-Museum für Völkerkunde, 1985, pp. 336-44

du Mortier 1986
B.M. du Mortier, 'Het kledingbeeld op Amsterdamse portretten in de 16de eeuw', in exhib. cat. *De Smaak van de Elite*, Amsterdam, Amsterdams Historisch Museum, 1986, pp. 40-60

Muller 1853
F. Muller, *Beschrijvende catalogus van 7000 portretten, van Nederlanders, en buitenlanders, tot Nederland in betrekking staande ...*, Amsterdam 1853

Murphy 1985
Alexandra R. Murphy, *European Paintings in the Museum of Fine Arts, Boston: An Illustrated Summary Catalogue*, Boston 1985

N.K.J.
Nederlands Kunsthistorisch Jaarboek

Naamregister 1733
Naamregister van de Heeren van de Regeering der Stadt Haerlem, Haarlem 1733

Nash 1972
John Nash, letter in *The Listener*, 24 February 1972 (response to Berger 1972a)

van Nierop 1930
L. van Nierop, 'De zijdenijverheid van Amsterdam, historisch geschetst', *Tijdschrift voor Geschiedenis* XLV (1930), pp. 18-40, 151-172

Nieuwenhuys 1834
C.J. Nieuwenhuys, *A Review of the Lives and Works of Some of the Most Eminent Painters*, London 1834

Norgate 1919
Edward Norgate, *Miniatura, or the Art of Limning*, ed. M. Hardie, Oxford 1919

Novotny 1960
Fritz Novotny, *Painting and Sculpture in Europe, 1780-1880*, London 1960

O.H.
Oud Holland

Oldewelt 1934
W.F.H. Oldewelt, 'Thesaurier Memorialen', *O.H.* LI (1934), pp. 69-72, 140-2, 162-5, 237-9, 267-70

Oldewelt 1935
W.F.H. Oldewelt, 'Thesaurier Memorialen', *O.H.* LII (1935) pp. 87-8, 179, 258-60

Ormond 1970
Richard Ormond, *John Singer Sargent. Paintings, drawings, watercolours*, London 1970

Paillot de Montabert 1829
J.-N. Paillot de Montabert, *Traité complet de la peinture*, 9 vols., Paris 1829

du Pays 1862
A.J. du Pays, *Itinéraire descriptif, historique et artistique de la Hollande*, Paris 1862 (Guide Joanne)

Péladan 1912
Joséphin Péladan, *Frans Hals*, Paris 1912

Pennell 1930
Elizabeth Robins Pennell, *Whistler the Friend*, London 1930

Pepys 1928
Samuel Pepys, *The Diary of Samuel Pepys M.A. F.R.S.*, ed. H.B. Wheatley, 10 vols., London 1928

Pers 1657
D.P. Pers, *Bellerophon, of Lust tot Wysheyt*, 2 vols., Amsterdam 1657 (1st edn. 1614)

Pietersz. 1610
D. Pietersz., *Den Bloem-Hof vande Nederlandtsche Ieught beplant met uijtgelesen Liedekens ende Dichten*, Amsterdam 1610

Pilkington 1770
M. Pilkington, *The Gentleman's and Connoisseur's Dictionary of Painters ...*, London 1770

Pisano 1983
Ronald G. Pisano, *A Leading Spirit in American Art. William Merritt Chase 1849-1916*, Henry Art Gallery, University of Washington, Seattle 1983

Plantijn 1573
C. Plantijn, *Thesavrvs Thevtonica lingvae, Schat der Neder-duytsche spraken*, Antwerp 1573

Pollock 1980
Griselda Pollock, *Vincent van Gogh and Dutch Art*, unpublished doctoral thesis, London University, 1980

Pollock & Orton 1978
Griselda Pollock & Fred Orton, *Vincent van Gogh. Artist of His Time*, Oxford & New York 1978

Popper-Voskuil 1973
N. Popper-Voskuil, 'Self-Portraiture and Vanitas Still-Life Painting in 17th-Century Holland in Reference to David Bailly's Vanitas Oeuvre', *Pantheon* XXXI (1973), pp. 58-74

Posthumus 1910-4
N.W. Posthumus, *Bronnen tot de geschiedenis van de Leidsche Textielnijverheid*, 4 vols., The Hague 1910-4

Posthumus 1943
N.W. Posthumus, *Nederlandsche Prijsgeschiedenis*, 2 vols., Leiden 1943

Potterton 1986
Homan Potterton, *Dutch Seventeenth and Eighteenth Century Paintings in the National Gallery of Ireland*, Dublin 1986

Proust 1901
Antonin Proust, 'The Art of Edouard Manet', *The Studio* XXI, 94 (January 1901), pp. 227-36

Puttfarken 1985
Thomas Puttfarken, *Roger de Piles' Theory of Art*, New Haven & London 1985

Quick 1978
Michael Quick, 'Munich and American Realism', in exhib. cat. *Munich and American Realism in the 19th Century*, Sacramento, E.B. Crocker Gallery, 1978, pp. 21-36

Quick 1987-8
Michael Quick, exhib. cat. *An American Painter Abroad. Frank Duveneck's European Years*, Cincinnati Art Museum, 1987-8

Ratcliff 1983
Carter Ratcliff, *John Singer Sargent*, Oxford 1983

Ratelband 1950
K. Ratelband, *Reizen naar West-Afrika van Pieter van den Broecke, 1605-1614*, The Hague 1950

Regtdoorzee Greup-Roldanus 1936
S.C. Regtdoorzee Greup-Roldanus, *Geschiedenis der Haarlemmer Bleekerijen*, The Hague 1936

van Regteren Altena 1983
I.Q. van Regteren Altena, *Jacques de Gheyn: Three Generations*, 3 vols., The Hague, Boston & London 1983

Rehorst 1939
A.J. Rehorst, *Torrentius*, Rotterdam 1939

van Reyd 1596
E. van Reyd, *Historiën der Nederlandsche Oorlogen*, Arnhem 1626

Reynolds 1981
The Works of Sir Joshua Reynolds, ed. Robert R. Wark, Yale University Press, London 1981

Reznicek 1956
E.K.J. Reznicek, 'Jan Harmensz. Muller als tekenaar', *N.K.J.* VII (1956), pp. 65-120

Reznicek 1961
E.K.J. Reznicek, *Die Zeichnungen von Hendrick Goltzius*, 2 vols., Utrecht 1961

Riat 1906
G. Riat, *Gustave Courbet, peintre*, Paris 1906

Riegl 1931
A. Riegl, *Das holländische Gruppenporträt*, 2nd edn., ed. K.M. Swoboda, Vienna 1931

van Rijckevorsel 1937
J.L.A.A.M. van Rijckevorsel, 'De beide portretten van Isaac Abrahamsz. Massa op de Frans Hals-tentoonstelling', *Historia* III (1937), pp. 173-5

van Rijn 1887
G. van Rijn, 'Arent van Buchell's "Res Pictoriae"', *O.H.* V (1887), pp. 143-54

RKD
Rijksbureau voor Kunsthistorische Documentatie (Netherlands Institute for Art History), The Hague

Robins & Pennell 1908
Elizabeth Robins & Joseph Pennell, *The Life of James Whistler*, 2 vols., London 1908

Rochefort 1886
H. Rochefort, *Les Aventures de ma Vie*, 5 vols., Paris 1886

Rochefort 1896-8
Henri de Rochefort, *Les aventures de ma vie*, Paris 1896-8

van Roey 1957
J. van Roey, '"Frans Hals van Antwerpen": nieuwe gegevens over de ouders van Frans Hals', *Antwerpen: Tijdschrift der Stad Antwerpen* III (1957), 4, pp. 1-4

van Roey 1972
J. van Roey, 'De familie van Frans Hals: nieuwe gegevens uit Antwerpen', *Jaarboek van het Koninklijk Museum voor Schone Kunsten Antwerpen* 1972, pp. 145-70

Rogge 1865
H.C. Rogge, 'Een preek van Jacobus Trigland', *Godgeleerde Bijdragen* XXXIX (1865), 1, pp. 777-96

Rogge 1902
H.C. Rogge, *Brieven van en aan Maria van Reigersberch*, Leiden 1902

Rosand 1987
David Rosand, 'Style and the Aging Artist', *Art Journal* XLVI (1987), 2, pp. 91-3

Rosen & Zerner 1974
Charles Rosen & Henri Zerner, *Romanticism and Realism. The Mythology of Nineteenth-Century Art*, New York 1974

Rosenberg et al. 1966
Jakob Rosenberg, Seymour Slive, E.H. ter Kuile, *Dutch Art and Architecture: 1600-1800*, The Pelican History of Art Series, Harmondsworth, Baltimore & Ringwood 1966

Roy 1988-9
A. Roy, 'Rembrandt's palette', in exhib. cat. *Art in the Making: Rembrandt*, London, National Gallery, 1988-9, pp. 21-6

Royalton-Kisch 1988
Martin Royalton-Kisch, *Adriaen van de Venne's Album in the Department of Prints and Drawings in the British Museum*, London 1988

de Royer 1835
Alphonse de Royer, 'Des Arts en Hollande', *Revue des Deux Mondes* III (1835), pp. 438-49

Ruhmer 1978
Eberhard Ruhmer, 'William Leibl and his Circle, 1871-73', in exhib. cat. *Munich and American Realism in the 19th Century*, Sacramento, E.B. Crocker Gallery, 1978, pp. 9-17

Ruppert 1947
J. Ruppert, *Le Costume* II, Les Arts Décoratifs, Paris 1947

Samuels 1979
Ernest Samuels, *Bernard Berenson*, Cambridge (Mass.) 1979

Sayre & Lechtman 1968
E.V. Sayre & H.N. Lechtman, 'Neutron Activation Autoradiography of Oil Paintings', *Studies in Conservation* XIII, 4 (1968), pp. 161-85

Schama 1987
S. Schama, *The Embarrassment of Riches: an Interpretation of Dutch Culture in the Golden Age*, London 1987

Scheltema 1817
J. Scheltema, *Rusland en de Nederlanden*, vol. 1, Amsterdam 1817

Scheltema 1885
P. Scheltema, 'De schilderijen in de drie doelens te Amsterdam beschreven door G. Schaep', *Amstel's Oudheid of Gedenkwaardigheden van Amsterdam* VII (1885), pp. 121-41

van Schendel 1956
A. van Schendel, 'De Schimmen van de Staalmeesters', *O.H.* LXXI (1956), pp. 1-23

Schipper-van Lottum 1980
M.G.A. Schipper-van Lottum, *Over merklappen gesproken*, Amsterdam 1980

Schoonbaert 1968
L. Schoonbaert, 'Addendum beschrijvende catalogus 1948. Een verzameling tekeningen van Ensor (Deel 1)', *Jaarboek van het Koninklijk Museum voor Schone Kunsten Antwerpen* 1968, pp. 311-43

Schotel 1854
G.D.J. Schotel, *Bijdrage tot de geschiedenis der kerkelijke en wereldlijke kleding*, The Hague 1854

Schotel
G.D.J. Schotel, *Het Oud-Hollandsch Huisgezin der Zeventiende Eeuw*, Leiden n.d.

Schrevelius 1647
T. Schrevelius, *Harlemum sive urbis Harlemensis incunabula*, Leiden 1647

Schrevelius 1648
T. Schrevelius, *Harlemias ofte, om beter te seggen, de eerste stichtinghe der stadt Haerlem*, Haarlem 1648

Schwartz 1985
Gary Schwartz, *Rembrandt: his life, his paintings*, Middlesex & New York 1985

Senenko 1980
M. Senenko, 'Single Figure Genre Paintings in the Work of Frans Hals', in *From the History of Western Art*, ed. M. Liebman (Festschrift V. Levinson-Lessing), Moscow 1980, pp. 130-52 [text in Russian]

Sensier 1873
Alfred Sensier, *Georges Michel*, Paris 1873

Sewel 1691
W. Sewel, *A new Dictionary English and Dutch*, Amsterdam 1691

Sewter 1942
A.C. Sewter, 'A Frans Hals Portrait', *B.M.* LXXXI (1942), p. 259

Shiff 1984
Richard Shiff, *Cézanne and the End of Impressionism*, Chicago & London 1984

Siccama 1895
W. Hora Siccama, *Louis Bernard Coclers*, Amsterdam 1895

Six 1893
J. Six, 'Opmerkingen omtrent eenige meesterwerken in 's Rijks Museum', *O.H.* XI (1893), pp. 96-104

Slatkes 1981-2
L. J. Slatkes, [review of Benedict Nicolson, *The International Cara-vaggesque Movement*, Oxford 1979], *Simiolus* XII (1981-2), pp. 167-83

Sliggers 1979
Bert Sliggers Jr. (ed.), *Dagelijkse aentekeninge van Vincent Laurensz van der Vinne*, Haarlem 1979

Sliggers 1984
B. J. Sliggers, *Haarlemmerhout 400 jaar*, Haarlem 1984

Slive 1953
Seymour Slive, *Rembrandt and His Critics: 1630-1730*, The Hague 1953

Slive 1958
Seymour Slive, 'Frans Hals' Portrait of Joseph Coymans', *Wadsworth Atheneum Bulletin*, Winter 1958, pp. 12-23

Slive 1961
Seymour Slive, 'Frans Hals Studies: I. Juvenilia; II. St. Luke and St. Matthew at Odessa; III. Jan Franszoon Hals', *O.H.* LXXVI (1961), pp. 173-200

Slive 1961a
Seymour Slive, 'Henry Hexham's "Of Colours": A Note on a Seventeenth Century List of Colours', *B.M.* CIII (1961), pp. 378-80

Slive 1962
Seymour Slive, *Frans Hals. Festmahl der Offiziere der St. Georg-Schützengilde in Haarlem, 1616*, Stuttgart 1962

Slive 1963
Seymour Slive, 'On the Meaning of Frans Hals' "Malle Babbe"', *B.M.* CV (1963), pp. 432-6

Slive 1969
Seymour Slive, 'A Proposed Reconstruction of a Family Portrait by Frans Hals', *Miscellanea I.Q. van Regteren Altena*, Amsterdam 1969, pp. 114ff

Slive 1970-4
Seymour Slive, *Frans Hals*, 3 vols., New York & London 1970-4

Small Paintings 1980
Small Paintings of the Masters: Masterpieces Reproduced in Actual Size, intro. by E. Haverkamp-Begemann, 3 vols., Redding (Conn.) 1980

de Smet 1977
R. de Smet, 'Een nauwkeurige datering van Rubens' eerste reis naar Holland in 1612', *Jaarboek van het Koninklijk Museum voor Schone Kunsten Antwerpen* 1977, pp. 199-218

Smith 1829-37
John Smith, *A Catalogue Raisonné of the works of the most eminent Dutch, Flemish and French painters ...*, 9 vols., London 1829-37; Supplement 1842

Smith 1982
David R. Smith, *Masks of Wedlock, Seventeenth-Century Dutch Marriage Portraiture* (Studies in the Fine Arts: Iconography, no. 8) University Microfilms International, Ann Arbor (Mich.) 1982

Smith 1986
David R. Smith, 'Courtesy and its Discontents: Frans Hals's Portrait of Isaac Massa and Beatrix van der Laen', *O.H.* C (1986), pp. 2-34

Snoep 1969
D. P. Snoep, 'Honselaersdyck; restauraties op papier'; *O.H.* LXXXIV (1969), pp. 270-94

van Someren
J. F. van Someren, *Beschrijvende catalogus van gegraveerde portretten van Nederlanders ... vervolg op Frederik Mullers catalogus van 7000 portretten van Nederlanders ...*, 3 vols., Amsterdam 1888-91

Starter 1634
Jan Jansz Starter, *Friesche lust-hof, beplant met verscheyden stichtelijcke minneliedekens, gedichten, ende boertighe kluchten*, 5th enlarged edn., Amsterdam 1634

Starter 1864
J. J. Starter, *Friesche Lusthof, beplant met verscheyden stichtelijcke minneliedekens, gedichten, ende boertige kluchten*, ed. J. van Vloten, Utrecht 1864

Steingräber 1970
Erich Steingräber, 'Willem van Heythuysen von Frans Hals', *Pantheon* XXVIII (1970), pp. 300-8

Sterck 1932
J. F. M. Sterck, 'De Roomskatholieke familie Kies', *Bydragen voor de Geschiedenis van het Bisdom Haarlem* CXCIV (1932), 2, pp. 151-4

van Sterkenburg 1977
P. G. J. van Sterkenburg, *Een glossarium van zeventiende-eeuws Nederlands*, Groningen 1977

Stevens 1984
Jane R. Stevens, 'Hands, Music and Meaning in Some Seventeenth-Century Dutch Paintings', *Imago Musicae* I (1984), pp. 75-102

Strauss & van der Meulen 1979
Walter L. Strauss & Marjon van der Meulen (with the assistance of S. A. C. Dudok van Heel & P. J. M. de Baar), *The Rembrandt Documents*, New York 1979

Stubbes 1583
Phillip Stubbes, *Anatomy of Abuses*, London 1583 (facsimile edn. Amsterdam 1972)

Sumowski 1983—
Werner Sumowski, *Gemälde der Rembrandt Schüler*, London & Landau Pfalz 1983—

Swaart 1962
Koenraad W. Swaart, '"Individualism" in the Mid-Nineteenth Century (1826-1860)', *Journal of the History of Ideas* XXIII (1962) pp. 77-90

Sweet 1966
Frederick A. Sweet, *Miss Mary Cassatt. Impressionist from Pennsylvania*, Norman (Oklahoma) 1966

Swillens 1961
P. T. A. Swillens, *Jacob van Campen*, Assen 1961

Talley 1981
M. K. Talley, *Portrait Painting in England: Studies in the Technical Literature before 1700*, Guildford 1981

Tardieu 1873
Charles Tardieu, 'Les grandes collections étrangères, II, M. John W. Wilson', *G.B.A.* VIII (1873), pp. 215-22

Temminck 1971
J. J. Temminck, *Haarlem Vroeger en Nu*, Bussum 1971

Terwesten 1770
Pieter Terwesten, *Catalogus of naamlyst van schilderyen, met derzelver prysen, zedert den 22. Aug. 1752 tot den 21. Nov. 1768 ... verkogt ...*, The Hague 1770

van Thiel 1961
P. J. J. van Thiel, 'Frans Hals' portret van de Leidse rederijkersnar Pieter Cornelisz van der Morsch, alias Piero (1543-1629). Een bijdrage tot de ikonologie van de bokking', *O.H.* LXXVI (1961), pp. 153-72

van Thiel 1967-8
P. J. J. van Thiel, 'Marriage Symbolism in a Musical Party by Jan Miense Molenaer', *Simiolus* II (1967-8), pp. 91-9

van Thiel 1980
P. J. J. van Thiel, 'De betekenis van het portret van Verdonck door Frans Hals: De ikonografie van het kakebeen', *O.H.* XCIV (1980), pp. 112-40

van Thiel et al. 1976
P. J. J. van Thiel et al., *All the Paintings of the Rijksmuseum in Amsterdam*, Amsterdam & Maarssen 1976

van Thienen 1930
F. van Thienen, *Das Kostum der Blutezeit Hollands, 1600-1660*, Berlin 1930

van Thienen 1969
Fr. W. S. van Thienen, 'Een silvre portefraes. Een zeventiende eeuws kostuumonderdeel', *Antiek* III (1969), pp. 482-7

Thoré 1868
T. Thoré, *Salons de T. Thoré, 1844, 1845, 1846, 1847, 1848 avec une préface par W. Bürger*, Paris 1868

Trivas
N.S.Trivas, *The Paintings of Frans Hals*, London & New York 1941

van der Tuin 1948
H. van der Tuin, *Les vieux peintres des Pays-Bas et la critique artistique en France de la première moitié du XIXᵉ siècle*, Paris 1948

Unger & Vosmaer 1873
William Unger & C.Vosmaer, *Eaux-Fortes d'après Frans Hals* [by W. Unger], *avec une étude sur le maître et ses œuvres* [by C.Vosmaer], Leiden 1873

Unger & Vosmaer 1873-4
William Unger, *Etsen naar Frans Hals*, ed. Carel Vosmaer, Leiden 1873-4; English edition: *Etchings after Frans Hals*, with a notice of the life and works of the master by Mr. C.Vosmaer, Leiden 1873 [1874]

Valentiner 1925
W.R.Valentiner, 'The Self-Portraits of Frans Hals', *Art in America* XIII (1925), pp.148-54

Valentiner 1935
W.R.Valentiner, 'New Additions to the Work of Frans Hals', *Art in America* XXIII (1935), pp.85-103

Valentiner 1936
W.R.Valentiner, *Frans Hals Paintings in America*, Westport (Conn.) 1936

Valéry 1938
Paul Valéry, *Degas, Dessins*, Paris 1938

van Valkenburg 1958
C.C. van Valkenburg, 'De Haarlemse schuttersstukken'. Part one: 'Maaltijd van officieren van de Sint Jorisdoelen (Frans Hals, 1616): identificatie der voorgestelde schuttersofficieren', *Jaarboek Haerlem* 1958, pp.59-68

van Valkenburg 1961
C.C. van Valkenburg, 'De Haarlemse schuttersstukken'. Part four: 'Maaltijd van officieren van de Sint Jorisdoelen (Frans Hals, 1627)'. Part five: 'Maaltijd van officieren van de Cluveniersdoelen (Frans Hals, 1627)'. Part seven: 'Officieren en onderofficieren van de Sint Jorisdoelen (Frans Hals, 1639)', *Jaarboek Haarlem* 1961, pp. 46-76

Véron 1879
Eugène Véron, *Aesthetics*, trans. by W.H.Armstrong, London 1879 (1st edn. *L'Esthétique*, Paris 1878)

Verwer 1973
Willem Jansz Verwer, *Memoriaelbouck*, ed. J.J.Temminck, Haarlem 1973

Vinken & de Jongh 1963
P.J.Vinken & E. de Jongh, 'De boosaardigheid van Hals' regenten en regentessen', *O.H.* LXXVIII (1963), pp.1-26

Visscher 1614
Roemer Visscher, *Sinnepoppen*, Amsterdam 1614

van Visvliet 1905
M.H. van Visvliet, 'De Kleerkast van Piet Hein', *O.H.* XXIII (1905), pp.189-96

Vollenhoven & Schotel 1857
H.Vollenhoven & G.D.J.Schotel, *Brieven van Maria van Reigersberch*, Middelburg 1857

Vons-Comis 1988
S.Y.Vons-Comis, 'Kleren maken de man. Zeventiende- en achtiende-eeuwse kleding van Spitsbergen', in exhib. cat. *Walvisvaart in de Gouden Eeuw. Opgravingen van Spitsbergen*, Amsterdam, Rijksmuseum, 1988, pp.97-119

Vosmaer 1863
Carel Vosmaer, *Rembrandt Harmens van Rijn. Ses précurseurs et ses années d'apprentissage*, The Hague 1863

Vosmaer 1871
C.Vosmaer, 'Oude aanteekeningen over Rubens, Jordaens, Rembrandt, Hals en Wouwerman', *De Nederlandsche Spectator* XII (1871), pp.62-3

de Vries 1885
A.D. de Vries Azn., 'Biografische aanteekeningen betreffende voornamelijk Amsterdamsche schilders, plaatsnijders, enz. en hunne verwanten', *O.H.* III (1885), pp.55-80, 135-60, 223-40, 303-12

de Vries 1955
A.B. de Vries, 'Negentiende Eeuwse Kunstcritiek en Zeventiende Eeuwse Schilderkunst', *N.K.J.* IV (1955), pp.157-68

Waagen 1854; Waagen 1857
G.F.Waagen, *Treasures of Art in Great Britain ...*, 3 vols., London 1854; supplemental volume (4), London 1857

Waagen 1860
G.F.Waagen, *Handbook of Painting. The German, Flemish and Dutch Schools* [based on Kugler 1854], 2 vols., London 1860

Waagen 1864
G.F.Waagen, *Die Gemäldesammlungen in der Kaiserlichen Ermitage zu St. Petersburg*, Munich 1864

van de Waal 1956
H. van de Waal, 'De Staalmeesters en hun legende', *O.H.* LXXI (1956), pp. 61-88

Wagner 1981
Anne M.Wagner, 'Courbet's Landscapes and their Market', *Art History* IV (1981), pp.410-31

Wardle 1983
P.Wardle, 'Needle and Bobbin in Seventeenth-Century Holland', *The Bulletin of the Needle and Bobbin Club* LXVI (1983), 1/2, pp.3-15

Wardle 1986
P.Wardle, 'Embroidery Most Sumptuously Wrought: Dutch Embroidery Designs in the Metropolitan Museum of Art, New York', *The Bulletin of the Needle and Bobbin Club*, LXIX (1986)

Weber 1987
Gregor J.M.Weber, ''t Lof van den Pekelharingh'. Von alltäglichen und absonderlichen Heringsstilleben', *O.H.* CI (1987), pp.126-40

Welsh-Ocharov 1976
Bogomila Welsh-Ocharov, *Vincent van Gogh. His Paris Period*, Utrecht & The Hague 1976

Welu 1975
James A.Welu, 'Vermeer: His Cartographic Sources', *The Art Bulletin* LVII (1975), pp.529-47

Welu 1977
James A.Welu, *Vermeer and Cartography*, diss., Boston University 1977, University Microfilms International, Ann Arbor (Mich.) 1977

van Westrheene 1855
T. van Westrheene, *Jan Steen. Etude sur l'art en Hollande*, The Hague 1855

Weyerman
J.C.Weyerman, *De Levensbeschryvingen der Nederlandsche Kunstschilders*, 4 vols., The Hague 1729-69

White 1982
Christopher White, *The Dutch Pictures in the Collection of Her Majesty the Queen*, Cambridge 1982

Wiersum 1935
E.Wiersum, 'Harmen Hals te Vianen', *O.H.* LII (1935), p.40

Wijn 1982
J.W.Wijn, *Het Beleg van Haarlem*, The Hague 1982

van der Willigen 1866
A. van der Willigen Pzn., *Geschiedkundige aanteekeningen over Haarlemsche schilders en andere beoefenaren van de beeldende kunsten, voorafgegaan door eene korte geschiedenis van het schilders- of St. Lucas gild aldaar*, Haarlem 1866

van der Willigen 1870
A. van der Willigen Pzn., *Les artistes de Harlem: notices historiques avec un précis sur la Gilde de St. Luc, édition revue et augmentée*, Haarlem & The Hague 1870

Winkler 1871
J.Winkler, 'Het Oorijzer', *Oude Tijd*, Haarlem 1871

Wishnevsky 1967
Rose Wishnevsky, *Studien zum portrait historié in den Niederlanden* (diss.), Munich 1967

Wittkower 1963
Rudolf & Margot Wittkower, *Born Under Saturn*, London 1963

WNT
Woordenboek der Nederlandsche Taal, The Hague & Leiden 1882—

Wolleswinkel 1977
E.J. Wolleswinkel, 'De portretten van Petrus Scriverius en zijn familie', *Jaarboek van het Centraal Bureau voor Genealogie en het Iconographisch Bureau* XXXI (1977), pp. 105-19

Worp 1897
J.A. Worp, 'Fragment eener autobiographie van Constantijn Huygens', *Bijdragen en Mededelingen van het Historisch Genootschap Utrecht* XVIII (1897), pp. 1-122

Wurfbain 1988
Maarten Wurfbain, 'David Bailly's *Vanitas* of 1651', in *The Age of Rembrandt: Studies in Seventeenth-Century Dutch Painting*, ed. R.E. Fleischer & S.S. Munshower, *Papers in Art History from Pennsylvania State University* III (1988), pp. 48-69

Wurzbach
A. von Wurzbach, *Niederländisches Künstler-Lexikon*, 3 vols., Vienna & Leipzig 1906-11

Wussin 1863
M.J. Wussin, *Jonas Suyderhoef, son œuvre gravé ...*, trans. from the German, annotated and augmented by H. Hymans, Brussels 1863

Young 1960
Dorothy Weir Young, *The Life and Letters of J. Alden Weir*, New Haven 1960

Young *et al.* 1980
A.M. Young, M. MacDonald & R. Spencer, *The Paintings of James McNeill Whistler*, vol. 1, New Haven & London 1980

Yule 1983
Exhib. cat. *William James Yule*, London, Pyms Gallery, 1983

Exhibitions cited in Abbreviated Form

Amsterdam 1867
Amsterdam, 'Arti et Amicitiae', 1867, *Tentoonstelling van zeldzame en belangrijke schilderijen van oude meesters.*

Amsterdam 1872
Amsterdam, 'Arti et Amicitiae', 1872, *Tentoonstelling van zeldzame en belangrijke schilderijen van oude meesters.*

Amsterdam 1906
Amsterdam, F. Muller & Co., 10 July - 15 September 1906, *Catalogue de l'exposition de maîtres hollandais du XVIIᵉ siècle organisée ... en l'honneur du Tercentenaire de Rembrandt.*

Amsterdam 1945
Amsterdam, Rijksmuseum, 15 July - 30 September 1945, *Weerzien der meesters in het Rijksmuseum. Keur van schilderijen uit: Rijksmuseum, Mauritshuis, Frans Halsmuseum, Dordrechts Museum.*

Amsterdam 1948
Amsterdam, Rijksmuseum, 18 July - 24 October 1948, *Meesterwerken uit de Oude Pinacotheek te München.*

Amsterdam 1950
Amsterdam, Rijksmuseum, 17 June - 17 September 1950, *120 beroemde schilderijen uit het Kaiser-Friedrich Museum te Berlijn.*

Amsterdam 1952
Amsterdam, Rijksmuseum, 29 June - 5 October 1952, *Drie eeuwen portret in Nederland.*

Amsterdam 1955-6
Amsterdam, Gemeentemusea, 16 December 1955 - 15 January 1956, *Kinderen en Kinderleven in Nederland 1500-1900.*

Amsterdam 1970
Amsterdam, Amsterdams Historisch Museum, 27 March - 31 May 1970, *4th C.I.N.O.A. Exhibition.*

Amsterdam 1971
Amsterdam, Rijksmuseum, 1971, *Hollandse schilderijen uit Franse musea.*

Amsterdam 1976
Amsterdam, Rijksmuseum, 16 September - 5 December 1976, *Tot Lering en Vermaak* (catalogue by E. de Jongh).

Amsterdam 1984
Amsterdam, Rijksmuseum, 6 April - 1 July 1984, *Prijst de lijst: De Hollandse schilderijlijst in de zeventiende eeuw* (catalogue by P.J.J. van Thiel & C.J. de Bruyn Kops).

Atlanta 1985
Atlanta, High Museum of Art, 24 September - 10 November 1985, *Masterpieces of the Dutch Golden Age* (catalogue by Frits Duparc).

Auckland 1982
Auckland, Auckland City Art Gallery, 1982, *Still Life in the Age of Rembrandt* (catalogue by E. de Jongh et al.)

Baltimore 1968
Baltimore, Baltimore Museum of Art, 22 October - 8 December 1968, *From El Greco to Pollack: Early and Late Works by European and American Artists.*

Berlin 1906
Berlin, Palais Redern, 27 January - 4 March 1906, *Ausstellung von Werken alter Kunst aus dem Privatbesitz der Mitglieder des Kaiser-Friedrich-Museums-Verein.*

Berlin 1909
Berlin, Akademie der Künste, 1909, *Bildnis-Ausstellung.*

Berlin 1914
Berlin, Akademie der Künste, May 1914, *Ausstellung von Werken alter Kunst, aus dem Privatbesitz von Mitgliedern des Kaiser-Friedrich-Museums-Verein.*

Birmingham 1950
Birmingham, Museum and Art Gallery, 1950, *Some Dutch Cabinet Pictures of the 17th Century.*

Birmingham 1989-90
Birmingham, City Art Gallery, 7 October 1989 - 14 January 1990, *Images of a Golden Age: Dutch 17th Century Paintings.*

Bloomington 1939
Bloomington, Illinois, Scottish Rite Temple, 19 March - 8 April 1939, *Central Illinois Art Exposition.*

Boston 1970
Boston, Museum of Fine Arts, 4 February 1970, *Centennial Acquisitions: Art Treasures for Tomorrow.*

Brussels 1873
Brussels, Galerie du Cercle artistique et littéraire de Bruxelles, 1873, *Collection de M. John W. Wilson* (Paris 1873).

Brussels 1873a
Brussels, Société néerlandaise de bienfaisance à Bruxelles, 1873, *Exposition de tableaux et dessins d'anciens maîtres.*

Brussels 1873b
Brussels, Musée Royal, 22 December 1873, *Catalogue d'une collection [B. Suermondt], de tableaux et dessins anciens et modernes.*

Brussels 1935
Brussels, International Exhibition Centre, 24 May - 13 October 1935, *Exposition Universelle et Internationale: Cinq siècles d'art.*

Brussels 1946
Brussels, Palais des Beaux-Arts, 2 March - 28 April 1946, *De hollandsche schilderkunst van Jeroen Bosch tot Rembrandt.*

Brussels 1961
Brussels, Musées Royaux des Beaux-Arts, 22 January - 9 February 1961, *Les plus beaux portraits de nos Musées.*

Brussels 1962-63
Brussels, Musées Royaux des Beaux-Arts, 15 December 1962 - 10 February 1963, *Peintures et dessins hollandais du XVᵉ au XVIIᵉ siècle dans les collections des Musées royaux.*

Brussels 1967-8
Brussels, Musée Royaux des Beaux-Arts, 15 November 1967 - 7 January 1968, *Un demi-siècle de mécénat.*

Brussels 1971
Brussels, Paleis voor Schone Kunsten, 23 September - 21 November 1971, *Rembrandt en zijn tijd.*

Cape Town 1952
Cape Town, National Gallery of South Africa, 1952, *Exhibition of XVII Century Dutch Painting.*

Celle 1954
Celle, Schloss, July - September 1954, *Kostbarkeiten alter Kunst.*

Chicago 1933
Chicago, The Art Institute of Chicago, 1 June - 1 November 1933, *A Century of Progress.*

Chicago 1934
Chicago, The Art Institute of Chicago, 1 June - 1 November 1934, *A Century of Progress.*

Chicago 1942
Chicago, The Art Institute of Chicago, 18 November - 16 December 1942, *Paintings by the Great Dutch Masters of the Seventeenth Century.*

Cincinnati 1941
Cincinnati, Cincinnati Art Museum, 15 January - 9 February 1941, *Masterpieces of Art.*

Cleveland 1936
Cleveland, Cleveland Museum of Art, 26 June - 4 October 1936, *Twentieth Anniversary Exhibition of the Cleveland Museum of Art, the Official Art Exhibit of the Great Lakes Exposition.*

Cologne 1876
Cologne, 1876, *Kunsthistorische Ausstellung.*

Delft 1953
Delft, Stedelijk Museum 'Het Prinsenhof', 31 May - 10 August 1953, *Kind en spel.*

Detroit 1935
Detroit, The Detroit Institute of Arts, 10 January - 28 February 1935, *An Exhibition of Fifty Paintings by Frans Hals.*

Dublin 1896
Dublin, National Gallery, 1896.

Düsseldorf 1886
Düsseldorf, Kunsthalle, 1 September - 17 October 1886, *Ausstellung von Bildern älterer Meister aus Privatsammlungen in den Rheinlanden und Westfalen.*

Düsseldorf 1970-1
Düsseldorf, Kunstmuseum, 23 October 1970-3 January 1971, *Die Sammlung Bentinck-Thyssen.*

Fort Worth 1953
Fort Worth, Texas, Fort Worth Art Association, 3 March-26 March 1953, *Twenty-One Paintings from the Kimbell Art Foundation.*

Haarlem 1937
Haarlem, Frans Halsmuseum, 1 July-30 September 1937, *Frans Hals. Tentoonstelling ter gelegenheid van het 75-jarig bestaan van het Gemeentelijk Museum te Haarlem.*

Haarlem 1962
Haarlem, Frans Halsmuseum, 16 June-30 September 1962, *Frans Hals. Exhibition on the Occasion of the Centenary of the Municipal Museum at Haarlem* (catalogue by Seymour Slive).

Haarlem 1979
Haarlem, Frans Halsmuseum, 15 September-25 November 1979, *Johannes Cornelisz. Verspronck; Leven en werken van een Haarlems portretschilder uit de 17de eeuw* (catalogue by Rudolf E.O. Ekkart).

Haarlem 1986
Haarlem, Frans Halsmuseum, 15 February-19 May 1986, *Portretten van echt en trouw: Huwelijk en gezin in de Nederlandse kunst van de zeventiende eeuw* (catalogue by E. de Jongh).

Haarlem 1988
Haarlem, Frans Halsmuseum, 12 May-17 July 1988, *Schutters in Holland: Kracht en zenuwen van de stad* (edited by M. Carasso-Kok and J. Levy-van Halm).

The Hague 1881
The Hague, Gotisch Paleis, 1881, *Catalogus van oude meesters te 's Gravenhage ten behoeve der waternoodlijdenden.*

The Hague 1903
The Hague, Haagsche Kunstkring, 1 July-30 September 1903, *Tentoonstelling van oude portretten.*

The Hague 1979-80
The Hague, Mauritshuis, 21 December 1979-1 March 1980, *Zo wijd de wereld strekt, Tentoonstelling naar aanleiding van de 300ste sterfdag van Johan Maurits van Nassau-Siegen op 20 december 1979.*

Hamburg 1987
Hamburger Kunsthalle, 1987, *Courbet und Deutschland.*

Indianapolis & San Diego 1958
Indianapolis, John Herron Art Museum, 14 February-23 March 1958 – San Diego, The Fine Arts Gallery, 11 April-18 May 1958, *The Young Rembrandt and his Times.*

Lausanne, Paris & Brussels 1986-7
Lausanne, Fondation de l'Eremitage, 1986 – Paris, Musée Marmottan, 1986 – Brussels, Palais des Beaux-Arts, 1987, *La Collection Bentinck-Thyssen, De Breughel à Guardi.*

Leeds 1955
Leeds, City Art Galleries, 1955, *Paintings from Chatsworth.*

Leeds 1982-3
Leeds, City Art Gallery, 27 November 1982-29 January 1983, *Dutch 17th Century Pictures in Yorkshire Collections.*

Leningrad & Moscow 1988
Leningrad, The Hermitage – Moscow, Pushkin Museum, 17 August-25 October 1988, *Masterpieces of Western European Painting from the Collection of the National Gallery in London* (Russian text).

Liverpool 1968
Liverpool, Walker Art Gallery, 1 April-12 May 1968, *Gifts to Galleries (National Art-Collections Fund).*

London 1900
London, Burlington Fine Arts Club, 1900, *Exhibition of Pictures by Dutch Masters of the Seventeenth Century.*

London 1903
London, Guildhall Gallery [Art Gallery of the Corporation of London], 28 April-25 July 1903, *Catalogue of the Exhibition of a Selection of Works by Early and Modern Painters of the Dutch School.*

London 1904
London, Whitechapel Art Gallery, 30 March-10 May 1904, *Dutch Exhibition.*

London 1906
London, Royal Academy of Arts, 1906 [Winter Exhibition], *Works by the Old Masters.*

London 1928
London, Royal Academy of Arts, 12 January 1928 [Winter Exhibition], *Exhibition ... of the Iveagh Bequest.*

London 1929
London, Royal Academy of Arts, 4 January-9 March 1929, *Exhibition of Dutch Art, 1450-1900.*

London 1938
London, Royal Academy of Arts, 3 January-12 March 1938, *Exhibition of 17th-Century Art in Europe.*

London 1945
London, Arts Council of Great Britain, 1945, *Dutch Painting of the 17th Century.*

London 1946-7
London, Royal Academy of Arts, 26 October 1946-16 March 1947, *Exhibition of the King's Pictures.*

London 1948
London, Thos. Agnew & Sons, October-November 1948, *Exhibition of Pictures from the Devonshire Collection.*

London 1952-3
London, Royal Academy of Arts, 1952-3, *Dutch Pictures: 1450-1750.*

London 1961
London, National Gallery, 2 March-20 April 1961, *From Van Eyck to Tiepolo: An Exhibition of Pictures from the Thyssen-Bornemisza Collection.*

London 1962
London, Victoria and Albert Museum, 1962, *Third International Art Treasures Exhibition.*

London 1971-2
London, Buckingham Palace, The Queen's Gallery, 1971-2, *Dutch Pictures from the Royal Collection.*

London 1972
London, National Gallery, 10 August-17 September 1972, *The Alexander Gift.*

London 1976
London, National Gallery, 30 September-12 December 1976, *Art in Seventeenth-Century Holland.*

Los Angeles 1947
Los Angeles, Los Angeles County Museum, 18 November-31 December 1947, *Loan Exhibition of Paintings by Frans Hals-Rembrandt.*

Lucerne 1948
Lucerne, Kunstmuseum, 5 June-31 October 1948, *Meisterwerke aus den Sammlungen des Fürsten von Liechtenstein.*

Lugano 1949
Lugano [Castagnola-Lugano], Villa Favorita, 1949, *Aus dem Besitz der Stiftung Schloss Rohoncz.*

Luxembourg 1988
Luxembourg, Musée d'Etat, 1988, *Exposition de la Collection Bentinck-Thyssen.*

Madrid 1981
Madrid, Museo del Prado, April-July 1981, *Tesoros del Ermitage.*

Manchester 1957
Manchester, Art Gallery, 30 October-31 December 1957, *Art Treasures Centenary: European Old Masters.*

Milan 1954
Milan, Palazzo Reale, 25 February-25 April 1954, *Mostra di pittura olandese del seicento.*

Montreal 1906
Montreal, Montreal Museum of Fine Arts, 1906, *A Catalogue of the Paintings by Rembrandt and the Great Dutch Painters of the XVII Century.*

Montreal 1944
Montreal, Art Association, 9 March-9 April 1944, *Five Centuries of Dutch Art.*

Montreal 1967
Montreal, Expo 67, 1967, *Man and his World.*

Munich 1869
Munich, in the *königlichen Kunstausstellungsgebäude gegenüber der Glyptothek,* [probably 20 July-31 October] 1869, *Ausstellung von Gemälden älterer Meister.*

Munich 1892
Munich, Glaspalast, 1 June-31 October 1892, *6. Internationale Kunst-Ausstellung: Kollektion von Werken alter Meister.*

Munich 1930
Munich, Neue Pinakothek, 1930, *Sammlung Schloss Rohoncz.*

New Brunswick 1983
New Brunswick, Rutgers, The State University of New Jersey, The Jane Vorhees Zimmerli Art Museum, 20 February-17 April 1983, *Haarlem: The Seventeenth Century* (catalogue by Frima Fox Hofrichter).

New York 1909
New York, The Metropolitan Museum of Art, September-November 1909, *The Hudson-Fulton Celebration. Loan Exhibition of Paintings by Old Dutch Masters.*

New York 1937
New York, Schaeffer Galleries, Inc., 9-23 November 1937, *Paintings by Frans Hals, Exhibition for the Benefit of ... New York University*.

New York 1939
New York, New York World's Fair, May-October 1939, *Catalogue of European Paintings and Sculpture from 1300-1800, Masterpieces of Art*.

New York 1945
New York, Wildenstein, 1-28 March 1945, *The Child through Four Centuries*.

New York 1956
New York, Wildenstein Gallery, 1956, *Treasures of Musée Jacquemart-André*.

New York 1973a
New York, The Metropolitan Museum of Art, 23 January-5 March 1973, *Dutch Couples: Pair Portraits by Rembrandt and his Contemporaries* (catalogue by John Walsh, Jr.).

New York 1973b
New York, Wildenstein & Co., 8 November-15 December 1973, *12 Years of Collecting* [Carnegie Institute, Pittsburgh; unnumbered handlist].

New York 1988
New York, National Academy of Design, 1988, *Dutch and Flemish Paintings from New York Private Collections* (catalogue by Ann Jensen Adams).

New York, Toledo & Toronto 1954-5
New York, The Metropolitan Museum of Art – Toledo, The Toledo Museum of Art – Toronto, The Art Gallery of Toronto, 1954-5, *Dutch Painting: The Golden Age, An Exhibition of Dutch Pictures of the Seventeenth Century*.

Nottingham 1945
Nottingham, Nottingham Central Y.M.C.A., 10-29 September 1945, *Dutch and Flemish Art Exhibition*.

Osaka 1988
Osaka, The National Museum of Art, 19 March-15 May 1988, *The Golden Age of the Seventeenth Century. Dutch Painting from the Collection of the Frans Halsmuseum*.

Oxford 1975
Oxford, Ashmolean Museum, 10 May-27 July 1975, *Dutch Pictures at Oxford* (catalogue by Johan de Wit).

Paris 1866
Paris, Palais des Champs-Elysées, 1866, *Exposition Rétrospective. Tableaux anciens empruntés aux galeries particulières*.

Paris 1883
Paris, Galerie Georges Petit, 12 June 1883, *100 chefs-d'œuvre des collections parisiennes*.

Paris 1911
Paris, Musée du Jeu de Paume, April 1911, *Exposition rétrospective des grands et petits mâitres hollandais*.

Paris 1921
Paris, Musée du Jeu de Paume, April-May 1921, *Exposition hollandaise: tableaux, aquarelles et dessins anciens et modernes*.

Paris 1937
Paris, Bibliothèque Nationale, 1937, *Descartes Exposition organisée pour le IIIᵉ Centenaire du Discours de la Méthode*.

Paris 1946
Paris, Musée de l'Orangerie, June-August 1946, *Les chefs-d'œuvre des collections françaises retrouvées en Allemagne*.

Paris 1949
Paris, Palais des Beaux-Arts [Petit Palais], [1949], *Chefs-d'œuvre de la Pinacothèque de Munich*.

Paris 1960
Paris, Musée du Louvre, 1960, *Exposition de 700 tableaux ... tirés des réserves du département des peintures*.

Paris 1969
Paris, Musée du Louvre (Galerie Mollien), April-September 1969, *Hommage à Louis La Caze* (exhibition catalogue published in *La Revue du Louvre* XIX [1969], pp. 121-32; unnumbered).

Paris 1970
Paris, Institut Néerlandais, 20 May-28 June 1970, *Choix de la Collection Bentinck*.

Paris 1970-1
Paris, Musée du Petit Palais, 17 November 1970-15 February 1971, *Le siècle de Rembrandt: Tableaux hollandais des collections publiques françaises*.

Paris 1985-6
Paris, Musée du Louvre, 1985-6, *Anciens et Nouveaux. Choix d'œuvre acquises par l'Etat ou avec sa participation de 1981 à 1985*.

Paris 1986
Paris, Grand Palais, 19 February-30 June 1986, *De Rembrandt à Vermeer. Les peintres hollandais au Mauritshuis de la Haye* (catalogue by Ben Broos).

Paris 1987
Paris, Musée du Louvre, 1987, *Nouvelles acquisitions du Département des Peintures (1983-1986)*.

Philadelphia, Berlin & London 1984
Philadelphia, Philadelphia Museum of Art – Berlin, Staatliche Museen Preussischer Kulturbesitz – London, Royal Academy of Arts, 18 March-18 November 1984, *Masters of Seventeenth-Century Dutch Genre Painting*.

Raleigh 1959
Raleigh, North Carolina Museum of Art, 6 April-7 May 1959, *Masterpieces of Art: In Memory of William R. Valentiner (1880-1958)*.

Rome 1928
Rome, Galleria Borghese, 1928, *Mostra di Capolavori della pittura Olandese*.

Rome 1954
Rome, Palazzo delle Esposizioni, 4 January-14 February 1954, *Mostra di pittura olandese del seicento*.

Rome 1956-7
Rome, Palais des Expositions, December 1956-January 1957, *Le XVIIᵉ siècle européen*.

Rotterdam 1938
Rotterdam, Museum Boymans, 25 June-15 October 1938, *Meesterwerken uit vier eeuwen 1400-1800 ... schilderijen ... uit particuliere verzamelingen in Nederland*.

Rotterdam 1939-40
Rotterdam, Museum Boymans, 23 December 1939-29 January 1940, *Kersttentoonstelling*.

Rotterdam 1955
Rotterdam, Museum Boymans, 19 June-25 September 1955, *Kunstschatten uit Nederlandse verzamelingen*.

Rotterdam 1985
Rotterdam, Museum Boymans-van Beuningen, 19 May-14 July 1985, *Masterpieces from the Hermitage Leningrad: Dutch and Flemish Paintings of the Seventeenth Century*.

Rotterdam & Essen 1959-60
Rotterdam, Museum Boymans-van Beuningen, 14 November 1959-3 January 1960 – Essen, Museum Folkwang, 1960, *Collectie Thyssen Bornemisza (Schloss Rohoncz)*.

Rotterdam & Paris 1974-5
Rotterdam, Museum Boymans-van Beuningen, 10 November 1974-12 January 1975 – Paris, Institut Néerlandais, 24 January-9 March 1975, *Willem Buytewech: 1591-1624*.

St. Louis 1947
St. Louis, City Art Museum, 6 October-10 November 1947, *Forty Masterpieces*.

San Francisco 1939
San Francisco, Golden Gate International Exposition, 1939, *Masterworks of Five Centuries*.

San Francisco 1940
San Francisco, Palace of Fine Arts, 1940, *Art: Official Catalogue, Golden Gate International Exposition*.

San Francisco, Toledo & Boston 1966-7
San Francisco, California Palace of the Legion of Honor - Toledo, The Toledo Museum of Art – Boston, Museum of Fine Arts, 1966-7, *The Age of Rembrandt. An Exhibition of Dutch Paintings of the Seventeenth Century*.

Schaffhausen 1949
Schaffhausen, Museum zu Allerheiligen, 10 April-2 October 1949, *Rembrandt und seine Zeit*.

Sheffield 1955
Sheffield, Graves Art Gallery, 1955, *Pictures from Chatsworth*.

Sydney & Melbourne 1988
Sydney, Art Gallery of New South Wales – Melbourne, National Gallery of Victoria, 1988, *Western European Art of the 15th-20th Centuries. Masterpieces from the Hermitage Leningrad*.

Tokyo 1966
Tokyo, National Museum, 1966, *Le Grand Siècle dans les collections françaises*.

Tokyo & Kyoto 1968-9
Tokyo, National Museum for Western Art, 19 October-22 December 1968 – Kyoto, Municipal Museum, 11 January-2 March 1969, *The Age of Rembrandt, Dutch Paintings and Drawings of the 17th Century*.

Tokyo & Kyoto 1976
Tokyo, National Museum of Western Art, 10 September - 17 October 1976 – Kyoto, Municipal Museum, 1 November - 5 December 1976, *Exhibition of Masterpieces, East and West, from American Collections.*

Tokyo, Fukuoka & Kyoto 1983-4
Tokyo, Isetan Museum of Art, Shinjuku, 21 October - 4 December 1983 – Fukuoka, Fukuoka Art Museum, 6-29 January 1984 – Kyoto, Kyoto Municipal Museum of Art, 25 February - 8 April 1984, *Masterpieces of European Paintings from the Museum of Fine Arts, Boston.*

Tokyo et al. 1986
Tokyo, Nihonbasi Takashimaja Art Galleries – Toyama, Art Museum Toyama Kaminkaiken – Kumamoto, Prefectural Museum of Art – Miyagi, Miyagi Museum of Art, 1986, *Chefs d'œuvre de la Collection Bentinck-Thyssen.*

Toronto 1926
Toronto, Art Gallery of Toronto, 29 January - 28 February 1926, *Inaugural Exhibition.*

Utrecht & Brunswick 1986-7
Utrecht, Centraal Museum, 13 November 1986 - 12 January 1987 - Brunswick, Herzog Anton Ulrich-Museum, 12 February - 12 April 1987, *Holländische Malerei in neuem Licht: Hendrick ter Brugghen und seine Zeitgenossen* (catalogue by Albert Blankert and Leonard J. Slatkes).

Vienna 1873
Vienna, Österreichischen Museum für Kunst und Industrie, August - September 1873, *Gemälde alter Meister aus dem Wiener Privatbesitze.*

Washington et al. 1948-9
Washington, D.C., National Gallery of Art, 17 March - 18 April 1948, *et al., Paintings from the Berlin Museum.*

Washington 1949-50
Washington, D.C., National Gallery of Art, 1949-50, *Art Treasures from the Vienna Collections.*

Washington et al. 1975-6
Washington, D.C., National Gallery of Art, *et al.*, 1975-6, *Master Paintings from the Hermitage Museum Leningrad.*

Washington et al. 1982-3
Washington, D.C., National Gallery of Art, *et al.*, April 1982 - September 1983, *Mauritshuis: Dutch Painting of the Golden Age.*

Washington 1985-6
Washington, D.C., National Gallery of Art, 3 November 1985 - 16 March 1986, *The Treasure Houses of Britain: Five Hundred Years of Private Patronage and Art Collecting.*

Yokohama, Saporo & Hiroshima 1985-6
Yokohama, Saporo & Hiroshima, 1985-6, *Masterpieces of the Renaissance and Baroque from the Museum der bildenden Künste Leipzig* (Japanese text).

Zurich 1953
Zurich, Kunsthaus, 4 November - 20 December 1953, *Holländer des 17. Jahrhunderts.*

Index

434

436

Friends of the Royal Academy of Arts

Benefactors

Mrs Hilda Benham
The Lady Brinton
Sir Nigel and Lady Broackes
Keith Bromley Esq
The John S Cohen Foundation
The Colby Trust
Michael E Flintoff Esq
The Lady Gibson
Jack Goldhill Esq
Mrs Mary Graves
D J Hoare Esq
Irene and Hyman Kreitman
The Landmark Trust
Roland Lay Esq
The Trustees of the Leach
 Fourteenth Trust
Sir Hugh Leggatt
Mr and Mrs M S Lipworth
Sir Jack Lyons CBE
Mrs T S Mallinson
The Manor Charitable Trustees
Lieut. Col. L S Michael OBE
Jan Mitchell Esq
The Lord Moyne
The Lady Moyne
Mrs Sylvia Mulcahy
C R Nicholas Esq
Lieut. Col. Vincent Paravicini
Mrs Vincent Paravicini
Richard Park Esq
Phillips Fine Art Auctioneer
Mrs Denise Rapp
Mrs Adrianne Reed
The Late Anne M Roxburgh
Mrs Basil Samuel
Sir Eric Sharp CBE
The Reverend Prebendary E F Shotter
Dr Francis Singer
Lady Daphne Straight
Mrs Pamela Synge
Harry Teacher Esq
The Henry Vyner Charitable Trust
A Witkin. Vacuum Instruments
 & Products Ltd
Charles Wollaston Esq

Individual Sponsors

Gerald M Abraham Esq
Kent Alessandro Esq
Richard Alston Esq
I F C Anstruther Esq
Mrs Ann Appelbe
Dwight W Arundale Esq
J R Asprey Esq
Edgar Astaire Esq
W M Ballantyne Esq
M G Bell Esq
Mrs Olive Bell
E P Bennett Esq
P F J Bennet Esq
Miss A S Bergman
Mrs Susan Besser
P G Bird Esq
Mrs L Blackstone
Peter Boizot Esq
Peter Bowring Esq
Miss Betty Box OBE

Mrs J M Bracegirdle
John H Brandler Esq
Lady Brown
Jeremy Brown Esq
Mrs Susan Burns
Richard Butler Esq
Mrs A Cadbury
Mr and Mrs R Cadbury
Mrs L Cantor
Miss E M Cassin
Mrs F M Cator
W J Chapman Esq
Miss A Chilcott Fawcett
Ian Christie Esq
Mrs Joanna V Clarke
Clarkson Jersey Charitable Trust
Mrs R Cohen
Mrs N S Conrad
Mrs Elizabeth Corob
C Cotton Esq
Philip Daubeny Esq
Miss C H Dawes
John Denham Esq
The Marquess of Douro
Kenneth Edwards Esq
Miss Beryl Eeman
Charles and Lady Katherine Farrell
S Isern Feliu Esq
Mrs J G G Firth
Dr Gert-Rudolf Flick
J G Fogel Esq
M J Foley Esq
Ronald D Fowler Esq
Miss C Fox
Jeremy Francis Esq
Princess Ira Von Furstenberg
R P Gapper Esq
Graham Gauld Esq
M V Gauntlett Esq
Robert Gavron Esq
Stephen A Geiger Esq
Lady Gibberd
Mrs E J Gillespie
Anthony Goatman Esq
Michael I Godbee Esq
Mrs P Goldsmith
Michael P Goodman Esq
P G Goulandris Esq
Gavin Graham Esq
Mrs J M Grant
R Wallington Green Esq
Mrs M Greissmann
Mrs O Grogan
Mrs P O V H Grogan
Mrs W Grubman
J A Hadjipateras Esq
Mrs L Hadjipateras
Jonathan D Harris Esq
Richard M Harris Esq
Miss Julia Hazandras
R Headlam Esq
M Z Hepker Esq
M Herring Esq
Mrs Penelope Heseltine
Mrs K S Hill
R J Hoare Esq
Reginald Hoe Esq
Charles Howard Esq
Mrs Annemarie Howitt
John Hughes Esq
Christopher R Hull Esq

David Hyman Esq
Norman J Hymans Esq
Mrs Manya Igel
Mr and Mrs Evan Innes
J P Jacobs Esq
Mrs J C Jaqua
Alan Jeavons Esq
Mrs Sonya Jenkins
H Joels Esq
Irwin Joffe Esq
Lady Joseph
G M A Joseph Esq
Roger Jospe Esq
Mr and Mrs Kaham
Mr and Mrs S H Karmel
Mrs M Kidd
Peter W Kininmouth Esq
Mrs C Kirkham
Andria Thal Lass
R A Lee Esq
Morris Leigh Esq
Mr and Mrs R Leiman
Mr and Mrs N S Lersten
David Levinson Esq
David Lewis Esq
Owen Luder Esq
Mrs Graham Lyons
Ciaran Macgonigal Esq
Mrs G M S McIntosh
Peter McMean Esq
Stuart MacWhirter Esq
Mrs S G Maddocks
Mrs H Malouf
Dr Abraham Marcus
Jan Marks Esq
The Hon Simon Marks
B P Marsh Esq
Dr A D Spalding Martin
J B H Martin Esq
R C Martin Esq
Christopher Mason-Watts Esq
P Matthewman Esq
Dr D S J Maw
A Mehta Esq
M H Meissner Esq
The Hon Stephen Monson
Mrs Alan Morgan
Mrs Angela Morrison
Mrs A K S Morton
Miss L Moule
A H J Muir Esq
The Michael Naughton Foundation
The Oakmoor Trust
Ocean Transport and Trading PLC
Mrs E M Oppenheim Sandelson
Anthony Osmond-Evans Esq
Brian R Oury Esq
R A Parkin Esq
Mrs Jo Palmer
Mrs Olive Pettit
Mrs M C S Philip
Ralph Picken Esq
G B Pincus Esq
William Plapinger Esq
Barry G Rebell Esq
Mrs Margaret Reeves
F Peter Robinson Esq
D Rocklin Esq
The Rt Hon Lord Rootes
Baron Elie de Rothschild
Mr and Mrs Oliver Roux

The Rufford Foundation
The Hon Sir Steven Runciman CB
Mrs Margaret Rymer
Saddlers Company
Sir Robert Sainsbury
Gregoire Salamanowitz Esq
Lady Samuel
Mrs Bernice Sandelson
Selcuk Avci Esq
V Schonfield Esq
Mrs Bern L Schwartz
Fouad Shasha Esq
Christopher Shaw Esq
Mrs Pamela Sheridan
Desmond de Silva Esq QC
R J Simia Esq
R J Simmons Esq
The Spencer Wills Trust
Cyril Stein Esq
James Q Stringer Esq
Mrs B Stubbs
Mrs A Susman
Robin Symes Esq
Nikolas D Tarling Esq
G C A Thom Esq
Anthony H Thornton Esq
P Tingey Esq
Herbert R Towning Esq
W van der Spek Esq
Mrs C R Walford
Kenneth J Wardell Esq
Neil Warren Esq
Mrs V Watson
J B Watton Esq
Miss L West Russell
W Weston Esq
Frank S Wenstrom Esq
R A M Whitaker Esq
J Wickham Esq
Graham V Willcox Esq
Anthony Wilson Esq
David Wilson Esq
Peter Windert Esq
Mrs Bella Wingate
B G Wolfson Esq
Mrs S Wood
W M Wood Esq
Fred S Worms Esq
Mr and Mrs M Yamauchi
John P Zinn Esq

Royal Academy Trust

Corporate Members

Arthur Andersen & Co
BAT Industries PLC
Britannia Arrow Holdings PL
British Alcan Aluminium PLC
British Gas PLC
British Telecom
Chelsfield PLC
Chesterton International
Cookson Group PLC
The Daily Telegraph
Diamond Trading Company Ltd
Alfred Dunhill Ltd
Esso UK PLC
Ford Motor Company Ltd
John Laing PLC
Josef Gartner & Co (UK) Ltd
Glaxo Holdings PLC
Grand Metropolitan PLC
Hillier Parker
ICI PLC
The Levitt Group Ltd
Lex Service PLC
Logica PLC
London & Edinburgh Trust PLC
Marks and Spencer PLC
MoMart Ltd
Mountleigh Group PLC
Nico Construction Ltd
The Nikko Securities Co, (Europe) Ltd
R J Reynolds International Inc
Rosehaugh PLC
Rothmans International PLC
Rothmans International Tobacco (UK) Ltd
Royal Insurance Holdings PLC
Shearson Lehman Hutton International Inc
Sibec Group
TI Group PLC
Thorn EMI PLC
Unilever
Williams Lea Group Ltd

Corporate Associates

3i PLC
Allen & Overy
Allsop & Co
American Express Europe Ltd
Arco British Ltd
Arthur Young
The Arts Club
Art For Offices
Ashurst Morris Crisp
Bankers Trust Company
Banque Paribas
Barclays Bank PLC
Bass PLC
Beecham Group PLC
BET PLC
The BOC Group
Booker PLC
Bovis Construction Ltd
British & Commonwealth Holdings PLC
British Olivetti Ltd
BP International
Brixton Estate PLC
Bunzl PLC
Burmah Oil Trading Ltd
H P Bulmer Holdings PLC

C & A
Cable and Wireless PLC
CJA (Management Recruitment
 Consultants) Ltd
Capital & Counties PLC
Carlton Beck
Charles Scott & Partners
Charterhouse PLC
The Chase Manhattan Bank NA
Christie's
The Churchill
Clifford Chance
Costain Group PLC
Courage Charitable Trust
Coutts & Co
CoxMoore PLC
The De La Rue Company PLC
Deutsche Bank AG
Durrington Corporation
Eagle Star Insurance Company Ltd
Econocom UK Ltd
Edward Erdman
ED & F Man Ltd. Charitable Trust
Enterprise Oil PLC
Financial Group of North Atlantic Ltd
Gardiner & Theobald
Gavin Martin Ltd
General Accident
Gleeds
Global Asset Management
Goldman Sachs International Ltd
Granada Group
Greycoat PLC
Guiness PLC
Guiness Mahon Holdings PLC
The Hammerson Group
Hay Management Consultants Ltd
HJ Heinz Company Ltd
IBM UK Ltd
Ibstock Johnsen PLC
Inchcape PLC
Jaguar Cars Ltd
Johnson Wax Ltd
KHBB
Kleinwort Benson Group PLC
Kodak Ltd
Ladbroke Group PLC
Laurentian Holding Company Ltd
John Lewis Partnership PLC
J Walter Thompson Company Ltd
Lister Drew Haines Barrow Architects
London Wall Holdings PLC
London Weekend Television
Marlborough Fine Art (London) Ltd
Mars Corporate Services
Martini & Rossi
MEPC PLC
The Worshipful Company of Mercers
Michael Peters Group
Morgan Guaranty Trust Co of New York
Morgan, Lewis & Bockius
Morgan Stanley International
Nabarro Nathanson
National Westminster Bank PLC
NCR Ltd
NEC (UK) Ltd
The Nestle Charitable Trust
Occidental International Oil Inc
Olympia & York
Ove Arup Partnership
The Park Lane Hotel

Pearson PLC
The Peninsular & Oriental Steam
 Navigation Company
Pentagram Design Ltd
Pentland Industries PLC
Petrofina (UK) Ltd
Pilkington Glass Ltd
The Post Office
Priest Marians Holdings PLC
Publicis
Quanta Group (Holdings) Ltd
Renton Howard Wood Levin (Partnership)
Richard Ellis
Richardson Greenshields of Canada Ltd
The Royal Bank of Scotland PLC
RTZ Ltd
J Rothschild Holdings PLC
J Sainsbury
Save & Prosper Educational Trust
J Henry Schroder Wagg & Co Ltd
Sears PLC
The Sedgwick Group PLC
Slough Estates PLC
W H Smith & Son Ltd
Smith & Williamson
Smiths Industries PLC
Solaglas International BV
Sony UK Ltd
Sotheby's
Speyhawk Public Ltd Company
Stanhope Properties PLC
Staveley Industries PLC
StoyHayward
Sun Life Assurance Society PLC
Sir Richard Sutton's Settled Estates
Taylor Joynson Garrett
Thames Television PLC
Thos Agnew & Sons Ltd
Tomkins PLC
Trusthouse Forte
TVS Entertainment
UEI PLC
United Biscuits (UK) Ltd
Vogue
S G Warburg Group PLC
The Wellcome Foundation Ltd
Wickes PLC
Wood & Wood International Signs Ltd
Yamaichi International (Europe) Ltd

Sponsors of Past Exhibitions

The Council of the Royal Academy thanks sponsors of past exhibitions for their support. Sponsors of major exhibitions during the last ten years have been included.

AMERICAN EXPRESS FOUNDATION
Masters of 17th-Century Dutch Genre Painting 1984
Je suis le cahier: The Sketchbooks of Picasso 1986

ARTS COUNCIL OF GREAT BRITAIN
John Flaxman 1979
Ivan Hitchens 1979
Algernon Newton 1980
New Spirit in Painting 1981
Gertrude Hermes 1981
Carel Weight 1982
Elizabeth Blackadder 1982
Allan Gwynne Jones 1983
The Hague School 1983
Peter Greenham 1985

BANQUE INDOSUEZ
Gaugin and the School of Pont-Aven 1989

BAT INDUSTRIES PLC
Murillo 1983
Paintings from the Royal Academy US Tour 1982/4, RA 1984

BECK'S BIER
German Art in the 20th Century 1985

BENSON & HEDGES
The Gold of El Dorado 1979

W.I. CARR
Gauguin and the School of Pont-Aven 1989

BOVIS CONSTRUCTION LTD
New Architecture 1986

BRITISH ALCAN ALUMINIUM
Sir Alfred Gilbert 1986

BRITISH GYPSUM LTD
New Architecture 1986

BRITISH PETROLEUM PLC
British Art in the 20th Century 1985

CANARY WHARF DEVELOPMENT CO
New Architecture 1986

THE CHASE MANHATTAN BANK
Cézanne: The Early Years 1988

CHRISTIE'S
Treasures from Chatsworth 1980

COUTTS & CO
Derby Day 200 1979

THE DAILY TELEGRAPH
Treasures from Chatsworth 1980

DEUTSCHE BANK AG
German Art in the 20th Century 1985

ELECTRICITY COUNCIL
New Architecture 1986

ESSO PETROLEUM COMPANY LTD
British Art Now: An American Perspective
Summer Exhibition 1988

FINANCIAL TIMES
Derby Day 200 1979

FIRST NATIONAL BANK OF CHICAGO
Chagall 1985

FRIENDS OF THE ROYAL ACADEMY
Elizabeth Blackadder 1982
Carel Weight 1982
Allan Gwynne Jones 1983
Peter Greenham 1985
Sir Alfred Gilbert 1986

JOSEPH GARTNER
New Architecture 1986

J. PAUL GETTY JR. CHARITABLE TRUST
Age of Chivalry 1987

GLAXO HOLDINGS PLC
From Byzantium to El Greco 1987

CALOUSTE GULBENKIAN FOUNDATION
Portuguese Art Since 1910 1978

DR ARMAND HAMMER &
 THE ARMAND HAMMER FOUNDATION
Honoré Daumier 1981
Leonardo da Vinci Nature Studies
Codex Hammer 1981

THE HENRY MOORE FOUNDATION
Henry Moore 1988

HOECHST (UK) LTD
German Art in the 20th Century 1985

IBM UNITED KINGDOM LTD
Post-Impressionism 1979
Summer Exhibition 1983

THE JAPAN FOUNDATION
The Great Japan Exhibition 1981

JOANNOU & PARASKEVAIDES (OVERSEAS) LTD
From Byzantium to El Greco 1987

LLOYDS BANK
Age of Chivalry 1987

LOGICA
The Art of Photography 1989

LUFTHANSA
German Art in the 20th Century 1985

MARTINI & ROSSI LTD
Painting in Naples from Caravaggio to Giordano 1982

MELITTA
German Art in the 20th Century 1985

MELLON FOUNDATION
Rowlandson Drawings 1978

MERCEDES-BENZ
German Art in the 20th Century 1985

MIDLAND BANK PLC
The Great Japan Exhibition 1981
The Art of Photography 1989

MOBIL
Treasures from Ancient Nigeria 1982
Modern Masters from the Thyssen-Bornemisza Collection 1984
From Byzantium to El Greco 1987

MOËT & CHANDON
Derby Day 200 1979

NATIONAL WESTMINSTER BANK
Reynolds 1986

THE OBSERVER
Standey Spencer 1980
The Great Japan Exhibition 1981

OLIVETTI
Horses of San Marco 1979
The Cimabue Crucifix 1983
The Last Supper 1988

OTIS ELEVATORS
New Architecture 1986

OVERSEAS CONTAINERS LTD
The Great Japan Exhibition 1981

PEARSON PLC
Eduardo Paolozzi Underground 1986

PILKINGTON GLASS
New Architecture 1986

PRINGLE OF SCOTLAND
The Great Japan Exhibition 1981

REED INTERNATIONAL PLC
Toulouse-Lautrec
The Graphic Works 1988

REPUBLIC NEW YORK CORPORATION
Andrew Wyeth 1980

ROBERT BOSCH LTD
German Art in the 20th Century 1985

ARTHUR M. SACKLER FOUNDATION
Jewels of the Ancients 1987

SALOMON BROTHERS
Henry Moore 1988

SEA CONTAINERS &
 VENICE SIMPLON-ORIENT EXPRESS
Genius of Venice 1983

SHELL (UK) LTD
Treasures from Chatsworth 1980

THE SHELL COMPANIES OF JAPAN
The Great Japan Exhibition 1981

SIEMENS
German Art in the 20th Century 1985

SOTHEBY'S
Derby Day 200 1979

SWAN HELLENIC
Edward Lear 1985

JOHN SWIRE
The Great Japan Exhibition 1981

THE TIMES
Old Master Paintings from the Thyssen-Bornemisza Collection 1988

TRAFALGAR HOUSE
Elisabeth Frink 1985

TRUSTHOUSE FORTE
Edward Lear 1985

UNILEVER
Lord Leverhulme 1980
The Hague School 1983
Frans Hals 1990

WALKER BOOKS LTD
Edward Lear 1985

WEDGWOOD
John Flaxman 1979

WINSOR & NEWTON WITH
 RECKITT & COLMAN
Algernon Newton 1980